INTERIOR
DESIGN
&DECORATION

INTERIOR DESIGN &DECORATION

FIFTH EDITION

Sherrill Whiton
Stanley Abercrombie

Prentice Hall

Upper Saddle River, New Jersey 07458

Library of Congress Cataloging-in-Publication Data

Whiton, Augustus Sherrill, 1887–1961.
 Interior design and decoration/Sherrill Whiton, Stanley Abercrombie.—5th ed.
 p. cm.
 Includes bibliographical references and index.
 ISBN 0–13–030748–3
 1. Interior decoration. 2. Decoration and ornament. I. Abercrombie, Stanley. II. Title.
NK2110.W55 2001
 747'.09—dc21 2001021252

VP/Editorial Director: *Charlyce Jones Owen*
Acquisitions Editor: *Bud Therien*
Assistant Editor: *Kimberly Chastain*
Development Editor-in-Chief: *Susanna Lesan*
Development Editor: *Gerald Lombardi*
Director of Production and Manufacturing: *Barbara Kittle*
Production Editor: *Louise Rothman*
Editorial Assistant: *Wendy Yurash*
Prepress and Manufacturing Manager: *Nick Sklitsis*
Assistant Manufacturing Manager: *Mary Ann Gloriande*
Prepress and Manufacturing Buyer: *Sherry Lewis*

Marketing Director: *Beth Gillett Mejia*
Marketing Manager: *Sheryl Adams*
Creative Design Director: *Leslie Osher*
Interior and Cover Design: *Kathryn Foot*
Director, Image Resources: *Melinda Reo*
Photo Research Supervisor: *Beth Boyd*
Photo Researcher: *Karen Pugliano*
Image Permission Supervisor: *Kay Dellosa*
Manager, Production/Formatting and Art: *Guy Ruggiero*
Electronic Page Layout: *Rosemary Ross*
Electronic Art Creation: *Maria Piper and Mirella Signoretto*

Cover Art: The double-height interior of Inigo Jones's Banqueting House. The ceiling painting is by Rubens. Photo: Crown Copyright, reproduced with permission of the Controller of Her Majesty's Stationery Office. Historic Royal Palaces Enterprises, Ltd.

This book was set in 11/13 Cantoria MT Light by Prentice Hall in-house formatting and was printed and bound by Web Crafters. The cover was printed by Web Crafters.

Pearson Education LTD., London
Pearson Education Australia PTY, Limited, Sydney
Pearson Education Singapore, Pte. Ltd
Pearson Education North Asia Ltd, Hong Kong
Pearson Education Canada, Ltd., Toronto
Pearson Educación de Mexico, S.A. de C.V.
Pearson Education —Japan, Tokyo
Pearson Education Malaysia, Pte. Ltd
Pearson Education, Upper Saddle River, New Jersey

CONTENTS

THE CLASSICAL WORLD

PART 2

PART

4

THE EAST

PART

5

THE RENAISSANCE

PART
7

THE MODERN WORLD

Preface

Sherrill Whiton and his Book

It has been said that the modern profession of interior design was established by Edith Wharton and Elsie de Wolfe. It might also be said that the modern discipline of interior design was established by Frank Alvah Parsons, for whom the Parsons School of Design was named, and Sherrill Whiton. (In both cases, admittedly, the claims oversimplify a complex history.)

Augustus Sherrill Whiton, the author of the original text on which the present book is based, was the founder and first president of the New York School of Interior Design. One might imagine that his text had been developed for the school, but the genesis of the text actually preceded the school (and, by three years, Parsons's own textbook, now long out of print). Whiton was born in New York in 1887, the son of Louis Claude Whiton, a lawyer, and the former Harriet Bell. He earned a degree in architecture at Columbia University, then went to Paris for the study at the Ecôle des Beaux-Arts that was every architecture student's goal at the time. While in Paris, he married Claire Henriette Bouché. Her family was French, but had moved to New York in the 1870s, and Claire's father, Henri Bouché, was a designer employed by Tiffany & Co.

Back in New York and finding the field of architecture in a slow period, Whiton conceived and wrote a series of Home Study Catalogues in the Decorative Arts. The first catalogue was published in 1916 and was followed by several others. During the next years, Whiton's home study readers frequently stopped at his office on East 40th Street, many of them hoping to find classes being taught there. Finally, in 1924, Whiton opened what was at first called the New York School of Interior Decoration. Its first home was in a building on the southwest corner of Madison Avenue and 57th Street, where the IBM headquarters now stands.

The home study manuals were assembled in book form and published by Lippincott in 1937 as *Elements of Interior Decoration*. The book was reissued in 1944. New editions in 1951, 1957, and 1963 were retitled *Elements of Interior Design and Decoration*, the last of these being published after Whiton's death in 1961. Whiton was succeeded as both the director of the school and the reviser of the textbook by his son, Sherrill ("Pete") Whiton, Jr. After the latter's early and sudden death in 1972, his revision, titled simply *Interior Design and Decoration*, was also published posthumously. In the late 1980s, Arthur Satz, then president of the New York School of Interior Design, and design writer Nick Polites began a thorough revision, which was to be based on new chapters contributed by a variety of scholarly experts, but that work was never completed.

Preparing the present revision has brought heightened respect for Sherrill Whiton's pioneering accomplishment, and it is presented with admiration and gratitude for his work. I also thank the late architect and author Paul Heyer, who, while president of the New York School of Interior Design, first suggested that I undertake the book's revision, and Inge Heckel, Paul's successor, who has been an enthusiastic advocate for the project. Among the many scholars whose ideas I have depended upon are Professor Jody Brotherston of Louisiana Tech University, who helped substantially with the chapter on Spanish design, and Dr. David G. De Long of the University of Pennsylvania, who suggested corrections and clarifications for the first five chapters. Later chapters were reviewed by Mary Ann Beecher, Iowa State University; Denise Bertoncino, University of Arkansas; Theodore Drab, University of Oklahoma; Victoria Brinn Feinberg, CSU at Northridge; Abe Kadushin, Eastern Michigan University; Nancy Kwallek, University of Texas, Austin; James Landis, International Academy of Merchandising Design; Maureen Mitton, University of Wisconsin at Stout; Christine Myers, University of Arkansas; Luann Nissen. University of Nevada, Reno; Sharran Parkinson, Ohio Univer-

sity; Nicholas Politis, Fashion Institute of Technology, New York; Susan Ray-Degges, North Dakota State University; Karen Rutherford, Indiana State University; Margaret Segalla, Brooks College, California; Ludwig Villasi, Kansas State; and Crystal Weaver, Savannah College of Art and Design.

At Prentice Hall, I thank publisher Bud Therien, who gave his support to Interior Design as fine art; assistant editor Kimberly Chastain, who has been patient and helpful; Gerald Lombardi, whose fearless (and sometimes ferocious!) suggestions for cutting brought the book down to size; Karen Pugliano, tireless picture researcher who searched far and wide to find the wanted illustration at every point; and Louise Rothman, who somehow kept track of all of the pieces and saw the book through the production process. I am particularly grateful to photographer Peter Paige, Upper Saddle River, NJ, and the Chicago photography studio of Hedrich-Blessing for their skill and generosity.

To the Instructor: How the Book Has Been Changed

In many schools of interior design, Sherrill Whiton's book has been known for generations as "the bible," and tampering with the bible, I realize, is heresy. Trying to avert the academic equivalent of being burned at the stake, therefore, I would like to explain what changes have been made.

Covering the Years Between 1974 and 2000

With a quarter century having passed since the Whiton book was last readied for publication, it is obvious that new material was needed to cover the interior design developments of that period. Those developments have been many. Stylistically, they include neo-ornamentalism, postmodernism, and deconstructionism, to name only three. Technically, they include new composite materials, new acoustic controls, and new lighting types. The profession itself has new organizations, new certification laws, and new developments in design school

accreditation. And the practicing designer faces new fire-safety and abrasion-resistance requirements for furniture and fabrics, new accommodations for universal access, and new issues of environmentalism. This revision attempts to cover all these developments and more.

Reorganizing the Material

Another change is that the contents are being presented in a different order. In previous editions of the Whiton book, two long sections, "Period Decoration and Furniture" and "Contemporary Design," together comprising more than two-thirds of the book, chronologically related the history of interior design from antiquity to the present, with the last chapter of the first section giving separately the history of painting and sculpture, retracing the chronology. The sections that followed, "The Basic Interior" and "Selection, Arrangement, and Harmony" (this last section divided in the 1974 edition into "Design Materials and Accessories," and "Interior Planning") gave detailed information about the component materials and techniques developed during that history. In the present edition, the histories of interior design and the fine arts are given together, and the information about materials and techniques has been integrated with those histories, featured along with the accounts of the periods when they were first developed or became important.

A final chapter in the 1974 edition, "Socio-Psychological Aspects of Interior Design," has been omitted, even its author, my respected colleague Ann Ferebee, now considering it outdated. That does not mean, of course, that interior design does not continue to have social and psychological implications, and references to those implications will be found throughout the book.

The organization of the various chapters necessarily varies from one to another, but some attempt has been made at standardization. Chapters generally begin with some consideration of design determinants. Sometimes, as in the case of Egypt, these determinants are predominantly geographical; often, as in the case of India, they are primarily religious; and, increasingly as we approach modern times, they are technological. Also near the beginning of each chapter is a historical sum-

mary outlining key periods, dynasties, rulers, or events. After these sketches of design determinants and chronologies, artistic accomplishments are reviewed. In most cases, these are in the order of decreasing scale—architecture first, then interior design, then furniture design, and finally decorative arts and decorative details. A summarizing review of common characteristics closes each chapter.

Broadening the Scope

The scope of Whiton's original text focused on design in the Western tradition, and that focus still remains. Some enlargements of sections within that tradition have been made, however, and some further ventures into cultures outside that tradition. For example, descriptions of the design of Crete and Persia, each formerly limited to a paragraph between Whiton's chapters on Egypt and Greece, have now been expanded. A former section titled "Miscellaneous Styles and Arts" has been broken apart, its major components now enlarged and placed chronologically within the world picture, resulting in, for example, new chapters on the design of Japan, India, and Islamic design.

The motivation for these expansions has not been a desire for "political correctness," legitimate as that may be, but a realistic acknowledgment of the increasing internationalism of today's interior design practice and of today's interior design. The designer of the coming decades will want to be prepared to work globally and will want a broad knowledge of the styles and techniques of many different times, locations, and civilizations.

Becoming More Visual

In a textbook on interior design and the decorative arts, a picture may be worth much more than a thousand words. In this revision, the number of color images has been greatly increased, and those images have been distributed more evenly throughout the book. Among the black and white illustrations, the meticulous line drawings by Gilbert Werlé, a faculty member of Sherrill Whiton's school, have been retained from the first edition and restored to their original compositions. In increasing the total number of illustrations, attention has been given not only to increasing the number of subjects covered, but also to increasing the number of presentation techniques represented, thus helping the student develop a useful vocabulary of those techniques.

Finally, some information formerly presented only in written form is now presented graphically, as in chronologies presented in the form of timelines. In addition to timelines, other learning aids now supplement the text, giving parenthetical information or clarifications. These are in the form of boxes distributed through the text, and they are of several types, chiefly Vocabulary boxes explaining the forms, variations, and spellings of terms and, where appropriate, their pronunciations.

Revising the Glossary

Several small glossaries at the ends of chapters in the 1974 edition have been combined into one greatly expanded glossary at the end of the book. In the text itself, important figures and terms are still identified when they first play an important role, now being printed in **bold type** and immediately described or defined. All words and phrases in **bold type** are listed in the Glossary; foreign terms in *italic* type are not.

Revising Bibliographies

Obviously, many new books have been written since the 1974 edition was published, and many of these have been added. Books listed in previous editions that the present author was unable to find or no longer found useful have been eliminated. The bibliography is both larger and more specific, divided by chapter, and some of the entries have been annotated.

Continuing the Revision: A Request for Help

No edition of a book so ambitious in scope and covering so volatile a field can ever be complete. This one will soon need its own overhaul. Some valuable elements of earlier editions may be seen to have been overlooked and will need to be reinstated; some facts may be discovered wrong; some emphases may be considered misplaced; further

changes in taste and in professional practice may require further changes in the text; and—the happiest prospect of all—new design will deserve new illustrations. For all these future improvements and corrections, I ask your help. The more professional advice and collaboration I receive, the more useful can be the next edition. Please, therefore, send your comments, criticisms, and suggestions directly to the desk where I will be working on that edition: Stanley Abercrombie, 17273 Seventh St. East, Sonoma, CA 95476. Thank you.

To the Student: How the Book Can Be Used

A perfect memory for the contents of a book would surely be a useful thing, but far more valuable is a rich imagination applied to those contents. For this book, such an application could be accomplished in many ways; here are five of them. A few examples of the first three will be given near the end of each chapter in sections called "Summary." The last two will depend solely on individual initiative.

Looking for Character

In looking at the book's images and reading their descriptions, it is important to discern the underlying characteristics of their subjects, both as groups and as individuals. Ask yourself, for example, which characteristics seem to be common to all Greek vases and which seem specific to a single vase; the answers may then enable you to identify and evaluate a Greek vase you have never seen before. Or ask what a Gothic chalice has in common with Gothic window tracery, and the answer may enable you to look at an altar screen and identify it as Gothic. An important factor in becoming a successful designer is the development—a development that comes only from experience—of an "eye," and an important part of having an "eye" is knowing what you are seeing.

Looking for Quality

Not everyone is required to like everything, and all the objects illustrated here are not equal in value.

By all means, form opinions and then examine them. Consider what the rooms and objects you like most may have in common, or the rooms and objects you like least. Discuss with your fellow students and instructor why one piece of furniture may be a finer example than another. Test yourself to see if your attitude toward an object changes as your knowledge about it develops. Another important factor of a designer's "eye" is informed judgment.

Making Comparisons

Effort has been made to present the book's material in an orderly, coherent way but it can be instructive to ignore the book's organization at times and compare things from diverse times and places. After the first few chapters, therefore, we shall begin not only to look for character and quality within a single chapter's content, but also to compare spaces and objects from one chapter with similar spaces and objects from others.

What, you might ask, is the formal relationship between a Roman basilica and an Early Christian basilica? What are the correspondences among the cabriole leg of a Queen Anne chair, the so-called "cabriole" leg of a Chinese daybed, and a curving door lever of the modern period? Among a Greek Ionic capital, a Roman Ionic capital, and the capital of a postmodern "Ionic" column by Robert Venturi? The difference between a Gothic ceiling and a Gothic Revival ceiling? Such comparisons strengthen our understanding of stylistic character, and they also help develop our understanding of which styles may be compatible with one another. Learning to identify inherent commonalities and potentially sympathetic combinations is another part of becoming a skilled designer.

Looking at Presentations

A major task of a book with a subject such as this one is to present three-dimensional spaces and objects on two-dimensional pages. It is a task that the practicing designer faces constantly. Attention should be given, therefore, to the number of different presentation techniques that perform that task here: plans, elevations, sections, and composite views, line drawings and washes, freehand sketches and ruled drawings. An interesting per-

sonal exercise is to take a presentation style from one page and apply it to a subject on another page. Such experimentation will strengthen your understanding of which techniques are most appropriate for conveying different types of information and which are most appropriate for your own tastes and skills.

Imagining Possibilities

Perhaps the most useful exercise of all is to consider the effects of changes, alterations, and new combinations. If the color of the Korean celadon vase were deeper, what would be the result? What if the dimensions of the office cubicle were a foot smaller? If the bedpost were thicker? If the fabric texture were rougher? If the light were reflected off the ceiling rather than shining directly on the desk? If the armchair shown on one page were moved into the reception room shown on another page? In the practice of interior design, the possibilities and choices are unlimited. The ambitious student will use this book in every way possible to explore those choices and envision their results.

INTERIOR
DESIGN
&DECORATION

CHAPTER

1

DESIGN BEFORE HISTORY

BEFORE 3400 B.C.

In the earliest traces of human life that we have been able to investigate, we find evidence of two human inclinations. One is the nesting instinct, or the desire for a permanent and personal home. The other is the artistic instinct, or the urge to create visual order and visual significance. These two inclinations remain today, as they were in prehistoric times, the bases of interior design.

Prehistoric times are simply the times of human development that preceded written records. The earliest roots of interior design were in this preliterate time, but we know little about the creatures who might be called the first interior designers, or even about the

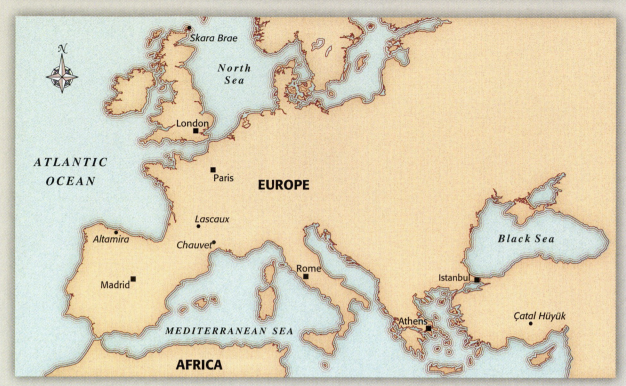

Figure 1–1 Map of locations mentioned in this chapter. Ancient sites are shown in italic type, modern cities in roman type.

ORTELIUS DESIGN

creatures who might be called the first humans. Prehistoric times ended and history began with the invention of writing c. 3400 B.C. by the Sumerians in what is now Iraq.

The Arts of Prehistory

The terms prehistoric art and primitive art have very different meanings. Prehistoric art may not be primitive, and primitive art may not be prehistoric. *Prehistoric* is a term relating to time, specifically to the preliterate period. *Primitive* relates to character, specifically to a simple, crude, or untrained character. Some of the earliest art we know, such as the exquisitely realistic animal murals in French and Spanish caves, are prehistoric but hardly primitive. Some later art of the New Stone Age, however, regressing to a hasty shorthand of abstract strokes, could fairly be said to have become primitive. And so-called primitive art

continues to be produced today in native villages and even in the hearts of great cities throughout the world.

We must be careful not to misuse the term *primitive*. Many observers, outside the tradition in which a particular art is produced, may assume an art to be primitive, while those within the tradition, aware of the art's significance and subtleties, recognize it to be quite sophisticated. We must also be careful not to think of primitive art as being negligible or unworthy. It can be moving, and it can be powerful. Artists of the early modern period found valuable inspiration in primitive art. Today, accustomed as we are to interpreting abstractions of every kind, much primitive art is meaningful to us to a degree previously unknown outside the communities for which it was made. While few of us would be comfortable in a thoroughly primitive interior, elements from primitive cultures can make arresting and stimulating contributions to the most elegant rooms.

- A convention followed in this book describes dates more than 10,000 years before the present as a number of "years ago." In other books and articles, this is sometimes abbreviated as *y.a.*, and sometimes as *b.p.*, "before the present."
- Dates more recent than 10,000 years ago but older than the year 1 are expressed here as *B.C.*, "before Christ."
- In other readings, the abbreviations *B.C.E.* and *C.E.* may be seen, meaning "before the common era" and "common era."

- In the Christian calendar, there was no year zero. Dates more recent than the year 1 are expressed as *A.D.*, "Anno Domini" or "year of our Lord." Most dates in the book will be in the last group, of course, and when there can be no confusion, the *A.D.* will be omitted.
- As is customary, the abbreviation *B.C.* will be placed after the date, and the abbreviation *A.D.* before the date.
- The abbreviation *c.* before a date, meaning "circa" or "around," indicates that the date is inexact.

We should also be careful not to assume that prehistoric humans had no regard for history. Many societies, before developing a written language, developed a tradition of oral history. Their cultural legends, myths, and facts were passed along by speech. Other distinctions to be made within the general field of art, design, and decoration concern the specific type of activity undertaken or the specific medium used. One of these specialized areas is the art called *interior design*.

What is interior design? Interior design is the composition and adornment of interior spaces on a habitable scale. It is an art that usually occurs within the art of architecture, but not always; the cave dwellings that will be mentioned in this chapter are among the exceptions. When interior design does occur within architecture, however, these two arts must usually find some means of relating to one another in order that the total result may have a pleasing coherence. These two arts also share some of the same materials, techniques, and forms.

Which of these twin arts, architecture and interior design, should be conceived first, which should lead the other, and which should dominate their collaboration, are questions that must be decided on the basis of specific circumstances and talents. It is worth noting, however, that the great twentieth-century architect Le Corbusier, in his 1923 book *Towards a New Architecture*, wrote: "A

plan proceeds from within to without. A building is like a soap bubble. This bubble is perfect and harmonious if the breath has been evenly distributed and regulated from the inside. The exterior is the result of the interior."

It is also noteworthy that, because the interior design of prehistory seems to have begun within naturally existing caves before any long-lasting freestanding structures were erected, we can say that interior design seems to be older than architecture. Indeed, the cave culture endured for more than 20,000 years, nearly twice as long as the time that has passed since it ended.

Both architecture and interior design, in any case, arose from the human need for appropriate shelter. And the need for shelter, along with the needs for food and clothing, must have arisen as different aspects of the single, even more basic, urge for self-preservation. Shelter, whether found or constructed, responded to this urge by providing protection against climate and preying animals. Later, it was surely seen as satisfying a more subtle need, that for some territory that was personal and private. Primitive humans must have made progress in their long evolution toward becoming recognizable individuals by providing themselves with acknowledged addresses, and a personalized environment must have supported the development of human personality. We shall look briefly at a few steps in that process.

The Stone Ages

The earliest art we know dates from the periods called the Stone Ages. The Old Stone Age is sometimes called the age of chipped stone, because tools were made by chipping stone until sharp edges were produced. Archaeologists and anthropologists call it the Paleolithic period. It is generally considered to have begun about 35,000 years ago and to have ended c. 8000 B.C.

The New Stone Age is sometimes called the age of polished stone, for its stone tools came to be more skillfully finished. Scientists call it the Neolithic period. They also identify an intermediate period that was a transition between Old Stone Age and New, called the Middle Stone Age or Mesolithic period, and they divide all these periods into briefer subperiods that need not concern us here. The New Stone Age began c. 8000 B.C. and ended, at different times in different locations, with the invention of writing and the development of ways of working with metals.

The Old Stone Age and Its Art

During the Old Stone Age, people lived in caves or in the shelter of stone outcroppings, and they gathered food in the form of fruit, nuts, berries, and edible roots. Gradually, they began to hunt for meat as well, adding protein to their diets. Their art was surprisingly skillful and realistic. The most striking manifestation of Old Stone Age art, and the oldest evidence of anything we might reasonably call interior design, was painting on the walls and ceilings of caves.

As archaeology develops, the discoveries of these paintings take us further and further back in time. In the late nineteenth century, the Altamira painted caves in northern Spain were discovered. Radiocarbon tests have dated them to between 9,000 and 11,000 years ago. A few years later, the Lascaux painted caves in southern France were discovered, and they were dated to between 15,000 and 17,000 years ago. In 1994, the Chauvet painted caves, also in southern France, were discovered, and have been dated to roughly 30,000 years ago.

In most cases, the paintings occur in remote underground chambers difficult to reach. These painted chambers are not, therefore, thought to have been living quarters, but secretive shrines. In these dark recesses, lit only by torches and perhaps accompanied by ritual ceremonies, the painted images exercised their magic to increase the number of edible animals, to guide the hunters to their locations, or to make the hunters more triumphant over them. A few of the painted animals are shown with weapons striking them, and the painting of the weapons must have represented—and, in the minds of their painters, somehow fostered—the killing of the animals.

Most of these paintings cannot be considered domestic decor. Cave dwellers must have done something to improve their living quarters, however. Undoubtedly, animal skins were hung at the cave entrances to keep out wind, rain, and animals. Undoubtedly, too, furs were used to create comfortable sleeping areas. But all evidence of such improvements has vanished. Only the wall paintings remain, and many of them are remarkably well preserved. As examples, we will look at the oldest ones known, those in the Chauvet caves.

THE CAVE PAINTINGS AT CHAUVET In December 1994, Jean-Marie Chauvet and two other explorers in southeastern France uncovered a long-hidden entrance to a complex of underground caverns. Inside, they found footprints, the remains of ancient fires, and the skeletons of bears. Most astonishingly, they found more than three hundred vivid wall paintings. Tests showed them to be almost as old as the beginning of the Old Stone Age. Only their being hidden far from sunlight and the changing conditions of the earth's surface has preserved them for us to see today.

The paintings are of two types: geometric signs and pictures of animals. Sometimes the two are combined, as in five red stripes on the neck of a lion, or two red dots and a stripe on the muzzle of a horse. The animals depicted also include bison, reindeer, mammoths, ibex, panthers, bears, rhinoceroses, and aurochs (Figure 1–2). Animals of the same species are often shown in groups (such as a row of four horses) and often in action (stalking lions, running deer). There are no complete images of human figures, but a few segments of figures are shown, and one curious composite crea-

ture has the upper part of a bison and the lower half of a human.

Red and black are the colors primarily used, but there are also traces of yellow. The red was made from rusted veins of iron ore found in stone, the black from soot and charred wood, and the yellow from pollen or other plant sources. Color-stained tubes of hollow bone found in the caves indicate that pigment was blown on rather than painted on. Black outlines too precise to have been blown on may have been wiped on with bits of moss or animal skin. There is no evidence that brushes were used.

Perspective effects were produced by overlapping, showing some animals in front of others. Sometimes an animal was shown full-face, staring directly out at the spectator, while its body was shown in profile. Shading was also employed, with paint spread in gentle gradations to suggest rounded forms. By almost any present standards of artistry and realism, these earliest known works of art are remarkably skillful.

But no attention was given to overall compositions on these cave walls and ceilings. The focus is on individual images of animals or groups of animals, not on the surface as a whole. This does not mean that the painters were incapable of composition; it simply means that their intention was different.

The prehistoric painters, we know, depended for their survival on hunting animals. Their animal paintings, in their remote recesses, were surely not created merely as wall decoration, but as some kind of hunting aid. But, despite an intended function beyond the artistic, it would be wrong to deny them the status of art. The impulse behind these paintings on cave walls and the impulse behind the stained-glass windows of Chartres Cathedral or the ornately carved altarpiece of the Escorial near Madrid were, after all, not entirely different. All make their appeal to the supernatural rather than the natural world. Their subjects are realistic, but their intended function is to lift our thoughts or to effect our fortunes beyond the real.

In addition to these impressive cave paintings, there were other artistic expressions. While the main subjects in the caves were animals, these other expressions reflected the early humans' fascination with their own bodies.

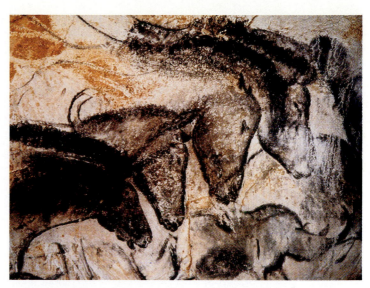

Figure 1–2 Rhinoceroses and aurochs on the walls of the Chauvet Cave in southeastern France were painted more than 30,000 years ago.

MINISTERE DE LA CULTURE ET DES COMMUNICATIONS

PICTURING THE BODY AND ADORNING THE BODY Other Old Stone Age paintings, found in these same locations and others, are simply outlines of the human hand. These were probably unrelated to hunting and may have originated simply in prehistoric humans' desire to record their own presence. The human form was also reproduced in three dimensions. Prehistoric stone objects, shaped by chipping, have been found in abundance in Africa, Europe, and Asia, many of them small statuettes in the image of animals or humans. The human forms were usually female, often with pregnant bellies and exaggerated breasts, clearly symbolizing fertility.

One example of the decorative instincts of early humans is the adornment of their own bodies. This practice may have been a kind of signage identifying their sex or some other characteristic, or perhaps some sort of good-luck charm. Carved and painted animal and human bones and teeth have been found with pierced holes from which they could be hung, and it is assumed that these were used as pendant jewelry.

THE EVOLUTION OF THE EARLIEST KNOWN ART As realistic as many of the cave paintings were, abstraction and symbolism were

also present in the oldest art we have found. Here we see the earliest of human artists transforming the randomness of nature into something more orderly. On decorated bones and tools, tangles of accidental scratches were translated into neat series of parallel stripes. Symmetry, a quality observed by humans in their own bodies, was introduced by mirroring the stripes and creating V shapes or chevrons. Symmetry was applied in another direction, and the V became an X. Shapes were alternated with other shapes, and rhythm was introduced: two chevrons, a circle, another two chevrons, another circle. Early dances must have had similar patterns. Indeed, so do some modern dances. The paintings and patterns of the Old Stone Age were the foundation for the bolder artistic accomplishments that would follow.

The New Stone Age, Its Art, and Its Architectural Forms

In the New Stone Age that began c. 8000 B.C., cave paintings continued to be produced. Rather than hidden deep in the caves as before, they were painted near the cave entrances, meant to be seen. The painters had, perhaps, become conscious of the artistic value of their work. The subject matter changed as well. As hunting wild animals had been at least partly replaced by the raising of animals and the growing of crops as the means of survival, the depiction of animals was partly replaced by the depiction of human figures. These were shown in action: tending crops, hunting, fighting, dancing. And these activities were represented by exaggerated gestures and proportions. Runners were shown with impossibly long legs, and strong warriors were shown with many arms. These exaggerations led to the use of suggestive strokes that represented actions without clearly showing the figure. The realism of the Old Stone Age was replaced by the abstract symbols of the New Stone Age.

There were new crafts as well. The weaving of straw and cloth was begun in this period, and baskets were made that aided in food gathering. Later, pottery, sometimes richly decorated, began to replace some stone utensils, and aided in cooking. In general, art and ornament became less realistic and more abstract.

The Beginnings of the City

When humans learned to feed themselves more efficiently by domesticating animals and cultivating crops, these new activities required that they stay in the same places for long periods. This new stability led to the growth of villages of built—rather than found—dwellings. Most of these were constructed of wicker or thatch, but some more permanent dwellings were made of wood, stone, and mud brick. Living in small groups led, in turn, to the need for greater social organization. Rudimentary cities were born, rulers and administrators were named, human activities became specialized, and technology advanced. Most of these early settlements have perished, but a few, which were built partly of masonry, have left visible ruins. We shall look briefly at two of them.

ÇATAL HÜYÜK Çatal Hüyük, a settlement occupied from c. 6500 to c. 5700 B.C., was in Anatolia, in what is now Turkey. It is an area with very little native stone, so stone construction was not possible. Çatal Hüyük was a prosperous town, controlling the trade of obsidian, a black volcanic glass that was prized for its use in making both tools and ornaments. At the height of its prosperity, the town covered 32 acres (13 hectares).

Roughly rectangular buildings of wood and mud brick were clustered tightly together. Building one against another gave them greater structural stability than they would have had if they had been freestanding. There is some question about whether there were passages between some of the houses; if not, they must all have been entered, for security reasons, not through doors but by ladders from openings in their roofs.

Within the structurally independent, self-supporting wood framing, the walls were infilled with sun-dried rectangular mud bricks, well formed in wooden molds and joined with mortar. Typically, two stout main wooden beams and numerous small beams supported the roof, which was made of bundles of reeds covered with a thick layer of mud. Although all Çatal Hüyük's buildings shared the same construction technique and were not greatly different in size, their interiors suggest that about a fourth of them were shrines and the rest houses.

Inside all the buildings, the wood framing divided the wall surfaces horizontally and vertically into panels. The framing itself was usually visually emphasized with red paint. Red also sometimes accented doorways, niches, and platforms. In houses, the lower panels, no more than 3 feet (1 m) high, were decorated in a number of ways: Most frequent were plain panels in various shades of red, but there were also geometric patterns (Figure 1–3) and images of hands and feet. One house had panels with a pattern of stars and concentric circles, and another had pictures of birds, but such naturalistic subjects were generally found not in houses, but in shrines. The red pigment was derived from minerals—iron oxide for a rust red, mercury oxide for a deep red—mixed with fat. Black was obtained from soot, blue from the mineral azurite, and green from the mineral malachite. These colored paints were applied with brushes on backgrounds of white, cream, or pale pink.

The single room of a house was divided by use, about a third of the space devoted to a hearth and oven, the rest to other uses. Each house had a fixed wooden ladder leading to a hole in the roof, which also served as an escape for smoke from the hearth, oven, and lamps. From the main rooms, small secondary rooms used for storage were entered through open doorways no more than 2 or 3 feet high.

In the two-thirds of the house not devoted to cooking, raised mud-brick platforms, carefully plastered, were arranged around the walls. These, we know from paintings of the interiors, were often covered with reed or rush matting and then, over the matting, with cushions and bedding. The padded platforms were designed for sitting, working, and sleeping. They also served a funerary purpose, former occupants of the houses being buried within the mud-brick platforms. Their skeletons suggest that a small, square platform in one corner belonged to the chief male of the household, and one or more longer platforms belonged to the females and children. One house has been found with a single platform, and none has been found with more than five.

TIMELINE	THE PREHISTORIC ERA	
APPROXIMATE DATE	HUMAN DEVELOPMENTS	DEVELOPMENTS IN ART
35,000 years ago	Old Stone Age begins	
30,000 years ago		Paintings in Chauvet caves
25,000 years ago		Fertility figures
16,000 years ago		Paintings in Lascaux caves
10,000 years ago (8000 B.C.)	Origins of food cultivation; New Stone Age begins	Paintings in Altamira caves
6,000 years ago		Houses and shrines at Çatal Hüyük
5,000 years ago	Origins of metallurgy	
3,400 years ago	Origins of literacy in Sumeria	
3,000 years ago		Houses and furniture at Skara Brae

Figure 1–3 Wall painting in one of the houses at Çatal Hüyük. The painting is in red pigment on a white ground, and the pattern may be an abstract representation of ladders. (Drawing by Grace Huxtable)

JAMES MELLAART, ÇATAL HÜYÜK, NEW YORK: MCGRAW-HILL, 1967

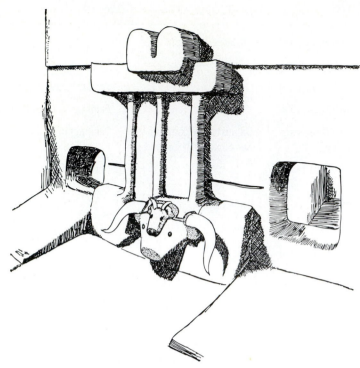

Figure 1–4 Wall relief with bulls' heads in a Çatal Hüyük shrine. The small opening at left led to a granary, the one at right to a light shaft from the roof. (Drawing by Grace Huxtable)

JAMES MELLAART, *ÇATAL HÜYÜK*, NEW YORK: MCGRAW-HILL, 1967

Platforms also occur in the buildings that have been identified as shrines, and they also have bodies buried within them, probably those of priests and their families. The shrines, however, are slightly larger in size than the houses and are distinguished by elaborate wall paintings that seem to have ritual significance. There are also plaster reliefs of gods, goddesses, and animals. And there are human skulls and bull's skulls and horns adorning the built-in benches and platforms (Figure 1–4). Sometimes these last are the remains of actual bulls; sometimes they are imitations modeled in plaster and clay. Other animals are represented as well, such as stags, leopards, vultures, and foxes.

A three-dimensional feature found in both houses and shrines was a small mud-brick pillar topped by a pair of bull's horns. A single such pillar, probably a symbol of protection by the gods, was found in a number of houses, set on the edge of the largest platform. In the shrines, they occur in rows.

Traces of finely woven textiles, probably made of wool, have been found at Çatal Hüyük. These are the oldest textiles discovered so far. Three different types of weave have been identified, and some of the geometric patterns painted on the walls (similar to those in Figure 1–3) are thought to represent the patterns of **kilims,** flat-weave textiles without pile that are used for carpets. This may indicate that carpet weaving was practiced in Stone Age times.

These ancient buildings have also yielded a number of artifacts, some of them quite luxurious in character: hand mirrors of polished obsidian, wooden vessels, metal trinkets, baskets, ceramics, and tools of obsidian, flintstone, copper, and lead. Weapons buried with the men include obsidian spearheads and flint daggers with bone handles and leather sheaths. Jewelry buried with the women and children includes necklaces, bracelets, anklets, and arm bands made of stone, shell, chalk, clay, copper, and mother-of-pearl.

Most of the New Stone Age town of Çatal Hüyük is thought to still be underground, and excavations continue.

SKARA BRAE At Skara Brae on Pomona, the largest of the Orkney Islands off the northern coast of Scotland, a cluster of houses was built c. 3000 B.C. Having been buried for almost 5,000 years, the houses are remarkably well preserved. Because the climate here can be severely windy, and because there was an ample amount of stone to build with, construction was sturdy. Even interior furnishings were built of stone.

At least seven dwelling units have been discovered so far, built closely together in what might be called a small village or an early example of multiple housing. They were built in the form of squares with rounded corners. Their stone walls, built of layers of stone without mortar, were 6 feet (2 m) thick at the base and thinner at the top, not only tapering but also curving inward slightly as they rose. Now roofless, they may have originally been roofed with whalebones covered with animal skins or turf. The largest rooms are about 21 feet (6.4 m) wide. As in the houses of Çatal Hüyük, the main rooms were supplemented with small storage spaces; at Skara Brae, these were hollowed out of the thick stone walls.

In a typical main room (Figure 1–5), the central focus is a large rectangular hearth edged with stone. An opening in the roof directly above it prob-

ably would have allowed smoke to escape and daylight to enter the windowless room. At the end of the hearth opposite the entrance, a square stone seat may have been a seat of honor for the head of the household, with the other family members seated on the floor or stone benches. On either side of the hearth, against the wall, is a bed. These two beds are actually stone-sided containers that were probably filled with leaves, reeds, or mosses, and these in turn covered with warm animal furs. Beyond the hearth against the wall is an impressive piece of built-in furniture, a sort of cabinet that is a predecessor of a dresser or sideboard, its vertical supports and its two horizontal shelves all made of stone. This symmetrical, two-tiered stone cabinet, prominently placed on axis with the door and the hearth and carefully built, must have been used to display the family's prized possessions, such as pottery bowls with incised decoration, some remnants of which have been found at Skara Brae. The cabinet itself is clearly the result of attention to aesthetics as well as to function.

In addition to pottery, many other artifacts have been found at Skara Brae, made of ivory, bone, and stone. A whalebone dish containing red pigment was found in one house, and a finely carved stone ball in another. Some of the pottery displays spiral designs, and some of the stone furnishings seem to have been decorated with incised lines and dots, although much of this decoration has worn away.

Summary: Prehistoric Design

As will be the case in many chapters of this book, we will close with an attempt to summarize the nature of the examples we have discussed. Typically, we will look briefly for the distinguishing common characteristics, if any, of those examples. Then we will look for demonstrations of quality among the examples. Finally, we will try to find comparisons between our chapter's examples and those from other times and places, comparisons that may indicate how one period or style relates to others.

Looking for Character

There was no single style we can identify as prehistoric. Different tribes in different places, facing

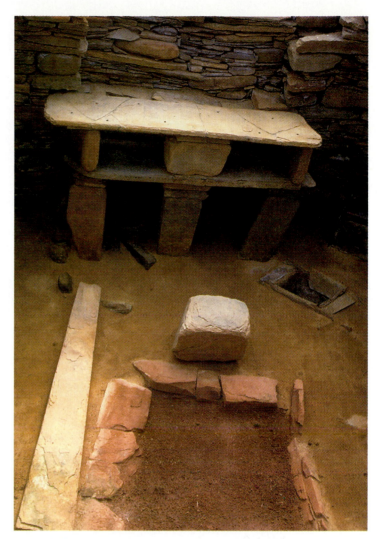

Figure 1–5 House interior at Skara Brae, off the coast of Scotland, c. 3000 B.C. The hearth is in the center of the room, a stone seat and two-tiered stone cabinet beyond.
CHERYL HOGUE/BRITSTOCK

different climates and finding different materials with which to build, naturally produced different effects. And what they produced was very likely more varied, more surprising, and more remarkable than we can imagine today, for we have so far discovered only a minute fraction of what was produced.

The evidence we have discovered, however, is both impressive and instructive. We know of skillfully realistic cave paintings, of ambitious stone monuments, and of interiors where attention has been given to both use and appearance. This evidence tells us clearly that the instincts and abilities that are at the root of interior design and of

all aesthetic endeavor have been with us a very long time. For almost as long as we have been humans, we have been artists. And for almost as long as we have been artists, we have been interior designers.

Looking for Quality

A great principle that becomes obvious when looking at the design of many different cultures is that each one has its own determining network of traditions, goals, and expectations. Many of those determinants are beyond the complete understanding of those who have never shared them. But a second, seemingly contrary principle is that a sympathetic spectator in one culture can detect and appreciate quality in another. We know very little about the lives and thoughts of prehistoric humans, but we can still thrill to the recognition that at times they created something magnificent.

The paintings of the prehistoric caves impress us with their execution. There is no need for us to make allowances for their creators' primitive conditions, crude materials, or lack of training. These animal representations seem to have been produced exactly as their artists intended, with nothing essential missing and nothing extraneous added. These horses and bison are evidence of artistic mastery among some of the earliest members of the human family.

Making Comparisons

One comparison we might make reveals a surprising likeness between prehistoric and later art. If we imagine ourselves entering the Skara Brae dwelling of Figure 1–5, we must be struck by the orderliness of the scene before us. The great stone hearth pit is directly before us, with the stone seat and stone cabinet directly beyond that, all aligned with our view from the door. The two beds are a matching pair in a balanced arrangement, one at either side. The room and its contents, in other words, display the organizing principle known as *symmetry*, a principle the prehistoric designers must have observed in many aspects of nature, in their own bodies, and in the animals they hunted. It is a principle that would be used to powerful effect throughout history. Its importance will be demonstrated by the temples of Greece, the Roman baths, the Gothic cathedrals, the French chateaux, and much more. The little room at Skara Brae demonstrates its age.

From Prehistory to History

We have seen, in the transition from Old Stone Age to New, the partial replacement of realism by abstraction. The new abstract symbols in turn led to geometric decoration. Through pictographs that represented objects in simplified forms, they also led eventually to writing. And the increasingly complex interaction of humans in increasingly large settlements led to the need for setting down laws and keeping records. Writing became both possible and necessary.

In addition to the development of writing, humans at the end of the New Stone Age developed the ability to extract metals from the rocks around them, to blend the metals, and to form them. The earliest metal artifacts discovered so far are copper pieces dated c. 7000 B.C. and found in southern Turkey. They had been not only hammered into shape but also **annealed,** heated in a fire to make them malleable rather than brittle. Gradually, stone tools and weapons were replaced by much more efficient metal ones. At different times in different locations, the Stone Ages yielded to the Bronze Age and then to the Iron Age.

With writing and metal tools, the stage was set for the development of the earliest of the historic civilizations. Of these, the most accomplished was that of Egypt, the subject of our next chapter.

CHAPTER

2

EGYPT

4500 B.C.–A.D. 30

At the beginning of recorded time we find Egypt, a vigorous, fully developed civilization that had evolved from the prehistoric era. Its art, monumental and majestic, but designed and erected according to fastidious standards, was an immense achievement.

The architecture and design of all great periods and civilizations have been in part determined by the character of those civilizations' religions, governments, and societies. That is certainly true of Egypt, where power and faith combined to support the rule of a series of monarchs believed also to be gods. The absolute authority of those monarchs, called

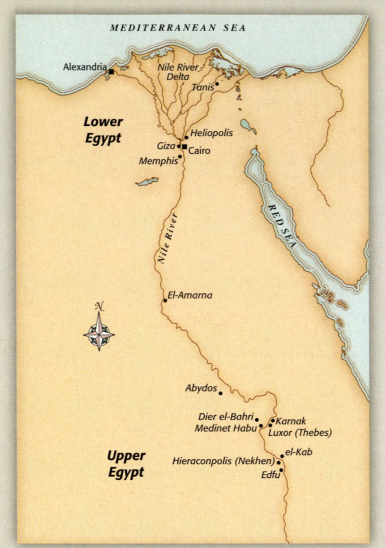

Figure 2–1 MAP OF EGYPT
Ancient sites are shown in italic type, modern cities in roman type.

ORTELIUS DESIGN

Pharaohs, enabled them to command the construction of some of the world's most enormous and most elegantly finished monuments. But the arts of Egypt were also, to a rare degree, determined by the country's unique geography, climate, and natural resources.

The Nature of Egypt and Its Influence on the Art of Egypt

Africa's Nile is the world's longest river. The habitable land of Egypt, as the ancient Greek historian Herodotus wrote, is "a gift of the Nile." An entrenched valley seldom more than 10 miles (16 km) wide and often only a little wider than the river, it was made arable every year, after the spring rains and the melting of snow in the highlands far to the south, by the summer flooding and the consequent deposit of rich sediment. The river thus served as the main source of life for both plants and animals, as well as providing the country's chief transportation route. Controlling and distributing the river's floods required the building of dykes, reservoirs, and canals, and in their construction the Egyptians became early masters at engineering.

Beyond the green, irrigated valley, lush with date palms and figs, pomegranates and papyrus, the desert stretched impenetrably on either side. It was Egypt's protection against invasion, immigration, or even visits from outsiders. Thus isolated, Egypt was allowed a freedom from foreign interference rare in

human history, ensuring for the Egyptians a continuing and unadulterated development. Its relative isolation from other cultures, however, contributed to a repetition of established art forms throughout its long history, and this stable (though not, as we shall see, entirely unchanging) character is one of the most pronounced features of Egyptian art. The forms and details of Egypt's architecture, its interior embellishment, and its furniture remained largely the same for more than 4,000 years.

The Egyptians' own name for the desert part of their country was *deshret*, meaning "the red land," and their name for the arable, habitable strip along the river was *kemet*, meaning "the black land." This strip offered not only soil but also large quantities of hard and durable building stones, such as granite, basalt, and diorite, stones without which the pyramids and other great monuments of Egyptian architecture could not have been possible. Limestone and sandstone, softer and more easily cut materials, were available as well for use in protected places. Wood, however, was in limited supply. Where wood was needed for structural purposes, the palm tree and the papyrus reed were employed, and the acacia and sycamore were also used, with some heavier lumber being imported from Syria. The leaves and branches of these trees and the wildflowers from the banks of the Nile became a principal inspiration for Egyptian ornamental design.

The dependable cycle of the Nile's annual renewal set the rhythm of agricultural work and was fundamental to the Egyptian experience. The Egyptians divided their year into three seasons, called Flood Time, Seed Time, and Harvest Time. And the cycles of the Nile were echoed in the cycles of the sky: the sense of endless repetition was reinforced by the similarly dependable course of the sun through generally cloudless skies. Developing skill in astronomy, the Egyptians also found endlessly repeated cycles in the paths of the planets. Their environment of apparent constancy is thought to have been the source of the Egyptians' firm belief in continued life after death. This belief was in turn the source of an astonishing architecture, for the Egyptians built for eternity. When the Greeks invaded Egypt in 332 B.C., they found what seemed to them to be a culture that was tremendously old and changeless. Indeed it was; the pyramids then were almost 2,000 years old.

The History of Egypt

Among all the civilizations of the world, only China surpasses Egypt in the length of its history, and none surpasses Egypt in its constancy. Although enduring for almost 5,000 years, the culture of Egypt and its astonishing art maintained a strikingly

VOCABULARY EGYPTIAN NAMES

Egyptian proper names, derived from hieroglyphic symbols, are bedeviled by variants in spelling and pronunciation, some of the commonly used ones (such as Cheops) being Greek versions of the Egyptian originals. Here are a few pairs of alternates, for example:

- Cheops = Khufu
- Chephren = Khafre
- Gizeh = Giza

- Ikhnaton = Akhenaten
- Mycerinus = Menkaure
- Zoser = Djoser

In addition, some figures are given more than one name; the sun god Ra, for example, is also called Atum or sometimes Atum-Ra. He was also identified with the god Amon and called Amon-Ra. And some Egyptian deities were incorporated into Greek mythology, where they were given new names, such as Horus, the son of Ra, symbolizing the rising sun, who became the Apollo of the Greeks.

unchanging identity. We shall look at some of the ways in which Egyptian history has been made known, and at the various periods that comprise Egyptian history, for, despite its impressive stability, it did undergo changes that at times affected its art.

Discovering Egyptian History

Our knowledge of the history of Egypt is still evolving, with some dates and facts still being disputed and revised. What we do know is derived from many sources: from the surviving buildings, artifacts, and inscriptions, many of which have been remarkably well preserved by Egypt's generally dry climate; from Greek and Roman authors; from the Bible; from the writings of Manetho, who was a priest at Heliopolis under the Egyptian rulers Ptolemy I and Ptolemy II, and who first divided the rulers of Egypt into dynasties; and from the work of archaeologists.

Measuring Egyptian History: Kingdoms, Dynasties, and Pharaohs

Egypt became a cohesive country c. 3100 B.C., when Upper Egypt, the narrow strip following the Nile northward from the highlands, was unified under strong rulers with Lower Egypt, the land of the Nile delta. (The name "delta" for the fan-

Figure 2–2 The Great Pyramids at Giza, near present-day Cairo. From foreground to rear, the pyramids of Mycerinus, Chephren, and Cheops.

HUGH SITTEN/STONE

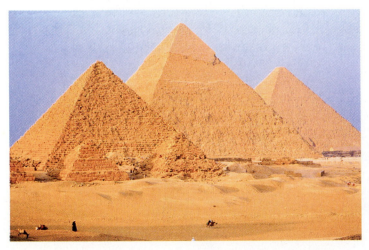

shaped area where the river enters the Mediterranean Sea is of Greek origin, stemming from the shape's similarity to the fourth letter of the Greek alphabet, *delta*).

Even in a civilization as steady and unchanging as that of Egypt, there are ups and downs. Despite the regularity of the Nile flood, there were droughts, and despite the protection of the desert, there were invasions. In the course of a history that endured for 4,000 years, there were three periods that seem to us now to have been times of extraordinary achievement. These are known today as the Old Kingdom (2686–2134 B.C.), the Middle Kingdom (2065–1783 B.C.), and the New Kingdom (1550–1070 B.C.). Egyptian history is further divided into dynasties, each dynasty divided into the reigns of individual pharaohs. The term *pharaoh*, meaning "great house," did not come into use until the New Kingdom, but is now generally used for the older Egyptian rulers as well.

The first dynasty came to power at the time of unification, c. 3100 B.C., five centuries before the beginning of the Old Kingdom, and the last dynasty, the thirty-first, ended in 332 B.C., when the great Macedonian military leader Alexander the Great conquered Egypt and established a new series of rulers known as the Ptolemies. Roman rule followed in 31 B.C., and Arab rule in A.D. 642.

Beliefs Expressed in Stone: Egyptian Monumental Architecture

The Egyptians' reverence for their gods and for their god-related rulers fostered one of history's most ambitious building programs, including pyramids, sphinxes, obelisks, and temples, some of which were stupendous in scale.

PYRAMIDS The most famous of Egypt's artistic and engineering triumphs, the Great Pyramids of Giza (Figure 2–2), were built not as the culmination of Egypt's long history but relatively early, during the Old Kingdom. It was during that time that the rulers came to be identified as living gods. The great Old Kingdom pharaohs included Cheops, Chephren, and Mycerinus. These living gods were able to command all the wealth and energy of all their subjects for the construction of any project they imagined, and it was for the last three of these

TIMELINE EGYPT

APPROXIMATE DATE	PERIOD	DYNASTIES	CHIEF RULERS	LOCATION OF CAPITAL	CHIEF PRODUCTS AND EVENTS
2686–2134 B.C.	Old Kingdom	Dynasties 3–8	Snefru, Zoser, Cheops, Chephren, Mycerinus, Pepi I, II, et al.	Memphis	Age of Pyramids: Great Pyramids of Giza
2065–1783 B.C.	Middle Kingdom	End of 11th dynasty to dynasties 12–13	Series of kings named Mentuhotep, Amenemhat, and Sesostris	Thebes, then Memphis	Funerary temple of Deir el Bahari; development of portraiture
1550–1070 B.C.	New Kingdom	Dynasties 18–20	Amenophis, Hatshepsut, Tuthmosis II, Ikhnaton, Tutankhamun, Horemheb, Ramses I–XI, Seti	Thebes, then Tel-al-Amarna, then back to Thebes	Funerary temple of Hatshepsut; Tuthmosis conquers Syria; temples of Luxor and Karnak
332–31 B.C.	Ptolemaic Period		Alexander the Great, Ptolemy I–XV, Cleopatra, Julius Caesar	Alexandria	In 332 B.C. Alexander occupies all Egypt; in 48 B.C. Julius Caesar lands to defend Cleopatra; in 31 B.C. Octavian defeats Marc Antony
31 B.C.–A.D. 642	Roman Period		Roman rule		New Roman temples constructed to Egyptian gods

pharaohs that the great trio of pyramids at Giza was built. The pyramid, although it had symbolic uses as well, was primarily a protective shield built to encase the **mummy** (the eviscerated, embalmed, and carefully wrapped corpse) of a member of the Egyptian royalty.

The three Great Pyramids of Giza were built as parts of religious precincts. At Giza on the western edge of the Nile floodplain, the ruling pharaohs built three adjacent valley temples for the ritual purification of the pharaohs' bodies and, next to the central temple, the lion-bodied statue of the Great Sphinx (although some date the Sphinx to an earlier time). From these temples, causeways for water transport of the royal bodies terminated at three enormous granite pyramids: from south to north, and from smallest to largest, the pyramids of Mycerinus, of Chephren, and of Cheops (Figure 2–2).

These structures impress first with their sheer mass: the pyramid of Cheops is built of 6 million tons (5.4 million t) of stone, each casing block weighing 2 tons (1.8 t) or more. But there is more to wonder at, for these stones are fit together with joints of only 1/50 inch (0.5 mm): a mountain erected with a jeweler's precision. And beyond both mass and precision, there are elegance and austerity that still inspire awe.

The pyramid was a potent symbol of Cheops's power and assumed immortality. It was also a solid shield for his burial chamber. But it was in no way an expression of interior space. The burial chamber at the heart of the pyramid is, in fact, tiny (Figure 2–3). Inside the structure, measuring 755 feet (245 m) for each side of its base, the chamber occupies only about 17 by 34 feet (5.5 x 11 m). Passages leading to it, however, as well as false

1. Entrance (55 ft. above grade)
2. Unfinished chambers
3. Ascending corridor
4. Grand gallery
5. King's chamber
6. Ventilation shafts

Figure 2–3 Section through the pyramid of Cheops.

AFTER EDWARDS

passages leading deceptively away from it to thwart robbers, display impressive constructional ingenuity. For example, the walls of the Great Gallery, a 150-foot-long (49 m) corridor sloping upward toward the burial chamber (Figure 2–4), has 26-foot-high (8.5 m) walls that are **corbeled,** each of their layers of stone projecting slightly beyond the one beneath.

Some have speculated that a red-ochre pigment was applied to the whole visible surface of some pyramids, although others have claimed hieroglyphic evidence that often the pyramids' bases were clad in pink granite, their upper faces dressed in white limestone, and their tips capped in gold, reflecting the rays of the sun. As we see them today, denuded of their color and largely stripped of their smooth-finished surfaces, they still stand as one of architecture's most powerful achievements.

SPHINXES A sphinx is a mythical monster with the body of a lion and the head of another animal, a deity, or a human. In the largest and most famous example, the Great Sphinx of Giza, the head is that of the Pharaoh Cheops, wearing the royal headdress (Figure 2–5) or, in the opinion of some, Horus, the god of the rising sun. Perhaps it is both Cheops *and* Horus, for the Egyptians were not troubled by multiple meanings. In the long row of

Figure 2–4 As drawn by Napoleon's expedition forces, explorations in the pyramid's Great Gallery. The section shows the corbeled stone construction.

NORTH WIND PICTURE ARCHIVES

sphinxes that links the temple of Luxor with the temple of Karnak, the heads are those of rams. And in the many examples used as carved or painted decoration or as furniture legs during the Renaissance, Adam, Empire, and Regency periods, the heads—and busts—are those of women.

The Great Sphinx, in any case, is thought to date from the reign of Cheops and to have been repaired by his successor, Chephren. It is adjacent to the valley temple of Chephren, which was originally connected by a canal to the Nile. The re-

Figure 2–5 The Great Sphinx of Giza. In the background is the pyramid of Mycerinus, smallest of the three Great Pyramids.

cumbent figure thus lies at the foot of the three Great Pyramids, facing the Nile. The body of the Great Sphinx is 150 feet (46 m) long, and between its paws is a large flat slab that may have been a sacrificial altar. Its beard, found buried in the sand nearby, is now in the British Museum.

OBELISKS Like the pyramid, the Egyptian obelisk is a form imbued with a natural authority that we continue to recognize. A tall, slender, four-sided tapering shaft of stone—generally granite, quarried from a single piece—the obelisk tapers upward to a pyramidal tip (Figure 2–6). It is most often square in plan, but occasionally rectangular. Like the pyramid, its tip may have at times been gilded, and its four faces were carved with dedicatory inscriptions in hieroglyphics, the most frequent dedication being to the sun god Ra.

Written records of obelisks date back to the Age of Pyramids in the Old Kingdom, but none quite that old has been discovered. The Pharaoh Seti I in the thirteenth century B.C. boasted of having "filled Heliopolis with obelisks," and his son, the great King Ramses II, is known to have erected fourteen obelisks in Tanis and two more before the temple of Luxor. In all, at least a hun-

dred large obelisks were erected in Egypt, perhaps many more. Some were over 100 feet (30 m) high, and their raising was a remarkable engineering feat.

TEMPLES Awesome as are the pyramids and striking as are the obelisks, these two structures offer only exterior views. It is in the Egyptian temples that both a manipulation of enclosed volume and a sense of movement through space were skillfully developed.

Figure 2–6 The hieroglyphics-covered tip of one of the two obelisks of Hatshepsut at Karnak. Carved from a single block of rose granite, it is 97 feet (30 m) high.

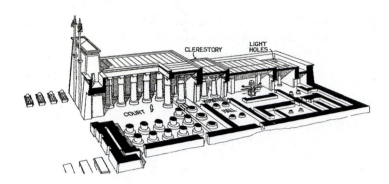

CLERESTORY LIGHT HOLES COURT HYPOSTYLE HALL

Figure 2–7 Cutaway perspective view of the Temple of Khons at Karnak, c. 1200 B.C. In a typical Egyptian temple plan, rows of sphinxes lead to the frontal pylons. Inside, there is a series of increasingly private and sacred spaces. The object shown near the back is the sacred boat of the god Khons.

SIR BANISTER FLETCHER. REPRINTED BY PERMISSION.

Temples had always been part of the sacred areas adjacent to pyramids, but they came increasingly to be built independently of pyramids. Large temples generally conformed to the same **axial** plan, by which pairs of elements were symmetrically arrayed around a center line. Typical elements of the temple plan (Figure 2–7) included an avenue of sphinxes or other statues leading to the entrance; sometimes a pair of obelisks before the entrance; tall entrance pylons with battered faces; an open courtyard with colonnaded sides; an inner **hypostyle** hall, a large hall with a roof supported by many columns; and, finally, an inner sanctuary with an image of the deceased ruler, this last sometimes surrounded by storerooms and living quarters for priests. The whole plan was ordered to accommodate a procession, the spaces becoming increasingly sacred and private, increasingly small in scale, and increasingly dark.

The largest and most impressive of the temples built to this general plan include those at Karnak and Medinet Habu, the hypostyle hall at Karnak (Figure 2–8) having densely spaced columns rising 70 feet (22 m) and bearing stone

�֎ VOCABULARY "STYLAR" TERMS

The text refers to Karnak's *hypostyle* hall, and this term can be defined as simply meaning "with many columns." Similar terms can indicate exact numbers of columns, *tetrastyle* referring to four columns, *hexastyle* to six columns, and *octastyle* to eight columns, for example.

Another group of terms ending in *-style* refers to the placement of columns, *prostyle* describing a building with columns only in the front, *amphiprostyle* a building with columns in the front and rear, and *peristyle* a building (or courtyard) surrounded by columns. The term *mono-prostyle* is sometimes used if a portico is only one column deep, *di-prostyle* if it is two columns deep.

Still another set of terms refers to column spacing, based on multiples of the columns' diameters. For example:

pycnostyle	=	1½ diameters apart
systyle	=	2 diameters apart
diastyle	=	3 diameters apart
araeostyle	=	4 diameters apart

This last term is also sometimes used to mean simply "widely spaced." Many of these terms will be encountered again in readings about the temples of Greece and Rome.

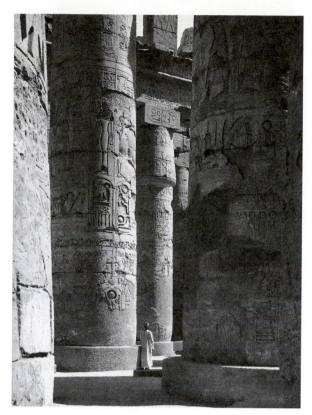

Figure 2–8 Columns of the great hypostyle hall of the temple at Karnak. The shape of the capitals is an abstraction of the lotus bud.

G. E. KIDDER SMITH/CORBIS

architrave blocks (horizontal members spanning between columns) weighing 60 tons (54 t) each. An important variant was the great funerary temple of Queen Hatshepsut built about 1500 B.C. at Deir el-Bahri. As in earlier temples, the entire composition is axial and symmetrical. Great ramps climb from terrace to terrace, each landing presenting a monumental colonnade. The tomb itself is buried deep within the stone cliff, and there are many subsidiary chambers, most elaborately painted. An example is the Chapel of Tuthmosis I (Figure 2–9), entered from the second terrace, with its painted ceiling representing a starry sky.

The Egyptian temples are awesome in their size, massing, and strength, but they are not lacking in subtlety or detail. Virtually every surface of these great structures was carved and painted with scenes and writing that were not only decorative but, for the Egyptians, powerfully meaningful.

Beliefs Expressed in Symbols: Egyptian Ornament

Today when we apply a decorative figure to an object—when, for example, we weave the image of a rose into a carpet—we usually do so simply for pleasure or amusement. For the Egyptians, however, almost all decorative figures conveyed distinct meanings. Many of those meanings were related to the complex religious beliefs of the Egyptians, so that decoration was often, for them, a form of worship.

It is surely more than coincidence that hieroglyphics, the written form of communication of all literate Egyptians, was itself based on symbols, rather than on representations of sounds, so that Egyptians were well practiced in symbolic expression. Even their architecture symbolized its

Figure 2–9 A chapel within the Temple of Hatshepsut, painted with figures of gods, serpents, sun disks, and—on the ceiling—a starry sky.

CORBIS

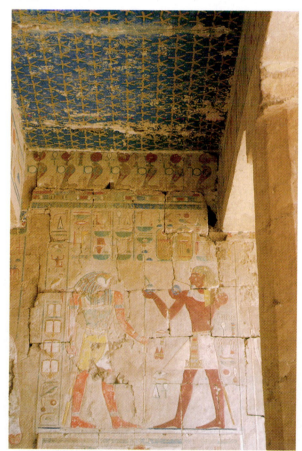

Figure 2–10 The winged sun disk, symbol of a victorious ruler, was a favorite Egyptian ornament.

precedents, stone buildings emulating the mud-brick buildings they replaced, and stone columns imitating the reed bundles that had supported earlier roofs.

It is not necessary here—even if it were possible—to learn the whole vocabulary of Egyptian symbols, but a few examples will suggest the character of the ideas they conveyed. The serpent, for example, was the badge of royalty. The lotus bud and flower, extensively used in architecture, sculpture, and painted ornament, were the symbols of purity. The sacred dung beetle or scarab represented eternal life (perhaps because it buries an egg in dung as the sun is apparently buried in the earth, both burials ending in rejuvenation). The sun disk or globe and the vulture with outstretched wings were both considered symbols of protection and were often combined in a winged disk (Figure 2–10). Other images referred not to such general qualities but to specific deities, rulers, cities, or events.

W. M. Flinders Petrie, a prominent Egyptologist and author of the 1895 book *Egyptian Decorative Art*, classified all ornament into four types: geometrical ornament, based on such figures as squares and circles; natural ornament, based on plant and animal life; structural ornament, springing from the necessities of building or manufacturing processes; and symbolic ornament. Petrie found examples of all four types in Egyptian art, but for the Egyptians, ornament of the symbolic type was of overwhelming importance. It enhanced, identified, explained, or sanctified all objects and surfaces to which it was applied.

The Egyptian House

Our impressions of Egyptian design are dominated by the magnificence of its major monuments, but these were built for the glorification of gods, the commemoration of great rulers, or the protection of royal mummies. None of the architecture we have discussed so far was meant to shelter the living (except for a few priests). Where, then, did the Egyptians live? Egyptian houses, even the palaces of the great, were built with less permanence in mind than were the pyramids, obelisks, and temples. Formed from rubblestone or mud brick—fired brick for the homes of the wealthy, unfired brick for the poor—rather than **ashlar,** the precisely cut, straight-sided stone that was used for the monuments, these residential buildings have vanished with few physical traces. Even so, foundations still indicate where Egyptian houses were built, and drawings and paintings still provide records of what they were like.

Residences of rulers, priests, and nobles, along with satellite structures, were often built adjacent to great temples as parts of royal precincts. In the teeming cities, however, Egyptian town planning apparently lacked the great order and discipline we associate with Egyptian architecture: the houses of noblemen might be next to the houses of workmen, and residential buildings might be scattered among bazaars, workshops, storehouses, shrines, wells, and parks, all packed closely together.

The earliest Egyptian house, and the simplest one in all ages, was nothing more than a single rectangular room with an entrance door on one of the shorter sides and, on the opposite side, a small open window for ventilation. The door, and sometimes the window too, was topped by a wooden **lintel,** a member spanning an opening and carrying the weight of the wall above it.

More affluent Egyptians had houses of several rooms and on several levels, the lowest level used for food preparation, storage and utility rooms, perhaps also for a workshop, and the upper levels for living quarters. Those even more prosperous had elaborate layouts with porticoes, colonnades, and enclosed gardens. An example was the town house of Thutnefer at Thebes, shown in vertical section in a drawing (Figure 2–11). In almost every house type, however, an important feature was at least one flat roof area used for living and sleeping in hot weather; if possible, it was screened from the neighbors' view with trelliswork, and, for much of the year, it was the center of family activity.

Some Egyptian furniture was built as an integral part of the mud-brick house—for example, a

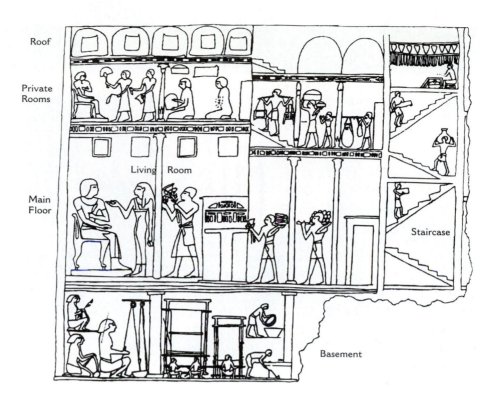

Figure 2-11 Vertical section through the multilevel town house of Thutnefer at Thebes.

AFTER BADAWY

Roof

Private Rooms

Living Room

Main Floor

Staircase

Basement

dais, often plastered and whitewashed or edged with limestone, that could serve as a dining area, or a mastaba (seating bench). For storage, open cupboards were carved out of the masonry walls. But within the house, the Egyptians also enjoyed a highly developed assortment of movable furniture.

Egyptian Furniture

Just as some of the most powerful architecture ever built dates back to Egypt, so do some of the most elegant and elaborate pieces of furniture ever made. Two important groups of that furniture, dating from roughly a thousand years apart but discovered within three years of one another, are the furniture belonging to Queen Hetepheres, entombed c. 2300 B.C. and unearthed in 1925, forty-two centuries later, and the furniture belonging to King Tutankhamun, buried c. 1300 B.C. and uncovered in 1922.

The Furniture of Queen Hetepheres

Queen Hetepheres was the wife of the Pharaoh Snefru, who built a pyramid tomb for himself at Dahshur, and the mother of the Pharaoh Cheops, for whom the greatest of the Great Pyramids was built. A complete suite of her furniture was discovered in a chamber near her son's pyramid. It is the oldest Egyptian furniture that has so far been found. Even though it was built of wood that had been destroyed by rot or insects, the wood members had been encased in heavy gold plates that are still intact; now encasing new supports, they form a dazzling display in the Cairo Museum (Figure 2–12), and there are replicas in the Museum of Fine Arts, Boston.

The furniture includes an armchair, a bed, a headrest, a great framework for netting or draperies that could be hung to enclose the bed, and a box for jewelry, all finished in the most perfect technique. On the box, carved hieroglyphs were covered with gold, and there were also inlays of **Egyptian faience,** a glassy material we shall study later, and carnelian. The armchair is low, with a wide, deep seat. Its overall appearance is rather severe, but it has animal legs, and the open arms are filled with representations of papyrus flowers.

Also discovered were a long rectangular box for storing the folded draperies, a smaller box for bracelets, and a carrying chair on poles, the poles

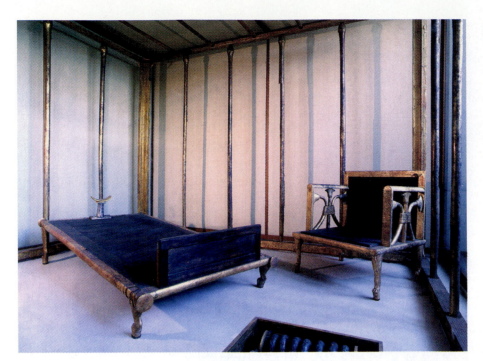

Figure 2–12 Furniture of Queen Hetepheres was built of wood encased in gold. Seen here are a chair, a sloping bed with "pillow" and footrest, and around the whole group, a frame for fabric hangings.

WERNER FORMAN ARCHIVE/ ART RESOURCE, NY

terminating in gold-encased imitations of palm fronds. A second armchair, of a more elaborate design, had disintegrated too completely to be reconstructed. In addition were found vases, chests, and toilet articles of gold and enamel enriched with rare stones.

The Furniture of King Tutankhamun

Tutankhamun's furniture was also admirable in both design and construction. It was more abundant, more varied, and more elaborately decorated than that of Hetepheres, although its close similarity to the furniture of a thousand years earlier is a good measure of Egyptian conservatism. The opening of the tomb in 1922 revealed some sensational riches, and jumbled among them were about fifty pieces of royal furniture. They included armchairs, armless chairs, a number of stools—some fixed, some folding, many four-legged, some three-legged—several beds, one of them folding for travel, and thirty chests of different size and design, many with interiors carefully fitted to hold specific contents.

The two most impressive pieces of furniture found in Tutankhamun's tomb were a ceremonial chair and a gold throne. The ceremonial chair (Figure 2–13) has a curiously shaped wood seat on a

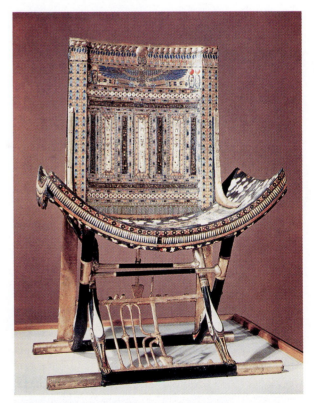

Figure 2–13 The ceremonial chair found in Tutankhamun's tomb. Made of ebony that is gold-leafed and inlaid with ivory, colored glass, Egyptian faience, and precious stones, it is 44 inches (112 cm) high.

RAINBIRD: ROBERT HARDING PICTURE LIBRARY LIMITED

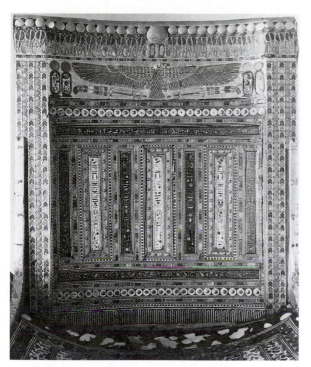

Figure 2–14 Details of the richly inlaid back of Tutankhamun's ceremonial chair.

ASHMOLEAN MUSEUM, OXFORD, ENGLAND, U.K.

base obviously meant to represent a folding stool, although it was not built to actually fold. The seat is primarily ebony inset with ivory in a pattern resembling leopard's skin, with strips that imitate the skins of other animals. Under the seat, remnants of red leather are visible. The base still displays, between the front legs, part of a gold grillwork of entwined lotus plants, symbolizing the unification of Upper and Lower Egypt. Parts are joined with gold mounts.

The ceremonial chair's back (Figure 2–14) is particularly ornate, although the ornament is never so aggressive that it distorts the basic rectangular shape. It is again of ebony, richly inlaid with a wealth of materials. At the top the vulture Nekhebet is shown, representing both a goddess and the town of El Kab in Upper Egypt. Below the vulture are hieroglyphs listing the king's titles and accomplishments. A rear view of the back (Figure 2–15) reveals a structure of two side stiles directly above the rear legs and a single stile between them. Seen through this structure is a delicately carved relief faced with gold leaf, also depicting the vulture.

The ceremonial chair was accompanied by a low footstool. A simple rectangular box in shape, it was inlaid with pictures of a row of bound prisoners, placed so that the young pharaoh rested his feet on the subjugated enemy.

The gold throne from Tutankhamun's tomb is a far more fanciful concoction (Figure 2–16). Encased almost entirely in gold, it incorporates inlaid details of silver, lapis lazuli, translucent crystal, Egyptian faience, and colored glass. The chair legs are in the form of the fore- and hind legs of a lion, and the front pair are topped by lion's heads. The side panels are formed primarily by a pair of glass-eyed cobras with the sweeping wings of vultures. Double crowns of Upper and Lower Egypt, which the cobras are wearing, tilt backward and rest against the chair back. On the back itself, the sun disk shines above a domestic scene of the young king and his slender wife, wearing silver robes.

These two chairs, of course, were extraordinary, even among the treasures of Tutankhamun.

Figure 2–15 Reverse side of the ceremonial chair's back. Beyond the structure, a delicate relief covered with gold leaf.

ASHMOLEAN MUSEUM, OXFORD, ENGLAND, U.K.

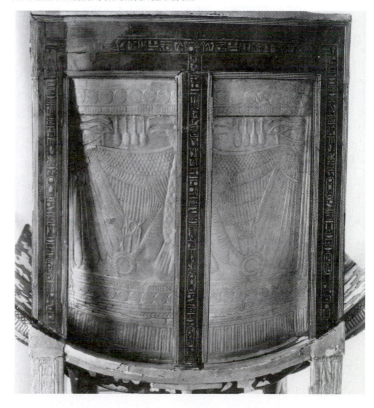

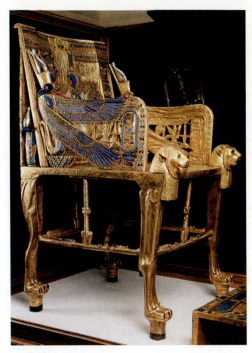

Figure 2–16 The gold throne, another treasure from Tutankhamun's tomb, the arms of which are formed by winged serpents.

SCALA/ART RESOURCE, NY

Most Egyptian furniture was far simpler; yet much of it was equally handsome.

Other Furniture

Furniture for commoners was, of course, less admirable in both materials and workmanship than furniture for royalty, but the basic designs of Egyptian pieces differed little throughout the social scale. The poorest Egyptians, however, probably had no movable furniture, for the shortage of appropriate trees in Egypt must have made freestanding wood furniture expensive. Paintings and carvings suggest well-furnished interiors, but these depictions are probably representative of only the upper- and middle-class households.

STOOLS The most common pieces of furniture in Egypt were the low stools. Some of these were quite humble, some carried the prestige of rank—such as the portable stools of army commanders—and some were used by Pharaohs themselves. To

return to Tutankhamun's tomb, for example, a stool found there (Figure 2–17) is an ebony-and-ivory imitation of a draped leopard skin, as was the same ruler's great ceremonial chair. Like the chair, it appears to fold, but having a solid wood top, it cannot. Many other Egyptian stools did fold, however.

CHAIRS The chair was an extremely important piece of furniture in Egypt, though not as commonplace as the stool. Ordinary chairs were similar to royal ones, but, naturally, had less extravagant ornamentation. Some, by today's standards, seem unusually low, their closeness to the ground perhaps due to the fact that they were first made for people accustomed to sitting on the earth. An example now in the Metropolitan Museum, New York (Figure 2–18), has a carved openwork frieze in the back and the popular animal-shaped legs. As was almost always the case, the hind legs of the animal were represented in the rear and the forelegs in front, all facing the same direction, as would the feet of a real animal. The feet, carved like paws, rested on small blocks of wood that probably disappeared into the straw matting that usually covered the floors.

A more upright chair (Figure 2–19), made for common use about the same time as Tutankhamun's reign, has a back of neatly joined wood slats,

Figure 2–17 Tutankhamun's stool of ebony and ivory appears to be draped with a leopard skin. The appendage at the right side represents the leopard's tail, and duck's bills hold the bottom rails.

PHOTOGRAPHY BY EGYPTIAN EXPEDITION, THE METROPOLITAN MUSEUM OF ART

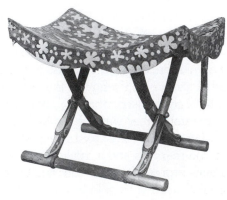

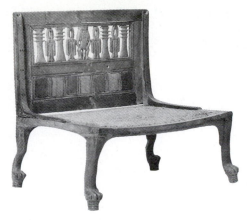

Figure 2–18 A low chair of boxwood and acacia, c. 1500 B.C.

Figure 2–19 Wood chair from Thebes, late eighteenth dynasty.

Figure 2–20 Ivory furniture leg in the shape of a bull's foot, Elephant ivory Egyptian, Thinite Period, 3100-2700 B.C. The holes at the top are for attaching it to the wood frame.

virtually unornamented, and the usual animal legs. The seat was of woven rush.

Sometimes the animal legs, for both chairs and beds, were quite simplified; at other times, they were beautifully carved of ebony or other fine woods. Examples also exist of animal feet made from ivory, which would have supported the frames of wood furniture. An example in the Louvre of a bull's foreleg (Figure 2–20) is quite beautifully carved.

BEDS Beds were rarer than chairs in Egypt. Those who lacked wood-framed beds slept on reed mats or mud-brick platforms. The simplest wooden bed frames had rails at each edge, supported by a leg at each corner. The center was filled with plaited rope or leather thongs. Even the simplest versions, however, often had legs carved as animal legs and side rails carved in a curve that the Egyptians apparently found comfortable. Other Egyptian beds were not only curved but sloping, with the head end raised slightly above the foot (Figure 2–21), as was the bed of Queen Hetepheres. Footboards added to such sloping beds could be elaborately carved and decorated.

Figure 2–21 An Egyptian bed with a raised head (at left) and a footboard (right) of three carved panels.

ASHMOLEAN MUSEUM, OXFORD, ENGLAND, U.K.

Used in conjunction with such beds were Egyptian "pillows" or headrests. A gold one belonging to Queen Hetepheres is in place on the head of her bed. They were most commonly made of wood, but could also be made of ivory or even of colored glass (Figure 2–22). The Egyptians generally slept on them with their heads turned, cradling the sides of their heads—not the backs of them—in the support, and the headrest was often wrapped in linen for greater comfort. Similar headrests will also be seen in other cultures, and it has been speculated that they were popular in those societies where elaborate hair arrangements were considered important, or in hot climates, where lifting the head slightly above the bed allowed greater air circulation.

OTHER FURNISHINGS Tables existed from at least as early as the Old Kingdom. Some have been found from the time of the pyramids that are small, round, and made of alabaster; it is assumed that they were used for some kind of sacrifice or other ritual. There were also round wooden tables at a convenient height for use with chairs. And, from the sixth dynasty on, there were also small tables with square tops.

Loose cushions covered in cotton, painted leather, or even metallic cloth added comfort and further color to Egyptian seating. None of these has survived, of course, but some can be clearly seen in wall paintings and carvings (Figure 2–23). In addition to the storage niches in the walls, there were wooden boxes and baskets to hold household goods including clothing and bedding. Such

Figure 2–23 A limestone relief carving in the Temple of Seti I at Abydos, c. 1300 B.C., shows the goddess Isis seated on a low throne with a cushion folded over its back.

SILVIO FIORE/SUPERSTOCK, INC.

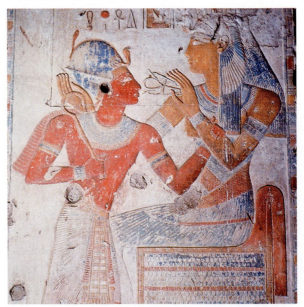

Figure 2–22 From the eighteenth dynasty, a "pillow" or headrest made of turquoise-colored glass.

ABERCROMBIE, AFTER HALL

fabrics, highly prized, constantly washed, and carefully folded, were generally marked with the names of their owners.

For lighting, there were oil lamps, the most common made of pottery, the finest made of bronze. The affluent Egyptians used tableware made of pottery, alabaster, bronze, gold, and silver, and they also possessed personal accessories and jewelry of great beauty and value. But, with these, we leave the realm of furniture and enter that of the decorative arts.

Egyptian Decorative Arts

The character of any body of art is dependent not only on general and pervasive factors such as geography, government, and religion, but also on the minute details of the specific tools and techniques employed to create the art. We will not fully understand any art without understanding something of how it has been made. The construction methods used in building the pyramids and erecting the obelisks and temples are well covered in other texts; what concerns us more in a study of interior design are the Egyptians' methods of painting, carving, and working with materials like wood, cloth, and glass. We shall look first at the so-called fine arts of painting and sculpture, arts generally concerned with the creation of beauty rather than the satisfaction of function; for the Egyptians, however, painting and sculpture, even when very beautiful, were also thoroughly functional.

Painting

Most of the surfaces of the great monuments, both outside and inside, were covered with paintings, often in brilliant colors, and low relief carvings. For the paintings, outlines were first sketched with charcoal, then a shallow groove was chiseled around the outline of each shape. The grooved surface was then covered with a thin layer of **plaster,** a paste, usually made of cement, lime, or gypsum mixed with sand and water, that forms a hard surface when it dries. Colored pigment was then applied to the plaster. The Egyptians obtained their pigments from minerals—iron oxides, for example, for red and yellow, and carbonate of copper for

blue—which contributed to their permanence. Large areas of pigment were applied with coarse brushes made of palm fibers, and fine outlines and details were applied with thin brushes made of reeds. Generally, each colored area was flat and uniform, no attempt being made to suggest gradations, shadings, shadows, or highlights.

The subject matter of these mural decorations included actions in the daily life of individuals, religious and allegorical events, flowers and birds, boats and barges on the Nile, wild animals being hunted in the desert, warriors and workers, musicians and dancers, tragedy and humor. Around and between these scenes, the wall surface was frequently filled with hieroglyphic writing, further explaining the figures and events. These pictures and pictorial writings together have given historians detailed knowledge of Egyptian life.

The character of this art had no use for the convention of perspective that is a familiar part of most Western art. Instead, the Egyptians suggested depth by the placement of one object above another. Size, in the Egyptian convention, was used to indicate importance, a ruler being drawn larger than a slave or an enemy, for example. In early periods, women were drawn smaller than men; in the New Kingdom, the same size.

The representation of the human figure was strictly conventionalized, represented in poses only a contortionist could hold: the legs and feet were in full profile with the insides of both feet facing outward, the upper torso in a three-quarter view, with the profiles of hip and breast visible, the shoulders in a fully frontal view, and the head again in profile but with the single visible eye drawn as if from the front. This composite view (Figure 2–24), to the Egyptian eye, gave a good two-dimensional representation of a three-dimensional figure.

Representation of the features of a specific individual was a goal at some stages of Egyptian art, while in others a more generic figure was shown. At no time, however, was the personality of an individual artist expressed; indeed, most murals and sculptures were collaborations of a number of painters or carvers, and, in any case, the goal was almost always to conform to an existing artistic ideal, not to explore new territory. If what we today think of as the creative artist was missing from Egyptian art, so also, in many cases, was what

Figure 2–24 The conventional Egyptian representation of the human body combines profile and frontal views.

we think of as the spectator, for much of the finest art of the Egyptians was sealed in the interiors of tombs with the intention that it never be seen by the living.

Sculpture

The Egyptians excelled in sculpture, not only the low reliefs that often covered wall surfaces or the sides of obelisks, but also freestanding sculpture in the round that could be viewed from all sides. Because of the hardness of the stone from which it was carved, much of the sculpture was extremely simple in form. The surfaces were smooth, and a strong, dignified effect was obtained through clear, vigorous massing.

Many of the stone sculptures were brightly colored in flat tones. Male figures were conventionally shown with reddish brown skin color and females with light yellow. Placement of art also conformed to tradition.

Wall paintings and raised reliefs (with the backgrounds cut away from the figures) were generally found in temple interiors, and sunken reliefs (with figures cut into the surface and casting stronger shadows) were more often found on exterior sur-

faces. Both types of relief were usually gently plastered and then painted.

An example of relief sculpture within the Temple of Horus at Edfu lines the staircases leading to and from the roof. Fitting the ornament closely to the architecture, the carvings show how the stairs were used. They represent an elaborate ceremonial procession, in which priests carried the temple's sacred objects to the temple roof (via the east stair) for exposure to the life-giving sun, and then brought them inside again (via the west stair).

Pottery

As early as predynastic times, the Egyptians were producing pottery, primarily utilitarian pieces, but some of it interestingly decorated. At some times and locations, the pottery was decorated with light lines on dark backgrounds; at others, with red lines on buff-colored grounds. Geometric ornament prevailed, but there were also stylized representations of animals, birds, plants, and humans. A predynastic red bowl with cream-colored painting (Figure 2–25) shows three hippopotamuses circling a plant form and surrounded by a zigzag. Other pottery forms include freestanding ceramic figurines of gods, kings, animals, and mythical beasts.

Figure 2–25 Pottery bowl decorated with three images of hippopotamuses, predynastic period, c. 4000 B.C.

Woodworking

Of the few native woods available for furniture, acacia was the most frequently used, others including willow, sycamore, and tamarisk. Better quality wood was imported: cedar from Lebanon, which was used for the furniture found in Tutankhamun's tomb; ebony from Ethiopia, which, although hard to work, was a favorite of the Egyptians and found in Tutankhamun's bed frames; yew from Syria; and oak from Turkey.

Because of the rarity and consequent value of good native hardwood in Egypt, it was used with appropriate economy. And understanding that the valued wood could warp, twist, split, and shrink, the Egyptian craftsmen developed sophisticated techniques for the design and construction of wood furniture. Many of their techniques were duplicated in unrelated cultures; many are still in use today. Tools used by the Egyptians for furniture manufacture included axes, adzes, flat-pointed chisels, saws, and awls. **Mortise-and-tenon joints** (Figure 2–26) were used at least as early as the first dynasty, and **dovetail joints** as early as the fourth dynasty. Corners were formed not only with dovetails, but also with **butt joints, half joints,** and various kinds of **miter joints,** strengthened with pegs, nails, or dowels, and sometimes with leather thongs. Butterfly clamps were also employed. Animal glues were not in use until the New Kingdom.

When only poor quality wood was available for important pieces, it was finished with veneers made from **flitches** (thin sheets of veneer, usually stacked in the order in which they were sawn from a log) of cedar or ebony, these held in place with tiny pegs of wood or ivory. Decorative **inlays** (shaped pieces of one substance embedded in another) in lighter woods were also made of ebony, as well as of ivory and Egyptian faience. An early version of **plywood** (a structural material now made by gluing sheets of veneer together) was even manufactured by the Egyptians by laminating thin sheets together, with the grain of one sheet at right angles to that of the next, the sheets held together with wooden pegs. Ivory pegs were also much used for joining wood. For cutting timber into planks, the Egyptians used only the technique called **through cutting** (Figure

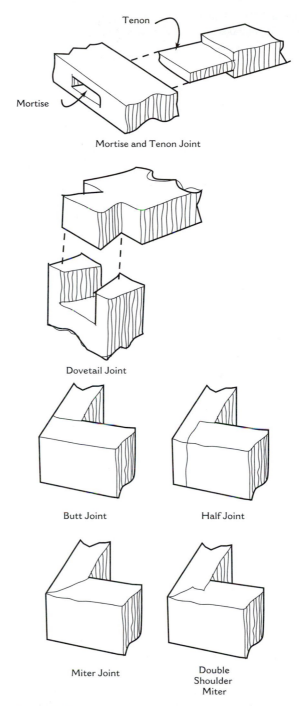

Figure 2–26 Types of wood joints.

2–27). The more complicated technique called **slash cutting** is today considered superior because it produces planks less susceptible to warping; it is, however, relatively wasteful of the wood being cut.

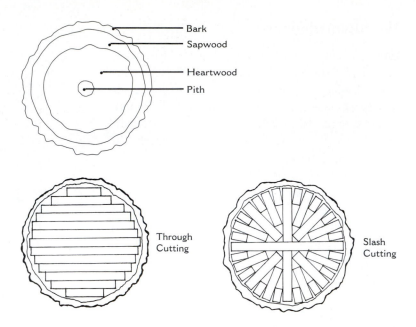

Figure 2–27 A section through a tree and two methods for cutting a tree into planks.

Bark
Sapwood
Heartwood
Pith

Through Cutting

Slash Cutting

Decorative treatments of wood furniture, in addition to inlays, included paint, plaster, **varnish** (a protective coating made of resin dissolved in alcohol or oil), **gesso** (a pore-filling ground made of glue and whiting), **gilding** (thin gold leaf over gesso), and thicker sheets of gold or silver.

Weaving

While modern Egypt is admired for its production of a strong, lustrous, long-staple cotton, the first weaving of ancient Egypt began less extravagantly, with such home-grown materials as the country's plentiful reeds and rushes, which were used to make baskets and even wickerwork tables and stools. But the cultivation of the flax plant, a winter crop, and its use in weaving linen was already a sophisticated industry in predynastic times. Different harvesting times yielded different products, the young green stems being appropriate for very fine thread, the tougher ripe stems for ropes and matting. Cleaning and combing processes also affected quality. The final results varied from fine gauze, bleached white and with as many as two hundred threads per inch, to a coarse canvas-like linen pale brown in color. The finest linen of all, reserved for royal use, including the wrapping of royal mummies (Figure 2–28), was described in Egypt-ian writings as being so fine as to be translucent, sometimes even transparent.

Wool, shorn from both sheep and goats, was also produced for curtains and wall hangings, as well as for blankets and clothing. Herodotus wrote in the fifth century that wool was considered unclean by the Egyptians and therefore little used. Later explorations, however, show considerable use of wool, and, indeed, the cool nights of the Egyptian climate suggest that fabrics heavier than cotton or linen would have been needed.

Dyes (such as red from the madder root, yellow from the safflower, and blue from fermented woad leaves) were in common use. Patterned textiles were also produced, but were costly and highly prized because of the labor involved, the degree of ornament in one's clothing and draperies being an indication of social rank.

The earliest Egyptian looms were horizontal ground looms (Figure 2–29), and pottery depictions of them show they were in use as early as predynastic times. By the New Kingdom, vertical framed looms, similar to modern tapestry looms, were also in use.

Egyptian weaving was highly skilled, with very few weaving errors found among surviving textiles. The royal harem instructed and trained textile weavers, important private estates employed their

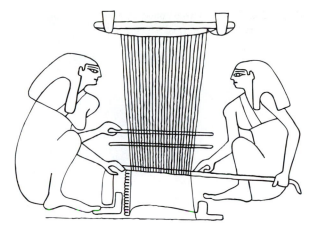

Figure 2–29 Two women weaving on a horizontal ground loom. The conventions of Egyptian art make the loom appear vertical.

ABERCROMBIE, AFTER HALL

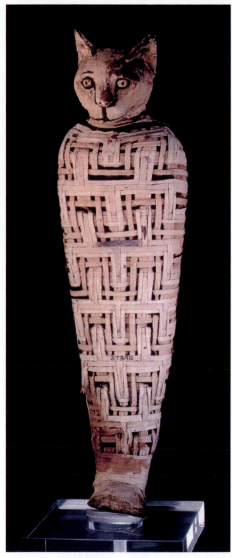

Figure 2–28 Mummy of a cat, probably a royal pet, wrapped in an elaborate pattern of linen strips.

COPYRIGHT THE BRITISH MUSEUM

own weavers, and all temple complexes included weaving studios that produced textiles not only for funerary garments and other ritual use, but also for sale or barter.

Glass and Egyptian Faience

Glass-like substances first appeared in Egypt around 4000 B.C. as glazes for decorative beads. The glazes were made of silica (in the form of sand, as Pliny said) and an alkaline element such as potash. Soon after, they were refined into Egyptian faience, a nonclay ceramic made of powdered quartz (another silicate) and a binding agent such as a solution of natron, a salt found in nature. The resultant paste could be modeled or turned on a

VOCABULARY EGYPTIAN FAIENCE

Note that the glass-like product described here is best called by the complete name *Egyptian faience*, because later we will see the general name *faience* as a term originating in sixteenth-century France (and derived from the Italian town of Faenza). The French term will commonly be used to describe a different kind of product, opaque-glazed earthenware such as English delftware and Italian majolica.

Figure 2–30 Lotus ornament in polychrome Egyptian faience from Amarna, eighteenth dynasty, 2½ inches (6 cm) high.

© PETRIE MUSEUM OF EGYPTIAN ARCHAEOLOGY, UNIVERSITY COLLEGE, LONDON. UC.907

potter's wheel, then hardened by firing. The product was naturally white, but could be painted with powdered minerals before firing, giving it both color and a fine, smooth finish. Different minerals produced different colors, but by far the most popular colors for the Egyptians were blue and green, possibly because of their resemblance to some of the most costly materials known to them: lapis lazuli, malachite, and turquoise. Ever conscious of symbolism, the Egyptians may also have seen in these colors a reference to the life-giving Nile.

By 3000 B.C., Egyptian faience was being used not only for beds and amulets, but also for small statuettes. Later it was also used for decorating wall tiles and, in the Middle Kingdom, for many delightful small animal figures, such as the hedgehog, a desert symbol, and the hippopotamus, a Nile symbol sometimes decorated with lotus flowers. Egyptian faience was used for delicate objects in the shape of lotus blossoms (Figure 2–30) and even for chalices imitating the same flower.

The Egyptians also produced glass, of course. Glass, like Egyptian faience, is largely a product of crushed quartz or sand. Following its use as glazing for other materials, it came to be used independently. The earliest Egyptian glass products were flawed with small bubbles, the result of firing temperatures lower than ideal. But by the eighteenth dynasty, good, clear glass was being made. With additives, the Egyptians also developed blue, green, red, gold, black, and opaque white glass.

In the New Kingdom, purple and lemon yellow were added to the palette of colors. New Kingdom glassware was generally delicate and ornamented, and was most often made by **core forming,** in which ropes of soft glass are wound around a core of dung or clay. An alternate method was to dip such a core in molten glass. After the vessel was **annealed,** or slowly cooled, the core material was broken up and extracted through the mouth.

Other techniques used by the Egyptians were **cold cutting,** in which crude glass forms were refined by chipping at them with flint or quartz instruments, and **molding,** in which molten glass was poured into a mold. An elaborate type of molding process was the **lost wax** or cire perdue (pronounced "seer pehr-dyoo") method, in which the desired shape was made of wax, encased in clay but with an opening left, then heated until the wax melted and could be poured out. The result was a clay form into which molten glass could then be poured.

A remarkable number of these techniques used by the Egyptians to produce their art and their crafts—in woodworking, weaving, and glassmaking, among other skills—are still in use today.

Summary: The Design of Ancient Egypt

It is natural that the Egyptians, surrounded by a vast, empty desert, gave little thought to the creation of spacious interiors. They concentrated instead on an impressive provision of monumentality achieved through weight and mass. The most obvious example is the Egyptian pyramid, a giant casing protecting one or two small rooms. In the Egyptian temple, as well, the interior volumes are overwhelmed by the great number, close spacing, and gigantic size of the stone columns. Egyptian architecture and its interiors give us the earliest and most thorough demonstration of the psychological effects that can be created through sheer amounts of construction.

This monumentality was reinforced by the use of symmetry and axial movement. Virtually every element in Egyptian monumental design is mirrored by an equal element. The pyramid exists as a singularity, as do sometimes the sphinx and the obelisk, but these are exceptions. In the vast temple complexes, symmetry and repetition abound, impressing visitors with an awareness of being surrounded by the vast, perfectly ordered, and timeless universe of Egypt, a universe combining both the natural and the supernatural.

The excellence of Egyptian art, however, is found not only in its great size and scope, but also in its detail. The fineness of its sculptured reliefs, and their sensitive relationships to the surfaces in which they were carved, have never been surpassed. The Egyptian artist was well aware of the need to subordinate ornament to form and to use decoration to enhance—but not obscure—the major statements of architecture.

Also remarkable is the persistence of Egyptian art, not just through Egypt's own long history, but also afterward. The political, religious, and social institutions that fostered the distinctive style of Egyptian architecture and design vanished long ago, of course. With the 1970 damming of the Nile, even some of the geographic determinants of the style have been altered. Egyptian art can never mean to us all that it meant to the Egyptians. Yet the Egyptian style has not vanished.

Egyptian art directly influenced the Greek and Roman art that would follow and that would in turn influence all subsequent Western art. Centuries later, traces of the Egyptian heritage can be found in art as different as the work of Baroque goldsmiths, chimney pieces by Piranesi, a clock by Percier and Fontaine, a mausoleum in Buckinghamshire, and ornament of the Art Deco period. A particular resurgence of interest in Egyptian art followed Napoleon's North African campaign at the end of the eighteenth century and the flood of drawings and information it produced, and another resurgence followed the sensational news of the twentieth-century discovery of the tomb of Tutankhamun. And even in our own time, in a phenomenon we shall see repeated with other highly developed styles, the distinctive character of what the Egyptians produced endures as an established part of our artistic vocabulary.

It may be absurd to build a Las Vegas hotel in the shape of a pyramid and name it the Luxor, but such absurdity shows that the works of Egypt still have a place in the popular imagination. Similar reminders of Egypt are the pyramid on the U.S. dollar bill and the one that appears when we log on to America Online. In more serious design, the miniature obelisk of crystal or precious stone is a frequently (some would say too frequently) employed decorative object, and Egyptian motifs abound in Regency and Empire furniture that we still appreciate and sometimes reproduce. Of greater importance is the fact that the artistic legacy of ancient Egypt is available for us to use today in any way we like—to reinterpret it in new materials, to use it in new combinations, to let it inspire us to new inventions, or simply to admire it. The art of Egypt, like all art, is dead for us only if we choose to ignore it.

CHAPTER

3

THE ANCIENT NEAR EAST

2800–331 B.C.

Parallel with the history of Egypt is the history of the ancient Near East. But that parallel history was more brief: the Near East's period of greatest accomplishment did not begin until Egypt's Great Pyramids were already built, and its heyday ended while Egypt still flourished.

The Near East, lying east of the Mediterranean Sea, south of the Black Sea, and northwest of the Persian Gulf, is the edge of Asia that bridges to the continents of Africa and Europe. Its lands now constitute the nations of Israel, Jordan, Syria, Lebanon, Turkey, Iraq, and Iran. Our history will focus first on the most accomplished early civilizations in the area,

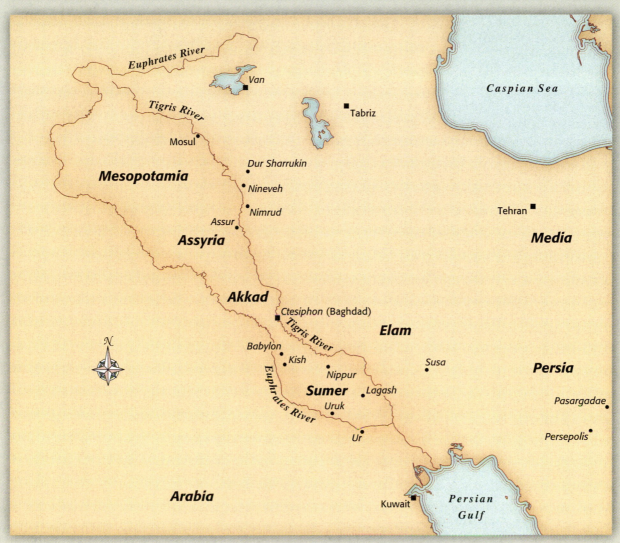

Figure 3–1 MAP OF THE NEAR EAST. Ancient sites are shown in italic type, modern cities in roman type.

ORTELIUS DESIGN

those of ancient Mesopotamia, the site of present-day Iraq. We will then consider the culture of ancient Persia, site of present-day Iran.

The name Mesopotamia, meaning "between the rivers," is derived from two Greek terms, *mesos* or "middle," and *potamos* or "rivers." The two rivers referred to are the Tigris and the Euphrates, and so rich was the soil deposited by these rivers that the area has been called the Fertile Crescent. So rich has been its history that it has also been called "the cradle of civilization."

Although its art never achieved the power or elegance of the art of Egypt, Mesopotamia made a number of important contributions to culture and design. As was noted in Chapter 1, "Design before History," the Sumerians of southern Mesopotamia are thought to have been the first inventors of written language, and the region may also have produced the earliest versions of the potter's wheel, the plow, and advanced techniques of boat building.

Our knowledge of this rich Near Eastern history is relatively recent and probably far from complete. French archaeologists introduced us to the Assyrians in 1842 with their excavations of the ancient cities of Dur Sharrukin (now the site of the modern village of Khorsabad, Iraq) and Nineveh (across the Tigris River from the modern city of Mosul, Iraq). The written language of the region was first deciphered in the middle of the nineteenth

century. And the 1877 excavations of ancient La-gash (now Telloh, Iraq) first brought us knowledge of the Sumerians.

Unfortunately, the findings have not been as spectacular as in Egypt, because Mesopotamian and Persian architecture and design are not as well preserved. Unlike Egypt, the Near East was not protected by desert from foreign invaders, nor did it have Egypt's dry climate to help preserve its art. Lacking Egypt's plentiful supply of fine building stone, the Near East also built with more perishable materials. However, from the remains that have been discovered, we can discern a distinctive character. Just as the Egyptians had discovered the artistic effectiveness of mass and used it to great advantage, the artists of the Ancient Near East discovered and used the potency of stylization and repetition. This artistic character is interesting in itself and also made interesting contributions to the later Islamic art of the same region.

Determinants of the Near Eastern Culture and Its Art

What determines the culture of any location at any time is impossible to fully understand. That is particularly true when the history of a culture is as complicated as that of the ancient Near East. Even so, we can see clearly that the region's geography, religion, and natural resources must have had definite effects on how the people of its various societies lived and how they designed.

Geography

We have seen how Egypt's topography, confining settlement to the banks of the Nile, fostered a national unity of government and economy, and how the surrounding desert offered protection from external attacks. The Near East was more exposed, easily invaded from every side, and its history is consequently more complicated. Unlike the Nile, the Tigris and the Euphrates are turbulent rivers for much of their length, making communications between different areas difficult, another deterrent to unity.

The Near East suffered a succession of raids and battles, triumphs and collapses, and rises and falls of various rulers, capitals, and gods. These upheavals meant that a long period of peaceful unity, such as Egypt enjoyed, was impossible. Whatever unity the ancient Near East enjoyed was partial and temporary. The upheavals also meant that a large part of Near Eastern wealth was necessarily spent on arms rather than on arts. To geography as a determinant must be added human nature, of course; the extent to which the chaos and militarism of the ancient Near East was forced upon its people and the extent to which its people created it are impossible to measure.

Religion

In an area with so little protection, it is natural that less attention was paid to provisions for an afterlife than to provisions for security in the present life. The people of the Near East built to create strong impressions and to convey messages of power, but, unlike the Egyptians, they did not build for eternity.

And in an area with such a fractured system of government, it is natural that religion was fractured, too. In place of Egypt's single almighty pharaoh commanding a whole nation of worshipful workers, the ancient Near East had a succession of rulers who were combinations of king, master, and god. Usually there were a number of such rulers, each competing for loyalty from a local base. A massive architectural and religious undertaking like the Great Pyramid of Giza could hardly be expected to arise from this situation. Even so, the builders of the ancient Near East, at times, came surprisingly close to such accomplishment.

Religious leadership in the ancient Near East seems often to have taken a practical course, with local temples and their rulers and priests organizing their dependent societies into efficient workforces. The temple collected and distributed food and directed the construction not only of palaces and further temples, but also of impressive systems of dikes, ditches, and canals for flood control and improved irrigation. These activities demanded record keeping, as did the unprecedented number of legal codes that began to be made. Written language was invented here—almost, it seems, by necessity—earlier than anywhere else we know. Clay

tablets inscribed with lists of accounts and laws are a commonplace of excavations in the Near East.

Natural Assets

The great asset of the ancient Near East was the favoring of agriculture. The rich soil, the variable climate, and the waters of the two rivers, supplemented by natural tributaries and man-made canals, combined to produce conditions well suited for the cultivation of crops. But the Near East, as we have mentioned, was less well endowed than Egypt with fine building stone. Although there was some limestone in the northern part of the land, there was none in the south. The chief building material, therefore, was mud brick, made of wet clay and chopped straw. Most mud brick was simply dried in the sun and was perishable. Some mud brick, however—usually heavy slabs about 1 foot (30 cm) square and 3 inches (75 mm) thick—was baked in kilns and was slightly more durable. Because of the limitations of this building material, ancient Near Eastern buildings and sculptures, compared to those of Egypt, were often smaller, more rounded in form, and generally rougher in quality.

The land also lacked large amounts of metals and timber. Copper, tin, silver, and gold were imported. Semiprecious stones such as carnelian and lapis lazuli were obtained by trading native textiles, crafts, and crops.

Generalizations sit uncomfortably, of course, on any land as complex as the Near East. Although much of it deserves the name Fertile Crescent, some parts are mountainous, some marshy, and some desert. And, as the Near East varies from place to place, it varies, too, from time to time, a whole parade of people with different origins and different goals arriving and departing through all its early history. We shall concentrate on four of them.

Four Players on the Near Eastern Stage

Although it was unified at several times during its history, the ancient Near East was composed of a number of distinct regions. The northern part was called Assyria, and the southern part Babylonia. Babylonia, in turn, was divided into a northern section called Akkad and a southern one, around the deltas of the twin rivers, called Sumer. To the east of all these areas lay Persia. Our simplified survey of the history of the ancient Near East will mention only the successive domination of the region by four groups: first, the Sumerians; second, the Babylonians; third, the Assyrians; and fourth, the Persians. The first three of these groups are collectively called Mesopotamians.

The Sumerians (c. 2800–c. 2003 B.C.)

The Sumerians were a settled people, raising livestock and cultivating crops. They joined together in cooperative projects for the clearing of the two rivers, the control of floods, and the irrigation of the surrounding fields. Their various communities prospered and developed into a number of city-states, each composed of an important town and surrounding territory that the town dominated. The most important of these city-states was Ur, the seat of the earliest Sumerian government. Also important was Nippur, which seems to have been a prominent religious center. Other Sumerian city-states were Umma, Kish, and Lagash.

The Sumerians, we believe, invented writing, an invention spurred by the need to document the commodities being traded and the laws being established. Literacy was widespread; however, because of its unaccustomed difficulty, it was probably limited to a small percentage of the total population. Writing and reading spurred the dissemination of knowledge in many ways. As literacy spread, so did the Sumerian culture, religion, and art that the writings described. These writings continue to inform us today, telling us much about the Sumerian buildings and decorations that have vanished.

The supremacy of Sumer was interrupted c. 2340 B.C. by the Akkadians, a dynasty founded by King Sargon. From the city of Akkad in Babylonia, the dynasty ruled a large territory stretching from the Mediterranean to the Persian Gulf, but their power declined and ended two centuries later, c. 2150 B.C. Akkadian art is exemplified by the stele

There are alternate versions for the names of many of the cities and rulers mentioned in the text. Xerxes, for example, is a name of Greek derivation, but in Old Persian the same king is called Khshayarsha, and in the Bible he is called Ahasuerus. There are also whole groups of Near Eastern people who are not mentioned in the text but who may be encountered in other readings. Briefly, some of these are:

- *The Achaemenids* were a particular dynasty of Persian rulers in the years 550 to 330 B.C. Their greatest ruler was Cyrus the Great, who used both Susa and Babylon as his capitals. He built a great palace for himself at Pasargadae, however, and he is buried there. Other Achaemenid rulers were Darius, Xerxes, and Artaxerxes Mnemon.
- *The Elamites* lived in what is now western Iran. Susa was their capital. Their golden age, the fourteenth century B.C., produced much literature and art, such as a great ziggurat at Tehoga-Zanbil. They were enemies and rivals of the Babylonians and were conquered by the Assyrian king Assurbanipal. Their capital of Susa later became a provincial capital of Persia, and the great palace of the Achaemenids was built there.
- *The Sassanians* were the last ruling dynasty of Persia, their power lasting from c. A.D. 226 to c. 640. They fought wars with the Romans, the Byzantines, and the Arabs. Their architecture included the palace of Shapur at Ctesiphon, with its huge brick-vaulted audience hall, and they also excelled in relief sculpture, metalwork, and woven silks.
- *The Semites* are people with related languages that derive from a common language called Semitic. In ancient times, they were largely nomadic, living in tribes ruled by hereditary leaders called *sheiks*. In Mesopotamia, Semites included the Assyrians and the Akkadians.

of Naram Sin, a sandstone plaque showing King Naram Sin, Sargon's grandson, dispatching his enemies.

Ur regained a measure of its previous importance between 2135 and 2027 B.C., and some monumental architecture was built there, including a great palace for King Sargon. A few decades later, however, Ur and all of Sumer were overcome by invasions of tribes from beyond the valley: the Elamites, the Amorites, and the Semites. A period of anarchy followed.

The Babylonians (c. 2003–c. 1171 B.C.)

Near the beginning of the third millennium before Christ, the city of Babylon became the chief center of all Mesopotamia, and the Babylonian king Hammurabi became the chief power. He ruled from 1792 until 1750 B.C., conquered Sumer, and commanded a unified state that also included what is now northern Syria.

Under Hammurabi, Mesopotamia reached its golden age. Agriculture, finance, and commerce all flourished, some on a higher level than even in Egypt. The Babylonian of this period is perhaps the first character on the human stage who can properly be described as a businessman. The arts and important buildings also developed.

Hammurabi is most often remembered, however, for his code of laws. There had been a number of earlier legal codes in Mesopotamia, now lost, but the Code of Hammurabi summarized, systematized, and modernized them. Its most famous tenet, quoted in Genesis 11:4, is "an eye for an eye," though this punishment was reserved for a nobleman who had destroyed the eye of another noble. If a noble destroyed the eye of a com-

moner, the specified punishment was only a small fine. The death penalty was specified for extravagant wives and for those who diluted beer. In addition to its picture of the laws and ethics of the time, the code tells us much about Babylonian social organization; professions mentioned include those of the shoemaker, the smith, the sculptor, and the master builder. The code of laws also suggests some of the restrictive conventions of the ancient Near East, conventions that demanded individual conformity to group standards. Such pressure to conform must surely have been felt throughout society, including the realms of architecture and design, even though the code itself does not include artistic matters.

The city of Babylon fell to an invasion of Hittites in 1595 B.C., but it remained an important center. Around 800 B.C., the city's famous Hanging Gardens were constructed, and they came to be considered one of the Seven Wonders of the Ancient World. Babylon was destroyed by the Assyrian king Sennacherib in 689 B.C. By then, however, the rule of the Babylonians had been succeeded by that of the Hittites, then in turn by the Kassites, the Elamites, and the Assyrians.

The Assyrians (884–612 B.C.)

The Assyrian people from the northern part of Mesopotamia had previously been held in subjection to other Mesopotamians, but they came to power themselves during the last two centuries of the first millennium. Their capital was first at Assur, then at Nimrud, and finally at Nineveh. Their chief rulers were Assurnasirpal, who reigned from 884 to 859, Sargon II (722–705), Sennacherib (705–681), and Assurbanipal (668–626). These rulers commanded impressive armies, and their empire extended beyond Mesopotamia to Syria, Palestine, the island of Cyprus, and even parts of Egypt. Under Sargon II, the great palace at Dur Sharrukin was built, and, under Assurbanipal, the capital city of Nineveh was embellished with a splendid palace of its own and a library holding a valuable collection of inscribed tablets.

In 612 B.C., the Babylonians, having rebuilt their city, came again to power and conquered Nineveh, aided by Medes and Persians. This new alliance is sometimes called Neo-Babylonian. Its greatest ruler was Nebuchadnezzar, and under his reign was built a great temple, probably the origin of the Bible story of the Tower of Babel. In 538 B.C., the city and its dominions were captured by the Persian leader Cyrus the Great. Mesopotamia was subsumed into the Persian Empire. It was wrested from the Persians by the Arabs, who established Baghdad as the area's new capital in A.D. 762. In 1258, the land was overrun by Mongol invaders, the city of Baghdad was devastated, and the ancient irrigation systems were destroyed. Mesopotamia never regained its past significance.

The Persians (538–331 B.C.)

Like Mesopotamia to its west, Persia was early to develop agriculture and settled communities. Unlike much of Mesopotamia, it enjoyed a good supply of building stone. The dynasty founded there by Cyrus the Great was named in honor of a mythical king, Achaemenes, from whom Cyrus claimed to be descended. The period dominated by that dynasty is therefore sometimes called Achaemenid Persian.

After Cyrus's army of Persians captured Babylon in 538 B.C., it conquered Egypt in 525, and by 480 B.C. the Persian Empire had become the largest that the world had ever known. It stretched from the Danube River in what is now Germany to the Indus in what is now Pakistan. The capital of this empire moved from place to place, but the great royal complex remained at Persepolis, and today

TIMELINE	THE ANCIENT NEAR EAST	
APPROXIMATE DATE	DOMINANT CULTURES	ARTISTIC ACHIEVEMENTS
2800–2003 B.C.	Sumerians	Ur
2003–1171 B.C.	Babylonians	
884–612 B.C.	Assyrians	Sargon's Palace
612–538 B.C.	Neo-Babylonians	Hanging Gardens Walls of Babylon Ishtar Gate Tower of Babel
538–331 B.C.	Persians	Persepolis

its ruins constitute the empire's principal relic. Its construction took almost sixty years, having been begun about 518 B.C. by one of Cyrus's successors, King Darius, and completed in 460 B.C. by Darius's son and heir, King Xerxes.

An important religious figure of ancient Persia was the prophet Zoroaster or Zarathushtra. He is thought to have lived from 628 to 551 B.C. and to have converted King Vishtaspa (possibly identical with King Hystaspes, the father of Darius) to a new religion. Its beliefs valued peace, kindness to animals (except for the sacrificing of bulls, which it favored), and permanent settlement rather than nomadism. This last belief could have been the impetus for Darius's ambitious building program.

In 331 B.C. Alexander the Great of Greece defeated Darius III, conquered Persia, ended its empire, and sacked Persepolis, perhaps in revenge for Persian raids on the Athenian Acropolis. The stones of Persepolis that remain, however, still make a profound impression.

The Architecture of the Ancient Near East

We have already noted Mesopotamia's shortages of stone and timber. These necessitated building with thick walls of mud brick. They also determined the shapes of many rooms. Whether the rooms were spanned by roof constructions of palm tree trunks—virtually the only wood available except for expensive imported cedar—or by vaults constructed of mud brick, the dimensions of the spans had to be kept small, although the numbers of spanning members could be multiplied as needed. Mesopotamian architecture of all types, therefore, is characterized by a series of long, narrow rooms, generally clustered around interior courtyards.

There were three main building types in Mesopotamia and Persia: the house, the palace, and the temple. The major building type seen in Egypt that is missing here is the tomb, for Middle Eastern religions did not require the elaborate accommodations of mummified bodies so important to the Egyptians.

The house was sometimes built on a single level, sometimes on two. Its thick exterior wall of mud brick was windowless and punctuated only by a single door. Within, however, the larger houses were built around private courtyards open to the sky, and a very important house might have several courtyards.

The palace was constructed in the same way but on a much larger scale. It might have a dozen or more courtyards and hundreds of rooms, some of them used as living quarters, some as chapels. It was also often distinguished from the houses of commoners by being raised on a brick-faced earth platform. Further distinction came in the decorative embellishment of the various rooms and apartments.

As the palace was the precinct of the city-state's earthly ruler, the temple was the precinct of its chief god. There must at times have been some rivalry between the two, but generally their reigns reinforced each other, the earthly ruler allegedly inspired or even anointed by the god and interpreting the god's wishes for the other citizens. The palace complex was, therefore, often adjacent to the temple complex, with shops and offices also clustered nearby. These few building types—the house, the palace complex, and the temple complex—constitute almost the whole architectural vocabulary of the ancient Near East, supplemented only by the fortified walls surrounding many of the towns and cities.

The Royal Citadel at Persepolis (518–460 B.C.)

With building stone available, the ancient Persians were able to construct a columnar architecture that would have been impossible with the mud bricks of the Mesopotamians. The religious practices of the Persians centered on altars of fire and water in the open air, so enclosed temples were not part of their building vocabulary, but their palaces and administrative centers were still elaborate. By far the greatest of these was at Persepolis (now Takht-I-Jamshīd), at the foot of the mountains near the Persian Gulf. As already mentioned, it was begun by King Darius and completed sixty years later by his son, Xerxes.

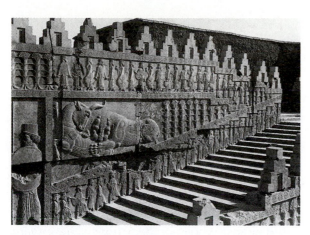

Figure 3–2 At the great ceremonial center of Persepolis, carved reliefs on the balustrade of the monumental stair.

The vast complex was a citadel with ceremonial and administrative elements for state occasions. It was raised on a series of platforms from 20 to 50 feet (6-15 m) above the surrounding plain, and down below was a sprawling group of palaces. The platforms covered an area roughly 900 feet wide and 1,400 feet long (about 300 x 450 m). Beneath the platforms was a great system of drainage tunnels, and climbing the platforms from the west was a monumental stairway (Figure 3–2) with generous treads, gentle risers, and handsomely carved stone parapets. Here, as elsewhere in the complex, carvings were impressively fine and astonishingly repetitive.

One of the major spaces of the complex is the Chehil Minar or Audience Hall. It is 250 feet (76 m) square, and originally held thirty-six columns 64 feet (20 m) tall. The dozen columns that remain show them to have been more slender than their counterparts in either Egypt or Greece. The column shafts were finely carved into **flutes,** parallel vertical semicircular grooves or channels, such as had begun to be used in Greece, leading some to speculate that stone carvers may have been brought from Greece to work on the palace. The columns must have supported a wooden roof, because their small size and wide spacing would not have carried beams

Figure 3–3 A scholar's reconstruction of the Hall of the Hundred Columns, Persepolis.

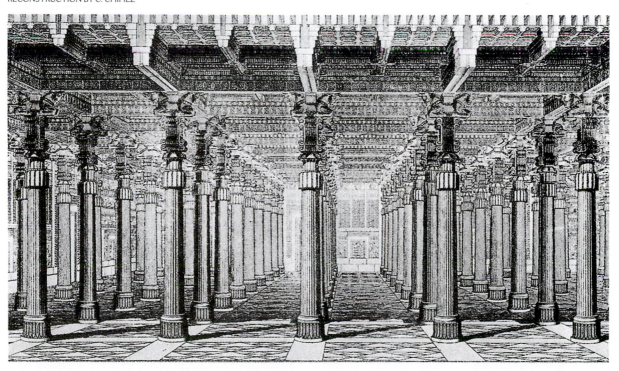

THE ANCIENT NEAR EAST 41

middle of their foreheads), and eagles (or perhaps griffins, mythical animals with eagles' heads and lions' bodies).

Furniture of the Ancient Near East

Some Egyptian furniture survives because it was sealed in tombs and further protected by a dry climate. The furniture of Mesopotamia and Persia has been less fortunate, and what we know of it is based almost wholly on depictions. These were carved in sculpture, in relief panels and plaques, or on cylinder seals—small embossed cylinders that could be rolled through wax, moist clay, or ink to leave an image or inscription. Some were no larger than a little finger, but they have left us much valuable information.

The peasant of the ancient Near East probably had no furniture other than a few cushions. Most middle-class seating seems to have been made of wood, a costly material, and woven reeds. Some storage pieces, which we might today call sideboards, appear to have been made of wood lattice. For the royal furniture of Babylonia and Assyria, more precious materials were also employed: bronze, gold, silver, and inlays of ebony and ivory.

The surviving images indicate a taste for elaborate ornamentation. Chair legs and their **stretchers,** the bracing members that connect the legs and strengthen the construction, are often elaborately **turned,** rotated on a lathe and shaped with cutting tools into a series of swellings, concavities, and disk-like shapes. The legs sometimes terminate in carvings imitating animal paws, and these rest on inverted cones, like small, upside-down ziggurats (stepped pyramids of square or rectangular platforms). These may represent cones from the pine or cedar tree, which may have had some special significance for the users of the furniture. Chair backs are often elaborately scrolled. A clear picture of a good example is the carving at Persepolis that shows Darius the Great seated on his throne (Figure 3–5).

There were stools as well as chairs, and the folding stool is depicted as early as 2300 B.C., sug-

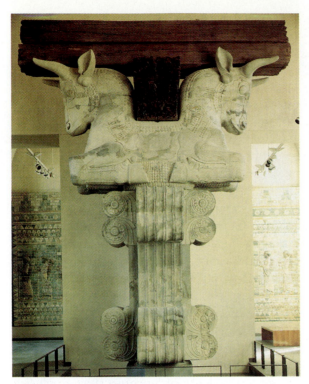

Figure 3–4 A pair of bulls form the top of a column capital, cradling the roof beam between them. Hall of the Hundred Columns, Persepolis, c. 500 B.C.

of stone. The room's brick walls were faced with tiles, their brightly enameled surfaces depicting animals and flowers. Beyond the Audience Hall, similarly columned antechambers adjoin it on three sides.

Another major space is the Throne Hall or Hall of the Hundred Columns (Figure 3–3). In this room, it is said, King Xerxes sat on a golden throne under a golden canopy. Only slightly smaller than those of the great Audience Hall, its columns were more closely spaced and did, in fact, number a hundred. Their **capitals,** the upper parts of their shafts, are topped with curious pairs of bulls' heads and forequarters. A depression between these bulls' heads formed an unusual sort of "cradle" that held a wooden beam (Figure 3–4). There is no known precedent for this column design. Similar columns elsewhere in the palace were in the shape of pairs of the heads and forequarters of lions, unicorns (mythical horse-like beasts with single horns in the

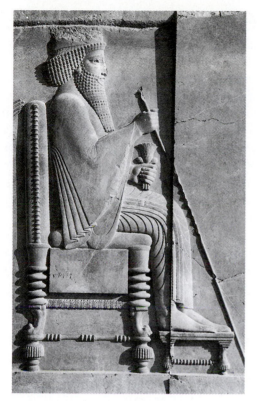

Figure 3–5 A relief from the Treasury of the complex at Persepolis shows King Darius's throne and footstool.

gesting that its appearance in the Near East may have been earlier than in Egypt. Squarish four-legged stools that did not fold are also depicted.

The Decorative Arts of the Ancient Near East

Some ancient Near Eastern decoration has already been mentioned—processions of carved figures, reliefs of lions, bull-headed column capitals, turnings on chair legs. Altogether, what we know of this decorative art was highly stylized, brightly colored, and often exotic in subject matter.

We saw in prehistoric art the tendency toward realistic representation, later joined by symbolic abstraction. Both realism and abstraction were present in the art of Egypt, and both in the ancient Near East. In the abstract realm, there were patterns that were purely geometric—squares, rectangles, circles—and some that were geometricized versions of plant forms.

Less abstract but hardly realistic is the tree-of-life motif. It was originated by the Assyrians, who named it *Hom,* and later it was also used by the Persians. Even later, we shall see it reappear in India and in the English Renaissance. It depicted an elaborate tree or vine with numerous branches, leaves, and flowers, growing from or around a column-like trunk (Figure 3–6). Sometimes, but not always, there were small figures of real and mythical animals among the foliage.

More characteristic of Near Eastern art, however, are animalistic decorations that are both more realistic and more strange. At about the same time that the Egyptians were carving the human-headed lion we call the Sphinx, the artists of the Near East were painting, carving, or inlaying figures that were also fantastic combinations of animals and humans, animals and birds, or animals of different species, such as a female human figure with the head of a lioness, or a scorpion with the head of a man. Most popular of all were bulls and lions with human heads, many of which also boasted great pairs of wings. These curious composite beasts may have been fetishes of supernatural powers, or they may have been illustrations of legends, or neither, or both. Their exact meaning is a mystery not yet solved.

One curiosity of some of the impressive animal carvings of Assyria is that the artists intended that each elevation present a complete view of the

Figure 3–6 Assyrian relief carved in alabaster shows a tree-of-life design between two winged men. The original is in the British Museum.

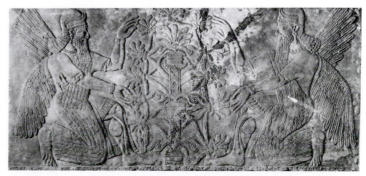

Wall Treatments

In addition to the carved reliefs, walls were sometimes faced with tile or brick with a glazed enamel surface. One unusual sort of mosaic frequently used was in the form of pointed clay cones, their circular flat surfaces brightly colored. The cones, after being painted or glazed, were hammered into the walls, with only the colored circles left exposed.

Walls were also painted with frescoes, only a few remnants of which have survived. On a base of white lime, these were painted in flat tones without the use of shading or perspective. Dominant colors were white, black, red, and blue. The few remaining fragments show that subject matter included religious figures, winged lions and other mythical beasts, and fancifully stylized trees and plants.

Rugs and Other Floor Treatments

The Near East has long been famous for its rugs, and the weaving tradition there is thought to have been well established even in ancient times. Both carpets on the floor and hangings on the wall, all sumptuously colored, brightened important interiors. Although these early textiles have vanished, they are mentioned in written accounts, and some of them were imitated in colored paving stones or carved marble in areas of heavy traffic. One such "rug" (Figure 3–8) embellished the entrance to the palace at Nineveh of Sennacherib, who was King of Assyria from 705 to 681 B.C. It is edged with a

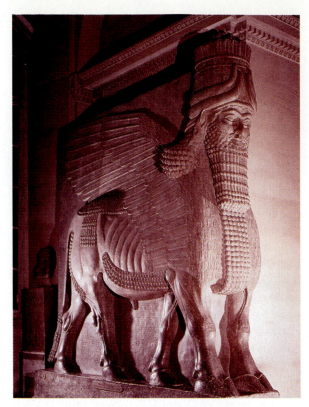

Figure 3–7 One of a pair of giant winged bulls with human heads (and five legs) flanking the palace entrance at Dur Sharrukin, Assyria, c. 720 B.C. Carved of limestone, 13 feet 10 inches (4.2 m) high.

SCALA/ART RESOURCE, NY

animal. When seen from the front, two legs were visible; when seen from the side, all four were seen. The result, often, is that one of the front legs was shown twice, making a total of five. Examples are the large winged bulls that stood guard at the entrance to the palace of Dur Sharrukin (Figure 3–7).

These great five-footed bulls must be considered reliefs, not sculpture in the round, for they project only slightly from the mass of the solid wall behind them. We have already seen the long stretches of repeated figures carved in relief at Persepolis. In the ancient Near East, such relief sculpture seems to have been more frequent than sculpture completely in the round. The reason may have been that a major aesthetic problem to be solved was the treatment of the large expanses of blank wall created by the mud-brick construction.

Figure 3–8 Marble pavement slab from the palace of Sennacherib, Nineveh c. 700 B.C., probably carved in imitation of a rug design.

AFTER FLETCHER, *A HISTORY OF ARCHITECTURE.* REPRINTED BY PERMISSION.

border of lotus buds, probably Egyptian in origin, and includes rosettes and palmettes that may have been inspired by early Greece. The weaving tradition of the ancient Near East, in the hands of the later Persians, as we shall see, would be continued to produce rugs that came to be the envy of all Europe.

Summary: Design Qualities of the Ancient Near East

The varied styles of the ancient Near East, which we shall consider together here, shared some strong common characteristics. They were rhythmic and energetic. They possessed a high degree of stylization. In many examples—a man clasping a pair of lions, a tree of life flanked by a pair of winged men—they displayed a heraldic symmetry. In others, axes were bent and processional routes were repeatedly turned, adding a sense of mystery and anticipation, while sacrificing the nobility of a more axial approach.

The subject matter of Near Eastern art and decoration seems to our eyes full of strangeness. We see animals performing actions that, in reality, we have never observed. We also see composite beasts never encountered except in myths and dreams. It was an art apparently intended to amaze or even terrify, not to ingratiate or comfort, and its exotic display would be glimpsed again in the mysterious art of the Byzantine Empire and in the later Islamic art of Syria and Palestine.

It was also an art determined to impress. Perhaps its most striking single characteristic is its use of repetition. The repetition of columns at Persepolis is one of many possible examples. The Near Eastern artists apparently never worried that regimentation would bore their audience and dull the mind. They knew that instead the multiple images would inspire awe, respect, and perhaps even fear at the power of the rulers who could command such numbers.

The ancient Near East failed, as almost all subsequent cultures have failed, to match the controlled grace and elegant polish of Egyptian art. The ancient Near East also lacked, as do all other cultures, the harmony, balance, and humanism we shall see in the architecture of Greece, an art that was beginning to develop in these same years. But ancient Near Eastern art had a robust vitality and an insistence on stating its message that, in the end, cannot be ignored. It was an art that achieved its goals.

GREECE

2800–146 B.C.

The ancient Greeks reached unprecedented heights of accomplishment in philosophy, ethics, politics, and many of the fine arts, all reflecting their respect for nature, for humanity, and for moderation. Their influence is with us still. For all their accomplishments, however, the frequent creation of outstanding interiors was not among them. Yet so sublime was their architecture that its elements are still in use, not only on the exteriors of our buildings, but also in our interiors, and frequently in our furniture. Some elements of the ornament devised by the Greeks to adorn that architecture are also still an important part of our own vocabulary.

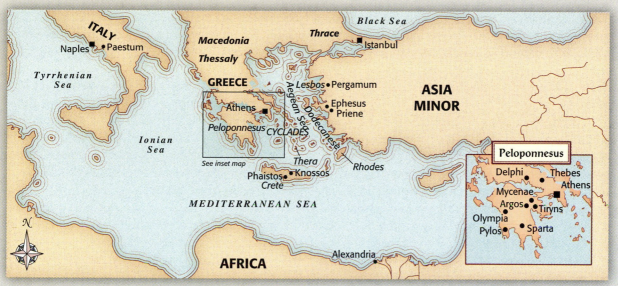

Figure 4–1 MAP OF ANCIENT GREECE

ORTELIUS DESIGN

The accomplishments of Greece were respected models for the Roman civilization that would replace it. In many ways, they are our models still. Whether or not today's designer ever attempts to work in the classical idiom, a familiarity with the basic elements of Greek architecture and the relationships among those elements are essential for design literacy.

The Determinants of Greek Art

In Egypt, a great river and its fertile shores surrounded by an immense desert, helped determine the character of a civilization and its art. In Greece, geography was again an influence, but there were other factors as well, among them the examples of earlier cultures. The most remarkable of those cultures—according to our present knowledge—were on the island of Crete and at Mycenae, on the mainland of Greece.

Geography and Climate

Greece comprises a large peninsula extending south toward the Mediterranean Sea, and many islands in the Ionian Sea to its west and in the Aegean Sea to its east. The climate and geography of this country are different from those of Egypt and produced different effects on those who lived there. The long, ragged Greek coastline with many bays and inlets bounds a fertile land of sunshine and rain. Tall mountains tower above it.

An important contributing factor to the character and detail of Greek architecture and decoration was the ready availability in those mountains of a perfect material: marble. Harder than alabaster, but softer than granite, this magnificent white stone had a fine grain and texture and could be cut easily into shapes having minute details with crisp edges. It was found on the Greek peninsula as well as on the adjacent islands, the most prized being the Parian marble from the island of Paros and the Pentelic marble from the Pentelikon mountain of central Greece, northeast of Athens.

The geographical character of the Grecian peninsula and the surrounding islands produced a race of seafaring people, and the search for metals and other materials, for new markets, and for foreign exchange impelled the Greeks to adventurous sea travel. Far from home, they encountered foreign and often subversive ideas.

At home, the mountainous topography of the land tended to isolate neighboring communities, which resulted in misunderstandings, jealousies,

and lack of amity. Strife between isolated city-states was constant, and political cohesion unattainable. Ancient Greece remained a loose federation of communities, although led by the most advanced and accomplished of them: Athens.

With foreign ideas to consider, and with local character a matter of rivalry and pride, independence of thought developed. The Greeks were the great individualists of antiquity. They were adamant in their desire for freedom to act, speak, and think as they wished. They considered as barbarians all those who lived under despots, accepted rule blindly, or lived without liberty, which included most of the then-known world. They regarded wisdom as the greatest of human attributes, and to attain it, they thought it essential to be curious and inquisitive, to doubt and to question all things until they were proved. To know truth and to understand were the Greeks' passions.

Foreign Influences, Heritage, and Identity

While the geography of Egypt, ringed by desert, had imposed centuries of isolation on the Egyptian culture, the more exposed geography of Greece encouraged interaction with other lands and peoples. Of all these influences on Greek culture, the two closest and most powerful were the civilizations of Crete and Mycenae. The older of those two cultures was that of Crete.

Crete

Crete, 60 miles (97 km) from the Greek mainland, is a narrow strip of an island, 170 miles (275 km) long. An agricultural society may have existed on the island since c. 6000 B.C., joined c. 3000 B.C. by emigrants from Asia Minor who brought new metalworking skills for making tools and weapons. The Cretans enjoyed extensive trade routes to central Europe, from which they imported tin and copper. They built important cities, centered on impressive compounds of reigning priest-kings, but the largest, most sumptuous palace compound was at Knossos, near the center of the northern coast. It was the palace of King Minos, a ruler whose name has been taken

for the entire culture: rather than Cretans, the people of ancient Crete are popularly referred to as Minoans.

Although the Minoan influence on classical Greece—either directly or through their Mycenaean imitators on the Greek mainland—is difficult to trace, its influence on the contemporaneous cultures of Egypt and the ancient Near East are clearer. Minoan artifacts have been found in these places, indicating the existence of both trade and some degree of admiration.

There was much to admire, not least the prevalence of a lighthearted, fanciful—some writers have used the term "fairyland"—character. In many cultures and periods we will survey, religion dominated the architecture and design; in others, the need for military security. What we know of Crete, however, suggests that most of its art was created for the pleasure of living. Unfortunately, the history of Crete was punctuated by disasters.

Around 1700 B.C. a major earthquake destroyed most of the structures on the island, including the first palaces. Around 1470 B.C. a catastrophic volcanic eruption sent tremors, tidal waves, and volcanic ash over Crete. A final disaster, probably an invasion by the Mycenaeans from the Greek mainland, occurred around 1380 B.C., causing the abandonment of most of the palace centers.

MINOAN ARCHITECTURE: THE PALACE OF KING MINOS AT KNOSSOS The city of Knossos is thought to have had a population of about 100,000, including those in the great palace compound. The palace complex is roughly rectangular, some 320 feet (98 m) from north to south and almost 500 feet (154 m) from east to west. Its rectangular central court is its most immediately striking element. The court's sides are diverse in function and appearance, many freely disposed elements being given monumental facades and porticoes.

This diversity pervades the complex that surrounds the court. One might even be forgiven the impression of a chaotic lack of design if it were not for the skilled arrangement of some of the parts, many rooms being opened to loggias or terraces (Figure 4–2) with carefully framed views of the landscape or the central court. The palace's

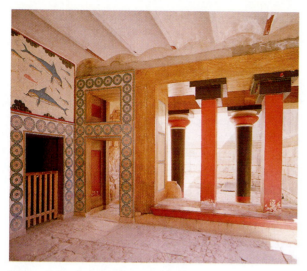

Figure 4–2 Reconstruction of a room in the queen's quarters of the palace at Knossos. The portico looks into one of the palace's many light shafts.

ROGER WOOD/CORBIS

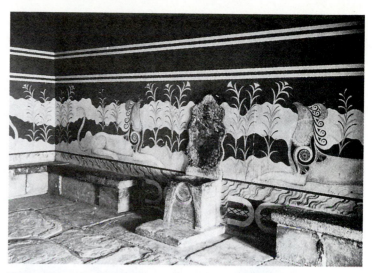

Figure 4–3 The brightly frescoed throne room of the palace at Knossos. The king's throne is surrounded by benches for his council.

HIRMER FOTOARCHIV, MUNICH, GERMANY

circulation pattern—a traffic system dictated by the layout of doors, corridors, and stairs—is a free and open one, with long corridors leading from one part to another, and with many exits and entrances, one room communicating directly with those adjacent to it, rather than being entered only from a corridor. The palace's most splendid and significant room is the throne room (Figure 4–3), which contains a stone throne built for the ruler and a row of stone benches at each side for his council. Its walls are covered with frescoes of mythical beasts and foliage.

A stately staircase (Figure 4–4) connects three floors of the palace, wrapped around a large light well, and is lined by a procession of fourteen distinctively tapered columns, which flare outward so that they are larger at their tops than at their bases.

MINOAN POTTERY The ceramic arts in Minoan Crete developed with ever increasing skill and exuberance. Although the designs of the famous Greek vases that would follow were different from those of Minoan vases, the Minoan tradition of pottery of artistic excellence may have influenced Greece. This is a tempting assumption because, although the Aegean world was barbarized, with most of its civilized arts virtually disappearing until the Greek civilization began to

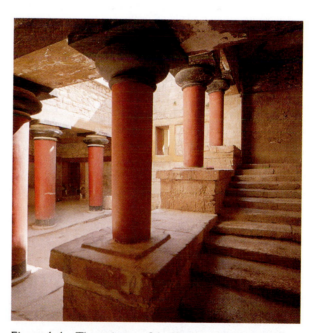

Figure 4–4 The staircase of the Knossos palace, its columned flights wrapping around a light well open to the sky.

ROGER WOOD/CORBIS

awake centuries later, the art of pottery seems to have survived. Fine examples of painted pottery have been dated to the twelfth century and even later, both on mainland Greece and in the Aegean islands (Figure 4–5).

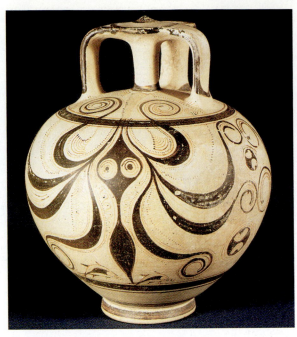

Figure 4–5 From the Cyclades Islands in the Aegean Sea, but found on the Greek mainland, a jar painted with a stylized octopus, c. 1150 B.C., 9 inches (25 cm) high.

NATIONALMUSEET DANSKE AFDELING

Mycenae

Mycenaean culture lasted slightly longer than Minoan. It occupied the southern part of mainland Greece. Its language was an early form of Greek, and Mycenae also left the Greeks technical skills such as pottery making, agriculture, and metallurgy.

The culture was centered in the city of Mycenae, from which it took its name. Other important Mycenaean cities were Tiryns and Pylos. The Mycenaeans are thought to have entered Greece from the north c. 2000 or 1900 B.C., bringing skills in metallurgy, pottery, and architecture, gaining supremacy in the Aegean after the violent destruction of Knossos c.1380 B.C., perhaps because of their own invasion of Crete, and ruling until c. 1200 B.C. Like the Minoans, the Mycenaeans erected large palaces and decorated them with bas-reliefs and brightly colored **frescoes.** They also made pottery and metalwork painted with geometric and natural designs.

THE MYCENAEAN PALACE AND ITS MEGARON Palaces and towns in Mycenae

were always sited on hilltops or other easily protected locations and were strongly walled. Some of the walls were built thick enough to hold a network of corridors and storage rooms for arms and food.

Perhaps related to this concern for protection, the Mycenaean palaces were not centered, like the Minoan ones, on large open courtyards, but on spacious halls called **megara,** meaning "great rooms." At Pylos, the megaron (Figure 4–6) measured 34 by 39 feet (11 x 12.5 m). The megaron was often placed at the north side of a courtyard, which it faced with a **portico,** a porch with a roof supported by columns. Beyond the portico was an entrance vestibule, and beyond the vestibule was the megaron itself, usually the largest room in the palace, centrally located, and rectangular. At the center of the megaron was a fixed circular hearth, where religious ritual involving fire may have been performed. Four columns were symmetrically placed around the hearth and supported a raised portion of roof, allowing smoke to escape and providing indirect light from above. The megaron and its hearth had symbolic significance, and some believe its use was restricted to the men of the palace.

Figure 4–6 Reconstruction of the possible appearance of the megaron of Pylos.

PIET DE JONG, THE THRONE ROOM OF THE MEGARON. REPRODUCED BY PERMISSION OF THE DEPARTMENT OF CLASSICS, UNIVERSITY OF CINCINNATI

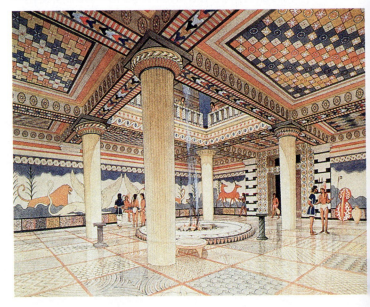

In the circulation pattern of the Mycenaean palace, the megaron is always isolated. It is reached only through the single door from its vestibule. Often it is surrounded by a corridor, so that it does not even share a wall with any other room. This isolation is typical of the Mycenaean plan. Unlike the linked rooms of the Minoan palace, its principal rooms open onto corridors or courtyards that provide the rooms' only access. This type of circulation pattern was to be shared by the later Greek house and, after it, by the Roman house.

BURIAL STRUCTURES: THOLOI AND SHAFT GRAVES

Other Mycenaean buildings are stone tomb structures with round, beehive-shaped burial chambers. Examples of these are one 44 feet (14 m) in diameter, called the Tomb of Clytemnestra, and another 47 feet (15 m) in diameter and almost the same dimension in height, called the Tomb of Agamemnon, both of which are at Mycenae. The Greek term for the round chamber is *tholos* (the plural is *tholoi*). Holes and bronze pins still visible in the inner surface of the Agamemnon tholos suggest that the interior was originally faced with bronze plates, although the interiors of other tholoi were plastered and painted. The door of the building was originally framed in red and green marble with projecting half-round columns (Figure 4–7).

Other Peoples

EGYPTIANS

The early Greek artists were undoubtedly influenced by Egyptian art. This is seen in their continued use of the column and lintel form of construction that the Egyptians had used extensively. The Greeks refined the Egyptian column, made it less a copy of natural forms, more slender and more graceful, allowed it more space, and used more moldings for its enrichment. The Egyptian effort to reproduce the clustered trunks of trees and bundles of reeds in the length of their columns was discontinued, and, in place of the convex tubes of Egyptian columns, Greek columns were faced with concave grooves called **flutings.** Egyptian influence is also seen in Greek sculpture, particularly in the use of Egyptian relief carvings as early models for the Greeks.

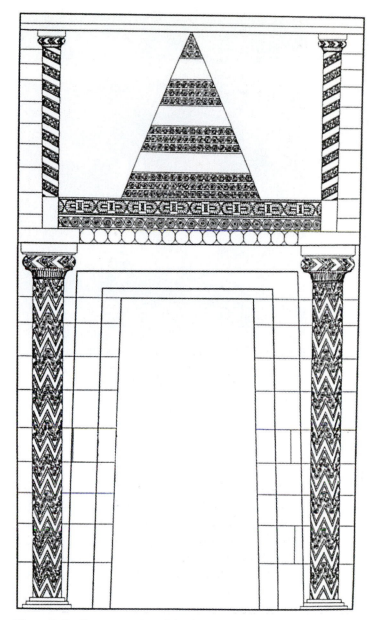

Figure 4–7 Reconstruction of the doorway to the so-called Tomb of Agamemnon. The triangular element over the door was of red marble, and the engaged half-round columns beside the door of green marble.

DORIANS AND IONIANS

The population of Greece itself was composed of many diverse groups. One of these was the Dorian people, originally barbarians from the northwestern mountains. Between 1100 and 950 B.C., they swept down into the Greek mainland, possibly bringing iron tools with them, and settled largely in Crete

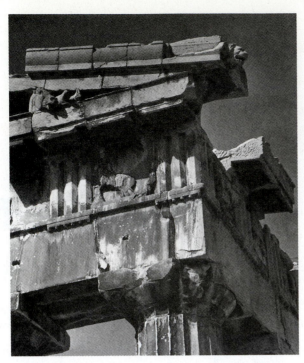

Figure 4–8 Detail of the northeast corner of the Parthenon as it appears today.

ALISON FRANTZ/AMERICAN SCHOOL OF CLASSICAL STUDIES AT ATHENS

and Sparta. It is for them that the **Doric order** is named: it is the simpler and sturdier of the two main Greek **orders,** or building styles (Figure 4–8).

As the Dorians penetrated the Greek peninsula, several groups already living there fled elsewhere. Some settled in Ionia, a strip of land along the coast of what is now Turkey, which therefore became part of the Greek world, and others settled on some of the islands in the Aegean. It is for them that the **Ionic order** is named; it is the more delicate of the two main Greek orders.

PERSIANS Influence from the Near East in general and from Persia in particular was most notable in Greece in the seventh century B.C. As we shall see, this influence was so strong that the century has come to be called Greece's Orientalizing period. But relationships between Greece and Persia were not always friendly. Expansion of the Persian Empire led to the Persian Wars, which lasted from 499 to 449 B.C. From these, however, Greece emerged victorious and with a greater degree of unity than it had previously enjoyed. A later con-

flict came in 331 B.C., when Alexander the Great, the mighty warrior from Macedon in northern Greece, conquered Persia and burned Persepolis.

Religion

The dramatic geography of Greece and her islands also influenced Greek religion, which was founded on the worship of nature. Special gods and goddesses were thought to embody the spirits of places. Mountains, valleys, islands, and harbors were protected by their own guardian divinities. Each god was also associated by the Greeks with one of the fundamental forces of nature.

The greatest three of these gods were Zeus, Athena, and Apollo. Zeus, the supreme god, was associated with earth and heaven and was responsible for storms and darkness; he was supposed to favor the locations of Olympia and Dodona. Athena, queen of the air, was especially linked with the city of Athens. And Apollo, the sun god, had as his favorite sites Delos and Delphi.

These divinities were peculiarly human. For the Greeks, humanity was the focus of attention and admiration, and the Greek gods were not the divine, supernatural, mysterious beings we find in most religions. They were slightly larger-than-life but still quite recognizable men and women. They were credited with powers that humans are denied, but their ambitions, problems, weaknesses, and passions were very human indeed.

The Greeks honored these near-human deities with shrines and temples that were appropriately scaled—not as modest as Greek domestic architecture, but far less grandiose than the monuments of Giza, Luxor, or Persepolis. Greek religious art is fully comprehensible to a human observer, and gods and goddesses, heroes and heroines, men and women were all considered joint participants in a remarkably balanced life. The Greek religion focused on life, not on an afterlife. Emotional satisfactions attained full scope in religious festivals and processions, athletic games, and every phase of private life. Idealism was maintained in all the best creative efforts.

Political and Military Factors

As a nation, the Greeks were essentially proud and convinced, not without reason, that they were su-

perior to all others as warriors, artists, philosophers, mathematicians, and writers. The first duty of the Greek citizen was service to the state, which included its glorification and the promotion of its cultural development. The objects of this service were the particular city-states, semi-autonomous units each comprised of a city and its surrounding, dependent lands. These units were small enough that every individual could be known.

By the standards of all the cultures that had preceded it, Greece was a marvel of democracy. And so it was, by any standards, for those men who were Greek citizens. But no women were citizens, not all free men were citizens, and certainly no slaves were citizens. Greek democracy was only a beginning step toward true democracy. But for its citizens there were freedom and equality. Extremes of wealth and poverty were not tolerated, and wealth was seldom displayed.

The happy result of the Greek spirit of service to the state and the Greek version of democracy was that the greatest amount of available funds, effort, and artistry was spent not on glorifying individual citizens, political leaders, or military figures, but on glorifying the locality's resident gods and goddesses. For most of their history, the Greeks themselves lived modestly while enshrining their deities in some of the most perfect structures ever built.

But the isolation of one Greek city-state from another that brought an admirable independence to the Greek character also brought a regrettable amount of warfare. Throughout Greek history, one city-state quarreled with another. The most famous and prolonged quarrel was that between Athens and Sparta, the city-state settled by Dorians and nestled in a mountain-ringed valley. The Spartans were courageous, self-disciplined, and warlike, but lacked philosophers, historians, or artists. It is Athenian idealism and its cultural results that have proved to be immortal.

The Chronology of Greek Art

In Greek art, we see a development toward increasingly naturalistic representation of the seen world. And throughout this development we see an equally striking constant: the desire to find order

TIMELINE GREECE

DATE	PERIOD	POLITICAL AND CULTURAL EVENTS	ARTISTIC ACCOMPLISHMENTS
1000–700 B.C.	Geometric	Olympic Games instituted, 776 B.C.	Vases and ornament with geometric designs
700–600 B.C.	Orientalizing	Alexander the Great conquers Egypt, 332 B.C.	Influences from the Near East, including curvilinear designs
600–480 B.C.	Archaic	Greek victory in the Persian Wars, 480 B.C.	Vase painting; early Doric temples; proto-Ionic columns
480–404 B.C.	Classical	Greek drama, poetry, history, philosophy; Pericles, 495–429 B.C.; Sparta defeats Athens, 404 B.C.	Perfection of the Doric and Ionic orders; buildings on the Acropolis, including the Parthenon
404–323 B.C.	"Fourth Century"	Death of Alexander, 323 B.C.	Introduction of Corinthian order
323–146 B.C.	Hellenistic	Roman conquest, 146 B.C.	*Victory of Samothrace; Laocoön*

in (or, failing that, to superimpose order on) the bewildering variety of personal experience.

The development of Greek art and architecture was a remarkably steady process. Even so, scholars divide that development into several chronological stages. Not all scholars make exactly the same divisions, but it is generally agreed that there were several formative stages that were followed by great periods of artistic maturity.

Three Formative Periods

One widely accepted division of Greek history identifies three formative periods—the Geometric, the Orientalizing, and the Archaic—followed by three mature periods. All, of course, had been preceded by prehistoric phases such as a Stone Age, which occurred in Greece around 4000 B.C., and a Bronze Age, around 2800 B.C., but little evidence has been discovered that could tell us what those times were like.

THE GEOMETRIC PERIOD (1000–700 B.C.)
As we have seen, with the destruction of the Cretan palaces around 1400 B.C., the Minoan culture was suddenly shattered. The Mycenaean culture

Although the familiar Christian calendar is used for dates throughout this book, the Greeks—among many others—recorded their own history with their own system. The Greek calendar began with the first year that the Olympic Games were held. That year 1 corresponds to the Christian calendar's year 776 B.C.

Other calendars in use by other cultures include:

- The *Mayan* calendar, which begins at a date corresponding to the Christian calendar's year 31,111 B.C., thought by the Mayans to be the beginning of time.
- The *Byzantine* calendar, which begins in 5508 B.C., another assumed date for the creation of the world.
- The *Jewish* calendar, which begins in 3761 B.C., still another assumed first year.

- The *Roman* calendar, which begins in 753 B.C., the date of the legendary founding of the city of Rome.
- The *Islamic* calendar, which begins in the year A.D. 622, the year that Muhammad left Mecca.
- The *French Revolutionary* calendar, which began with September 22, 1792, the first full day of the French Republic. It was in use only from 1793 to 1805.

Figure 4–9 A Greek vase from the Geometric period. It is an earthenware jug patterned in dark brown. Athens, eighth century B.C., 16½ inches. (42 cm) high.

ANCIENT GREEK PITCHER (OLPE) WITH GEOMETRIC DESIGN. © ROYAL ONTARIO MUSEUM, TORONTO, ONTARIO

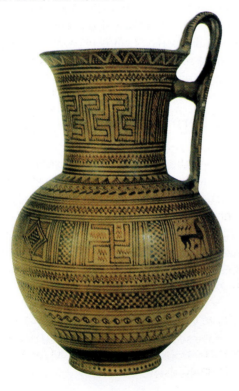

also, but more gradually, declined into chaos. The invasions of the Greek mainland from the north by the Dorians and other barbarians before 1000 B.C. further laid waste the two earlier civilizations and laid the foundations of a new one.

The earliest stage of truly Greek art, considered to have begun about 1000 B.C. and to have lasted around 300 years, is termed the Geometric period. In contrast to the naturalistic and fluid style of Crete, its decoration was highly abstract and angular, more akin to the style of Mycenae. This decoration of the Geometric period was limited in type and formal in character. Pottery vases, for example, displayed elaborate panels and horizontal bands of linear, geometric patterns—circles, triangles, squares, diamonds, and zigzag shapes (Figure 4–9). Even when human and animal forms were finally reintroduced, they were at first highly schematic, reduced to a series of geometric shapes.

The Olympic Games were initiated near the end of this period, in 776 B.C. These athletic contests and festivals were held every four years thereafter at Olympia in honor of Olympian Zeus, the supreme god. Because the games represented an unusual degree of national unity and cooperation,

the Greeks themselves considered this date the true beginning of their civilization.

THE ORIENTALIZING PERIOD (700–600 B.C.)

The seventh century B.C. is often called the Orientalizing period of Greek art, as influences from the Near East brought more lifelike representations and the introduction of arabesques and floral decoration. New subject matter appeared, more expressive than pure geometry had been of actual Greek life and thought. These new subjects included stylized plants, animals, birds, and mythological beasts. Also from the Near East came important luxury goods—spices, perfumes, textiles, and objects of ivory and precious metals. Imported to Greece as well were mythology, the alphabet, and the science of astronomy.

Near the end of the Orientalizing period and through the sixth century, new ideas were also imported to Greece from Egypt, where most of that country's most notable works had already been built. Egypt was naturally visited by the Greek seafarers, and it would remain a source of Greek inspiration for a long time. Alexander the Great would conquer Egypt in 332 B.C. and would found the city of Alexandria there the following year.

THE ARCHAIC PERIOD (600–480 B.C.)

From about 600 to 480 B.C., the time of the Persian Wars, was the so-called Archaic period, during which Greek sculpture became a major form of artistic expression. Outstanding among the early sculptures were figures of young Greek men, sometimes shown carrying sacrifices to the gods (Figure 4–10). Among these Archaic figures were the *kouroi*, statues of young nude men, usually striding, and in their simplicity recalling Egyptian forerunners. Vase painting also flourished in this period. Greek architecture, too, was becoming a recognizably powerful artistic form around the beginning of the Archaic period. Large limestone and stucco temples were built by the Dorians, both in Greece and in the Greek colonies in Sicily, southern Italy, and elsewhere. They were massive in proportion, and their design was dominated by the use of rows of columns on the outside of the buildings.

One of the earliest temples in which we can recognize the Doric style is at Thermum, built c.

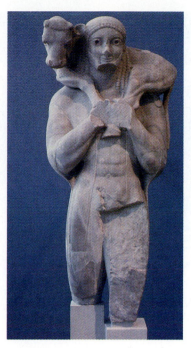

Figure 4–10 A sculpture from the Archaic period, found on the Athenian Acropolis, shows a calf being brought as a sacrifice to the goddess Athena, c. 560 B.C.

640 B.C. on the ruins of a more primitive temple. More advanced is the Heraeum at Olympia, built c. 590 B.C. Proto-Ionic column capitals—that is, the crowning features of columns from which the distinctive Ionic style later developed—are seen about the same time, c. 580 B.C., for example, at Neandra, and also on the island of Lesbos. The temple of Apollo at Corinth and the temple of Zeus at Selinus, in Sicily, also date from the Archaic period.

So does the great cluster of temples at Paestum, in southern Italy, with their robust early versions of the Doric order (Figure 4–11), their columns thick and with exaggerated swelling, topped with wide and sturdy capitals. At Paestum, the subtle refinements of the finished Doric order have not yet been worked out, but the Doric temple has already begun to express itself with authority and strength.

These three early phases—the Geometric, Orientalizing, and Archaic periods—established the foundation for the great flowering of Greek art that would immediately follow.

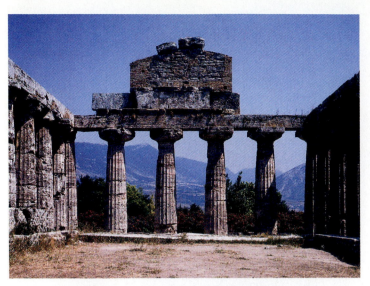

Figure 4–11 Inside the ruins of an early Doric temple dedicated to Athena at Paestum, southern Italy, built c. 510 B.C.

PHOTO: ABERCROMBIE

Three Mature Periods

In the transition of Greek art from its formative to its mature phases, and throughout that maturity, we see a remarkable consistency. There are no abrupt changes, no swings of fashion, no shifting of goals or abandonment of ideals. In general, building on the formative years' establishment of an artistic vocabulary, the mature years seek only to refine the elements of that vocabulary. Once an agreed-upon standard is reached, it is repeated with only minor changes. The pinnacle of Greek art, therefore, is generally thought to be in its first mature period, when many of the standards were first set.

THE CLASSICAL PERIOD (480–404 B.C.)
The greatest period of artistic achievement in ancient Greece, and one of the greatest of all history, came between Greece's victory in the Persian Wars with the Battle of Marathon in 480 B.C. and Athens's defeat by Sparta in the Peloponnesian War in 404 B.C. This time is variously called the Classical period, the Golden Age, or the Age of Pericles, named for the Athenian statesman who lived c. 495–429 B.C. and led the country to an unprecedentedly democratic form of government.

The fifth century, which includes most of the Classical period, has also been called the Athenian century, for it was then that the city of Athens was at the height of its artistic and intellectual glory. It was the age of the Greek dramatists Aeschylus, Sophocles, Euripides, and Aristophanes, the poet Pindar, the historians Herodotus and Thucydides, and the master of philosophers, Socrates, who died in 399 B.C. The harmonic proportions of the Doric and Ionic orders were perfected in this period, with a number of great Doric monuments being built in Athens, including the Hephaestum (465 B.C.), the Parthenon (c. 447–432 B.C.), and the Propylaea (437–432 B.C.). The most magnificent of the Ionic temples were built at Miletus, but the Ionic order was also employed for the Erechtheum on the Athenian Acropolis (421–405 B.C.) and for the interior of the nearby Propylaea.

THE FOURTH CENTURY (404–323 B.C.)
The period from the defeat of Athens (404 B.C.) to the death of Alexander the Great at Babylon (323 B.C.) is loosely called the Fourth Century, although the term *Late Classical* is also sometimes used. Although Athens in particular and the Greek city-state in general declined from their previous power, Greek civilization continued to expand, and the Fourth Century was the time of the orator Demosthenes, the philosophers Plato and Aristotle, and the "father of medicine," Hippocrates. Greek art continued to be increasingly realistic, but the ideal forms of the Classical period were replaced by more emotional forms, the most gifted sculptor of the period being Praxiteles. In architecture, the Corinthian order began to be used, although it never rivaled the Doric and Ionic orders in popularity with the Greeks.

THE HELLENISTIC PERIOD (323–146 B.C.)
In the Hellenistic period, 323–30 B.C., the effects of Alexander's conquests spread Greek culture over the Near East and far into Asia, with important new centers at Pergamon (or Pergamum), Rhodes, and Alexandria. Advances were made in mathematics and science, but, compared to their finest achievements, Greek literature became relatively ponderous, Greek architecture relatively complicated, and Greek art relatively sentimental. Even so, many familiar Greek masterpieces date from

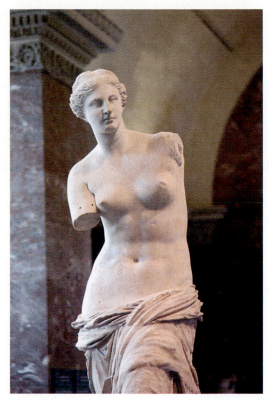

Figure 4–12 The Venus de Milo or, more properly, the
Aphrodite of Melos, carved in the second century.

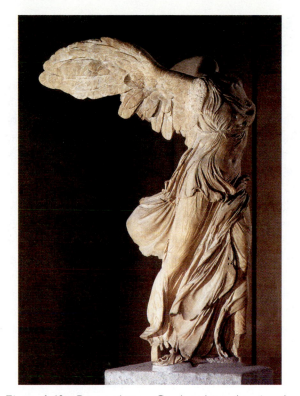

Figure 4–13 By an unknown Greek sculptor, the winged
marble *Victory of Samothrace*. She is seen having just landed
on the prow of a ship.

Hellenistic times, such as the *Venus de Milo* (Figure 4–12), her name a distortion of the Aegean island of Melos where, in her armless state, she was found. Other Hellenistic triumphs include the great altar at Pergamon and its friezes, and sculptures such as the *Victory of Samothrace* (Figure 4–13) and the original version of the *Laocoön* sculpture group (Figure 4–14).

Greece became a Roman province after the Roman conquest of 146 B.C., but Greek lives, customs, and arts would continue for centuries under Roman rule. The most outstanding of these arts was architecture.

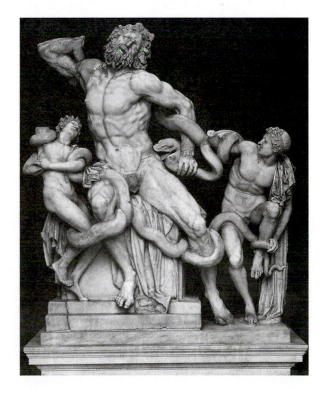

Figure 4–14 The *Laocoön* group, c. 200 B.C. The Trojan
priest Laocoön and his two sons are struggling against
serpents sent by the god Apollo to destroy them. The
sculpture was admired by the Romans and rediscovered in
Rome during the Italian Renaissance.

Greek Architecture

Greek architecture is basically functional, with every feature having a practical purpose. Columns were used solely for support, never for decoration. Little was introduced solely for its decorative effect, and although structural surfaces were enriched, the ornament was never applied to a degree that would reduce the structure to secondary importance in the design.

The prehistoric inhabitants of Greece undoubtedly built their houses of wood cut from the ample forests that covered the hills and valleys of the peninsula. Many authorities believe that, at the beginning of the Stone Age, the early Greek masons modeled the details of their buildings after the old wooden structures. There is much evidence in the early stone architecture of the Greeks that details and ornament were cut to imitate original wooden features, as the early Egyptian builders had done.

The Greek architecture that remains, however, and for which the Greeks are famous, is of stone. Walls of the great temples were in solid marble throughout, a material that was of such beauty that it could serve, without embellishment, as the interior decorative finish. The stones were so accurately cut that it was not necessary to use mortar in the joints (although metal clamps were often used to tie blocks of marble together). Craftsmanship in building was carried to a supreme degree of perfection. Careful attention was given to the ratios between all the parts of the building, even to the placement of joints between stones and to the relationship of the rhythms of the stone joints and of the roof tiles above them.

Although Greek architecture now appears the natural white of its marble, and although many later imitations would also be built with light-colored stone, evidence remains that the Greek buildings were originally brightly painted. Like the Egyptians, the Greeks chose colors for their symbolism and traditional use. Relief carvings, for example, were customarily painted in blue, green, and two shades of red, and their backgrounds painted in blue. For the relief figures of the Parthenon frieze, the most celebrated sculpture of Greece's most celebrated structure, the background was a brilliant scarlet.

The Greeks lavished most of their great architectural skills on their public buildings. Secular public buildings, such as gymnasiums and stadiums, were later developments, but the public buildings of religious character—the temples—were important from the beginning of Greek art.

The Temples of the Gods

The Greek gods and goddesses and their innumerable offspring were at first worshipped at altars open to the sky, then under increasingly elaborate shelters, these temples developing—as did also the Greek house—from rounded to rectangular in plan. These last were entered at the center of one of the short sides, often between pairs of columns that formed a roofed porch. Roofs were originally of **thatch,** a covering of straw, or of **wattle and daub,** a type of construction consisting of branches or thin wood strips ("wattles") plastered with clay or mud ("daub"). Later, the roofs were made of terracotta tile.

As these temples increased in size, internal columns were also needed. Growing still larger, the temples required two interior colonnades, rows of supporting columns, forming a central section with side aisles and focusing on the statue, at the rear of the sanctuary, of the god or goddess to whom the temple was dedicated. It was customary for these cult statues to be placed facing eastward, thus determining an east-west axis for almost all later temples.

These early temples were thus composed of two elements, the sanctuary, called the **cella** or **naos,** and the porch, called the **pronaos,** and sometimes of a third element, a second inner room, the **adytum,** considered more sacred than the first. Exterior walls were of mud brick, an unsatisfactory material to leave exposed to the weather, so that soon the front porch was extended to the sides and rear of the building. The basic character of the Greek temple was thus established early in Greece's formative period.

Also protecting the building from weather was the slightly pitched roof ending in **pediments,** triangular portions of wall carrying the pitched roof. Cicero, in his handbook on oratory, noted that the temple pediment was first devised simply to make

roofs shed their rainwater; but, having become a familiar and respected design element, the pediment would be repeated "even if one were erecting a citadel in heaven, where no rain could fall."

These basic elements—the sanctuary wrapped by a colonnade and topped with a pedimented roof—constitute the Greek temple form. It was a simple formula for a building, but one that was capable of infinite variation and the most subtle refinement. As an example, we shall look at the most refined example of all, the Parthenon on the Acropolis of Athens. It is a masterpiece that, according to architectural historian A. W. Lawrence, "is the one building in the world which may be assessed as absolutely right."

The Acropolis and the Parthenon

An *acropolis,* meaning "the high point of a city," was an elevated section in a Greek town. Many of them existed throughout Greece. Some of them were fortified and used for defensive purposes, like their Mycenaean predecessors, although the most famous one (spelled with a capital *A*), the Acropolis at Athens, was devoted solely to religious purposes. Special attention is due the famous buildings on this hill (Figure 4–15). They were erected under Pericles in the latter half of the fifth century B.C., a time of wealth, se-

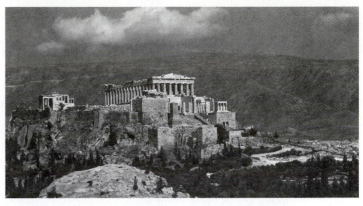

Figure 4–15 Overall view of the Acropolis, Athens, from the northwest. The largest building, on the highest ground, is the Parthenon. At the left is the Erechtheum. Directly below the Parthenon is the gateway building called the Propylaea. And at the right is the tiny Temple of Nike.

ALISON FRANTZ/AMERICAN SCHOOL OF CLASSICAL STUDIES AT ATHENS

curity and confidence following the success of Athens in the Persian Wars.

A winding processional path led from the city up the western slope of the hill, about 260 feet (80 m) high, to the monumental Propylaea (Figure 4–16), which served as gateway to the fairly level hilltop. From the Propylaea, a path called the Sacred Way passed a giant bronze statue of the goddess Athena and the site of an early temple,

Figure 4–16 Reconstructed view as one enters the sacred precinct of the Acropolis through the Propylaea. To the left is the Erechtheum. To the right is the Parthenon. Between them is a giant statue of Athena, now destroyed.

DRAWING: JOHN TRAVLOS

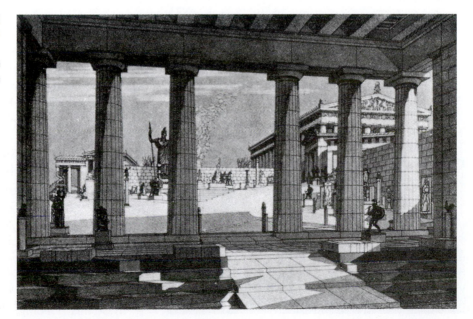

and then led to the Parthenon on the highest part of the hill.

To the north stood the Erechtheum, a rarity in Greek architecture because of its irregular plan, shaped to incorporate several sacred shrines from earlier times. Its six-columned portico on the east was in the Ionic style, and a smaller portico on the south was supported by sculptured female figures in place of columns.

Southwest of the Parthenon was the small Temple of Athena Nike, and completing the composition on the southern slope of the hill were the theater of Dionysus and, added later, the Odeum of Herodes, a roofed building for musical contests and rehearsals.

The culminating masterpiece of Greek architecture was the Parthenon (Figure 4–17). Ictinus and Callicrates were its architects, and Phidias its master sculptor. The building was constructed from fine white Pentelic marble. It measured roughly 101 by 228 feet (31 x 69 m), for a proportion of about 4 to 9. It was peripteral, with eight columns at each short end and seventeen on each long side (forty-six in all), standing on a **crepidoma,** a stepped platform, the upper step of which is called the **stylobate.** Within its surrounding ambulatory, the body of the building consisted of two rooms (Figure 4–18). The larger room, the cella or naos, was entered from the eastern porch, the pronaos, and

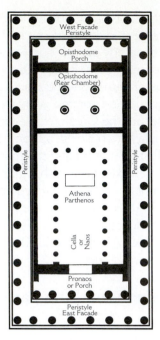

Figure 4–18 Floor plan of the Parthenon.

featured two rows of Doric columns, connected—perhaps for the first time in Greek architecture—across the back of the space. Within these columns, near the back, was placed Phidias's 40-foot-high (12 m) statue, in gold and ivory with precious jewels for the eyes, of the virgin goddess, *Athena Parthenos* (Figure 4–19). Some believe that a shallow pool between the entrance and the statue reflected light from the exterior onto the figure of the goddess. The smaller room was entered from the western porch and may have served as a treasury.

The upper part of the cella walls and the vertical surfaces above the porticoes constituted a 525-foot-long (170 m) frieze in shallow relief, showing the Panathenaic ("all Athens") procession, a ritual undertaken every fourth year in honor of the goddess. Masterful sculpture filled the pediments at each end of the building, the group on the eastern end representing the birth of Athena and that on the west the contest between Athena and Poseidon. Brilliant color was applied to parts of the stonework.

Impressive as was the harmony of the basic form of this building, and exquisite as was the

Figure 4–17 The east front of the Parthenon and its eight Doric columns.

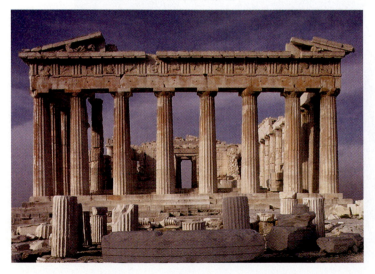

Figure 4–19 Model of a reconstruction of the interior of the Parthenon with Phidias's ivory and gold statue of Athena before a shallow reflecting pool. The exact appearance of the statue is unknown.

sculpture applied to it, it was further enhanced by a number of subtle refinements. Probably never in history has greater thought been devoted to a building design.

The stylobate, for example, was not perfectly flat, but was curved slightly upward in the center of each side, giving the whole floor a carefully calculated compound curvature. Columns near the corners of the building tilt slightly inward. Corner columns are given an added thickness of diameter and are placed slightly closer to their neighbors than typical. All columns are given a slight convex bulge or **entasis.** And inscriptions were carved with slightly larger lettering on the top lines, so that, from below, all letters would appear equal. These refinements have been much studied and

much admired but—except for the entasis, which appears on almost all columns—they have been seldom imitated.

These refinements, all deviating slightly from the expected rectangularity, repetition, and even spacing, must have added a great deal of difficulty to the construction process. Not all spacings are equal; not a major line is straight; not a major surface is level. We naturally wonder why the Greeks felt these refinements were worth the effort. The most frequent speculation has been that they were calculated to correct optical illusions that, without them, would have occurred. For example, if the corner columns, which are sometimes seen in outline against the sky, were not thicker than those seen against the temple wall, they might appear to be thinner than the others. Or, if the stylobate did not rise slightly in the center, it might seem to sink. But, although the refinements are subtle, they are not invisible. They were clearly meant to be seen, and compensating for possible illusions does not seem to fully explain them. Nor does their possible functional value: The inward tilt of its columns may somehow have added to the temple's structural stability, and the curving of its stylobate may have speeded the drainage of rainwater, but these seem minor advantages for such difficult adjustments.

Undoubtedly, a heightened aesthetic experience was their goal. Perhaps the convergence, at an imaginary point roughly a mile overhead, of the centerlines of all the columns gives the composition a unity and coherence it would otherwise lack. And certainly the curving of the stylobate and the bulging of the column shafts, and the variations in their spacing, give the building a sense of movement and organicism—of being similar to the form of a living organism—that a more static building could not have achieved.

This wonderful structure has not had an easy existence. In the sixth century, it was converted to a Christian church, an addition containing an altar being built onto its east end. It later served as a mosque, with a minaret added. In the seventeenth century, while being used by the Turks as a powder magazine, it was partly destroyed by an explosion. Further desecration occurred in the early nineteenth century when many of the carved reliefs were removed from the site and carried to England by the Earl of Elgin, a British diplomat.

They can now be seen in the British Museum, London.

Enough still remains to establish the Parthenon's supremacy among world architecture. It is clear that its architects made a great many choices, some of them highly unusual but all of them wise, and that they attempted some novel but successful experiments. Yet all their choices and experiments were within the framework of one dominant set of compositional rules, the Doric order.

The Greek Orders

When the term *order* was first introduced, earlier in this chapter, it was defined simply as a building style. It is that, but it is more. A classical order, either Greek or Roman, specifies the style of a column, the style of the **entablature** (the beam-like member that the column supports), the details of both column and entablature, and the relationships between the component parts of the whole assemblage. Such a system of specifications was not a matter of individual inspiration or originality; it developed only through years of study, trial and error, and constant refinement. In all the history of Greek architecture, there were only two principal orders, the Doric and the Ionic, and one subsidiary order, the Corinthian.

The two principal orders developed on opposite shores of the Aegean Sea, the Doric on the west, the Ionic on the east, though both have common elements inherited from Mycenae and Egypt. The Doric order had achieved a definite, recognizable form by the seventh century B.C., the Ionic by the sixth, and both were perfected in the fifth.

The Roman architect-theorist Vitruvius characterized these two styles as male and female: "The Doric column, as used in buildings, began to exhibit the proportion, strength, and beauty of the body of a man. Just so afterward, when they desired to construct a temple to Diana in a new style of beauty, they translated the . . . footprints (lower diameters) into terms characteristic of the slenderness of women . . . ," and the volute of the Ionic order, he thought, resembled "graceful curling hair. . . . Thus in the invention of two different kinds of columns, they borrowed manly beauty, naked and unadorned, for the one, and for the other the

- The Greeks never called themselves Greeks. The term derives from the Roman's word for them, *Graeci*. Terms used by the Greeks themselves included *Hellas* (sometimes spelled *Ellas*), meaning the country of Greece or, more precisely, the total aggregation of Greek city-states, and *Hellenes*, meaning the people or the things of Hellas.
- *Hellenism* refers to the whole of Greek culture, as does the adjective *Hellenic*, while, conventionally, *Hellenistic* is used for only the final period of that culture. The term *Helladic* is used for early development on the Greek mainland.

- The term *Hellenist* has two meanings: first, a person living in a Greek manner but not of Greek ancestry; and second, a person knowledgeable about ancient Greek culture.
- *Helen*, with one *l*, is a figure in Greek mythology, the daughter of the god Zeus and the princess Leda, and considered the most beautiful of women; jealousy between Menelaus, her husband, and Paris, her captor, was said to be the cause of the Trojan War; she appears as a character in both the *Iliad* and the *Odyssey*.

delicacy, adornment and proportions characteristic of women."

Historian William Dinsmoor makes a similar distinction based on ethnic characteristics: "Hence the differing treatments became not only symbolic of the two greatest divisions of the Greek race, whose rivalry makes the history of Greece, but also they most expressively represent, on the one hand, the grave, severe Dorian of Hellas and, on the other, the lighter, more versatile and luxurious emigrant to Asia who stands for the type of the Ionian race farthest removed from the Dorian."

Both these characterizations of the two chief orders, however, are oversimplifications at best. Only familiarity with the details of the orders themselves can give a good understanding of their distinctive characters.

THE DORIC ORDER The earliest, most severe, and most popular of the Greek orders is called Doric because it was the most frequent style in those western areas inhabited by the Dorian Greeks. As we have seen, an early version of the Doric order was employed at Paestum. A more mature version was used not only for the Parthenon, but also for the temple of Apollo at Delos, for the temple at Segesta, Sicily, for the temple of Zeus at Stratos, and for countless other structures.

In every order, columns support an entablature. In the Doric order (Figure 4–20), the column is divided into a **shaft,** its main vertical body, and a **capital,** its topmost part. The Greek Doric shaft

Figure 4–20 Elements of the Greek Doric order.

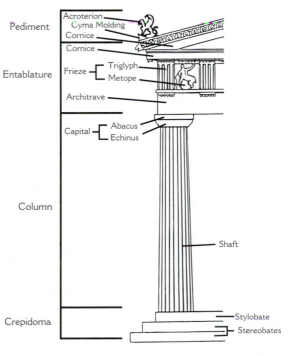

meaning any painted or decorated band.) The Doric frieze presents a horizontal sequence of two alternating elements: the **metopes,** squarish panels that may be filled with carvings in low relief as at the Parthenon (Figure 4–21) or left plain, and **triglyphs,** triple-grooved elements that are thought to be survivals of the wooden beam ends visible in early temples. The alternation is such that there are always triglyphs at both ends of each side of the frieze. Other general rules are that triglyphs are spaced twice as frequently as columns, and that every other triglyph is centered on the column beneath it (Figure 4–22). This last rule obviously cannot be strictly obeyed if a triglyph is to be at the end of the

Figure 4–21 Carving of a man and a centaur (half man, half horse) on a metope from the south side of the Parthenon, c. 447–442 B.C., 4 feet 8 inches (1.5 m) high.

LAPITH BATTLING CENTAUR, METOPE FROM THE PARTHENON. BRITISH MUSEUM, LONDON, GREAT BRITAIN. ART RESOURCE, NY

Figure 4–22 Drawing of a detail from one of the Doric temples at Selinus, Sicily, sixth century B.C. In this case, the metopes have been left plain, and alternate ones align with the centerlines of the columns below.

DRAWING: KOLDEWEY AND PUCHSTEIN, *GRIECHISCHE TEMPEL IN UNTERITALIEN UND SICILIEN,* 1899

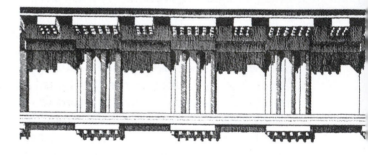

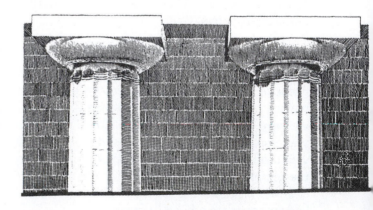

usually sits directly on the stylobate without an intervening **base,** although the Romans would later add a base to their version. The Doric shaft is carved into vertical channels called **flutes,** and the adjacent flutes meet in a crisp edge called an **arris.**

The Doric capital has two parts. The lower part is the **echinus,** a convex—that is, cushion-shaped—molding circular in plan; it is often banded with thin grooves, but is otherwise unadorned. The upper part of the Doric capital is the **abacus,** a plain square block that helps distribute the load of the entablature above to the column below.

The Doric entablature has three elements. The lowest is the **architrave,** a plain member resting directly on the column capitals and spanning between them. (The term is also sometimes more loosely used to refer to a molded frame surrounding a door or window.) Above the architrave is the **frieze.** (This term, also, has a more general use,

frieze, a difficulty that, in practice, is overcome by adjusting the widths of the metopes and—a refinement discussed above—also adjusting the distances between the columns.

The topmost element of the Doric entablature is the **cornice.** (This word, as well, has come to have a more general meaning, referring to any projecting molding on a wall.) The front surface of the cornice is generally plain, but the bottom surface displays a series of miniature slabs called *mutules.* Projecting from the mutules, as well as from the bottoms of the metopes, are tiny pendants in the shape of tapered cylinders; these are called *guttae.*

Above these elements on the two gable ends of the temple are the triangular pediments topped with their own cornices and with a further molding called a *corona.* All three angles of the pediment are often embellished with **acroteria,** ornaments or figures—such as small winged lions—sitting on small plinths. The singular form of the word is *acroterion,* but *acroterium* is also sometimes seen.

THE IONIC ORDER The Ionic order, which originated in the eastern part of Greece, is less architecturally limiting than the Doric, allowing more decorative features and more variety. It appears less frequently than the Doric, but it was used for some of the largest Greek buildings ever erected. The gigantic Ionic temple of Artemis at Ephesus, for example, measured about 180 by 377 feet (58 x 122 m). It was one of the few Greek temples to approach the size of Egyptian examples. It has been destroyed, but intriguing fragments remain, such as a column top with its capital (Figure 4–23). At a very different scale, the tiny Temple of Athena Nike on the Acropolis (Figure 4–24), only 18 by 27 feet (6 x 9 m) was also Ionic, and there were many other examples.

Like the Doric, the Ionic order (Figure 4–25) is divided into column and entablature. The Ionic column, in addition to shaft and capital, has a third element, a base composed of moldings circular in plan and of slightly greater diameter than the shaft. The Ionic shaft, more slender in proportion than the Doric, is also carved into vertical flutes, but here they do not generally meet in a sharp arris,

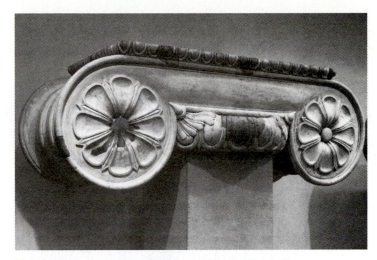

Figure 4–23 From the sixth-century Temple of Artemis at Ephesus, the remains of an early Ionic capital. The rosette within the volute is an unusual variation.

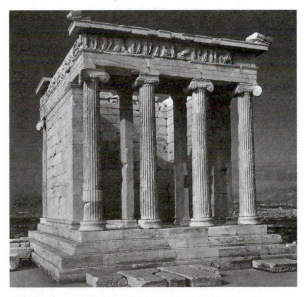

Figure 4–24 On the Athenian Acropolis, the Ionic order in the Temple of Athena Nike, c. 425 B.C.

but with a thin, flat, intervening surface called a **fillet.** (Another of those words with double meaning, the fillet is also a narrow flat molding.)

It is the column capital of the Ionic order that is its most distinctive feature. On each face is a pair

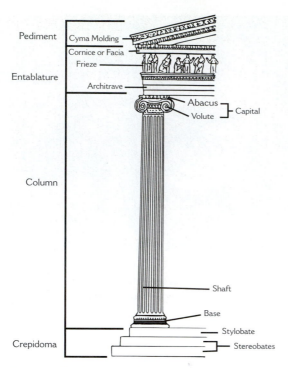

Figure 4–25 Elements of the Greek Ionic order.

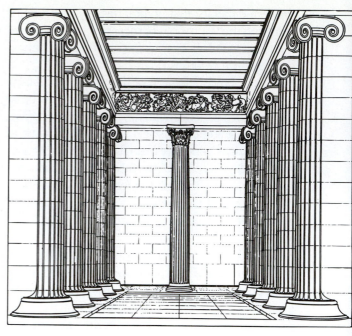

Figure 4–26 Reconstruction of the interior of the Temple of Apollo at Bassae, fifth century B.C. Rows of Ionic columns are engaged with side walls, and before the back wall is a single example of the Corinthian column.

FROM *GREEK ARCHITECTURE*, BY A. W. LAWRENCE, © 1973 BY YALE UNIVERSITY PRESS. USED BY PERMISSION OF THE YALE UNIVERSITY PRESS.

of spiral scrolls called **volutes.** Seen between the volutes is an encircling echinus, more decorated than its Doric counterpart. And at the top of the column is an abacus, but one much smaller than the Doric one. The Ionic capital (and a very similar variant with more vertical emphasis, called an **Aeolic** capital) was used not only on buildings, but also on furniture, in such places as bed and table legs. These capitals, some think, may even have had their origin in furniture design.

Ionic columns support an Ionic entablature, and, like the Doric, it is divided into three parts: architrave, frieze, and cornice. All these may be plainly finished, with perhaps only a small projecting molding separating architrave and frieze. But at times the architrave can be stepped in three horizontal planes, each stepping slightly forward of the one below. And at times the frieze and cornice can both be in the form of highly ornamental moldings. Again, at the ends of the building, pediments capped with their own cornices top the entire composition.

THE CORINTHIAN ORDER The Corinthian is more decorative than the Doric or the Ionic. Its name derives from the supposition that it was first introduced in the Greek city of Corinth. Appearing relatively late, it can be considered an ornate version of the Ionic, and was used for relatively few Greek buildings. It was used for some important ones, however. A single Corinthian column, a recent invention at the time, appeared in the interior of the fifth-century Temple of Apollo at Bassae (Figure 4–26). It was more extensively used in the Temple of Zeus Olympius (also called the Olympieum) at Athens (Figure 4–27), the Temple of Zeus at Euromus, and the temple at Knidos, in Turkey, that may have housed Praxiteles's famous statue of Aphrodite. Later, the Corinthian order would become a favorite of the Romans.

The Corinthian column shaft has a smaller diameter than either the Doric or the Ionic, but the order's chief distinction is its capital (Figure 4–28). In addition to pairs of spiral volutes like those of the Ionic capital, the Corinthian capital, in the shape of an upside-down bell, bristles with a multitude of leaf shapes modeled on the prickly foliage

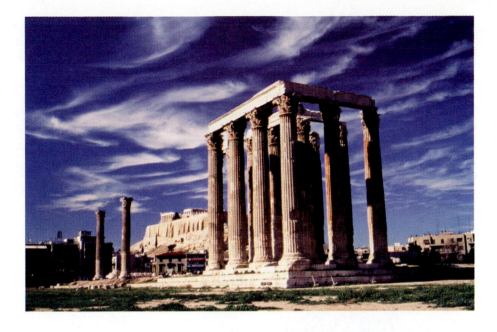

Figure 4–27 Corinthian columns and a remnant of a stepped architrave from the Olympieum, Athens, c. 170 B.C.

GEORGE GRIGORIOU/STONE

of the acanthus plant. Other differences occur chiefly in the entablature. Here the frieze is sometimes omitted. Even when it is present, the Corinthian entablature is the lightest of any order, as we would expect, for it is carried by the most slender columns.

COLUMN SUBSTITUTES: CARYATIDS

Not an order, but a dramatic exception to the three orders mentioned above, is the use of a **caryatid,** a sculptured female figure, in place of a column. Such figures occur often in fanciful furniture designs, forming chair and table legs, but they also made occasional appearances in Greek architecture. Perhaps the earliest were a pair at the entrance to the Siphnian Treasury (a storehouse of the men of Siphnios) in the sanctuary of Apollo at Delphi; it dates from around 520 B.C. But the most prominent use of caryatids is on the south porch of the Erechtheum on the Acropolis of Athens (Figure 4–29), built between 421 and 405 B.C. Six figures stand erect, facing the Parthenon, their heads supporting abaci and the entablature above, the pleats of their gowns simulating column flutes. Originally, it is thought, their arms were extended, holding cups as offerings to passing processions.

These striking exceptions to the vocabulary of the orders may have had their inspiration in Egypt,

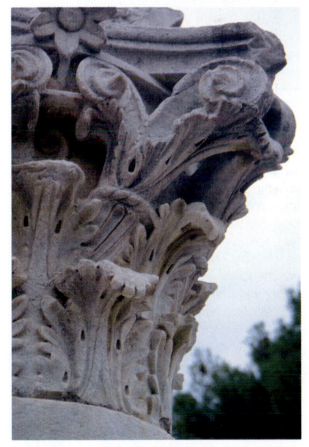

Figure 4–28 Corinthian capital from ruins of the Temple of Octavia in ancient Corinth, Greece.

RUGGERO VANNI/VANNI ARCHIVE

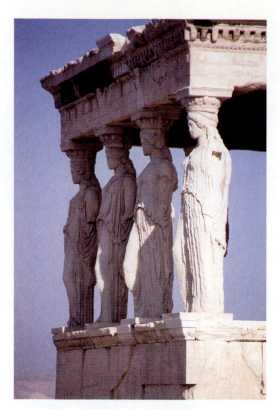

Figure 4–29 On the Acropolis, caryatids (sculptured female figures) support the roof of the south porch of the Erechtheum, 421–405 B.C.

CORBIS

where colossal statues of the god Osiris were sometimes used in place of columns. A Greek variation on the caryatid is a similar figure carrying a replica of a basket on her head, rather than an abacus; she is called a *canephora*, and the plural is *canephorae*. The Romans will later produce a male version called a *telamon* (plural *telamones*), even later Renaissance architecture will produce partial figures called *herms* and *terms*, and finally the German Baroque will revive the telamon and call it an *atlas* (plural *atlantes*).

THE ORDERS AS GUIDES, NOT FORMULAS
All three Greek orders presented detailed sets of guidelines about which parts might best complement other parts to achieve desired results. In addition to these guidelines, there were other considerations for the Greek builders. Their attention was applied to the ratios between all parts, to the placement of joints between stones, and to the

relationships of entablatures to the roof tiles above them. But these guidelines and concerns were not precise formulas. Within and beyond them, individual architects and sculptors could create individual effects, and no two Greek temples are exactly alike. There were also, of course, more humble structures that were built largely without the use of the orders, such as the Greek house.

The Greek House

The average Greek house (and, before Hellenistic times, even the house of an important statesman) was a simple affair. There were many variations, as would be expected in a democracy of such varied city-states and such individualistic citizens. Made of impermanent materials, added to and remodeled many times over the ages, most of them have been destroyed, but some examples have been unearthed, as in Olynthus, a town destroyed by invaders from the north in 348 B.C. (Figure 4–30). Based on this and other evidence, we can make some generalizations about a typical Greek house.

Windowless to the outside, the rooms of the Greek house opened to a central courtyard or a series of courtyards. Its floors were commonly of hardened earth, sometimes paved with stone, sometimes covered with reed mats. Its walls of sun-dried mud brick, sitting on foundations of stone, would, in early Greece, have been simply plastered and whitewashed. The fifth-century statesman and general Alcibiades, in fact, created a scandal among his fellow Athenians when he

Figure 4–30 Floor plans of two houses from the Greek town of Olynthus show individual variations using the same basic elements. Each is inward facing, with a courtyard open to the sky.

FROM BOARDMAN, ED., *THE OXFORD HISTORY OF CLASSICAL ART* OXFORD: OXFORD UNIVERSITY PRESS, 1993. BY PERMISSION OF OXFORD UNIVERSITY PRESS.

painted the walls of his house. Within a few years, however, as in so many aspects of Greek life, simple traditions gave way to more elaborate ones. By the end of the fifth century, house walls were being covered with real or imitation marble, mosaics, murals, and tapestries. And Homer, in the *Iliad*, vi, 313–17, refers to the "sumptuous house of Paris, which that prince had built with the aid of the most cunning architects in Troy."

Even such a house, built for an affluent Greek, probably followed a standard plan composed of standard elements; more humble houses followed the model as best they could. A general planning principle in Crete seemed to be that rooms were connected to other rooms in communicating series, or were linked by corridors. In Greece, the flow of space seems more staccato, with rooms generally clustered around interior courtyards and being entered only from those courtyards.

Following this planning principle, the humble Greek house was organized around a single open courtyard (Figure 4–31), and a more prosperous Greek house around two of them. From the street, a narrow entrance hall led to the first (or only) courtyard, called the *andronitis* and serving as the chief living room where the master of the house would receive guests and where many household chores might be done. This courtyard opened to a central covered space, the *andron*, which was used for dining and where there was an altar to the household gods. The andron, or men's dining room, was the most honored room in the house, and the one most likely to be adorned with mosaic designs on the floor. It varied in size, but the most conventional size accommodated seven couches **(klini)** placed around the walls for reclining diners. Sometimes a vestibule was placed between the courtyard and the andron, and it, too, was likely to boast a mosaic floor. It was in the anteroom, if it existed, that the mixing bowl for wine would have been placed. There was also a living room with a central hearth or *oikos*.

Sometimes the andron in turn opened to a rear courtyard, but this rear courtyard was sometimes omitted. Both courtyards were surrounded by colonnades and, beyond those, by a series of small rooms. These rooms were generally without windows, lighted only by their single doorways. Extant examples show that, in the bright sunlight of

Figure 4–31 Cutaway model of the so-called Villa of Good Fortune at Olynthus, fourth century B.C. The tiled roofs slope down toward an opening over the central courtyard.

MODEL OF VILLA OF GOOD FORTUNE AT OLYNTHUS. © ROYAL ONTARIO MUSEUM, UNIVERSITY OF TORONTO.

Greece, this degree of lighting was adequate. The rooms surrounding the outer courtyard were men's bedrooms, and those surrounding the inner courtyard were women's bedrooms and a kitchen. Heating, when needed, was obtained from portable charcoal braziers made of terra-cotta or bronze. Behind the house was a small private garden.

A special form of the house was the *prytaneum*. It featured a courtyard, a dining room, and a shrine where a perpetual flame was maintained in honor of Hestia, goddess of the hearth. This special house, however, was semipublic in nature, used not by a private family but by city officials, council members, foreign ambassadors, or other honored guests. The Greek building vocabulary included a number of other semipublic building types as well.

Other Greek Building Types

The temple and the house did not, of course, exhaust the vocabulary of building types. They were both private buildings—the temple entered only by a few priests, the house only by family and guests—but there were also Greek structures for public gatherings. Only a few of them had enclosed interiors. One example was the council house or *ekklesiasterion*, a roofed assembly hall. The one at

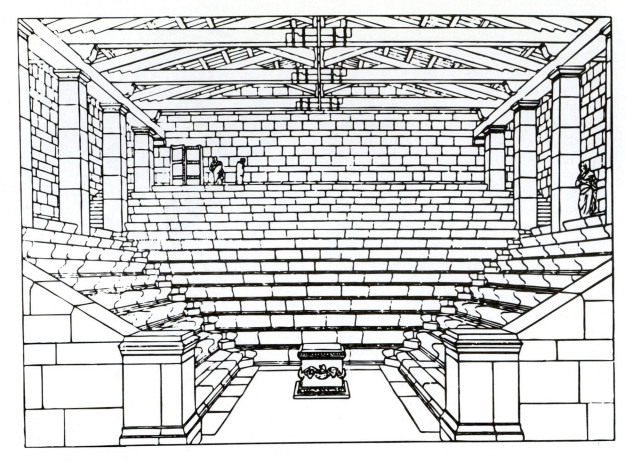

Figure 4–32 Interior perspective view of the council house at Priene, c. 200 B.C.
DRAWING: F. KRISCHEN

the town of Priene (Figure 4–32), built c. 200 B.C., could seat six or seven hundred on tiers of backless stone seats, virtually the whole population of the town at the time. Its stone walls and stone piers supported a wooden roof. Similar council houses were built at Miletus and Athens.

Related to the council house is the *bouleuterion*, a small rectangular or semicircular theater building. And there were splendid open-air theaters built into the hillsides of many Greek cities, some of them exhibiting impressive acoustics. Stadiums and gymnasiums, too, were largely unroofed structures for athletic games and exercise.

Other types of public gatherings took place in the Greek **stoa,** which functioned as a town center and marketplace. In its simplest form, the stoa was a colonnade placed in front of a solid wall, the wall frequently decorated with painting. The area between the columns and the wall was roofed, but all was open to the weather through the colonnade. More complex versions had two colonnades and a wall. And the most elaborate had a row of enclosed shops at the back, rather than a simple wall. The Stoa of Attalos at Athens (Figure 4–33), built in the mid-second century B.C., was even grander, with two floors, each having two rows of columns and a row of shops. On the lower floor, the outer colonnade was of the Doric order, and the inner was Ionic. On the upper floor, the outer colonnade was Ionic, and the inner a simplified version of Corinthian. Its total depth was 66 feet (20 m), and its length was an impressive 377 feet (115 m). The building has now been rebuilt.

One last category of Greek buildings to be mentioned is that of the tomb or funerary struc-

Figure 4–33 Cut away model of the two-story Stoa of Attalos, Athens. Shops along the rear of each floor were fronted by generous promenades.

Figure 4–34 Perspective view of how the Mausoleum at Halicarnassus may have looked. The artist has drawn a number of Greek houses in the foreground.

ture. The largest and most legendary of these was built for a provincial governor in the east, Mausolus of Halicarnassus, a town that has been replaced by the modern city of Bodrum, Turkey. The building gave its name to a whole genre of building, the mausoleum. Nothing remains of the building but fragments of its sculpture, but it reportedly had a massive base, an Ionic peristyle containing the sarcophagus, and a pyramidal roof (Figure 4–34). It was built c. 352 B.C. and was considered one of the Seven Wonders of the World.

Less bombastic and much more typical was the **tholos,** a cylindrical building form generally erected as a memorial to the dead, but sometimes having other uses (a fifth-century one at Athens apparently having served as a sort of dining club for the Athenian senators). Sometimes tholoi were surrounded by colonnades, sometimes not. In the fourth-century example at Epidauros (Figure 4–35), there were colonnades both inside and out. In this case, the twenty-six exterior columns were of the Doric order, the fourteen interior ones Corinthian, and there was a striking pavement pattern of alternating diamonds of black and white stone.

Almost all the building types listed, as well as the public open spaces of the Greek city and the gardens and atria of the Greek house, were often adorned by the products of an art at which the Greeks excelled: sculpture.

Greek Sculpture

The art of sculpture, it is generally agreed, reached its highest level in ancient Greece. The Greeks' achievement was certainly aided by their knowledge of the earlier sculpture of Crete and Mycenae and of the magnificent sculptures and reliefs of Egypt.

Like Greek architecture, Greek sculpture was expected to conform to ideals. The figures shown, both male and female, were almost always models of perfect form. Yet, again like Greek architecture, the rules and ideals were free enough to allow a broad range of individual taste to be expressed.

The natural supply of marble was as great an asset for Greek sculpture as it was for Greek architecture. More easily cut than the granite used by the Egyptians, and capable of holding fine detail, marble encouraged sculptural mastery. One characteristic of the material, however—its pure whiteness—was not apparent in most of the original statues. Much Greek sculpture, like much Greek architecture, was painted.

With the superb marble already mentioned, and also with bronze, the development of Greek sculpture went beyond that of any previous civilization. That development can be divided broadly into three parts: the Archaic, corresponding to the Archaic period of Greek architecture; the Hellenic, corresponding to the Classical period and to the Fourth Century; and finally, as in architecture and the other arts, the Hellenistic.

Figure 4–35 Plan of the circular tholos at Epidauros, showing exterior and interior rings of columns and the paving pattern. The outside diameter is 66 feet (22 m).

FROM *GREEK ARCHITECTURE*, BY A. W. LAWRENCE, HARMONDSWORTH, PENGUIN, 3RD. ED., 1973. © YALE UNIVERSITY PRESS

Archaic Sculpture

The oldest marble statue dates from about 620 B.C. This was more primitive in character than the sculpture produced in Egypt in her earliest history. The Greek advancement was rapid, however, and in two centuries would reach its highest point of development. During the years from 620 to 480 B.C., sculptural forms were highly conventionalized. The earliest Greek figures were influenced by those of Egypt, Assyria, Crete, and Greece's own Ionian coast. By 550 B.C. the first Greek figures were being made in which movement was indicated by the position of the legs,

and in which emotion was expressed in the face by a sort of grimace, now called the Archaic smile. Eyes were modeled with an Oriental slant, and the eyeballs bulged in a convex surface. These characteristics continued during the whole of the period.

Hellenic Sculpture

After the Greeks' defeat of the Persians at Marathon in 490 B.C., a great advance occurred in both relief and freestanding sculpture. The enthusiasm aroused by the military victory and culminating in the Golden Age of Pericles was reflected in the enrichment of the new temples with sculptural work of the greatest magnificence. From this time on, many statues were made commemorating heroic contests and deeds. During the latter portion of the fifth century, the work of Greece's three greatest sculptors was produced. These three were Polyclitus, Myron, and Phidias.

- Polyclitus was the first known sculptor to show figures in action, standing on one foot. He is most admired for his bronze statues of athletes, in which he displayed his ideal of physical perfection. A famous example is the *Doryphorus* or *Spear Bearer*, which we know only through a Roman copy. His son, Polyclitus the Younger, was also a sculptor, but was better known as an architect, his designs including the great theater at Epidauros.

- Myron also represented athletes in bronze. A fine example is his *Discobolus* or *Discus Thrower*, also known today only through a Roman copy (Figure 4–36). In his day, Myron was highly

Figure 4–36 A Roman marble copy of the original bronze sculpture *Discobolus (Discus Thrower)* by the Greek sculptor Myron. The original was cast c. 450 B.C.

"DISCUS THROWER," ROMAN COPY OF A GREEK BRONZE BY MYRON, C. 460–450 B.C. MARBLE, LIFE-SIZE. MUSEO DEL TERME, ROME.

praised for his sculptures of animals, but none of these survives.

• Phidias, the most celebrated of the fifth-century Greek sculptors, was responsible for much of the adornment of the city of Athens. His two most famous statues, both now vanished, were the great figure of Athena in the Parthenon, the chief treasure of Athens (Figure 4–19), and the figure of Zeus in the temple of Olympia. Both figures were colossal and both were made in **chryselephantine,** a technique combining ivory veneers for the flesh areas (imported from Elephantine in Egypt) with beaten gold for the draperies. Phidias was also in charge of all the sculptural reliefs on the Parthenon (Figure 4–21). Because the carving of all the friezes, all the metopes, and both the pediments was accomplished in less than a decade, however, it is unlikely that a single

sculptor could have carved them; much of the work may have been done by Phidias's pupils and assistants

All three of these great sculptors and their Hellenic colleagues expressed the Greek adoration of the human body, which approached the majesty and grace attributed to the deities. Faces were slightly conventionalized and expressed the dignity, strength, and serenity that characterized the people of this period. Like Greek architecture, Greek sculpture was often colored, and in many examples fragments of pigmentation remain.

After the humiliation of Athens by Sparta in 404 B.C., sculpture increased in emotional representations. During the Fourth Century that followed, Greek sculpture expressed enthusiasm, pathos, and elegance. Compared to earlier examples, there was greater freedom of motion, more realism, and more accuracy of detail. Facial expressions indicated a deeper consciousness and intensity of spiritual struggle; hair was modeled more naturally; the head became more oval and less blocky in shape; eyes were more deeply set; passion and nervousness were made visible. When clothing or draperies were shown, their structure and movement were clearly visible. In the *Victory of Samothrace,* by an unknown sculptor of the late Hellenic period and now in the Louvre Museum, Paris (Figure 4–13), the figure is represented as standing on the prow of a ship; a windswept tunic covers her body; every fold is indicated, but one is also conscious of the flesh underneath, of the magnificent grace of the figure, and even of the sea breeze it is supposed to be resisting. The greatest sculptors of Fourth Century Greece, however, were Scopas and Praxiteles.

• Scopas was known among his peers as the first sculptor to display violent feelings in his figures' faces. His dramatic work was on a number of prominent buildings, including the Temple of Artemis at Ephesus and the Mausoleum of Halicarnassus (Figure 4–34). Roman copies of his freestanding sculptures can be seen in the Villa Borghese, Rome, and the Fogg Museum, Cambridge, Massachusetts.

• Praxiteles is honored for the strength of his conceptions and the delicacy of their execution.

Much of what we know today about ancient Greece is due to the findings of archaeologists, and much more to what the Greeks wrote about themselves and their art. These are typical sources of information. For Greece, however, there is another source: the remarkable copies of Greek architecture, Greek sculpture, Greek furniture, and Greek ornament that were made in the following centuries by the admiring Romans. For many famous Greek works, in fact, our *only* visible evidence is Roman copies, for the originals have never been found. In such cases, of course, it is impossible to know the accuracy of the imitations, and, when there are several Roman copies of the same Greek original, variations among the copies can sometimes be seen. It is also true that the copies show us Greek art translated through Roman eyes and Roman tastes. Even so, our knowledge of Greece would be much poorer without Rome.

Aware, more than most sculptors, of the translucency of marble, he emphasized this quality with soft transitions between contours. His finest work was thought to be the *Aphrodite of Knidos*, a copy of which is in the Vatican Museum, Rome (Figure 4–37).

Hellenistic Sculpture

The period of Alexander saw the center of Greek culture moved from Athens to Alexandria. It also saw Greek sculpture adopt a new degree of theatricality that was intended to dazzle the populace and reflect the splendor and grandeur of the regime. Realism, rather than stylization, dominated. Anguish, pain, violence, and confusion became the chief expressions. These are emotions that are not again approached in sculpture until modern times. Portraiture commences as well as the representation of landscapes and rural scenes.

Many of the most poignant examples of Greek sculpture are seen in the funereal monuments and gravestones known as **stelae,** on which the deceased are represented as in life. Husbands and wives are often shown in attitudes expressive of their affection and companionship, and there are other sorts of domestic scenes as well (Figure 4–38). Some of these stela reliefs, along with paintings on Greek vases, are not only admirable examples of Greek art, but also some of our best sources of information about another art form, Greek furniture.

Figure 4–37 The goddess Aphrodite in a Roman copy of a famous sculpture by Praxiteles for the shrine at Knidos. It was the most famous sculpture of its day, and the goddess herself was said to have posed for it.

APHRODITE OF KNIDOS. ROMAN COPY AFTER AN ORIGINAL, c. 330 B.C. BY PRAXITELES. MARBLE. H.: 6 FT. 8 IN. VATICAN MUSEUM. ALINARI/ART RESOURCE, NY

Figure 4–38 The relief carving on the stela marking the grave of Hegeso, c. 400 B.C., shows a woman taking a necklace from the jewel case held by a servant. The woman is seated on a klismos chair. The gravestone is 59 inches (150 cm) high.

HELLENIC REPUBLIC MINISTRY OF CULTURE

Greek Furniture

Lacking the preservation aid of Egypt's dry climate, Greek furniture has not generally survived except for rare items made of bronze or stone. Because furniture was frequently pictured on Greek vases and sculpture and sometimes described in Greek literature, however, we have a good idea of its appearance.

Evidence suggests that the furnishings of Greek buildings and houses were spare indeed by present standards. This is certainly consistent with our knowledge of Greek restraint and moderation. "Nothing in excess" was a maxim of the Delphic oracle.

Wood was the dominant material for Greek furniture, and the plentiful species included beech, citrus, maple, oak, and willow. But marble and bronze were sometimes used instead, and the finest of the wood pieces had inlays of ivory, ebony, and precious stones. The feet of tables and chairs were sometimes encased in silver.

But Greek furniture, like Greek architecture, was characterized by elegance, not by opulence, and never by extravagance. In the Neoclassical period of the eighteenth century, when there was a great revival of interest in Greek and Roman design, furniture would be made that resembled Greek temple architecture, with elaborate systems of miniature orders decoratively applied to cabinets, bookcases, tables, and clocks. Such applications were not unknown in ancient Greece, it even having been suggested that the Ionic order may have appeared in furniture design before it was seen in architecture. But, in general, such decoration was not typical. Greek furniture design was derived from its own function.

The Greeks used all the woodworking tools that were known to the Egyptians and, in addition, the plane and, after the seventh century B.C., the wood-turning lathe. Joints were made with mortise and tenon, nails, and glue. A passage in Homer claims that Greek carpenters were "welcomed the world over."

Like Greek architecture, the vocabulary of Greek furniture was small. Pieces were limited to a handful of types—beds, chairs, stools, tables, and chests—and each type was limited to a small number of conventional forms, persisting from century to century. But within those limitations, there was opportunity for infinite variation.

Bedding and Seating

In all the cultures we have studied so far, even in highly accomplished Egypt, beds and chairs that approach today's standards of comfort seem to have been limited to the use of royalty or religious leaders. In Greece, more democratic than any civilization before it, such furniture finally became widespread.

THE KLINE The **kline** (Figure 4–39) was a bed, but also had some of the functions of the modern sofa and also served as seating for dining. It was in many ways similar in use to the modern **chaise longue** or "long chair," used for sleeping, napping, eating, drinking, lounging, and conversing.

Figure 4–39 A fifth-century B.C. vase painting shows a young man carrying furniture. On his back is a *kline*, similar to a *chaise longue*, and on it, upside down, a small table.

ASHMOLEAN MUSEUM, OXFORD, ENGLAND, U.K.

The kline was usually made of wood, klini of maple and olive being specifically mentioned in the *Odyssey*, the epic poem attributed to Homer. They were also made of iron or bronze (Figure 4–40),

however, and sometimes wood klini were finished with silver or ivory feet.

Klini had sweeping curved headboards, which also acted as headrests for those who were reclining while dining. In some cases, they also had footboards, but they were generally lower than the headboards. The legs were of three types: rectangular in section and curving away from the frame; round in section and vertical, with **turnings**—that is, having been turned on a lathe to produce swellings, disks, and other shapes—and sometimes carved with little figures of sphinxes; or in the shape of animal legs, this last type probably of Egyptian origin. The frames formed open rectangles, within which were strung interlacings of cords or leather thongs. These interlacings supported the bedclothes, which consisted of mattresses stuffed with wool or feathers, mattress covers, pillows, and sometimes animal skins and fleeces. Linen or wool bedclothes, sometimes perfumed, were added for sleeping, and embroidered mattresses and cushions might be added for dining.

THE THRONOS The **thronos,** from which our term *throne* is obviously derived, was a formal chair of honor. Unlike most Greek furniture, it was often highly decorated, and there are many literary references that describe thronoi as "shining," "golden," "silver-studded," "ivory-inlaid," "many-colored," or "beauteous." In Homer's *Iliad*, "far-seeing Zeus," the king of the gods, is said to be seated on a golden thronos, and the geographer and writer Pausanius reports that Phidias's statue of Zeus at Olympia

Figure 4–40 Bronze version of a kline, Staatliche Museen zu Berlin-Preussischer Kulturbesitz, Museum fur Islamische Kunst, Photo by Ernst Herzfeld. Berlin 2002.

BILDARCHIV PREUSSISCHER KULTURBESITZ

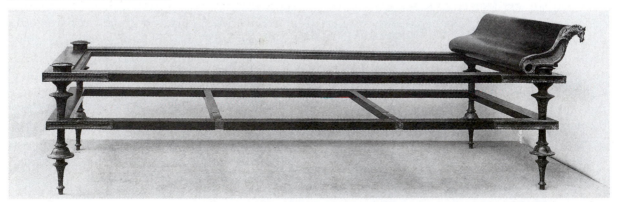

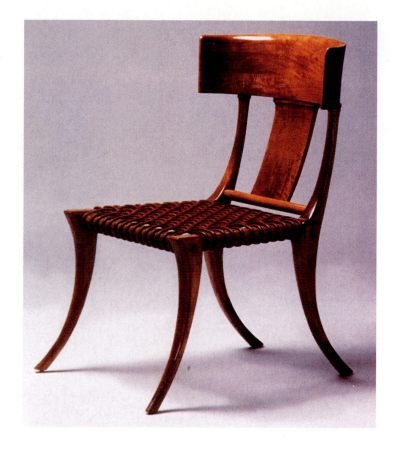

Figure 4–41 Modern reconstruction, based on vase paintings, of a klismos chair. This version, executed by T. H. Robsjohn-Gibbings, has a frame of walnut and a seat of leather thongs.

was seated on a thronos "adorned with gold and precious stones, also with ebony and ivory, and with painted figures and wrought images." These ceremonial seats were not limited to shrines and sanctuaries, however; they also appeared in private houses, at least in the most prosperous ones. Even there, their use was reserved for the most important person present at any gathering. Stone versions of thronoi also appeared as seats of honor in Greek theaters.

The thronos took several forms. Its back was often low. It could have arms, sometimes supported by sphinxes, or it could be armless. Legs were of several types: Most popular in the Archaic period was a thronos with legs carved like birds or ending in animal feet. Most popular in the fifth and fourth centuries were thronoi with rectangular or turned legs. And most popular in Hellenistic times were thronoi with solid sides, sometimes with their arms ending in the shapes of lion's heads, sometimes with their whole front edges in the forms of animal legs. Cushions and fabrics were sometimes used to add comfort and color; the *Odyssey,* for

example, describes a thronos "strewn with purple coverlets."

THE KLISMOS The most graceful, the most characteristic, and the most influential piece of Greek furniture was the **klismos,** the wood side chair. It seems to have been a purely Greek invention, without Egyptian, Assyrian, or Aegean precedent, but it was a design that would last. Echoes of the klismos appear centuries later in chairs of the **Directoire, Empire, Regency, Duncan Phyfe,** and even the modern styles. Unlike the thronos, it was generally left undecorated, its beauty deriving solely from its form.

Like the Greek temple, the klismos took some time to evolve to its perfected state. Early versions in the formative periods had parts that were not so harmoniously related to one another as in later versions. And archaic klismoi sometimes had decorative elements—such as backs terminating in swans' heads or finials—that were later eliminated.

In its perfected form, the klismos (Figure 4–41) featured a curved backboard and curved legs. The

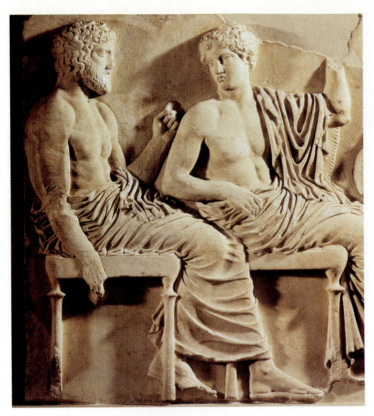

Figure 4–42 A section of the Parthenon frieze, carved between 442 and 438 B.C., shows the gods Poseidon and Apollo seated on diphroi, Greek stools.

ERICH LESSING/ART RESOURCE, NY

curved backboard was generally supported by a broad central **splat** or wooden panel, with a narrow **stile** or vertical wood strip on either side, and these side stiles were made in one piece with the rear legs, their combination forming one continuous sweeping curve. The front legs, curving in the opposite direction, were broad at the top, tapering to a smaller end that projected beyond the chair frame. The frames of the seats were mortised into the legs with tenons or dowels, and sometimes, in an expression of construction technique, these bits of joinery were shown protruding through the sides of the legs. The seat within the frame was filled in with plaited thongs, and sometimes a cushion or animal skin was added for comfort.

In addition to their beauty, klismoi had many practical uses. They were lightweight and easily portable. Their depictions on vases show them being carried about and being used by craftsmen and workers, as well as by noblemen and -women. The women usually dined seated on klismoi while the men reclined on klini.

THE DIPHROS The **diphros** was a stool without arms or back. It was of two types, one with fixed legs and the other with folding legs. The fixed legs, one at each of the stool's four corners, generally were perpendicular to the seat, cylindrical, and turned on a lathe (Figure 4–42). Sometimes there were stretchers between the legs, sometimes not. Diphroi were made of many kinds of wood, but the most grand ones were made of ebony or other costly woods and had their legs tipped with silver feet. Leather slings or interlacings of leather thongs were suspended within the wood frames to form the seats.

This popular furniture design remained in vogue throughout the fifth and fourth centuries. Later, in Hellenistic times, some modifications were made, the lower part of the legs becoming taller and more spindly, and more elaborate turnings being introduced. A quite different leg design was also seen on some diphroi, divided into two sections, both slightly concave, with the upper section thicker than the lower one.

The hinged, folding version of the Greek stool was called a *diphros okladias*. Like the Egyptian model on which it was probably based, its two pairs of legs crossed in an X shape and were joined, below the crossing, by stretchers. They sometimes had straight legs, and sometimes curving legs that ended in animal hooves or claws (Figure 4–43). They were used both indoors and out. Paintings on Greek vases show that a privileged Greek would sometimes be followed through the streets by a slave carrying his master's stool, ready to unfold it whenever it was wanted.

OTHER SEATING The kline, thronos, klismos, and diphros virtually exhaust the Greek seating types. But there were a few more objects that should be mentioned. There was a plainer form of stool, which was simply a small wooden box. There were small versions of diphroi used as footstools or as aids in climbing into high klini. Finally, there were benches long enough to accommodate several people, found frequently in schools and theaters.

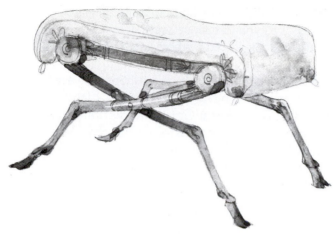

Figure 4–43 Watercolor sketch by a modern designer of a folding stool *(diphros okladias)*. Its legs are in the shape of deer feet.

DRAWING: T. H. ROBSJOHN-GIBBINGS

Figure 4–44 Profile and front views of a bronze table leg from the Hellenistic period.

HOLLIS S. BAKER, *FURNITURE IN THE ANCIENT WORLD*, NEW YORK: MACMILLAN, 1966.

Tables

By our own standards, the Greeks used few tables. With fewer possessions, and with less inclination to display them, with such items as mirrors and drinking cups put on shelves or hung on the wall when not in use, and with oil lamps usually freestanding on their own bases, the need for tables was far less than ours. Tables were frequently used at dinner, however, for both serving and eating. They were often brought out before a meal, placed by the sides of the gentlemen's klini, one for each person, and then taken away after dinner. Many were low enough to be pushed under the klini when not in use. The general name for a Greek table is **trapeza,** and the plural is trapezai. They were most frequently made of wood, but there were more luxurious versions in bronze, marble, or carved ivory. Wood tops, which have disappeared, were sometimes supported on bronze legs, some of which have survived (Figure 4–44).

The most commonplace Greek table was probably the three-legged trapeza (Figure 4–45). Greek house interiors were often roughly finished, and a three-legged table stands more securely on an uneven surface than a four-legged table, which might rock. The table usually had a rectangular top, with the three legs fastened into it with tenons or dowels. The top projected beyond the pair of legs at

Figure 4–45 The three-legged wooden table called a *trapeza*. It has a T-shaped stretcher bracing its legs.

DRAWING: ABERCROMBIE

one end, but was fairly flush with the single leg at the other. These legs were sometimes, but not always, connected by a T-shaped stretcher.

There were at least four variant table designs that were used by the Greeks: a rectangular table similar to the one just described, but with four legs; a rectangular table on two transverse solid supports, this table type usually being made of stone; a round table on three legs, the legs usually given animal form; and a round table on a single central pedestal above spreading feet.

Furniture for Storage

The Greeks obviously had need for putting away clothing, jewelry, tools, and other objects, so naturally they devised pieces of storage furniture. Greek clothing for both men and women consisted primarily of simple rectangles of cloth that were draped around the body in various ways. There was no need to hang them, as they could be easily folded. Not surprisingly, there has been found no picture of—or reference to—any sort of tall Greek cupboard or armoire. The Greeks stored many of their household objects on open shelves or hung them from wall pegs.

But chests, boxes, and caskets were often used. The **kibotos** was a wooden chest used for storage; its hinged lid could be used as a seat. Simple in form, it may have been adapted from Egypt, where similar containers were used, but it is so basic an object that tracing its origin seems pointless. The four-sided kibotos could have flat, gabled, or curved covers, and it stood on four short legs extending from its corner posts. In some cases, the legs terminated in lion's-paw feet. Typically, its top was not secured with a lock, but by winding a string or thong around two knobs, one on the hinged lid and one on the chest. Its sides could be plain or decorated with any number of the characteristic Greek ornaments, executed in ivory or polychrome inlays.

Greek Decorative Arts

On a smaller scale than architecture, sculpture, and furniture, the Greek artistic genius was evident in a number of other fields—in weaponry and armor; in vessels and figurines of bronze; in jewelry of bronze, silver, and gold; in molded terra-cotta objects and figures; and in finely made silver coins stamped with animals and portraits. The techniques of Egyptian faience were admired by the Greeks and duplicated by them in the late seventh century in workshops on the Greek island of Rhodes and elsewhere. The workshops may even have been staffed by Egyptian workers. Here we shall look particularly at Greek wall decoration, at the moldings and patterns of Greek ornament, many of them still in use today, and at the greatly admired Greek vase.

Greek Wall Decoration

Many of the Greek buildings were covered with paint or glazed color both inside and out. Brick and stone were often covered with a cement stucco that was polished so highly it reflected like a mirror. Scenic decoration and conventional ornament were used to enrich marble, wood, and plaster. Painted decoration was at first entirely subordinate to the architecture; later it became an independent art. Little remains of Greek wall painting, but it is generally assumed that the art never equaled the perfection reached in Greek sculpture.

Greek Ornament: Moldings

Masters of harmonic structure, the Greeks were masters as well of ornament sympathetic to such structure, rarely using overall patterns that might obscure architectural forms, but developing instead graceful linear patterns that would accentuate those forms. As in architecture, the Greek vocabulary of ornament was small, with a few devices thoroughly studied and refined, and with the devices developed for architecture adapted for furniture, vases, and other decorative objects. As in architecture, also, there was a distinct difference in character between ornament intended for the earnest, sober structures of the Doric order and those meant for the more elaborate Ionic and Corinthian orders.

Greek moldings, later adopted by the Romans and generally known now by their Latin names, were designed to accentuate edges or junctions or to divide large surfaces into smaller areas. Their shapes were derived from the geometric curves known as the ellipse, the parabola, and the hyperbola, and were carefully calculated to produce the

desired highlights and shadows. The principal Greek moldings (Figure 4–46) were:

- The **fillet,** a small, flat, plain band (sometimes called a *listel*) used to separate other moldings, as on the shaft of the Ionic column.
- The **fascia,** another flat, usually plain band, larger than a fillet and sometimes used directly below a fillet in the composition of a cornice.
- The **torus,** a convex, cushion-shaped molding, approximating a semicircle. It appears in the base of the Ionic column and elsewhere.
- The **scotia,** a deep, hollow, concave molding, often used between two torus moldings and also often found at the base of an Ionic column.
- The **cavetto,** another concave molding, its shape approximating a quarter circle.
- The **ovolo,** meaning "egg-like," another convex molding. While the shape of the torus derives from a circle, the shape of the ovolo is taken from a parabola.
- The **cyma recta,** a molding with a compound S-shaped curve that begins and ends horizontally (sometimes spelled *cima*, sometimes called a *cymatium*, sometimes called a *Doric cyma*, and sometimes called an *ogee* molding). The S shape of this molding is sometimes called "Hogarth's line of beauty," because it was greatly admired by the eighteenth-century English painter William Hogarth.
- The **cyma reversa,** a molding with a compound S-shaped curve that begins and ends vertically (sometimes called a *Lesbian cyma*, and sometimes a *reverse ogee* molding). Another description of the differences between these two moldings is that the cyma recta has a concave element above a convex one, and the cyma reversa a convex above a concave. A **quirked cyma** of either type has a small, flat, vertical band attached to the top and bottom of the molding.
- The **dentil** motif, a series of small square projecting blocks. It was used in the cornice of the Greek entablature, particularly in the Ionic and Corinthian orders, less frequently in the Doric.

These Greek moldings, like other elements of Greek architecture, were sometimes left plain, but

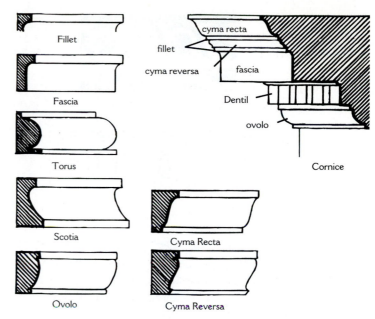

Figure 4–46 The principal Greek moldings.

were often treated with appropriate ornamental patterns.

Greek Ornament: Patterns

While the simplest of the Greek moldings—the fillet, fascia, scotia, and cavetto—were usually left plain, the others were often inscribed with various enriching patterns that made their shape more apparent. Here are a few of the most frequently used patterns:

- The **guilloche** (Figure 4–47). The torus molding was frequently treated with the pattern called the guilloche, which consisted of circles and interlaced curving bands. The guilloche pattern is sometimes called a *rounded fret* and sometimes an *interlacement band*. Another pattern sometimes seen on a torus represents laurel leaves tied with crossed ribbons.
- The **egg and dart** (Figure 4–48). The ovolo molding was often enriched with the pattern called egg and dart, which alternates vertical egg shapes with spiky, dart-like forms. Egg-and-dart pattern is often found on the echinus of the Ionic capital. This pattern's many variations have names like egg and tongue, egg and anchor, and egg and leaf. The egg and dart is

Figure 4–47 Examples of guilloche ornament.

from the Latin term "our father," probably because the row of beads resembles a rosary.

- The **anthemion** (Figure 4–50). Cyma recta and cyma reversa moldings were often enriched with the anthemion pattern, which some believe was based on the honeysuckle leaves and flower, and which is indeed sometimes called honeysuckle ornament. Others, however, think the pattern was based on the palm, the term *palmette* also being used, or on the lotus.

- The **fret** (Figure 4–51, page 84). Perhaps the most frequently used and the most characteristic of all Greek ornamental patterns is the fret, composed (typically) of vertical and horizontal straight lines linked in a continuous band. It is also sometimes called the *meander*, the *key* pattern, the *labyrinth*, the *Chinese key* (for it also appears in Chinese decoration), or the *Greek key*. Whereas the bands of the guilloche interlock, crossing under and over each other, the single band of the fret reverses direction frequently

Figure 4–48 Examples of egg-and-dart ornament.

similar to another pattern, also used by the Greeks, called **bead and reel** (Figure 4–49), in which circular or horizontally elongated elements (beads) alternate with vertical oblongs (reels). The bead and reel is usually symmetrical about a horizontal axis, while the egg and dart and its variations are not. The bead-and-reel pattern is sometimes called a *paternoster*,

and may even sometimes cross itself, but it does not generally display the plaiting effects that belong to the guilloche. A pattern curved like the guilloche, but unplaited like the fret, is sometimes called a *wave* or *scroll* pattern.

- The names **rinceau** and **arabesque** are used for a wide variety of less repetitive decorative bands or panels, usually symmetrical, and usually including both scroll shapes and literal representations of plant forms or, sometimes, animals as well.

These patterns are often used in combination, of course. Typical is a carved molding from the

Figure 4–50 Examples of anthemion ornament.

Figure 4–49 Examples of bead-and-reel ornament.

Temple of Athena at Tegea (Figure 4–52). It features a row of egg-and-dart molding; below that is a row of bead and reel, and below that a rinceau or arabesque pattern. Painted ornament along the top of the Parthenon's architrave combined fret and anthemion patterns (Figure 4–53).

In addition to these repeating or linear patterns, there were a large number of motifs that appeared singly in Greek decoration. A ceiling coffer of the Propylaea, gateway to the Acropolis, was painted with a symmetrical cluster of four anthemion sprays, and surrounding it was a painted version of

Figure 4–51 Examples of the Greek fret.

Figure 4–52 A molding from the Temple of Athena at Tegea, c. 350 B.C., combines egg-and-dart, bead-and-reel, and rinceau or arabesque patterns.

Figure 4–53 Fret and anthemion patterns combined along the top of the Parthenon's architrave.

an egg and dart molding (Figure 4–54). Many single motifs were geometric, such as the spiral or the **swastika,** a cross composed of equal L-shaped arms. Some of them were derived from plant forms, such as rosettes and garlands. And some were derived from animals, such as representations of complete forms or parts of horses, lions, oxen, birds, and fishes. Festoons and ribbons also frequently appeared.

In addition to their appearance on the interiors and exteriors of buildings, many of these patterns and motifs appear in paint on an art form that has come to be considered one of the great achievements of classical civilization: the Greek vase.

The Greek Vase

The pottery wheel was known to the Greek world at least as early as 1800 B.C. As we have seen, the Cretans and Mycenaeans were practiced potters, but their Greek successors carried the craft to a new level. The painted Greek vase was a utilitarian object, intended for practical use, not for mu-

Figure 4–54 Painted ornament on a ceiling coffer of the Propylaea, Athens, 437–432 B.C. Different coffers were given different designs.

- The text describes the Greek **guilloche** as having interlaced curved bands and the Greek **fret** as having straight lines. In later times, however, the term *guilloche* will also be used for patterns of interlaced angular bands, and the term *fret* will be used for patterns of curved lines. These curvaceous frets will also be given such names as *undulated fret*, *scroll fret*, and *Vitruvian scroll*. Another name that will sometimes be used for the fret is *broken batoon*. In the eighteenth century, the terms *guilloche* and *fret* were sometimes used interchangeably (as in James Gibbs's 1732 *Rules for Drawing the Several Parts of Architecture*).

- The term **fretwork** has also been used to refer to a wide variety of ornament, as on a plaster ceiling or on the gallery of a table in the Chinese Chippendale style. A surface, such as a ceiling, that has a pattern of small openings in it can be said to be *fretted*.
- The term **meander** comes from Latin and Greek words that referred to the wandering path of the Maiandros River (now called the Menderes) in what is now Turkey.
- **Rinceau** is a French word meaning "scroll;" the plural is **rinceaux.**
- An **arabesque** is so called because such ornament was frequently used in Arabia.

seum display. Yet, at its best, it was one of the supreme achievements of all the history of the decorative arts. It displayed perfection of form—highly conventional form, with each **krater** shape, for example, emulating the ideal krater shape known to every Greek potter, just as every Doric column emulated the ideal Doric column. It also displayed perfection of surface decoration—highly individual decoration, with each scene different from all others and with no detail wasted or lacking in character. And it displayed perfection in the relationship of decoration to form, the pictorial element enlivening but never violating the shape beneath. No perspective effects, no casting of shadows, no shadings or excessive modelings were allowed to create the illusions of three-dimensional form that would contradict the flat surface of the vase.

THE TWO CHIEF VASE TYPES: BLACK-FIGURE AND RED-FIGURE

The earliest examples of Greek vases we know, from the formative periods, are made with a buff-colored ground, on which geometric designs—and, later, animal and human figures—were sketched in black paint. To this, gradually, were added details in red and purple paint. Occasionally, in some city-states, yellow and blue paints were used as well.

But as Greek art entered its Classical period, the colors of the Greek vase were simplified and standardized.

In the most famous examples of Greece's mature periods, the vases' surface elements are only two: areas of glowing red orange and areas of glossy black. The red orange was derived from clay from the area of Cape Kolias, treated with red ochre, and the areas of black were derived from varnish brushed onto the fired clay, then fired again. As first developed in Corinth, in Chalcis, and then in Athens in the early sixth century B.C., the scenes, figures, and decorations were painted in black on the red clay; the results are called **black-figure vases.** In the most refined examples, the painted areas are not solid black, but have thin lines incised through them with a metal tool, the lines indicating facial features, the shapes of muscles, or the folds of drapery and clothing.

A few decades later in Athens, a new style brought the reverse practice of painting the background black, leaving the pictorial elements showing through in the red orange clay color; the results are called **red-figure vases.** As incised lines had added detail to the black painted areas, now thin black brush strokes added detail to the unpainted

Figure 4–55 Types of Greek vases: a, **amphora,** used for wine storage; b, **oinochoë,** a wine jug; c, **kylix,** a drinking cup; d, **aryballos,** a container for olive oil, used by the Greeks as soap; e, **pyxis,** a container for toiletries; f, **skyphos,** another drinking cup; g, **lekythos,** an oil jug; h, **volute krater;** i, **kylix krater;** j, **bell krater.** All three types of krater were used for mixing wine and water.

DRAWING: ABERCROMBIE

areas. The switch from black-figure to red-figure styles came in the years c. 530 or 525 B.C., and, in the context of Greek artistic conservatism and gradual development, it seems a radical change of fashion. The change was accompanied by a new degree of pictorial invention. Figures that had previously been shown only in profile or in full frontal view might also now be seen in three-quarter views or even, sometimes, from the rear.

Both black-figure and red-figure types were produced during the period of the finest Attic wares, the last quarter of the sixth century B.C. and the first quarter of the fifth. In addition to the two basic colors of red and black, some small amounts of white, gold, and red-purple paints were sometimes used to pick out details, and some vases—most often, the tall, slender-necked **lekythoi**—were produced with a white ground and painting in red or black, or in browns shading from gold to almost black. In the fourth century B.C., even other colors—blue, green, and pink—came to be sanctioned for some vase shapes.

VASE SHAPES AND THEIR USES Greek vases were made for use, not for display. However-er beautiful and admirable we may find them today, our present notion of a vase as a decorative object would seem quite strange to an ancient Greek. But, although the painted vase was not revered then as it is today, it was not negligible. The Greeks valued fine painted pottery—both aesthetically and monetarily—more highly than the plain unpainted wares that were also produced.

By the eighth century B.C., most of the basic forms of Greek vases, suited to their uses, had been established, and these basic forms (Figure 4–55) continued to be used unvaryingly for four or five hundred years. As historian Rhys Carpenter has written, "Species appear and maintain themselves with the most startling definiteness of shape." Some of these vase shapes came to be traditionally made in the red-figure style, some were usually black-figure, and some could be either. Some were dedicated to the gods, some became part of burial rituals, and others were for more mundane uses.

Shapes were designed for specific functions. The three-handled **hydria** was for drawing, storing, and pouring water; the **psykter** was for cooling wine; the various types of wide-topped bowl

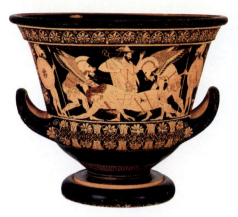

Figure 4–56 A red-figure kylix krater for mixing wine and water, c. 510 B.C., attributed to the vase painter Euphronios. The scene shows the body of the warrior Sarpedon being carried from the battlefield at Troy, while the god Hermes (at center) watches. Above and below the scene are rows of anthemion ornament.

METROPOLITAN MUSEUM OF ART, PURCHASE, BEQUEST OF JOSEPH H. DURKEE, GIFT OF DARIUS OGDEN MILLS AND GIFT OF C. RUXTON LOVE, BY EXCHANGE, 1972. (1972.11.10, SIDE A)

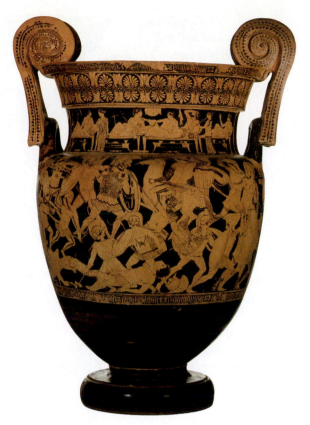

Figure 4–57 From the Classical period, a red-figure volute krater, its handles resembling the volutes of an Ionic capital. The scene around the neck shows a drinking party, with men reclining on klini. The larger scene shows a battle with Amazons. At top and bottom are small rows of fret pattern. This is an unusually large krater, 28 inches (73 cm) tall.

ANTIKENMUSEUM, BASEL UND SAMMLUNG LUDWIG, BASEL, SWITZERLAND. INV. BS 486. PHOTO: CLAIRE NIGGLI.

called the **krater** (Figure 4–56 and 4–57) were for mixing water and wine (a popular Greek drinking custom); the two-handled **amphora** (Figure 4–58) with cover was used for storing grain; the **alabastron** was used for storing easily evaporated body oils; the **pelike** and the **stamnos** were for the storage of water, wine, or spices; the **oinochoë** was a one-handled pitcher; and the **kylix,** the **kantharos,** and the **skyphos** were all drinking cups. Some miniature vases were meant to be children's toys, and some—the Panathenaic amphorae—were prizes given to champion athletes, one side painted with a figure of the goddess Athena carrying a shield, the other with scenes of athletic games.

Finer distinctions in vase type are made by experts according to such details as the shapes of the vase feet (disk, ring, or double ring); the shapes of the vase handles (flat, cylindrical, twisted, button-shaped, or—in the case of some kraters—volute-shaped); and whether vase bodies and necks curve smoothly into one another or are abruptly joined Even further distinctions are based on decorative details and on whether or not decorative scenes are framed in panels. And, obviously, the work of some master potters and painters is considered of higher quality than that of others.

THE VASE PAINTERS The names of some of these masters—such as Lydos, Exekias, Euphronios, and Makron—are known from signatures on their works. Some vases were also signed by their potters. Some that were unsigned can be attributed to particular painters on the basis of similarity of style with those that were signed. In other cases, painters can be identified only by the names of the potters whose work they painted, such as the Brygos painter. And in still others, painters have been identified by their subject matter, given such names as the Gorgon Painter, the Pan Painter, or the Achilles Painter.

SUBJECT MATTER The subjects of the designs painted or outlined on Greek vases were as varied

as life itself, including the actions of gods, heroes, and common folk. We see Achilles bandaging the wound of his friend Patroclus, Herakles slaying his children, the contest of Hercules and Apollo, the rape of Europa, the judgment of Paris. We see dogs and horses, jars and ewers, stools and chairs. We see athletes and warriors, farmers and bathers, lovers and satyrs. And, naturally, we see potters and vase painters (Figure 4–59), undoubtedly picturing themselves with no suspicion of how greatly admired their work would be more than 2,000 years later.

Summary: The Design of Ancient Greece

No nation or race of people has had more cultural influence upon Western civilization than has ancient Greece. Its architecture, decoration, literature, and sculpture have rarely been equaled and have stood as models for centuries. How can those Greek achievements be characterized, and in what ways did they excel?

Looking for Character

Greek art was intellectual. Its beauty arises from exquisite proportions, graceful lines, and simplicity. While color and surface ornament are often inte-

Figure 4–58 Signed by the vase painter Exekias, a black-figure amphora, c. 530 B.C. Two heroes of the Trojan War, Ajax and Achilles, are seen playing a board game.

EXEKIAS (6th B.C.E.), "ACHILLES AND AJAX PLAYING DICE." BLACK-FIGURED AMPHORA, ATTIC. MUSEO GREGORIANO ETRUSCO, VATICAN MUSEUMS, VATICAN STATE. SCALA/ART RESOURCE, NY

grated parts, the emotions they arouse are never allowed to obscure the intellectual satisfaction provided by the perfection of the underlying form.

Greek art was serious. There are, to be sure, elements of slapstick in the comedies of Aristophanes and elements of ribaldry in Greek vase painting, but, for the most part, the Greeks were almost modern in their anxiety about life.

Greek art was not concerned with novelty, innovation, or originality. Its development was due to a necessarily gradual approach to an imagined ideal, almost never to a change of taste. Greek art was as disinterested in the impressions made by giant scale or enormous mass as it was in the shock of new fashions. It sought clarity and a comprehensible relationship to the human condition.

To achieve these, it developed a well-ordered system, in which all parts were interdependent and mutually attuned. In Plato's words, "Measure and commensurability are everywhere identified with beauty and excellence." The language of Greek architecture and its components, its interiors, and its ornaments obeyed rules of composition at least as strict as those of music and written language. So consistently logical and perfectly composed was that language system that still today, 2,500 years later, it continues to be understood and admired.

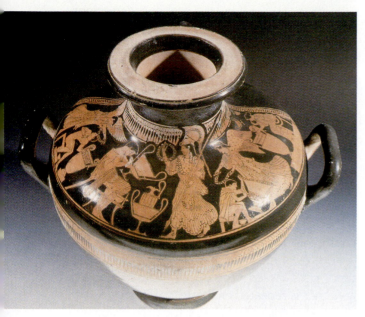

Figure 4–59 A vase painting showing a vase painter just left of center. He is seated on a klismos and is painting a large-handled kylix.

In all Greek art—the temples, the orders, the sculpture, the vases—there are rules. The success of these rules—and the reason for our continued respect for them—is that they are not absolute. They encourage continuity, but allow change. They impose ideals, but admit individuality. They supply formulas, but can be infinitely varied.

An important lesson of Greek architecture and its interiors is the sense of strength imparted by the clear expression of logical structure. The Greek structural vocabulary, repeated in example after example, is simple and basic: vertical supports (columns) carry horizontal members (entablatures).

Even more important is the sensitive relationship of details to wholes. In the Greek temple, the structure is embellished in ways that explain and refine the basic statement, never obscure it. In the Greek vase, similarly, the vase form is painted with designs that enhance, never contradict it.

Most important of all, Greek architecture demonstrates the value of a dominant system of proportions that rules over all constituent parts. If a single dimension of a Greek temple is changed, all other dimensions must be adjusted accordingly. This internal interdependence of elements, Greek examples show, can impart a sense of repose, rightness, and harmony of design.

Looking for Quality

Enough has been said about the quality of Greek sculpture, the Greek vase, and the Greek temple. Equally admirable, but beyond our scope here, are the quality of Greek science, philosophy, and literature. In all these fields, the Greeks set the standards by which all subsequent Western art measures itself. In all these fields, we find examples of the highest quality ever achieved.

But perhaps not enough has been said about the wide extent of quality in ancient Greek art. There was a percentage of incompetent or crude work in every field, but it seems to have been remarkably small. It is not just the exceptional painted Greek vase or the rare Greek temple that is excellent; it is almost every painted Greek vase and almost every Greek temple. One reason seems to be the power in Greek art of established types and established relationships. Once a successful form had been reached, it was repeated with only minor changes and attempted further refinements. There was little experimentation, little hunger for novelty, and no apparent urge to be original, only the urge to be as perfect as possible.

Yet, in the field with which we are most concerned here—interior design—the highest quality was still to come. Classical Greece was a land largely without palaces or mansions, largely without buildings for public worship or government. It was, therefore, largely a land without interiors. Greek temple architecture had some admirable interiors, to be sure, but they were rare, accessible to very few, and of secondary importance to the magnificence of the exterior shell. Greek stoas and theaters were open-air architecture, without significant interior spaces. And most Greek houses were simple affairs, plainly built of plain materials. Where it existed, as in architecture, Greek quality was of the highest level and contributed greatly to subsequent interior design, but Greek interiors themselves were not a focus of the Greek genius.

Making Comparisons: Greece and Egypt

One way to compare the design of two different cultures is to compare their most outstanding achievements. The Great Pyramid of Giza is still an astonishing sight, no more powerful structure ever having been conceived during the 4,000 years since it was built. When it still had its outer casing of dressed stone, its enormous triangular faces reflecting the sun and meeting in crisp edges, it must have been even more astonishing.

In size, the Parthenon is puny by comparison. It astonishes as well, but not at first glance. Like the pyramid, it is a wonder of mathematical calculation and precise construction, but its effects are quieter. It is a complex composition of many parts, and our appreciation of its beauty arises slowly from our contemplation of the relationships between those parts. The pyramid has a boldness and scale appropriate for the launching of the spirit of a great emperor-deity into the heavens, and, as we view it, we marvel at the power of the mighty Cheops and the mysteries of eternity. The Parthenon honors a goddess and commemorates a procession of her admirers, but, as we view it, we marvel at the creativity of its architects and sculptors and at the civilization that supported them. The pyramid operates in the realm of the superhuman; the Parthenon in that of the human.

Another way to compare two bodies of art is to compare corresponding examples of a more common nature, such as seating. Egyptian furniture achieved great elegance. Of the surviving examples, perhaps the most beautiful we know are the pieces found in 1925, made for Queen Hetepheres. The obvious Greek parallel is the thronos, meant similarly to convey honor or express importance. But the most beautiful Greek seating is the more popular klismos, its curves cohering in a perfect composition that needs no embellishment. The Egyptian example would be diminished without its rich casing of precious metal; the Greek could be diminished if ornament were added.

Making Comparisons: The Parthenon and Persepolis

We have seen in the art and design of Mesopotamia, Assyria, Babylon, and Persia a dramatic striving for size, power, and spectacle. To take the Persian palace at Persepolis as an example standing for the whole of the ancient Near East, we see there a hall meant to amaze and humble the visitor with a display of a great room densely packed with a hundred colossal columns. Then to take the Parthenon as a Greek parallel, we see a building with roughly half the number of columns, and slightly shorter columns at that, but a building meant to engage and delight the visitor with the gracefulness of their form and the subtle perfection of their placement. Persepolis demonstrates the effect of physical might; the Parthenon demonstrates intelligence.

Details of the two buildings offer a similar contrast. In the carved reliefs of Persepolis, the figure of a warrior is repeated endlessly, impressing us with the inexhaustible vastness of the military force of which he is an element. We lose count of the repetitions. In the Parthenon frieze, we are also impressed by the numbers of marchers in the procession, but here each is a different individual. Persepolis deadens our senses with superhuman innumerability; the Parthenon intrigues us with human variety.

Similar comparisons could be made between the two cultures' use of color and materials. The Persians knew the bewitching effects of brilliant color and the dazzling reflections of gold and brass. The Greeks enjoyed bright color, too, but used it in ways that identified and clarified their architecture and sculpture, never allowing it to blur contours or destroy the sense of form. Persian color overrides the senses and fills the spectator with awe; Greek color appeals to the senses and offers clarification.

Persian design is typical of all design meant to induce a sense of mystery, and Greek design is the epitome of all design meant to establish understanding. In the fourth century A.D., we shall see these two very different attitudes combine as Persian and Greek influences meet in the art of Byzantium. Before that, we shall see Greek order and restraint modified by the flamboyant showmanship of Rome.

Greece Succeeded by Rome

The immediate successor to Greek civilization was that of the Romans. Militarily far stronger and geographically far more extensive than Greece had

ever been, mighty Rome never equaled its predecessor in artistic accomplishment. But Rome would apply Greek artistic principles in areas—such as interior design—that the Greeks themselves had largely ignored.

Just as Greece had risen supreme after its military victory over the Persians at Marathon in 480 B.C., Rome triumphed over neighboring Greece in a series of battles that culminated in Carthage in 146 B.C. Of that Greek-allied city on the northern shore of Africa, only a tenth of the population was left alive, and those were taken into slavery. The city itself was totally destroyed. From that date, Roman domination of the Mediterranean was assured.

Even as conquerors, however, the Romans recognized the supremacy of Athenian culture. Although Greece no longer ruled, the principles of its art were spread by its admiring conqueror throughout Europe, Asia Minor, northern Africa, and Britain. Culturally, it could be said that Greece dominated the Roman Empire, and the time from 146 B.C. until A.D. 313 is frequently called the Graeco-Roman period, not the Roman. As the Roman poet Horace wrote, "Captive Greece has made her captor captive."

CHAPTER

5

ROME

753 B.C.–A.D. 550

The Romans took the architectural and artistic vocabulary that the Greeks had perfected and added construction techniques the Greeks had seldom used. Among the results were the largest and most dramatic interior spaces the world had seen. In their shared elements, Greek and Roman arts were similar. In other ways, they were different.

Roman architecture built on the principles of Greece and adopted the elements of the Greek orders—columns, entablatures, and pediments. But Roman architecture added its own character through more structural variation, greater richness, and bigger size. With the Romans' virtuoso use of the vault, the arch, and the dome, and with their employment

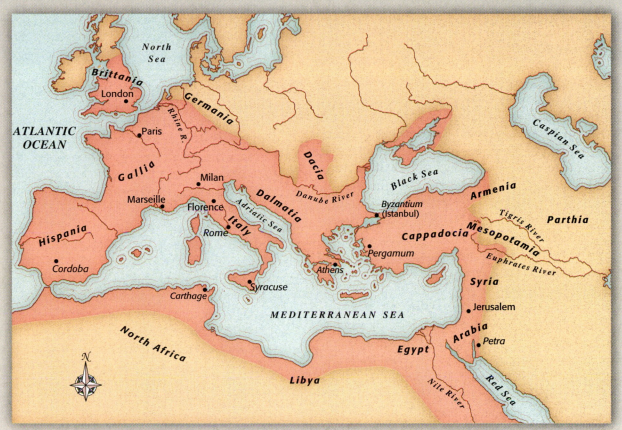

Figure 5–1 MAP OF THE ROMAN EMPIRE AT ITS GREATEST EXTENT.
Historic sites are in italic and modern cities are in roman type. Some historic sites, of course, have become modern cities.

ORTELIUS DESIGN

of massive piers and walls in addition to column supports, the simplicity and restraint of Greek architecture were lost, and the Greek orders often became mere decorative applications. However, a dazzling variety of impressive interior spaces, unprecedented in size, openness, structural daring, and complexity of form was gained. In Roman architecture, for the first time in history, interior space became supremely important. And, also for the first time in history, interior space—at almost every level of wealth and social status—was embellished with decoration.

Determinants of Roman Art

We have seen that the deserts of Egypt enforced a long isolation on the Egyptian people, and that the long, rocky coastline of Greece encouraged seafaring and exploration. The Italian peninsula and the land around Rome were less dramatic—gentle, rolling hills and an agreeable shore—and its climate mild and pleasant. These conditions would have supported a wide variety of cultures and artistic expressions, so we can say that geography and climate were not, in this case, important determining factors.

We might also note that, at its height, the Roman Empire stretched over a vast area, encompassing every extreme of geography and climate. Yet Roman culture and art remained uniform throughout the empire and was little influenced by local conditions.

Rather than geography or climate, the two chief determinants of Roman life and art were cultural: that of the Greeks, their near neighbors to the east, and that of their own ancestors in Italy, the Etruscans.

The Greek Heritage

Greece had been a civilization anchored in constancy, its art a steady process of coming closer and closer to a fixed ideal. Rome, instead, was a civilization interested in the new, curious about the exotic, and highly conscious of changing fashion. The Romans were style conscious in their diet, clothing, social duties, language, and—of course—in interior design and decorative arts. They were eager to follow, as well as they could, the taste of an emperor or an important senator; they watched with curiosity the importation of foreign objects and materials from the outskirts of their vast empire; they reveled in experiment, change, luxury, and sensation. They were, in other words, much like ourselves.

The Romans recognized the supremacy of Greek culture. They borrowed—and sometimes subverted—every Greek concept, principle, or material object that seemed useful. They imported Greek scholars to teach their youth, enslaved Greek craftsmen to educate their artists, and copied Greek art in all its forms.

Yet, for all their admiration of things Greek, the Romans developed a different civilization. The contemplative life of the Greek philosophers did not appeal to the Romans. The Roman gods, appropriated from the Greek pantheon and given Latin names, were now allied to the state. Political and military leaders used religion to advance the state and themselves, while the personal religion of the individual became less important. Greek idealism was subordinated to Roman realism.

This realistic attitude was focused on the power of the state, the forcefulness of its armies, and its ability to rule over a vast empire. Realism also governed the laws and customs that made such a large, complicated society workable. Greek simplicity was subordinated to Roman complexity.

The Roman combination of realism, force, and complexity was highly successful, particularly after Rome's conquest of the eastern Mediterranean. Wealth poured into Rome, both for the state and for private citizens, making possible the embellishment of both public and domestic interiors. Greek modesty was subordinated to Roman display.

The Etruscan Heritage

The Romans owed many aspects of their culture to the Greeks, but they were also inheritors of Etruscan civilization. The Etruscans were perhaps im-

 VOCABULARY GREEK AND ROMAN GODS AND GODDESSES

The Romans adopted many of the gods and goddesses of the Greeks, but changed their names. Here are the original Greek names of a few of them, the corresponding Latin names used by the Romans, and a brief identification. Knowing their powers and characteristics will often help explain the character and decoration of buildings and objects dedicated to them. The Greek names are given first.

- Aphrodite = Venus, goddess of love and beauty
- Artemis = Diana, virgin huntress and goddess of wildlife
- Athena = Minerva, goddess of wisdom and the arts
- Demeter = Ceres, goddess of agriculture
- Dionysus = Bacchus, god of wine and drama
- Eros = Cupid, god of love, youngest of all the gods

- Hephaestus = Vulcan, god of fire and metalworking
- Hera = Juno, queen of the gods, protectress of women
- Hermes = Mercury, messenger of the gods
- Poseidon = Neptune, god of the sea
- Zeus = Jupiter or Jove, king of the gods and protector of the state.

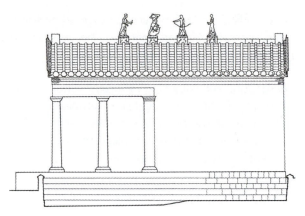

Figure 5–2 Side elevation of a reconstruction of an Etruscan temple. Large terra-cotta figures of gods stand on the ridge of the roof. The temple is about 60 feet (19 m) long.

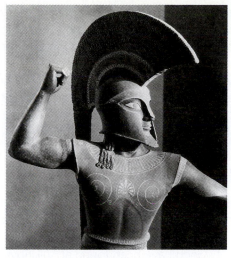

Figure 5–3 Head of an Etruscan terra-cotta warrior. The whole figure is 8 feet (2.4 m) high.

migrants to Italy from Asia Minor and they, in turn, were influenced by both Greece and the Near East. They developed a prosperous and accomplished culture between the eighth and fourth centuries B.C. Their tombs are virtually all that remains of their buildings, but the frescoes and stucco reliefs in those tombs show elegant domestic interiors.

Etruscan temples were also impressive, generally with wide spacings between unfluted columns (so that wood beams, not stone, were required to span between them), with a deep porch and wide eaves (to protect the walls of mud brick), and with **axial entrances (Figure 5–2). The temple forms** were enlivened with painted pediments and terra-cotta ornament, such as finials at the apex and outer corners of the pediments **(acroteria)** and decorative pieces covering the ends of rows of roof tiles **(antefixes).** The Etruscan temple had steps only up to the entrance facade, not surrounding the building like the Greek temple, and the Roman temple's high stone podium would follow the Etruscan example. The Etruscans also built **corbeled ashlar** masonry tombs in circular form **(tholoi).**

The Etruscan style was robust, vivacious, and exuberant, as some terra-cotta sculpture (Figure 5–3) demonstrates. Although much of the construction was crude, the mud-brick structures were sometimes faced with sheets of bronze, as were some chariots and fine pieces of furniture. The Etruscans also excelled in working with gold.

Etruscan kings (the Tarquins) ruled the city of Rome for much of the sixth century, and during their reign the Cloaca Maxima (the city's great sewer) was constructed, the city was walled, and the first temples were built in the Forum. In 509 B.C., the Etruscan rule was ended with the establishment of the Roman Republic.

In many ways, the Etruscan heritage reinforced the influence of Greece, for the Etruscans—long before the Romans—were great admirers of Greek accomplishments. The many painted Greek vases found in Etruria prove that a large trade between the two countries existed. And where the vases were found is telling: many were uncovered in Etruscan tombs, suggesting a great esteem for their quality. It would never have occurred to the Greeks themselves to be buried with their vases.

The Chronology of Roman Art

Rome was, of course, a great city before it gave its name to a great empire. According to legend, it was founded by orphaned twins, Romulus and Remus, in 753 B.C. In those earliest days, to be a Roman meant to be an inhabitant of that city. By the time of the founding of the empire in the first century

B.C., and for three and a half centuries more, Roman citizenship was being bestowed on worthy allies and brave soldiers from England in the north to Egypt in the south, from the Iberian Peninsula on the west to Mesopotamia on the east. The history of these Romans, who commanded the largest and most powerful political unit that had ever been assembled, can be divided into several stages.

Early Rome

The earliest Romans, contemporary with the Etruscans and the Geometric period of the Greeks, were a rude lot, erecting huts of wattle and daub, ruins of which have been found at Villanova, near the present city of Bologna, and on Rome's Palatine Hill. As the groupings of huts spread, they incorporated similar settlements on Rome's Esquiline, Caelian, and Quirinal Hills. These tiny hamlets were amalgamated by the Etruscans into a single city-state in the eighth century B.C., an event that perhaps paralleled the legendary founding of the city of Rome by Romulus and Remus. The Romans overthrew their Etruscan rulers c. 500 B.C., while keeping many aspects of their art and architecture, and established the Roman Republic, which would last for four centuries. The patrician class controlled the government, but the plebs, the populous general body of Roman citizens, were given increasingly large amounts of power. Even so, the republic never became a true democracy by present standards.

In the fourth century B.C. Rome exerted its influence over the surrounding areas and came into full contact with the Greek culture, which greatly affected Roman life and artistic taste. The top of the Capitoline Hill was cleared in the early days of the Republic for the building of a great three-**cella** temple dedicated to the god Jupiter and the goddesses Juno and Minerva. When the Gauls sacked Rome in 386 B.C., the Capitoline temple would be virtually all of the old city left standing. The Janiculum and Aventine Hills would be settled later to complete the city's fabled Seven Hills.

Republican Rome

Although in later Roman settlements throughout Italy and far beyond, the typical city plan would be distinguished by a strict grid of right-angled streets, the Romans after 386 rebuilt their ruined city in haste and without such geometric order. A great fire in 210 B.C. brought the need for further rebuilding. Julius Caesar (102–44 B.C.), the great political and military leader of early Rome, was also visionary about the city of Rome, initiating some ambitious building programs in the Forum and elsewhere. His tumultuous career was a turning point in Roman history, and—after his assassination in 44 B.C.—the republic ended and foundations were laid for the empire.

The Early Empire

The assassination brought an immediate state of anarchy to Rome. Caesar's nephew and heir, Octavian, restored order, was given the title Augustus, and is considered the first Roman emperor. He presided over an age of stability, expansion, and

 DISCOVERING THE **PAST** SECONDARY EVIDENCE

For the buildings and artifacts of ancient Rome, much primary evidence still remains: remnants of the buildings and artifacts themselves. For those that have vanished, however, there are written descriptions and ample secondary evidence. In the case of Roman furniture, much of which was made of wood and has disintegrated, we can see depictions of it on Roman coins and medals, in wall paintings, and in tombstone and sarcophagus carvings. Most informative of all are Roman statues that show important figures seated in chairs, so that the shape and details of the chair can be seen from all sides.

prosperity, and the two hundred years of peace that followed is known as the Pax Romana. As Octavian boasted, he "found Rome a city of brick and left it a city of marble." He was followed by other famous (and infamous) emperors, including Tiberius, Caligula, and Claudius. Around A.D. 50, Rome entered its most successful and productive period, the High Empire.

The High Empire

The city of Rome grew to over a million residents and boasted many public amenities, including baths, sports arenas, stadiums, bridges, and aqueducts. There was a fine police force, an excellent water supply, and an elaborate sewage system. It would not be until the eighteenth century that any other European cities could match the efficiency and luxury of ancient Rome.

Abroad, the power of the empire stretched to the Danube, the Rhine, the Irish Sea, the Red Sea, the Black Sea, and the Arabian Desert. Emperors included Nero, Vespasian, Titus, Trajan, Hadrian, and Caracalla. The great public construction projects of the High Empire included the Colosseum, the Pantheon, the Forum of Trajan, and the Baths of Caracalla; private building efforts included Nero's Domus Aurea and Hadrian's Villa.

The Decline of the Roman Empire

Edward Gibbon, who wrote the classic *The Decline and Fall of the Roman Empire* in the eighteenth century called that event "the greatest, perhaps, and most awful scene in the history of mankind." He lists among the causes of Rome's collapse the deception of the Caesars, the unpopularity of military despotism, the rise of the religions of Christ and Muhammad, and the invasions of barbarians from Germany and other northern countries. Other causes may have been pestilence, lowered moral standards, the exhaustion of natural resources, and the burdens of heavy taxation.

The end of Rome is sometimes given the symbolic date of A.D. 330, which marks the founding of the city that would succeed Rome as the center of western civilization: Constantinople. Others mark the end of Rome in A.D. 476, when the Germanic barbarian Odoacer was crowned the first king of

TIMELINE ROME

DATE	PERIOD	POLITICAL AND CULTURAL EVENTS	ARTISTIC ACCOMPLISHMENTS
753–386 B.C.	Early Rome	Foundation of the city of Rome; Etruscan rule; Gauls sack Rome	Etruscan temples and tombs; the Cloaca Maxima
386–44 B.C.	Republican Rome	Roman conquest of northern Italy; Roman conquest of Greece; Julius Caesar	Construction of Appian aqueduct; Vitruvius's *De architectura*
44 B.C.– A.D. 50	Early Empire	Egypt declared a Roman province; emperor given supreme power	Ara Pacis
A.D. 50–250	High Empire	Fire destroys most of Rome; volcano destroys Pompeii; expansion of empire	Domus Aurea; Colosseum; Pantheon; Hadrian's Villa; Forum of Trajan; Baths of Caracalla
A.D. 250–550	Late Empire or the Decline of Rome	Founding of Constantinople; last reign of a Roman emperor in the West	Baths of Diocletian; Villa at Piazza Armerina; Basilica of Maxentius

Italy. But the Roman people and their culture did not, of course, vanish upon the founding of Constantinople or the election of Odoacer, and most consider Rome's end to have come c. A.D. 550. Its monumental buildings remained visible and continued to be admired well into the Middle Ages that followed. Rome's end was gradual and its influence remained powerful for several centuries more. To some extent, particularly in Italy, it continues today.

Roman Architecture

The buildings of the Roman Empire are as distinguished for their diversity as those of Greece were for their uniformity. The range of building types, the vocabulary of building forms, the expression of the individual tastes of building patrons, the influence of unusual elements from the far reaches of an expanding empire—all these contributed to an architecture of great variety and richness.

The architecture of Rome was also an important propaganda tool. This was nothing new; the temple of Queen Hatshepsut had shown her to be a mighty ruler, and the beauties of the Parthenon

The introduction of concrete construction brings with it a whole new group of terms. Some currently used ones are listed and defined here, although not all those listed are relevant to Roman building. The professional designer should be familiar with all of them. Particularly annoying to professionals, it should be noted, is the layman's habit of using the term *cement*, which is a dry powder and one of the ingredients of *concrete*, as a synonym for concrete itself.

- **adobe** A traditional masonry building technique using sun-dried mud brick.
- **aggregate** The sand or gravel particles in a concrete mix.
- **cement** The binding agent in a concrete mix.
- **cement mortar** A concrete mix with a high lime content, used for joining masonry materials or for surfacing, rather than as structure.
- **cement plaster** An exterior grade of plaster containing Portland cement.
- **concrete** The substance formed by the mixture of cement, aggregate, and water.
- **ferrocement** A structural material composed of a sand-aggregate concrete mix forced into intimate contact with several layers of wire mesh.
- **ferroconcrete** Any steel-reinforced concrete, including ferrocement.
- **grout** A mortar liquid enough to be poured or injected into narrow joints in masonry work.
- **lime** A powder made by burning crushed limestone; an ingredient in many cement mixes.
- **masonry** Anything built of substances used by masons, including stone, brick, and concrete.

- **mortar** Any mixture of a cement-like material (such as cement, plaster, or lime) with sand and water.
- **plaster** A hard-surfaced material composed of cement, lime, or gypsum with sand and water.
- **plaster of paris** A quick-setting plaster composed of calcined gypsum and water.
- **Portland cement** The cement most commonly used in recent years, first discovered in 1824. Its name derives from the resultant concrete's imagined resemblance to the limestone quarried on the English isle of Portland.
- **reinforced concrete** A composite building material composed of concrete and (usually) steel reinforcement.
- **slurry** A mixture of cement and water without aggregate, sometimes used as a finish material.
- **stucco** A nonstructural exterior masonry coating made of lime, cement, sand, and water, usually roughly textured; also, a plaster used for decorative effects on interior walls.
- **terra-cotta** Hard, glazed earthenware, used as tile or as decorative elements.
- **terrazzo** Concrete incorporating irregular pieces of stone, most often used for flooring.

had added to the glories of Athens. But Rome was the most dominant civilization yet known, and it was felt appropriate that a large number of her buildings be powerful, magnificent, and even, at times, ostentatious.

Grandeur and boldness were the chief characteristics of the empire's public buildings and of the city of Rome. Contributing to this variety was the Romans' development of a remarkably flexible building material still popular today: concrete. That development, in turn, would make possible dramatic new building forms.

Roman Construction: The Development of Concrete

The use of concrete completely differentiates Roman architecture from earlier styles. This inex-

pensive and strong material was made by a mixture of small stones, sand, lime, and water that was poured into a wooden form, becoming a solid, monolithic mass as it dried and hardened **(cured).** As concrete was considered unpretentious and unsuitable for finished effects, its surface was covered with slabs of marble, alabaster, brick, or stucco, and these **veneers,** facings or overlays of different materials, served to protect as well as dress the concrete beneath. We could therefore say that Roman walls were less honest aesthetically than the Greek walls that were built of marble throughout; the solid Greek walls tell us clearly what they are built of, but the veneered Roman walls do not.

The Roman development of concrete occurred not in a single leap but in a gradual evolution, using mixtures that cured increasingly slowly (thus becoming increasingly strong), using ever more regular placements of stone or brick insertions, and insisting more and more on the use of particular volcanic sands that, mixed with lime, produced a mortar of great strength. A parallel development was the opening of the quarries at Carrara, with the result that marble became abundantly available as a facing material. From farther away, there was also increased importation of more exotically colored marbles.

Concrete was used mainly where downward pressure was the principal force, such as in walls, arches, and domes. There is no evidence that Roman engineers knew the principles of modern methods of reinforcing concrete with iron rods; the material was therefore never used for beams that were subjected to a bending stress. **Cantilever** beams and building elements, self-supporting projections that are so much a part of modern design, were unknown to the Romans. Even so, they mastered the largest vocabulary of architectural forms the world of that time had ever known.

Roman Construction: The Arch, the Vault, and the Dome

The Roman builders adopted the principles of Greek construction in using the column, lintel, and truss. In addition, with the new possibilities afforded by the use of concrete, they also began to span space with structurally curved forms. With-out a material such as concrete, an **arch** could span an opening only with a carefully balanced group of radiating wedge-shaped stones called **voussoirs.** With concrete, the whole element could be poured in one piece. The arch became an intrinsic part of Roman architecture and greatly affected both exterior and interior design. It was also used for decorative purposes in doorways, windows, arcades, and niches. Its use served to introduce a variety of shapes in Roman design that did not exist in earlier styles.

Extending the principle of the arch over a larger area, the Romans evolved the **barrel vault,** or curved ceiling (Figure 5–4) Semicircular in cross section, it was supported by parallel walls or arcades. Where two barrel vaults met at right angles, a **groin vault** might be formed. Rotating the principle of the arch around a central point produced a dome. These forms had been invented before, of course, but never before had they been built so easily and on so large a scale. The new Roman methods of spanning the distance between two walls with a fireproof material permitted wider rooms than either the Greeks or the Egyptians had been able to construct. The new methods also brought a freedom from the previous dependence on the column and the architrave, a freedom that would eventually relegate those elements to what would often be a mere decorative appliqué.

The earliest concrete dome may have covered the Stabian Baths in the town of Pompeii in the second century B.C., and the earliest large-scale concrete vault may have spanned the Tabularium in Rome erected in 78 B.C. to house the state archives. The Tabularium's applied half-columns, not needed for structural support, have been described as "the first instance of the divorce of decoration and function." Other early examples of colossal vaults appeared at Domitian's Palace, dating from the late first century A.D.; the Baths of Caracalla, A.D. 215; the Baths of Diocletian, A.D. 306; and the Basilica of Maxentius, A.D. 312 (Figure 5–5, page 101).

These dramatic new forms, we have said, were no longer dependent on the principle of columns supporting entablatures. But the architectural orders, even when no longer structural, remained a fundamental element in Roman design. As with so

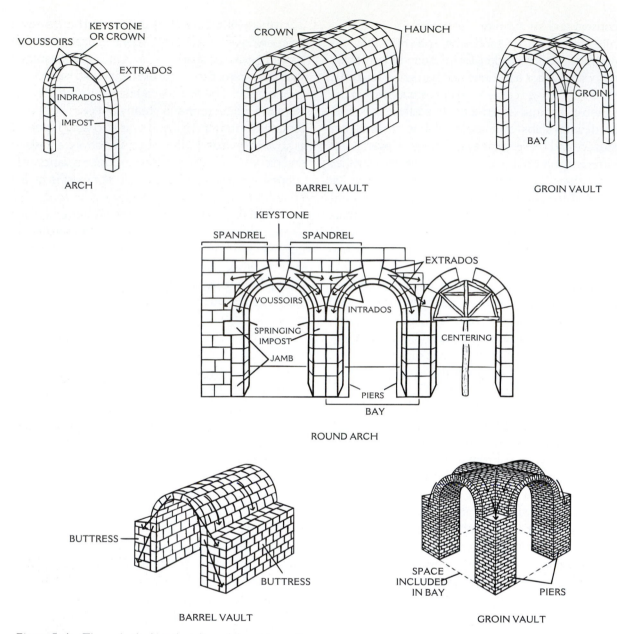

Figure 5–4 The arch, the barrel vault, and the groin vault.

many other parts of their inheritance from Greece, the Romans made changes.

Roman Variations on the Greek Orders

Throughout all Roman architecture, the vocabulary of the Greek orders continued to dominate both exterior and interior decoration. The Romans, however, expanded that vocabulary and used it with greater flexibility than Greek reticence would have allowed. The three orders of Greek architecture were increased to five (Figure 5–6).

They were:

- **Roman Doric order.** The simple sturdiness of the Doric order inherited from the Greeks was not very popular with the Romans, and when

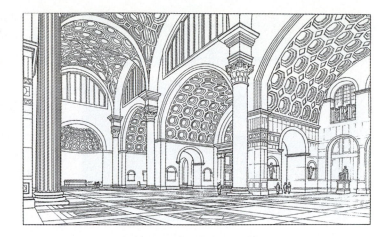

Figure 5–5 A reconstructed view of the interior of the Basilica of Maxentius as originally designed. c. 307–312 B.C. It is roofed with a combination of barrel vaults and groin vaults, all built of concrete.

they did use the Doric, they made it more slender than its predecessor, lightened its entablature by reducing the height of its architrave, enriched its capital with additional moldings, and added a base to the column.

- The Romans also introduced a new variant of the Doric order, called the **Tuscan order** (derived from Etruscan models). Its column, like all Roman columns, also sat on a base, and the column had a smooth, rather than fluted, shaft. The triglyphs and metopes of the Doric frieze were eliminated, and the Tuscan frieze was a smooth plane.

- The Greek **Ionic order** was very popular with the Romans. Again, they slenderized it somewhat, using a greater height-to-diameter ratio than the Greeks. Roman Ionic also used slightly smaller volutes, eliminated the ornament on the necking below the volutes, and sometimes employed volutes on all four sides of the capital, rather than on two.

Figure 5–6 The five Roman orders. The Greek Doric order has been added for comparison, even though it was not used by the Romans.

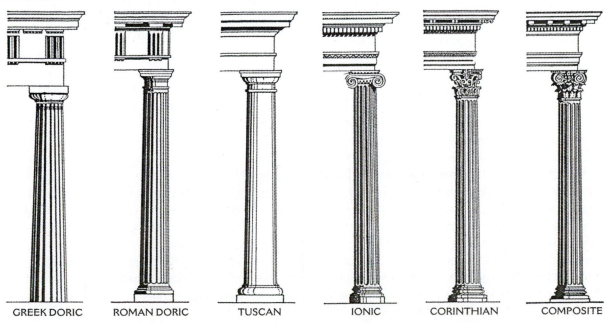

GREEK DORIC ROMAN DORIC TUSCAN IONIC CORINTHIAN COMPOSITE

Figure 5–7 An early example of the capital of the Composite order, carved c. 3 0 B.C., and later reused in the church of Santa Costanza, Rome.

- The Romans' favorite order, however, was the **Corinthian order,** invented by the Greeks during the Fourth Century, but not frequently used by them. The Roman version took full advantage of this order's capacity for elaborate decorative treatment, particularly in the capitals with their ornament based on acanthus leaves.

- Further indulging their taste for richness, the Romans also devised a new order called the **Composite order** (Figure 5–7), its capitals combining the volutes of the Ionic with the acanthus leaves of the Corinthian. The Corinthian capital also displayed small versions of Ionic volutes, but in the Composite order they were larger and more pronounced. The Composite is the most elaborate, most slender, and most decorative of all five Roman orders.

During the reign of Augustus, the first-century Roman architect Vitruvius wrote a treatise called *De architectura,* in which he codified the proportions of the orders. This code greatly facilitated the building of the various administrative buildings needed throughout the Roman colonies, work that often had to be undertaken by local builders and stonecutters who lacked training and aesthetic judgment. The codes of Vitruvius would be rediscovered and translated by Italian architects in the fifteenth century, and they would influence all the Renaissance styles of Western Europe. One element of the Vitruvian codes related the height of columns to their diameters (measured at their base). These were the proportions prescribed:

Order	Column Height
Greek Doric	5½ diameters
Roman Doric	7 diameters
Tuscan	7 diameters
Greek Ionic	8 diameters
Roman Ionic	9 diameters
Roman Corinthian	9½ diameters
Composite	10 diameters

There were rules, as well, for proportioning other parts of the Roman orders, the height of the entablature, for example, being one-fourth the height of the column supporting it, and the column shaft being one-sixth smaller in diameter at its top than at its base. Fixed numbers of flutes were designated for the column shafts, only twenty flutes for the Doric column, but twenty-four or even thirty-two for the others.

Important additions made by the Romans to the Greek classical language include the **pilaster** and the **pedestal.** As already mentioned, the use of columns as decorative rather than as load-bearing members made possible their application to wall surfaces in the form of shallow piers or pilasters, sometimes half-round, sometimes rectangular versions of actual columns. When rectangular, their projection from the wall was never more than half their width, and usually only one-fourth. Their capitals and bases were often identical with those of the columns they represented, but sometimes were variations.

The pedestal under the base of a column was a Roman invention to enhance the loftiness of the orders. About a fourth or a third the height of the column, it was square in plan, featured its own cornice and base, and can be thought of as a Roman substitute for the Greek crepidoma. Used first on the exteriors of buildings, it later became an important feature of interior design and was the prototype for the **dado** or **chair rail** of many later interior wall treatments, a molding about waist

height that divides an interior wall into upper and lower sections.

All these Roman alterations of the Greek orders rested on still another alteration. In place of the Greek crepidoma, the sturdy base that was generally composed of three giant steps, the Romans built long flights of smaller, more easily climbed steps, adding to the impressiveness of their buildings by raising them higher above the ground.

The Roman orders were widely applied to a great variety of public building types and appeared as well in domestic buildings and even furniture design. But the building type that was unthinkable without their use was the temple.

Roman Temples

The most impressive architectural achievement of the Greeks had been the Greek temple. Naturally, the admiring Romans would want to imitate it and, if possible, to make it bigger and better. For the Romans, as for so many of the world's builders—the Greeks being notable exceptions—bigger *was* better. The Romans also felt a functional need for larger temple interiors, for the Roman temple became a depository of the spoils of war. Shields, trophies, and enemy weapons were often brought into the temple as tributes to a god or goddess thought to have guided the Romans to military victory.

Another change, as we have seen, was the Romans' alteration of the Greek orders, making them slightly more slender and slightly more elaborate. But perhaps the most dramatic change was the increased variety of the Roman temple, not just in the number of orders employed, but also in the shape and configuration of the temple form. One of the most impressive Roman temples, for example, was circular in plan and topped by a dome. Although we know Greek examples of round temples, the Greeks had never conceived a structure like the Pantheon.

THE PANTHEON The Pantheon was a temple devoted to all the gods. Marcus Agrippa was the builder of the first Pantheon, 25 B.C., but, although his name appears in bronze lettering on the

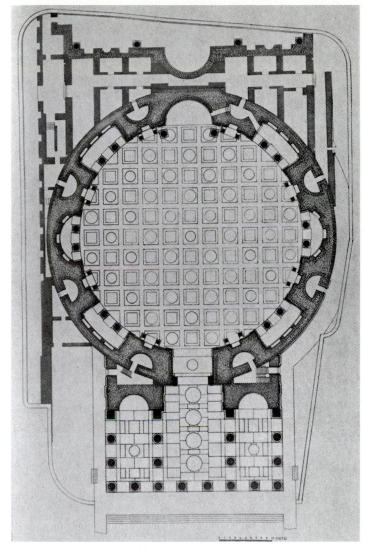

Figure 5–8 Plan of the Pantheon, Rome, with the entrance portico at the bottom of the drawing.

FRANK E. BROWN, *ROMAN ARCHITECTURE*, NEW YORK: BRAZILLER, 4TH ED., 1971

architrave of the present building, his original structure was destroyed in the fire of A.D. 80. Rebuilt by the emperor, it was again destroyed in A.D. 110, and what we now see is almost entirely the work of the emperor Hadrian, probably between A.D. 120 and 124.

The composition of the building is in two parts, their conjunction in a single composition being an example of Roman ingenuity without Greek precedent (Figure 5–8) The front part of the building, which may have been all that was clearly visible when it was first constructed in the heart of Rome,

is a classical pedimented portico. It is in a giant Corinthian order, and it was originally several steps higher above ground level than it appears today. Its columns divide the facade into three aisles, two leading to apses set into the wall, the central one leading to a large entrance door.

Beyond this is the second part of the building, and entering it is a powerful experience (Figure 5–9). As in other temples, it may be called a **cella,** but it is unlike any previous cella ever built, its only parallels being some future rooms of the colossal Roman **thermae.** It is a vast **rotunda,** 142 feet (44 m) in diameter, and measuring the same 142 feet from its floor to the top of its dome. These identical dimensions meant that the interior could have held within it a perfect sphere. Though such a sphere is not seen, it is implied, and the proportions of the space give it a harmony and repose that few other spaces can approach.

Lacking conventional window openings, the rotunda admits light instead through an **oculus** overhead, an unblinking eye opening the dome to the greater dome of the sky. The inside of its great masonry drum is visually lightened by the insertion of eight symmetrically placed round-headed niches,

and its floor and walls are richly patterned with multicolored marbles. The coffers of the dome interior impart a clear impression of the dome's curvature and also some sense of the dome's thickness; this is ornamentation with perfect fitness and purpose.

In this building, the Romans broke free from Greek and Etruscan models and created a new and unprecedented building type. The rectangularity of the Greeks was supplanted by a curved form, their post-and-beam method of construction by a daringly domed one and the persistent exteriority of their buildings by a new focus on interior volume. In the words of historian J. B. Ward-Perkins, "Architectural thinking had been turned inside out; and henceforth the concept of interior space as a dominating factor in architectural design was to be an accepted part of the artistic establishment of the capital."

OTHER ROMAN TEMPLES The Pantheon was not, of course, typical. Most Roman temples followed the Etruscan model of a rectangular structure with a columned portico fronting a cella. A significant alteration from the Greek temple, as we have noted, was that the Roman cella and portico were raised on a relatively high base and approached by a tall flight of stairs. The portico itself was often deeper than was usual in Greece, creating a dramatic depth of shadow at the entrance. Proportions, too, were changed, the Romans often preferring taller, more slender shapes, not just for columns, but for buildings themselves.

Roman Public Buildings

The Roman temples were public in the sense that they reminded the entire population of their religious duties, but they were not meant to be entered except by a few priests and priestesses. The Romans did, however, build for the masses, and they did so magnificently.

THE BATHS Among the most impressive examples of Roman public architecture were the great **thermae,** or baths, rich in decoration and spatial variety. The Roman thermae were based on the Greek gymnasia, but far surpassed them in both size and complexity. They began to be built in the

Figure 5–9 Looking into the Pantheon's great rotunda from the entrance portico.

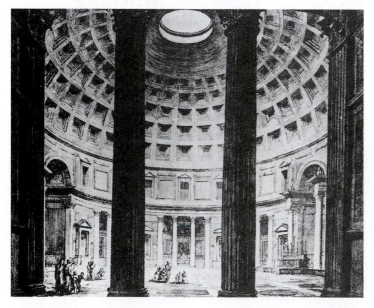

first century B.C., when the Romans developed hypocaust heating (with underground furnaces and tile flues), and became increasingly large and grand. Layouts varied, but generally included a changing room (an *apodyterium*), a warm room, usually without a bath *(tepidarium)*, a hot room with a hot plunge bath *(caldarium)*, and a cold room with a cold plunge bath *(frigidarium)*. Natural light, which had hardly penetrated Greek interiors, was a powerful and enlivening presence in many of these rooms, entering their upper reaches through great window areas. Bath complexes sometimes also included an outdoor swimming pool *(natatio)*, a porticoed enclosure for wrestling and boxing *(palaestra)*, an indoor or outdoor space for other athletics *(gymnasium)*, and, often, generous garden areas and even lecture halls and libraries. Two of the grandest of the thermae were those built in Rome by the emperors Diocletian and Caracalla, already mentioned in connection with their vaulted concrete construction, but other important ones were named for the emperors Constantine, Domitian, Titus, and Trajan. Thermae were not limited to Rome, of course, but were built all over the empire, such as the one at Trier, Germany (Figure 5–10).

Also sometimes associated with the thermae were public lavatories *(foricae)*, with unpartitioned lines of wooden or stone seats set over a sewer flushed with waste water from the baths. In addition to the great thermae, there were relatively small private baths called *balnea*. A building catalogue of A.D. 354 lists 952 bathing establishments in the city of Rome alone, but this number probably included balnea as well as thermae.

FORUMS In addition to both rectangular and round temple forms, the public architecture of the Romans included several innovations in building types for public assembly and entertainment, many of them grouped in civic centers called **forums** (or, to use the Roman plural, *fora*). The greatest of these, in Rome herself, were the Forum Romanum, a collection of many buildings constructed over a long period, and the Forum of Trajan, a majestic composition conceived as a whole. Among these urban composition were the great basilicas, or commercial exchange halls, which, with their interior colonnades, have been likened to Greek temples

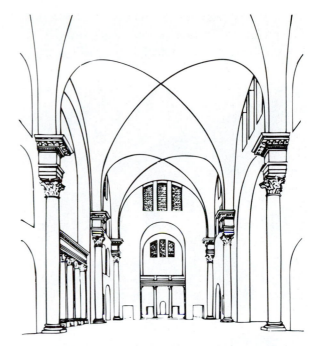

Figure 5–10 A scholar's reconstruction of the frigidarium of the Imperial Baths at Trier, Germany, built c. 300 A.D. The immense scale is indicated by the rectangular doorways at the far end.

AFTER D. KRENKER

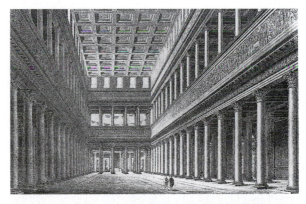

Figure 5–11 Reconstructed view of the interior of the Basilica Ulpia, part of the great Forum of Trajan complex, Rome.

FROM CANINA, *EDIFIZJ*

turned inside out, and which later formed the model for the earliest Christian churches. An example is the Basilica Ulpia (Figure 5–11), just one part of the immense Forum of Trajan complex.

Figure 5–12 The Colosseum, Rome. The orders applied in the form of half-round columns and pilasters are decorative, not structural.

DAVID BUFFINGTON/PHOTO DISC, INC.

There were several examples of the amphitheater in Rome itself, but the largest and most remarkable was the Flavian amphitheater, commonly called the Colosseum (Figure 5–12). It was begun by the emperor Vespasian in A.D. 70 and completed ten years later, shortly after his death. Measuring 510 by 615 feet (156 x 188 m), it was built of a combination of concrete, tufa (a porous type of rock), and travertine. It accommodated between 45,000 and 55,000 spectators, fed to their seats through an elaborate system of barrel-vaulted corridors, radiating stairs, and ramps *(vomitoria)*. Its three tiers of exterior arches were embellished with purely decorative half-round columns, ascending from the ground in Tuscan, then Ionic, and finally Corinthian orders, and, above these, an attic story carried tall Composite pilasters.

OTHER TYPES OF ROMAN PUBLIC BUILDINGS Other nondomestic Roman building types included the *circus* for chariot races, the *stadium*—a building type taken from the Greeks—for other athletic events, the imperial reception hall *(aula)*, great aqueducts for water supply, city walls and gates, and warehouses and granaries. Most characteristically Roman of all, perhaps, were the memorial columns and triumphal arches that marked city entrances or important spaces and that celebrated important figures and events.

In addition, elaborate temporary decorations were erected for the great festivals, such as the Saturnalia, honoring Saturn, god of the harvest. For the Saturnalia, which was celebrated for several days, schools and courts were closed, class distinctions were suspended, gifts were exchanged, and the streets were filled with revelry.

Roman Houses

Unlike the Greeks, whose magnificent temples, theaters, and stoas were unmatched by similar accomplishments in domestic architecture, the Romans' living quarters were as highly developed as personal finances would allow. Romans lived in town houses, apartments, and country villas. There were military barracks as well, consisting of rows of very simple cubicles. Built by the troops them-

THEATERS AND AMPHITHEATERS The Romans built open theaters on Greek models, and also invented a small, roofed theater, the **odeum.** The plural of the word odeum is *odea*, and the term *theatrum tectum*, "roofed theater," was also sometimes used for such buildings.

The Romans also invented an enormous new building type, the amphitheater The earliest known amphitheater was built in Pompeii c. 80 B.C., and Rome's first permanent one in 29 B.C. They were round or oval structures with sloping tiers of seating focusing on an open space (the *arena*) where gladiatorial events and shows of wild beasts took place. In some cases, voluminous fabric awnings *(velaria)* could be unfurled to protect the spectators, and, in the largest examples, trapdoors in the arena floor could be opened to corridors and chambers below.

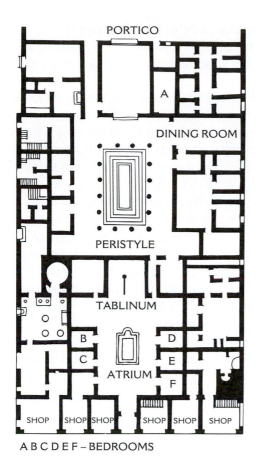

PORTICO

DINING ROOM

A

PERISTYLE

TABLINUM

B D
C E
ATRIUM F

SHOP SHOP SHOP SHOP SHOP SHOP

A B C D E F – BEDROOMS

Figure 5–13 Floor plan, the house of Pansa, Pompeii.

FROM *HOUSES, VILLAS, AND PALACES IN THE ROMAN WORLD* BY A. G. MCKAY.
© 1973 THAMES & HUDSON. REPRINTED BY PERMISSION.

selves within forts and fortresses, they exhibit no particular design skills, and will not be considered here. There were also a few extremely luxurious palaces constructed by Roman emperors, and we shall look at two examples of those. But we begin with the typical Roman house.

THE DOMUS The Roman town house or **domus** was most commonly a single-family house. It was generally on a single level, but there was frequently a cellar below grade, including a water cistern beneath the impluvium. Some remains of second stories have also been found, but it is generally thought that these were built later, added as city conditions became crowded. Construction of the domus was usually of stone or stucco-faced brick, and the interior surfaces of major rooms highly decorated.

The Greek house had been a private enclave, used only by the family and, occasionally, a few male dinner guests. The Roman house was a much more public building, serving as a place for welcoming business and political associates, and for impressing visitors with a family's importance, affluence, and taste. The master of a Roman household did not go to an office; his business was conducted in the domus.

Although it might have a couple of small windows facing the street, the domus focused inward (Figure 5–13). Its major rooms clustered around an **atrium** (Figure 5–14) or central hall usually lit from above by a central opening in the roof called a **compluvium.** Through this opening, rainwater was directed into the catch basin, the **impluvium,** in the floor beneath it. The atrium served as a reception hall and circulation space. Recesses at the sides of the atrium, called **alae,** meaning "wings," could be used as waiting rooms.

A narrow passage led from the street to the atrium. It was called the **fauces,** literally meaning "jaws" or "throat." The fauces was sometimes flanked by small shops or food stalls called **tabernae,** the source of our word "tavern." The tabernae opened to the street but not into the house itself. The exterior doors that opened into the

Figure 5–14 Interior of the so-called House of the Silver Wedding, Pompeii, 1st century A.D. The view is from the atrium into the tablinum, with the peristyle beyond.

ALINARI/ART RESOURCE, NY

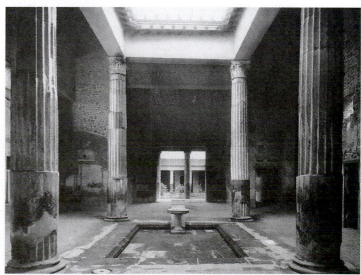

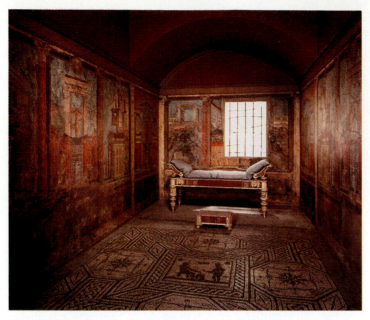

Figure 5–15 Bedroom (cubiculum noctumum) from the villa of P. Fannius Synistor. Mosaic floor, couch, and footstool come from other Roman villas of later date. Fresco on lime plaster. H: 8ft, 8 1/2 in (2.62m). L: 19ft, 1 7/8 in. (5.83m). W: 10ft, 11 1/2 in. (3.34 m). The lectus is a tall version having matching headboard and footboard, and turned legs. The mosaic floor is a geometric pattern around a central scene. The wall murals are in the Second Style of painting.

fauces were wooden and generally double. They were not hung on hinges from the sides of the doorways, but turned on metal pivots that extended from the door down into a metal socket in the floor and up into another socket in the lintel above the door. Often the frame around these doors was elaborated with pilasters made of stone or stucco-covered brick.

Centered on the atrium at its far end, opposite the fauces, was a large room called the **tablinum.** This important space housed the family records (the *tabulae*) and the images of its ancestors. It also served as a chief reception area for important visitors and for formal functions. Suitably, the tablinum's entrance from the atrium was often treated with pilasters supporting a cornice, and for privacy this entrance could be shielded with curtains or folding screens. The three adjacent spaces of fauces, atrium, and tablinum—usually arranged on an axis with their openings in an aligned procession called an **enfilade**—combined to make an impressive architectural statement for the most public part of the domus.

Also important was the dining room, the **triclinium,** traditionally furnished with three banqueting couches called **klinia,** a word obviously based on the Greek *kline*. The three klinia were placed around three sides of the dining room, at right angles to each other, and the male family members and guests reclined on the klinia while eating. Women sat on chairs. Although much less frequent, some Roman dining rooms accommodated only two couches. Naturally, such a room was called a *biclinium*. The dining room of an important Greek house, we noted, usually held seven klini, but the Roman dining room with two or three klinia could hold as many or more diners, for the narrow Greek bed held only one person and the larger Roman one was used by two or three diners reclining together. The most typical number of diners at a Roman banquet was nine, with three to each couch. A very elaborate domus might have more than one dining room, and the writer Vitruvius describes houses with dining areas positioned for winter use, for spring and fall use, and—perhaps out in the garden—for summer use.

The domus also contained a number of bedrooms, called **cubicula** (Figure 5–15). The typical bedroom *cubiculum* was sometimes divided by curtains into three parts, one being a section for the attendant, the second for dressing, and the third—furnished only with a bed, called a **lectus**—for the sleeping quarters. The term *cubiculum* was sometimes extended to describe other small, private rooms in the domus; obviously, it is the source of our word *cubicle*.

Other rooms of a domus might include a daytime resting room, a **diaeta;** a room for entertaining guests, an **oecus;** a shrine, a **lararium** that honored the household gods, the *lares;* a kitchen and a lavatory, placed near the kitchen to minimize the carrying of water; and, sometimes, a rear garden or **hortus,** or perhaps a peristyle courtyard. The domus of a scholar would also contain a library, a **bibliotheca.**

The domus grew larger and more elaborate as the Roman Empire grew wealthier. By the time of the High Empire, the traditional atrium-centered spaces near the street were being used only

for formal purposes, and most family activity centered on a generously sized **peristyle,** or garden courtyard at the rear of the domus. Larger and more open to the sky than the atrium, it was considerably lighter. It was surrounded by another series of cubicula and perhaps another dining room.

Many of the houses had roof gardens. Terrariums, aquariums, and flower boxes were frequently featured. Cool water was carried by lead pipes to elaborate baths, ornamental pools, and drinking taps. Heat was obtained from portable charcoal-burning braziers or, in the houses of the most affluent, from central heating systems.

By any preceding standards, and by most that would follow, the Roman domus was a dwelling of rare elegance.

In addition to the atrium-centered domus just described, there were some Roman houses that were linear in plan. These so-called strip houses were sometimes built with a long side facing the street, but, where street frontage was expensive, with a narrow end, usually used as a shop, facing the street.

By the end of the first century, however, overpopulation and scarcity of land in the largest Roman towns, and particularly in the city of Rome itself, had dictated that only a few could afford the luxury of the domus, either atrium-centered or strip.

The majority lived in relatively cramped urban apartment houses called **insulae.**

THE INSULA The Roman insula was a building four or five floors high, the upper apartments reached by communal stairs (Figure 5–16). Insulae were of varying size, but typically were built six or eight to a block. On the ground floor were shops or warehouses with large windows facing the street. Living above these shops without access to private gardens and with less interior space, the occupants of an insula were obviously less fortunate than the occupants of a domus, but the insula came to greatly outnumber the domus. Actual fourth-century figures cite 46,000 insulae in the city of Rome, each with six to ten apartment units or sometimes more, and cite less than 1,800 examples of the domus.

Constructed at first of wood and mud brick (but later, at least partly, of concrete), the insulae were notoriously subject to collapse and fire (not surprisingly, as heating and cooking in the apartments were by brazier). The apartments were often clustered around an open courtyard, as was the domus, but because the insulae were so tall, the courts were relatively dark, and their air relatively stale. Communal latrines were generally found only on the ground floors of these apartment blocks, although at the seaside town of Ostia, near Rome, a single example has been found of an upper-floor latrine. Another distinction between the domus and the insula was one of ownership: Generally, a family owned its own domus, but apartment dwellers rented from a landlord, usually one who lived elsewhere. This absenteeism, of course, sometimes exacerbated the problems of safety and sanitation.

The emperor Augustus and later the emperor Nero, after a terrible fire in Rome in A.D. 64, both realized housing reforms were needed. In what may have been the world's first attempts to legislate better housing conditions, they sought to enforce building height limitations on the insulae. Augustus's imposed limitation on the height of insulae was 60 Roman feet or about 58 feet (17.75 m) as measured today. With the ceiling heights then in common use, somewhat more generous than those in

Figure 5–16 Model of a reconstruction of a Roman insula, Ostia, Italy, second century A.D.
ALINARI/SCALA, ART RESOURCE, NY

use today, this allowed a maximum of five floors. Augustus and Nero also specified separations between their exterior walls, but these early efforts at building regulation were inconsistently enforced and only marginally successful.

In addition to the insula, another housing type that varied from the traditional Roman domus was the house in the country.

THE VILLA There came to be an increasing fashion, among the most affluent Romans, to leave the restrictions and noise of the city for life in the surrounding countryside.

Collectively called **villas,** the suburban houses and their lands were of several types and sizes, were sometimes by the sea, and sometimes in the hills. Generally, even when they were not working farms but only weekend retreats for city dwellers, they contained some agricultural component. For senators and other prominent citizens, direct connection to privately owned land was considered a source of status.

The villa, which might also be called a farmhouse or *aedificia rustica,* could take many forms. The atrium and peristyle of the urban domus were frequently present, and there were elements necessary to the working farm as well: workrooms, storerooms, threshing floors, water cisterns, olive presses, animal quarters.

In addition to this practical element, the villa also served the loftier purpose of accommodating relaxed living and entertainment. Baths, libraries, colonnades, dining rooms, and gardens with fruit trees and fountains provided pleasant retreats for the Roman gentry. Inside, some rooms might be furnished with central heating, and many would boast painted walls and mosaic floors.

In addition to these three characteristic types of Roman housing—domus, insula, and villa—two very uncharacteristic houses, built for their own pleasure by two remarkable emperors, compel our attention. Although one bears the name *domus* and the other the name *villa,* these both must be classed as extraordinary palaces. They are Nero's Domus Aurea and Hadrian's Villa.

THE DOMUS AUREA The emperor Nero's Domus Aurea (meaning "golden house") was one of the most notorious yet progressive houses in all of history. It was notorious because of its blatant usurpation of an entire quarter in the center of Rome for its siting. After a disastrous fire (which some accused Nero of having set himself) swept the city in A.D. 64, he had the inhabitants of a large central area removed and their damaged houses razed, claiming the land for his own grandiose building program, which included 900,000 square feet (83,700 m²) of enclosed space and acres of private parkland, game preserves, aviaries, waterfalls, and baths of seawater and sulfur water. In the words of the Roman biographer Suetonius, "There was an artificial lake to represent the sea, and on its shores buildings laid out as cities; and there were stretches of countryside, with fields and vineyards, pastures and woodland, and among them herds of domestic animals and all sorts of wild beasts." It was an enormous country villa in the heart of a densely populated city. The only part of the house still remaining, a section of about a hundred rooms on the slope of the Esquiline Hill, was preserved only because it was built into the foundations of the later Baths of Trajan; this wing is only a small part of the original.

The house itself was revolutionary in its construction techniques, making full use of recently developed brick-faced concrete, which, it should be pointed out in all fairness, Nero also mandated for the rebuilding of the city's burned insulae. The new material provided more than permanence, however; it also provided a new freedom in the shaping of interior space. It allowed an unprecedented modeling of interior volume, and the enrichment of that volume with apses, niches, hidden lighting coves, and generous openings into adjacent spaces. As never before, the Domus Aurea employed long interior views framed by the successions of aligned openings called **enfilades.**

Unusual for any residence of the time, the Domus Aurea, thanks to the writings of a Roman naturalist and historian called Pliny the Elder, has an interior designer whose name we know: Famullus. Its architects were Severus and Celer, and the painter of its wall and ceiling murals was Amulius.

One of the house's spectacular rooms, described in literature, was a circular dining room in which the dinner guests were seated on a revolv-

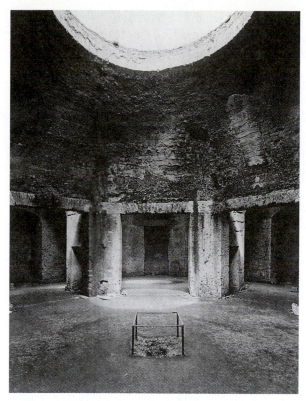

Figure 5–17 Octagonal fountain room, Nero's Domus Aurea, Rome, built between A.D. 64 and 68.

AMERICAN ACADEMY IN ROME

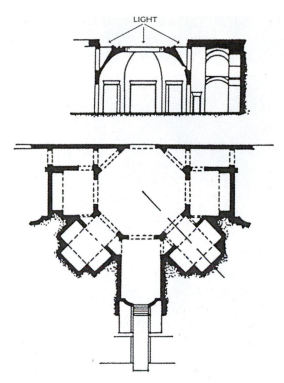

Figure 5–18 Plan and vertical section of the octagonal fountain room of the Domus Aurea. The central space is about 40 feet (13 m) wide.

J.B. WARD-PERKINS, *ROMAN IMPERIAL ARCHITECTURE*, HARMONDSWORTH: PENGUIN, 1981. COPYRIGHT YALE UNIVERSITY PRESS.

ing platform. Another, the ruins of which are still visible, was an octagonal room (Figure 5–17) having a fountain in the center, a dome above—one of the earliest concrete domes still standing—with an open oculus in its center, and ingenious skylights lighting a series of surrounding anterooms (Figure 5–18). In a few of the rooms, such as a vaulted corridor (Figure 5–19), remnants of some of the original wall paintings are still visible.

Famullus devised a wealth of decorative details for the house. Through openings in fretted ivory ceilings, flowers were dropped on the guests below, and through other openings, jets of rose water and other scents were sprayed. Parts of the exterior walls are thought to have been faced with gold, and some interior walls were inlaid with gems and mother-of-pearl. In addition, the house and grounds contained a treasury of painting and sculpture, including the famous *Laocöon* group from ancient Greece (Figure 4–14), now in the Vatican Museum.

"Now at last," Nero is reported to have said upon the completion of the Domus Aurea, "I am beginning to be housed like a human being."

HADRIAN'S VILLA We have already met the emperor Hadrian as the builder of the Pantheon, but nothing could be more different from that building in the heart of Rome than the country villa he built for himself near the suburb of Tibur (now Tivoli). The Pantheon is a model of order, unity, centrality, and geometric discipline; the villa's fanciful elements are dispersed in a free, sprawling, picturesque composition (Figure 5–20) that, in its present ruined state, is beyond the immediate comprehension offered by the simple domed temple. One of their few similarities is that, in size, both buildings surpassed any of their predecessors. Another, much more speculative similarity is that both aspired to universality, the Pantheon a temple to all the gods, and the villa, some say, an attempt to represent in one complex all aspects and all regions of the empire.

Figure 5–19 A vaulted corridor in the Domus Aurea, with the wall paintings still visible.

Hadrian began the Villa in A.D. 118, and construction continued for twenty years. Scattered over many acres, the elements of the villa included various porticoes and pavilions, banqueting halls, guest quarters, large and small baths, a temple, a *palaestra* or exercise ground, a stadium, a theater, a library, and a number of ornamental pools and water courts, many of them formally distinguished by compound curves and complex geometry.

One of these elements, the island villa (sometimes called the island enclosure, sometimes the maritime theater or Teatro Marittimo) can serve to demonstrate the ingenuity and originality typical of the whole complex (Figures 5–21 and 5–22). Within a vaulted ring supported by a colonnade of forty unfluted Ionic columns, a moat open to the sky surrounds an island retreat reached by two bridges. The island is divided by curving walls into four groups of domed and vaulted rooms: on the north, a semicircular entrance vestibule; to the east, a small bedroom suite with two bedrooms and two latrines; to the south, a dining room with antechambers; to the west, a small bath complex with hot and cold plunges. Surprising vistas into unusual spaces, dramatic effects of light and shade, and the reflectivity of the sunlit water must all have contributed to a rare experience.

Figure 5–20 A model of the vast complex of Hadrian's Villa at Tivoli, built between A.D. 118 and 134.

Figure 5–21 Floor plan of the island villa, one small part of Hadrian's Villa. The diameter of the outer wall is 135 feet (44 m).

Figure 5–22 The island villa as it appears today.

The Domus Aurea and Hadrian's Villa both provided their imperial owners with interiors that could hardly be approached by more mundane building. But, as we shall see, even the ordinary Roman enjoyed interior design more carefully planned and executed than almost any that had come before it.

Roman Interiors

Public or domestic, Roman architecture was more than just a pretty face. To a degree unprecedented in history, the design of the interior came to be as well considered as that of the exterior. So important are the size, shape, and character of some Roman interiors that many Roman buildings can truly be said to have been designed "from the inside out." How those interiors were finished and furnished were also matters of great concern. What evidence we have suggests that the Romans were more restrained in matters of furnishings than in some other areas. Rooms seem to have been sparely furnished with a small number of ob-

jects. But often, especially in imperial times, much care and expense was lavished on those few.

Roman Rooms

Many rooms in Roman houses, many shops, and many inner precincts of temples were windowless. Ceilings were generally high, however, by today's standards, and doorways were also tall. They were sometimes framed with a pair of pilasters supporting an entablature, an assemblage sometimes called an **aedicule,** although the term more properly applies to a small temple so framed. If the entablature extended beyond the pilasters, as it often did in Roman rooms, the frame type is called an **aedicule with ears.** It was popular again in the Renaissance and in the Neoclassical period. Doors themselves were of hardwood, mortised to a cylindrical hardwood projection that rotated in sockets above and below the opening.

Whenever possible, floors were paved with mosaics of marble tesserae; sometimes these were in black and white patterns, sometimes colored. Ceilings were painted in geometrical patterns or intertwining floral and leaf designs, often accented with perched or flying birds. Sometimes gilded beams or panels were used. The richest decorative effects, however, were saved for the walls of Roman rooms.

The Legacy of Pompeii and Herculaneum

Before we turn to the subject of Roman wall painting, we should acknowledge an event that provided the primary source of our information about such painting: the sudden burial of two Roman towns near the Gulf of Naples. Both Pompeii and Herculaneum had suffered some damage in an earthquake in A.D. 62; both were in the process of being rebuilt when, in A.D. 79, disaster struck them both: The nearby volcanic mountain of Vesuvius erupted violently and without warning. The fallout of light ash was apparently gradual, but many inhabitants (probably one-tenth of the total population of about 20,000) died of asphyxiation. As the fallout continued, the deposit of ash and pumice

Figure 5–23 A sculptured figure at the Temple of Apollo overlooks the ruins of Pompeii.

PHOTO: ABERCROMBIE

stone eventually reached a depth of more than 20 feet (6 m), a covering that both hid and protected the ruined towns until their dramatic rediscovery in the eighteenth century.

What Vesuvius had hidden were settlements of considerable elegance. Pompeii had an urbane forum and public buildings (Figure 5–23), including temples, markets, theaters, restaurants, baths, shops (including pawnshops), and a sizable amphitheater. Most surprising, however, when excavations began in 1753, were the residential quarters of both towns.

Houses conformed to the domus model already described, with largely windowless rooms ranged around interior courtyards. They were built directly on the streets and were frequently flanked by small shops. The houses were by no means splendid on the exterior, being plainly designed and finished with cheap stucco rather than stone. But their rooms were found to be adorned with interior decor more elaborate and more refined than other, more badly weathered Roman houses had ever suggested.

Most remarkable of all, as we have said, is the series of wall murals that the volcanic ash preserved for us to see.

Roman Wall Treatments

Whenever it could be afforded, it seems, the wall surfaces of a Roman room were treated with fine marble veneers, painted murals, or carved stone reliefs. According to Roman literature, the first use of white marble as a facing for brick walls was in a palace built for Mausolus of Halicarnassus in the fourth century B.C. The first such use in Rome itself may have been by Mamurra of Formiae, an engineer for Julius Caesar, for the walls of his house on the Caelian Hill. In 74 B.C, a wealthy Roman named Lucius Lucullus used *black* marble veneer in his house; it was considered extremely luxurious and came to be called Lucullan marble.

When such luxury was not possible, relief panels might be made of stucco, or masonry walls might be coated with plaster that was then ruled to imitate stone coursing. The most common interior wall treatment, however, was painting.

Almost all the interior walls of the buried houses of Pompeii and Herculaneum were covered with painted murals. Often these represented architecture that was not actually present. Usually the walls were divided into a lower section treated as a pedestal or dado and a high upper section reserved for more decorative paintings. The panels in the pedestal or dado often imitated marble slabs or a balcony **balustrade,** a series of short vertical posts or miniature columns.

Often the high upper section was divided into vertical panels by painted columns or pilasters, crowned with entablatures realistically represented in perspective. The painted architectural features were often reduced to the most delicate and slender proportions, showing that Roman painters understood the posibilities of their medium, which was not subject to structural limitations. These imaginary constructions did not need to support themselves, and their painters felt no need to observe the Vitruvian rules for the proportions of the orders.

The panel centers within these frameworks were treated in one of several ways: they could be

painted a plain color framed with painted moldings, or they could enclose an ornamental arabesque or a scenic pattern.

In plain panel areas, the color was generally a yellowish red or black. The moldings on four sides formed a rectangular frame realistically painted with natural highlight, shade, and shadow effect, with the light indicated as coming from the door of the room. Sometimes a small figure or other motif was placed in the center of the panel, or a picture was painted as though hung on the wall, with the frame and the shadow realistically indicated. Where conventional arabesque patterns were used in the centers of the panels, they were sometimes combined with naturalistic climbing ivy or leaf forms that spiraled around the slender columns and continued upward, forming part of the ceiling decoration.

The most interesting of the Roman mural decorations were those showing scenic effects in which the subject matter was drawn from an infinite number of sources. Mythology, allegory, history, landscape, still life, humor, city streets, portraiture, and animals were charmingly depicted. Playful nymphs and satyrs were shown in woodland settings. The draperies of a dancing girl would so accurately indicate the movement of her body that one could almost feel the rhythm of the dance. A forest grove would transport a city dweller to a verdant retreat. A painted view through an imaginary open window would lead the eye down a shady path by waterfalls or splashing fountains. Members of the family were often shown seated in chairs, giving us a record of their wooden furniture, costumes, and hairstyles. Shops, taverns, and other business houses were decorated with subjects appropriate to their activities. The barber, butcher, shoemaker, fortuneteller, and prostitute were all identified in wall paintings with special symbols depicting their talents and wares.

The colors were comparatively brilliant, as was necessary in rooms having only a dim light. The medium was true fresco, the pigments being applied to and absorbed by the wet plaster; when dried, the surface was waxed and polished for protective purposes. Backgrounds were most commonly in black, white, or red, but other colors were also used, including saffron yellow, vermilion, and a bright green obtained from malachite.

Scholars have classified the painted wall decoration of Pompeii and Herculaneum from the second century B.C. until A.D. 79 into four distinct styles, each having different conventions of realistic and illusionistic representation. These four styles are also thought to have been in general use in the areas around Naples and Rome about the same time.

- The **First Style** or **Incrustation Style,** used in the second century B.C., employed a *faux marbre* technique to imitate inlaid marble slabs ("crustae"). Examples are the murals in the House of Sallust. Even when succeeded by other styles, the marble representations of the First Style continued to be used along the dadoes or bottom portions of walls (as in Figure 5–25).

- The **Second Style** or **Architectural Style,** used in the first century B.C., employed painting to resemble a building or a colonnade, usually seen from within with open countryside visible beyond. An example is the panorama on a wall of a cubiculum (Figure 5–15) in a villa at Boscoreale, on the outskirts of Pompeii; it is now reconstructed in the Metropolitan Museum of Art, New York.

- The **Third Style,** also known as the **Ornate Style,** used in the period from c. 20 B.C. to A.D. 50, still included architectural forms, but in a more ornamental way, among figures and landscapes. Delicate bands divide the panels, some of which were painted in solid colors. An example from Boscotrecase, also near Pompeii, is predominantly red (Figure 5–24).

- The **Fourth Style** or **Intricate Style,** used from A.D. 50 until Pompeii's destruction twenty-nine years later, employed fantastic structures in grotesque and sometimes impossible arrangements. An example is seen in Pompeii's House of the Vetii (Figure 5–25). A more extreme example of the Fourth Style, found in Nero's Domus Aurea, makes the architectural framework even more fantastic, less substantial, and airier, displaying its delicate structures against a white background (Figure 5–26).

Related to the painted walls of Rome and perhaps even following the same changing fashions were interior walls decorated with stucco. These added three-dimensional effects to the illusions of paint, rendering some of the moldings and slender columns in shallow relief (Figure 5–27). Because of the extreme fragility of this stucco work, however, very few examples remain.

Details of stylistic differences in wall painting and stucco are important only to the specialist, perhaps, but the fact that such differences did exist and were so widely followed gives us unmistakable proof of the importance of changing fashion to the Roman artist and connoisseur. A similar sense of fashion must also have been at work in the Romans' taste for particular furniture designs, although sudden changes are less easily found in that field.

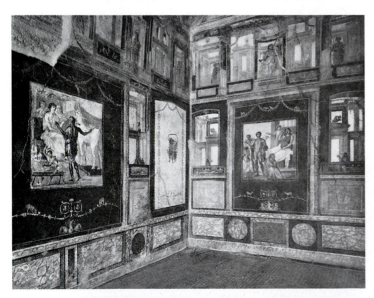

Figure 5–24 Painted wall decoration of the Third Style in the villa of Agrippa Postumus at Boscotrecase, c. 20 B.C.

NATIONAL MUSEUM OF NAPLES, ITALY GEMEINNUTZIGE STIFTUNG LEONARD VON MATT

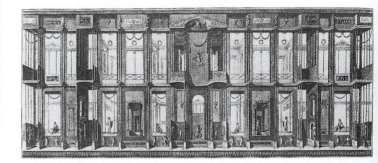

Figure 5–26 Fourth Style painted wall from Nero's Golden House. The columns have been drawn too thin to be self-supporting, unless made of metal.

AFTER JOHN R. CLARKE, *HOUSES OF ROMAN ITALY, 100 B.C.–A.D. 250: RITUAL SPACE AND DECORATION,* REPRINTED BY PERMISSION.

Figure 5–25 Fourth Style wall paintings at the House of the Vetii, Pompeii, painted between A.D. 63 and 79. The imitation marble painting of the dado is typical of the First Style.

ART RESOURCE, NY

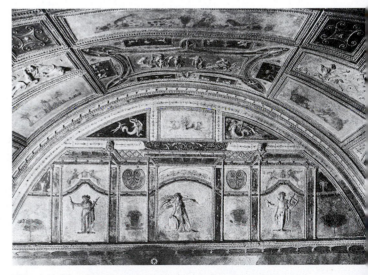

Figure 5–27 Vaulting with stucco reliefs in the Mausoleum of the Anicii, Rome, second century A.D.

ALINARI/ART RESOURCE, NY

Roman Furniture

The furnishings of the Roman house grew to be as elegant as the house itself. By the time of the emperor Cato (234–149 B.C.), couches were being inlaid with decorations of ivory, bone, antler, silver, and gold (although, after A.D. 354, a law reserved the use of both gold and ivory for consuls and their families). Tables and chairs were inlaid with metals and precious stones. Beds were made of wood or metal, their slender legs often ending in animal feet. Elegant bronze tripods served as end tables, and highly polished bronze plates served as mirrors. Bronze braziers warmed the rooms (Figure 5–28), and bronze lamps lighted them. Elaborate library cabinets were built with pigeonholes for rolled manuscripts. Rich furnishings were more widespread than ever before in history.

Beds and Seats

More than the people of any of the other cultures we have considered so far, the Romans liked to be seated. Like the Greeks, they liked to recline while dining. Their dining and sleeping beds, their thrones, chairs, and stools all had Greek origins, but were all given Roman interpretations.

THE LECTUS The Roman couch or **lectus** was a highly valued piece of Roman household furniture. It could be single or double or even triple in width, and it could be used either for sleeping or dining. It had antecedents in both the Greek and Etruscan traditions. The Etruscan and Roman versions were in some cases somewhat lower to the floor than the Greek couch, and the Roman version usually had turned legs decorated with moldings (Figure 5–29), although it sometimes had rectangular legs, such as were popular in Greece. It had a headboard, called a **fulcrum** (the plural being *fulcra*), and often a footboard, both elaborately shaped and carved. Sometimes it also had a back, so that it resembled a modern sofa. Made of wood, most examples have vanished, but some bronze fittings, such as legs and headboard ornaments, remain. Ropes or metal strips within the rectangular frame supported a straw or wool mattress, which might be covered with silk cushions or costly textiles imported from the East.

Figure 5–28 Roman brazier on a folding tripod base, bronze, first century A.D. The legs have animal heads and feet.

REUNION DES MUSEES NATIONAUX/ART RESOURCE, NY

When used for dining, the usual arrangement was to place a couch at each of three sides of the room, with a square table in the center. Two or three reclining diners might share a single lectus. In this arrangement, one lectus might have only a headboard, the one opposite only a footboard, and the central one neither headboard nor footboard, so that the diners might have more flexibility in placing themselves. A lectus in a dining room was called a **klinium,** as already noted, or a *lectus tricliniaris* after *triclinium*, the name of the dining room.

A lectus in a sleeping cubicle was called a *lectus cubicularis*. A ceremonial marriage couch, an example of which was often displayed in the tablinum of a domus, was called a *lectus genialis*.

An interesting variant is a child's crib. One was found at Herculaneum, enough parts surviving to allow a reconstruction (Figure 5–30). It was simply made of wood slats, with the two bottom members curved to allow rocking. In its unadorned simplicity—admittedly rare for Roman furniture—it looks as if it might have been made in our own time.

Figure 5–29 Bronze and wood lectus found at Boscoreale, the wood parts seen here having been restored. Note the similarities with the Greek kline (Figure 4–40).

SCALA/ART RESOURCE, NY

THE SOLIUM One passage in Roman literature describes the **solium** as a chair so important it was reserved for emperors and gods; another describes it as a chair for a patron, or someone honored as a protector or supporter. In any case, it was a seat of honor, used in formal receptions, and it was closely based on the Greek thronos (Figure 4–41), although there were also Etruscan precedents made of bronze (Figure 5–31) or of white marble. In the domus, the

Figure 5–30 A wooden cradle on rockers found in the ashes at Herculaneum.

ABERCROMBIE, AFTER RICHTER

Figure 5–31 Etruscan throne of bronze with relief carvings, Seventh Century.

HERVE LEWANDOWSKI, COURTESY RÉUNION DES MUSÉES NATIONAUX/ART RESOURCE, NY

Figure 5–32 A Roman wicker chair, a humble version of the solium.

solium might be rendered in stone and prominently displayed in the atrium. Like the thronos, it might have several forms, but the most favored had a rounded or rectangular back and solid sides, the fronts of which might be carved in the forms of animals or monsters.

Not unlike the solium in shape, but very different in materials and very different in prestige, was a solid-sided chair made of **wicker,** woven pliant reeds, on a wooden frame (Figure 5–32). It was made in the Roman colonies in England, in Germany, and probably elsewhere, and might have been found in the tablinum of a modest domus. It was a relatively humble and utilitarian piece of furniture, but probably quite comfortable.

THE CATHEDRA More often used was the **cathedra,** but even this chair was sometimes reserved for dignitaries and for the women of noble families. It was based on the Greek klismos (Figure 4–42) having a rounded back supported on vertical stiles, curving legs, and (usually) no arms. But it was based on the Hellenistic version of the klismos, and, judging from carved and painted representations, usually lacked the gracefulness and elegance of the best Greek examples. It was also used as a litter for conveying wealthy Roman women about town. Later, the cathedra would give its name to the cathedral, the "seat" of a bishop.

STOOLS AND BENCHES The Roman seating in most common use was the wooden stool, and one popular version, based on the Greek dipthros, had a sturdy seat on four perpendicular legs that were ornamented with turnings. Historian Gisela Richter says that it was "often made so substantial that it might qualify as a backless throne." Such stools appear in reliefs and wall paintings.

Even more popular was the folding stool or **sella** (Figure 5–33). Also modeled on the dipthros, it was most often made of wood, but was also made in bronze or iron. Its crossed legs were sometimes straight and sometimes curved, sometimes plain and sometimes terminated in animal feet.

The most illustrious version, which came to be associated with political power, was the **sella curulis** or **curule.** This was a stool on an X-shaped base with multiple parallel legs in two interlocking sets (Figure 5–34). It came to be a symbol of the authority of the Roman magistrate, and eventually its use was limited to high public officials. Roman literature mentions the sella curulis as an adaptation of an Etruscan stool and describes it as an emblem of dignity, along with the purple robe, the signet ring, and the gilded laurel wreath. Later, the Roman Catholic Church would appropriate the sella curulis as the special seat of a bishop.

Figure 5–33 The Roman sella or folding stool. Examples were made in both wood and metal.

Figure 5–35 Table on a single pedestal. Its square marble top is edged in bronze. Such tables were also made with circular tops.

THE METROPOLITAN MUSEUM OF ART, ROGERS FUND, 1906. (06.1021.301)

Figure 5–34 The sella curulis of a Roman magistrate. It is carved here on a first century A.D. grave stele, indicating that the deceased had been a government official.

MUSÉE CALVET, AVIGNON, FRANCE. PHOTO BY ANDRE GUERRAND.

Despite its significance, the sella was basically a simple camp stool, so naturally there were efforts to upgrade it. Some later versions added a back and arms to the original design, and sometimes a footstool was used with it. Sometimes it was placed on a raised platform for added height. Some officials had sellae made of ivory (an ivory version being called a *sella eburnea*), and Julius Caesar is said to have had one made of gold.

Another popular Roman seating type was a bench that could seat two or more, and stone versions were found in lecture halls, in sepulchral chambers, in temple vestibules, and elsewhere. Some had backs, some not, and some had armrests in the shape of Ionic volutes. Legs could also be shaped like volutes, or like animal legs. There was also a broad stool called a *bisellium* and a semicircular bench popular for use in the garden. There were footstools as well, called *scamna* and *suppedaria*, some of them used—as they had been

in Greece—for climbing into bed, when the klinia was high (as in Figure 5–15).

Tables

The Greeks had used tables primarily during meals and then had put them away. The Romans, having greater numbers of possessions and greater pride in showing them, needed tables as permanent display platforms. The tables themselves could also serve as objects of display. The great orator Cicero (100–43 B.C.) was reported to have paid an enormous sum for a table made of citrus wood, while tables of cypress were even more highly prized, and the finest were made of marble, bronze, silver, or gold.

The dining table among the klinia was customarily low for the convenience of the diners, and it was called a **mensa.** The Romans also used smaller, taller tables for holding flowers or candles or other objects. The Greek table type with a round top and three animal-shaped legs became very popular with the Romans. The type with a round or square top on a single central support, rarely used by the Greeks, was also very popular. An example of this last type, which has a marble top edged with bronze on a marble and bronze pedestal, is in the Metropolitan Museum (Figure 5–35).

The **cartibulum** was a ceremonial marriage table, made of marble, which might have had a place of honor in the atrium of a domus, beside the

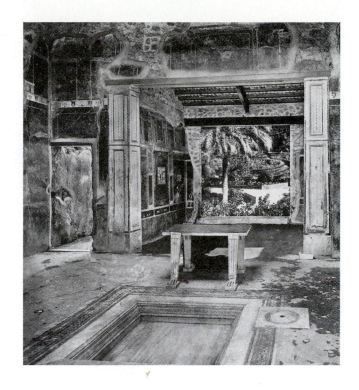

Figure 5–36 The ceremonial table called a cartibulum, shown here beside the impluvium (water basin) of the atrium of a house in Herculaneum. The table top is 4 feet (1.3 m) long.

ALINARI/ART RESOURCE, NY

impluvium, and on which might have been a display of fine utensils and serving ware (Figure 5–36). Marble was also used for the decorated slab supports of a table popular for outdoor use (Figure 5–37); its rectangular top was sometimes made also of marble, sometimes of wood. It became a favorite again during the Italian Renaissance, when copies were made entirely of wood.

Another type of Roman furniture was the *abacus*. Corresponding to today's sideboard, it was a cross between a table and a piece of storage furniture.

Storage Furniture

Storage furniture in Rome was rare by today's standards, but more frequent than in Greece. In modest houses, clothing and other family possessions were hung on hooks or nails. There were chests, however, some of them elaborately finished. And the Romans were probably the first to develop the open cupboard or sideboard on which family treasures of glass, silver, or gold could be displayed; it was called an **armarium.** An example found in 1935 in the ruins of Herculaneum, fairly well preserved, was made in two parts. The upper part,

which contained statuettes of the household gods, the Lares and Penates, was made in the form of a miniature temple, flanked by small Corinthian

Figure 5–37 Carved marble support of a table found at Pompeii.

ALINARI/ART RESOURCE, NY

columns, and may have served as a shrine. The lower part was a cupboard with shelves, where were found glassware, vases of bronze and terracotta, and a number of small ornamental objects.

On a smaller scale, there were boxes and containers of many shapes and sizes, generally called by the name **arca.** There were small round or rectangular versions for jewelry and for toilet articles, and—in a society without bank vaults or safety deposit boxes—there were, of course, strongboxes for the keeping of valuables. These were made sturdily of wood; when they were sheathed with iron for further protection, they were called *arca ferrata*.

Lighting

Roman lamps holding wicks floating in oil were made of pottery, iron, carved stone, or bronze. They were all decoratively embellished. Some were

Figure 5–39 From Hadrian's Villa, one of a pair of carved marble candelabra, more than 6 feet (2 m) high.

Figure 5–38 From the Villa of Diomedes at Pompeii, an ornate lampstand made of bronze, holding four oil lamps.

designed to sit on tables or stands, some were on tall pedestals, usually with a tripod base, and others were designed to be hung from the ceiling on chains. An example found at Pompeii (Figure 5–38), executed in bronze, has a base on which a satyr is riding a panther. Above, four oil lamps hang from branches that curve outward from the elaborate (and unidentifiable) capital of a square column.

Candles and candleholders were also used. From Hadrian's Villa, examples remain of **candelabra**—branched, highly ornamental candleholders—that are more than 6 feet (2 m) tall (Figure 5–39). (A **candelabrum,** however, is not always floor based. It can also sit on a table or be suspended from the ceiling.)

Soft Furnishings

It is clear from painted, carved, and written descriptions that fabric hangings and fabric-wrapped

cushions and mattresses were important features of the Roman interior. Because these goods are extremely perishable, however, our knowledge about how they looked is speculative. We do know that materials used included wool, linen, silk, and leather, and we know that fabrics were not only woven but also embroidered and sometimes painted.

In the Roman domus, doorways of the cubicula and other rooms were often closed with curtains, rather than with pivoting wood doors, and bronze curtain rings have been found in a number of excavations. Curtains also substituted for doors in the case of some cupboards and armaria.

What we today call upholstery—padding fixed to a chair or sofa frame—would not be developed until the seventeenth century, but it was commonplace in Rome to soften a seat with a cushion. Sometimes, paintings show, these cushions were elaborated with fringes and tassels.

There were also, it seems from painted evidence, decorative curtains, wall hangings, canopies, and the Roman equivalent of what we call **valances**—pieces of fabric that finished the tops of curtains or that hung over the frame of a bed or couch. And there were, of course, mattresses (*culcitae* or *tori*) and bed pillows (*pulvini*). For floors, a kind of rush matting (*matta*) was woven.

Painted evidence indicates that most of these soft goods—perhaps excluding the rush matting—were highly decorative. Striped cushion covers are seen in a Pompeii wall painting, for example. Probably many of them were brilliantly colored. The evidence has mostly vanished, but all we know of Roman taste and temperament suggests that these furnishings would not have been left unadorned.

Roman Decorative Arts and Ornament

We have looked at some examples of Roman painting in the section on interior wall decoration. Now we shall consider the Roman taste in sculpture and other decorative arts. We have also looked at the changes the Romans made to the great system of architectural orders that they inherited from the Greeks. Now we shall look at the changes they made to the inherited vocabulary of Greek ornament. We shall also survey Roman accomplishments in the areas of pottery, glass, and mosaics.

Roman Sculpture

Sculpture was a frequent feature of Roman architecture, both outside and inside, and both freestanding figures and carved reliefs were used. Generally, sculpture was in service to the state or to the state religion, which, like so much else of Roman culture, was based on the model supplied by the Greeks. Roman sculpture depicted gods, emperors, senators in togas, or generals on horseback. It was a curiously anonymous art form, the names of very few sculptors having been recorded. It was also the most derivative of the Roman arts. There is little in Roman sculpture that moves beyond the influence of the Greeks, and many of the best Roman works are, deliberately, direct copies of Greek models.

Examples include the relief carvings in the Altar of Augustan Peace (the Ara Pacis) in Rome, showing a procession not unlike the one shown on the frieze of the Parthenon. One Roman innovation was to take such a storytelling frieze and wrap it in a continuous spiral around a memorial column. Trajan's Column in Rome, which stood in a colonnaded courtyard adjacent to the great Forum of Trajan (Figure 5–40), was such a column; it was 115 feet (37 m) high, in a giant Roman Doric order, and was wrapped with a linear sculptured frieze 800 feet (260 m) long. It was originally topped by a statue of Trajan, but the emperor has since been replaced by Saint Peter.

Sculpture, on as large a scale as space would allow, was a frequent ingredient in interior design. The Greek *Laocöon* group, as has already been mentioned, was found at Nero's Domus Aurea. According to literature, an even larger sculptural group adorned part of the emperor Tiberius's villa at Sperlonga; it was a Roman product based on models from Hellenistic Greece.

Variations on Greek Ornament

The ornament of the Romans was also taken from Greek precedents, and also transformed from those

Figure 5–40 Restored view of the peristyle that once surrounded the Column of Trajan, Rome. Upper galleries allowed viewing of the carved relief spiraling around the column. The interior of the column contained a spiral stair.

UGGERI

The acanthus leaf appeared not only on the Corinthian and Composite capitals, but was also carved in festoons and scrolls, as in a relief panel from the Forum of Trajan (Figure 5–41). The honeysuckle and anthemion also made an appearance, as did other foliage. Human figures, divinities, and small cupids—also called **putti** or **amorini**—were frequently employed, as were serpents, swans, eagles, lions, and oxen. Fantastic figures such as sphinxes, satyrs, griffins, and genii were used in "grotesque" ornament. And there was more abstract, less representational ornament patterned after the Greek fret, swastika, key, spiral, egg-and-dart, and dentil motifs.

Roman moldings were taken directly from Greek models, but most underwent slight modifications (Figure 5–42). In general, the Greek prece-

precedents. In general, Roman ornament was more elaborate than Greek and was applied more lavishly. Roman craftsmanship, however, was sometimes less refined than Greek, partly because the limestone and cast stucco often used by the Romans allowed less precision than the marble favored by the Greeks. Also employed for Roman ornament were bronze castings and two-dimensional painting.

Figure 5–41 A carved scroll of acanthus leaves from a frieze in the Forum of Trajan. Grammar of Ornament, 1868 by Owen Jones (1809-74) Chpt VI, Plate XXVI, Roman Ornament: 1) & 2). Private Collection/Bridgeman Art Library.

Figure 5–42 A comparison of Greek and Roman molding shapes. In general, the Romans regularized the more subtly curved Greek models.

FGSN TK

OVOLO	QUARTER ROUND
TORUS	TORUS
SCOTIA	SCOTIA
CYMA RECTA	CYMA RECTA
CYMA REVERSA	CYMA REVERSA
GREEK MOLDINGS	**ROMAN MOLDINGS**

dents were based on complex geometrical figures such as the parabola and the ellipse; their curvatures were subtle and varied. Their Roman counterparts were based on simpler geometrical figures such as the circle; they were bolder and more obvious. The Roman shapes could be comprehended quickly; the Greek ones invited study. But the Roman moldings were appropriate for the forceful character of most Roman architecture, and they had the great advantage of being simply laid out and simply carved, even in remote parts of the empire and even by relatively unskilled builders.

Roman Pottery

The Greek painted vase is so highly praised, and Rome was so mindful of Greek accomplishments, that it is natural to ask if the Romans did not inherit some of the great artistry of the Greek vase. Romans did indeed manufacture and export large amounts of pottery: tableware, cups, beakers, mortars, figurines, candleholders, lamps, and storage vessels (*amphorae*). Much of this pottery was crude, but the finest, called **terra sigillata**, was finely made, though seldom with decoration of Greek excellence. Terra sigillata means "clay stamped with a seal" (a *sigillum*) identifying the maker, although in practice the term is applied also to vessels without such seals. Terra sigillata is usually red in color, made from a fine red clay, and unglazed, although some black and even some marbled examples have been found. In Britain, the term *Samian* ware is used for terra sigillata. Some beautiful examples, made at Arretium (modern Arezzo) in the first century B.C. and the first century A.D., are called *Arretine* ware.

The Roman Development of Glass

Glass was probably invented somewhere in the Eastern Mediterranean area; some think the process of glassblowing to have been discovered in Syria in the first century B.C. Glass beads and pendants were known to the Cretans, and we have already noted the casting and molding of solid glass objects in Egypt. By the middle of the first century A.D., sophisticated glassmaking was well established in Rome and well adapted to Roman taste. In quality, quantity, and variety, the Romans produced glass as no earlier civilization had done.

Roman glass included extraordinary showpieces for the delectation of the aristocracy. It also included mass-produced items for common use. It could serve utilitarian purposes, as vessels for holding either perfumes or pungent sauces made from preserved fish. It could also serve as propaganda, displaying images of emperors and gods. All types were distributed throughout the empire. Because much of the distribution was done by Phoenician merchants, however, what should properly be called Roman glass has sometimes been called Phoenician glass.

WINDOW GLASS The Roman use of glass with the greatest impact on the character of interior space was the use of glass in window openings. This use, it is thought, was a Roman invention, and both shattered glass and strips of leading, used between glass panes, have been found at Pompeii. Such use was not widespread in Rome and occurred only in very small openings, but its future potential was enormous. When Roman windows were not filled with glass, they were sometimes filled with parchment, prepared from untanned animal skins. They were also sometimes filled with thin sheets of mica, a crystalline mineral substance that easily separates into thin, translucent sheets. And sometimes they were filled with grilles of fine metal mesh. Roman windows of all kinds were also frequently covered, as were doorways and cupboards, with fabrics hung from bronze or wooden rings.

Within the Roman interior, whether or not protected by glazed windows, there were many examples of glass objects displaying unprecedented techniques and ingenuity. We shall look at several types.

CAST GLASS AND BLOWN GLASS All glass, of course, is the result of working with a material that must be formed while it is too hot to touch with the hands. The earliest tool for gathering molten glass from the furnace and beginning to form it was a metal rod called a **pontil.** The rod was later replaced by a hollow blowpipe, through which a gob of molten glass could be inflated, but the rod remained in use as an auxiliary handling aid. Another common glassblowing tool, the *sofietta,*

was a short tube used for further inflating an already blown vessel. From earliest times, glass manufacture was divided into the "hot working" done by glassmakers and the "cold working" done later by glasscutters.

The earliest Roman glass factories, established by Hellenistic glassmakers from the eastern end of the Mediterranean, used **cast-glass** techniques to produce bowls, plates, and bottles that were smooth or ribbed, monochrome or variegated in color. A great step forward came in the second half of the first century B.C., when blown-glass techniques were introduced and perfected, techniques that, with few variations, are still in use today. Roman glass generally ceased to be considered an imitation of silver or ceramics and came to be appreciated for its own qualities. Even so, the most spectacular examples of early Roman **free-blown glass** were the **glass cameos,** carved by glasscutters in imitation of onyx and other fine layered stones. Many glass cameos were found at Pompeii. The category of free-blown glass that includes cameos is **flashed glass,** which involves coating the outer surface of a glass object with a thin coating of glass in another color. The coating can then be partly carved away to produce a desired design, and repetition of the process can produce multilayered, multicolored effects. Another name for the flashing technique is **dip-overlay,** and in France such glass is known as **verre doublé.**

A quite similar technique, which became popular in the nineteenth century, involves coating the *inner* surface of one glass with another; it is called **cased glass,** or **cup-overlay,** or sometimes even **plated glass,** although this last term must not be confused with **plate glass,** a nineteenth-century term for a fine grade of flat window glass.

CAGE CUPS Another type of glasscutting at which the Romans excelled was the creation of some astonishing pieces called **diatreta** (Figure 5–43), after the Roman term for glasscutter, *diatretarius.* Today they are often called **cage cups.** In these vessels, thick glass was cut into deep relief, and the relief then undercut, leaving it attached to the solid vessel beneath only by a structurally minimal number of glass bridges. The process was laborious, requiring much time and great skill, and

the results were extremely fragile; obviously these were luxury items.

MOLD-BLOWN GLASS Another great advance in Roman glass came around A.D. 25 with the development of blowing glass, not freely at the end of the gaffer's blowpipe, but into the enclosure of a mold. The molds were made from pottery or, for finer pieces, metal. Because glass does not shrink slightly as it cools after firing, as clay does, making it easy to remove, the glass molds were made in two or more pieces. With this **mold-blown** technique, a predetermined and complex shape could be repeatedly achieved. Glass objects consequently became less expensive and more widely used than ever.

PAINTED GLASS Painting on glass was also developed in the first century A.D. The vessels were fired after painting so that the paint would be fused

Figure 5–43 The Lycurgus Cup, with relief decoration depicting the death of Lycurgus. Lit from the front, it appears opaque and greenish in colour. Its layered glass depicts the story of Lycurgus, strangled by vines for taunting the god Dionysus. Roman, 4th century A.D., glass, 6½ inches (16 mm) high. The gilt base and rim were added centuries later.

THE BRITISH MUSEUM, LONDON, U.K./BRIDGEMAN ART LIBRARY

to the glass. Subjects included plant and animal forms as well as mythological and domestic scenes. Painting was sometimes combined with gilding. The Romans also produced vessels and portrait medallions in which gold leaf was sandwiched between disks of colored and clear glass. This gold-between-glass technique is now known by the German name it acquired when it became popular again in Germany beginning in the eighteenth century: **zwischengoldglas.**

OTHER ROMAN GLASS TECHNIQUES
Three other glassmaking techniques used by the Romans were **mosaic glass, millefiori,** and **murrhine.** Mosaic glass is made by fusing together previously made canes of colored glass. The millefiori ("thousand flowers") method, developed later than mosaic glass, slices such canes into thin pieces and embeds the pieces in a blown-glass object. Both the mosaic glass and millefiori techniques can produce brilliantly colored patterns. A more subtle accomplishment was the fragile opalescent ware known as murrhine. It was used for wine-cups, vases, and other ornamental vessels. The name *murrhine* is sometimes used today for a product imitating the Roman ware. In the imitation, a transparent body holds embedded pieces of colored glass. All three of these complex, multicolor processes were perhaps attempts to imitate in glass some of the effects that the Romans were producing with great virtuosity in another medium: mosaic work.

Roman Mosaics

The technique of facing surfaces with a layer of small, closely spaced particles of near-uniform size is known as **mosaic** work, and the particles themselves are known as **tesserae.** Mosaics are older than Roman civilization, and the Greeks had made frequent use of them. In Rome, however, they became an important art form for the first time. As with so many other of their customs and skills, the Romans carried their mosaic techniques to many parts of the empire: to Britain, France, Spain, North Africa, and elsewhere.

Greek tesserae had generally been pebbles, usually white or pale tan ones, creating designs against

Figure 5–44 An example of opus vermiculatum, made of tiny tesserae in wavy rows.

black or dark blue backgrounds. Roman tesserae were made of a wide range of materials: mostly small cubes of marble or other natural stone, but also shells, terra-cotta, mother-of-pearl, colored glass, and, in later years, glass with applied or embedded pieces of tin, silver, or gold. Generally, the sparkling glass mosaics were used for wall panels, pools, or niches holding statuary or fountains, and the sturdier stone mosaics were used for floors that received more foot traffic.

Most Roman mosaics were assembled on site, but some incorporated **emblemata,** small decorative panels of unusually fine work that could be prepared in an artisan's studio on a tray of slate or terra-cotta, then brought to a building site and set into a larger composition. The emblemata were clearly luxury items with limited use.

A type of Roman mosaic called *opus vermiculatum* (Figure 5–44) is composed of tightly spaced tesserae in undulating rows that might be described

Figure 5–45 A pavement of opus sectile, made of larger pieces of colored stone.

as wormlike or vermicular in appearance. A technique similar to mosaic work, but composed of patterns of larger stone pieces cut into regular shapes, is called *opus sectile* (Figure 5–45).

Floor and wall mosaics used the same decorative patterns that we have already seen, patterns inherited from the Greeks and including elaborate rinceaux and arabesques. Geometric devices,

some quite elaborate, were also popular, and there were combinations of geometry and stylized plant forms. Good examples (such as those in Figure 5–46) have been unearthed at a Roman villa near the town of Piazza Armerina, Sicily. The villa, built in the fourth century A.D., contained roughly forty-five rooms, one of them paved with marble slabs and almost all the others paved with mosaic, comprising a total of 38,000 square feet (3,500 m$^2$) of mosaic work!

A frequent criticism of Roman floor mosaics is that their patterns contrast too strongly with their backgrounds and frequently appear to project from the floor. The designs often intentionally accentuate the highlights and shadows, causing one unwittingly to fear to fall or stub one's toe. And sometimes, as in some mosaics from Rome's Baths of Diocletian, dating from A.D. 302, the geometry has become so vigorously active that the floor can appear unlevel (Figure 5–47). According to current opinion, motifs used in floor patterns should be flat and unobtrusive, but this principle was apparently considered unimportant to the Roman mosaic artist.

Similarly contrary to current practice was the Roman use of highly realistic scenes for both walls and floors; today such scenes would be considered appropriate for walls, but seldom for floors. The Romans used them wherever they liked, and their subjects included groupings of masks, heads, gar-

Figure 5–46 Two examples of fourth century A.D. Roman floor mosaics at Piazza Armerina, Sicily.

Figure 5–47 A spirited geometric mosaic pavement pattern at the Baths of Diocletian, Rome.

PHOTO: ABERCROMBIE

lands, and wreaths. Pigeons drink from a bowl, parrots strut, ducks waddle. Some of the floors at Piazza Armerina show chariot races, children hunting, cupids fishing, couples dancing and kissing, an elephant and a rhinoceros, and bikini-clad girls performing some sort of exercises with dumbbells (Figure 5–48). In Pompeii, the mosaic of a barking dog on a vestibule floor is combined with the inscription *Cave Canem*, "Beware of the dog." If we assume that the Roman makers of mosaic, millefiori, and murrhine glassware were, to some extent, imitating the mosaicist, we may also assume that the Roman mosaicist was imitating the painter and sculptor, applying tesserae in such a way as to make the result as convincingly realistic as possible.

Summary: The Design of Ancient Rome

The Romans were responsible for disseminating the ideas and achievements of Greek art and architecture throughout a vast empire. If they had done nothing else, we would owe them a great

debt. But Rome was by no means a neutral conduit for the ideas of others. It left the definite stamp of its own distinct personality.

Looking for Character

One remarkable characteristic of Roman design was its uniformity. In the days of empire, Rome spread its dominion throughout a wide range of wildly differing climates, geographies, and cultural traditions. Curious people, fascinated by the novel and the exotic, Romans assimilated many of those traditions from the lands they conquered. Yet Roman design always remained dominant and identifiable. There was a distinct Roman city plan, whether laid out in Britain or North Africa. There was a Roman temple, whether built in France or Spain. There were recognizable Roman houses, Roman tables, Roman lamps, and Roman wall paintings, whether at home in Italy or at the most distant borders of the empire.

Another remarkable characteristic of Roman design was its decorative quality. The Romans, like no other culture before them, had a flair for

Figure 5–48 From one of the mosaic floors at Piazza Armerina, girls at their calisthenics.

elaboration and embellishment. And this flair, for the Romans, was not confined to special precincts of the gods or special possessions of rulers. The Romans brought decorative art home. To the greatest extent possible, the Roman citizen lived richly and luxuriously among the products of design.

But how were these two characteristics of universality and decoration reconciled? If all the empire bore the stamp of Rome, and if an important part of that stamp was enrichment by design, that design had to be interpreted and reproduced by a great variety of artisans with different training and different ability. Some simplification and standardization of Roman art was necessary. We saw an example of this in the Roman variations on Greek moldings. The Greek curves were, perhaps, more subtle and more intriguing, at least to the trained eye; but the more regular Roman curves were more easily understood, more easily drawn, and more easily carved. This regularization of de-

sign was not a shortcoming, but a brilliant recognition of the realities of efficiently conveying design ideas.

Looking for Quality

We most often look for quality in small things. We find many examples of such quality in Roman art: in the delicacy of a cage cup, the intricate details of a mosaic floor, the fine brushwork of a wall mural.

But in Roman art we also find quality in the large and robust. Perhaps the supreme achievements of Roman art are its most expansive: the great sweep of an arena, the exhilarating span of a huge dome, the power of a great vault, the magnificence of a long enfilade of aligned doorways. However exquisitely faced or finished these architectural forms may be, their intrinsic drama is in their basic construction, and it is a drama best appreciated in interior spaces.

Making Comparisons

The most obvious comparison to make—and one that has been made several times already here—is between the two great classical civilizations, Greece and Rome. In doing so, we must try to avoid judging one culture by the standards of another. Greek art and Roman art were different largely because the Greeks and Romans had different ideas, different ideals, and different aims.

Most obvious of all is the comparison between the Greeks' finest building, the Parthenon, and the Romans' finest building, the Pantheon. Both were major temples, both important to their cities, their religions, and their native populations. Both were outstanding achievements. The Greek Parthenon excelled in its subtle refinements and acute optical adjustments to an orderly scheme. The Roman Pantheon excelled in the resonance of a perfect geometric harmony. We cannot say that one of these great buildings is superior to the other, however, because each does inimitably well what it set out to do. We can only say that these two masterpieces are incomparable.

For lesser works, comparisons are easier. In the field of furniture, we can say that the Romans were productive and creative, but that nothing

they designed seems to have had the splendid grace of the Greek klismos chair. In pottery, as well, the painted Greek vase was on a level superior to its Roman counterparts. In the fields of glass and mosaic, however, the Romans surpassed the Greeks in both technical skill and inventive design. In buildings less perfect than the Pantheon, Roman architects achieved a size and complexity that Greek architects never approached (and perhaps would never have wanted to approach).

But it was in the field of interior design that the Roman genius clearly outshone the Greek genius. Although Roman interiors drew on the experience of Greece and other predecessors, the quality and quantity of Roman interior design constituted a great leap forward. It is almost as if, with Roman interiors, a new art was born.

6

EARLY CHRISTIAN AND BYZANTINE DESIGN

A.D. 330–800 AND 330–1453

The Romans had enjoyed unprecedented power and influence, but the architects and designers of Rome had appropriate models, notably those of Greece. For the Early Christian architects and designers, no such models existed. Theirs was a new religion, and it demanded new forms of expression. Adapting existing elements of building and decoration and transforming them into a physical embodiment of the Christian spirit involved trial and error, success and disappointment, invention and inspiration. It would progress beyond the Early Christian and Byzantine styles into the Romanesque and eventually culminate in Europe's great Gothic cathedrals.

Figure 6–1 EARLY CHRISTIAN AND BYZANTINE SITES

The Early Christian Era
(A.D. 330–800)

The Roman empire, which had seemed invincible, began to decline in the first centuries of the Christian era. As vast and powerful as the empire was, it had its geographic limits, and beyond these were hostile un-Romanized groups. The Roman legions, at the fringes of their realm, suffered defeats that weakened the confidence of Rome, as did inter-nal problems—insurrections, civil wars, economic decline, and murders of emperors.

Into the disintegrating fabric of the empire came new decorative influences from the Celts of Ireland and Scotland, and more violent interruptions from German invaders such as the Goths and the Vandals. But the Middle Ages between the years 300 and 1500, between classical antiquity and the Renaissance, was not only a time of relative barbarism; it was also a time of the barbarians' contact

Figure 6–2 Detail of a ceiling painting in the Catacomb of S. Callisto, Rome, first half of the third century.

KENNETH T. LAWRENCE, TEXAS CHRISTIAN UNIVERISTY

Christianity had been founded in the Roman provinces of Syria and the oppressed classes in Rome had welcomed it. Although the Christians were persecuted, their numbers and influence grew. However, during its first three hundred years, the new faith did not build churches. As historian Richard Krautheimer has noted, the religion's "early believers had neither the means, the organization, nor the slightest interest in evolving an ecclesiastical architecture. They met in whatever place suited the occasion." Among these places were the catacombs (named for the district of Rome called Catacumbas, where many of these places were found) beneath the streets and buildings of Rome and cut into the soft tufa rock outside the city. They were crude spaces, and the meetings and entombments held there were furtive. They were decorated, if at all, in the same style as the domestic buildings of the time. In the so-called Vault of Lucina, for example (Figure 6–2), in the catacomb of San Callisto, Rome, the ceiling painting and what remains of the wall paintings show the same spare, attenuated manner, with isolated figures floating within spidery lines, that was then popular above ground. It was a style that seems an abstracted, shorthand, less architectural version of the Fourth Style of painting that had been employed in Nero's Golden House (Fig. 5–26). In the catacombs the isolated figures had begun to be images of religious significance, such as portraits of early saints and martyrs.

Constantine changed the Christians' fortune. He became emperor in 306, espoused Christianity as his own religion in 312, and recognized it as the empire's official religion in 313. For the first time in the new religion's history Christian architecture and interior design became possible. But what would such design look like?

If the earliest Christian structures resembled pagan temples, it was because they were literally based on them. Many of the temples lay in disrepair, and they were rich with columns, decorative panels, and other features made from rare and beautiful stones sent to Rome from all over the empire. A wave of religious enthusiasm encouraged building activity, and no stone quarries were more convenient than the ruined temples of the old Roman gods. These classical "spare parts" were the building blocks from which the

with the remnants of Roman civilization and their consequent—although slow—process of learning and assimilation. Although overshadowed by what came before and after, these twelve hundred years have a glory of their own.

As the Roman Empire had been maintained by the power of the state, personified in the Caesars, the Middle Ages were unified by the power of the church, personified in the popes. For all of Europe for all this time, art and life were focused on the Christian religion; all people and all acts were judged either Christian or pagan; all time was related to a single supreme event, the Incarnation of God in Christ, and all that had preceded that event—including most of the accomplishments of Rome and all those of Greece—were considered pagan and were therefore condemned.

new churches were constructed. In fitting them together in new compositions, naturally some of the old refinements were lost. Columns were reerected without their entablatures, and arches frequently rose directly from the capitals without intervening moldings.

In these years the newly liberated church was developing more elaborate rituals and growing in both size and wealth. Many of the descendants of Rome's patrician families, losing faith in civic order and fearing barbarian attack, sought refuge within the church and transferred much of their wealth and many of their most valuable belongings to its religious orders. New prosperity encouraged larger and finer buildings. By 324, Constantine had decided to erect a large church in Rome that would house the shrine of St. Peter and would accommodate thousands of pilgrims. It would be the most important building of the Early Christian style.

Old St. Peter's, Rome

For the model for his building on the site of St. Peter's tomb, Constantine turned to the ancient basilica, a building type that had been in continual use since the second or third century B.C. It was a long, narrow building form with a central aisle, well suited for ritual processions, and with one or more pairs of side aisles from which the congregation could watch. The masonry walls of the central space, sometimes lifted on arcades, were straight and tall, pierced with windows at the top, and supported a wood roof. The basilica was a simple form, but the growing wealth of the church and the elaboration of its ritual gradually contributed to the enrichment of the equipment and furnishings, with mosaics, paintings, and marble encrustations producing brilliant and colorful surfaces.

By 330, the basilica of Old St. Peter's was completed, standing as the chief monument of Christianity. The building was enormous. It was built in the form of five parallel aisles, the large central one rising 120 feet (37 m) and terminating in an **apse** (Figure 6–3 and 6–4). This main body of the church was fronted by a **narthex,** an antechamber at its entrance, and by an **atrium,** the total length being slightly less than 700 feet, (213 m), almost as long

as the Renaissance giant that replaced it (and because of which the adjective "old" is properly used in the name of the original St. Peter's). As historian Kenneth Conant has written, "The magnificent first church in the ancient capital . . . naturally had a wide influence, which was augmented by its importance as a pilgrimage church of the first rank, and its extraordinary dimensions. It is difficult to realize from the old drawings that the nave was as long and as high as that of a great Gothic cathedral, and twice as wide."

Typical of the Early Christian basilicas, its exterior was severely plain, but, in compensation, its interior was overlaid with the lavish application of precious materials: murals, mosaics, giant bronze peacocks and pinecones, columns of porphyry, green serpentine and yellow giallo antico, topped with capitals of Corinthian or Composite order, and with the space further adorned with hangings

TIMELINE | EARLY CHRISTIAN AND BYZANTINE DESIGN

DATE	POLITICAL AND CULTURAL EVENTS	EVENTS IN EARLY CHRISTIAN DESIGN	EVENTS IN BYZANTINE DESIGN
c. A.D. 30	Crucifixion of Christ; persecution of Christians	Decoration of catacombs	
4th century	Edict of Milan, 313; toleration of Christianity, capital of empire moved to Byzantium, 330	Old St. Peter's erected, 330; S. Costanza, Rome, 350; St. Paul's Outside the Walls, 386	
5th century	Visigoths invade Italy; last Roman emperor abdicates	S. Maria Maggiore, Rome, 440	Mausoleum of Galla Placidia, Ravenna, 420; Baptistery of the Orthodox, Ravenna, 452
6th century		S. Apollinare Nuovo, Ravenna, 525; S. Apollinare in Classe, Ravenna, 549	Hagia Sophia, Constantinople, 537; S. Vitale, Ravenna, 547
Later centuries	Charlemagne crowned Holy Roman Emperor, 800; Turks capture Constantinople and end Byzantine Empire, 1453	Transition to Romanesque	St. Mark's, Venice, 1085; St. Basil's, Moscow, 1560

- A **basilica** is a large meeting hall. Within that general definition, however, it has taken various forms. In Roman architecture, it was often a simple, aisleless hall, subdivided by structural elements as necessary and roofed with wooden trusses. In Early Christian and Byzantine architecture and later in Romanesque architecture, it was more often a building with a high, wide, central nave flanked by two or more lower, narrower side aisles.

- The Roman Catholic Church makes its own distinctions about which buildings deserve the name **Basilica** (with a capital *B*). *The Roman Catholic Almanac* defines the word as "A title assigned to certain churches because of their antiquity, dignity, or historical importance as centers of worship," a definition that has nothing to do with architectural form. The church considers both St. Peter's in Rome and St. Mark's in Venice Basilicas.

and altar cloths of purple and gold. By the fifteenth century, however, the building was disintegrating, and it was razed in the sixteenth-century to make way for the present Renaissance structure.

Other Early Basilicas

Slightly later than St. Peter's and similar in scale is the five-aisled St. Paul's Outside the Walls (in Italian, S. Paolo fuori le Mura), built at what was then the edge of the city of Rome. Its enormous nave is lined with eighty great granite columns, and above them are mosaic medallions with portraits of the early popes. The building was begun in 386 by the emperor Theodosius, the mosaics in its apse were added in the thirteenth century, and it stood intact until 1823, when it was destroyed by fire. It has been rebuilt to its original plan, however, and its interior, as it existed in the eighteenth century, can be seen in an engraving by Piranesi (Figure 6–5).

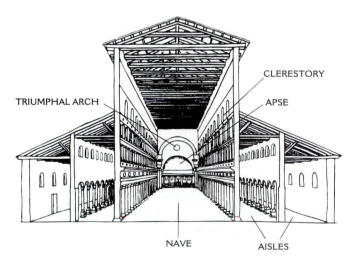

Figure 6–3 Vertical section through Old St. Peter's, Rome (A.D. 300), looking west toward the apse.

AFTER CONANT

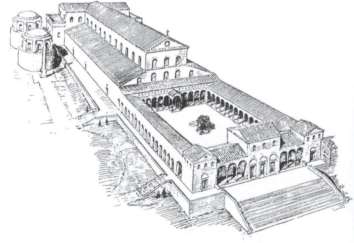

Figure 6–4 Old St. Peter's, Rome, in a reconstruction by historian Kenneth. J. Conant.

FRANCIS LOEB LIBRARY, HARVARD UNIVERSITY

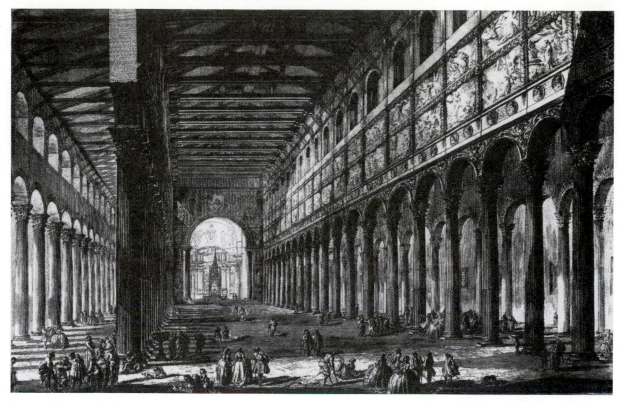

Figure 6–5 St. Paul's Outside the Walls, Rome, begun A.D. 386, seen in an etching of 1749 by G. B. Piranesi.

FOTO VITULLO, ROME

Two other important Early Christian structures on the basilican plan were built in Ravenna, a town in northern Italy with an adjacent port (Classe) on the Adriatic. These were S. Apollinare Nuovo, built between 493 and 525, and S. Apollinare in Classe, built between 534 and 549. Both these buildings are magnificently clear and simple in plan, with arcades dividing the naves from the lower side aisles, and with remarkable mosaic murals above the arcades (Figures 6–6 and 6–7). Both naves end in

 VOCABULARY NAMES OF CHURCHES

The abbreviations that precede the names of many Christian churches identify the sex and number of the saints for whom the church is named. In English names, of course, *St.* can refer to either a male or female saint. In French, *St.* indicates a male saint and *Ste.* a female one. In Italian examples:

- *St.* is masculine singular.
- *Sta.* is feminine singular.
- *S.* is either masculine or feminine singular.
- *SS.* is plural.

- *Ssa.* or *SSo.* (or sometimes *SS.* again), indicating the female Santissima or the male Santissimo, means *"most* holy."

semicircular apses, although the apse floor of the later building was raised high above the nave floor in the ninth century to accommodate the insertion of a crypt. Both had interior surfaces enriched with marble **revetments** (facings over less attractive or less durable materials) and mosaics, although most of the marble in the aisles of the later building has been stripped away. Adjoining S. Apollinare in Classe on its north side is a cylindrical campanile, one of the first built.

Buildings with Centralized Plans

Not all Early Christian church buildings were basilican. Also important were buildings with centralized plans, either round, polygonal, or cruciform. These were used as baptisteries, as mausoleums, or as *martyria*, memorial shrines to martyrs or saints. One of these, S. Costanza, was built in 350 as a mausoleum for Constantine's daughter. It features a domed central cylinder lighted by clerestory windows, that central space ringed by an arcade of twelve pairs of Composite columns, and that arcade in turn ringed by a barrel-vaulted ambulatory. (Figure 6–8).

Figure 6–6 View of the nave looking west toward the apse, S. Apollinare in Classe.

A. F. KERSTING

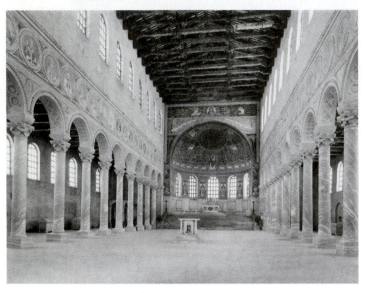

Figure 6–7 Mosaics on the South wall of the nave, S. Apollinare Nuovo, Ravenna, 493–525. The building represented at the bottom, with tied curtains hanging in its arcade, is Theodoric's Palace.

ART RESOURCE, NY

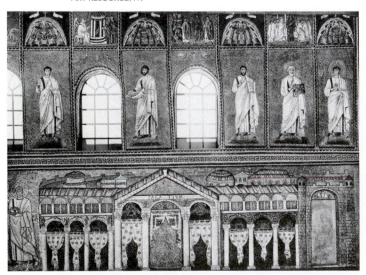

Figure 6–8 S. Costanza, looking from the ambulatory toward the sarcophagus under the central dome.

HIRMER FOTOARCHIV, MUNICH, GERMANY

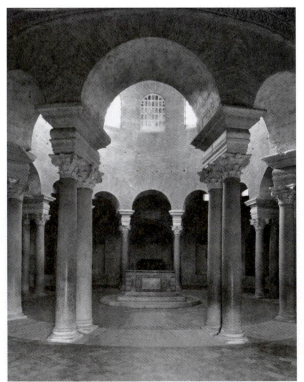

Other Early Christian Churches

In the Holy Land itself, important structures were built at the sites of the Holy Sepulchre in Jerusalem and the Nativity in Bethlehem. In addition, a number of earlier pagan buildings were adapted for use as Christian churches. For example, the Roman Pantheon was rededicated to the Virgin and renamed S. Maria Rotonda, and a Roman bath in Ravenna, octagonal in plan, was converted into a Christian baptistery.

Coptic Design

An offshoot of Early Christian art and architecture is the Coptic design of Christianized Egypt. It came to full maturity in the late fifth century and flourished until the Arab conquest of Egypt in 640, after which Islamic forms dominated Egyptian art. Coptic design is characterized by highly stylized, flat forms, pure and simple in outline. It found expression in sculpture, bronze, glass, ivory, and illuminated manuscripts. Coptic textiles, some with striking geometric ornamentation in decorative panels and bands (Figure 6–9), achieved a high level of skill and appeared in cathedral treasuries across Europe. White limestone was a common material for important buildings, and frescoes and other decorative elements were often in red, yellow ocher, and other bold colors on white grounds.

Celtic Design

The art and artifacts of the Celts (pronounced with a hard *c* and sometimes spelled Kelts) can be defined as the art and artifacts of those who spoke the Celtic language, and they would include people of Ireland, Wales, parts of Scotland, the Isle of Man, the English county of Cornwall, and the French province of Brittany. Celtic art is usually associated with Ireland, however. Its origins are pagan, and it was devised to accompany the worship of a complex pantheon of nature gods, worship led by Druid priests. After the conversion of Ireland and northern England to Christianity, the same artistic style was applied to the new faith, so that in medieval times it was a Christian style. It flourished in the seventh and eighth centuries and influenced the European monasteries established by

Figure 6–9 Fragment of a Coptic textile of linen and wool, fifth century.
VICTORIA AND ALBERT MUSEUM, ART RESOURCE, NY

Irish missionaries. It did not recover from the Viking invasions that began in the 800's.

It is a complex style. Plant forms, mythological beasts, and even human figures appear in it, but it is highly abstract, not an art of realism or naturalism. Perhaps its most characteristic manifestation is *knot work*, decorative motifs in which tangles of linear elements are intricately interwoven (Figure 6–10). It is also represented by tall stone crosses of distinctive design (see the Vocabulary box on page 147), by pottery, by metal artifacts such as chariot fittings, helmets, shields, spearheads, and scabbards, and by illuminated manuscripts.

The Move from Rome and the End of the Early Christian Era

By the time the building of Old St. Peter's was completed, Constantine had became attracted to the physical beauty and military advantage of the ancient Thracian city of Byzantium. Sited on the peninsula beside the crescent-shaped inlet known as the Golden Horn, it was a meeting point between Europe and Asia. In 330 he officially declared it a capital of the empire, changing its name to New Rome, but willingly acquiescing to the custom of calling it Constantinopolus, later Constantinople. It is now called Istanbul.

Figure 6–10 An example of a Celtic knot-work pattern.

AFTER MEEHAN

After Constantine, Early Christian design was largely moribund until the "Sixtine Renaissance" under Pope Sixtus III (432–40), which brought a revival of classical tradition, as exemplified by the simple strength of the three-aisled basilica of S. Maria Maggiore in Rome (Figure 6–11), its large central nave flanked by side aisles. The nave's deeply coffered flat ceiling was added around 1500.

The last Roman emperor abdicated in 476, and in 586 the Lombards overran Italy, except for a few enclaves such as Rome, Ravenna, and Venice. The Early Christian style was superseded by the Romanesque, and both were paralleled by an exotic style called the Byzantine.

The Byzantine Period (A.D. 330–1453)

Byzantine art is the art of imperial Constantinople, the city founded on the site of Byzantium. Byzantine design was original, powerful and lavish. It was also long-lived and broad-based, lasting until the

Figure 6–11
The basilica of S. Maria Maggiore, Rome, built 432–40.

CANALI PHOTO BANK, MILAN/SUPER STOCK, INC.

Turkish conquest of Constantinople in 1453, and extending its influence to the Italian cities of Ravenna and Venice, to Syria, to Greece, and to Russia. Although it has been called the culmination of the Early Christian style, the Byzantine departed from both Early Christian and classical precedents.

The scale, grace, and balance of early Greek art had been enlarged and complicated in Hellenistic times, then enlarged and complicated further in Rome, but it had remained rooted in the natural world. From the Eastern element in Byzantium and from the emotional element in Christianity came another artistic vision entirely, one that disdained both nature and the niceties of composition and sought instead a raw religious emotion. The Greek god Apollo had been depicted with cool restraint; Christ, the sufferer, the martyr, the redeemer, needed to be depicted with passion.

The natural world was also dismissed in the rejection of the representation of human and animal form in favor of geometric pattern. This biblical proscription of images from life was somewhat moderated by the second half of the fourth century, however, perhaps because of the apparent need to instruct illiterate converts by means of picture stories from that same Bible, and there was a revival of realistic images. Later, an even more severe wave of proscription resulted in the Iconoclastic Controversy of 726 to 843, when thousands of works of figurative art were destroyed.

Under the emperor Justinian, who ascended to the throne in Constantinople in 527, the basilica model was changed to that of a centrally planned church with vaulted roofs and a dome above the crossing. This central plan suited the most recent development of the Christian liturgy, in which the celebration of Mass, not the procession of clergy down the nave, was its central event. Thus, two centuries after the shift of the capital to Byzantium, the basic building form that, for us, typifies Byzantine architecture was born. That form, a dome above a square plan, presented an inherent problem: how to fit the circular base of the dome on the walls of the square?

Two solutions were devised, and both were used extensively. The earlier and cruder method was to place a diagonal element across the top of each corner, turning the square into an octagon,

Figure 6–12 Transitional elements to support a dome: the pendentive and the squinch.
ABERCROMBIE

which more closely approximated the shape of the dome. In masonry construction, this diagonal member was supported on an arch, or on a graduated series of arches. These arches were called **squinches** (Figure 6–12). It is probably from the multiplication of such forms that the honeycomb-like decorative elements characteristic of many Islamic building interiors derive. The second, more sophisticated method was to support the dome with pendentives in each corner. A **pendentive** is a concave triangular stone surface that starts at a point on the corner of a pier, rises, and spreads out to the two upper points of the triangle in a concave-curved fanlike shape until it approaches a horizontal and meets the circle of the lowest part of the dome, which the masonry of the pendentive supports. Each pendentive supports one quarter of the dome. The visual effect is that of a dome resting on the tops of four arches, the spaces between the arches and the ring of the dome filled with triangular segments of a sphere. Pendentives were employed not only in important Byzantine churches, but also in some Romanesque ones and, later, in some churches of the Renaissance.

In addition to the familiar name Hagia Sophia, the names Santa Sophia and Sancta Sophia are sometimes seen. Of those two, only Sancta Sophia is correct, for the building was not dedicated to a saint named Sophia, but to Holy Wisdom. The spelling Sofia is also seen. In Turkish, the building is called Ayasofya Muzesi.

Justinian is reputed to have built more than thirty churches (all now destroyed) in Constantinople alone on this new model of dome upon square, and throughout the Eastern empire it would prevail for the next thousand years. His greatest achievement, however, was the church of Hagia Sophia (Holy Wisdom) in Constantinople.

Hagia Sophia

A basilica church of the same name and on the same site had been built in the fourth century, remodeled in the fifth, and burned in 532. Immediately after the fire, Justinian began the building of a new church on a grander scale, a process that would be completed in an impressively brief five years.

The building as it stands today is not exactly the same as the building consecrated in 537. After a succession of earthquakes in 557, the eastern main arch and much of the original dome collapsed in 558, and a new, taller dome was completed five years later. The western half of the second dome fell in 989 and was repaired and steadied with four flying buttresses extending into the forecourt; the eastern half then fell in 1346 and was also repaired. After the Turkish conquest of 1453, minarets were added at each corner of the church, mausolea were added to the sides, whitewash was painted over the mosaics, and huge shields with verses from the Koran were hung in the interior.

The two architects Justinian chose to design Hagia Sophia were Anthemius of Tralles and Isidore of Miletus. Anthemius was primarily a geometrician and theorist and is credited with a specialized definition of architecture: the application of geometry to solid matter. To him, presumably, is owed the clarity of the building's basic structure. Isidore (sometimes called Isidorus) of Miletus was also a geometrician.

Within a rectangular plan 230 by 250 feet (71 x 77 m), four immense piers inscribe a central square. Seventy feet (21 m) above it, four great arches are joined by pendentives, each rising 60 feet (18.5 m) and curving forward 25 feet (8 m). Above the tops of the arches and pendentives rises the great dome, 100 feet (31 m) in diameter, "floating" above an unprecedented number of windows ringing its base, and the astonishing volume beneath it is supplemented by half domes at each end (Figure 6–13). The design has been described as a combination of the Early Christian basilica with the dome of the Pantheon. That resolution into one structure of two different building forms, however, necessarily included much that was new and much that was daring.

The result is a combination of the classically rational and the mysterious, the church's well-lighted central space and main structure clearly intelligible, but its subsidiary spaces—beyond screened aisles, galleries, and hangings—dark, complex, and obscure. The sense of enigmatic immateriality is furthered by decorative treatments that emphasize surfaces, not mass: multicolored marbles and porphyry (Figure 6–14), carnelian and onyx, mother-of-pearl and ivory inlays, silver in the chancel screen, gold in the hanging lamps, colored glass in the window openings, and column capitals, spandrels, and ornamental metalwork overrun with **rinceaux,** the scroll-like patterns based on vegetation (Figure 6–15). Most notable among these decorative treatments are the interior's mosaics.

In this building we see a characteristic that will pervade much of Byzantine construction: the

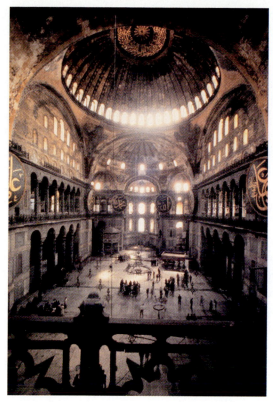

Figure 6-13 Under the great dome of Hagia Sophia, looking toward one of the adjacent half domes.

MARVIN TRACHTENBERG

Figure 6-14 Porphyry dolphins in a panel of inlaid marbles from the nave of Hagia Sophia.

COURTESY OF DUMBARTON OAKS, CENTER FOR BYZANTINE STUDIES, WASHINGTON, DC

concentration of decorative art in the interior, resulting in an architecture of plain exterior surfaces (if not always simple exterior forms) enclosing spaces of fantastically opulent ornament. Hagia Sophia was unprecedented in structural daring, in decorative splendor, and in size, boasting for centuries the largest enclosed space in the world. Justinian, on the day of its consecration, is alleged to have boasted, "Solomon, I have vanquished thee!"

The Mausoleum of Galla Placidia, Ravenna (420)

In A.D. 395 the Roman Empire was divided into Eastern and Western parts, the West beset by Visigoths and Vandals, gradually becoming dependent on the stronger East. In the West, nevertheless, some remarkable architecture was built, most notably in the town of Ravenna under the rule of the Ostrogoth King Theodoric (495–526).

Figure 6-15 Detail of bronze gates, Hagia Sophia. The central band features a fret or Greek key motif, the outer band and a smaller inner one feature rinceaux.

AFTER OWEN JONES

EARLY CHRISTIAN AND BYZANTINE DESIGN 143

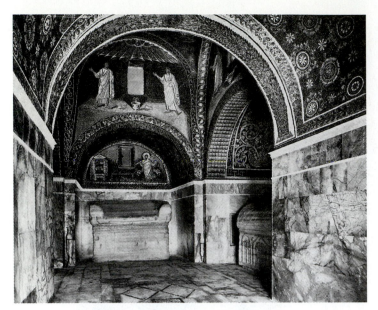

Figure 6–16 Interior of the Mausoleum of Galla Placidia, Ravenna, A.D. 420. Sarcophagi are visible in two of the cruciform building's short arms.

sion only 39 feet or 12 m) cruciform (cross-shaped) building. Constructed in the 440s, it may even have been the *first* cruciform building. It is unassuming on the exterior, but with a rich interior, its walls lined with marble slabs, its vaults and dome faced with striking mosaic work (Figures 6–16 and 6–17), and the arms of the cross still holding their massive stone sarcophagi. Especially notable is the central dome above the crossing, its construction unusual in that the dome and its supporting pendentives are all parts of the same hemisphere; its mosaics unusual, too, with their abstract pattern of gold stars against the deep blue ground of a night sky; and the circular geometry of the star pattern perfectly complementing the geometry of the dome (Figure 6–18). In the mausoleum's other mosaics, there are realistic human figures, but most of these—the so-called Good Shepherd mosaic being an exception—are shown like the stars against the same quite abstract ground of dark blue rather than in some representation of an architectural setting.

It was under Theodoric that the Early Christian basilica of S. Apollinare Nuovo had been built, and before Theodoric, Ravenna had already seen the construction of the mausoleum of the princess Galla Placidia, a small (its longest interior dimen-

Baptistery of the Orthodox, Ravenna (449–452)

The baptistery for the Orthodox community is a centrally planned building octagonal in shape.

Figure 6–17 Pattern of the glass mosaic on the vaulted ceiling seen in Figure 6–16.

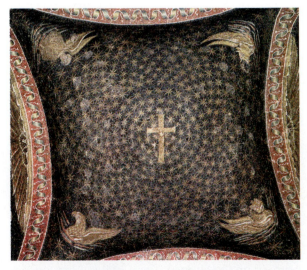

Figure 6–18 In the Mausoleum of Galla Placidia, mosaics in the dome over the crossing show the cross against a night sky with rings of golden stars.

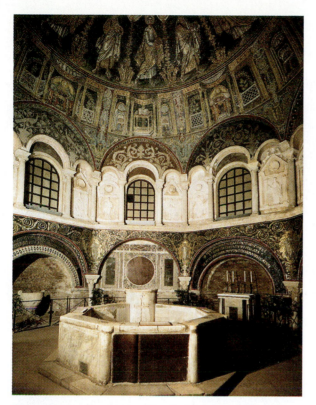

Figure 6–19 Baptistery of the Orthodox, Ravenna, first half of the fifth century.

SCALA/ART RESOURCE, NY

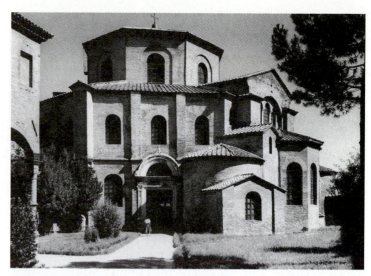

Figure 6–20 S. Vitale, Ravenna, finished 547. The view shows the small church's complex massing.

G. E. KIDDER SMITH/PEARSON EDUCATION PH COLLEGE

Its interior is distinguished by two arcades, one above the other, with the arches of the upper level divided into three smaller arches (Figure 6–19). This is an early example of a type of wall treatment that would become popular in Romanesque architecture. The dome's mosaics, appropriately depicting the Baptism of Christ, are much admired.

S. Vitale, Ravenna (526–547)

S. Vitale, built by the emperor Justinian, is another centrally planned church, but one with a complex geometry of interlocking volumes. Outside (Figure 6–20) and inside (Figure 6–21), the graded relationships of stacked volumes make the building a worthy successor to the earlier and much larger Hagia Sophia.

A tall, domed inner octagon 55 feet (17 m) across is enclosed by a lower outer octagon 115 feet (35 m) across. One of the inner octagon's

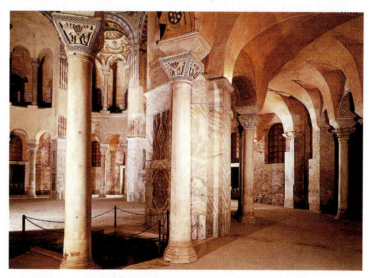

Figure 6–21 S. Vitale, Ravenna, as seen from the ambulatory.

SCALA/FOTO MARBURGH/ART RESOURCE, NY

eight sides opens toward an apsidal altar, and the other seven open to semicircular arcades that project into the surrounding ambulatory and carry an upper-level gallery. The pendentives supporting the dome are formed of small arches, giving the lower part of the dome an unusual scalloped appearance. The building's interior

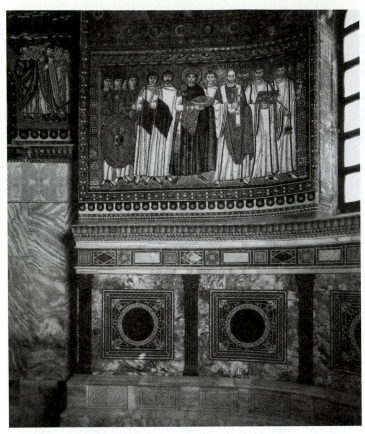

Figure 6–22 In the apse of S. Vitale, Ravenna, a mosaic of an imperial procession.

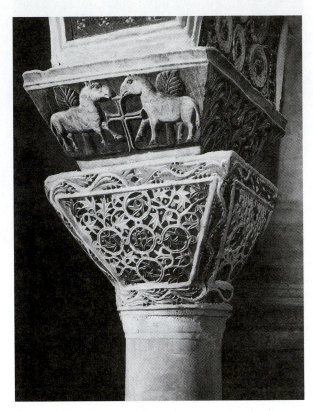

Figure 6–23 Impost capital and dosseret atop a column in S. Vitale, Ravenna.

details are as rich as its spatial effects. These include some fine marbles, famous mosaics, some of them showing the emperor in gift-bearing processions (Figure 6–22), and some delicate stone carving on the capitals of the columns, particularly those around the central space (Figure 6–23). These are in the form of truncated upside-down pyramids, flaring outward as they rise, and such a capital is called an **impost capital,** from the term **impost,** meaning a member, such as a bracket projecting from a wall, on which an arch rests. Both terms are derived from the Latin *imponere,* "to lay upon." Between the impost capital and the arch above is an additional, similarly shaped block called a **dosseret** or, sometimes, a *super-abacus.* The dosseret came to be frequently used in Byzantine design and also appeared in Romanesque design.

Like the adjacent Mausoleum of Galla Placidia, S. Vitale has a plain brick exterior that gives no hint about the riches within it.

St. Mark's, Venice (1042–85)

The most sumptuously decorated of all Byzantine buildings is St. Mark's, guarding the entrance from the Grand Canal to Venice's famous Piazza San Marco (Figure 6–24). A basilican church had been built on this prominent site in 864 to hold the body of St. Mark, which had just been abducted by the Venetians from its previous location in Alexandria. Construction of the present church was begun in 1063 and was basically finished in 1085.

Decoration and additions continued for centuries, however. The interior colonnades were finished in

Figure 6–24 St. Mark's, Venice, completed 1085. View of the facade from the Piazza San Marco.

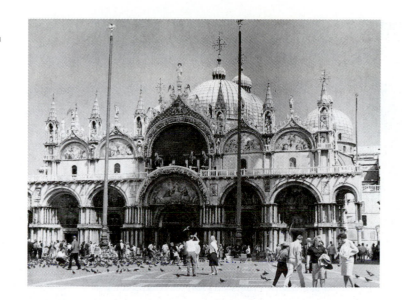

 VOCABULARY TERMS FOR CROSSES

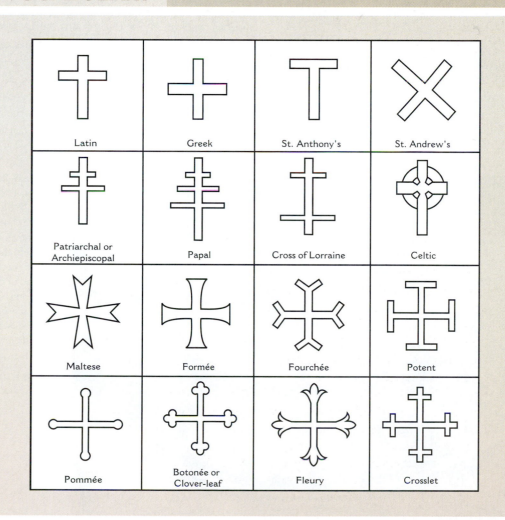

Latin	Greek	St. Anthony's	St. Andrew's
Patriarchal or Archiepiscopal	Papal	Cross of Lorraine	Celtic
Maltese	Formée	Fourchée	Potent
Pommée	Botonée or Clover-leaf	Fleury	Crosslet

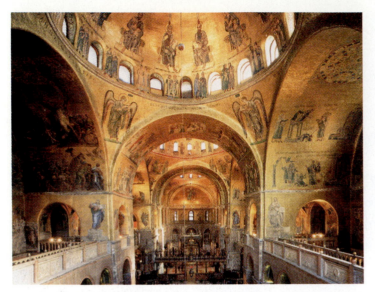

Figure 6–25 St. Mark's, Venice. Interior view looking toward the apse.

The facade's Gothic gables, the ogee arches above them, and the crocketed pinnacles rising between them were all added in the fifteenth century, and the mosaics within the gables not until the seventeenth.

Its plan is a Greek cross (a cross with four arms of equal length) inscribed in a square, and its great central dome, 42 feet (13 m) in diameter, is supplemented by a smaller dome over each arm of the cross (Figure 6–25). This plan was reportedly derived from that of the Church of the Holy Apostles in Constantinople, built by Justinian in the sixth century to house the relics of St. Andrew and destroyed in the fifteenth century to make way for the Mosque of Sultan Mahomet II. The piers that carry the dome are massive, 21 by 28 feet (6.5 x 8.5 m), but they are lightened with passages through them on both the ground and gallery levels.

The domes on pendentives and the half dome above the apse are ringed with windows, so that the brilliantly colored mosaics (Figure 6–26) in the upper reaches of the church are softly lighted.

Within the basically Byzantine character of the church, a richness of material and styles is everywhere evident. The round arches add a Romanesque element to the mix, the four great bronze horses over the entrance portal have a classical ori-

the eleventh and early twelfth century, the marble revetments on the piers and inside walls were applied in the twelfth century, and most of the mosaics were laid in the twelfth and thirteenth centuries.

Figure 6–26
Mosaic in the vault of St. Mark's, Venice. The outer ring shows Adam, Eve, and the serpent in the Garden of Eden; the inner rings show other scenes from the biblical book of Genesis.

gin, the facade's gables are obviously Gothic, and the five domes encased in tall, slightly bell-shaped timber shells topped with small onion domes have, on their exterior, an Islamic flavor. These shells, encased in gilt copper, add an emphatic note of grandeur and provide an instantly recognizable profile, even from far out in the lagoon.

Secular Architecture

Early Christian and Byzantine art and architecture were dominated by work for the church, but there was, obviously, some secular building. Around the oldest part of Constantinople, for example, a great fifth-century double wall, studded with towers, still partly stands. Justinian himself was responsible for the Senate House, for a monumental column crowned by his own equestrian statue, and for the reconstruction of most of the imperial palace. Little is known about Byzantine domestic architecture.

The End of the Byzantine Empire

The Byzantine Empire was extensive, and buildings reflecting the Byzantine style were erected in Mesopotamia, Bulgaria, Armenia, the Balkans, and North Africa. Although it suffered many invasions, the empire did not end until 1453, when Constantinople was captured and pillaged by Sultan Muhammad II and, renamed Istanbul, became the capital of the Ottoman Empire. The crescent (which had been stamped on early Byzantine coins) replaced the cross as the symbol of the empire, appearing as an ornamental motif in textiles, rugs, and other patterned designs, and most of the great Christian churches were converted into great Muhammadan mosques.

A Postscript to the Byzantine Era: St. Basil's, Moscow (Sixteenth Century)

Even after 1453, however, Byzantine culture persisted. Russia's Ivan the Terrible (Ivan IV, 1530–84), descended from the last of the Byzantine emperors, assumed the title of czar (based, perhaps, on *Caesar*) in 1547 and established the Byzantine style in buildings at Kiev, Novgorod, and Moscow.

Figure 6–27 An eighth-century fabric of heavy silk. The pattern shows a quadriga, a chariot pulled by four horses.
GIRAUDON, ART RESOURCE, NY

Adjacent to the Kremlin, Moscow's 90-acre (36 ha) administrative center built within fifteenth-century crenellated walls, is St. Basil's Cathedral (Vasily Blazheny). Along with similar Russian churches, St. Basil's is generally considered a Byzantine structure, even though it was built more than a century after the fall of Constantinople. Its construction was begun in 1555 and finished five years later.

Here a decorative quality that is fantastic to the point of playfulness replaces the austerity and mystery of other Byzantine works. The domes are onion shaped, each with its own pattern—stripes, spiral, or chevron—of brightly colored tile. The interior space is as complex as the exterior, the church's large central space ringed by eight other chapels, each topped by its own dome, and all nine spaces linked by low passages.

Byzantine Decorative Arts

There were practically no secular arts in the Byzantine era except for small objects such as jewelry, jewel boxes, bridal caskets, and textiles. Within the

Figure 6–28 The sixth-century ivory throne of the Byzantine archbishop of Ravenna, Maximian.

walls of the monasteries, however, decorative arts were lavishly produced. From the tenth to the twelfth centuries, exquisite religious cloisonné and champlevé enamelware, brass utensils, and textiles were made, many of the textiles for royal or liturgical use being elaborately patterned and made of heavy silk (Figure 6–27). Many monks spent their lives working on richly illuminated manuscripts. The expenditure of effort and labor was of no consideration so long as it resulted in a perfect object of lasting beauty that would contribute to the glory of the church. We shall look specifically at two expressions of this attitude: ivories and mosaics.

Byzantine Ivories

An unusual Byzantine art form was ivory. Ivory, technically known as dentine, is most commonly found in elephant tusks, although at times other substances—all chemically identical—have been used: tusks of the walrus, pig, and boar, and teeth of the whale and hippopotamus. A substitute for ivory is sometimes taken from the beak of a bird called the helmeted hornbill, and synthetic substitutes have been produced since 1865. Ivory jewelry and figurines date back to around 20,000 B.C., and ivory objects were found in the tomb of Tutankhamun. The great statue of Athena in the Parthenon was partly of ivory, and ivory carving was also practiced in the ancient Near East, on Crete, and by North American Indians.

Byzantine ivory came from elephant tusks, and, because these had to be imported from either Africa or India, it must have been an expensive medium. Because the tusks are seldom more than 7 inches (18 cm) across, ivory ware is limited to small objects or must be made of several small pieces fastened together. It was carved into religious symbols and figures, sometimes into highly realistic figures of saints, which were often gilded and painted, at least in part. Ivory **diptychs,** works made of two attached panels, were carved to show religious figures; they were about 1 foot (30 cm) high, the panels hinged together, and intended to stand on altars. Later, beginning in the tenth century, there were also three-paneled **triptychs** of ivory, the central panel being twice the size of the side panels and typically showing a cross or a Crucifixion scene. Ivory book covers for Bibles were also made, and ivory sacramental vessels called *pyxes.*

An impressive example of ivory work—and one of the few pieces of furniture still extant from the early Middle Ages—is a sixth-century bishop's throne or *cathedra* made for Maximian, the Archbishop of Ravenna (Figure 6–28). The ivory plaques that covered its whole visible surface were probably once supported by a wooden substructure that has rotted away, but the external appearance of the throne is still as it was originally. Every square inch is intricately carved with foliage, birds, animals, and biblical scenes. The front panels beneath the seat show John the Baptist and the four evangelists, and above and below these figures are panels of rinceaux. The origin of the throne is unknown, but some authorities think it was shipped to Maximian from Constantinople.

Few pieces of furniture can have been finished completely in ivory, of course, but less extravagant

Figure 6–29 A ninth-century ivory carving shows a monk at his studies and also provides a record of some of his furniture. St Gregory writing with scribes. Carolingian, Franco-German School, c 850-875 (ivory). Kunsthistorisches Museum, Vienna, Austria/Bridgeman Art Library.

wood pieces were often given decorative ivory inlays. And some ivory carvings—as is also the case with murals and mosaics—give us information about much more humble furniture forms that have vanished. A ninth-century plaque, for example (Figure 6–29) shows us not only a monk at his studies, but also some of the wooden furniture he used and curtains hung from a rod.

Byzantine Mosaics

The art of mosaic reached new levels of skill and importance in the buildings of the Byzantine era. Byzantine mosaics are distinguished from their predecessors by the size of their **tesserae,** being generally smaller than the ½ inch-square (13 mm) pieces used by the Romans and much smaller than some of the stone pieces used in Early Christian work. They are also distinguished by their glitter, their backgrounds often having been made of reflective glass squares bonded with gold leaf. Silver and mother-of-pearl were also sometimes used. These mosaics, spreading from wall to arch, from pendentive to dome, were capable of dissolving interior structure into a dazzling, seemingly insubstantial shimmer.

Subject matter for many Byzantine mosaics, as for all Early Christian ones, was religious, but perhaps even more famous among Byzantine examples are the highly stylized secular portraits at S. Vitale of the emperor Justinian (Figure 6–30) and his empress Theodora, shown carrying offerings to the altar, with their attendant retinues and with Bishop Maximian beside them. These portraits

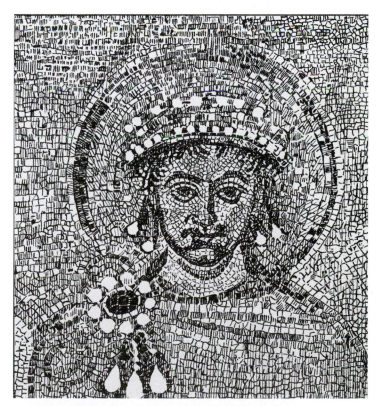

Figure 6–30 Head of the emperor Justinian from the mosaic in the apse of S. Vitale, Ravenna, showing a detail of the procession seen in Figure 6–22.

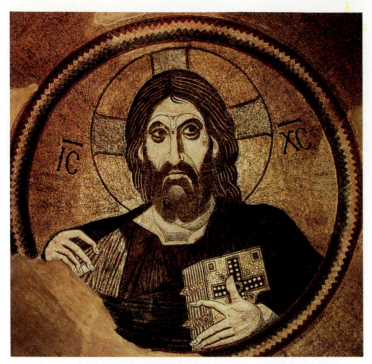

Figure 6–31 Dome mosaic showing the figure of Christ Pantocrator in the eleventh-century church at Daphni, Greece.

ERICH LESSING/ART RESOURCE, NY

began a long series of depictions of Byzantine rulers that continued until the fall of the empire. Decorative patterns in Byzantine mosaics are based on a variety of symbols—the monogram of Christ, the endless knot symbolizing eternity, and the peacock symbolizing eternal life—and other decorative bands flatly simulate the three dimensions of projecting moldings. Among religious subjects, perhaps the quintessential Byzantine images are those of Christ Pantocrator (ruler of all), such as the one from c. 1020 looking sternly down from the dome of the formerly fortified monastic church at Daphni, near Athens (Figure 6–31). By the fourteenth century, near the empire's end, mosaic subject matter had become considerably more gentle and less severe, as in *The Birth of the Virgin* and other scenes in Constantinople's Monastery of the Chora (now called Kariye Camii).

In Byzantine mosaic work, the tesserae were applied directly on floor, wall, vault, or dome surfaces that had first been prepared with one, two, or three layers of plaster and with the sketching of preliminary designs *(sinopia)* on the plaster. The finest, most closely spaced work, using the most delicate tesserae, was used for showing hands and faces. As the skills of the Byzantine mosaicists developed, clearly defined monochrome areas were abandoned in favor of subtle shadings and gradual transitions.

At their best, the mosaics did not simply embellish the architecture but cooperated with it in producing a total effect that would involve, impress, and move the observer. Historian Otto Demus has written that "[i]n the case of church decoration—the field in which Byzantine art rose, perhaps, to its greatest heights—the single works are parts of an organic, hardly divisible whole which is built up according to certain fixed principles." One of those principles, Demus says, is "the establishment of an intimate relationship between the world of the beholder and the world of the image." This relationship was certainly closer in Byzantine than it was in Western mediaeval art. In Byzantium beholders were not kept at a distance from the image; they entered within its aura of sanctity, and the image, in turn, partook of the space in which they moved. They were not so much 'beholders' as 'participants.'

Byzantine mosaic work was widely admired. Byzantine mosaic artists were respected as masters and were commissioned to execute work in Rome (a chapel in Old St. Peter's), in France (the apse of Germigny-des-Prés), in Jerusalem (the Dome of the Rock), and in Spain (the *mihrab* or prayer niche of La Mezquita, Córdoba, for which the emperor sent the caliph a gift of 325 tons (295 t) of extraordinarily fine mosaic cubes in red, blue, green, and gold, along with the services of an artist to place them). Even when work was not done directly by Byzantine artisans, it was often inspired by their skill.

Summary: Early Christian and Byzantine Styles

The two styles of Early Christian and Byzantine have been covered in a single chapter because for much of their time the two coexisted. The two also at times combined. For example, Ravenna's S. Apollinare Nuovo is a clear example of an Early Christian basilica, yet its striking mosaics show el-

ements of exoticism that are related to Byzantine style. And the nearby S. Apollinare in Classe, placed here under the Early Christian heading, has been called Early Byzantine by some scholars. Geographically, we can generalize that Early Christian was a style of western Europe, its chief example being Old St. Peter's in Rome, and that Byzantine was a style of eastern Europe, its chief example being Hagia Sophia in Constantinople, but in Ravenna and some other places the two were built side by side. It must be admitted, therefore, that the distinctions between the styles are oversimplifications of a complex situation. Perhaps the Christian design of the centuries following A.D. 330 can most accurately be thought of as a continuum, with Early Christian examples at one extreme, Byzantine examples at another, and a wide range of expressions between.

Looking for Character

However many combinations and compromises may exist between them, the two styles of Early Christian and Byzantine are strikingly different responses to the same religious beliefs, the first architecturally simple, though subject to a great degree of interior ornamentation, the second architecturally complex and subject to even greater elaboration. In the first, we recognize signs of the heritage of the classical world; in the second, the more exotic influence of the Near East.

Not even Early Christian design, however, sought either a continuation or a revival of Roman design principles. Fragments of classical architecture were recycled for economy and convenience, and there was obviously some appreciation for the beauty of their materials and workmanship. But all the religious design of the Middle Ages shared the single goal of making the supernatural manifest in the physical world. Compared to the supreme and confident daring that the Gothic would eventually bring to this task, the early attempts of Early Christian and Byzantine work must seem tenta-

tive and only partly successful. But without the foundations they laid, the Gothic could never have developed.

Looking for Quality

As Early Christian and Byzantine styles differ, we must look at them for quality in different ways. Early Christian offers the simpler, more basic satisfactions of logical plans—both the basilica and the centralized plan—built with conviction and sometimes built at impressive scale. The spiritual world is evoked in them through power, and the direct strength of these buildings is perhaps diminished as their decoration is increased and their simple organization obscured.

In the Byzantine style, obscurity—or at least a sense of mystery—is a chief goal, and that sense is further enhanced as ornamentation proliferates. The spiritual world is evoked in them through astonishment. We find the highest quality of this style, therefore, in the ornament itself—the colors of the murals, the minute and dazzling tesserae of the mosaics, and the carvings in wood, ivory, and stone.

Making Comparisons

Much of this chapter has already been devoted to comparisons between Early Christian and Byzantine expressions. A more general comparison would distinguish both styles—and the Romanesque, Gothic, and Islamic styles along with them—from the classical world that had come before and the Renaissance that would eventually follow. Both of those eras between which the Middle Ages were sandwiched are distinguished by beauty achieved through the exercise of logic, exalting human accomplishment. The Middle Ages looked for their inspiration beyond the human to the spiritual realm. Their ideal was not worldly harmony, composure, and comprehension but the apprehension of an otherworldly divinity.

CHAPTER

7

ROMANESQUE AND NORMAN DESIGN

c. 800–c. 1200

The term *Romanesque* means "in the manner of the Romans." It was coined by nineteenth-century art historians because the roundheaded arches and vaults characteristic of the style were similar to forms that had been used in ancient Rome. The term is applied to the style of art that arose in Italy and southern France around 800 and continued until it evolved in the twelfth century into Gothic. The style was carried by William the Conqueror in 1066 from Normandy in France to England, where it is known as *Norman*. By the end of the eleventh century, the Normans had also captured Sicily from the Arabs, who had ruled most of the island since the ninth century; Sicily is therefore also

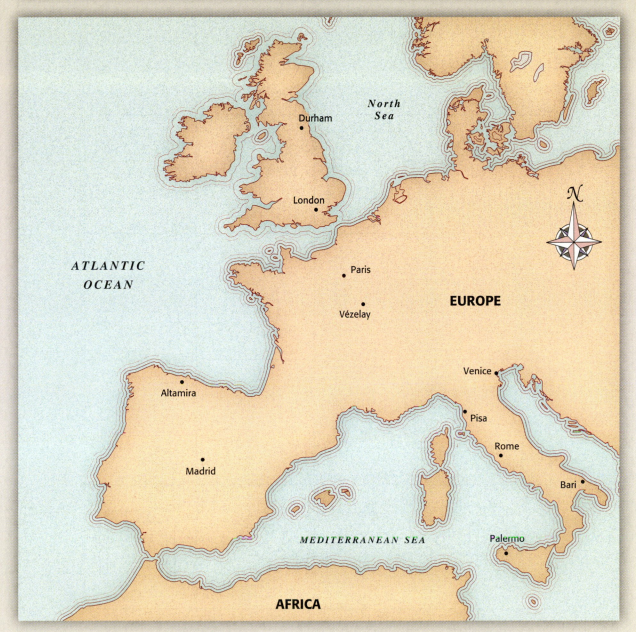

Figure 7–1 MAP OF ROMANESQUE SITES

ORTELIUS DESIGN

home to Norman architecture. The basic differences between the Romanesque and the Norman are political rather than stylistic, although there are stylistic variations according to the taste of various religious orders and according to location. In Sicilian Norman buildings, for example, the characteristic roundheaded arch is sometimes replaced by the pointed arch of the conquered Arabs.

The activating cause of the Romanesque style was the comparative tranquillity that settled upon Europe after the barbarian invasions, which was followed by a hunger of the masses for peace and security. These essentials were offered by a leadership that carried a cross as well as a sword, furnished religious salvation, and proposed a practical system of daily life. The response, impelled by loyalty and necessity, resulted in the construction of

Arches shown are not limited to those of the Romanesque style.

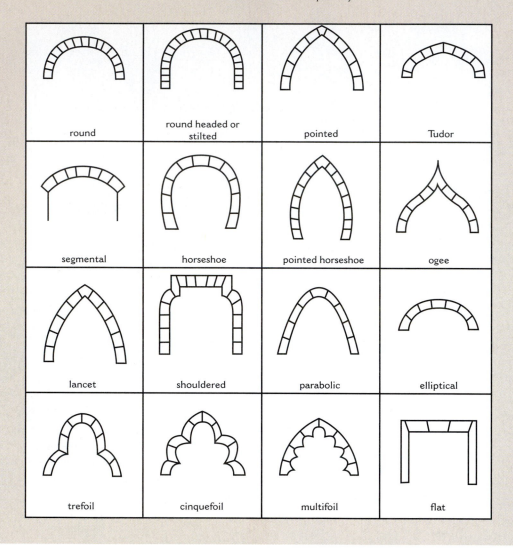

churches throughout Europe that were to serve not only as places of worship, but also as strongholds, schools, libraries, town halls, museums, and centers of social life.

The monks, as amateur architects, were the planners. They taught craftsmen elementary masonry, carpentry, and ironworking. Untrained as designers, builders logically used the only models that were at hand. The designs were their own crude conception of Roman architecture adapted to Christian requirements and limited by the materials, craftsmanship, and tools that were available (the chisel, for example, was not used for stonecutting until the end of the Romanesque period). The buildings that resulted were massive and strong, simple in surface enrichment, and often forbidding in appearance, but they faultlessly expressed the spirit of a simple but devout population and the vigor of the early church.

Romanesque Architecture

Few secular Romanesque buildings still exist. A few stone house-barns *(pallozas)* can still be seen in northwestern Spain, their design dating to Celtic times; mortarless stone structures with rounded corners and thatched roofs, they originally had interior partitions separating the human and animal quarters, with the humans on the uphill side.

Less humble secular structures were also built, of course. A surviving shell of a town house in the French town of Cluny has an elegant stone face and space for a shop on the ground floor. It dates from before 1150, and its fine carvings were probably by the artisans who came to work on the town's great monastery. Castle-like Romanesque structures had narrow window slits in deep recesses within their thick walls; also hidden within the thickness were winding staircases, closets *(garderobes)*, private chapels *(oratories)*, and even small sleeping chambers.

But secular buildings were mostly temporary structures, and all were negligible compared to the great Romanesque churches. Beginning in Early Christian times, the steady growth of monastic orders had demanded a growth of accommodations for the monks, their prayers, and their processions; lay worshippers, too, needed appropriate space. In many cases, the church became the central building of an entire village of living quarters and services.

Some of the early Romanesque churches in Italy were constructed in part from the ruins of ancient Roman buildings, but in western Europe, and particularly southern France, there was an insufficient number of these to fulfill the demand. The stone that was required for the new structures often had to be transported from distant quarries, and the character of the arched construction necessitated that such materials be cut into small sizes. The Christians did not have the slave and military labor that had been available to the Romans, but many of the workers contributed their services as a religious obligation. Without this economic system, the majority of the great cathedrals could never have been built.

Many of the Early Christian churches had been destroyed by fire, due to the use of wood in their roof construction. Romanesque builders depend-

ed entirely upon the stone arch. The Temple of Diana in Nîmes, France, was an example of a second-century building that was roofed by a semicircular vault supported on columns, the thrust being counteracted by the weight of an additional small arch placed on either side. This structure is generally accepted as the prototype of all Romanesque and later Gothic churches.

The basilica plan, perhaps for sentimental reasons, gave way to one in the form of a **Latin cross** (see the box on terms for crosses in chapter 6), having a horizontal member shorter than the vertical member. This change was effected by the introduction of the **transept.** The church was usually made to face westward to enable worshippers seated in the **nave** to face eastward toward the altar. Not only was the Roman semicircular arched vault used in the construction of the roof, but this arch form was eventually to become the shape of all doors, windows, and other openings, and finally was used for purely ornamental purposes.

The nave of the church was separated from the side aisles by a row of heavy columns proportioned without regard to Vitruvian standards, which had been forgotten. A semicircular arch rose directly from the capital of each column, and spanned to an adjoining column. This row of arches supported a wall pierced with **clerestory** windows. In later

DATE	CULTURAL AND MILITARY EVENTS	DESIGN ACHIEVEMENTS
9th century	Charlemagne crowned first Holy Roman Emperor, 800; Arabs sack Rome, 846	Mosaics in church of St. Germain-des-Prés, Paris, 803
10th century	Benedictine Abbey founded at Cluny, 910; monastery church at Cluny, 980	Augsburg Cathedral begun, 942
11th century	The second millennium, 1000; Norman Conquest of England, 1066; Norman Conquest of Sicily, 1072; First Crusade, 1095	Winchester Cathedral begun, 1050; Bayeux Tapestry, c. 1080; Pisa Cathedral begun, 1063; Ste.-Madeleine, Vézelay begun, 1089; Durham Cathedral begun, 1093
12th century	Second Crusade, 1145; Third Crusade, 1189	Cappella Palatina, Palermo, begun, 1132

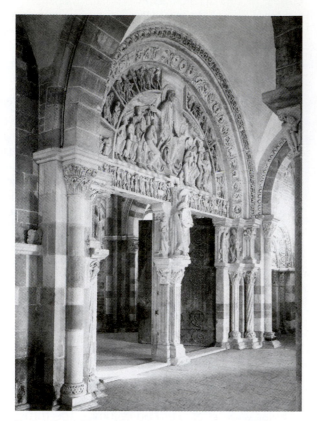

Figure 7–2 The entrance portal at Vézelay with its semicircular carved stone tympanum. The carved center support under the tympanum is called a *trumeau*.

Romanesque churches, the arched ceiling was supported by the ribs that crossed the nave both at right angles and diagonally. We shall look briefly at four specific examples.

Abbey Church of Ste.-Madeleine, Vézelay, France (1089–1146)

Atop a prominent hill in the village of Vézelay in the Burgundy region of France is the abbey church dedicated to Ste.-Madeleine (Mary Magdalen). It enjoys a view of rolling hills and vineyards. A nunnery had been established on the site in 860, but the present building was begun at the end of the eleventh century. A disastrous fire in 1120 damaged the church and killed many pilgrims, but the rebuilding was completed in 1146, with the nave designed in the new Gothic style. On Easter Sunday of that year, the preacher at Vézelay was

Bernard of Clairvaux (later St. Bernard), and his sermon spurred the second of the Middle Age's Crusades to Jerusalem. Bernard, however, was a member of the severe Cistercian order, opposed to rich adornments and to the carvings of panels and capitals with saints, monsters, and other figures, which, he thought, disturbed the prayers of the monks. Vézelay, however, was a dependency of the more worldly Cluniac order, and the abbey church's interior is crowded with such carvings, not only on its capitals but also on its **tympana,** the semicircular stone overdoors above the portals to the nave. The tympanum of the central portal, almost 20 feet (6 m) in diameter, is both the largest and the most emotionally charged of the carvings (Figure 7–2); it shows Christ, in swirls of draped clothing, surrounded by people from many lands to whom the Gospel had been preached.

Beyond this portal, the nave (Figure 7–3) is roofed with groined vaults in each bay. Transverse

Figure 7–3 Beyond the entrance portal, the Romanesque nave of Ste.-Madeleine, Vézelay. The apse beyond is in the later Gothic style.

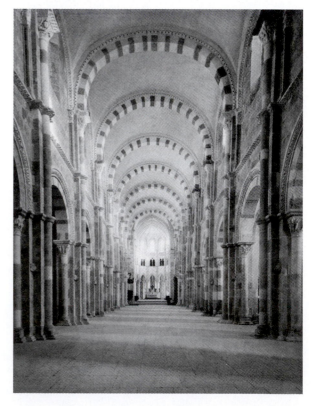

arches between the vaults carry much of the thrust from these vaults to the piers, thus allowing windows to be cut in the upper of the nave's two stories. The arches are picked out in alternating light and dark stone colors, a treatment that will become particularly popular in Italy.

In the nineteenth century, restoration work at Vézelay was done by French architect Eugène Emmanuel Viollet-le-Duc, an avid proponent of the Gothic Revival; Viollet-le-Duc repaired some parts, duplicated others, and replaced still others with his own creations. Basically, however, what we see today is twelfth-century construction.

Other notable French buildings in the Romanesque style include the porch of St.-Trophime, Arles, France (twelfth century), portions of Mont St.-Michel, France (thirteenth century), and the Abbaye-aux-Hommes (1066, also known as St.-Étienne) and Abbaye-aux-Dames (1083, also called "La Trinité"), Caen, France.

Durham Cathedral, Durham, England (1093–1175)

In Durham, near the city of Newcastle in the North of England, is the chief monument of English Norman architecture. Construction was begun in 1093 and basically finished forty years later. Later additions, particularly on the east end, are in the Gothic style.

Foursquare, solid, and handsome, the three-storied nave (Figure 7–4) is supported by two rhythmically alternating types of support, thick cylindrical columns and piers of compound shape with many thin half columns applied. The cylindrical columns also alternate in their treatment, some fluted, some incised with zigzag patterns, some with diagonal checkerboards. The ceiling is an early—possibly, even, the first—example designed with ribbed vaults, a device that will become standard in the Gothic cathedrals to follow.

South of the cathedral is Durham Castle, a complex in which the earliest surviving buildings were built c. 1070. The castle's chapel has column capitals carved with figures in 1072, and other decorative features date from the twelfth century. Also noteworthy among English Norman structures are the Abbey Church at Tewkesbury (1088), Gloucester Cathedral (1089), and Peterborough Cathedral (1117–1190).

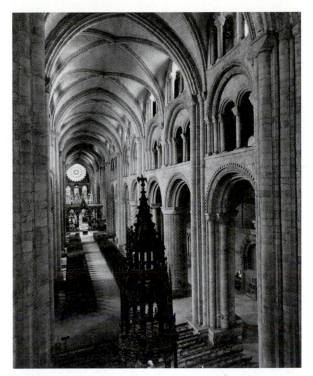

Figure 7–4 The nave of Durham Cathedral with its three-tiered wall construction and round arches on columns with varying designs.
BRITISH TOURIST AUTHORITY

The Cappella Palatina, Palermo, Sicily (1132–43)

The Cappella Palatina or the Palatine Chapel of San Pietro is part of Palermo's Royal Palace and was built by the Norman king Roger II. It was consecrated in 1140, but probably only the shell was finished at that time, the densely ornamental interior mosaics, marbles, and murals for which it is famous probably being added later (Figure 7–5).

These interior elements are in an eccentric variety of styles and ages. The nave's ten columns of granite and cipollino are antique. Much of the fine mosaic work, with religious figures against a gold background, is Byzantine in character, some of the mosaics said to be by Greek artisans, some by native Sicilians. Most surprising of all, the nave ceiling by some of the local Islamic population is covered with **muqarnas,** or stalactite work, which we shall see again in Chapter 9.

Other important Norman structures in Sicily are the cathedrals of Cefalu and Palermo, and, near

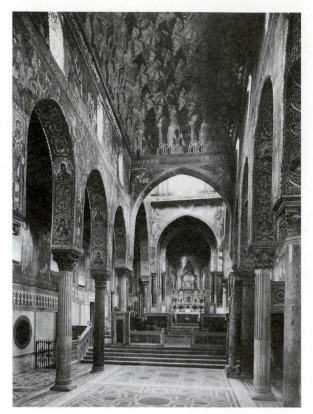

Figure 7–5 The nave of the eclectic Cappella Palatina in the Norman Royal Palace, Palermo.

A. F. KERSTING

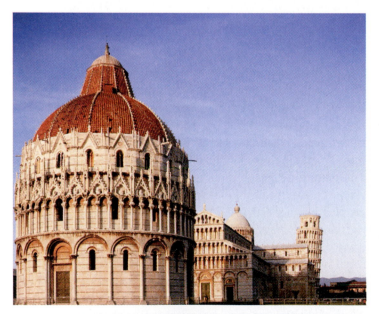

Figure 7–6 The composition of Romanesque buildings at Pisa: left foreground, the baptistery; center, the cathedral; right background, the campanile or Leaning Tower.

STEPHEN STUDD/STONE

Palermo, the cathedral and adjoining cloisters of Monreale.

The Cathedral, Baptistery, and Leaning Tower, Pisa, Italy (1172)

Prosperous from their trade with the East, the people of Pisa began an ambitious building program in 1063. Dedication of the complex was in 1118, but completion was not accomplished until 1172. Some alterations were made in the twelfth and thirteenth centuries, and Gothic touches were added to the baptistery in the fourteenth.

The famous composition on a large open site (Figure 7–6) includes a walled cemetery and three freestanding buildings: the cross-shaped cathedral, the cylindrical baptistery, and the tall campanile or Leaning Tower famous for having settled unevenly. All three components make use of the nearby marble quarries that are still in use today, and all are faced with delicate marble arcades of round-headed arches.

Inside the cathedral (Figure 7–7), the nave is edged with double sets of side aisles. The nave ends in a great apse, and the two transepts end in their own smaller apses. An ellipsoidal dome covers the crossing, and the rest of the nave is covered with a flat coffered ceiling. The chief decorative effects

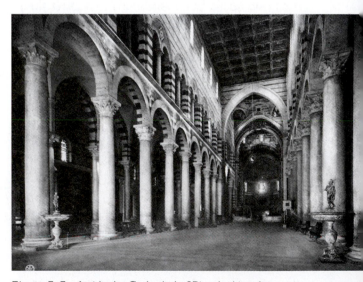

Figure 7–7 Inside the Cathedral of Pisa, looking down the nave toward the apse.

EDWARD CHAUFFOURIER/ART RESOURCE, NY

of the interior are produced with stripes of colored marble, not by elaborate or emotion-charged carvings.

Romanesque Ornament: Instruction and Terror

Three of these four examples of Romanesque architecture—Vézelay, Durham, and Pisa—are notable for the clarity and rationality of their structure. Two of them—the Cappella Palatina and Vézelay again—are notable for the mystery and irrationality of their ornament (Figure 7–8). These dual aspects coexisted throughout the Romanesque era. The strength and logic of Romanesque churches may appeal directly to our modern sensibilities, but we misunderstand the Romanesque spirit if we neglect the dark and sometimes grotesque imagery of its ornament.

For the benefit of an illiterate people, the ornament used to enrich the interiors of Romanesque churches was largely informative or

Figure 7–9 An imaginary winged beast, possibly a sphinx, is seen in two joined profile views at the corner of a column capital in the church of St.-Pierre de Chauvigny, Chauvigny, France. The animal is devouring an unfortunate sinner.

SONIA HALLIDAY PHOTOGRAPHS

instructional in character. Sculptured panels and column capitals showed scriptural subjects, allegorical scenes indicating the rewards of virtue and the punishment of vice (Figure 7–9), seasonal occupations, historical events, foliage, and fantastic animals. The sculptured figures were ascetic in character, unnatural in proportions, and often intended to terrorize sinners. Capitals of columns showed leaves reminiscent of Corinthian classic forms intertwined with biblical personages. The abstract patterns included the checkerboard, the chevron or zigzag, rosettes, and embattlements resembling the fret. The technique of the carving was crude and clumsy, and motifs were often conventionalized.

A favorite decorative and religious motif of Romanesque and, later, Gothic designers was the crucifix, a representation of Christ on the cross. From the first appearance of the crucifix, in the tenth century, until the middle of the thirteenth century, the figure of Christ was always shown with halo, head erect, feet resting on a support, and one nail driven through each foot. In the later Gothic centuries a more pathetic attitude of the figure was represented, the body sagging, the head bent under the crown of thorns, the eyes closed, blood streaming from wounds, pain and exhaustion indicated, and the feet crossed and pierced with a single nail.

Figure 7–8 Stone carving on a column capital in the south aisle, Ste.-Madeleine, Vézelay.

BILDARCHIV FOTO MARBURG/ART RESOURCE, NY

Romanesque Furniture

Romanesque furniture was made of various kinds of native woods, chiefly oak and walnut in England and northern Europe, beech and fir in southern Germany, and cypress in Italy. A rough sort of lumber called "riven timber" was often used; made by splitting logs radially, from their outside bark to their centers, it produced planks that were admirably strong but often quite rough in appearance.

The roughness was often mitigated with carving, the most commonplace being the type called **chip carving,** in which chips of the wood surface were gouged or chiseled away to form patterns, the patterns usually contained within a circular or oval shape called a **roundel.** Crude as it was, such carving could create interesting effects (Figure 7–10).

Turning or turnery was also frequently used. It was popular throughout the Middle Ages and remains popular today. In this process of shaping wood (or other materials), the turner spins the piece of wood on a lathe and, while it is spinning, presses it against a knife edge or some other cutting or abrading tool. It is a particularly appropriate type of ornament for long, thin furniture members such as legs, arms, and stretchers. Later, it would also become a popular treatment for spindles and balusters. Figure 7–11, an illustration from the Canterbury Psalter, shows "the scribe Eadwine" working (with both hands) at a manuscript; the vertical posts at the corners of his chair have been turned into cylinders with bulbous projections, not unlike the bead-and-reel ornament of classical architecture (Figure 4–49).

Figure 7–11 Monk Eadwine at work on the manuscript, c. 1150. Eadwine Psalter, c. 1150 (stained glass) by French Schook (12 century) "The scribe Eadwine" from the Canterbury Psalter, seated on a chair with architectural motifs.

Eadwine's chair and writing desk (draped with a fabric cover) also display another sort of ornament popular in Romanesque furniture: its treatment as miniature architecture. The side of his chair has a base in imitation of an arcade, and the bands above represent two successive stories of round-headed windows. Even small diamond-shaped panes of glass are shown, probably in painted representations. An actual example of such treatment still surviving is a thirteenth-century chest or *hutch* now in a museum in Switzerland; in addition to arcades on the front panel and legs, it bears some skillful roundels of chip carving.

Seating

The most common seat, through all the Middle Ages, was probably a floor cushion. There were a

Figure 7–10 Roundels of chip carving in three patterns decorate a thirteenth-century English chest.

few pieces of seating furniture, however. Finely carved chairs with backs or half backs existed for grand people and occasions. More often, seating was on benches or on folding stools, similar to those that had been used by the Romans, the Greeks, and even the Egyptians. The Romanesque period's so-called Chair of Estate repeated the curving X-shaped legs of the Roman's **sella curulis** or **curule** (Figure 5–34). For the most important religious and royal uses, there were even some thrones carved of stone, such as the elephant-based one of Archbishop Elia in the Italian city of Bari (Figure 7–12).

Tables

Like much of the other furniture of the Middle Ages, most tables were designed to be collapsed when not in use, the tops being tilted or taken off, and the whole assembly stored against a wall. The term *table* in these times seems to have referred only to the top, with the base of legs and rails being called the *frame*, and the whole assembly being called a *table and frame*. Our expression "set the table" originally referred to the act of assembling a table in preparation for a meal, not in covering it with dishes and utensils.

However, there were also tables with tops permanently attached to their bases and meant not to be moved. They were called *tables dormant*. Semicircular *console tables* were similar to some tables of late Roman times and designed to be placed against a wall, their wall-facing sides left unfinished; unlike the console tables that became very popular in the eighteenth century, they were not actually attached to the wall.

Casegoods

Chests and cupboards, constructed of heavy wooden planks hewn with axes rather than cut with saws, were common to most households, as were smaller wooden caskets for holding valuables. More expensive caskets were made of ivory or silver. These, and even the larger, heavier chests were inevitably carried along when travels were made, but beginning in the fifteenth century a distinction was made between chests meant to travel and larger ones *(great standing chests)* meant to stay at

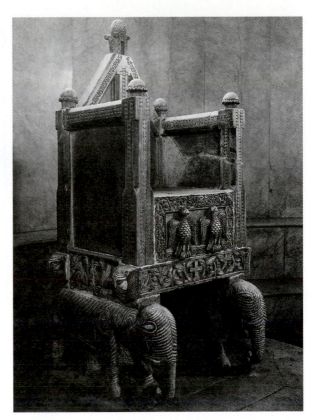

Figure 7–12 The marble throne of Archbishop Elia in the church of S. Nicola, Bari, Italy, 1098.

home. Corner legs *(standards)* were also developed for the stay-at-homes, in order to keep the storage compartments above the damp floors. There were also cupboards (literally "cup boards"), wardrobes, and washstands. Many of these received the mock-architectural treatment mentioned above.

Beds

The English word *bed* and the French *lit* (pronounced lee) may have originally meant only a collection of what we would today call bed linens or bedclothes, with the later words *bedstead* and *châlit* (shah-lee) signifying the frame into which a mattress and linens could be fit. Bedsteads had become familiar by medieval times, but without the connotations of privacy they now possess. Family members of several generations were accustomed to sharing a bed, and, when traveling,

so were complete strangers. Medieval beds were therefore at times, by our own standards, enormous. Some of them, though, called trussing beds, were smaller portable ones that could be folded and then wrapped up (trussed) for easy carrying. Also popular was a small daybed called a *couchette* that could also be folded; it sometimes was on wheels so that it could be moved from room to room. In the most stately homes, beds were surrounded by fabric canopies, generally hung from frames separate from the structure of the bed.

Romanesque Decorative Arts

We have already seen that stone carvings, sometimes of the most fantastic nature, were integral parts of many Romanesque churches. Not all such carvings were meant to inspire wonder, piety, or fright, of course. The simple geometric patterns of the great round columns at Durham had no such intent, nor did the more elaborate carvings of the piers at Lincoln Cathedral (Figure 7–13). Whatever their character, such carving was an important medium of artistic expression in the Romanesque era. Others of importance were textiles, metal-

work, and work with pavements and wall surfaces of flat stone.

Textiles

Rich textiles, such as silk wall hangings and altar cloths, were common in church interiors. Fine textiles were also used in important houses. To block drafts, the beds were often surrounded by fabric hangings or recessed in alcoves closed by fabric hangings, and, although some beds were elaborately carved and decorated, in most cases it was the hangings that were the subject of the most artful attention. Other hangings covered wall surfaces, carpets covered floors, fabric *bankers* were draped over benches or seatbacks, and *dorcers* (also spelled *dorsers*, *dorsors*, or even *dorsals*) were hung between walls and benches, or between walls and the storage chests that frequently doubled as seating. Tables, often crudely made, were covered with tablecloths before being used.

Few textiles remain from the Romanesque period, a notable exception being the Bayeux Tapestry. It is a strip of linen with wool embroidery (and therefore, strictly speaking, not a tapestry at all) showing scenes from the Norman Conquest of 1066. It is thought to have been woven before the

end of the eleventh century, possibly in Canterbury or Winchester, England, although tradition attributes it to Queen Matilda, the wife of William the Conqueror, and her handmaidens. Now preserved in Bayeux, France, in a special museum, its surviving section is 238 feet (68 m) long and about 20 inches (50 cm) high. Its parade of scenes has served as a source of information about English history and about many aspects of daily life in early medieval Europe.

Even with few actual examples, we know from writings, carvings, and paintings that the Romanesque age was a time in which textiles in interiors were both more evident and more prestigious than furniture.

Metalwork

Bridging the late years of the Romanesque style and the early years of the Gothic was a wave of skilled work in metal. Much of the wooden furniture already mentioned, particularly the chests and cupboards, was strengthened, protected against wear, and decoratively embellished with metal straps, hinges, bolts, and bindings of various sorts.

Bronze doors for cathedral fronts began to replace carved wooden ones in the eleventh century. Some were cast in a single piece, others in separate small plates that were then nailed to wood boards. Generally they were sculptured in low reliefs showing biblical scenes, kings, prophets, saints, and animals, both real and imagined. The bronze was sometimes gilded. Inside the churches, metals were used in many ways, iron for grilles of various designs (Figure 7–14) and more precious metals for liturgical pieces. Enameling on metal emerged as a major form of decoration for such liturgical objects in the twelfth century.

An interesting aspect of Romanesque metal artistry, and an indication of the importance accorded it when it was new, is that many of the pieces were signed by their creators. We therefore know the names of some of the age's most prominent goldsmiths and metalworkers. Among them were Roger of Helmarshausen, Germany; Nicholas of Verdun, France; and Godefroid of Huy, the Netherlands; all three men were active during the twelfth century.

Figure 7–14 Grille in Winchester Cathedral.
DOVER PUBLICATIONS, INC.

Work of the Cosmati

Cosmati is the name traditionally given to the marble workers of Rome who were active in the twelfth and thirteenth centuries. Until recently it was thought that all decorative marble work in Rome and even far beyond Rome (as far, indeed, as Westminster Abbey in London) had been done by members of a single extended family, the Cosmatus family, over several generations. It is now thought that many artists and many different families of artists were involved. Even so, the term *Cosmati* does still identify marble work of a distinctive type (Figure 7–15).

Much of the work was based on the reuse of marble pillaged from the classical ruins so plentiful in Rome and throughout the empire. Ancient columns of verde antique, porphyry, and other stones, for example, were sawn into thin slices, thus producing colorful disks *(rotae)* that were key parts of many Cosmati compositions. Other

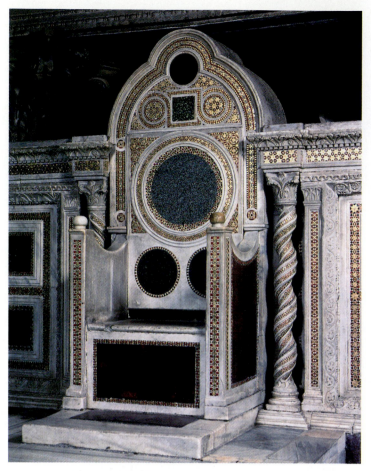

Figure 7–15 Cosmati type marble work by members of the Vassalletto family on the Chair of St. Lorenzo, the Basilica di San Lorenzo fuori le Mura, Rome, c. thirteenth century.

MAURO MAGLIANI/SUPERSTOCK, INC.

compositions were directional: church floors were often paved in patterns that gave directions for religious services, leading along a central axis through the chancel of the nave and up to the altar; a special pattern involving more disks emphasized the altar area, and a cluster of five disks *(quincunx)* marked a stopping place in the middle of the nave.

Cosmati work was chiefly in marble, but the marble was animated by stone, glass, and gold mosaic **tesserae.** A rich color palette is typical of such work, as is the use of emblematic lions and eagles, of Solomonic columns (with spiral twisted shafts), and, on some examples of freestanding liturgical furnishings, feet in the form of lions' paws clutch-

ing balls. Despite these exotic touches, the design inspiration is clearly classical.

Other Aspects of the Romanesque Experience

An unusual date fell within the Romanesque era of A.D. 800–1200, the year 1000. Unlike the year 2000, the first millennium or thousandth anniversary was an event of great cultural and artistic import. Unusual, too, was the manner in which the Romanesque era was superseded.

The Millennium Arrives

In the tenth century most of the population of northern and western Europe lived in hovels of mud and straw. For centuries they had been degraded, murdered, dispossessed, and without competent leadership. As the year A.D. 1000 approached, so did a degree of apprehension and even terror. The people of the time were enormously superstitious and put great trust in signs and symbols, so that it seemed to them certain that the world would end when the thousandth year of the Christian era arrived. When the year came and passed safely, there was widespread relief, joy, thanksgiving, and optimism about the future.

These feelings gave rise to a new wave of religious construction. The monks, who were the confidants of the people, needed administration buildings, hospitals, schools, and shelters for the weak, poor, and orphaned, and they needed churches in which to assemble the faithful and demonstrate the benefits of Christian principles. The people grasped the opportunities offered to them, and with gratitude and enthusiasm donated their time, energy, and worldly goods to the promotion of a Christian civilization and its external evidences. As Raoul Glaber, a historian of the time, wrote in 1003, "As the third year that followed the year one thousand drew near, there was to be seen over almost all the earth, but especially in Italy and in Gaul (the Roman name for France), a great renewal of church buildings; each Christian community was driven by a spirit of rivalry to have a more glorious church than the others. It was as if the world had shaken itself, and, casting off its old gar-

ments, had dressed itself again in every part in a white robe of churches."

The End of the Romanesque

The end of the period dominated by Romanesque design was marked not by a political, military, or social event, but by a series of architectural inventions: the pointed arch, the flying buttress, and the ribbed reinforcing of stone vaulting. These three made possible a new architectural vocabulary: the Gothic. The Romanesque style ended because it became possible to build something more dramatic.

Summary: Romanesque Design

The Romanesque church is a strong, well-built edifice. It deserves the implicit comparison with Roman construction and even with Greek. But its characteristics are primarily its own, not imitative.

Looking for Character

Unlike Early Christian models, the Romanesque builders employed powerful, thick walls, relieving and often emphasizing their thickness with a variety of articulations—projections, niches, piers, half columns, blind arcades, and openings. Unlike Byzantine models, they presented themselves architecturally with clarity, not with mystery. Simple basilica plans were given three-dimensional expressiveness with round vaults, with hemispherical domes, and with groin vaults intersecting over the central squares formed by the crossing of naves and transepts. Ornament in stone, brick, metal, and wood was often rich and geometrically complex but sympathetic, adorning but never obscuring the construction beneath it.

Looking for Quality

The great virtue of the Romanesque and its great design lesson for those working in any style was its consistency and its consequent harmony. The Romanesque architectural vocabulary was a relatively small one—in the matter of arches, for example, the round arch was employed almost exclusively (a few exceptions occurring in Burgundy and Sici-

ly). The insistent repetition of this single element seldom produced a boring result and almost always produced a pleasingly coherent one. This is partly due to the fact that all round arches, of whatever size, share exactly the same form in which the height of the span is twice its width. In the case of the pointed arches that would supplant them in the Gothic revolution, there could be a wide variety of proportions.

Making Comparisons

The most obvious comparison is the one suggested by the style's name: Romanesque. The term is a nineteenth-century one, and its obvious meaning is "Roman-like." This characterization is an apt one if we think of Romanesque vaults, domes, and roundheaded arches, all of which the style does share with Rome. But this analogy directly contradicts another that we shall examine in a future chapter: the Renaissance, which with much justification considered its own design the "rebirth" of classical principles after a long succession of styles—including the Romanesque—that it considered barbarous, confused, and "dark."

Was Romanesque Roman-like? The question must be answered with another: "Compared to what?" Compared to the Early Christian and Byzantine styles that immediately preceded it and to the Gothic that immediately followed, the Romanesque did employ forms with more similarity to those of the Romans. But compared to the Renaissance that would eventually eclipse the Gothic, the Romanesque could claim relatively little of the order (or the orders), the discipline, and the sense of proportion and composition that the Romans, following the Greeks, had mastered. The Renaissance was to be a conscious and well-informed revival of classical design; the Romanesque, for all its handsome strengths, was not.

Another comparison difficult to avoid is that of the Romanesque and the great Gothic style that would immediately follow it. The two share some characteristics. The most fundamental of these is the basilica form with its central nave rising above the side aisles and pierced with windows so that the central part of the building is given outside light. Yet it is difficult to see Gothic as a further development of Romanesque, so different are the two

styles in their apparent intent—the Romanesque careful to display the solidity and strength of its massive construction, the Gothic eager to amaze us with its apparently impossible absence of mass. Nor is there a natural transition to Gothic from either Early Christian or Byzantine construction. There is a geographic difference as well, for the areas in which the most characteristic Romanesque structures were built—central and southwestern France, northern Italy, and along the Rhine—were not the areas of the great Gothic cathedrals. These had their birth in northern France, in the provinces near Paris.

We must, therefore, see the Gothic cathedral as a new invention, quite distinct from its Romanesque precedents, and one of the most remarkable and unlikely inventions in the whole history of architecture. It is the chief subject of the next chapter.

CHAPTER

8

THE GOTHIC

1132–c. 1500

Gothic was a pejorative term coined in Italy in the fifteenth century, when the Renaissance had begun to honor classical design. It referred to the barbarian Goths who had wrecked many of the great classical monuments. Only such barbarians, Renaissance thinkers assumed, could have preferred the emotional extremism of the last phase of the Middle Ages to the decorous principles of ancient Greece and Rome. Today we have forgotten that pejorative meaning and accept Gothic to designate a style that first appeared in France before the middle of the twelfth century, reached its height in thirteenth-century France and England, and endured to the beginning of the fifteenth century in central Italy and even

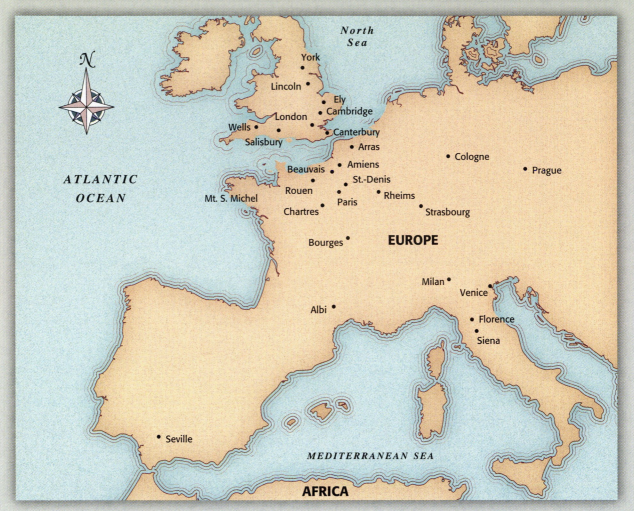

Figure 8–1 MAP SHOWING KEY GOTHIC SITES

ORTELIUS DESIGN

later in Spain and northern Europe. In this period, religious enthusiasm conceived and built many cathedrals that are among the supreme architectural achievements of human history.

Before we look at these astonishing structures and their interiors, however, we should consider their context. In the Gothic period, what was life like, and how was it housed, outside the sacred precincts of the cathedrals?

Gothic Domestic Architecture and Interiors

The social and political conditions of the Middle Ages, as we have seen in chapters 6 and 7, permitted little comfort or luxury in domestic living except in the feudal fortress castles of the nobles. Most people lived in log or stone houses roofed with thatch. Not until the thirteenth century did castles begin to have conveniences and comforts.

One reason for the change was an advance in weapons technology that made the old fortified castles obsolete. The power of government also advanced, and with the increasing power and efficiency of the laws, it was no longer necessary to consider strength before convenience in residential design. Instead of seeking a hilltop or other easily defended position, people began to choose situations for dwellings that were agreeable or beautiful, where they might be protected from inclement weather, and where gardens and orchards could be planted.

Living conditions were still far from ideal. In northern Europe the winter was chill, dark, and damp. Glass for windows did not become common in dwellings until the fifteenth century. Before that period the windows had wooden shutters, pierced with small holes that were filled with mica, waxed cloth, or horn to admit a little light.

In the houses of the common people, the stone walls were often bare or covered with rough plaster. After 1400, tapestries were extensively used in the princely castles of both France and England to cover walls, to hang over windows and doors, and to enclose beds, or as partitions to subdivide large rooms for greater privacy. When actual tapestries were not available, the interior walls of the castles were sometimes painted in imitation of hung textiles or with mural decorations of historical and religious scenes or legends of chivalry. The paintings were treated in a flat manner, with few gradations of coloring and no perspective in the drawing.

The ceilings of the rooms usually showed the exposed beams or trusses of the roof construction, frequently enriched with colorful painted ornament. On plaster ceilings gold star patterns on a blue or green ground were often painted. When flat-beamed ceilings were used, the ends of the beams were supported by projecting ornamental brackets, variously shaped or carved into figures.

Floors were in stone, brick, or tile, and generally covered with straw or leaves. Among these were sweet-scented shrubs and herbs, chosen for their aroma—or for their ability to disguise other aromas. "Oriental" carpets, which will be described in the following chapter on Islamic design, were first imported into England in the thirteenth century, but were rare for many years.

The Great Hall

The castles of the nobility of both England and France were built around the **great hall** (Figure 8–2), a large room principally used for banquets, trials, entertainments, and the assemblies of vassals. The entrance was at one end under a balcony known as the *minstrel gallery,* sometimes occupied by musical entertainers. At the opposite end was a raised platform known as a *dais* that was reserved for the owner and his family. On the dais stood two thrones or chairs of honor, having arms and high

TIMELINE	GOTHIC CULTURE	
DATE	CULTURAL FIGURES AND EVENTS	SECULAR BUILDINGS
12th century	St. Bernard; Abbot Suger; second and third Crusades	
13th century	Later Crusades; Magna Carta; Cimabue;Duccio; St. Thomas Aquinas	Ca d'Oro, Venice; Doge's Palace, Venice; Palazzo Vecchio, Florence
14th century	Giotto; Petrarch; Dante; Boccaccio; Chaucer; the Black Death; beginning of the Hundred Years' War	Palace of the Popes, Avignon; Windsor Castle

backs that terminated in roof-like canopies. A temporary table supported on trestles was brought in at mealtimes; the rest of the dais furniture consisted of a sideboard or *credence,* a chest, and possibly a few stools or benches.

The room was meagerly furnished with benches built or placed against the wall. Sometimes a high post bed surrounded with draperies was

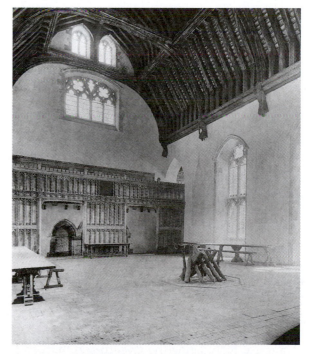

Figure 8–2 The Great Hall of Penshurst Place, Kent, England, dating from 1341. At the far end is a carved wood screen with a minstrel gallery above. A fire is laid in the center of the stone floor, and simple tables and benches are placed along the walls.

COUNTRY LIFE PICTURE LIBRARY, LONDON, ENGLAND

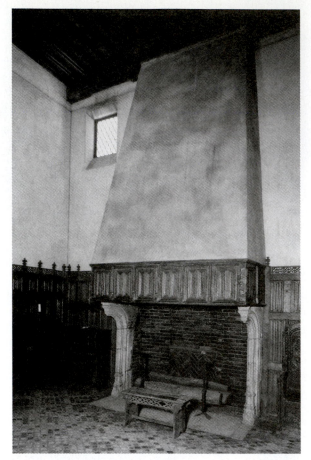

Figure 8–3 French Gothic interior with fireplace and projecting hood. The oak wainscot is carved in a linenfold pattern. There is a high beamed ceiling and a tiled floor.

PHILADELPHIA MUSEUM OF ART

door, window, or hole in the roof. During the fourteenth century, the fire was moved from the center of the hall to a side wall, and a projecting hood was built over it to direct the smoke out through either a wall hole or a chimney (Figure 8–3). The projecting hood was frequently ornamented with architectural forms or a carved coat of arms. Chairs or benches and a small rug were frequently placed before the fire. It was at this time that the fireplace and hearth became the symbols of the home.

Wall Paneling

Oak-paneled wainscots were built in both ecclesiastical and domestic interiors to give greater warmth and finish to a room. The panels of the Gothic period were of small dimensions and were usually placed vertically. The panel field was sometimes left plain, but was more often carved with a **linenfold** pattern (Figure 8–4), a pattern imitating fabric in soft vertical folds. Other patterns imitated Gothic window tracery. Oak branches, leaves, and acorns were occasionally used as decorative motifs for paneled surfaces.

The framework holding the panels was rectangular, composed of vertical **stiles** and horizontal **rails** with molded edges on only three sides of each panel frame. The top rail and the two stiles of each were usually treated with a simple curved molding; the lower rail was plain and *splayed* (slanted downward). This method of treating a panel frame was due to the woodworker's basing a de-

placed in the corner of the great hall, although separate bedrooms were eventually introduced.

The plaster walls of the great hall were hung with tapestries or covered with an oak wainscot to a height of about 12 feet (3–4 m). On the upper portion of the walls were hung armor, trophies of the hunt, and colorful flags and standards.

The Fireplace

The great hall, during the twelfth and thirteenth centuries, had a brazier or an open fire, used for both heating and cooking, built on the stone or brick floor in the middle of the room. The smoke filled the room until it made its escape through a

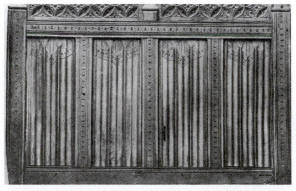

Figure 8–4 Wood paneling carved in a linenfold pattern.

VICTORIA AND ALBERT MUSEUM, LONDON. ART RESOURCE, NY

sign on that of the stoneworker, who placed a trim molding on three sides of a window with a slanting sill at the bottom to carry off rainwater. A few moldings ran along the top of the wainscot, and the cresting was often treated with a carved tracery design and finial motifs. The average dimension for a Gothic panel was about 9 inches (23 cm) wide—never wider than a single plank of oak—and was sometimes 2 or 3 feet (60 or 90 cm) high. The wood was generally waxed.

The Gothic Cathedral

The great Gothic cathedrals were the culmination of the Christian Middle Ages and are among the most surprising achievements in architecture. They still convey how intense their builders' faith and dedication must have been.

Intentionally, the Gothic cathedral was an architecture of excess. Unlike the classical architecture that came before it and the Renaissance architecture that would follow, both of which were concerned with carefully reasoned harmonies among building elements, Gothic cathedrals strove for extreme dimensions and proportions. They were concrete expressions of strongly felt emotion, not of logic or rationality.

Not that logic was absent. An elaborate and highly rational system of construction had to be devised to erect such structures. That technology was at the heart of the nineteenth century's admiration for Gothic architecture, and it is widely admired still. But Gothic architecture did not value an organic unity of exterior and interior or of structure and space. Its structural system upheld—but was largely unexpressed in—its great interior spaces. What the visitor to these spaces saw were walls so towering and transparent that their mere existence seemed impossible. Indeed, without the support of structural buttresses invisible from within, they *would* have been impossible. The vertical lines of piers (Figure 8–5) and the arching lines of ribs, all pointing heavenward, emphasized height and contributed to the otherworldly effect. Surfaces glistening with mosaics or glowing with stained glass further helped to dematerialize the building when seen from inside.

A related preference was for lightness rather than weight, further emphasizing the drama of height by constructing the tall walls with as little visible support as possible. Contributing to the desired sense of weightlessness was the practice of piercing the walls as much as possible and filling the openings with the products of a newly developed

VOCABULARY — THE CATHEDRAL

Just as we saw in chapter 6 that the term **basilica** has come to have a specific meaning within the Roman Catholic Church, so has the term **cathedral.** It is not simply a large Gothic church; more specifically, it is the seat of a bishop and the administrative center for the bishop's *diocese* or territorial jurisdiction. The term is derived from the fact that the building traditionally holds the bishop's *cathedra* or official throne.

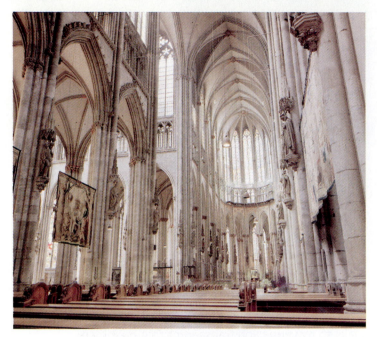

Figure 8–5 Clustered piers almost 90 feet (27 m) high in the cathedral at Cologne, Germany.

art form: stained glass. The total effect that was wanted and achieved transcended earthly experience and approached the miraculous.

The plans of Gothic churches are usually in the form of a **Latin cross,** which has a horizontal member shorter than the vertical member (see the box on terms for crosses in Chapter 6). The long vertical member corresponds to the **nave,** the main body of the church extending from the entrance, which is usually at the west end of the building, to the liturgical focus (the choir, chancel, altar, or apse—or a combination of several of these) usually at the east end. The short horizontal member corresponds to the **transept,** the transverse part of the church that runs from north to south, crossing the nave at right angles. The nave is usually supplemented by one or more pairs of parallel side aisles lower than the nave, and these in turn are sometimes flanked by small chapels dedicated to saints. In some plans, the side aisles continue to form a semicircular passageway called an *ambulatory* behind the choir, and the ambulatory may also be flanked by chapels. The plan of Amiens Cathedral (Figure 8–6) is an example, although its transepts are shorter than typical. In some other examples, however, such as the cathedrals of Bourges and Albi, the transepts are omitted altogether, and at Albi the side aisles are omitted as well.

The vertical sections of Gothic cathedrals (Figure 8–7) are dominated by the central nave, their

Figure 8–6 Floor plan of the cathedral at Amiens, France, begun in 1220.

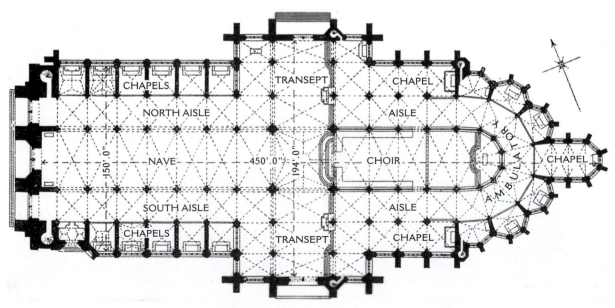

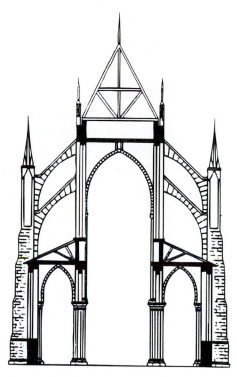

Figure 8–7 Typical vertical section through a Gothic church or cathedral. The two levels of flying buttresses counter the thrust of the arch above the nave. Clerestory windows light the nave from above the side aisles.

ings, these being sustained on very slender isolated piers, designed as groups of clustered columns with overlapping shafts. This new method of supporting a great arched roof on slender stone piers is the basic principle of Gothic design and was the fundamental cause of the details that are usually considered the characteristics of the style. These include the pointed arch, the flying buttress, and rib vaulting. All three were in use before the Gothic era, but it was the Gothic architects who combined them in the service of a wholly new vision.

The Pointed Arch

The most easily recognized characteristic of Gothic design is the **pointed arch,** substituted for the roundheaded arch of Romanesque style. The pointed form had been used in ancient times but never to the extent to which it was applied in the

tallest feature. Their height is generally divided into several levels, the lowest being called the *arcade,* the next highest (in the form of a narrow gallery) being called the *tribune* or *triforium,* typically opening to the nave through arcades of three arches *(tres fores)* in each bay. In a few cases, there are two intermediate levels, the lower being called the tribune and the upper the triforium. The highest portion of the nave walls, rising clear above the structures of the side aisles, are pierced with windows called **clerestories** (pronounced—and sometimes spelled—clearstories). The nave of the great cathedral at Amiens, France, 138 feet (42 m) tall, shows a typical vertical composition (Figure 8–8).

Gothic ecclesiastical architecture developed from the Romanesque but was so elaborated and enriched that it developed a quite different character. Its basic structural difference from the earlier style was the fact that the exterior walls of its churches served to enclose the building, but were no longer used to support the arched roof and ceil-

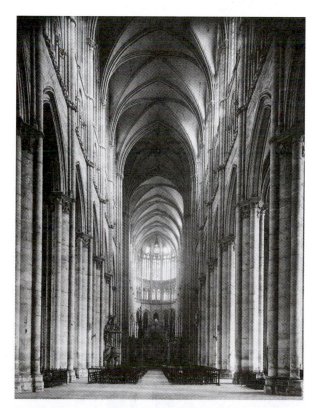

Figure 8–8 In the nave of Amiens Cathedral, begun in 1220, we see, from floor to roof, the arcade (beyond which is a side aisle), the triforium (beyond which is a narrow gallery), and the clerestory windows.

MARBURG/ART RESOURCE, NY

Gothic period. The shape probably developed from the necessity for having arches of the same height starting at the same level but having different widths of span. The arch across the nave was often 50 feet (15 m) wide, whereas the arch from pier to pier along the length of the nave averaged 20 feet (6 m), yet the design called for near similarity in height. As the height of a round arch is always only half its width, similar heights could not be attained from the same spring line. The pointed arch fulfilled this requirement.

Much has been written about the fact that such an arch points toward heaven and symbolizes aspiration. This is undoubtedly true, but it is also true that the pointed arch, more flexible in its proportions than a round arch, was a practical solution to the problems of Gothic church design.

Figure 8–9 Stone courses near the spring line of a ribbed arch. The top course is seen dividing into separate ribs.

FROM *THE GOTHIC CATHEDRAL: THE ARCHITECTURE OF THE GREAT CHURCH*, BY CHRISTOPHER WILSON. COPYRIGHT 1990 THAMES & HUDSON. REPRINTED BY PERMISSION..

The Flying Buttress

The elimination of the supporting wall often placed too great weight upon the piers, a problem that was solved by making the pier thicker in depth by the introduction of a **buttress** on the outside. This buttress was not originally exposed, but was concealed beneath the roofs of the side aisles. By the end of the twelfth century, it had become acceptable to expose these supports, and once support was divorced from the visible walls of the interior, the nave design could be entirely rethought, the height of the clerestory extended into what had been the levels of the tribune gallery and triforium, and the amount of glass dramatically increased. The buttress also allowed the elimination of the tribune gallery, which previously had stiffened the nave wall construction.

Where a single buttress was still insufficient in weight, another buttress was built a short distance beyond, which was connected to the pier buttress by an arch. This construction, supporting the church wall but standing some distance from it, was called a **flying buttress.** Buttresses were also given greater stability by crowning them with a weighty **finial,** or **pinnacle,** and these were generally given elaborately ornamental shapes.

The Ribbed Vault

Gothic ceiling vaults were not built monolithically, as Roman vaults had been. Instead, they were built by first constructing heavy arched **ribs** composed of a series of wedge-shaped stones connecting directly opposite piers. Other ribs starting from each support ran in a diagonal direction to the adjoining opposite piers. This resulted in an X-shaped pattern of ribs, which could carry the loads of the vaults to piers at each corner of the bay. The diagram in Figure 8–9, drawn by Eugène Viollet-le-Duc, a nineteenth-century architect and archaeologist who restored the cathedrals of Notre Dame and Amiens, shows the stone courses between the top of a pier and the point where the ribs begin to separate; this part of the pier construction is called the *tas-de-charge* (roughly, "lots of load"). When the construction of the rib cage was completed, the space between the ribs was filled in with masonry supported by the ribs. As the ribs were visible and pro-

jected below the infilling masonry, the pattern formed by the infinite number of rib intersections produced a gossamer effect. Ribbed construction was one of the most characteristic features of Gothic design.

It reached its most extravagant expression in some of the late English Gothic cathedrals and chapels. At Gloucester Cathedral, the vaults of the cloister ceiling (Figure 8–10), built between 1351 and 1364, develop into the shapes of inverted cones. Such vaulting is called **fan vaulting,** and the forms are easily read from below because of the multiplicity of ribs on their surfaces. These ribs have gone beyond the structural function of earlier examples and have become decorative; they even end in foliate forms that echo the tops of the stained-glass windows below. The flat diamond-shaped surfaces between the fans are also patterned with window-like shapes of cusped circles.

A later, grander example is the fan vaulting of King's College Chapel in Cambridge, built between 1446 and 1515. Here the fans have been extended

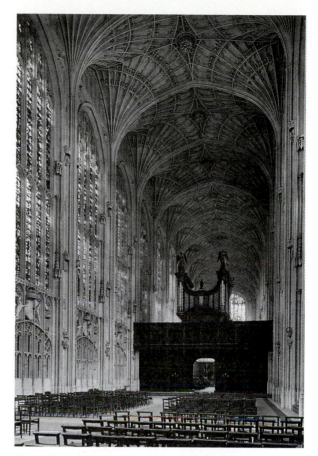

Figure 8–11 Fan vaulting in King's College Chapel, Cambridge, 1446–1515.

A. F. KERSTING

Figure 8–10 Fan vaulting on the cloister ceiling of Gloucester Cathedral, England, c. 1351–64.

ROBERT HARDING PICTURE LIBRARY LIMITED

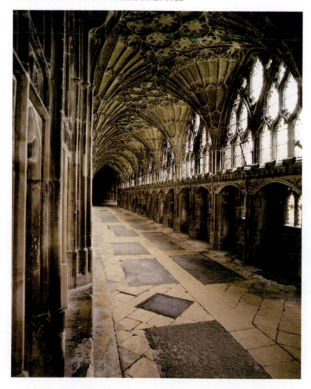

to minimize the flat area between them, and this reduced area has been given a pendant boss. In the view shown (Figure 8–11), the organ topped by trumpeting angels is a later addition.

By the time we reach Henry VII's Chapel, added to London's Westminster Abbey between 1503 and 1519, we see fan vaulting developed to its most audacious, with the usual half cones against the outside wall, but also with two rows of full cones in the middle of the span that turn downward into pendants (Figure 8–12). The perspective view from above the roof (Figure 8–13) gives an idea of how this construction was accomplished. From below, the effect is astonishing, the pendant forms apparently ignoring or even overturning the principle of structural logic and the law of gravity. Such pendant vaulting also appeared in France, but the profuse ribbing of fan tracery was distinctly English.

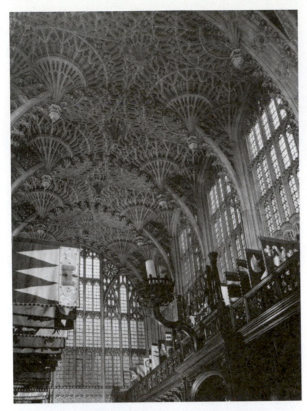

Figure 8-12 Pendant vaults hang from the ceiling like stalactites in Henry VII's Chapel, added to Westminster Abbey from 1503 to 1519.

BRITISH TOURIST AUTHORITY

The Race for Height

Great rivalry developed between towns and villages to outdo each other in the beauty, size, and grandeur of their cathedrals. This resulted in a trend toward larger and higher buildings. As the construction was designed without modern engineering skills and building codes, many of the buildings fell before completion and were rebuilt with stronger supports.

St.-Denis, which has been called the first Gothic cathedral, had a nave 88 feet (27 m) high. The nave of Notre Dame in Paris rose to 105 feet (32 m), that of Chartres Cathedral pushed upward to 120 feet (37 m), Rheims to 124 feet (38 m), and Amiens to a breathtaking 138 feet (42 m).

The vault of Beauvais Cathedral, intended to be the highest in the world, sought a nave height of 156 feet (48 m). This was achieved, but the great structure stood for only a decade before collapsing, in 1284. It is now thought that the designers' calculations for carrying the vertical loads of the construction were sound; the failure came instead from unexpected lateral forces of wind against the great wall surfaces. The choir of Beauvais (Figure 8–14) remains, however, suggesting what the entire interior might have been like.

Cathedral spires and towers rose even higher, of course, reaching 466 feet (143 m) at Strasbourg, France, and 500 feet (154 m) at Cologne, Germany.

The whole problem of Gothic design was a contest in equilibrium between the weight of the stone arches and the economy of material in the buttresses. It was a matter of equalizing the thrust and counterthrust. This problem differed from the simplicity of Roman or Romanesque design, where heavy walls had such inert stability and were so extravagant of stonework that they could resist

Figure 8–13 View of vault construction from above, Henry VII's Chapel, Westminster Abbey.

SIR BANISTER FLETCHER. REPRINTED BY PERMISSION.

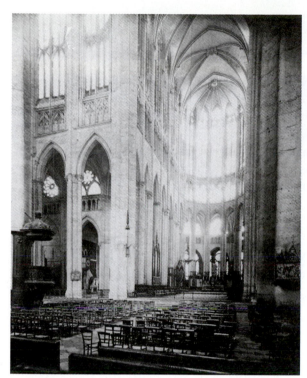

Figure 8–14 The choir, Beauvais Cathedral, begun in 1225.

FRENCH GOVERNMENT TOURIST OFFICE

	TIMELINE	THE RACE FOR HEIGHT IN FRENCH GOTHIC CATHEDRALS		
DATE BEGUN	CATHEDRAL	NAVE HEIGHT	WIDTH-TO-HEIGHT RATIO	
1132	St.-Denis	88 ft. (27 m)	1 to 2.2	
1163	Notre Dame, Paris	105 ft. (32 m)	1 to 2.6	
1194	Chartres	120 ft. (37 m)	1 to 2.5	
1211	Rheims	124 ft. (38 m)	1 to 3	
1220	Amiens	138 ft. (42 m)	1 to 3.4	
1225	Beauvais	156 ft. (48 m)	1 to 3.5	

the thrust of almost any arch that could be placed upon them. Gothic structures were built of small stones and much mortar, as shown diagrammatically in Figure 8–15. Such construction enabled the designers to introduce curved forms with greater ease than could have been accomplished with massive blocks.

Architectural historian Spiro Kostof has written that "[t]he audacity of . . . that new breed of hero-architects . . . was to reach ever upward at the same time that they continued to reduce the built mass below the vaults. In the end we can hardly speak of walls at all. The skeleton of clustered piers, rib vaults, and flying buttresses is really all there is of substance—that and the finespun tracery for the glass."

For all their emphasis on height, however, the Gothic "hero-architects" did not attempt world height records, as would the twentieth century's skyscraper builders. Ancient Egypt's Great Pyramid of Cheops was three times the height of Beauvais Cathedral, the interior of Byzantium's Hagia Sophia was 22 feet (7 m) taller than Beauvais, and

Figure 8–15 Perspective section through part of a bay of Chartres Cathedral. At upper left, the section cuts through stone courses of the roof vault; at lower right, through part of a flying buttress. The cast-iron roof structure shown here replaced the original oak-timbered roof after a fire in 1836.

COURTESY BIBLIOTHÈQUE DE LA DIRECTION DU PATRIMONIE, PARIS.
PHOTO © PHOTEB

THE GOTHIC **179**

As the Middle Ages can be divided into several stylistic periods, the last of them being the Gothic, so the Gothic style itself can be divided into different phases. The fine points distinguishing these from one another need not concern us here, but the terms should at least be familiar. In most European countries, the Gothic is simply divided into Early Gothic, High Gothic, and Late Gothic. The succession of one after another was not uniform across Europe, however: the Early Gothic is generally considered to have superseded the Romanesque or Norman c. 1160 in France, c. 1175 in England and Germany, c. 1200 in Italy, and slightly later in other countries. Dates for the High Gothic range from c. 1240 to c. 1310, and for Late Gothic from c. 1350 to c. 1420.

These three divisions of Gothic, however, are given more descriptive terms in both France and England. In France, they are successively called *lancette* (spear-like), *rayonnant* (radiant), and *flamboyant* (flaming). In England, they are called Early English, Decorated, and Perpendicular.

that of Rome's Pantheon was taller than all the cathedrals except those of Beauvais and Milan.

What apparently interested the Gothic builders even more than sheer height was the *proportion* of height to width. In the relationships between parts of the Gothic cathedral—the height of the piers compared to the height of the shafts above the piers, or the width of the nave compared to the widths of the side aisles—many classical proportions can be found, and it is known that Gothic architects were concerned with both Vitruvius's theory of proportion and the general ideal of the congruence of parts. Even so, the most obvious of all these buildings' proportions—the height of the nave compared to its width—increasingly demonstrates the ideal not of congruence but of extreme contrast. As cathedral building continued in France, the relationships of nave heights and widths grew ever more exaggerated. The intention was not to celebrate the reason of humankind but to demonstrate its subservience to the divine.

The Spread of Gothic through Europe

The Gothic style spread from its home in the Île-de-France throughout most of Europe. There were Gothic buildings and interiors in Belgium, the Netherlands, and Austria. Fine Gothic cathedrals were built in Brussels, Prague, Vienna, Antwerp, Bruges, and Ghent. And some of the Gothic design of Spain and Portugal will be considered in chapter 14. Most of the great cathedrals outside of France, however, were built in England, Germany, and Italy.

ENGLISH GOTHIC By the end of the twelfth century, great Gothic cathedrals were beginning to be built in England, such as the ones at Lincoln (1185–1200) and Ely (1198–1322), and the Norman cathedral at Canterbury was being given new Gothic elements. The thirteenth century in England saw the construction of cathedrals at Wells (1214–1465) and Salisbury (1220–58, with its octagonal chapter house added in 1263–84). Westminster Abbey was built between 1245 and 1269, and York Cathedral, begun in 1261, was finished in 1324. In the fourteenth century, new English cathedrals included the one at Gloucester (1332–57). As we have seen, King's College Chapel, Cambridge, was built between 1446 and 1515, and Henry VII's Chapel, with its pendant fan vaulting, was added to Westminster Abbey between 1503 and 1519. Windsor Castle, a royal residence in Berkshire, is a rambling complex built and rebuilt over several centuries; two of its elements with striking interior spaces are St. George's Hall and

St. George's Chapel, both built between 1473 and 1516. The English taste for Gothic continued as late as 1638, when part of Christ Church, Oxford, was built in Gothic style. And, as we shall see in chapter 16, England by the late eighteenth century would be welcoming the style's return in the form of the Gothic Revival.

The English cathedrals were not as likely as the French ones to be found at the heart of a town. Set somewhat aside in a clearing, on a hill, or along a riverbank, they are spectacular elements in the English countryside. Their naves generally lack the extreme height and narrowness of the French naves, but they are often extreme in another dimension: their length. A typical French nave might have a length four times its width, but an English nave's length might be six times its width. English ground plans are also more complex: in French cathedrals, the transepts project only slightly, but in English ones they project much more boldly, and sometimes (as at Salisbury) there is even a second pair of transepts smaller than the first. The English cathedral is also more likely to be complicated by other adjoining elements, such as sacristies, chapter houses, cloisters, and sometimes walled enclosures with gatehouses. Apses at the east ends of cathedrals are generally semicircular in France and generally square in England. The interiors of the English cathedrals, while less tall than the French, are sometimes even more ornate. While less rational, they are sometimes even more decorative and picturesque.

GERMAN GOTHIC The collection of central European states that would become the German Empire was, naturally, in close contact with France, its neighbor to the west. As in England and France, the fierce sun of Italy and the south was absent, encouraging large window areas. Heavy snows mandated sharply pitched roofs. One German departure from the French examples was a western entrance elevation, as at Ulm, with a massive single central tower rather than a pair of towers. Another German variant is the so-called hall church, such as St. Elizabeth, Marburg, in which the side aisles rise to the same height as the nave.

Of those German cathedrals closer to the French models, the most gigantic is Cologne, begun in 1248 but not completely finished until the nine-teenth century. Its nave, at 150 feet (46 m) is almost as tall as that of Beauvais. The nave width is 42 feet (13 m) and the entire building footprint is an astonishing 275 feet (85 m) wide and 468 feet (144 m) long. Cologne is more distinguished for its size, however, than for its proportions. Its nave, despite its impressive length, seems rather short for its width, and the enormous towers at the west end dwarf the rest of the great building.

One general distinction between German cathedrals and French ones is the number of apses. French examples have a single apse at the eastern end of the nave, but some German ones, as at Naumburg, have an apse at both the eastern and western ends, and some others, as at St. Elizabeth, Marburg, have an apse at the eastern end and two more apses at the southern and northern ends of the transept.

ITALIAN GOTHIC Italy (though not then yet unified under that name) was more resistant to France's Gothic ideas than were England and Germany. The Romanesque lingered longer in Italy than elsewhere, and, because of the ever-present reminders of the classical glories of ancient Rome, the Renaissance began earlier there. The number of Italian Gothic monuments is therefore relatively small. Among them were the cathedrals of Siena, Florence, and Milan. Even within this relatively small group, the Italian enthusiasm for the Gothic seems lukewarm: the naves are tall and narrow, but—by French standards—not *very* tall and narrow; the arches are pointed, but not *very* pointed.

Siena Cathedral (1245–1380) constitutes one of the greatest building programs of the Gothic era. Its present nave is 320 feet (98 m) long, but the astonishing intent was that this element would be the finished church's transept and that a much longer nave—never completed—would be added to the southeast. At the crossing is an unusual dome, its plan in the shape of a hexagon, and the entire interior (Figure 8–16) is animated by the zebra-like stripings on walls and piers of marbles in contrasting colors.

Florence Cathedral (1296–1462) is more properly known as S. Maria del Fiore (St. Mary of the Flowers). The features of its earliest elements are Gothic, but without the pronounced vertical emphasis of the French models. Its early architects

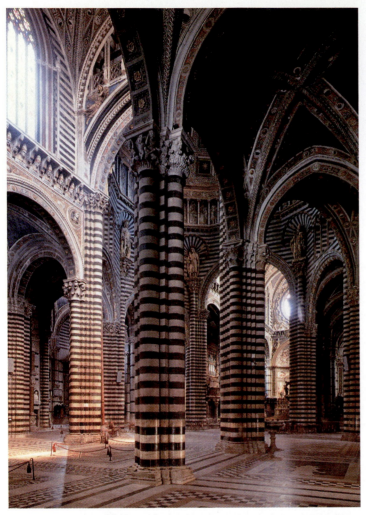

Unlike the earlier elements at Florence, the vertical emphasis here is insistent. The decorative profusion continues inside, and the dimensions are huge. Its nave is 148 feet (46 m) high, 490 feet (151 m) long, and 55 feet (17 m) wide. With its two pairs of side aisles, the total interior width is 193.5 feet (60 m). For most of the church's length, the clerestory windows are small and the interior consequently dim, no doubt considered an asset in the bright sunlight of Italy (Figure 8–17). There are, however, three very large and famous stained-glass windows in the apse.

Among notable Gothic secular buildings in Italy is Florence's Palazzo Vecchio (Old Palace), a municipal headquarters built in 1298. It is the commanding presence among the buildings surrounding the city's Piazza della Signoria, and its crenellated roofline and off-center tower present a characterful and idiosyncratic silhouette.

Figure 8–17 The interior of Milan Cathedral, begun in 1385. The tall double aisles limit the size of the clerestory windows above. The column capitals are in the form of rings of canopied niches for carved figures.

ALINARI/ART RESOURCE, NY

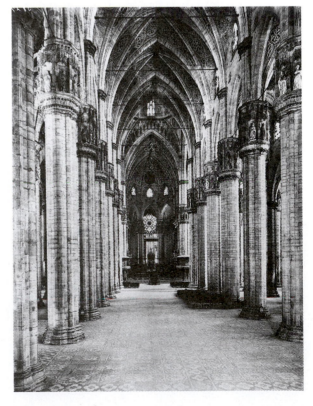

Figure 8–16 A view into the domed crossing of the Siena Cathedral, begun in 1245. The stripes in the colored marble are horizontal, contrary to the lines of most Gothic interiors.

SCALA/ART RESOURCE, NY

included Arnolfo di Cambio, the painter Giotto, and Andrea Pisano. Its baptistery (1290) has famous bronze doors designed by Pisano and Lorenzo Ghiberti, and its campanile (1334–87) is by Giotto. The crowning glory of the composition, however, is the competition-winning dome design by Filippo Brunelleschi, one of the works that will usher in the new style of the Renaissance.

Milan Cathedral (1385–1485) is, except for the cathedral at Seville, the largest in volume of all the Gothic cathedrals. Decoratively, it is also perhaps the busiest, its exterior alive with an intricate lacework of marble tracery, buttresses, and pinnacles.

An exception to the relatively tepid Italian response to the Gothic influence was the city of Venice, then busily engaged in trade with northern Europe and understandably enthusiastic about the northern fashions. There were a large number of ecclesiastical and secular buildings in Venice in the Gothic style, and these included the Doge's Palace and the Ca d'Oro.

The Doge's Palace, built between the basilica of San Marco and the lagoon, is a key part of an ambitious urban design scheme. The present facades date from 1309–1424 and feature open arcades on two lower levels topped by walls of white and rose-colored marble pierced by Gothic windows. The notable features of the interior are all of a later period, postdating a disastrous fire of 1577.

The Ca d'Oro ("House of Gold") is one of Venice's great private palaces. Built along the Grand Canal between 1421 and 1436, its famous facade (Figure 8–18) combines an area of almost solid masonry with another area of three arcaded levels, each one more slender and delicate than the one below it. Inside, generously scaled rooms are disposed around a couple of interior courtyards, and the front rooms enjoy splendid views of the canal.

Let us now look more closely at some of the arts that adorned the interiors of these buildings.

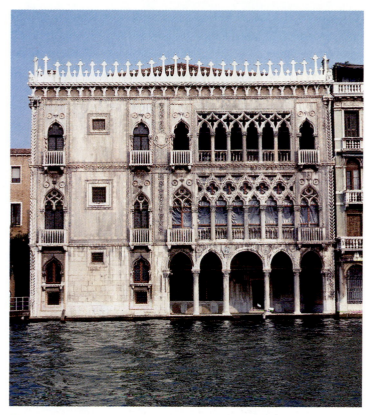

Figure 8–18 The Ca d'Oro as seen from Venice's Grand Canal.

Gothic Ornament and Decorative Arts

Many of the Gothic structural features already mentioned—pointed arches, flying buttresses, and ribbed vaults—were in themselves quite ornamental. Even at its simplest, the Gothic style was a more decorative one than the earlier Romanesque. Whether to leave it at its simplest, however, was a question that was much debated, especially in the early years of the Gothic era.

The Proportions of Gothic Ornament

As we have seen, Gothic design accentuated the vertical dimension, producing churches with extraordinarily tall naves. The buildings' verticality was accentuated on the interior by the vertical stripings of piers and ribs and on the exterior by the addition of towers, spires, and pinnacles. Many of the horizontal moldings and cornices associated with classical temples were discarded. The spirit of the time preferred the vertical, seeing it as a symbol of the aspirations of the faithful, soaring above the problems of the earthbound and pointing toward their future home in heaven.

This preference was expressed not only in the proportions of naves and the repetitions of shafts and ribs, but also in the sculptured figures carved into the stone. Those at the portals on the west front of Chartres (Figure 8–19) are examples, so tall, thin, and attenuated as to hardly seem human. They stand stiff and erect, with arms close to their bodies and clothing in minute vertical folds. Not only does their elongation reflect the architecture, but these figures are themselves integral parts of the architecture, designed to fit particular places among the building's shafts and ribs.

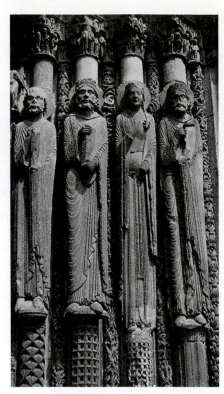

Figure 8–19 Carved stone figures at the entrance portal of Chartres repeat the upward elongations of the cathedral.

ART RESOURCE, NY

Christian historical or symbolic association, such as St. Peter with his key, St. George and the Dragon, the Creation of Man, Jonah and the Whale, the Wise and Foolish Virgins, and the Last Supper. To the medieval mind nearly everything was symbolic, and the ornament of the church was an encyclopedia in stone.

There was more abstract ornament as well. At the top of the windows the arched mullions were often treated with **trefoils, quatrefoils,** and **cinquefoils,** resembling three-leafed, four-leafed, or five-leafed clovers, forming **cusps** between them. The finials crowning vertical forms were enriched with **crockets,** projections cut in the form of stylized buds or leaves. Niches were formed with pointed tops to frame the important statuary, or projecting canopies were placed above freestanding statues. Geometrical forms such as frets, dogteeth, chevrons, zigzags, battlements, and crenellations often formed running ornament. Family crests, monograms, coiling stems with foliage, and the oak

But who are these figures, and what do they signify?

The Subject Matter of Gothic Ornament

As would be expected, statues of saints, prophets, and other religious personages were carved into the cathedral surfaces, as were portraits of royalty (Figure 8–20). But there were also less holy and less dignified figures—dwarfs, grinning goblins, devils, monkeys, donkeys, and fantastic animals—introduced in unexpected places to amuse the people. Gutter ends and waterspouts were **gargoyles** often carved in grotesque animal forms. Figures of those who labored on the buildings were also used as decoration. A bust of the architect in a quandary, the mason straining to lift a stone, the carpenter with his raised hammer, or the painter with his symbolic brush and palette were all given recognition. Many of the sculptured representations had a

Figure 8–20 A crowned head, carved in stone, supports a corbel in Wells Cathedral.

DRAWING: JAMES KELLAWAY COLLING

branch and leaf were the most common forms of ornamental motifs.

Among this ornamental variety, one particular figure takes a place of special honor and significance: the Madonna, or Virgin Mother of Christ.

The Madonna and Her Influence in Art

In the early days of the Christian church, great reverence was given the relics of the saints. The original cross was claimed to have been found in Jerusalem in 328 by St. Helena, and supposed portions of the shroud of Christ and the tunic of the Virgin were distributed throughout Christendom. *Reliquaries* were made in gold and enamel and inlaid with precious jewels to hold sacred fragments of all kinds. By the tenth century a large commerce had developed in these objects, which sold for enormous prices and were often later proved to be spurious. The sale of relics was forbidden by the pope in 1198 without effect. The exhibition in church pageants of dismembered corpses was finally ridiculed, and people turned from the relics in disgust.

The church authorities, realizing a change in the practice was necessary, began to substitute images of the Virgin for adoration. Christ was considered too sublime, too regal, for this purpose, his divinity placing him aloof. But not even the frailest or most sinful would fear to approach or revere one whose attributes were infinite humility, love, pity, and forgiveness.

Eventually, Mary's importance began to overshadow the Trinity of Father, Son, and Holy Spirit. Shrines were erected directly to Mary. One church in every town was dedicated to Notre Dame (Our Lady), and the Lady Chapel, the one of greatest beauty in every church, was placed behind the high altar. The Lady Chapel was decorated in the most feminine taste, with softened colors, and dimly lit to enable the worshipper to commune in silence, feel her presence and sympathy, and address her in person. The earliest development of an aesthetic sense and appreciation among the masses of western Europe can be traced to the emotional reactions occurring from constant contact with the representations of Mary and her Infant. The painters, stonecutters, glassworkers, and sculptors who worked on her chapel felt that they were in the Virgin's employ and understood that they would be compensated after death on the basis of their efforts and ability.

The Madonna, as an ideal of artists in every medium, has been used in every art period of the Christian world. Only the style of representing her has changed. The conception of her character has varied from deep compassion and sorrow to one of joyful, healthy motherhood. Many representations of the Madonna have been made in stained glass, stone, wood, and in tempera and fresco. In the Russian icons she is framed in wrought gold studded with precious gems, and she was interpreted in a more primitive manner to add to the charm and spirit of the Franciscan missions in California.

The Virgin and other symbolic figures were presented in many mediums. Two of these were of particular significance in Gothic times: stained glass and tapestry.

Stained Glass: Colored Sunlight

Stained-glass windows achieved several purposes: they transmitted light; they provided decoration, sharing the work previously done by murals and mosaics, which they partly replaced; they provided instruction by depicting saints and scenes from the Scriptures; and, not least, they added a sense of poetry that no clear glass window could have produced.

Romanesque stained glass had been limited to relatively small openings in relatively large wall surfaces. With the shift from Romanesque to Gothic styles, the solid wall was minimized and the area devoted to stained glass was increased enormously. Some of the finest Gothic stained glass ever produced was also some of the earliest, including choir windows ordered by Abbot Suger for the abbey church of St.-Denis. Soon after, a larger amount of stained glass was made for the Gothic rebuilding of Chartres Cathedral. St.-Denis has been much changed, but most of Chartres's original 180 stained-glass panels are still in place, still producing the "miraculous light" praised by Abbot Suger.

It has been said that no one visits Chartres to look at the building. This is obviously false, but it is true that the visitor to Chartres, especially on a

sunny day, is at first overwhelmed by the visual brilliance of the windows (Figure 8–21). It is also true that the varicolored light obscures—rather than clarifies—the structure around it. This cannot have been seen as a fault, however, as the cathedral builders valued a sense of mystery more highly than clarity.

Another factor in our experience of the cathedral interior is that the colored glass, translucent but not transparent, cuts off all exterior views. As Titus Burckhardt has written, "The spiritual unity of the inner space . . . is ensured by the fact that the outside walls . . . do not have holes in them: the luminous curtain of stained glass protects the interior space from the profane outside world. The church must not appear as if illuminated from without, but as if its walls . . . were fashioned out of self-luminous precious stones. . . . Around the space in a Gothic church, Heaven descends like a mantle of crystalline light."

The techniques of the stained-glass window, which originated in the Romanesque period, make possible the assemblage of numerous pieces of colored glass. These pieces, necessarily small because of the limits of manufacturing techniques, were joined together by grooved strips of lead, collectively called **leading.** In the largest windows, these leaded-together areas of glass were held by slender stone divisions called **mullions,** the overall mullion pattern being called **tracery.**

Tracery, originating as a structural requirement, was later adapted as ornamental motifs for furniture and woodwork panels. Even some glass windows, too small to need actual stone tracery, came to have such structure painted on. The earliest tracery, called *plate tracery,* simply pierced the **spandrel** above a pair of windows with a circle, quatrefoil, or other opening that was then glazed. Later tracery, first introduced at Rheims and called *bar tracery,* consisted of vertical mullions crowned with simple pointed arches. In the thirteenth century, *rayonnant tracery* in a radiating wheel-like pattern was used for circular windows at Rheims, Bourges, Amiens, and elsewhere.

But the culminating masterpiece of stained-glass design was the Ste.-Chapelle, near Notre Dame in Paris. It was built between 1242 and 1248. Here (Figure 8–22), the walls have virtually disappeared, replaced by an astonishing quantity of windows bathing the interior in colored light.

In the final development of the Gothic style during the fourteenth and fifteenth centuries, the tracery members became **ogive** in type, each side following an S curve (Figure 8–23). This latter form was called *flamboyant,* meaning "flame-like," and the term was later used as a designation for the whole Late Gothic style.

Within the tracery and the leading, each piece of glass was typically a solid color. As in mosaic work, multicolored pictorial effects were achieved by juxtaposing these pieces. The colors have often

Figure 8–21 The Life of Christ, New Testament Cycle, lower half of window, c. 1145-50 (stained glass) by French Schook (12 century). Chartres Cathedral, Chartres, France/Bridgeman Art Library.

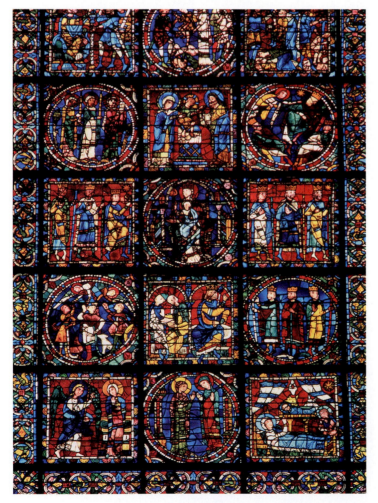

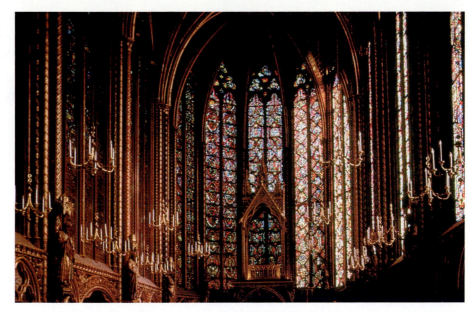

Figure 8–22 Vast areas of stained glass in the chapel of Ste.-Chapelle, Paris, create a space seemingly without walls.

MARVIN TRACHTENBERG

been described as "jewel-like," and were dominated by deep blues and reds. Some red and yellow glass was made by the **flashed-glass** technique that had been developed by the Romans. Most famous of all, perhaps, was a sapphire blue or *bleu de ceil* used at both Chartres and York. An exception to the brilliant colors of Gothic glass was in the Cistercian structures, where colorless (or very softly colored) *grisaille* panels were used. And in the last century of the Gothic period, the deep colors were replaced in most new construction by paler, subtler hues.

The lead strips holding the glass produced a geometric pattern that, in the most successful windows, contributed to the total effect. In some windows the glass design is overlaid with unrelated strips of leading, but in others the two patterns reinforce each other. One often repeated subject, the tree of Jesse, offered a subject matter of branching divisions that lent itself particularly well to the restrictions of the leading.

In addition to the effects of the panes of solid colored glass, details were added by painting in black or gray on the inside surfaces of some of the panes. At first, this was limited to such items as eyes, mouths, and folds of drapery. By the middle of the fourteenth century, however, a taste for increased naturalism had resulted in more widespread paint-

ing. What had been the art of the glazier had become a collaboration between glazier and painter. Modeling in terms of light and shade was achieved in different ways, the most common being to paint

Figure 8–23 Tracery diagram of the rose window in the chapel of Ste.-Chapelle, Paris. A fifteenth-century reproduction of the original thirteenth-century window, it holds eighty-five major panels of glass.

FROM COWEN, *ROSE WINDOWS*

shadows on the glass. The resultant opacity was often alleviated by the method of **stippling** while the color was still wet, rather than uniformly painting an entire area. Another method was to scratch out part of the color painted into the shadows.

The windows of the Late Gothic period were marked by the ultimate dominance of the painter, who usurped the premier position of the glazier. The larger sections of glass that had become practicable were used as surfaces that were completely painted over with biblical illustrations. The effect of these late windows moved away from the spirituality of the earlier Gothic style and anticipated the realism of oil painting of the Renaissance. For this reason, some of the earliest of Gothic stained

Figure 8–24 "The Hunt of the Unicorn. VII: The Unicorn in Captivity," One of 6th hanging and two fragments from 2 or more sets of tapestries. Silk, wool, silver-gilt thread. H: 145 in. W. 99 in. (368 x 251.5 cm). Franco-Flemish, 16th century, c. 1500. H: 12 ft. 1 in. W: 8 ft. 3 in. The Metropolitan Museum of Art, Gift of John D. Rockefeller, Jr., The Cloisters Collection, 1937. (37.80.6)

PHOTO: © 1993 THE METROPOLITAN MUSEUM OF ART

glass is considered the finest. Especially admired is the glass of Chartres Cathedral in France, Canterbury in England, and Cologne in Germany.

Tapestries: Woven Stories

Tapestry was not only decorative and colorful but soft. Its use could transform the bare and damp interiors of churches, castles, and citadels into spaces with a degree of warmth and beauty. It was also eminently movable, a characteristic well suited to the peripatetic lives of medieval nobles and their families.

The oldest surviving examples of medieval tapestry date from the end of the eleventh century and are attributed to Germany. By the mid-fourteenth and early fifteenth centuries there were a number of centers in both Germany and Switzerland producing tapestry of professional quality. In France, there were also productive centers in Paris, in the Alsace region of eastern France, and in the northern French town of Arras, this last location inspiring the names *arrazzi, arras,* and *draps de raz,* all referring to tapestries of the highest quality, not necessarily made in Arras itself. By the middle of the fifteenth century, tapestries had become widely popular with the nobility of Italy, Spain, and England. And in the sixteenth century, one of the most important times for tapestry production and a time of change from Gothic to Renaissance taste, Flanders was established as the most important center for such production, and Flemish tapestries came to be considered the finest.

As a rule, Gothic tapestries are of the *millefleurs* (thousand flowers) design. In such a design, the background or other parts of the tapestry are covered with images of numerous small bushes, plants, flowers, and leaves (Figure 8–24). Many of these bushes have small animals of various types crouching upon or under them.

Within the millefleurs category, Gothic tapestries cover a wide range of subject matter, but they are all easily recognizable because of special characteristics. The laws of perspective were considered unadaptable to the tapestry medium, and pictorial depth, distance, and atmosphere were not shown. Consequently, in Gothic tapestries objects behind other objects do not appear reduced in size, nor do they become fainter in tonal value; shad-

ows are absent or only vaguely suggested; horizon lines are close to the top of the composition; and the design as a whole resembles a flat-colored line drawing, with little or no gradations in the coloring or rounding of forms. The general effect is stiff and conventional, though beautiful and dignified. The best tapestry work does not hide its construction, and, just as the best vase painting avoids effects that negate the shape of the vase, the best tapestry avoids effects, such as dramatic perspective, that negate the flatness of the wall surface on which it hangs.

Gothic tapestries can also be identified by subject matter. Religious subjects were paramount. Biblical, allegorical, and ecclesiastical personages were often pictured in a setting of Gothic architectural forms. Scenes of pastoral, agricultural, and courtly life were often represented. Many Gothic tapestries were made showing the unicorn and other animals chased by hounds and hunters or caged in a pen. The majority of Gothic tapestries did not have frames, although some were enclosed with a narrow border carrying out the millefleurs idea.

The weaving of tapestries differs from the weaving of most cloth. In almost all weaving, there are two sets of threads. One set, called the **warp,** consists of parallel threads running the length of the loom. The other set, called the **weft** (or the *woof* or the *filler*) consists of parallel threads running crosswise on the loom. The weft threads are woven in and out of the warp threads, usually by means of a shuttle or bobbin. In tapestry work and in many other types of weaving, the weft threads are then compacted with some sort of comb so that they completely conceal the warp threads. In tapestry work, but in few other types, the weft threads are not generally shot the full width of the loom, but are limited to the areas where their particular color is wanted, each section being built up independently (Figure 8–25). This peculiarity means that, between areas of different colors, there is a discontinuity or split, which, if small, can be left open, or, if extensive, can be tied together with other threads. Other tapestry techniques modify these boundaries between color areas by giving them a sawtooth or comb-like edge rather than a straight one.

The simple tapestry weaving technique can be enriched and complicated by many variations, of

Figure 8–25 In this enlargement of a tapestry weave, weft threads in two different colors, running horizontally, are seen woven through the vertical warp threads. Some small gaps in the weaving occur where the color changes.

MURRAY L. EILAND, JR. AND MURRAY EILAND III, *ORIENTAL CARPETS, A COMPLETE GUIDE,* LONDON: LAWRENCE KING PUBLISHING 1998.

course. The weaving can be coarse, employing approximately eight warp threads per inch, or it can be much finer, employing twenty-four per inch. The weaving can also be patterned. Gold and silver threads, sometimes following the outlines of a design, sometimes not, can add a rich brocaded effect. Wool tapestries can be given vitality and sheen by introducing silk for certain highlights, or embroidery can be added for such details as the faces of figures. Even **appliqué** work and embroidery (as on the so-called Bayeux Tapestry of the Romanesque period) and paint can be applied, although appliqué, strictly speaking, is not actually tapestry, and painting on fabric is considered a degraded practice.

Tapestry has often been designed in imitation of painting, however, and even in imitation of Coromandel screens, although, at its best, it is its own art, imitating no other. The great beauty of Gothic tapestries lies in the qualities in which they are unlike paintings, and not in the qualities in which they resemble them. They are distinctly textile patterns and never attempt to compete with painted decoration. It is the design interest, not the pictorial interest, that makes them superior to later

weaves that followed more closely the modeling and detail of the painted **cartoon.** They are the most valuable tapestries on the market today, partially because of their rarity and partially because they are considered the finest examples of the art of tapestry weaving.

Tapestries were highly valued elements of Gothic interiors, both ecclesiastical and secular. There were other types of furnishings as well, of course.

Gothic Furniture

In the Gothic period, furniture continued a tradition that had been prominent in the Romanesque period, the tradition of imitating the architecture of the time. Naturally, therefore, rounded arches on furniture gave way to pointed ones, and plain surfaces

Figure 8–26 High-backed French Gothic throne of carved oak.

DRAWING: JACQUEMART

became more elaborately ornamented. The ornamental forms consisted almost entirely of small-scale carved architectural details such as tracery, pointed arches, rose windows, buttresses, finials, and crockets.

Local woods necessarily continued to be used, but there was a taste for natural-finished oak whenever it could be obtained. Occasionally walnut was used. Thrones and seats of honor, such as the one in Figure 8–26, were elaborately carved and sometimes gilded. Most of the pieces were heavy in their proportions and dimensions and rectangular in design. The parts were assembled with wooden dowels rather than screws or nails, and the wood joints employed included the **dovetail** and the **mortise and tenon,** two types of joinery that we saw used by the Egyptian woodworkers (p. 29). Sometimes the face of the stiles and rails of the case furniture were enriched by parallel grooves or reeds running lengthwise; as these features were cut before the piece was assembled, the grooves did not **miter** at the corners. Furniture panels were usually enriched with carved linenfold motifs, just as wall paneling was. There were also tracery motifs and coats of arms, and, as in the wainscoting, moldings were placed only on the top and two sides of the panel, the lower stile having a splayed edge.

Among liturgical furniture designed for the cathedrals, churches, and chapter houses, there were pews, stalls, pulpits, thrones, screens, and some important tables (Figure 8–27). The **rood** was a large cross that appeared in some churches, and the chancel screen that supported it was called a *rood screen.* The *misericord* was a type of bench with a hinged seat that could be raised, affording a surface against which a standing person could lean; the underside of the hinged seat was often grotesquely carved. Furnishings generally fashioned of carved stone were the fonts and the *piscinas,* the latter being stone basins in niches near the altar, used to receive the water in which the priest rinses the chalice.

Among residential furniture, the *chest* (Figure 8–28) was the most important piece because it could be easily transported, a necessary advantage during unsettled political conditions. The Gothic chair was frequently in the form of a small chest with arms and a high back, and was reserved for

Figure 8–27 A round fourteenth-century table from the chapter house of Salisbury Cathedral. Its top has been replaced.

ENGLISH HERITAGE/NATIONAL MONUMENTS RECORD

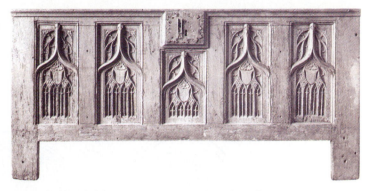

Figure 8–28 A fifteenth-century oak chest from France.

THE METROPOLITAN MUSEUM OF ART, ROGERS FUND, 1905 (05.24.13).

the use of important persons. The panel in the back was usually decorated with a carved pattern and often crowned with a wooden canopy. The dominant lines of the design of chairs were straight; the seat was square and covered with a loose cushion for comfort. The cupboard was a chest on legs. The *credence*, or serving table, originally derived its name from the Latin word *credere*, meaning "to believe," because food placed upon it was tested by a servant before it was offered to the master of the house, who lived in dread of poisoned potions.

Gothic beds were gorgeously carved and were sheltered with a canopy and curtains hung from the ceiling or supported by corner posts. Sometimes the canopy was made larger than the bed, to enclose a chair within the drawn curtains. A *hutch* or chest containing the family valuables was placed at the foot of the bed where it could be watched by its owners. A lamp hung within the canopy, and a stool or step was placed beside the bed. Beds were covered with mattresses, finely woven linen sheets, and many pillows. Servants or children frequently slept on a low *truckle* or *trundle bed* that was stored under the large bed and pulled out at night. A few benches and stools were placed in the smaller rooms, and in front of the fireplace was placed a bench with a movable back that could be swung so that the occupants could sit with either their faces or their backs to the fire.

The hardware on doors and Gothic case furniture was in hammered wrought iron and was always placed on the surface of the woodwork, rather than being let into the surface. Hinges, locks, and bolts with scroll and foliage designs were used.

The End of the Gothic

The Gothic style had demanded extraordinary dedication and effort from its builders, most of whom led difficult, impoverished lives. The Gothic style could not be sustained without an extraordinary faith. As the spiritual focus of the Middle Ages gave way to the humanistic focus of the Renaissance era and as religious fervor waned, the Gothic style would be replaced by a new architecture.

Summary: The Gothic Style

Some of the accomplishments of the Gothic style are visually summarized by Gilbert Werlé's drawing (Figure 8–29). These accomplishments still have the power to astonish. The daring of the Gothic builders still impresses. And, for many, the forms and towering spaces of the Gothic cathedrals still inspire worship. Perhaps it is easier now than ever to find the cathedrals admirable, now that we can no longer see the great contrast that must have existed between their grandeur and the squalor of other aspects of life at the time.

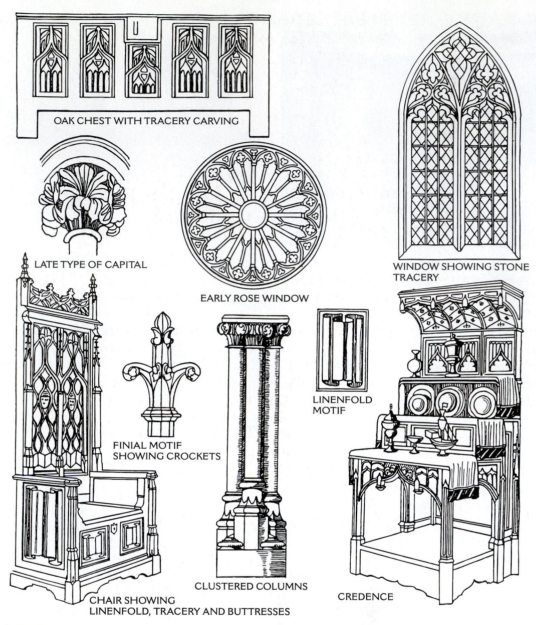

OAK CHEST WITH TRACERY CARVING

LATE TYPE OF CAPITAL

EARLY ROSE WINDOW

WINDOW SHOWING STONE TRACERY

FINIAL MOTIF SHOWING CROCKETS

CLUSTERED COLUMNS

LINENFOLD MOTIF

CREDENCE

CHAIR SHOWING LINENFOLD, TRACERY AND BUTTRESSES

Figure 8–29 Details of Gothic design.

DRAWING: GILBERT WERLÉ

Looking for Character

The supreme symbol of Gothic design and the most succinct embodiment of its character is the pointed arch. It is ubiquitous, serving as structural support, window frame, door frame, niche outline, furniture detail, and decorative carving. It appears in stone, wood, glass, metalwork, and tapestry. Like so much of Gothic architecture, it is both an economical solution to a constructional problem and—in its heavenward pointing—a potent sign of spirituality.

Looking for Quality

The highest quality in Gothic design is naturally found where the greatest amount of effort, energy, imagination, ingenuity, and funds were direct-

ed: in the great cathedrals. This is true not only for their building shells, but also for all their myriad components: their stained glass, their tapestries, their carvings, and their furnishings.

Even the most secular Gothic objects, far removed from liturgical use, reach their highest level of achievement when they take their inspiration from the cathedral.

Making Comparisons

We have already mentioned the differences between the sturdy masses of the Romanesque style and the airy dematerializations of the Gothic. We have also made some comparisons between the Gothic cathedrals of France and those of England, Germany, and Italy.

In the next chapter we shall see a very different kind of design—that of the Islamic world—that has been practiced during many of the years covered so far in this section on the Middle Ages. Islamic design will be seen to share some motifs with the Gothic, such as the pointed arch. It will also be seen to share some philosophical parallels, such as theology-based controversies about the proper role of ornament. But Islamic and Gothic design are vastly different from one another, as we shall also see.

Finally, one of the most striking contrasts in the history of design is that between the Gothic and the Renaissance that would directly supersede it. The Gothic was inspired by the emotion arising from religious faith in forces not of this world; the Renaissance by reason arising from knowledge of this world and a new respect for humanity. The Gothic was highly original; the Renaissance would seek a rebirth of classical design. The Gothic accomplishment was dominated by the great cathedrals; the Renaissance would have its great churches, too, but also great palaces and places of public accommodation.

Because of this striking revolution in culture and design, we shall—after our look at Islamic design—take this occasion to break with our generally chronological survey and look at what has been happening in the ancient civilizations of the Eastern Hemisphere. When we return to Europe in the Renaissance period, we shall witness the birth of a new attitude, offering new sources of pleasure, new levels of self-esteem, and a new freedom from the oppression of religious strictures. It will have to be expressed in new design.

9

ISLAMIC DESIGN

A.D. 622 TO THE PRESENT

slamic design is a term different from most of this book's chapter headings. It does not denote a specific period of *time,* as Victorian and Early American design do. It is placed here because it began and flourished during the Middle Ages, but it continues to flourish today. That flourishing has not been steady and continuous, however: as Jonathan Bloom and Sheila Blair have pointed out, in the year A.D. 1000, Islamic art was being produced in Spain but not in Turkey, yet in 1500 it was being produced in Turkey but not in Spain. Islamic design does not denote the design of a specific *location,* as Egyptian and Chinese design do, because Islam's influence is seen in many parts of the world, not only in the Middle East, but

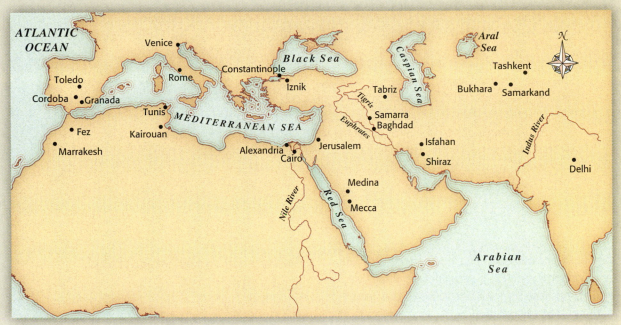

Figure 9–1 ISLAMIC LANDS

ORTELIUS DESIGN

also in North Africa, in Europe, and in Asia; we shall consider outstanding examples of Islamic interiors in our chapters on India and Spain. Although its branches certainly share some stylistic characteristics, Islamic design does not denote a *style* as strictly as Romanesque and Gothic design do; any art form that stretches around the globe and extends for thirteen centuries must undergo many changes. And, finally, it does not denote a *religion* as strictly as Buddhist and Christian design do, because Islamic design covers all aspects of life, and the buildings, interiors, and decorative elements we shall see here are by no means all designed for religious use; furthermore, one sometimes sees references to Jewish Islamic art and Christian Islamic art, products of Jewish and Christian communities within the sphere of Islamic control.

Islamic design, therefore, is not tied to any one place or time or use, and our definition of it must be a long and cautious one: design that is the product of cultural groups that, in general or in the majority, profess the Islamic faith. This faith was founded by the Prophet Muhammad in the year A.D. 622 when he established himself as the head of the (then small) Muslim community. That year in the Christian calendar is the first year of the Muslim calendar, and one definite thing we can say about Islamic design is that it cannot have existed earlier than that date.

Even so, just as Early Christian design built upon pre-Christian models such as the temple and the basilica, early Islamic design built upon the traditions, the climates, the materials, and the methods of the various lands where it was found. These local conditions were determinants of the national variations within Islamic design. Some of its characteristics—notably geometric ornament—can even be said to have been based on the Christian art of Byzantium, heir to the pagan civilizations of Greece and Rome, of which the earliest Islamic design was itself an inheritor. The Persian Empire, with a foothold in southwestern Arabia, was also a factor. And centuries later, Islamic design showed the very different influence of the arts and decorative motifs of China.

There were also temporal variations, of course. Various dynasties and their rulers had differing tastes and differing priorities, and in all Islamic lands the structures and decorations of

The Muslim calendar begins with the departure of Muhammad from Mecca to Medina, a day that the Christian calendar calls July 16, A.D. 622. The Muslim year, related to lunar rather than to solar cycles, has only 354 days, so that correspondences between the two calendars are more complex than the simple subtraction of 622. Another consequence of the short Muslim year is that months are unrelated to seasons, so seasons are often indicated in the Islamic world by referring to the signs of the zodiac.

prosperous times differed from those of political and economic decline. Such differences included, in good times, the use of stone rather than mud brick, a higher degree and quality of ornamentation, and the preservation of older structures rather than their destruction in order to reuse their materials. Similarly, decorative objects in precious and semi-precious metals were preserved in prosperous times but melted down in other times.

The characteristic that unified all these geographic and temporal variations was the religion of Islam.

Islam as a Determinant of Form

Islam means "submission to God." Like Judaism and Christianity, it is a monotheistic religion and, like them also, it has a basis in prophecy. Its prophet was Muhammad, a native of the city of Mecca in what is now Saudi Arabia. Opposition to his preaching led to his emigration (hegira, from the Arabic *hijra*) 200 miles (320 km) north to the city of Medina in A.D. 622, where he continued to preach and began to organize the first Muslim state.

- The terms *Muhammadan, Muslim,* and *Islamic* are almost—but not quite—synonymous, *Muhammadan* meaning "a follower of Muhammad," *Muslim* meaning literally "one who submits [to God]," and *Islamic* meaning "a follower of Islam," the religion founded by Muhammad. A distinction between the three terms is that *Islamic* may be slightly broader, referring not only to a religion, but also to the culture associated with it. Variant spellings of *Muhammadan* include *Mohammedan, Muhammetan,* and *Mahomettan. Muslim* is also seen as *Moslem.*

- There is a group of terms that relate to geographic areas under Islamic influence, such

as *Iranian* and *Turkish.* And there are terms that relate to geographic areas only at certain times: *Sassanian,* for example, refers to pre-Islamic Iran, and *Ottoman* refers to the lands including—but not limited to—Turkey during the Ottoman Empire, founded by Osman in the thirteenth century. *Saracenic* relates to Northwestern Arabia, but it can also refer to some Sicilian construction, for the Saracens ruled in Sicily from the ninth to the eleventh centuries.

- There is another group of terms that refer to particular dynasties of Islamic rulers. These need not be defined here, but they include such names as Safavid, Timurid, Fatimid, Abbasid, Umayyad, and Seljuk.

After Muhammad's death, in 632, there was an impressively rapid territorial expansion of Islamic influence, with military forces carrying the new religion into Egypt, Syria, Iran, and Iraq, and eventually into North Africa and Spain and the steppes of Central Asia.

Following Islam's military conquests between the seventh and fourteenth centuries, great Middle Eastern cities were built that became seats of learning, science, and art, many of them responsible for preserving the records of antiquity while western Europe was in chaos. Mecca was the center of the faith; Kufa and Basra were the seats of Arabian theology. Damascus boasted of her poetry, science, and industry. Baghdad, built on the ruins of ancient Babylon, was one of the proudest cities in the world. The mere mention of Tabriz, Isfahan, and Samarkand recalls the entrancing descriptions and events related in the *Thousand and One Nights*. Delhi, Agra, and Lahore, in India, and Cordova, Seville, and Granada, in Spain, were centers of luxury and splendor whose beauties still remain.

Muhammad's teachings are collected in the Koran (or *Qur'an*), the sacred book of Islam. For the faithful, the teachings specify five obligations, called the Five Pillars of Islam: the profession of faith; charity to the poor; daytime fasting during the annual period of Ramadan; a pilgrimage *(hajj)* to Mecca at least once during a lifetime; and, five times a day, a ritual prayer (performed, if possible, in a mosque), the most important prayer of the week being the one at midday on Friday (performed, if possible, in a city's congregational mosque, called the *masjid al-jami*, or Friday Mosque).

This last obligation, of course, has architectural implications. The most important types of Islamic architecture are religious buildings such as the mosque, the shrine, the convent, the religious school *(madrasa* or *medrese)*, and the mausoleum,

TIMELINE — ISLAMIC DESIGN

PERIOD	DATE	POLITICS, CULTURE, AND RELIGION	ACHIEVEMENTS IN ART AND DESIGN
Early Islamic	622– c. 900	Migration of Muhammad, 622; his death, 632; rule of the caliphs; great territorial expansion;Umayyad dynasty rules in Syria, late 7th century; Baghdad founded by Abbasids, 762	Umayyad hunting lodges and mosaics; Dome of the Rock, 691–92; Great Mosque, Damascus, Syria, 706–15; Great Mosque, Kairouan, Tunisia, 836 and later; Great Mosque, Samarra, Iraq, 848–52
Medieval	c. 900– c. 1250	Fatimid dynasty begins, 909; Marrakesh founded by Almoravids, 1062; Berber empires, 11th and 12th centuries; Mongol invasions led by Genghis Khan end Seljuk rule	Rock crystal carving in Cairo, 11th century; jade carving in India; ivory carving in Spain; Friday Mosque, Isfahan, Iraq, 1089; Citadel begun in Cairo, 1183
Late Medieval	c. 1250– c. 1500	Baghdad sacked by Mongols; Mamluk regime; Osman founds Ottoman Empire; Timur creates Timurid empire; Sa'di dynasty in Morocco; Sufism	Rise of artists as independent personalities; establishment of carpet factories; expansion of Isfahan; construction of Topkapi Palace, Istanbul, begins, 1473
Early Modern	c. 1500– c. 1800	Safavid dynasty in Iran, 1501–1732; Suleyman the Magnificent, Sultan, 1520–66; Shah' Abbas, 1588–1629; Napoleon invades Egypt, 1798	Iznik pottery; architecture of Sinan: Suleymaniye Mosque, Istanbul, 1552–59, and Selimiye Mosque, Edirne, 1569–75; Blue Mosque, Istanbul, 1609–16; Ali Qapu Palace, Isfahan, 1597

✦ VOCABULARY — ARABIC SPELLINGS

- The transliteration of Arabic terms into English has many variants. Here it is done without the diacritical signs present in some texts and without the final *h* that some writers prefer: *hijra* and *madrasa,* rather than *hijrah* and *madrasah.* A final *s* has sometimes been added, however, to make plural forms seem more consistent with English grammar.
- Arabic is not the only traditional language of the Islamic world. Others include Persian, Hindustani, Urdu, and Turkish. All these have their own quirks of transliteration.

and secular buildings such as the palace, the citadel, the bazaar, the hospital, and the inn for traveling caravans (caravanserai). Secondary constructions include the *minaret,* a slender tower attached to—or near—a mosque from which the faithful can be called to prayer, and such structures as bridges and fountains. Of all these, the most important by far is the **mosque.**

The Islamic ritual of worship within the mosque was strictly codified and invariable throughout the Muslim world, demanding interiors with a few essential elements. These included a central area, either opened or covered, where the faithful could pray; a prayer niche or **mihrab** (Figure 9–2) indicating the direction of Mecca, which the faithful faced during their prayers; a pulpit or **minbar** (Figure 9–3) adjacent to the prayer niche; and a water basin where the faithful performed a ritual wash-

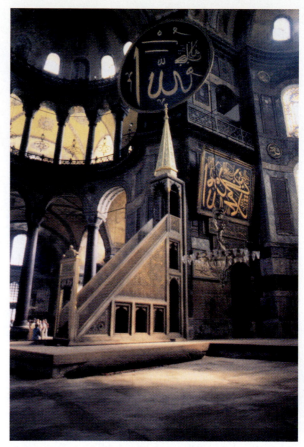

Figure 9–3 A minbar in a mosque in Istanbul, Turkey. From its top, the sermon is preached during Friday prayers.

Figure 9–2 Iranian Mihrab faced with ceramic mosaic, c. 1354, 11 ft. 3 in. (3.5 m) high. Composite body, glazed sawed to shape and assembled in mosaic.

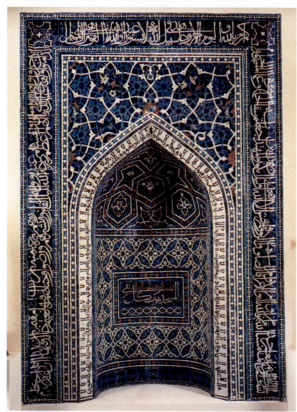

ing before their prayers. The mihrab niche may have been derived from the apse of the Roman throne room and is traditionally the most highly decorated part of the mosque interior. The steeply stepped minbar is usually adjacent to the mihrab and is most commonly built of wood, although there are examples in stone and brick; the minbar also is richly decorated with panels and carvings, and it generally carries an inscription honoring the sultan in whose reign it was built.

These simple requirements were joined, naturally, by more elaborate architectural conventions such as arcades, portals, and supplemental prayer halls. These were not strictly necessary for the performance of the required ritual, but became customary nevertheless. And the structure of the mosque, though basically simple, came to be dazzlingly ornamented.

Islam as a Determinant of Ornament

Much has been written about what Islamic ornament is *not*. Because of religious constraints, we often read, it is not representational of living things, and is consequently reliant on geometric design. This is partially true, but an oversimplification. The proscription of representational art was not total, but varied greatly with both time and location. Indeed, a characteristic of much Islamic art is the representation of luxuriant plant life, although it does tend to be highly stylized. Animal forms appear less often, human forms scarcely at all, and almighty Allah never. For a Muhammadan, the depiction of God as an old man with a beard (as in the work of the great Michelangelo in the Italian Renaissance) would seem both blasphemous and ridiculous.

Geometry was a natural alternative to the depictions of humans and animals. In the development of geometric patterns, the most complicated interlacings of straight lines occur (Figure 9–4). Squares, rectangles, hexagons, octagons, stars, and an infinite variety of irregular and overlapping forms are seen. In ceramic and textile design, rosettes, pearls, dots, hatchings, diamonds, circles, stars, vase forms, and many other motifs were employed. **Diaper** patterns—checkerboards of lozenge shapes—were often subdivided into panels formed by lines or bands arranged in an ogival, circular, or scalloped manner. Walls were given interest by alternating red and white stone courses, producing horizontal stripes, a system that was also used in the **voussoirs** of arches. Stalactite forms were occasionally used for brackets or a decoration on the underside of domes.

But geometry was not the only recourse of Islamic artists. They also made abundant ornamental use of plant forms, but in a highly stylized manner. One example is that the generally slender columns of Islamic architecture were crowned with capitals that vaguely resembled the Corinthian shape but were covered with minute leaves of lacelike detail. Elsewhere, scrolls were developed from stems and pseudo-acanthus and palmette leaves.

Prominent among Islamic ornament is a composition based on plant life that is aptly called the **arabesque** (Figure 9–5), a designation that was

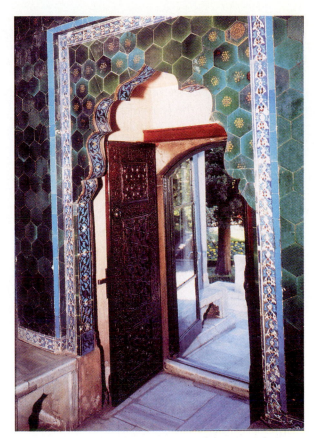

Figure 9–4 In a mosque at Bursa, Turkey, seen through a multifoliate arch with several cusps, a door panel is carved with geometric shapes within borders of calligraphy.

F. GODFREY GOODWIN

Figure 9–5 An arabesque carved in stone at the mausoleum of Timur in Samarkand, Uzbekistan.

PHOTO: JOSEPHINE POWELL

later misapplied to similar forms of classical ornament. This pattern consists of a stem rising from a root, from which branch conventionalized flowers,

fruits, leaves, and abstract shapes that overlap and interlace. The conception of the arabesque probably originated in the Assyrian tree-of-life pattern from the ancient Near East (Figure 3–6). The term *arabesque,* however, was invented in the Italian Renaissance, as was the term *moresque;* the distinction between the two is a small one, the first word referring to ornament of the North African Arabs and the second to ornament of the Spanish Moors. Owen Jones, in his 1856 book *The Grammar of Ornament,* makes the distinction that "the constructive features of the Arabs possess more grandeur, and those of the Moors more refinement and elegance." Jones also says that the Moors developed ornament on several overlapping planes, while Islamic design of the Middle East tended to be on a single plane, and he detected (or perhaps imagined) a "fixed law, never broken by the Moors, that however distant an ornament, or however intricate the pattern, it can always be traced to its branch and root." We shall see some of this Moorish ornament in Chapter 14.

In discussing Islam as a determinant of ornament, it is necessary to distinguish among various sects of Islam, for different sects have different attitudes toward design as well as toward religious matters. Two major sects are the Sunni and the Shia (or Shiite); a seventh-century dispute over the proper succession to Muhammad led to the long-lasting schism between these two factions.

The Sunni were orthodox Muslims who held that, after Muhammad's death, leadership of the Islamic community was elective. Prominent in Turkey, Arabia, and Spain, the Sunni were strictly opposed to the representation of living things in art, on the basis that they were idolatrous.

The Shia held that Islamic leadership could only be hereditary—that is, only direct descendents of Muhammad could rule. Prominent in Persia and India, the Shia held more liberal artistic views, however, that allowed floral, animal, and human subject matter in their designs. In Shia designs, real and imaginary animals play a prominent part; the ibex was a royal symbol, and the lion represented power. Equestrian subjects were common. Human beings, birds, leaves, flowers, ivies, and trees were often beautifully combined in patterns or arabesques. Pinecones were considered a symbol of good luck. After the Mongol invasion, patterns often also showed the use of Chinese motifs such

as clouds, butterflies, rose and peony blossoms, and plants growing out of rocks.

Sufism must also be mentioned, a mystical and ascetic order that emerged from the Shia sect in the last years of the tenth century and later became integrated into some Sunni sects. Its name derives from the fact that Muslim mystics often dressed in cloaks made of coarse wool *(suf).* The Sufis maintained craft guilds, considered artistic beauty a reflection of inner beauty, and were firm believers in a saying attributed to Muhammad, "God is beautiful and loves beauty." The Sufis were not only inclined to value the arts, but also to value art of a specific kind: ecstatic, allegorical, metaphorical, and rich with layers of religious reference not immediately obvious.

No matter what the sect of the artist, however, some general principles apply to all Islamic design. All patterns are relatively small in scale, and much conventionalization is used. Even when the representation of living things is allowed, the emphasis is always placed on the decorative quality rather than the representational.

Varieties of Islamic Architecture

In addition to the great cities already mentioned as centers of Islamic culture, there was also an Islamic tradition of nomadic life, served not by permanent structures, but by tents. One of the tents of the ruler Timur, pitched on a plain near Samarkand, was said to be large enough to hold 10,000 people, but visible evidence has vanished. Another of Timur's tents was described as having gates, an upper gallery level, battlements, and turrets, and its interior was said to have been richly furnished with carpets, tapestries, and silk cushions.

Some audiences, banquets, and religious services were held outside without even a tent, and these also employed carpets and fabrics. The famous Ardabil carpet, for example (Figure 9–6), now in London's Victoria and Albert Museum, at 36 feet (11 m) long, is too long to have fit in any room of the Ardabil shrine and must therefore have been used outside.

The study of the interiors of nomadic tents and of decorative objects designed for use either in tents

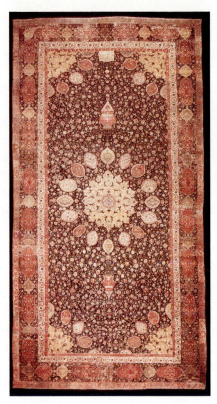

Figure 9–6 The Ardabil carpet of knotted wool pile, one of a pair made in 1540 in Iran.

or in the open air is limited, of course, by the general impermanence of such structures and objects. Today we can only imagine what some great tented spaces must have been like, with their richly colored fabric flowing between exposed structural elements and billowing in the wind, and with the earth beneath covered with fine carpets. We shall look instead at a few more fixed structures and at one already familiar building that strongly influenced many of them.

The Influence of Hagia Sophia

In chapter 6, we considered the Hagia Sophia, built in stages after 537, as one of the great buildings of the city of Constantinople, one of the great buildings of the Byzantine era, and one of the great buildings of Christianity. The Islamic people who came to rule Constantinople and all of Turkey naturally saw it differently: as one of the great buildings of their own inheritance. Just as the early Christians

did not hesitate to adopt the temples and basilicas of pagan classicism for Christian purposes, the Muhammadans did not hesitate to adopt this Christian monument for Islamic use. The great example of the Hagia Sophia is visibly respected in many of the finest mosques of the Islamic world, some of them, such as the Suleymaniye Mosque and the Blue Mosque, within a few yards of their great model.

But Islam not only adopted Hagia Sophia; it also adapted it. Minarets were added in the fifteenth century, making it conform to what had by then become an Islamic tradition and doing little harm to the great composition. More serious damage came when the famous tile work, mosaics, and marbles of the interior were obliterated under white paint and inscriptions from the Koran. Restoration began in the late twentieth century.

The Dome of the Rock, Jerusalem (692)

Islamic architecture's earliest major monument remains its most revered and one of its most impressive, but not one of its most typical. The Dome of the Rock was built in Jerusalem in the year 692, within an enclosure called the Noble Sanctuary (Haram al-Sharif). Although the building is much altered, much of its seventh-century character remains. Its basic form, an octagon with a central dome, is reminiscent of centrally planned Christian buildings such as baptisteries or martyria. On the exterior, four of its eight sides have projecting columned porches with vaulted roofs, facing the cardinal points of the compass (Figure 9–7). The lower part of the exterior wall is faced with marble; the upper part, originally faced with mosaic, has been tiled since the sixteenth century. The dome is a double shell of metal-plated wood rising 114 feet (39 m); it was probably gilded from the first, but in modern times it has been sheathed in gold-anodized aluminum.

Inside, the octagon of the exterior wall is duplicated by an inner one supported by eight piers, one at each intersection, with two slender columns between each pair of piers. Within the inner octagon is a circular wall supported on four piers, with three slender columns between each pair (Figure 9–8). Tie beams, faced in metal with ornamental **repoussé** reliefs, connect the piers and columns of

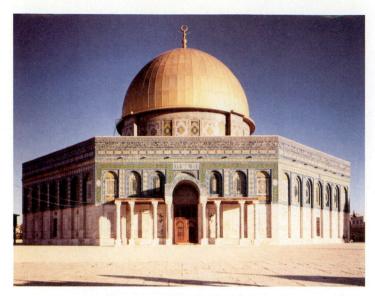

Figure 9–7 Exterior view, Dome of the Rock, Jerusalem, Israel, completed in 691.

SCALA/ART RESOURCE

these inner constructions, and, less structurally, they are also connected by an underlying geometric order (Figure 9–9).

Innermost of all is a sacred rock outcropping, believed to be the spot from which Muhammad ascended into the heavens. Beneath the rock is a grotto with a flat mihrab of black stone.

The most remarkable aspect of the Dome of the Rock, however, is its interior array of mosaics (Figure 9–10). Above the arcades are inscriptions from the Koran with gold calligraphy on a dark blue ground. Elsewhere are elaborately curled scrolls of stylized plant materials—acanthus, grape, and palm among them. Garlands and vases are also recognizable, although some of the patterns, as on the soffits of the arches, are purely geometric abstractions. The mosaics' colors are cool greens and blues, enlivened by the iridescence of mother-of-pearl and the glitter of gold, this last provided by glass **tesserae** in which bits of gold foil have been embedded.

The Great Mosque, Kairouan, Tunisia (836 and Later)

One of the early great mosques of North Africa is the ninth-century one at Kairouan (or Qairouan or Qairawan), Tunisia, altered and enlarged in the eleventh and thirteenth centuries. Beyond a courtyard entered by eight doorways, there is a great hypostyle sanctuary of almost two hundred columns. The marble mihrab is surrounded by over a hundred luster-glazed tiles, possibly imported from Baghdad (Figure 9–11). The minaret, predating more slender versions, is based on the stepped multistoried form of Roman lighthouses. The entrance

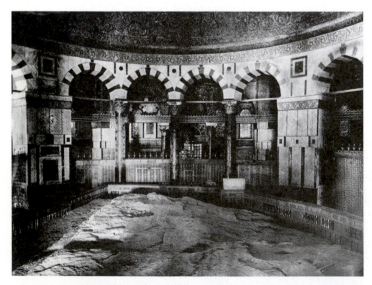

Figure 9–8 Interior, Dome of the Rock, looking across the central rock outcropping toward the encircling ambulatory.

LIBRARY OF CONGRESS

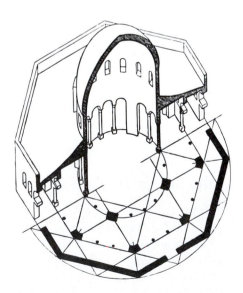

Figure 9–9 Plan/section diagram showing the geometric order of the plan of the Dome of the Rock.

DRAWING: AUGUSTE CHOISY

Figure 9–10 Mosaics inside the Dome of the Rock.

JANE TAYLOR/SONIA HALLIDAY PHOTOGRAPHS

porches, the arcade around the courtyard, and probably the top story of the minaret are among the later additions.

Suleymaniye Mosque, Istanbul (1550–57)

The Suleymaniye Mosque was built by the great architect Sinan for his chief patron, Sultan Suleyman, often called "Suleyman the Magnificent." The mosque is the dominant element in a great complex of buildings including religious schools *(madrasas),* a medical school, student quarters, an area for a bazaar, a hospital, a kitchen, a bath

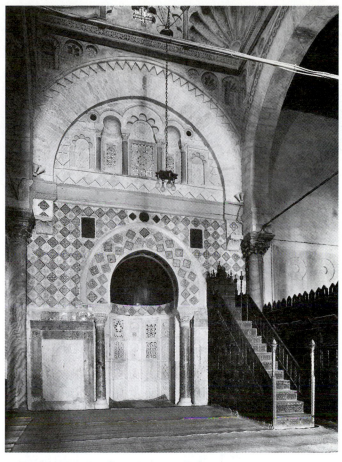

Figure 9–11 In the Great Mosque, Kairouan, the mihrab is surrounded by luster-glazed tiles, and the triangular wood sides of the minbar are carved in complex vegetal patterns.

A. F. KERSTING

PROFILE SINAN

Sinan (c. 1490–1588) was the chief architect for a series of powerful sultans (Suleyman the Magnificent and two of his successors) during the most glorious period of the Ottoman Empire. Both the number and the size of his works are astonishing. His biographers credited him with the design of 460 buildings, including 136 mosques, 57 religious schools *(madrasas),* and 48 public baths *(hammams).*

Sinan was fifty years old before he built his first building, his earlier work having been as a soldier, bodyguard, mechanic, and engineer. With that background, he came to architecture with an extremely practical knowledge of construction. His many experiments with the possible forms of monumental domed structures were all guided by that sense of construction logic, not—as is the case with Italian Renaissance architects working at the same time, such as Bramante and Leonardo—by theories of geometric combinations and formal harmony. Sinan was, in the fullest sense, a master builder.

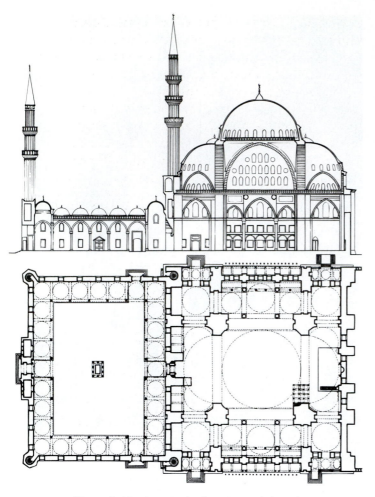

Figure 9–12 Longitudinal section and plan, the Suleymaniye Mosque, Istanbul. The height of the tallest minarets is 272 feet (83 m).

AFTER VOGT-GÖKNIL

Figure 9–13 Detail of the door, Suleymaniye Mosque.

F. GODFREY GOODWIN

complex, and the mausoleums of Suleyman and his consort Roxelana.

The building's great dome has a diameter (87 feet or 26.6 m) that is half its height, and it rests on four massive piers (Figure 9–12). Unlike the shadowed mystery of its great model, Hagia Sophia, the Suleymaniye Mosque is flooded with light, and the structural system supporting the dome is made obvious. The entirety of the huge building can be perceived at a glance.

The interior surfaces are enriched with great quantities of tiles, constituting the first large commission given to the tile makers of Iznik. Also specially commissioned for the mosque were wood carvings (Figure 9–13), stained glass, carpets, mosque lamps, and Koran manuscripts and stands to hold them. In all, more than 3,500 craftsmen are said to have worked on the mosque.

Near it is the mosque of Sultan Ahmed, designed by a follower of Sinan, Mehmet Aga, and dating from 1609–16. Its six slender minarets give the exterior a sense of lightness, and the 21,000 blue Iznik tiles of its interior have given it the popular name of the Blue Mosque (Figure 9–14).

Topkapi Palace, Istanbul (begun 1459)

The Arabic word for place is *saray* or *sarai*, a *caravanserai* being a lodging place for travelers in a caravan. The Topkapi Palace is therefore also called Topkapi Saray, and so great is the building's prominence over all others of its type that it is sometimes called simply "The Saray." It dominates the point of land overlooking the Sea of Marmara and the Golden Horn, occupying the site of an earlier structure, the great palace of the Byzantine emperors. Begun in 1459, the construction of Topkapi continued over several centuries, and some additions in the sixteenth century were designed by the great Sinan, including the gigantic kitchen complex that remains the complex's largest single structure. Topkapi remained the chief residence and administrative center of the Ottoman sultans until the nineteenth century. It is now a museum.

The overall effect of Topkapi is that of the accretion of many different ideas and styles. It lacks

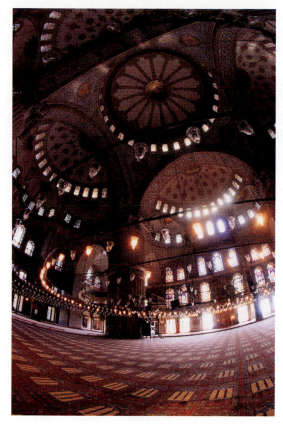

Figure 9–14 Interior of the Blue Mosque, Istanbul.

GLEN ALLISON/PHOTO DISC, INC.

a powerful unified image, but it does possess a clear organization: The plan is of scattered pavilions, kiosks, halls, harems, libraries, and service buildings, but these all find their proper places within three consecutive courtyards. These three are arranged in the order of increasing privacy, with only the sultan, his family, his most honored guests, and their attendants allowed into the innermost courtyard and its structures. The royal audience hall is one of these most private structures.

A relatively late but unusually agreeable interior among Topkapi's various elements is that of the Kara Mustafa Pasha Koschku (Kiosk of Mustafa Pasha) within the innermost courtyard (Figure 9–15). It is simple and open, but with an elaborately molded, paneled, and painted ceiling. Its slightly raised seating platform enjoys views through generous expanses of window.

Islamic Furnishings and Decorative Arts

Although the exteriors of Suleymaniye and the other great Islamic mosques were designed to make an impressive display, other examples of

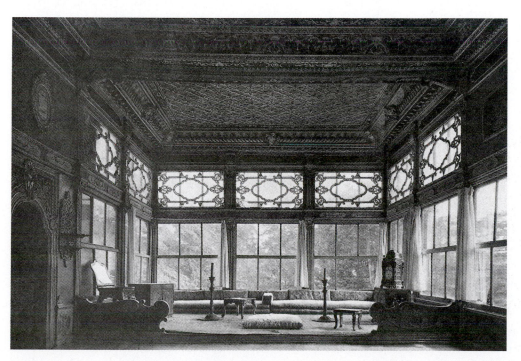

Figure 9–15
The Kara Mustafa Pasha Koschku in the Topkapi Palace, Istanbul. Its large windows overlook the sea.

PHOTO: EDUARD WIDMEN, *OTTOMAN TURKEY,* HENRY STIERLIN, ED. © BENEDIKT TASCHEN VERLAG GMBH.

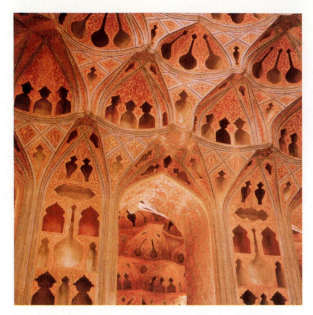

Figure 9–16 Muqarnas of the Music Room of the Ali Qapu Palace, Isfahan, Iran, begun in the late sixtenth century.

PAUL ALMASY/CORBIS

Islamic architecture—like most elements of the Topkapi complex—are unassuming in exterior massing but bursting with vitality and creative energy in the decoration of interior spaces. Even in the great mosques, the brilliant colors of interior tile and mosaic work can hardly be guessed at from outside the building.

It can also be said—and again Suleymaniye is a powerful exception—that Islamic interiors do not as a rule display the structure that supports them. Elaborate stucco or plasterwork or even carved woodwork may appear to be structural, but that appearance is often false, however delightful the effect may be. Typical of such effects are the *muqarnas* found overhead in many important Islamic interiors.

Muqarnas

Also called *honeycomb work* or *stalactite work*, **muqarnas** consist of superimposed tiers of concave shapes, like a great network of adjacent **pendentives.** One example is in the Music Room of the Ali Qapu Palace, one of the structures edging the Royal Maidan, the great open space of Isfahan. Ali Qapu means "Lofty Gate," and the building was

built in stages between 1597 and 1660. The Music Room's stucco work is pierced in shapes that resemble Chinese porcelains and musical instruments (Figure 9–16); the actual building structure is beyond and unseen.

Muqarnas are also prominent features of the domed ceiling of a pleasure pavilion called the Hesht Behest (Eight Paradises), also in Isfahan. It dates from 1669. Octagonal in shape with a cruciform plan, the interior opens through four great portals to views of the surrounding Garden of the Nightingale, delightfully integrating interior and exterior spaces. Alterations made in the 1920s unfortunately covered with stucco much of the original ornament.

Woodwork

Ornamental woodwork was an important part of Islamic buildings and interiors, although it was in scarce supply in some Islamic lands. When available, it was used for a number of architectural elements—door panels, wall panels, tie beams—and was used as well for smaller objects—furniture, chests, Koran covers. Exuberant floral motifs are common, in varying degrees of geometricization, their exuberance often held in check by surrounding geometric frameworks—rectangles, ovals, lozenge shapes. Within the carved wood pieces, there were often inlays of ivory, bone, and mother-of-pearl.

A particular glory of Islamic woodwork is the open grille of turned wood members, sometimes used within a mosque to separate a princely sanctum from the rest of the congregation. An example is in the thirteenth-century tomb of Sultan Qala'un in Cairo (Figure 9–17). And a particularly interesting and prevalent use of turned-wood grillwork is the *mashrabiya* or window grille (Figure 9–18). Found throughout the Islamic world, its chief use is as a privacy screen for the women's quarters of a residence or palace, allowing the women inside to observe the street life outside, while preventing them from being seen.

Stucco

Another medium for Islamic ornament is stucco, a composition similar to plaster. It can be molded

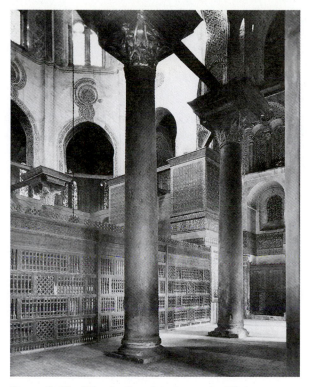

Figure 9–17 Wood grillwork in the tomb of Sultan Qala'un, Cairo, Egypt c. 1285.

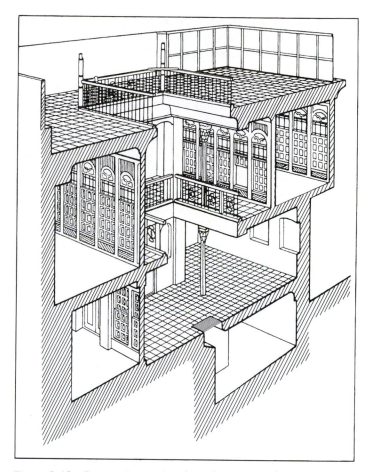

Figure 9–18 Perspective section through a courtyard house in Baghdad, showing window openings filled with grillwork.

while damp or allowed to harden and then carved like wood. Because it is relatively cheap and can be applied relatively quickly, it was extremely popular. Ornamental effects vary from simple crosshatching to elaborate geometricized vegetal forms. Fine examples are found in the ruins of the ninth century Balkuwara Palace in Samarra (Figure 9–19).

Painting and Lacquer

Islamic artists, particularly those of Persia, excelled in the arts of illuminated manuscripts and miniature painting. Many of these productions, despite their small size, are considered masterpieces. An infinite range of storytelling subject matter was used, including court and amorous scenes, folklore, historical and religious events, landscapes, animal fights, *houris* (beautiful maidens) of the Muhammadan paradise, and portraiture. The pictures are often composites of several scenes, and the eye roams until the whole story is understood. The

Figure 9–19 Stucco wall decoration, Balkuwara Palace, Samarra, Iraq, Staatliche Museen zu Berlin-Preussischer Kulturbesitz, Museum fur Islamische Kunst. Photo by Ernst Herzfeld. Bildarchiv Preussischer Kulturbesitz, Berlin 2002. Built from 849 to 859.

compositions show breadth of conception, balance, mastery of detail and color, and, with a high horizon line, usually appear as bird's-eye views. Perspective was used, but shadows were generally omitted. The artists showed skill in eliminating unnecessary features and often conventionalized for the sake of simplicity.

In addition to its use in miniatures and manuscripts, the technique of painting was also often applied to architectural elements and furnishings, as was the more durable technique of enamel work. Most of the woodwork and stuccowork already mentioned was painted or enameled. But the favorite Islamic surface treatments were mosaic work and tile.

Mosaics

Mosaics were used on both building exteriors (as was originally the case at the Dome of the Rock) and on the interiors, as flooring as well as wall decoration. When used as flooring, mosaic work sometimes was designed in imitation of rugs or carpets; at other times, it was gloriously abstract and endlessly inventive, as in the eighth-century baths at Khirbat-al-Mafjar, near Jericho (Figure 9–20).

In the grandest of mosques and palaces, gold glass mosaic was used. Even the most ordinary

mosaic work, however, was relatively difficult and expensive. Ornamental and pictorial effects were more readily available with tile.

Tile

Islamic design is hardly imaginable without the profuse and virtuoso use of glazed ceramic tile. Like mosaics, these were used outside and in, on both vertical and horizontal surfaces. A sample of the brilliant, decorative effects of tiled walls is seen in Figure 9–21, part of the Selimiye Mosque in Edirne. Built between 1569 and 1575 for Selim II, it was another of the great building designs by Sinan.

Production techniques for tile are related, of course, to those for other ceramic work, to be discussed shortly. Here we need only note that the range of sizes of Islamic tiles was enormous, from a few inches to 3 feet (8–100 mm) high, and the quality often displayed an impressive technical command.

Designs with tile can be divided into two basic types: those in which the design is made by the outlines of the tiles themselves, and those in which the design extends across numbers of tile. In the first type of design, the tiles are plain but eccentrically shaped, and the design is derived from the interlocking of those shapes (Figures 9–22a and 9–22b). In the second type, the tiles are simple in shape but covered with complex patterns that are unrelated to those shapes, as in the decorative tile panel in Figure 9–23, page 210.

Tiles of both types, but usually of the first type, were sometimes combined to form small decorative panels *(kashi);* these were prepared in advance and then set into a wall surface, over bricks, or within a bed of stucco.

Having briefly considered some of the Islamic decorative elements and techniques applied to building shells— muqarnas, woodwork, stucco, paint and lacquer, mosaics, and tile—we shall now look at some of the smaller, more movable decorative elements housed within those shells.

Furniture

It has been said that Islamic interiors are rooms without furniture. This is an exaggeration, but

Figure 9–20 Mosaic flooring in the ruins of the baths at Khirbat al-Mafjar, Jordan.

COURTESY ISRAEL ANTIQUITIES AUTHORITY

Figure 9–21 Tiled vaults and domes in the Selimiye Mosque, Edirne, Turkey.

Figure 9–22a A tile pattern using only two tile shapes.

Figure 9–22b A tile pattern using seven tile shapes.

Figure 9–23 Panel of twenty-eight Iznik-ware tiles in blue, turquoise, and green, showing a Tree of Life growing from a Vase of Immortality. Turkish, c. 1650–1700.

VICTORIA AND ALBERT MUSEUM, LONDON/ART RESOURCE, NY

certainly the amount of furniture was minimal compared to that of most other cultures, luxurious carpets and cushions being preferred to seats and benches. One factor may have been that wood was scarce, yet there were examples of wood furniture. In domestic interiors there were storage chests and low tables, and in mosques there were the pulpits called **minbars,** the screened enclosures called *maqsuras,* reading stands (Figure 9–24), and bookcases. In both mosques and houses there were elaborately carved wooden boxes for storing manuscripts of the Koran, such a box being called a *koursis* (Figure 9–25).

Important also were long, low benches, some of them upholstered in luxurious fabrics. Examples are visible in the Topkapi Palace interior (Figure 9–15). The Arabic word for such a long seating element was *suffa,* obviously the source of the English word *sofa.*

Figure 9–24 A carved wood reading stand for the Koran.

HASAN IBN SULAYMAN OF ISFAHAN, KORAN STAND, TURKESTAN, WEST. WOODWORK, 14TH CENTURY, 1360. CARVED WOOD. H. 51¼ IN. (130.2 CM). THE METROPOLITAN MUSEUM OF ART, ROGERS FUND, 1910 (10.218)

Ceramics

Islamic ceramics are of many types and reached pinnacles of excellence. Many grades of ceramics were made, ranging from humble earthenware to the harder and more delicate **frit ware** (Figure 9–26), wares with elements fused by heat. Lacking the proper clay, however, traditional Islamic potters were never quite able to duplicate the brilliant whiteness and exquisite translucency of Chinese porcelains, which we shall consider in chapter 11.

Figure 9–25 Hexagonal walnut box veneered with ebony for a manuscript of the Koran, Istanbul, c. 1505, height 32 inches (82 cm). The ivory inlays carry Koranic inscriptions.

MUSEUM OF TURKISH AND ISLAMIC ARTS, ISTANBUL

metallic surface. The process was difficult to master but such mastery was evident in Baghdad in the ninth century and later in Syria and Iran.

- *Minai ware* and *lajvardina ware. Minai* means "enamel" and is a fairly new term for wares that were once called *haft rang*, which means "seven-color." As the names suggest, such wares have the bright gloss of enamel and are multicolored. In making them, some colors are applied to the clay, glazed over and fired, then more colors are applied and there is a second firing. Lajvardina is a similar product made with a similar technique; the name is Persian for "lapis lazuli," although that stone was not actually used in the process.

Figure 9–26 Frit ware bowl with blue underglaze painting, Iran, fifteenth century.

VICTORIA AND ALBERT MUSEUM, LONDON/ART RESOURCE, NY

Among the many types of Islamic ceramics were these:

- The *earthenware* mentioned above, which was sometimes left a coarse tan color, but at other times coated with a glossy white slip and painted with **calligraphy** (Figure 9–27). The slip-coated earthenware could also be incised with decorative patterns, then glazed in green, yellow, or brown, the glaze collecting in the incisions.
- *Sultanabad wares* (Figure 9–28), named for a town in northwestern Iran, although the wares were not actually made there. They sought to imitate the shapes and the soft gray-green color of Chinese and Korean celadon.
- *Lusterware*, which used a tin glaze and a second firing in the kiln to produce **luster,** an iridescent

Figure 9–27 A tenth-century Persian earthenware bowl with black Thuluth calligraphy on a ground of white slip.

© THE BRITISH MUSEUM

Figure 9–28 Underglaze-painted Sultanabad bowl, Iran, early fourteenth century, 10½ inches (27 cm) in diameter.

Gold, however, hammered into strips and then cut into small pieces, was sometimes applied to the surfaces of *lajvardina*. In general, lajvardina ware (Figure 9–29) employed more somber colors and more abstract designs than did minai ware. Both were luxury items, meant for display rather than practical use.

• **Iznik** *ware,* the most famous of all types of Islamic ceramics. It is named for a town of potters in western Anatolia, near Nicaea (now Bursa), an important trading stop on the ancient Silk Road linking Europe and Asia. Highly valued Chinese blue-and-white porcelains were frequently traded there, and in the late fifteenth century the Iznik potters began making their own blue-and-white wares. By the early sixteenth century, production was at a high level of quality and quantity, and Sinan used enormous quantities of Iznik underglaze tiles to face the walls of his Suleymaniye Mosque. Iznik techniques were also used for candlesticks, and a variety of dishes and implements for both the mosque and the domestic table. The backgrounds of the Iznik wares were invariably a white glaze, and the patterns on them most often blue, but not always, sometimes being sage green, turquoise, lilac, manganese purple, or tomato red. (Some wares produced at Iznik in colors other than the traditional blue have at times been called *Damascus ware* or *Rhodian ware,* but these terms are obviously misnomers.) In addition to the basic color scheme, the Iznik potters also adopted some Chinese designs—clouds, waves, clusters of grapes, and trios of balls—and added some of their own—arabesques, scrolls, chevrons, and other geometric and vegetal motifs (Figure 9–30). They added some roughly realistic representations as well—ships, rabbits, and tulips (native to Turkey before they were introduced to the Netherlands). They also emulated the dazzling luster of the Chinese wares, developing a formula that was 90 percent silica (glass) and 10 percent clay.

Metalwork

Until about the thirteenth century, when the arts of the book and calligraphy came to be the most prominent Islamic art forms, it was metalwork that led. Because washing before prayer is part of the Muslim ritual, metal ewers and basins for that purpose have traditionally been beautifully crafted, and

Figure 9–29 Overglaze-painted lajvardina bowl, Iran, early fourteenth century, 8 inches (21 cm) in diameter.

Figure 9–30 Late fifteenth-century Iznik ware basin, 16½ inches (42 cm) in diameter.

metals have also been used for chests, lamps, candlesticks, censers, hand warmers, ornaments, furniture, and jewelry. They were worked by casting, by hammering, by the **cire perdue** technique (page 32), by embossing, and by filigree.

The most extraordinary metalwork, not surprisingly, was done with the most precious metals, gold and silver, and such pieces were often signed by their artists, indicating general recognition of individual talents. The most pious of the Muslims, however, came to feel that it was distastefully ostentatious or even sacrilegious to drink or eat from precious metal. More humble metals therefore became popular, such as iron, steel, bronze (an alloy of copper and tin), and brass (an alloy of copper and zinc). (Confusingly, medieval Arabic made no distinction between bronze and brass, using the same word, *sufr*, for both.)

A happy compromise that seemed to please both the pious and the impious was to enrich the appearance of base metals with relatively small additions of precious ones. One technique for such enrichment was known as **damascening**. The name derives from its supposed origin in Damascus, the ancient capital of Syria and, for a time, the capital of the whole Islamic world. Damascening is a form of decorating by inlaying, a process of beating thin gold or silver wires into tiny grooves that have been cut into the surface of the base metal. The grooves form decorative patterns that thus become highlighted (Figure 9–31). Damascening is most often applied to steel objects, but it can also be applied to iron, copper, or brass, and the inlays, in addition to gold and silver, can also be of **niello,** a silver compound with a lustrous black appearance. The technique was popular in the East as well as in the Near East and Middle East. (The term *damascening* is also used for a heating process that gives a watermark pattern to steel sword and knife blades. Even more confusingly, it is also sometimes applied to a quite different technique that gives fabric a **moiré** or watermarked effect.)

Glass and Rock Crystal

Muslim artisans seem to have been traditionally attracted to the decorative uses of glass and rock crystal. Before glassblowing was developed by the Syrians around the first century A.D., making possible thin-walled glass vessels, glass was already much used in Middle East. A number of palaces (such as Qasr al-Hayr and Khirbat al-Mafjar) had windows filled with thick colored glass similar to our "bottle glass," and many of the mosaics used at the Dome of the Rock and elsewhere were made

Figure 9–31 Detail of a damascened brass dish, Venetian-Saracenic, early sixteenth century. Arabesques surround a central maze.

of glass. Many mosques are lit by arrays of glass oil lamps (Figure 9–32); they generally have inner containers, also of glass, that hold the oil and wick.

Figure 9–32 Glass mosque lamp with gilt and enamel decoration, Egyptian, mid-fourteenth century.

© THE BRITISH MUSEUM

Figure 9–33 Rock crystal goblet from Iran, ornamented with palmettes, probably ninth century.

© THE BRITISH MUSEUM

Rock crystal is a colorless, transparent quartz found naturally in many Islamic countries—Morocco, East Africa, Afghanistan, Kashmir, and others. It is hard and difficult to cut, but it can acquire a high polish and, when skillfully faceted, it can produce brilliant reflections (Figure 9–33).

Luster, the iridescent decorative technique we have already seen to be applied to Islamic ceramics, was also often applied to Islamic glass and rock crystal. In these cases, the surfaces were painted with a liquid such as vinegar in which, when heated, a film of metallic oxide could be suspended. The earliest known Islamic example is a goblet dated to the eighth century.

Calligraphy

The Islamic world revered two arts that have relatively little prestige in the Western world: carpet weaving and calligraphy. Both these arts are reflected in the inscriptions and decorations of Islamic architecture and its interiors: Painted patterns taken directly from textiles and carved phrases taken directly from scripture are ubiquitous on wall surfaces, on ceilings and floors, on tiles and pottery, and on furniture and objects. Of these two arts, calligraphy may seem the more foreign to most non-Islamic traditions in the West (though not, as we shall see in the next section of the book, to the traditions of the East).

Calligraphy, or beautiful writing, has religious implications for the Islamic faithful. The world, they believe, is created in the image of God (Allah), and that image is made known not through any pictorial likeness but through the written word of God (the Koran). Just as Christian painters, mosaicists, and stained-glass artists devoted their most skilled efforts to pictorial representations of Christ, Islamic artists devoted themselves to the perfection of the holy writing. (This importance of writing in Islamic life led, of course, not only to the mastery of calligraphy, but also to a high level of achievement in the related arts of papermaking, bookbinding, and manuscript illustration.)

The most important work of a master calligrapher was the copying of the Koran itself, and such copies were often extravagant productions, generously embellished with gold leaf. But calligraphers also worked on less important manuscripts and on

Figure 9–34 The same *basmala,* an invocation of the name of God with which most chapters of the Koran open, written in four different styles of calligraphy: (a) Kufic, (b) Naskh, (c) Thuluth, and (d) Muhaqqaq.

AFTER SCHIMMEL ET AL.

the decoration of a multitude of building surfaces and objects. The calligraphers were highly respected, and their work required not only artistry but also scholarship (they were expected to be knowledgeable about the work of past masters) and, in a way, athleticism, needing considerable muscular control for the proper arm and shoulder movements (many calligraphers, we are told, having also been skilled archers).

Islamic calligraphy is designed not in a single style, but in many. The earliest use for important writing was the Kufic (Figure 9–34a), named for the Mesopotamian (now Iraqi) town of Kufa, where it may first have been officially employed; it is relatively severe and relatively angular, its horizontal baselines often dramatically elongated and its upright strokes often joined to the baselines at right angles. By the tenth century, the more elegant, more rounded Naskh (Figure 9–34b) was in general use for the body of texts, although Kufic was still used for chapter headings, and until the twelfth century the Kufic style continued to be used almost exclusively for the decoration of buildings and their interiors. The distinctions between the Kufic and Naskh version of Arabic letters are similar to distinctions between block lettering and handwriting or "cursive" writing. In addition to the basic

Naskh style there are many variants, and the differences between them may be compared to differences between typefaces. Talik, for example, is a sloping, drooping variation, and Nastalik, credited to a fifteenth-century master named Mir Ali, is a combination of Talik and basic Naskh. Others among many that might be mentioned are Thuluth (pronounced sulss), a particularly curvaceous variant (Figures 9–34c and 9–27) easily and often executed in tile work, and Muhaqqaq, more slender and elongated (Figure 9–34d).

Individual calligraphers have developed their own personal styles as well, and in some cases artistry has overwhelmed legibility, so that some inscriptions are beautiful but difficult to read. Arabic words are written from right to left, but in some of the calligraphy, letters may be arranged in quite a different order, combined with arabesques, or given superfluous loops and flourishes. The results can be quite abstract and fanciful (Figure 9–35).

Some calligraphy—or, rather, some Western imitations of calligraphy—are not even meant to be read. Renaissance European paintings sometimes show saints and Madonnas whose haloes are edged with Kufic-like script, probably copied from the Islamic carpets then very popular in Europe.

Figure 9–35 Detail of the royal signature of Sultan Suleyman I, c. 1556. It is rendered in black and gold ink with floral embellishments in blue, red, and gold.

MUSEUM OF TURKISH AND ISLAMIC ARTS, ISTANBUL

Figure 9–36 Kufesque or mock-Kufic calligraphy on the tunic border of Andrea del Verrocchio's *David*, 1473–75.

HIRMER FOTOARCHIV, MUNICH, GERMANY

Similarly, the famous sculpture of David, c. 1475, by Andrea del Verrocchio (Figure 9–36) shows mock-Arabic characters on the borders of the young warrior's tunic, but the lettering is merely gibberish. Such imitation calligraphy, used in western Europe in both medieval and Renaissance times, is generally called Kufesque.

Carpets

In interiors that were furnished with a minimum of hard furniture, soft furnishings such as carpets must have enjoyed a heightened significance, providing color, warmth, and comfort for seating and sleeping. It may also be true that the large number of beautiful carpets available made the production of hard furniture seem unnecessary.

The large number of carpets was due to an unusual combination of factors that caused the central Islamic lands to be called the Rug Belt. These conditions were both cultural and geographic: ties to a nomadic past in which personal belongings had to be portable and durable, providing a weaving tradition of hand knotting; and terrain and climate suitable for sheep grazing, providing a fine supply of wool.

 VOCABULARY CARPETS AND RUGS

The distinction between *carpets* and *rugs* is imprecise, but it is similar to the distinction between ships and boats: the difference is a matter of size, carpets being generally larger than rugs just as ships are generally larger than boats. Flooring textiles installed wall to wall are always referred to as carpets, however, no matter how small the room, and loose and movable flooring textiles can also be called carpets, given some degree of size or importance.

The fashion for carpets spread throughout the Islamic world, however, to places that lacked these supportive conditions, and beyond the Islamic world to Europe and America. So-called **Oriental carpets** outgrew their origins, which were never limited to the Orient, and became popular in many parts of the world. Today, the hand-knotting techniques are still practiced in countries with cheap labor, and in other places they have been replaced by machines.

CARPET TECHNIQUES Machines have introduced new types of carpet weaves, and we shall consider them in our chapters on nineteenth- and twentieth-century design. Before the machines, there were four basic types of carpet, distinguished by the ways in which they were made: *embroidered and needleworked, flat-woven, tapestry-woven,* and *pile.* The Oriental carpets of the Islamic world are *cut-pile* carpets—that is, their surfaces are textured with the cut ends of pieces of yarn projecting upward from the surface. (Such a texture is sometimes called a *nap,* although some make a technical distinction between pile and nap, saying that pile naturally results from the cut ends of yarn woven into the fabric, and that nap results from a mechanical finishing process that raises fibers from the surface of a woven product.)

Materials used for these carpets are most often wool and silk for the visible pile and wool or cotton for the underlying foundation. Some are therefore all wool, and all-silk carpets also exist. Goat or camel hair is sometimes added to wool for the pile, and jute is sometimes substituted for cotton for the foundation.

As in Gothic tapestries and as in most weaving, the basic structure of the pile carpet is of **warp** and **weft,** two series of threads that are at right angles to one another. The weft threads, running across the face of the loom, are woven in and out of the warp threads, running the length of the loom. In the pile carpet, there are additional elements, short pieces of cut yarn that are knotted around one or more warp threads and held in place by one or more weft threads. The projecting ends of these short lengths produce the pile.

Important distinctions are made between Oriental carpets on the basis of the kinds of knot used.

Figure 9–37 The symmetrical or Turkish carpet knot.

MURRAY L. EILAND, JR. AND MURRAY EILAND III, *ORIENTAL CARPETS, A COMPLETE GUIDE,* LONDON: LAWRENCE KING PUBLISHING, 1998.

In Islamic carpets, there are only two basic knot types, but each of them has four names.

- The first type wraps its short lengths of yarn around two adjacent warp threads, then pulls them under and out (Figure 9–37). It is called the *Turkish knot,* the *Ghiordes knot* (for the ancient Turkish town of Ghiordes), the *closed knot,* or, most descriptively, the *symmetrical knot.*

- The second type wraps the yarn under one warp thread, over the adjacent warp thread, then pulls it back between the two warp threads and out (Figure 9–38). It is called the *Persian knot,* the *Senna knot* (for the city of Sinneh in western Persia), the *open knot,* or the *asymmetrical knot.* The

Figure 9–38 The asymmetrical or Persian carpet knot.

MURRAY L. EILAND, JR. AND MURRAY EILAND III, *ORIENTAL CARPETS, A COMPLETE GUIDE,* LONDON: LAWRENCE KING PUBLISHING, 1998.

asymmetrical knot results in a projection of pile in every space between the warp threads, and therefore can produce a denser and more even pile than can the symmetrical knot.

Some of these names can be misleading: Persian knots are not restricted to Persian carpets, nor Turkish knots to Turkish carpets, and carpets made in the city of Sinneh do not use the Senna knot that is named for it.

For each of these two basic knot types, which here we shall call *symmetrical* and *asymmetrical*, there is a variant called the *jufti* knot or *double knot*, which stretches the short length of yarn over three or more warp threads rather than the usual two, but ties it in the same way. The double knot is often used in solid-color areas of carpets, but seldom in patterned areas or outlines; this often produces effects of greater density where the design is more complex. Whatever knot is used, the face of the carpet has to be sheared to give an equal length to the pile.

When the finished carpet is cut from the loom that has held it taut, the ends of the warp threads projecting from the top and bottom edges form the fringe—sometimes knotted or plaited—that is almost invariably a feature of the Islamic carpet. (Almost, because there are a few exceptions: carpets from the old desert province of Baluchistan, for example, have narrow flat-woven strips at the tops and bottoms.) The two long sides of the carpet, without projecting fringe, have edges that are formed when the warp threads reverse direction; they are often reinforced with rows of additional weft and warp threads (called *overcasting*) that are not part of the rug design. These edges, not only in Islamic carpets but also in most textiles, were originally called *self-edges*, then *selvedges*, and are now called **selvages.** They are also sometimes called *lists* or *listings*. A cord or strip of edge reinforcement that is not woven into the fabric but merely sewn on is called a *false selvage*.

CARPET QUALITY Other important distinctions indicate carpet quality rather than technique. This is based not on the type of knots used but on their density. The lowest density in any respectable Oriental carpet is around 25 knots per square inch (4 per cm$^2$), but 100 knots per square inch (16 per cm$^2$) is commonplace, and fine examples can have several times that number. A Mughal carpet in the Metropolitan Museum of Art, New York, has a knot count of 2,500 knots per square inch (390 per cm$^2$), and an all-silk prayer rug woven in the western Turkish town of Hereke around 1970 is said to have an astonishing 4,360 knots per square inch (676 per cm$^2$). As an experienced weaver can tie only about twenty knots per minute, it is clear that some carpets must have taken months or years to weave. The designer considering buying a carpet can usually count from the back of the carpet the number of knots in a horizontal inch (2.54cm) and the number in a vertical inch, multiplying them together to give the density. Whether this is possible or not, the buyer may ask any reputable carpet dealer for a certificate of authentication that will specify a carpet's age, origin, construction, and density.

Other types of quality measurement include a *line count*, often applied to Chinese carpets. *Line* measures the number of pairs of warp threads per linear foot. When applied to weaves with one knot per pair of warp threads, it obviously equals a knot count. A "90-line" carpet has 90 pairs of warp threads per linear foot, or (dividing 90 by 12) 7.5 per linear inch, or (multiplying 7.5 by 7.5, as most weaves have about the same spacing vertically and horizontally) roughly 56 per square inch (9 per cm$^2$).

Raw materials are another factor in carpet quality. Silk, wool, and cotton can all vary greatly in quality, and cotton that has been *mercerized*—that is, cotton that has been treated with alkali under pressure to increase its strength and to give it a silk-like sheen—may, with wear, soon lose its artificial luster.

But the finest quality of the Oriental carpet cannot always be equated with the highest degree of perfection. Although high knot density is generally an asset, some relatively coarse tribal rugs can be more beautiful and more valuable than their refined city cousins. An inherent irregularity of color (called *abrash*), the result of an uneven absorption of dye by the yarn, is considered an attractive feature (unless it is so pronounced that it has obviously been planned). The mellowing effects of slight fading with age are also admired. And even a certain amount of visible wear is often con-

sidered an aesthetic asset, if it stops before the fabric is actually threadbare.

Other aspects of carpet condition obviously affect both the carpet's beauty and its value. Holes, rips, patches, or alterations from the original size are serious flaws, as are dry rot in a cotton foundation or insect damage in wool. Reknottings, replaced selvages, replaced fringes, and other repairs also reduce the worth of an old carpet. Considered by experts to be less serious—and at times even assets—are the results of *inherent vice*, the tendency of the textile to deteriorate because of its own construction. Some old dyes, for example, particularly brown and black dyes, are naturally corrosive and result over time in a loss of pile that is called *etching*; because etching is an indication of age, it is sometimes faked in newer carpets by clipping their pile.

CARPET SHAPES AND SIZES

Many carpet types have characteristic shapes, even though they may come in a variety of sizes. Shapes are sometimes defined by a *shape ratio* that expresses the length of the carpet divided by the width. The shape ratio of a carpet 12 by 9 feet (360 x 270 cm), for example, would be 1.33.

Carpet sizes are extremely variable, limited only by the sizes of available looms. Those larger than 14 by 24 feet (430 x 730 cm) are generally called "palace carpets." Traditional village carpets, made to fit long, narrow rooms, were most commonly 60 by 108 inches (150 x 365 cm), a size called a *keleh*, and other common sizes were 4 by 7 feet (120 x 215 cm) and 3 by 5 feet (90 x 150 cm). Since the middle of the nineteenth century, however, sizes have been adapted to suit the squarer rooms of western Europe and America, two common sizes now being 79 by 118 inches (200 x 300 cm) and 108 by 144 inches (275 x 370 cm). But there are also long, narrow rugs called "runners" *(kenarehs)* useful for hallways and stairs. Those examples smaller than 4 by 6 feet (120 x 180 cm) are sometimes called "scatter rugs," as are any flooring textiles of small size; if used as a cover for a bed or for furniture, they may be called "throw rugs."

The change in carpet sizes is related to a change in carpet placement. The common placement today is the center of a room, but the common placement in a traditional Islamic room would have been around the edges, with a keleh at the head of the room, where the hosts might be seated, and two kenarehs at right angles to the keleh, along the side walls where guests might be seated.

A specialized type of small rug is the *prayer rug* (Figures 9–39a, b, c, d). It is an important feature of Islamic life, used in mosques to provide a clean, soft area on which to kneel. It is unlike its larger counterparts not only in being small, sized to accommodate a single person, but also in being asymmetrical in design, one end of it woven with a design, usually in the shape of a mihrab, that indicates the direction of Mecca. (An exception to the asymmetrically designed prayer rug is the less common double prayer rug with a mihrab motif at each end.) The Islamic prayer rug is more often made of silk than of wool. Other small Islamic rugs are the

Figure 9–39a Silk medallion rug, Kashan, second half of sixteenth century, silk pile on silk warp and weft, 2.4 m (95 in.) x 1.7 m (68 in.). Widener Collection.

Figure 9–39b Isfahan silk rug, the camel field centered by an urn issuing flowers and scrolling vines, enclosed by cartouche horn borders; Bonhams, London, UK/Bridgeman Art Library.

mats called *pushti*, a word meaning "back." They were traditionally used to cover cushions placed against a wall for those seated on carpets to lean against; they are only about 2 by 3 feet (60 x 90 cm).

Woven in the same manner as carpets are pillow covers called *balisht* (meaning "cushion" or "bolster"). And many varieties of Islamic storage bags are made with at least one pile face; they can also be used as pillow covers or as upholstery for chair seats.

CARPET DESIGNS Designs on Islamic carpets can be geometric or curvilinear or an infinite number of combinations of those extremes. Tribal carpets, for which weaving is relatively (but only relatively) coarse, making curves difficult to execute, are more likely to be geometric; city-woven carpets, with more refined techniques and greater

density, tend to be more curvilinear. But these are by no means rules, and, in any case, the Islamic geometric designs can be fully as beautiful as curvilinear ones.

However ordered or lyrical, the patterns of these carpets are not invented by individual weavers, but taken from traditional vocabularies. Each of them has a traditional meaning, although that meaning may be unknown to the modern user or even to the modern weaver.

Some carpets have bold central figures surrounded by smaller, supplementary ones. Some have all-over patterns of small figures. Some are compartmentalized, with figures within each compartment. In every case, there are borders around the edges. And in every case, also, standardized

Figure 9–39c Persian prayer rug, first half of sixteenth century, woven of wool, cotton and silk with asymmetrical knots, about 552 per sq. in. 63.5 x 42.5 in. (1.6 x 1.1 m)

Figure 9–39d Prayer rug from Bursa, Turkey, Ottoman period, late sixteenth century. Silk, wool, and cotton. 66 x 50 in. (167.6 x 127 cm)

Figure 9–41 A few examples of the many different guls found in Oriental carpet designs. Shown are (a) the *ay gul*, a rounded medallion containing several rosettes; (b) the *C gul* with C shapes facing both directions; (c) the *chemche gul*, some of its eight radiating arms ending in ram's horns; (d) the *tauk noska gul*, each quadrant containing two small animals; and (e) *Temerchin gul*, a flattened octagon with four angelfish images in each quadrant.

Figure 9–40 Examples of the boteh or Paisley motif.

motifs are used and reused. A few of the very many Islamic carpet motifs are described below:

- The **boteh** is the motif familiar from the Paisley pattern (Figure 9–40). It probably originated in Kashmir, but it is named for the town of Paisley, Scotland, where, in the nineteenth century, the pattern was duplicated in the manufacture of shawls. It is sometimes called a "pear" because of its shape, although it has also been said to resemble a leaf, a pinecone, an almond, or a flame. It can appear singly on a carpet, but it is usually seen in overall repeat patterns.

- The **gul** or *gol* is a geometric emblem (Figure 9–41). Its name is the Persian word for "'flower" or "rose," so it may have been floral in origin, but it has evolved into octagonal, hexagonal, diamond, or serrated shapes. Many nomadic tribes have their own "signature" guls that are traditionally woven into carpet designs.

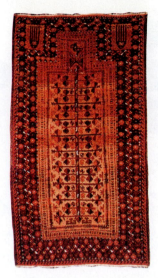

Figure 9–42 Carpet with hands-of-Fatima motif at the top.

Figure 9–43 Curvilinear and geometricized *herati* borders, each composed of a linear series of herati floral patterns.

Figure 9–44 Tree-of-life motifs from Oriental carpets: (left) from a Baluchi carpet from Baluchistan, which comprises parts of Iran, Afghanistan, and Pakistan; (right) from a Kazak carpet from the Caucasus area of southern Russia.

- The **hands-of-Fatima** motif is named for the daughter of Muhammad and refers to the outlines of a pair of hands that are found near the tops of some prayer rugs (Figure 9–42). They indicate where the worshipper's hands might be placed when kneeling, and the thumb and outstretched fingers are reminders of the Five Pillars of Islam.

- The **herati** is a floral representation within curving or diamond-shaped figures. A linear series of such motifs is called a *herati border* (Figure 9–43).

- The **mihrab** shape, rectangular with an arched top, represents, as we know, the prayer niche of a mosque. In carpets, as in mosques, these can take a variety of shapes.

- The **palmette** is a floral motif based on the lotus. It is depicted in profile, with a stem end at the bottom and spreading petals above. Like many of the other motifs listed here, it is found on fabrics as well as on carpets.

- The **tree-of-life** motif symbolizes the life force in the form of a tree, sometimes with fruits and birds in the branches. It is seen in many cultures and in many variations: In the ancient Near East, we saw a stylized version (Figure 3–6), and in Islamic design it is sometimes naturalistic, but in carpet design it is more often highly geometricized (Figure 9–44). Similar in significance and

appearance to the tree of life is a motif called the *vase of immortality,* showing similar foliage sprouting from a vase rather than from the ground. The vase has been a favorite motif in all classical and neoclassical styles. In the Islamic world, many parts of which are hot and dry, the vase carries special intimations of a supply of life-giving water and of a source of lively plant materials. It appears frequently in carpet designs.

These Islamic motifs were supplemented by foreign ones, naturally, in foreign copies and in the

rugs intended for import. English-made carpets in the Tudor period, for example, sometimes added the coats of arms of the intended users. And a particularly sad sight, showing the expenditure of much time and skill on a trivial subject, are the "Maggie and Jiggs" carpets woven in Iran in the 1920s and showing two comic strip characters popular in the United States at the time.

CARPET NAMES AND THEIR MEANINGS

There are three basic types of Oriental carpet: Persian, Turkish, and Chinese. The Chinese type will be presented in chapter 11, and carpets produced in neighboring India will be mentioned in chapter 10. In China, of course, the religious environment was Buddhist, Confucian, and Taoist, rather than Islamic, and a tradition of furniture made the carpet a luxury rather than a necessity for daily comfort. In India, the carpet was an even greater luxury than in China, and most examples were woven for royalty; they owe much to Persian precedents.

The terms *Persian* and *Turkish* may seem self-explanatory, but the history of their usage is marked by confusion. The first Oriental carpets that came on the Western market, whatever their origins, were referred to as Turkish, and European and American imitations were called "Turkey work." This was probably due to the fact that most of the authentic examples were bought from Turkish merchants in Istanbul. Later, it became known that many of the carpets had originated in Persia, present-day Iran, and had been brought to Istanbul by caravan. So romantic were the connotations of the term *Persian* that it was then for a while applied to all such carpets.

Today these names are understood to indicate the country of origin (except that it should be remembered that ancient Persia was somewhat more extensive than present-day Iran). Turkish carpets were more strictly obedient than many Persian ones to Islamic edicts against the representation of living things and were therefore more stylized and geometric. Their technique was also slightly less refined. Even so, many of them were dazzling.

Persia is generally considered the center of fine carpet weaving, and its highest level of achievement is thought to have been in the Safavid dynasty, from 1505 to 1722. There are many types of Persian carpet, each with its special characteristics (Table 9–1, page 224). Most of them are named for their places of origin, some for the tribes that wove them, some for the places where they were frequently traded.

Other Textiles

Carpets, for all their prominence and prestige, have not been the only notable Islamic textiles. The variety and quality of other Islamic woven goods is suggested by their influence on western Europe. Robert Irwin, in *Islamic Art in Context*, cites the following English terms that "all derive from Arabic words or place names": alpaca, blouse, chiffon, cotton, damask, mohair, muslin, and satin.

Silks were the luxury products of the Islamic textile trade, and the most important center of that trade was the city of Bursa in northwestern Turkey, a city ruled in succession by the Seljuk Turks, the Crusaders, the Byzantines, and the Ottomans, for whose empire it served as capital. The silks and silk velvets woven at Bursa and elsewhere served as covers for the sofas and low divans of Turkish palaces and fine houses and for window coverings. They were also made into elaborate costumes.

As we would expect, the Islamic flair for pattern, which we have seen demonstrated in wood carvings, stucco, metalwork, pottery, tiles, calligraphy, and carpets, was also prominent in the design of textiles.

Summary: Islamic Design

This chapter began with a description of how widely the term *Islamic design* could be applied—to many times, many locations, and many styles. Nevertheless, at least one common trait can be identified.

Looking for Character

Islamic design is most strongly characterized by a prevailing sense of order. Perhaps it is only in calligraphy—the most personal of the Islamic arts, often practiced alone and without the constraints imposed by patronage—that any great degree of spontaneity or individuality can be detected. Other Islamic arts exhibit both an obedience to traditions that exist before and beyond the works at hand,

TABLE 9.1 PERSIAN CARPETS AND THEIR CHARACTERISTICS

NAME	KNOT TYPE	KNOTS PER SQ. IN.	FIBER CONTENT	TYPICAL APPEARANCE
Bijar (or Bidjar)	Symmetrical	100–160	Wool	Medallions and scrolls; rich reds and blues
Feraghan (Farahan)	Asymmetrical	60–160	Wool pile on a cotton foundation	Fish bordered with vines; blue or green
Hamadan	Asymmetrical	40–100	Wool with camel hair on cotton	Central medallion; red and blue floral design on yellow or brown ground
Herez (Heriz, Heris)	Asymmetrical	30–80	Wool on cotton	Lobed medallion with straight outline; floral patterns in red and blue with lighter borders
Isfahan	Asymmetrical	As many as 750	Mohair or silk	Floral medallions, animals, or palmettes; rich red, sometimes with gold or silver threads
Kashan	Asymmetrical	200	Merino wool or silk with velvet-like pile	Center medallion, floral surrounds
Saraband (Sarabend, Sereband, Sarband, et. al.)	Older knots asymmetrical; newer ones symmetrical	Varies	Usually wool on cotton	Rows of botehs, bordered with narrow bands; dark reds and blues
Tabriz	Symmetrical	40 to over 400	Wool, but sometimes silk	Large center medallions surrounded by smaller ones
Teheran (Tehran)	Asymmetrical	130 to 325	Wool on cotton	Floral designs and pine tree patterns

and also an obedience to an inner organization that assigns every detail to its proper place.

This high degree of order is related, as is almost every aspect of Islamic life, to religion. And the relationship is this: As everything in existence has been willed by Allah and has its place in Allah's divine scheme, it would be unseemly and false to represent any part of that scheme as unruly, wild, or chaotic. Nature is never seen in random extravagance, but always in orderly patterns, systematically imposed. In everyday life, the world's underlying order may at times be difficult to see, but the Islamic artist represents the world not as it appears but as it must be.

And the genius of Islamic art, of course, is that such a world view is at least partly self-fulfilling. A filigreed lamp, a tiled wall, or a carpet pattern in which every element has a well-considered relationship with every other element can lead us to a trance-like contemplation of those relationships. Hypnotized by interlocking angles and swirling arabesques, we can come nearly to believe that the universe is as ordered as the art we see.

Looking for Quality

Perhaps it is this unaccustomed mathematical perfection of Islamic patterns that makes the foreign observer treasure the occasional flaw—the faded area, the worn spot, the discontinuity that occurred when the loom was moved. But such charming incidents are unrelated to the main point of Islamic design. Its heart, and its highest quality, lie in the mastery of an intricately balanced sense of order, and in the mastery, too, of impressive techniques for presenting that sense of order. Islamic design takes unapologetic pleasure in displays of virtuosity and in high levels of manipulation and polish. Expressions can be bold and vigorous or they can be subtle and refined, and equal excellence can be found in both extremes. Both extremes of Islamic design also obey tradition, and

the highest quality in Islamic design obeys tradition most reverently. This is not an art in which originality is a measure of success.

Nor is the achievement of realistic effects highly valued. Islamic design's strengths are in its very artificiality, its wondrous decoration, its transformation of natural forms into supernaturally composed patterns. Islamic design does not record nature or humanity; it suggests divinity in its miraculously complex organization.

Making Comparisons

Within the realm of Islamic design, comparisons can be made between the work of the nomadic tribespeople and that of the city dwellers, between old hand techniques and new machine ones, between native inclinations and foreign impulses (or native impulses to please a foreign market), or between straight lines and curves.

Between Islamic design and the Christian styles with which it shares the period of the Middle Ages, there are great differences, just as there are great differences between Islamic and Christian society. While both were strongly focused on their own religions, Islamic society was often superior in literacy and in the pursuit of art, science, and philosophy. We might even say that the Islamic world during the Middle Ages exhibited much of the sophistication of the Renaissance that would follow in Christian Europe. Paradoxically, just as that Renaissance was reaching its highest level, Islamic accomplishments began to decline. This, some have suggested, may have occurred because Islamic society, passionately enamored of richly handcrafted manuscripts, virtually ignored a development that transformed European society: the invention of printing. In any case, Islamic design has at times been in advance of—and at other times behind—other styles. Throughout its history, its ideals and accomplishments, its conventions and character, have been distinctly its own.

Another comparison may be provoked by this chapter's placement in the book: preceding it, the styles of the rest of the Middle Ages; and following it, the styles of the Far East: Indian, Chinese, Japanese. Islamic design stands between these two great bodies of culture and art, conspicuously separate from both of them.

Most of all, the Islamic respect for virtuosity, abstraction, and richness is thoroughly opposed to those styles (including some Japanese design, Shaker design, the late-nineteenth-century Arts and Crafts movement, or twentieth-century modernism) that respect simplicity, naturalism, and even roughness.

Of all the styles previously considered, Islamic shares the most geography and history with the design of the ancient Near East. Of all the styles to come, it overlaps most greatly with the Mughal phase of Indian design. And its exoticism and penchant for detail certainly show the influence of Byzantium. The products of Islamic design—most famously, its carpets—can be handsomely and effectively combined with French armchairs or English paneling or a Mies van der Rohe daybed, but they retain their own character. Islamic design is to a rare degree a world of its own, self-sufficient, self-referential, and self-perpetuating.

Finally, Islamic design, compared to other design, is strictly traditional. David Talbot Rice concludes in the last sentence of his *Islamic Art* that it demonstrates "that the great concern with self and self-expression which so much obsesses the artists of today in the West is not necessarily to be regarded as an essential in the production of good art." Islamic art and design was generally unconcerned with originality and personal vision. In this regard, it stands close to much of the art and design of the Far East, which we shall consider in our next section.

CHAPTER

10

INDIA

2500 B.C. TO THE PRESENT

India's Architecture and Its Interiors

India's religions, especially Hinduism and Islam, were major determinants of the country's arts, including its architecture. Indian examples clearly establish that religious architecture, however, need not be either fanciful or illogical. Indeed, the most rational of all planning devices—the grid—is often the basis of sacred Indian construction, for the grid itself, especially the grid of multiple squares, was endowed with spiritual significance. Such a composition of squares is the basis of many Indian buildings and building complexes, including the Hindu temple (Figure 10–2, page 228) and the Islamic mosque and mausoleum.

Figure 10-1 MAP OF INDIA

ORTELIUS DESIGN

The square is also found in numerous decorative motifs in the temple interiors, such as a ceiling design (Figure 10–3) of squares within larger squares.

Circles, octagons, equilateral triangles, and other geometric forms also sometimes play symbolic roles, the circle being the basis for one of the earliest manifestations of Indian architecture, the **stupa.** While the perfect stupa form is a pure hemisphere, geometric purity of form is not always the rule in Indian architecture. Rather than a roundheaded arch, for example, Indian architecture favors a **pointed arch,** its sides meeting in a point at its apex (an Indian pointed arch being lower and flatter than the slender Gothic pointed arch). Sometimes Indian arches are not only pointed but also scalloped with a series of concave

Figure 10–2 Plan of a Hindu temple based on a grid of squares.

DRAWING: ANDREAS VOLWAHSEN AND GERD MADER

shapes (as in Figure 10–4). And rather than a hemispherical dome, Indian architecture often favors an **onion dome,** a slightly bulbous form in which the diameter of its base is smaller than its greatest diameter, such as the one topping the famous Taj Mahal. It is also true that the buildings based on simple squares and circles are rarely simple in appearance but are overlaid with ornament. Columns were complex in form, with bell-shaped bases, octagonal shafts, and capitals in the shape of a lotus blossom or a honeycomb. In southern India, particularly, as in some Hindu temple complexes, the columns were elaborated into huge floor-to-ceiling sculptures in the round, representing human figures, lions, and prancing horses.

The Palace and the House

Palaces took many forms, but generally they were compositions of many distinct elements such as audience halls, throne rooms, men's quarters, and women's quarters. The design of each element was often symmetrical, modular, and strictly ordered, but the overall composition, which might accrue incrementally over a long period, was often less orderly.

Figure 10–3 Rotating and diminishing squares in the ceiling design of a Hindu temple to Shiva, Pandrethan, ninth or tenth century.

DRAWING: ANDREAS VOLWAHSEN AND GERD MADER

Figure 10–4 Scalloped arches of white marble in the Amber Fort, near Jaipur, early eighteenth century.

ABERCROMBIE

Figure 10–5 Northern Hindu temple complex, Bhuvaneshwar, c. A.D. 1000.

ELIOT ELISOFON/TIME PIX

Water was often a delightful accompaniment to palace architecture. Water gardens, symmetrically disposed, incorporated plantings, terraces, and water channels. Fountains and water channels were also frequent features of palace interiors. The chief building material for palaces was stone, sometimes reddish sandstone, as at Fatehpur Sikri, and sometimes white marble, as at the *diwan-i-am* (public audience hall) and the *diwan-i-khas* (private audience hall), both built within the Red Fort at Delhi. In Jaisalmer and other locations, mansions *(haveli)* for wealthy merchants were built of amber- or ochre-hued sandstone, centered around interior courtyards and rising several floors high. The haveli walls,

inside and out, were frequently elaborately frescoed. Houses for the middle class might be made of fired brick and tile, more modest houses of sun-baked mud brick. Doors and other woodwork elements were elaborately carved, whenever the owner's budget allowed. House plans often included verandas and planted courtyards.

The Temple and the Mosque

Temples, shrines, and mosques were built in abundance throughout India. They differ according to religion, of course, and also according to region and local custom. Changes in design due to the passage of time, however, are negligible. The many variations of the Indian temple are essentially constant and conservative building types.

The Hindu temple of the north, for example, is characteristically a tall, tapering form (Figure 10–5). The Hindu temple of the south is a simpler, more rectangular form, or a stack of such forms, capped by a miniature cupola (Figure 10–6). Both types of temple had impressive interior spaces, decorated and frequently aligned in a series of increasingly tall rooms. So thick was the stone construction, however, that the interior spaces had surprisingly small volumes compared to the bulk of the exterior forms.

The Taj Mahal

The Islamic temple reached its highest stage of development in India in the Mughal period, and shared

Figure 10–6 Elevation, southern Hindu temple complex, Pattadakal, eighth century. The tower at left is 54 feet (16.5 m) high.

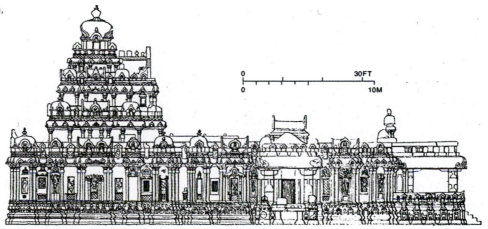

INDIA 229

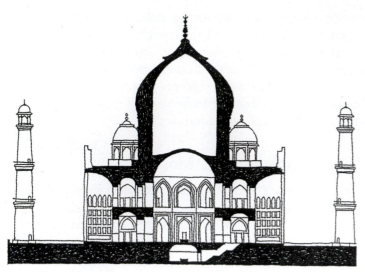

Figure 10–7 Vertical section, the Taj Mahal, Agra, India. The construction is so heavy that the interior spaces are small, relative to the exterior.

ABERCROMBIE

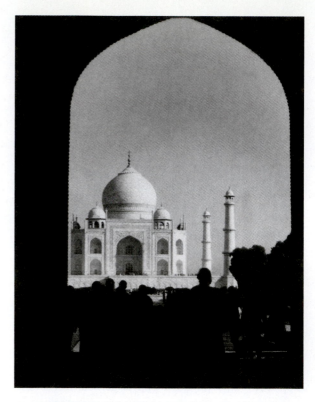

Figure 10–8 One of the most famous sights in the world, the Taj Mahal, Agra, completed in 1648.

ABERCROMBIE

its architectural characteristics with Islamic mausoleums. One of these is the Taj Mahal (Figures 10–7 and 10–8).

The Taj Mahal (a name meaning "Crown of the Palace") was built by the emperor Shah Jahan as a mausoleum for his wife, Mumtaz Mahal (Exalted One of the Palace), who died in childbirth in 1631. The building was completed in 1648 amid spacious gardens graced with fountains, waterways, plantings, and marble paths. Rather than centered in the garden, however, as would have been typical for such a royal mausoleum, it was placed near the end of the garden on a bluff overlooking a river.

The building itself is faced with white marble and decorations of **pietra dura,** inlays of precious and semiprecious stones in patterns of floral sprays, arabesques, and Islamic calligraphy. The use of white marble, striking in the intense Indian sunlight, had a precedent in the mausoleum Shah Jahan's father had built in Agra for his empress's parents, the Itimad-ud Daulah, and in Shah Jahan's own palaces and audience halls in several locations.

The center of the Taj Mahal is topped—and the entire composition is dominated—by a slightly swelling 200-foot-high (66 m) onion dome. Close around it, near the corners of the main structure, are four **chattri,** honorific umbrella-like cupolas.

At each corner of the building's marble platform stands a 133-foot tall (44 m) **minaret,** a slender tower usually associated with a mosque. These minarets are divided into sections by narrow balconies from which the faithful can be called to prayer, and these balconies align with the floor levels of the main structure, helping to tie the composition into a whole. On the left of the main building, when viewed from the gardens, is a small mosque; balancing it on the right is an identical building that has been called a guest house, although its only purpose may have been symmetry.

The building's interior is no less impressive. Although square in plan and symmetrical in both directions, the building is entered through the great portal on its south side. The interior is subdivided into a composition of nine squares, and the first space one encounters is one of the ring of eight interconnected spaces circling the central one. A second ring of another eight rooms is on the floor

above, overlooking the central space through pierced marble screens. The central octagonal space rises to a dome 80 feet (26 m) tall, high but considerably more human in scale than the great dome visible outside. As outside, however, the chief material here is marble, inlaid with crystal, topaz, pearls, jade, coral, amethyst, agate, lapis lazuli, and other stones. While the pietra dura work at the Itimad-ud Daulah had been chiefly geometric, at the Taj Mahal it was chiefly floral and gently lyrical. For all its richness and movement, however, the inlaid decoration of the Taj Mahal is spare, embellishing but never dominating the pure white marble.

Within the central space is an octagonal screen of pierced marble 6 feet (2 m) high. Centrally placed within the screen is Mumtaz Mahal's **cenotaph,** a monument honoring a person whose body is elsewhere, elsewhere in this case being a crypt directly below the central space. Next to her is Shah Jahan's own cenotaph, his body also being in the crypt below. Both monuments are covered with white marble inlaid with colored stones, the pietra dura work here surpassing in quality that found anywhere else in the building and perhaps equaling that found anywhere in the world. That of Shah Jahan features a flaming halo and highly geometricized plant forms; his wife's features similar plant forms and Islamic calligraphy.

The Taj Mahal is the epitome of balanced architectural composition. It is also a masterpiece of finish, demonstrating the key importance in Mughal architecture—and in Indian architecture in general—of decorative detail.

India's Decorative Arts and Crafts

The pietra dura of the Taj Mahal was a luxury item, of course. But similar decorative treatments in building interiors were fashioned in more humble materials. One technique used for interior wall surfacing involved the fitting together of small, regularly shaped (often hexagonal) pieces of painted wood. Sometimes these wood compositions included many small mirrored pieces and were called mirror mosaics (shish). Ivory inlay was also popular, particularly in the Punjab.

TIMELINE | INDIA

DATE	CULTURAL DEVELOPMENTS	ARTISTIC DEVELOPMENTS
2500–1500 B.C.	Height of the Indus civilization	City of Mohenjo-Daro
800–400 B.C.	Vedas in written form; life of Buddha, 563–483	
400–100 B.C.	Maurya period, 322–185; spread of Buddhism and Jainism	Edict pillars of Asoka; stupa at Sanchi; first cave decorations at Ajanta
100 B.C.–A.D. 300	Composition of the Bhagavad-Gita	
A.D. 300–800	Gupta period; 300–540	Cave temples at Ajanta, Ellora, and Elephanta
800–1100		Carved temples at Khajuraho
1100–1400	Muslim conquest of Northern India, 1192; sack of Delhi by Timur, 1398	Qutb-Minar at Delhi
1400–1500		Artistic renaissance in Rajputana
1500–1600	Founding of Mughal dynasty by Babur; reign of Akbar	Humayun's tomb, Delhi; building of Fatehpur Sikri
1600–1650	Reign of Jahangir; reign of Shah Jahan	Shalimar gardens, Kashmir; Delhi and Agra forts; Taj Mahal
1650–1700	Founding of Calcutta	Rajasthani miniature painting
1700–1750	Death of Aurangzeb	Last Mughal mosques; founding of Jaipur; palaces at Udaipur
1750–1800	British East India Company rules India	Palaces at Jodhpur
1800–1850		Golden Temple, Amritsar
1850–1900	British Crown appoints viceroy to India; Queen Victoria named Empress of India	British neoclassical architecture in Bombay and Calcutta
1900–1950	Independence for India and Pakistan, 1947	Building of new capital at New Delhi, 1913–31
Since 1950	First general elections in India, 1952	Le Corbusier buildings in Chandigarh; Crafts Museum established in New Delhi; National Institute of Design established in Ahmedabad

Figure 10–9 In the interior of Humayun's mausoleum, Delhi, built c. 1565, light is filtered through a pierced marble screen.

ABERCROMBIE

Indian carvings, both in wood and stone, were frequently used and highly developed. Pierced screens or lattices of marble or sandstone *(jalis)* were fashioned in complex patterns to filter India's strong sunlight but still admit the breeze (Figure 10–9). Wood carvings were used lavishly and expressively throughout Indian interiors, appearing on columns, door panels, door- and window frames, roof brackets, balcony parapets, ceiling panels, low headpieces of beds, and elsewhere. The character of the carving was naturally affected by the wood being used. As two early-twentieth-century observers, Watt and Brown, noted, there were the "deep under-cutting and sculpture that is possible with teak, redwood and walnut, the low relief of *shisham* and *deodar*, the incised designs of ebony, the intricate and minute details of sandal, and the barbaric boldness of *ro-*

hira, sal, and *babul (kikar)* and other coarse grained and hard woods."

There were wonderful Indian objects made of brass or steel. Steel objects were often treated with a process called **damascening** (Figure 9–31). As discussed, its name was derived from the Syrian city of Damascus, but it was also popular in India, China, and Japan. As described in the previous chapter, it involves beating gold or silver wire into grooves cut into the surface of the steel in decorative patterns, and it can also be called **inlaying.** Similarly, there are Indian inlays of silver or brass into copper surfaces, and inlays of brass and other metals into wood.

There were Indian enamels applied to gold and silver plate and Indian equivalents of the **champlévé** work we will consider in the chapter on China. There were Indian carvings of ivory, and Indian literary references as early as the fifth century A.D. to building interiors with ivory portals. Ivory was also used for the facing of columns and as inlay on wooden doors, small wooden tables, and musical instruments. Carved ivory was also seen in the form of Buddhas, chessmen, small puppets, combs, and boxes. In the Mughal period, there were sumptuous cups and bowls of carved crystal and jade. There were also, particularly in the northern state of Kashmir, Indian objects of painted **papier-mâché,** a material made of pulped paper and glue that became popular in seventeenth-century France.

Along with these elaborately decorated objects and within these elaborately decorated walls, the Indian interiors also, of course, contained some furniture.

India's Furniture

Traditional Indian interiors, both institutional and domestic, were spare in their use of furnishings. Seating was generally on the floor, softened by cashmere or cotton rugs or, in simpler circumstances, grass matting. Wardrobes and storage caskets were commonplace, the most popular native woods being sandalwood and blackwood (and, in Bengal, palm). Teak was imported from Africa.

Chairs were not in common use, but important personages sat on thrones. Gold thrones were mentioned in the religious texts such as the Vedas, the Ramayana, and the Mahabharata. When

thrones were made of wood, which must have been more frequent than gold, they were often in-laid with gold, silver, copper, and crystal. Carvings represented lions, horses, elephants, conch shells, the bull, the peacock, or the lotus. In addition, thrones were draped in plain or brocaded silks.

The most common article of domestic furni-ture was the **char-pai** or rope bed, its four-legged frame laced with rope that would support bedding. In wealthy houses, the rope might be replaced with boards of wood or even strips of ivory.

Indian interiors, for all their basic plainness, achieved a sense of great luxury through the gen-erous use of textiles in the form of wall hangings, cushion covers, and carpets. Textiles, indeed, have long been one of India's most admired products.

India's Textiles

The cultivation of cotton and the weaving of tex-tiles have been important parts of India's culture since prehistoric times. Large amounts of cotton seed along with an impression apparently made by woven fabric were found in what is now Pakistan at a grave site dated to c. 5000 B.C. A stone Figure of a bearded man, possibly a priest (Figure 10–10), wearing a garment of printed fabric, has been dated to 2000 B.C. In the Vedas, the Hindu religious texts compiled c. 1500 B.C., there are references to fab-rics made of cotton, wool, and silk, both woven and embroidered, and the universe itself is de-scribed as a fabric woven by the gods. Actual frag-ments of cotton cloth, along with a needle made of bronze and spindles made of terra-cotta, survive from the ruins of Mohenjodaro, the city on the banks of the Indus that flourished from 2500 to 1500 B.C.

One of these fragments was dyed with red madder, a plant-derived dye also sometimes called turkey red. This is significant, showing that India had long ago mastered the use of catalysts called **mordants,** necessary for cotton's absorption of almost all dyes. Animal fibers such as wool and silk take dye readily, but not vegetable fibers such as flax, the plant from which linen is made, or cotton. A mordant is a metallic salt with which the resist-ant fibers can be saturated; the dye solution then reacts chemically with the mordant and forms an insoluble colored compound called a **lake.** Varia-

Figure 10–10 A stone figure wearing a garment patterned with cloverleaf or trefoil forms. The raised pattern may represent embroidery. From Mohenjodaro, c. 2000 B.C.

SCALA/ART RESOURCE, NY

tions in the amount of mordant applied can alter the hue and intensity of the resultant color. The early perfection of this technique gave Indian weavers a great advantage, and the virtuoso use of brilliantly colored dyes became a major feature of Indian textile art.

Foreigners were impressed. When European visitors first saw cotton plants in India, they de-scribed them as wool-growing trees. The plants themselves and the fabrics woven from them both were exported from India to Egypt and Rome in ancient times, and, in Nero's reign, Indian **muslin** was all the rage in Rome. This was a delicate, soft, translucent cotton and was sometimes given the full name *Indian muslin*. Within India, the nearly in-visible material was given such poetically descrip-tive names as "running water," "evening dew," and "woven air." Such material was infinitely finer than what we today call muslin: a stout, plain cotton

cloth used for shirting and bedsheets. Some of the exported muslin was embroidered with gold or silver threads.

Silk was also exported from India to ancient Rome, both as yarn and as finished cloth. Silk's affinity for absorbing dye and the Indians' affinity for color were a natural pairing, and silk weaving reached a high level of achievement in India. In addition to the refined products of the cultivated silkworm, there was popularity in India for the rougher, more nubby silk obtained from wild cocoons. This was called **tussah,** derived from the Hindi word *tasar,* meaning "a shuttle used in weaving." India had imported its first silk, however, from China, where it originated, and a detailed account of silk manufacture will be given in the China chapter that follows.

Buddhist paintings and carvings in the Ajanta caves, dating from early times to the seventh century A.D., show many products of Indian textile arts. Some of the paintings depict fabric panels used to divide and screen interior spaces. Pali literature, a collection of sacred Buddhist texts, also includes many references to textiles.

Indian textiles began to be distributed by the British East India Company in the early seventeenth century. In the following two centuries, India became the largest textile producer and exporter the world had ever known.

All Europe was hungry for Indian textiles, and England especially so. In the seventeenth and eighteenth centuries there was great English demand for wall hangings, tablecloths, bedclothes, and yard goods from India. The **palampore** was a particular favorite, a hand-painted cotton (**chintz**) bedcover with a central medallion and related corner patterns, similar to some Persian carpet designs. In Europe, palampores were sometimes called *persanes* and *indiennes,* referring to their origins.

INDIAN CARPETS Like their Persian models, early Indian carpets were patterned primarily with flowers, leaves, and vines (Figure 10–11), sometimes with a few animals added among the foliage. In the earlier carpets, few of which remain, the weavers drew the flowers with great care, as if they were botanical specimens. The colors in Indian carpets are often brilliant.

Indian carpet-weaving skill and originality grew steadily. The Lahore carpets came to be particularly fine, their pile often made of **pashmina,** Kashmir goat's hair, known to us as *cashmere,* rather

The text mentions that our word *calico* has an Indian origin. Other textile terms with predecessors in Hindi, one of India's major languages, include:

- *Chintz,* based on the Hindi word *chitta,* meaning "spotted." It refers to a decoratively printed cotton, usually with a hard, lustrous *(glazed)* surface on one side.
- *Dungarees,* based on the word *dungri.* It originally referred to a coarse East Indian cotton used for tents, sails, and rough clothing.

- *Khaki,* a Hindi word meaning "dusty" or "dust-colored."
- *Pajama,* based on *pa,* meaning "leg," and *jama,* meaning "garment."
- *Seersucker,* based on the phrase *shir-sakkar,* literally meaning "milk and sugar" and suggesting a mixture of textures.
- *Shawl,* based on the word *shal.*

Some of these Hindi terms, of course, were in turn based on similar terms in other languages, such as Persian and Sanskrit.

than the coarser sheep's wool. The Lahore carpets were extremely well made as well, their weaves ranging from about 400 knots per square inch (62 knots per cm$^2$) to—it is said—more than 2,000 (300 per cm$^2$)! For good reason, these carpets are generally known as *Indian fine-weave carpets.*

INDIAN TEXTILE TECHNIQUES The Indian application of mordants and dyes was accomplished in many ways, each technique producing its own special effect. Painting and block printing were two techniques, the latter depending on a design cut into a wooden block (Figure 10–12), then stamped onto the cloth. Other, more complex techniques used in India include resist-dyeing, tie-dyeing, and ikat.

- **Resist-dyeing** involves treating parts of the cloth with a substance that resists dye. The entire cloth is then dyed, leaving a pattern of natural and colored areas. If a second color is applied along with the resist agent, the result is a two-tone effect.
- **Tie-dyeing,** sometimes called *tie-and-dye,* sometimes called *bandanna work,* is a technique done by hand and not dependent on chemical reaction. Variations of the technique have been used in many places at many times, most no-

Figure 10–12 Carved wooden block for printing a repeat fabric pattern.
ABERCROMBIE

tably in India and Indonesia. Small sections of the cloth to be colored are gathered up and tied tightly together with thread or string. Sometimes waxed strings are used to further repel the dye. The whole cloth is then submerged in the dye, which is unable to penetrate the tightly bound sections. The result is a pattern of undyed areas, usually somewhat irregular in shape, against a dyed background.

- **Ikat** is a similar technique in which the yarn is treated or tied to resist dyeing before the cloth is woven. If this is done in a carefully measured manner, a planned pattern then emerges as the weaving proceeds. The edges of the woven patterns cannot be exactly predetermined, however, so they appear with a slightly blurred outline that many find very attractive. Although the term *ikat* is Javanese, the technique is believed to have originated in India.

- **Embroidery** is a further embellishment of needlework designs that can be applied to any cloth. In India, it has often been applied by women and has often reflected local traditions. The types of stitching—with such names as satin stitch, chain stitch, and cross-stitch—as well as designs and colors reflect regional tastes. Although hand embroidery is still practiced, it has now been largely replaced by machine embroidery.

Each of these textile techniques, naturally, is appropriate for the production of a particular vocabulary of design effects. It is also natural that textile design is determined by other factors as well.

Figure 10–13 The Paisley motif, a favorite in Indian textile designs, but with a Persian history and a Scottish name. Shawl with parts of two cone borders, Gibb & Macdonald, Edinburgh, 1820-30 (wool) by Scottish School (19 Century) .
NATIONAL MUSEUMS OF SCOTLAND/THE BRIDGEMAN ART LIBRARY INTERNATIONAL LTD.

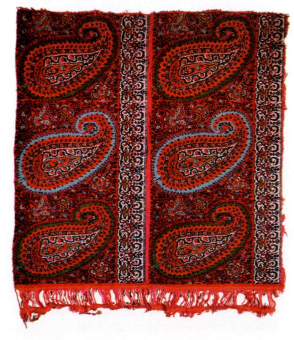

INDIAN TEXTILE DESIGNS Like so much else in Indian art and life, Indian textile design is largely a matter of tradition and symbolism. Perhaps the most basic traditional family of Indian design motifs, appearing also in sculpture, is called *buti, boota,* or *bootari.* It is a series of small floating shapes, most usually based on flowers, singly or on sprigs or sprays, and appearing against a plain background. Handwoven cotton fabric employing such motifs are sometimes called *boota muslins.*

Other frequently seen design motifs are based on native animals, birds, or plants.

These include:

- The *peacock (mor)*, now India's national bird, which is found in ancient Indus Valley burial pots, in Buddhist sculpture, and in Mughal miniature paintings, as well as in textiles. It symbolizes a wide variety of attributes, including love, courtship, fertility, and immortality.

- The *parrot (tota)*, which is seen primarily in textiles and art from western India and often in the company of Hinduism's most celebrated pair of lovers, Krishna and Radha. It represents passion.

- The *goose (hamsa)*, which has been found in Indus Valley pottery and in murals in the Ajanta caves, although its appearance in textile designs became less frequent beginning with Mughal times. It is a Buddhist symbol of spiritual purity.

- The *lotus (kamal)*, which was a symbol of spiritual power for both Buddhists and Hindus. It also represents the material world, its goods, and general prosperity, and it is associated with the Hindu goddess Sri Lakshmi.

- The *hunting scene (shikar)*, with obvious references to vigor and physical activity. Such scenes depict horsemen pursuing elephants, tigers, rabbits, deer, and other animals, all seen in forest or jungle settings. Such scenes were often found on Indian textiles made for the Portuguese market.

- The *Paisley.* By far the most famous design motif of Indian textiles is the **Paisley** *(kalga)* (Figure 10–13). It is less venerable than many other Indian motifs, having been introduced less than three hundred years ago, but it is now immensely popular. The origins of this distinctive

motif are probably Persian. According to art historian Ananda Coomaraswamy, the Paisley motif is "derived, almost certainly, from the Persian wind-blown cypress." By the seventeenth century, the motif had evolved into Mughal floral and tree-of-life designs. By the late eighteenth century, it had been codified into the leaf-shaped form with rounded base and curving, pointed top familiar today. The shape has also been compared to that of an amoeba or paramecium. The Paisley motif appeared frequently on the famous wool shawls woven in Kashmir. The finest of these, measuring more than 20 square feet (2 m$^2$) and weighing less than 6 pounds (2.7 kg), were so sheer that they could be drawn through a finger ring. These were popular items for foreign export and eventually became popular items for foreign imitation. The most famous imitations were those made in the Scottish town of Paisley, where a weaving factory had been established in 1759. From that source, the shawls became a European fashion for more than a century, and the motif today has become widely known by the town's name.

INDIAN TEXTILE COLORS It has been reported that the Paisley shawls of India were made in more than three hundred colors. In textiles of all kinds, the Indian taste has generally been for a generous variety of vibrant colors; an exception is that at some periods the area of eastern India around Calcutta has expressed a taste for quieter effects, with more interest in texture and pattern than in color. Indian dyes were traditionally made, of course, from natural substances. Some examples are:

- *Reds* came from madder, lac, the al root (also called Indian mulberry), or cochineal, a substance made from the dried bodies of a particular insect.
- *Yellows* came from turmeric, now used as a condiment.
- *Greens* came from pomegranate rind.
- *Blacks* came from a mixture of iron shavings and vinegar.
- *Blues*, the most potent dye of all, so strong that it could be applied without the use of a mordant, came from the indigo plant, *indigofera tinc-*

toria. It produced a deep purplish blue color popular in India and throughout Southeast Asia.

Colors in Indian textiles traditionally had their own symbolism. Some colors represented particular gods—white being the color of Shiva, blue the color of Vishnu or Krishna. In earlier times, colors represented castes or social divisions—red or white being the color of the Brahman class, green the color of merchants and traders, yellow the color of the religious and ascetic, blue the color of the low caste. For the Indians, colors have also held less literal, more subjective meanings—white the color of purity and mourning, saffron yellow the color of spring and youth, red the color of early marriage and love.

Whether in use as clothing or as a feature of interior design, Indian textiles have long constituted a highly significant vocabulary of techniques, designs, and colors,

Summary: The Design of India

It is difficult to briefly characterize India's design, for like its religions it is extremely varied. It is fair to state, however, that most Indian design is created in service to Indian religion. It also seems fair, at least to an outsider, to state that while Indian religions are primarily transcendent, otherworldly, and spiritual, more concerned with higher states of being than with the here and now, Indian design, perhaps necessarily, is often palpably present, appealing directly to our human senses.

It does this primarily through ornament. This, at every scale, is elaborate, detailed, complex, and intricate. It is also often highly repetitive: a row of identical Paisley motifs, a row of identical pointed arches. But such repetition can have powerful, hypnotic effects. At its most powerful, an insistently repeated design element acting on the consciousness like an insistently repeated chant, it can achieve a degree of transcendence to match its spiritual subject matter. In the West, we have come to equate serenity with plainness or emptiness; the design of India achieves it through multiplicity.

Indian multiplicity, however, is not random or disordered. Always underlying it is some organizing pattern. For Indians, there are rules that govern

the relationship of the real and the spiritual. There are rules, therefore, that govern the design of real buildings, spaces, or objects meant to invoke the spiritual. Indian design is often the product of tradition and religious dictates. It may also be the result of inspiration or skill, but it is never the result of chance or whim.

The traditional interiors of India do not meet our current standards of comfort and function, and they certainly do not satisfy the modernist taste for simple forms and unadorned surfaces. They are minimally furnished, their major concessions to making their users comfortable being in the area of soft goods—carpets, fabric hangings, and large, soft cushions. Yet they are far from minimally decorated. When circumstances allow, walls, floors, and ceilings are embellished with intricate designs, well conceived and expertly executed.

Remarkable, too, is the relationship of this decoration to the architectural form beneath. The form is generally a strong one, often based on the clear rhythm of repetitive geometry, and the decorator of form respects it. Indian decoration, in this sense, is similar to Greek vase painting. Both are admirable in themselves, but doubly admirable in their deference to the shapes they decorate. Neither is so bold that it blinds us to that underlying shape, and neither uses illusionistic three-dimensional effects that would visually distort that shape. They lie flat, so that we can see both the Greek battle scene and the *krater* on which it is painted, both the Indian stone inlay and the building to which it is applied.

We have noted that Indian design enjoys the hypnotic effects of multiplicity. But this use of a hundred scrolling plant tendrils or a thousand writhing figures never has the purpose of overwhelming the structure beneath. On the contrary, this very repetition turns the decoration into a surface pattern spreading rather evenly over a form. A multitude of small decorative effects distracts us much less from the form beneath than would a small number of large ones.

CHAPTER

11

CHINA

4000 B.C.–A.D. 1912

Chinese history is measured in dynasties. Beautiful objects were produced in all periods, but most of the Chinese art we see, even in museums, was made during the last two dynasties, the Ming (1368–1644) and the Ch'ing (1644–1911).

Chinese Architecture

First, we shall look at Chinese buildings, both public and private, then at the furniture made for those buildings, then at a variety of arts practiced in China that produced the small, precious articles the Chinese treasured.

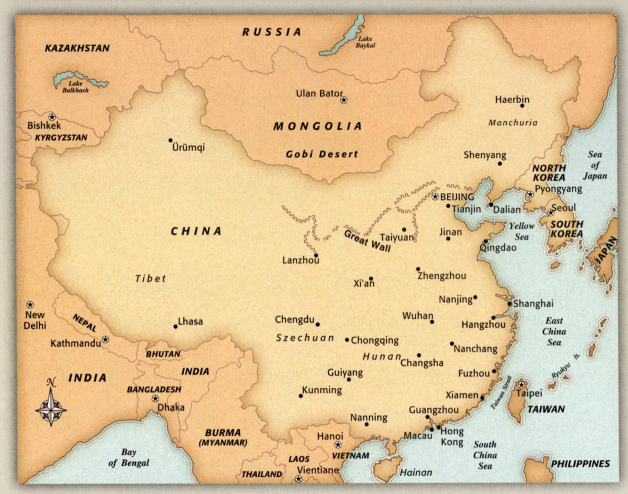

Figure 11–1 MAP OF CHINA AND KOREA

ORTELIUS DESIGN

Like many other Chinese arts, Chinese architecture is rigorously conventional, its basic forms repeated for centuries. Although other building traditions feature tall structures and daring engineering as expressions of unprecedented achievement, Chinese architecture expressed instead the qualities more highly regarded by its builders: adherence to precedence and repose.

These forms are generally **modular,** based on repeated identical units, generally built in wood, and generally horizontal. The module is a bay called a *jian*, and it was often roughly 10 by 20 feet (3 x 6 m) in early buildings, although, from the tenth century on, very important structures might have bays as large as 15 by 30 feet (5 x 10 m). Larger bays than that were precluded by the wooden construction, the beams being incapable of longer spans. Most commonly, a building had an odd number of bays, the central one being considered the chief one, and sometimes this central bay was slightly larger than the others.

A large complex was typically composed of a large number of such simple structures, although they were often clustered around courtyards and joined by covered walkways or verandas. These modular building elements were generally arranged in an **axial** plan, one arranged symmetrically around an axis or center line. Just as the central bay was the most important space within a building, the central building—on the main axis or at the intersection of two perpendi-

Giving Western-language equivalents of the sounds of Chinese symbols is, at best, a matter of approximation. The two most popular systems of romanization are the Wade-Giles, the system that was until recently the most commonly used in scholarly writing, and the pinyin, the system approved by the Chinese government. In general, the pinyin spellings are given here, but Wade-Giles or other spellings are used when they have become more familiar, or when, as in the case of the Ch'ing dynasty, the Wade-Giles spelling is closer to the pronunciation. A complication to be noted within the Wade-Giles system is that the introduction of the aspirate (') changes the pronunciation to a slightly breathier "h" sound. Within the pinyin system, the consonant q is pronounced "ch." For comparison, here are a few pairs of spellings for the same words in both systems:

Wade-Giles	Pinyin
Peking	Beijing
Canton	Guangzhou
Szechuan	Sichuan
Shantung	Shandong
chi	ji
ch'i	qi
Ch'ing	Qing
tsung	zong
ts'ung	cong

cular axes—was the most important building in a complex. Whenever possible, this most important building was at the northern part of the site, facing south, and its back (north) wall might be solid, built of earth rammed into wooden forms or of fired brick.

The most distinguishing part of a Chinese building was its roof. The roof was larger than the building beneath it, extending to form wide, sheltering eaves, and these eaves were supported on wooden brackets (dou-gong) projecting from the tops of the supporting columns. These brackets were sometimes elaborated into constructions of dazzling complexity. Another striking feature of the roof was the fact that it curved gracefully upward as it extended outward, giving an admirable sense of lightness and movement to a building form that was basically a large rectangular box.

The building characteristics outlined above were applied to a wide range of building types—temples, palaces, government buildings, and all but the most humble residences. We shall look first at examples of Chinese civic and religious architecture, and then at Chinese architecture on the domestic scale.

The Chinese Temple, a Succession of Bays

The Chinese temple complies with the general description of Chinese architecture outlined above. This modular, axial assemblage of bays is a distinctly skeletal form of construction, with regularly spaced columns providing support for the roof. Walls between these columns, thus deprived of structural necessity, can be thin screens. Most traditional temple structures are a single story high, although their roofs might be built with more than a single tier. Most are built of wood, often of an aromatic Persian cedar (nanmu).

The temple is distinguished from other Chinese architecture by the splendor of its decoration. The roofs were often faced with glazed tile, sometimes in brilliant colors (although yellow roof tiles were reserved for use only by the emperor), and the roof-supporting brackets often carved and painted. It is primarily the degree of this ornamentation, growing richer over time, that dates a Chinese temple, for its form remained basically unchanged for centuries.

A temple complex was surrounded by an exterior wall providing privacy and protection and

was entered through a central gate (and, often, through a second, "spirit" gate). For privacy the first gate was sometimes placed off center, opening only to a small forecourt, with a passage to a more impressive axial gate. More public areas were closer to the gate, more private ones (such as residential units for royalty or the priesthood) farther removed, and even within rooms such hierarchy was observed, the places of greatest honor being those farthest distant from the entrance.

The greatest temple complex of all is the one called the Forbidden City.

The Forbidden City

Under the reign of the Ming emperor Ch'eng Tsu (1403–25), a great burst of building activity produced an enormous ensemble of royal buildings at the heart of Beijing. The ensemble is called the Forbidden City, for it was originally forbidden to all but members of the imperial household and their servants and guests. It is entered through the Gate of Heavenly Peace *(Tian-an Men)*, actually a complex structure of five vaulted gateways topped by a pavilion. Beyond the vast Square of Heavenly Peace is another gate, the Meridian Gate, and, beyond that, an immense courtyard with a water-

way crossed by five bridges, and then still another gate, the Gate of Supreme Harmony (Figure 11–2). The Forbidden City beyond contains almost a thousand structures linked by marble terraces edged with marble balustrades and interspersed with courtyards, waterways, bridges, and additional walls and gates. For almost five hundred years, China was ruled from this complex, and it was both headquarters and home for fourteen emperors of the Ming dynasty and ten of the Ch'ing.

The buildings can be divided roughly into the larger ones nearer the entrance, which were used primarily for ceremonies, banquets, lectures, sacrifices, and receptions of visiting dignitaries, and the smaller ones farther from the entrance, which were used as the emperor's residence. Among the larger, more public buildings is a central group of three great ceremonial halls, the largest being the Hall of Supreme Harmony, and the others being the Hall of Complete Harmony and the Hall of Preserving Harmony. The Hall of Supreme Harmony or *Taihe Dian* is on the important central axis shared by the entrance gates. It is 108 feet (33 m) deep and 197 feet (60 m) wide. Its roof height is the same as the building's depth (Figure 11–3, page 244), and its hipped-roof construction is of the double-eaved type. It is the largest of all the traditional wood-

Figure 11–2 Near the entrance to the Forbidden City, the so-called River of Golden Water and the Gate of Supreme Harmony.

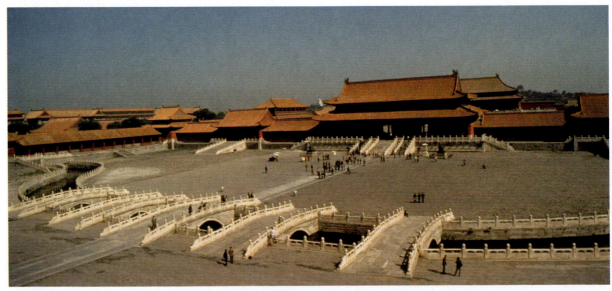

DATE	DYNASTY OR PERIOD	KEY RULERS AND FIGURES	RELIGIOUS AND POLITICAL EVENTS	TECHNICAL AND ARTISTIC HIGHLIGHTS
2205–1766 B.C.	Hsia			
1766–1123 B.C.	Shang			Beginning of poetry tradition; bronze ceremonial vessels; jade ornaments
1122–255 B.C.	Chou	Lao-tze, Confucius	Origins of Taoism and Confucianism	Use of iron; gold and silver ornament
	Period of warring states			
255–206 B.C.	Ch'in	"First Emperor" Shih Huang-ti and counselor Li Ssu	Conquest and unification of China	Terra-cotta tomb figures; Great Wall begun
206 B.C.–A.D. 221	Han		Peace, expansion, the arrival of Buddhism	Manufacture of paper; establishment of Silk Road
221–581	Minor dynasties	Painter Ku K'ai-chih	Warfare	Oldest extant pagoda
581–618	Sui		Building of Chang-an; beginning of golden age	Great age of Buddhist sculpture
618–905	T'ang	Painters Li Ssu-hsün, Wang Wei, and Wu Tao-tze	Establishment of examination system for civil service employment	Invention of porcelain; oldest extant woodblock prints; oldest extant printed book
907–960	5 dynasties and 10 independent states		Chaotic times	Paper money; block printing of Chinese classics
960–1127	Northern Sung	Painter Li Lung-mien		First novel; first great Chinese encyclopedia
1127–1279	Southern Sung	Genghis Khan	Invasion of China	Conventional painting
1260–1368	Yüan	Kublai Khan	Mongol rule	Islamic influence
1368–1644	Ming	Ch'eng Tsu	Portuguese settlement of Macao	Earliest known cloisonné; monochromatic porcelain; fine furniture; the Forbidden City begun
1644–1911	Ch'ing	Emperors K'ang Hsi and Ch'ien Lung	Manchu rule; abolition of examination system; Canton opened to foreign trade; Boxer Rebellion; revolution, 1911	Elaborately patterned porcelain
1911–49	Republic of China	Sun Yat-sen first resident; Chiang Kai-shek	Emperor abdicates	
1949 to the present	People's Republic of China	Mao Tse-tung		

framed halls of China, and the most elaborately ornamented. Inside, in its central bay, is an elevated platform, approached by three short flights of stairs and carved with dragons, clouds, and stylized lotus petals. On the platform is the imperial dragon throne of carved gilt lacquer, behind it is a screen of the same material, and beside it are bronze incense burners in the shape of elephants. Around the platform are six gold-faced columns with images of dragons wrapping around them, the columns farther from the throne being vermilion in color. The panels of the coffered ceiling above display more dragons, and everywhere—including on door- and window frames—is the sparkle of gold.

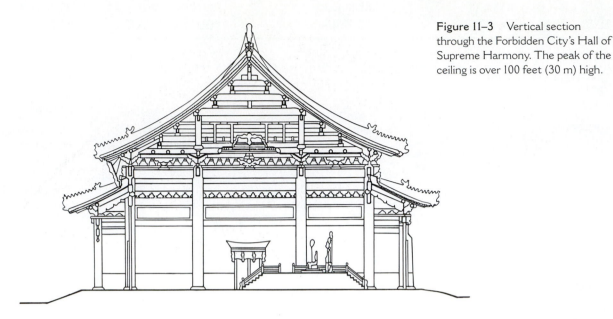

Figure 11–3 Vertical section through the Forbidden City's Hall of Supreme Harmony. The peak of the ceiling is over 100 feet (30 m) high.

The smaller, more private buildings, within their own wall, repeat the plan of the first cluster at smaller scale: they are the Palace of Heavenly Purity, where the emperor held private audiences, the Hall of Union, where the imperial seals were kept, and the Palace of Earthly Tranquility, which was the domain of the empress. The interiors of these somewhat smaller pavilions are less stupendous in their effect than those of the public ones, but they are by no means simple or plain, and some of their furnishings are quite extraordinary.

All the buildings of the Forbidden City are elaborately decorated. Their tile roofs are brilliantly colored, and the intricate wooden brackets supporting them are brightly painted. Virtually every surface of every interior is embellished, the chief colors throughout being red, blue, green, and—the color with imperial associations—yellow. Yet, despite its size, variety, and vivid colors, the Forbidden City appears cohesive. Its vocabulary of building forms is a small one, its elements are symmetrically disposed, and its organization is orderly and readily understood.

Chinese Houses

Houses of all sizes were generally composed around a central courtyard, or sometimes a progression of courtyards. In the grander houses, these were carefully landscaped, planted with weeping willows, quivering ginkgos, bamboo, and flowering shrubs, and also furnished with paths, pools, moss-covered rocks, footbridges, and pavilions. Flowers—lotus, peony, azalea, chrysanthemum—were chosen not only for their appearance and the time of their blooming, but also for their symbolic meaning. And hanging from archways and beams to light the gardens were colorful lanterns.

Within this natural context, the living quarters of a large house were disposed in a number of related but unconnected units (Figure 11–4). These units were carefully graduated in size and importance, expressing the traditional Chinese living pattern of the patriarchal family, with several generations living in the same domestic compound, and the younger members subordinate to their elders.

The windows of the houses were traditionally infilled with strong white paper rather than glass. Whatever their thermal shortcomings, they were important decorative features, both inside and out, being also filled with narrow strips of wood in geometric latticework patterns. Sunlight through these during the day cast an interesting play of shadows on the interior; at night, lighted from within, they cast a similar shadow play on the surrounding garden walls.

The Chinese house and its garden courtyards were interwoven, inextricable parts of a whole composition—one could not exist without the other. Yet the design of the house may be said to conform to Confucian ideals and the design of the

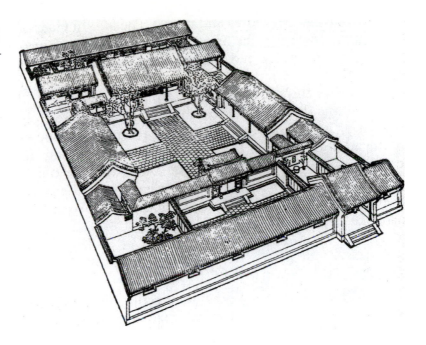

Figure 11–4 Perspective drawing of a typical Chinese courtyard house. Except for the entrance, elements are symmetrically disposed around a central axis.

AFTER LIU DUNZHEN

garden to Taoist ideals. The built elements were symmetrical, regular, and axially disposed, all in accordance with the practical Confucian notions of discipline and hierarchy, of man in harmony with orderly society. The garden, however, was more freely designed, more irregular, more animated, and with more surprises, all in accordance with the more mystical Taoist notions of man in harmony with unpredictable nature. The total composition of buildings and gardens together well demonstrates the assimilation of divergent forces typical of much of Chinese life and art.

The influence of Confucianism continued inside the house, with men's and women's quarters being separated and given furniture and décor of different character. The eighteenth-century scholar's study that has been reconstructed at the Minneapolis Institute of Arts, for example (Figure 11–5),

Figure 11–5 Scholar's study named Studio of Gratifying Discourse. China, 1797.

THE MINNEAPOLIS INSTITUTE OF ARTS. GIFT OF RUTH AND BRUCE DAYTON.

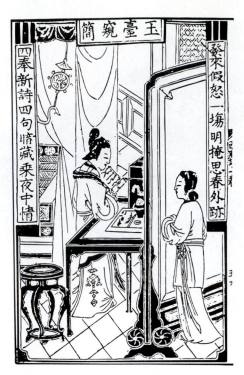

Figure 11–6 A scene in the women's quarters, wood-block illustration from the drama *The West Chamber,* Nanjing edition, Ming dynasty, Wanli period (1573–1620).

is attractive but clearly masculine in character. The windows open to a garden through a variety of wood lattice patterns, and furnishings, appropriately, are restrained and simple, saved from severity only by a few graceful curves. It is clearly a retreat for a scholarly gentleman and the other scholarly gentlemen who were his guests. An inscription on a ceiling beam describes the room as "the studio of gratifying discourse."

For comparison, a wood-block print from around 1600, illustrating a scene from the drama *Xi Xiang Ji* (The West Chamber), shows an interior of quite different character (Figure 11–6). We are in the women's quarters here. The furniture is more curvaceous and more ornate, and the openings are covered not merely by lattice but also by quantities of flowing fabric. The table in the lower left corner of the print is of the type traditionally used for burning incense.

Despite such differentiations between rooms and furnishings with masculine and feminine characters, however, the vocabulary of Chinese furniture pieces was small.

"Friends of the House," Chinese Furniture

Inside the Chinese house, even inside the most important of Chinese houses, furniture was scarce by today's standards. But the furniture and décor that existed were often of the highest quality. And, on festive occasions, the rooms were brightened and softened with fabrics: carpets, brocade runners draped on chairs, and ornamental frontal pieces tied to tables.

Information about furniture in the Han dynasty, the earliest about which we have any knowledge, comes not from any surviving examples, but from depictions of furniture on Han bronzes, in Han paintings, and on clay models of Han houses that were used in burial rites. In these early days, the largest and most important piece of furniture was the k'ang.

The K'ang

The **k'ang** was essentially a large, low platform for sleeping or sitting (traditional Eastern sitting postures being cross-legged or with one leg tucked under the body, not, as in the West, with the legs vertical). In the cold north, the k'ang was often placed along an interior wall and built of brick with a system of flues beneath it for heating, using the warm air from a nearby cooking stove. In the warmer south, the k'ang was usually freestanding and built of wood (Figure 11–7). Even in the north, it eventually evolved into a wooden platform, and, for privacy and comfort, it often had uprights supporting an overhead **tester.** (Pronounced "tee-ster," the word is related to the French *testière* meaning "headpiece"). The tester is sometimes of solid wood, sometimes only a wood frame for the support of a fabric covering. In either case, side panels of fabric could be hung vertically from the tester, and the k'ang could also be supplemented with screens, rush mats, and silk-covered cushions. Sometimes backrests were added, and sometimes also side rails, turning the platform into a kind of sofa with low enclosures on three sides. (Some writers, it should be noted, use the term *k'ang* only for the built-in, heated platforms, and other terms for the movable versions.)

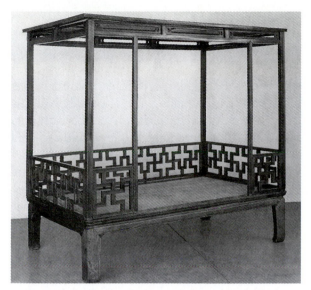

Figure 11-7 A sixteenth-century k'ang bed frame with six vertical posts supporting a tester. It is primarily of huang-hua-li wood with some pieces of red pine, 77¼ inches high, 81½ inches wide, 47½ inches deep.

PHILADELPHIA MUSEUM OF ART: PURCHASED

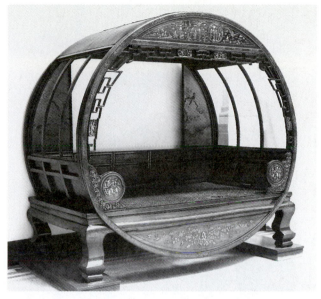

Figure 11-8 Circular version of a k'ang, inlaid with ivory. It dates from c. 1850 and its length is 7 feet 3 inches (2.2 m).

VICTORIA AND ALBERT MUSEUM, LONDON/ART RESOURCE, NY

Later developments of the k'ang include such novelties as a version with a completely circular canopy (Figure 11-8). The curved wood members at its sides would have supported silk hangings completing the cylindrical form. Such a fanciful object would probably have been used in the women's quarters of a house.

The k'ang was often large enough so that two or more people could recline or sleep on it. It was so large, in fact, that it often had its own subsidiary pieces of furniture that could be placed on it. These included the *k'ang ji,* a small table, and the k'ang cupboard, a small chest in which could be stored eating vessels and utensils, reading or writing materials, or other objects.

The K'ang Becomes a Table

Eventually, the k'ang form was adopted for a low table. A characteristic detail, in both bed and table form, was the corner leg that curved gracefully inward as it descended, recalling the lilt of the Chinese roof gable (Figure 11-9). Early in the Ming dynasty, these legs began to be terminated by the form of a horse's hoof *(ma-t'i),* and in the eighteenth century the horse's hoof was replaced by a scroll form.

Another type of table, called a *melon table* because of its shape, was a small side table with a hexagonal top of wood or marble and six convex legs curving to meet another hexagon at the floor. Still another is the long, narrow *t'iao-an,* an imposing piece meant to be centered against a wall. When, in a more formal version, its ends were curved upward, it was called a *ch'iao-t'ou* (upturned head). There were also tables for writing, tables for painting, game tables, altar tables, nested tables, and

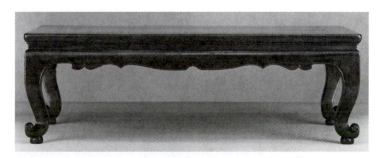

Figure 11-9 A Ming dynasty k'ang table of huang-hua-li wood, its curved legs ending in a small ball toe. The height is 1 foot (30.5 cm) and the rectangular top is 23 inches by 3 feet (92.4 cm).

THE NELSON-ATKINS MUSEUM OF ART, KANSAS CITY, MISSOURI (BEQUEST OF LAURENCE SICKMAN) F88-40/51

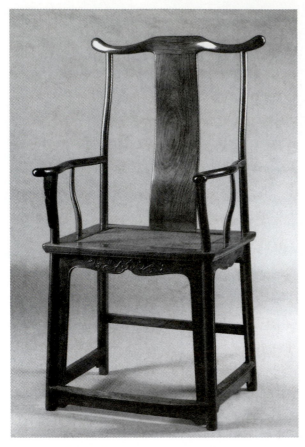

Figure 11–10 High yoke-backed "official's hat chair" with a flat central splat at the back. The arms are supported at their centers by S-shaped braces. Huang-hua-li wood, seventeenth century, 47½ inches (120 cm) high.

lute tables, these last designed to hold a Chinese zither.

Seating

Throughout most of the East, life was traditionally lived on or near the floor, sometimes with nothing more than a mat separating people and earth. The Chinese were exceptional in having developed the custom of sitting in chairs. The origin of this custom has been the subject of much speculation, but it may be that, in the fourth century, the chair and the folding stool were both brought to China from India (where they may have been brought from Europe by the forces of

Alexander the Great). In any case, chairs were in general use in affluent Chinese households by the ninth century, their form, as might be expected, simplified and highly refined. There were both armchairs and armless versions, and often the seats of Chinese chairs were unusually high, as they were designed for use with foot bars or footstools so that the occupants' feet could be lifted above the cold floor.

A version with its **crest rail**—the horizontal member or **slat** across the top of its back—projecting slightly beyond the vertical members that support it (Figure 11–10) is sometimes called an *official's hat chair,* perhaps because the rail ends recalled fabric projections at the sides of ceremonial headwear. The **splat** or central vertical member at the back might often be a plain, wide plank, but subtly and very beautifully curved. (Note the terminology just used, *slat* meaning a horizontal member of a chair back, and *splat* a vertical one.) Such chairs were originally intended for emperors or high officials, and the projections were originally of gold or brass, decorated with dragons' heads. Later, such a chair came to be widely used. Some versions have a fan-shaped or trapezoidal seat, the back edge of the seat slightly wider than the front.

Another elegant type of Chinese chair also has a plain central splat, but it rises to join a slat that is in a horseshoe shape, continuing down to form an arm and continuing even further to become the front leg (Figure 11–11). This design is sometimes called a *grand tutor chair.* In the example shown, the **apron** just under the seat and perpendicular to it is made of a slightly curved horizontal stretcher joined to the bottom of the seat with short vertical members.

Variations on the horseshoe-back chair were also constructed so that they could be folded (Figure 11–12). In these cases, the back might be joined to the rear legs, rather than to the front ones. It is thought that the folding versions, used by emperors when traveling around the country, were older than the stationary ones, and the example pictured has been dated to c.1500. It is a large chair, its wood members covered with lacquer, and the presence of five-clawed dragons in its decoration indicates that it was made for an emperor, for no lesser noble was allowed to be represented by such

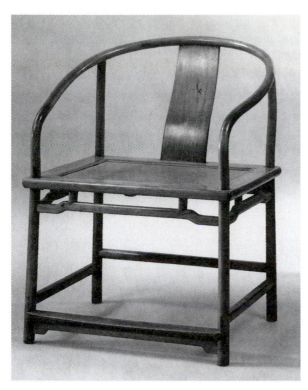

Figure 11-11 Three-quarter view of an armchair with a horseshoe back. Huang-hua-li wood, seventeenth century, 33½ inches (85 cm) high.

© CLEVELAND MUSEUM OF ART, THE NORWEB COLLECTION, 1955.40.2

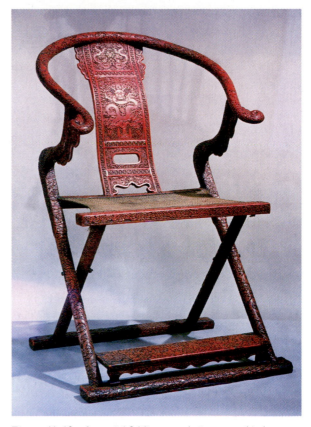

Figure 11-12 Imperial folding armchair encased in lacquer. A large chair, its curved back is 45 inches (114.5 cm) high, and its seat is 23½ inches (60 cm) high.

VICTORIA AND ALBERT MUSEUM, LONDON/ART RESOURCE, NY

beasts, the other aristocrats employing only four-clawed dragons.

Some thrones for the emperors continued to follow the low, wide k'ang tradition that would accommodate a cross-legged posture (Figure 11-13). Their **stretchers** (the horizontal members connecting and stabilizing the legs) were characteristically close to the floor. Variations for use by top civil servants, often with polychrome decoration, were called *mandarin chairs*.

A chair type that was popular beginning in the Song dynasty and on into the Ming was the *san cai tu hui*, which means literally "the chair of the old man who has been drinking." It was a folding lounge chair with an X-shaped frame at each side, long arms, a headrest attached to its back, and a footrest attached to the stretcher between its front legs. In the Ch'ing dynasty, this was modified into the *zui weng yi* or "drunken lord's chair." It was often made of caning within a bamboo frame, also had a

Figure 11-13 Lacquer throne in various colors over a black ground, seventeenth century.

VICTORIA AND ALBERT MUSEUM, LONDON/ART RESOURCE, NY

CHINA **249**

headrest atop its back, and sometimes also had a footrest that could be pulled out from beneath its seat. Both chairs' backs reclined at quite a slant, so that they could almost be said to be convertible to daybeds.

Storage Furniture

Storage furniture was very highly developed in China, there being no closets built into the thin-walled houses. Chests were built for storing books and manuscripts, and there were pairs of chests, chests on chests, and cupboards with open shelves. Tall, rectangular cupboards for clothing (or wardrobes) were commonplace and were made with various numbers of doors, although the most

Figure 11–14 From the reign of Wanli (1573–1620) in the Ming dynasty, a travel coffer lacquered in red, gold, and black. It rests on a black stand, and handles at its sides make it easily carried. Musee Guimet, Paris, France.

typical had a single pair of doors, sometimes with a single compartment beneath. Sometimes such casegoods had a single door and sometimes removable lids. Many had handles at their sides for easy transportation (Figure 11–14).

Palace furniture and other fine pieces were frequently lacquered in various brilliant colors, although, in A.D. 1029, an imperial decree stated that only the emperor himself could sleep in a bed of red lacquer. When a clothing cupboard was lacquered with a scene or design, the image typically spread across both doors and the intervening **stile,** the vertical member of the framework. Interiors of the cupboards were lacquered as well, at least the backs of the doors, and often in contrasting colors to the exteriors. Even the backs of such cupboards were frequently lacquered with elaborate designs.

In addition to lacquerwork, shallow carving was often used to enliven a small piece of storage furniture, such as a chest with a pair of hinged doors. Carvings of five-clawed dragons suggest that such a chest was made for the imperial household.

Such fine lacquerwork and carving was reserved for only a small percentage of Chinese cabinets and cupboards, of course. The majority of Chinese storage pieces are very much simpler, and some are so elegantly plain that they could easily be mistaken for designs from our own time.

Specialized storage units not originally built as furniture (although sometimes used today as coffee tables, end tables, or decorative storage units) are Chinese wedding boxes. Made for display as well as storage, they were traditionally paraded through the streets before wedding ceremonies, their number and beauty indicating the worth and prestige of the bride and her family. After the ceremony, they were used in the household for clothing storage. Built to the same design for a thousand years or more, the boxes varied in dimensions from a few inches to several feet. Made of pine, balsam, or other soft wood, the boxes were covered with pigskin, the leather serving as a hinge for the lid. The leather was typically painted with a wedding scene or other decoration.

All these boxes, cupboards, chests, and cabinets, which collectively would be called case furniture or **casegoods** today, were fitted with carefully designed hinges, mounts, pulls, and es-

cutcheons of nickel silver, brass, and other metals, and often these were countersunk so that their surfaces were flush with the wood or lacquer.

Furniture Woods and Joinery

Aromatic camphorwood was often chosen for casegoods, but the most frequently used furniture woods in China were variations of rosewood. One of these was *zitan,* so dense that it will not float on water, and known in the West as "sinking rosewood." Another, *jichimu* or *chi-ch'ih-mu,* known in the West as "chicken wing wood," was gray-brown with a rough, feathery pattern. A third was *tzut'an,* imported from the Philippines and known in the West as "purple sandalwood" or "purplewood" or even "blackwood." But most highly prized of all by Chinese craftsmen was *hua-li* or *huang-hua-li,* a fragrant rosewood that can acquire a soft, seemingly translucent luster. Ebony was also employed, more often for inlaid ornament than for whole pieces. In southern China as early as the Sung dynasty, some furniture was made of bamboo rather than wood, those bamboo pieces made for domestic use generally simple and unornamented, those meant for export generally trimmed with metal or ivory.

Wood elements in Chinese furniture were assembled without dowels or nails (except in later repairs) and generally without glue or dovetailing. The mortise and tenon (page 29), which allows the wood greater movement than any other sort of connection, an important factor in a country where temperatures can change radically from day to night, was the mainstay of furniture construction. The mortise and tenon also allows easy dismantling and reassembly, valuable to a population that was frequently on the move.

Furniture Placement

Placement of furniture within rooms was strictly ordered and related to the status of its users. Within the major reception room of a house or palace, the place of honor, as we have noted, was farthest from the entrance and facing directly toward it. Less important chairs for less important people were placed in pairs, a small table between them, around the walls of the room, all perfectly parallel to the walls behind them. The notion of an informal furniture grouping in the center of a room would be adverse to traditional Chinese taste; for the devout Confucian, it would even be profane.

As with Chinese architecture, Chinese furniture types remained constant for centuries, so that progressively rich ornamentation is often the only key to dating a furniture design. Even at its richest, however, traditional Chinese ornamentation was always respectful of the basic form of the building or chest or object being adorned, and respectful, too, of accepted limits of taste. Throughout every aspect of Chinese art and culture, as historian Craig Clunas has written, "The highest praise offered is *ya* 'elegant,' the most damning condemnation, *su* 'vulgar.' "

The "Casual" Art of Ch'an (Zen) Buddhism

A special branch of Chinese art, expressed in paintings and ink drawings, is that practiced within the Ch'an branch of Buddhism, better known by its Japanese name, Zen. This art aims at being spare, simple, quick, and spontaneous. An example is the sketch of *Six Persimmons* (Figure 11–15) by Much'i in the early thirteenth century. Mu-ch'i's six pieces of fruit are almost identical in shape, yet each has its own character; their relationships to one

Figure 11–15 *Six Persimmons,* a Ch'an Buddhist painting from the early thirteenth century, ink on paper, 14¼ inches (36 cm) wide.

THE BRIDGEMAN ART LIBRARY INTERNATIONAL LTD.

another and their placement on the paper appear random yet invite study; and their execution has been obviously rapid yet is based on practiced technique. Such art, deceptively casual in appearance, would come to be greatly admired and widely practiced in Japan.

The Arts of Carving and Molding

The Chinese were adept at sculptural form. In keeping with their concern for "the perfection of the little," as much care was given to the forming of small objects as of large ones. We can divide Chinese carving and molding into work with materials found in nature, such as jade and other stones, and work with materials deliberately created, such as lacquer.

Jade, the Virtuous Stone

Jade carving reached its highest level of achievement in the late Chou period, when the techniques of lacquerwork were also being perfected, both jade and lacquer exemplifying the Chinese attention

to small detail. Jade is extraordinarily hard and brittle, and therefore challenging to cut and shape, the challenge adding to the value of a well-crafted object. In China, and in Japan as well, jade was regarded as the most precious of gems.

Objects made from jade include amulets, pendants, garment hooks, seals, small bowls, ceremonial weapons, and figurines (Figure 11–16). So admired were jade carvings that, during the Sung dynasty, much effort was made to develop ceramic wares that would resemble the luminosity, color, and feel of jade.

Lacquer, the Layered Art

Lacquer is a durable, glossy, tough material that can be brilliantly colored and expressively carved. Its production requires time, skill, and a great deal of patience.

It is made from the sap of the lac tree, a variety of sumac indigenous to China and later introduced into Japan. When the raw lac is gathered and purified, it is a shiny, transparent gray syrup that, on exposure to the air, **polymerizes,** its small molecules combining to form larger ones. This process causes the syrup to harden into a tough, durable material. The syrup, therefore, must be stored in airtight jars until the hardening is wanted.

Lacquerwork is a patient technique of multiple layering, letting each layer dry before applying the next. Most commonly, the layers coat a core of wood or woven bamboo, but some lighter, thinner, more delicate examples are made by alternating layers of cloth and lacquer, or by lacquering onto a foundation of cloth, which is later removed.

Color is not natural to the lac, but is given by adding mineral pigments, such as iron to produce black or mercury to produce red, the two most traditional colors. The brownish red called *cinnabar,* made with mercuric sulphide, was a particular favorite (Figure 11–17). Muticolored and sculptural effects are also possible. Different layers can be of different colors, and the outer layer then incised to reveal the color beneath (Figure 11–18). The material can also be built up until it is thick enough to carve, cutting straight down to leave a flat upper surface. If even thicker, the material can be shaped with a knife into rounded forms.

Figure 11–16 Jade ring in the form of a dragon, probably carved in the Ming dynasty, 3¼ inches (13 cm) in diameter.

© THE BRITISH MUSEUM

Lacquer objects include bowls, jars, dishes, toilet boxes, trays, folding screens, low tables, and cabinets. Subjects frequently depicted in these lacquer objects are the peony, the lotus, the dragon, and garden and terrace scenes. A peak of great skill at lacquer working was achieved in the Chou dynasty, and an even greater peak in the Ming. Later, however, the greatest experts in lacquer were the Japanese, so that, by the end of the Ming period, Chinese artisans would be traveling to Japan to study their technique.

In the eighteenth century, there was a great demand in the West for the import of Chinese lacquer, particularly large screens in low relief (while similar but smaller screens were being made for the Chinese home market). So many of these were shipped (to Europe, Russia, Mecca, and elsewhere) by way of the Coromandel Coast of Southeast India, where the East India Company had a trading post, that the popular term in England for this kind of lacquer was **Coromandel ware.**

Imitation Lacquerwork

Because true lacquerwork was expensive to produce and difficult to access out of China, imitations such as shell-lac, seed-lac, and gum-lac were developed. The most successful of these was shell-lac or **shellac,** obtained by boiling an insect larva

Figure 11–18 Covered box in layers of green, red, and black lacquer, Yüan or early Ming dynasty, 3¾ inches (8.5 cm) in diameter.

INSCRIBED TRAY (NOT SHOWN) AND ROUND BOX, BOTH LACQUERED. MING DYNASTY 14TH–15TH CENTURY C.E. PHOTOGRAPH COURTESY OF THE ROYAL ONTARIO MUSEUM, TORONTO, ONTARIO. © ROYAL ONTARIO MUSEUM.

until it secretes a liquid, or by taking the liquid from tree branches where the insect has deposited it. The liquid hardens when spread in thin sheets, and the sheets can later be dissolved in an alcohol medium, then used as a transparent paint to produce a lacquer-like appearance. It is not, however, as durable or waterproof as true lacquer.

Shellac was not used in China, but it was used extensively in the European eighteenth-century imitation lacquerwork called *japanning*. Japanning reached its highest level of accomplishment in France with developments made by Guillaume Martin (died 1749) and his three brothers; their products, and later imitations of them, were called **vernis Martin.** (The term *japanning* is also used for some kinds of painting on metal, such as toleware, which will be considered in a later chapter.) Another eighteenth-century type of imitation lacquerwork that was popular in Italy, called **lacca contrafatta,** consisted of applying varnish (the general name for a solution of gum or resin, such as shellac, in a volatile solvent) over cut-out paper prints.

The Fiery Arts

The Chinese also excelled in a number of techniques involving changes brought about by intense heat. Glassblowing was not among them, but they included terra-cottas, ceramics, and enamels. The

Figure 11–17 Ming dynasty table of carved cinnabar lacquer on a wood core, c. 1430, 47 inches (119 cm) wide.

VICTORIA AND ALBERT MUSEUM, LONDON/ART RESOURCE, NY

earliest of such arts practiced in China, however, was the forging of impressive vessels in bronze.

Bronzes

First unearthed in the 1930s, the oldest artifacts from China that we know are bronzes. The practice of bronze casting may have begun as early as 1500 B.C., and soon it acquired an astonishing level of skill and sophistication. Clearly, the artistry of bronze vessels predated the systems of belief that later became determinants of Chinese art. This fact leads us to suppose that, from earliest times, the Chinese had an instinct for form and formalism that made them welcome the introduction of certain religions and philosophies, and that those in turn codified and strengthened those instincts. But this is only speculation.

Chinese bronzes can be divided into the functional and the ritual. Functional bronzes included vessels for cooking food, food servers, water containers, wine jars, and wine goblets. Ritual bronzes were intended for important ceremonies, and, because those ceremonies involved the ritual offerings of food and drink to deceased ancestors, their shapes were patterned after those of the functional bronzes (Figure 11–19). The shapes of both types of vessel were as highly specific, conventionalized, and repetitive as those of Greek vases. The ritual bronzes were, however, more carefully made and more richly decorated than their functional counterparts. They were inscribed with the names of ancestors and inlaid with gold, silver, copper, and turquoise. Decorative motifs included dragons, birds, oxen, sheep, and goats.

Bronze is an excellent medium for the reproduction of such decorative motifs in fine detail. It can be molded or carved, being able in its molten state to flow into every crevice of a mold and also highly susceptible to the graver's tool. It is an alloy of copper and tin (other alloys frequently used in the decorative arts being **brass,** composed of copper and zinc, and **pewter,** composed of tin and lead).

In ancient Chinese bronzes, the percentage of tin varied from 5 percent to 20 percent. The addition of a small amount of lead made the material flow better, lowered the alloy's melting point, and improved the finished surface. Alloys were heated in earthenware crucibles, then poured into clay molds or forms made by the lost wax method (described in the section on Egyptian faience, Chapter 2, page 31). The techniques of Chinese bronze casting were dependent on the techniques of the potter, which were even older (just as the potter was preceded by the basket maker). Bronzes, in turn, influenced later pottery, with the shapes of the metal containers translated into less expensive ceramic versions.

In addition to making the celebrated functional and ritual bronze vessels, the Chinese used bronze for weapons, chariot parts, bells, mirrors, and large and small statuary (Figure 11–20).

Terra-cottas

Terra-cotta, literally meaning "cooked earth," is a kind of ceramic. It is the product of a type of natural plastic clay that hardens when fired. The color most often associated with terra-cotta—and sometimes even given the name terra-cotta—is a rich reddish brown, the result of iron oxide in the clay. The presence of other impurities and variation in firing techniques can give the material other colors, however, and the terra-cottas of China are often a warm gray in color.

Terra-cotta objects were probably produced in China even before bronze ones. Being more frag-

Figure 11–19 Inlaid bronze ceremonial vase with cover, from the Warring States period, 6 inches (15 cm) high.

TING, CHINA, 4TH-3RD CENTURY B.C. BRONZE WITH INLAID SILVER DECORATION. THE MINNEAPOLIS INSTITUTE OF ARTS. BEQUEST OF ALFRED F. PILLSBURY. 50.46.76A,B.

Figure 11–20 Han dynasty bronze figures of two pawing and neighing horses and two horsemen, one of them holding a spear, which is 21 inches (53 cm) high.

ile, however, few of the earliest ones have survived. Those we know were made for similar uses—both functional and ritual—to their bronze counterparts, and they have similar shapes. Terra-cotta was also sometimes used for the molds in which the bronze vessels were made. Other Chinese uses for terra-cotta were for roofing tiles, small burial figurines, life-size effigies, tomb construction, and, to be placed in the tombs, for models of houses, palaces, pagodas, and scenes from daily life.

Enamels and Cloisonné

Enamel is a term with several meanings. It sometimes refers to a thin coating of a material that, when fired, gives a durable, glossy surface to another material, such as pottery or porcelain; in these cases, it is synonymous with **glaze.** As commonly used today, it refers to a paint that imitates the baked finish of such enamel. On wood furniture, more rarely, it refers to a glossy finish obtained by rubbing the surface with pumice stone and oil.

In the decorative arts of China, as we saw to be the case in medieval art, enamel refers to a substance thicker than a surface finish. Like such a finish, however, it **vitrifies** when fired, becoming a hard, glassy material. As this process occurs, it fuses with a metal backing or a metal container, so that the result is durably encased. It would be a relatively simple matter to create such an object in a single color, but the enamel artist's challenge is to create brilliantly multicolored designs. To do this without having areas of one color bleed into areas of another, techniques were devised in the Orient for containing the pre-firing pastes within small cells. The best known of these techniques is **cloisonné,** in which the cells are created by gluing or soldering thin metal ribbons (in French, *cloisons*) to a metal plate. It was mastered during the Ming dynasty, with the earliest known pieces dating from around 1430. Cloisonné was employed for making dishes, cups, boxes, jars, incense burners, animal and bird figurines, ice chests (Figure 11–21), and objects that we would call "desk accessories."

As in so much of Chinese art, the forms of cloisonne objects and the decorations on them persisted for centuries, and traditional designs are still produced today. Dating is difficult, therefore, although in the earliest pieces the cells were rather unevenly filled and sometimes pitted, giving the surfaces a lively irregularity, while later cloisonné work was more careful and therefore more smooth. Over time, intense colors were replaced

Figure 11–21 Cloisonné ice chest from the Summer Palace, Beijing, Ch'ing dynasty, late eighteenth century, 45½ inches (117 cm) long.

VICTORIA AND ALBERT MUSEUM, LONDON/ART RESOURCE, NY

with softer ones, simple patterns with more complex ones, and gilded bronze cloisons with copper.

Foreign Variations on Chinese Enamel

Just as shellac came to be used to reproduce the effects of Chinese lacquer, a number of other substances and techniques have been used to produce effects like those of Chinese enamel and cloisonné. Similar to cloisonné, for example, is **champlevé,** known to the Romans and used later in the Limoges enamel work of the twelfth to fourteenth centuries, in which the small cavities are formed not by attaching wires but by carving or etching hollows in pieces of cast bronze or brass. Champlevé is therefore generally heavier than cloisonné, and the elements forming the edges of its cells are part of the body metal.

Other related techniques are **repoussé** and **basse-taille.** Repoussé work involves stamping, hammering, or pressing of decoration on a metal surface (usually silver or copper), so that, when enamel is applied, the decoration is left standing in relief above the enamel surface. Repoussé therefore differs from cloisonné in the method of creating containers for the enamel. The term is also used

for hammered metal reliefs that are not enameled. An early example of enameled repoussé is a cup from Crete, dating from 1600 B.C., in the National Museum in Athens.

In basse-taille, the surface (usually silver or gold) is also stamped, hammered, or pressed, then immersed completely in a translucent enamel, so that the entire surface is coated, but with the color of the enamel strongest where the relief is most deeply indented. It can produce very subtle and beautiful effects. Some fourteenth-century ecclesiastical basse-taille pieces made in France are known as **Paris enamels,** and similar work of the same period in Italy is called **lavoro di basso rilievo.**

If cloisonné work is made without a metal base, so that light can penetrate translucent areas of enamel, creating a stained-glass effect, the result is called **plique-à-jour.** It is made by cutting small holes through a sheet of metal and filling them with enamel, or by spreading enamel over a thin metal filigree. Temporary backings of mica or copper can be used to support the enamel until it hardens. If the openings are small enough, however, (no more than ¼-inch or 6 mm wide), capillary action can keep the enamel suspended in the opening. This action can be increased by thickening the enamel with tragacanth, a kind of gum, but too much gum will cloud the enamel with fine bubbles. Subtle effects can be obtained in plique-à-jour, as in other types of enamel work, by building up several layers of differing color. The technique has been used for vases, cutlery, jewelry, cups and saucers, salt dishes, and other decorative objects for the dinner table. The earliest surviving example of this delicate art form is a fifteenth-century cup in London's Victoria and Albert Museum, and more recent artists working in plique-à-jour have been René Lalique in Paris and Louis Comfort Tiffany in New York.

In the late fifteenth century, enamel work was revived in Limoges, France, but without the provision of separate cells for each color. Rather, thin layers of enamel were simply brushed onto metal surfaces, a more expedient technique with much less impressive results. Other painted enamels of the same date, made in Italy, are now called **Venetian enamels.** Later ones include **Canton enamels,** actually made in Canton, but only after having

first been made in Europe, and **Battersea** and **Bilston enamels,** named for the locations of their British factories.

Ceramics

The Greek vase, as we have seen, is justly celebrated for the perfection of its form and the vitality of its painted design, but it was a specific and limited achievement. In the whole culture of China, no accomplishment is more greatly revered than the creation of fine pottery, and in the whole art of pottery, the Chinese accomplishment is unsurpassed. That accomplishment is both technical, as in the invention of porcelain and fine glazes, and aesthetic. It is entirely appropriate that the common term today for any vitrified (glass-like) ceramic is *china*.

The earliest Chinese ceramics, dated approximately 6,000 years ago, were red pottery funeral vessels. Meant to be seen from above, in graves surrounding the dead, their tops were decorated with fertility symbols and other painted designs. By 2000 B.C., other types of pottery were being produced, including hard, lustrous, jet-black pottery and gray pottery decorated with cord and basket markings. In the Shang period, stylized animals appeared on glazed pottery, and in Chou times the Shang style was continued but with the more flowing curved forms that would characterize Chinese vases ever afterward.

VARIETIES OF CERAMIC TYPE AND DECORATION The range of Chinese ceramics is large. In material, they include the humblest **earthenware,** an opaque, nonvitreous ware that is fired at a relatively low temperature (2010°F or 1100°C) and may or may not be glazed. They also include **stoneware** (Figure 11–22), known in France as **grès** and in Germany as **Steinzeug,** which is composed of clay and feldspathic stone, fired at a temperature high enough (2190–2550°F or 1200–1400°C) to vitrify the stone but not the clay. At the apex of achievement, they include **porcelain** itself, described in the next section.

The range of character of decoration on Chinese ceramics is also large, encompassing elaborate, multicolored scenes and floral patterns as well as some wares that, emphasizing pure form and

Figure 11–22 Stoneware vase with an overall floral design painted in brown on a white ground, then covered with a clear glaze, twelfth or thirteenth century, 15½ inches (40 cm) high.

VICTORIA AND ALBERT MUSEUM, LONDON/ART RESOURCE, NY

color, dispense with decoration altogether. These plain, monochrome porcelains, more appreciated in China than in the export market, are thought by many to be the highest artistic achievement of the Chinese culture. By the end of the Sung period, the fine cracks called **crazing** that may appear in a glaze during firing came to be admired as decorative and were deliberately sought as a ceramic finish.

THE COLORS OF CERAMICS For much of Chinese history, the prevailing taste was for simply formed ceramics with beautiful monochrome glazes. In the Song dynasty, these were often delicately colored in translucent tones. The Ming dynasty and the rituals of its court demanded glazes of more brilliant color—white, deep blue, bright red—each with its own symbolic meaning. In the Ming dynasty also, white pottery with underglaze decoration in copper red or cobalt blue became popular. The blue-and-white patterns that would become famous on porcelains were also used on earthenware and stoneware. Rough versions of

blue-and-white, along with some five-color wares and large dishes painted in red and green, were made for export purposes in the kilns of south China beginning in the sixteenth century. Because they were thought to have been shipped from the port of Swatow, they were called **Swatow wares.** From the kilns of **Shiwan,** in the southern province of Guangdong, came robust stoneware figurines and vases, their most admired glaze being a deep coppery color known as pomegranate red.

The Secret Arts

China's greatest two accomplishments in the decorative arts, porcelain and silk, exemplify not only the skill of the country's artisans but also the country's exoticism and isolation. For, although both products were widely exported and internationally admired, the techniques of their production were closely guarded from the outside world and held secret within China for centuries.

Porcelain, the Most Precious Ceramic

The interchangeable terms *pottery* and *ceramics* refer to all types of ware formed from soft nonmetallic minerals, such as clay, that are hardened by heat. Porcelain is a type of pottery, of course, but one with a specific definition and specific characteristics. It is constituted of two essential ingredients, both native to China. The first is a white clay called *kaolin* (or sometimes *china clay*). The second is *chinastone* (often spelled as two words, *china stone,* known in China in its raw form as *tz'u-shih* and in its prepared form of small white blocks as *baidunzi* or *pai-tun-tzŭ,* and anglicized as *petuntse*), a fusible crystalline mineral that comes from decomposed granite. Kaolin and chinastone are sometimes called the "bones" and "flesh" of porcelain. The combination, fired at a temperature of 2335°F (1280°C) or more, yields a result that is vitrified (transformed into a glassy substance), translucent when held to the light, sonorous when tapped, white, and very hard. Porcelain cannot be scratched with a steel knife,

but inferior wares, such as earthenware and stoneware, can be. It is not porous, even when left unglazed.

THE HISTORY OF A NATIONAL TREASURE
The process for porcelain manufacture was found early in Chinese history, but its perfection took centuries. By the Ming dynasty, Chinese potters had achieved both an absolute whiteness and an exquisite thinness, some porcelain featuring decorative motifs under the glaze (*an-hua* or "secret decoration") so subtle that they could be seen only when the vessel was held up to the light.

By the middle of the fifteenth century, an important ceramic center had been established at Ching-tê-Chên (sometimes seen spelled *Jingdezhen*) in the province of Kiangsi; here there was a plentiful supply of both kaolin and chinastone, and from here the goods could be shipped by lake and river to Nanking and by the Grand Canal from Nanking to Beijing. Reorganized in the early years of the Ch'ing dynasty, with its 500 kilns increased to 3,000, its production became immense. It made a wide variety of porcelain objects—plates, bowls, cups, vases, bottles, boxes, hat racks, candleholders, chessboards, and more—and it supplied an estimated 27,000 pieces of porcelain a year to the imperial household alone.

Another important producer of porcelain was the factory at Te-hua in Fukien, established in Sung times and continuing into the Ming dynasty. It was noted for its production of the white porcelain products that, from the seventeenth century onward, were shipped to Europe, where they were called **blanc de chine.** Bowls, cups, and incense burners (in the form of archaic bronzes) were made in blanc de chine, but more frequent were figurines of favorite subjects, such as Kuan-yin, the goddess of mercy; Bodhidharma, the semilegendary founder of Zen Buddhism; and the Buddha himself.

BEYOND WHITE: PORCELAIN IN COLOR
Chinese porcelain was not always white, of course. The so-called Ting ware, an imperial favorite during Sung times, was given an ivory glaze and occasionally a protective rim of copper. The fourteenth and fifteenth centuries saw underglazes of coppery red. Celadon green glazes were

also popular, as was a delicate blue-green glaze called *ying ch'ing* (shadowy blue) or *ch'ing-pai* (bluish green-white). There were also glazes of rich browns, black, powder blue, celadon (Figure 11–23), and a deep red known in Europe as *sang de boeuf* (bull's blood) or, when the red glaze had a streaky effect, as *flambé*. Other subtle colors were given romantic names in the West, such as peach bloom (peach dappled with green), ashes of roses (rosy gray), and clair de lune (silvery blue). In Ming times *san-ts'ai* (**three-color**) and *wu-ts'ai* (**five-color**) **wares** were popular. Three-color wares employed glazes of turquoise, blue, and aubergine (and sometimes more) colors, with slightly raised ridges separating the colors. Five-color wares had multicolored enamel glazes, usually depicting vines or flowering branches, against a white porcelain ground; they were much copied in Europe in the eighteenth century. In Ch'ing times, monochrome porcelains in a soft golden yellow were limited to use by the imperial family, although the most favored concubines were granted use of wares that were yellow outside and white inside.

BLUE-AND-WHITE PORCELAIN Perhaps the most famous of all Chinese porcelains, however, is so-called **blue-and-white**, which featured designs in a deep cobalt underglaze against a white ground (Figure 11–24). These designs were originally all hand-painted, but later some came to be applied by transfer printing. Designs included overall patterns of scrolls, flowers, and aquatic birds, but others were more extensive scenes of landscapes and figures, sometimes wrapping around vessels with little apparent regard for their shape. The famous **willow pattern,** depicting a story of eloping lovers, originated in England, not China. It became so popular in the eighteenth century, however, being imitated by over a hundred English sources, that it was eventually copied also in China.

Blue-and-white ware dates from the golden age of the T'ang dynasty. Initially, Chinese potters relied for their blue coloring on cobalt imported from Persia, but stable cobalt ores were discovered within China's borders during the Yüan dynasty. Great progress in blue-and-white technique occurred in the Ming dynasty, particularly under the

Figure 11–23 Fourteenth-century porcelain vase decorated with a relief of a scrolling peony.
© THE BRITISH MUSEUM, LONDON

emperor Xuande (1426–35). The "Muhammadan blue" coloring in use during the reign of Chia Ching (1522–66) is considered particularly deep and rich. Blue-and-white production continued for centuries, and it became an important feature of China's export market.

Blue-and-white was admired and emulated in Japan (in some Imari ware), Persia, Indochina, England (Lowestoft), and the Netherlands (Delft). Sets of blue-and-white vases in groups of three and later in groups of five or more (but always an odd number), alternating in shape, were popular on the European market and were frequently displayed with pride on seventeenth- to nineteenth-century parlor mantelpieces or over doorways. They were

Figure 11–24 Blue-and-white porcelain jar with a pair of small handles, Yüan dynasty, c. 1300.

called **garniture de cheminée.** It is, indeed, because of serious European attention to Chinese porcelain in the nineteenth century (such as Jacquemart and Blant's study, *Histoire de la Porcelaine,* published in Paris in 1862) that many of the terms used today to describe porcelain and its substitutes are French.

MULTICOLOR PORCELAINS The Ming dynasty five-color porcelains, with their show of color against a white ground, led to Ch'ing dynasty porcelains that were even more showy. From the late seventeenth century to about 1720, the most popular of these was called **famille verte,** named for the brilliant apple green often used for a background color. On this field or on white, profuse ornament (usually floral) was enameled in red, yellow, aubergine, and blue-violet, sometimes outlined in black. The turquoise popular in Ming times was dropped, and the blue underglaze that had sometimes been used was replaced by the blue-violet enamel and a soft overglaze blue or a watery green tint. Similar and contemporary was **famille jaune,** with a yellow background.

Around 1720, Europe introduced a soft rose pink color made from gold chloride and tin, which created a sensation. Along with the older enamels, it was mixed with white for a paler, more opaque effect, and produced a new and popular palette called *falang,* meaning "foreign" in China. In the West, to which it was exported in quantity, it was known as **famille rose.** For its design, figure subjects were added to the earlier vocabulary of flowers and fruit. A fourth "family" of Chinese porcelain, **famille noire,** gained popularity in the mid-nineteenth century. Its dark background was made with a brown-black pigment of cobalt and manganese overlaid by a thin greenish enamel. Figures 11–25a, b, and c show examples of ceramics from the East.

KOREAN CELADON Celadon is a ceramic ware distinguished by its soft gray-green color, and there are two legends about the origin of its name. One is that it is based on the character Céladon, the shepherd lover of the heroine in Honoré d'Urfé's seventeenth-century pastoral romance *L'Astrée,* in which the shepherd wears gray-green ribbons. The other legend is that the name derives from Saladin, the Sultan of Egypt, who sent forty pieces of such ware to the sultan of Damascus in 1171.

Across the Yellow Sea from the Korean Peninsula, celadon wares were produced in China, notably during the Sung dynasty, and these had been widely admired and emulated by the Koreans. Chinese celadon was of two types: northern celadon, which was noted for the fineness of its carved floral designs and which is not thought to have been exported, and southern (or *Lung-ch'üan*) celadon, which, being exported, was obviously more influential.

By the twelfth and thirteenth centuries, however, the Koreans had transformed celadon wares with their own exactingly controlled glazes based on native clay rich in iron content. Some Korean celadon of the Koryo dynasty has been said to evoke "the blue of the sky after the rain" and "the radiance of jade and the crystal clarity of water." The Chinese themselves proclaimed it "first under heaven." It is said that at the peak of celadon artistry, only one of ten pieces met the strict color

standards of the Korean potter, and that those pieces that failed to achieve the desired color were destroyed.

Celadon was used for many wares: bowls, cups, dishes, wine pots and oil bottles for the table; water droppers for the desk; water sprinklers for Buddhist rituals; tall, small-mouthed vases for holding plum blossoms; incense burners; roof tiles; toilet cases; and even, reminding us of Egypt, ceramic pillows.

There were two general types of Koryo celadon: painted and inlaid. Painted celadon, the type adapted from Chinese precedents, was made by painting a design on the unfired, unglazed clay with an iron solution (or sometimes a copper oxide solution), then glazing and firing it. Inlaid celadon, unique to Korea, was made by incising a design into the raw clay (the incised designs being called *son-hwa*), filling the incisions with white or red slip, then

A

B

C

Figure 11–25 a, b, c Three examples of ceramics from the East: (a) Vase and cover, famille rose, Yung Cheng period (1723–35); (b) Water bottle, porcelain with incised decoration; Korean, thirteenth century; (c) Group of tea ceramics. Fresh water jar (208–1877), tea caddy (211–1877) and tea bowl (219–1877). Japanese Edo period, seventeenth–eighteenth century. (CT14655).

Figure 11–26 Vase of porcelaneous stoneware with a celadon glaze over an incised design of dragons and clouds, from the Koryo dynasty of Korea.

biscuit-firing it (a preglazing firing at relatively low temperature). After being given the celadon glaze, it was fired again at higher temperature. Frequent subjects for the painted or incised designs were the peony, the lotus, stylized clouds, flying cranes, and dragons (Figure 11–26).

VARIATIONS AND IMITATIONS The Chinese invention of porcelain was a milestone in the decorative arts. The method of its manufacture was kept a national secret as long as possible, and the subsequent history of ceramics is crowded with attempts—some successful, some not—at reproducing it. As a result, there are innumerable varieties, imitations and substitutes.

If left unglazed, true porcelain is sometimes called **biscuit porcelain** (or sometimes, to the annoyance of experts who consider the term incorrect, *bisque*). Given a firing at 1470–2370°F (800–1300°C), it achieves a matte surface similar to that of white marble. When decorative enamels are painted on the biscuit, the result is called *émaillé sur biscuit*. A popular object in enameled biscuit was a so-called *Fo* dog (Figure 11–27), actually not a dog at all, but a representation of a sacred Chinese lion (a *shih tz'ŭ*), the guardian of the threshold of a Buddhist shrine.

In addition to such a variation, there are many types of wares that imitate true porcelain. Wares described as **porcelaneous** (or porcellanous) generally contain kaolin but not chinastone, are fired at slightly lower temperatures, and may or may not achieve a translucent, vitrified character. An unusually strong type of porcelaneous ware, which would be patented in England in 1813, is **ironstone,** popular for tableware and for large "vestibule vases," 5 or 6 feet (150–180 cm) high.

Soft-paste porcelain or *pâte tendre*, as opposed to true porcelain, which can be called hardpaste or *pâte dure*, was produced in the West as a porcelain imitation before the true formula for porcelain manufacture was known there. It can be made of many combinations of materials, one being white clay and ground glass. It is fired at a much lower temperature than porcelain, and its wares are much less durable. Curiously, because of its very vulnerability, some soft-paste ware has be-

Figure 11–27 Porcelain *Fo* dog (actually a lioness), late seventeenth century, 7 inches (18 cm) high.

come more rare (and in some quarters, therefore, more valuable) than the genuine article.

Somewhere between hard-paste and soft-paste porcelain is **bone china,** softer than the former, but both harder and less expensive to produce than the latter. It is basically a soft-paste porcelain to which bone ash has been added. Agreeably white and translucent, it was the standard for English ceramic wares of the nineteenth century.

Chinese porcelains are often identified by the names of the rulers in whose reigns they were made, and this identification is sometimes exhibited in a reign mark of Chinese characters on a vase or figurine. (These reign marks are unreliable guides, however, as they were sometimes faked.) Some important porcelains manufactured at Ching-tê-Chên, for example, are called by the names of the emperors K'ang Hsi (reigning A.D.1662–1722), his son Yung Chen (1723–35), and his grandson Ch'ien Lung (1736–95).

Finally, ceramic wares of all sorts manufactured in the West are commonly called by the names of the factories producing them, and, confusingly, some factories produced several types. Long after its production in China, true porcelain was produced in the European factories of Meissen and Sèvres, in the Plymouth factory of England, and in the Tucker factory of Philadelphia. Producers of soft-paste porcelain included the factories of the Medici, Rouen, Bow, Capidomonte, Chelsea, Derby, Vincennes, and Worcester. Factories producing bone china included Bow (where it was first patented in 1748), Sèvres, Chelsea, Derby, and Lowestoft, with a lead-glazed variation being made at Spode and Worcester.

Silk, the Most Precious Fabric

According to the *Odes* of Confucius, **silk** was discovered when the Princess Hsi-Ling (c. 2700 B.C.) was drinking tea under a mulberry tree from which a cocoon fell, unraveling its lustrous thread in her teacup. The actual history of silk, however, seems to have been a little less poetic, the earliest known pieces of Chinese silk—ribbons and fragments dyed red—dating back to 3000 B.C. In any case, the raising of silkworms for the production of silk in China was well established by c. 1750 B.C. This silkworm cultivation is called *sericulture,* the name coming from *seres,* the Latin term for silk.

The end product of sericulture is the world's most beautiful textile fiber, wonderfully supple and possessing an unmatched natural luster. Having also a natural affinity for dye, it can be produced in brilliant colors. Its filaments are extremely long, 600 yards (550 m) being typical (compared to 1 to 2 inches or 25–50 mm for cotton and 1 to 18 inches or 25–450 mm for wool), extremely thin, and extremely strong, surpassed in strength only by nylon.

PRECIOUS, BUT NOT PERFECT Silk has disadvantages as well. Because of their very thinness, many silk filaments must be spun together to make a thread the size of a human hair, and the contents of twenty-five hundred cocoons are needed to produce 1 pound (454 g) of silk yarn. Strong natural light, over a period of years, can cause silk not only to discolor, but to actually disintegrate. In humid conditions, the fibers are subject to mildew and rot. They swell when damp and shrink when dry, creating a condition called *hiking.* Silk fibers will burn (slowly), and they will abrade, particularly in textiles that blend them with other fibers of high tensile strength.

Another disadvantage, although one that lends silk some of its charm, is the curious process of producing it, a process that was a closely guarded secret of the Chinese for centuries and one that is largely immune to modern efforts at industrialization. It begins with the growing of white mulberry trees, then proceeds to the selective breeding and raising of the grayish silkworms that are the larvae of the moth *Bombyx mori*. These caterpillars, said to be so delicate that loud noises or strong smells may kill them, feed on the young mulberry leaves, freshly gathered and finely chopped for them daily, and then, from glands in their heads, spin their cocoons. If the chrysalis within a cocoon is allowed to mature, it will eat its way out, severing the long filaments. The cocoon must therefore be heated to kill the chrysalis. Unwinding the filament is the next painstaking chore, traditionally done with the cocoons floating in a bowl of boiling water, the strands from six or eight of them unraveled at once and spun together on a reel. Dyeing, weaving, and finishing processes can then begin (Figure 11–28).

Figure 11–28 Detail from *Ladies Beating and Preparing Silk,* a painting attributed to the Sung dynasty emperor Hui Tsung.

TYPES AND GRADES OF SILK There are many types of silk, and many grades. Perhaps the two most fundamental categories are the **true silk** from the *Bombyx mori,* described above, and so-called **wild silk** produced by other species of silkworms. Among true silk, the finest is that made from the longest filaments, such as the types called *thrown silk.* In their production, an important step between reeling and weaving is the "throwing" or twisting together of filaments, a greater number of twists per inch producing a yarn with greater contraction. Types of thrown silk include *tram* and *organzine,* both rather loosely twisted, and *crêpe,* tightly twisted, some strands to the left, some to the right, and placed alternately. *Crêpe de chine* is a type of construction with crêpe yarn made from *raw silk,* which is silk not cleansed of the natural gummy protein *(sericin)* that binds it together in the cocoon. The retention of the gum results in an uneven absorption of dye, and this unevenness is considered attractive for many uses. Another construction made from crêpe yarn, of a transparent fineness, grainy texture, and soft sheen, is *silk chiffon.* Filaments too short to be twisted into thrown silk are twisted more crudely into *spun silk,* considered of lesser quality. A silk made of even rougher, more uneven filaments is known as *bourette.*

Best known among the types called wild silk is Indian *tussah,* a product of a large moth that feeds on tropical trees and produces a strong but coarse silk; it takes dyes unevenly, so is often left in its natural light-brown color. Two popular fabrics made from tussah are *pongee,* a soft, medium-weight weave with obvious nubs and irregularities (collectively called *slub*), and *shantung,* also roughly textured and originally made in (and named for) the province of Shandong. Another type of wild silk is *African silk,* a product of moths feeding on fig trees and constructing large nests with clusters of cocoons. *American silk,* cultivated in the Oaxaca area of Mexico from a species feeding on the ailanthus tree, is often used by the Indians to make a crêpe fabric dyed bright magenta. Other species feed on oak leaves, cherry leaves, or the poorer varieties of mulberry, and the results vary greatly.

FABRICS MADE OF SILK Silk fabric is sometimes classified as plain, figured, or embroidered. *Plain silk* is woven with no integral decoration or pattern, *figured silk* does have such an integral pattern woven into it, and *embroidered silk* has a pattern applied to its surface by needlework. One type of figured silk is *brocade,* in which a raised pattern is created by interwoven threads of silver or gold.

Finally, a number of fabric types originated for silk fibers. These include *satin,* woven with its face smooth and lustrous, its back dull, and named for the Chinese seaport of Zaytun, and *taffeta,* a crisp weave with both sides glossy, named after a Persian fabric called *taftah.* Both are still made in silk, but also in a number of other materials such as rayon, or even in blends of several at once.

CHINESE CARPETS Although Chinese carpets were also made of wool, the finest ones were woven of silk, and, for imperial use, metal threads were sometimes added to the silk. Although some

were designed in imitation of Persian examples, many were of designs original to China. These designs could be symbolic (employing Buddhist, Confucian, or Taoist symbols) or floral, or both at once. Some Chinese carpets, beginning in the nineteenth century, were pictorial, showing realistic figures or scenes. Many designs have round or octagonal central medallions in a field that may be plain or diaper patterned. Corners may repeat segments of the central medallions, and borders between them are generally narrow.

No Chinese carpets earlier than the fifteenth century survive, but there are a number of examples from the early Ch'ing dynasty. Large-scale carpet production was not introduced in China until the late nineteenth century, however. Chinese carpets use the **asymmetrical** or **Persian knot** primarily, with the **symmetrical** or **Turkish knot** sometimes used at the edges. In general, Chinese carpets are not finely knotted, having between 30 and 120 knots per square inch (5–20 knots per cm$^2$).

The most popular colors in Chinese carpets were yellow, tan, blue, and white. Reds are sometimes used as well—never bright primary reds, but soft apricot or peach shades, or deep persimmon color. The surface of the pile was often cut down around flowers, figures, or symbols, so that they stood out in a relief effect.

An unusual Chinese use for carpets was to wrap them around cylindrical columns. Such carpets are narrow and long, with patterns—frequently depicting dragons—that align when their sides are joined. They are now generally called **pillar rugs,** and they were used in Buddhist temples in northern China, Mongolia, and Tibet (where they were called *katum*).

Another Chinese use for carpet is as chair covers. These were made in two pieces, one for the seat and one for the back, and the back cover was often stepped or scalloped to fit the form of the chair. Rectangular pile carpets were also used as k'ang covers, their sizes varying from about 5 by 8 feet (152 x 244 cm) to about 6 by 10 feet (183 x 305 cm).

From the early nineteenth century, the Chinese have also woven circular carpets and oblong carpets with rounded ends. Such carpets were probably originally used for covering the tops of round tables and are sometimes called **table rugs,** although they later found decorative use on floors.

Summary: The Design of China

In the history of all the countries of the Far East, the culture of China has at every stage been both the oldest and the most advanced. It has also had the power to absorb and transform most outside influences, never losing its own well-established character. Despite invasions by Mongols and Tartars, despite intercourse with border nations such as India, Persia, and Scythia, and despite later contact with the West after the opening of the silk trade routes, Chinese art and design maintained their own dignified, independent, and highly accomplished course for thousands of years.

Independent as China remained from foreign influences, its own influence abroad was enormous, especially on its neighbors to the east—Korea and Japan.

Less pervasive, but perhaps even more remarkable, has been China's influence in Europe and America. Chinese enamels and porcelains were brought to Europe by other travelers. Throughout the seventeenth and eighteenth centuries, the East India trading companies imported large numbers of porcelains and silks, firing a European passion for duplicating their closely guarded methods of production. By the middle of the eighteenth century, Chinese taste affected European furniture design, interior design, and every branch of the decorative arts. In France, Chinese style was thought to blend particularly well with the Rococo style of Louis XV, and, at the chateau of Chantilly and elsewhere, entire rooms were painted in the modified Chinese style that the French called **chinoiserie.** In England, Thomas Chippendale was an enthusiast of Chinese taste, using it to create a new hybrid furniture style that was widely imitated. In the American colonies, wallpapers in Chinese style covered important rooms in Williamsburg and Philadelphia.

Looking for Character

Chinese beauty is quiet beauty. Its essence is a small, finely wrought, perfectly formed object and a serene, uncluttered space in which to enjoy it.

Chinese art also shares with other art of the Orient a character—conventional, symbolic, and highly stylized—that is immediately recognizable as being outside the Western tradition. The occasional and understanding introduction of such serenity, simplicity, quality, and character into today's Western interiors can be a valuable element in the interior designer's vocabulary.

To be more specific, we see in Chinese art a general tendency toward the use of curving and circular forms: vases swell, roof eaves curve, table legs turn, painted landscapes are caught up in a rhythmic swirl. Related to this tendency, there is also an apparent preference for continuity, whenever possible. When rosettes or stars or other small motifs are repeated, they are generally not isolated but are bound together with connecting elements such as scrolls or ribbons or branches. The world is a coherent whole, the Chinese artist seems to be saying, and it is a coherent whole alive with movement.

Looking for Quality

Even in the smallest of details—or, more accurately, *especially* in the smallest of details—the Chinese artist was a perfectionist. We see this demonstrated in many arts and crafts, but we see it most clearly in finely made, subtly shaped furniture, in lustrous silks, and in exquisite porcelain. We shall see, in the next chapter, that Japanese artists admired and cultivated a degree of roughness and informality in some of their work, as had some Korean artists, but we see none of this tendency in China. All Chinese artists and craftsmen kept before them the ideal of a faultless product; a surprisingly large number of them had the techniques to achieve it.

Making Comparisons

Chinese art is the chief embodiment of the qualities that distinguish Eastern art from Western. The distinctions are perhaps most strikingly shown when we compare Chinese art in its native home with Chinese art intended for export to the West and conforming (the Chinese thought) to Western taste. We may also compare real Chinese art with the Western chinoiserie that was a foreign imitation of it, conforming (the Europeans thought) to Chinese taste. The export versions and the imitations, by themselves, would give us an impression that Chinese art was often overwrought and overly ornate, and that the Chinese artist was often a sentimental clown. This is a false impression. Chinese art for a Chinese audience was impressively mature, serious, sophisticated, and sober. In the fields where it focused its attention, it was masterful.

12

JAPAN

A.D. 593–1867

As we have already mentioned, China profoundly influenced Japanese art and architecture. But Korea, Europe, and the South Seas also influenced Japan. In most cases the Japanese imbued the foreign styles and forms with Japan's own character. In place of Chinese formality and axiality, for example, the Japanese liked things impromptu and off center; in place of the close observation and careful representation of nature in Chinese art, the Japanese sought underlying geometries and inner meanings; in place of the Chinese admiration for age, lineage, and permanence, the Japanese valued serendipity and change; and in place of the Chinese ideal of perfection, the Japanese treasured variation, even imperfection.

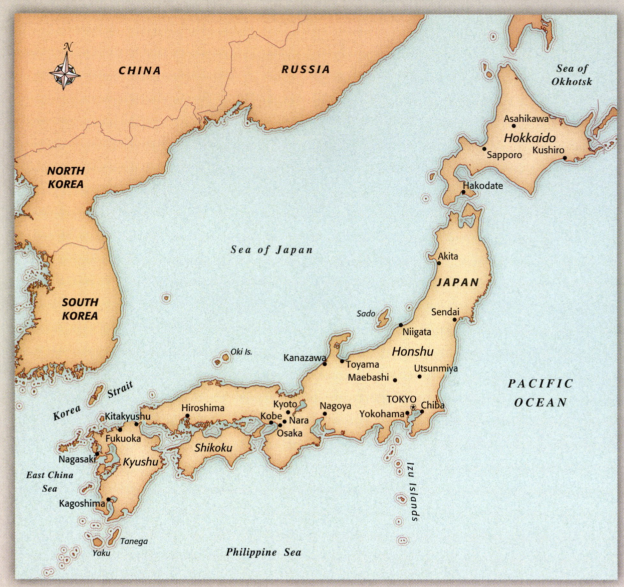

Figure 12–1 MAP OF JAPAN

ORTELIUS DESIGN

Determinants of Japanese Design

Within Japan two formative factors influenced design: geography and religion.

Geography

Japan (or, in Japanese, Nippon) is a string of islands off the east coast of China. The four chief islands, from northeast to southwest, are Hokkaido, Honshu (where Tokyo is located), Shikoku, and Kyushu. To Japan's south and east is the Pacific Ocean; to its north and west, the Sea of Japan. Volcanic mountains crowd the islands, which are intensively cultivated and densely populated. In Japan few lack a view of the mountains or are far from the sea.

Plentiful forests and frequent earthquakes have encouraged building in wood and bamboo,

although stone is often used for platforms and foundations.

Religion

From India, through China, came Buddhism, and directly from China came Confucianism, both of which became major religions (or ethical systems) in Japan. But there was also Shinto (or *Kami-no-michi*, "the way of those above"), an ancient religion native to Japan. In Shinto belief, the *kami* (those above) are supernatural deities with power over important human activities and fortunes, such as the fertility of crops.

The Shinto deities were not generally worshipped with icons and images. Shinto art is therefore an art of a limited variety of artifacts, such as vessels and relics. But a distinctive Shinto architecture of simple, unpainted wooden shrines did develop.

Through many centuries, Buddhism, Confucianism, and Shintoism have affected Japanese thought and design. Japanese Buddhism, for example, split into individualistic sects such as Zen, which fostered its own meditative style of worship and intuitive style of art.

Japanese Architecture and Its Interiors

As in Chinese architecture, wood is the chief material of Japanese architecture and rows of columns the chief structure, infilled with thin—often movable—panels of woodwork, plaster, or rice paper. As in Chinese and Greek architecture, framing is essentially orthogonal (vertical and horizontal). Graceful curves are introduced, however, in column outlines, rafters, roof brackets, and the great overhanging roofs they support.

This sort of wood construction is incapable of long spans, so that Japanese buildings are basically repetitions of similar bays, called **ken.** The bays at the center of an important structure may be twice the depth of typical bays, producing an open area called a **moya;** it may be three, five, seven, or some other odd number of bays long. Around

the moya, rings of single bays form subsidiary peripheral spaces called **hisashi.** The roof over the central moya is typically more steeply pitched than the roof over the surrounding hisashi.

Almost all traditional Japanese structures, sacred and secular alike, follow this general model. General characteristics of the architecture are:

- Proportionality. There are fixed relationships between elements, and as one dimension is increased, others are increased proportionally.
- Modularity. In any one structure, a single bay size is repeated throughout (except when, in the moya, it is exactly doubled).

TIMELINE | JAPAN

DATE	PERIOD	CULTURAL EVENTS	ARTISTIC EVENTS
A.D. 593–644	Asuka	Capital at Asuka; Buddhism introduced from Korea; emulation of China	Buddhist temple at Hōryū-ji
645–710	Early Nara	Capital at Ōtsu and elsewhere	Hōryū-ji burned and rebuilt
710–784	Nara	Capital at Nara	Shoso-in established
784–1185	Heian	Capital at Kyoto; high court culture; esoteric Buddhist sects	Hand scroll painting; calligraphy; Hōōdō; *Tale of Genji*
1185–1334	Kamakura	Capital at Kamakura; Zen Buddhism adopted; military dictatorship	Painting; lacquerwork
1334–1573	Muromachi	Capital at Kyoto; Zen dominant; rule by warlords	Ink landscapes; Kinkaku-ji; Noh drama
1573–1614	Momoyama	Capitals at Momoyama and Azuchi; first Westerners arrive	Warlords' castles; gold screens; Shinto shrines; Zen temples; raku ware
1615–1867	Edo	Capital at Tokyo; Japan closed to foreigners; ceramic artists brought from Korea; peace and prosperity	Wood-block prints; Katsura villa; "scholarly decorators"; lacquerware
1868–1912	Meiji restoration	Japan open to foreigners; industrialization	Traditional and Western arts coexist

Figure 12–2 Typical Japanese floor plans, showing the arrangements of the tatami mats. The symmetrical arrangement of mats at top left might be used in rooms of temples, palaces, or aristocratic mansions; more typical plans always avoid four intersecting lines. The second, four-and-a-half-mat plan is typical of a teahouse, with a fire pit or square wood platform sometimes taking the place of the half mat. Below that are six-, eight-, ten-, and twelve-mat rooms.

AFTER DREXLER

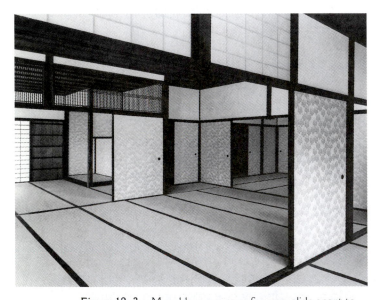

Figure 12–3 Movable screens, or fusuma, slide apart to reveal a reception room in the Old Shoin of the Katsura villa. Above them is an open wood lattice, or ramma.

YASUHIRO ISHIMOTO/PHOTO GALLERY INTERNATIONAL, TOKYO, JAPAN

- Deference of decoration. The decorative elements are subordinate to the proportional, modular construction, so that they embellish it without obscuring it.

Inside these structures, there are also characteristics common to both religious and lay building types. These are less repetitive and rigid than the basic construction might lead us to expect. These characteristics of Japanese interiors are:

- Modularity. Naturally, the modularity of the structural bays is evident in the interior. Another module, however, is based on the **tatami,** a floor mat, and the structural module and tatami module are generally coordinated, the former being a multiple of the latter. Tatami size varies slightly in different parts of Japan, but is generally constant for all the rooms of a single building, and the usual size is slightly larger than 3 by 6 feet (1 x 2 m). A room's area is typically expressed in terms of the number of tatami it contains (Figure 12–2.)

- Fluidity of plan. The areas among the various modular bays and around the columns that demarcate them are often divided quite freely. The spatial divisions are often made by movable screens or panels **(fusuma)** sliding in floor tracks that can be easily reconfigured (Figure 12–3).

- Dim light. Lighting within the typical Japanese structure is diffuse, partly because the interior is shielded by deeply overhanging eaves, partly because the major spaces are often at the center of the structure, without direct illumination, and partly because openings are often screened with wooden shutters or paper partitions that softly filter the light.

- Integration of interiors with their surroundings. The well-designed Japanese building presents its users with a consciousness of its surroundings. Surrounding verandas **(engawas)** are transitional spaces between indoors and outdoors. Exterior walls have many operable elements that fold out or swing upward to afford views, and these views are often carefully calculated to include a distant mountain or an interestingly planted garden area.

With these general characteristics in mind, we shall look at several specific types of Japanese architecture, each represented by one of many possible examples.

A Buddhist Temple Precinct: Hóryú-ji

After Buddhism was introduced to Japan in the sixth century, buildings were needed for its observance. These were naturally based on Chinese examples, but with more attention to the provision of picturesque approaches and settings. Two fine early examples are the great late-seventh-century Buddhist monastery of Hōryū-ji (pronounced ho-ree-oo-gee), near the ancient capital of Nara, and the mid-eighth-century monastery of Tōdai-ji.

The Hōryū-ji complex includes the oldest Buddhist buildings in Japan. They are: a gateway, a central hall, a pagoda, and a surrounding roofed walkway. Added in the eighth century were a second, outer gateway and an octagonal structure called the Yume-dono (Figure 12–4).

A Pavilion for Family Worship: The Hóó-dó

Among the celebrated Japanese Buddhist architecture is the Hōō-dō (pronounced ho-oh-doh), "Phoenix Hall," built at Uji in the year 1052. It was built to house a gilded statue of the Amida Buddha, seated on a lotus throne, which could be viewed from across the pond. Over this icon is a canopy of gilded openwork carving. The altar platform is lacquered and has a delicately figured inlay of mother-of-pearl. Panels high on the surrounding walls feature carvings of heavenly musicians. All members of the wooden structure are painted in intricate patterns, the bottoms of the beams are studded with gold rosettes, and the intersections of members are marked with gold plates. Even in this instance of elaborate decoration, however, the effect is light, not oppressive, and the basic structure of the building remains unobscured.

A Country Villa: Katsura

Built by a member of the Japanese royal family, the Katsura villa has the formal name Katsura no Rikyu,

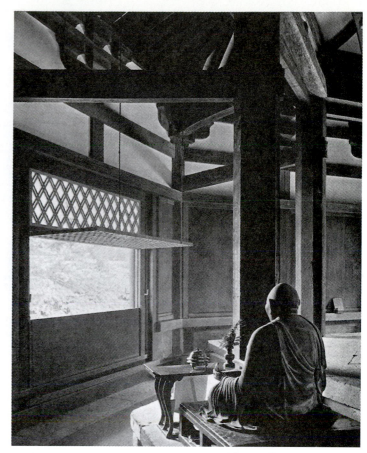

Figure 12–4 The interior of the octagonal Yume-dono at the Hōryū-ji temple complex. In the foreground is a statue of the Buddhist priest who established the shrine.

PHOTO: YOKIO FUTAGAWA, FROM *ARCHITECTURE OF THE WORLD: JAPAN*, HENRI STIERLIN, ED., LAUSANNE: BENEDIKT TASCHEN, N.D.

which means "Katsura Detached Palace" (Figure 12–5). Construction began early in the seventeenth century and was completed in 1658.

The main building is in three linked sections built over a period of thirty years and arranged in an irregular zigzag across the landscape (Figure 12–6). Rooms of all three sections open freely to each other through sliding partitions, and the variety of spaces is given coherence by the repeated module of the tatami mat.

Spaces not only open to each other, but also to the exterior. And many spaces—platforms, covered verandas, entrance foyers—are intermediaries between open and enclosed spaces (Figure 12–7). Perhaps the most carefully considered and most admirable feature of the villa is

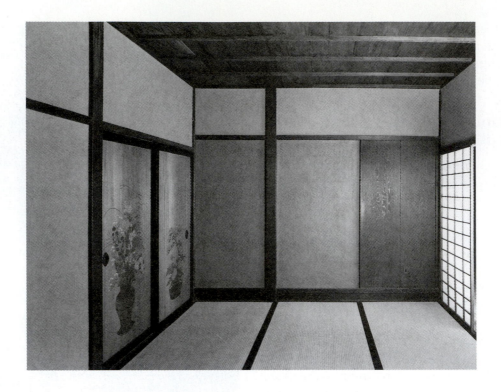

Figure 12–5 Interior details of the Katsura villa, near Kyoto, seventeenth century: (above) the Attendants' Room in the Old Shoin; (below left) built-in closets in the Clothes Room of the wing called the New Goten; (below right) the north corner of the First Room in the Shōkin-tei tea pavilion.

PHOTOGRAPHS: YASUHIRO ISHIMOTO/PHOTO GALLERY INTERNATIONAL, TOKYO, JAPAN

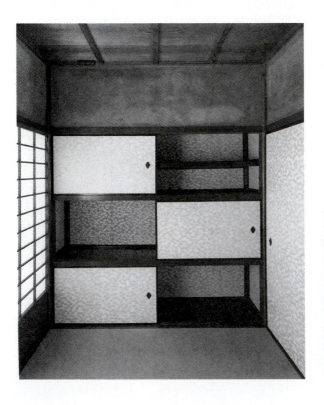

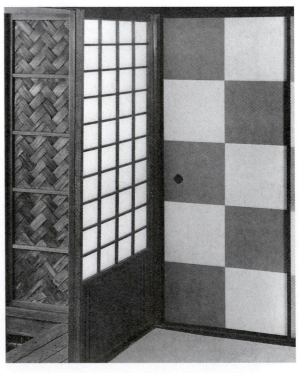

Figure 12–6 Katsura palace, Kyoto, perspective view with roof removed. From left to right: the New Shoin, the Middle Shoin, and the Old Shoin with its projecting Moon-Viewing Platform.

KAZUO NISHI AND KAZUO HOZUMI, *WHAT IS JAPANESE ARCHITECTURE?*, NEW YORK, TOKYO, AND SAN FRANCISCO: KODANSHA, 1985. REPRINTED BY PERMISSION.

the relationship of inside and outside. While the arrangement of the rooms and the landscaping of the gardens both display an apparent casualness, both of them—and the relationships between them—have been designed with great attention to detail.

A Teahouse: Shōkin-tei

Accommodations for the highly ritualized ceremony of brewing and serving tea are varied. Sometimes they consist of only a small alcove within a building that serves other purposes. Ideally, they are separate, small buildings dedicated only to tea. Ideally, also, they are built in picturesque garden settings.

On the grounds of the Katsura villa, there were at one time five teahouses, four of which are still extant. We shall look at one of these, the Shōkin-tei or "Pine-Lute Pavilion." It is unusual in its size, having two large rooms (eleven- and six-tatami in size) and some subsidiary spaces in addition to the tearoom, but it is exemplary in other ways. On a promontory extending into the pond, it can be approached by a boat mooring or by a stone slab bridge. (An earlier bridge of red-lacquered wood no longer exists.) The path from the stone bridge passes a spot at the edge of the pond where visitors can wash their hands in running water, and other nearby garden features include areas called the Beach Garden and the Outside Resting Place.

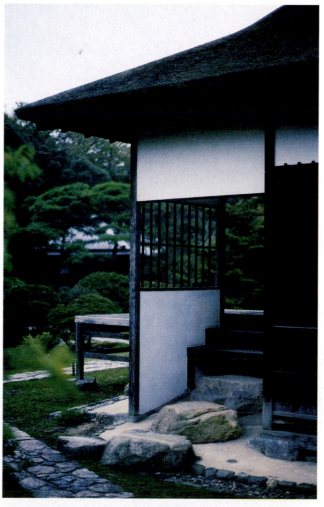

Figure 12–7 Entrance porch to Katsura's Old Shoin mediates between exterior and interior.

PHOTO: ABERCROMBIE

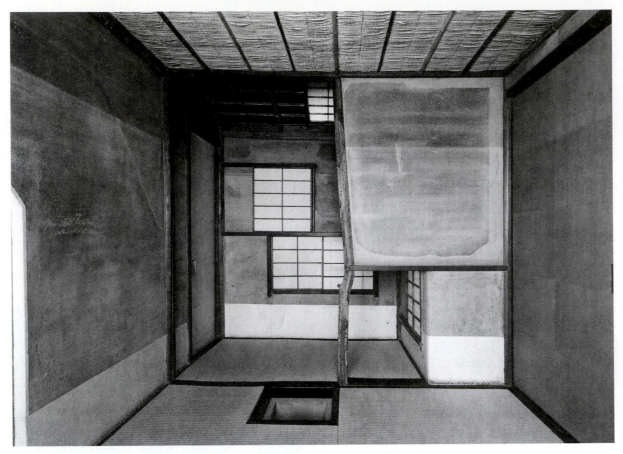

Figure 12–8 In the Katsura villa's Shōkin-tei teahouse, an artfully composed backdrop for the tea ceremony.

Within the Shōkin-tei, a carefully considered asymmetrical composition of elements (Figure 12–8) is the backdrop for the tea ceremony. Lines are straight and surfaces rectangular, except for the wall plane bounded by a structural support formed from a slightly bent tree trunk. It rises from one corner of a shallow pit where the fire will be made for boiling the tea. Beyond the tree-supported wall plane, a pair of shelves is held in place by a bamboo pole hung from the ceiling, providing a place for some of the tea utensils.

Japanese Furniture

In a traditional Japanese interior, the center of gravity is low, and the focus is on the floor. Within the flexible spaces, furniture is minimal and movable, so that by putting away a low table and bringing out a rolled pad, a room that had been a dining room is transformed into a bedroom. Even so, there are some distinctive pieces of Japanese furniture, particularly storage pieces.

The most popular Japanese furniture woods included magnolia (in Japanese *ho-no-ki*), paulownia *(kiri)*, zelkova *(kikeya)*, white mulberry *(kuwa)*, and chestnut *(kuri)*. Metal fittings included locks, latches, escutcheons around keyholes, pulls, hinges, handles, rings through which carrying poles could be threaded, finger holes for sliding panels, and some purely decorative hardware. These fittings were made of iron, brass, copper, silver, or silver-nickel, although iron was by far the most widely used. Before we look at various types of movable Japanese furniture, we should briefly review the basics of built-in Japanese furniture

elements, some of which have already been mentioned. They include:

- The **shoji,** a sliding exterior panel, functioning either as door or window. It is made of a light wood lattice infilled with translucent paper.
- The **amado,** a sliding wood shutter that might be used in conjunction with the shoji.
- The **fusuma,** a third type of sliding panel. It is found in the interior and is often surfaced with painted silk or painted paper.
- The **ramma,** a partially open surface above the fusuma. It can be filled with a simple wooden grille, as seen in Figure 12–3, or with an elaborately carved one.
- The **tatami,** a rice-straw floor mat approximately 3 by 6 feet (1 x 2 m) and about 2 inches (50 mm) thick.
- The **tokonoma** or display niche for flower arrangements, scrolls, or other art works. It graces important rooms in Japanese houses, and an example can also be seen in Figure 12–3.
- The **shoin,** a windowed bay near the tokonoma that is used for reading or writing.
- The **chigai-dana** or **tana,** built-in shelving, often in a recess.

To these built-in elements, the following movable furnishings were added.

Beds and Seating

Beds play a minor part in the traditional Japanese interior, as places for sleeping are generally **futon,** thin mattresses of padded cotton. They are rolled up and put away when not in use. Supplementing the futon are pillows and quilted coverlets.

Chairs, until recently, have had only brief periods of popularity in Japanese interiors. Usually, the Japanese sat directly on the tatami mat or on one of two types of cushion. The first is called an *enza* which means "round seat." It is just that (Figure 12–9), about 20 or 22 inches (50 or 55 cm) in diameter, and it is made of rice straw (like the tatami), rush, or some other plaited grass. The enza were used in a wide variety of building types until the beginning of the seventeenth century; since then, they have been used primarily in temples and

Figure 12–9 The enza, a round cushion of straw or grass, very popular until the seventeenth century, but now used mainly in temples.

KAZUKO KOIZUMI, *TRADITIONAL JAPANESE FURNITURE,* TOKYO AND NEW YORK: KODANSHA, 1986. REPRINTED BY PERMISSION.

shrines. More popular now is a square padded cushion called a *zabuton* (Figure 12–10). Roughly 2 feet (60 cm) square, sometimes a bit larger, it could be covered with cotton, linen, silk, or sometimes even leather, and it was eminently easy to store, carry, or stack as desired.

An interesting comparison with the seating for royalty that we have seen in other cultures is the seating for the great warrior-ruler Hideyoshi. His audience hall in Kyoto's Nishi-Honganji temple, first built in 1594 and thoroughly remodeled in

Figure 12–10 The zabuton, a square padded pillow covered with decorative fabric. The ones shown here, faced with plaid cotton, were made in the mid-nineteenth century.

KAZUKO KOIZUMI, *TRADITIONAL JAPANESE FURNITURE,* TOKYO AND NEW YORK: KODANSHA, 1986. REPRINTED BY PERMISSION.

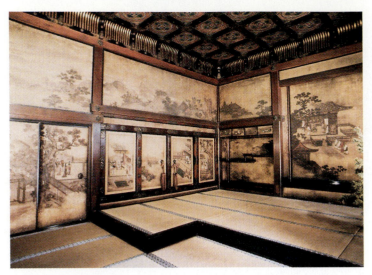

Figure 12–11 Hideyoshi's audience hall at the Nishi-Honganji temple, Kyoto, remodeled in 1632. The ruler received his respectful guests seated on the tatami mats in the right of the picture. The wall paintings are attributed to Kano Tannyu.

1632, was a vast room 67 feet (20.4 m) square and 15 feet (4.6m) high. Along one side of the room was a platform raised only a step above the rest, and on this platform the great man received his guests seated not on a throne but on tatami mats (Figure 12–11).

Tables

Small tables were natural accompaniments to the floor-focused life, as were trays. Some of these small tables were on central pedestals (Figure 12–12), some were on broad pedestals with decorative cutouts (Figure 12–13), and some were on corner legs. There were small desks or writing tables as well, often used at special gatherings for the writing of verses or the reading of holy scriptures, and other scholarly pursuits. Emblematic of aesthetic, scholarly, or pious pursuits, they were often more elaborately carved or decorated than was usual in Japanese furniture (Figure 12–14).

Storage Furniture: The Tansu

The most popular and most characteristic piece of Japanese furniture is the **tansu** or storage chest. It

Figure 12–12 Footed tray table finished with lacquer. The height is 8 inches (20 cm), and the top is 12 inches (30 cm) square.

Figure 12–13 Lacquered broad-pedestaled tray table, sixteenth century, 7 inches (18 cm) high.

Figure 12–14 Lacquered reading desk for religious tracts, early seventeenth century, 8 inches (20 cm) high.

was similar to the Chinese and Korean chests we have already seen, but the Japanese versions were often more complex, with more elaborate interior fittings, and more determinedly characterful and asymmetric. The most frequently seen are the

The word *tansu*, as the text explains, is applied to a variety of Japanese storage chests, but it is also sometimes used for the entire field of Japanese wooden cabinetry. The word is pronounced as if it were spelled *dansu*, and the spelling actually changes to that form when used in one of the many compounds that describe specific types of chests. For example:

- *cho-dansu* A chest for a merchant's account books, writing instruments, and so forth, usually with a wide drawer across the top and a stack of small drawers on the right.
- *funa-dansu* A small chest with decorative ironwork, often used on shipboard for storing valuables.
- *ishō-dansu* A clothing chest, usually with three full-width drawers above a slightly smaller bottom drawer and a small door that opens to reveal two smaller drawers.
- *kaidan-dansu* The largest and most spectacular of the tansu, in the form of a staircase used for reaching the loft in a traditional

Japanese building, with many storage compartments below the steps.
- *kuruma-dansu* A large cupboard on four wheels, usually with sliding doors.
- *kusuri-dansu* A pharmacist's chest with many small drawers.
- *mizuya-dansu* A chest for kitchen use, usually in two parts, the upper part having sliding or hinged doors made of wire grilles (to allow air circulation) above a row of small drawers, and the lower part having two large doors covered with thin vertical slats and opening to reveal a variety of compartments.
- *zeni-dansu* A small money chest, often with a coin slot in its top, named for the zeni, a coin used in the Edo period.

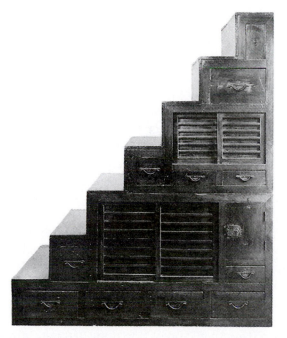

Figure 12–15 Staircase chest of cryptomeria wood, Meiji era, 69½ inches (176.5 cm) high.

ROSY CLARKE, *JAPANESE ANTIQUE FURNITURE*, NEW YORK AND TOKYO: WEATHERHILL, 1983, 5TH PRINTING 1996. REPRINTED BY PERMISSION.

clothing chests or *ishō-dansu*, but perhaps the most striking are the staircase chests or *kaidan-dansu*, which doubled as storage and as stairs leading from the main floor of a house to its sleeping loft (Figure 12–15).

The Folding Screen

We have said that the tansu is the most popular and characteristic piece of Japanese furniture. Certainly a close second to the tansu is the folding screen. It is both furniture and painting, a portable and functional work of art. It is used for breaking the line of vision in open Japanese interiors, for blocking the wind, and for marking off special areas of space. When it had a highly reflective gold background, it was useful in reflecting light into dim corners. And, of course, it was used as decoration.

There are many types of Japanese screens. There are single panels, doorway curtains, and blinds. But the term most often brings to mind the folding assemblages of wood-framed canvas, paper,

or silk panels on wood frames. These might have any even number of panels, from two to ten. There were small versions, less than 2 feet (60 cm) high, called *pillow screens;* there were screens used around braziers during the tea ceremony; and there were screened clothes racks. The most classic examples, however, were those with six tall panels.

The six-panel screens were often painted with traditional themes for special occasions—cranes and turtles celebrating births, for example, or calligraphy honoring Buddha. But often they were pure works of art, and at their best they were supreme examples of Japanese accomplishment. At their most interesting, they combined highly naturalistic elements with highly stylized abstract ones (Figure 12–16).

Accessories

Minimal as Japanese furnishings were, they included a number of items for increasing comfort or usefulness. There were lighting devices, of course, often incorporating the translucent papers that were so important to the Japanese interior during daylight hours. There were items of kitchen equipment, and there were items for the processes of the bath and the toilette. For those seated on the floor, an important aid to comfort was a portable armrest, and for those bravely enduring the Japanese tradition of unheated interiors, there were charcoal braziers or *hibachi.* These were never intended to heat a room in any sub-

stantial way, but merely to warm the hands of those seated nearby.

Japanese Arts, Crafts, and Rituals

In Japan, more than anywhere else, it is difficult to make distinctions between arts and crafts or between arts and techniques or between arts and rituals. Some pursuits, such as arranging flowers, that are considered minor occupations in other cultures, are raised to high art in Japan, and some, such as making and serving tea, that are performed carelessly in other cultures, are the subject of the most refined ceremony in Japan. We cannot fully appreciate the aesthetic sensibility of Japan without a look at some of these practices.

The Tokonoma and the Flower Arrangement

The **tokonoma,** as has been said, is an alcove for artistic display, one of which is visible in Figure 12–3. Usually the tokonoma is in an important room, its floor is raised slightly above the floor of the room, and it is partially enclosed to express its distinction. In the uncluttered space of a Japanese interior, it is the natural focus, as the fireplace is the natural focus of many rooms today.

The displays within the tokonoma can include painted scrolls, ceramics, figurines, and any number of other objects, but often they include flower arrangements. The art of arranging cut flowers has achieved a degree of excellence in Japan as it has nowhere else. Called *ikebana,* "living flowers," it has an intense aesthetic sensibility and an ancient lineage, the earliest school of flower arranging having been founded thirteen hundred years ago by a member of the royal court who sought to devise appropriate floral offerings to Buddha. Now there are more than three hundred distinct schools of flower arranging in Japan, each with its own philosophy and style, but all share the general precept that flowers and plant materials are to be presented in ways that suggest how they naturally grow. This goal of representing natural form, however, is accompanied by the goal of adhering to strict and

Figure 12–16 A six-panel screen by Ogata Kōrin showing a group of cranes, Edo period.

quite man-made rules about the numbers (always an odd number) of major branches in the arrangement, and the lengths and shapes of those branches. Ikebana presents another example of the curious practice in Japanese art of the application of artificial rules to achieve natural appearance.

The Tea Ceremony

We have already looked at the teahouse that is the traditional setting for the tea ceremony, and we have seen that it is generally small but far from insignificant. Every element of its architecture obeys tradition and conveys meaning. That is equally true of every element employed in the ceremony it houses.

First is the setting in which the teahouse is approached. Ideally, this is a garden, and the path leading through it is indirect and circuitous. It may follow the edge of a small stream, then cross it with an arched bridge. Along the way may be flowering shrubs and trees, stone lanterns, and a view of a distant mountain. Finally reaching the teahouse, the tea master and his or her guests stoop to enter, for the door (a "creeping-in door") is too small and low to enter standing up.

Once inside the miniature building, the guests seat themselves on the tatami matting, admire the flower arrangement or other artistic display that has been prepared, and watch as the tea master begins an elaborate and precisely prescribed ritual of grinding tea leaves, ladling water into a kettle, making a charcoal fire, rinsing and wiping implements, bowls, and cups, and gracefully presenting the entire process and its results to the guests.

The process requires the use of a number of objects, each one of which may be a work of art. These may include a lacquered box to hold the tea leaves, a wooden implement for grinding the leaves, an earthenware bowl in which to grind them, an ivory lid to cover the earthenware bowl, a wide-mouthed jar for storing water, a delicate bamboo dipper for taking the water from the jar, an iron kettle in which to warm the water, a shallow basket to hold the charcoal, a pair of bronze tongs for handling the charcoal, a feather brush for dusting away cinders or ash, a small box to hold incense that is added to the fire, a pottery bowl in which to make

Figure 12–17 A tea bowl for the Japanese tea ceremony, made by Hon'ami Koetsu (1558–1637), 3.5 in. (9 cm) high. Other examples are shown in Figure 11–25c.

HON'AMI KOETSU (1558–1637), TEA BOWL NAMED "AMAGUMO," MOMOYAMA OR EARLY EDO PERIOD. 3½ X 4⅞ IN. (H. 8.8 CM., D. 12.3 CM). MITSUI BUNKO, SECTION OF FINE ARTS, TOKYO, JAPAN.

the tea, a shallow pan in which to pour the water that has been used for cleansing the bowl, a square of silk with which the bowl can be wiped, a bamboo whisk for stirring the tea, a small circular mat on which the hot kettle will be placed, a small bronze rest for the lid of the kettle, and, finally, the cups from which the tea will be drunk (Figure 12–17).

These cups may be made of **raku ware,** a rough-textured, low-fired pottery with black, white, brown, or pink glaze, formed with a small foot and no handle, and slightly irregular in shape. For the tea ceremony's evocation of nature, the raku cup is considered perfect in its deliberate imperfection.

Japanese Painting

For the first seven centuries after its introduction to Japan, Buddhism provided the principal themes for Japanese painting, and Buddhist temples and monasteries were the chief locations for those paintings. By the ninth century, however, in conditions of prosperity and luxurious living, a tradition of secular painting began as well.

Excellent examples of Japanese painting have already been seen in architectural applications such as wall panels and folding screens. In smaller pieces, landscapes—some of them highly fantasized—were

Figure 12-18 A painting on paper by Nishikawa Sukenobu (1671–1751) shows a lady preparing ink by grinding an ink stick on an ink stone. Behind her is a folding screen, and in front of her is a paper lantern.

DETAIL OF PAINTING BY NISHIKAWA SUKENOBU (1671–1751). COURTESY OF THE FREER GALLERY OF ART, SMITHSONIAN INSTITUTION, WASHINGTON, DC F1899.19.

popular. Favored techniques included loose areas of pale color outlined with thin black lines and paintings entirely of ink washes (Figure 12–18). Also popular were the technically extraordinary methods of painting that imitated marble *(suminagashi)*. But even more admirable than Japanese paintings were Japanese prints.

The Wood-Block Print

Many civilizations are noted for their accomplishments in painting, but only Japan is identified with the wood-block print as an exalted art form. The woods used by the Japanese for their printing blocks were smooth and evenly textured, such as cherry *(sakura)*. A different block was used for each color, with the lighter colors being printed before the dark ones, and with more than a dozen blocks required for some intricate designs (although in some cases only a black print was made, and colored areas were painted in by hand). The desired color area, transferred from paper to the wood surface, where it appeared in reverse, was left intact, and the surrounding area was cut away by chisel. Ink was then applied, the paper to be printed placed on top, and its back rubbed with a pad *(baren)*.

Exact alignment of the various blocks was critical and was guided by positioning marks *(kentō)*. Printing was far from a mechanical process, as inks were applied by hand and sometimes partially wiped off to create tonal effects. As with most types of printing, the first edition, which might be limited to one hundred or two hundred prints, was most accurate and most valuable, for the woodblocks would later become worn or warped.

The most famous of the Japanese prints, and the ones that created a sensation when exported to the West, were those of the Edo period from the seventeenth to the mid-nineteenth centuries. Japan's merchant class, once considered a lowly element (inferior to both farmers and artisans) in Japanese society, at that time enjoyed new respect and new wealth, much of which they spent on art and pleasure. The wood-block print was the most popular art form of the day. Some prints were tall and narrow, intended to be shown on house pillars; some were meant to be pasted on fans; some *(surimono)*, commemorating festivals or other events, were small and squarish, but the most common size was about 10 by 15 inches (25 x 38 cm). Some of the prints had landscapes and scenes of nature as subject matter, but others depicted the rarefied, extravagant urban life of Tokyo.

Wood-block prints are made today all over the world, sometimes deliberately using rough wood so that the wood grain is visible in the print. Also popular since the early twentieth century is the **linocut,** which substitutes an easily carved block of linoleum for the block of wood. Most printing today, however, is **intaglio** printing, which is printing with incised metal plates; it was first developed in the fifteenth century and is now in use in various forms, such as engravings, etchings, drypoints, aquatints, and mezzotints. In the late eighteenth century, another form of printing was invented in Germany; called **lithography,** it depends for its effects not on incising lines in a plate but on wetting areas that will then repel greasy inks.

Japanese Lacquer

Lacquering techniques were introduced into Japan from China, but the Japanese became unequaled, even by the Chinese, in their use. One variation invented in Japan, called *heidatsu*, involved carefully

silhouetted sheets of silver or gold in decorative shapes embedded in the lacquer; the lacquer was then sanded down until the precious metals were visible. Powdered gold or silver was employed in another technique *(maki-e,)* and mother-of-pearl inlay *(raden)* was used on some expensive pieces.

The Japanese also developed lacquer techniques with only a single layer, some of them transparent to reveal the wood grain beneath. In some versions *(shunkei* and some examples of *kijiro)* the wood is first colored with a tint, often yellow. Other techniques (such as *fuki-urushi)* involve repeatedly brushing clear lacquer on the wood or rubbing it on with a cloth, then wiping off the excess, preventing a buildup on the surface, but allowing the liquid to penetrate deeply into the wood. Still another Japanese variation *(negoro),* often used for Buddhist ceremonial wares, consisted of spreading a layer of vermilion lacquer over a base of black lacquer, then allowing the vermilion to wear away, exposing areas of black.

Summary: The Design of Japan

The design of Japan is distinctive among the cultures of the East, but that distinction is not easily defined. The Japanese have a term for their artistic ideal: *shibui.* But that ideal is generally defined by sets of contrasting qualities: an object with shibui is quiet, but not inert; simple, but not superficial; beautiful, but not ostentatious; original, but not foreign; sober, but not dull. The Japanese ideal, therefore, is an artistic expression that strikes a careful balance and avoids extremes. The Greek ideal of "nothing in excess" might apply here, but the serene classical composure of Greek art is a world away from the character of Japanese art.

Looking for Character

Japanese art displays a respect for the idiosyncrasies as well as the harmonies of nature. It often eschews the axiality and alignment favored by Chinese art, preferring instead asymmetry and a dash of eccentricity. The Japanese artist shows us that imperfection—if presented with taste and restraint—can sometimes be more interesting than perfection.

Looking for Quality

Having said that the Japanese artist values imperfection, it would be strange to then look for perfection. There is much immaculate craftsmanship in Japanese design, but we find the essence of Japanese taste when we look for the subtle exceptions to expected rules: the little bubble in the glaze of the teabowl, the tiny young bamboo sprout growing from the side of the bamboo vase, the irregular grain in the wood. To be more specific, the wood post in the Shōkin-tei teahouse (Figure 12–8) is clearly natural and clearly not exactly vertical, yet it is not exaggeratedly picturesque or so eccentric that the room becomes undignified. This ability to find the correct balance between freedom and discipline is the mark of quality in Japanese design. It is the ability, to use another example, to place fifteen stones in a field of sand: no other culture would think to pose this problem; no other culture would solve it so beautifully.

Making Comparisons

The obvious comparisons for Japanese design are with the Chinese precedents that influenced it so profoundly, and there are many times when those precedents were followed slavishly: a Japanese chair imitates a Chinese chair so slavishly that, until modern times, we can say that a truly Japanese chair never existed. To a lesser extent, we see similarities to Chinese models in other Japanese forms—pagodas, landscape paintings, lacquerwork, cloisonné.

The telling comparisons, of course, are those between Chinese art and that part of Japanese art that seeks to assert its own independent nature. Such a telling comparison can be made with bowls. The Chinese bowl may be a masterpiece of porcelain technique, a masterpiece of subtly curving form, and a masterpiece of glazing. It is an unquestionably admirable object. But the Japanese artist does not often seek to emulate such an object, presenting us instead with a rougher form in cruder material and with apparently hastily applied glazing. The Chinese bowl is sublime in its quiet perfection; the Japanese bowl is sublime in its naturalness and its ingratiating character. Luckily for us, we can appreciate both models.

CHAPTER

13

THE ITALIAN RENAISSANCE AND LATER DEVELOPMENTS

FOURTEENTH TO EIGHTEENTH CENTURIES

The term *Renaissance*, meaning "rebirth," is used as the name of the great revival of classical philosophy and art that began in the Italian town of Florence in the fourteenth century. Although the forms of art produced during the following four centuries were based on classical inspiration, the movement eventually developed extreme aesthetic originality. The Renaissance was not just the revival of antiquity, but its union with the Italian people.

The first stirrings of the Italian Renaissance were in the fourteenth century (or, in Italian, the *trecento*, meaning those years ending with numbers in the three hundreds). In

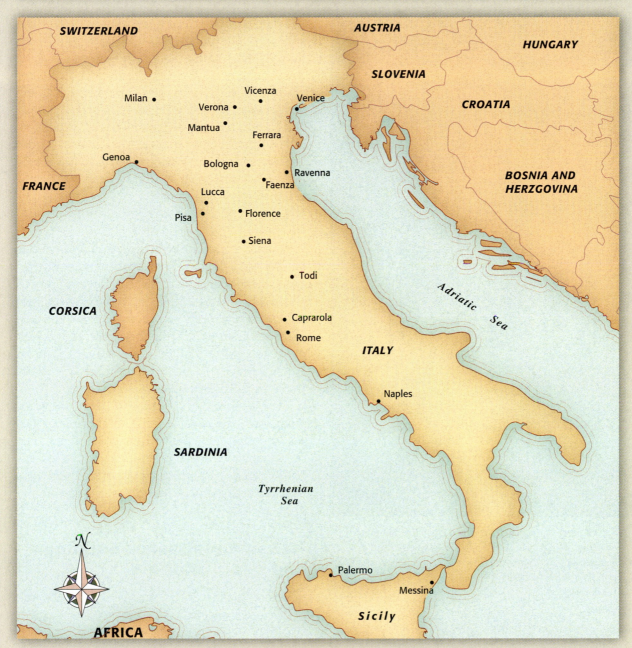

Figure 13–1 MAP OF ITALY

ORTELIUS DESIGN

interior design, the rooms of the Davanzati palace in Florence were exemplary, begun in the thirteenth century and still showing Medieval influence.

The fifteenth century brought what is now called the Early Renaissance, its first constructions by the Florentine architect Filippo Brunelleschi (1377–1446). These included the handsome little Pazzi Chapel added between 1430 and 1444 to the Gothic church of S. Croce in Florence. Its interior (Figure 13–2), a display of harmonious geometric relationships, was given only the degree of ornament that would complement the geometry. Other fifteenth-century master architects included Alberti and Bramante.

The first half of the sixteenth century is considered the High Renaissance. Classical forms

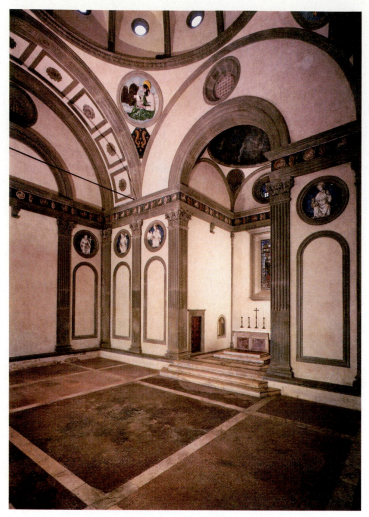

Figure 13–2 Interior of the Pazzi Chapel at S. Croce, Florence, begun in 1430. The geometric elements are outlined in gray stone, and the chief decoration is the group of della Robbia roundels.

SCALA/ART RESOURCE, NY

The seventeenth century saw the birth of the style we call Baroque, the term perhaps adapted from the Portuguese *barocco*, meaning misshapen or irregular. Wall surfaces, inside and out, were given surprising concavities and convexities, and designs were dominated by vivacity, optical illusion, and florid ornament. While still using the classical orders, the Baroque spirit was far removed from the classical simplicity and was instead full of motion and emotion. St. Peter's in Rome is the great epitome of Baroque design, and other examples include rooms in the Palazzo Farnese, Rome, and in the Palazzo Pitti, Florence.

In Italy, as in much of Europe, the Baroque style was succeeded in the eighteenth century by the Rococo, which brought new levels of novelty and lyricism. Design became lighter and more graceful, with the curved line preferred to the straight, the pale color to the strong, and the small salon and boudoir more fashionable than the grand *salone*. Examples of Italian Rococo include the frescoes of Tiepolo and the late works of architect Filippo Juvarra.

The last half of the eighteenth century was influenced by the excavation of Italy's ancient cities and a consequent passion for the antique. The Neoclassical style was practiced by Giovanni Battista Piranesi and others, anticipating the revival styles of the nineteenth century.

Italian Renaissance Buildings and Their Interiors

The determinants and successive styles of the Italian Renaissance found potent expression in a great wealth of architecture, and it was characteristic of the age's concern for human activity and pleasure that great attention was given to the design of interior spaces. In the fifteenth century, their treatment was modest and decorous, but beginning in the sixteenth century there was increasing exuberance and inventiveness. By the Baroque period of the seventeenth century, Italian interior design had reached a level of richness far beyond the requirements of the present day.

The architectural forms of classical antiquity greatly increased, and these were applied to the decorative treatment of the important rooms of the interior. Pedestal, column, pilaster, entablature, ped-

were revived, with beauty of line and mass more important than surface enrichment. This was a period of activity of many great artists, including Leonardo, Michelangelo, Sansovino, Vignola, Vasari, Raphael, and Palladio.

The second half of the sixteenth century is called the Late Renaissance. Its chief style is given the name Mannerism, characterized by the introduction of unexpected details: overlapping, crowding, and deliberate distortions of the established rules of composition. Examples are the Palazzo del Té, Mantua, designed by Giulio Romano, and the interiors at San Lorenzo, Florence, by Michelangelo.

PERIOD AND DATE	POLITICAL AND CULTURAL EVENTS	MAJOR ARTISTIC FIGURES	MAJOR ARTISTIC WORKS
The Trecento, 1300–1400	The Black Death, 1348; Boccaccio's *Decameron,* 1353	Giotto (1266–1337); Brunelleschi (1377–1446); Ghiberti (1378–1455); Donatello (1386–1466); Fra Angelico (1387–1455)	
Early Renaissance, 1400–1500	Medici family gains power, by 1450; first Italian printing press, 1465; Lorenzo the Magnificent prominent in Florence, 1469–92	Luca della Robbia (1399–1482); Alberti (1404–72); Mantegna (1431–1506); Botticelli (1444–1510); Bramante (1444–1514); Leonardo (1452–1519); Michelangelo (1475–1564)	Ghiberti's doors for the Florence baptistery, 1403–24; Brunelleschi's dome for the Florence Cathedral, 1420–36; Ghiberti's "Gates of Paradise," 1425–52; Brunelleschi's Pazzi Chapel, Florence, finished, 1465
High Renaissance, 1500–1550	Martin Luther spurs Protestant Reformation, 1517; Machiavelli's *The Prince,* 1532	Sansovino (1486–1570); Raphael (1483–1520); Titian (1487–1576); Cellini (1500–1571); Vignola (1507–73); Vasari (1511–74)	St. Peter's, Rome, begun, 1506; Michelangelo's Sistine Chapel, 1508–41; Raphael's rooms in the Vatican, Rome, 1508–20; Palazzo Farnese, Rome, 1517–50; Villa Madama, Rome, begun, 1518; Michelangelo at S. Lorenzo, Florence, 1519–62; Palazzo del Té, Mantua, 1525–32
Late Renaissance and Mannerism, 1550–1600	Vasari's *Lives of the Artists,* 1550	Palladio (1518–80); Tintoretto (1518–94); Veronese (1528–88); Caravaggio (1569–1609)	Vasari at work in Florence in Palazzo Vecchio and on Uffizi, 1555; Palladio's Villa Capra, Vicenza, 1565; Palladio's Teatro Olimpico, Vicenza, 1580
The Baroque, 1600–1720	Monteverdi's *Orpheus* performed, 1607; Galileo uses telescope to view stars, 1610; his findings banned by the church, 1633	Bernini (1598–1680); Borromini (1599–1667)	St. Peter's, Rome, completed, 1626
The Rococo, 1720–50		Tiepolo (1696–1770)	Tiepolo frescoes; Palazzina di Stupinigi, 1729–35
Neoclassicism, 1750–1800		Piranesi (1720–78)	Salone d'Or, Palazzo Chigi, Rome, 1767

iment, and panel were employed for both structural and ornamental purposes, and these features aided in producing rooms of great formality, dignity, and magnificence. Column capitals, on the whole, followed classical lines, but novelties and variations were introduced. Door and window openings were treated with architrave moldings as trim. In the more elaborate examples, openings were frequently flanked with pilasters supporting triangular, segmental, or semicircular pediments. To supplement the architectural forms, painted frescoes, elaborate embroideries, velvets, or tapestries were used on the walls. The subject matter for the mural decorations consisted of scenes of antique ruins, distant garden views, scenes from classical history and mythology, religious and astronomical subjects, and portrayals of memorable events in the owner's family history.

During the cinquecento and later, elaborate use was made of colored marble slabs for wall treatments and architectural trim. Wall panel effects were produced by the use of borders or stripes with contrasting fields. Columns and pilasters with gilt-bronze capitals were added for further enrichment. Moldings and relief ornament were either carved or made of gilded stucco. Cast plaster heraldic devices, flower and leaf forms, grotesque ornament, and *amorini* ("little loves" or cherubs, also called *putti* if they lack wings) eventually increased in size and number. Wood-paneled walls left in a natural finish or decorated with paint were a late development.

We shall look at some specific interiors in several building types: not only religious structures, but also palaces and country houses.

The Church

Although not as dominant as it had been in the Middle Ages, the church continued as a powerful force in the Italian Renaissance, and impressive structures and interiors continued to be designed for its use. The great Christian monument of the Renaissance was St. Peter's.

ST. PETER'S, ROME (1506–1626) The early Baroque style is seen at its best in St. Peter's Cathedral in Rome, which has been called "the climax building of the Renaissance." Occupying the same site as the Old St. Peter's that was the most important of Early Christian structures, the new St. Peter's was built on such a colossal scale that it is almost impossible to visually gauge its dimensions. The building is 710 feet (216 m) long and covers 227,000 square feet (21,000 m²). Its dome is 450 feet (137 m) high; the nave is 84 feet (26 m) wide, roofed by a great barrel vault 150 feet (46 m) high, and the supporting Corinthian pilasters are 84 feet (26 m) from base to capital. The statues of the saints in their niches are 16 feet (5 m) tall, and the little cherubs are 7 feet (2 m).

Work on St. Peter's was begun in 1506, and it took 120 years to complete. Those who worked on its design constitute a roster of Renaissance talent.

Figure 13–3 The Basilica of St. Peter's, with Bernini's great colonnaded piazza before it. The buildings to the north (at upper left in the photo) are parts of the Vatican Palace, and the whole ensemble is called the Vatican City.

GUIDO ROSSI/THE IMAGE BANK

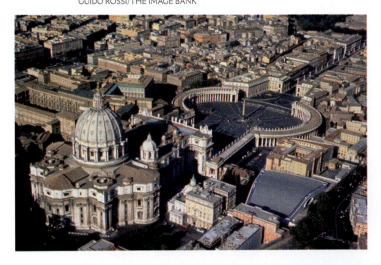

The first plans were produced by Alberti in 1454 and called for a huge basilica in the shape of a Latin cross. In 1506 Bramante replaced Alberti's scheme with one for a Greek cross and a great central dome, but alterations to the Bramante plan were made by Raphael, Peruzzi, and Antonio Sangallo the Younger. Michelangelo then proposed a return to Bramante's Greek cross, which he thought to be "clear, comprehensive, and luminous." For both Bramante and Michelangelo, the centralized plan suggested the universality of God. After Michelangelo's death, however, the nave was extended by Carlo Maderno, returning the plan to the shape of a Latin cross and of the Old St. Peter's. Maderno also added the travertine facade and its giant Corinthian order, the dome was designed by Giacomo della Porta and Domenico Fontana, and Bernini added the imposing colonnade that grips the facade like a great pair of tongs and encloses the Piazza di San Pietro and its ancient Egyptian obelisk (Figure 13–3).

Within the Michelangelo/Maderno shell, the interior of St. Peter's is a vast display of arches, columns, pilasters, and other classical architectural features in colored marbles, frescoes, mosaics, sculpture, grilles, candelabra, paintings, organ pipes, gilded plaster ornament, and inlay work. Alabaster altars and chapels are ornamented with gold, rock crystal, and enamel. But the generous dimensions of the interior easily accommodate the wealth of decoration.

Bernini is responsible for the remarkable composition in the apse of St. Peter's, covering the wall farthest from the entrance (Figure 13–4). What is called the Glory, created between 1647 and 1653, is a dramatic sunburst of golden rays, surrounded by angels and clouds of gilded stucco and centered on a radiant oval window, its stained glass representing the Dove of the Holy Spirit. Lower on the same wall and added between 1656 and 1666 is the Cathedra Petri or Throne of Peter. What Bernini designed, however, is nothing like the humble wooden stool that was the actual relic of the saint's life. He has given us instead an opulent and gigantically scaled throne rendered in bronze, marble, and stucco, held aloft by figures of the Four Doctors of the Church. The back of the throne bears a relief illustrating Christ's charge to Peter, "Feed my Sheep," and just above it two amorini hold the papal keys and tiara. At the foot of the composi-

Figure 13–4 Bernini's Cathedra Petri and dove window in the apse of St. Peter's.

SCALA/ART RESOURCE, NY

The Italian word *stanze* simply means "rooms," but in the context of the Vatican Palace it has come to refer to three rooms in particular, famous for their frescoes by Raphael (1483–1520) beginning in 1508 and lasting until his death. The rooms had previously been decorated with paintings by Sodoma, Perugino, and others, but Raphael's all-encompassing program replaced most of the earlier work. The three rooms are known as the Stanza della Segnatura (the first to be painted), the Stanza di Eliodoro, and the Stanza del' Incendio, names referring to the elaborately planned subject matter. Two other rooms, the Sala di Constantino and the Sala dei Chiaroscuri, were planned by Raphael but executed by others.

The general scheme of the Vatican Palace was to cover the four walls and ceiling of each room with related scenes. In the Stanza della Segnatura,

Figure 13–5 Michelangelo's frescoes for the Sistine Chapel of the Vatican Palace, Rome. On the far wall behind the small altar is *The Last Judgment*.

MICHAELANGELO BUONARROTI (1475–1564), ENTRANCEWAY TO THE SISTINE CHAPEL. SISTINE CHAPEL, VATICAN PALACE, VATICAN STATE. SCALA/ART RESOURCE

tion, gilt bronze statues of two Greek and two Latin Fathers of the Church stand on a colossal base of red jasper and black marble.

The Vatican Palace adjoining St. Peter's is a vast, irregular complex of buildings stretching 1,500 feet (460 m) long and 750 feet (229 m) wide. So closely is it tied to the functioning of the great basilica that we place it here under the heading "Churches" rather than under "Palaces." It incorporates the work of many of the Renaissance's greatest artists and designers. Among them are Bramante, responsible for the courtyard known as the Cortile del Belvedere; Bernini, who designed the Scala Regia or Royal Stair; Michelangelo, who painted the frescoes in the Sistine Chapel (Figure 13–5); and Raphael, who painted the *stanze* and *loggie*.

Figure 13–6
In the Stanza della Segnatura at the Vatican, is Raphael's fresco *The School of Athens*. Other frescoes by Raphael in the Stanza are *The Virtues, Parnassus,* and the *Disputá* (The Dispute over the Holy Sacrament).

SCALA/ART RESOURCE, NY

for example, one mural, called the *Disputá* or the *Triumph of the Church,* represents supernatural truth; *The School of Athens* (Figure 13–6) represents rational truth; and other surfaces represent the good and the beautiful. Overhead, there are representations of theology, philosophy, justice, and poetry. In each room, Raphael has given the paintings meaningful relationships to one another, and even the figures within them have been given positions and gestures appropriate to their roles.

Raphael also is responsible for the decoration of some of the *loggie* ("loggias," or rooms with open arcades or colonnades along one side) of the Vatican Palace. The work was done between 1514 and 1519, with the aid of Giulio Romano, Giovanni da Udine, Caravaggio, and others, and the striking decorations of the pilasters are in the style of ancient **grotesque** work (Figure 13–7).

MICHELANGELO AT S. LORENZO, FLORENCE (1519–62)

Michelangelo's first major architectural commission was for the facade of the church of S. Lorenzo in Florence. That was never built, but Michelangelo did carry out two major works of interior design within the church complex. The first to be begun, in 1519, was the New Sacristy, meant to be a balancing element for the Old Sacristy that had been designed by Brunelleschi a century earlier. Also called the Medici Chapel, the New Sacristy was meant to serve as a tomb for members of the Medici family. The room's high windows have been tapered, their sides converging slightly as they rise. The two major sculptural groups—one dedicated to Giuliano de' Medici (Figure 13–8) and incorporating symbolic figures representing Night and Day, and the other dedicated to Lorenzo de' Medici ("Lorenzo the Magnificent") with figures of Evening and Dawn—seem to be deliberately squeezed between the gray stone pilasters that frame them. Work on the New Sacristy continued until 1534, when Michelangelo moved from Florence to Rome.

In 1523, Michelangelo was also asked to design a library at S. Lorenzo to house the books of Lorenzo de' Medici, uncle of the newly elected pope. It is called the Biblioteca Laurenziana (Laurentian Library), and work on it continued until 1562, two

years before Michelangelo's death. There are two chief elements: a tall vestibule with a monumental stair and, at the top of the stair, a reading room. The reading room is long and rectangular, entered through one of the short ends. Its walls are rigorously organized with a regular pattern of dark stone pilasters against white walls, and the three-part division of Michelangelo's ceiling design (Figure 13–9) aligns with the division of the end walls: wide central bays between narrow outer bays.

The library's vestibule is more eccentric (Figure 13–10). Its pairs of Tuscan columns, rather than forming an arcade in front of the walls, are recessed into them, and they rest on volute-shaped brackets. Also recessed in the walls are empty **aedicules**

Figure 13–7 The Vatican Loggie decorated by Raphael and his assistants, 1514–16.

SCALA/ART RESOURCE, NY

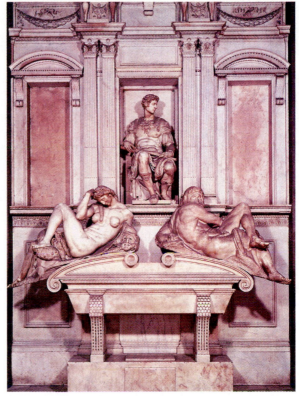

Figure 13–8 In the New Sacristy, Michelangelo's tomb of Giuliano de' Medici.

SCALA/ART RESOURCE, NY

shaped like miniature temples and also resting on brackets. The stair that almost fills the vestibule begins on the lower level with three parallel flights that merge into one at an intermediate landing.

Both the New Sacristy and Biblioteca Laurenziana were described by Vasari as breaking with both ancient and modern tradition. In these rooms Michelangelo produced effects never seen in any treatise, and his highly individual, dynamic, emotional compositions have come to be considered the essence of Mannerism.

The Palazzo

The use of gunpowder by the armies of Europe was greatly increased during the fifteenth century. By 1450 the medieval fortified castle with its moat, drawbridge, and portcullis was of little value for defensive purposes, and, as the forts were removed to more strategic outlying districts, the towns themselves burst the bounds of their ancient walls,

Figure 13–9 The coffered wood ceiling of the Biblioteca Laurenziana, designed by Michelangelo and executed by Giovan Battista del Tasso.

ALINARI/ART RESOURCE, NY

Figure 13–10 The vestibule and entrance stairs of the Biblioteca Laurenziana, S. Lorenzo, Florence, 1523–62.

ALINARI/ART RESOURCE, NY

and construction of more luxurious city dwellings and suburban villas began. The Italians were the earliest designers of a type of domestic architecture in which comfort, convenience, and beauty were the important considerations, rather than safety, strength, and protection. The beginning of the modern art of interior design is coincident with that of domestic architecture.

THE PALAZZO VECCHIO, FLORENCE (1314 AND AFTER)

On its exterior, Florence's Palazzo Vecchio (Old Palace) is medieval in character, but its interior spaces include many Renaissance delights. The building's main features were completed in 1314, more than a century before architecture would rediscover classical forms and harmonies. It also predated the firm establishment of political stability—there was still great strife among families and factions—so it was appropriate that the building be fortress-like and topped with battlements. Its familiar tower was built to lift above the city an 11-ton (10 t) bell that could announce public assemblies or call the citizens to arms.

Originally called the Palazzo della Signoria ("Palace of the Signory" or group of city fathers), it was intended as both a municipal building and a temporary residence. The elected *signori* served two months in office, during which they lived in the building, forbidden by law to leave it until their terms expired.

The list of contributors to the palazzo is long and distinguished. In 1457 the architect Michelozzo (1396–1472) was hired by the signori to reinforce the building against collapse and to make additional changes. In the 1480s Domenico Ghirlandaio painted the decoration of the palazzo's Sala del Orologio (Hall of the Clock). In 1494, Simone Pollaiuolo—called Il Cronaca because of the chronicle he kept—remodeled a number of small adjacent rooms into the single Sala dei Cinquecento (Hall of Five Hundred), large enough to hold that number of people.

Not all plans for the interior were successful. In 1503, in a famous example of artistic rivalry, Leonardo da Vinci was commissioned for a mural on one wall of Il Cronaca's enormous *sala*, and Michelangelo for one on the facing wall. Both artists completed cartoons for their murals, but neither was ever finished. Leonardo was experi-

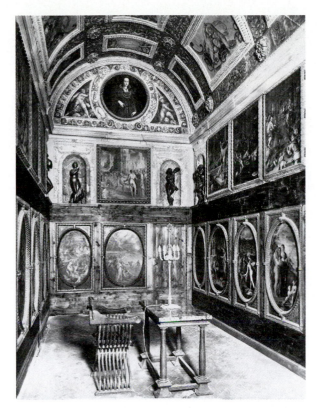

Figure 13–11 The studiolo of Francesco I de' Medici in the Palazzo Vecchio, Florence, 1570–75. The overall design and some of the paintings are by Vasari.

ALINARI/ART RESOURCE, NY

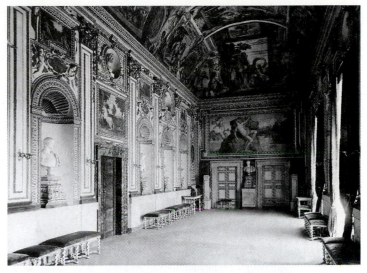

Figure 13–12 The great gallery on the piano nobile of the Palazzo Farnese. The windows on the right open to the courtyard, and the fresco on the vaulted ceiling is by the Carracci brothers.

ALINARI/ART RESOURCE, NY

menting with encaustic techniques, and the paint was not properly absorbed by the stucco; Michelangelo was called to Rome by the Pope before he ever began his painting.

Between 1555 and 1572, Giorgio Vasari remodeled and redecorated many interiors of the Palazzo Vecchio, including the intimate *studiolo* (study) for one of the Medici princes, a windowless room literally buried within the palace construction (Figure 13–11); its only access, originally, was by a hidden spiral stair. At the same time Vasari designed the adjacent government administration building known as the Uffizi (The Offices), now one of the world's great museums.

PALAZZO FARNESE, ROME (1517–50) This supremely elegant palace was built to express the power and wealth of the Farnese family. Cardinal Alessandro Farnese hired Antonio da Sangallo the Younger, a leading Roman architect of his day, to design the building, and when the cardinal was named pope in 1534, he asked that it be enlarged and embellished. After Sangallo's death in 1546, Farnese turned for the completion of the work to Michelangelo, who increased the height of the top story and designed its boldly projecting cornice. The loggia on the back of the palace, overlooking a rear garden and the River Tiber, was added by Giacomo della Porta, and interior frescoes were painted by Francesco Salviati and others. The palace is now the French Embassy.

The 185-foot-wide (57 m) symmetrical plan of the Palazzo Farnese surrounds an arcaded central *cortile* (courtyard) 81 feet (25 m) square. From the arcade a generous stair leads up to the main rooms of the **piano nobile;** among these are the great gallery (Figure 13–12) with its ceiling mural, *The Triumph of Bacchus and Ariadne*, painted in the years 1597–1600 by Annibale Carracci (1560–1609) and his brother Agostino.

The Villa

During the Early Renaissance many smaller palaces and country villas were built by wealthy merchants. These were decorated in a more modest fashion

than the homes of the nobility. The academic architectural forms were used reservedly or were omitted in such interiors, and the thick stone walls

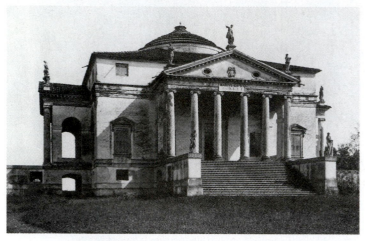

Figure 13–13 The Villa Capra, near Vicenza, designed by Andrea Palladio, 1557–83. Its four identical porticoes command four sweeping views over the countryside.

ALINARI/ART RESOURCE, NY

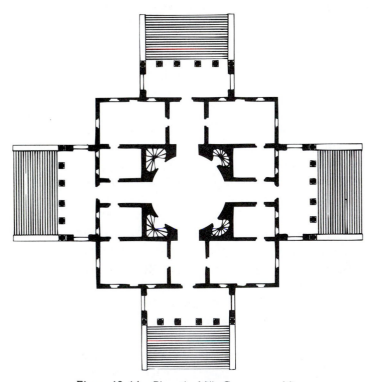

Figure 13–14 Plan, the Villa Capra, near Vicenza.

FROM *PALLADIO* BY JAMES S. ACKERMAN, "VILLA ROTONDA, PLAN," FIGURE 32 (P. 77). BALTIMORE: PENGUIN, 1966. COPYRIGHT © JAMES S. ACKERMAN, 1966. REPRODUCED BY PERMISSION OF PENGUIN BOOKS LTD.

were pierced by doors and windows having deep reveals without trim. The openings were treated either with a flat lintel or had a segmental or semicircular arch. The Florentine arch, usually used in arcades, was semicircular, and consisted of an architrave molding springing from a classical column. The coarse sand plaster used on the walls was accentuated by an irregular surface produced by the plasterer's trowel, giving an interest and richness in tone and texture. Walls were sometimes painted to imitate hung textiles; not only the pattern of the fabric, but the folds, nails, highlights, and shadows, as well, were reproduced. The rooms of these smaller dwellings were large in comparison with those of a modern house, though smaller than those of the great palazzi of the period.

At times, however, the quality and scope of country villas reached a level of sophistication equal to that of the city palaces, receiving fully as much design attention and fully as much richness of treatment.

VILLA CAPRA (LA ROTONDA), NEAR VICENZA (BEGUN 1565)

The work of Andrea Palladio (1508–1580), clustered in and around Venice and Vicenza, was a built expression of his architectural principles, which he published in a famous treatise, *The Four Books of Architecture*, in 1570. Among his buildings are many fine villas, but here we shall focus on the last one to be built: the Villa Capra atop a gentle hill near Vicenza. It is a centralized structure, bilaterally symmetrical, showing on its exterior four identical porticoed facades (Figure 13–13), the sort of structure often conceived by Renaissance architects but seldom actually built. Inside, the arrangement of rooms is as orderly and as repetitive as the exterior implies (Figure 13–14), and at their center, under a shallow dome, is a cylindrical sala, the obvious heart of the house. Four vestibules lead from the four porticoes to the central space, but, allowing himself some degree of variation, Palladio has not made the vestibules of equal width. Every relationship of house to site, of room to room, and of width to length to height within each room has been carefully considered, and the result is a remarkably cohesive realization of an ideal country villa. La Rotonda, as it is sometimes called, is one of those few accomplishments in the history of

art and design that seem to deserve the adjective *perfect*.

Interior Components of the Italian Renaissance

It is time to look at some of the components of these interiors, after which we shall consider some of the furniture designed for them and some of the decorative techniques they employed.

Types of Rooms and Their Distribution

Within the Italian Renaissance palazzo, fine distinctions were made among room types, room sizes, and room uses. The *salone* was the palazzo's principal room, the grandest and most ornamented space where important guests would be received; it might also be called a *sala* or a *sala di ricevimento*. The *salotta* was a smaller room, the equivalent of a parlor, and smaller still was the *salottino*, a sitting room or boudoir. The salotta could also be the room where the family dined, and could be called the *sala da pranzo*. The *camera* was a family member's private bedroom, and tucked behind and around it could be a number of small subsidiary spaces, which might have names like *camerino* or *cameretta*. (In France, such closet-like spaces would be called *cabinets*, and in Italy there was also the term *cabinetti*.) Reflecting their placement in relation to the camera, these could also be called *anticamera* or *dietrocamera*. The term *camera picta* indicates any room with elaborate painted wall and/or ceiling decoration.

Among the anticamera, perhaps the most personal and intimate of all would be the small study called a *studio* or *studiolo*. The studiolo was usually small and often windowless, and access to it was generally limited to its owner. The owners were not all men; Isabella d'Este, for example, had a studiolo in Mantua, for which she commissioned paintings by Perugino. Some studioli were designed with decorative themes reflecting the humanitarian and artistic inclinations of their owners (such as the one in Figure 13–15); others were designed as private art galleries (such as the one by Vasari we saw in Figure 13–11). One last room among these

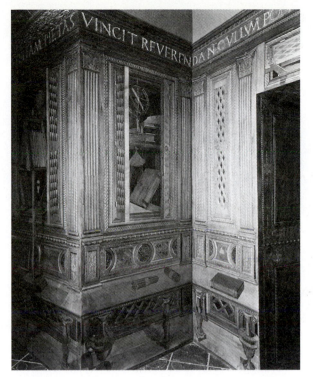

Figure 13–15 Federico da Montefeltro's studiolo in the Ducal Palace, Gubbio. The intarsia work portrays cabinets filled with books, a caged parrot, and musical and scientific instruments. Woods employed include walnut, oak, poplar, and fruit woods.

WORKSHOP OF GIULIANO DA MAIANO. PROVENANCE: DUCAL PALACE, GUBBIO. WALNUT, SPINDLE TREE, OAK, BOG, MULBERRY, AND FRUIT WOODS. H. OF ROOM: 8'10"; L. OF ROOM: 16'11½"; W. OF ROOM: 11'10". THE METROPOLITAN MUSEUM OF ART, ROGERS FUND, 1939. (39.153)

small subsidiary spaces was the *destro* or *necessario*, corresponding to our toilet.

How were these various rooms to be arranged? In the layout of rooms, there seem to have been three guiding principles:

- First, there was the principle of symmetry, urged by all the architectural writers of the Renaissance, though perhaps most strongly advocated by Palladio. In the interest of order and clarity, this ideal mandated a central entrance, often with a vestibule leading straight to a central courtyard, with identical arrays of rooms on either side. Building in old cities with irregular pieces of land made this ideal one that could not always be observed.

- Second, there was the principle espoused by Leon Battista Alberti and other writers that the

most public rooms were those most immediately accessible from the main entrance, and that the deeper one penetrated into a house the more private the spaces became. This is so natural a principle that its use is commonplace in many cultures (in China, for one example).

- Third, somewhat less obvious than the first two, was the principle of dividing large houses or palazzi into apartments, each a group of contiguous rooms that constituted the private realm of a single person (or married couple, although it seems to have been more common for a couple to have two linked apartments). Historian Peter Thornton maintains that "[d]evising the apartment was the most important contribution made by the Renaissance to the civilizing of life indoors." Within principle three, principle two was often at work—that is, within an apartment a linear sequence of rooms, whether in a straight line or some other configuration, led from the most public to the most private spaces. Somewhere in the middle of the series would be the camera or bedchamber, preceded by spaces where the occupant might receive guests and followed by closets, studio, and toilet, perhaps terminating with a back stair that could offer a private exit.

Care was also given to the vertical distribution of rooms. The most important and the most well-embellished spaces were one level above the street on the **piano nobile** (pee-ah-no noh-bee-lay). The ground floor of a palazzo might have only a few finely finished spaces—an entrance vestibule, of course, and perhaps a summer bedroom for the owner, the thick walls of the lowest floor helping to keep it cool. Other residence-related spaces on the ground floor might include a kitchen, toilets for the staff, and storage rooms. Also on the ground floor of most palazzi—at least until the mid–sixteenth century—were shops that opened to the street but not into any other interior spaces. The floor or floors above the piano nobile were, just as they would be today, devoted to less important family quarters.

Walls and Wall Treatments

In the sixteenth century important rooms were wood paneled, the divisions in the paneling re-

flecting elements of the classical orders then so greatly admired: a base at the floor, a wainscoting extending roughly 3 feet (1 m) above the floor (representing a classical pedestal), a tall main section (representing a column), and a crowning cornice at the ceiling (representing a capital or an entablature). Three-dimensional half columns and pilasters were also applied to wall surfaces.

Less expensive than paneling was painting, and the classical orders often appeared on Italian Renaissance walls in painted form, as they had on the walls of ancient Rome. Entire walls were not always painted, but all important rooms at least had a frieze painted around the tops of the walls. Where left plain, walls were generally covered temporarily—as when guests were expected—by wall hangings of fabric, painted leather, or gilt leather. In more humble circumstances, walls could be hung with rush matting, sometimes with a black pattern woven in or painted on.

Ceilings

Ceilings were high, and were often elaborately treated in either wood or plaster or a combination of the two. The wood ceilings consisted of enormous walnut, oak, cedar, or cypress beams, spaced several feet apart, spanning the width of the room. The large beams in turn supported smaller beams, spaced 1 or 2 feet (30–60 cm) apart, running in the opposite direction, and supporting the floor above. The beams were striped with paint in vivid colors, and an occasional cartouche, medallion, or coat of arms was introduced in the center. Wood-paneled and coffered ceilings also were used in which both the wood and the panel were decorated with painted arabesques, conventional ornament, or scenic patterns. Illusionistic painting in *chiaroscuro* (effects of light and shadow) could be substituted for more costly carving; gilding could be added to rosettes; and rooms with lower ceiling heights could have ceiling designs with smaller compartments.

Ground-floor rooms were often vaulted with masonry. Those on upper floors might be vaulted with a lighter-weight material with the appearance of masonry, such as plaster or stucco, or might be made of wood. Peter Thornton suggests there were two distinct types of wood ceiling, the *palcho,*

with regularly spaced joists visibly spanning the width of the room, and the *soffito*—perhaps the source of today's term **soffit**—which was structurally the same but had suspended beneath the joists a surface of framed wooden panels.

Plaster ceilings were usually flat and appeared to be supported at the wall with coved arches springing from brackets resembling pilaster capitals. Vaulted plaster ceilings were also sometimes made in the form of a low segmental arch. Especially in the Rococo period, fantastic ceiling effects were contrived from plaster or stucco (Figure 13–16.) And, as we have already seen (Figure 13–12), the Baroque style was fond of its own fantasies painted in fresco.

Floors

Tile, brick, and marble were the materials most suitable for floors in a warm climate, and all were extensively used. The accessibility and supply of colorful marbles made them popular for flooring. Checkerboard and scroll patterns in black, white, gray, and color were made. The floors of the grandest Italian Renaissance rooms were of marble laid in intricate geometric patterns, juxtaposed with a variety of different colors. For such work, the designs that had been originated in Gothic times by the Cosmati family continued to be popular.

Floors were also made of a crushed colored marble mixed with cement, known as **terrazzo**. Quarry tiles, both plain and embossed, were often used, usually 6- or 8-inch (15 or 20 cm) squares or hexagons. Brick floors were usually laid following a herringbone pattern called *spinapesce* (fish spine). Plank floors of oak and walnut were used as well in the early period, and after 1600 elaborate parquetry patterns in rarer, colored woods came into use. When floor coverings were used, they consisted of small Oriental rugs placed where most needed.

Doors

Single wood doors were the most commonplace in the Italian Renaissance, as they still are, but an important room might be entered through a pair of matched doors within a single frame. The desire

Figure 13–16 On the ceiling of the ballroom of the Palazzo Albrizzi in Venice, lifesize amorini frolic beneath billowing fabric, all executed in stucco. The designer was Abbondio Stazio, and the work was done between 1690 and 1710.
COUNTRY LIFE PICTURE LIBRARY, LONDON, ENGLAND

for symmetry within important rooms led often to the provision of false doors *(porte finte)* that matched real ones but did not actually open. When such doors were not actually constructed, they were sometimes painted on the wall.

In minor rooms, doors were left plain; in major rooms they were ornamented. The fashionable door treatment in the first half of the fifteenth century was to inlay them with decorative woods. In the second half and in the sixteenth century, the fashion changed to three-dimensional embellishments with raised moldings and paneling.

Framed openings, with or without wooden doors, were also often hung with door cloths which would later come to be called **portiere**. These pieces of fabric served to block drafts and were also thought to provide a touch of elegance. An **intarsia** wall panel in the study of the Palace of Urbino shows the duke of Urbino stepping through a doorway hung with two door cloths (Figure 13–17). The door cloths are pulled up at the sides and held in place by pushing them through small metal rings; another piece of fabric across the top of the door is woven in a flame pattern and finished with fringe. Similar hangings served as window treatments.

Figure 13–17 An intarsia panel showing the duke of Urbino at a doorway hung with two portieres and a small fabric valance across the top.

ALINARI/ART RESOURCE, NY

Windows

Although the Gothic cathedrals were famous for their stained glass, few other structures of the Middle Ages had enjoyed such luxury. Windows were either open to the weather or closed against it with opaque wood shutters. It was not until the fourteenth century that window glazing became commonplace.

One popular type of glazing in the early Renaissance consisted of small circular pieces of glass called *occhi* (eyes) framed with rings of lead. Such glazing is seen in some palazzi dating to the sixteenth century. The diamond shapes between the circles were sometimes solid lead and sometimes also filled with glass. One effect frequently employed had the circles of clear glass and the diamonds of colored glass. Later, glass in flat sheets, which was much more transparent, became available and was much preferred to the occhi.

Also popular in Italy during the Renaissance was a window treatment less expensive than glass, the *fenestre impannata*. This was a wooden frame fitted to the window opening, over which a linen panel was stretched, the linen blocking the view but admitting a pleasant soft light. Often the bottom halves of the impannate were hinged along their top edges so they could be opened out for view and air. In humble circumstances, paper was substituted for linen.

Fireplaces and Mantels

In the Middle Ages, as we have seen, the great halls had first been built with an open hearth *(focolaro)* in the middle of the floor, the smoke rising (it was hoped) to a hole in the roof above. Later the more agreeable practice was adopted of placing the fireplace against the wall with a flue embedded in the wall to conduct the smoke upward to a chimney. Further efficiency was sometimes gained by a hood that projected into the room. The most common form for a hood, tapering from a broad base to a narrow top, resembled a tent and was therefore called a *nappa a padiglione*. It was sometimes decorated with the family's coat of arms, sometimes with scenes—painted or in relief—of such fire-related classical myths as Phaeton in his fiery chariot or Vulcan at his forge.

In a room of any importance, this opening in the wall, with or without a hood, required embellishment, much as a door or window opening would. Indeed, as the sole source of heat and—at night—a chief source of light, it deserved to be treated as a major feature. When the fireplace was recessed in the wall and there was no projecting hood, the mantel shelf—a vestige of a hood—began to be projected above the opening and began to be used as a resting place for the display of prized decorative objects. Peter Thornton, however, says that "[i]t does not seem . . . that ornaments were specially made to go on mantelshelves until after 1600."

When the fireplace opening was countersunk in the wall, the opening was trimmed on three sides with a flat architrave molding. The bolection mold-

ing, used as a trim, was also very typical. This latter form consisted of a heavy torus molding grouped with smaller moldings projecting several inches from the wall. In the more elaborate fireplace treatments, the architrave form of trim was crowned with a carved frieze and projecting cornice moldings, forming a mantelshelf. Dwarf columns, pilasters, caryatids, and acanthus leaf brackets were also used as side supporting motifs to support the entablature or cornice. Ornament consisted of carvings, marble inlay, and paint, showing arabesques and rinceaux, classical figures, heraldic forms, portrait busts, or grouped foliage patterns. When not in use, the fireplace opening was covered by a chimney board of wood or stretched canvas.

Just as a very grand room might be entered through a pair of doors, it might also boast a pair of fireplaces. Small or unimportant rooms might have none, these being heated with portable braziers, as in Roman times.

Niches and Plaques

The niche, a recessed wall space, was borrowed from classical architecture and adopted by the Renaissance interior designers for both ornamental and useful purposes. The ornamental niche, both with and without flanking pilasters, usually contained a statue in bronze, marble, or glazed or painted terra-cotta. The useful niche was used as a storage space and sometimes contained shelves or a washbasin. It often had two wooden doors or shutters that were plain, painted, or treated with a simple pattern. The niche heads were flat, segmental, or semicircular.

Color Schemes

The Italians had a sophisticated understanding of the use of color for interior work. The large scale of many of the rooms permitted strong tones in primary colors to be used, although discretion was maintained in their distribution. When plain, neutral-colored plaster was used for a wall, draperies and accessories could afford to be in brilliant reds, blues, yellows, purples, and greens. In the later Renaissance, colors were softened. When brocades and damasks were used for wall treatments, the size of the room was taken into consideration in the selection of the colors. Strong tones were still used in the larger rooms, but delicate shades were selected for the smaller ones.

Italian Renaissance Furniture and Furnishings

In the Early Renaissance, furniture was sparingly used, and what existed was consistent with the large dimensions of the rooms. By the middle of the quattrocento a more general demand for improved richness and comfort in the movable furnishings of the house was prevalent, and, as great thought was placed upon entertaining, the general design and arrangement of the furniture was made with this activity in view. By the sixteenth century, the Italians had developed a variety of furniture forms (Figure 13–18). Much of the furniture was monumental, and its logical position was against the wall, forming a dominant note in the wall composition, along with decorative wall plaques, portrait busts on brackets, heavily framed paintings, or panels of relief sculpture.

There were certain characteristics of Italian furniture that carried through the whole period of native design from 1400 to 1700. The principal one was the use of walnut as a cabinet wood. The fertile soil and temperate climate of Italy were particularly suitable to this tree, which often grew to a height of 75 feet (23 m). Walnut planks with beautiful grain and rich brown color over 3 feet (1 m) wide could be had, and these were made into tabletops or panel fields. While various other woods were used by the country cabinetmakers, almost 90 percent of the furniture of these centuries was made of walnut.

The earliest Renaissance cabinetmakers followed the principles of their Gothic predecessors in applying architectural forms to the ornament and decoration of their furniture. The change required only the substitution of classic orders, acanthus leaf, grotesque, and arabesque for pointed arch, tracery, and linenfold.

From the beginning of the cinquecento, Renaissance furniture was enriched by carved

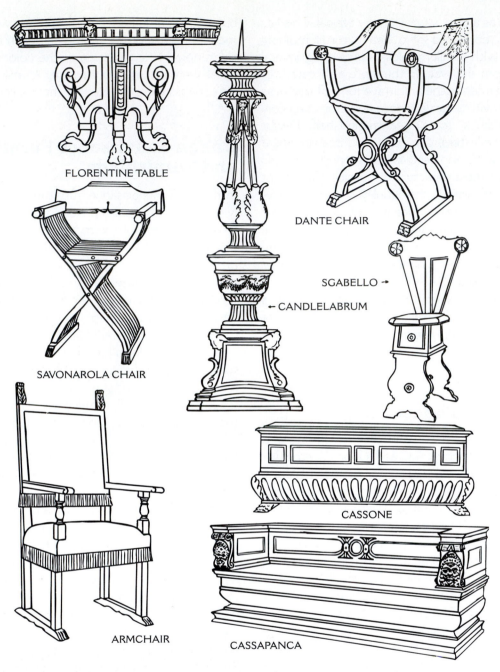

FLORENTINE TABLE

SAVONAROLA CHAIR

DANTE CHAIR

SGABELLO →

← CANDLELABRUM

ARMCHAIR

CASSONE

CASSAPANCA

Figure 13–18 Several characteristic pieces of Italian Renaissance furniture.

DRAWING: GILBERT WERLÉ

relief patterns, by ornamental inlays, and by painted decorations consisting of cartouches, rinceaux, arabesques, grotesques, gadroons, dolphins, and other forms borrowed from antiquity. The ornament on Italian Renaissance furniture was frequently touched up with dull gold, which gave it added sparkle and interest and caused it

to harmonize well with all other colors used in a room.

Seating

The **sedia** was a chair, of which there were several varieties, none very comfortable by today's stan-

dards, although an improvement over their predecessors. The armchair was rectangular in its main lines, with square, straight legs. The legs were connected with **stretchers,** which were sometimes placed so as to rest on the floor. A characteristic feature was the upward extension of the rear legs to form the back uprights, which were terminated with a finial motif intended to represent an acanthus leaf bracket. The arm support was usually turned in the form of a **baluster**, an architectural detail never used by the Romans, but extremely popular in the Renaissance. Upholstery of back and seat consisted of velvet, damask, or ornamental leather, trimmed with silk fringe. In the Baroque period, as would be expected, the armchair became more ornate, its arms and legs carved into exaggerated sculptural forms.

The smaller side chair was built on the same general lines as the armchair, but often was made entirely of wood and enriched with simple turnings. Seats were made of rush, wood, or textiles. Ornamental nailheads were used with leather upholstery.

Other chairs were of the folding or X-shaped type, of which there were three varieties. The **Savonarola** type was composed of interlacing curved slats and usually had a carved wooden back and arms. The **Dante** or **Dantesque** type had heavy curved arms and legs, and usually had a leather or cloth back and seat. The **monastery** type was smaller and was built of interlacing straight splats. Folding chairs were also made of wrought iron with brass trimmings and cushion seats.

The **sgabello** was a light wooden chair used for dining and other purposes. The early types had three legs, small octagonal seats, and stiff backs. The later examples show two trestles or splat supports, and when carving was introduced, both the trestles and backs were elaborately treated. The sgabello was also made without a back, forming a low bench.

Beds and Cradles

The *letto*, or bed, was often a massive structure with paneled headboard and footboard, sometimes raised on a platform above the drafty floor. Other beds were of the four-poster variety, with a fabric tester *(cortinaggio)* above, Such hangings were commonplace, needed for both warmth and privacy. Many beds were treated with richly carved, painted, or intarsia ornament. Cradles were made in the form of miniature beds or hollowed-out half cylinders that could be easily rocked. Other variants included the *lettucio* or daybed and the *piumacci* or feather bed. Bedsheets were called *lenzuoli*.

Tables

Tables were made in all sizes. Large rectangular **refectory tables** often had tops made of single planks of walnut. The supports were elaborately carved trestles, dwarf Doric columns, or turned baluster forms (Figure 13–19). Both plain and carved stretchers were used. Small tables often had hexagonal and octagonal tops, and were supported by carved central pedestals. The edges of the tabletops were usually treated with ornamented moldings.

Storage Furniture

Storage furniture in Renaissance times included the **cassone**, the **cassapanca**, the **credenza**, the drop-leaf writing cabinet, the wardrobe, the bookcase, the double-deck storage cabinet, and—

Figure 13–19 A sixteenth-century walnut table supported on four richly carved cylindrical columns and three baluster-turned columns.

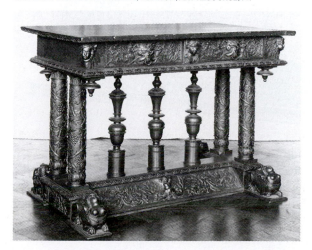

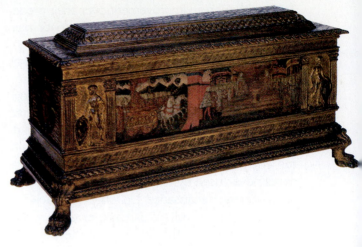

Figure 13–20 Types of cassone: A carved wood cassone from Rome, mid–sixteenth century (above); A gilt cassone with a panel painted by Francesco di Giorgio (right).

VICTORIA AND ALBERT MUSEUM, LONDON/ART RESOURCE, NY

after c. 1600—the chest of drawers. The armoire was an important large piece, and the *cofanetto* a small one.

The cassone was a chest or box of any kind, from the small jewel casket to the enormous and immovable wedding or dowry chest that was the most important piece of furniture in the Italian room. The cassone was also used as traveling baggage. The lid was hinged at the top, and when the piece was closed, it could be used as a seat or a table. The cassone served the purposes of the modern closet. It could also be highly decorative, its long front panel richly carved or painted. Two examples are seen in Figure 13–20.

Figure 13–21 A Florentine cassapanca of carved walnut from the mid–sixteenth century. The hinged seat can be raised to reveal a storage compartment.

BENCH (CASSA PANCA): CARVED IN PANELS, MASKS, AND CARTOUCHES. WALNUT. THE METROPOLITAN MUSEUM OF ART, ROGERS FUND, 1912. (12.135.8)

The cassapanca was a large cassone with a back and arms added to it to form a settee or sofa. It was thus both seating and (beneath the seat) storage (Figure 13–21). The cassapanca was particularly a Florentine production. Loose cushions were used for comfort.

The medieval *credence* developed into the Renaissance credenza, a cabinet-sideboard with doors and drawers intended for the storage of linen, dishes, and silverware. It was made in various sizes, and the smallest type was known as a *credenzetta*. The credenza often had an ornamental wooden back rising from its shelf.

A small counterpart to those larger pieces was the *cofanetto*, a storage casket for personal treasures. It was most often made of walnut, cypress, ivory, or amber, and was often decorated with ornaments in *pastiglia*, gesso relief that was painted or gilded or both.

Lighting

After sunset, interiors were, of course, dark except for the light from fireplaces, candles, and lanterns. There were many sizes and grades of candles, the finest perhaps being beeswax candles produced in Venice. And there were many types and qualities among candleholders. Some of these were given the names *candelieri* and *candelabre*, words that are obviously the origins—but not necessarily indicating the same objects—of our terms *chandeliers* and *candelabra*.

The most common candleholder was of the picket type, a flat base with an affixed spike onto which the candle was pressed. Sometimes they were small, for tabletop or mantel use; sometimes they were taller, standing on the floor; and sometimes they were attached to the walls (Figure 13–22). They were often of brass or silver, either of which nicely reflected the candlelight, but also of bronze, iron, or wood. Candleholders were also made—as they are today—with cylindrical cups into which the candles are fitted.

Lanterns featured shields of sheet metal around the candles, punctured with holes to let the light through, that protected the flame from drafts. They were particularly useful for moving about the house after dark. There were also lamps that burned oil or kerosene.

Fabric Hangings

Wall hangings have been mentioned in the section on wall treatments. Italian Renaissance hangings were of at least two types: the *capoletto* and the *spalliera*. The capoletto originated as a hanging suspended from the wall at the head of a bed (*capo* meaning "head" and *letto* "bed,") but the name came later to be used for other hangings as well, such as canopies over dining tables. The spalliera was originally a long horizontal hanging against a wall behind a dining room bench, so that diners could lean their shoulders (*spalle*) on something softer and warmer than the wall. That name also came to have wider applications. Perhaps the basic distinction that remained was that the capoletto was suspended more or less parallel to the floor and the spalliera was on or parallel to the wall. An example of a spalliera is seen in Figure 13–22.

In addition to these wall hangings, as we have seen, there were hangings in front of doorways to eliminate drafts, these being called *portiere*. The portiere were generally of the same design as adjacent wall hangings, but sometimes a contrast was provided. *Arazzi* were tapestry hangings, the term referring to how they were made rather than how they were placed. As mentioned in the chapter on Gothic design, they were named for the town of Arras in northern France, but such textiles were made in many locations.

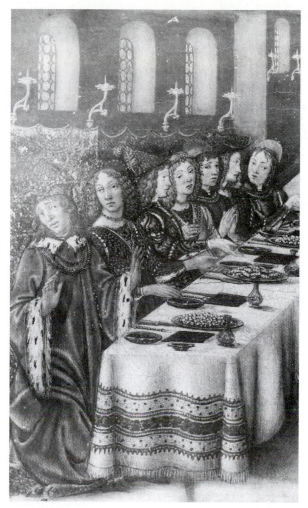

Figure 13–22 A detail from a 1485 painting by Francesco and Raffaello Botticini, *Herod's Feast*, shows dinner guests seated against a fabric hanging called a *spalliera*. Above it is a row of candle pickets.

ALINARI/ART RESOURCE, NY

Italian Renaissance Decorative Arts

The love of beauty so penetrated the Italian mind that the most insignificant article of household use was designed with care and thought. As a result, most of the decorative accessories used in the rooms were of extraordinary charm and maintained the standard of excellence set by the productions of the greater artists, many of whom had spent their apprenticeships in the metal, jewelry, and glass ateliers, or as designers of pottery or textiles. Rock

crystal carving, the enameling of metal panels, and the carving of cameo and intaglio medallions were also extensively carried on in Italy.

Ceramics

In the late fourteenth and early fifteenth centuries, before the import from Spain of the first **majolica** wares and with Gothic notions still lingering, Italy produced some delightfully plain ceramics with simple designs in green, yellow, or dark blue painted on cream-colored grounds. Most later ceramics, however, reveled in decoration. During the height of the Renaissance, ceramics became a familiar part of Italian life and an important feature of Italian interiors. For Bernard Rackham, a scholar who cataloged the Italian majolica in London's Victoria and Albert Museum, ceramics is the "peculiarly Italian art." And of all ceramics it is majolica that is *most* "peculiarly Italian," though its origin was elsewhere.

Majolica

The name *majolica* (muh-*jah*-lih-kuh) is one of those terms—like *China, Oriental carpet, Turkish knot*, and *American Indian*—that have their basis in a misconception. Majolica (or, in Italian, spelled *maiolica* and pronounced my-*yoll*-ee-kah) is derived from the island of Majorca, off the coast of Spain at the western end of the Mediterranean. When first imported to Italy in the fifteenth century, the wares given that name were supposed to have been made on that island, though probably they had been made on the Spanish mainland and brought to Italy by Majorcan traders. By the sixteenth century, the Italian potters had surpassed their Spanish inspiration, and the name had stuck: all wares of that type, including those known not to have a Spanish origin, had come to be called Majolica, even in languages other than Italian, and even to the present time.

Majolica is a type of earthenware, but one that was originally treated with an opaque white glaze so that it might resemble the highly prized porcelain from China. The more common transparent glazes are made with lead or silicon; the opaque white glaze with tin. Whatever its success may have been in imitating porcelain—and it must have been limited—the tin glaze was found to be an excellent ground for colored decoration, not only because of its solid whiteness, but also because it was stable when fired and pigments painted over it did not "run" or blur in the kiln. In fact, during firing the pigments actually were fused into the glaze so that their brilliance became permanent. A disadvantage of the technique, however, is that a brush stoke of pigment on the unfired white glaze is irrevocable; there is no chance for erasure or correction. The decoration of majolica therefore often appears more spontaneous and fresh, even at times more naive and accidental, than the decoration on porcelain, which can be retouched as needed.

For the painting, a limited range of pigments was developed that would not fade in firing. These were chiefly made from the metallic oxides. Ones frequently used for the outlines of the decoration were a deep manganese purple and, later, a cobalt blue, and, by the middle of the sixteenth century, a brownish black. Other colors included a green made from copper, a yellow from antimony, and an orange from iron rust. A rich cherry red was the secret of some potteries, but not of many.

Luster colors with iridescent effects, known in Renaissance Italy from earlier Islamic and Spanish wares, were also sometimes used, though these required an additional firing. Another sort of decoration, in direct imitation of Chinese blue-and-white porcelains, was limited to those two colors. Such blue-and-white wares were called *alla porcellana.*

A variant of majolica is called *sgraffiata* ware, a term that literally means "scratched." Rather than applied with a paintbrush, the decoration is made with a sharp wood or metal tool (a *stecca*) that cuts through the white glaze to reveal the dark red or buff-colored earthenware beneath. If the earthenware is painted before the glaze is applied, other colors would, of course, be revealed.

Like easel paintings, the decoration of Italian ceramics came to be dominated by classical themes. Majolica of the sixteenth century often copied from engravings of classical scenes that had themselves been copied from paintings or murals by Michelangelo or Raphael, and Raphael himself is said to have painted majolica in his

youth. Animals, flowers and fruits were shown as well (Figure 13–23), along with cherubs and dolphins and not-so-simple garlands, arabesques, and grotesques. Other subjects were portrait busts and the shields and arms of noble families. On flat plates, such subjects were sometimes painted within decorative circular borders; at other times they occupied the entire surface. As the Renaissance progressed, the decoration came to be increasingly important and the utility of the plate or vessel less so. Such items as platters, urns, bowls, pitchers, vases, and apothecary jars continued to be made, but the trend to decoration also gave birth to the "show dish"—the *piatta del pompa* —intended for display rather than for any practical function. Such frankly ornamental wares became an important decorative element in Italian Renaissance interiors, as they would again half a millennium later in Victorian ones. Beginning in the sixteenth century, there were even some examples of majolica floors, as in the 1510 Cappella dell' Annunziata in S. Sabastiano, Venice.

There were also geographic variations. The Florence area was an important ceramic center, specifically, the nearby village of Montelupo and the castle of Cafaggiolo. Another important center, mentioned in connection with Egyptian **faience** (page 21), was the town of Faenza, near Bologna. Other centers of production were Bologna itself, Siena, Urbino, Gubbio, Pesaro, Palermo, Venice, and Deruta. Each had its special time of prominence and each its particular color palette and decorative character, which we shall leave for the majolica specialists.

The Work of the della Robbias

In addition to functional tablewares and "show dishes," an important ceramic product in the Italian Renaissance was the ornamental plaque or panel designed to be built into a wall surface, either exterior or interior. The most famous of these were produced by members of one Florentine family, the della Robbias. The founder of the family workshop was Luca della Robbia (c. 1399–1482), who is credited with inventing the tin-glazed terra-cotta sculpture for which the family was famous. Most of his work was executed in a chaste color scheme of white figures in

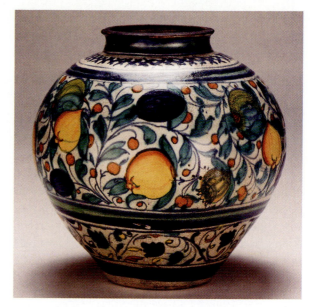

Figure 13–23 A globe-shaped majolica jar from Venice, c. 1545. The decoration shows fruit hanging from sweeping curves of leafy vines.

ONE OF A PAIR OF CAFFAGIOLA JARS. ITALIAN, 16TH CENTURY. CERAMIC, 13 IN. (33 CM) HIGH x 13 IN. (33 CM) IN DIAMETER. VIRGINIA MUSEUM OF FINE ARTS, RICHMOND. GIFT OF MRS. E. A. RENNOLDS IN MEMORY OF MR. AND MRS. JOHN KERR BRANCH. © VIRGINIA MUSEUM OF FINE ARTS. 53.18.85/86.

high relief against a light blue ground. Luca's nephew Andrea della Robbia (1435–1525) inherited the workshop and introduced more complex compositions and additional colors. Coming later to the workshop at various times were Andrea's sons—Marco, Giovanni, Francesco, Girolamo, and Luca della Robbia the Younger. In the sixteenth century Girolamo and Luca the Younger carried the della Robbia artistry to France, where they worked for the royal court. There was a revival of interest in della Robbia work in the nineteenth century, producing many reproductions and imitations.

The della Robbias' typical subject matter was religious, and the most frequent subject of all was the Madonna and Child. These were most often displayed in circular forms or **roundels,** ringed with simple frames or wreaths of leaves, flowers, and citrus fruit. Among the many works of Luca della Robbia were roundels of apostles and evangelists for the portico and the interior of Brunelleschi's Pazzi Chapel at S. Croce in Florence (Figure 13–2). Perhaps the most famous of the family's commissions, executed by Andrea, was for a series of

roundels showing foundling infants for the facade of Brunelleschi's Ospedale degli Innocenti in Florence.

Italian Porcelain

The first attempt to make porcelain in Europe was in Venice in the latter years of the fifteenth century. In the early years of the sixteenth century, the Medici family supported these efforts, which finally produced a translucent soft-paste ware that resembled opaque glass and was frankly called "counterfeit porcelain," but which is now known as *Medici porcelain*. The examples were usually dishes, platters, ewers, and flasks (Figure 13–24). The colored patterns were taken from both Renaissance and Eastern sources. This Medici porcelain was produced only between the years 1575 and 1587, and only about five dozen pieces are known to survive today. For all its rarity and curiosity, it is thought that Medici

Figure 13–24 A flask of Medici porcelain made at the Medici factory in Florence, c. 1580. It is 10 inches (26 cm) tall.

THE J. PAUL GETTY MUSEUM, LOS ANGELES, MEDICI FACTORY, PILGRIM FLASK (FIASCA DA PELLEGRINO), ABOUT 1575–1587, H: 10⅜ IN.; MAXIMUM W: 7⅞ IN. [H: 26.4 CM; DIAMETER (LIP): 4 CM: MAXIMUM W:20 CM]

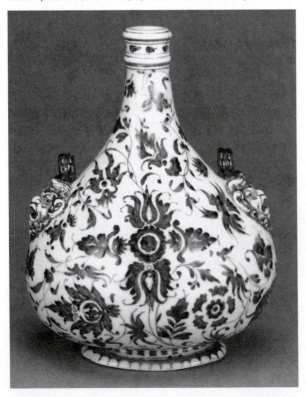

porcelain served as an inspiration for the important later makers of soft-paste porcelain in France.

In 1620 a potter named Niccolo Sisti wrote that he had been summoned by another Medici prince to make porcelain in Florence and then in Pisa, but the results of his work are not known. Two soft-paste porcelain bowls in the Victoria and Albert Museum, London, have been identified as Italian, however, and have been dated 1627 and 1638.

The Vezzi ceramics factory was founded in 1719 or 1720 in Venice by Francesco Vezzi and his son Giovanni. It produced hard-paste porcelain using Saxon clay similar to that employed in the famous factory at Meissen, Germany, which had been operating since 1710. Colors of the Vezzi wares were brick red, green, yellow, and deep blue, and their decoration was of armorial emblems, flowers, long-necked birds, and chinoiserie. Financial troubles closed the factory in 1727, and less than two hundred examples of Vezzi porcelain have been identified.

In 1728 a majolica factory was established at Nove, on the mainland near Venice. Pasquale Antonibon, son of the founder, began experimenting with porcelain production there in 1752, and a decade later he was producing hard-paste porcelain using genuine kaolin (china clay) from the Vicenza area. The products were slightly gray, however, and were decorated in an elaborate Rococo style executed mainly in green and purple. Production stopped in 1773; after that the factory had several owners and at times reverted to the production only of earthenware. Returned to the Antonibon family in 1825, it closed finally in 1835.

Another factory was founded at Doccia in 1737 by the Marchese Carlo Ginori. It produced hard-paste porcelain. The early paste was dull and slightly gray, but was brightened and whitened by various experiments later in the eighteenth century. The wares featured pierced decoration and figures in relief, and subject matter for the decoration included the bronze casts in the Marchese's collection. The factory continued to operate until 1896, when it was merged with Milan's Società Ceramica Richard. Under the name Richard-Ginori, the merged operation continues today as one of Italy's largest manufacturers of industrial ceramics.

The factory at Capodimonte was begun in 1743 by Charles VII, king of Naples. It produced a

clear, white, soft-paste porcelain. Its decoration included chinoiserie, battle scenes, peasant figures, and characters from the commedia dell' arte, a form of comic theater with masked figures that was popular in Italy from the sixteenth through the eighteenth centuries. Useful tableware was made at Capodimonte, as were snuff boxes and figurines, and a celebrated commission was for the painted and relief tiles lining the Salottino di Porcellano (Small Porcelain Salon) of the Palazzo Reale in Pórtici. The room was designed by Giovanni Natali, and the tiles were made between 1757 and 1759. When Charles VII, patron of the factory, became Charles III, king of Spain, in 1759, the factory was closed and reopened in Madrid; we shall see some of its subsequent products in the next chapter.

A successor to Capodimonte was the Real Fabbrica della Porcellana (Royal Factory of Porcelain), founded in 1771 at Pórtici by Ferdinand I, king of Naples and the Two Sicilies, and moved to Naples the following year. Its earliest wares repeated the Rococo style of Capodimonte, and the neoclassical style was introduced later. Classical ware excavated at nearby Pompeii and Herculaneum were particular models, and a "Herculaneum" table service was made at Naples for Charles III of Spain, the former king of Naples and Capidomonte factory founder. There was also an "Etruscan" service made at Naples for England's King George III c. 1785. After c. 1790, wares from Naples were marked with a crowned N in underglaze blue. The factory closed in 1806.

Metalwork

The Italians developed extraordinary ability as workers in both precious and base metals. While such artists as Sansovino, Ghiberti, and Verrocchio are best known for their figure sculpture, they did not hesitate to also design decorative relief panels, lanterns, candelabra, ink stands, andrions, door hardware, knockers, and other articles of architectural and household use. Filippo Brunelleschi became a master goldsmith in 1404, and Lorenzo Ghiberti, after apprenticing as a goldsmith under Bartolo di Michele, in turn trained Donatello and Luca della Robbia in the goldsmith's art. Giulio Romano designed silver tableware for his patron Federico Gonzaga. Some sculptors such as Il Riccio

and Vittoria devoted themselves to small objects, and the production of bronze statuettes by the **cire perdue** or lost wax process, in imitation of large classical originals, was a flourishing art that enriched mantel, shelf, and table.

Siena, in the thirteenth and fourteenth centuries, was a center for the production of objects—oil lamps, andirons, and decorative hardware—in wrought iron and bronze. Venice, in the sixteenth century, excelled in objects—plates, cups, incense burners, and candle holders—made of brass. In other times and places, extensive work was done in copper, bronze, and pewter. After the sixteenth-century Counter-Reformation, there was great demand for metal liturgical objects such as candelabra and cruicfixes; among these were the ones in gilt bronze that Bernini designed for St. Peter's. Portrait medals in gold and silver were frequently given as signs of honor or friendship, and the pope annually awarded a golden rose to the secular authority or person he considered most helpful in upholding the faith.

Prominent among the Italian Mannerist artists of the sixteenth century was the goldsmith and sculptor Benvenuto Cellini (1500–1571), who worked in his native Florence for the Medici, in Rome for several successive popes, and in France for King Francis I. One of his small but exquisite works for Francis I was a gold and enamel saltcellar (Figure 13–25); it is topped by figures of Neptune and Earth, and the base is decorated with smaller figures of Morning, Day, Evening, and Night. Another famous Cellini work, at larger scale, is the statue *Perseus with the Head of Medusa* in the Loggia dei Lanzi at Florence, outside the Palazzo Vecchio. Cellini wrote a *Treatise on Goldsmithing and Sculpture*, in which he named the artists Michelangelo, Donatello, and Andrea Mantegna among the leading goldsmiths of his time. Cellini also wrote the autobiographical *Vita*, now considered an important work of literature; it is a story not only of art and art collecting, but also of adventure, bisexual passion, sadism, violent temper, and murder. His romantic image in the nineteenth century was reinforced by Hector Berlioz's 1838 opera, *Benvenuto Cellini*.

Of particular importance in embellishing the domestic interior of the Italian Renaissance were small bronzes. Important large statues were cast in this

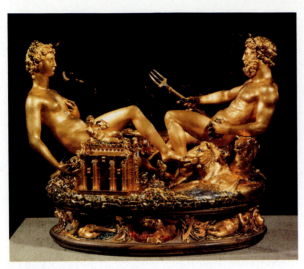

Figure 13–25 Benvenuto Cellini's gold and enamel saltcellar for Francis I, made between 1540 and 1543. It is 10 inches (26 cm) long.

BENVENUTO CELLINI (1500–1571), "SALIERA (SALTCELLAR), NEPTUNE (SEA) AND TELLUS (EARTH)," 1540–1543. GOLD, NIELLO WORK, AND EBONY BASE. HEIGHT: 26 CM. KUNSTHISTORISCHES MUSEUM, VIENNA, AUSTRIA. ERICH LESSING/ART RESOURCE, NY

sensuous material for public display, of course, but the cultured aristocrats also wanted miniature bronze objects and statuettes in their own homes. These included medals, vases, mirrors, lamps, reliefs, and plaques.

In the eighteenth century, Italian metalwork was influenced by French work as well as by the Rococo fashion. There were also two important eighteenth-century workshops run by two Roman families, the Guarnieri family of silversmiths and the Valadier family, the latter noted for pendulum clocks, tableware, sanctuary lamps, and reliquaries in neoclassical style and continuing its work until the middle of the nineteenth century. Giuseppe Valadier, son of the founder of the family workshop, was not only a goldsmith, but also an important neoclassical architect in Rome and the draftsman of fine archaeological drawings of ancient Roman monuments.

Glass and Mirrors

From medieval times, the center of Italy's glass industry had been Venice, and the Venetian glassmakers' guild was established in the early thirteenth century. More specifically, the center was Murano,

an island in the Venetian lagoon; because of fire risk, the city's glass furnaces were restricted to the island. Fine glassware is still made there. During the Renaissance and thereafter, Venice was acclaimed by the whole world for the high quality of its glassware, which included ornamental as well as useful pieces, mirrors, and beads. Paul Perrot has written: "There is probably no period of history where the full potential of glass was more clearly realized than during the sixteenth century. The incredibly fragile and pellucid forms developed by the Venetian craftsmen move in space and lead one around the object in a manner akin to the great achievements of [the Venetian painter] Tintoretto." Although other Italian cities had their own glass furnaces, many of their products were called Venetian.

Most Venetian glass was produced with the blow-pipe. Because of its thinness, it was never cut but modeled, sometimes into extraordinary shapes. Many types of Venetian glass were developed and made into goblets, vases, plates, beakers, and bowls. They were variously colored—most often in turquoise, emerald green, dark blue, and amethyst—and decorated with enameling and gilding in forms resembling dolphins, flowers, wings, stems, leaves, or abstract patterns. Other surface finishes included net, crackled, marbled, lace, and spiraled effects. Specific Venetian glass types included **millefiori** (thousand flowers, incorporating multicolored blossoms), *filigrana* (striped), *calcedonio* (looking like the pale blue or gray precious stone chalcedony), *aventurino* (flecked with sparkling particles like the mineral aventurine), *ghiaccio* (looking like ice), and *lattimo* (looking like milk). This last type was probably the invention of Angelo Barovier (c. 1400–1460), a member of a family of glassmakers that had been working in Murano as early as 1324.

In 1450 Angelo Barovier perfected his greatest invention, a glass type called **cristallo**. The astonishing quality of Barovier's new glass—though it may be difficult today to appreciate its novelty—was that it was absolutely transparent. No previous glass had been so clear. The process involved the use of ash imported from Islamic lands and cleansing processes including repeated boiling of the ingredients. In practice, cristallo ware was not often left completely transparent. Perhaps, as ex-

pensive luxury ware, it was thought to need appropriately opulent decoration, or perhaps it was thought that its transparency was best displayed by a contrast with opaque areas. Two examples are seen in Figure 13–26.

Both cristallo and its inventor were highly celebrated at the time, and the Barovier family continues to be prominent in glassmaking. At the end of the nineteenth century, the Baroviers became the proprietors of the Salviati glass company on Murano, an important contributor to the revival of Venetian glass. Guiseppe Barovier created Art Nouveau glassware, and Ercole Barovier was a prominent glassmaker in the 1920s and a cofounder of the firm Barovier and Toso, still in operation today.

Glass mirrors had been known to the ancient Romans, but throughout medieval times most mirrors were made of highly polished steel, although other metals were also used. The process of mirroring glass with an amalgam of tin and mercury (quicksilver) was first used in Venice in 1317. In the next century, small wall mirrors made of glass were available for sale. So costly and valued were these early mirrors that they were usually covered by a silk curtain or by a wooden door or panel, with great attention paid to their frames. In the sixteenth century, mirrors increased in size, and the convex mirror increased in popularity. In that century also, small bits of mirror were sometimes incorporated into patterns of wood wall paneling, providing unexpected glitter in the often dark interiors.

Another Italian Renaissance decorative technique that had been known to the Romans and practiced in both Christian and Islamic lands was that of painting on the back of glass and then protecting the paint with a thin sheet of metal foil (such as gold leaf), a coat of varnish, or another sheet of glass. This technique has come to be called **eglomisé,** and its name is owed to the eighteenth-century French artist Jean-Baptiste Glomi, who made picture frames in this manner.

Intarsia

Intarsia is the technique of creating decorative patterns or representational scenes with small, thin pieces of wood or wood veneer. A type of **intarsia** had been practiced by the ancient Romans, called *tarsia certosina*, which consisted of hollow-

Figure 13–26 Two Venetian goblets of Renaissance cristallo glass. The one at left was made between 1475 and 1525, and the one at right between 1500 and 1525.
VICTORIA AND ALBERT MUSEUM, LONDON/ART RESOURCE, NY

ing out small cavities in pieces of solid wood and filling the cavities with precisely sized pieces of veneer. This sort of work is what we today would call **inlay.** The practice fell into disuse in the Middle Ages, but it was revived during the Italian Renaissance, and another type of intarsia was added, *tarsia geometrica,* which consisted of entirely covering a surface with an assemblage of small pieces of veneer. No cavities were needed.

The earliest intarsias of the Italian Renaissance were confined to geometric patterns formed from pieces of veneer with straight sides. Later, representational scenes with appropriate perspective effects were added, and the pieces of veneer were more irregularly shaped. In the fifteenth century, intarsia artists (*intarsiatori*) began tinting pieces of wood by boiling them in water with penetrating dyes, adding a further touch of realism. The illusion of shadows was also created by singeing pieces of wood over fire. And in addition to wood, inlays were sometimes made of lapis lazuli, onyx, amber, ivory, and crystal.

A virtuoso example of intarsia work lines the walls of the *studiolo* of Federico II da Montefeltro in the Palazzo Ducale, Urbino, finished in 1476. The tiny pieces of veneer form a realistic picture of cabinetwork: some of the cabinet doors open to

Figure 13–27 Tabletop of colored marbles laid in the pietra dura technique, Rome, c. 1600. The long dimension is 3 feet (90 cm).

Mosaics, *Pietra Dura* and *Scagliola*

Mosaic work, so important in the Italy of Roman and Byzantine times, continued to be provided there, although by the fourteenth century its role was largely taken over by the art of fresco painting, which was quicker, less expensive, and more realistic. The quality of mosiac work suffered a decline as it came increasingly to imitate painting and as its production was divided between those who designed it and others who executed the designs.

Some of the designers of Italian Renaissance mosaics, however, were the finest artists of their time. In Rome, Giotto designed mosaics for St. Peter's and Raphael for the Chigi Chapel of S. Maria del Popolo. In Venice, mosaics for S. Marco were designed by Andrea del Castagno, a Florentine artist, and by both Titian and Tintoretto.

A special type of mosaic that had been known in ancient Rome and for which the Italian Renaissance developed a great enthusiasm was called **pietra dura** (hard stone). It was used often for the tops of important tables (see Figure 13–27) and also for plaques and cabinet panels. Later these two-dimensional applications were joined by large vases, ewers, bowls, and statuary set into gold and enamel mounts. The technique involved pieces of stone as small as mosaic **tesserae** and also much larger pieces, and the stones were generally of fanciful color and often of great value, popular types being onyx, malachite, carnelian, and polished quartz. The main center for the art of pietra dura was Florence, where in 1588 the Grand Duke Ferdinando de' Medici established a factory in the Uffizi. It was called the Opificio delle Pietra Dura, and its products were sometimes called *Florentine mosaics*. The factory is still in operation. Similar workshops were formed in other parts of Italy, however, as well as in other European countries. There were some geographical differences of taste: In the north of Italy, around Florence, the most popular effects were highly naturalistic, imitating birds, flowers, animals, and landscapes. In Rome and the south, there was a fashion for choosing stones of extraordinary color and veining and leaving them in their natural state, as in the center and four corners of Figure 13–27.

Scagliola is a technique for imitating marble. Although the Romans used marble imitations, the

reveal books, statues, and musical and scientific instruments. One intarsia panel depicts a rural landscape seen through a classical arcade. Another fine example for the same patron was a studiolo designed for the Palazzo Ducale, Gubbio, which has been reconstructed at the Metropolitan Museum of Art, New York (Figure 13–15). The intarsia in both rooms is sometimes attributed to two Florentine brothers, Giuliano da Maiano (1432–90) and Benedetto da Maiano (1442–97), who were both also noted as architects and sculptors.

In chapter 15, we shall see how French artisans developed Italian intarsia work into brilliant displays of **marquetry**. The technique was also very popular in the Netherlands and, later, in England.

technique known as scagliola was developed in Italy in the seventeenth century and used for columns, pilasters, moldings, and fireplace surrounds. It was much used in England in the eighteenth century and is still sometimes used today. It consists mainly of plaster in which are embedded fine chips of marble and other minerals, especially a crystalline form of gypsum called selenite. Coloring can also be added, and the result is generally given a high polish.

Frescoes

The words mural and fresco are sometimes used interchangeably to refer to large wall or ceiling paintings. More strict usage, however, considers all such paintings as murals but only those prepared in a special way as frescoes. True fresco painting— or, in Italian, *buon fresco*—is a demanding art, requiring long preparation and swift execution. Fresco painting is always on plaster (which may, in turn, be on a wall of brick or stone). It must be executed before the plaster has dried, so that it becomes not a layer on the surface but an integral part of the plaster itself. The plaster is a compound containing slaked lime and water, often prepared several months before the actual painting. Several rough coats may be applied to the entire surface, but the final, smoother coats are applied only to the area that is to be painted immediately. Earth or mineral pigments mixed with water (some insist that only distilled water be used) are then applied to the fresh plaster. As the painted plaster dries, a process of carbonation occurs that binds the materials together into a hard, protective, crystalline substance, durable and beautifully reflective.

Not only must fresco painters be quick and accurate, but they must have at their command considerable knowledge about their materials, as many pigments applied to wet plaster undergo a chemical change and an alteration of color in the process. Because of its demands as well as because of its beauty, true fresco work is highly regarded.

Inferior to—and far less durable than—true fresco work is **tempera** painting, which is a type of watercolor combined with a binding substance such as egg, milk, or gum. Other substitutes for true fresco are called *fresco secco* and *distemper.* All these are types of painting on *dry* plaster.

Textiles

Wall hangings, bed hangings, and door hangings have already been mentioned and were only part of the Italian Renaissance enthusiasm for fine fabrics and skill in producing them. The making of fine laces, for example, was a specialty of Venice beginning in the middle of the sixteenth century and lasting until the early eighteenth century, with lace for ecclesiastical use continuing until the twentieth century. Genoa and Milan were also noted for their lace production. Lavish embroideries were another specialty of the Italian Renaissance, used for church vestments and coronation robes, but also used in secular interiors as borders on linen drapery and upholstery. After the invention of the printing press, pattern books were published for the designs of both lace and embroidery. Oriental carpets were frequently used for table covers as well as for floor coverings.

Here, however, we shall concentrate on two other aspects of Italian Renaissance textiles: the further development of the medieval tapestry tradition, and the establishment of a silk industry.

Tapestry

The tapestry production of the Middle Ages, which we have considered in the previous chapter, continued without interruption into Renaissance times, becoming increasingly democratized and affordable by more households. Through the fourteenth century, tapestry making continued to be based in northern France and Flanders, although the tapestry designs often had Italian origins: Leonardo da Vinci, Botticelli, Raphael, and other noted Italian artists drew tapestry cartoons that were sent north to be woven. By the early fifteenth century some Italian courts were employing northern-trained tapestry weavers. Perhaps they were hired originally to maintain the courts' existing inventory, but soon there were weavers at work on new tapestries in Ferrara, Milan, Urbino, Naples, and in the papal court in Rome. Itinerant weaver-merchants from the north also settled in Venice and Milan. One of these, active in the sixteenth century in Ferrara

Figure 13–28 A tapestry designed by Francesco Salviati and woven c. 1548 in the Florence workshop of Jan Rost. Called *The Meeting of Dante and Virgil*, it is 17 feet (5.3 m) high.

FLORENTINE TAPESTRY. MINNEAPOLIS INSTITUTE OF ARTS

and later in Florence, was Jan Rost from Brussels, who wove the large piece shown in Figure 13–28 to a design by Francesco Salviati.

In the sixteenth century, tapestry production tended to move out of the courts into separate establishments, and tapestry production slowed in the sixteenth and seventeenth centuries as fashions changed and the taste for tapestry was overwhelmed by the passion for painting. There was a revival of activity in the eighteenth century, but the only producer to survive beyond the Napoleonic era was the San Michele workshop in Rome, whose specialty was the reproduction of paintings in the Vatican collections.

Throughout the Renaissance, some characteristics distinguished Italian tapestries from northern ones. The Italian ones featured borders much earlier than the northern ones and emphasized them more, sometimes relating the borders to the subject matter they framed. The Italian tapestry cartoons were generally colored to indicate the colors desired in the woven product; the northern cartoons were generally not colored, leaving the choice of colors to the weaver. Further, the Italian tapestries were generally designed for one specific use, while northern patterns were repeated many times in a sort of mass production.

Silks

Italian Renaissance textiles used for draperies and upholstery were usually of silk, and during this period Italy became a dominant force in silk manufacture. Silks had been imported to Venice from the Byzantine Empire since the eighth century. Silk weaving had also been introduced into Sicily by its Islamic rulers in the years before the eleventh-century Norman Conquest, and, after a political upheaval in Sicily in 1266, many of the silk workers there moved to Lucca in northern Italy. Lucca became a great center of both sericulture and silk weaving, with over 3,000 active looms. After the Mughal conquest of India in the thirteenth century and the opening of trade between Europe and the East, Italian silk design was stimulated by exposure to Islamic and Eastern ideas: exotic creatures such as the dragon and the phoenix were introduced, and the stately rows of roundels were replaced by diagonal arrangements and more animated compositions. To the plain silk velvets of the thirteenth century, the fourteenth added stripes and floral patterns, including Chinese varieties like the lotus and peony. The pomegranate, a popular motif in Persian design, was also adopted by the Italians and transformed into an artichoke, which came to be one of the dominant motifs of the Renaissance. Among more classical motifs, the ogee curve was developed into an elongated S-shaped scroll.

Anti-papal forces sacked Lucca in 1314, and many of the weavers moved on to Florence and to Venice, already a thriving silk producer. Both peace and silk making returned to Lucca a few years later, and by the last quarter of the fourteenth century three-color velvets in two pile heights were being woven there. The combination of cut and uncut piles, with the cut pile higher than the uncut, became popular and was known as *ciselé* velvet. Details, such as the heads and feet of exotic beasts, were often picked out in gold.

But Venice came to outshine Lucca in the fifteenth century with over 10,000 looms. Venetian gold brocades employed gold thread against a silk

ground, and even more extravagant was the Venetian "cloth of gold" (*drap d'or*) with a silk pattern against a gold ground.

The fourth great Italian silk city—along with Lucca, Florence, and Venice—was Genoa, prominent in silk making from the fifteenth century. By the end of the sixteenth century, Genoa was producing more silks than any other Italian city. Remarkable among them, beginning in the sixteenth century, was a polychrome velvet of scrolled or floral design with the plain linen or hemp weft left visible between parts of the design; these were often given a wax finish. From the middle of the eighteenth century, these silks were imitated at Versailles, France, where they were given the name *velours de Gêne* (velvets of Genoa). Another Genoese silk specialty was called *ferronerie* because its patterns of delicate tracery resembled work in wrought iron (*ferro*).

By the end of the seventeenth century, when French silks had become more fashionable than Italian ones, silk weavers left Italy to work in France, and, as Philippa Scott has written, "[T]he French silk industry was founded on Italian expertise."

Summary: The Design of the Italian Renaissance

In almost every field of human endeavor—certainly in every field of art and design that was undertaken—the Italian Renaissance was a time of remarkable achievements. The influence of those achievements was felt throughout Europe and beyond. We can feel them still today.

Looking for Character

In Italian Renaissance design, the deliberate extremities of the Gothic have been calmed and reconciled. Mystery has been replaced by understanding. There is a resumption of the classical vocabulary of columns, bases, entablatures, pediments, and ornaments, all harmoniously interrelated, and a resumption of the classical system of proportions. There is a coherence among parts and

between exterior and interior. And this new logic, clarity, and cohesion is found in the hyperactive Baroque examples almost as obviously as it is in the serene examples of the Early Renaissance.

Looking for Quality

It is obvious that certain aspects of the Italian Renaissance are remarkable for their quality: the quiet simplicity of Brunelleschi's Pazzi Chapel, the drama of Michelangelo's Sistine ceiling, the balanced perfection of Palladio's Villa Capra. But there is a broader sort of quality that pervades the accomplishments of this period. The goal of the Italian Renaissance may have been the resurrection of classical antiquity, and that it accomplished imperfectly, but it accomplished something else that has proved even more valuable: the formulation of new ways of looking at buildings and interiors and furniture and ornament, and the formulation of new ways to unite those elements into coherent wholes. Whether or not the Italian Renaissance can properly be considered a rebirth of classical design, we must acknowledge that in the Italian Renaissance our own knowledge of how to design was born.

Making Comparisons

Comparisons beg to be noticed between the Italian Renaissance and contemporaneous developments in other countries. When, in the early sixteenth century, the High Renaissance period was at its peak in Italy, the rest of Europe was still repeating the formula of Gothic style. And when, a century later, Italy moved beyond the High Renaissance into the Baroque, the rest of Europe was finally beginning to understand the fundamentals of Renaissance design.

In design, it seems, locations have their times. France, as we have seen, was supreme in the last glorious days of Gothic cathedral building, and France, as we shall see, would be supreme again in the refinements of the eighteenth century. But in the centuries between, it was Italy that, remembering the glories of her ancient past, brought to the modern world a rebirth that still inspires, ennobles, and warms us.

CHAPTER

14

SPAIN

THE EIGHTH TO THE NINETEENTH CENTURY

This chapter covers the design of the whole Iberian Peninsula, both Spain and Portugal. Spanish design is distinctive but varied. It can be lavishly ornamental or severely plain. Distinct geographical regions within Spain—Castile, Aragón, Asturias, Catalonia, Andalusia, Valencia, Extremadura—have their own characters that have all contributed to the Spanish style.

Determinants of Spanish Design

In many respects, the Spanish style in design is one of formality, dignity, and vigor. Spanish style was influenced not only by the characters of Spain's component regions, but by rela-

Figure 14–1 MAP OF SPAIN

ORTELIUS DESIGN

tionships with foreign countries and their customs, geography and climate, and religion.

Spain and Portugal produced some of the world's most famous explorers and were themselves often invaded and conquered. There is hardly a major power of antiquity that did not establish some settlement on the Iberian Peninsula. And after Spain's backing of Columbus's voyage in 1492, her reign extended to the New World as well.

The most dramatic and most lasting influence from abroad came from the Moors, Islamic people from North Africa who conquered most of Iberia in A.D. 711 and who maintained a degree of control there until 1492. Foreign influence also came from two royal families: the Hapsburgs from Austria, who ruled in Spain from 1516 to 1700, and the Bourbons from France, who have ruled there from 1700 to the present day.

Within the peninsula, cultural life was also influenced by differences between Spain and Portugal. Portugal had freed herself of Moorish control in 1140, three and a half centuries before Spain, and Portugal's contacts abroad included India and China, whereas Spain's were largely in the Netherlands and the Americas. The Moorish influence is thus less strong in Portugal than in Spain, the Eastern influence far stronger.

Much of Spain is mountainous, rocky, and arid. The weather is hot and dry. Severe conditions demanded strength, endurance, and stoicism. The mountains hindered transportation and slowed the exchange of ideas, dividing the land into distinct areas and peoples. Politically, Spain was unified for centuries under a single king, but practically it long remained a collection of small states within the wrinkles of its topography.

Two of the world's great religions—Islam and Christianity—have dominated the history of Spain, and much Spanish history is the record of their violent struggles against each other. Spanish art combines both influences,

The History of Spain

Politically and artistically, the history of Spain is a history of foreign influences, sometimes as a result of invasions and conflicts. In such a history we cannot expect to find the gradual and logical development of native instincts that we saw, for example, in Egypt, but instead a succession of challenges to such instincts. No one phase of Spanish history is more essentially Spanish than any other or tells the Spanish story more directly. Instead, the character of the Spanish people and their design must be inferred from a succession of greatly varied styles.

Spain had already been conquered by the Romans and the Visigoths, when in the early eighth century, the Islamic Moors crossed the Straits of Gibraltar and overwhelmed the weak and disorganized Christian feudal states of Iberia. In 1085 Alfonso, king of the Spanish regions of Aragon and Navarre, bordering France, captured the city of Toledo from the Moors and began the long struggle to push them out of Spain. In 1140 they were expelled from Portugal. In 1492 the last Moorish stronghold in Spain, the kingdom of Granada, fell to the Christians. Thereafter Spain was one of the major powers in Europe until the nineteenth century, and the Spanish and Portuguese empires occupied much of the Americas and parts of Africa and Asia.

Spanish Architecture and Interiors

We shall begin our survey of Spanish architecture and interior design with work done by the Moors, mostly in southern Spain, after their arrival from North Africa in 711.

Hispano-Moorish Design (after 711)

Moorish design in Spain shared many of the characteristics we saw in Islamic design, but it was nat-urally influenced by its Spanish setting. We shall look first at some elements of this architecture and at relevant terms and then at specific examples of the style.

The chief focus of Hispano-Moorish buildings was invariably on the interior. Exterior surfaces are blank, plain, and unadorned, leaving the first-time visitor without anticipation of the richly decorated wonders they enclose. Some have seen this "plain brown wrapper" approach as a form of security, hiding interior treasures from the view of potential thieves. Others have seen it as part of a tradition dating from the desert tents of nomadic Arabs—blank canvas tent flaps exposed to the sun, sand, and wind, but tent interiors filled with luxurious hangings, beautiful rugs, and colorful cushions.

The Moorish buildings and their interiors share some elements not generally found elsewhere. Among these are:

MOORISH ARCHES There are several combinations and variations among the arches of Moorish construction, but there are three basic arch forms that should be noted: the **horseshoe arch,** the **ogee arch,** and the **scalloped arch.**

- The horseshoe arch has a curve, like that of a horseshoe, that is slightly more than a semicircle, so that the distance across its base is less than its greatest width. Its top can be either round or pointed.

- The ogee arch is named for the **ogee** curve, an S-shaped curve that we saw used in the **cyma recta** and **cyma reversa** moldings of the Greeks (Figure 4-46); both sides of the arch have combinations of convex and concave sections. The ogee arch was also used in Christian architecture of the late Middle Ages throughout Europe.

- The scalloped arch consists of a series of small curves within the main curve of the arch (Figure 14–2, page 316). It is also called a **multifoil arch,** and it is similar to the Islamic **cusped arch** (Figure 9–4). We have seen scalloped arches also in the Mughal architecture of India (Figure 10–4). In Spain, the scalloped arch and other Moorish details appear not only in

- As we discussed in chapter 9, the terms *Moorish* and *Muhammadan* are sometimes used synonymously with *Islamic*, but more often *Moorish* has a more limited meaning, referring to architecture and design of only the westernmost lands of the Muslims, those—such as Morocco, Tunisia, Algeria, Libya, and southern Spain—that constitute the area called the Maghreb. The French version of *Moorish* is *Mauresque*, and the German version *Maurisch*. In Spain itself, the terms *Moro* and *Árabe* are used.
- *Moresque* is sometimes used as another synonym for *Moorish* and *Islamic*, but more often refers specifically to patterns of scrolled bands that were much used in sixteenth- and early-seventeenth-century design, particularly in embroidery and lace. *Hispano-Moresque* is often seen applied to two groups of objects: silk weavings and luster pottery.
- *Mozarabic* refers to Christian work, following the Moorish invasion of 711, that was executed under Arab rule and influenced by Moorish tradition.
- *Mudéjar* (pronounced moo-*day*-har) refers to Muslim work, following the Reconquest of the eleventh to fifteenth centuries, that was executed under Christian rule but in accordance with Muslim tradition.
- *Morisco* refers to work done by Muslims who, after the Reconquest, were converted to Christianity.

In practice, distinctions among these styles, all of them hybrids of Moorish and Spanish influences, will be of importance only to specialists.

mosques, but also in secular buildings and even in Christian ones.

MUQARNAS **Muqarnas** are similar to the **squinches** of medieval construction, used to span between walls at right angles in order to support domes above (Figure 6–12). In the case of muqarnas, however, they are used not singly but in multiples, **corbeled** one above another. Each element is shaped like a small niche, and together they create a fantastic, multifaceted decorative effect, as we saw in Figure 9–16. They were also sometimes used as intermediate elements connecting the square shapes of column capitals to the round shapes of the columns below. Over time, the original structural purpose of muqarnas was overwhelmed by their decorative purpose, so that they often support only themselves. They are frequently faced with tile, and they are frequently used as linings for mihrabs.

MIHRABS As we noted in chapter 9 a **mihrab** is a niche within a mosque, but one with particular significance. It is generally located in the mosque's *qibla*, the wall that faces the holy city of Mecca, and it therefore indicates the direction that worshippers should face when they pray. Appropriately, the *mihrab* is often a focal point of decorative treatment

THE MOORISH PLAN Structurally, the villas of the Moors were simple, with plain exterior walls and few windows. They were built around a landscaped patio off which the rooms were placed. Elaborate arrangements were made for reception rooms, master's quarters, and baths, and an isolated section with a private garden was devoted to the use of the women and children. The Moors were adept at formal gardening and used this art to its fullest extent as a contribution to the enjoyment of life. Their gardens, closely related to the composition of the house, were terraced and trellised and had winding pathways lined with black cedars, tamarisks, myrtle, and orange trees. Alleys of trimmed hedges and rosaries of scented thorn were located for surprise vistas showing pavilions

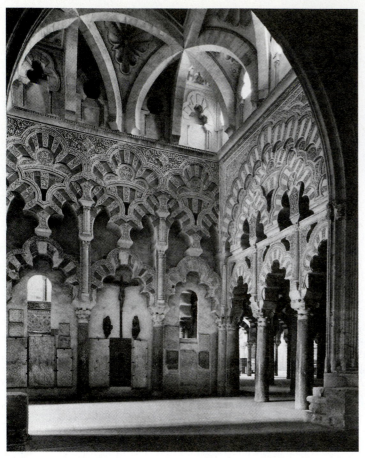

Figure 14–2 Scalloped arches in the Capilla de la Villaviciosa of La Mezquita, the mosque built in Córdoba in the tenth century. This chapel became the Capilla Mayor when the mosque became a cathedral in the sixteenth century.

A. F. KERSTING

tery was arranged in definite compositions on shelves and walls. Colors used for tilework, plaster ornament, painted woodwork, and in the rich wool textiles were the brilliant primary hues inherited from nomadic forebears.

MOORISH ORNAMENT As we have seen in chapter 9, some Islamic sects forbade the copying of natural forms. Therefore, the Moors, who were excellent mathematicians, resorted to geometry for pattern inspiration, and they developed an extraordinary originality in the design of surface ornament. The most intricate arrangements of interlacing straight and curved lines were devised. Squares and rectangles were usually avoided, but stars, crescents, crosses, hexagons, octagons, and many other forms were used. As in the Middle East, the **arabesque** and other plantlike ornaments were also used,

Geometric ornament, particularly, was adapted to wood, plaster, tile, and textile designs, and was accentuated by gorgeous coloring in red, blue, green, white, silver, and gold. The pinecone and the cockleshell, regarded as symbols of good fortune, were extensively used as decorative motifs, and the latter was carried over into Christian art as the symbol of Santiago. A specialty of Moorish décor was the **yeseriá,** a wall surface covered with allover plaster ornament of minute scale, delicately tinted in various colors. The Moors also produced painted patterns, also at very small scale.

Moorish carpenters were more skilled than their fellow workers in the Christian north. They applied their ability particularly to the design and construction of ceilings and doors, which were the only visible wooden portions of their houses.

There were two kinds of Spanish wooden ceilings. One was the exposed structural beam type that consisted of heavy wooden girders spaced some distance apart, in turn supporting closely spaced smaller beams running at right angles to the girders. This was a simple structural arrangement seen in all countries. In the Moorish case, both the beams and the girders were painted with ornamental motifs. The other type of ceiling consisted of shallow wooden panels arranged in complicated geometric shapes. Stars, hexagons, and irregular forms were produced by the use of series of care-

or extensive landscapes. Short flights of low brick steps connected the various levels, each of which was treated differently. Circular and semicircular landings enclosed with balustrades were paved with pebbles arranged in mosaic patterns. Fountains, troughs, and squirting jets of water played their cooling streams in all directions.

The interior walls were treated with plain plaster, colored tiles in geometric patterns, brickwork, colored plaster ornament in relief, ornamental leather, or a combination of these materials. Woodwork was limited to the doors and ceiling. The floors were in tile, brick, or stone, and were covered with rugs of both tapestry and pile weave in Muhammadan patterns. Heavy earthenware pot-

fully fitted moldings forming the framework of the panels, which often occupied greater space than the field of the panel itself. An example is the ceiling of the Ayuntamiento Viejo, or Old Town Hall, of Granada (Figure 14–3). Doors, similarly treated, were subdivided into a multitude of small panels of varied geometric shapes. Such Moorish woodwork was known as **artesonado** (craftsmen) and was made chiefly from local cedar, a soft wood of fine grain, somewhat resembling red pine. In dwellings, the wood-paneled ceilings and doors were usually left in natural finish; in public buildings, gilding or color was sometimes used.

A special decorative feature popular in the Moorish house was the ornamental wall niche. Recessed for a distance of about 18 inches (46 cm) it started at the top of the wainscot and normally carried two hinged doors similar to modern window shutters. Sometimes the doors were pierced

Figure 14–3 *Artesonado* woodwork on the ceiling of the Ayuntamiento Viejo (Old Town Hall), Granada, sixteenth century.

BYNE AND STAPLEY

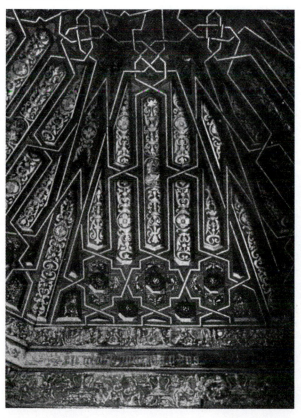

TIMELINE SPAIN

DATE	PERIOD	CULTURAL AND POLITICAL EVENTS	DEVELOPMENTS IN DESIGN
8th–15th centuries	Moorish Spain	Religious wars; *Chansons de Roland*	Palaces, mosques, *artesonado*, tiles; La Mezquita, Córdoba; Alhambra, Granada
12th–16th centuries	Middle Ages	Discoveries of West Indies, North and South America; expulsion of Jews; Christian reconquest of southern Spain; Spanish Inquisition	Cathedrals of Burgos, Toledo, Seville, and Gerona; Gothic and Plateresco styles; El Greco
16th–17th centuries	Spanish Renaissance	Hapsburg rule; Spanish Armada defeated; *Don Quixote*	Desornamentado style: El Escorial; Churrigueresco style: cathedral of Valencia; painters Ribera, Zurbarán, Velasquez, Murillo
18th century	French and Italian influences	Bourbon rule	Palácio Nacional, Mafra; Palácio Real, Madrid; Transparente, Toledo; Palace of the Marques de Dos Aquas, Valencia; Goya

with silhouettes or painted with bright patterns on both sides. The rear and sides of the niches were treated with colored tiles or painted in brilliant colors, forming a strong point of contrast with the neutral plaster walls. The niches were furnished with shelving that supported useful and ornamental accessories.

THE MUDÉJAR AND MOZARABIC PERIODS

As discussed so far, the building and decoration of the Islamic Moors in Spain were true to the traditions established in the Islamic countries of the Middle East. But there were also interesting transitional styles produced by the fusion of the Moorish forms with Gothic ones and later with the arts of sixteenth-century Italy.

There was much that was beautiful in the Moorish decorative materials and patterns, and

those that were suitably free from Muhammadan religious significance were eagerly adopted by Christian builders. Many of the interiors in the fused styles of Mudéjar and Mozarabic Spain exhibit Islamic and Gothic influences together, as in a room reconstructed at the Decorative Arts Museum, Madrid (Figure 14–4). And as Renaissance features were gradually popularized and transposed

from church to secular construction, they were sometimes used simultaneously with the earlier elements, producing interiors that blended Moorish, Gothic, and classical motifs. Stylistic fusion was also seen in accessory production such as pottery, textiles, furniture, and metalwork.

In these mixed styles, the tile floor and low dado maintained their popularity. Polychrome ornament in

Figure 14–4 A sixteenth-century Mudéjar interior with artesonado ceiling treatment and a hooded fireplace.

MUSEO NACIONAL DE ARTES DECORATIVAS, MADRID, SPAIN

geometric patterns persisted in spite of the introduction of painted figures. Plain plaster walls were often enriched by heavy silk textiles or tapestries hung in loose folds. Tile panels showing heraldic devices were frequently inserted in the wall near the ceiling, and the extensive ornamental use of majolica plates and ewers continued for a long time to count as an important feature in the color interest of the rooms. Windows were small, as a rule, with deep reveals, and the glass, if any, was leaded in either circular or rectangular forms. Heavy wooden interior shutters with pierced holes or spindled panels for ventilation were common. Segmental, semicircular, and horseshoe forms were employed for arched openings. The persiana or Venetian blind was also used. Where colonnades were used, the column capitals often consisted of brackets extending outward on both sides to support a lintel.

The ceilings and doors continued to be treated with elaborately designed wood panels, as they had been in the Moorish rooms. Fireplaces began to assume the early Italian Renaissance character, having projecting hoods and with lower portions treated in a classical architectural manner. Framed paintings hung on the wall were more common than mural decoration, and pottery continued to be extensively used for both practical and ornamental purposes.

We shall look now at two particular examples of Hispano-Moorish design. Both are representative of the pure Islamic influence, although the first example shows the contrast—unfortunate, in this case—between Moorish and Christian styles.

THE MOSQUE IN CÓRDOBA (AFTER 785)

The Mezquita (meth-*kee*-tah), the great mosque of Córdoba, is one of those buildings that, on the exterior, appears to be extensive but thoroughly ordinary and dull. Its entrance through a walled patio of orange trees is pleasant, but nothing outside the mosque prepares us for its interior.

The first part to be built, about a third of the present structure, was finished in the year 785. It replaced a Christian church that had occupied the site, and it incorporated stone pillars from that church, some of which had already been recycled from even older Roman buildings in the area. Other stone pillars came from other buildings in Spain, some were shipped from Carthage in North Africa,

and some from Constantinople. They are naturally of different heights, with varying bases to compensate for the differences. The capitals were all of carved and gilded marble, but most have been replaced by characterless concrete replicas.

Three additions were made during the next two centuries, bringing the mosque to its present enormous size of 390 by 600 feet (120 x 185 m). At its greatest extent, the mosque had 850 pillars of jasper, porphyry, and various marbles supporting arches made of alternating bands of red brick and pale yellow limestone.

The most striking feature of the interior is the series of these arches. To achieve the desired ceiling height of about 40 feet (13 m) with the much shorter existing column shafts, an unusual double arch was devised. The lower arch springs freely through the air at the tops of the columns, obviously supporting nothing, but acting as stiffening braces for the taller arches above them that actually carry the roof. The striking visual effects of such a multiplicity of similar elements is therefore doubled (Figure 14–5).

Roughly half the original pillars and arches remain. The rest were destroyed in the sixteenth century, when the mosque was the victim of a disastrously insensitive act of architectural vandalism: A large, overly ornate Gothic cathedral was built *inside* the Mezquita and, in addition, a large number of Christian chapels. Most of the original ceiling—flat wood coffers with Islamic decoration—has been replaced, so that the Moorish arches now support Gothic vaults—and not true stone ones, at that, but plaster imitations.

THE ALHAMBRA IN GRANADA (1309–54)

The Alhambra in Granada, begun in 1309, was the last of the palaces constructed by the Moors and remains today the supreme pearl of Moorish architecture and decoration. The Alhambra is planned around numerous arcaded courtyards, agreeably blending architecture—though, on the exterior, exceedingly plain architecture—with gardens, fountains, and reflecting pools. In this complex one seldom loses the sound of splashing waters or the perfume of jasmine and orange. Its enclosing walls maintain the desired seclusion, while arched openings offer vistas overlooking distant snowy peaks. One of the Alhambra's two principal

Figure 14–5 Interior of the Mezquita, Córdoba, built in several stages beginning in 785.

SHAUN EGAN/STONE

water. The majority of the rooms are treated with tiled wainscoting in colorful geometric patterns to a height of about 4 feet (120 cm), above which there is a wall surface covered with the delicately tinted allover plaster ornament called **yesería.** Near the ceiling the walls are treated with a frieze usually enriched by decorative cursive inscriptions stating that "There is no God but Allah." These are placed on a groundwork of an elaborate abstract pattern. In some cases the friezes contain a running geometric motif of intersecting polygons, stars, and crosses.

The most impressive room is the Salón de Embajadores (em-bah-hah-*doh*-rays) or Hall of the Ambassadors (Figures 14–6 and 14–7). This tall, square, thick-walled chamber occupies a structure called the Comares Tower at the end of the Patio de la Albérca. It exhibits, like other rooms, fine tile wainscoting topped by delicate yesería plasterwork. Crowning this particular room, however, is the additional wonder of a seven-level ceiling of cedar marquetry, its 8,000 polygonal wooden panels inlaid with box and arranged in a pattern of interlocking stars. It symbolizes the "seven heavens" of Islamic literature. Because of its roughly hemispherical form, such a ceiling is called a *media naranja,* "half-orange." Here and elsewhere in the complex, for all the wealth of detail, the total effect is quiet and serene.

The Gothic Style in Spain (Eighth to Fifteenth Centuries)

While the Moors in southern Spain were building their elegant palaces and impressive mosques, the Christians in northern Spain were building in a style closely related to the Gothic work we have seen north of the Pyrenees. Two major expressions of the style were castles and cathedrals.

CASTLES IN SPAIN Beginning in the eighth and ninth centuries, noble Christian families had embarked on a program of castle building, particularly in the province that—because of the number of such castles—came to be called Castile. There were probably more of these fortified castles in Spain than in any other European country. They were mostly built on precipitous heights and were not only of formidable defensive strength, but in

courtyards is the Patio de la Albérca, or Court of the Pool, sometimes also called the Court of the Myrtles for the plantings that edge its 113-foot-long (35 m) reflecting pool. The other principal courtyard is the Patio de los Leónes (Court of the Lions), named for a central fountain supported by twelve figures of lions, exceptions to the Islamic proscription of natural representations.

The interior walls of the surrounding rooms are covered with fantastic and minutely colored ornamental details scaled to be subordinate to the effect of the whole. Private apartments overlook the more public courtyards through the interstices of decorative wooden grilles. Tiled niches accommodate beds. Elaborate baths contain taps from which once spouted cold, hot, and perfumed

Figure 14–6 A nineteenth-century drawing of the fourteenth-century Salón de Embajadores of the Alhambra, Granada, emphasizes the uniformity of the applied ornament.

EDICIONES TURPIANA, S.A.

their residential sections elaborately treated in Gothic detail. It was not without reason that the phrase "castles in Spain" became synonymous in both the French and English languages for fantasies and unlikely achievements.

GOTHIC CATHEDRALS IN SPAIN The Gothic arts that had been practiced in Italy, France, and northern Europe were introduced into Spain chiefly by the Cistercian monks of Cluny. Churches with sculptured portals and adjacent cloisters, famous for their carved columns and capitals, rose along the roads that were used by the pilgrims to visit Santiago de Compostela. Throughout other sections of Christian Spain, ecclesiastical edifices, domed or roofed, attest to the art and originality of Romanesque architects and artists.

Figure 14–7 Detail view of the Salón de Embajadores, with its yesería plasterwork above a tiled dado.

INSTITUTO AMATLLER DE ARTE HISPANICO, BARCELONA, SPAIN

Although the thirteenth- and fourteenth-century Gothic cathedrals of Burgos, Toledo, León, Salamanca, and Seville are of a later date than those in France, they give evidence of the splendor and power of the movement.

These and other cathedrals with their almost incredible wealth of altarpieces, sculptured alabaster, polychromed woodwork, gilded wrought-iron grills, and marble tombs are treasure-houses of decorative detail. The Spanish Gothic churches usually have smaller fenestration than those in northern climates, a necessity for tempering the glare of the southern sun. The large wall areas produce a marked austerity, and these large surfaces are extensively ornamented with geometric patterns in the Moorish manner. The horseshoe arch is often used, as is the Gothic pointed arch. The somberness of the interiors accentuates the brilliance of the color on the walls and pavements revealed by the diagonal rays of the sun through the

Figure 14–8 Gothic vaulting in the cathedral of Seville, almost 100 feet (30.5 m) above the floor.

PHOTO: ABERCROMBIE

stained-glass windows. In the darker corners there is an impressive use of candlelight.

In Portugal, an impressive Gothic example is the Monastery of Santa Maria of Victory in Aljubarrota. Completed in 1433, it commemorates the 1385 battle there that secured Portuguese independence from Spain.

THE CATHEDRAL OF SEVILLE (1401–1519)

Judged on the basis of floor area, the cathedral of Seville is the third largest in the world, the only larger ones being St. Peter's in Rome and St. Paul's in London. So high are its ceilings, however, that, judged on the basis of enclosed volume, the cathedral of Seville is the world's largest. It is 406 feet long, 268 feet wide, and 99 feet high (126 x 83 x 30 m), the vault over the nave rising still farther, to 130 feet (40 m). Some French Gothic cathedrals, as we have seen in chapter 8, rose to greater heights at their tallest points, but they did not maintain those heights over such a large area. Commissioned in 1401, Seville Cathedral took more than a century to build and was consecrated in 1519. It was probably designed by a German, although most of its counterparts in Spain are of French origin.

The interior of the cathedral (Figure 14–8) is divided into a nave and double aisles by 32 immense clustered piers. In addition there are numerous side chapels and a *parroquia* or parish church. Stained glass is amply used, in the French manner, and bold in color. Within the lofty ceiling vaults, the ribs are arranged in a pattern more decorative than structurally logical, and between the ribs there are fields textured with projecting **bosses,** pendant ornaments that are more typically used only at the intersections of ribs. The iron grilles or **rejas** (*ray*-hahss) are highly decorative, and the altar screens or **retablos** (ray-*tah*-blohss) are among the richest specimens of medieval woodworking to be found anywhere.

Adjacent to the cathedral are two remnants of the mosque that previously occupied the site. One is the forecourt, planted with orange trees, through which the building is entered. The other is the Giralda Tower. The original tower, standing 197 feet (60 m) high, was built in the twelfth century as the mosque's minaret. To this simple square structure

the cathedral builders added a more elaborate bell tower, bringing the total height to 320 feet (98 m), including a rotating iron weather vane or *giraldillo* that gave the tower its present name. It turns gracefully in the wind, even though it weighs more than a ton.

THE CATHEDRAL OF GERONA (1312–1604)

Also impressive in its dimensions is the cathedral of Gerona. Its apse and ambulatory, along with the beginnings of side aisles, were built to a rather conventional Gothic plan between 1312 and 1347. In 1369, however, architect Pedro ça Coma made the daring proposal of completing the cathedral with a single enormous nave, eliminating the usual transept and side aisles. A later architect, Jaime Bofill, supported the scheme, and in 1417 it was begun; construction was not to be finished until almost two centuries later, in 1604. The Gerona vault as built is 110 feet (33.5 m) high, slightly higher than that of Seville but still less than some French prototypes. It is the vault's width, however —73 feet (22 m)—that makes it the largest Gothic example ever built. Among masonry vaults of all styles, it is exceeded—by a mere 11 feet (3.4 m)—only by that of St. Peter's in Rome. Shielding the interior from the bright Spanish sunlight, the walls have been kept largely uninterrupted by glass, their solidity precluding any need for flying buttresses and emphasizing the unity and immensity of the interior volume (Figure 14–9).

ISABELLINA AND MANUELINO VARIATIONS ON THE GOTHIC

For both Spain and Portugal, the discoveries and their consequent new riches and new associations were to be powerful influences on the arts. In both countries, a taste developed for covering wide surfaces with a richness—in some cases, it seems, an excess—of small-scale ornament. This taste seems to have had two origins: it was a development of the myriad details of Moorish decoration (though not always applied with Moorish delicacy), and it was also a response to the wealth of riches and exotic goods flooding into the peninsula. In Spain, this phase of superabundant ornament was called **Isabellina** after Queen Isabella I, who reigned from 1474 to

Figure 14–9 The great aisleless nave of the cathedral of Gerona, begun in the fifteenth century. It is 73 feet (22 m) wide. The earlier and more conventional apse and ambulatory are seen beyond the nave.

INSTITUTO AMATLLER DE ARTE HISPANICO, BARCELONA, SPAIN

1504; it would lead directly into the Renaissance style called **Plateresco.**

The Portuguese equivalent of Isabellina was called **Manuelino.** It originated during the reign of king Dom Manuel I, 1495–1521, and it differed from the Spanish Isabellina and Plateresco styles by being more hybrid in origin and expression. The Manuelino included reminiscences of Roman construction, Gothic arches, architectural features from Arabia and India, and marine ornaments that seemed to symbolize the seafaring destiny of Portugal. Among these last were sea

plants, shells, sails, prows of vessels, ropes, pennants, and *armillary spheres,* globe-shaped astronomical instruments.

New Riches and New Ornament: the Plateresco (First Half of the Sixteenth Century)

As quantities of gold and silver continued to flow to Spain from the new colonies in America, there was ample opportunity for displays of virtuosity by the Spanish silversmith, the *platero.* The fine detail and elaborate ornament of such metal work lent its name to the **Plateresco** style, which is distinguished from the Isabellina only in being later, not

Figure 14–10 Sacristy doors and adjacent pilasters in an anteroom of the chapter house of Toledo Cathedral, carved in the *plateresco* style by Gregorio Pardo in 1549.

INSTITUTO AMATLLER DE ARTE HISPANICO, BARCELONA, SPAIN

in being basically different. Its source is not solely the work of the silversmith, of course, but also the architecture and interiors of the Gothic, Italian Renaissance, and Moorish styles. Underneath its profusion of ornament, the Plateresco structure can be either Gothic or Italian Renaissance in its construction and volume, although some historians view it as an intermediate phase between Gothic and Renaissance. In any case, it is the ornament itself that defines the style. The ornament included heraldic shields, portrait medallions, and elaborations on Italian motifs such as the rinceau, the acanthus, and the anthemion.

The Plateresco style was primarily used for exterior architectural treatments, patios, formal rooms in churches and public buildings (Figure 14–10), and for furniture and accessory design. It was not extensively used as a style for the interior walls of houses, but domestic interiors of this period begin to reflect the greater richness of detail, increase in types of furniture, and improvements in comfort and conveniences that were seen in contemporary Italian rooms.

Some important names of Plateresco-style architects and designers, all active between 1500 and 1550, include: Juan de Badajos, Alonso Berruguete, Alonso Covarrubias, Rodrigo Gil de Hontañon, Enrique de Ergaz, Pedro Gumiel, Diego de Riaño, and Diego de Siloë. After the middle of the sixteenth century, when Sebastiano Serlio's treatises on architecture were first published in Spain, the Plateresco passion for ornament began to abate somewhat, easing the transition to the very different style that would follow.

New Rulers and a New Austerity: The Desornamentado (Late Sixteenth and Early Seventeenth Centuries)

The Hapsburgs, the ruling house of Austria, by means of well-planned marriages, had come by the early sixteenth century to control the Spanish throne as well as overseeing an empire that circled the globe. The Hapsburg Philip II (1527–98) also inherited Portugal and the Italian provinces of Naples and Sicily. He presided over the beginning of a so-called golden age of Spanish art and literature. Both his power and his personality were crit-

ical elements in the formation of a new style. Noted for its severity, the style was called **Desornamentado** (day-sor-nah-men-*tah*-do), meaning unornamented. Its great monument, built by Philip himself, was El Escorial.

THE ESCORIAL, NEAR MADRID (1559–84)

The Escorial, 30 miles (48 km) northwest of Madrid, is one of the great archetypes of architectural history, a gigantic structure hardly matched for its austerity, plainness, and simplicity. It is built of solid gray granite quarried from the neighboring mountains, and it measures 570 by 740 feet (175 x 228 m), not including the altar wing that is the sole projection beyond the plan's basic rectangle. Within the rectangle, a grid divides the complex into square and rectangular courtyards surround-

ed by building masses that contain a royal palace, a large church, a monastery, an infirmary, and a mausoleum for a large number of Spanish monarchs (Figure 14–11).

The building mass is enlivened only by corner towers and by the 300-foot-high (92 m) church dome rising above the rest. Its endlessly repetitive windows are evenly spaced and in unadorned frames. Outside and in, detailing is spare and restrained except for the church's high altar and **retable,** a shelf or cabinet above an altar where altar lights, flowers, a cross, and other liturgical items can be placed. When a classical order is applied, it is, appropriately, the simple, sturdy Tuscan. (Although there are a few exceptions: pilasters in the Ionic order appear on the topmost level above the building's main entrance, Corinthian pilasters

Figure 14–11　Plan of the ground floor of the Escorial. The monastery occupies the wing at lower right. The church is at top center. The king's reception room and private apartments are in the wing projecting above the church.

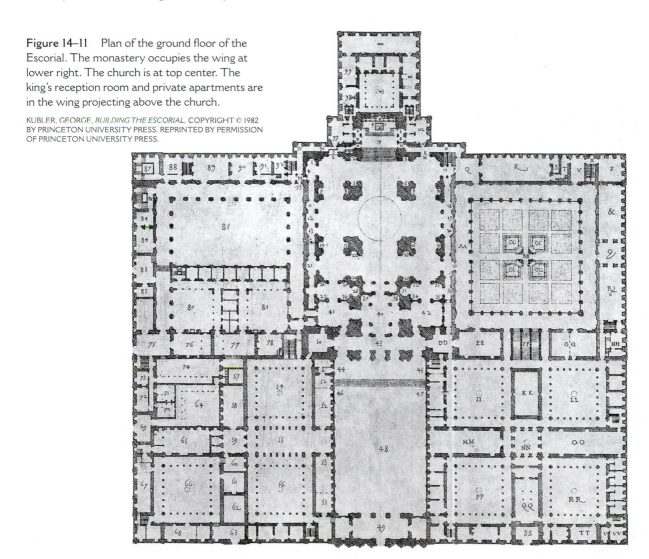

in the mausoleum, and in the center of the church the pilasters applied to the massive piers supporting the dome are fluted and should therefore be called Roman Doric—not Greek Doric, for these have prominent bases.)

Planning for the Escorial was begun in 1559 when the Italian-trained Juan Bautista de Toledo was brought from Naples by Philip II and appointed architect. He immediately began studies for a master plan and site preparation, and the first stone was laid in 1565. Toledo died two years later and was succeeded by Juan de Herrera, an architect, mathematician, and humanist, who continued Toledo's work until the building was finished in 1584.

Nothing like it had existed before. We may see four factors in its original style: first, an expression of the rational, pious, and grave personality of its patron, Philip; second, a reaction against the sometimes frivolous complexities of the ornate Plateresco style that had prevailed before it; third, an expression of faith; and, fourth, an admiring knowledge by both Toledo and Herrera of recent accomplishments in Renaissance Italy. Toledo, indeed, was reported to have worked on St. Peter's under the leadership of Michelangelo, but what he may have done there is uncertain. The resemblance between the lavish interior of St. Peter's and the extreme reticence of the Escorial is, in any case, slight. Only the most insignificant and utilitarian buildings of the Italian Renaissance would have been as plain as Philip's palace. What St. Peter's and the Escorial share is a ruling sense of proportion and a profound respect for reason.

And both buildings, in very different ways, are expressions of Christianity. In the case of the Escorial, Philip saw the new austerity as an ideological declaration. Purged of unnecessary ornament, the building manifested the severe discipline of Catholic orthodoxy at the time. It was conceived as a highly moral building, truly a "sermon in stone." In this sense, it may seem odd that the least severe part of the huge complex is the church itself, but the message must have been that spiritual matters are worthy of glorification, but worldly matters are not.

In addition to the church itself, there are a few richly embellished rooms in the Escorial, most notably the library (Figure 14–12) that occupies the central wing of the monastery section, its richness showing that religious learning was also to be celebrated. The room's great vault, soaring above some elegant bookcases of ebony and walnut designed by Herrera and containing rare Greek, Latin, and Arabic manuscripts, is punctuated with **lunettes,** round framed openings, and is painted with allegorical frescoes by the Italians Pellegrino Tibaldi and Nicolás Granello. Tibaldi (1527–96) also completed the retable of the chapel's high altar (begun by Federico Zuccaro) and painted a series of forty-six large arched frescoes on the cloister walls of the building's Patio de los Evangelistas. Granello (1550–93) also painted frescoes on the vaults of the chapter rooms and the sacristy, and decorated the walls of the Sala de Batallas with scenes of battles and naval victories.

Figure 14–12 Library of the monastery, the Escorial, 1584. Ceiling frescoes by Tibaldi and Granello represent the seven liberal arts.

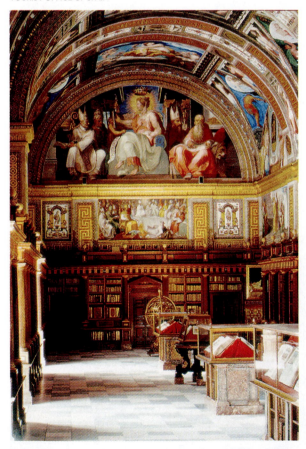

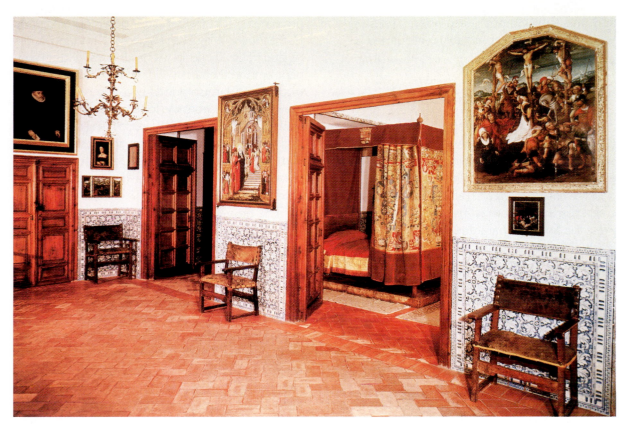

Figure 14–13 The dining room of Philip II's private apartments at the Escorial. The door on the left leads to a small study. The door on the right leads to the king's small bedroom, which opens to the altar of the church.

INSTITUTO AMATLLER DE ARTE HISPANICO, BARCELONA, SPAIN

But the most characteristic of all the many rooms of the Escorial are the private apartments of Philip II in the projecting east wing. They are poignantly simple. Their door and window openings are framed in pale gray marble, their floors are of clay tile, and their walls are whitewashed above a wainscot of glazed Talavera tile (Figure 14–13). A tiny sleeping alcove opens directly onto the church's high altar, so that the king—even when bedridden in his painful last years—could hear the Mass. A small canopied bed virtually fills the room. Next to it is another small alcove that served as the king's study. It is modestly furnished with a straight-backed armchair, a second chair on which he could rest his infected leg, a book stand, and a writing desk. Even the royal audience chamber, over 100 feet (30 m) long, with eleven windows and a pair of stone fireplaces, is remarkably plain

and unembellished. Some fine paintings, mostly of religious subjects, hang on the plain white walls. Virtually the only note of decorative luxury is in five pairs of finely detailed marquetry doors, made as a gift for the Escorial by the German artist Bartolomé Weisshaupt.

It must be admitted, however, that these rooms as they appear today are partly a result of conjecture. They conform to written accounts of what they were originally like, and all the pieces in them were taken from storage rooms in the Escorial cellars, but the specific choice and placement of the pieces is the result of restoration work begun at the end of the nineteenth century and finished in the 1920s by José Maria Florit. At least the rooms, like the building itself, are in the spirit of what Philip II had ordained. Among Philip's orders to Herrera had been the demands for "nobility without arrogance"

and "majesty without ostentation." These goals seem to have been remarkably well fulfilled.

The Return of Ornament: The Churrigueresco (c. 1650–1750)

The architecture and decoration of the Iberian Peninsula came into its own in the century between 1650 and 1750. During this period a style emerged that had never been—and probably never could have been—created elsewhere. It was a style steeped in a riotous enrichment that seemed to express the Spanish character at its most passionate. With the death of Herrera in 1597 a reaction against the severity of the Desornamentado quickly developed. That style had always been limited to court, ecclesiastical, and public buildings, and it had never been considered fully suitable for domestic use. Plain surfaces with carefully refined proportions had never been as immediately appreciated as richer treatments. To replace the Desornamentado, popular taste returned enthusiastically to the lavish use of ornamentation. Feeling a need to reassert the vigor of the Roman church after the Reformation movement and sensing the new style's emotional effect on the masses, the Jesuits promoted it strongly.

The new architectural conceptions were promoted by a remarkable family of sculptors, wood carvers, and architects named Churriguera. The founder of the family tradition was José Simón de Churriguera, "the elder," who died in 1679. Joining him in the family profession were his five sons, the most prominent of whom was José Benito de Churriguera (1664–1725), and the most talented of whom may have been the younger Alberto de Churriguera (1676–1750). Three of Simón's grandsons also joined the family profession.

The style they fostered, suitably called the Churrigueresco, was primarily a style of surface decoration, rather than one of structural changes. Its most characteristic features were applied to exterior entrance doorways and to the interior decoration of churches and palaces. In a considerably subdued form it reached the houses of the people, where it was seen more in the furniture and accessories than in the decorative treatment of the walls.

The style came to be practiced by more than Churriguera family members, of course. Other prominent Churrigueresco designers included Pedro Ribera, Miguel de Figueroa, Cayetano Acosta, and Pedro Cornejo. Another family was prominent among them as well: Antonio Tomé and his two sons, Narciso and Diego, the two younger Tomés being responsible for the facade of the University of Valladolid, and Narciso being chiefly credited with the Transparente in the apse of Toledo Cathedral. Together, all the Churrigueresco designers were labeled by their detractors as *fatuos delirantes*, the "delirious fools."

The new style was not just a revival of the *Plateresco*. Its scale was larger and its effects more three-dimensional. Natural objects used for the new ornamental motifs were in bold relief and frequently heroic in size. In the design of public buildings the classical orders were used in free and unconventional ways. Columns were often Solomonic, with spiral shafts; at other times, they were disguised with heavy rustication. Entablatures and moldings bulged upward or outward; broken and scroll pediments ended in squirming volutes; Doric capitals sprouted Corinthian acanthus leaves; brackets were nonsupporting; and pyramidal forms stood on their apexes. Stucco decoration was modeled to imitate rock formations, waterfalls, and drapery swags. Nude figures cringed under heavy loads; cherubim and seraphim emerged from plaster clouds, and religious symbols were profuse; optical illusions bewildered their observers; and transparent alabaster carvings glowed with the light from dozens of candles. Silver, tortoiseshell, and ivory inlay enriched the remaining wall surfaces. Fantasy ruled.

The movement attained great popularity, spread throughout the peninsula, and eventually crossed the Atlantic to Latin America, where, fused with indigenous elements, it intoxicated the colonials and the Christianized Indians with its combinations of color, ornament, sculpture, and twisted architectural forms. In Mexico, where it was—if possible—even more ornate than in Spain, the style was called *estípite* after an element that was popular in both Spanish and Mexican versions of the style: The *estípite*, derived from Italian Mannerism, was a pilaster in the shape of an inverted truncated pyramid, narrower at its base than at its top.

Popular as it was in its day, the Churriguuresque later came to be considered quite distasteful. Ar-

chitectural historian A. D. F. Hamlin, for example, in his 1923 *History of Ornament*, wrote of the style's "riotous defiance of every law of architectural decency." Today we can again appreciate the style's ingenuity and energy. It was characterized by a near anarchy of detail, but in the best work overall compositions were still balanced and symmetrically composed. Perhaps the most extreme example, which Hamlin thought an "abomination," is the Transparente in the cathedral of Toledo (Figure 14–14).

Italian, French, and English Influences (Eighteenth Century)

By 1725 the nobility and the upper classes of both Spain and Portugal began to decorate and furnish rooms in the French manner. Rooms became smaller, and furniture was reduced in scale. By the middle of the eighteenth century, the curved line dominated the shapes of the wooden wall panels and the design of all furniture. Lacquered panels were brought from the Far East and inserted in both wall and cabinet paneling. The Spanish versions of French forms lacked some of the refinements and fine proportions of the originals, being bolder, heavier, richer, and more masculine. They were often exaggerated in form, color, and ornament. There was a general tendency to finish furniture in white lacquer and gold or in pastel tints. Mirrors played a prominent part in interior design and were inserted in the wall panels or placed in elaborately carved frames and hung on the wall. Many new types of furniture were introduced, such as card tables, consoles, varieties of sofas and settees, clocks, and commodes. Comfortable upholstery was introduced. The Spaniards continued their traditional use of leather upholstery and often applied it to French furniture framework.

From the beginning of the eighteenth century the English also shipped a great deal of furniture to both Spain and Portugal. The style of Queen Anne became popular and was extensively copied by local craftsmen. The chair backs, however, were usually much higher than in the English examples. Later in the century Chippendale forms were adopted. England made special furniture for export, and many of the English pieces were finished in red lacquer, to appeal to the Spanish taste. With this finish, cheaper woods could be used in construction, with the result that both tables and chairs often required the use of stretchers. Many of the chairs had caned seats and backs. In much of the

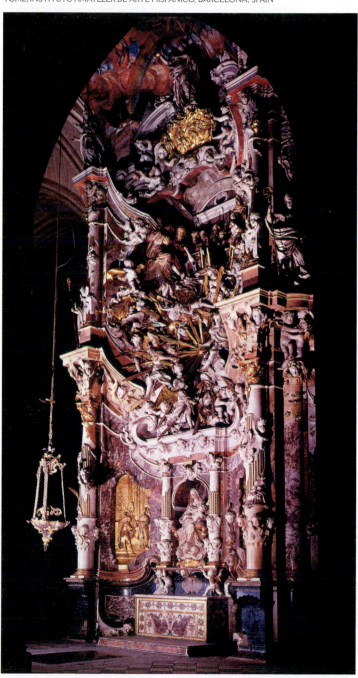

Figure 14–14 The Transparente chapel of Toledo Cathedral, designed by Narcisco Tomé and completed in 1732, is an extreme example of Churrigueresco complexity.
TOMÉ/INSTITUTO AMATLLER DE ARTE HISPANICO, BARCELONA, SPAIN

furniture made in Spain, both English and French elements were combined in the same piece. In the Mediterranean regions of Spain—Valencia, Catalonia, and the Balearic Islands of Majorca and Minorca—there was also influence from Venice.

THE PALÁCIO REAL, MADRID (AFTER 1735)

The Alcázar of Madrid, a fortified royal pleasure palace, had been completed by the middle of the seventeenth century, its decoration and the enhancement of its art collection entrusted by Philip IV to the great court painter Velázquez, who was given studio space there. In the early eighteenth century, redecoration by René Carlier and Robert de Cotte sought to reflect the current French influence by opening long perspectives of interlocking rooms and adding tapestries and marquetry. In 1734, however, the Alcázar burned to the ground and all was destroyed, including paintings by both Velázquez and Titian.

Work began immediately on a replacement, the Palácio Real. A whole series of workshops—the Talleres Reales—was set up to produce the wanted components of marble, bronze, textiles, plasterwork, porcelain, cabinetry, and upholstery, thus institutionalizing these trades in Spain. Staffing the workshops were Italian, French, German, and Flemish artisans, with a few native Spaniards.

The palace's chief architect was Filippo Juvarra (1678–1736). Born in Messina, Sicily (and therefore a Spanish subject), Juvarra worked in Rome, where he was an apprentice to Carlo Fontana, and in Turin, where his best-known works included the renovation and facade of the Palazzo Madama, the churches of San Filippo Neri and II Carmine, and the hunting lodge at Stupinigi. Before coming to Madrid, he was also familiar with the best new architecture of Paris, Lisbon, Naples, and London. Juvarra died two years before construction of the palace began, and the king replaced him with his disciple Giambattista Sacchetti (1698–1784).

Together, Juvarra and Sacchetti produced a design reflecting the current Italian taste. Specifically, it recalled Rome's Palazzo Chigi-Odescalchi as it had been remodeled in the 1660s by Bernini, and the related scheme of Bernini for an addition to the Louvre. A nicely articulated mass of pale gray stone built around an almost square courtyard 164 by 165 feet (50.4 x 50.9 m), the exterior impresses by its extent and rectitude. It hardly prepares one for the rich exuberance displayed within.

The great Gaimbattista Tiepolo, Italy's most renowned eighteenth-century painter, lived the last eight years of his life in Spain and contributed three ceiling frescoes to the palace: *The Glory of Spain* for the Throne Room, *The Glory of the Spanish Monarchy* for the *saleta*, (little drawing room) and *The Apotheosis of Æneas* for the Hall of the Halberdiers.

Adjacent to the Hall of the Halberdiers is the palace's great staircase hall, rising from ground level to the main floor. The staircase itself, with a central lower flight that splits at an intermediate landing into a pair of upper flights, is the design of Francesco Sabatini, and the stair hall, with a vaulted ceiling above lunettes and with frescoes by the Neapolitan painter Corrado Giaquinto, is the palace's most voluminous space. Almost as spacious is the State Dining Room, originally three adjacent rooms in the queen's quarters of the building, but combined into a single space in 1880 by the resident palace architect José Segundo de Lema, working for King Alfonso XII, grandson of Philip V. As at the Escorial, an ornate chapel is an integral part of the architectural composition, its interior designed by Ventura Rodriguez, its dome painted with another fresco by Giaquinto, but here the chapel is subordinate to other elements, clearly a convenience for the court rather than a centerpiece. More impressive is the Throne Room, decorated by the Neapolitan designer Giovanni Battista Natali with a largesse of red-velvet wall covering framed in gilt. Three of the other rooms are worth particular attention.

The Yellow Room The palace's Yellow Room, situated next to the State Dining Room, derives its name from the general hue of its wall covering and upholstery of silk damask and its tapestry wall hangings by José del Castillo from Spain's royal tapestry factory of Santa Bárbara. The most interesting elements of the room, however, are the pieces of furniture—chairs, tables, chests, pedestals—designed by Jean-Démosthène Dugourc. Dugourc (1749–1825) was an important French designer who had studied in Rome. With his onetime employer and brother-in-law François-Joseph Bélanger and with Georges Jacob, he had been largely responsible for

the late Louis XVI style in French furniture. Fleeing the French persecution of the nobility, he had come to Madrid in 1799 as architect to the Spanish court and stayed fifteen years. His other work in Spain included furniture for the Casita del Principe, a pavilion built on the grounds of the Escorial, more furniture for the Casita del Labrador, built for the Duchess of Alba in the park of Aranjuez, and a room design in Egyptian revival style (not executed) for the Escorial.

The Porcelain Room A relatively small room, the Porcelain Room was used as the king's boudoir. Its walls, except for some inset mirrors, are completely surfaced with porcelain plaques screwed into a hidden wood framework, presenting surfaces of unfading color and unusual sheen. The effect is somewhat similar to that of a room faced with ceramic tiles, but it is not the same: the porcelain plaques are more varied in size, many of them larger than tiles; the joints between them are mostly hidden; and they are far more three-dimensional than tiles, some porcelain representations of medallions, urns, cupids, garlands, and drapery swags extending several inches beyond the wall plane. The rich modulation and sheen of the wall surface are tempered by a restrained color palette, the background color of the plaques being cream and the ornament being limited to green and gold.

The Porcelain Room's plaques are attributed to Giuseppe Gricci, brought by Charles III (reigned 1759–88) from Florence to help establish a royal Spanish porcelain factory in the gardens of the Buen Retiro Palace. Other designers credited with the room's decoration are Giovanni Battista della Torre and Gennaro Boltri.

A possible inspiration for such a room is one in the Santos Palace at Lisbon, Portugal, dating from the middle of the seventeenth century, which has a ceiling virtually covered with Chinese blue-and-white porcelain plates held within a wood frame. Contemporary with the Porcelain Room at the Palácio Real is another in the palace at Aranjuez. In the more purely rococo Aranjuez example, the porcelain plaques depict scenes such as the mythical Andromeda chained to a rock, Chinese figures dancing and swinging from trees, and a man in a turban climbing a tree to escape a leopard. In Italy, a porcelain-lined room was constructed at Naples,

but later dismantled and reassembled at Capodimonte. Behind all such rooms, of course, was the European fascination with things Chinese; the Porcelain Pagoda in Nanking, for example, completely faced with porcelain tile, had become famous in Europe after publication there in 1665, and had led directly to the 1670 construction of a porcelain-faced pavilion, the Trianon de Porcelaine, built by Louis XIV adjacent to the French royal palace at Versailles for his mistress Mme. de Montespan. The pavilion is no longer standing.

So difficult and expensive is the process of porcelain surfacing, however, that it has never entered the common vocabulary of wall treatments. Most rooms with the name Porcelain Room—and there are many, such as in the German palaces of Charlottenburg and Oranienburg, in the Bavarian palace of Herrenchiemsee, and in some of the great country houses of England—are simply rooms in which collections of porcelain objects are displayed, not rooms faced with porcelain. There is even such a room on the grounds of the Escorial in the Casita del Principe, its walls hung with small gilt-framed porcelain plaques made by the Buen Retiro royal workshop in imitation of Wedgwood.

The Gasparini Room The most impressive, the most florid, and generally the most successful rooms in the palace are those designed by Mattia Gasparini from Naples. His rooms, in the palace's southwest corner (the "King's Tower") include some small office rooms paneled with exotic woods from Africa and America, a parlor with a ceiling fresco by Antonio Rafael Mengs, an antechamber with four royal portraits by Goya against a wall covering of deep blue and gold, and the so-called Gasparini Room. He also designed some furniture and the marble mosaic floor of the Porcelain Room and served as head of the royal embroidery workshop.

The Gasparini Room (Figure 14–15) is the most spectacular example of his room design, perhaps because it is the least altered from its original state. It was designed to be the king's dressing room, but in times when the king's dressing was not a private matter but a daily court ceremony of considerable importance. The room can fairly be called a rococo fantasy or, better, a *fantasia*, a word shared by both Italian and Spanish languages, because it is

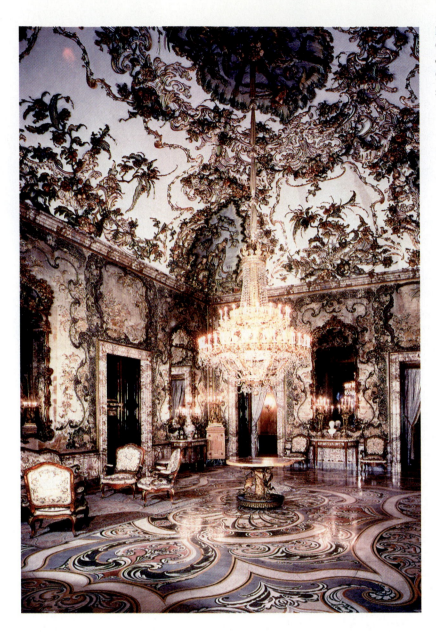

Figure 14–15 The Palacio Real's Gasparini Room, named for its designer, the Neapolitan Mattia Gasparini.

SCALA/ART RESOUCE, NY

evident that its influences are Italian, but evident as well that the room is Spanish.

The most striking feature is the floor, an ebullient swirl of inlaid marbles in rust, olive, pale blue gray, beige, and gold. Its ceiling, equally exuberant, displays life-size Chinese figures at each corner and, between them, ornate jungles of vegetation on a cream-colored ground. A high glaze gives these ceiling decorations the sheen of porcelain, but they are in fact stucco. From the center of the ceiling hangs an enormous chandelier (of later date) with a gilded bronze lion (symbolic of a king) lying among its crystal pendants. The whole room is saved from careering into madness by its walls. These most visible surfaces mediate between the great dramas of the floor and ceiling with quieter, more delicately detailed designs of silk embroidery in pale shades of gold and silvery green. This fabric participates fully in the room's rococo spirit, but its *relative* simplicity and *relatively* small scale skillfully moderate the bolder gestures above and below. The wall's wainscoting, cornice, and door and window surrounds are of beige marble, and these are quite plain—in this context, even rather severe—in form.

Together, the wall fabric and the marble trim, through all the room's torrent of movement, maintain a crisp distinction of planes; we are never disoriented here, for walls, floor, and ceiling all read clearly as separate elements. Throughout the room, colors are often strong but carefully chosen and limited in number.

It is fitting that this original and daring room is named for its designer, but there are other credits to be mentioned both for work along with Gasparini and for work after his death, in 1774: the stucco workers Gennaro de Mattei and Giovanni Pennelli; the marble worker Domenico Galleoti; the bronze workers Antonio Vendetti and—especially—Giovanni Battista Ferroni; Gasparini's widow Maria Luisa Bergonzini, and their son Antonio Gasparini. A special contributor among these is the room's furniture designer, José Canops (flourished c. 1759, died 1814). His tulipwood sofas and chairs for the Gasparini Room are larger in scale than their French models and have arms supported by extraordinary serpentine curves that reverse their direction not once, but twice.

In the Gasparini Room particularly, but in most of the other rooms of the Palacio Real as well, there is an exuberance we have not seen before in Spanish design. We have noted that the extensive but quiet patterns of Moorish ornament combined well with Spanish taste. We have seen that the harmonic proportions of the Italian Renaissance, as at the Escorial, also complemented the sober Spanish temperament. In the Palacio Real, imports from the later Italy of the rococo period were far less restrained and seem more foreign to the Spanish tradition into which they were assimilated. In fact, they *were* foreign. The clients for these interiors were the Bourbons who had arrived from France in 1700 to rule Spain, and most of the artists and artisans they hired were from other parts of Europe, chiefly from Italy and Sicily. Still, the rococo seen here is not the rococo of France nor the rococo of Italy; less delicate than those, it has a truly Spanish vigor.

Spanish Furniture

Before the Renaissance, rooms in Spain, as elsewhere in Europe, were sparsely furnished. Paintings and inventories of those times indicate the few types of furniture that were used. There were stools, benches, folding seats, chairs of honor, canopied beds, simple desks, occasional sideboards, and cabinets with drawers. Dining tables were assembled from loose planks set on trestles and were often covered with an Oriental rug.

Moorish houses in Spain contained benches that were built in and attached to the wall. Cushions and straw mattresses were placed on the floor, a custom continued from the times of the nomads. Rugs were used in profusion on floors, benches, and as wall hangings. Leather and wood chests were used for the storage of clothes. Pottery, bronze, and copper were the materials for cooking and eating utensils. Elaborate embroideries, laces, and loom-made textiles added color and pattern interests. Bottles, flasks, and perfume containers were made of an iridescent glassware of great beauty.

Throughout Spanish history, the most common piece of furniture, used in almost every room, was a chest with a hinged lid. It served as storage for the elaborate clothes worn at special occasions—banquets, fiestas, jousting tournaments, and bullfights—and it could also be used as a seat, a table, or a writing desk. It was made in all sizes and in many different woods and was often covered with embossed leather, decorated with metal ornaments, and fitted with complicated locks.

Much Spanish Gothic furniture was painted in bright colors and gold. Detail was taken from Christian Gothic architectural elements, but many pieces show Mudéjar influence in the use of geometrically patterned inlays. Heavy proportions and sound construction were the rule and were considered more important than lightness or elegance. Pieces were well joined and were often braced with wrought iron.

With the advent of the Renaissance, luxury was introduced to Spanish interiors from Italian precedents. Almost all Spanish furniture from 1500 to 1650 was of Italian inspiration. Although local conditions and traditions affected designs, little was produced that was wholly indigenous. Some of the finest furniture was created for the church, and its ornament was naturally sacred in character, including such symbols as the pope's miter and the keys to heaven. Lacquered furniture from England was imported by both Spain and Portugal in the second half of the seventeenth century.

In the eighteenth century, the influence of Venice was strong in southern Spain. This accounts for the fine lacquered furniture, at first imported and later copied locally, found in these regions. Chairs, console and corner tables, and handsome secretary cabinets were generally lacquered in red, yellow, green, and sometimes in blue. The surface decoration, consisting of **chinoiseries** or stylized eighteenth-century motifs, was applied in different shades of gold, reinforced with black lines.

The preferred type of chair was a splat back with cabriole legs based on modified Queen Anne models. The earlier secretary cabinets were often crowned with elaborately curved and ornamented pediments, but in the later examples a more classic type of pediment was used. Another Venetian influence was seen in the copious employment of mirrors, with or without lighting fixtures, hung against the brilliant red or yellow damask wall coverings.

Toward the end of the eighteenth century, both interiors and furniture began to be influenced by the Adam brothers of England, who had studied the ruins of Pompeii and other cities of antiquity. Antique classical, rather than Renaissance forms, also came through French designers who were creating the neoclassical style called *Louis XVI.* The straight line was substituted for the curved or rococo forms; the cabriole leg was eliminated; and all the sentimental elements of design associated with Louis XVI and Marie Antoinette became fashionable. The English Hepplewhite and Sheraton furniture in satinwood and painted finishes was also much in demand. Silk woven textiles for draperies and upholstery followed the French patterns, and the East Indian cotton prints were extensively used in both Spain and Portugal.

The woods most commonly used for Spanish Renaissance furniture construction were walnut (a great favorite), chestnut, cedar, oak, pine, pear, box, and orange, with inlays of ebony, ivory, and tortoiseshell. Beginning about 1550, the Spaniards were the first Europeans to use mahogany as a cabinet wood, importing it from their colonies in the West Indies. Often it was recycled: because of the enormous size of the mahogany trees, the wood had first been used in the construction of Spanish galleons; when these ships were wrecked or taken out of service, the wood was then salvaged for smaller structures and for furniture. Such wood was sometimes called *Spanish mahogany* and sometimes *San Domingo mahogany,* in honor of its source, now Santo Domingo. The great English furniture designer Thomas Sheraton referred to the fine mahogany of the Spanish West Indies in his 1803 book *The Cabinet Dictionary.*

Other Spanish furniture woods were less beautiful to work with, however. There was a continued tendency among Spanish cabinetmakers to cover inferior woods and sturdy but crude workmanship with paint, so that in all periods polychrome effects were more common in Spain than in other European countries.

The character of carving in Spanish furniture varied greatly. Some fine work on the best Renaissance pieces was done by Italian wood-carvers and shows an accurate interpretation of classical motifs, but in the smaller towns and country districts, carving was in conventional and naturalistic patterns, unrelated to classical tradition. One such pattern was a series of short chiseled grooves rippling along a rail or chair leg or drawer front; such carving was called *tremido* (trembling). Panel areas often consisted of square, diamond-shaped, or circular figures distributed on the surface as allover patterns. In Portugal (and, to a lesser degree, in Spain) from the sixteenth century on, a popular type of carving was a portrait profile within an ornamentally framed round medallion. At the same time, such carvings were also being produced in England, where they were called **Romayne work.**

Short **clavated** (club-shaped) turnings were popular for use on furniture legs and on stretchers between legs. The use of splayed or slanting legs was also popular. At the ends of furniture legs, several types of feet were used, but the most characteristic is called the **Spanish foot,** although it is sometimes also called the *Spanish scroll foot* and sometimes the *Braganza toe,* named for the Braganza family that ruled Portugal from 1640 to 1910. It is shaped like a hoof or paw, its surface cut in narrow grooves. It projects outward from the leg, then curves inward slightly at the floor. Much used in Spain and Portugal beginning in the seventeenth century, it was also used on English and American furniture of the eighteenth century.

There were, of course, wood frames for paintings and mirrors, many of them gilded, and mirrors of all shapes and sizes became so popular that in 1736 Philip V established a royal mirror factory at San Ildefonso. Some of its products were the largest mirrors that had ever been produced, and one example, with its frame, was said to weigh 9 tons (8.2 t). Toward the end of the eighteenth century, one particular type of mirror design, featuring gilt wood moldings over strips of marble veneer and, at the top, a small painting within an oval medallion (Figure 14–16), came to be known as a *Bilbao mirror*, named for its northern Spanish city of origin. Because Bilbao was a frequent port for American ships on their way to or from France, many Bilbao mirrors were brought to America.

Nailheads of both iron and brass were a great enthusiasm of Spanish and Portuguese furniture makers. Large and elaborate, they were used not only to secure upholstery materials to wood frames, but also by themselves to decorate plain surfaces. Also used for enrichment were metal ornaments of iron or silver in the form of rosettes, scallop shells, or stars, or in the form of sheets with patterns of pierced openings. Wrought iron was used extensively in many types of household furniture. Chairs, beds, chests, tables, washbasins, candlestands, and other objects were often made entirely of wrought iron, and it was also used in combination with wood, such as in chairbacks and in the gracefully curved braces between table legs. After silver began to be mined in the colonies of the West Indies, silver began to be used quite generously in Spanish furniture design, some wood pieces being entirely surfaced with silver, and a few other pieces being made of solid silver. Naturally, the ascetic Philip II considered such practice excessive and ostentatious, and both he and his son Philip III passed sumptuary laws (in 1593 and 1600) outlawing it.

The decorative application of metal remained a key characteristic of Spanish furniture, however. Important artisans in the production of furniture included not only the *ebanista* (cabinetmaker) and the *tornero* (turner or lathe worker), but also the *platero* (silversmith) and the *dorado* (goldsmith).

Figure 14–16 A late-eighteenth-century Bilbao mirror with a frame of marble veneer and a painted oval medallion. Many such mirrors were exported from Bilbao, Spain, to America.

THE METROPOLITAN MUSEUM OF ART, ROGERS FUND, 1919. (19.177.1)

With these terms and general characteristics in mind, let us look at some specific pieces of Spanish furniture.

Seating and Beds

The Spanish term for a side chair is *silla;* for an armchair, *sillón*. There are many categories of each, of course. *Sillas del Renacimiento* means simply chairs of the Renaissance. The *sillón de cadero* was a chair with an X-shaped frame (Figure 14–17), modeled on Italy's so-called **Dante chair** or *Dantesca;* it was a favorite in early-sixteenth-century Spain and was frequently upholstered in crimson velvet edged with fringe. It is sometimes called a *scissors chair* or a *hip chair. Sillerías* are choir stalls,

Figure 14–17 A sillón de cadera with a frame of wood marquetry and with seat and back of repoussé leather.

INSTITUTO AMATLLER DE ARTE HISPANICO, BARCELONA, SPAIN

Figure 14–18 A seventeenth-century Spanish frailero with embroidered and fringed upholstery.

MUSEO NACIONAL DE ARTES DECORATIVAS, MADRID, SPAIN

and some of them were very elaborately carved in the rich Plateresco style, such as those in the choir of the cathedral of Granada, their carvings credited to Alonso Berruguete (1480–1561) and Felipe Vigarni, and those in the cathedral of El Pilár at Saragossa, created in 1542 by the Italian carver Giovanni Moreto.

The best known of Spain's chairs, however, was the **sillón de frailero,** commonly referred to simply as a *frailero*. This "monk's chair" was introduced late in the sixteenth century (Figure 14–18) and given its name because it was so frequently used in monasteries. It had a wooden frame of square or rectangular members, sometimes with turnings, and a straight back separate from the seat, and both back and seat were most frequently upholstered in leather. The leather was commonly fastened to the chair frame with a double row of nails with ornamental heads. Sometimes the stretchers between the legs were removable, so that the chair could be folded. Its arms sometimes ended in rather Baroque volutes. The Portuguese version was slightly different, with a higher back, more elaborately turned legs, and ball feet.

Many other chairs had plain wood seats, with loose cushions added for comfort, and chairs with rush seats were very common even in the most elaborate homes. Other Spanish terms for chairs are *butaca* and *dureta,* a bench is called a *banca,* and a stool is a *taburete.* Through the seventeenth century Spanish ladies often used floor cushions for seats both at home and while attending Mass. In Barcelona, a form of **ladder-back** chair (a chair with a back formed by a column of horizontal slats) was made, in which the topmost slat was greatly enlarged and elaborately carved.

The chair known as the *Spanish chair,* a low, armless, upholstered piece with the seat and back joined in a continuous curve, was not in fact Spanish at all, but an English chair of the Victorian period.

Beds were made both with and without corner posts. Spiral (Solomonic) posts were often used, frequently with the addition of fabric valances (Figure 14–19). Headboards (*olatinas*) were sometimes separate from the bed, fastened to the wall, and they were either elaborately painted, designed as an architectural pediment, or carved with a pattern of intricate scrolls. Beds

connecting the end legs, near the floor. Such curved iron bars were known as **fiadores** (Figure 14–20). Tabletops frequently had a long overhang, with plain, square-cut edges. Many of the tables were collapsible.

Case Furniture

We have noted the frequency of the Spanish chest with a hinged lid. Many other sorts of case goods were also popular in Spain. These included the large chest called the *arcaza* or *arcón* with a flat top surface that could serve as a seat and, when covered with a straw mattress, as a bed. There were also the simple box or *arca*, the trunk or *baúl*, the sideboard or *credencia*, the sideboard with a glass front or *aparador*, the ventilated food cabinet or *fresquera*, the clothing armoire or *armario*, the washstand or *palanganero*, and many others. Drawer pulls for these various case goods were of two chief types: turned wood knobs and iron drop handles.

Two closely related pieces of case furniture were developed in Spain to a degree not seen elsewhere. These characteristically Spanish articles, which deserve a closer look, are the **vargueño** and the **papalera**.

THE VARGUEÑO Beginning in the Plateresco period of the sixteenth century, no Spanish domestic interior was considered complete without the writing desk known as the **vargueño**. The

Figure 14–19 Seventeenth-century Spanish bed with spiral posts and an elaborately carved headboard.

INSTITUTO AMATLLER DE ARTE HISPANICO, BARCELONA, SPAIN

were often draped with silk damask enriched by fringes and tassels.

Tables

Spanish tables were sometimes supported on four legs, sometimes on a pair of trestles. In rare cases, the tables were so long that intermediate pairs of legs or trestles were also needed. The legs represented straight or spiral classical columns or balusters. The trestle supports were much simpler than those found in Italy; they were usually pierced and silhouetted in a series of contrasting curves often taking the approximate shape of a lyre. Both table legs and trestles were often splayed and braced by a diagonal wooden or curved iron piece which started at the center point of the underside of the tabletop and ended at the stretcher

Figure 14–20 Spanish wooden table braced with iron fiadores.

ABERCROMBIE, AFTER BYNE

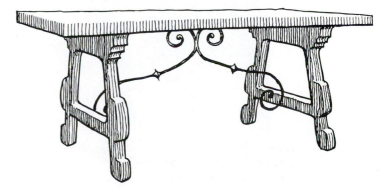

- Some authorities shun the term **vargueño** as a misnomer, for it suggests that such writing desks were made in the village of Vargas, near Toledo, and there is no record of a furniture workshop there that made such pieces. Those authorities prefer the term *escritorio* or simply "writing desk." A provincial term for the same piece of furniture is *arquimesa*.

Vargueño remains in common use, however. Because *v* and *b* are sometimes considered interchangeable in Spanish, the spelling *bargueño* is also seen.
- The term **papalera** is also still in common use, but today the word is even more frequently used to mean a wastepaper basket than a writing cabinet.

earliest examples were simple unadorned boxes, with a hinged lid at both the top and the front, both furnished with strong locks. Handles were always placed at each end, so that the vargueño could be easily transported. The interior was subdivided into many drawers and compartments for papers, writing equipment, and valuables, some of the compartments with secret sections, and the front of each subdivision came to be elaborately decorated with metal hinges and ornaments (Figure 14–21) or with inlaid patterns made of ivory, mother-of-pearl, and wood. Beginning in the seventeenth century, miniature classical architectural motifs were also applied.

Runners were pulled out from the case to support the fall front, which then served as a writing surface. The body of the vargueño rested on a variety of supports—on simple trestles or on turned legs braced by wrought-iron fiadores or on tables or chests—but in every case the vargueño was separate from the support below.

The vargueño was usually made of walnut, but in the early years of the seventeenth century, mahogany was sometimes used. In the later examples the front of the drop lid became highly decorated with inlay or lacelike pierced metal mounts, gilded and applied to small squares of crimson velvet that were distributed in a pattern over the woodwork. The locks, corner braces, keyholes, bolts, and handles were both numerous and decorative and were often supplemented with ornamental nailheads arranged in patterns such as swags, circles, and geometric shapes.

THE PAPALERA Similar to the vargueño, but often smaller and always without the drop front/writing surface, is the cabinet called a **papalera** (Figure 14–22). It also featured a variety of storage compartments, the faces of which were also often elaborately decorated and which, without the vargueño's drop front, were always visible. The papalera stood on feet, sometimes pear-shaped ones. Both the vargueño and the papalera can be considered ancestors of the French eighteenth-

Figure 14–21 A Spanish vargueño, its fall front closed. It is separate from its trestle base, and handles on the sides make it easily portable.

HISPANIC SOCIETY OF AMERICA

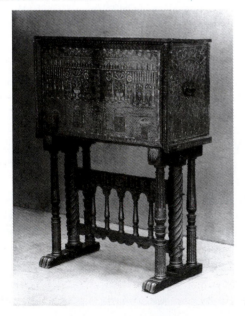

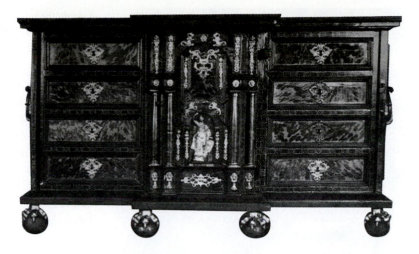

Figure 14–22 A late-eighteenth-century papalera, its compartment faces decorated with shell veneers and copper, its central door between pairs of columns. From the Palace of Liria.

century *secrétaire à abattant,* which we shall see in the next chapter.

Portuguese Variations

All the types of furniture used in Spain were seen in Portugal, and many novelties introduced in Portugal were copied in Spain. One general difference is that in Portuguese examples, the size and complexity of the turnings that were used for chair and table supports and for the headboards of beds were likely to be more exaggerated. Spiral and bulbous shapes were also more common.

The most important difference, however, was seen in the East Indian and, later, in the Chinese influence in Portuguese furniture, the result of a monopolistic trade policy with these countries. It is claimed that furniture caning and the cabriole leg were first used in Europe by the Portuguese, who brought them from China.

The Indo-Portuguese furniture manufactured in Goa, the Portuguese colony on the Malabar Coast of western India, was made in teak, ebony, and amboyna wood with ivory inlay or veneer. The Hindu craftsmen often endeavored to copy Western designs. Pierced metal patterns, nailheads, and carving form the ornamental detail. Lacquered furniture was also brought from the Far East, and Oriental woven and printed textiles were first imported into western Europe by the Portuguese traders.

During the Manuelino period (1495–1521), in such places as Batalha and Tomar, the East Indian influence was very strong and expressed itself in extravagantly rich detail that seemed to be inspired by crustacean and tropical vegetation forms. This was the first Far Eastern influence on Western art.

Spanish Decorative Arts and Crafts

The vigorous Spanish spirit was expressed in every sort of decorative art and craft. Here, however, we shall focus on a few techniques and materials that seemed most particularly to catch the Spanish imagination. The most obvious of these, already seen in many of this chapter's illustrations, is tile.

Tile and Other Ceramic Wares

In many of the ancient cultures we have considered—in Egypt, in the ancient Near East, in the East—it was, from a very early time and for a very long time, commonplace to build with earth. For almost as long, it was commonplace to protect the earth surfaces with panels of more durable materials: woven matting, slabs of terra-cotta or marble, or glazed tiles. Only slightly more recently, these surfacing materials were brought indoors, where they formed surfaces that were easily cleaned, reflective of light, and delightfully decorative. Among these materials, the tiles of Spain and Portugal have an outstanding place.

Once again, we see a Moorish inheritance behind the Iberian accomplishment. While pottery

Figure 14–23 Tile panels with an overall design on door surrounds, wainscots, and window embrasures in the Alcázar, Seville, seventeenth century.

EWING GALLOWAY INC.

was certainly made in Spain before the arrival of the Moors, they greatly expanded the use of ceramic material for decorative and practical purposes and added refinements such as lead and tin glazes and the **luster** technique, described later.

ARCHITECTURAL USES The floors of Spanish rooms were frequently covered with small quarry or baked clay tiles of a dull red color. Color accents were often introduced by insertions of glazed tiles in contrasting tones. Black-and-white checkerboard effects were popular. Brick floors were usually laid in square or herringbone patterns.

Tile was also used for dadoes carried up the walls to a height of 3 or 4 feet (90–120 cm). These were invariably in polychrome effects and in geometric patterns. A band course at the top of the wainscot, often consisting of a repeating conventionalized pine tree motif, varied the pattern of the field. Door and window facings, window jambs and seats, risers of steps, and linings of niches were also made of ceramic material.

These tiles were most often about 5 or 6 inches (12–15 cm) square and were known in both Spain and Portugal as **azulejos.** Some say the term is derived from the Arabic *al zulaich,* meaning "lit-

tle stones"; others say it derives from the Arabic *az-zulaca,* meaning "brilliant surface." It was first used by the Moors of North Africa to describe the mosaic pavements they found in the ruins of Roman cities there, such as Volubilis in Morocco or Leptis Magna in Libya, then later used for their own tile production.

These azulejos, though Moorish in origin, were readily adapted for Christian as well as secular uses. In 1503, for example, the **retablo** or altarpiece of the chapel of the Alcázar in Seville was completely faced with azulejos in a design by Niculoso of Pisa. There was apparently never a prejudice in Spain that Moorish materials or motifs might be inappropriate for places of Christian worship. In the Alcázar's Salón de Carlos V, added to the complex after 1630, tile panels with extensive nonrepetitive designs cover the lower parts of the walls and line the window embrasures (Figure 14–23).

In Lisbon, Portugal's National Museum of Azulejo is housed in the former convent of Madre de Deus. Built in the sixteenth century and completely remodeled in the eighteenth, the building was already rich in large wall panels of tile, making it an ideal site for such a museum.

NONARCHITECTURAL USES In addition to the production of the architectural and ornamental wall tiles, vast quantities of heavy earthenware plates, jugs, ewers, vases, fountains, washbasins, and pitchers were made. These objects, produced from the thirteenth century in southern Spain, particularly in Málaga and Paterna, and also produced from the fifteenth century in Valencia and Seville, are given the name **Hispano-Moresque ware** (Figure 14–24). They constitute the finest ceramics produced in Europe since the classical era, and they were a direct and important inspiration for the Italian **majolica** ware mentioned in the previous chapter.

While not attached to floors or walls, these wares were nevertheless important elements in the interior design of their time. Pitchers and vases were scattered profusely on shelves, and plates of all sizes were hung on the walls in circles, curves, and other arrangements, often producing a dazzling appearance. These products were considered

Figure 14–24 Hispano-Moresque ware dish with a luster finish, probably made in Valencia in the fifteenth century.

D. ARNAUDET/REUNION DES MUSEES NATIONAUX/ART RESOURCE, NY

of such high quality that in 1455 the Venetian senate decreed that "the majolica of Valencia should be admitted duty-free (to Venice) for such is their quality that local kilns cannot compete with them."

DECORATION The Moors furnished Spain not only with new ceramic techniques, but also with motifs for decorating the results. Patterns were both stamped and painted on Hispano-Moresque ware, and consisted of geometric and abstract forms, coats of arms, figures, and conventionalized floral forms. One of these last, somewhat resembling an acanthus leaf caught in a pinwheel current, is called the *florón arabesco* motif (Figure 14–25).

After the Reconquest and the Christian subjection of the Moors, human and animal figures and Christian symbols were more commonly represented in the tile patterns.

TECHNIQUES One problem inherent in making multicolored tiles is that adjacent areas of different color glazes tend to "run" into one another during firing, producing muddy effects. The Spanish tile factories developed two related techniques to deal with the problem: **cuerda seca** and **cuenca.** *Cuerda seca,* which means "dry cord," was much used in Spain during the fifteenth and sixteenth centuries. It involves drawing lines around

each colored area with a mixture of dark ceramic pigments and some sort of grease that will repel the water-based glazes. The lines keep each area distinct until, during firing, the grease burns away, leaving a slightly recessed unglazed line between the glazed areas. Similar results can be obtained by imprinting a design in the soft clay with a mold. After a first firing, the sunken lines incised by the mold are filled with a greasy substance. Tiles of the cuerda seca type were exported from Spain to Italy, and examples in the Borgia apartments of the Vatican date from the papal reign of the Spanish-born Alexander VI at the end of the fifteenth century.

Cuenca, which means "bowl" or "valley," is a later technique employing individual molds for each color area. Imprinting them in the soft clay leaves thin ridges around each area. The hollows inside the ridges are then filled with the colored glazes.

Figure 14–25 Section of a panel of blue-and-white tiles made for the Escorial in the florón arabesco pattern c. 1570. Each tile is about 4 inches (10 cm) square.

INSTITUTO AMATLLER DE ARTE HISPANICO, BARCELONA, SPAIN

Figure 14–26 A black iron *candelero* or candelabra for the king's reception room at the Escorial. The room is near the dining room seen in Figure 14–13.

PHOTO: ABERCROMBIE

Obviously, tiles made with either the cuerda seca or the cuenca method need to be kept horizontal during firing to keep the glazes within their boundaries. Comparing these techniques of applying glazes to clay with the techniques of applying enamels to metal, we could say that cuerda seca with its ridges is to cuenca with its hollows as cloisonné is to champlevé.

Lustreware—or, in the modern spelling, lusterware—adds a second glaze to already glazed tile or pottery. The second glaze, using pigments made from metallic oxides, is fired at a relatively low temperature (about 800°C). A thick glaze can produce the effect of burnished metal, and a thin glaze, allowing the color beneath to show, can produce unusual iridescent effects. Luster glazing seems to have been practiced in Egypt in the seventh or eighth century A.D., and in Baghdad in the ninth. It was brought to Spain by the Moors and was used there, chiefly in Málaga, at least as early as the thirteenth century. It is still practiced there.

Metalwork

We have already mentioned the influence of metalwork in the Spanish colony of Flanders, and we have seen several examples of metalwork in Spain: the iron weather vane atop the Giralda Tower of the cathedral in Seville; the iron fiadores bracing the legs of Spanish tables; the brass escutcheons around the locks of vargueños; and the decorative nailheads along the seats and backs of Spanish chairs. Other uses included braces and brackets supporting balconies and other architectural elements, candelabra (Figure 14–26), torch holders, door knockers, braziers, locks, bosses, and hasps. Door hardware in Spain was developed to a degree never imagined elsewhere. In Mudéjar interiors, impressive doors and pulpits were beaten from sheets of iron.

The most impressive and virtuosic metalwork of Spain, however, appears in the grilles or gratings known as **reja** (*ray*-hah), the metalwork involved being called **rejería** (ray-hah-*ree*-ah). When these grilles were used to protect window openings, as they often were, they were called *reja de ventana*.

The most elaborate rejería was reserved for the large screens that enclosed the altars of churches and cathedrals, protecting their treasures. These rejas were not mere expanses of grillwork, but were laden with religious symbolism and ornament. Basically **wrought iron,** they were enriched with silver and gold. A fine example (Figure 14–27) is the reja of the Capilla Real in the cathedral of Granada.

The silver and gold were sometimes in the form of **filigree,** delicate openwork decorations made of slender metal threads and tiny metal balls. Filigree was used not only on rejas, but also for jewelry, for small decorative caskets, for the handles of flatware, for reliquaries (vessels made to hold relics of saints), for imperial crowns, for miniature pieces of furniture, and for other uses. Spain was famous for such work until late in the eighteenth century, as were Venice and Genoa. In Italy, some filigree work is still produced, but chiefly as tourist souvenirs.

In Renaissance times, the design of rejas became even more elaborate than before. In addition to filigree work, the ironmakers learned to divide iron bars into separate strands and twist the strands into

Figure 14–27
The great reja of the sixteenth-century Capilla Real (Royal Chapel), Granada Cathedral. Before it are the carved marble tombs of Spanish royalty.

BARTOLOME ORDONEZ, INSTITUTO AMATLLER DE ARTE HISPANICO, BARCELONA, SPAIN

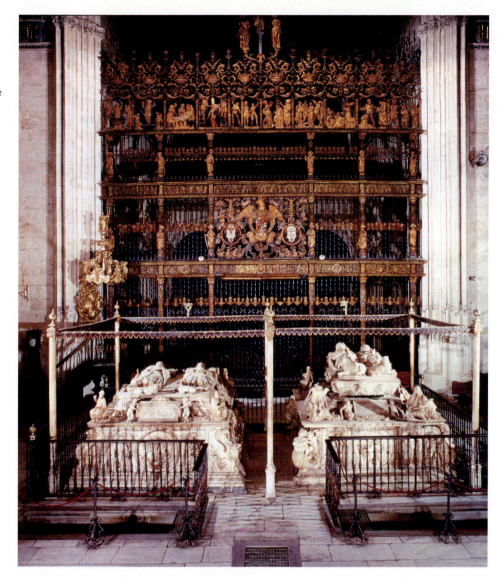

different silhouettes. Other elements were given three-dimensional relief effects by cutting openings of slightly different sizes in two sheets of metal, then joining the sheets together (Figure 14–28).

Other metalworking techniques popular in Spain were **damascening** and **repoussé** (ray-poo-say). Damascening, also used in Islamic design (see page 213) and in India (page 232) is a process of beating thin wires of gold or silver into grooves cut in the surface of a less precious metal such as steel, iron, or brass. Repoussé decoration is obtained by hammering the backs of metal sheets so that a desired pattern projects on the front. As damascening can be described as a kind of inlaying, repoussé can be described as a kind of embossing. It was one of the earliest methods of metal decoration to be developed, and was used in Crete as early as 1600 B.C. Silver and copper are the metals most frequently treated with repoussé.

Leather

The term *leather* is used for any preserved animal hide or skin, a nicety of terminology being that large animals, like horses and cows, are said to have hides, and small animals, like goats and lizards, are said to have skins. Both hides and skins are organic tissues

Figure 14–28 Relief effect produced by joining two sheets of metal. The openings in the front sheet are made slightly larger than those of the sheet behind.

ABERCROMBIE, AFTER BYNE

composed of water and proteins; without being preserved, they naturally decay. But preserving leather is a venerable process, having been practiced in prehistoric times. The Egyptians used leather for bags, clothing, and sandals before 5000 B.C.

There are three traditional methods of preserving leather, and all are known as **tanning.** The most often used—and the one that has given the process its name—steeps the leather in solutions containing *tannin,* a substance that can be obtained from soaking tree bark, leaves, or nuts. This process is called *vegetable tanning.* Less frequently used are *oil tanning* or *chamoising* (sham-ee-zing), which involves soaking the leather in animal or fish oils to soften it, and *mineral tanning* or *tawing,* which involves soaking it in solutions of mineral salts such as alum. Since the nineteenth century, all three of these traditional methods have been replaced by *chemical tanning* processes. The new chemical processes are more easily controlled and produce leather that can accept brighter dyes than before, but the vegetable tanning process had produced leather that was both thicker and more natural-looking than modern leather. The older method also produced very sturdy products: Roman soldiers, for example, fought with battle shields made of vegetable-tanned leather.

The Spanish, more than any other people, were fond of using leather in their interiors. They used it not only for chair upholstery and cushion covers, but also for making large hangings and covering whole walls and even floors. Chests for clothing were often traditionally clad in leather (while chests for household silver were traditionally clad in vel-

✦ VOCABULARY TYPES OF IRON

- Iron, discovered in prehistoric times, is the fourth most abundant of the elements. It is a common part of the earth's crust, but usually in combination with other elements, from which it can be separated under intense heat. Even after separation, what is called iron is almost always an alloy of iron with traces of carbon and other elements. In early times, molten iron was cast into rough depressions in beds of sand; the resultant crude castings were called *pigs* and such unrefined iron is called *pig iron.*

- If pig iron is remelted and poured into more precise forms or molds, the result is called **cast iron.** Cast iron has been much used, particularly in the nineteenth century, in producing columns and other architectural elements, machinery, radiators, stoves, and other equipment, but it is a material of limit-

 ed malleability and can neither be hammered nor welded. In China, cast iron was used for making molds in which bronze castings were made.

- If pig iron is remelted and purified in a second furnace and then pressed between rollers, the result is called **wrought iron.** It is more pure and more malleable than cast iron, can be welded, and is appropriate for producing a wide variety of useful and ornamental forms.

- When iron is refined to remove undesirable alloying elements and to add desirable ones, the result is **steel,** a material so hardened that it strikes sparks from a flint. The steel produced in Toledo, Spain, was particularly admired for its quality. When one of the added components is a large percentage of chromium, the result is **stainless steel;** it is rustproof, stainproof, and lustrous.

vet). Especially in Andalusia, leather chests and boxes decorated with brass studs and escutcheons were very popular.

As early as the tenth century, the Spanish city of Córdoba was famous for producing a soft leather called *guademeci* or *guademecil.* It was characterized by raised patterns and brilliant coloring, with gold or silver sometimes added. Its name was derived from the town of Ghadames in Libya, where a similar leather was produced, and Córdoba in turn lent its name to our term *cordovan* and the English term *cordwainer.* So admired was the leather of Córdoba that in 1502 Queen Isabella ruled that no leather produced elsewhere could use the city's name. In 1570 Catherine de Médici ordered four sets of Córdoban guademeciles for the decoration of the Louvre. But fine leathers were also produced in Valencia, Granada, Seville, and other Spanish cities.

The Spanish did not leave much of their leather unadorned. Their methods of decorating it included piercing, scoring, punching, carving, dyeing, painting, gilding, embossing, scorching, and molding. The last few of these methods deserve some description:

- To gild leather, a design can be pressed or carved into the leather surface with hot tools. An adhesive—such as beaten egg whites, called *glair*—can then be applied, and sheets of gold leaf laid over it. After the gold leaf adheres to the uncarved surfaces, the excess is brushed away, revealing the design. In a less expensive variation, silver or tin foil is used and then painted with yellow varnish to simulate gold.

- To emboss leather, designs are etched into metal plates or cut into wood blocks (Figure 14–29) that are forced onto the surface in a screw press or roller press. Sometimes a countermold with the design in reverse is simultaneously pressed into the rear surface. Alternately, a small tool called a *spade* can be used to flatten some areas of the surface, leaving others raised. Today, embossed leather is called by the French term **gauffrage.**

- To scorch leather—a process popular in Spain in the sixteenth, seventeenth, and eighteenth centuries—light tan sheepskin was brought into brief contact with heated metal that left decorative patterns of brown scorch marks. Some old inventories list items said to be made of

Figure 14–29 Spanish wood mold for embossing leather, seventeenth century, 29 by 36 inches (75 x 93 cm).
VICTORIA AND ALBERT MUSEUM, LONDON/ART RESOURCE, NY

"leather damask," and these are thought to have probably been scorched leather.

- To mold leather, a technique in use since Neolithic times, the first step is to soak the leather in very hot water, and for this reason the process is often given the French name *cuir bouilli,* "boiled leather." The second step is to mold the wet leather around a form of wood, stone, or metal to produce the desired shape. This technique was often used to produce leather cups, jugs, or flasks, for which a lining of wax or resin was often added. The formed leather could then, of course, be decoratively treated in any of the above methods.

Cork

An unusual feature of the Portuguese landscape is the abundance of cork trees, an evergreen species of oak, and an unusual feature of Portuguese interiors is the use of cork, the spongy bark of those trees. (There is a layer of cork in all trees, but in these

particular oaks it is unusually thick.) The material is resilient, light, chemically inert, water and sound absorbent, and has excellent insulating properties against extremes of heat or cold. It has long been used for bottle stoppers and fishing floats, but for at least as long as since the Middle Ages, it has also been used for interior wall surfacing, flooring, tabletops, and seat covers. The seventeenth-century English diarist John Evelyn (in *Sylvia*, 1679) wrote of the use of cork in Spain: "The poor people in *Spain* lay broad *Planks* of it by their Beds-side, to tread on (as great Persons use *Turkie* and *Persian* Carpets) to defend them from the *floor*, and sometimes they line or *Wainscot* the Walls, and inside of their Houses built of Stone, with this *Bark*, which renders them very warm, and corrects the *moisture* of the Air."

Portugal remains a major source of cork. Today, cork for interior use is most often seen in tile form, and sometimes in thin sheets. Some of it is still the natural material, which—for all its virtues—is easily dented and stained. Most of the cork commercially produced now is therefore made more durable by being laminated with vinyl or impregnated with vinyl resins.

Textiles

Like other Spanish and Portuguese decorative arts, the textiles of Iberia were often strikingly patterned and brilliantly colored. The Islamic influence was obvious in the Middle Ages, and walls in the royal palaces and mansions of the nobles were often hung with tapestries from Flanders, a part of the Netherlands that was under Spanish rule for periods during the fifteenth to eighteenth centuries. During the Renaissance, Italian influence was also felt, with many of the textiles used for draperies, cushions, and upholstery either imported from Italy or woven in Spain to Italian designs. In the eighteenth century, Portuguese cotton prints were also in favor.

Among the Iberian textile techniques were embroidery, tapestry weaving, carpet weaving, and needlepoint.

EMBROIDERIES Spanish embroidery was at first inspired by the fine pre-Columbian embroideries imported from Peru. In turn, Spanish embroidery then influenced the rest of Europe, so-called Span-ish work becoming highly popular, having been introduced into England (it is thought) by Katharine of Aragon, the daughter of Spain's Ferdinand and Isabella, who became Queen of England as the first wife of Henry VIII. Spanish work was made with black outlines on a white ground and, later, in all black. Gold and silver threads were also sometimes added. Within Spain, rich embroideries were used for ecclesiastical work, and sometimes (as examples in the Musée Cluny, Paris, show) in imitation of paintings by Murillo and other popular artists. In Portugal, embroidery showed more influence from the East, and flowers, birds, butterflies, and dragons were popular embroidered motifs.

TAPESTRIES In addition to the tapestries imported from Spanish Flanders, where the art was well developed, many tapestries were made in Spain itself. When Spain lost control of the Netherlands colony in 1714, Philip V felt compelled to offset the loss by establishing a national tapestry factory in Madrid: the Real Fábrica de Tapices y Alfombras de S. Bárbara began to function in 1720 and is still in business today.

CARPETS At least since the fifteenth century, the weaving of carpets (*alfombras*) has been an important industry in Spain. The earliest Spanish carpets we know were long and narrow, and were often woven with the coats of arms of Spanish families and other heraldic devices as central features, often on backgrounds of diaper patterns. Colors were limited to a small but intense palette of blue, red, green, and yellow. The designs of other early Spanish carpets reproduce Eastern or Moorish patterns, some of them recalling tile work.

Two important Spanish centers of carpet weaving were Alcaraz and Cuenca. The Alcaraz factory, from the late fifteenth to the mid-seventeenth century, produced carpets with wool pile on undyed wool foundations. The dominant color of Alcaraz carpets was red, and the chief design motifs were geometric. The Cuenca weavers, continuously active since the fifteenth century, produced carpets with wool pile on foundations of goats' hair. The early models for Cuenca designs were Turkish carpets, but from the eighteenth century on Cuenca weavers began making fine imitations of Aubusson and Savonnerie carpets.

Figure 14–30 The Spanish knot or single-warp knot for carpet weaving, each knot wrapping around a single strand. Compare it with the symmetrical and asymmetrical knots shown in the chapter on Islamic design (Figures 9–37 and 9–38).

MURRAY L. EILAND, JR., AND MURRAY EILAND III, *ORIENTAL CARPETS, A COMPLETE GUIDE*, LONDON: LAWRENCE KING PUBLISHING, 1998.

Many Spanish carpets are woven with a distinctive knot that loops once (or sometimes twice) around only a single warp thread. Although such knots have been found in rugs from other places (such as Chinese Turkestan and Coptic Egypt), such a knot is generally known as a **Spanish knot.** It is distinct from the **symmetrical** or **Turkish knot** and the **asymmetrical** or **Persian knot**, both of which are attached to two warp threads. In its most common version (Figure 14–30), the Spanish knot is tied to alternate threads in one row and to the other threads in the row above, producing a weave with smooth diagonals but with slightly serrated vertical and horizontal lines. The knot was used at both the Alcaraz and Cuenca factories, although at Cuenca it was replaced by the symmetrical knot in the late seventeenth century.

PORTUGUESE NEEDLEPOINT RUGS About 60 miles (100 km) inland from the city of Lisbon is the small Portuguese town of Arraiolos, which from at least as early as the seventeenth century and perhaps from even earlier times has been the chief source of a distinctive type of pileless needlework wool rug, originally woven on a linen ground and later on linen, jute, or hemp canvas. When, in the seventeenth century, the popularity of delicately patterned Persian carpets swept Europe, the

arraiolos rugs naturally imitated Persian designs, and it is said that they even served as substitutes for the more expensive Persian models: the copies were laid over the originals to protect them and to serve for family use, but were taken up on special occasions. In any case, the swirling floral motifs and central medallions from Persia were important in early arraiolos design (Figure 14–31).

The use of a color for these motifs that contrasts strongly with the background color is characteristic. In times when natural dyes were used, the predominant colors were blue (obtained from

Figure 14–31 A Portuguese needlepoint wool rug or *arraiolos*, with three central medallions, seventeenth century, 12 feet 6 inches (3.8 m) long.

THE TEXTILE MUSEUM, WASHINGTON, DC, NO. R44.6.I. ACQUIRED BY GEORGE HEWITT MYERS IN 1945.

indigo), yellow (from dyer's weed or a shrub called spurge), and red (from brazilwood). Even after other dyes became available, color schemes were still often limited to only blue and yellow, but at other times they included green, brick red, and a deep blue green. Later designs also varied. Some of the design influences came to Portugal from India. Other designs included hunting scenes, family crests, coats of arms, patterns taken from *azulejos* tiles, peacocks and other birds, and—during Hapsburg reign—the two-headed Hapsburg eagles. In the eighteenth century, production of these rugs was at a peak, with over fifty workshops in Arraiolos alone, one of which is reported to have employed three hundred workers. There were workshops in other locations as well, and rugs were also produced in convents, homes, and even prisons. During the nineteenth century, however, there was a decline in the production of arraiolos, and by the end of the century the art was almost forgotten. Two American importers, Aram Morjikian and Arthur Stark, have been responsible for a modest twentieth-century revival of Portuguese needlepoint rug production, but it is no longer centered in Arraiolos. Collections of arraiolos rugs can be seen in the Palacio Nacional de Queluz, Queluz, and the Museu Nacional de Arte Antigua, Lisbon.

Summary: Spanish Design

The design of Spain and Portugal is obviously an important part of the story of European design, a story that reaches its climax in the years of the Renaissance. While Spain may be overshadowed by Italy and France in some aspects of that story, Spain's own design history is larger and deeper. It began earlier with the Moorish wonders of southern Spain that surpassed in sheer delight anything then being produced in the rest of Europe. And its influence penetrated farther: as we shall see in chapter 17, from the voyage of Columbus to the early years of the nineteenth century, virtually the whole of Central America and South America and a large part of the West Indies were under Spanish or Portuguese control. The character of Spanish design is therefore one of the most important elements of the entire world picture of design.

Looking for Character

Art historian Oskar Hagen has suggested that the character of the Spanish people and their design can best be expressed with two Spanish terms, *grandeza* and *sosiego*. *Grandeza* can be translated as "greatness or nobility," and *sosiego* as "calm or composure." Together, they give us a picture of a national spirit that is formal, dignified, quiet, self-assured, sober, and strong.

There are grand gestures and violent passions in Spanish art, but these are generally kept in check by an inherent restraint. Spain, in its national character and in its design, seeks to demonstrate its exercise of control over the emotional forces it obviously feels. Such a demonstration can at times be melancholy or melodramatic, but at others it can be genuinely dramatic and powerfully moving.

The reason for the long popularity of Moorish decoration in Spain seems to be that it fit so naturally into the character of Spanish taste. It is not only in Moorish decoration, but also in the florid Spanish Gothic, in the Plateresco of the Renaissance, and in the Churrigueresco of the eighteenth century that interior planes are completely overspread with intricate pattern. In Hagen's words, "In a Spanish interior, whether it be a church or a palace hall, a profuse interlace of ornaments covers every square foot of wall space. It spreads from the floor to the ceiling, over the piers and vaults of the basilica . . . , over the retable, over the iron trellises that enclose the . . . chapels. The ornamental web may be incised, carved in bas-relief, wrought in metal, painted, woven, or embroidered; but whatever the medium, it extends as an allover pattern on every available plane."

Not only was the Spanish spirit receptive to the overall planar ornament of Moorish decor; it was also receptive to the fact that such décor is generally subservient to the planes it ornaments. Its details are precise and its effects are multiple. Wherever the eye looks it is entertained. But there are no bold forms or gestures that seize the spotlight by being larger or more dramatic than their neighbors; there are no thrilling perspectives or foreshortenings that destroy our sense of flat decorated surfaces. Moorish décor is remarkably extensive in scope, seeming to encompass everything within reach, but remarkably reticent in detail. In

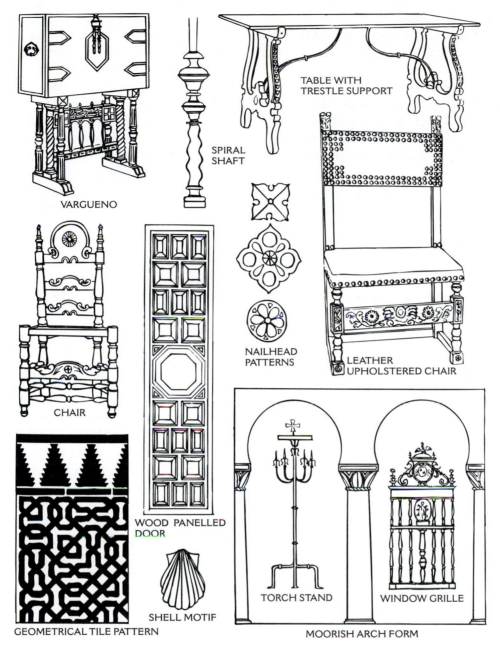

Figure 14–32 Typical Spanish furniture and decorative details.

DRAWING: GILBERT WERLÉ

VARGUENO

SPIRAL SHAFT

TABLE WITH TRESTLE SUPPORT

CHAIR

WOOD PANELLED DOOR

NAILHEAD PATTERNS

LEATHER UPHOLSTERED CHAIR

GEOMETRICAL TILE PATTERN

SHELL MOTIF

TORCH STAND

WINDOW GRILLE

MOORISH ARCH FORM

both characteristics, it seems to have found a natural home in Spain.

Looking for Quality

Much of the Spanish architecture, interior design, and furniture that we have seen is a local translation of foreign influences (Figure 14–32). In many cases, perhaps most clearly in Spanish versions of French and Italian Renaissance furniture, some of the originals' fineness of detail, subtlety of curve, or elegance of finish seems to have been lost. But there are impressive compensations. The Spanish versions almost always express the same tendencies with greater vigor. Proportions are more masculine, scale is larger, members are heavier and

stronger, gestures tend to be more angular, expressions are bolder. One quality we find in Spanish design to an exceptional degree is forcefulness of expression.

Yet there is fineness and delicacy, too. Solid interiors and sturdy pieces of furniture can be given surface treatments of fascinating intricacy. A curving chair arm can reverse its direction a surprising number of times. Metalwork can be wondrously filigreed or richly inlaid. Leather can be decoratively treated in ways unimagined elsewhere. And there is a wonderland of small-scaled geometric tile patterns.

Making Comparisons

The most obvious comparisons are between Spanish design and the Italian and French design that at times influenced it so strongly and that at times it deliberately imitated. Italian design of the Renaissance, which we considered in the last chapter, constituted one of the great artistic achievements of history, particularly in architecture and painting. The French design that followed, which we shall consider next, also reached great heights of accomplishment, particularly in furniture design and the decorative arts. These both set very high standards against which to judge any other work. Even so, we see in Spanish design a unique combination of vigor, strength, and pride. At its best, Spanish design possesses a nobility beside which Italian design can seem frivolous and French effete. In all the centuries between the classical period of Greece and Rome and the modern period that began in the eighteenth century, Italian and French design may surpass all other European efforts in their perfected refinement, but Spanish design reminds us that refinement is not the only quality worth valuing.

Another obvious comparison is between Spain and Portugal, a neighbor with which its history is inextricably bound. As already suggested, the differences between these two bodies of art can be traced to Spain's longer exposure to the design of the Moors and to Portugal's greater exposure to the design of the East. The two countries, of course, were well aware of each other's artistic activity, so that Spain was not immune to influences from Portugal's Far Eastern colonies.

Finally, comparisons demand to be made *within* the Spanish vocabulary. We have seen some Spanish facades and altar screens and tiled floors writhing with ornament and pattern, and we have seen others that are strikingly still and mute. Can these extremes be reconciled within a single artistic temperament? Perhaps they can, for, as we have seen, Spanish ornament at its most dense — and at times there seems to have been no room for one more tile or one more tendril — even then, there is a reticence and a regularity that respects the integrity of the plane (not plain) surface and that keeps every element in its place. Even at its most profuse, there is a stillness at the heart of Spanish ornament. Spanish design may be effusive, but it is seldom disorganized. It may be emotional, but it is seldom sentimental. It may at times lack humor and charm, but never nobility and strength.

15

THE FRENCH RENAISSANCE AND LATER DEVELOPMENTS

FIFTEENTH TO EIGHTEENTH CENTURIES

In France, the Gothic style had been employed with passion, and the greatest of the Gothic cathedrals had been built there. Naturally, France was slower than Italy in moving beyond the Gothic vocabulary. When the French Renaissance finally appeared, however, it developed with extraordinary skill and grace, producing some of history's most beautiful rooms, most elegant furniture, and most lavish decorative arts.

Achievement, Decline, and Revolution

The styles of French interior design, furniture, and decorative arts are traditionally identified by the names of French rulers. Obviously, however, no matter how influential a ruler's

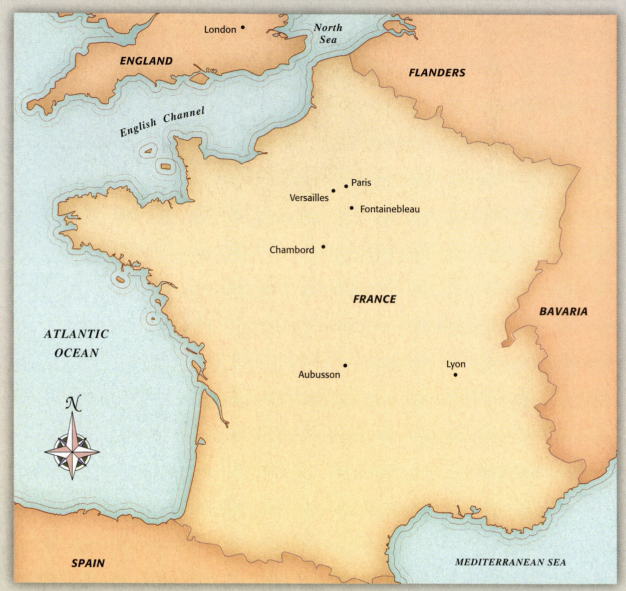

Figure 15–1 MAP OF FRANCE

ORTELIUS DESIGN

personal taste may be, styles do not change overnight when one reign succeeds another. There are in fact some noticeable discrepancies between the dates of French rulers and the dates of the styles named for them. For one example, Louis XV was overseen by a regency from 1715, when he was five years old, until 1723, when he was thirteen, but what we now call the Régence style is considered to have begun earlier (in 1700) and lasted longer (until 1730). And what we call

the Louis XVI style began in 1760, fourteen years before Louis XVI was crowned. Perhaps, therefore, a better policy is to use only more descriptive terms such as Baroque and Rococo, as some now do, but so frequently encountered are the traditional terms that they need to be understood. In the outline that follows, the dates in parentheses are the generally accepted dates for French styles, not necessarily the dates of actual reigns.

 VOCABULARY TERMS FOR THE FRENCH STYLES

When styles are identified by the reigns of French kings, the cardinal—not the ordinal—numbers of their titles are used (in English, *fourteen* not *fourteenth*). For example:

- **Louis XIV** is pronounced (and often spelled) Louis Quatorze (kha-torz)
- **Louis XV** = Louis Quinze (khaz)
- **Louis XVI** = Louis Seize (sez)
- **François I** is sometimes seen as *François I^{er}* or François Premier (prem-yeh).
- It is good practice to refer to the style associated with the regency of young Louis XV by using the French spelling and pronunciation,

Régence (ray-jhanz), thus making a distinction between it and the English **Regency,** which came in a different country and a different century.
- The term **French Provincial** refers to any of the provinces of France, such as Normandy, Brittany, Burgundy, or Champagne. The term *Provençal* refers only to Provence, a region (and former province) of southeastern France.

The Early Renaissance (1484–1547)

The French kings Charles VIII, Louis XII, and François I broadened the horizons of French culture by acknowledging the accomplishments of Italy and Spain. Their reigns constitute what can be called France's Early Renaissance, a time of transition, with Gothic forms overlaid with Renaissance details and ornament. We shall later look at the château of Chambord as one example.

In the interiors of the Early Renaissance, the change was visible in the shaping of both stone and wood decorative elements. In wood paneling, the **grotesques** adapted from Raphael's *loggie* added a lighter, more fanciful touch to the linenfold and tracery motifs inherited from Gothic times. Near the end of the reign of François I and into that of Henri II, some further purifying took place, Gothic pilaster decoration being replaced by classically proper fluting with capitals and bases.

Furniture for these transitional interiors was massively built. Like the buildings themselves, it used Gothic structural forms to which Renaissance ornament was applied. The important chairs continued to have the aspect of thrones and to be built with storage compartments under the seats. Both oak and walnut were used as cabinet woods.

The Middle Renaissance (1547–1589)

This comprised the reigns of the next four French kings, Henri II, François II, Charles IX, and Henri III, and the period's dominant personality was Catherine de' Medici, wife of the first of those kings and mother of the other three. In this period the transition toward Renaissance design progressed, gradually eliminating Gothic forms. Paneling was beautifully carved with graceful figures, arabesques, and grotesques. The small four-legged conversational chair called the **caquetoire** came into use (Figure 15–2). Architects of the period were Philibert De l'Orme and Pierre Lescot, a sculptor who often collaborated with Lescot was Jean Goujon, and leading furniture designers included Jacques Androuet du Cerceau and Hugues Sambin.

The Late Renaissance (1589–1643)

In the reigns of Henri IV and his son Louis XIII, the Italian influence continued in France but was joined by the influence of Spanish-ruled Flanders. Part of the Flemish influence was the introduction of bun-shaped **Flemish feet** under pieces of case furniture (top right and bottom left in Figure 15–3, page 355). Furniture supports consisted of slender

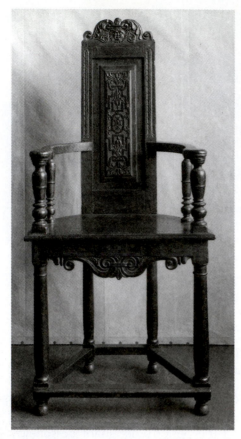

Figure 15–2 Wood armchair of the caquetoire type, c. 1575.

KUNSTINDUSTRIMUSEET I OSLO, THE OSLO MUSEUM OF DECORATIVE ARTS AND DESIGN

classic columns or spiral turnings. Table and cabinet legs were braced with flat stretchers in the shape of a letter X with a vase form or finial at its crossing. Walnut and oak continued to be used, but ebony also became popular as a furniture wood. In the finest pieces, ornaments were carved or inlaid in woods of contrasting colors, in tortoiseshell, semiprecious stones, and gilt bronze. Upholstery consisted of elaborately embossed cordovan leather, velvet, damask, and needlework, often trimmed with fringes.

The Baroque Style (1643–c. 1700)

The first half century of the long reign of Louis XIV has been called France's golden age. It was a time of great splendor and astonishing displays of wealth. Its earliest days under the regency of Cardinal Mazarin (1642–61) still felt foreign influences,

most strongly those of Italy (where Mazarin himself had been born), but after 1661, when Mazarin died and Louis, age twenty-two, became sole ruler of France, these influences began to be assimilated into an accomplished native style.

We have said that changes in artistic style do not always follow the successions of royalty. Even so, the height of the style identified with Louis XIV seemed to reach its apogee in the years 1685–90, just when that king's reign seemed most secure and glorious. In those years he presented himself as—and perhaps even believed himself to be—a god on earth. His architecture, his rooms, and his furniture were suitable for the role.

All these arts were distinguished by unity, majesty, and distinction. There was extensive use of the classical orders, used in authentically classical proportions. Columns, pilasters, and entablatures were enriched with gilded metal and carved ornament. The pilasters either rose from the floor or stood on a pedestal that established the height of a low dado around the room, and the wall area between them was enriched with one or more panels extending the whole height from the dado to the architrave at the ceiling. Ceiling coves were enriched by plasterwork and painted ornament, and the central areas of ceilings were painted with celestial scenes.

Walls were faced with paneling, usually of wood (and most commonly oak) in the private apartments, but of stone and colored marble in the more formal public rooms. Sometimes the panels were painted with portraits and historical or mythological scenes. Large plate-glass mirrors, considered the height of luxury and extravagance at that time, were also used as panel enrichment. Paneling was consistently rectangular, but sometimes the tops would follow a semicircular or segmental curve, and sometimes circular frames above panels would enclose portraits or flower paintings. Panels were framed in large ornamental moldings, often gilded, and medallions or other decorative carvings were sometimes placed in the panel centers. The French word *boiserie* is used for carved wood paneling of all the French periods.

Baroque doors and windows were also framed with heavy moldings. Overdoors were frequently enriched with wood sculpture carved in high relief. Mantels of enormous size were invariably of col-

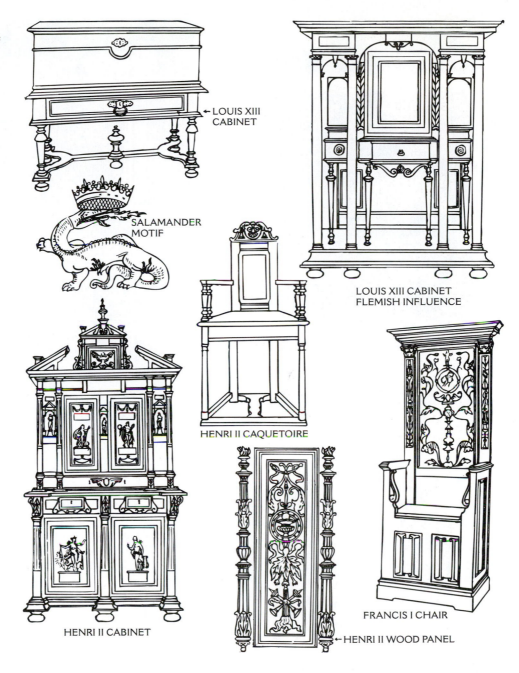

Figure 15–3
French Renaissance furniture and details. The fire-breathing salamander was a decorative motif associated with François I.

DRAWING: GILBERT WERLÉ

LOUIS XIII CABINET

SALAMANDER MOTIF

LOUIS XIII CABINET FLEMISH INFLUENCE

HENRI II CAQUETOIRE

FRANCIS I CHAIR

HENRI II CABINET

HENRI II WOOD PANEL

ored marble, richly carved, their shelves slightly shaped and with molded edges. Overmantels were mirrored or paneled.

Floors were patterned with oak parquet or with black and white marble squares. Floor coverings were usually Savonnerie pile rugs in colors and patterns chosen to harmonize with the architecture and ornament of the room. The room was treated as one magnificent composition of classical orders, decorative paintings, carvings, tapestries, and mir-

rors. Movable objects were considered secondary elements in the composition: most of the furniture (such as the armchair in Figure 15–4) was placed against the walls, leaving the center of the room free. Crystal or carved wood chandeliers hung in the center of the room, but additional light was given by torchères, wall brackets, and elaborate candlestands.

There were strong and contrasting colors. Ornamentation included intertwined L's and sun faces

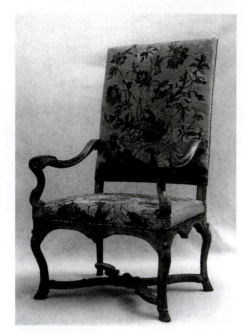

Figure 15–4 Walnut armchair from the late seventeenth century. Its scroll-shaped legs are braced by an X-shaped stretcher.

Figure 15–5 A sun symbol carved on a door of the Salon d'Apollon in the Grand Appartement of Versailles. As the salamander had represented François I, Louis XIV was known as the Sun King.

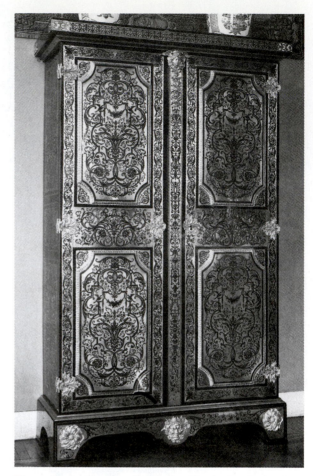

Figure 15–6 Cupboard by André-Charles Boulle faced with his characteristic decorative work in gilt metal and tortoiseshell, c. 1690.

with spreading rays, both symbols of the king (Figure 15–5). Newly introduced furniture included chests of drawers, settees, console tables, and daybeds. Accessories consisted of busts, hanging mirrors, Eastern porcelains, terra-cotta urns, paintings, and statues, and there was extensive use of wall tapestries.

Although all final decisions were made or approved by the king, three great powers at court were Louis XIV's minister Jean-Baptiste Colbert; his chief painter, Charles Le Brun; and his architect Louis Le Vau (later succeeded by Jules Hardouin-Mansart). André-Charles Boulle was the outstanding furniture designer of the Baroque period (Figure 15–6 and upper left in Figure 15–7), but important also were the *ébénistes* Pierre Gole, Dominique Cucci, and Alexandre-Jean Oppenordt. Jean Berain I was an important decorator *(ornemaniste)* of the Baroque style, and the trans-

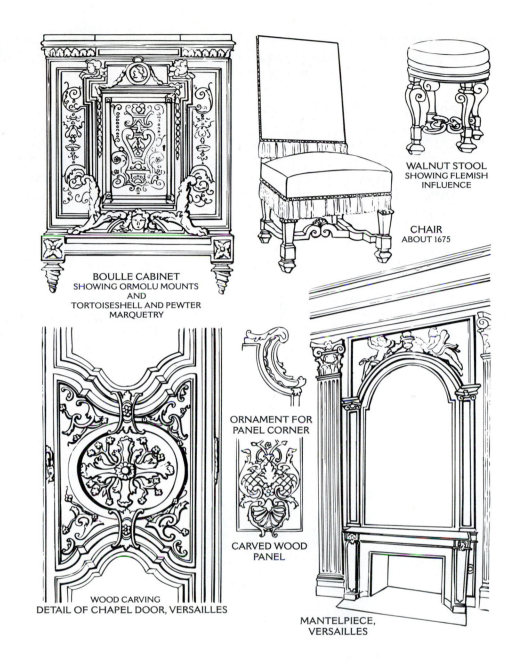

Figure 15–7 French Baroque furniture and interior details.

DRAWING: GILBERT WERLÉ

BOULLE CABINET
SHOWING ORMOLU MOUNTS
AND
TORTOISESHELL AND PEWTER
MARQUETRY

WALNUT STOOL
SHOWING FLEMISH
INFLUENCE

CHAIR
ABOUT 1675

ORNAMENT FOR
PANEL CORNER

CARVED WOOD
PANEL

WOOD CARVING
DETAIL OF CHAPEL DOOR, VERSAILLES

MANTELPIECE,
VERSAILLES

formation of Versailles was the period's great design accomplishment.

The Régence Style (c. 1700–1730)

In 1685, when Louis XIV ended religious freedom for French Protestants, many talented designers left France. Prominent among such émigrés was Daniel Marot (1661–1752), who had been a designer of ornament, paneling, and furniture. He moved to Holland in 1686, taking the seeds of the French Baroque style with him, and in 1694 he moved on to England, where he also introduced it.

When Louis XIV died in 1715, the crown passed to his grandson Louis XV, then a child of five. A regent governed until the king was of age. The style of the Régence period was that of another transition, this time from the exuberant Baroque to the more delicate Rococo that would follow (Figure 15–8). Symmetry was still preserved, but the rigidity of the Baroque style was softened with new serpentine forms. Furniture innovations

were hinge-topped writing desks and tall clock cases *(regulateurs)*. Seating moved away from the walls and was placed more informally in the center of the room. Chairs were given comfortably thick cushions, and canework became popular. Boulle

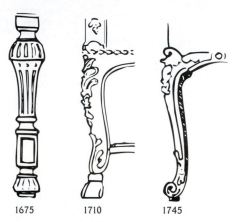

Figure 15–8 Changes in chair leg profiles are typical of the progression of French styles. From left to right: Baroque, Régence, and Rococo legs.

DRAWING: GILBERT WERLÉ

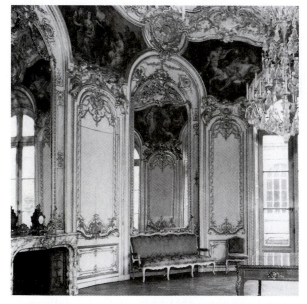

Figure 15–9 In the Hôtel de Soubise, a salon designed by Germain Boffrand for the Princesse de Soubise, 1736–37. All the relief work here is gilded, and the spandrels are filled with paintings by Charles-Joseph Natoire.

GERMAIN BOFFRAND (FRENCH, 1667–1754) AND CHARLES-JOSEPH NATOIRE (FRENCH, 1700–1777). THE PRINCESS SALON, HOTEL DE SOUBISE, PARIS, 1732. WAYNE ANDREWS.

continued his outstanding furniture design and was joined by another master, Charles Cressent.

The Rococo Style (1730–60)

The Rococo style in France dominated the central years of the reign of Louis XV, which would last until 1774. It was a style that had great impact on interiors. It was not only more economical than the Baroque, with smaller rooms and smaller furniture, but also more fanciful, even at times fantastic (Figure 15–9). Straight lines, classical orders, and symmetry were replaced with curves. Bold colors lost favor to pale ones. Pomp surrendered to charm.

The walls of some Rococo rooms, particularly foyers and entrance halls, were faced with marble or limestone, but most were covered with wood paneling, the panels being smaller than in earlier styles and sometimes in alternating widths. Panels were often asymmetrical in shape. The carved decorations in the centers of earlier panels were replaced by painted scenic or floral compositions in delicate colors. Textiles, either silks or printed cottons, were sometimes stretched in the panel centers as substitutes for painting. In some rooms the oak woodwork was merely polished with wax, but in most it was painted in soft rose, turquoise, green, mustard, or putty color.

The dado was used less frequently and, when used, was usually lower than it had been in the Baroque period. Walls were finished at the top with a simple architrave molding—never with a complete classical entablature—and rising from the molding was a decorated plaster cove that eliminated the angle between wall and ceiling. The corners of rooms were also sometimes curved in plan to avoid right-angled intersections. Mantels were made in marble, with sweeping curved shelves and fire openings. The overmantel was generally a wood-framed mirror called a **trumeau** (the word having originally indicated the wall area between two windows and then the pier-glass mirror often hung in that area). On the wall directly opposite, above a console or cabinet, was usually another mirror, the facing pair providing an infinity of reflections. Elaborate cast-iron firebacks, gilt-bronze lighting fixtures, and andirons in Rococo forms were used. Textile patterns were reduced in scale and consisted of scrolls, ribbons, flowers, and shells in flowing, all-over pat-

PERIOD AND DATE	CHIEF REIGNS AND DATES	ARCHITECTS, DESIGNERS, AND ARTISANS	ARTISTIC MILESTONES
Early Renaissance, 1484–1547	François I, 1515–1547	Lescot	Chambord, from 1519; Fontainebleau, from 1530; remodeling of Louvre, from 1546
Middle Renaissance, 1547–89	Henri I, 1547–59	De l'Orme; du Cerceau	Work continues at Louvre
Late Renaissance, 1589–1643	Henri IV, 1589–1610; Louis XIII, 1610–43	Mansart	Hunting lodge at Versailles, 1623; Hotel Lambert, 1640
Baroque, 1643–1700	Louis XIV, 1643–1715	Le Vau; Le Brun; Le Notre; Hardouin-Mansart; Le Pautre; Boulle; Berain; Perrault	Vaux-le-Vicomte, 1653–61; Versailles enlarged, Grand Trianon at Versailles; Louvre enlargement finished
Régence, 1700–1730	Louis XV king, but Philippe II d'Orleans acting as regent, 1715–23	de Cotte; Cressent; Delamair	Chapel at Versailles, 1699–1710; Hôtel de Rohan, 1705
Rococo, 1730–60	Louis XV, 1723–74	Boffrand; Oeben; Pineau; Verberckt; Meissonnier	Reconstruction of royal apartments at Versailles; Hôtel de Soubise, c. 1740
Neoclassical, 1760–89	Louis XVI, 1774–93	Gabriel; Ledoux; Boullée; P. Garnier; de Lalonde; Riesener; Carlin; Roentgen; Delafosse; Dugourc	Petit Trianon, 1768; the Ópera added to Versailles, 1748–70; Hôtel de Salm, 1783
Revolution and Directoire, 1789–1800	The Directorate, 1795–99; The Consulate, 1799	Weisweiler; Jacob; Molitor	Production revived at the Sèvres and Savonnerie factories

terns. Brocades, damasks, taffetas, satins, moirés, and other fine silk weaves were used for full draperies at the windows. Floors were in rectangular parquet patterns or in elaborate marquetry arrangements made of contrasting woods. Public rooms had floors of marble squares. Floor coverings were made at the Aubusson and Savonnerie factories in curvaceous patterns and delicate colors.

The cabinetmakers of the Rococo period developed so many new furniture types—including small gaming tables and toiletry tables—that they left few possibilities to their successors, and they neared perfection in technique and comfort. Rococo furniture was designed for the human body, not for pageantry, and most of it was small and unpretentious. The infallible characteristic was the use of the curvilinear form at all times, particularly the cabriole leg with a scroll foot rather than a goat's hoof. The straight line was diligently avoided; the framework of the furniture was designed to eliminate the appearance of joints; and the principle of continuity was maintained wherever possible (Figure 15–10).

Mahogany came into use as a furniture wood, and other popular woods were walnut, oak, cherry, beech, and elm. Many pieces were made in whole or in part of fruitwood—apricot, pear, plum, and others. Marquetry designs were of tulipwood, kingwood, violetwood, yew, amaranth, palisander, and lignum vitae. Among these, black whalebone was used for narrow strips.

Louis XV's favorite, Mme. de Pompadour (1721–64), was intensely interested in the decorative arts and spent both time and money furthering them. French artists who became adept at Eastern motifs such as **chinoiseries** and **singeries** (scenes of monkeys at play) included Christophe Huet and Jean Pillement. The latter worked on Marie-Antoinette's rooms at the Petit Trianon and also carried the French Rococo style to Spain, Portugal, England, and Poland. Germain Boffrand (1667–1754) was a major Rococo architect and designer of interiors, although he also worked in more severe styles. Important furniture designers—who, beginning in 1751, were required to stamp their work—included Juste-Aurèle Meissonnier, Jean-François Oeben, and Gilles Joubert.

At its most debased, the Rococo style was artificial, sentimental, trivial, and undisciplined; at its best, it was pure delight. It was perhaps the most original and characteristically French of all

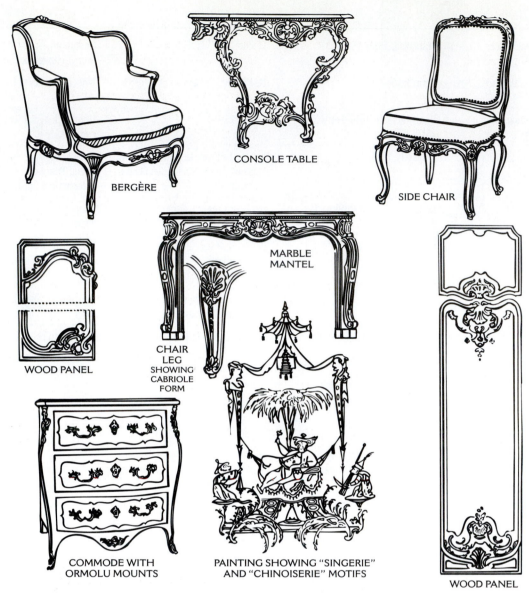

BERGÈRE

CONSOLE TABLE

SIDE CHAIR

WOOD PANEL

MARBLE MANTEL

CHAIR LEG SHOWING CABRIOLE FORM

COMMODE WITH ORMOLU MOUNTS

PAINTING SHOWING "SINGERIE" AND "CHINOISERIE" MOTIFS

WOOD PANEL

Figure 15–10 French Rococo furniture and details.

DRAWING: GILBERT WERLÉ

the French styles, and for thirty years it enjoyed popularity at all levels of society. By 1760, however, guided by the taste of Mme. de Pompadour, the country was ready for a more restrained expression: Neoclassicism.

Rococo in the Country: French Provincial

Before we continue our chronological survey of French styles, however, we shall take a brief de-

tour away from the artistic and aristocratic centers of Paris and Versailles and visit the countryside. What has come to be called the French Provincial style was essentially a simplified version of the French Rococo (although, as in Figure 15–11, there are also examples of Provincial versions of the Neoclassical style). The simplification was necessary, for in the countryside and smaller towns there were smaller budgets for interior embellishment and fewer skilled craftsmen to produce it.

Wood paneling was in fashion there, as it was in the great houses, but the chief rooms of humbler dwellings often had only a single wall of paneling, with the others painted, covered with wallpaper, or stenciled to imitate wallpaper. The motif of a fireplace topped with a trumeau was popular throughout France, but in the provinces the mirror was likely to be composed of smaller panes than in more cosmopolitan areas. Woodwork was generally painted in the soft colors of the period, with simple moldings picked out in contrasting colors. Bookshelves were built in, and sleeping rooms contained alcoves for the beds.

French Provincial furniture reproduced Rococo outlines in oak, ash, walnut, or fruitwoods such as apple and cherry. Carving was minimal, and ormolu mounts and marquetry effects were rare. The names of most French Provincial furniture makers are unknown, but members of the Hache family in the Grenoble area and the Demoulin family in Dijon are notable exceptions.

Both silks and printed cottons (the choice depending on budget) were used for panel areas, draperies, and upholstery, with the printed cottons known as **toile de Jouy** being particularly popular. Fabrics were embellished with embroidery of all kinds, including *gros point* and the more delicate *petit point*. Handpainted and stenciled linens were also used. In the provinces, pewter was the common substitute for silver.

Tôle is the French name for sheet iron, and the same term was used for accessories in eighteenth-century provincial interiors (such as lamps, trays, and small boxes) that were made of thin sheets of iron or tin. These were most often painted black with chinoiseries or floral decorations painted over the black ground in gold. Toleware, as we shall see, would also be popular in America in the early nineteenth century.

Rococo beyond France: South German Churches

The influences of French style in general and French Rococo in particular spread across Europe and—as we shall see in chapters 16 and 18—to England and America. In this chapter, we shall consider only one instance of such influence: the Rococo church in Bavaria in southern Germany.

The combination of florid ornament and religious ecstasy was a potent one, and the south German church of the eighteenth century was

Figure 15–11 French Provincial furniture.

DRAWING: GILBERT WERLÉ

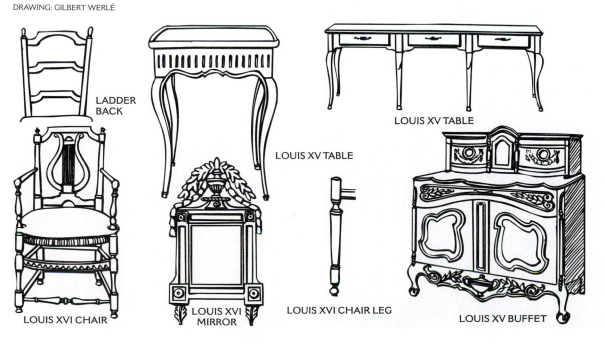

LADDER BACK

LOUIS XV TABLE

LOUIS XV TABLE

LOUIS XVI CHAIR

LOUIS XVI MIRROR

LOUIS XVI CHAIR LEG

LOUIS XV BUFFET

often a spectacular extravaganza. It was characterized by indirect light sources, by complex shapes with indeterminate boundaries, and by stucco decoration in high relief that occupied a middle ground between fresco and architecture—all calculated to produce a sense of wonder. Examples include Zwiefalten, the Benedictine abbey in Ottobeuren, begun in 1744 and designed by Johann Michael Fischer, and Die Wies, a pilgrimage church on the River Wies, built between 1745 and 1754 and designed by Dominikus Zimmermann.

Perhaps the greatest monument of south German Rococo, however, is Vierzehnheiligen (Figure 15–12), the pilgrimage church overlooking the River Main near Banz, built between 1742 and 1792 and designed by Balthasar Neumann (1687–1753).

Figure 15–12 View toward the altar, the pilgrimage church at Vierzehnheiligen, Germany, by Balthasar Neumann, 1742–92.

A. F. KERSTING

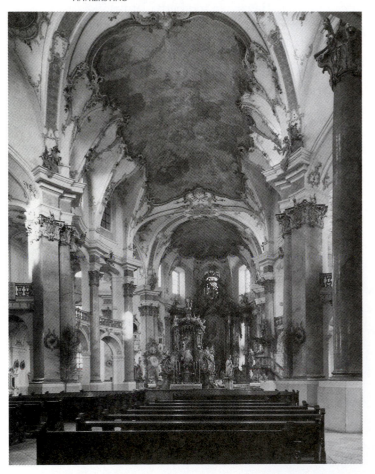

Vierzehnheiligen (named for fourteen saints seen on the site by a young shepherd in the fifteenth century) is based on a complex plan composed mainly of overlapping ovals. The interior is lighted by three tiers of windows. Dominant colors are pink and gray, but there are also marble columns and pilasters in green and yellow, all seen against white walls and multicolored stucco. The stucco artists were Johann Michael Feichtmayr, Franz Zaver, and Johann Georg Übelhör, and the ceiling fresco is by the Italian painter Giuseppe Appiani. The total effect, as in the French examples that inspired it, is one of restlessly fluid movement.

The Neoclassical Style (1760–89)

Back at Versailles, the last fifteen years of the reign of Louis XV saw a dramatic change of style. Just as the straight lines and classic details of the Baroque had been swept away on the frothy waves of the Rococo, that style in turn was replaced by a new sobriety and an even more rigorous respect for classical principles. Fueled by excitement over the 1752 discovery of Pompeii, the Neoclassical style would dominate the reign of Louis XV's grandson, Louis XVI, who succeeded him in 1774.

Neoclassical interiors retained all the intimacy of the Rococo style, but discarded its free curves, restricting curved forms to the circle and ellipse. Most wall panels, however, became rectangular. Architectural orders were revived, although they were used at smaller scale than in the Baroque period. Symmetry was revived as well, and applied to whole rooms and all their parts.

Neoclassical walls usually had low dadoes. In high rooms the paneling was crowned with a complete entablature, but low rooms had merely a cornice or small cove at the top. Panel moldings were sometimes painted a color contrasting with the field, or a narrow paint stripe would be added near the edge of the panel to accentuate the frame. Panel centers were often left undecorated, but in the more elaborate rooms they might be enriched with stucco reliefs or paintings of classical figures and garlands of naturalistic flowers. Stretched fabric and wallpaper were also used in panels, and in rooms where paneling was omitted, they might cover the whole wall. In Marie-Antoinette's bedroom at Fontainebleau, the background treatment

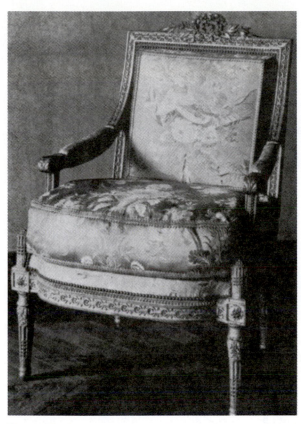

Figure 15–13 Armchair of the Neoclassical style stamped by Georges Jacob, c. 1775.

FRENCH CULTURAL SERVICES

of the wood panels is silver leaf rubbed with dull gold, and on this glowing surface are painted classical arabesques.

Furniture continued to be light and its proportions delicate, but its silhouette became rectangular. The cabriole leg straightened out, and the scroll foot disappeared. By 1770 the legs of all pieces of furniture were straight and tapered, either round or square in section and often enriched with vertical or spiral flutings. The legs were often topped by square blocks on which small rosettes were carved. Chair backs were either rectangular or oval (Figure 15–13).

The four-poster bed returned to popularity, and some beds were made with head- and footboards of equal height. Many small tables and much of the case furniture were topped with colored marble. Writing tables and desks usually had tooled leather surfaces. Woods of the Rococo period continued to be used, with mahogany used more extensively

and with ebony becoming popular again. Painted furniture also became more common, but the lacquer finishes popular in Rococo times lessened in use (Figures 15–14 and 15–15).

Around 1780 many books on Greek, Etruscan, and Egyptian art and architecture were issued, and artists in all mediums drew on those sources. Sphinxes, winged vultures, sarcophagi, palms, lotus blossoms, frets, guilloches, and acroteria appeared in furniture and ornament.

Inside and out, the Petit Trianon at Versailles was a sublime example of the French Neoclassical style. Its architect, Ange-Jacques Gabriel, had been named *premier architecte* in 1742. The leading furniture makers of the Neoclassical style included Jean-Henri Riesener, Martin Carlin, Adam Weisweiler, Pierre Garnier, and Georges Jacob, who founded a highly successful family dynasty of cabinetmakers.

The French Revolution (1789) and the Directoire Style (1795–99)

The French Revolution that began in 1789 abolished the monarchy, established a constitutional government, and beheaded many—including Louis XVI and Marie-Antoinette. Years of unrest brought a general suspension of artistic activity. The abolition of artisans' and craftsmen's guilds allowed more freedom, but ended the enforcement of high standards for craftsmanship. In 1795 a new governing body was established called the Directorate, and the style that prevailed during its rule is called **Directoire.**

The Directoire style, as might be expected, retreated from the sumptuousness of the previous French styles. Furniture became more severe and angular, though it was still classical in form. Large surfaces of plain waxed wood and painted wood replaced elaborate marquetry, and gilt bronze enrichments were curtailed. Ornamentation on furniture, fabrics, wallpaper, and ceramics began to include symbols of the Revolution, such as spears, drums, and the cap of Liberty, and the colors of the new Republican flag—white, with small areas of blue and scarlet—began to appear on trimmings, edgings, and small moldings. Imagined parallels between democratic Greece and revolutionary France brought a popular revival of Greek furniture forms.

Figure 15–14 French Neoclassical furniture and details.

DRAWING: GILBERT WERLÉ

SIDE CHAIR

ROSETTES

CONSOLE TABLE

URN MOTIF

COMMODE

DETAIL OF CHAIR LEG

ARABESQUE

OVER-DOOR MOTIF-MEDALLION, GARLAND, RIBBON

ARM CHAIR

In 1799 a military coup replaced the Directorate with a Consulate whose chief was Napoleon Bonaparte. What would follow, including the crowning of Napoleon as emperor and the establishment of the Empire style, is a story for chapter 19.

French Architecture and Interiors

Having summarized the progression of French styles, we shall now look at a few specific examples of French architecture and interior design. It is a field dominated to a striking degree by a single structure, its outbuildings, and its interiors: that was Versailles, the great palace Louis XIV created. But other designs also demand attention. We shall begin with one of the first buildings to demonstrate a movement beyond the long domination of the French Gothic.

Chambord (begun in 1519)

Chambord, in the Loire Valley, is an enormous complex of 440 rooms, 365 of them with fireplaces. It was conceived by François I as a hunting lodge

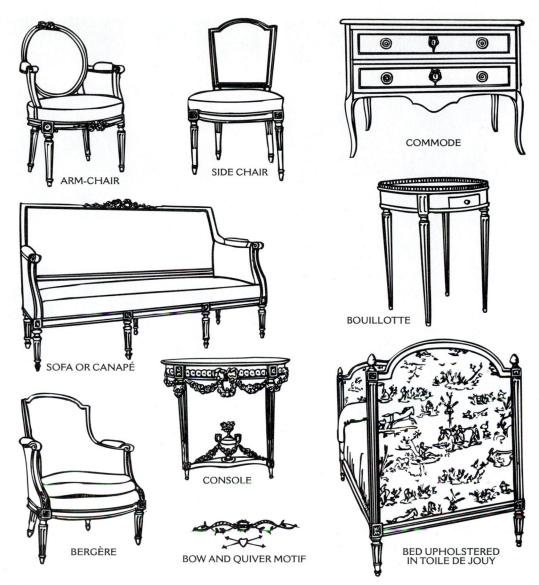

ARM-CHAIR

SIDE CHAIR

COMMODE

SOFA OR CANAPÉ

BOUILLOTTE

BERGÈRE

CONSOLE

BOW AND QUIVER MOTIF

BED UPHOLSTERED IN TOILE DE JOUY

Figure 15–15 French Neoclassical furniture.

DRAWING: GILBERT WERLÉ

for the adjacent forest and, of more importance, as a symbol of his reign. Construction began in 1519 and continued for decades, coming to a close in the reign of Henri II. Repairs and finishing touches were added later by Louis XIV.

Behind a facade 500 feet (156 m) long, there is a great enclosed courtyard (Figure 15–16) ringed by a composition of rectangular building elements ending in huge cylindrical towers (most rooms within the tower, however, being rectangular in shape). Within this is a smaller, bilaterally sym-

metrical element 143 feet (44 m) square with a hall in the shape of a Greek cross. At the crossing is a double spiral stair, one run above the other, interlocking so that those ascending one stair never meet those descending the other (Figure 15–17).

The top of this central stair culminates in a lantern adorned with a giant fleur-de-lys, the lily that has been the emblem of the French kings since the twelfth century. Around the lantern is a fantastic rooftop landscape of chimneys, turrets,

Figure 15–16 One of Chambord's cylindrical towers rising from the enclosed courtyard.

PHOTO: ABERCROMBIE

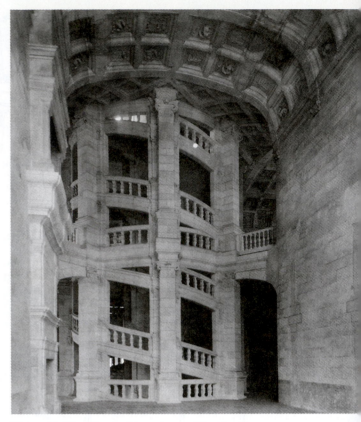

Figure 15–17 The double staircase, Chambord.

COUNTRY LIFE PICTURE LIBRARY, LONDON, ENGLAND

pinnacles, and dormer windows, medieval in character, but the pure geometry and symmetry of the floors below are clearly derived from the Italian Renaissance.

Versailles (after 1660)

Versailles, a dozen miles (about 20 km) southwest of Paris, had been chosen by Louis XIII as a site for another hunting lodge. Louis XIV's decision around 1660 to develop it as a monument to royal power was a surprise to all. For the design, Louis appointed a team whose work he had admired (and envied) at Vaux-le-Vicomte, a chateau that had been built by his superintendent of finance. The team consisted of architect Louis Le Vau, interior painter Charles Le Brun, and garden designer André Le Nôtre.

His father's brick and stone lodge was too small and dated for Louis XIV's ambitious plans, but

tearing it down, he feared, might seem disrespectful. The architect Louis Le Vau produced the happy solution called the **enveloppe,** which retained the old lodge but wrapped it almost completely in new construction. Faced all in white stone ashlar, the enveloppe had a rather solid ground floor as its base, a tall *premier étage* (*second floor* in American usage, *first floor* in English, *piano nobile* in Italian), and a short top floor for subsidiary rooms. A giant order of Ionic pilasters marched along the exterior of the premier étage. Inside that chief floor, the Grand Appartement of the king was in the north wing and consisted of a *chambre* or bedchamber, an *antichambre* or waiting room, a *garde-robe* or dressing room, and three *cabinets* or offices. The south wing held the apartments of the queen, her children, and the king's brother. On the long west side facing the gardens, a marble terrace on the premier étage linked the quarters of the king and queen. Interiors that survive from this

earliest stage of new construction show the clear influence of the Italian Baroque: a lavish use of marble wall paneling in geometric patterns (Figure 15–18), illusionistic murals by Le Brun and his staff on walls and ceilings, and a profusion of gilding and statuary.

Among Le Nôtre's landscaping, Le Vau also designed some subsidiary buildings, including the Trianon de Porcelaine mentioned on page 331, an orangerie, a menagerie for rare animals, and a grotto celebrating the Greek sun god Apollo, with whom Louis like to be identified (Figure 15–5).

In 1678 a new phase of work began at Versailles under the direction of Jules Hardouin-Mansart (1646–1708), who was appointed first architect of the king in 1681 and who was a great nephew of the architect François Mansart, for whom the double-pitched mansard roof was named. Hardouin-Mansart had already designed

the Hôtel des Invalides, the enormous Paris building for wounded and retired soldiers (Figure 15–19).

Hardouin-Mansart transformed Versailles into a great residential complex unprecedented in scale. He rebuilt Le Vau's brick and stone orangerie all in stone and doubled its size. He added three important elements: the Grand Trianon, the Galerie des Glaces (Hall of Mirrors), and the chapel.

The one-story Grand Trianon replaced the Trianon de Porcelaine. It was much larger than the earlier building and was faced with white stone and pink marble, refined and austere. Louis XIV occupied a suite there between 1691 and 1703. Its interior decorations featured a series of twenty-one views of Versailles and its gardens painted by Jean Cotelle, which are still in situ.

Hardouin-Mansart's Galerie des Glaces is the most spectacular room at Versailles and one of the most spectacular in the history of interior design, filling in the space once occupied by the marble terrace. A vaulted room 237 feet (73 m) long, it is a dazzling parade of seventeen tall windows reflected in a matching series of seventeen mirrors (Figure 15–20), both windows and mirrors alternating with Corinthian pilasters of green marble. The

Figure 15–18 Detail of the marble wall surface of the Salon de la Paix, Versailles.

PIERRE LEGROS THE ELDER. DETAIL OF THE MARBLE WALL SURFACE FROM THE SALON DE LA PAIX, 1684. WITH CUPIDS AND MASK OF MINERVA. PHOTO: GERARD BLOT. CHATEAUX DE VERSAILLES ET DE TRIANON, VERSAILLES, FRANCE. REUNION DES MUSEES NATIONAUX/ART RESOURCE, NY

Figure 15–19 Central crossing of the Hôtel des Invalides, Paris, by Jules Hardouin-Mansart, 1677–1706.

A. C. CHAMPAGNE

Figure 15–20 The great Galerie des Glaces, Versailles, by Hardouin-Mansart and Le Brun, 1678–84.

DANIEL THIERRY/FRENCH GOVERNMENT TOURIST OFFICE

Figure 15–21 Decorative detail of Louis XIV's chambre at Versailles. The intertwined L's are a symbol of the king.

FRATELLI ALINARI/GIRAUDON

semicircular ceiling vault, which springs from a richly treated entablature, is painted by Le Brun.

In 1682 Versailles was officially named the king's main residence and the seat of the French government. The king's private apartment was moved to a location directly behind the Galerie des Glaces, where it contained a chambre (Figure 15–21), two antichambres (one of which was the room called the Oeil de Boeuf (Figure 15–22), a garde-robe, the Cabinet de Conseil, and a suite of galleries and salons for the display of art.

The last element added by Louis XIV was the chapel (Figures 15–23 and 15–24), begun in 1699 to designs prepared a decade before by Hardouin-Mansart. It was finished in 1710 under the direction of Robert de Cotte. Two stories tall, its lower level was meant for the courtiers and public, its more important upper level for the king, entered directly from his private *appartement* and ringed by Corinthian columns supporting an entablature from which the painted vault springs.

Louis XIV died in 1715, and Louis XV did not move to Versailles until 1722. Beginning in 1738 the new king made extensive interior changes, creating many smaller, more intimate rooms, some faced with magnificent white and gold paneling by Jacques Verberckt and Ange-Jacques Gabriel.

In 1761, Louis XV, as requested by Mme. de Pompadour, asked Gabriel to design a smaller pavilion in the Trianon gardens. The Petit Trianon was built between 1762 and 1768, a perfect little white stone palace (Figure 15–25, page 370). It embodied a reaction to the Rococo style that preceded it: its rooms were rectangular, with no rounded corners; its ceilings were flat, with no coves; and its restrained ornamental details were the classical ones of acanthus, guilloche, garland, and wreath; gilding and lacquering were avoided, and most rooms were painted a soft off-white. The designer of some of the restrained wall paneling was Antoine Rousseau. By the time of the little building's completion, Mme. de Pompadour had died and the Petit Trianon was used by the king's new mistress, Mme. du Barry, who often gave supper parties there for the king and his intimate friends.

Louis XVI began his residence at Versailles in 1774, and he gave the Petit Trianon and its grounds to his queen Marie-Antoinette, who rearranged the interior, creating a seven-room apartment for herself on the main floor. All rooms were well proportioned and elegantly finished, but some were low-ceilinged and surprisingly small (Figure 15–26, page 370).

Changes to the main structure had continued as well, including the addition of a splendid opera house also designed by Gabriel (Figure 15–27, page 371). The design of the Opéra seems to have gone through a Rococo phase in the 1750s, but from c. 1765 it had become decidedly more Neoclassical.

Figure 15–22
The c. 1701 antichambre called the Salon de l'Oeil de Boeuf after the room's "bull's-eye" window. The frieze surrounding the window is of gilded stucco, and the marble bust of the king in front of the trumeau is by Antoine Coyzevox.

GIRAUDON/ART RESOURCE, NY

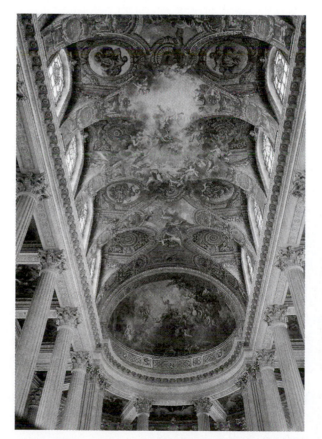

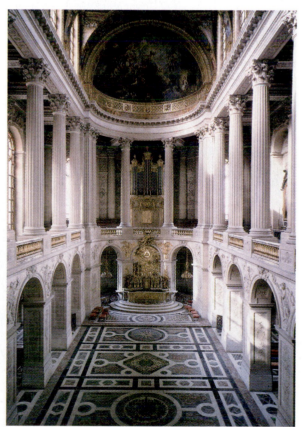

Figures 15–23 (left) and 15–24 (right) Ceiling vault and interior of the chapel at Versailles, designed by Jules Hardouin-Mansart and built 1699–1710.

PALACE OF VERSAILLES, FRANCE/SUPER STOCK, INC.

Figure 15–25 The Petit Trianon at Versailles, designed by Ange-Jacques Gabriel. Built 1762–1768.

CAISSE NATIONALE DES MONUMENTS HISTORIQUE ET DES SITES

It was completed in 1770, in time for the wedding of the future Louis XVI to Marie-Antoinette.

The Hôtel Particulier (Sixteenth to Eighteenth Centuries)

Not a single building but a building type, the private town house known as a **hôtel particulier** was an important part of French urban life from the middle of the sixteenth century to the end of the eighteenth. For the first century of that time, the term was restricted to city residences of the nobility, crowded together on small plots of land in order to be close to the royal palaces; later, with distinctions between the more ordinary *maison* and the *hôtel* fading, the latter term came to be used as well for city houses of the rising middle class. Thousands of such houses were built, and dozens of manuals were published giving examples that might be be followed. An early one was Jacques Androuet du Cerceau's *Premier livre d'architecture* published in 1559.

Two chief characteristics distinguished the hôtel particulier from the town house of other capitals: open space at both its front and back, and the appearance of symmetry. Although in London and elsewhere, town houses of all sorts were built flush with the property line at the street, the French version whenever possible had a forecourt in front and a garden in back. This layout was literally called the *hôtel-entre-cour-et-jardin*, and the principal building block in the center was called the *corps de logis*. Narrow service wings might extend along the sides of the forecourt, and small service courts, shielded from the view of visitors, might be placed at the sides.

In the design of the hôtel particulier, care was taken that every visible element—the entrance wall, the facade seen from the forecourt, the fa-

Figure 15–26 Marie-Antoinette's bedroom in the Petit Trianon.

AKG LONDON LTD

Figure 15–27 The Ópera, Versailles, designed by Ange-Jacques Gabriel and added to the château between 1748 and 1770.

cade seen from the back garden—be perfectly symmetrical. Often, however, because of irregularly shaped sites, ingenious planning devices were employed to create impressions of an overall order that was not fully present (Figure 15–28).

Inside the fashionable hôtel, there were public reception rooms, such as the entrance vestibule and a salon for social gatherings, and there were several private appartements, one for each important member of the family. The assemblage of public rooms might be called an *appartement de parade* or an *appartement de société*, and the private suite an *appartement privé*. Each of the private suites consisted of a chambre, one or more antichambres, one or more cabinets, and a garde-robe. As in the grander palaces, the master and mistress of the house customarily had their own appartements. The most elaborate hotels might also have a *galérie*, a *bibliothèque*, a *salle de compagnie* for entertaining,

games, and music, and—for dining—a specially designated *salle à manger*. The rooms within an appartement were often arranged **en enfilade**—that is, in a row, with doorways aligned so that long vistas through series of spaces were created. For this and other planning compositions, architects and theorists used the general term **distribution,** a matter given unprecedented attention from the Rococo period on.

Monochromatic—or at least closely harmonizing—color schemes gave unity to the rooms. This practice may have been established by the Marquise de Rambouillet in the second quarter of the seventeenth century. The Chambre Bleu of the Hôtel de Rambouillet, where the marquise entertained, featured blue walls, blue woodwork, and blue furnishings. Similarly, it was the fashion to coordinate all the textiles within a room: wall coverings, draperies, table covers, chair covers,

Figure 15–28 On an irregular site was Jacques-François Blondel's 1773 plan for an abbot's residence. Even so, the facades facing both the court and the garden give an impression of symmetry.

and bed hangings might all be made from the same fabric.

Wood parquetry was the flooring of choice, except for vestibules and corridors, where stone or tile was the rule. Oriental carpets or products of the Savonnerie or Aubusson factories were used over the wood floors. Tapestries also continued to appear as wall coverings. Silk or cotton curtains over windows and portieres over doorways were generally hung straight from metal rings over metal rods, with the fabric split into two halves, each drawn to the side. Between these draperies and the window glass, sheer white muslin curtains cut the glare of outside light.

Although the progress of French interior design was often, as we have seen, dictated by the king himself, the hôtel particulier was also often the source of new design directions. In the most gen-

eral way, it contributed to the Rococo style's taste for new levels of intimacy, privacy, and comfort. In more specific ways, it brought important innovations. The Marquise de Rambouillet, for example, is credited in her hôtel not only with monochromatic color schemes, but also with the introduction of the long floor-to-ceiling windows that became so important to both the exteriors and interiors of French architecture.

In the last half of the eighteenth century, the most fashionable of all the architects of hôtels partculiers was Claude-Nicolas Ledoux, who—along with Etienne-Louis Boullée—is better known today for his "revolutionary" projects of immense size. Most of Ledoux and Boullée's visionary schemes remained unbuilt, however (Figure 15–29). Ledoux's hôtels and his visionary projects shared a passion for bold and simplified

Figure 15–29 Etienne-Louis Boullée's 1785 scheme for a royal library recalls the imaginary interior Raphael painted in his *School of Athens* (Figure 13–6). If built, it would have been the world's largest reading room.

PHOTO: BIBLIOTHÈQUE NATIONALE, PARIS

geometry, and his hôtel designs displayed virtuoso combinations of round, oval, and rectangular rooms. Among them are the 1766 Hôtel d'Hallwyl, the 1769 Hôtel d'Uzès, and the 1781 Hôtel Thélusson, all in Paris.

In addition to those by Ledoux. and the already-mentioned Hôtel Rambouillet, notable examples of the Parisian hôtel particulier include:

- The 1640 Hôtel Lambert on the Île St.-Louis, its architecture by Louis Le Vau with interior design by Eustache Le Sueur and Charles Le Brun (Figure 15–30).

- The 1658 Hôtel Lauzun, also by Le Vau and with ceiling paintings attributed to Le Brun (Figure 15–31).

- The 1705 Hôtel de Rohan, with architecture by Alexandre Delamair and interior decorations by Christophe Huet and others.

- The c. 1740 Hôtel Soubise (now the Archives Nationale) by Delamair with interiors by Germain Boffrand. Paintings were commissioned from Pierre-Charles Trémolières, and some of the ornament was probably carved by Jacques Verberckt.

- The Hôtel Carnavalet (now a museum of furnishings and decorative arts), dating from the mid-sixteenth century and extensively remodeled later.

- The 1783 Hôtel de Salm (now the Palais de la Légion d'Honneur) by Pierre-Marie Rousseau, a

Figure 15–30 The Galerie d'Hercule of the Hôtel Lambert, Paris, 1640.

GIRAUDON/ART RESOURCE, NY

building much admired by Thomas Jefferson when he was the American minister to France (1784–89) and used as a model for Jefferson's

shape and character matched to almost every activity and nuance of sophisticated society. The finest examples were impeccably made and luxuriously finished. And this furniture also achieved levels of comfort beyond any that had been expected before. When Mme. Victoire, the daughter of Louis XV, was asked if she might enter a convent as her sister, Mme. Louise, had, she replied that she was "too fond of the comforts of life," and, pointing to her comfortable bergère, she said, "An armchair like that is my undoing" (Figures 15–32 and 15–33).

Examples of these furniture designs are outlined below, many of them still unsurpassed and still being imitated. Following the examples is some information about the artists and craftsmen who produced them.

The Furniture Types

Within each basic furniture type—seating, beds, tables, and casegoods—the French developed novel variations. And within each variation, changes in profile and character came with each successive style. What follows is a greatly abbreviated summary of a subject to which many specialists have devoted lifetimes of study.

Figure 15–31 Paneling in the grand salon of the Hôtel de Lauzun, Paris, 1658.

COUNTRY LIFE PICTURE LIBRARY, LONDON, ENGLAND

own Monticello. Its interiors were redone in the nineteenth century in Empire style.

Now we shall look at some of the remarkable creations with which these French châteaux, palaces, and houses were furnished.

French Furniture

The French, particularly in the seventeenth and eighteenth centuries, produced some of the most elegant pieces of furniture the world has known. They also produced a remarkable number of new furniture types, their subtle differentiations of

Figure 15–32 A comfortable Rococo bergère by menuisier Louis Delanois.

CHAIR, ARM (BERGÈRE). OAK. CIRCA 1760. THE METROPOLITAN MUSEUM OF ART, GIFT OF J. PIERPONT MORGAN, 1906. (07.225.122)

Figure 15–33 An eighteenth-century Crillon Room decoated in painted and gilded oak by Pierre-Adrien Pâris. It contains a daybed and a bergère by Jean-Baptiste-Claude Sene.

THE CRILLON ROOM. FURNISHED WITH DAYBED AND ARMCHAIR (BERGERE) MADE BY JEAN BAPTISTE CLAUDE SENE (1745–1803) IN 1788. DECORATION BY PIERRE ADRIEN PARIS (1745–1819) FOR LOUIS MARIE AUGUSTIN, DUC D'AUMONT (1709–1782). PAINTED AND GILDED OAK. H. 9 FT. 3½ IN. (283.2 CM.) L. 14 FT. 3½ IN. (435.6 CM.) W. 15 FT. 5½ IN. (471.1 CM.) THE METROPOLITAN MUSEUM OF ART, GIFT OF SUSAN DWIGHT BLISS, 1944. (44.128) PHOTOGRAPHER © 1995 THE METROPOLITAN MUSEUM OF ART.

SEATING During the sixteenth-century reign of François I, chairs were still medieval in character, massive square objects, some with storage compartments under their hinged seats. When Henri II came to the throne, bringing Catherine de' Medici as his queen, the storage function was abandoned and the whole chair was lightened, an opening made beneath the chair arms and another between the seat and the back, the legs joined by a stretcher near the floor. Other chairs did away with the arms altogether in order to accommodate the current fashion of women in hoopskirts, and were called *chaises à vertugadin* after the skirts. A lighter chair among these relatively heavy Early Renaissance types is the **caquetoire** (sometimes called the *caqueteuse*), a movable little piece that could be pulled up for "cackling" or gossiping (Figure 15–2). The **escabelle** was similar in appearance as well as in name to the Italian **sgabello** that Catherine had known at home. The hardness of the seats—and, in many cases, the hardness of the floor when there were no seats—was mitigated by *carreaux*, flat square cushions with big tassels by which they could be easily picked up.

By the time of Louis XIII in the seventeenth century, new standards of comfort called for upholstery rather than cushions. The upholstery was secured to the seat and back with rows of decorative metal nails, and the chairs were still boxy in form. The legs were columnar with decorative turnings, and they ended in small bun feet. The legs were strengthened with an H-shaped stretcher near the floor and a single stretcher above it, its placement at the front of the chair indicating that it was considered an aesthetic asset.

For Louis XIV these chairs developed into great armchairs of generous size, at once more imposing and pleasing than their predecessors. Their tall upholstered backs were suitable backdrops for the elaborate hairstyles of both women and men. The earlier H-shaped stretchers bracing the legs were replaced by the more graceful X-shaped ones (Figure 15–4). The arms ended in curves or volutes. In some cases, these were imagined to resemble crows' beaks, the chair then being called a *chaise à bec de corbin*. Of most importance for the future of furniture design, the legs assumed the **cabriole** shape of a languorous S curve, often terminating in a small hoof-like foot or *pied de bêche*.

Seating types proliferated under Louis XIV. The chief type, descended from more rigid examples, was the **fauteuil,** an armchair with a high upholstered backrest, open arms, and baluster-like arm supports and legs. In the Louis XIV period it most

often was made of walnut. During the Régence period, the cabriole legs were joined just under the seat with a carved wood molding, and the legs ended in small volutes rather than animal hooves, and later in tiny gilt bronze shoes called *sabots*. Small padded areas *(manchettes)* appeared on the chair arms for added comfort. As the chairs became lighter, the structural need for stretchers diminished.

In the Louis XV period, the stretchers disappeared, and the chair was consumed with curves, not a straight line remaining. By this time, the specialization of seating furniture had reached its zenith, the various types including:

- The *bergère*, a comfortably upholstered wing chair with solid sides (Figures 15–32 and 15–33).
- The *canapé*, a small sofa. A canapé with arms and back joined in a single curvaceous line, popular in the Louis XV period, was called a *canapé en corbeille*. A small settee, just large enough for two people in intimate conversation, was called a *marquise* or *tête-à-tête* or *confident*. If such a settee had a back so tall and enveloping that it gave a great deal of privacy to the seated pair, it was called a *bergère en confessional*.
- The *méridienne*, a sofa with an asymmetrical back, one side higher than the other. Such sofas were sometimes also called *veilleuses*, and they closely resembled daybeds or *chaises longues*. After about 1740 some were made in three sections (like an ottoman with a large bergère at one end and a smaller bergère at the other).
- The *tabouret*, a stool.
- The *placet*, a stool slightly higher than a tabouret.
- The *ployant* or *pliant*, a folding stool.
- The *perroquet*, a folding chair.
- The *chauffeuse*, a chair small and light enough to be brought to the fireside for conversation, a successor to the older caquetoire.
- The *chaise voyeuse*, a small chair with a low seat, designed for the occupant (always a man) to sit astride with his arms resting on the padded back of the chair while watching card playing or other games. An English equivalent was called a *cockfighting chair*, and a version for women (with the occupant kneeling rather than astride the seat) was called *a voyeuse à genoux*.
- The *fauteuil à coiffer*, a chair with a low back and a revolving seat, designed specifically for ladies having their hair done and sometimes called a *fauteuil de toilette*.
- The *chaise percée* or toilet chair, with a chamber pot beneath a hinged cane seat.
- The *bidet*, with a washbasin concealed beneath a hinged upholstered seat.

BEDS Beds in Louis XIII's time had come to be draped in a great deal of fabric, no longer hung from the ceiling as it had been in Gothic times, but hung as a **tester** from four wood pillars, one at each corner of the bed. Because of these columnar posts, such a bed was called a *lit à colonnes*, but it was also known as a *lit à la française*.

For the court of Louis XIV and its imitators, the bedroom was not the intimate chamber it has since become, but was a very public space in which visitors were received with great ceremony: a *chambre de parade*. The bed itself, the *lit de parade*, was ceremonial, too, an object of great splendor but not one in which people might actually sleep except for an occasional guest of great importance (although, in more humble residences, this grandest of rooms might also serve as the bedroom and dressing room of the lady of the house). The *lit de parade* was draped in a generous yardage of fabric supplemented with fringe, tassels, braid, heron feathers, and ostrich plumes, and it was often separated from the rest of the room by a balustered railing, as in the Chambre de Roi at Vaux-le-Vicomte and in Louis XIV's own bedroom at Versailles, which served, of course, as the model for all those who could copy it.

A much less pretentious development, beginning c. 1625, was the popularity of the daybed, resting bed, or *lit de repos*. It was a forerunner of the **chaise longue,** which would be immensely popular in the eighteenth century.

The *lit à l'impériale* had a canopy shaped like a dome. Other variations included the *lit à la duchesse*, the *lit d'ange*, the *lit à la polonaise*, and the *lit à la turque*. This last was placed with its long side against a wall and could be used as a sofa dur-

Figure 15–34 A great round table used by Louis XVI in his study at Versailles. Its top, made from a single piece of mahogany, measures almost 7 feet (2.15 m) in diameter. The design is attributed to Jean-Henri Riesener.

REUNION DES MUSÉE NATIONAUX/ART RESOURCE, NY

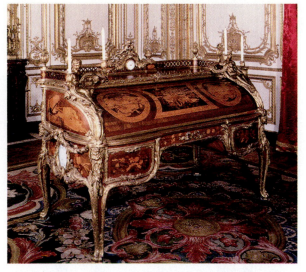

Figure 15–35 The bureau a cylindre of Louis XV by the ébénistes Jean-François Oeben and Jean-Henri Riesener, finished in 1769. It is veneered with marquetry of holly, box, and other woods on panels of pearwood.

D. ARNAUDET/REUNION DES MUSÉE NATIONAUX/ART RESOURCE, NY

ing the day; its back and sides were of the same height, and it was often covered with a small canopy attached to the wall. By the end of the seventeenth century, it was the custom to hang a panel of fabric from the tester flat against the wall behind the bed. In front of this panel was a headboard *(dossier)* that might itself be covered in fabric or might be of carved and gilded wood,

TABLES As Louise Ade Boger wrote in her history of furniture, the medieval table of boards laid on trestles and covered with fabric "went out of fashion, but not out of use" around the middle of the sixteenth century. Italian tables were the new fashion, including those with round, square, or octagonal tops on central supports and others with tops that could fold out to larger sizes. These were often heavy and ornate, but beginning with the Louis XIV style they became lighter, with their legs often braced by X-shaped stretchers. As with all other furniture types, the Rococo period brought graceful cabriole legs, and Neoclassicism a newly restrained classicism (Figure 15–34).

A type of table especially for writing, the forerunner of our desk, was the **bureau.** Its name seems to come from *bure*, a coarse wool fabric that was used as a cover for a writing surface. Some bureaux have cabinetry above the writing surface with small drawers and storage compartments; many are of kneehole shape, with a recess for the

writer's legs between storage pedestals. Specific types include:

- The *bureau plat*, a writing table with four legs and without drawers. It was a very simple furniture form, but could be lavishly embellished.
- The *bureau de dame*, a smaller version of the above, meant for a lady's use.
- The *bureau semainier*, with seven storage drawers, one for each day of the week.
- The *bureau Mazarin*, with a kneehole between two banks of drawers. Some early examples had eight scroll-shaped legs, but later the number of legs was reduced. It was named for Cardinal Mazarin, but the first example seems not to have been produced until after his death. Such a desk was also called a *bureau de ministre*.
- The *bureau à cylindre*, a rolltop desk. The first example was begun for Louis XV by the *ébéniste* Jean-François Oeben in 1760 and finished in 1769 by Jean-Henri Riesener, after Oeben's death (Figure 15–35). When its top was rolled back, an inner mechanism pushed the writing surface forward. Another example, veneered in

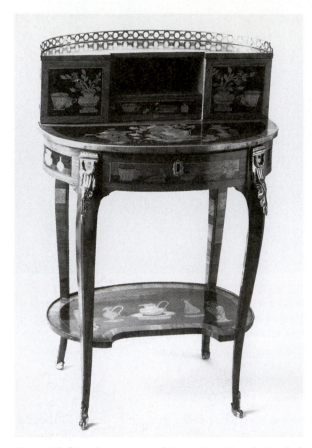

Figure 15–36 An example of the small writing desk called a bonheur du jour, a favorite of the eighteenth century. This one is by ébéniste Charles Topino, c. 1775.

PHOTO: MUSÉE DES ARTS DÉCORATIFS, PARIS, FRANCE

mother-of-pearl, was made by Jean-Henri Riesener c. 1785 for Marie-Antoinette's boudoir at Fontainebleau.

- The *bureau à pente,* having storage compartments enclosed by a slanted front panel hinged at the bottom. When opened, the panel served as a writing surface.
- The *bureau à gradin,* having a long, low superstructure in several graduated tiers.

Occasional adjuncts to the bureau were the *cartonnier* and the *serre-papiers,* both sorts of filing cabinets. A *serres-bijoux* was a jewelry cabinet, and a *bonheur du jour* was a small, exceedingly graceful writing table, probably the invention of Louis XVI's ébéniste René Dubois (Figure 15–36).

In addition to bureaux, with their open writing surfaces, there were **secrétaires** or secretaries with enclosed ones. A *secrétaire en armoire* was a secretary that looked like an armoire but incorporated a drop front that became the writing surface; a famous example was made for Louis XV by the ébéniste Bernard van Risamburgh for his use at the Trianon. Similar were the *secrétaire en abattant,* an *abattant* meaning a leaf, and the *secrétaire en pente,* a lean-to version in which (like the bureau à pente) the closed leaf was at an angle.

The *console* was a table meant to stand against a wall. Some consoles had four legs and could be freestanding if desired; others had only one or two legs and were dependent on being attached to the wall. Such pieces were often topped by a wall mirror and carried decorative objects such as clocks, vases, or candelabra.

There were various sorts of game tables *(tables à jeux),* and they were as specialized as the games played. Some had triangular tops for games for three players, square ones for four players, or pentagonal ones for five; others had hinged tops that could be unfolded to form larger playing surfaces. Almost all were surfaced with fabric. Some had circular depressions at the corners for holding candlesticks, and when they did not they were often accompanied by small table-height **guéridons** or candlestands (Figure 15–37).

There were tall guéridons as well, and their general form, similar to some ancient Roman models, was a circular top on a central standard with three splayed feet. In the time of Louis XIV they took another quite different form as well, however, that has given them their name: *guéridons* was the name given by the French to African boys who had been brought to serve the court as pages, and some candlestands were actually carved figures of elaborately uniformed young black servants holding trays on which candlesticks could be placed.

Because dining rooms were nonexistent until the time of Louis XVI and rare even then, dining tables were equally rare. When they existed, they were apparently considered rather foreign, being called *tables à l'anglaise.* Portable trestle tables were used instead, set up in antichambres as desired, their humble structures hidden by white tablecloths. Accompanying such movable dining tables were supplementary side tables for serving. These were called *servantes,* and two specific types of servante were the *cabaret à café* and the *rafraîchissoir.*

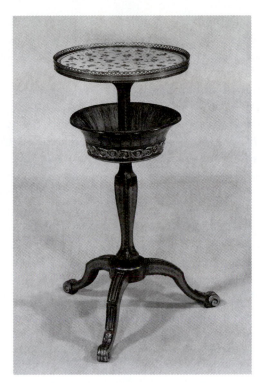

Figure 15–37 Candlestand and workbox designed by Martin Carlin and inlaid with Sèvres porcelain.

WOODWORK, FURNITURE-FRENCH XVII. PROB. BY MARIN CARLIN (MASTER 1766-1785) CANDLESTAND AND WORKBOX. CHASED AND GILDED BRONZE MOUNTS VENEERED ON OAK WITH TULIPWOOD, BOXWOOD, EBONY, HOLLY, SYCAMORE, ETC., INLAID WITH SEVRES PORCELAIN. H. 31¼, DIAM. TOP 14⅜ IN. THE METROPOLITAN MUSEUM OF ART, GIFT OF MR. & MRS. CHARLES WRIGHTSMAN, 1976. (1976.155.106)

The cabaret à café was a light table incorporating trays for serving coffee, hot chocolate, or—after c. 1785—English tea. The rafraîchissoir or *table à rafraîchir* had one or more wells sunk into its top and lined with lead or silvered metal for chilling wine; shelves below could hold plates. One well might be found at the elbow of each dinner guest, and enabling the guests to serve themselves allowed more independence from the servants and more opportunity for unguarded conversation. Like the rafraîchissoir but with a single large metal-lined well that could hold plants was the **jardiniere** or *table à fleur*, which could also be used as a washbasin.

Toile is the French word for linen or canvas, and a **toilette** was originally a small square of cloth on which cosmetics, brushes, combs, and mirrors might be spread out. The word later came to be applied to the articles on the cloth, to the ritual of application, and to the table that finally replaced the cloth, held the articles, and supported the ritual. A more elaborate version that appeared in the eighteenth century was the *poudreuse* or *coiffeuse*, which had a number of hinged leaves that opened to reveal storage compartments, the inside face of the central leaf being mirrored. A multipurpose curiosity that combined the functions of the toilette and the writing table was called a *toilette à transformations*. Toiletries could also be accommodated in *tables de lit* or *tables d'accouchée*, little tables on very short legs that were placed directly on the bed. Standing beside the bed during the night (and carried away the next morning) were *tables de nuit* (Figure 15–38), and low cabinets for bedside use included the *table de chevet* and the *meuble d'en cas*. Also found in the bedroom was the *vide-poche*, a tiny table with a raised gallery around the top, which was used for emptying one's pocket.

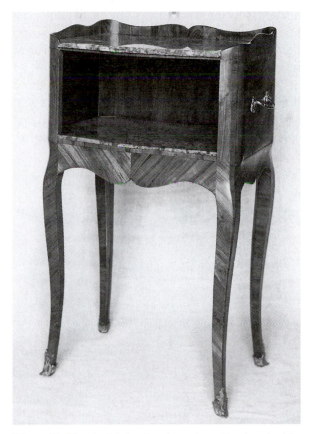

Figure 15–38 A plain but handsomely proportioned table de nuit made by the ébéniste Mathieu Criaerd in 1755 and used by Louis XV and Mme. de Pompadour at their bedside.

MUSÉE DES ARTS DÉCORATIFS, PARIS, FRANCE

Finally (although the subject of French furniture types is seemingly endless), any tables small enough to be picked up and moved about were called *tables ambulantes.* Some had handles on the sides for easy carrying.

CASE GOODS By the reign of Henri II in the mid–sixteenth century, three basic pieces of storage furniture had been developed by the French. The simplest was the **coffre** or chest, a simple box that could be carried about and used as storage or as a seat or even as a table. Most coffres were plain, but some—such as the *coffre à mariage* or "marriage chest"—were often elaborately decorated and sometimes placed on a tall stand. There were also coffres on stands that were elaborately finished, some with small porcelain plaques.

The *dressoir* or *buftet* was a cupboard raised on a stand. Its cupboard part might have both doors and drawers concealing the storage areas, and there might also be open shelves for the display of fine tableware.

The *commode,* a low chest of two or three drawers (Figure 15–15 and 15–39), began to be popular around 1690. It can be thought of as a smaller, lighter version of the Italian **cassone.**

Figure 15–39 A commode by André-Charles Boulle in ebony marquetry with ormolu mounts, one of a pair made for Louis XIV's bedroom at the Grand Trianon, Versailles, 1708–9. Note that Boulle has supported it with eight legs.

RÉUNION DES MUSÉES NATIONAUX, PARIS

Some commodes, in which the rounded drawer fronts recalled the shape of a sarcophagus, were called *commodes en tombeau.* In the Régence and Louis XV periods this shape was agreeably modified: rather than being wholly convex, the commode became concave directly beneath its marble top, then prominently convex, then concave again at the bottom. Such an undulating form is called **bombé.** Though both were bombé, the Régence version was heftier, with three drawers on short legs, and the Louis XV lighter, having only two drawers on longer legs. Through several periods, a frequent ensemble of furniture for placement against an important wall was a pier-glass mirror with a commode below it and a tall guéridon at each side.

The **armoire** was a wardrobe, usually tall enough to hold hanging clothes, although there was a lower version called a *bas d'armoire.* Other variations include the *armoire à ligne* or linen press, with shelves for folded items; the *armoire à glace* with glass doors; and the *armoire à provisions* for food. The *armoire à deux corps* had "two bodies," these being superimposed cases, the upper one narrower and shallower than the lower, and each with two doors. Small inlaid marble plaques sometimes embellished the doors, and a pediment often crowned the upper part.

The *encoignure* was a corner-cupboard, triangular in shape to fit into the corner of a room. Often this was low, its height aligning with the dado of the room's paneling, and was called a *bas d'encoignure.* Such cupboards often had a single bow-shaped door facing into the room.

ACCESSORIES In all periods and styles, the variety of furniture pieces sketched here were accompanied by a full complement of accessory items: sconces, candelabra, chandeliers, vases, urns, figurines, small ornamental boxes, and clocks. Here we shall consider only one representative example, a clock by André-Charles Boulle (Figure 15–40), in which the gilt-bronze figures of Venus and Cupid are larger and more important than the case that actually contains the clock movement: function has been given a role subsidiary to décor. Many other examples can be found in interior views throughout the chapter.

Figure 15–40 A "Venus" mantel clock, c. 1715. The movement is signed by Jean Jolly. The case of rosewood. tortoiseshell, ebony, brass, and gilt bronze is attributed to André-Charles Boulle.

L. MOINET, "MANTEL CLOCK (FRENCH) PENDULE DE CHEMINEE," FRENCH, C. 1715.© THE TRUSTEES OF THE WALLACE COLLECTION, LONDON. BY KIND PERMISSION OF THE TRUSTEES OF THE WALLACE COLLECTION.

The Division of Occupations

At some time in the Middle Ages, the artisans who produced crafts in wood *(métiers du bois),* including wood furniture, had broken free of the guild of carpenters as a separate group with its own guild, called the **menuisiers.** Within this general group there were several specialties, such as those who joined solid wood furniture and those who applied veneers and marquetry. In 1743 this latter group began to call itself *menuisiers en ébène* or, more simply, **ébénistes,** and the guild was officially renamed that of the *menuisiers-ébénistes.*

Distinctions between the work of the *menuisiers* (the joiners) and of the *ébénistes* (the cabinetmakers) were formally established in a 1745 revision of

the guild's statutes and were theoretically simple: the first group produced such pieces as chairs, beds, and tables of solid wood but were prohibited from adding extensive ornamental carvings; the second group produced case pieces embellished with marquetry and gilt-bronze mounts. In practice there were exceptions and overlapping.

Georges Jacob (1739–1814), who produced furniture for Marie-Antoinette, is rare in having excelled both as a *menuisier* and as an *ébéniste.*

Also important were the *vernisseurs* (lacquerers), the *tabletiers* (makers of small intricate objects such as toiletry cases), and the *tapissiers* (upholsterers, some of whom also designed and made draperies, and some of whom sold the furniture they had upholstered). Notable among the tapissiers were Bon, Delobel, and Losne.

Finally, the *marchands-merciers,* the dealers or merchants, were given state permission to import or sell specified furnishings but not to manufacture them. Prominent ones included Poirier, Daguerre, and Darnau.

The *Maîtres* or Masters

The ébénistes considered most highly skilled were singled out for a special honor: They were appointed *maître-ébénistes* or master cabinetmakers. These had met stringent requirements of apprenticeship and study, had paid a fee, and had satisfactorily produced an important piece of furniture demonstrating their skills. Once named maître-ébénistes, artisans were required to have the quality of their work examined several times a year and to have and use personal stamps to identify most of their output. The stamping was generally out of sight—under the seats of chairs or under the tops of tables—but it has aided the identification of eighteenth-century furniture artists and their work. It has also led to the idea in today's antiques market that a stamped piece is more valuable than an unstamped one. This idea is an oversimplification of the facts, for the very finest of pieces—those commissioned directly by the king or the royal household—were often unstamped.

Over 1,000 such artisans were named maître-ébénistes during the eighteenth century. A few of

the most outstanding were, in the order of their births:

- *André-Charles Boulle (1642–1732)*. An important French cabinetmaker, Boulle was the first great maître-ébéniste and in 1672 was appointed head cabinetmaker to Louis XIV. His furniture was known for its elaborate ornamentation, often in fanciful materials, which came to be known as Boulle work, After his death his workshop was continued by his two sons, André-Charles and Charles-Joseph. We have already seen his work in Figures 15–6, 15–39, and 15–40.

- *Charles Cressent (1685–1768)*. A leader in the Régence and early Rococo styles, Cressent was appointed maître-ébéniste in 1714 and later also became a *maître sculpteur*. His furniture was often of showy woods (rosewood, purplewood, or satinwood) and featured lavish gilt ormolu mounts (Figure 15–41). Cressent was ébéniste to the Duc d'Orleans. Several of his descendents, who spelled their name Cresson, became prominent menuisiers.

- *Gilles Joubert (1689–1775)*. Joubert was renowned for small furniture, such as tables and secretaries, ornamented with wood inlay, The date of his appointment as maître-ébéniste is not definitely established, but was probably around 1749. He was employed at court from 1748.

Figure 15–41 Régence commode designed by Charles Cressent c. 1730 with ormolu foliage and cupids.

- *Bernard van Risamburgh II (c. 1696–1766)*. One of a family of French cabinetmakers of Dutch origin, van Risamburgh was a maître-ébéniste whose patrons included Louis XV and Mme. de Pompadour. For most of history he has been best known by the initials with which his furniture was stamped, B.V.R.B., and also by the name Bernard.

- *Jean-François Oeben (1721–65)*. Oeben was a cabinetmaker of the Louis XV period, appointed maître-ébéniste in 1754. We saw his desk for Louis XV in Figure 15–35. Oeben was given lodgings and work space in the Louvre and later at the Gobelins. He worked for Mme. de Pompadour and trained Jean-Henri Riesener. His younger brother, Simon-François Oeben, was also an ébéniste, and their sister married cabinetmaker Martin Carlin.

- *Jean-Henri Riesener (1734–1806)*. Riesener first worked under Oeben and became his successor. He was named maître-ébéniste in 1768 and became supplier to the Garde Meuble de la Couronne the following year and ébéniste du roi in 1774. In the succeeding dozen years he almost completely refurnished the royal palaces of Louis XVI and Marie-Antoinette (Figure 15–34).

- *David Roentgen (1743–1807)*. French cabinetmaker of German origin, Roentgen was appointed maître-ébéniste in 1780. He worked for Marie-Antoinette and supplied furniture for Louis XVI, Frederick William II, King of Prussia, and Catherine II of Russia.

- *Adam Weisweiler (c. 1750–c. 1810)*. A Louis XVI ébéniste, Weisweiler was appointed maître-ébéniste in 1778. His luxury pieces were often set with Sèvres porcelain plaques or with Wedgwood medallions. He worked often on orders from the *marchand-mercier* Dominique Daguerre, who sold some of his pieces to Marie-Antoinette and also the English prince regent, later to be George IV. Weisweiler often used plain veneers rather than elaborate marquetry, but his ormolu mounts—some of them attributed to Pierre Gouthière—were unusually fine. His business survived the Revolution and flourished in the Directoire and Empire periods.

- *Bernard Molitor (1755–1833).* One of the last of the guild members and one of the last cabinetmakers to work for the ancien régime, Molitor worked in a wide vocabulary of styles, including Egyptian Revival. Like Weisweiler, he escaped serious suspicions during the Revolution and survived to work for the emperor Napoleon. One of his early pieces is shown in Figure 15–42.

The Decorators

We have considered the role of architects such as Le Vau and Gabriel. We have seen the contribution of painters such as Le Brun. We have also seen something of the important role of the master furniture designer. It is obvious, from today's perspective, that an intermediary role needed also to be filled: that of someone who could take these built and crafted elements and produce interiors that were consistent and harmonious. At Versailles we have seen this role played by the painter Charles Le Brun. It was also often taken by the *tapissiers* who, in choosing upholstery, window draperies, and perhaps wall hangings, were sometimes largely responsible for the overall look of a room.

But in the eighteenth century there came to be a new group of contributors, the *ornemanistes* or decorators. Among their skills was a talent for engraving—they could conceive the design of an interior and, through the medium of engraving, explain the design to a client. Both clients and artisans were then better able to choose and design appropriate furniture, fabric, carpet, wall paneling, chandeliers, sconces, clocks, and other decorative details. And many of these engravings directly influenced furniture designs by the menuisiers and ébénistes. Pierre Verlet, in his *French Furniture of the Eighteenth Century*, quotes from the Abbé Jaubert's 1773 *Dictionnaire . . . des arts et métiers* (Dictionary of Arts and Crafts): "The decorator is the only person who knows how to use the talent of each artist to best advantage, to arrange the most elaborate pieces of furniture, to position them to best effect. . . . To excel in this art, which has been born before our eyes, it is necessary to have a good eye, to have a good knowledge of design, to understand perfectly the merits of each piece of furniture, to show them in their true light, and to

Figure 15–42 Mahogany-veneer commode with ormolu mounts, c. 1785–88, designed by Bernard Molitor, probably at the request of a marchand-mercier.

BERNARD MOLITOR, "CHEST-OF-DRAWERS (COMMODE A VANTAUX)," FRENCH, C. 1788.© THE TRUSTEES OF THE WALLACE COLLECTION, LONDON. BY KIND PERMISSION OF THE TRUSTEES OF THE WALLACE COLLECTION.

create an ensemble that will give a pleasing impression."

Among those working in this manner were:

- *Jean Le Pautre (1618–82).* Le Pautre and his architect brother Antoine founded a family dynasty of designers, architects, engravers, and sculptors. Jean was a master menuisier but was best known as a prolific engraver. A follower of Le Pautre, noted for his architecture, interiors, and gardens, was Alexandre-Jean-Baptiste Le Blond (1679–1719), and Le Pautre's influence can also be seen in the work of Jean Berain I.

- *Jean Berain I (1640–1711).* Berain, through the patronage of Charles Le Brun, was hired in 1670 as an engraver by the French crown. The following year he prepared engravings showing Le Brun's ceiling decorations for the Galerie d'Apollon in the Louvre. Berain's subsequent work included designs for theater, ballet, court masques, fireworks, funeral decorations, coaches, tapestries, and gardens. Berain designed many of the furniture pieces executed by Gilles-Marie Oppenordt, with whom he was a frequent collaborator, and other of his designs were done in collaboration with his son, Jean Berain II.

- *Nicolas Pineau (1684–1754).* Pineau was in Russia with twenty Parisian craftsmen between 1716 and 1727, working for Peter the Great.

Figure 15–43 Two sketches for door panel designs by Nicolas Pineau.

MUSÉE DES ARTS DECORATIFS, PARIS, FRANCE

Figure 15–44 Silver tureen designed by Juste-Aurèle Meissonnier, c. 1734–40, 15¼ inches (39 cm) high.

JUSTE-AURÈLE MEISSONNIER, FRENCH, (1695–1750). DESIGN FOR A SOUP TUREEN, 1735. BIBLIOTHEQUE NATIONALE, PARIS.

Many of his designs were executed by the ébéniste Jacques Dubois. He left sketches for furniture design and a variety of interior treatments (Figure 15–43).

- *Juste-Aurèle Meissonnier (1695–1750).* Meissonnier was both an architect and a goldsmith, and he designed furniture, royal festivities and pageants, ornament, and tableware, most of his work characterized by flowing movement (Figure 15–44.) He worked at the Gobelins and was appointed *dessinateur de la chambre et du cabinet du roi* in 1726, succeeding Jean Berain II. His engravings of varied designs were published after his death.

- *Jacques (originally Jacob) Verberckt (1704–71).* Verberckt was born in Antwerp, but came to Paris at an early age, where his skill was admired by Jacques Gabriel V and his son Ange-Jacques Gabriel. Verberckt worked on many of the royal châteaux, including Versailles. He also produced marble garden vases and freestanding sculpture.

- *Jean-Charles Delafosse (1734–89).* Delafosse designed at least two houses in Paris, the Hôtel Titon and the Hôtel Goix, both in the Rue du Faubourg-Poissonière. In his decorative work he experimented with taking architectural elements—bases, pediments, volutes—from their usual contexts and using them in surprising new juxtapositions. He published his *Nouvelle iconologie historique* in 1768, containing 110 plates showing furniture designs, architectural ornament, and decorative objects in the Louis XVI style and identifying himself as an "architect, decorator, and teacher of design."

- *Richard de Lalonde (flourished 1780–97).* Lalonde published a series of popular plates shortly before the Revolution. His designs were executed by the maître-ébénistes Adam Weisweiler, Joseph Stöckel, and Guillaume Benneman.

- *Jean-Démosthène Dugourc (1749–1825).* Dugourc was the brother-in-law of the architect, landscape architect, and interior designer François-Joseph Bélanger, whose works included the small Château de Bagatelle in the Bois de Boulogne and its furnishings. Dugourc worked on the Bagatelle with Bélanger and with maitre-ébéniste Georges Jacob. Dugourc was an enthusiast of

the Neoclassical style, even claiming in his 1800 autobiography to have been one of the inventors of the *style étrusque*. He designed palace interiors in Madrid for the Spanish kings Charles III and Charles IV, the throne room at the Tuileries, and designs for silks and for Beauvais and Savonnerie tapestries.

Materials and Techniques

The predominant material for French furniture was wood, of course, and the use of the term *ébéniste* suggests that ebony was frequently used. It was indeed in great fashion at times, particularly in the first half of the eighteenth century. When its popularity exceeded its supply, substitutions were made: at times pear was stained black to resemble ebony, and at other times bog oak, naturally stained black by decades of immersion in watery bogs, was used. Many other species were also popular, however. The bodies of case furniture were often made of pine and then later of oak, with veneers of more exotic woods applied as finish. Oak was also popular as a finish wood, however, as were walnut and mahogany. Wood chairs whose frames were meant to be painted or stained were often made of beech. For veneers, woods of choice included cherry, tulipwood, satinwood, and amaranth. There were also local woods that were favorites because of their accessibility: elm in the Burgundy region, chestnut in Périgord, and olive in Provence.

French Decorative Arts

The French furniture we have been considering was of wood supplemented with many other materials, including insets of marble, porcelain, ivory, mother-of-pearl, pewter, and brass, and hardware of gilt bronze. In surveying the decorative arts of France, we shall begin with those that were often directly related to furniture: **marquetry, lacquer,** and **ormolu.**

Marquetry

Marquetry is the art of completely covering surfaces with compositions of small shaped pieces of veneer. It corresponds to the *tarsia geometrica* of Italy that we met in chapter 13, and is different from *tarsia certosina* or inlay, in which isolated pieces of veneer are sunk into surfaces of solid wood. The term **intarsia** is often used to cover both techniques.

Another distinction sometimes made is that marquetry refers to relatively elaborate patterns involving curves, arabesques, and illusionistic scenes, and **parquetry** refers to abstract geometric patterns limited to checkerboards, herringbones, diamonds, rhomboids, stripes, and the like. According to this distinction, marquetry is more often used for furniture, and parquetry more often for flooring. The distinction is not a strict one, however, and some examples of geometric parquetry, such as the flooring designed by Jean Macé for the Palais-Royal in the seventeenth century, have been given the combined name of *parquet marqueté*.

Marquetry today is done with extremely thin sheets of veneer—about 1/100 inch (0.25 mm)—but in the seventeenth century, when such work was first being perfected in France, thicknesses were sometimes ten times as much. A special type of saw (the *French horse*) was developed c.1780 that aided the cutting of complex patterns, replacing the fretsaw that had been used since the early seventeenth century. A wide variety of native woods was employed, including box, cedar, hawthorn, lime, oak, olive, sycamore, and walnut. To these were added in the seventeenth and eighteenth centuries more exotic woods imported from the tropics, such as amboyna, amaranth, ebony, rosewood, and tulipwood. By the end of the eighteenth century, the vocabulary of woods used in French marquetry reached almost a hundred varieties. Much skill was used to compose pleasing combinations of various wood colors and grains.

The techniques of marquetry are difficult, but the results can be remarkable and exquisite. In the early eighteenth century the great furniture maker André-Charles Boulle added the additional enrichment of inlays other than wood. With ebony, for example, he combined layers of brass, pewter, tortoiseshell, and mother-of-pearl. Such work is justly named **Boulle work** and its use spread from France to other parts of the continent and

to England. An example is the pair of commodes made by Boulle for Louis XIV's bedroom at the Grand Trianon, one of which is shown in Figure 15–39.

Other French ébénistes skillful in marquetry included Charles Cressent, Jean-François Oeben, Jean-Henri Riesener, Jean-François Leleu, and, in the Neoclassical period, David Roentgen.

Lacquerwork

Beginning in the seventeenth century, the French fashion for Chinese decoration had included an interest in Chinese **lacquer.** It was both imported and imitated, and panels, drawer fronts, and other furniture parts were sent from France to China to be lacquered. It was not until the eighteenth century that a really convincing French technique of imitating Chinese lacquer was invented. The process was patented by two brothers, Guillaume and Etienne-Simon Martin, in 1730, and in 1744 they were granted a monopoly on the production of such work for twenty years. Two younger brothers, Julien and Robert Martin, joined the firm around 1748, and sons of the elder brothers joined shortly after. Most of the Martins were granted the title *vernisseur du roi,* and the company was called the Manufacture Royale des Vernis Martin.

The Martins' lacquer was produced in the typical Chinese colors of black and scarlet, and also in a deep blue and in the pale tints of yellow, green, and lilac that were then so popular in France. The Martin enterprise and its products—furniture, and also pieces as large as carriages and sedan chairs and as small as fans and snuffboxes—were sensationally successful. The term **vernis Martin** was used for its lacquerwork and, later, for its furniture designs, and, still later after the monopoly expired, for the work of its many imitators.

Voltaire was a Martin customer and in his writing commended "these Cabinets where the Martins have surpassed the art of China." Voltaire may have been overly generous; even so, vernis Martin was of sufficient quality to be found in some apartments of Versailles and to have been ordered for her Hôtel d'Ormesson by the great connoisseur of things Chinese, Mme. de Pompadour.

Gilt Bronze or Ormolu

True **ormolu** (from the French *or moulu,* "ground gold") is decorative metalwork, such as used for furniture mounts (Figure 15–45), that is made of fire-gilt bronze. To ormolu is owed much of the brilliance we associate with fine French furniture. It is also known as *bronze doré* or, in English, *gilt bronze,* and the French themselves refer to it as *les bronzes d'ameublement* or simply *les bronzes.*

The fire-gilding process of true ormolu depends on the ability of heated mercury to unite with gold, forming an amalgam. In the French Renaissance and later periods, it was accomplished in two ways. In the first, a bronze surface was coated with mercury, and then thin sheets of gold were applied to the surface and forcefully burnished. In the second method, gold filings were added to heated mercury, the result stirred with an iron rod until it was the consistency of butter, then brushed onto the surface. In both methods, a final step applied heat to evaporate the residual mercury. If wanted, chemicals could then be used to alter the color or texture of the result. The technique, using either method, was fraught with difficulties and health hazards and is no longer in use. It has been replaced by electrogilding, a type of electroplating.

(True ormolu should not be confused with the inferior effects of imitation ormolu, which is made by dipping metal objects in acid and then painting them with gold-tinted lacquer. This less expensive alternative to fire gilding was used on many furniture mounts until the end of the Louis XV period, and is called *bronze verni* (bronze varnish) or *bronze en couleur.* In later centuries the term *ormolu* would come to be used also for materials—alloys of copper and zinc, for example, sometimes with the addition of tin—that only approximated the appearance of real gold.)

During the Rococo period, members of the Caffiéri family were prominent artisans of ormolu work, particularly Jacques Caffiéri (1678–1755) and his son Philippe Caffiéri II (1714–74). Prominent in the late Rococo and Neoclassical period were Etienne Forestier (1712–68), who supplied bronze mounts for André-Charles Boulle, Jean-François Oeben, and Gilles Joubert, and his two sons. Pierre Gouthière (1732–c. 1813) was credited with the invention of the matte-finish ormolu

Figure 15–45 Rococo ormolu mounts by Jacques Caffiéri on two drawer fronts of a commode by Antoine Gaudreau for the chambre of Louis XV at Versailles, 1739.

work popular in his day. Other prominent workers in ormolu during the eighteenth century included Jean-Claude Duplessis, his son Jean-Claude-Thomas Duplessis, and Pierre-Philippe Thomire. Duplessis père, Duplessis fils, and Thomire were all also employed as designers at the Sèvres porcelain factory, and many fine ornamental porcelain objects during that period were mounted in ormolu. As the ancien régime came to a close, however, at the end of the eighteenth century, so did the most brilliant period of ormolu work.

Porcelain

At the factory of St.-Cloud, near Paris, soft-paste (*pâte tendre*) porcelain was made as early as 1672. The factory, which thrived between the years 1690 and 1766, was established under royal patronage by two brothers, Claude and François Révérend, who had previously been importers of faience from the Netherlands. Their products included blue-and-white ware and all-white ware made in imitation of Chinese blanc de chine, and some of the St.-Cloud tiles and vases were made for Versailles. Other early French soft-paste factories were established at Chantilly and Mennecy,

What would become a more important factory was established in 1740 at Vincennes, its success greatly aided by a series of royal privileges and licenses. It was also fortunate in having as its first director Claude-Humbert Gérin, who had discovered a method of making a soft-paste porcelain of unusual whiteness. An important part of the production of Vincennes in its first decade was small porcelain blossoms that could be mounted on gilt-bronze stems and placed in vases—early and charming versions of artificial flowers. Dinner services were also made, at first on yellow grounds and later on pale greens and blues, including a turquoise hue called *bleu céleste*. Customers were royalty (including Louis XV) and nobility (including the Marquise de Pompadour), but around 1751 a shop was opened in Paris selling Vincennes wares to affluent members of the public. In 1756

Louis XV advertised the factory's skill with a gift of a Vincennes dinner service to the king of Denmark. That same year the factory, by then employing more than two hundred workers, was moved to Sèvres, ideally located between Paris and Versailles.

At Sèvres, the factory's reputation and technical skills both flourished, although there were some economic troubles requiring further royal patronage. Unlike Germany, France at that time had no access to kaolin (china clay), so the manufacture of true hard-paste porcelain was not possible, and much of the soft-paste production at Vincennes and Sèvres had been in imitation of the hard-paste wares from the German factory at Meissen. It was not until 1769 that kaolin deposits were discovered at St.-Yrieix, and production began there about three years later. Soon Sèvres was making soft-paste and hard-paste porcelains simultaneously, and it was not until the end of the century that it began to make hard-paste porcelain exclusively.

Pottery

Although the finest of French Renaissance ceramics were porcelains, there were also interesting and admirable accomplishments with more humble wares. French ceramics during medieval times had been limited chiefly to paving tiles for churches. Useful wares such as pots, bowls, and jugs were being produced in the twelfth century, and the 1399 inventory of Charles VI mentions "a pottery beaker from Beauvais mounted in silver." By the end of the fifteenth century France was producing earthenware stoves, fountains, statues and other religious wares, and a large variety of tableware, including such specialized items as paté dishes.

In the sixteenth century, candlesticks and bowls were made from fine clay inlaid with brown and black slips and covered in a transparent lead glaze. Decorations included the new fashions brought from Italy, such as grotesques, arabesques, and Vitruvian scrolls. Within this unremarkable context, a late-sixteenth-century artist of idiosyncratic vision produced some remarkably original work.

PALISSY Bernard Palissy (1519–90) traveled throughout France in his younger days working as a *peintre-vitrier*, a worker in stained glass. His early patron was Antoine de Pons, and a later patron was the Constable of France, Anne de Montmorency, for whom he worked on an (unfinished) rustic grotto for the château of Ecouen. By the middle of the century he developed a mixture of glazes that could make ceramics resemble jasper and other exotic stones then coming into fashion. The wares were called *terre jaspées.* A French Protestant, Palissy was arrested as a heretic in 1563, but the queen, Catherine de' Medici, arranged his pardon and named him *inventeur des rustiques figulines du roi.* His *rustiques figulines* for the king were inventive indeed, the most typical being oval platters covered in representations of ferns, mosses, and shells against which squirmed three-dimensional snakes, lizards, lobsters, frogs, insects, and assorted sea creatures (Figure 15–46). For Catherine, Palissy used the same marine-reptilian vocabulary in a grotto for the Tuileries garden in Paris. His work was highly influential, and many later French ceramics were produced in the Palissy style. In the middle of the nineteenth century examples would be shown in the international exhibitions at Paris and London.

FAIENCE The celebrated **faience** of Italy and Moorish Spain was introduced to France in the

Figure 15–46 Lead-glazed earthenware platter with a snake, a lobster, and other creatures by Bernard Palissy, second half of the sixteenth century, 19½ inches (493 cm) wide.

LARGE OVAL DISH, FRENCH, BERNARD PALISSY OR A FOLLOWER, LATE XVI CENTURY. BY KIND PERMISSION OF THE TRUSTEES OF THE WALLACE COLLECTION.

fourteenth century. Potters from Faenza and other Italian centers were active in France in the sixteenth century. In 1603 Henri IV granted a thirty-year monopoly for the production of faience to the three Conrade brothers in Nevers, whose production included some work in the style of the della Robbias. Italian styles continued in popularity for a long time, although they were joined by a more native style based on the paintings (admittedly Italianate) of Poussin, and after 1670 by Eastern influences, such as blue-and-white ware and, later, **famille verte.**

In the late seventeenth and early eighteenth centuries, the Poterat family established an important faience pottery at Rouen, producing pale blue monochrome wares with decorations picked out in reddish brown (*style rayonnant*). Large "services" were produced, consisting of dozens of pieces of tableware for various uses. Later in the eighteenth century, the success of the Rouen factory was emulated at new faience works at Lille, Marseilles, Moustiers, Strasbourg, and Lunéville.

CREAMWARE By the end of the eighteenth century, however, the popular taste had turned from faience to English **creamware,** a cream-colored type of earthenware that was less expensive and thought to be more suitable for the new Neoclassical designs. In 1772 the Pont-aux-Choux factory in Paris declared itself the "Royal Manufacturer of French earthenware in the imitation of that of England." Potters came from the famous English factory at Staffordshire to open new factories in France, and by 1786 creamware was being made at Lunéville and Chantilly. It was called *faïence fine.*

Glass

French glassware was strongly influenced by the glass of Venice. Much Venetian glass was imported to France until the end of the seventeenth century, and many who made glass in France had moved there from Italy. Some came in the sixteenth century to the glassworks at St.-Germain-en-Laye supported by Henri II and his wife Catherine de' Medici. Another, given the French name of Bernard Perrot, settled in Orléans in 1662 under the patronage of the Duc d'Orléans, the brother of Louis XIV. Perrot's innovations include tech-

niques for making *porcelaine en verre* (an opaque white glass resembling porcelain), *rouge des anciens* (a transparent red glass imagined to be similar to ancient products), and, of most importance, cast (rather than blown) panels of flat glass.

Flat glass and mirrors were important ingredients of the interior design of the time, and mirrors, of course, performed the valuable function of reflecting light, an important service in an age dependent on candlelight. Producing them, rather than importing them at great cost, was a major economic concern of the court. Louis XIV and his minister Colbert founded a plate-glass factory in 1665 in the Paris suburb of St.-Antoine, employing Italian workers. It was the St.-Antoine factory that, between 1678 and 1683, provided the glass and mirrors for the Galerie des Glaces at Versailles. Another royal glass factory was established in 1693 at St.-Gobain, and in 1695 the two factories were merged to form the Manufacture Royale des Glaces de France.

In smaller blown-glass wares such as vases and cups, the late-seventeenth- and eighteenth-century fashion was for cut and faceted pieces. "English crystal" or lead glass, containing a large amount of lead oxide, was developed in England in 1676 and was thought to be particularly appropriate for such treatment. During the next century, many French glass factories turned to the production of lead glass, including the famous Baccarat factory, which had been founded in 1764, and the St.-Louis factory, founded in 1767.

The Revolution of 1789 ended the royal privileges of French glassmakers, and the end of the eighteenth century also brought changes in taste and technology. Glass began to be made in more utilitarian forms, and it came from new factories, located where canals and railroads provided ready supplies of coal for their furnaces.

Wallpaper

In the thirteenth century the use of a coat of arms had been granted in Paris to a group called the *dominotiers*. The *domino* was a cape worn by a member of the clergy, and possession of its image was taken, in those superstitious times, as proof that the owner was not a heretic. It was the dominotiers who produced such images on walls.

In the fourteenth century, wood blocks, developed for printing patterns on fabric, were also used for printing on paper that could be pasted on walls, making the work of the dominotiers less costly and more popular. By the fifteenth century, they were sharing a guild with the makers of stationery and playing cards. By the sixteenth century, their original trade in religious symbols forgotten, the *cartiers-dominotiers* were busy producing a type of goods new to Europe: wallpapers.

Their customers were members of the middle class that had recently emerged. They were acutely aware of—but unable to afford—the fashion among royalty and nobility for luxurious wall coverings such as stuccowork, frescoes, tapestries, and paneling in wood, marble, and leather. Decorative papers that imitated these rich treatments offered a very welcome solution. And later, when scenic papers were being imported from China at great expense, the French papermakers learned to imitate them as well. The Chinese imitations, along with all such things, were called **chinoiserie,** and the papers that imitated tapestries, brocades, Indian chintzes, and other fabrics were called **papiers de tapisserie.**

THE PAPILLONS One dominotier, Jean-Michel Papillon (1698–1776), the son and grandson of dominotiers, wrote in his text, *Traité historique et pratique de la gravure sur bois,* that it was to his father, Jean Papillon II, that "we owe the invention of *papiers de tapisserie,* for which he started a fashion in 1688." What Jean-Michel's father may have done is to make repeating patterns on large carved wood blocks that would match on all sides when separate printed images were joined. The wood blocks were covered with pigments and then pressed against the paper, and, by using separate blocks for each color, Papillon could print his repeating patterns in any number of colors.

Jean-Michel Papillon's text, the first history of wallpaper, included information about hanging papers, even in such difficult places as circular rooms and around stairways, and it gave an idea of the variety of papers that had already been developed: flocked paper, imitation wood paneling, imitation cut velvet, floral designs, landscapes, borders, friezes, and rosettes for ceilings.

RÉVEILLON The Papillon family's accomplishments were overshadowed later in the eighteenth century by those of Jean-Baptiste Réveillon (1725–1811) who established his business in 1752, after Jean-Michel Papillon had left the wallpaper business to concentrate on wood engravings. Réveillon's techniques were similar to those developed by the Papillons and used in numbers of small crafts workshops, but he practiced them on a much larger scale, eventually employing over three hundred workers, and with stricter standards than most. He bought his own paper factory so that he could control paper quality, and he was equally meticulous about the pigments used. Rather than attempt to design everything himself, he assembled a staff of designers, some of them previously employed at the Gobelins tapestry factory.

The designs produced by the Réveillon factory were dominated by the **grotesques** that Raphael had adapted from Roman models for his *loggie* at the Vatican two and a half centuries earlier (Figure 13–7) and the similar but more natural **arabesques** taken from Islamic art. Réveillon's great contribution to interior design was his arrangement of these motifs into elements that could be adapted to rooms of varying shapes and sizes. There were large paper panels for large wall surfaces, smaller panels for overdoor use, narrow vertical panels that could be extended to any height like pilasters, and narrower strips that could be used as borders and frames. These parts could be assembled to give any room not only decoration in the latest taste, but a sense of architectural order it may have lacked.

Louis XVI made Réveillon a royal warrant holder in 1784, and from then until the Revolution of 1789 his wallpapers were stamped MANUFACTURE ROYALE. His factory, which he had worked to make symbolic of aristocratic taste, was one of the early casualties of the Revolution, but Réveillon escaped to England, where he died. His business was sold to a firm called Jacquemart and Bénard, which operated from 1791 to 1840. It continued to produce some of Réveillon's grotesques and arabesques, but added designs with themes related to the Revolution and, in the early nineteenth century, new designs in the Empire style. Despite the destruction of Réveillon's factory, some of his original

wood blocks are still in existence and are used today for making copies of his designs.

Tapestry

The technique of tapestry weaving described in our chapter on the Gothic period (pp. 188–190) may have been introduced to France as early as the thirteenth century. From the middle of the fourteenth century to the middle of the fifteenth, the most important French center of tapestry production was the northern town of Arras, and work there was supported by the dukes of Burgundy. Writings of the time suggest a sizable output, but only a few examples remain by which its quality can be judged. The early history of French tapestry is further complicated by the fact that many weavers and cartoon makers were itinerant, moving around the country to find work.

In the middle of the sixteenth century, François I established a royal tapestry workshop at Fontainebleau, and at the end of the century Henri IV established another in the Galeries du Louvre. There were also tapestry workshops in provincial centers such as the towns of Toulouse and Rheims. In 1658 Nicolas Fouquet, Louis XIV's superintendent of finance, established his own workshop solely for the production of tapestries for his grand château of Vaux-le-Vicomte, then under construction. When Louis arrested Fouquet three years later, he confiscated the tapestry workshop along with the château. Colbert, the king's chief minister, then transformed it into part of a much more ambitious undertaking, the Gobelins.

THE GOBELINS Tapestries had been woven since 1607 in a Paris town house called the Hôtel des Gobelins (goblins), and in 1663, having added Fouquet's artists and weavers as well as a large number of other studios, Colbert established there an organization to supply a wide variety of luxury goods—including tapestries—for the royal households. It was formally known as the Manufacture Royale des Meubles de la Couronne, but informally known all over the world as the Gobelins, a name that—like Arras—has come to be almost synonymous with tapestry.

Charles Le Brun was artistic director of the entire enterprise, and under him more than three hundred workers and apprentices staffed the tapestry studio. Le Brun approved every tapestry's subject matter and quality, both of which were intended to enhance the image of the Sun King. Some designs were made by Le Brun himself, including a cycle called *Story of the King,* woven between 1665 and 1678. One panel of the cycle depicted the king visiting the Gobelins and inspecting a wide variety of rich goods, all probably intended for Versailles, as was the tapestry cycle itself. Other famous tapestry cycles by Le Brun were titled *The Elements, The Four Seasons,* and *The Months,* and he also ordered tapestry versions of paintings by Raphael and Poussin.

The expenses of war depressed the activity of the Gobelins in the last decade of the seventeenth century, but a revival was effected in 1699 by Jules Hardouin-Mansart, the crown's new Superintendent of Buildings, who appointed architect Robert de Cotte director of the workshop. Among de Cotte's eighteenth-century successors was Jacques-Germain Soufflot, architect of the church of St.-Geneviève in Paris, to be later known as the Panthéon.

To suit the eighteenth-century taste for smaller, more intimate rooms, the products of the Gobelins became somewhat smaller and their appearance more delicate. Historical scenes were still popular, but so were more lighthearted genre scenes depicting everyday life, and an eighteenth-century innovation was the portrait tapestry, the first being of Louis XV after a painting by Louis-Michel van Loo. Another eighteenth-century introduction was the tapestry *à alentours* with its central image framed by elaborate borders. And the last half of the century, of course, brought Neoclassicism to the Gobelins as it did elsewhere.

BEAUVAIS In 1664, the year after establishing the Gobelins, Colbert also founded a tapestry workshop at Beauvais, a cathedral town northwest of Paris. Beuavais struggled for success in its first sixty years. Its later success was largely due to Jean-Baptiste Oudry, who was employed there as a painter in 1726 and became director of the factory in 1734. One of his first acts as director was to bring François Boucher to Beauvais as the chief painter. In the next

twenty years Boucher designed dozens of compositions for Beauvais, and the factory's success was assured. Oudry continued his own designing as well, and other Beauvais subjects included *verdures* (representations of leafy plants), chinoiseries, masked figures from the Italian commedia dell'arte, and pastoral and mythological scenes. In addition to tapestries, Beauvais produced woven furniture covers, usually designed to match the wall hangings. Louis XV supported Beauvais with funds and honored it by purchasing its tapestries for diplomatic gifts.

AUBUSSON The towns of Aubusson and Felletin in south central France had been centers of tapestry production beginning in the sixteenth century. Originally both the quantity and the quality of production were inferior to those of Flanders, but royal support in the early seventeenth century eliminated customs on tapestries sent from Aubusson to Paris and also curtailed Flemish imports. By 1637, two thousand workers were employed at Aubusson, working out of their homes rather than (as at the Gobelins) in a central factory. During the next century, quality was improved as well, and popular subjects for Aubusson tapestries came to include paintings by François Boucher and, later, Jean Pillement.

The prestige of these three chief centers of French tapestry production varied through time, but in general we can say that the works of the Gobelins were designed for the king, those of Beauvais for the nobility, and those of Aubusson for the prosperous middle class. After the French Revolution, tapestry production would continue on a greatly diminished scale.

Carpets

Copies of carpets imported from the Near East had been made in France as early as the fifteenth century, and pile carpets made in France were listed in the inventories of François I in the sixteenth century. The French carpet industry that would become world famous, however, was not established until the early seventeenth century.

SAVONNERIE CARPETS By 1608, under the patronage of Henri IV, a weaver and embroiderer named Pierre Dupont had set up a workshop in space beneath the Grande Galerie of the Louvre, the great palace in the heart of Paris, for the manufacture of carpets in the Turkish fashion (*façon de Turquie*). In 1627, needing to expand, Dupont sent one of his apprentices, Simon Lourdet, to establish a similar workshop at Chaillot, just outside Paris and near an orphanage founded by Marie de' Medici. The quarters for Lourdet's workshop had previously been occupied by a soap factory (*savonnerie*), which gave its name to all the workshop's later production.

Using cheap labor from the orphanage, the Savonnerie factory flourished. Together with Dupont's factory at the Louvre, it was granted a monopoly on carpet manufacture for eighteen years, and competition was further discouraged by the prohibition of imports. The name *Savonnerie* came to be applied to the Louvre products as well, and in 1663 Jean-Baptiste Colbert, Louis XIV's chief minister, placed all carpet production within the jurisdiction of the Gobelins, which had just been formed. By this time, imitation of Islamic designs had been superseded by designs in the French Baroque style, and the Gobelins' director Charles Le Brun mandated that the carpet designs be coordinated with current furniture designs—largely ebony pieces inlaid with floral motifs and arabesques. The typical result (such as Figure 15–47) was a wool carpet of floral and vegetal garlands against a black ground; it might have a scenic panel at each end with an allegorical scene, and a central medallion often referred to Louis XIV by depicting a sunburst or the head of Apollo. Le Brun ordered more than a hundred carpets of this type for rooms at the Palais du Louvre and the Palais des Tuileries, and some think them the finest carpets ever made in Europe. They were woven with a **symmetrical** (or *Turkish* or *Ghiordes*) **knot** on upright looms, and they have 90 knots to the square inch (14 per cm$^2$). In addition to carpets, the Savonnerie workshops produced wall hangings, door hangings, bed canopies, and covers for chairs and sofas.

Royal patronage dwindled, however, as the country's financial situation worsened, and by the end of the seventeenth century many Savonnerie looms were idle. Another surge of activity came in 1712 with carpet orders for the royal châteaux at Versailles and Fontainebleau, but the surge was followed by another downturn in the difficult decades

before and after the Revolution. In the early nineteenth century Napoleon would declare Savonnerie an imperial factory, and it would produce fine works in the Neoclassical style. In 1825 the Savonnerie workshop would be absorbed by the Gobelins; by then, however, its prominence had been eclipsed by that of Aubusson.

AUBUSSON CARPETS We have identified the town of Aubusson as an important center of tapestry production. In a 1743 reorganization of the Aubusson factory, carpet manufacture was added to tapestry work, and for three years the new venture had the financial support of the king. At the time, the total output of the Savonnerie factory was earmarked for royal use, so Aubusson found a ready market among the nobility and middle classes. Samples of Turkish carpets were sent to Aubusson to be copied, but by 1750, reflecting a change in taste, Savonnerie carpets were being sent instead. The Aubusson imitations, however, were generally simpler than their Savonnerie models. The Aubusson factory produced both tapestry-weave carpets woven on horizontal looms and pile carpets woven on vertical ones. Colors were generally soft and pale: rose, dove gray, buff, light brown, and light yellow. Examples were obtained for some of the smaller rooms at Versailles, and there were Aubusson exports to northern Europe and even to the United States.

Other Textiles

In addition to tapestries and carpets, the French Renaissance produced interesting lace (used primarily for clothing), embroidery (used for bedcovers and wall hangings as well as for clothing), silk, and printed cotton. We shall look briefly at the last two of these.

SILKS Italy and France dominated the European silk market until late in the seventeenth century, and France also imported some silk from the Near East. King Charles VII was concerned to establish a native French silk industry, and his son Louis XI in 1466 made a serious attempt to found a factory for making cloth of gold in the city of Lyon. This was at first opposed by the merchants involved in silk importation, but in 1470 a more successful at-

Figure 15–47 Detail of a Savonnerie carpet made for the Grande Galerie of the Louvre, ca. 1680 (wool); French School (17 Century). Mobilier National, Paris, France/Bridgeman Art Library. 30 feet (9.14 m) long.

tempt was made at Tours on the Loire River in west central France, near Louis's own château at Plessis-lès-Tours. The king afforded the Tours factory financial safeguards, and by 1490 there were a hundred looms in operation there. In 1536, under François I, similar royal privileges were granted to the Lyon facility: foreign weavers were encouraged to move to France, and Paris, Rouen, and Orléans also became silk producers. A great boon to the whole French silk industry came in 1599, when the king banned all silk importation for a year.

But French silks were still plain and dull compared to the richly figured silks and ciselé velvets from Italy. A talented weaver was brought from Milan to Lyon in 1604 to teach the French new techniques and to adjust their looms for more elaborate effects; in 1665 Louis XIV's minister Colbert set new standards for silk production, including a

mandate for the production of new designs every year; and in 1667 there was another ban on imports. By this time Tours had developed its own specialty, a stout, durable silk taffeta called *gros de Tours,* and in 1686 Louis XIV considered the silks made in St.-Maur-les-Fossés, near Paris, to be fine enough to serve as a gift to the king of Siam.

By the eighteenth century the French silk industry had become fully the equal of the Italian, and France's leadership in all phases of fashion made French silks highly desirable. Lyon became the most important silk city of Europe. In Paris, the related craft of silk ribbon weaving flourished.

In the early eighteenth century, silk designs were dominated by dense floral patterns, from the 1720s by geometric bands and diaper patterns, in the next decade by naturalistic effects, and then from the 1740s by the Rococo style with its asymmetrical sprays of plant forms. Later in the century the paintings of Boucher and Pillement were highly influential, as was the general craze for chinoiserie. One of Lyon's weavers, Philippe de Lasalle (1723–1804), achieved an international reputation: some of his silk brocades were commissioned by Russia's Catherine the Great and some by Marie-Antoinette (though she never lived to see them).

The French Revolution brought a hiatus in silk production, but a revival came shortly afterward with large orders of French silks from Charles IV of Spain and then from Napoleon. Today the French silk industry remains important, and Lyon remains its capital.

TOILE DE JOUY In the description of the small table called a **toilette,** the word *toile* was translated as "linen" or "canvas." **Toile de Jouy,** however, identifies printed cotton of the type originally made in the French village of Jouy-en-Josas, near Versailles. Indian chintzes and other cottons had been imported into France in the late sixteenth century, and France had experimented in the seventeenth century with duplicating Indian techniques. Both the Indian originals and the French copies became so popular that they threatened the carefully nurtured silk industry and the wool industry as well, leading to legal prohibitions against the cottons beginning in 1686. It is said to have been Louis XV's manipulative and fashion-conscious mistress Mme. de Pompadour who persuaded the king to

lift the ban in 1759. Just three years before, the Irish textile artist Francis Nixon had introduced into England his technique for printing cotton patterns with large copper plates rather than with the small wood blocks previously used.

Taking full advantage of the new law, Christophe-Philippe Oberkampf opened his Jouy-en-Josas factory in 1760. Soon he abandoned his wood blocks and also took advantage of Nixon's new technique. His operation would be a very fashionable success through the end of the century, and it would continue after his death in 1815, not closing until the 1840s. Contributing to Oberkampf's success was his insistence on quality material, fast dyes, and expert engraving, his use of the most modern techniques (introducing France's first copper-roller printing machine in 1797), and his hiring of fine artists.

Among these last the most prominent was Jean-Baptiste Huet (1745–1811), nephew of Christophe Huet, who decorated the Hôtel de Rohan. His designs included pastoral scenes (Figure 15–48), as well

Figure 15–48 A pastoral toile de Jouy designed by Jean-Baptiste Huet, c. 1797.

as mythological, historical, and allegorical ones. Some actually depicted the manufacture of toile de Jouy. They were designed in fine lines meant to be printed in a single color—blue, red, green, sepia, eggplant, or black—against a pale cream-colored ground. The results were charming, and Huet's designs are still imitated today.

Summary: The French Renaissance

In many times and places we have seen interior design influenced by royal taste, but in no case has that influence been as pervasive as in Renaissance France, particularly during the seventy-two-year reign of Louis XIV. Interior design was then institutionalized as never before: style became a part of government policy; opulence became an advertisement for the state; the products and techniques contributory to design became a part of the national economy; and almost every level of French society became a participant in the pleasures of beautiful rooms and fine furniture design. Louis left as a heritage the ultimate of all the arts: he had taught the people the art of living.

Looking for Character

We have seen a variety of artistic expressions in French design, from the pomp and power of the Baroque to the delicacy of the Rococo to the restraint of the Neoclassical and Directoire styles. Fundamental to all these are three abiding characteristics of French thinking: a love of romance, a love of order, and a remarkable openness to intellectual freedom. Although, as we have seen in chapter 8, the French were leaders in the race for the tallest and most structurally unlikely cathedrals (exercising their love of romance), from the Renaissance on they have been noteworthy for their candid acknowledgment of human instincts that the Middle Ages had preferred to screen. France's great Renaissance writers and philosophers— Rabelais, Montaigne, Descartes—have been in the background of our story of the visual arts, but they were the intellectual forefathers of modern tolerance and democracy. And congruent with this tradition has been the French concern for interiors remarkable for their high style, their artistic unity, and their unprecedented comfort.

Looking for Quality

We have said that French Rococo design could be a pure delight or something lesser. Such variations in quality are found to some degree in the design of all times and places. In no case, however, is lack of quality in any French style due to lack of attention to detail. Fine materials, fine finishes, and meticulous workmanship characterize all French design, even the provincial. In the rare cases that may be judged unsuccessful, the fault is likely to be a surfeit, rather than a lack, of attention to detail. And at their best, French interiors, furniture, and decorative arts from the fifteenth through the eighteenth centuries reached levels of quality that have never been surpassed.

Making Comparisons

Comparisons among the French styles have already been noted: the Rococo lighter, more lyrical than the Baroque; the Neoclassical more restrained than either. Comparisons between French styles and the Italian and Spanish styles that inspired them are equally obvious: the French designs with less passion and less movement than the Italian, yet with less solemnity and less severity than the Spanish. In chapters 16 and 18, dealing with England and America, respectively, we shall see how French taste was tempered as it in turn exerted its influence on other cultures. And after that, we shall see its development in the nineteenth and twentieth centuries.

Beyond any comparison, however, is the enduring position of France in general and of Paris in particular as outstanding arbiters of taste and civilization. For centuries the world has turned to French culture—and not least to French interior design—for artistic nourishment.

16

THE ENGLISH RENAISSANCE AND LATER DEVELOPMENTS

SIXTEENTH TO EIGHTEENTH CENTURIES

We have traced the Renaissance from Italy to Spain and France, seeing that as it spread it brought enlightenment, a new appreciation of the world, and a new sense of human value. New art and design were integral parts of the new spirit.

Despite a long English devotion to Gothic form and ornament, the Renaissance spirit inevitably crossed the Channel from the continent of Europe to the British Isles. We shall see that, after a tentative beginning, that spirit would produce there interiors and furnishings of great distinction.

Figure 16–1 MAP OF ENGLISH SITES

ORTELIUS DESIGN

English Architecture and Its Interiors

We shall consider developments of the Early English Renaissance first, then the introduction to England of Palladian design principles, then the remainder of the seventeenth century and first half of the eighteenth century, and finally the great classical revival of the late eighteenth century.

Buildings of the Early English Renaissance (1500–1620)

Coinciding roughly with what has been called the Age of Oak, the Early Renaissance in England

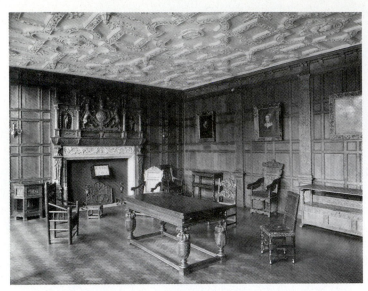

Figure 16–2 A Jacobean room from Bromley-by-Bow, built in 1606. The ceiling is of pargework, and the oak paneling is divided by classical pilasters.

VICTORIA AND ALBERT MUSEUM, LONDON/ART RESOURCE, NY

comprised the Tudor, Elizabethan, and early Jacobean periods. Gothic forms and ornament still dominated. The sixteenth century brought domestic architecture of brick and stone, but the most characteristic houses were **half-timbered,** built of heavy timber members that were visible on both the exterior and the interior. These members were spaced roughly 2 feet (60 cm) apart with occasional diagonal members connecting them for bracing, the spaces between them being filled with plaster or masonry or, in the most rustic cases, wattle and daub, a mixture of woven twigs, clay, and mud. Houses were generally built in irregular shapes, fully or partially enclosing courtyards.

Inside, the multipurpose **great hall** of medieval times persisted well into the Tudor period as the chief room of the house. This space, able to accommodate at times a community of a hundred or more, customarily had stone floors, tapestry-hung walls, a central fire pit, and windows of wicker or horn. Gradually it evolved into a series of smaller, more intimate rooms with wood floors, paneled walls, fireplaces with chimneys, and windows of glass.

These windows were divided into leaded panes, similar to the windows of Gothic churches, but with panes that were smaller and rectangular or diamond-shaped. Colored glass was limited to small designs showing family coats of arms, although impurities gave unintended tints to many of the panes. The window openings were sectioned by wooden or stone mullions and were typically topped with the flat but pointed Tudor arch, as were most important door openings and fireplace openings.

The interior walls of brick or stone houses were sometimes finished in rough plaster, sometimes above a wainscot of oak panels, which were sometimes plain, sometimes enriched with linenfold carving (Figure 8–4) or diamond shapes; the wood was sometimes left in its natural state, sometimes polished with oil and beeswax. In fine rooms, the panels could rise the full height of the wall and be topped with a cornice at the ceiling, as in the early-seventeenth-century room in the "Old Palace" at Bromley-by-Bow (Figure 16–2). Columns and pilasters also began to appear, borrowed from Renaissance Italy, but they seldom appeared in classically correct relationships or proportions. In the Jacobean period, more elaborate paneling was introduced, usually in geometric forms—squares, hexagons, semicircles, and more irregular shapes. Another popular type of carving in both Elizabethan and Jacobean times was **strapwork,** in which fanciful shapes appeared to be composed of interwoven flat bands or straps.

Ceiling beams were exposed in the early sixteenth century, occasionally edged with moldings and ornamental carvings. Unusually large rooms might have exposed trusses rather than simple beams, the most impressive being the hammer-beam truss in the form of a Tudor arch springing from brackets. By the last half of the sixteenth century, these exposed structures had been replaced in fashion by a covering of decorative plasterwork, sometimes in direct imitation of the ribs and beams that would previously have been exposed. Such plasterwork employed the geometric forms also used for wall paneling but rendered them in greater depth. This plaster relief work was called **parge-work** or pargetry. Original to the Jacobean period (though, as its name suggests, of classical inspiration) was **Romayne work,** consisting of **rondels** filled with medallion heads in profile (Figure 16–3), with scrollwork, or with foliage. They appeared as

Figure 16–3 An English oak stool, c. 1535, with carvings of Romayne work.

AFTER STAFFORD AND WARE, *AN ILLUSTRATED DICTIONARY OF ORNAMENT*

TIMELINE THE ENGLISH RENAISSANCE

PERIOD	RULERS AND THEIR DATES	PRINCIPAL DESIGNERS	DESIGN MILESTONES
Tudor, 1485–1558	Henry VII, 1485–1509; Henry VIII, 1509–47; Edward VI, 1547–53; Mary I, 1553–58		Chapel of Henry VII, Westminster Abbey, 1503–19
Elizabethan, 1558–1603	Elizabeth I, 1558–1603		Hardwick Hall, 1590–96
Jacobean, 1603–49	James I, 1603–25; Charles I, 1625–49	Inigo Jones, c 1573–1652	Banqueting House, Whitehall, 1619–22; St. Paul's, Covent Garden, 1630–31
The Commonwealth, 1649–60	Oliver Cromwell, 1649–60		
Restoration, Stuart, or Carolean, 1660–88	Charles II, 1660–85; James II, 1685–88	Christopher Wren, 1632–1723	Hampton Court Palace addition, 1690
William and Mary, 1689–1702	William III, 1689–1702; Mary II, 1689–94	Christopher Wren	
Queen Anne, 1702–14	Anne, 1702–14	Christopher Wren; John Vanbrugh, 1664–1726	St. Paul's Cathedral, London, 1675–1711; Blenheim Palace, 1705–16
Georgian, 1714 to the end of the century	George I, 1714–27; George II, 1727–60; George III, 1760–1820	Lord Burlington, 1694–1753; William Kent, 1685–1748; Thomas Chippendale, 1718–79; George Hepplewhite, d. 1786; Robert Adam, 1728–92; Henry Holland, 1745–1806; James Wyatt, 1746–1813; Thomas Sheraton, 1751–1806	Mereworth Castle, 1723; Chiswick House, London, 1730; Pantheon, London, 1769–72; Carlton House, London, 1783–95

ornament in plasterwork, in paneling, on furniture, and—in miniature—as knobs at the tops of chair-backs or as drawer pulls.

Flooring on the ground levels of sixteenth-century English houses was usually of flagstone or slate. The flooring of upper levels was of random-width oak planks, generally the full size of the logs from which they were cut. Before the seventeenth century, even some of the grandest houses continued the medieval custom of strewing rushes and grasses over the floor. Paul Hentzer, a traveler from Germany, reported that Elizabeth I's rooms at Greenwich Palace, London, were scattered with hay when he visited there in 1598.

The stair hall of the sixteenth-century English house was often made a special feature. Often of immense size, the staircase was built with elaborately carved newel posts and rich balustrading, and the side walls were treated with small oak panels and leaded-glass windows, as in the most major rooms.

An important country house of the time was Knole in Kent, for which Gerrit Jensen, a cabinet-maker of (perhaps) Flemish origin is said to have made furniture in silver, and certainly made some in marquetry. A suite of chairs and stools made by Thomas Roberts for the ill-fated James II is at Knole as well. The house also boasted silver andirons and numerous tapestries, the hinged-arm sofa to which it gave its name, and a richly carved stair rising three floors around an open well. More architecturally innovative, however, was Hardwick Hall.

HARDWICK HALL, DERBYSHIRE, (1590–96)

Elizabeth Talbot, Countess of Shrewsbury, familiarly known as Bess of Hardwick, was known for her ambition, shrewdness, and temper. She left four marriages with ample financial settlements, and she undertook a number of building projects, including extensive remodeling at Chatsworth, the property of an ex-husband. In her sixties, she began her largest project, Hardwick Hall, adjoining a small manor house where she had been born and which she had later enlarged and then partly demolished. What remained of it would house servants and guests, allowing the new Hardwick Hall to provide only rooms for the family and public entertaining. The design of her new house, which she began building in 1590, is thought to have been by architect Robert Smythson, whose other houses of the Elizabethan and Jacobean periods included Longleat and Wollaton.

"Hardwick Hall, more glass than wall" was a popular jingle of the day, and the stone house did have an extraordinarily large window area in a time when glass was still expensive. The leaded glass not only provided bright interiors but was also an advertisement of personal accomplishment, for part of Bess's great fortune came from her investment in lead mining and glass manufacturing. The floor plan was a simple rectangle with six attached towers, and an interior innovation was that the two-story-high great hall was not stretched along the entrance front, as had been customary for centuries, but was placed at right angles to it, extending right through the house. The hall's appearance was traditional, however, with oak wainscoting and a minstrel gallery above the screened entrance.

Other important rooms include Bess's own chambers on the house's first floor (second floor in American usage) and on its top floor the high great chamber and the 160-foot (49-m) long gallery. This last room was used for grand entertainments and, on rainy days, for long walks by the owner (Figure 16–4).

The furnishings of Hardwick Hall include two magnificent sets of tapestries from Brussels

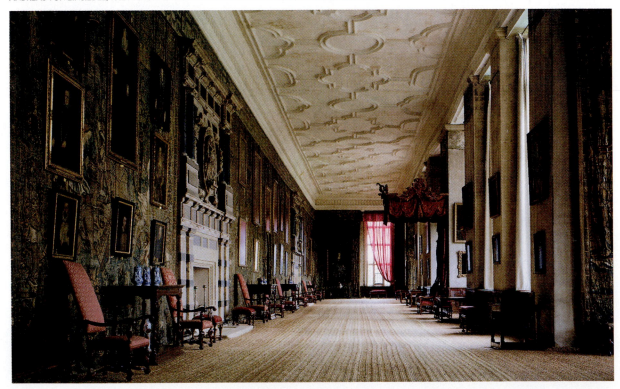

Figure 16–4 The long gallery at Hardwick Hall. Its height and length were designed to accommodate tapestries, some of which have been covered with paintings.

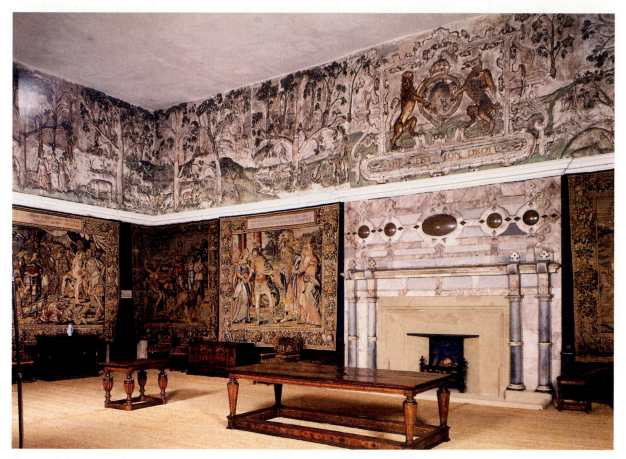

Figure 16–5 The high great chamber at Hardwick Hall. The top half of the wall is a painted plaster frieze incorporating real tree trunks; the lower half is hung with tapestries. The floor is covered with rush matting.

illustrating *The Story of Ulysses*. Bess had bought them in 1587, four years before construction began, and the high great chamber and adjacent long gallery were designed with wall space on which to hang them. Another tapestry cycle, *The Story of Gideon*, was also hung in the long gallery. Those in the high great chamber cover only the lower half of the wall, and above them is a mural of painted plaster depicting a woodland scene, in which, for realism, actual trunks of small trees were embedded in the plaster (Figure 16–5). Another decorating curiosity, infuriating to textile enthusiasts but giving an impression of profligate richness, is that a large collection of family and royal portraits has been hung directly over the valuable tapestries (Figure 16–4). The rush matting on the floor of the high great chamber is of a distinctive weave that has been copied elsewhere under the name *Hardwick matting*.

The Introduction of Palladian Influence (after 1619): Inigo Jones

A dramatic change occurred in English architecture and design during the Jacobean period. Although the English had already begun to employ some of the Renaissance forms they had observed in Italy, Spain, France, and the Netherlands, these had been used without knowledge of their classical roles, as if letters of the alphabet had been copied without forming them into meaningful words. A new understanding of the classical relationships among classical elements came to England through the efforts of a single architect, Inigo Jones.

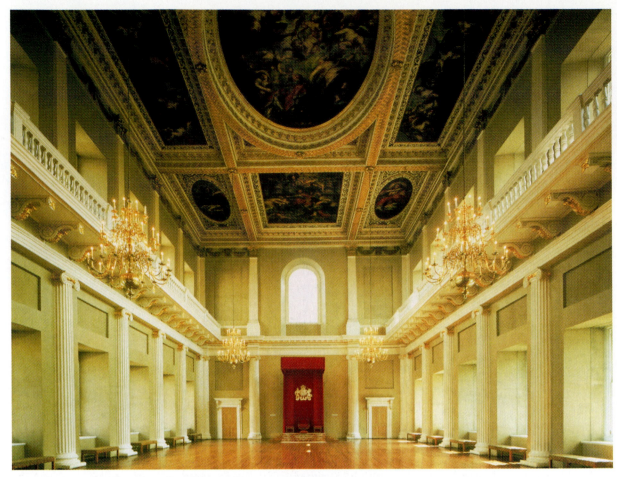

Figure 16–6 The double-height interior of Inigo Jones's Banqueting House. The ceiling painting is by Rubens.

INIGO JONES Inigo Jones (1573–1652), though most celebrated today as an architect, seems to have been best known in his own time as a designer of entertainments for the Stuart courts of James I and Charles I. His knowledge of both stagecraft and architecture was gained in an extensive and fortuitous trip to Europe: from 1598 to 1603 he studied in Venice and other Italian centers, where he bought a copy of Palladio's *Quattro Libri dell'Architettura*. Jones's architectural masterpiece was the Banqueting House at Whitehall, and his influence is seen in another fine work of the time, Wilton House.

THE BANQUETING HOUSE, WHITEHALL (1619–22) The Banqueting House was meant to accommodate royal entertainments and masques. It was later conceived as one element of a vast royal palace to be built in the Whitehall area of London, a project never carried out. The interior was designed by Jones, with Palladian attention to proportion, in the shape of a double cube, its height equal to its width, and its length twice that dimension (Figure 16–6). The half columns and pilasters are in the Ionic and Corinthian orders. The room is ringed by a colonnaded balcony supported on brackets and is spanned by a flat ceiling. The ceiling's paintings, within plaster moldings, were executed by the Flemish painter Peter Paul Rubens and installed in 1635.

WILTON HOUSE, WILTSHIRE, (1636 AND LATER) Inigo Jones is also often credited with the design of Wilton House in the 1630s, a major addition to an older group of buildings known as Wilton Abbey, but it is now thought that Jones's

role was only supervisory, with the actual design executed by Isaac de Caus, a French architect working in England.

However the responsibilities were divided, the collaboration produced a celebrated new south front 420 feet (130 m) long with a stately pavilion at each end. De Caus is also credited with the original layout of the garden that the new front faces. After a disastrous fire in 1647 gutted the new south wing, its interiors were re-created by Inigo Jones's pupil John Webb.

The interior of Wilton is distinguished by a number of finely proportioned state rooms, notably the Single Cube Room and, twice as long, the white and gold Double Cube Room (Figure 16–7). Handsome as these two rooms are, their geometry is not quite as clearly grasped as that of the Banqueting House because in both cases deep curving ceiling coves protrude into the cubic volumes. The ceiling panels are richly painted by Giuseppe Cesari, Emanuel de Critz, Edward Pierce, and others, and the paneled walls are adorned with carved garlands and swags. Portraits of family members and royalty by Anthony Van Dyck hang in both rooms.

Wilton was a model for many houses that followed it, including two fine neo-Palladian houses in

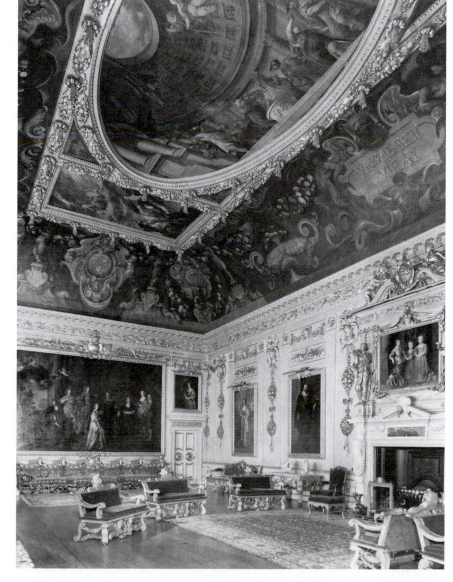

Figure 16–7 The Double Cube Room at Wilton. The original shape of the room is by Isaac de Caus under the supervision of Inigo Jones; the chimney piece is by John Webb; the furniture, by William Kent.

A. F. KERSTING

Norfolk: Houghton Hall, by Colen Campbell with interiors by William Kent, 1722–35, and Holkham Hall by William Kent, Lord Burlington, and Matthew Brettingham, 1734–65.

The Restoration, William and Mary, Queen Anne, and Early Georgian Periods (1660–1762)

The restoration of Charles II in 1660, the Great Fire of London in 1666, changes in social life, and the desire to imitate the new king in his introduction of French luxury combined to change English design. Many houses were built, reconstructed, or redecorated. Inigo Jones, who had died in the early years of the Commonwealth, was followed as a design leader by Sir Christopher Wren (1632–1723), who had visited Versailles while the palace was under construction and had made a careful analysis of current French Renaissance design. Wren liked to design, he said, "in a good Roman manner." As the popularity of classical design increased, the old Gothic and Tudor forms disappeared from English decoration, and Charles II's 1662 marriage to Catherine of Braganza, the daughter of John IV of Portugal, brought a brief fashion for all things Portuguese.

Under the Restoration, the walls of the majority of rooms continued to be treated with wood paneling, although the panels themselves were enlarged to run the full height of the room from the dado cap molding to the wooden cornice, after the manner of the new designs introduced at Versailles for Louis XIV. The panels were rectangular, framed with a heavy **bolection** molding (a molding projecting beyond the adjacent surfaces) surrounding a slightly sunken stile.

The wood, oak or walnut, was usually left in a natural waxed finish, although poppy oil and linseed oil were also used. Sometimes the wood was reddened with the root of the henna shrub, and the richest effects were produced by painting the woodwork to imitate marble. Where cheaper woods, such as fir and **deal** (pine), were used for the paneling, the wood was frequently grained to imitate walnut or olive. Moldings and ornament were sometimes gilded. Where wood paneling was not employed, the plaster walls were covered with stretched velvet or damask.

Door openings were formally treated with an architectural trim and complete entablature, including architrave, frieze, and pedimented cornice. Occasionally both door and window openings were framed in a heavy projecting bolection molding in marble or wood. Carved ornament on the moldings and cornice was customary in the more sumptuous interiors.

An innovation of the first years of the eighteenth century was the introduction of the built-in arched niche, which formed an important feature of the architectural composition of the room. The niche was usually decorated at the top with a large shell motif, and was lined with shelves for holding china and other ornaments. Many of these niches were framed—like door and window openings—and crowned with triangular or broken pediments.

Ceilings in the smaller rooms were left plain. In the ceilings of more elaborate rooms, ornamental plaster moldings formed a border; the center portion received a painted decoration. The complex plaster motifs imitated the realistic detail of the work by the great wood-carver Grinling Gibbons. Workers from Italy, France, and the Netherlands were largely employed in both the modeling and the painting.

Oriental pottery continued to be popular as a decorative accessory in the rooms of the Restoration period. English and French tapestries hung in important panels. The floor was in parquet patterns in which oak, ebony, and other colored woods were used. Oriental rugs covered the floor. Painted landscapes, hunting scenes, and mirrors were framed and hung on the walls, and hangings were also made of **stumpwork,** embroidery given a relief effect by stitching over raised bits of padding. Needlepoint was made for upholstery materials.

In the early years of the eighteenth century, the fireplace trim changed from the simple bolection molding to a complete classical architectural treatment, with dwarf columns, architrave, frieze, and a projecting cornice forming a mantelshelf. Marble was extensively used as a mantel material, and different colored marbles were frequently employed in the design of the same mantel. The carved ornament was, as a rule, done in a white statuary marble, and its character was the bold, vigorous

relief of Gibbons's inspiration. A warm, orange-colored sienna marble and a dark green verde were used for the plain areas. The moldings and general proportions of these mantels were heavy.

Knotty pine, left in its natural color, began to be used for wall panels, and wallpaper, as a cheap substitute for textiles, was introduced on plaster walls that had not been wainscoted. Other popular woods were mahogany, walnut, and various tropical hardwoods, and popular wood treatments included gilding, lacquering, and painting.

About the middle of the eighteenth century a romantic movement resulted in a revival of pseudo-Gothic structures, deliberately at odds with the prevailing classic revival. Strawberry Hill (1753–78), Middlesex, the country house of writer Horace Walpole, was the most notable example, filled as it was with fan ribbed vaulting and tracery patterns and details copied from medieval tombs (Figure 16–8). The movement was extended later to garden design, which included sham Gothic ruins and later Turkish, Chinese, Moorish, and other exotic pagodas, colonnades, pavilions, sheltered seats, and gazebos. Even the great classical revivalist Robert Adam ventured into a modified Gothic style when his clients insisted, providing a chimneypiece (Figure 16–9) and ceiling for the Round Drawing Room of Walpole's Strawberry Hill and interiors for Alnwick Castel, Northumberland, and for Hulne Abbey on the Alnwick estate.

The Gothic movement was a minor diversion, however, and design continued to be dominated by classical forms and ornaments. The Palladian style was continued with Chiswick House, London, designed in 1729 by William Kent and the Earl of Burlington, and Mereworth Castle, Kent, designed by Colen Campbell. Examples on a more monumental scale include Christopher Wren's cathedral of St. Paul's in the heart of London and two great country houses by Sir John Vanbrugh (assisted in the design of both by Nicholas Hawksmoor), Blenheim in Oxfordshire (1705) and Castle Howard in Yorkshire (1702–14). We shall look briefly at Chiswick and Blenheim.

CHISWICK HOUSE, (1725–29) Richard Boyle, the third Earl of Burlington, who owned Chiswick House and who designed it in collaboration with William Kent, was one of the great art patrons of

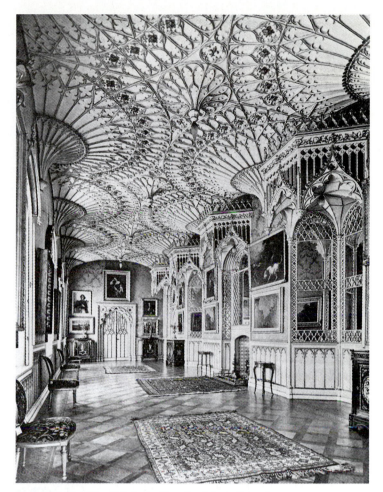

Figure 16–8 The "Holbein Chamber" from Strawberry Hill, Twickenham, the house "Gothicized" by Horace Walpole beginning in 1753.
BRITISH INFORMATION SERVICES

Figure 16–9 Chimneypiece by Robert Adam for the Round Drawing Room of Strawberry Hill, c. 1766.
COUNTRY LIFE PICTURE LIBRARY, LONDON, ENGLAND

his day. He was among the first of the many English nobles who completed their education with a grand tour of European cities and ancient monuments, and upon his return to England he supported a number of painters and sculptors, the architecture of Kent and Colen Campbell, the music of Handel, the philosophy of Bishop Berkeley, the satirical writing of Jonathan Swift, and the poetry of Alexander Pope.

In design, Lord Burlington's taste was for the Palladian, and it was epitomized by Chiswick House, which he and Kent based on Palladio's Villa Capra (Figures 13–13 and 13–14). On a more theoretical level, Burlington collected and reproduced Italian Renaissance drawings and commissioned a new, accurate translation of Palladio's *Quattro libri*, begun by Colen Campbell and completed by Isaac Ware.

The exterior of the villa (Figure 16–10), which was chiefly the work of Burlington, presents us with four symmetrical elevations but not (as in Palladio's model) four identical ones. Rising above them is a central dome on an octagonal drum punctuated by "thermal" windows (that is, windows like those used in Roman baths). Near the corners are four chimneys, shaped like obelisks. The classical orders are used only in a structural way, not as decoration, and many of the wall surfaces are severely plain. The interior, chiefly the work of Kent, is more ornamented and Baroque, though the order, proportions, and geometric clarity of the basic layout remain strongly legible. Kent's work shows his knowledge of the precedent set by Inigo Jones.

The ground floor of the villa held Lord Burlington's library; the main floor was designed for entertaining and for displaying Burlington's painting collection. Even though one room has traditionally been called a "bedchamber," it was probably never intended for such use. The rooms of Chiswick are small but stately nevertheless. The Domed Saloon or "Tribunal" at the center of the house is a tall octagonal space with pedimented doorways in four of its sides and, between the doors, classical busts on brackets. The dome itself is decorated with octagons that, like the squares of the dome of the Roman Pantheon, diminish in size as they near the top. Smaller but more richly decorated are the surrounding rooms called the Red Velvet, Blue Velvet, and Green Velvet Rooms; these were named for their original wall coverings,

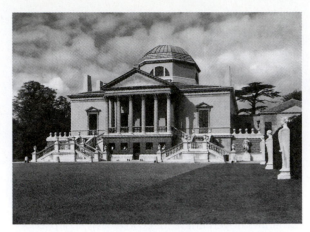

Figure 16–10 The east front of Chiswick House, London, begun in 1725.

which have now been replaced with flocked papers. Across the garden front, opposite the entrance, is a suite of three connecting rooms used as a gallery, the central one a rectangle with apsidal ends, the others circular and octagonal. In geometry and in color the rooms show great variety, yet all share the same general character, and a lavish touch occurs throughout in Kent's generous use of gilding on wainscoting and moldings and on the furniture he designed for the house.

Outside, the gardens designed by Kent are credited with beginning a trend away from the geometric formalism for which the house is noted and toward the more natural landscaping that would be popularized by the English landscape architect Lancelot "Capability" Brown. Chiswick in its little park was a small, perfect gem. For an English country house on a completely different scale, we turn to Blenheim.

BLENHEIM PALACE, (1705–20) Blenheim, a country house near Woodstock, Oxfordshire, has been called "England's biggest house for England's biggest man." The "biggest man" was John Churchill, the first Duke of Marlborough, and the house was a royal gift to him in gratitude for his 1704 military victory over the French at the Bavarian village of Blindheim. Queen Anne invited the duke to choose his own architect, and his choice was Sir John Vanbrugh, then forty-one, a playwright, a noted wit, the comptroller (under Sir

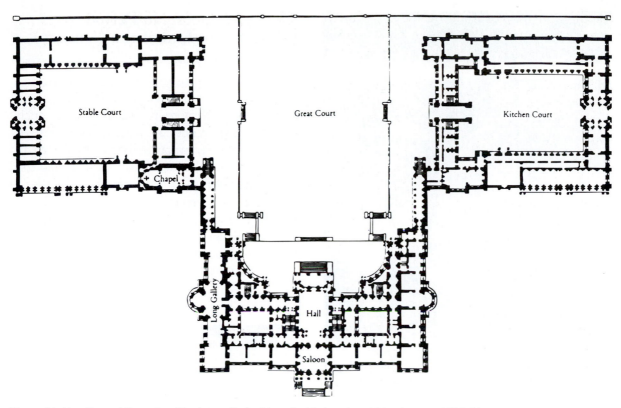

Figure 16–11 Ground floor plan, Blenheim, Oxfordshire, by Vanbrugh and Hawksmoor, 1705–20.

AFTER JACKSON-STOPS. REPRINTED BY PERMISSION.

Christopher Wren) of the Queen's Works, and a genius. Vanbrugh chose as his assistant the more experienced Nicholas Hawksmoor, also a distinctive talent.

Blenheim (Figure 16–11) is built around a vast entrance courtyard and two smaller kitchen and stable courtyards, the three elements linked by colonnades. The palace is said to have 187 rooms, and several of them are enormous. It is entered through a clerestoried great hall (Figure 16–12), its ranks of arches somewhat resembling a Roman aqueduct; 67 feet (20.5 m) above, the ceiling features an oval allegory of the duke presenting his battle plan to Brittania, painted by Sir James Thornhill. From the hall one can turn left or right to monumental stairs and, beyond them, to symmetrical suites of state apartments, each with bedchamber, antechamber, and drawing room, or continue straight ahead to an eastfacing saloon in the center of the garden front. This 30-foot-high (9 m) room was (and still is) used for dining on important state occasions (Figure 16–13), even

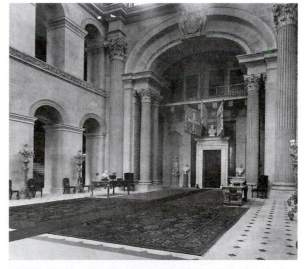

Figure 16–12 The great hall, Blenheim.

A. F. KERSTING

though it is nearly ¼ mile (0.4 km) from the kitchen wing. The family quarters, on a slightly more domestic scale, are along the east side of the main

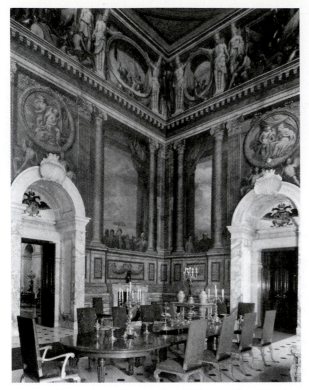

Figure 16–13 The saloon, Blenheim. From the murals by Louis Laguerre, figures representing the four continents peer down at the assembled diners. Doors and fireplaces are framed in marble.

A. F. KERSTING

The Later Georgian Period (1762 to the End of the Century)

The last decades of the eighteenth century brought a new seriousness to the revival of classicism in England. The emulation of Italian Renaissance forms, filtered through the sensibilities of Spain, Flanders, and France, was replaced by a fascination with something more authentic: the Greek and Roman antiquities that the Renaissance had tried to imitate, not always successfully. With this change, the English moved beyond the influence of their European contemporaries. Making their own assessments of antiquity and its relevance, they entered a period when, for the first time, they could claim artistic originality and preeminence.

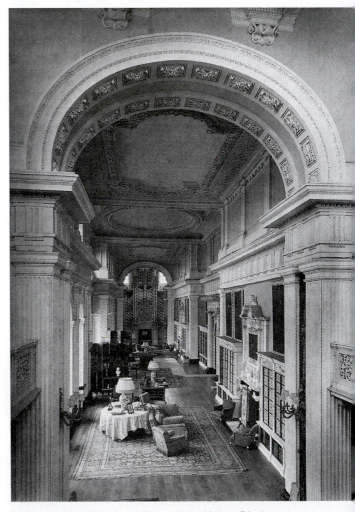

Figure 16–14 The long gallery or long library, Blenheim.

A. F. KERSTING

block. Blenheim's most surprising interior, however, is its long gallery (Figure 16–14), which stretches 180 feet (55 m) along the whole west end of the main block. Originally built as a picture gallery, where works by Titian, Rubens, and Raphael were hung, it was converted into a library shortly after construction.

In addition to Thornhill, mural painters included Louis Laguerre, and the chief carver at Blenheim was Grinling Gibbons, here working chiefly in stone. The state apartments were hung with Brussels tapestries. Blenheim's formal gardens, originally laid out by Vanbrugh and Henry Wise, were redesigned by Capability Brown in his more natural style in the 1760s and 1770s, and some of the palace's interiors were redesigned by William Chambers in the same years. Sir Winston Churchill, grandson of the seventh Duke of Marlborough and prime minister of England during World War II, was born at Blenheim in 1874.

The change, like many others throughout history, can be dated to the publication of a book.

Beginning in 1762, James Stuart and Nicholas Revett, two young English architects, published *The Antiquities of Athens,* the best information then available about how classical Greek architecture and ornament had really looked. That information brought a return to Greek classicism after two centuries of domination by the Italian Renaissance.

ROBERT ADAM In 1764 the Scottish architect Robert Adam published a book based on his own measurements of an ancient building, *The Ruins of the Palace of the Emperor Diocletian at Spalatro in Dalmatia.* In the following few years there was also considerable publication about the temples being discovered at the Greek colony of Paestum in central Italy. Earlier and more primitive than the Parthenon, the temples encouraged an interest in a heavier version of classicism and a return to favor of the simplest of the orders, the Doric.

Robert Adam (1728–92) was born into a prominent Scottish family of architects and designers. His father, William (1689–1748), was Scotland's leading architect in the second quarter of the eighteenth century. Robert's older brother John (1721–92) took over the father's business, taking Robert into the firm with him and later practicing alone in Edinburgh. Robert's younger brother James (1732–94) also joined his brothers in the Scottish practice and later joined Robert in a London partnership. He traveled in Italy as Robert had, and most of his work was done in England within the partnership with Robert, but after Robert's death he spent his last two years doing independent work in Scotland.

Robert was the chief designer of the firm he shared with James. It was Robert's study of classical precedent and the writing based on his study that was a chief instrument leading to classicism's dominance of English design; and it was Robert's own design, beginning even before the publication of his book, that was the chief glory of that dominance. Inigo Jones, Lord Burlington, and others had brought to England Palladio's vision of classicism with its carefully proportioned cubes and rectangles. Robert Adam brought to England a virtuoso vocabulary of complex interior forms that had not been used since the building of the great

Roman fora and baths, and with these forms he brought an equally rich vocabulary of ornament (Figure 16–15).

It was not Roman antiquity alone that formed Adam's style, however. The Palladianism of Jones and Burlington was a significant influence, as were French planning principles such as the use of **enfilades.** The Italian architect and designer Piranesi, whom Adam had met in Italy, was also influential; Adam wrote of him that his "amazing and ingenious fancies . . . are the greatest fund for inspiring and instilling invention in any lover of architecture that can be imagined," and he returned to London with two Piranesi drawings.

In 1773, having mastered a synthesis of all these elements, Adam and his younger brother began to publish their own work: *The Works in Architecture of Robert and James Adam,* which appeared in three volumes. In the first volume, the brothers rightly claimed to have "introduced a great diversity of ceilings, friezes, and decorated pilasters, and [to] have added grace and beauty to the whole, by a mixture of grotesque stucco, and painted ornaments, together with the flowing rinceau, with its fanciful figures and winding foliage."

Spurred by Adam's example, classical precedent became the concern of every social level that could afford choices about living style, and it affected those choices at every scale, from architecture to the smallest article of household furnishing. A major benefit of this obsession was a rare degree of unity in room design, and it was best demonstrated by Robert Adam himself, who, having designed the building and the volume and proportions of each room, considered the room's wall and ceiling surfaces, and then proceeded to design practically everything in it, including door and window frames, chimneypieces, furniture, carpets, lighting fixtures, textiles, silver, pottery, and metalwork. His carpet designs often reflected the designs of the ceilings above them. We shall focus here on the interior of one of his buildings, Syon House, and we shall see more of his work in the later section on English furniture.

SYON HOUSE, MIDDLESEX (1760–69) Syon House was already an old building, originally a Tudor nunnery, when Adam was asked to make it a fashionable residence of the eighteenth century.

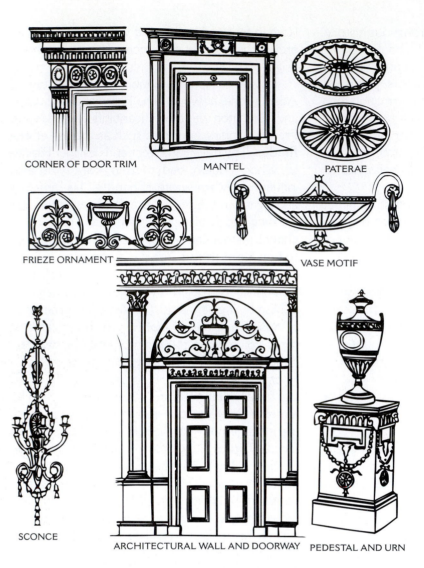

CORNER OF DOOR TRIM

MANTEL

PATERAE

FRIEZE ORNAMENT

VASE MOTIF

SCONCE

ARCHITECTURAL WALL AND DOORWAY

PEDESTAL AND URN

Figure 16–15 Examples of Robert Adam's classically inspired details and ornaments.

DRAWING: GILBERT WERLÉ

Its exterior, with battlements across the top and towers at each corner, could not be changed. Its interior, however, was transformed into what some consider Adam's masterwork, a suite of spatially varied rooms wrapping around a central quadrangle. Adam proposed that an enormous rotunda be built within the quadrangle (Figure 16–16), but this proposal proved too expensive even for Adam's wealthy client, the Duke of Northumberland.

Even without this climactic focus, Syon House offers plenty of visual drama. One enters a great hall finished with stucco decoration by Joseph Rose, one of Adam's favorite artisans, with a coffered apse at one end and a screened recess at the other, both ends framing classical sculpture (Figure 16–17) and both accommodat-

ing stairs to the adjacent rooms, for the old structure's floor levels were uneven. Adam capitalized on this flaw. In his own words, "The inequality of the levels has been managed in such a manner as to increase the scenery and add to the movement." The Doric order, Adam's frequent choice for entrance halls, has been used, and colors here have been limited to white, cream, and (in the floor paving) black.

The adjacent rooms up a few steps from the hall are both anterooms, the one on the north (left of the entrance) leading to the private family dining room, the one on the south leading to the larger state dining room. The south anteroom, originally 36 by 30 feet (11 x 9 m) and 21 feet (6.5 m) high, has been given a correction of proportions by

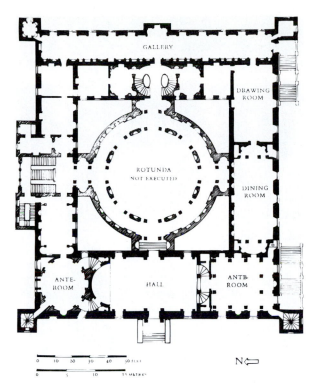

Figure 16–16 Plan of Syon House, London. Adam's proposed addition of a great central rotunda was not built.

AFTER A DRAWING IN BOOK II, *THE WORKS IN ARCHITECTURE OF ROBERT AND JAMES ADAM*, LONDON, 1778. PHOTO: VICTORIA AND ALBERT MUSEUM, LONDON

the proper shape for a Georgian room. Adam treated it as a library, with bookcases lining the long inner wall opposite the windows; divided the ceiling into a repeated pattern of circles, octagons, and squares; and modulated the length with clusters of Corinthian pilasters, within which the bookcases have their own subsidiary Ionic order. The stuccowork is in low relief, and the colors here are similarly muted—greens, grays, and mauves (Figure 16–19). Near the center of the gallery there is access to curved stairs that connect to private apartments on the floor above.

The gallery is furnished with Adam chairs, tables, and sofas, and the drawing room has some

means of a screen of columns held away from the wall on one side, within which the space seems a perfect cube (Figure 16–18). The dozen *verde antico* columns (or, according to some, at least two of them) were shipped from Italy, and the wall panels between them bear gilt representations of military trophies, a motif Adam borrowed from the etchings of his friend Piranesi. The gilt anthemion frieze near the ceiling is on a blue background, and the ceiling, echoing the geometric pattern of the floor, is gold on cream, and the floor is brilliantly colored **scagliola,** the imitation marble invented in seventeenth-century Italy that is made of plaster of Paris and marble chips.

From the anteroom we move on to the state dining room, almost a triple cube, and the coloring is tranquil again, all cream and gold. At each end of the room is a semicircular apse screened with Corinthian columns.

Finally one comes to the gallery, 136 feet (42 m) long and only 14 feet (4 m) wide, hardly

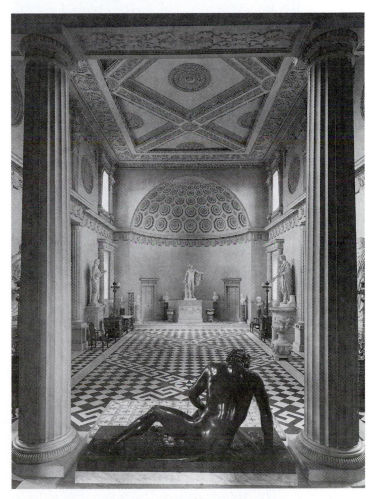

Figure 16–17 View through a pair of Doric columns to the entrance hall of Adam's Syon House. In the foreground, the bronze of the *Dying Gaul* is a copy of a Hellenistic Greek original.

A. F. KERSTING

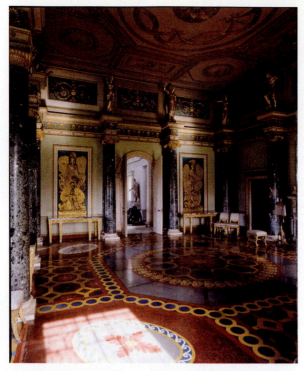

Figure 16–18 The south anteroom, Syon House, with door open to the entrance hall.

CHRISTOPHER SIMON SYKES/THE INTERIOR ARCHIVE LTD.

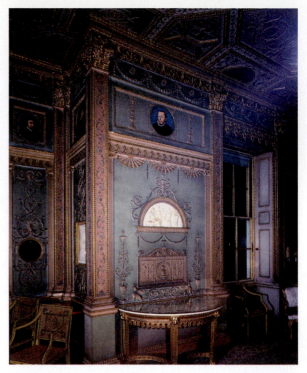

Figure 16–19 Adam's more subtle (and more typical) coloring of the long gallery, Syon House.

A. F. KERSTING

Adam side tables (Figure 16–26), but much of the furniture now at Syon House is of a later date.

Adam and his brothers, as royal architects, had many commissions of unusual importance that required monumental treatment with an extensive use of the orders. In only a few instances were columns or pilasters entirely omitted from an interior wall treatment, and even in those cases classical architectural effects were obtained with entablatures, arches, domes, vaults, and ornamented panels. The semicircular arched wall niche, a very common feature of Adam design, was used to frame a plaster cast or marble reproduction of an antique statue or urn. Many of the Adam rooms had semicircular, segmental, or octagonal end walls embellished with architectural orders, a treatment copied from ancient Roman prototypes.

The mantels designed by Adam (Figure 16–9) were particularly beautiful and were admired and copied in colonial America as well as in England.

Adam dominated the English design scene at least until 1780, but other architects working in the neoclassical style included Sir William Chambers (who shared with Adam the post of architect of the King's Work), George Dance II, and Sir John Soane. The end of the eighteenth century was also the age of England's most famous furniture designers— Adam himself, Chippendale, Hepplewhite, and Sheraton and of the figure we might call England's first interior designer, Henry Holland.

HENRY HOLLAND Slightly younger than Adam was Henry Holland (1745–1806). Holland's first important work was a London clubhouse for William Brooks, its most admired interior being its Great Subscription Room. George, Prince of Wales, who became King George IV, chose Holland to redesign his London mansion, Carlton House. Among Holland's other works were the "Chinese dairy" at Woburn Abbey, Bedfordshire, and the interiors of the Covent Garden Theater and the Theater Royal, Drury Lane, both in London. His work, even the fanciful "Chinese dairy," was characterized by elegance, simplicity, and restraint. Among those influenced by

his work was architect Sir John Soane, who was an assistant in Holland's office beginning in 1772.

English Furniture Design

Changes in England's political climate effected changes in furniture design, as did influence of French furniture design, the publication of furniture style books, and the leadership of native designers. We shall consider these design determinants, then the changing use of furniture woods, and finally the development of English furniture types.

The Influence of French Furniture

The accomplishments of French furniture design were reflected in English furniture during the whole of the Renaissance period, and as French furniture, beginning with the Louis XV style in the second quarter of the eighteenth century, tended to more delicate proportions, similar characteristics became popular in England. The later work of Chippendale shows distinct signs of this trend, but it was left to other cabinetmakers to carry lightness of line to its final perfection.

Toward the end of the eighteenth century many English cabinetmakers openly copied French furniture of both Louis XV and Louis XVI styles. This was particularly true of Hepplewhite and his imitators. The difference between the English work and the French (as in many cases where copies are made) was that the English did not always carefully analyze French proportions, so that English pieces can seem clumsy when placed side by side with French originals. But even an expert can have difficulty with some identifications.

A personification of French influence was Daniel Marot, an engraver and designer mentioned in the last chapter, who had fled from France after Louis XIV's 1685 revocation of the Edict of Nantes. Marot had gone to Holland and entered the service of Prince William III of Orange, who had begun building his palace at Het Loo in Gelderland from French plans. Marot is known to have taken charge of this work in 1692, designed the interiors and gardens, and also patterned some of the contemporary Delft pottery. About 1695, he moved to England and is known to have been em-ployed in the design of Hampton Court, although his actual work is obscure. Before he returned to Holland, he produced a wealth of engravings that had considerable influence on the English design of their day. Marot was only one of many, however, who influenced the English design scene through their publications.

Furniture Designers and Their Style Books

We have seen the important role of publications by architects Stuart and Revett, Robert Adam, and others in inspiring the great wave of English interest in classical design. And those authors were motivated as well as instructed by the published works of the Italians Palladio and Piranesi. Publications by furniture designers and cabinetmakers were at least as important in guiding popular taste in furniture design. They were also important in publicizing their authors' skills. Today's closest equivalents might be manufacturers' trade catalogs. Of course, some important designers did not write books, and some influential authors left negligible examples of actual work. Prominent authors, furniture designers, or furniture makers active in the great eighteenth-century renaissance of English design included those mentioned below.

Batty Langley (1696–1751) was at different times a landscape designer, a manufacturer of artificial stone ornaments, the master of a drawing school in the Soho area of London, and an architect. The subjects of his nine books were equally varied. He is best known, however, for his importance in fostering the Gothic Revival through the sixty-four plates of his *Antient Architecture Restored and Improved*, published as two volumes in 1741 and 1742. They were reissued in a single volume in 1747 under the title *Gothic Architecture, Improved by Rules and Proportions*. The book included designs for chimneypieces, doorframes, window frames, and other interior details, all in the Gothic manner and all so clearly drawn that they could be easily copied. Horace Walpole copied some of them for his Strawberry Hill, but later came to call Langley's designs "bastard Gothic" because they were not taken from actual medieval buildings.

Matthias Lock (c. 1710–65) was a London furniture designer and carver in the Rococo style. In

1744 he published *Six Sconces,* in 1746 *Six Tables,* in 1747 *A Book of Ornament,* and in 1752 *A New Book of Ornament.*

Benjamin Goodison (died 1767) was a London cabinetmaker specializing in mahogany pieces with gilt fittings. He supplied furniture to several royal households, and some of his work can still be seen at Windsor Castle and Hampton Court.

Pierre (or Peter) Langlois was a French cabinetmaker active in London between 1759 and 1781. He was noted for marquetry and work with brass and tortoiseshell in the style of Boulle.

Abraham Swan trained as a carpenter and joiner and also worked as an architect, although he left few buildings that can be identified. His known interior design work included fittings for Edgcote House, Northamptonshire, c.1750, and the front staircase at Blair Castle, Tayside, 1757. His books, which were very popular in America as well as at home, were *The British Architect: or the Builder's Treasury of Staircases,* published in London in 1745, in New York in 1758, and in Philadelphia in 1775; the two-volume *A Collection of Designs in Architecture,* London, 1757; *One Hundred and Fifty New Designs for Chimneypieces,* London, 1758; and *The Carpenter's Complete Instructor in Several Hundred Designs,* London, 1768. Swan's taste as expressed in these books was for buildings with strictly Palladian exteriors, but with more elaborate Rococo effects inside.

John Linnell (1729–96), a London cabinetmaker, produced furniture in "Chinese Chippendale" style and in several other styles. He also designed furniture for Adam's Osterley Park House, London, and produced furniture to Adam's own design.

In addition to such individual talents, large organizations beginning in the eighteenth century produced creditable furnishings for the middle classes and even for nobility and royalty. Outstanding among these was Gillow, a company of cabinetmakers, furniture makers, and upholsterers founded c. 1728 by Robert Gillow in the port city of Lancaster, where mahogany was imported and from which finished furniture could be shipped. In 1757, Robert's oldest son Richard, trained as an architect, joined the firm, and in 1765 a London branch was opened. In the nineteenth century Gillow and Company would be responsible for numbers of important design commissions and would

produce some technically innovative (if artistically conservative) furniture designs. Members of the Gillow family controlled the business until 1814; it was restructured as Waring and Gillow in 1903; and it continued until 1962. One valuable legacy is the Gillow Archive at the Westminster City Libraries. Dating from 1731, the archive is an unmatched record of the English furniture business over two centuries.

Following the example of Gillow was another firm that became even more successful. George Seddon (c. 1727–1801) was the founder of the largest furniture-making firm in eighteenth-century London and the head of a family that followed him into the business (including his sons Thomas and George, his son-in-law Thomas Shackleton, and several grandsons). In 1786 the company employed four hundred artisans, and its success continued into the nineteenth century.

William Ince (1738–1804) and John Mayhew (1736–1811) were London cabinetmakers who formed a partnership in 1758. The next year they began to publish their designs in serial form under the title *The Universal System of Household Furniture,* and the total of eighty-nine designs (plus six new ones for fire grates) were collected in a single volume in 1762. The designs have been said to be inferior versions of those by Thomas Chippendale, but they include tripod tables, which Chippendale's own book did not. Later, in their own work for such prestigious clients as the Duke of Bedford and the Earl of Coventry, they followed the prevailing fashion from Rococo to a stricter neoclassicism; they also demonstrated a knowledgeable use of marquetry and ormolu mounts.

Robert Manwaring is known only from his writings, as none of his furniture has been identified. He contributed fifty furniture designs to a book called *Household Furniture in Genteel Taste,* published by the Society of Upholsterers and Cabinetmakers in 1760. That same year he published fourteen other designs as the *Carpenter's Compleat Guide to the Whole System of Gothic Railing,* in 1765 he published a hundred more as the *Cabinet and Chair-maker's Real Friend and Companion,* and in 1766 another two hundred as *The Chair-maker's Guide.* This last work "borrowed" two plates from Ince and Mayhew and several others from a book of chair designs by Matthias Darly. Manwaring's

collections, which included iron garden furniture, were mixtures of Gothic, Chinese, Rococo, and rustic styles. He was prolific and at times original, but his perspective was sometimes faulty and his engraving sometimes crude. Thomas Sheraton is said to have considered his designs "worthless."

Thomas Shearer was the artist for twenty-nine plates that were included in the *Cabinet-Maker's London Book of Prices*, published in 1788, and they were reissued later that same year under his own name as *Designs for Household Furniture*. The designs were almost entirely limited to case furniture and were similar to the work of Hepplewhite. Shearer designed many pieces of furniture that fulfilled two purposes, such as chairs that opened into ladders, cabinets that were folding beds, and a fire screen that contained a writing table.

These authors, designers, and furniture makers were all part of the remarkably active artistic life of eighteenth-century England. Others worthy of mention include William Bradshaw (1700–1775), William Vile (c. 1700–1767), Vile's partner John Cobb (c. 1710–78), and William Hallett (1707–81). Towering above them all, however, are five other figures: William Kent, Thomas Chippendale, Robert Adam, George Hepplewhite, and Thomas Sheraton.

WILLIAM KENT William Kent (1685–1748) did not write a style book, although he was involved editorially with the 1727 publication of work by Inigo Jones, and his book was republished in 1744 with some of his own work added.

Kent was one of the first English architects to be equally concerned with interior design and furniture design, and perhaps the very first to view a building, its interiors, and its furniture as a single aesthetic whole. In these respects his career was a model for that of Robert Adam. He studied painting in Italy during the decade 1709–19 and while there he met Richard Boyle, the Earl of Burlington, who would be his lifelong patron. Accompanying him back to England, he was given lodging in Burlington House, the earl's London house, where he would remain for thirty years, and one of his first commissions was for a series of ceiling paintings in the house. A commission for the decoration of state rooms for George I at Kensington Palace followed.

Kent designed Chiswick House in collaboration with Lord Burlington as a country retreat for the earl. In the same years Kent was designing interiors for Houghton Hall in Norfolk, a house designed by Colen Campbell for Sir Robert Walpole. It was for Houghton Hall that Kent designed his first furniture, and it was large, rich, heavy, and flamboyant, such as the state bed seen in Figure 16–20. Compared with the much simpler designs of the day, such furniture must have seemed a sensational departure, but it set a new fashion for a time and led to Kent's appointment as master carpenter in the Office of Works. Many other projects followed, but the two most important of those were for Holkham Hall in Norfolk, which he designed with Lord Burlington and with Holkham's

Figure 16–20 The state bedroom at Houghton Hall, Norfolk. Its gilt furniture by William Kent includes a bed with hangings of green velvet, c. 1732. Its canopy is treated like a classical entablature, and behind its pedimented headboard is a giant scallop shell. The side chairs have cabriole legs.

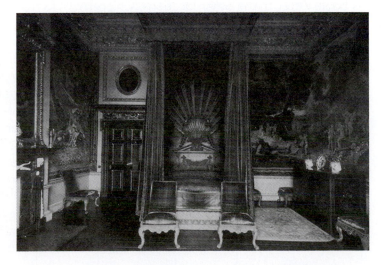

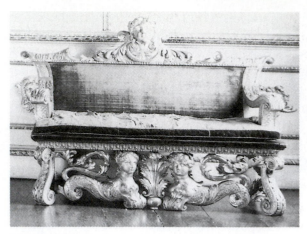

Figure 16–21 A gilt wood settee at Wilton by William Kent, c. 1735–40. It is upholstered in red velvet.

owner Lord Leicester, and a house at 44 Berkeley Square, London, for Lady Isabella Finch. As we have seen, some of Kent's furniture is also found in the Double Cube Room at Wilton (Figures 16–7 and 16–21).

THOMAS CHIPPENDALE One of the best-known names in the history of furniture design is that of Thomas Chippendale (1718–79). He was preceded by a father of the same name who was a joiner from Otley in Yorkshire. After apprenticeship to his father, he moved to London in his twenties and was probably given lessons by the drawing master Matthias Darly, who shared a house with Chippendale and his young bride and who would later engrave many of the plates for his book. After trying other locations, Chippendale settled his cabinetmaking business in St. Martin's Lane in 1753.

In the next year, he published the first edition of his book *The Gentleman and Cabinet-Maker's Director*, which brought Chippendale many admirers and many imitators. It was an age when plagiarism was rampant (indeed, plagiarism from the ancients was the highest ideal), and Chippendale encouraged it by providing clear drawings, dimensions, and instructions for making his furniture. Not only did the *Director* enable local cabinetmakers all over England, Ireland, and Scotland to follow the fashions of London, but it was also translated into French "for the convenience

of Foreigners." Because of the book's widespread use, it is difficult to distinguish the pieces actually made in the Chippendale shop, so that the name Chippendale is freely applied to any pieces in the style in which he worked. Some authorities on English furniture attribute pieces to Chippendale himself only when the original bills of sale exist, and those are pitifully few.

Chippendale's style is seen most characteristically in his chairs, and they were designed in a variety of styles (Figure 16–22). He also designed many other types of furniture, from insignificant washstands to magnificent bookcases, desks, sofas, clocks, organ cases, four-poster beds, piecrust and gallery-top tables, benches, consoles, mirrors, and dining and serving tables. (Figure 16–23, page 418). In Chippendale's earliest work, the chair, stool, and chairback sofa were similar to the early Georgian development of the Queen Anne type, displaying the cabriole leg with carved foot and the elaborated splat back with a yoke form at the top. In his later work, the straight leg and the block-footed straight leg known as the **Marlborough leg** were used (Figure 16–24, page 419), and with them Chippendale reintroduced stretchers between them for greater strength. Intricate backs imitating Gothic tracery were introduced, as were Chinese latticework, bamboo-like forms, ribbon, and Rococo motifs borrowed from Louis XV furniture, and ladder slats with gracefully curved lines. The principal ornaments were Greek and Chinese foliage, fretwork, flutings, paterae, husks, and cartouches. These designs were taken from many sources. Classical, Louis XV, Gothic, and Chinese forms and ornament were combined in extraordinary harmony. The furniture designs with the clearest Chinese inspiration have been given the specific name of **Chinese Chippendale.**

Chippendale worked almost exclusively in mahogany, although after 1765 he made a few pieces in satinwood, rosewood, and other exotic species, and there are in existence a few painted, gilded, lacquered, and japanned pieces attributed to him. In general, Chippendale's designs are sturdy in structure and robust in proportion, which accounts for their durability. A fine example of Chippendale's skill is a commode he made in 1773 for the State Dressing Room of Harewood House in Yorkshire; it is of marquetry on satinwood, and because of

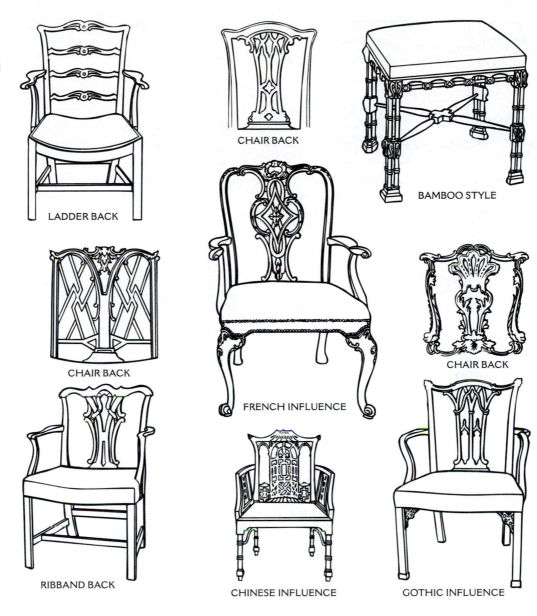

Figure 16–22
Examples of Chippendale chair and stool designs.

DRAWING: GILBERT WERLÉ

LADDER BACK

CHAIR BACK

BAMBOO STYLE

CHAIR BACK

FRENCH INFLUENCE

CHAIR BACK

RIBBAND BACK

CHINESE INFLUENCE

GOTHIC INFLUENCE

the subjects of the two ivory medallions on the front it is called the "Diana and Minerva" commode (Figure 16–25, page 419).

Paul Hardy has written that, while Adam and other architects were pleased to design furniture for the interiors they had designed, "this was something for which they charged." Chippendale and other furniture makers, however, were "able to offer the service nominally free of charge, . . . within the price of supplying the furniture itself. This gave a certain commercial advantage." Hardy has added, however, that "Chippendale's aristocratic patrons . . . demonstrated a cavalier

attitude to settling their debts which resulted in a lifetime of financial insecurity."

The firm continued its work, nevertheless, with Thomas Chippendale the Younger succeeding his father, who died in 1779. The firm's bookkeeper, Thomas Haig, had been taken into partnership in 1771, and the firm was known after that as Chippendale, Haig, and Company. The son also proved to be a skilled designer, and the firm did not close until 1796.

Unlike George Hepplewhite, who left no identifiable work, Chippendale and his son left more than seven hundred pieces that are thought to be

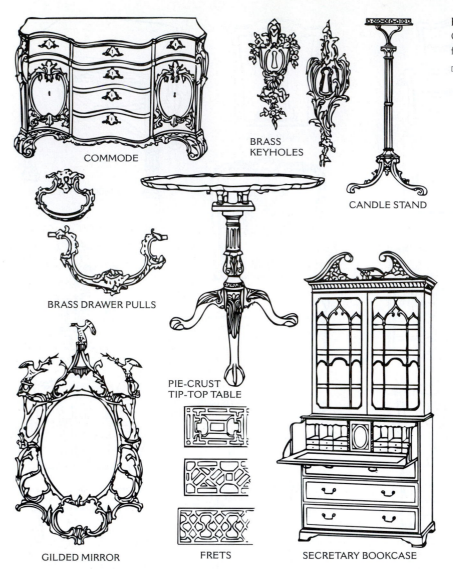

Figure 16–23 Other types of Chippendale furniture and furniture hardware design.

DRAWING: GILBERT WERLÉ

COMMODE

BRASS KEYHOLES

CANDLE STAND

BRASS DRAWER PULLS

PIE-CRUST TIP-TOP TABLE

GILDED MIRROR

FRETS

SECRETARY BOOKCASE

theirs. Many are in the collection of the Victoria and Albert Museum, London (which has a statue of Chippendale carved in its west facade), and other pieces can be seen *in situ* at Nostell Priory, Yorkshire, at Temple Newsam House, Leeds, and at other country houses. The Metropolitan Museum of Art, New York, has many of the drawings for the first edition of Chippendale's *Director.*

ROBERT ADAM We have already seen architecture and interior design by Robert Adam, but he was equally adept at furniture design. The architect Sir John Soane, addressing the Royal Academy thirty-one years after Adam's death (when Adam's accuracy as a classicist was being questioned and his work had fallen from fashion), pointed out that "[t]he light and elegant ornaments, the varied compartments in the ceilings of Mr. Adam, imitated from Ancient Works in the Baths and Villas of the Romans, were soon applied in designs for chairs, tables, carpets and in every other species of furniture. To Mr. Adam's taste in the ornament of his buildings and furniture we stand indebted, inasmuch as manufacturers of every kind felt . . . the electric power of this revolution in art."

In addition to the "species" mentioned by Soane, Adam designed mirrors, candelabra, silver-

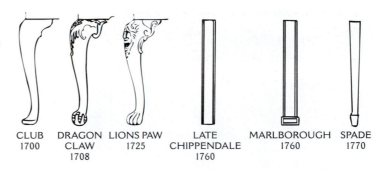

Figure 16–24 The development of the English chair leg through the eighteenth century. The dates given are approximate dates of introduction.

DRAWING: GILBERT WERLÉ

CLUB	DRAGON CLAW	LIONS PAW	LATE CHIPPENDALE	MARLBOROUGH	SPADE
1700	1708	1725	1760	1760	1770

ware (Figure 16–50), inkwells, sedan chairs, fireplace furnishings, door hardware, and window treatments. He was particularly noted for his designs for commodes, side tables (Figure 16–26), sideboards, consoles, cabinets, and bookcases. More rarely he designed chairs, settees, and beds. The first two volumes of Adam's famous book *The Works in Architecture* showed more than architecture; many of these furniture designs were included as well.

The most characteristic ornaments popularized by Adam were the Grecian honeysuckle and **fret,** the fluted frieze or apron, the **patera** and rosette, the urn, and the husk. Husks were arranged in swags or drop ornaments and were frequently tied with ribbons. All Adam's designs were delicate and finely detailed (*overly* detailed, his critics complained), all his reliefs were low and flattened, all the results elegant. Neither Robert nor James Adam was a cabinetmaker, so Adam furniture designs were made by others. Some pieces, therefore, are called by such terms as *Adam-Chippendale* or *Adam-Hepplewhite.*

GEORGE HEPPLEWHITE Considering the familiarity of his name, little is known about George

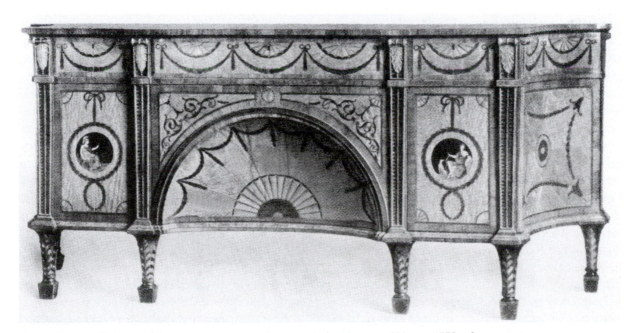

Figure 16–25 Chippendale's "Diana and Minerva" commode for Harewood House, 1773, of marquetry on satinwood.

COUNTRY LIFE PICTURE LIBRARY, LONDON, ENGLAND

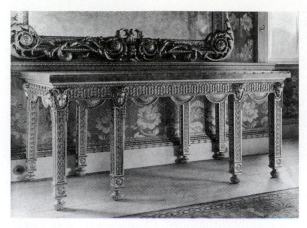

Figure 16–26 A side table designed by Adam for the drawing room at Syon House. It is 71 inches (181 cm) wide, of carved and gilded wood, with brass mounts and with a Roman mosaic top said to have come from the Baths of Titus.

Hepplewhite. He made furniture in London as early as 1760 and was a leader toward delicacy of line and fine proportion in furniture. He died in 1786, but his business was carried along for a few years afterward by his wife, Alice, who two years after his death published his pattern book, the *Cabinet-maker and Upholsterer's Guide*.

The chair was the most typical example of Hepplewhite's designs, and the forms and ornament used in that piece were seen in nearly all his other pieces. He specified the use of both mahogany and satinwood. His leg designs were always straight and slender, either round or square in section, tapered toward the foot, and sometimes ending in what is known as a spade, thimble, or sabot form. He used five different shapes for chairbacks: shield, camel, oval, heart, and wheel (Figures 16–28 and 29). The tops, pediments, and aprons of Hepplewhite's tables and case goods were also often designed in this form, as were the testers of his beds.

His carved ornament was sparsely applied, and consisted of wheat blossoms, oval paterae forms, ribbons, fluting, reeding, vases, and festoons. Ornamental figures—humans, nymphs, and putti—were carved on chairbacks and pier glasses. Painted decorations showed the three-ostrich-feather crest of the Prince of Wales, natural flowers, and classical figures in the style of Angelica Kauffman, the

painter. Marquetry was frequently seen in tulip, sycamore, yew, holly, pear, ebony, rose, cherry, and kingwood.

Hepplewhite is credited with three features of English furniture design: the popularizing of satinwood after 1765, the use of painted motifs as a means of surface enrichment, and the movement toward greater delicacy of line. Hepplewhite's designs were, in some cases, structurally fragile, partly because of their slender proportions and partly because they were meant to be veneered on softwood carcasses. What the furniture lacked in strength, however, it gained in gracefulness, beauty of color and enrichment, and charm. No authenticated examples of Hepplewhite furniture exist.

The *Guide* would be republished in 1897, and Hepplewhite's designs would participate in a revival of appreciation for eighteenth-century English furniture styles.

THOMAS SHERATON Thomas Sheraton (c. 1751–1806) was another great figure in English furniture design. However, it is probable that he never had a furniture shop of his own. He published *The Cabinet-maker and Upholsterer's Drawing-book* between 1791 and 1793 and *The Cabinet Dictionary* in 1803, and in 1804 he began publishing *The Cabinet-maker, Upholsterer, and General Artist's Encyclopedia;* this last project was to have 125 sections, but Sheraton died when he had completed only 30. In 1812 Josiah Taylor republished eighty-four of Sheraton's drawings as *Designs for Household Furniture by the Late Thomas Sheraton,* and Sheraton's first book, like Hepplewhite's *Guide,* was republished in the last years of the nineteenth century.

The style demonstrated in that first book was elegant, crisp, and light. Sheraton replaced the serpentine lines of Hepplewhite (by whom he was nevertheless greatly influenced) with segmental curves and straight lines, just as the style of Louis XVI had straightened the curves of Louis XV. Sheraton's designs, in fact, were quite popular in France, where they were called *Louis Seize á l'Anglaise.* The later books reflected the new Regency taste.

Sheraton specified mahogany and satinwood for many of his furniture designs, noting that the former was a "masculine" species appropriate for dining rooms and libraries, the latter right for ladies' withdrawing rooms and dressing rooms. He also

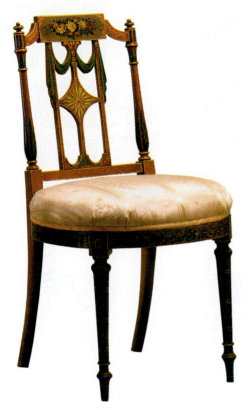

Figure 16–27 A painted satinwood chair based on Plate XXXIV of Sheraton's *Drawing Book, 1791–1793.*

WOODWORK—FURNITURE. ENGLISH. 18TH CENTURY, 1795. SIDE CHAIRS (2). SHERATON STYLE. WEST INDIAN SATINWOOD, BEECH, BIRCH, WITH PAINTED DECORATION. MODERN SILK TAFFETA UPHOLSTERY. H. 34½ IN. W. 19½ IN. D. 17¼ IN. THE METROPOLITAN MUSEUM OF ART, FLETCHER FUND, 1929. (29.119.3–4)

specified exotic woods—tulipwood, zebrawood, kingwood—for many of his furniture designs, and he ornamented wood with delicate marquetry and paintings of flowers, feathers, acanthus leaves, and classical urns. He was the first in England to propose attaching ornamental porcelain plaques to furniture, and he helped make Wedgwood plaques as fashionable in England as Sèvres medallions had been in France.

Sheraton's chair legs were similar to Hepplewhite's. His chairbacks, however, were more rectangular in shape (Figure 16–27 and 16–28). The rear legs of the chair usually continued upward to form the side braces of the back. A horizontal rail was placed near the seat, between the two back uprights, and an ornamental rail was placed at the top. The space between the rails was filled with one or more ornamental splats, the center one sometimes having the form of an elongated vase. Many of Sheraton's designs were for very small pieces of furniture suitable to the dressing room and boudoir, and dining room furniture was another of his specialties. Hepplewhite and Sheraton are often mentioned together, and indeed their designs share the qualities of rationality and elegance, and both bodies of work take the neoclassicism of Robert Adam and adapt it for use in small domestic interiors (Figure 16–29).

Figure 16–28
A comparison of Hepplewhite and Sheraton chairbacks.

DRAWING: GILBERT WERLÉ

CAMEL BACK

OVAL

HEPPLEWHITE CHAIR BACKS

HEART

SHERATON CHAIR BACKS

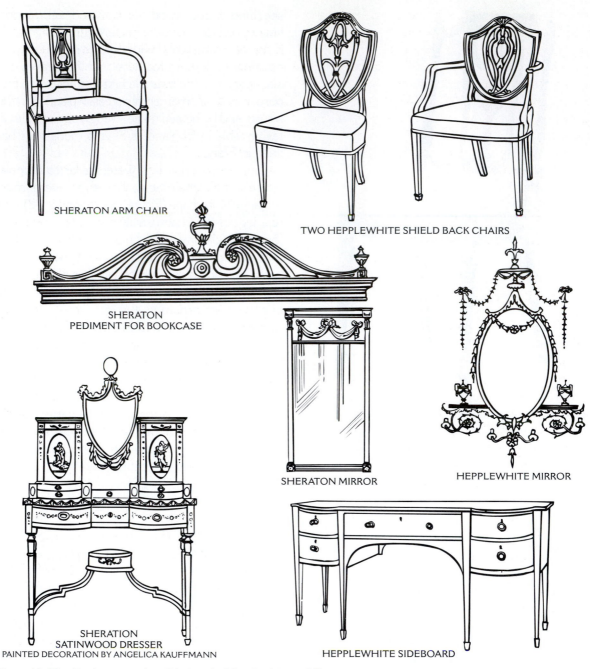

SHERATON ARM CHAIR

TWO HEPPLEWHITE SHIELD BACK CHAIRS

**SHERATON
PEDIMENT FOR BOOKCASE**

SHERATON MIRROR

HEPPLEWHITE MIRROR

**SHERATION
SATINWOOD DRESSER**
PAINTED DECORATION BY ANGELICA KAUFFMANN

HEPPLEWHITE SIDEBOARD

Figure 16–29 Further examples of designs by Hepplewhite and Sheraton.

DRAWING: GILBERT WERLÉ

Furniture Woods, Techniques, and Finishes

The naming of different periods of English design by their most popular furniture woods, a practice mentioned earlier, seems to place inappropriate importance on a minor detail. Even so, these changes in wood usage are not without interest. They are described here in brief.

THE AGE OF OAK (c. 1500–c. 1660) Oak was the great wood of Gothic Europe. Although in France it had been largely replaced in the early sixteenth century by walnut, a more finely grained

wood that allowed more delicate moldings and more minutely carved ornament, oak kept its popularity in England for another century and a half, through the first six decades of the seventeenth century. In the Tudor, Elizabethan, and Jacobean periods, furniture was heavily constructed and massive in appearance. Its structural forms were rectangular, continuing the Gothic tradition, the various parts being held together by wooden dowels and pins, and by the mortise-and-tenon or dovetail joint.

THE AGE OF WALNUT (C. 1660–C. 1720)

Walnut trees in those days were rare in England, but the French fashion for walnut finally resulted in intense cultivation of that wood beginning in the middle of the sixteenth century, and by the middle of the seventeenth an English supply was becoming available. Its frequent use in English furniture dates from the Restoration period.

In the William and Mary period, four changes in furniture materials and finishes took place: first, thin wood veneers were applied to flat surfaces, permitting the full glory of the wood grain to be seen; second, various forms of marquetry and of Japanese and Chinese lacquerwork became more common; third, furniture was more highly polished than before; and fourth, walnut came to be by far the most popular furniture wood. Walnut, however, never replaced oak completely, and because it was particularly subject to worm damage, its use was discontinued when mahogany became available early in the eighteenth century.

THE AGE OF MAHOGANY (C. 1720–C. 1770)

Mahogany was imported from the Caribbean, the dark, rich red variety from Santo Domingo being considered the finest. The use of mahogany for English furniture grew gradually. It was used in a few cases beginning in the late seventeenth century, but a high import duty was placed on it in 1720 and not removed until 1733. After that year its use grew to such an extent that all native woods were eliminated for cabinetmaking, except in the provincial districts. Mahogany trees grew to a very large size, and the wide boards that were available eliminated the necessity for veneered surfaces, which were particularly unsuitable for dining tables. The wood was both more free from worm attack and stronger than walnut, allowing struc-

tural portions of furniture, such as the legs, to be made in more slender proportions. Although its graining was, perhaps, less interesting than that of walnut, mahogany could be richly carved with greater ease. The popularity and advantages of this new wood were also among the causes of the decline in the use of marquetry.

THE AGE OF SATINWOOD (C. 1770–C. 1820)

During the last decades of the eighteenth century and the first part of the nineteenth, there was great use of an exotic wood called satinwood, popularized by Hepplewhite. Light blond with a satiny finish and a handsome figure, satinwood was cut from various species of trees that grow in India, Florida, and the West Indies. The variety from India—hard, aromatic, and a warm yellow—was thought to be the finest, and that from the West Indies was paler and less lustrous, It was used for finishing only in the finest work, and particularly for inlay and parquetry. It was most frequently used in combination with other exotic species: zebrawood, tulipwood, kingwood, "harewood" (sycamore dyed gray), and amboyna. Also adding to the colorful mixture were veneers of beech or pear that were stained green with the use of copper oxide.

The Development of English Furniture Types

The history of English furniture from Gothic times to the end of the eighteenth century was a remarkable progression from some of the heaviest furniture ever made to some of the lightest and from some of the most stolid to some of the most elegant. The variety of styles that were popular within this 140-year span is suggested by Gilbert Werlé in Figure 16–30. Just as remarkable as this change of character was the proliferation of new furniture types. We shall briefly review these developments in both quality and quantity.

SEATING The characteristic chairs of the Tudor, Elizabethan, and Jacobean periods were those known as **wainscot chairs** or *panel chairs,* because their backs, often carved or inlaid, resembled the panels of a wainscot wall. These heavily proportioned chairs were usually made with a high rectangular seat, so that they required

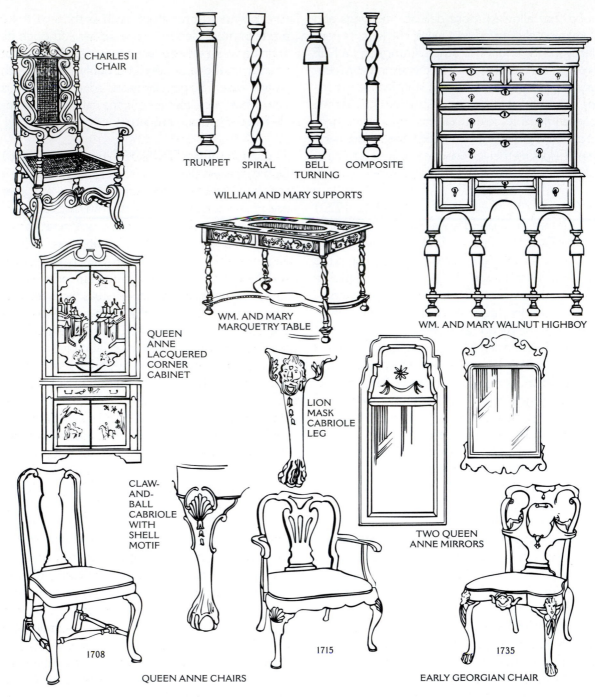

Figure 16–30 Examples of furniture from the Restoration, William and Mary, Queen Anne, and Early Georgian periods.

DRAWING: GILBERT WERLÉ

a footstool, and they had either turned or column legs and slightly curved arms. Others, called **turned chairs,** had triangular seats with arms, back, and legs entirely composed of short, thick turnings. During the Jacobean period, chairs were improved in comfort by the addition of upholstered seats and backs nailed to a rectangular framework. For smaller country dwellings, chairs of lighter

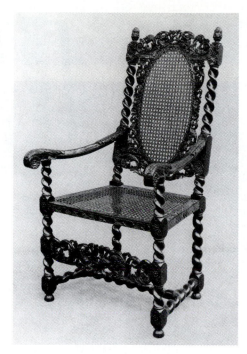

Figure 16–31 A walnut armchair, c. 1680. The spiral turnings of the arm and back supports are called barley twists. The back crest and stretcher are elaborately carved walnut. The seat and oval back panel are caned. Period of Charles II.

WOODWORK—ENGLISH—17TH CENTURY, CA. 1680. PERIOD OF CHARLES II (1660–1685). ARM CHAIR. WALNUT. THE METROPOLITAN MUSEUM OF ART, FLETCHER FUND, 1923. (23.257.2)

weight such as the **Yorkshire** and **Derbyshire** types, were also made, both of which had turned or shaped front legs and straight square back legs that terminated in small scrolls and were joined by pairs of arch-shaped back panels.

After the restoration of the monarchy in 1660, the design of chairs underwent a definite change. Chair seats and backs were made with caning and covered by loose cushions, and the front legs were joined by an S- or U-shaped scroll called a **Flemish scroll** or by an elaborately carved **stretcher** (Figure 16–31). Elaborate upholstery textiles and leather, both plain and patterned, with heavy hand-made silk fringes, were also used. Some wood-work was gilded. The backs of large chairs were slanted for comfort. The wing back was introduced, and was first called a **sleeping chair**, where the back could be inclined at several angles until horizontal, as in some versions of modern beach chairs. Related to such chairs was the ad-

justable Knole sofa. Stools and benches were also important pieces of furniture during Charles II's reign, and they were made quite as elaborate as chairs. Romayne work (Figure 16–3) continued to be used as an ornamental feature of wooden chairs and other pieces of furniture.

In the William and Mary period, the Flemish scroll form gradually disappeared as a decorative motif. Settees or sofas designed with two, three, and four chairbacks were introduced. The legs of chairs and tables returned to the straight form. Some were square and tapered, after the French fashion of Louis XIV. Most of them were turned with large mushroom, bell, and inverted-cup turnings. Flat-shaped stretchers were usually used, and feet were made to imitate spherical or flattened balls, the spherical ones called **ball feet,** the flattened ones called **bun feet.** If either of these was carved into lobes, it was called a **melon foot.** The bun foot was on axis with the leg above it, but if the flattened sphere was off center, projecting to the side like the head of a golf club, it was called a **club foot,** and if it rested on a small flat disk it was called a **pad foot** (as in the Queen Anne chair, Figure 16–32). The term **Dutch foot** is applied to either the club or the pad foot. The **spiral leg,** resembling a twisted rope and sometimes called *barley sugar turning* or **barley twists** (as in Figure 16–31), and the **trumpet leg** (Figure 16–44, page 431), with a flared end resembling the bell of a trumpet, were also seen in a variety of patterns.

The Queen Anne style, which—despite its name—continued into the reign of George I, saw more development in furniture design than in other aspects of interiors. The products of the joiner and cabinetmaker were of great purity and beauty, and the principal characteristics were the introduction of the curved line as a dominating motif in furniture design, the first use of mahogany as a cabinet wood, the use of the **cabriole leg,** and the great development of the use of lacquer as a finishing material.

A splat was introduced in the center of the back that ran from the seat to the crest (Figures 16–32 and 16–33), its interest derived at first only from its curved silhouette and beauty of grain. The framework of the back of the chair near the top was frequently treated with one or two small breaks in the general sweep of the curve. The frame of the seat of the chair was curved on the

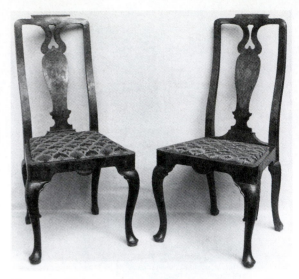

Figure 16–33. A pair of early-eighteenth-century Queen Anne side chairs in walnut. They have the cabriole legs characteristic of the style, and their back splats have been enriched with intarsia.

THE METROPOLITAN MUSEUM OF ART. ENGLISH, 18TH CENTURY, PERIOD OF QUEEN ANNE. SIDE CHAIRS. WALNUT WITH INTARSIA.

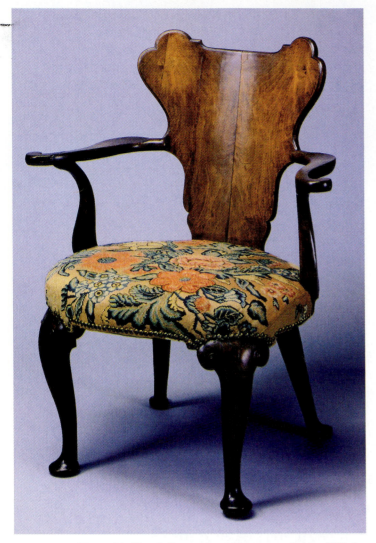

Figure 16–32 A Queen Anne library armchair, c. 1715. Its cabriole legs end in pad feet.

QUEEN ANNE LIBRARY ARMCHAIR, CIRCA 1715. PHOTOGRAPH COURTESY OF THE ROYAL ONTARIO MUSEUM, TORONTO, ONTARIO. © ROM

acanthus leaf, on the shoulder of the splat, and the addition of a scallop shell motif on the knee of the cabriole leg. From this point the carving increased, and the splat of the back began to be pierced to a greater extent, forming a much more complicated design. The shell motif was then used in other portions of the chair, particularly in the front center of the seat frame and at the top of the back. At the same time, the club foot disappeared, and the **claw-and-ball foot** was introduced. This may have been taken from the Chinese symbol showing the dragon's claw clasping the "pearl of wisdom," and the English may have taken the idea from the Dutch. Stretchers between chair legs were discontinued after 1708, and did not reappear until Chippendale revived them near the end of the century.

The splat-back chair also continued in popularity long after Queen Anne's reign ended in 1714, although after 1725 the splat itself was elaborated to an extreme degree by mean of piercing and carving. The tops of chairbacks assumed what is known as the **yoke** form of two S-shaped curves, thought to resemble an ox yoke (Figure 16–34), and variations of the classical acanthus leaf and other types of foliage were substituted for the shell motif of the

sides and front, and the legs were designed in a cabriole fashion, having a conventionalized knee-and-ankle form, and coming down to a pad or club foot. The cabriole form is supposed by some to have been inspired by Chinese designs, although the English version was much simplified. In armchairs, the arms also followed irregular curved forms.

The first change in the development of the Queen Anne chair was in the piercing of the splat with simple curved cutouts. The next was the addition of a small amount of carving, usually an

earlier part of the century. Wing armchairs and other forms of upholstered seats, stools, benches, and sofas became much more popular.

The Early Georgian may be considered the flowering of the more simple Queen Anne forms. There was evident a general tendency toward greater heaviness of structure, but the subtle curves, the natural beauty of the graining, the almost exclusive use of mahogany after 1733, and the irresistible charm of the increased carving contribute to the general opinion that the years between 1720 and 1750 produced some of the greatest examples of furniture ever made.

A SPECIAL CASE: THE WINDSOR CHAIR

One piece of English Renaissance seating furniture was so distinctive and so popular that it seems to deserve a heading of its own. It was originally called the *stick chair* for obvious reasons, but is now known as the **Windsor chair.** It long predates the rule of the Windsor family. Some say the name was taken from Windsor Castle, on the grounds of which a rustic version was discovered, perhaps by King George III, taking shelter in a cottage during a rainstorm. Others say it was taken from the town of Windsor, near which the chair's characteristic spindles were once turned. Its first appearance seems to have been in the early eighteenth century, and by the middle of the century it was already much in use.

Every Windsor chair exhibits the row of parallel vertical rods that forms its back. Within this family resemblance, there are many variations. In the **comb-back** Windsor, spindles of equal length rise

to meet a straight top rail (Figure 16–35). In the **bow-back** Windsor, spindles of differing length connect to a curved back member (Figure 16–36). The **shawl-back** member is a comb-back that rises to a great height; its top rail, curved in plan, is designed for a shawl to be draped over it, eliminating chilly drafts (Figure 16–37). *Fiddle-string-back* is a term sometimes applied to any of the above, as the repeated spindles suggest the strings of a fiddle. Central splats are sometimes introduced among the spindles; these can be solid with a decorative outline or decoratively pierced. If part of the piercing is in the form of a spoked wheel, the chair is called a **wheel-back.** If the round spindles are replaced by narrow flat splats, it is called a **lath-back.** Some

Figure 16–35 A comb-back Windsor chair of painted wood that belonged to the playwright Oliver Goldsmith (1728–74). The top rail curves upward at its ends into "ears."

Figure 16–34 Comparison of early eighteenth-century English chairbacks. The yoke replaced the Queen Anne splat at the beginning of the Georgian style.

DRAWING: GILBERT WERLÉ

QUEEN ANNE

YOKE BACK

Figure 16–36 A bow-back Windsor, c. 1790 The curved front stretcher is called a cow-horn stretcher.

Figure 16–37 A shawl-back Windsor, over which a shawl could be draped. It has a vase-shaped central splat.

"Gothic" Windsors have no spindles at all but a series of splats carved in Gothic form and rising to a back in the shape of a pointed arch (Figure 16–38). These, of course, are artifacts of the Gothic Revival, no such finely crafted chairs having existed in the households of the Gothic age.

Seats of Windsors are generally solid and gently scooped to a slightly concave shape for comfort. The seat is supported, particularly in early versions, by cabriole legs, but straight turned legs set at a slight splay later became standard. In all true Windsors, the back legs are inserted into the bottom of the seat rather than continuing upward, as in some other chairs, to form the back. Many Windsors have stretchers between their legs, most commonly in an H shape and most rarely in an X shape. A curved stretcher joining the two front legs and bending back toward the center of the chair (called a *cow-horn* or *crinoline stretcher*) is sometimes seen, joined to the back legs by two straight diagonal members. The arms generally continue in a curve through the back of the chair, with the spindles passing through. Farm and orchard woods were commonly used in the manufacture of these chairs, and many mahogany examples were also made. In many Windsor chairs, several different woods were combined.

As we shall see in chapter 18, the Windsor chair would become even more popular and even more varied in America than in England.

BEDS The beds used in the homes of the nobility were often of great size and were the chief

pieces of furniture in most households. They were designed with four carved corner posts (Figure 16–39) or with two posts at the foot and a paneled headboard. The posts were often enriched by a bulbous ornament and an architectural capital that supported a wooden tester, modeled as a simplified entablature. Long velvet draperies hanging from the tester were drawn at night for warmth and privacy. These draperies became increasingly elaborate until they were principal decorative features of the bed, as in Figure 16–20.

The four-sided wood frame at the bottom of the bed was drilled with holes through which ropes were strung, and on the ropes rested the mattress, filled—according to budget—with rushes, wool, or feathers and down. Beds with fabric canopies but without

wood testers began to be popular in the eighteenth century, and a bed with a canopy suspended from the wall or ceiling was called an **angel bed.**

TABLES Although collapsible trestle tables continued to be used during the sixteenth century, the permanent table was also a feature of the furnishings. Large refectory tables were built with solid oak tops, some of which were of the extension type. These were used for the elaborate banquets and sometimes turbulent entertainments that took place during the holidays, after the hunt, or on special occasions when the boar's head, Yule log, holly, and mistletoe were featured. **Drop-leaf** and **gate-leg tables** (Figure 16–40) were used in the smaller houses. A small four-legged drop-leaf table with

Figure 16–38 A Gothic Windsor, c. 1765, with a back in the shape of a pointed arch and with carved splats rather than spindles. The stretcher is in cow-horn shape.

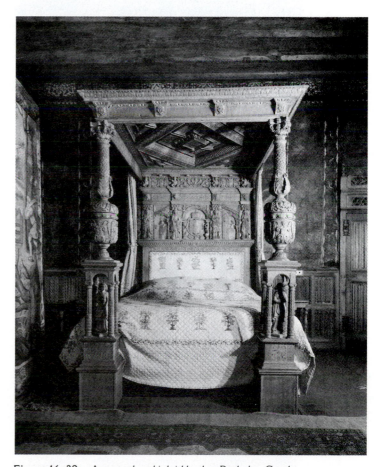

Figure 16–39 A carved and inlaid bed at Berkeley Castle, early seventeenth century. At the foot, freestanding figures occupy miniature pavilions. The wainscoting on the wall behind has linenfold paneling.

THE ENGLISH RENAISSANCE AND LATER DEVELOPMENTS **429**

one or more small drawers under the fixed part of the top was called a **Pembroke table** (Figure 16–41), thought to have been named for a Countess of Pembroke. It was popular in England after the middle of the eighteenth century

Round tables and smaller tables were popular in the convivial Restoration period. Both marquetry and Japanese lacquer ornament were applied, and such enrichment would increase until it reached a peak in the late seventeenth century. Bookcases and gaming tables also began to be used.

In the William and Mary period, as coffee, chocolate, and tea drinking became popular, the **tilt-top, piecrust,** and **gallery-top tables** for serving purposes were made in great numbers. Thomas Sheraton made some elegant three-legged tea tables at the end of the seventeenth century (Figure 16–42). **Dumbwaiters** were tiered tables, also often on a three-legged base, that were two or three tiers high, with each circular surface projecting from a central support and with the surfaces sometimes designed to rotate around the support (Figure 16–43).

CASEGOODS The heavy wooden cupboards and chests of medieval times had persisted through the Tudor, Elizabethan, and Jacobean periods. After the Restoration, however, they were joined and eventually supplanted by many new types of cabinets, clocks, writing desks, dressing tables, and bureau mirrors. The most important introduction of the Restoration period was the **tallboy,** which in

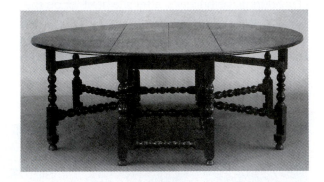

Figure 16–40 A gate-leg table of carved and turned elm, c. 1700. Extra legs swing like a gate to support a folding extension of the top.

ENGLISH FURNITURE, MID-XVII CENTURY. TABLE, GATE-LEG. H. 31, DIAMS.: 84 AND 88", W. CENTER SECTION 30½ IN. THE METROPOLITAN MUSEUM OF ART, GIFT OF MRS. GEORGE WHITNEY, 1960 (60.25).

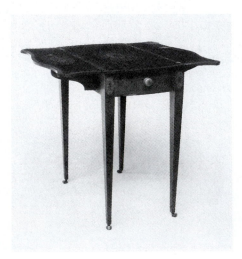

Figure 16–41 A Pembroke table of satinwood inlaid with ebony, c. 1800.

WOODWORK—ENGLISH—XVIII, 1775–1800. TABLE, PEMBROKE, SHERATON STYLE. SYCAMORE ON MAHOGANY. THE METROPOLITAN MUSEUM OF ART, GIFT OF MRS. RUSSELL SAGE, 1909. (10.125.165)

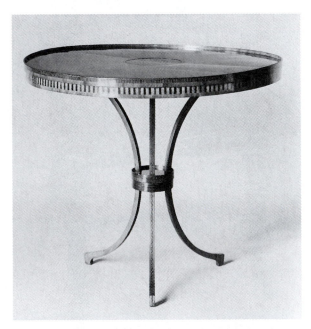

Figure 16–42 A satinwood tea table by Sheraton, c. 1795. The top has inlay of kingwood, a border of mahogany, and a center medallion of black and gold Japanese lacquer. The table is now at Buckingham Palace.

COUNTRY LIFE PICTURE LIBRARY, LONDON, ENGLAND

Figure 16–43 A Sheraton two-tier mahogany dumbwaiter, late eighteenth century, with a gallery top of pierced brass.

SHERATON TWO-TIER MAHOGANY DUMB WAITER, MALLETT & SON ANTIQUES LTD., LONDON/BRIDGEMAN ART LIBRARY INT'L LTD, LONDON/NEW YORK.

the nineteenth century would come to be called the **highboy.** It was at first a chest of drawers on a low stand or on a table-like base that also had drawers (Figure 16–44); by the Queen Anne period it would be standing on cabriole legs with a carved apron between them and would have gained an impressive pediment and finials on top. If the tallboy incorporated a fall-front writing surface and if its upper drawers were replaced by doors, it was called a **secretary** (Figure 16–45). The English term does not exactly correspond to the French **secrétaire,** which lacked the upper chest. As we shall see in chapter 18, both the highboy and the secretary would be popular furniture forms in America.

China cabinets for side walls and corners were made to display the collections of imported ware. Case furniture, such as cabinets, bookcases, and

Figure 16–44 An oak tallboy or chest on stand, made between 1675 and 1700. It stands 57 in. (144 cm) high. Its trumpet legs rest on a scroll-shaped stretcher and ball feet.

HIGHBOY. OAK. (1675–1700). H. 56¾, L. 38¾, W. 22¼ INCHES. THE METROPOLITAN MUSEUM OF ART, GIFT OF MRS. RUSSELL SAGE, 1909. (10.125.57)

Figure 16–45 A Queen Anne secretary, c. 1705–15. Its broken pediment top with finials is characteristic. It is decorated with Chinese scenes in red and gold japanning.

SECRETARY: BLACK AND GOLD LACQUERED. CA. 1700–1715. THE METROPOLITAN MUSEUM OF ART, BEQUEST OF ANNIE. C. KANE, 1926. (26.260.15)

secretary desks, had double doors with single panels that were designed with broken curves at the top. The glass for mirrors was usually made in two pieces, since there was a revenue tax on mirrors over a certain size. The edges of the glass were *beveled,* as they had been in the time of William and Mary.

In the Queen Anne and Georgian periods, commodes, wardrobes, chests with drawers, wall tables, sideboards, dressing tables, and consoles were also in use. A lady's small writing table, called a **cheveret,** was similar to what the French called a *bonheur du jour* (Figure 15–36). An equally small but more masculine version with more storage drawers and a slanted writing surface, originally made by Gillow and Company for a Captain Davenport, was called a **davenport.** The **canterbury** was a storage unit on a stand, used beside a piano to hold music or by a dining table to hold plates and cutlery, and somewhat resembling today's magazine rack. It was popular in England from the end of the eighteenth century, and Sheraton attributed the name to the fact that the Archbishop of Canterbury commissioned such pieces.

FURNITURE DETAILS AND ORNAMENTS

In the Tudor and Elizabethan periods, the structure of the case and cabinet furniture was similar to that of the wainscots. The stiles and rails, however, were often enriched by simple surface grooving, by a narrow strip of inlay in contrasting wood or checker effect, or by a crudely carved pattern in low relief, inspired by the classical **rinceau, arabesque,** or **guilloche.** The field of the panel was usually carved with a **linenfold** or a coat of arms and, as the Italian influence increased, the panels were enriched by a carved or inlaid arabesque pattern or medallion, or by a dwarf arch, the latter type being called an **arcaded panel**.

During the Jacobean period the panels became larger, were treated with moldings on four sides, often had plain fields, and sometimes were shaped as diamonds, crosses, hexagons, double rectangles, and other geometric forms.

Furniture supports during the Elizabethan period were often of the bulbous form, resembling a large melon and occupying all but the extreme top and bottom of the support or leg. The melon portion was usually carved at the top with a gadroon and at the bottom with an acanthus leaf. The top of the support crudely imitated a Doric or Ionic capital. During the Jacobean period, the bulbous form of support gradually gave place to dwarf columns of straight or spiral shape or to the twisted rope form.

In addition to the simple inlay work and crude low relief and **strapwork** carving, furniture was sometimes enriched by an ornament known as the **split spindle.** This consisted of a short, turned piece of wood, often ebony, that was split into two parts and applied to the surface of the stiles of an oak cabinet or chest. Drawer pulls and knobs at the top of chairbacks were sometimes carved in a caricature of a human head, a miniature version of **Romayne work.** Carved Italian grotesques, face profiles, and the upper part of the human body, rising from a group of scrolls and leaves, were also used for furniture enrichment.

Under Charles II, furniture was strongly influenced by both France and Flanders. Furniture design under Charles began to show greater consideration for the comfort of the individual, as well as increased richness of form and ornament. The low relief carving of the earlier type continued to be used. The spiral turnings for legs and stretchers became much more frequent and the most characteristic feature was the Flemish S- or C-shaped curve, sometimes known as the **Flemish scroll.** Legs and stretchers, arm uprights, backs, aprons, and crestings were created with Flemish scroll arrangements.

The **lion mask** came into fashion about 1725, and that motif was placed on the knee of cabriole legs (Figure 16–30), or frequently used as a central motif on the apron of tables, consoles, and other pieces of furniture. At the same time, the claw foot gave way to the lion's paw grasping the ball. Variations were seen in the use of satyr and human mask motifs as furniture feet. The Eastern element in furniture structure and finish became less common c. 1725, and lacquerwork disappeared, though Chippendale later revived Chinese forms for a brief period.

The claw-and-ball, lion paw, duck, cloven hoof, grotesque mask, and scroll feet continued in use with the cabriole form of leg until c. 1760. Low-built case furniture, such as bureaus and writing desks, was usually supported on **bracket feet** (as

on the secretary of Figure 16–45) of varying forms and degrees of enrichment.

Unquestionably, the influence of the architects Sir Christopher Wren, Batty Langley, and Abraham Swan had much to do with the introduction of classical architectural elements in furniture design. This tendency necessitated the gradual elimination of the curved line in structural and panel forms. Columns, fluted pilasters, and entablatures were once again used, with the broken or scroll pediment, in the center of which was usually placed a bust or other ornament. As with French furniture, English furniture came increasingly to be embellished with the products of other decorative arts.

English Decorative Arts

The use of a variety of fine and decorative arts to enrich furniture and interior surfaces was particularly apparent in the work of Robert Adam. The potter Josiah Wedgwood made porcelain plaques, medallions, vases, and tableware that were designed by John Flaxman and other competent sculptors to harmonize with the Adam interiors. The work of Italian painters and of the Swiss-born Angelica Kauffman covered the walls, the overdoors, overmantels, and furniture of this period with groups of mythological figures, Italian landscapes, and paintings of the ruined temples of Greece and Rome. Italian-style gilded gesso was another English vogue, popular from c. 1700 to c. 1740 among those who could afford it.

Classical figures played an important part in the designs of all types of craftsmen. Marble worker and plasterer, wood-carver, textile designer, and painter turned to classical mythology and represented the gods, the demigods, the mythological beasts, and the Muses.

During the eighteenth and nineteenth centuries the use of decorative accessories greatly increased. These included mirrors, clocks, statues, busts in marble and bronze, and a variety of objects collected in the foreign travels that were then becoming possible and fashionable for English of the wealthy and cultivated classes. Fire screens were made in wood and painted to represent life-size human beings dressed in the costumes of the day; these are called *fireside figures*. Lighting fixtures were made of iron, brass, and silver, and in large rooms, crystal chandeliers were hung from the center of the ceiling.

The collection and exhibition of Eastern and domestic china became the rage. Delftware was imported from Holland and Meissen ware from Germany, and the production of the native ceramics factories was pushed to the highest level of perfection. It has been said, relative to the importations of chinaware at the time of Queen Anne, that everyone in England was "a judge of teapots and dragons."

Ceramics

In medieval times, English ceramics had been sturdy and utilitarian. They included bowls, mugs, jugs, pitchers, pots, chamber pots, candlesticks, and cisterns for brewing beer. The custom of drinking from cups instead of bowls was not widespread until the end of the fifteenth century. Colored glazes were used for decoration, lead glazes at first, and then in the second half of the sixteenth century, tin glazes.

In the sixteenth century new forms were also introduced—not only cups, but also porringers (small one-handled bowls), tygs (large mugs with several handles or with two handles close together), posset pots (to hold drinks of milk and ale or milk and wine), sweetmeat dishes (to hold candied fruit), and chafing dishes (to warm food in dining rooms). For the finest tables, stoneware was imported from Germany and faience from Italy. By the seventeenth century ceramic wares were also being imported from Delft and from the Far East.

Native English wares of the seventeenth century were heavy earthenware coated with deep orange-colored **slip,** a mixture of clay and water. When dried, this preliminary coating was covered with another yellowish white slip. The whole object was then covered with glaze, after which a simple pattern was scratched into the surface, exposing the underlying orange color. Decoration often included the name or initials of the owner, a date, and a verse or motto. Other ornaments used were rosettes, fleurs-de-lys, shields, and grotesques. John Dwight (c. 1635–1703), who had been granted a 1672 patent for "transparent Earthen Ware," set up a pottery in Fulham in 1674 that produced brown stoneware for more than two hundred years.

In 1689 William and Mary left the Netherlands and came to rule England, bringing a large amount of Chinese porcelain and Delftware. In designing the interiors of Hampton Court for the royal couple, Daniel Marot decided the plates should not be limited to table use; he arranged them on walls, placed them in rows along cornices and mantels, and displayed them in cabinets, beginning a fashion that still continues. By the end of the seventeenth century, delftware imitations were being made in factories at Lambeth, while factories all over England, some using imported clays and improved firing techniques, were struggling to imitate Chinese porcelains. These attempts continued into the eighteenth century, joined by English copies of Meissen wares from Germany and of Sèvres wares from France. This experience led, by the middle of the eighteenth century, to the establishment of a large English ceramics industry, successful commercially, technically, and artistically. The wares of this industry were most often identified by the towns or areas where they were made—such as Bristol, Chelsea, or Staffordshire—but the most interesting of all were named for their maker, a towering figure named Wedgwood.

BRISTOL The ceramics industry in Bristol seems to have flourished as early as the 1650s. It was first noted for its reproduction of Delft tin-glazed earthenware (called *galleyware*), using it for wall tiles as well as for the usual plates and bowls. Transfer printing is thought to have been used for ornamenting Bristol ware beginning around 1757. Transfer printing is the process of transferring designs to ceramic wares by pressing them with engraved copper plates that have been freshly inked, or—in a method invented by John Sadler of Liverpool in 1754—by transferring designs from plates to paper and then from paper to ceramics,

Several attempts to make porcelain were initiated in Bristol, but it was not until about 1770 that they were successful and, despite that success, the Bristol works closed in 1782. Bristol porcelain is milk white, exceedingly hard and durable, with a cold glittering glaze. Biscuit wares were also made at Bristol. Tableware, figures, and ornamental plaques were produced. Much of the painted ornament was in the Chinese manner, but products of Meissen were also a strong influence.

BOW Bow's white wares and figures were influenced by Chinese **blanc de chine.** Painted china, in both underglaze and overglaze enamels, was also produced. The subjects of Bow decoration included bamboo and plum branches, partridges, grotesque animals, and sportive boys with small red flowers. The early tableware was frequently edged in brown. The glaze of Bow wares has altered and now often appears iridescent and discolored. Bow ware was mainly of useful form and rough decoration; more ornamental forms with finer decoration came from Chelsea.

CHELSEA Chelsea wares, like those of Bow, aspired to the imitation of blanc de chine and produced undecorated wares in a creamy paste with a satin texture. Other Chelsea products showed the influence of Vincennes and Sèvres, with rich ground colors such as dark blue and claret, and panels painted with pastoral scenes, bouquets, and exotic birds.

In 1769 the Chelsea factory was sold to some Derby potters, whose work was mostly in the Japanese taste (Kakiemon) with paintings of flower sprays, insects, and other old Japanese patterns. From 1770 until 1784, during the Derby-Chelsea period, the original wares of both factories continued to be made, but finally the Rococo forms gave way to the simpler effects of the classical revival, while in the decoration lapis lazuli, Derby blue, gold stripes, medallions, and biscuit reliefs made their appearance.

DERBY Derby's best products were made between 1786 and 1811, when a beautiful biscuit ware was produced. Figures were always a specialty of the factory, although much tableware was also made. Flowers, particularly roses, were favorite ornaments. As already mentioned, Derby (pronounced "Darby") was also known for its designs in the Japanese style, and its other specialties were the use of brilliant lapis lazuli blue and of realistic representations of lace trimmings on costumed figures. Transfer printing was introduced in 1764, but was not extensively used. The Derby factory finally closed in 1848, and what is now called the Derby Crown Porcelain Company is a separate company founded in 1875.

Wedgwood was the youngest of a family of twelve. He was stricken with smallpox as a child, which left him with what was called an "abscessed knee," a handicap in using the wheel on which pots were thrown. In 1768 his leg was amputated. Yet he persisted in the family trade of pottery. He married a distant cousin, Sarah Wedgwood, and they had eight children. In addition to his trade, he was active in supporting civic projects such as turnpike construction and the building of a canal between the Rivers Trent and Mersey; the canal opened in 1777. For his technical innovations, such as finding an accurate method for determining the heat inside a kiln, he was made a Fellow of the Royal Society in 1783. He was an ardent supporter of both the American Revolution of 1776 and the French Revolution of 1789, and he campaigned for the abolition of slavery. He died a rich man and left his business to his children. In the chancel of the parish church at Stoke-upon-Trent, an inscription reads: "Sacred to the Memory of Josiah Wedgwood . . . who converted a rude and inconsiderable Manufactory into an elegant Art and an important part of National Commerce."

LOWESTOFT The Lowestoft factory was founded in Lowestoft, Suffolk, by Robert Browne in 1757. It produced a soft-paste porcelain containing bone ash, similar to the wares from Bow. Production included jugs, flasks, dishes, inkpots, tea caddies, and other small objects inscribed A TRIFLE FROM LOWESTOFT. In the first years, all decoration was in underglaze blue, but transfer printing and enamel decoration were introduced later. Copies were made of wares from China and also of wares from Worcester. The Lowestoft factory closed in 1802.

WORCESTER The wares of Worcester (pronounced "Wooster") were similar to those of Derby and Chelsea. The Worcester factory was founded in 1751 and, despite frequent changes of ownership, maintained a group of highly skilled employees (some formerly from Derby and Chelsea) who kept the quality high over a long period. The molds of the best models were kept and reused in later years with new color treatments. Transfer printing was brought to Worcester in 1757 by Robert Hancock; after that, images of portraits and engraved prints were applied directly (and inexpensively) to the pottery surfaces. Hand painting was renewed, however, after 1768. After King George III visited the factory in 1788, its wares

were called "Royal Worcester." Production continued until 1840.

STAFFORDSHIRE AND WEDGWOOD Staffordshire has been an important producer of earthenware for centuries. Its prominence is due to the quality, variety, and color of the local clays, the plentiful supply of coal for kilns, and the easy river access to the sea for distribution.

The more accomplished Staffordshire wares are usually known by the names of their makers, such as David Elers, his brother John Philip Elers, John Astbury, Thomas Whieldon, and Josiah Spode. But by far the most important name connected with the potteries of Staffordshire is that of Josiah Wedgwood (1730–95). After five years of partnership with Thomas Whieldon, he went home to Burslem, near present-day Stoke-on-Trent, where three generations of his family had operated a pottery, then being run by his older brother Thomas. He rented space from Thomas for his own pottery, called the Bell Works, which prospered. Molds and models were made for him by William Greatbatch, who had been a colleague at Whieldon's.

In 1768 Wedgwood opened a shop and showroom in the Soho district of London and in 1774 moved it to leased quarters in Portland House.

Figure 16–46 Wedgwood Queen's Ware pitcher, c. 1775. It is in the pattern called "Brown Broad and Fine Line" and is 10 in. (25 cm) high.

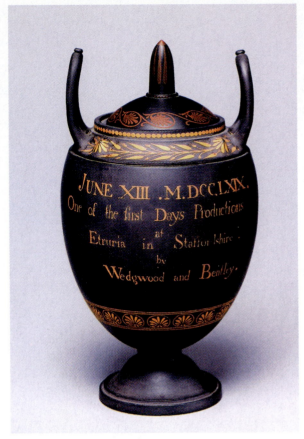

Figure 16–47 One of the First Day's Vases by Josiah Wedgwood and Thomas Bentley, 1769. It is of black basalt ware with figures in red, 10 inches (25 cm) high.

Wedgwood took care that displays were changed frequently, and the shop became a fashionable meeting place for the ladies of London society. *Queen's Ware* was a popular product (See Figure 16–46)

In 1769 Wedgwood and his partner Thomas Bentley opened a new factory near Burslem. They gave it the name Etruria, making clear their plan to reproduce the classical vase designs that were then thought to have been Etruscan. To celebrate the opening, the two partners—with Bentley turning the wheel and Wedgwood molding the form—produced six First Day's Vases of black basalt ware (Figure 16–47). Later innovations were a red stoneware called *Rosso Antico*, a buff-colored stoneware called *Cane*, a white stoneware called *Terracotta*, and a mottled ware called *Agate*. The factory's most celebrated product, however, was called **Jasper**.

Jasper, the result of more than 5,000 recorded experiments, was a dense, finely textured white biscuit ware that could be colored integrally or with a surface wash. A soft cobalt blue was the most popular color, but it was also made in olive green, sage, yellow, lilac, brown, gray, and black. On the colored ground were mounted (or **sprigged**) white ornaments, plaques, medallions, and figures in low relief. Frequent subjects for the ornaments were Greek motifs, children at play, and classical figures in graceful robes. The artists who produced these ornaments for Wedgwood were some of the best of their time, including John Bacon, John Flaxman, George Stubbs, William Hackwood, Lady Diana Beauclerk, and Lady Elizabeth Templetown.

In addition to a variety of tabletop items and some jewelry, Jasper products included a large

number of items for use in interior design: busts, clocks, candelabra, tiles, medallions for furniture and pianos, plaques for insertion in plaster wall treatments, medallions for chimneypieces, and even entire chimneypieces (Figure 16–48). They were perfect complements to the neoclassical style then being popularized by Robert Adam and others.

Wood Carving

Linenfold, mock linenfold, and Romayne work, all survivors from medieval times, continued to be used in Renaissance paneling, but were gradually replaced by a more classical vocabulary. The use of marquetry as an enrichment for furniture was gradually discontinued as walnut became unfashionable. Wall and table mirrors had frames in veneered woods, their lines broken at the top with the same curves that were used in chairbacks. **Crossbanding,** although used to some extent during the preceding period, became more common during the reign of Queen Anne. In veneering frames and panel borders, crossbanding is the placing of the grain of the veneer at right angles to the strip forming the frame or panel border itself

The marquetry used in the William and Mary period frequently took the form of elaborate floral patterns. Colored woods and natural and stained ivory veneers added to the richness of effect. One type of marquetry design, representing minute rambling foliage, is known as *seaweed marquetry.*

But the great glory of English Renaissance woodwork was the low relief—and the sometimes astonishingly high relief—of carvings.

THE GREAT CARVER: GRINLING GIBBONS Born in Rotterdam, Grinling Gibbons (1648–1721) became the most famous carver of his time and one of the chief authors of the English decorative style of the late seventeenth century. He is best known for his wood carving—mostly in limewood and oak, but also in box and pine—but he also worked in bronze and in marble and other stones (as, we have seen, he did at Blenheim). His work was fanciful, rich, and realistically detailed, in high relief and with deep undercuttings. Its subject matter included fruits, vegetables, flowers, animals, birds, fish, and dead game in panels, swags, garlands, and wreaths. It appeared on chimneypieces, overmantels, doorframes, overdoors, picture frames, organ screens, choir stalls (at St. Paul's Cathedral), and funerary monuments (such as one for the funeral of Queen Mary in Westminster Abbey). His many royal commissions included work at Windsor Castle (Figure 16–49), Hampton Court, St. James's Palace, Whitehall, and Kensington Palace. Gibbons's chief rivals among English carvers were his contemporary Edward Pierce and the Georgian carver Thomas Johnson.

JAPANNING In addition to marquetry, the process called **japanning** was a popular decorative treatment for wood furniture and other wood objects. It was an imitation of Eastern lacquer-

Figure 16–48 A chimneypiece of Wedgwood Jasper ware in green and white, made for the Master of the Dublin Mint c. 1785. It is 7 feet (212 cm) wide.

LADY LEVER ART GALLERY/NATIONAL MUSEUMS AND GALLERIES ON MERSEYSIDE, WIRRAL, ENGLAND, U.K.

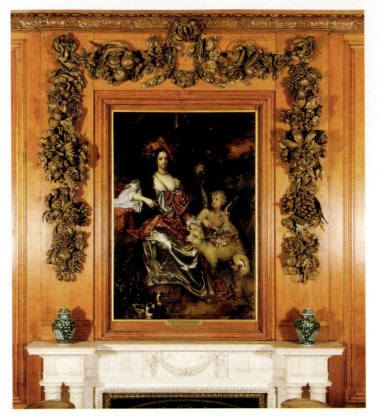

Figure 16–49 Grinling Gibbons's carving of the overmantel in the King's Eating Room, Windsor Castle, Berkshire, 1677–78. The portrait by Jacob Huysman is of Charles II's queen, Catherine of Braganza.

THE ROYAL COLLECTION © HM QUEEN ELIZABETH II

work, but produced without the genuine sap of the gum tree *Rhus vernicifera*. It was much in use in the late seventeenth century, and sometimes whole walls were covered with japanned boards. By the middle of the eighteenth century, increasingly inexpensive and inferior techniques had come to be used, until finally the term was applied to what was merely oil painting with a coat of varnish over it. In the nineteenth century, there would be a fashion for furniture that was not wood at all but japanned papier-mâché.

PARCEL GILT Another very popular English treatment of wood furniture and objects was **parcel gilt,** which is simply the practice of gilding parts, rather than whole surfaces. The term is sometimes applied to silver that is partly gilded, but more often to furniture and wood objects, such as

a wine cooler designed by Robert Adam for Kenwood House, London.

Metalwork

In the fifteenth, sixteenth, and seventeenth centuries, gold and silver were used lavishly by royalty, sparingly by others, although most noble households had a cupboard with a display of **plate**—a term referring not specifically to plates or to plated metals but to any objects wrought of silver or gold. Royal dinner tables sparkled with silver *chargers* (dishes on which meat was cut), *trenchers* (dishes on which cut meat was served), *standing salts* (elaborate saltcellars that were placed to identify the seat of the host), dishes, bowls, drinking vessels, spoons, and knives. Forks began to be used—at first only for desserts—in the seventeenth century. By the eighteenth century, great importance had come to be attached to the ceremony of dining, even in middle-class homes. Pewter utensils were replaced by silver ones whenever possible, and fashionable tables and sideboards were laden with silver tureens, sauceboats, candelabra, and *epergnes* (ornamental stands for the center of the table, usually with central dishes and branching arms holding several smaller dishes). A sauceboat, one of a set of eight, designed by Robert Adam is an example of how elegant late-eighteenth-century English tableware could be (Figure 16–50). It was made to Adam's design by Matthew Boulton and John Fothergill. Dining rooms and other fine rooms might also employ silver for chandeliers (Figure 16–51) or for sconces and **girandoles.**

Figure 16–50 One of a set of silver sauceboats designed by Robert Adam, 1776–77, 10 inches (25 cm) long.

VICTORIA AND ALBERT MUSEUM, LONDON/ART RESOURCE, NY

Figure 16–51 A silver chandelier from the State Dressing Room at Chatsworth House, Derbyshire, 1694.

COUNTRY LIFE PICTURE LIBRARY, LONDON, ENGLAND

Figure 16–52 A brass door lock by John Draper for Petworth House, Sussex.

COUNTRY LIFE PICTURE LIBRARY, LONDON, ENGLAND

A technical innovation of 1743 made silver more affordable. Thomas Boulsover of Sheffield invented a process of fusing a thin plating of silver to a base of copper; the result was called **Sheffield plate.** The process was improved by Matthew Boulton, who began in 1765 to make candlesticks, bowls, teapots, coffeepots, and other wares of Sheffield plate in his factory at Birmingham. One of Boulton's improvements was the addition of solid silver wires along those edges and rims that receive the most wear. By 1770 plated wares were popular all over England.

Baser metals had an important place in English interiors, too. Brass was particularly popular for lighting and for hardware and trim on doors and windows. Some of these fittings received elaborate decorative treatment (Figure 16–52). Brass substituted for silver tableware in less prosperous dining rooms, and it was also used for candlesticks, chandeliers, sconces, tobacco boxes, snuffboxes, clocks, nutcrackers, and trivets. Pewter, less popular than in medieval times, continued to be made and, because it was manufactured by casting in reusable molds, its style remained surprisingly constant. Copper and copper alloys were used for large sturdy wares such as basins, buckets, kettles, and pans. Iron and steel appeared in

architectural elements such as gates, fire grilles, and balustrades.

One last figure who deserves mention is the goldsmith Nicholas Sprimont (1716–71), who was born in Liège, Belgium, but worked in London. He is best known for some sculptural silver and silver-gilt centerpieces. One made for Frederick, Prince of Wales, in 1741 is in the British Royal Collection; another, called the Ashburnam Centerpiece and dated 1747, is in the Victoria and Albert Museum. Despite his apparent success as an artist in metal, he began around 1744 a second career in ceramics. He would become a pioneer in English soft-paste porcelain.

Textiles

The textile industry was greatly enlarged and perfected in England by the Huguenot immigrants after the 1685 revocation of the Edict of Nantes. Textile colors became particularly brilliant. In the William and Mary period that began in 1689, furniture upholstery materials continued to be made on the English looms set up by the French emigrants. Velvets, brocatelles, brocades, damasks, crewel embroideries, and needlepoint were used. The latter years of the seventeenth century saw

the introduction of chintz as a decorative material for window and bed draperies. As noted in the chapter on India, there was demand in the seventeenth and eighteenth centuries for Indian textiles throughout Europe, particularly in England, special favorites being the hand-painted chintz bedcovers called **palampores**.

PRINTED FABRICS Block-printed cottons and linens were made in factories in the London area beginning in the late seventeenth century. In the middle of the eighteenth century, the Drumcondra printworks near Dublin may have been the first source of copperplate printing on fabric, soon followed by a factory at Merton, Surrey. Many English textiles were exported to the United States in the eighteenth century, including some **blue resist** patterns, the parts of their grounds meant to remain white being coated with wax before being dipped in blue dye. Fine block-printed designs of the early eighteenth century were made by William Kilburn of Surrey and the Ware family of Kent. Richard Ovey was a leading London linen draper.

In 1736 the Manchester Act legalized the printing of cotton and linen blends, and a law of 1774 legalized the printing of pure cottons. In 1789 Manchester was the site of the first application of steam-powered machinery to the spinning of cotton.

Silk was also produced in England in great quantities beginning in the seventeenth century, though more of it was used for clothing than for interiors. Beginning in 1680 a series of legislative acts supported the silk industry, a law of 1766, for example, prohibiting the importing of silk from France.

CARPETS The first pile carpets in England were imported from the Near East and Spain, and these imports probably began in early Tudor times. By the middle of the sixteenth century, Henry VIII was reported to have amassed a collection of eight hundred pieces of fabric, and in several portraits of Henry VIII by the German painter Hans Holbein the Younger we can see Turkish carpets on floors and tables. About the same time, knotted carpets began to be made in England of wool pile on a hemp warp; their designs were imitations of Near Eastern and Middle Eastern ones, though some also incorporated the coats of arms of the English families for whom they were made. This **Turkey work** was costly, and it was used not only for carpets but also for more modestly sized objects, such as upholstery panels and cushion covers. It remained popular until the late seventeenth century, when there was increased importation of carpets from Turkey and Persia.

The English production of knotted carpets then virtually stopped until 1750, when it was revived by two weavers from the French Savonnerie factory, Louis Théau and Pierre Poiré. Their first English carpet was made for the Duke of Cumberland, and they later founded short-lived weaving workshops at Fulham and Exeter. Weavers from these studios were later employed by Thomas Moore in a new workshop at Moorfields. Given a royal warrant in 1763, Moorfields produced carpets for the Prince of Wales (later George IV) and other royalty. Moorfields also worked on carpets for Syon House and other works by Robert Adam, and operated until 1793.

Contemporary with the Moorfields workshop, Thomas Whitty, a Devonshire weaver, began producing Turkish-type carpets at Axminster using a vertical loom, which proved more suitable than the horizontal ones previously used. As Moorfields wove carpets to the designs of Adam, Axminster wove them to designs by Chippendale.

 VOCABULARY ENGLISH TERMS FOR CARPETS

A fine distinction in sixteenth-century English terms is that *Turkey carpets* was used for carpets imported from the Middle East and *Turkey work* was used for imitations made in England. The Turkish carpets of the type seen in Holbein's portraits have sometimes been called *Holbeins*.

Other English developments sought less expensive alternatives to hand-knotted carpets. One of these was a strong flat-weave worsted wool floor covering made from the late sixteenth century by individual weavers in Kidderminster. In 1735 a factory was established there for more efficient production. The product, some of which was used to carpet parts of Worcester Cathedral, was called *Kidderminster, ingrain,* or *Scotch carpet.* It was made in a limited color range but in long lengths.

Also in long lengths and more durable than Kidderminster was so-called Brussels carpet. A patent for its manufacture was taken out in 1741 by an upholsterer and clothier from Wilton and a merchant from London. Brussels carpets, woven in strips, could be cut and sewn to fit any floor area, and they were considered so useful they were imported by France, where they were called *moquettes.* A later variation in which the loops of the Brussels carpet were cut to form a velvet-like pile was known as *Wilton carpet.* Both techniques were imitated by the Kidderminster workshop, so that Wilton and Kidderminster were direct competitors during the last half of the eighteenth century.

FLOORCLOTHS Where budgets were modest, substitutions for carpets or other expensive flooring were made from painted canvas. These were called **floorcloths.** They were inevitably patterned to imitate carpet designs, tile work, marble patterns, or parquet flooring. Before the eighteenth century, such patterns were painted by hand, but after c. 1700 they were most often produced by stencils, and in 1755 Smith and Baber of London began printing floorcloths with wood blocks. One early source of patterns was published in 1739 by the London engraver John Carwitham, *Various Kinds of Floor Decoration . . . Being Useful Designs . . . Whether of Stone or Marble, or with Painted Floor Cloths.* Batty Langley's *Antient Architecture* also provided examples that could be used for floorcloth patterns.

TAPESTRIES The first known tapestry factory in England was in Barcheston, Warwickshire, with a second one at Bordesley, Worcestershire, both established c. 1560 by William Sheldon. Sheldon's factories wove some large pieces, but most of their products were small cushions and seat covers. The Netherlands and Flanders continued a near monopoly in the English tapestry market until 1619, when James I and his son the Prince of Wales (later Charles I) founded a workshop at Mortlake on the River Thames, near London. The Mortlake facility was probably inspired by the workshops that Henry IV had established in France. Charles brought dozens of Flemish weavers to work at Mortlake, and he bought Raphael's cartoons for the *Acts of the Apostles,* which served as the basis for several sets of tapestries woven at Mortlake. Despite its royal patronage, the factory suffered financial troubles. Its purchase by the Crown in 1638 saved it temporarily, but it finally closed in 1703.

William and Mary and Queen Anne continued to import Flemish tapestries, but a number of workshops were operating by then in the Soho district of London, their products called **Soho tapestries.** The most important of these was the workshop of John Vanderbank the Elder, who had been named Royal Arras Maker in 1689. Vanderbank's work included copies of Brussels and Gobelins designs and some *chinoiserie* designs for Kensington Palace, London.

In the 1720s and 1730s, many London upholsterers also produced tapestry work, including Joshua Morris, William Bradshaw, and Paul Saunders. By the end of the eighteenth century, however, the venerable respect for tapestry hangings had begun to be eclipsed by a growing taste for paint and wallpaper.

Wallpaper

The earliest English wallpaper that has been identified dates from the first decade of the sixteenth century and was used on the ceiling of the Master's Lodge at Christ's College, Cambridge.

Discovered during renovations four centuries later, it is thought to have been block-printed by a printer named Hugo Goes, who included a small figure of a goose as his signature (Figure 16–53).

Most wallpaper in England, however, was imported from France until the end of the seventeenth century. The Great Fire of London in 1666 and the consequent need for quick and extensive rebuilding boosted the wallpaper trade (as it did

Figure 16–53 Paper block-printed in black ink, c. 1509, from Christ's College, Cambridge. The small goose seen on the right of the pomegranate motif is a rebus for the name of the printer, Hugo Goes.

VICTORIA AND ALBERT MUSEUM, LONDON/ART RESOURCE, NY

A variant of flock paper was *spangled paper,* which was dusted with powdered isinglass (the mineral crystal we now call *mica*) to give the effect of velvet embroidered with silver threads. Improvements for the manufacture of flock paper have continued to the present time, even as its popularity has declined. When flock paper is made today, its applied particles are of synthetic material and they are held to the paper electrostatically.

The second eighteenth-century fashion was for pictorial and scenic papers imported from China and, when that was too costly, for the English imitation of Chinese papers. This fashion was wholly consistent with similar fashions in architecture, furniture, and decorative arts of all sorts.

In the last decades of the eighteenth century there were more than seventy wallpaper establishments (popularly called *paper stainers*) active in London alone and many others elsewhere in England. Among all these, the most important figure was John Baptist Jackson (c. 1701-c. 1780). Some of his papers reproduced paintings by the Venetian masters Titian and Tintoretto, and the subjects of others included landscapes in the manner of Piranesi, statues, trophies, and stucco representations of foliage. Some were series of small round or oval scenes framed in branches or garlands. Even in these, and particularly in the larger scenic papers (Figure 16–54), the scale and sweep of his work were in striking contrast to the

many others), and an Act of Parliament in 1690 supported papermaking. The first application at the London Patent Office for wallpaper printing was filed in 1692. But the great breakthrough in prestige for English wallpaper came c. 1720 when architect William Kent, decorating the Great Drawing Room at Kensington Palace for George I, chose to cover the walls with printed paper rather than velvet hangings. Royal use conveyed instant respectability.

Among the general eighteenth-century popularity of English wallpapers, two particular fashions were important. The first was for **flock paper** that imitated the texture of velvets by means of dusting finely sieved shearings of wool over surfaces where glue had been applied in desired patterns. Similar French papers were mentioned in the previous chapter.

Figure 16–54 Wallpaper by John Baptist Jackson with an Italianate landscape of classical ruins.

VICTORIA AND ALBERT MUSEUM, LONDON/ART RESOURCE, NY

Paper is notoriously fragile, and is often considered of little value. Finding early examples of paper goods such as wallpaper is therefore unusual. Some examples survive because they were covered for decades or centuries by other materials, others because they were used in situations less vulnerable than on walls—as, for example, the linings of boxes or drawers. But the quality of discoveries can be as telling as the quantity: those few fragments of English wallpaper that have been found from the sixteenth and seventeenth centuries are both sophisticated in design and careful in execution, leading experts to think that the use of paper was a highly respected custom and probably a widespread one.

delicate detail of the Chinese papers then in vogue.

Jackson was also technically innovative, creating his large decorative panels by fastening several sheets of paper together before printing them. His use of oil paints produced paper surfaces that could be wiped clean when necessary.

Another technical innovation, credited to Edward Deighton in 1753, was that of printing papers on a cylinder press using a metal plate engraved with the design, then brushing the colors on by hand. Another successful paper manufacturer of Jackson's time was Thomas Bromwich, whose business—the Golden Lion—at Ludgate Hill flourished between 1740 and 1760. Bromwich's papers copied chintz, calico, embroidery, and gilded leather, and he supplied papers to Horace Walpole for Strawberry Hill. Other firms included the Eckhardt Brothers of Chelsea and Sheringham's of Marlborough Street.

But Jackson's chief competitors and most important successors were the Crace family, early examples of English wallpaper makers who also offered complete interior design services, much as some French upholsterers were to do. Edward Crace, the son of a coach maker, became a coach decorator, setting up shop in the Covent Garden area of London in 1752. By 1768 he had progressed to the decoration of houses, and two years later he received an important commission for the interiors of James Wyatt's Pantheon in London, now destroyed. For the Pantheon he provided **grisaille**

panels, **scagliola** columns, and gilt furniture. In the decades that followed, Edward Crace's son and grandsons would carry the firm to greater size (a hundred employees) and greater prominence (papers and decorations for the Opera House at Covent Garden, Windsor Castle, and the Royal Pavilion, Brighton), but theirs is a story for our chapter on the nineteenth century.

PRINT ROOMS AND DECOUPAGE WALLS

An eccentric version of the paper-decorated wall is the print room. The fashion for such rooms is sometimes thought to have been begun c. 1750 by Lord Cadogan, and about the same time Horace Walpole boasted of having two print rooms at Strawberry Hill. In such rooms, fine engravings were not placed in wood or metal frames and hung, but were pasted directly on the walls, framed only with paper borders and sometimes linked with paper garlands—the result being a papered wall surface, but one that was highly individual, not repeated or manufactured. The cut-and-paste technique was similar to what we would today call *decoupage*. The prints themselves were generally black-and-white, and the wall surface behind them was usually painted a solid color—blue, blue-gray, yellow, buff, green, or, as in the billiard room of Fawley Court in Buckinghamshire, bright pink.

An elegant example from c. 1773 is Lady Louisa Conolly's dining room at Castletown, County Kildare, one of Ireland's first Palladian

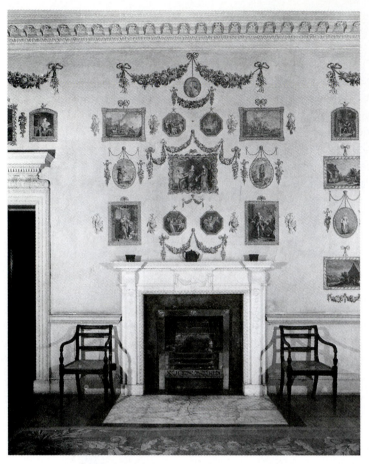

Figure 16–55 Decoupage wall treatment in Lady Louisa Conolly's house at Castletown, County Kildare, Ireland, c. 1700.

IRISH TOURIST BOARD

The fashion for print rooms continued into the early nineteenth century and was felt also in France and Sweden. By c. 1820, however, the fashion had faded, and it was not until the middle of the twentieth century that it had a mild revival. Carlos de Beisteguy, whom we shall meet later as an eccentric client of modernist architect Le Corbusier, installed a print room in his château at Groussaye, near Versailles, in the 1950s, and in the 1970s Sir Desmond Guinness installed one in his castle in County Kildare, near its eighteenth-century model at Casteltown. Print rooms occasionally appear today as interesting curiosities.

Summary: English Renaissance Design

English design between the Gothic period and the nineteenth century reached remarkable levels of achievement and individuality, displaying both great character and great quality.

Figure 16–56 The print room at Woodhall Park, Hertfordshire (now the Heath Mount School), 1782.

COUNTRY LIFE PICTURE LIBRARY, LONDON, ENGLAND

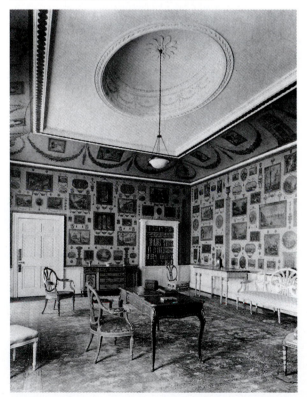

houses. Over the mantel is an arrangement of rectangular, oval, and octagonal prints (Figure 16–55), and such displays continue around the room. A denser display is seen in Sir Thomas Rumbold's print room at Woodhall Park, Hertfordshire, dating from 1782 and including more than three hundred prints, including engravings of the pilasters of Raphael's Vatican Loggie and a set of Piranesi's *Views of Rome* (Figure 16–56). Other examples were installed at Hickstead Place, Sussex, at Stratfield Saye, Berkshire, at Rokeby Park, Yorkshire, and at Mersham Le Hatch, Kent. This last one was arranged (at least in part) by Thomas Chippendale. His bill for "Cutting out the Prints, Borders and Ornaments and hanging them in the Room Complete" still exists, but unfortunately his work does not.

Looking for Character

The character of English design in this period was deliberately based, as we have seen, on styles of the past—classical, primarily, but with some attention to the Gothic. Yet the English results are an excellent demonstration of how variously and individually the past can be interpreted. The classical style as interpreted by Palladio and reinterpreted by Inigo Jones or William Kent yields one result; the classical style as interpreted more directly by Robert Adam yields another. And reactions to these variations demonstrate very well the changeability of taste over time, suggesting that no single expression, however fine, satisfies forever.

Yet all these versions share to some extent a single character that is English, distinct from any French, Spanish, or German interpretation: a courtly sturdiness that can be likened to the manners of an English country gentleman—robust and sporting, yet cultured and artistically aware. And in much English design, as in many English people, there is also an intriguing dash of eccentricity.

Looking for Quality

The English country house and the English city palace set a standard for gracious interiors that has never been surpassed—if it were not for their carelessness about heating, most of us would be happy to live in such rooms today. English furniture, too, of the Queen Anne and Georgian periods reached a level of excellence that ranks them, along with French furniture of the Louis XV and Louis XVI styles, as some of the most assured, consistent, and graceful pieces ever made. And individual artists—some now famous, some anonymous—rose at times above the general level to even finer achievements: the spatial and decorative inventiveness of Adam, the impeccable composition of curves in a Queen Anne chair, the virtuosity of a Gibbons carving.

Making Comparisons

Chief among many parallels between French and English design is the fact that both built upon Italian accomplishments, taking the revolutionary ideas of the Italian Renaissance in new directions. One difference is that in France artistic standards were set—and artistic fashions established—in Paris and in neighboring Versailles, while in England love of the countryside and love of the outdoor life prevented London, as great a city as it was, from playing a similarly dominant role. Another difference is that the decorative arts were never made a national industry in England as they were in France, nor given the same degree of royal patronage. And perhaps the greatest difference is that English conservatism and respect for tradition prevented the whole notion of artistic fashion from assuming the importance it held in France. Lacking the French passion for the *dernier cri,* the English welcomed stylistic change only in a slower and more measured way.

17

PRE-COLUMBIAN AMERICA

BEFORE THE SIXTEENTH CENTURY

Beginning in 1492, the explorations of Christopher Columbus and others changed humanity's perception of itself. Two important groups of cultures, previously unaware of each other, met for the first time, and in everyone's consciousness the world was permanently enlarged. The continents of North and South America and the isthmus connecting them had been the scene of a series of fascinating cultures flourishing for centuries before their first contact with their European counterparts. Among these, we shall review some of the major cultures of Central and South America and then the design of the native North Americans before we consider the changes brought by the European colonies.

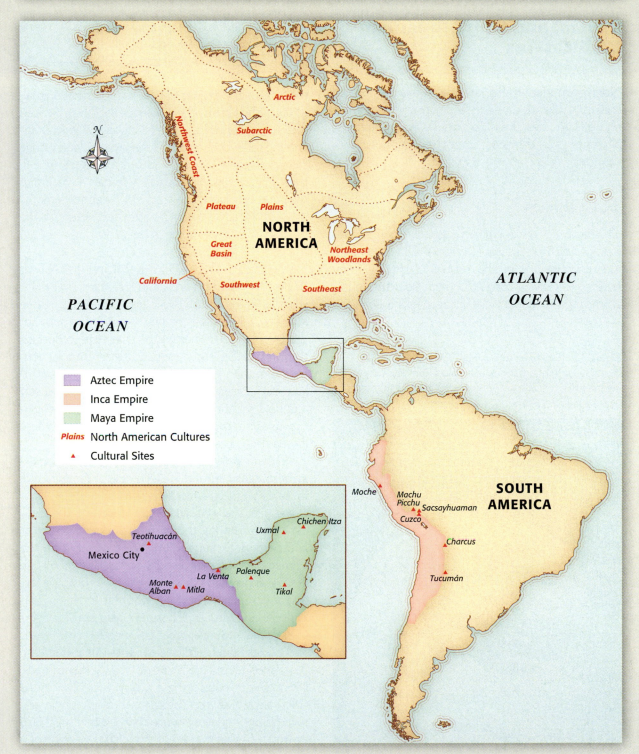

Figure 17–1 MAP OF PRE-COLUMBIAN CULTURES IN THE AMERICAS

ORTELIUS DESIGN

Central and South American Civilizations

The European explorers first landed south of North America. Here, they gradually discovered ancient civilizations, each fascinating in its culture and design. We shall look briefly at the accomplishments of the most important of these civilizations.

The Olmecs

The earliest of the important Central American civilizations to reach maturity was the Olmec (a name meaning "people of the rubber country"). They reached a height of accomplishment along the southernmost gulf coast of what is now Mexico, between

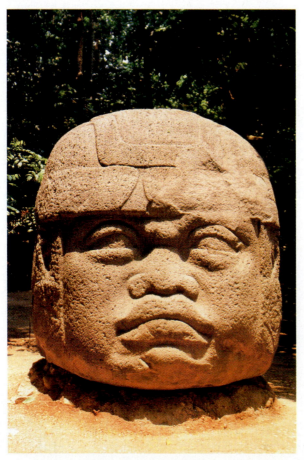

Figure 17–2 Similar to the four Olmec stone heads guarding La Venta, this one of basalt is from San Lorenzo Tenochtitlan, c. 1200 B.C. It is over 9 feet (2.75 m) high.

SUZANNE MURPHY/STONE

1000 and c. 400 B.C. when they seem to have come to a sudden and violent end.

The Olmecs have been called the great founders of Mesoamerican culture; they have also been called the Jaguar People because that animal, a rain symbol, was their chief deity. They devised a calendar, but not a written language. Without inventing the wheel, they still managed to carry huge stones great distances; without a potter's wheel, they still excelled at pottery. We can also admire the great ceremonial centers of Olmec settlements in the Mexican states of Tabasco and Veracruz, the most evocative of which is La Venta.

LA VENTA AND OTHER MONUMENTAL WORKS Built on an island less than 1 mile (1.6 km) long in the Tonalá River amidst great mangrove swamps, La Venta is the first example we know of the temple-focused city type that was to flourish throughout Central America. Its ceremonial center, more than 1,000 feet (305 m) long, was dominated by a great pyramid of beaten earth. Exactly a double square in plan at its base, its sides sloped upward to a height of over 100 feet (30 m), where it was topped by a square platform.

Other elements of the center were all disposed symmetrically around the long axis of the pyramid. Immediately to the north was a ball court, roughly the size of a modern football field and the earliest known among the many ball courts found in Mesoamerica, supporting the notion that the Olmecs were the inventors of the basketball-like game using a hard rubber ball that was both a sport and a ceremony and was popular in many pre-Columbian cultures. There are also smaller pyramids, burial mounds, great colonnaded courtyards and plazas, altars and stelae, and—as if guarding the island's sacred precinct—four giant stone heads. Monoliths of basalt, these weigh roughly 15 tons (14 t) each and were brought through jungle and swamp from quarries more than 50 miles (80 km) away. Each was carved to depict the wearing of a close-fitting helmet of some kind, such as may have been worn in the aforementioned ball games (Figure 17–2). Thus protected, La Venta was an environment for assembly, procession, and elaborate ritual.

Other monumental stoneworks of the Olmecs include the stelae, carved with calendric glyphs in

low relief, presumably commemorating astronomical events. Large monolithic altars were also produced, their carvings showing the jaguar god, priests in elaborate collars and headdresses, and the sacrifice of young children. Sandstone sarcophagi have also been found.

At a very different scale, the Olmecs also carved delicate miniatures of jade, rock crystal, and less valuable stones. Some of these were in the form of ax heads; some were masks; some were purely decorative objects. The techniques involved seem to have included all those developed later: abrasion, chiseling, drilling, crumbling, and (using finely powdered stones) polishing. Subject matter included the jaguar god, jaguar teeth, figures part human and part jaguar, deer jaws, stingray tails, clamshells, bats, and parts of the human body—hands, toes, and ears. Small flat stones were also arranged in mosaic patterns and used for flooring. The finest Olmec work, however, was of jade.

JADE CARVINGS The term **jade** is used for two minerals, nephrite and jadeite, which are similar in appearance but different in composition. Both nephrite and jadeite are cool to the touch, lustrous, sometimes translucent, and can be given a high, oily polish. They are also exceptionally hard, impossible even to scratch with steel, and the consequent difficulty of working the material seems only to have added to the value of finished pieces. How, then, were they carved?

Pieces of jade were patiently sawed by drawing cords repeatedly back and forth across the surface until grooves were formed, then continuing to make the grooves deeper, while using a solution of hard stone particles in water to create greater friction. Drills of bone and even of hardwood were employed, again using finely crushed stone and water as the actual cutting agent. The necessary patience and skill were remarkable, but amply supplied by Olmec artisans. Prominent among their subject matter was the all-important jaguar and a number of supernatural figures, and objects in these forms were used as pendants and in religious rituals.

Teotihuacán

Northeast of the central lake in the great plain of the Valley of Mexico, near the present capital city,

DATE	SOUTH AMERICA	CENTRAL AMERICA	NORTH AMERICA
Before 500 B.C.	Chavin de Huantar culture in the Andes 1200–400 B.C.	Maya precursors 1500–500 B.C.; Olmec culture at La Venta, Olmec jade carvings, 1200–400 B.C.	Basket Maker culture
500–1 B.C.	Pre-Inca Nazca and Chimú cultures in Peru	Monte Albán founded in Mexico by Zapotecs; ball game invented by Olmecs; Pyramid of the Sun at Teotihuacán	Precursors of the Pueblos
A.D. 1–500	Moche pottery in Peru; painted fabrics on Peru's Paracas Peninsula	Mayan ceremonial Centers; Monte Albán rebuilt; Mayan cities of Chichen Itzá, Tikal, and Palenque built	Mound Builders in central North America
500–1000	Monumental carvings at Tiahuanaco; painted underground tombs in Colombia; pre-Inca culture in valley of Cuzco	Mayan city of Uxmal built; Mixtecs capture Monte Albán and build Mitla	Pueblo culture begins in Utah, Colorado, and Arizona; Mimbres pottery
1000–1500	City of Cuzco founded; growth of Inca culture; Chimu and Mochica cultures in Peru	Aztecs found Tenochtitlán; Mayan frescoes at Tulum and Bonampak; many Mayan cities abandoned	Cliff Dweller culture in Colorado; Great Kiva at Aztec, New Mexico

lie the ruins of the city of Teotihuacán, its name an Aztec term for "Place of the Gods." But the city had come to a violent end and had been deserted long before the Aztecs found it. Unlike some other Mesoamerican sites that were ceremonial centers without dwellings, Teotihuacán was a true city, perhaps the first and, at its height, certainly one of the greatest in the Americas (Figure 17–3). Beyond the center were the houses of the ruling elite, associated with religious practices; beyond these were houses of artisans and peasants. The city lacked surrounding walls or fortifications, evidence of a society so powerful that it was virtually without enemies.

Most remarkable, however, was the city's great ritual center, almost 2 miles (3.2 km) in

After the early sixteenth-century discovery of the Americas by Spanish explorers, the remains of the American cultures went largely ignored for centuries. In the first years of the nineteenth century, German explorer Alexander Humboldt, having visited South America and Cuba, came to Mexico, publishing his findings in 1810. The North Americans John Lloyd Stephens and Frederick Catherwood began the exploration of Mayan ruins in 1839. In 1910, excavations were begun in the Valley of Mexico by Manuel Gamio, father of Mexican archaeology, although that title has also been given to Alfonso Caso, who directed the explorations at Monte Albán and Mitla in the 1920s and 1930s. The first important Olmec discovery was not until 1938, when Matthew Stirling began excavations at La Venta.

Our present recognition of the artistic merit of pre-Columbian artifacts owes much to the opinions of the Mexican painter Diego Rivera (1886–1957) and the Mexican-born artist and archaeologist Miguel Covarrubias (1902–57).

Today there is still much information to be unearthed. The exciting thing about pre-Columbian archaeology is that it is so far from finished. Many surprises may be ahead.

Figure 17–3 Interior court of a palace at Teotihuacán, seventh century A.D.

ADALBERTO RIOS/PHOTODISC, INC.

length, disposed about a 130-foot-wide (40 m) central spine, the Miccaotli ("Road of the Dead"). Along this spine—the scene, undoubtedly, of many impressive processions—were hundreds of stone platforms and groups of chambered buildings. And dominating all were three powerful structures: at the spine's southern end, the Temple of Quetzalcoatl (the "Plumed Serpent"); near its midpoint, the so-called Pyramid of the Sun; and serving as its northern terminus, the Pyramid of the Moon. All the structures are thought to have been finished with layers of white and red stucco.

A distinctive architectural feature common throughout the ceremonial complex was a framed masonry panel (**tablero**), its surface long but vertical, cantilevered from the sloping sides of the pyramids. The repetition of such panels gave the composition of buildings a remarkable cohesion. The framed surfaces of these panels was generally used for decoration, usually in the form of painted frescoes, and in the case of the temple, that decoration was especially elaborate, not painted but sculptured in stone reliefs. For the most part, these reliefs pictured the heads of two gods: the Plumed Serpent himself, shown as a sharp-fanged, fire-breathing, feathered dragon; and Tlaloc, the

rain god, shown as a geometrically stylized mask with ringed eyes. In the background of the panels are nautical motifs (such as shells and sea creatures) and meander patterns representing the Serpent. More stone heads of Quetzalcoatl lined the ramps that climbed the pyramid.

The Zapotecs and Mixtecs

More than 200 miles (321 km) southeast of Teotihuacán's plateau, the geography becomes mountainous. The early civilization here was known as Zapotec. Here, 1 mile (1.6 km) above sea level, is the present-day city of Oaxaca, and, 1,300 feet (400 m) higher still, was the ancient city of Monte Albán (White Mountain), sacred capital of the Zapotecs.

MONTE ALBÁN Leveled by years of labor, the mountaintop acropolis was protected against invasion by steep cliffs falling away on all sides, and on this man-made plateau a great complex of temples was built. Unlike Teotihuacán, Monte Albán seems not to have been a real city with a resident population, but a city of the gods and of the dead, visited by pilgrims from afar.

On a north-south axis, its central plaza is 850 feet (260 m) wide and slightly less than 1 mile (1.6 km) long. In its center and ringing its edges are disposed a dozen impressive pyramidal temple-tombs, and among and below these are hundreds of smaller tomb chambers, many of them still unexcavated. There is also an impressive ball court

for the ceremonial games mentioned earlier (Figure 17–4).

Like the ancient Egyptians, the people of Monte Albán seem to have lavished their finest design on spaces for the dead, and some of these

Figure 17–4 The ball court at Monte Albán for the ceremonial sport popular in many Central American cultures. It was built in the fifth or sixth century A.D.
PHOTO: ABERCROMBIE

tomb interiors were vibrant with frescoes of deities and priests mysterious to us today. Exterior building surfaces were faced with polychrome stucco, which, in the clear atmosphere and bright Mexican sun, must have given a dazzling effect, and even some tomb exteriors meant to be buried in the earth were elaborately carved.

MITLA Near Monte Albán, the Mixtec city of Mitla lacks the dramatic site and the dramatic monumentality of its predecessor. Here, however, are thoughtful compositions, well-proportioned public squares, interesting interior spaces, and unsurpassed decorative panels. There are five groups of buildings at Mitla, all with long rectangular elements (concealing cruciform burial chambers beneath them) surrounding central plazas. The best preserved group, called the Group of the Columns, consists of buildings on low pyramidal mounds ranged orthogonally around two plazas, their axes parallel but offset. Unlike those of the other groups, these two plazas are open at the corners as well

as along one side. The central building facing the northern of the two plazas was entered through a room (Figure 17–5) that still displays the six cylindrical columns that have given the group its modern name and that originally supported a flat roof.

The facades and courtyard walls of buildings in this group are decorated with horizontal friezes, each slightly overhanging the one below it (Figure 17–6). The repeated motifs of the friezes may remind us of Greece, being recognizable as key frets, spiral frets, rinceaux, and meanders, but here they have been treated in a resolutely geometric manner, most curved forms replaced by angular ones. Their construction is of two types, some carved into large stone panels, some assembled mosaic-like from small stones set into clay.

The Mayas

The earliest great Mayan site we know is Palenque, less than 100 miles (161 km) from the territory of the Olmecs. The major works there were built be-

Figure 17–5 The Hall of Columns in the Palace of the Columns at Mitla. The six monolithic shafts of volcanic stone supported a wooden roof that has disappeared.

tween 610 and 783, and the last inscription found on the site is dated 799.

An interesting discovery beneath Palenque's so-called Temple of the Inscriptions is a circuitous pas-

Figure 17–6 Three decorative friezes of carved stone on the Palace of the Columns at Mitla, each projecting slightly beyond the one below it.

ADALBERTO RIOS/PHOTODISC, INC.

sage leading downward to a royal tomb (Figure 17–7). Here was hidden the sarcophagus of a Mayan ruler-priest, his skull covered with a mask of jade mosaic, and with a thousand more jade ornaments—many of them heart shaped—accompanying him.

MAYAN STELAE **Stelae,** ceremonial pylons found at most Mayan sites, are generally about 12 feet (3.7 m) high and carved in fantastic detail, sometimes in shallow relief, sometimes with more depth. Often they were carved from trachyte, a soft green native stone that can be easily carved soon after excavation but that hardens upon exposure to the air.

CHICHÉN ITZÁ The cities of the Yucatán Peninsula were the great ceremonial sites of the Mayan civilization. The heart of one of them, Chichén Itzá, is the four-sided pyramid called the Castillo (Figure 17–8). Archaeologists discovered

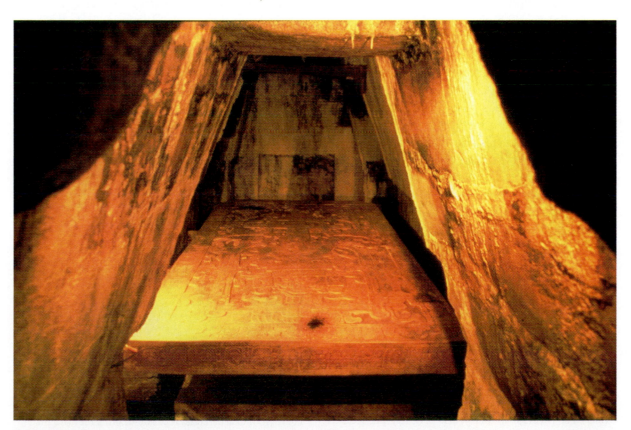

Figure 17–7 Slab of King Pacal with inscriptions, 7th century AD (stone) by Mayan. Temple of the Inscriptions, Palenque, Chiapas State. Mexico/Mexicolore.

THE BRIDGEMAN ART LIBRARY INTERNATIONAL LTD.

Figure 17–8 One of the four stairways climbing the great pyramid at Chichén Itzá. Inside the visible structure is buried an older, smaller one.

COSMO CONDINA/STONE

that the pyramid was built around an earlier, smaller one that remains intact, even including the temple on its top, and inside the antechamber of the temple was found a **chacmool,** a characteristic piece of ritual furniture, in the form of a reclining human figure and usually carved of stone (Figure 17–9). It was placed before an altar or a priest's throne, with its face turned toward the audience of worshippers, its knees raised, and holding on its stomach a container for offerings (such as the viscera of human sacrifices). Beyond the antechamber, in the buried temple's inner chamber, was found a piece of furniture known as the Red Jaguar Throne. Carved from limestone, it is painted with vermilion cinnabar, has teeth made of white flint, eyes of jade spheres, and on its body dozens of spots of jade disks.

MAYAN FRESCOES: TULUM AND BON-AMPAK Tulum, on a rocky coast of the Caribbean, was the last of the Mayan cities of which we have evidence, occupied c. A.D. 1200–1521. It was ringed with walls, an unusual feature in the Yucatán. Unusual decorative elements are the "diving god" figures found in niches over doorways and stucco masks found at the corners of buildings. Interior walls were brightly painted in black outlines infilled with only the primary colors red, yellow, and blue.

Even more famous are the frescoes of Bonampak, a Mayan word meaning "painted walls." Bonampak was a ceremonial center built in the tropical rain forest near Palenque. In its frescoes, the primary colors also dominate but have been joined by browns, pinks, and other hues. Black outlines and white highlights were added after the main color areas. The painting was applied to damp stucco, and the storytelling scenes continue

Figure 17–9 The limestone chacmool sacrificial altar figure from Chichén Itzá, A.D. 900–1200, 5 feet (1.5 m) long.

T. SAVINO/THE IMAGE WORKS

through three adjoining rooms. The paintings remain in place, suffering from water damage, but there are reconstructions of them at both the University of Florida Museum of Natural History and the Museo Nacional de Antropologia in Mexico City.

The Incas

The Moche culture of Peru existed as early as A.D. 100, flourished c. A.D. 500, and endured for two centuries more. The Moche people built pyramids and palaces of plastered walls covered with polychrome murals, but they are perhaps best known today for their expressive pottery. Moche wares represent fruits and vegetables, animals, deer hunts, warriors in combat, and human sacrifices, and some portrait vessels (Figure 17–10) are topped with distinctive stirrup-shaped spouts that are unknown outside Central and South America.

By A.D. 1200 all the lands and all the early cultures of the area had been consolidated under the

Figure 17–10 A stirrup-handled terracotta portrait vessel made by the Moche culture of Peru, before A.D. 200, 9¼ inches (23.5 cm) high.

rule of the Incas, with their capital at Cuzco. The Incas are noted for their engineering feats: a network of roads and the mountaintop city of Machu Picchu (Figures 17–11 and 17–12). Peru's varied ecology—ranging from a warm, dry coast to cool highlands to hot, humid inland slopes—demanded a variety of building types. The availability of building materials varied also, so that adobe was much used on the coast, stone in the highlands, and wood on the eastern slopes. Whatever the material, the plan of the Incan house was generally rectangular, enclosing a single room with a roof of thatch, porous for the escape of smoke from heating or cooking. When the walls were of adobe, carved niches within them held household wares. Hides or mats covered floors and doorways. For important public buildings, however, the Incas used stone, and their skill with that material is famous.

The architecture of the Incas, in the words of archaeologist and author J. Alden Mason, "was characterized by massiveness rather than by beauty,

Figure 17–11 The ruined Incan city of Machu Picchu: temples, palaces, and housing compounds on a terraced mountaintop.

MICHAEL J. P. SCOTT/ STONE

Figure 17–12 At Machu Picchu, looking out from the entrance to a ceremonial chamber.

in an unnecessary attempt to heighten the exoticism of the Incas, sometimes claim that Inca textiles were woven from bat wool. Bat hairs being too short to spin into yarn, however, the claim is probably nonsense.)

The cotton and wool varied in color—white, tan, yellow, brown—and for richer colorations animal and plant dyes were used—indigo for blue, mollusks for purple, and insect-derived cochineal for red. Finished textiles were also painted.

Not only was the Inca weaving remarkably skilled, employing extremely fine threads and yarns, but it was also remarkably varied, including almost every kind of pre-industrial weaving technique known anywhere: plain weaves, pattern weaves, tapestries, plaiting and braiding, twill, tie-dye, double cloth, gauze, reps, pile knots, embroidery, and brocade. The loom generally used was of the backstrap type, with the frame tied to a tree branch or other support. The weaver (usually, but not invariably, a woman) could then adjust the tension in the loom by leaning slightly forward or backward.

The woven products used in interiors included a thick and heavy baize-like woolen textile (*chusi*) for bed and floor coverings. Perhaps the most unusual fabrics were those in which the colorful

remarkable for its stupendous masonry rather than for its art." On a smaller scale, however, Incan artistry was more pronounced. In the realm of decorative and utilitarian objects—metalwork (Figure 17–13), pottery, wood carving, and textiles—as Mason points out, "art was a constant element of [the Inca's] life, not an interest apart from it." Perhaps the most accomplished of all these crafts was Incan textile art.

PERUVIAN TEXTILES The cool climate of much of Peru required warm clothing and bedcovers, and the raw material for these was plentiful. Flax and silk were unknown to the Incas, but there was cotton and an abundance of good wool from the llama and of much finer wool from the alpaca and the vicuña. So fine, indeed, was this wool, and so skillful its weaving, that the first Spanish invaders mistook it for silk. (Tour guides and others,

Figure 17–13 Made of silver, an Incan figure of an alpaca, 9½ inches (24 cm) high.

feathers of jungle birds were inserted quill first into the warp of the cloth being woven. Gold particles (*chaquira*) were also incorporated in Inca fabrics, as were gold bangles and tiny bells. The finest fabrics of all, however, woven only by specially trained "chosen women," were for the succession of elegant vicuña wool tunics for the Inca rulers, who wore each of them only once. After each royal wearing, the tunic was destroyed.

The Native North Americans

Native American settlements occupied all parts of North America from Mexico to the Arctic, and they are generally classified in different "culture areas" according to their location—for example, Northeast, Plains, and Plateau—each area having its own climate, raw materials, customs, and design characteristics.

Native American Architecture and Its Interiors

The Spanish gave the name *Pueblo* to the peoples of the Southwest. Spelled with a lower case *p*, the word is also used for a tribal community and for a communal dwelling within the community.

The Pueblos, also called Cliff Dwellers, would develop (in the eleventh to fourteenth centuries) two remarkable building types: The first and most visible type was the large, terraced, multiroomed community house (Figure 17–14), which was sometimes built, for safety from invaders, in the caves of rocky cliffs. The second type, often built within the community house complex, was the **kiva,** an underground ceremonial chamber.

The kiva is usually circular, although rectangular examples exist, and it is entered by a ladder through its roof. The interior is lined with stone blocks or adobe brick and typically contains several features (Figure 17–15). At its central and lowest point there is a small sand-filled pit, called a *sipapu,* which symbolizes the prehistoric emergence of the Pueblo people from the underworld. Near it is a larger pit in which fires are maintained during the ceremonies, representing the legendary fire with which life began. A ventilation shaft to the outside has an opening near the fire pit to clear the interior of smoke (although the roof hole for the ladder is also left open), and a slab of stone or adobe rises between the fire pit and the ventilator opening in

Figure 17–14 The communal complex called Pueblo Bonito, Chaco Canyon, New Mexico, built by the Anasazi tribe between A.D. 850 and 1150. The sunken circular spaces are the ceremonial rooms called *kivas.*

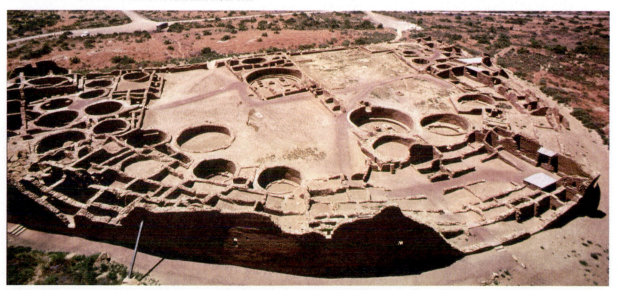

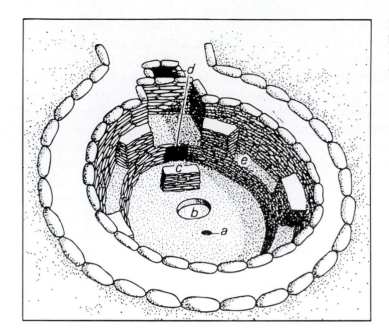

Figure 17–15 Diagram of the interior of a kiva: (a) the symbolic sipapu; (b) the fire pit; (c) the draft-deflecting wall; (d) ventilation shaft openings; (e) seating platforms.

order to block drafts. Graduated tiers of seating circle these central elements, the priests being seated closest to the center on the lowest level (symbolizing their humility), novices on a higher level, and uninitiated spectators on the highest level of all.

The largest kiva to be fully unearthed and rebuilt to date is the Great Kiva at Aztec, New Mexico. Dating from the twelfth century, it has a diameter of almost 50 feet (15 m), large enough to serve several villages or clans. Important settlements between the Colorado and Rio Grande Rivers using one or both of these building types include those at Chaco Canyon (Figure 17–14), Mesa Verde, Canyon de Chelly, Ventana Cave, Snaketown, and Casa Grandes.

Some of the many other ancient native North American settlements are those of the Plains area east and north of the Rio Grande, where earth lodges, grass houses, and *tipis* (conical tents of buffalo hides supported on wooden poles) were built; those of the Southeast, where *chickees* (open-sided huts with broad-eaved thatched roofs) were built; and those of the Northeast/Great Lakes area, where *wigwams* (hemispherical houses of reed matting over frames of bent saplings) were built.

The culture areas of the Subarctic and the Northwest Coast, having the most severe climates, developed building types to match. The most fa-

mous of these is the Arctic *iglu*, a domical construction made of blocks of snow. It was entered through a low vaulted passage, its openings at either end blocked by hanging skins. Inside a large iglu, the floor was generally stepped into two levels, the upper one for the women and their household goods, the lower one for the men and their tools. The snow shell was often lined with animal skins, held by cords drawn through the dome and tied to outside toggles. The Eskimos and the Aleuts of these lands also used tents and wood structures.

Native American Crafts and Decorative Arts

The skill of the Native American artist and craftsman is evident in many media, including wood carving, rock painting, sand painting, metalwork, and leatherwork. As the Central Americans treasured jade, so the North Americans treasured turquoise, considering it a defense against evil and fashioning from it admirable objects and jewelry. More famous still are Native American textiles, ceramics, and baskets.

TEXTILES The textile expressions of pre-Columbian North America are many and varied. They include the fringed "raven's-tail" robes of the

Northwest Coast cultures, and the later Chilkat blankets or "dancing robes" of the same people. The painted cloths of the Anasazi are notable. From Carolina, there were blankets woven of opossum hair. From Ohio and Illinois, there were the plaited reed mats of the Ottowas and the rush matting of the Chippewas.

The most famous today are the textile products of the Navajo in northeast Arizona, the largest of the present-day American tribes. Outstanding are the tapestry-woven Navajo blanket, adapted from the Spanish serape, and the Navajo rug (Figure 17–16). But the Classic period of these textiles did not come until the early nineteenth century.

MIMBRES POTTERY A number of Native American tribes and pueblos are celebrated for their fine pottery, and perhaps most celebrated of all are the Mimbres, in southwestern New Mexico. The first Mimbres pottery vessels seem to have been made about A.D. 200, the last ones about 1100, and between those dates they progressed from plain brown wares to burnished red ones and, about 650, when large ceremonial structures were being built, to the painted bowls that are so admired today. Among the painted bowls there was a progression from geometric patterns to abstracted representation. Many of the bowl paintings depict animals and birds, and some show men (perhaps priests) dressed in bat costumes or with antlers on their heads. In every case, the images are simple but intense (Figure 17–17).

We do not fully understand the significance of these bowls to the Mimbres. Bowls were placed upside down over the faces of the dead, who were buried beneath the floors of their families' houses. We also know that the potters who made them felt that when they completed a bowl they breathed life into it. When it had outlived its usefulness or when its owner died, a hole was broken in its center, "killing" the bowl. Some Mimbres patterns are still in use today by the potters of the Acoma and Laguna pueblos.

BASKETRY Fine weavings and pottery are found in many cultures, of course. The craft that reached its highest level of attainment in the hands

Figure 17–16 A Navajo rug of the "Two Gray Hills" type.

Figure 17–17 The hole in the bottom of this Mimbres bowl shows that the bowl has been "killed."

Figure 17–18 A coiled Pima basket tray from Arizona with a maze pattern, 1 foot (30.5 cm) in diameter.

COURTESY, NATIONAL MUSEUM OF THE AMERICAN INDIAN, SMITHSONIAN INSTITUTION, PHOTO NO. 11/0415. PHOTO BY DAVID HEALD.

of the Native Americans was basketry. It was one of the earliest of the crafts that they developed. Their first pots, in fact, were made by pressing baskets into damp clay, and, as O. T. Mason, an early student of the subject, wrote in 1902, "Basketry is the mother of all loom work and beadwork." By baking clay-covered or -lined baskets, fireproof cooking containers were made, and clay-covered basketry was even used to make huts for dwelling and grain storage.

The materials used for basketry are primarily plant material—roots, stems, twigs, grasses, barks, leaves—but strips of animal hide can be used as well, and great decorative use can be made by interweaving such objects as feathers, insect wings, teeth, and shells. There are two basic construction techniques employed: woven basketry, built on a warp foundation; and sewed or coiled basketry, built on a foundation of straws or splints. Each of these two types includes many subtypes. At present, the coiled baskets, which give an impression of greater substance, are more favored by collectors (and therefore more highly prized), but there are equal beauties to be found among the woven baskets.

Every tribe and pueblo had its own basketry tradition. But most outstanding of all, perhaps, was the basketry of the Pima (Figure 17–18) in southern Arizona. In every case, basket making (as well

as much of the other labor) was done by the women of the society.

Native American Art Today

Appreciation of native North American art and decoration has been slow in coming. Before the third decade of the twentieth century, Native American artifacts, when collected, were generally to be found in anthropological and natural history museums rather than in art museums. But three exceptional early exhibitions of such work were presented by three American painters: First, in the first decade of the nineteenth century, Charles Willson Peale showed discoveries from the Lewis and Clark expedition in his private museum in Philadelphia. Second, in 1838, George Catlin began touring the United States (and later Europe) with his own collection, which he tried unsuccessfully to sell to the U.S. government. The collection is now lost. Third, in 1931, John Sloan and others organized and put on tour an *Exposition of Indian Tribal Arts*. The first permanent collection of native North American art in an art museum is probably that of the Denver Art Museum, dating from 1925, and the first comprehensive exhibitions of it were at San Francisco's *Golden Gate Exhibition* in 1939 and *Indian Art of the United States* at New York's Museum of Modern Art in 1941.

Meanwhile, Native American buildings, their interiors, and their decoration have had some modern imitators. In the last years of the nineteenth century, Santa Fe architect Isaac Hamilton Rapp adopted Native American motifs for his New Mexico State Capitol, finished in 1900. In the 1920s archaeologist Jesse Nusbaum, director of Mesa Verde National Park in Colorado, and his architect John Gaw Meems constructed for the National Park Service a series of new but sympathetic buildings in what they called the "Pueblo Revival" style; this work later influenced building design in a number of other Southwestern parks. Frank Lloyd Wright chose freely from a range of pre-Columbian forms and decoration for some of his work. A decorative novelty of the 1930s was a briefly popular style called "Pueblo Deco." More naturally, the traditions of the early Native Americans continue to inspire the design of their descendants, on and off present-day reservations.

Summary: Design in America before the Europeans

So many and so varied are the cultures of the early Americas that it would not be sensible or fair to characterize them as a group. It is hoped that the foregoing paragraphs have given some inkling of the individual characters of the various cultures mentioned. Among all these, however, it is possible to single out specific accomplishments of high quality and to consider some comparisons.

Looking for Quality

In interior design, as in architecture, many of the Native American cultures have excelled in the creation of places of special significance. Even without knowledge of the builders' beliefs, traditions, and religions, it is impossible to contemplate a Mayan stela, a Palenque burial chamber, or a North American kiva without knowing that one is in a holy spot.

In the decorative arts that adorn interiors, one accomplishment that must demand our respect is Olmec jade work. Given a material so hard that a single straight cut through a cubic foot would take several weeks of work, the ancient jade worker deserves respect for perseverance as well as artistry. Mayan murals, Peruvian rugs, Mimbres pots, and Pima baskets prompt similar admiration.

Pre-Columbian American design, much of it still buried, offers many highlights of excellence. As our knowledge of these ancient cultures grows, and as we are better able to judge their products in the context of their original meanings and by the standards of their own makers, those highlights will surely shine even more brightly and will be joined by many others.

Making Comparisons

The design accomplishments of pre-Columbian America have been subjected to a great many comparisons, most of them in an attempt to answer a single question: whether or not the Americas were settled by people from Europe, Africa, or Asia—or, put another way, whether or not the New World was really an extension of the Old. Some of the comparisons that have been made, such as between the Mayan city of Palenque in Mexico and the Khmer city of Angkor Wat in Cambodia, or between Mayan and Egyptian hieroglyphics, or between Peruvian and Egyptian looms, have shown striking visual similarities, but no proof.

Some authorities have said that human life cannot have developed independently in the Americas, for no evidence has been found there of some of our ancestors in the long chain of evolution. Others, taking the opposite view, have said that the absence in early America of such crops as wheat and rice and of such conveniences as wheeled vehicles pulled by draft animals proves the lack of linkage. Those who favor the idea of older cultures planting the seeds of the American ones have been called diffusionists, while those who favor the idea that the Americans evolved from quite different origins have been called Americanists or inventionists, and the notion of independent beginnings is called polygenesis.

An idea that seems to be accepted by at least some on both sides of the controversy is that America's first settlers came across the Bering Strait from northeast Asia near the end of the last ice age using a strip of land that, after the melting of the ice, fell below sea level. This idea obviously involves the diffusion of other cultures, but it satisfies the inventionists as well by suggesting that a race of the human species, having been cut off from its ancestors near the beginning of its development, then invented its own arts and techniques in parallel with other races.

With an answer to the question of American origins still far from final, comparisons between American and other ancient cultures will continue to be made. Comparisons of a very different sort will be implicit in the next chapter, as we see people of a different background dealing with the same American geography, geology, and climate—factors that in other situations we have seen to be major design determinants—and yet producing design of a completely different character.

18

THE EUROPEANS IN NORTH AMERICA

SIXTEENTH TO EIGHTEENTH CENTURIES

The late fifteenth century began an era of remarkably adventurous European exploration. The first permanent European settlement in what would become the United States was Saint Augustine (Florida), established in 1565 by the Spanish, and the first permanent English settlement was established at Jamestown (Virginia) in 1607.

The new settlers in North America came from many backgrounds, and brought the influences of those backgrounds with them. The most obvious determinant of the society, customs, and design inclinations of the earliest colonists was their national origin. For

Figure 18–1 THE EUROPEAN COLONIES IN NORTH AMERICA C. 1779

ORTELIUS DESIGN

their design, as for all other aspects of their culture, the colonists looked back toward the lands from which they had come.

Periods of Early American Design

Although all North American design history from the first European settlements to the end of the eighteenth century is sometimes referred to as "Colonial," it is more informative to divide that history into three phases.

Early Colonial (before c. 1720)

The first century of European settlement in North America was characterized by unpretentious architecture and interiors, with little thought of design beyond the most utilitarian needs. Local

Figure 18–2 A Colonial American interior, c. 1675. The fireplace wall is faced with vertical pine planking, and the exposed structure includes a corner post and the summer beam supporting the low ceiling.

DRAWING: GILBERT WERLÉ

materials were used. In the houses of Early Colonial times, all rooms were multipurpose rooms; it would have been unusual to see a room without a bed in it. Furniture included crude copies of the English Jacobean, Carolean, and William and Mary styles. The earliest wood joinery was simple, using solid woods and mortise-and-tenon or pegged construction (Figure 18–2).

James I, for whom the Jacobean style was named, ruled England from 1603 to 1625, but the style's popularity did not reach America until the middle of the seventeenth century and continued until almost its end. It is the earliest kind of American furniture that still survives, and previous kinds must have been the crudest of tables, benches, and stools. By the last decade of the century, furniture of the William and Mary style was in demand and continued to be until about 1730. As in England at the time, oak was the most common furniture wood, with the difference that the English used white oak and the Americans red oak. Virginia walnut was also used. As in England, walnut began to replace oak as the wood of choice, and the veneering of fine grains over more common species came to replace the exposure of solid wood. When two different species were used in the same piece, a brown stain was applied to achieve a uniform appearance.

By the first years of the eighteenth century, the economic condition of the new country had improved and the struggle to tame the wilderness had been largely finished. A new group of immigrants was attracted, many of them from England and Scotland, including skilled craftsmen, carpenters, and cabinetmakers. They would contribute greatly to the increasingly luxurious interiors of the colonies.

Late Colonial or Georgian (c. 1720–87)

The population of the North American colonies more than doubled between 1730 and 1760, and their prosperity grew as well. With the new wealth and sophistication, there was a gradual introduction of recent English architectural forms and furniture. As before, there was a time lag. Queen Anne was succeeded by King George I in 1714, but the Queen Anne style did not reach the colonies for at least another decade. When it did, it was heartily welcomed. The elaborate turnings and ornament of the earlier styles (see, for example, Figure 18–17) began to be seen as fussy and old-fashioned, and the shapely curves of the Queen Anne style were seen as beautiful and fresh (Figure 18–3). The new style's emphasis on form and outline rather than on decorative detail, carving, and gilt must have seemed pleasantly sympathetic to the limited size and grandeur of the American house. Academic versions of classical architectural elements began to be applied to American interiors in such features as the chimney pieces of important rooms (Figure 18–4, page 466).

PERIOD AND DATE	POLITICAL EVENTS	DESIGN ACHIEVEMENTS	ARCHITECTS, DESIGNERS, AND CRAFTSMEN
Early Colonial, before c. 1720	Jamestown Colony, 1607; Plymouth Colony, 1620; Massachusetts Bay Colony, 1630; English take New York from Dutch, 1644	Wren Building, Williamsburg, 1695–1702; Governor's Palace, Santa Fe, 1610; Capitol, Williamsburg, 1701–5; Governor's Palace, Williamsburg, 1706–20	John Coney, 1655–1722; Caspar Wistar, 1696–1752
Late Colonial or Georgian, c. 1720–87	American Revolution, 1775–83; Declaration of Independence, 1776; first Shaker colony founded, 1776	Westover, 1730–34; Faneuil Hall, Boston, 1740–42; Redwood Library, Newport, 1747; King's Chapel, Boston, 1749; Parlange, Louisiana, 1750; St. Michael's, Charleston, 1751; first California mission, 1769; first Monticello, 1769–82; Mt. Vernon, 1757–87; Virginia State Capitol, 1785	Peter Harrison, 1716–75; William Savery, c. 1721–87; John Goddard, 1723–85; "Baron" Stiegel, 1729–85; John Townsend, 1732–1809; Paul Revere, 1735–1818; John Frederick Amelung, 1741–98; Thomas Jefferson, 1743–1826; Samuel McIntire, 1757–1811
Federal, after 1787	Federal Constitutional Convention, 1787; Constitution ratified, 1788; first meeting of U.S. Congress, 1789	White House, 1792–1801; U.S. Capitol, 1792–1830; Massachusetts State House, 1795–97; second Monticello, 1796–1809	William Thornton, 1761–1828; James Hoban, 1762–1831; Charles Bulfinch, 1763–1844; Benjamin Henry Latrobe, 1766–1820; Duncan Phyfe, 1768–1854

Chippendale's book *The Gentleman and Cabinet-Maker's Director* was published in London in 1754, and by 1760 its influence was felt in America, bringing new complexities and richness. Through Chippendale and other sources, the design of the Far East was also apparent, and Chinese porcelain, lacquerware, and wallpaper were imported via England. Chintz imitating calicoes from India was also imported from England.

Wallpapers were made in America also and became very popular. Longcase clocks and mirrors were elegant additions to American rooms. When it could be afforded, upholstered furniture was also added. The taste in color for walls, upholstery, and

Figure 18–3 Recreated at the Winterthur Museum, a 1725 room from Vauxhall Gardens, a house built in Cumberland County, New Jersey. The ceiling is still low, but the paneling is more refined, with a bolection molding around the large fireplace. On the mantel is an imported *garniture de cheminée*. The chairs are fine examples of Philadelphia design in the Queen Anne style.

COURTESY WINTERTHUR MUSEUM, PHOTOGRAPHY BY LIZZIE HIMMEL

Figure 18–4 Two eighteenth-century mantel treatments showing the early use of architectural elements.

DRAWING: GILBERT WERLÉ

1735

1750

curtains was chiefly for strong greens, reds, blues, and yellows (see Figure 18–5). Candles continued to be the chief lighting source, although there were also lamps, the earliest ones burning fish oil.

In 1782 the eagle was adopted as a symbol of America, and ever after it appeared frequently in American decorative arts. A ring of thirteen stars, representing the original colonies, was also a popular motif. About the same time, the neoclassical style of Adam, Hepplewhite, and Sheraton began to appear as a lighter alternative to the Chippendale style. Furniture makers in Boston, Newport, New York, Philadelphia, Charleston, and elsewhere were producing fine furniture of their own designs; we shall meet a few of these artists later in this chapter. In 1784, with the voyage of the *Empress of China* from New York to Canton, America began to import teas, silk, porcelain, and other goods directly from the Far East.

The American Revolution, however, absorbed all the colonists' attention and halted the development of furniture craftsmanship just when rapid

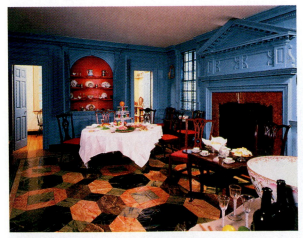
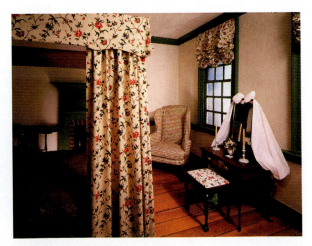

Figure 18–5 Two rooms from a reconstruction of the c. 1725 Cupola House in Edenton, North Carolina: (left) The dining room with woodwork from 1756–58. Wood venetian blinds were popular at the time, as were floor cloths and strong colors. (right) A bedchamber with wing chair and dressing table. Printed bed hangings like these might have been imported from England.

THE CUPOLA HOUSE. EDENTON, NORTH CAROLINA, USA, CIRCA 1725 (1980 RENOVATION) WOODWORK DATED 1756–1758. BROOKLYN MUSEUM OF ART, THE WOODWARD MEMORIAL FUNDS. 18. 170

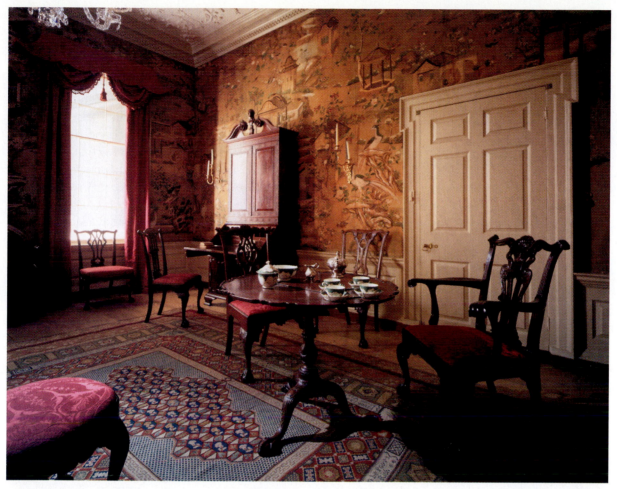

Figure 18–6 Hand-painted Chinese paper on three walls of the salon of the Samuel Powel house, Philadelphia, 1765–66, remodeled in 1769–71.

style changes were occurring in England. It was not until several years after peace was restored that American design began again to reflect the changes in foreign fashion.

Federal (after 1787)

The newly formed United States welcomed the Adam style, and the influence of Hepplewhite and Sheraton continued. Americans warmly sympathized with France during her struggle toward democracy, and President Jefferson's purchase of Louisiana in 1803 made U.S. citizens of many French settlers. There was a resultant fashion for French styles. They did not displace the prevailing English forms, however, but were frequently fused

with them. Chinese landscapes continued in popularity as a subject for American wallpapers (Figure 18–6).

In general, ornament in interiors became more delicate and refined, and the taste in color changed from bright to pastel or slightly grayed hues. Rooms in all but the most modest houses had by this time been given specific uses: bedrooms, kitchens, dining rooms, even sewing and reading rooms. There seldom were separate dressing rooms, but bedrooms customarily included dressing tables, which themselves were often elaborately dressed (as in Figure 18–5).

At the very end of the century, the invention of the Jacquard loom promised to revolutionize the textile industry; we shall see the results in the next

chapter. Also, as the century ended, the careers were just beginning of the United States's two best-known native furniture designers, Samuel McIntire, also a distinguished architect, and Duncan Phyfe.

Architecture and Interior Design

Written records by colonists, including Captain John Smith, president of the governing council of the English colony at Jamestown in 1608 and 1609, indicate that the first English settlers built huts or tents of clay, mud, bark, and tree limbs, roofing them with thatch. The first church in the colony was a tent made of rotten sailcloth. It is thought that the Swedish, who came from a land of small wooden houses and settled in Delaware in 1638, introduced the log cabin to America.

The earliest seventeenth-century houses consisted of a single all-purpose room with a large fireplace that served for both cooking and heating. Almost all seventeenth-century houses were built of wood. Oyster shells were available in some places for making lime, but the resultant plaster was of poor quality. Other materials for making mortar were not found in abundance until around 1680; after that, some houses were built of stone and domestic brick or from brick brought from Holland to New York (originally New Amsterdam) as ships' ballast.

When plaster became more available but was still expensive, only the inside surfaces of the exterior walls of the house were sealed with it. In the two-room house that succeeded the one-room cabin, the interior walls remained sheathed in wood planking, at first oak and, after 1700, pine. Three plastered walls and one wooden one therefore became a characteristic feature of the inte-

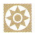 **DISCOVERING** THE **PAST** PERIOD ROOMS

There are plenty of examples of seventeenth-century interiors and interior fragments in long-settled countries, but few survive from the rugged experience of colonial America. Many of those we can now see are either reproductions (such as those at Colonial Williamsburg in Virginia, along with some actual restorations) or were salvaged early in the twentieth century and are now in museums.

The earliest of these may have been three room vignettes installed at the Essex Institute in Salem, Massachusetts, in 1907. The Metropolitan Museum of Art, New York, acquired its first Colonial woodwork (from a Long Island house) in 1910, and the Brooklyn Museum its first paneling (from Connecticut) in 1915. The Metropolitan opened its American Wing in 1924, Colonial Williamsburg was founded in 1926, and in 1928 period rooms were opened at both the Museum of Fine Arts in Boston and the Philadelphia Museum.

Today Early American rooms can be seen in many museums, most notably at the Metropolitan Museum of Art, the Brooklyn Museum, the Henry Francis du Pont Winterthur Museum in Delaware, and—unexpectedly—the American Museum at Claverton Manor near Bath, England.

Period rooms have their limitations, of course: they seldom show the context of exterior architecture, adjoining rooms, or views from windows; some details of furnishings and fabrics must often be based on conjecture; and modern requirements of access and lighting necessarily intrude. But they are valuable sources of information today, and for them we are grateful to the foresight of those, a century ago, who did not share the general neglect of the early American past.

riors of the two-room house. The wood wall was of vertically placed planks; cut from the first-growth trees of the virgin American forests, these were of great width, sometimes more than 3 feet (1 m) wide. To compensate for shrinkage of the planks, a tongue was cut along one edge of each plank to fit into a groove of the adjoining plank. Simple ornamental moldings were sometimes added to cover the joints. All the woodwork was left in a natural finish, and because pine becomes red with age, the walls were warm in color and rather dark.

For expediency in building, the rooms had low ceilings, seldom more than 7 feet (2.1 m) high. Windows were first of the casement type, the double-hung sliding sash not appearing until after 1700, and window panes, either rectangular or diamond-shaped, were separated by either lead or wood bars and filled with glass, isinglass (mica), or oiled paper. Some windows had no filling at all, being closed only with blinds or shutters. The flooring of the ground floor was at first simply earth, but pine, oak, and chestnut planks of varying widths were soon adopted, and stone was used in some cases. Each room had a fireplace centered in the wood wall, the two fireplaces sharing a central chimney. When the room was large, the ceiling span was cut in half by a **summer beam** (from the French *sommier*, meaning "rafter"), one end of it resting on the masonry chimney, the other on a post in the outside wall (Figure 18–2). Under the pitched roof was an attic reached by a steep stair.

By 1670 brick houses were being built in Virginia and other Southern states with evidences of classical trim in their interiors. Such details came later to the New England colonies. In the early years of the eighteenth century, the interior wood walls changed from vertical boards to rectangular panels with some pretension to architectural forms.

In the eighteenth century, houses grew larger and their plans more complex. The four-room, single-chimney house was developed, with a fireplace in the interior corner of each room; then the plan with rooms accessed from a central hallway and with a chimney on each side; then the larger house with rooms devoted to single purposes: parlors, dining rooms, kitchens, bedrooms. Movable sashes were used for windows, and their rectangular panes replaced earlier diamond-shaped ones. Wall paneling was frequent, sometimes with plaster above.

Williamsburg, the capital of Virginia between 1699 and 1779, is the site of a number of notable early buildings, many restored in the early 1930s through the funding of John D. Rockefeller, Jr. The Wren Building at Williamsburg's College of William and Mary was built between 1695 and 1702, perhaps to plans by Sir Christopher Wren, who never came to America. The Capitol building at Williamsburg was built between 1701 and 1705, its twin semicylindrical towers recalling medieval precedents, but its detailing more classical. Inside, there are two principal spaces: the large, rather severe, round-ended House of Burgesses on the ground floor, with a wood-paneled dado and plaster above and wood-paneled window reveals, and the more elegant, oval Governor's Council Chamber on the second floor, with full-height paneling and Doric pilasters.

Williamsburg's Governor's Palace, begun the year after the Capitol was finished and itself finished in 1720, was already much more Georgian in character. Inside the classically regular exterior, the entrance hall has walnut paneling and flooring of black and white marble. This hall and the other rooms of the original palace have marble fireplaces. Extending from the back of the building is a wing added between 1749 and 1751 to plans by Richard Taliaferro. It holds a large ballroom and a smaller supper room, both with lofty coved ceilings, crystal chandeliers, and lavish details, though some of those visible now have had to be based on conjecture, both the Palace and the Capitol having been devastated by fire.

In its day, the Governor's Palace must have been the most elaborate residence in the colonies, but it was not alone in its luxury. Other fine eighteenth-century houses in Virginia alone included the Lee family's Stratford Hall of 1725–30 on the Potomac River, Westover on the James (1730–34), and Carter's Grove in James City County (1750–53). Slightly later came Mount Airy in Richmond County (1758–62), Mount Vernon in Fairfax County (1757–87), and Thomas Jefferson's Monticello in Albemarle County, begun in 1769.

In 1747 Peter Harrison (1716–75), who had changed careers from ship's captain to architect,

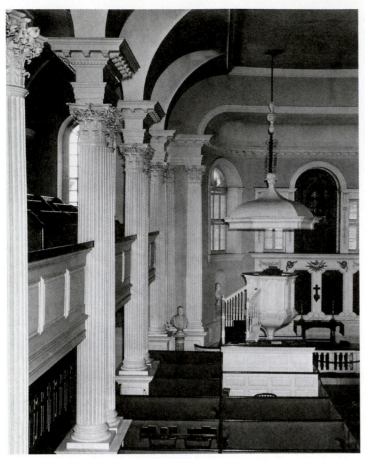

Figure 18–7 The interior of Peter Harrison's 1749 King's Chapel, Boston.

WAYNE H. ANDREWS

designed the Redwood Library in Newport, a porticoed Palladian temple. Five years later, Harrison probably also designed the classically inspired St. Michael's Church in Charleston (1751–61), and he certainly designed the 1749 King's Chapel, Boston, basing the interior's paired columns (Figure 18–7) on Nicolas Nicole's Church of Ste.-Madeleine at Besançon, which he had seen under construction during a 1748 tour of France and Italy. Having sided with the English, Harrison died in disgrace on the eve of the Revolution.

Other important churches of the time included the 1756 St. Paul's Chapel, New York, by Thomas McBean, a pupil of the English architect James Gibbs. St Paul's is the only pre-Revolutionary building still standing in New York. Early public buildings in the Georgian style included the Old State

House in Boston (1728) and the State House in Philadelphia (1733–41), and Boston's Faneuil Hall (1740–42), this last designed by the painter John Smibert and later enlarged by Charles Bulfinch (1763–1844). Georgian-style buildings were also built on the campuses of Harvard, Yale, Princeton, and William and Mary.

Also in the eighteenth-century, the latest and most fashionable design ideas from England came in the form of architectural handbooks and pattern books published in London and brought by ship to America. There were at least forty such books, but six or seven of them were of particular importance. The first of these were two by William Halfpenny, *Practical Architecture,* published in 1724, and *The Art of Sound Building, Demonstrated in Geometrical Problems,* published the next year. Halfpenny's later books, more exotic compilations of Chinese, Gothic, and generally picturesque styles, found less application in America. James Gibbs's *A Book of Architecture Containing Designs of Buildings and Ornaments* was published in 1728 and republished in 1739, and his *Rules for Drawing the Several Parts of Architecture* in 1732. Batty Langley's *Ancient Architecture Restored, and Improved* appeared in two volumes in 1741 and 1742 and was revised in 1747, retitled *Gothic Architecture, Improved by Rules and Proportions.*

The first handbook writer actually published in America was Abraham Swan. His 1745 *The British Architect* was republished in New York in 1758 and in Philadelphia in 1775. It featured Palladian exteriors with Rococo interiors, and many of Swan's interior details were imitated in American buildings. His designs for chimneypieces appeared, for example, in two fine houses in Fairfax County, Virginia: William Buckland's Gunston Hall, built before 1760, and George Washington's Mount Vernon, 1775.

The first handbook actually written in America was the 1797 *Country Builder's Assistant* by Connecticut architect Asher Benjamin (1773–1845), whose second and better-known book would be the *American Builder's Companion* of 1806; Benjamin's 1797 William Coleman house in Greenfield, Massachusetts, features one of the country's first elliptical stairs.

Near the end of the eighteenth century, a dramatically different architecture style was in-

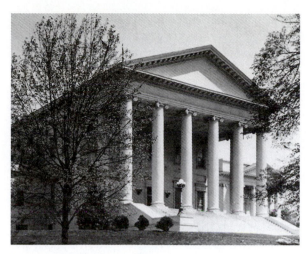

Figure 18–8 The Virginia State Capitol, Richmond, designed by Thomas Jefferson in 1785.

VIRGINIA TOURISM CORPORATION

teenth century the Spanish built a number of churches and missions in Mexico, New Mexico (Figure 18–9), Texas (notably the Alamo in San Antonio), Arizona, and—perhaps most memorably of all—California.

Father Junipero Serra (1713–84), a Franciscan missionary who arrived in America from Spain in 1749, going first to Mexico, was responsible for beginning the remarkable chain of twenty-one Spanish missions dotted, roughly a day's travel apart, up the California coast. The first and most southern of these was Mission San Diego de Alcalá in San Diego, established in 1769, and the last and most northern was Mission San Francisco de Solano in

Figure 18–9 Gateway into the courtyard of the adobe church of Santo Tomas, Las Trampas, New Mexico, built c. 1760.

COURTESY MUSEUM OF NEW MEXICO, NEG. NO. 11526

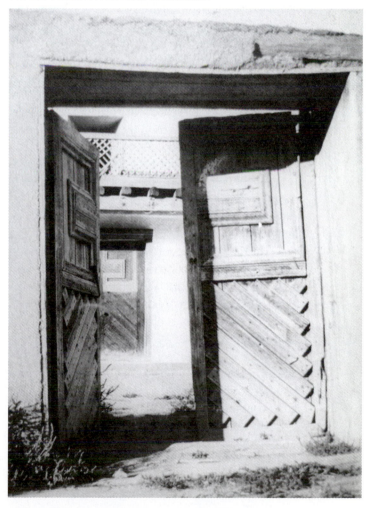

troduced to America. In 1785, Thomas Jefferson, then American ambassador to the court of Louis XVI at Versailles and not yet president, designed a new Virginia State Capitol for Richmond (Figure 18–8), the capital having recently been moved there from Williamsburg. With the help of French architect Charles-Louis Clérisseau, Jefferson based the design directly on an ancient Roman monument he had seen on his travels through France, the Maison Carrée at Nîmes. It was the first pure example, not only in America but in the world, of the Classic Revival (Harrison's Redwood Library being properly called Palladian, a step further removed from ancient Roman precedents). The Virginia State Capitol began a movement that would dominate the first half of the following century.

Away from the urban centers of the East Coast, architecture and interior design of a quite different style were being practiced. The heritage of the settlers in the American West was Spanish, rather than English. The oldest survivor among their buildings is the Governor's Palace at Santa Fe, New Mexico, begun in 1610 and built of bricks made from adobe (sun-dried earth and straw), a material that the local Pueblo natives had been using for centuries. St. Augustine, Florida, had been the earliest Spanish settlement, but nothing there survived a fire of 1702 except a fort, the 1687 Castillo de San Marcos. In the eigh-

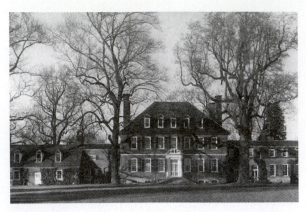

Figure 18–10 Westover, Charles City County, Virginia, 1730–34, The "hyphens" linking the main house and its dependencies were added later.

FROM THE HISTORIC AMERICAN BUILDINGS SURVEY. COPIED BY OFFICE OF ARCHEOLOGY AND HISTORIC PRESERVATION, NATIONAL PARK SERVICE, WITH THE PROFESSIONAL ASSISTANCE OF AMERICAN INSTITUTE OF ARCHITECTS. LIBRARY OF CONGRESS. PHOTO BY THOMAS T. WATERMAN.

Sonoma, established in 1823. Representative of these is Mission San Francisco de Asis in San Francisco, established in 1777, and more familiarly known as Mission Dolores.

Mission Dolores has walls of adobe 4 feet (1.2 m) thick, and its construction was joined with rawhide thongs and wood pegs rather than nails, yet it has endured earthquakes that have leveled more modern buildings. A striking feature of the interior, 114 feet (35 m) long, is the series of redwood roof beams painted by Ohlone tribe craftsmen in chevrons of red, blue, and ochre. The Native Americans also painted a **reredos** on the apse wall, arched over by a false stone arch, but the painting was covered in 1796 by a wooden reredos in high relief brought to the mission from San Blas, Mexico. In 1920 the mission was restored by architect Willis Polk, his chief work being to clear away a clutter of nineteenth century additions.

Meanwhile, the French in Louisiana were developing a housing type well suited to the climate. Unlike most houses of the English colonies, which lacked any sort of porch, the Louisiana houses were wrapped with a *galerie* that admitted the breeze but not the sun; an example from 1750 is Parlange in Point Coupée Parish.

Returning to the East Coast, we shall look in slightly more detail at three specific examples of

early American buildings and their interiors, one early-eighteenth-century house and two that were begun in the late eighteenth century and completed in the early nineteenth century.

Westover, Charles City County, Virginia (c. 1730–34)

On the banks of the James River, just 25 miles (40 km) from Williamsburg, is Westover. It was conceived and built by the successful tobacco planter William Byrd II, the grandson of a London goldsmith, born in the colonies but sent back to England for his education. Westover was the social and administrative center of Byrd's vast plantation, and its original front door faced the river, which was its main means of access.

The central block, which originally (unlike now) stood unconnected to dependent outbuildings, is a rectangular block of brick, more horizontal in proportion than the Williamsburg Governor's Palace and with a roof of lower pitch. It is perfectly symmetrical, reposeful, and elegant (Figure 18–10).

Its interior, however, departs from the symmetry of the exterior, as did many English and American houses of the time. The rooms are disposed on either side of a central hallway, but one that is not *exactly* central, so that there were two large rooms on one side (a drawing room and a music room), two smaller on the other (library and dining room, combined in a 1900 remodeling to make a larger dining room). The interior detailing is fine, but not consistently so. The beautiful mantelpieces, like the two stone entrance doorframes, were brought from London by Byrd. Some of the mantelpieces are stone, some wood; all are richly carved. The Rococo plaster ornament on the ceilings of the hallway and drawing room were also probably shipped from London in precast form. Other details are less elaborate. The floor-to-ceiling paneling in the first-floor rooms, for example, is handsome but simple in character; it was probably the work of slaves on the plantation.

In addition to Byrd's library of 4,000 volumes in the six languages he read, the house was furnished with his collections of English silver and portrait paintings. A 1783 visitor from Philadelphia, quoted by historian Mills Lane, also noted silk damask up-

holstery, silk curtains, and "a rich Scotch carpet." *Scotch carpet* was a common name for the strong wool Kidderminster carpet from the English town of that name.

Byrd, like his friend Peter Harrison, was an English sympathizer, and after the Revolution Westover had to be sold.

Monticello, Albemarle County, Virginia (1769–82 and 1796–1809)

Monticello, Jefferson's own house on a Virginia hilltop near Charlottesville, was, like his Virginia State Capitol, a demonstration of his disdain for the Georgian style and his enthusiasm for a more correct classicism. It also reflected his taste for—and knowledge of—the latest artistic developments in Europe and the principles outlined by Palladio, which he knew from a copy of Giacomo Leoni's 1715 English translation.

The first version of Monticello was begun in 1769, when Jefferson was twenty-five, and there was scarcely a time from then until his death in 1826 when some construction or alteration was not taking place there. The first phase of building, however, was generally completed by 1782. This initial scheme was for a central block with two-story porticoes (smaller versions of those at Palladio's Villa Cornaro of 1551–53) on both the entrance and garden fronts; half-octagonal bays were added to the ends of the building in 1777.

When the second phase began in 1796, Jefferson had returned from his years in France full of new ideas. His addition obliterated all but the central three rooms of the original house, enlarged it from a total of eight rooms to twenty-one, gave it the more reposeful appearance of a single story, and added a dome above the parlor on the garden front. The exterior of this second Monticello, as familiar as the U.S. nickel, needs no illustration here, but the interior had some distinctive features.

Spatially, the major public rooms (entrance hall, parlor, dining room, and tearoom) and Jefferson's own ground-floor bedroom were all given generous ceiling heights. The room shapes were inventive combinations of squares, octagons, and half octagons. Access to the upper-floor bedrooms and the dome room on the third floor was by a pair of narrow, steep stairs, perhaps because Jefferson thought grand stairs wasteful, perhaps because he wanted to continue the illusion of a single story.

In their detailing, the major rooms followed Roman precedents, as interpreted by Palladio and other authors represented in his library. The Doric order was used in the dining room, the Ionic in the entrance hall, and the Corinthian in the parlor and the dome room. The entablature of the A.D. 141 Temple of Antoninus and Faustina was reproduced in the entrance hall, that of the 509 B.C. Temple of Jupiter in the parlor, and that of the 40 B.C. Temple of Fortuna Virilis in Jefferson's bedroom.

The house's furnishings were less academic and much more eclectic. The entrance hall, for example, was filled with a collection of Native American artifacts and was known in Jefferson's day as the Indian Room. Other furnishings, some of them quite elegant, had been collected by Jefferson on his travels, and still others were probably made at Jefferson's direction by the Monticello slaves.

Finishes were as fine as Jefferson could afford. Wallpapers were imported from France. The curtains and bed hangings in Jefferson's bedroom are crimson damask with linings of pale green velvet and gold fringe. The parlor floor has a geometric parquet pattern of cherry and beech; installed in 1804, it was one of the first parquet floors in America (Figure 18–11).

Evident throughout were Jefferson's own idiosyncratic inventions: double-acting doors between entrance hall and parlor (when one was opened, the other—connected by a chain beneath the floor—would open automatically); triple-sash windows (when the lower two were raised, a door-height opening gave access to the veranda); a double-faced clock readable from both the entrance portico and the entrance hall, its cannon-ball weights marking the day of the week as they descended the hall wall; pivoting service doors into the dining room, with shelves on one side; and dumbwaiters built into the sides of the dining room fireplace to bring wine bottles from the service areas on the floor below, a level that, because of Jefferson's clever use of the change of grade, is invisible from inside the house. The reason for the pivoting shelves, the dumbwaiters, and the service level was to offer a comfortable life with minimal interruption from servants. Jefferson invented furniture as well: a folding music stand to be shared by

Figure 18–11
Monticello's parlor. The parquet floor was installed in 1804. The mantel clock is French. At left, under the large pier mirror, is Jefferson's daughter's piano.

R. LAUTMAN/MONTICELLO/
THOMAS JEFFERSON
FOUNDATION, INC.

a quartet, a Windsor chair, serving tables, clocks, and silverware.

Monticello remains one of America's most interesting and accomplished houses, designed by one of its most interesting and accomplished citizens.

The White House, Washington, D.C. (1792–1801)

The White House, originally known as the President's House, was designed by James Hoban (c. 1762–1831). Born in Ireland, Hoban studied at the Dublin Society's School of Architectural Drawing. Feeling he might have a better career in the young United States, he emigrated to Philadelphia in 1785 and then moved to Charleston in 1787, where he worked on houses and public buildings. While he was there the national capital was being laid out in the newly created District of Columbia by the French émigré Pierre-Charles L'Enfant.

In 1792 Hoban entered design competitions for both the Capitol building and the President's House. He lost the first competition, which was won by William Thornton, but won the second, basing his design on a building he had known in Dublin, the 1745 Leinster House designed by Richard Castle, residence of the Dukes of Leinster.

The other entrants included Samuel McIntire and Thomas Jefferson, who entered anonymously. George Washington altered Hoban's design somewhat, enlarging it and adding stone embellishments, and later Thomas Jefferson as president and Benjamin Henry Latrobe (1766–1820, who would also add to the Capitol and who would design the Bank of Pennsylvania in Philadelphia in 1799), as superintendent of public buildings, made other modifications. The sandstone exterior was whitewashed in 1798, and the interior, though unfinished, was complete enough for the second president, John Adams, to become the first occupant in 1800. Water closets were installed in 1801.

The house was a three-story rectangular block with a projecting central half cylinder, and inside this projection was the house's chief innovation, an oval salon on axis with the rectangular entrance hall. French precedents for such a plan included Le Vau's seventeenth-century Vaux-le-Vicomte and the Hôtel de Salm, which Jefferson had admired in Paris, and there were houses with such a feature that Hoban probably had seen in Ireland. In America, however, it was a great novelty and began a fashion for oval and circular rooms in fine houses. The room was the central one of a suite of three that, because of décor dating from the

nineteenth century, have come to be known, from east to west, as the Green Room, the Blue Room, and the Red Room. Another important feature of Hoban's plan was a room more than 80 feet (24 m) long occupying the eastern third of the ground floor; originally called the President's Audience Chamber, and then (on a drawing by Latrobe) the Public Drawing Room, it is now known as the East Room.

The house was burned by the British in 1814, destroying all the original furnishings and all the interior walls. We infer from written records and drawings, however, that the rooms had bold chair rails and baseboards with paneled dadoes between. Cornices extended from 6 to 12 inches (15–30 cm) below the ceiling, with wallpaper borders pasted below them, imitating friezes. The plaster walls above the chair rail were apparently painted in pastel tints. Doors were of Caribbean mahogany set in painted doorframes, and the cast-bronze doorknobs reportedly weighed 5 pounds (2.3 kg) each.

Chimneypieces were of American marble. Wooden shutters folded into the jambs of the windows. Of the original furniture we know little, except that the best of it, used in the oval salon, was upholstered in crimson damask.

After the fire, Hoban was asked to design and supervise the house's rebuilding, a process completed in 1820. Hoban also directed the addition of the south and north porticoes in 1824 and 1829. McKim, Mead, and White added the office wings in 1903. Throughout the history of the White House, its interiors have been the subject of many redesigns, some of which we shall see in the remaining two chapters.

Furniture

With a growing number of new households needing to be furnished, with the importation of furniture from England and Europe slow and expensive, with an ample supply of native American woods, and with woodworking skills learned by many colonists in English, Dutch, and other apprenticeships, it is natural that furniture making was an important colonial activity. Not only every city but every community had its local joiners, turners, carvers, chairmakers, and cabinetmakers.

The earliest American furniture makers were doubtlessly anonymous joiners who also worked as housebuilders. Among the earliest American furniture makers whose names we know were Phineas Pratt, who was working in Weymouth, Massachusetts, as early as 1622, and Kinelm Wynslow, who was working in Plymouth Colony as early as 1634. In the last quarter of the seventeenth century there were also Thomas Dennis of Ipswich and Nicholas Disbrowe of Hartford. By 1690 the Handicrafts Guild of Boston had registered more than forty upholsterers and more than sixty furniture makers in Boston alone.

Outside the five major urban centers of Boston, Newport, New York, Philadelphia, and Charleston, country cabinetmakers produced large amounts of furniture, some of it very fine but relatively independent of the London fashions that dominated urban production, and relatively free, also, of elaborate and expensive inlays and ornament. Some of the country cabinetmakers whose names we know were Michael Lind and John Bachman II of Lancaster, Pennsylvania; Eliphalet Chapin and Benjamin Burnham of Connecticut, both of whom served apprenticeships in Philadelphia; Thomas Salmon of Stratford, Connecticut; Daniel Clay of Greenfield, Massachusetts, who opened a shop selling his Windsor chairs in 1794; Nathaniel Dominy IV of Long Island and his descendents; and from New Hampshire, Thomas Dennis, John Gaines, Samuel Gragg, and the Dunlap family.

Contributions to American furniture design and decorative arts were also made by a number of religious groups who established their own communities and customs. Among them were the protestant Christian sects called Mennonites, Moravians, and Shakers. The Mennonites, also called the Amish, originated in Switzerland but are named for Menno Simons, a Dutch reformer. Their first settlement in America, at Germantown, Pennsylvania, was made by a group from Krefeld, Germany, in 1683. They are particularly known for the color and geometry of their quilts, but also produced admirable samplers, rugs, and furniture. The Moravians originated in the Moravia and Bohemia regions of Czechoslovakia, and their church in America was founded in 1735, its early centers being Bethlehem, Nazareth, and Lititz, Pennsylvania, and Salem, North Carolina. They produced both ceramics and furniture.

The Shakers, officially known as the United Society of Believers in Christ's Second Appearing, originated in England as a Quaker sect in 1747. Their leader, Ann Lee, and others immigrated to New York in 1774, and in 1776 founded a colony at Watervliet, near Albany. Later colonies were founded at New Lebanon, New York, where a meeting house was built in 1785, and in Connecticut, Massachusetts, and other states from Maine to Kentucky. At its greatest extent, about 1840, the sect may have had 6,000 members. Partly due to its members' vows of celibacy, the Shakers are now virtually extinct.

The Shaker aesthetic, which has been compared with the Japanese, is admirably spare, its asceticism arising from a disapproval of worldly extravagance. The sect's laws ordered that "odd or fanciful styles of architecture may not be used [and] beadings, mouldings and cornices may not be made." Similarly, Shaker historian Edward Deming Andrews quotes Ann Lee as having asked a Massachusetts hostess, "Never put on silver spoons for me nor tablecloths, but let your tables be clean enough to eat on without cloths."

Like Shaker tables, Shaker floors were usually bare and polished. Interior walls were smooth plaster with an eye-level wooden rail with pegs from which chairs, clocks, and other household items could be hung, and the walls were left white or painted only in approved colors, such as Meetinghouse Blue, Trustee Brown, and Ministry Green. Green was also specified for bedframes, blue for blankets, and white, blue, or green for window curtains, but not "checked, striped, or flowered." Shaker furniture makers disdained veneers as "sinful deception," using solid pieces of well-cured maple, pine, and cherry. In both the Shaker room and its furniture, beauty of form and an elegant lightness of parts amply compensated for the lack of ornamentation (Figure 18–12).

The most elaborate early American furniture, some of it in the greatest possible contrast to Shaker austerity, came from its urban centers. Beginning in the 1690s the port cities were importing lacquered furniture from the Far East as well as from Holland and England, and American cabinetmakers were copying it. Some of this furniture was painted to imitate tortoiseshell, and some was decorated with metallic paint. Massachusetts, Connecticut, and New York produced a great deal of lacquered furniture in the eighteenth century.

Notable furniture-making talents of the late Colonial period included Benjamin Randolph (1737–91), John Folwell (active in the 1770s), and Thomas Affleck (1740–95), all of Philadelphia, Josiah Claypoole (died c. 1757) of Charleston, and John Seymour (1738–1819) and his son Thomas of Boston.

Figure 18–12 A room used by the children of Hancock Shaker Village, Pittsfield, MA. The cupboard, desks, and ladderback chairs are typical of Shaker design, as is the pegged rail high on the wall.

HANCOCK SHAKER VILLAGE, PITTSFIELD, MASSACHUSETTS

Among all their colleagues, however, there were a few early American furniture designers whose work was outstanding. We shall look briefly at the accomplishments of five of these masters and then at the types of furniture produced in the colonies and early republic.

William Savery (c. 1721–87)

A cabinetmaker in Philadelphia, Savery served an apprenticeship to Solomon Fussell (died 1762), a fellow Quaker (as was Savery's talented contemporary Thomas Affleck). Savery had his own cabinetmaking shop by 1750. He was noted for the fine proportions and the smooth, plain, polished surfaces of his furniture, and was once credited with the fine Philadelphia highboy now in the Metropolitan Museum (Figure 18–33). Mahogany and curly maple were the woods Savery most favored. As he left no carving tools when he died, it is thought that he may have subcontracted the detailed carvings on his pieces to others. He was a member and supporter of several philanthropic and civic groups, such as the Friendly Association for Regaining and Preserving Peace with the Indians.

The Townsends and the Goddards

Newport's intermarried Townsend and Goddard families produced more than a dozen skilled furniture makers and some of America's most extraordinary pieces of furniture. Among the Townsends, those whose work is known and highly respected today include Job Townsend (1699–1765), the patriarch of the clan; his younger brother, Christopher Townsend; Christopher's son John Townsend; and John's cousin Edmund Townsend. Among the Goddards were John Goddard; his brother James Goddard; John's sons, Stephen, Thomas, and John Townsend Goddard; and Stephen's son John Goddard, Jr. Perhaps best known of all these are John Goddard and John Townsend.

JOHN GODDARD (1723–85) Born in Dartmouth, Massachusetts, John Goddard and his brother James soon moved to Newport with their father, Daniel Goddard, a carpenter and shipwright, who joined Newport's Quaker community. Both brothers were apprenticed to Job Townsend, and both married Townsend daughters. John Goddard opened his own shop in Newport in 1748. He worked chiefly in the Queen Anne style, to which he added elements from Chippendale, Hepplewhite, and Sheraton, as well as ideas of his own. He designed slant-lid desks, secretaries, bookcases, clock cases, and even coffins. After his death his business was continued by his sons Stephen and Thomas and his grandson.

JOHN TOWNSEND (1732–1809) After an apprenticeship to his father, John Townsend opened his own shop in Newport when he was twenty-one. He produced chests, kneehole desks, slant-lid desks, tall-case clocks (Figure 18–36), and high chests of drawers. He is most admired today for his blockfront casegoods with carved cockleshell ornament, called **block-and-shell** pieces (Figures 18–13 and 18–14). The term **blockfront** refers to a furniture front divided into three vertical panels, the center one slightly concave, the outer ones slightly convex. Such pieces were also called *tub*

Figure 18–13 A block-and-shell mahogany chest of drawers made in Newport in 1765 by John Townsend, 34½ inches (88 cm) tall.

WOODWORK-FURNITURE. AMERICAN, RHODE ISLAND, NEWPORT. XVIII CENTURY, 1765. CHEST OF DRAWERS. MAKER: JOHN TOWNSEND (1732–1809). MAHOGANY, TULIP, POPULAR, PINE. H. 34½ IN. W. 36¾ IN. DEPTH 19 IN. THE METROPOLITAN MUSEUM OF ART, ROGERS FUND, 1927. (27.57.1)

Figure 18–14 Detail of the John Townsend carving on Figure 18–13. The outer shells are convex, the central one concave.

WOODWORK-FURNITURE. AMERICAN, RHODE ISLAND, NEWPORT. XVIII CENTURY, 1765. CHEST OF DRAWERS. MAKER: JOHN TOWNSEND (1732–1809). MAHOGANY, TULIP, POPULAR, PINE. H. 34⅛ IN. W. 36¾ IN. DEPTH 19 IN. THE METROPOLITAN MUSEUM OF ART, ROGERS FUND, 1927. (27.57.1)

front or *swell'd front* pieces. They were popular in New England but rarely seen farther south.

Samuel McIntire (1757–1811)

With his father, grandfather, and two of his uncles working as housebuilders, and with his two brothers both carpenters, it was natural that Samuel

Figure 18–15 Hepplewhite-style shield-back chair by Samuel McIntire, Salem, Massachusetts, c. 1800. A scalloped row of brass nailheads embellishes the upholstery.

LOS ANGELES COUNTY MUSEUM OF ART, MR. AND MRS. ALLAN C. BALCH FUND.

McIntire would be encouraged to follow the family tradition. He did, but exceeded it. Studying drawing, art, and architecture, he became both an expert carver and a skilled architect, rivaling his contemporary Charles Bulfinch, whose buildings he admired and sketched.

Important among his early commissions was the Pierce-Nichols house (c. 1782), in his hometown of Salem, Massachusetts. Many of its interior details were taken by McIntire from Batty Langley's 1740 *City and Country Builder's and Workman's Treasury of Designs.* He also designed several houses for Salem merchant Elias Hasket Derby. For the fourth and largest of these, the original design for the house was by Bulfinch, but Derby turned to McIntire for revisions and execution, which included his carving of chimney pieces, doorways, and other interior details and his design of some furniture; the house was begun in 1795 and finished in 1799. In addition to designing the furniture wholly attributed to him (such as Figure 18–15) McIntire also—and perhaps even more often—provided carving for furniture that was designed by others.

Early McIntire essays in what is now called the Federal style, showing the influence of Robert Adam, were the Nathan Read house in Salem, fronted with a semicircular portico, and the Lyman house in Waltham, Massachusetts, featuring an oval room. His masterpiece in this style, containing some of his most refined carving, was the John Gardner house in Salem, finished in 1805 and now the home of the Essex Institute.

After his death in 1811, his business as a carver was continued by his son, Samuel Field McIntire.

Figure 18–16 A mahogany window seat by Duncan Phyfe in the Sheraton style, c. 1800.

Duncan Phyfe (1768–1854)

He was born Duncan Fife in Loch Fannich, Scotland. Coming to America in 1783 or 1784, shortly after England had recognized the independence of the United States, he settled in Albany. About 1792 he moved to New York, opened his own cabinet-making shop, and changed the spelling of his name, *Phyfe* perhaps seeming fashionably French. His business seems to have been an immediate success, and in 1792 he moved from Broad Street to the more fashionable Partition Street, now Fulton Street. To this showroom he would add a building on one side for a warehouse and one on the other for a workshop, and he eventually employed dozens of workers. His customers included the Astors of New York and the du Ponts of Delaware, and an agent in Savannah shipped his furniture throughout the South.

The furniture was at first in the Chippendale style, but soon shifted to follow Sheraton (Figure 18–16), and certain favorite Phyfe motifs, such as the lyre shape that he used for chair slats, table bases, and decorative carvings, were taken from Adam. Using fine mahogany from the Caribbean, his design was elegant (if not always highly original) and his craftsmanship was admirable. His furniture was to play a more important role in the design of the nineteenth century, as we shall see in the next chapter.

Duncan Phyfe took two of his sons into partnership in 1837, retired in 1847, and died in 1854, leaving a fortune of half a million dollars, a vast sum for that time.

Seating

The earliest colonial seating was on backless stools or on long benches called **forms.** During the first half of the seventeenth century, these were gradually supplemented and replaced by chairs (or "back-stools"). These seventeenth-century chairs were of four chief types: the turned chair, the wainscot chair, the Cromwell chair, and the slat-back chair.

Earliest in popularity were the **turned chairs,** their spindles and posts decorated by turning on a lathe, and they can be divided into two types, the Carver chair and the Brewster chair, both named for early New England governors. The Brewster type (Figure 18–17) has turnings in the back posts and spindles and also on the legs; the slightly simpler Carver type has turnings only above the seat. Both had seats of woven rush.

Figure 18–17 A turned Brewster armchair of hickory and ash, made in New England c. 1650.

Figure 18–18 A wainscot chair of walnut (though most were made of oak) by a Pennsylvania German maker c. 1725. The back is 42¾ inches (109 cm) high.

PHILADELPHIA MUSEUM OF ART: GIFT OF J. STOGDELL STOKES

The **wainscot chair** (or *joined chair* or *great chair*) was more expensive and more rare than the turned chair. Its tall back was usually paneled like wainscoting (Figure 18–18), although at times it was elaborately carved (top center, Figure 18–19). Its seat, rather than rush, was a flat piece of wood, and comfort was added with a cushion.

Even more rare among seventeenth century chairs in America (though popular throughout Europe) was the type now known as **Cromwell,** although some of them were actually made before Cromwell's English Commonwealth began in 1654. These chairs also have turned legs and stretchers,

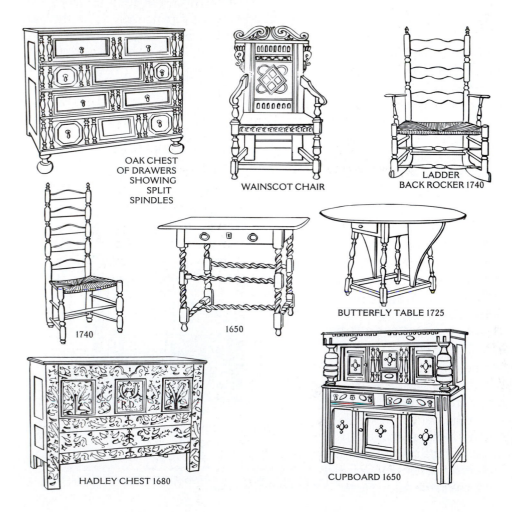

Figure 18–19 Early American furniture.

DRAWING: GILBERT WERLÉ

OAK CHEST OF DRAWERS SHOWING SPLIT SPINDLES

WAINSCOT CHAIR

LADDER BACK ROCKER 1740

1740

1650

BUTTERFLY TABLE 1725

HADLEY CHEST 1680

CUPBOARD 1650

but their seats and backs are upholstered, sometimes with leather attached by brass tacks, sometimes with the "turkey work" fabric mentioned in the chapter on England. Despite the upholstery, a loose seat cushion was usually added.

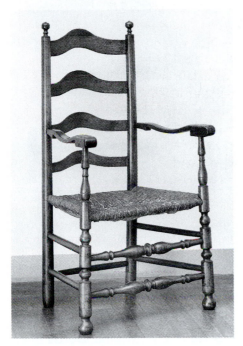

Figure 18–20 A rush-seated slat-back or ladder back armchair. Many such chairs were made in Connecticut in the middle of the eighteenth century. In this example, each slat has been given its own shape and size.

COURTESY WADSWORTH ATHENEUM, HARTFORD, CONNECTICUT. NUTTING COLLECTION. PHOTO BY E. IRVING BLOMSTRANN.

By the end of the seventeenth century, turners had begun to produce more comfortable **slat-back** chairs, and these continued to be made in many parts of America through the nineteenth century and, in the Appalachian Mountains, even into the twentieth. They are also called **ladder-back** chairs. Most of them have three or more identical horizontal slats with slightly curved profiles, but the most beautiful were made with subtle differences in slat shape (Figure 18–20). Like the turned chair, the slat-back had a rush seat.

The eighteenth century saw the development of the slat-back and the introduction of the banister-back chair, the Boston chair, the easy chair, the American Windsor, and the **fiddle back.** Resilient caning was added to rush and upholstery as a seat material. Cherry, pine, and maple were used as furniture woods, although sometimes stained to look like the more highly prized walnut, and mahogany began to be imported from the Caribbean. On the island of Bermuda, a native aromatic cedar was used.

The **banister-back** chair had a back of four or five flat vertical slats (typically four on side chairs and five on armchairs) that were given the silhouette of turned banisters. They had real turnings, however, on their legs and stretchers, and rush seats (Figure 18–21).

The **Boston chair** was a simplified and inexpensive version of a William and Mary chair. Instead of having an ornately carved crest, the top of the back had a flat one with a gracefully curved

Figure 18–21
Three types of early American chairs.

DRAWING: GILBERT WERLÉ

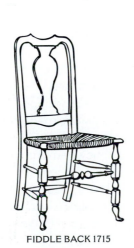

FIDDLE BACK 1715

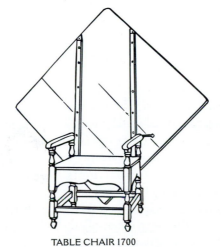

TABLE CHAIR 1700

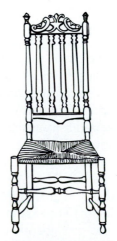

BANISTER BACK 1725

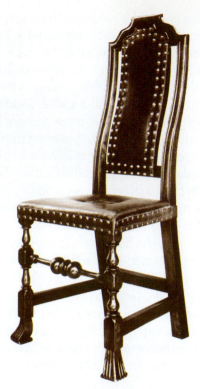

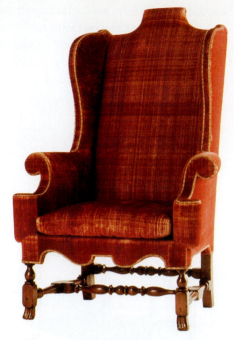

Figure 18–22 A so-called Boston chair upholstered in leather, made of maple between 1700 and 1725. Its flared, grooved feet are called *Spanish feet*.

Figure 18–23 An easy chair made in New England between 1710 and 1725. It also has Spanish feet.

outline. Its seat and back were upholstered in leather fastened with brass tacks to a frame that was usually stained black or red (Figure 18–22). Although Boston chairs were indeed made in Boston, they were exported from there to all the colonies. (The Boston rocker was different in design and was not developed until the 1820s.)

The **easy chair** was in use by 1710 and did provide easier seating than any previous American chairs. It was large in scale and fully upholstered except for the turned legs and stretchers, and the upholstery was usually of fine fabric. The upholstered seat cushion was removable and called a **squab.** Further comfort came from the wings (also called *cheeks*) projecting at right angles from the chair back and protecting the sitter from drafts. (Such chairs, in fact, would later be called *wing chairs*.) The easy chair was a prized possession and was prominently placed in the best room of the house (Figure 18–23).

The light, strong, comfortable **Windsor chair** was imported from England shortly after it appeared there in the 1720s and soon replaced the slat-back as America's most popular chair. By the 1740s they were being made in Philadelphia and were for a while called *Philadelphia chairs*. American variations of the Windsor chair included the **low-back,** which would be the basis of the nineteenth-century "captain's chair," the **high-back** or **fan back** with a straight top, and the **loop-back** or **sack-back** or **roundtop** (Figure 18–24). The **comb-back** had a comb-like projection above the central part of the back. There were also Windsors with writing arms, Windsor cradles, Windsor high chairs, and Windsor settees (Figure 18–25). After the Revolution, their popularity increased, and they were made not only in Philadelphia but also in New York, Connecticut, and Rhode Island. They were most commonly painted green in the early century and consequently called **green chairs,** but near the end of the century Benjamin Franklin is said to have bought some in white and Thomas Jefferson some in black and gold.

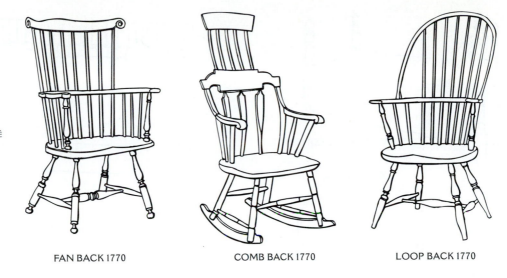

Figure 18–24
American Windsor
chairs.

DRAWING: GILBERT WERLÉ

FAN BACK 1770 COMB BACK 1770 LOOP BACK 1770

The fiddleback chair of the eighteenth and early nineteenth centuries was a likable bastard, its back slat, shaped like a fiddle or vase, taken from a Queen Anne chair, but its other members in the tradition of turned chairs. Its front stretcher was reminiscent of the William and Mary style, and its seat of rush like the slat-back. It came in many regional variations and was called by many other names, including *York* (many of them being made in New York) and *rush-bottom*. It was a small, useful, popular chair, and at its best quite attractive (Figure 18–21 and 18–34).

Beds

The earliest beds in colonial North America were simple frames with wooden slats or ropes between them to support mattresses filled with straw or feathers. Curtains around the bed provided privacy and protection from drafts; these were at first attached to the (usually low) ceiling, but later to a framework over the bed supported on the four extended corner posts. **Trundle beds** for children were very low beds slipped under adult beds during the day and pulled out at night; they were also sometimes called *truckle beds*. Daybeds (chairs with long extended seats) appeared at the end of the seventeenth century. The most frequently used types of Colonial American beds are shown in Figure 18–26.

Tables

The largest seventeenth-century table was the demountable **trestle table,** resting on wooden

Figure 18–25 A Windsor settee with three interlocking loop backs. It was made of a combination of oak, hickory, and maple in New England in the last quarter of the eighteenth century.

COURTESY WINTERTHUR MUSEUM

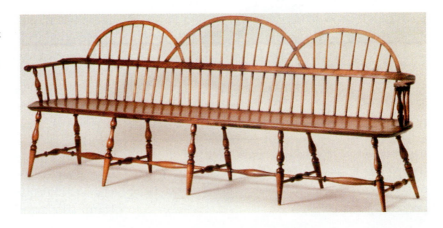

Figure 18–26
Types of
Colonial and
Federal beds.

DRAWING:
GILBERT WERLÉ

LOW FOUR-POSTER BED

FOUR-POSTER BED

TENT BED

SLEIGH BED

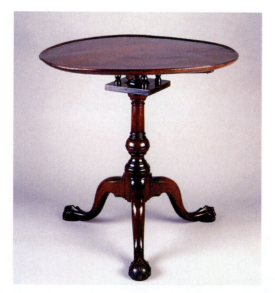

Figure 18–27 A cherry tip-top table of Southern origin, c. 1760. The "birdcage" mechanism under the top allows the top to be both tilted and rotated.

"TRIPOD TABLE" USA, NORTH AMERICA, CIRCA 1760. CHERRY. SOUTHERN TYPE PEDESTAL TABLE WITH THREE LEGS ENDING IN BALL AND BIRD CLAW FEET; THE TOP IS ROUND WITH MOULDING AT EDGE 28¾ x 31¼ IN. (73.0 x 79.4 CM). BROOKLYN MUSEUM OF ART, HENRY L. BATTERMAN FUND AND THE MUSEUM COLLECTION FUND 31.15

supports (often X-shaped) called *trestles* and as long as 8 feet (2.5 m) or more. The **tavern table** was a smaller rectangular table on four turned legs connected by stretchers, with one or more drawers in the **apron** under the top. The dual-purpose **chair table** was also an early favorite (Figure 18–21). By the eighteenth century, folding tables had become popular in both the **gateleg** type, usually with an oval top, and the **butterfly** type (Figure 18–19); small versions of such folding tables were used for card games. **Tilt-top** or **tip-top** **tables** had tops that could be tilted or revolved and were easily put aside when not in use; they frequently stood on a central support resting on a tripod base (Figure 18–27). **Pier tables** were made to be set against a wall, and **tea tables,** some with tray tops or tops edged with raised molding, were made to be set before a seating group (Figure 18–28). Candlestands were made beginning in the seventeenth century, and in the eighteenth century they began to take a distinctive form, supported (like tilt-top tables) on a single

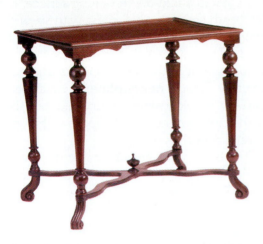

Figure 18–28 Cherry and mahogany tea table made in New York c. 1700–1710. The scrolled feet are called *trumpet feet*.

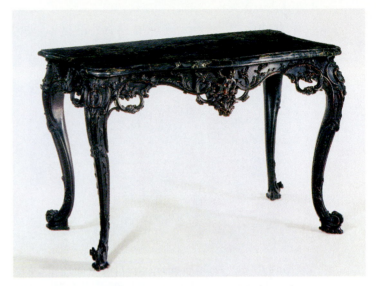

Figure 18–29 A richly carved mahogany marble-topped table made for a Philadelphia house between 1765 and 1775.

turned post that rested on a tripod base of three cabriole legs.

A particularly elaborate table for colonial times is one made between 1765 and 1775 for the Philadelphia house of John Cadwalader, that city's finest house at the time. Its top is a slab of black and gold Portoro marble, and its mahogany frame and doubly curved legs are carved with Rococo C- and S-shaped scrolls (Figure 18–29); its maker has not been identified.

Casegoods

American houses of the early seventeenth century had no closets, so casegoods provided the only storage. Among the earliest types made in the colonies were small boxes for Bibles and valuable family papers, and larger blanket chests for bedcovers. These both had many variants in size and design, an interesting cousin of the Bible box being the lap desk, a box with a slanting lid for writing that was held on the lap. Two specific types of blanket chest were very popular. Both originated in the Connecticut River Valley. One was the **Hadley chest,** plain in form but richly carved and painted (Figures 18–19 and 18–30). The front surface was paneled, and the central panel bore the initials of the owner; such chests were often used

Figure 18–30 A carved oak and pine Hadley chest made c. 1670–1710.

as "hope chests" or "dower chests," and the initials were then those of a young girl who would be given the chest's contents when she married. Another type of blanket chest was the **Connecticut**

Figure 18–31 A Connecticut-type blanket chest of oak with a pine top and applied half-spindles of ebonized maple, 1680–1700.

chest (Figure 18–31), with three panels across the top carved in patterns of tulips and sunflowers. Between the panels were applied half spindles of maple stained to look like ebony. There were drawers below.

Larger and more elaborate, intended for large and elaborate rooms, were the **court cupboard** and the **press cupboard.** They were fashionable throughout the seventeenth century. Both were divided into upper and lower sections with a variety of doors and drawers. Often the top sections had recessed corners with large turned corner posts supporting a cornice-like top. The court cupboard was a furniture type brought from England, seldom more than 4 feet (1.2 m) high, and its name was probably derived from the French *court* meaning "short." Its bottom section often had an open shelf or shelves (Figure 18–32). The press cupboard, also called a *wainscot cupboard* or simply a *press*, was similar but had doors or drawers in both its upper and lower sections. The **scrutoire** or **escritoire** was a writing desk with a slanted front that folded down to form a writing surface; it might or might not have a bookcase above it. Although the names are of French origin, they had been used in England.

Taller than these cupboards were the **highboy,** which was the American term for the English tallboy, and the **secretary,** which was a highboy that incorporated a fold-down writing surface. In the eighteenth century, a tall chest with six or more drawers in graduated sizes was called a **high daddy.** There were also slant-top desks with storage below but without the upper section of the secretary. The **corner cupboard,** which became popular in the eighteenth century, had open shelves for the display of household goods in its top section and doors below.

The block-and shell chests by the Newport cabinetmaker John Townsend and other members of the Townsend and Goddard families have already been mentioned, and an example is the 1765 mahogany chest of drawers we saw in Figures 18–13 and 18–14. Unlike most American furniture, this piece is signed by its maker.

A refinement highly regarded in Boston was a **bombé** swelling (colloquially called a "kettle shape") given to some casegoods. The fashion, copied from English examples (which had been copied from French examples), was probably begun by Boston cabinetmaker Benjamin Frothingham (1734–1809), who also made blockfront furniture with spiral flame finials and who served as a major in the American army during the Revolution.

Figure 18–32 A court cupboard of oak and maple made in New England in 1680. The splayed sides of its top section allow room for the heavy corner balusters.

Among the very finest examples of Early American furniture are the tall chests made in Philadelphia from c. 1755 to c. 1790. One of them (Figure 18–33), once (but not currently) attributed to William Savery, is now in the Metropolitan Museum. As historian Morrison Heckscher describes it, "The elegant proportions, the carefully chosen figured wood of the drawer fronts, and the delicate, discreetly placed and highly naturalistic carving—in the pediment scrolls the asymmetrical leafage seems to grow out of the architectural elements—merit panegyrics." It has been called the "Pompadour" chest because the bust between the pediment scrolls is thought to resemble Louis XV's mistress.

The **kas** was an American version of a wardrobe made in the Netherlands, where it was called a *kast*. A favorite of Dutch settlers in the Hudson and Delaware River Valleys, it was tall, large, fitted with paneled double doors and a pair of drawers beneath, was topped with a cornice, and sat on ball feet. Its typical decorative treatment was boldly scaled *grisaille* paintings of festoons and fruit, probably in imitation of relief carvings on the Dutch originals (Figure 18–34), though many kasten were left plain or painted with grained or ebonized surfaces. The best-known makers of kasten were the Egerton family of New Brunswick, New Jersey, particularly Matthew, Sr. (died 1802), and Matthew, Jr. (died 1837), but they were made by many American cabinetmakers from the seventeenth century into the nineteenth. A Pennsylvania-German variation was the **schrank,** similar to the kas except for the addition of a heavy molding, like an upside-down cornice, between the bottom drawers and the bun feet.

Altogether, American furniture of the seventeenth and eighteenth centuries was remarkably varied, reflecting almost every style popular in Europe as well as some local idiosyncrasies (Figure 18–35, page 489).

Figure 18–33 The "Pompadour" mahogany highboy from Philadelphia, c. 1765. It is topped with a double-scroll pediment, a central bust, and a pair of urn finials.

WOODWORK-FURNITURE. AMERICAN, PENNSYLVANIA, PHILADELPHIA. 18TH CENTURY, 1762–90. HIGH CHEST OF DRAWERS. CHIPPENDALE STYLE, WITH "POMPADOUR" FINIAL BUST. MAHOGANY AND MAHOGANY VENEER, WITH YELLOW PINE, TULIP POPLAR AND NORTHERN WHITE CEDAR. H. 91¾ IN. (233 CM) W. 42⅝ IN. (108.3 CM). DEPTH 22½ IN. (57.2 CM). THE METROPOLITAN MUSEUM OF ART, JOHN STEWART KENNEDY FUND, 1918 (18.11.4).

Accessories and Decorative Arts

Colonial life seems to have been heavily accessorized. Among the myriad items devised to make life more comfortable or interesting were tea caddies, saltcellars, cellarets (wine storage boxes that fit beneath sideboards), pipe racks, and knife boxes. Small decorative objects carved of ivory or bone were called **scrimshaw.** The origin of the name is unclear, but Fleming and Honour's *Dictionary of the Decorative Arts* notes a reference in Herman

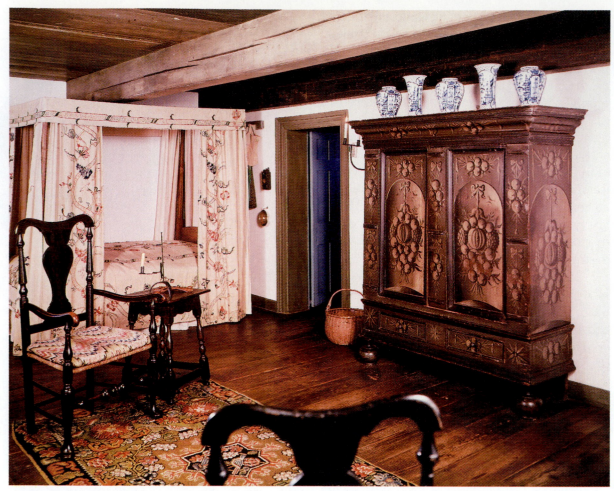

Figure 18–34 A prominent feature of this bedchamber from the 1762 Hardenbergh house in Ulster County, New York, is the grisaille-painted kas at the far right. There are also a table with turned legs, a fiddleback chair, and a canopied bed. Atop the kas is a *garniture de cheminée.*

COURTESY WINTERTHUR MUSEUM

Melville's 1851 *Moby Dick* to "skrim shunder articles." Many other decorative and useful objects made of carved or turned wood were classified as **treen,** perhaps referring to their origins in trees.

We shall look first at an object, both decorative and functional, that was just becoming available for residential use as the colonies were being settled: the clock.

Clocks

The invention of the clock is sometimes credited to the sixth-century Roman philosopher Boethius, sometimes to a ninth-century archdeacon in Verona. Certainly there were famous clocks in-stalled in St. Paul's Cathedral, London, and in Canterbury Cathedral in the thirteenth century, and in Strasbourg Cathedral in the fourteenth. But it was not until the development of the little device of the coiled spring at the beginning of the sixteenth century that clocks became small, light, and inexpensive enough for general production.

By the middle of the seventeenth century, clocks were being shipped from England to America in great numbers. The very earliest of these had only an hour hand on their faces, as the imprecise movements of the time made minute hands pointless. By the early eighteenth century, accuracy had improved and some clocks were being made in Boston, New York, and Philadelphia, as well as in

Maryland and Connecticut. Historian Irving W. Lyon quotes a 1712 advertisement of Boston clockmaker Joseph Essex, "lately arriv'd from Great Britain," whose variety of offerings included "30 hour Clocks, Week Clocks, Month Clocks, Spring Table Clocks, Chime Clocks, quarter Clocks, quarter Chime Clocks, Church Clocks, Terret Clocks, and new Pocket Watches. . . ."

The great prize among Early American clocks, however, was the tall case clock, an imposing piece of furniture (Figure 18–36). It appeared around the beginning of the eighteenth century when longer pendulums were added to clock mechanisms, necessitating longer cases to protect them. These new clocks stood on the floor rather than on tables, mantels, chests, or shelves. The cases were classically divided into three parts: the "bonnet" at top housed the clock movement and dial; the shaft housed the swinging pendulum, and the shaft and base together accommodated the drop of the weights over a period of (usually) eight days. (Tall case clocks did not come to be called *grandfather*

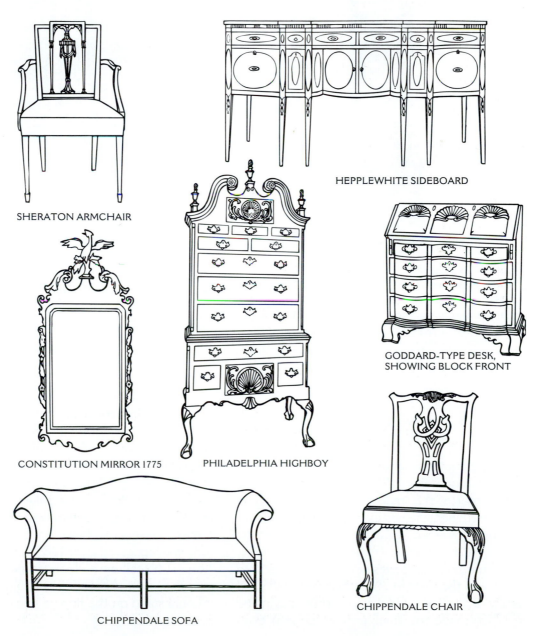

Figure 18–35
Late Colonial and early Federal furniture types.

DRAWING: GILBERT WERLÉ

SHERATON ARMCHAIR

HEPPLEWHITE SIDEBOARD

CONSTITUTION MIRROR 1775

PHILADELPHIA HIGHBOY

GODDARD-TYPE DESK, SHOWING BLOCK FRONT

CHIPPENDALE SOFA

CHIPPENDALE CHAIR

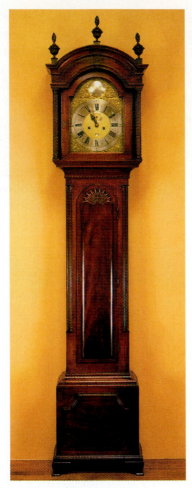

Figure 18–36 Tall case clock, 98 inches (250 cm) high. The movement and brass dial were made by William Tomlinson; the mahogany case with block-and-shell door and an arched top, by John Townsend. Newport, 1789.

HOROLOGY. AMERICAN, RHODE ISLAND, NEWPORT. XVIII CENTURY, 1789. TALL CLOCK. CASE MAKER: JOHN TOWNSEND (1732–1809). WORKS BY WILLIAM TOMLINSON (ACTIVE LONDON, 1699–1750). MAHOGANY, CHERRY, CHESTNUT, OAK. H. 99⅝ IN. W. 19¾ IN. THE METROPOLITAN MUSEUM OF ART, ROGERS FUND, 1927. (27.57.2)

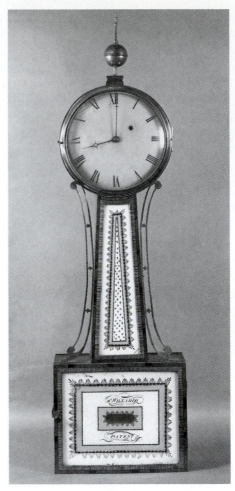

Figure 18–37 A banjo clock by Simon Willard.

BANJO CLOCK, 1802–1810. SIMON WILLARD, 1753–1848. MAHOGANY VENEER, CURLY MAPLE VENEER, PINE, BRASS FINIAL. 88.3 x 25.2 x 8.9 CM (34¾ x 9⅞ x 3½ IN.). BEQUEST OF MISS THEODORA WILLIAR. COURTESY, MUSEUM OF FINE ARTS, BOSTON. REPRODUCED WITH PERMISSION. © 2000 MUSEUM OF FINE ARTS, BOSTON. ALL RIGHTS RESERVED.

clocks until the last quarter of the nineteenth century.)

The Revolution interrupted clockmaking, as it did so much else, and when it was over, the new center of the trade was Connecticut. The most prominent names in Federal period clock-making, however, were from Massachusetts: Daniel Burnap (active 1780–1800) of Andover, Massachusetts, who was noted for his engraved faces, and the Willards. Members of the Willard family (active for more than a century beginning in 1743) made the small case clocks, an even

smaller clock that was covered with a bell of glass and called a **lighthouse,** and a variety of mantel clocks. Around 1800, Simon Willard (1753–1848) introduced the **banjo clock,** a small wall-hung clock that was encased in a banjo-like shape (Figure 18–37). Variations on the banjo clock were the lyre clock, shaped like that instrument, and the girandole, a banjo clock with a round—rather than square—base. Another innovation of form that appeared after 1785 was a smaller version of the tall case clock, sometimes called a *dwarf tall clock.* About 5 feet (1.5 m) high or less, it could stand on the floor, a chest, a mantel, or a wall bracket.

Eli Terry (1772–1853) of Connecticut would bring mass production and low prices to American clockmaking. His first clocks had wooden movements, his later ones brass.

Metalwork

Early American fireplace accessories such as andirons, fire tongs, and fire shovels were made of iron, as were cooking pots and caldrons, locks, hinges, candlesticks, and lamps. The earliest known blacksmith among the colonists was James Read, at work in Jamestown in 1607. An attempt was made in 1622 to establish an iron-producing furnace at Falling Creek, Virginia, but it was destroyed in an attack by Native Americans. A successful furnace was built at Saugus, Massachusetts, in 1664 and operated for almost twenty years. Another seventeenth-century furnace was built in Connecticut, and in the eighteenth century there were foundries in most colonies. The statesman, scientist, and writer Benjamin Franklin invented an iron stove made of cast-iron plates in 1742, its iron hearth extending into the room, and in 1756 "Baron" Stiegel of Pennsylvania, who would become famous as a glassmaker, was making iron stoves of his own design.

Colonial tinsmiths coated iron with tin to make a variety of kitchen and household objects, and tin-faced ironware was also imported from England. The first American tinsmith may have been Shem Drowne (c. 1683–c. 1750) of Boston, who made candlesticks, trays, and lamps; he also made the copper weather vane in the shape of a grasshopper that is still in place above Boston's Faneuil Hall. Piercing was a method of decorating tinware that was particularly popular in New England, while **wrigglework** was the fashion in seventeenth-century Pennsylvania, made by rocking a gouge along the surface of the metal, a technique also used for pewter and silver.

The most generally popular treatment of tin, however, was to lacquer or "japan" it. Japanned tinware and japanned tin-plated ironware were made from the early eighteenth century in both England, where they were called *Pontypool wares,* named for the town where many of them were made, and in France, where they were known as *tôle peinte* (painted iron). In America they were called **tole** or *toleware,* and they were used for picture frames, lamps, trays, teapots, water jugs, buckets, tea caddies, bread baskets, and many other items. The object was first coated with a brownish black asphaltum varnish, which was dried in an oven. The result was a shiny black surface that was then decorated with gilt or colored paint, sometimes applied through a stencil, sometimes handpainted.

Brass was used in colonial America for drawer pulls, cabinet knobs, and hinges, along with some implements such as warming pans, skillets, basins, and ewers. Joseph Jenks (died 1679) of Lynn, Massachusetts, is the earliest recorded American brassworker, but he and those who followed had to depend largely on melting down old brass for reuse, as England restricted American brassmaking in order to boost the market for English brass. This condition prevailed through the first decades of the eighteenth century, but after that there were brassworkers throughout the colonies. The brass of the eighteenth century, with relatively more zinc and less copper than today's brass, was paler and more yellow. Two brasslike alloys used in the colonies, made—like brass—of copper and zinc, but in different proportions, were **latten,** made in thin sheets and often used for making spoons, and **Prince's metal,** which was thought to resemble gold and was used for ornamental castings.

Pewter was probably made in the colonies before silver. An alloy of tin with copper and lead, it had been used by the Romans, the ancient Chinese, the French and English in the Middle Ages, and in many other times and places. The tin content of pewter can vary between 60 and 90 percent, the lower percentage giving a dull finish and a soft, easily dented surface, the higher percentage giving a bright luster. It was much in use in America in the seventeenth and eighteenth centuries, but because of its low value (compared to silver) much of that early production was melted down to make ammunition for the Revolution. After the Revolution, pewter was largely replaced by nickel, silver, silverplate, and china.

In its day, however, pewter was important in the colonies, and noted pewterers included Thomas Danforth (1703–86) of Massachusetts and Connecticut, Nathaniel Austen of Boston, and John

Christopher Heyne (active c. 1750–80) of Lancaster, Pennsylvania. Pewter wares included coffeepots, teapots, lamps, candlesticks, plates, cans, tankards, flatware, and *porringers*, small, shallow bowls for eating cereals or berries.

All these objects were also made in silver. Silverware was first owned in quantity by the wealthy plantation owners of the South. Standish Barry of Baltimore was an early Southern silversmith, and John Hull and Robert Sanderson early ones in Boston. Slightly later were Jeremiah Dummer (1645–1718), also of Boston, and Cornelius Kierstead (1674–1753) of New York. Early America's two most famous silversmiths, however, were John Coney and Paul Revere.

JOHN CONEY (1655–1722) John Coney of Boston was the brother-in-law of Jeremiah Dummer and became an engraver as well as a silversmith and goldsmith, producing the plates with which the colonies' first paper money was printed. He was an excellent craftsman. His designs closely followed English models, and he was the first to introduce some English forms to America, such as the chocolate pot and the *monteith*, a bowl with a scalloped rim from which wine glasses could be suspended in water to cool them.

PAUL REVERE (1735–1818) Like Coney, Paul Revere was an engraver as well as a silversmith, and also worked in Boston. His most famous single design is a silver punch bowl he made for a group called the Sons of Liberty (to which Revere himself belonged); its simple, graceful shape was derived from a porcelain bowl imported from China and has been widely copied in a variety of sizes (Figure 18–38). Revere was also noted for his silver coffeepots, teapots, tankards, and pitchers. He was the founder and president of an organization of artisans called the Massachusetts Charitable Mechanic Association, its membership including housebuilders, bricklayers, blacksmiths, coopers, and printers.

Textiles

Silks, damasks, and velvets had been brought from Europe in the sea chests of the first settlers, and cargoes of cotton were shipped from the West Indies to Boston and Salem beginning in 1638. The first textiles made in America, however, were necessarily plain and simple.

In 1640 the General Court of Massachusetts ordered the domestic manufacture of wool and linen cloth, and the earliest recorded production

 PROFILE PAUL REVERE

Apollos Rivoire was born in France in 1702, sailed to Boston when he was only thirteen, and served an apprenticeship under silversmith John Coney. He started his own business in 1723, the year after Coney died, and changed his name to Paul Revere. When he died in 1754, his son, also named Paul Revere and then only nineteen, took over his business. The younger Revere became known for his designs in silver. He also established a small iron foundry where he made church bells and a mill for making sheets of copper. His copper was used in 1802 to cover the dome of Charles Bulfinch's five-year-old Massachusetts State House in Boston, and the Revere Copper Company is still in business today.

The younger Paul Revere's fame as a silversmith, however, has been both amplified and overshadowed by his fame as a Revolutionary patriot. The chief vehicle for this reputation is Henry Wadsworth Longfellow's 1860 poem that tells of Revere's ride through Boston to warn his fellow citizens of the approach of British troops. Its familiar first lines are:

> Listen, my children, and you shall hear
> Of the midnight ride of Paul Revere . . .

came the following year. In 1643 twenty families from Yorkshire, a wool-producing county of England, settled at Rowley, near Ipswich, Massachusetts, and established the first professional textile mill in America; it would operate continuously until the nineteenth century, producing woolen broadcloth and, later, cotton and linen goods.

England began to watch its colonies carefully as potential competitors, and during the Commonwealth period (1649–59) wool produced in England was ordered to be kept there for English use. Other restrictive legislation followed, worsening in the eighteenth century. By then, textiles were being made in every part of the colonies, silk was being raised in Georgia and Carolina, cotton was being printed in Philadelphia, woolens being made in Hartford, and linen in Boston. In 1793 Massachusetts-born Eli Whitney invented the cotton gin, making simple the separation of cotton fiber from seed and revolutionizing early-nineteenth-century textile manufacturing.

BED AND WINDOW COVERINGS
The earliest and simplest Colonial fabrics for both bed and window coverings were of homespun wool. The most readily available dyes were red, brown, and indigo blue, but yellow and green homespun were also made. Linen was also available to the early colonists, and a popular blend of wool and linen was called **linsey-woolsey.**

Bed rugs (once spelled *bed ruggs*) were made like hooked rugs but on a heavier backing, canvas rather than linen, and their loops of wool were left uncut. Quilts, coverlets, and all kinds of bedcovers were also made, and they could be woven on small hand looms, pieced together in patchwork, or appliquéd.

UPHOLSTERY
A thick wool upholstery material of the seventeenth and eighteenth centuries called **morine** or *moreen* was made with a wool **warp** and fillers of wool, linen, or cotton. Its name may have come from the fact that some of it, stamped while wet with a hot iron in wavy patterns, imitated the appearance of **moiré.** It was usually dyed in strong colors: crimson, green, blue, or yellow.

Cromwell chairs, as mentioned, were upholstered in leather or in turkey work. The stuffing

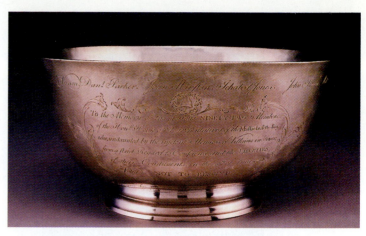

Figure 18–38 The much-imitated Sons of Liberty bowl by Paul Revere, 1768, 11 inches (28 cm) in diameter.

beneath the upholstery was often of horsehair taken from the manes and tails of horses, then washed and dried to make it more pliable. Hair from cows' tails was also used.

The later easy chairs were often upholstered in fine fabrics such as serge, camlet, or shalloon. **Serge** was a flat fabric of wool or wool blend with a fine pattern of diagonal ribs. **Camlet** was a fine, smooth-surfaced blend of wool and silk or wool and linen, and was made in imitation of an earlier fabric from Asia that had contained camel's hair or Angora goat's hair. **Shalloon** was a twilled worsted fabric. Some of these were patterned with a **flame stitch** of repeated jagged lines in different colors, and scenic tapestries were sometimes used for the larger areas on the backs of chairs.

We know from printed records and upholsterers' bills that slipcovers, sometimes referred to as "cases," were also made for many Early American chairs, but none of these survives.

CARPETS, RUGS, AND FLOORCLOTHS
The first American objects called rugs and carpets, surprisingly, were not laid on the floor but were used as table covers and bedcovers and draped over chests, cupboards, mantels, shelves, and even windowsills.

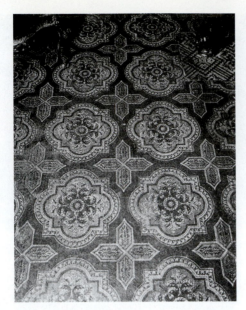

Figure 18–39 An eighteenth-century painted canvas floorcloth from the Safford house, Salem, Massachusetts.

Hooked or **pulled rugs,** which *were* used on the floor, had been popular in the northern countries of Europe and were probably introduced to the colonies by Scottish, Scandinavian, and Dutch settlers. They were made by using a small hook to pull narrow strips of cloth through a coarsely woven linen backing that had been stretched on a frame. Sometimes the exposed loops of cloth were cut; sometimes not. Geometric patterns were made, as well as representations of ships, animals, and flowers.

Braided rugs were also made for floors. Strips of cloth in various colors were plaited together, and the resultant braids were sewn together spirally, making round or oval rugs. A few rows of such braiding might be added to the outside of a hooked rug as a finishing touch.

Floorcloths of painted canvas, mentioned in the chapter on English design, came to be much used in America (Figure 18–39). In addition to serving as substitutes for fine carpets for covering large floor areas, they were also used in smaller sizes under dining tables or sideboards to protect the carpets beneath them from spilled food; these smaller versions were called **druggets** or **crumb cloths.** Floorcloths were also sometimes used as summer substitutes for more heavily textured carpets and were even used under carpets to provide a smooth surface and to stop drafts that might come through cracks in the flooring. Floorcloths of all sizes were often painted in striking geometric patterns, some of them imitating mosaics and marble tiles. They were produced by handcrafted methods until around 1800, but were then replaced by the manufactured material called **linoleum** and the lighter-weight material called **oilcloth,** which would be used as an easily cleaned surfacing for tabletops, shelves, and drawer linings.

Ceramics

Records show that both glazed and unglazed pottery was being made at Jamestown, Virginia, shortly after 1610. It was probably *redware,* made from common red or reddish brown clay. The Dutch East India Company sent Jan Van Arsdale to New Amsterdam (New York) in 1645 to establish a pottery there, and he seems to have done so, but the results are not known. Where brickmaking was established (in Virginia and New England by 1650, in Pennsylvania by 1685), the brick kilns were also used for making earthenware and roofing tiles. Also by 1685, more hard-bodied stoneware was being made by Daniel Cox from London at his pottery near Burlington, New Jersey.

Early pottery decoration in America included the use of slip and **graffito,** the scratching of patterns through the slip to reveal a different color beneath. Abraham Miller of Philadelphia is credited with producing America's first silver lusterware; he also experimented with making hard-paste porcelain but never produced any commercially.

Gottfried Aust (1722–88), a German-born master potter, was an important figure in America's Moravian communities, first in Bethlehem, Pennsylvania, and later in Salem, North Carolina. His work was chiefly earthenware decorated in floral or geometric patterns with colored slips. The large number of apprentices trained by Aust constituted a "school" of potters, using his style, in the Piedmont area of North Carolina.

In 1785 Captain John Norton moved his family from Connecticut to Bennington, Vermont, where he planned to farm. Finding a great need for simple ceramics in his own and neighboring households, he founded a pottery at Bennington in 1793.

He made earthenware and, later, stoneware, and his company would become larger and much better known in the nineteenth century.

Throughout the colonies, red earthenware was the staple of American ceramics until the end of the eighteenth century, but by that time more adventurous products were being encouraged. Tariffs against imports provided one sort of encouragement, and another came from societies of artisans and tradesmen. Susan H. Myers, for example, has written that the Pennsylvania Society for the Encouragement of Manufactures and the Useful Arts offered awards in 1792 for "the best specimen" of pottery "approaching nearest to Queen's Ware, or, the Nottingham or Delf Ware, . . . Stone Ware, or that kind of Earthen Ware which is glazed with Salt." These variations would indeed come in abundance in the century that followed.

Glass and Mirrors

Glassmakers were among the settlers at Jamestown in 1608 and were therefore some of the first craftsmen in colonial America. As there was plentiful need for window glass and utensils such as bottles and drinking vessels, and as there was a plentiful supply of wood fuel, the practice of glassmaking flourished. Most early American glassmaking was anonymous, but a few makers are well known today.

Caspar Wistar (1696–1752) emigrated from Germany to Philadelphia when he was twenty-one. His first trade was making brass buttons, but he opened a glass factory, which he called Wistarburgh, in 1739 in the southern part of New Jersey. He was the first financially successful glass manufacturer in the colonies, but his products were mostly utilitarian: window glass, bottles, and equipment for scientific experiments. Some tableware was produced, rather crude but delicately colored in tints of green and blue. After Wistar's death his son Richard took up the business until the Revolution made it impossible to continue. Just after the Revolution, some brothers named Stanger who had worked for Wistar opened a new glass factory in the same area, and Wistar and Stanger products are sometimes jointly known as *Jersey glass.*

A generation later, Henry William Stiegel (1729–85), like Wistar, moved from Germany to Philadelphia at age twenty-one. He opened a glasshouse in Pennsylvania in 1763. Stiegel's first products were bottles and window glass, but he gradually added more artistic products to his line. In 1769 he opened the American Flint Glass Manufactory at Manheim to produce tablewares in lead glass (the first in America) and colored glass. Complaining that his workers were "bunglers," he brought more experienced glassworkers and artists from Cologne, Venice, and Bristol, England. His decorative glass came in a variety of appearances. Stiegel glass colors were opaque white, emerald green, amethyst, brown, and sapphire blue.

Stiegel also added etching and enameling as decoration, employing the first glass engraver known to work in America, Lazarus Isaac, who came to Philadelphia from London in 1773. Stiegel products included wine glasses (Figure 18–40), tumblers, mugs, decanters, cruets, cream pitchers, and candlesticks. Attribution of specific pieces to Stiegel's glasshouses seems less certain today than it once did, and most experts now use the term *Stiegel type* for such glass, not meaning a type that Stiegel invented but one that he employed. Debts forced Stiegel to close his business in 1774. After the Revolution, imitations of Stiegel ware were made in the Pittsburgh area and in the Ohio River Valley; these were known as *Midwestern glass.*

A glassworks in New Bremen, near Baltimore, was founded in 1784 by John Frederick (originally Johann Friedrich) Amelung (1741–98) of Bremen, Germany, who staffed it with almost seventy craftsmen brought from Germany along with their equipment. His glasshouses produced window glass, utilitarian household objects, and some far-from-utilitarian wheel-engraved presentation pieces made as gifts for President George Washington and other important figures. Amelung was active in urging the federal government to protect American glassmakers with duties on imported glass, and such duties were imposed in several stages between 1790 and 1794. Amelung's enterprise, however, suffered from a flood, a windstorm, a fire, Amelung's own poor health, and eventual bankruptcy.

Other eighteenth-century glassworks in America included the Glass House Company established in the 1750s in New Amsterdam (later New York) by Loderwyk Bamper and others; the Philadelphia Glass Works established in 1771; the Schuylkill

Glass Works, also in Philadelphia, established in 1780; and the Craig and O'Hara works established in Pittsburgh in 1797. One of the few women in the early American glass trade was a Madame Descamps, who came from Paris and opened a glass-engraving shop in Philadelphia in 1795. According to Arlene Palmer Schwind, she advertised in 1800 that she was "assisted by several persons whom she successfully enabled to be proficient in that art." Madame Descamps later moved to Boston.

Mirrors were rare in the American colonies before 1700. When they became available, however, they were popular, thought to add elegance to an interior and multiplying the dim light from candles and lamps. Called "looking glasses," they also offered useful reflections of the colonists themselves.

Early mirrors came in a range of qualities. The poorest were made of *crown glass,* cut from the crown of a great bubble of blown glass, annealed in a furnace, and cut into panes. The most distorted of these panes, called the *bull's-eye,* was the center one, scarred by the blower's pontil rod. Such panes were often used in windows, where light transmission was more important than clear vision. Crown glass mirrors were often silvered on the back with paint. The finest mirrors, made of plate glass poured on a slab of polished marble or a sheet of metal, were silvered on the back with mercury or tinfoil. But mirrors are usually classified by frame type, and a poor mirror could be given a fine frame or a fine mirror a poor one.

The first to reach America were wall and dresser mirrors in the Queen Anne style, with plain walnut or lacquered frames, and with the characteristic cresting of broken curves. The glass was usually beveled around the edges and was usually in two parts until about 1750, when single pieces of glass began to be used.

The Georgian post-Revolutionary mirror had a rather heavily ornamented frame of architectural forms with gilded moldings and a scroll pediment on top. Between the scrolls, a vase or eagle might be placed. This type is known as a **Constitution mirror** (center left, Figure 18–35).

Rococo and Chinese mirror forms were also popular, particularly in shapes suitable for placement over a mantel or sideboard. The irregularly curved scrolls and leaves of these carved frames were usually gilded or painted white. Occasionally, candle brackets were attached.

Simple Adam or Hepplewhite mirror types came in rectangular, oval, and shield shaped frames and were ornamented with paterae, classical figures, husk garlands, drops, and arabesques. These were hung on walls or made for table and bureau tops, in which case they might stand on small boxes of drawers.

The **girandole,** dating from 1760 but popular only after the Revolution, was a combination mirror and lighting fixture, always made with candle brackets. (The term was also used in the eighteenth century for chandeliers and candelabra without mirrors and in the nineteenth century for

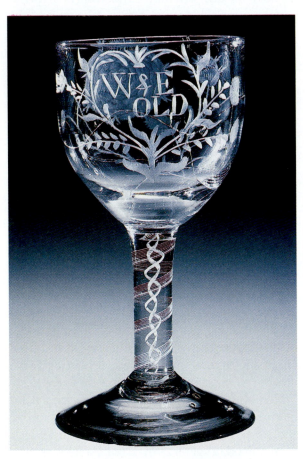

Figure 18–40 Engraved lead-glass wine glass made by Henry William "Baron" Stiegel on the occasion of the marriage of his daughter Elizabeth to William Old in 1773. It is 6¾ inches (17 cm) high.

a banjo clock with a rounded base.) The mirror was generally round with either a concave or convex surface. The frame was heavy, richly carved or ornamented, gilded, and often crowned with an eagle. The girandole was prominently placed in the dining room or best parlor.

At the end of the eighteenth century the **tabernacle mirror** or *Sheraton mirror* appeared, and it would become very popular in the early nineteenth century. Developed from the French **trumeau** mirror, it was architectural in design, like a miniature doorframe (such as might be the entrance to a tabernacle) with pilasters or colonettes at the sides and a simple entablature at the top, often ornamented with a row of acorns. Within this frame and above the mirror, a small glass panel was painted with scenery, floral decorations, or the eagle and thirteen stars.

Stenciling, Wall Painting, and Wallpaper

Before the production of printed wallpapers in America, the technique of stenciling was much in use. It is the reproduction of a design by rubbing or brushing (or, in modern times, spraying) ink or paint through holes cut in a thin sheet of stiff, waterproof material. Stenciling is as old as some prehistoric cave paintings, it was much in use by the Chinese and Japanese for decorating textiles, it was used in Europe in the Middle Ages for making playing cards, and it was used by the French *dominotiers* for making their wallpapers. Stenciling directly on the wall as a substitute for paper, however, is a technique particularly associated with early America. Repetitive patterns were used over large wall surfaces, borders were stenciled along the tops of walls, and large display pieces were stenciled on overmantels (Figure 18–41).

Much American wall stenciling was done at home by amateurs, and there was also a custom of stenciling on velvet as an artistic pastime for ladies, "French stencil printing plates" being advertised for such use as early as 1788. Some wall stenciling, however, was the work of itinerant professionals who carried their equipment and talents from town to town. The most famous of these latter was Moses Eaton (1753–1833), who mixed his dry colors with milk and brushed them through oiled cards.

His tools can be seen at the Boston Museum of Fine Arts.

Printed wallpaper began to replace stenciling in the early eighteenth century, with papers imported from both England and France. The first American wallpaper manufacturer is thought to have been Plunket Fleeson of Philadelphia, who opened his factory in 1739; Fleeson also worked as an upholsterer. By the middle of the century, printed papers were being advertised in the newspapers of many American cities. It was apparently quite inexpensive, even if one allows for some advertising exaggeration. Harold L. Peterson cites a January 19, 1765, ad by John Blott in the *South Carolina Gazette* maintaining that "[t]he expense of papering a room does not amount to more than a middling set of Prints," and one on April 16, 1783, by William Payntell in the *Philadelphia Journal* claiming his prices "make papering cheaper than whitewashing." The same William Payntell offered a stock of 4,000 patterns, some of them with **flock** textures. By 1800, there were more than a dozen wallpaper factories in America—several in Philadelphia, and others in Boston, Hartford, Albany, and Baltimore.

Patterns were widely varied—geometric, scenic, floral, and combinations (Figure 18–42, page 499)—and many of them were in the popular Chinese style (Figure 18–43, page 499) or imitations of imports from France.

Summary: Design in Colonized North America

Comparing this chapter with the previous one, we can see that the subjects share some identical geography and even some identical time. It is clear, however, that they do not share the same design.

Looking for Character

In the two centuries studied here, the American colonists, however eager they were for political independence, were equally eager that their interiors, furniture, and decorative arts should have a character as identical as possible with those of their European background. In this, they sometimes succeeded so well that it is difficult to tell if a chair or mirror was made in America or in Europe.

A

B

C

Figure 18–41　Late-eighteenth-and early-nineteenth-century examples of wall and floor stenciling: (a) a detail of the parlor overmantel from the Josiah Sage house, South Sandisfield, Massachusetts; (b) a border from a stairway wall in the Elisha Smith house, Stillwater, Rhode Island; and (c) the border of a hall floor in "The Lindens," Danvers, Massachusetts.

JANET WARING, *EARLY AMERICAN WALL STENCILS: THEIR ORIGIN, HISTORY AND USE*, NEW YORK: WILLIAM R. SCOTT, 1937.

The character of the design of the Native Americans impinged not at all upon the design of the colonists. The three feathers of the Prince of Wales might be used as an American decorative motif, despite growing hostility toward England, but not the feathers of a chief's headdress. In rare cases, as at Jefferson's Monticello, Native American artifacts might be collected and admired, but not until years later would they ever be considered a design source.

In early America, design character intentionally independent of European fashion is found only in those communities whose religious beliefs held them apart from European custom. Most admirably, the Shakers demonstrated such independence. The honesty, simplicity, and directness of their design was American in origin only in the fact that America offered limited resources, but it is possible to imagine that a widespread admiration for such design contributed to what would later become a true American character.

Figure 18–42 "Sawtooth Chain," a wallpaper found in the late-seventeenth-century Swain-Harrison house in Branford, Connecticut.

AFTER KATZENBACH

Looking for Quality

In the seventeenth century, the first century of their existence, the European colonies necessarily "made do" with design that was functional but rarely lavish. It is remarkable that by the eighteenth century they could have progressed enough to produce an object such as—to choose only one example—the John Townsend block-and-shell chest. Although founded on utility and expediency, American design matured quickly and at its finest came to be the equal in quality of the best design anywhere.

Making Comparisons

As suggested at the end of the previous chapter, it is interesting to compare the design of the North American Indians with the design of the European colonists, dealing with so many of the same conditions yet arriving at such different results. We may also compare the design in the English colonies with those in the Spanish and French colonies. Within the colonies, we may consider local variations—the distinctions, for example, among Newport, Philadelphia, Baltimore, and Charleston furniture. Or we may study the influence of reli-

Figure 18–43 Chinoiserie theme, French, 1880, gouache on paper.

SUSAN MELLER AND JOOST ELFFERS, *TEXTILE DESIGNS*, © 1991 SUSAN MELLER AND JOOST ELFFERS NEW YORK: HARRY N. ABRAMS, INC., 1991.

gious codes of behavior by comparing Pilgrim interiors with Shaker or Moravian ones. And certainly contrasts between the design of the Northern

colonies and that of the South tells us much about differences, not only in climate and soil, but also in economic and social organization.

But for the colonial Americans themselves, the comparison that dominated their consciousness was that between themselves and their European counterparts. The Old World was the measure of the New, and the remarkable progress just mentioned was surely spurred in part by a sense of competitiveness with the world the Americans had left behind. It was a factor that we shall see continuing to operate in the nineteenth and twentieth centuries.

19

THE NINETEENTH CENTURY

The nineteenth century, in design as well as in other fields, was a time of conflicting ideas. Two opposing forces were expressed in different forms: progress toward the future versus a retreat to the past; the charm of the handmade versus the efficiency of the machine-made; beauty versus usefulness.

Throughout the nineteenth-century we shall see the conflict raging, sometimes with one winner, and sometimes with another.

501

The Determinants of Nineteenth-Century Design

One development chiefly determined nineteenth-century design, overriding all others. It was the opening of new possibilities through technology and science, and one of those possibilities was unprecedented communication. It was a century in which designers could do things never imagined before, and one in which what they did in one country was soon known in others.

Technology as Catalyst

As suggested, nineteenth-century technology worked wonders and yet was not always welcome. Design changes often came in accordance with new inventions, techniques, and knowledge, but sometimes they came in resentful and suspicious reaction against the new. In either way, technology was a major catalyst.

A frank expression of the new possibilities came in the great exhibition hall of 1851, the Crystal Palace in Hyde Park, London. The Crystal Palace, with a floor area four times that of St. Peter's in Rome, demonstrated the tremendous spaces that the iron frame could span (Figure 19–1). Joseph Paxton, its designer, based it on a repetitive module of 4 feet (120 cm) square, the size of the largest pane of glass then manufactured. The modules were all factory-made and assembled on the building site, where erection took less than six months. Its principles of modularity and prefabrication would both become important aspects of twentieth-century design. There was a discrepancy, however, between the logic and economy of the Crystal Palace and the confusion and extravagance of many of the goods displayed inside it. (Figure 19–2).

Figure 19–1 Inside the Crystal Palace, London, 1851. At the crossing is seen the Fountain of Glass, 19 feet 6 inches (6 m) high.

VICTORIA AND ALBERT MUSEUM

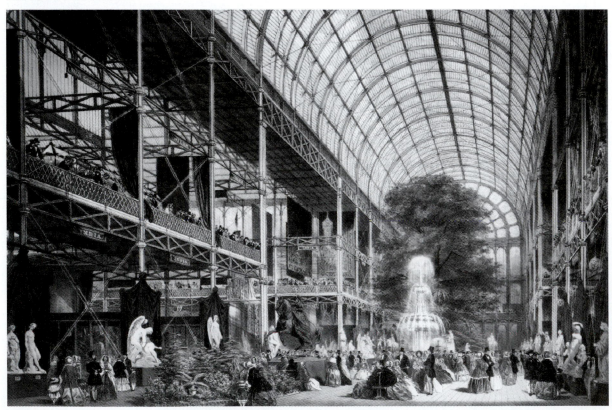

Figure 19–2 From London's Great Exhibition of 1851, a table of locust wood designed by Carl Leistler of Vienna. The catalogue stated that "there is much fancy displayed in the arrangement of the ornament upon the central support, which is of a quaint and original character."

THE CRYSTAL PALACE EXHIBITION ILLUSTRATED CATALOGUE

HEATING The fireplace and the stove served as the sole means of heating interiors until the late eighteenth century. In 1769 James Watt patented his steam engine, in 1774 he began manufacturing it with his partner Matthew Boulton in Birmingham, England, and he is said to have heated his own office with it in 1784. Also in England, closer to the end of the century, William Strutt devised a gravity warm-air heating system for Derby Hospital, and Joseph Bramah a system of hot-water radiators for Westminster Hospital. Two inventors born in America but living in England contributed to heating improvements: Benjamin Thompson, who became Count von Rumford (1753–1814), invented new kitchen stoves and ranges and was the first (in 1798) to propose that heat was the result of the motion of particles; and Jacob Perkins (1766–1849) developed a heating system using both hot water and steam. Philo Penfield Stewart (1798–1868), an American who stayed in America and who helped found Oberlin College in Ohio, patented a cast-iron stove that he named the Oberlin.

Despite these developments, central heating systems were slow to come. The first in America is thought to have been in the Eastern Hotel in Boston, c. 1845. Cooling of interiors came even more slowly; French physicist N.-L.-S. Carnot published the principles of mechanical refrigeration in 1824, but the first "air conditioning" would have to wait for Willis Carrier in 1902.

Efforts to improve heating were accompanied by efforts to rid interiors of airborne toxins. One of the most feared of these was carbon dioxide, then called carbonic acid. From the end of the American Civil War in 1865 through the end of the century, much attention was paid to improving the circulation of air. Windows could be opened in most cases, but that created unpleasant drafts and chills in winter, thought to be causes of disease as well. Inventions to improve matters included air inlets that deflected fresh air toward the ceiling, ventilating fireplaces, vacuum systems, and fans driven by steam engines, this last being too costly to have much application. Catherine Beecher's 1869 book suggested placing vents near the ceilings of rooms to carry off the foul air; others suggested vents near the floor. The subject was obscured by fear and misinformation until late in the nineteenth century, when the air was literally cleared by the advent of inexpensive electric fans. The American Society of Heating and Ventilating Engineers was established in 1895 and with it a new profession of specialists in interior comfort.

LIGHTING Candles and oil lamps had been lighting interiors for centuries, but these old methods were updated at the end of the eighteenth century, candles by efficient new manufacturing methods, oil lamps by a Swiss inventor named Aimé Argand. The Argand lamp, first marketed in 1783 and used throughout the next century, introduced air around

the wick to produce a brighter flame and less smoke than earlier lamps. Many experiments followed, both in lamp design and with lamp fuels, including gas and, after the first petroleum well was drilled in Pennsylvania in 1859, petroleum-based kerosene. Bishop and Coblentz have written that in America in the seventy years from 1790, when a patent was taken out for candlemaking, until 1860, the number of lighting-related patents was 556, but in the single decade between 1860 and 1870 the number soared to 2,000. As James Marston Fitch has written, "By the time of the Civil War, an entirely new concept had appeared in building design: that of a fixed, semi-automatic lighting system which *freed the building from its historic dependence upon natural daylight.*"

But the century's biggest advance in lighting came on the first day of 1876, when Thomas Alva Edison, in his workshop at Menlo Park, New Jersey, demonstrated the practical use of electricity. Joseph Wilson Swan in 1878 and Edison in 1879, working independently, invented the electric lamp (or "lightbulb"), and electric light would be demonstrated to a large audience in the "City of Light" at the World's Columbian Exposition in Chicago in 1893. The nineteenth century had begun with dark interiors; it ended with bright ones.

PLUMBING The Cretans had developed water closets in 1100 B.C., and the ancient Romans, with their aqueducts, fountains, baths, and latrines, had achieved a high standard of sanitation. When the Roman Empire fell, that standard fell, too. London's first water system after the Middle Ages, in fact, was the fifteenth-century rehabilitation of part of the system the Romans had left. It was not until the nineteenth century that the Roman standard was fully regained.

Two technical developments of the early 1800s contributed to sanitary progress: the recently developed steam engine that could produce water pressure, and cast-iron pipes for carrying water and waste. In Philadelphia there was a system of reservoirs and a steam-powered pumping plant before 1820. New York began piping water from the Croton River in the 1840s.

The first water closet had been developed in England in 1788; a pan closet with a water seal followed in 1833, also in England; and English inven-

tor Thomas Crapper introduced the flush toilet in 1872. The earthenware washdown water closet, similar to those in use today, appeared in the United States c. 1890. In most houses before midcentury, provisions for washing the body were simply a pail and a sponge, although some households enjoyed the use of elegant washstands, such as one designed by Percier and Fontaine (Figure 19–3). Small metal hip baths, sometimes with showers above them, then became customary, and the white-enameled cast-iron bathtub appeared c. 1870.

All these developments were offered first in hotels and railway carriages before they became standard equipment for houses. In the kitchen sink of the kitchen shown by Catherine Beecher in 1869, water still had to be drawn by a hand pump, but by the century's end many houses in America and Europe had hot and cold water piped to kitchen sinks, washbasins, and bathtubs. The nineteenth century was not inclined to revel in the new usefulness without giving it a proper appearance: all these new appliances were often encased in elaborate wood cabinetry or given fanciful guises (Figure 19–4), and toilets were partitioned off in tiny cubicles ("water closets").

THE SCIENCE OF DESIGN: COLOR THEORY
In addition to discoveries of new ways to moder-

Figure 19–3 A washstand designed by Percier and Fontaine in 1801.

RECUEIL DES DÉCORATIONS INTÉRIEURS, PARIS, 1801

Figure 19–4 Illustration from an advertisement for "The Dolphin," an ivory-tinted toilet fixture, 1880s.

AFTER GIEDION

ate the nature of the external world, there were design-related discoveries about the inner workings of the human body. One example was the expansion of knowledge in the field of color theory.

Newton and Voltaire in the eighteenth century and Goethe and Schopenhauer in the nineteenth all theorized and wrote about color, speculating on its nature and the role of the eye in perceiving it. Michel Eugene Chevreul (1786–1889), the master dyer at the Gobelins factory, experimented with the effects of colored light, afterimages, and subjective reactions that altered appearances. The harmonies of adjacent colors and complementary colors were first noted by Chevreul, and his observations inspired both Impressionist and Pointillist painting. Hermann F. von Helmholtz (1821–94) was a German-born physiologist, biologist, and physicist concerned among other matters with the workings of the eye, the ear, and the nervous system. His work, published in 1867 as *Treatise on Physiological Optics*, advanced the knowledge of

color vision. Wilhelm Ostvald (1853–1932) in Germany and Albert Munsell (1858–1918) in America carried the advance further, and Munsell's comprehensive theory would be published in 1905 as *A Color Notation*. By the end of the nineteenth century, the phenomenon of color had come to be scientifically understood. Still to come was greater knowledge about the brain's role in color perception and the psychological effects of color.

Parallel with new information about perceiving color came new discoveries in creating color. The first breakthrough in synthetic color came in 1858, when William Henry Perkin, an eighteen-year-old English medical student, was trying to make a synthetic solution of quinine. By distilling a coal tar, he accidentally produced a blue-red dye. This *Perkin's violet*, the first synthetic color, was available on the commercial market a year later, and the science of color chemistry was launched.

Publications as Stimulant

In our chapters on English and American design we have already seen the importance of publications in spreading design ideas. This importance grew even stronger in the nineteenth century.

In the tradition of those eighteenth-century style books was *Household Furniture and Interior Decoration*, 1807, by the English architect and collector Thomas Hope (1769–1831), its engravings showing interiors he designed for himself in a Robert Adam house in Duchess Street, London. The rooms were highly eclectic, primarily neoclassical, but with elements of Egyptian, "Hindoo," and other exotic styles. The book's title is said to have introduced the phrase "interior decoration" to the English language.

Other books of the same type included George Smith's *Collection of Designs for Household Furniture and Interior Decoration*, 1808, influenced by Hope's book, and the same author's *Cabinet Maker and Upholsterer's Guide*, 1826. John Claudius Loudon's *An Encyclopedia of Cottage, Farm, and Villa Architecture*, first printed in London in 1833 and reprinted several times in both England and America, offered 2,000 illustrations on which to model middle-class residential interiors. English architect Owen Jones in his 1856 *Grammar Of Ornament*, followed by French artist Albert Racinet in his 1873

- The origin of color is visible light, a small part of the electromagnetic spectrum of radiant energy. Invisible parts of the spectrum include infrared rays, ultraviolet rays, X rays, gamma rays, radio waves, and so on. Within the visible spectrum, each color has its characteristic **wavelength,** violet having the shortest and red having the longest.
- Color is said to have three chief characteristics: hue, chroma, and value. **Hue** is a function of wavelength, and different hues are denoted by names such as *yellow, green* and *orange.* **Chroma** is a hue's degree of intensity or saturation, yellow having the least chroma because of its paleness, and blue the greatest chroma. **Value** is an attribute of lightness, determined by the amount of black or white added to a hue. A hue with black added is said to be a **shade,** and a hue with white added is said to be a **tint** of the hue.
- Hues in light are said to be **additive** because all hues of light added together produce white. In the additive process, which is the basis of color on television and computer screens, the three **primary colors** from which all other colors can be produced are red, blue, and green.
- Hues in pigment are said to be **subtractive.** All wavelengths of light are absorbed by a pigment except those of its distinguishing hue, which are reflected to the eye. In the subtractive process, the three primary colors are red, blue, and yellow. **Secondary colors,** made by mixing two primary colors, are purple, green, and orange. Mixing a secondary and a primary produces a **tertiary color** such as red-orange or yellow-green.
- Hues are often arranged on a **color wheel** in the order of their wavelengths, with short-wavelength violet adjacent to long-wavelength red. Colors exactly opposite each other on the wheel, such as red and green, are said to be **complementary colors**. The color wheel can be divided into two halves, the **warm colors** of red, orange, and yellow, and the **cool colors** of green, blue, and violet. A pair of complementary colors, therefore, always contains one warm color and one cool one.

Encyclopedia of Ornament, codified decorative patterns and motifs from many cultures. Gothic Revival ideas were supported by A. J. Downing's *Cottage Residences. . . ,*1844.

Charles L. Eastlake's *Hints on Household Taste in Furniture, Upholstery, and Other Details,* 1868, had particular impact on the design of its time. Eastlake's own design, with which his book was illustrated, was a simplified and functional version of Gothic that he thought could be inexpensively manufactured. His ideas were taken up in America with more zeal than care, and what was called the Eastlake style, flourishing in America from c. 1875 to c. 1890 in architecture, interiors, and furniture design, was an ornate version of the Queen Anne Revival, busy with brackets, spindles, bobbins, turnings, and knobs (Figure 19–5).

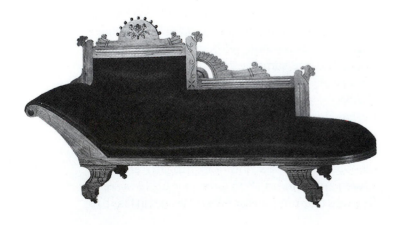

Figure 19–5 An "Eastlake" walnut *méridienne*, probably made in Grand Rapids, Michigan, c 1890.

HENRY FORD MUSEUM AND GREENFIELD VILLAGE

The Styles
of the Nineteenth Century

We have seen some styles—such as those of Egypt, Greece, and China—that evolved slowly over many centuries. The nineteenth century, however, with its many technological changes and its rapid communication of design ideas, was a time of many short-lived styles jostling for attention and favor. Most of them can be roughly divided into those that continued the established interest in classical Greek and Roman design and those that sought to revive the design of more exotic times and places. This last group corresponds to what is often called the **Victorian** style, meaning the style current in England—and to some extent in America also—during the reign of Queen Victoria. Yet so long did her reign last (from 1837 to 1901), and so varied was the design of those sixty-four years, that the term *Victorian* has only the vaguest meaning. Then, at the very end of the century, there were two styles—the **Arts and Crafts** movement and the **Art Nouveau**—that were more modern in their independence from earlier precedents.

The Classicist Styles

Two great classicizing styles coexisted in the first quarter of the nineteenth century, Empire in France and Regency in England. They would in turn inspire other styles in other countries.

THE EMPIRE STYLE IN FRANCE **Empire** was a style associated with one man, one of the great *parvenus* of history who became the emperor for which it was named: Napoleon Bonaparte. The son of a petty Corsican nobleman, Napoleon had risen to command the French army in a series of victories that put much of Europe under his control. Then with Napoleon as first consul, the Consulate of 1799 to 1804 had brought renewed stability to France for the first time after the wrenching upheaval of the 1789 Revolution. In 1804 Napoleon crowned himself emperor, and his First Empire lasted until 1814, when he was forced to resign after a failed attempt to conquer Russia and was exiled to the island of Elba.

Although Napoleon's chief skills were military, not artistic, he was well aware of art's value as propaganda. He provided new quarters for the Acédémie des Beaux-Arts and the École des Beaux-Arts in Paris and for the Académie de France in Rome, he completed the Cour Carrée of the Louvre, he built the arcaded rue de Rivoli and laid the foundations of the Arc de Triomphe, and he established museums in many of the European countries he had conquered. One of his policies was to refurbish the palaces of the deposed French royalty, many of which had been stripped of their contents, in a style appropriate for the new government. This policy accomplished three things: it revived the practice of interior design and the crafts that supplied it; it brought new life to the interiors of Fontainebleau, the Tuileries, the Elysée Palace, and other great houses; and it gave birth to a new decorative style.

The chief practitioners who defined the Empire style were Charles Percier (1764–1838) and Pierre-François-Léonard Fontaine (1762–1853). The two had met when they were both apprentices in the Paris studio of architect, painter, and decorator Antoine-François Peyre. They both traveled to Rome, where they made drawings that were published in 1798 and 1809. After the Revolution and his father's financial ruin, Fontaine fled to England, where he designed wallpapers and decorative objects, while Percier stayed in Paris and directed the scenery painting at the Opéra. Fontaine rejoined Percier, and together they designed scenery, furniture, and interiors. Among their interior commissions was a house adjacent to Malmaison, the house of Josephine Bonaparte, Napoleon's wife. Admiring it, she hired them to redesign Malmaison, and their career was launched (Figures 19–6 and 19–7, page 509).

Just as Thomas Jefferson had felt that the design of republican Rome was appropriate for the new American republic, Percier and Fontaine felt that the design of both ancient Greece and Rome, particularly that depicted on Greek vases, was appropriate for the new French state.

Revivals of classical design were not new, of course, but that of Percier and Fontaine was more strict, more severe, and more correct than any France had known before. They laid the ground rules of the new style in their 1801 publication *Recueil de décorations intérieures . . .* , thus defining what we now call the Empire style three years

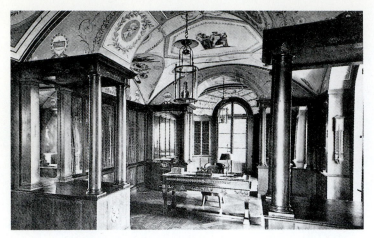

Figure 19–6 Napoleon's library at Malmaison, near Paris, by Percier and Fontaine, 1800.

AKG LONDON LTD

before there was an empire. (Some writers refer to this pre-1804 manifestation as the *Consulate* style, but the distinction seems unnecessary as the style changed little from its conception to its end c.1840.)

"One tries in vain," Percier and Fontaine wrote, "to find forms better than those we have inherited from Antiquity." Their Empire style was indeed based on antique models, as had been the **Directoire** style of 1795–99. It shared with the Directoire a vocabulary of simple, often angular and sharp-edged furniture shapes, but to those shapes it applied a new richness of ornament, always being careful to keep form and ornament distinct. Among the ornament were carved sphinxes, eagles, swans, bees, caryatids, terms, winged torches, and winged griffins. There were also monogram *N*s circled with laurel leaves.

Furniture types popularized by Percier and Fontaine included: the **lit en bateau,** a bed with curved, upturned ends, resembling a boat; the **méridienne,** a daybed or sofa with one end higher than the other; the ancient Greek **klismos** chair; the **psyche,** a tall mirror that could be tilted inside its frame, which stood on the floor; the **athénienne,** a tripod-based stand for a washbasin; and the circular **pedestal table,** often placed in the center of a room.

The most characteristic element of the Empire style, however, was the backdrop for these pieces:

walls crowned with entablatures (or at least cornices), articulated with columns or pilasters, and, between these articulations, plastered and painted in a semigloss polish or, more dramatically, draped. The most extraordinary wall treatments employed stretched, shirred, or loosely draped fabric filling the whole area from the bottom of the cornice to the top of the dado or baseboard. When the fabric was loosely draped, it was caught up at intervals and held with tassels and gold-headed nails. Josephine's bedroom at Malmaison, for example, was circular and represented the interior of a Roman emperor's military tent; its walls were draped in red silk that appeared to be supported by tent posts; the ceiling was also draped in cloth that was enriched with gold appliqué ornaments. Typical of many Empire bedrooms, Josephine's bed was placed with one of its long sides against the wall, and it, too, was given a tent-like drapery.

Empire doors had either square panels with center rosettes or rectangular panels with diamond shapes within them. Windows were hung with two or three sets of complex draperies with elaborate valances, fringes, tassels, jabots, and swags. The textiles were silk, wool, and cotton, all three often combined to cover one window. Marble mantels were severely classical with plain straight shelves. In palatial rooms, they were richly carved under the shelf and supported at the sides by caryatids or dwarf columns. In less grand rooms, the carving was often omitted, the sides were simple pilasters, and interest was maintained by the color and graining of the marble. The mantelshelf was usually furnished with an ormolu clock, perhaps with Grecian figures and covered with a glass dome. Floors were often left bare and were patterned with black and white marble squares or wood parquet; they might also be partly covered with Aubusson rugs or carpets from the Far East.

Accessories were classical or Egyptian in character. Many framed engravings and relief silhouettes of Napoleon's family and officers were used as indications of loyalty. These were combined with busts and statues, Greek vases, sphinxes, Pompeian bronze table lamps, and other objects. Wall sconces, torches, and hanging chandeliers were usually of bronze in designs adapted from Roman prototypes.

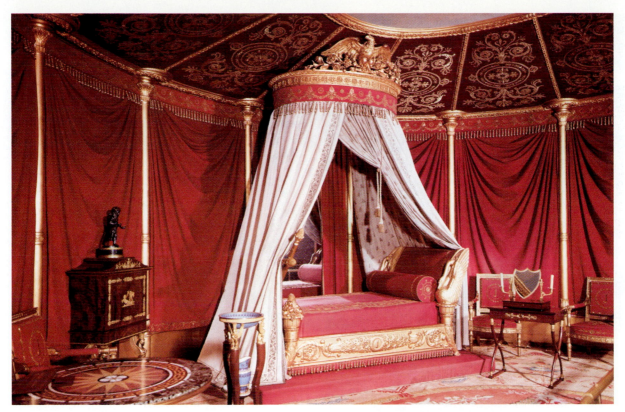

Figure 19–7 Josephine's tented bedroom at Malmaison, as decorated by Percier and Fontaine in 1810. The furniture is signed by French cabinetmakers F.-H.-G. Jacob-Desmalter and Martin-Guillaume Biennais.

GIRAUDON/ART RESOURCE, NY

The most popular wood for furniture was mahogany, but elm, yew, maple, and lemon were also used. Woods for veneers were imported from Africa, the West Indies, and the East Indies, such as thuya, amboyna, amaranth, palisander, and rosewood. Marquetry and fluting were completely avoided, but ebony, silver, and other metals were sometimes used for inlay, and gilding was often applied. Beneath the impressive surfaces, however, much of the furniture was made with inferior woods.

THE SECOND EMPIRE STYLE IN FRANCE

Napoleon Bonaparte's nephew Napoleon III would rule as president of the Republic from 1848 to 1852 and then as emperor of the Second Republic from 1852 to 1870. With his wife, the Empress Eugénie, Napoleon III's Second Empire would have its own glories.

The **Second Empire** welcomed the continuation of Empire design but combined it with elements taken from the Renaissance and Baroque periods. It still worshipped the antique, but with more romantic, less clear-eyed devotion. In decorating her own rooms at the château of Compiègne, Eugénie mixed Empire with Louis XVI and other styles.

It was under Napoleon III's Second Empire that Baron Georges-Eugène Haussmann began rebuilding the medieval street system of Paris into the wide radiating boulevards we know today, and monumental building programs of the time included the 1853–69 New Louvre by Louis-Tullius-Joachim Visconti and Hector-Martin Lefuel. It employed the Second Empire characteristics of mansard roofs with pedimented dormers and exterior and interior surfaces encrusted with French Renaissance detail.

Even more important was the 1861–75 Paris Opéra by Charles Garnier (1825–98). It lacked a mansard, but it amply demonstrated another important Second Empire trend, that of incorporating the work of painters, sculptors, and decorative

Figure 19–8 Around the grand staircase of the Paris Opéra designed by Charles Garnier, 1861–75, are marble columns and panels, bronze statues, and ornate stuccowork. At the top of the stairs, ivory caryatids guard the entrances to the boxes.

BILDARCHIV FOTO MARBURG

artists in interior design. The interior's sense of theatricality is by no means limited to its stage or even to its auditorium; the whole complex of lobbies, foyers, vestibules, and grand stairways is a stage set for the parade of Second Empire society (Figure 19–8). A later building by Garnier, which can also be said to be in Second Empire style although it was built during France's Third Empire, is the 1878–79 Casino at Monte Carlo. It incorporated remarkable mosaics and plasterwork.

THE REGENCY STYLE IN ENGLAND

When England's King George III became insane in 1811, his son began to rule as prince regent, be-

coming king when his father died in 1820. The official Regency, therefore, lasted hardly a decade, but the **Regency** period in design is generally considered to have begun as early as 1780, 1790, or 1800, and to have lasted until George IV's own death in 1830 or even longer. Like "Victorian," the term *Regency* has been applied to a wide variety of styles; its chief expression, however, was neoclassical.

The chief chroniclers of the Regency style were Thomas Hope and George Smith, whose books have already been mentioned. Hope's taste was formed in an extended grand tour of Greece, Turkey, Egypt, and Europe that lasted from 1787 to 1795, and while he was in Rome he commissioned from sculptor John Flaxman a set of more than a hundred illustrations for Dante's *Divine Comedy*. It was from their style, which Flaxman based on Greek vase paintings, that Hope adapted his own drawing style, dependent purely on outline, shadowless, and quintessentially neoclassical (Figure 19–9).

Two leading architects of Regency England were John Nash (1752–1835) and his rival Sir John Soane (1753–1837). Nash was responsible for a series of sedate stucco-faced row houses (called *terraces* in England), the Haymarket Theater, the conversion of Buckingham House into Buckingham Palace, and, for George IV, the Royal Pavilion at Brighton, which we shall see as an example of Anglo-Indian design.

Soane's great work was the Bank of England building in London, which was finished in 1823 and has been destroyed. Also notable was his own house in Lincoln's Inn Fields, London, which he left to the nation and which is now the Soane Museum, housing his fine collection of architectural drawings. In both buildings, the interiors are distinguished by Soane's virtuoso handling of spatial and lighting effects, combining shallow domes, vaults, lanterns, and hidden light sources (Figure 19–10, page 512). Although among the finest accomplishments of Regency style, Soane's rooms are too idiosyncratic to be considered typical or to have been widely copied. They did, however, reinforce the trend away from the plaster ornament of Adam toward smooth plaster walls painted in rather strong dark colors, such as browns and deep reds.

Figure 19–9 Thomas Hope's drawing of his gallery devoted to the display of a sculpture group by Flaxman. The figures are reflected in mirrors largely covered with satin curtains in blue, orange, and black.

PLATE VII, THOMAS HOPE, *HOUSEHOLD FURNITURE AND INTERIOR DECORATION*, 1807

Typical Regency rooms had a plain plaster ceiling as well, but many had curved coves joining ceiling and walls. Cornices and door and window frames were of straight classical molding, and a rather severe chimneypiece might be decorated only with a sculptured panel or a fluted frieze. Windows were often tall, reaching down to floor level. Marble busts of classical heroes and philosophers ornamented the rooms, often standing on short portions of column shafts.

In Regency furniture, mahogany continued its popularity, but was joined by lighter, more richly figured woods such as satinwood, rosewood, am-boyna, zebrawood, and maple. The doubly curved cabriole leg and the straight leg were replaced by the singly curved sabre leg recalling the Greek klismos (Figure 19–11). Ornament included lyres, palmettes, Greek frets, and acanthus leaves. Among the skillful Regency cabinetmakers was Charles Wyllys Elliott, who was working in London in the years 1783–1810. Satinwood was his favored wood, which he enhanced with delicate inlays.

NEOCLASSICISM IN IRELAND Neoclassical design in Ireland was led by James Gandon, a pupil of William Chambers who lived in Ireland

Figure 19–10 The breakfast room of Sir John Soane's house at Lincoln's Inn Fields, London. Around the dome lantern is a ring of convex mirrors, and the far wall is lighted from a concealed source.

1820. In design, it was a neoclassical period, strongly influenced by the "mother country" of England despite the struggles to overthrow English rule, influenced also by France, and retaining some of the conservative character of the country's colonial past. Another influence, discussed in the previous chapter, was Thomas Jefferson's Virginia State Capitol, a deliberate attempt to establish Roman architecture as a model for the important buildings of the young nation.

In Federal interiors, the influences of Adam, Hepplewhite, and Sheraton were clear, as well as those of Thomas Hope. Decorative motifs referred to both antiquity (urns, swags, Roman fasces) and the new government (eagles, the cap of Liberty). Architect and carver Samuel McIntire did his finest work in the first decade of the nineteenth century, including the John Gardner house of 1804–5 in Salem, Massachusetts, mentioned in chapter 18 and featuring finely ornamented mantelpieces, and Hamilton Hall of 1808–9, also in Salem, an assembly hall named for statesman Alexander Hamilton.

Duncan Phyfe continued his distinguished career as a furniture designer, doing his finest work in the first three decades of the century. His prestige was so great that his name was attached to particular furniture types—the Phyfe card table, the Phyfe sideboard—even when they were made by

from 1781, and James Wyatt, who in 1790 began work on Castlecoole in County Fermanagh. The house was finished c. 1797 and furnished in the first quarter of the nineteenth century. Plasterwork was by Joseph Rose, Jr., who had worked for Robert Adam; chimneypieces were by London sculptor Richard Westmacott, and furniture was commissioned from John Preston, a leading Dublin upholsterer. Among the well-proportioned rooms, the oval saloon (Figure 19–12) is the most outstanding.

THE FEDERAL STYLE IN AMERICA The federation of the American colonies, after their successful revolution, came in 1787, and what is now called the **Federal** period lasted from then until c.

Figure 19–11 Front and side views of a Regency chair design by Thomas Hope. It is obviously based on the Greek klismos, but winged lions have been added to support the arms.

PLATE XI, THOMAS HOPE, *HOUSEHOLD FURNITURE AND INTERIOR DECORATION*, 1807

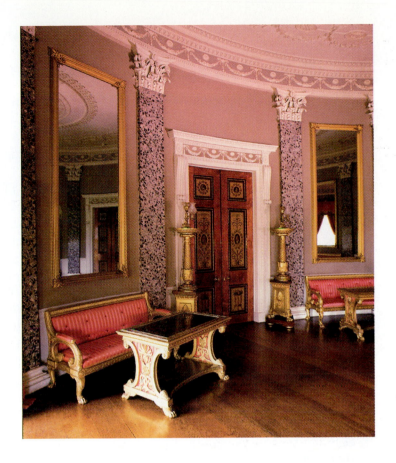

Figure 19–12 James Wyatt's oval saloon at Castlecoole, County Fermanagh, Ireland, c. 1797. The so-called Grecian furniture with brass inlay was supplied by John Preston of Dublin in the 1810s and 1820s.

PATRICK PRENDERGAST/THE NATIONAL TRUST PHOTOGRAPHIC LIBRARY, LONDON, ENGLAND

his competitors. In addition to the lyre motif, already mentioned, he employed cornucopias, swags, acanthus leaves, bowknots, fluted colonettes, and other neoclassical elements in his designs, but applying them all with restraint. A room in the Winterthur Museum (Figure 19–13) conveys the elegance of a Federal room furnished chiefly with Phyfe pieces. As his business prospered, he came to employ more than a hundred workers including, according to Charles F. Montgomery, "cabinetmakers, chairmakers, turners, upholsterers, inlay makers, and carvers and gilders." After c. 1830, however, Phyfe's touch grew heavier and his designs less pleasing.

Phyfe's only rival as the supreme furniture designer of his day was a talented French **ébéniste** Charles-Honoré Lannuier (1779–1819), who arrived in America in 1803 and settled in New York, producing finely crafted pieces in a delicate version of the Empire style (Figure 19–14). Lannuier's rich palette of materials included rosewood, ormolu, and white marble.

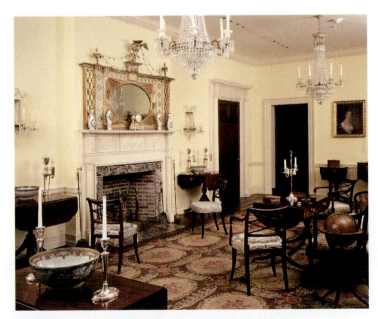

Figure 19–13 The Duncan Phyfe room at the Winterthur Museum near Baltimore houses a set of chairs and a cane-backed sofa made by Phyfe in 1807. They are upholstered in pale blue and gold silk lampas.

COURTESY WINTERTHUR MUSEUM

THE NINETEENTH CENTURY 513

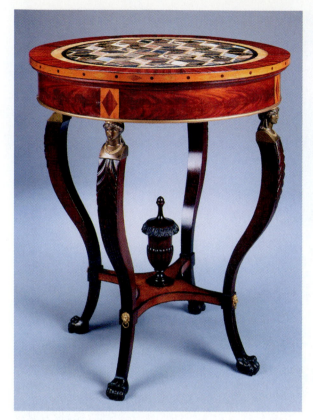

Figure 19–14 Small marble-topped mahogany center table or **guéridon** by Charles-Honoré Lannuier, c. 1810, now in the White House, Washington, D.C., 26 inches (66 cm) in diameter.

MAKER: HONORÉ LANNUIER. MAHOGANY, AND MAHOGANY, ROSEWOOD, SATINWOOD, AND POSSIBLY SYCAMORE VENEERS, "VERT ANTIQUE," GILDED BRASS, MARBLE; SECONDARY WOODS: YELLOW POPLAR, WHITE PINE AND MAHOGANY. H. 29¾ IN. (75.6 CM). DIAMETER 26 IN. (66 CM). THE WHITE HOUSE, WASHINGTON, D.C. GIFT OF MR. AND MRS. C. DOUGLAS DILLON (961.33.2). PHOTOGRAPHY BY BRUCE WHITE.

Other Federal furniture designers and cabinet-makers included John Seymour (c. 1738–1818), who was born in England but came to the United States in 1785 and settled in Boston in 1794; Seymour's son Thomas, who became his partner; Stephen Badlam (1751–1815) of Dorchester Lower Mills, Massachusetts, one of the few Americans to identify his furniture with a stamp; and Michael Allison (died 1855) of New York, whose company flourished for almost the whole first half of the century and who worked with highly figured mahogany veneers.

As a footnote to the Federal style in America, we should mention the furniture of Lambert Hitchcock (1795–1852) of Connecticut. He took the elegant frame of Federal chairs, particularly those based on Sheraton models, painted them

black, gave them cane or rush seats, and added (sparingly) gold or bronze stencils of fruit and flower decoration (Figure 19–15). The Hitchcock chair was introduced in 1818, and in the 1820s and 1830s it was the most popular chair on the American market, with as many as 15,000 manufactured per year. Case goods, clocks, and mirror frames were later added to the Hitchcock line.

KARL FRIEDRICH SCHINKEL AND NEO-CLASSICISM IN GERMANY

When Frederick William II began his reign in 1786, he instituted a program of building in the neoclassical style, employing architect Carl Gotthard Langhans and others. Some of Langhans's interiors were for the Winter Apartments at Schloss Charlottenburg, 1795–97, near Berlin; they used unpainted paneling with restrained ornament. For the Potsdam Stadtschloss in 1803, the brothers Ludwig Friedrich Catel and Franz Ludwig Catel designed an Etruscan Room, painted with figures taken from

Figure 19–15 A painted and stenciled side chair by Lambert Hitchcock, c. 1830.

COURTESY, WINTERTHUR MUSEUM

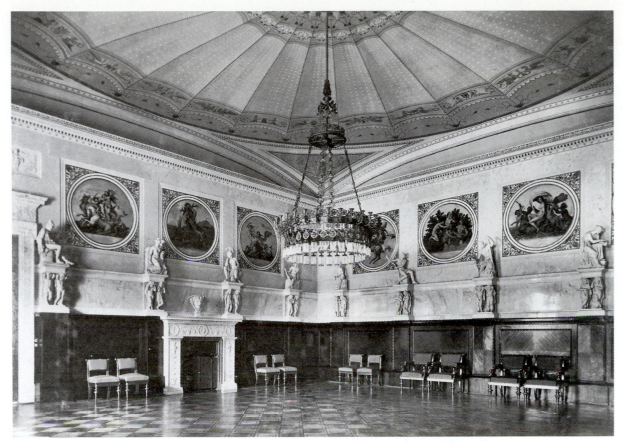

Figure 19–16 Karl Friedrich Schinkel's tea salon in the Konigliches Schloss, Berlin, c. 1825, now destroyed.

Greek vases. And during Napoleon's occupation of Germany the Empire style was naturally imported from France.

Germany's great neoclassicist, however, and one of the outstanding architects of the nineteenth century was Karl Friedrich Schinkel (1781–1841). He made trips to Italy in 1803 and 1824 to study Roman ruins, and he traveled to London in 1826 to see Sir Robert Smirke's British Museum, then under construction, as was his own Altes Museum in Berlin. His interiors included apartments for Crown Prince Frederick William in the Königliches Schloss, designed c. 1825. Walls in the tea salon were divided into panels into which circular paintings of mythological scenes were set, and further articulation came from classical figures atop shallow pilasters; the ceiling's shallow dome seems Adamesque (Figure 19–16). These and many other Schinkel interiors have been destroyed. Some that remain were for a royal summer house of 1824 in the park of Schloss Charlottenburg. Originally called the Neue Pavillon it is now open to the public as the Schinkel-Pavillon. Here a tent room is draped in blue-and-white-striped linen twill, and a bedroom for Queen Louise has pink wallpaper behind filmy drapes of white mousseline. The queen's bed (Figure 19–17) uses motifs from the *Recueil . . .* of Percier and Fontaine. Schinkel's meticulous etchings of his built and unbuilt work were published twenty-five years after his death as *Sammlung Architektonischer Entwürfe* (Collection of Architectural Drawings).

These early and rigorously accurate examples of neoclassicism gave way, however, to a more casual style, the Biedermeier.

THE BIEDERMEIER STYLE IN AUSTRIA In the early nineteenth century the government of

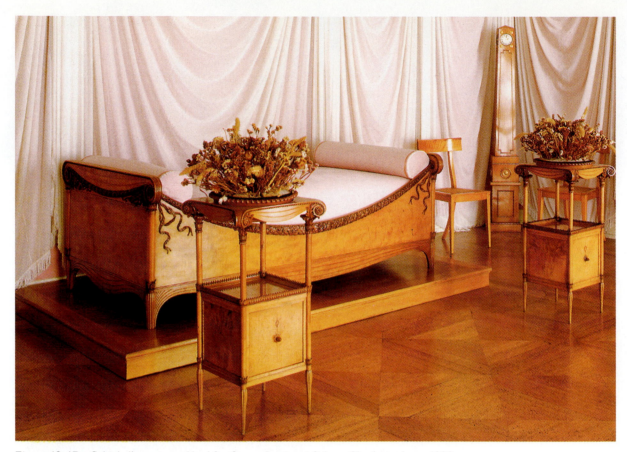

Figure 19–17 Schinkel's pearwood bed for Queen Louise at Schoss Charlottenburg, 1809.

Austria acted to prevent a local recurrence of the revolutions in America and France. Quiet family life in place of public discourse was encouraged by state controls and censorship, and these homely virtues came to be personified for the public by a completely fictional and comic character called Papa Biedermeier, pictured as stout, self-satisfied, and full of misinformation. The **Biedermeier** style, which became popular also in Germany and Scandinavia, disdained grandeur and the slavish copying of classical precedent. Such precedent is its inspiration, but it is careless of detail. Its products are sometimes charming, sometimes clumsy, sometimes both (Figure 19–18). Biedermeier furniture employed mostly light-colored woods such as pear, cherry, apple, birch, or maple, against which small ebony half columns or palmettes might be set as ornamentation, making a striking contrast.

Perhaps the most skillful and certainly the most prolific of the Biedermeier designers was Joseph Danhauser (1780–1829) of Vienna, whose large factory, established in 1807 and active until his death, also produced furniture in the more sophisticated Empire style and produced clocks, curtains, and lighting fixtures as well. One Danhauser customer was Archduke Charles of Austria, who commissioned many Empire pieces for his town house in Vienna, now the Albertina Museum, where a comprehensive collection of old master drawings can be seen. Danhauser also furnished the Schloss Weilburg in Baden, but his chief customers were the members of the middle class. Biedermeier was their style, and it was not a subtle one. It took the refined ornamental shapes of Empire furniture, such as volutes, lyres, and half columns, and enlarged them into structural members. Like Papa Biedermeier, it was often amusingly pompous.

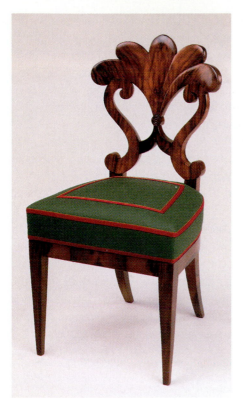

Figure 19–18 A walnut and walnut-veneer side chair in the Biedermeier style from the factory of Joseph Danhauser, 1815–20.

But it could also be refreshingly simple. Plain surfaces and smooth forms were the rule. Walls were often painted a single color or papered in striped patterns, with painted or papered dadoes and cornices in complementary colors. Plants were a favorite element of the Biedermeier interior. In humble circumstances, they could be displayed in clay pots; in richer ones, rooms were given conservatories or "winter gardens."

THE GUSTAVIAN STYLE IN SWEDEN AND NEOCLASSICISM IN THE NORTH The **Gustavian** style of the late eighteenth century, named for Gustav III, who reigned from 1771 to 1792, first brought neoclassical ideas to Sweden. Unlike some rulers for whom styles are named, Gustav was very interested in the visual arts and largely responsible for his namesake style. When he was still the crown prince, he commissioned a drawing-room interior from Jean Eric Rehn (1717–93) who had studied in Paris before returning to his native Stockholm; Rehn also designed interiors for Gustav's brother and sister. With the Gustavian style as its base, neoclassicism was firmly established in Sweden, its strictest representative being architect Carl Fredrik Sundvall (1754–1831), who decorated a large manor house, Stiernsund in Närke, in 1800 with sculpture-filled niches and painted relief friezes. Fredrik Blom (1781–1853), who went on study trips to Russia (St. Petersburg), Italy, France, Germany, and England, designed interiors for Rosendal Palace (Figure 19–19) and for

Figure 19–19 Designed by architect Fredrik Blom for Marshall Bernadotte, who became King Karl XIV, the saloon at Rosendal Palace, Stockholm, 1823–27. The walls are hung with silk beneath a wallpaper frieze imported from France. The white cylinder in the corner is a stove.

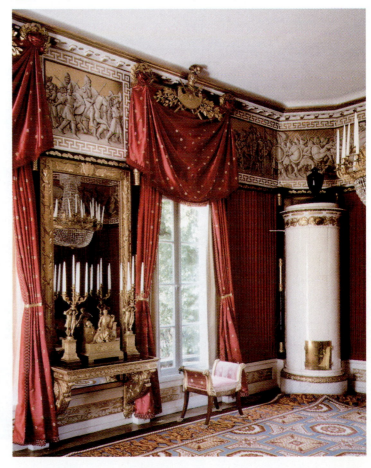

the royal country house, Rosersberg. Anders Hult-gren (1763–1838) designed interiors for Rosersberg and for the summer palace, Tullgarn.

The Romance of the Long Ago

Although neoclassicism had as its goal the revival of design from ancient Greece and Rome, it did so because such design was believed to have been based on timeless principles of proportion and composition. Far different were the romantic revivals that coexisted with neoclassicism, which sought to revive old forms and styles because of their novelty or charm or—in the case of the Gothic Revival—their association with religion. These revivals proliferated in the nineteenth century, often competing for attention on the same city block or within the same house.

THE GOTHIC REVIVAL The Gothic style had never completely disappeared from Europe since its peak of accomplishment ending in the sixteenth century. Historians call Gothic design in the two centuries from c. 1550 to c. 1750 **Gothic Survival** and anything after 1750 **Gothic Revival**.

A. W. N. Pugin was the great scholar and advocate of Gothic Revival. His most notable work was interiors for London's Houses of Parliament (Figure 19–20), which he designed between 1836 and 1852 in collaboration with the building's architect, Charles Barry, and with the help of John Gregory Crace. Crace was a member of the family that ran the decorating firm that, for most of its 131-year history from 1768 to 1899, was the most important in England; for the Houses of Parliament his contributions included wallpapers, carpets, decorative painting, and some furniture.

Figure 19–20 The House of Lords, Palace of Westminster, London, designed by A. W. N. Pugin with Charles Barry and John Gregory Crace, finished in 1847.

English Gothic Revivalists of the decades 1860–80 considered themselves **Reformed.** Rather than the rich ornament of Pugin and Crace, they developed an interior style of simply cut oak carvings in both paneling and furniture, and rather than paper their walls with bright patterns, they hung them with wool fabric in deep, muted colors such as rusts, ochres, and earthy greens. Wainscoting was popular, too, as were graining and stenciling. Among the Reformed Gothicists were the architects G. E. Street and Richard Norman Shaw and the designer William Morris. Morris, as we shall see, would soon discard his Gothicisms but keep his simplicity as he developed the Arts and Crafts style.

Too young to have had a Gothic past of its own, the United States was also enthusiastic for the style. Benjamin Henry Latrobe designed the first Gothic Revival house in America, the 1799 Sedgeley for Philadelphia merchant William Crammond. A. J. Davis designed and furnished Lyndhurst in Tarrytown, New York, in 1838–42. Countless Gothic Revival churches were built throughout the United States and Canada, and the style can be said to have culminated, but not ended, with St. Patrick's Cathedral in New York (1858–88) designed by James Renwick.

Although the Gothic Revival was centered in England and the United States, it had later and less enthusiastic counterparts in other countries: in France, where it was called *néo-gothique* or *le style Troubadour;* in Italy (*neogotico* or *Dantesque*); and in Germany (*Neugotik*). The style was also employed in the University at Glasgow, the Town Hall in Vienna, and the Houses of Parliament in Budapest.

THE GREEK REVIVAL All neoclassicism, including the Empire and Regency styles, is in part a revival of Greek design principles, but until c. 1790 the focus was on those principles as they had been revealed through Roman examples. The Greek Revival was a style apart, rejecting the Roman models and preferring the relative gravity, strength, and simplicity of their Greek antecedents. Although it was never advocated with the religious fervor that attached to the Gothic Revival, the Greek Revival was considered the proper expression of civic virtues and therefore the correct style for the build-

ings and interiors of government. Beiges and pastels were considered appropriate interior colors, and marble, gilding, stenciling, and ornamental plasterwork were used.

The term **Néo-Grec** is not, as might be expected, a synonym for the Greek Revival, but denotes a phase of Second Empire design in France. It was based on the neoclassical repertory of Greek and Roman forms, with special emphasis on the style of Pompeii and with more than a dash of Egyptian Revival.

THE EGYPTIAN REVIVAL The earliest imitators of the distinctive style of the ancient Egyptians had been their Roman conquerors, and through Rome's imitations such features as the sphinx and the obelisk had become accepted adjuncts to the classical and neoclassical vocabularies, so familiar that their origins were sometimes forgotten. From then until today, Egyptian imagery has never been long absent from architecture and interior design, its potency occasionally refreshed by new archaeological discoveries. An Italian example from the 1760s was Giovanni Battista Piranesi's interior for the Caffé degli Inglesi in Rome's Piazza de Spagna; Piranesi's murals were painted in the Egyptian style, using decorative elements he had seen in the collections of the Vatican.

The nineteenth-century **Egyptian Revival** owed its impetus to another conqueror, Napoleon. His successful campaign in Egypt was waged in 1798, causing much excitement in France. Napoleon fueled his nation's interest by taking with him not only an army of soldiers but also a second army of surveyors, scholars, and artists to study and record the wonders they found. Two publications that resulted were Baron Vivant Denon's 1802 *Voyage dans la Basse et Haute Égypte pendant les campagnes du Général Bonaparte* and the monumental *Description de l'Egypte*, published in twenty magnificently illustrated volumes between 1809 and 1828. Appropriately styled bookcases were also available to hold the folios of the *Description* (Figure 19–21): an example of the folios' draftsmanship is seen in Figure 2–4. Percier and Fontaine had also offered Egyptian models for secretaries and clocks in their 1801 publication *Recueil de décorations intérieures.*

Figure 19–21 Wood carving on a corner of a bookcase designed for the twenty-volume set of the *Description de l'Égypte*. It was made between 1813 and 1836 by French cabinetmaker Charles Morel after designs by Edme-François Jomard.

The decorative arts rushed to produce designs in the style so clearly set before them. Charles Percier designed a suite of furniture for Baron Denon himself, made by F.-H.-G. Jacob-Desmalter. France's Sèvres porcelain factory produced a *Vase égyptien* and in 1810–12 an entire Egyptian dinner service, which was considered quite scholarly in design, apart from its phony hieroglyphic writing. Given by Louis XVIII to the first Duke of Wellington, the *Service égyptienne* is now at Apsley House in London.

Chimneypieces (Figure 19–22), andirons, clocks, candelabra, glassware, and silver also appeared in Egyptian guise, and the fashion spread from France to Germany, England, and elsewhere. Egypt also found a presence in the theater: Mozart's last opera, *Die Zauberflöte*, first produced in Vienna in 1791, was given exceptional sets of

Egyptian character by Karl Friedrich Schinkel for an 1816 production in Berlin.

THE ROMANESQUE REVIVAL The **Romanesque Revival**, like its eleventh-and-twelfth-century models, was a style of spare ornament, large masonry expanses, round-headed arches, and barrel vaults. In its interiors, this strong architecture was supplemented with natural wood wainscoting, stained glass, decorative tiles, and murals. The style is associated chiefly with the work of one architect, the American Henry Hobson Richardson (1838–86), but it had appeared earlier in western Europe. In England, where the style was known as the **Norman Revival**, Thomas Hopper's Penrhyn Castle of 1822 was an early example

Figure 19–22 Chimneypieces designed in the Egyptian Revival style by English architect George Wightwick (1802–72), who also worked in the Gothic and Italianate styles.

Figure 19–23 The hall of H. H. Richardson's Warder house, Washington, D.C., 1885–87, with its Romanesque round-headed stone arches.

with impressive spatial effects, but the style was used in England mostly for churches and prisons. In Bavaria, Leo von Klenze had based a church of 1826–37 on the Romanesque Cappella Palatina (Palatine Chapel) in Palermo (Figure 7–5), and in France Emile Vaudremer used Romanesque elements in his church of St.-Pierre de Montrouge of 1864–70. Richardson may have seen Vaudremer's design, as well as original Romanesque examples, during his stay in Paris from 1860, when he began to attend the Ecôle des Beaux-Arts, until 1865.

On his return to America, Richardson's first major work was Trinity Church (1872–77) in Boston, which contained stained glass by Edward Burne-Jones and Henry Holiday. Other well-known works were railroad stations for the Boston and Albany Line and the Marshall Field Warehouse (1887) in Chicago. He also made contributions to the development of residential architecture; his houses in Boston, New York, and Washington, D.C. (Figure 19–23) demonstrated the charms of simple forms, informal planning, and casually rambling masses with freely organized fenestration and wide sprawling verandas. Richardson's work encouraged a proliferation of miniature Romanesque castles in city and country residential construction throughout the American Northeast and Midwest.

THE RENAISSANCE REVIVAL The name **Renaissance Revival** was used in the nineteenth century for buildings, interiors, furniture, ceramics, and enamels based mostly on Italian Renaissance

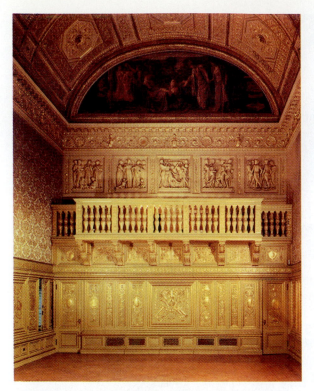

Figure 19–24 The gold-encrusted Music Room of McKim, Mead, and White's Villard Houses, New York, 1882–85. The paintings in the lunettes are by John La Farge. The room is now the site of the Le Cirque 2000 restaurant designed by Adam Tihany.

PHOTO: CERVIN ROBINSON

models, its chief model being the Palazzo Farnese in Rome, although in practice it was fairly eclectic. The style was a particular favorite for club buildings, such as Charles Barry's Travellers Club (1829–32) and Reform Club (1837–41), next-door neighbors in Pall Mall, London; Leonard Terry's Melbourne Club, Melbourne, Australia, built in 1859 and enlarged in 1883; and McKim, Mead, and White's Century Club (1891) and University Club (1899), both in New York.

McKim, Mead, and White also turned to the Renaissance for some important residential work, such as the Villard Houses in New York, 1882–85, a complex of six town houses, of which the largest was for Henry Villard (Figure 19–24). Among other residential examples of Renaissance Revival style was Detlef Lienau's 1869 château for LeGrand Lockwood at Norwalk, Connecti-

cut, with interiors by French emigrant Leon Marcotte and by German emigrants Gustave and Christian Herter. Herter Brothers, as their firm was called, was in business from 1859 to 1906, offering both interior design services and interior components. In 1878 they advertised "Furniture, Decoration, Gas Fixtures . . . recent importations of Fine French and English paper hangings. Rich Japanese silk brocades, Rare oriental embroideries, French moquette carpets" and a "stock of upholstery goods and curtain material." The wealthy clients of Herter Brothers included J. Pierpont Morgan and William H. Vanderbilt of New York and Mark Hopkins and John D. Spreckels of San Francisco, and they also designed interiors for New York's Union Club and St. Regis Hotel, and provided ornamental plasterwork and woodwork for all the major public rooms of the White House.

Renaissance Revival furniture had much success, particularly in the United States, where it was popularized not only by the Herter brothers but also by two designers with French backgrounds, A. Baudouine and Alexander Roux. They mixed motifs from the sixteenth, seventeenth, and eighteenth centuries, from Italy and France, producing some astonishing pastiches (Figure 19–25), although Baudouine's immense output (he employed two hundred in his New York cabinetmaking shop) also included some simplified versions of Louis XV furniture.

German-born John Henry Belter was another successful American furniture maker whose designs revived Renaissance and Rococo styles, but his fame is based less on his design (Figure 19–26) than on his technical innovations. Rosewood was the most popular wood for Renaissance Revival furniture, and the style was considered particularly suitable for dining rooms. Upholstery and draperies were elaborate, and colors were rich: reds, browns, blues, and purples.

The Romance of the Far Away

The nineteenth-century taste for the exotic was not limited to past styles. It also acknowledged the appeal of cultures that were contemporary but remote. These deliberately foreign styles were often

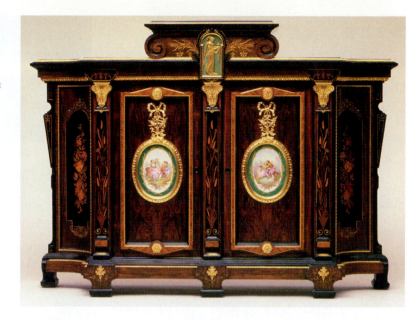

Figure 19–25 Renaissance Revival rosewood cabinet by Alexander Roux, 4 feet 5 inches (1.36 m) tall.

WOODWORK-FURNITURE. AMERICAN, NEW YORK. 19TH CENTURY, CA. 1866. CABINET. RENAISSANCE REVIVAL STYLE. MAKER: ALEXANDER ROUX (ACTIVE 1837–1881), NEW YORK CITY. ROSEWOOD, EBONY, PORCELAIN, GILT BRONZE. H. 53⅜ IN. (135.5 CM). W. 73⅜ IN. (186.4 CM). D. 18⅜ IN. (46.7 CM). THE METROPOLITAN MUSEUM OF ART, PURCHASE, THE EDGAR J. KAUFMANN FOUNDATION GIFT, 1968. (68.100.1) PHOTOGRAPH BY SCHECTER LEE (1970.321)

freely mingled with one another or with more classical elements.

THE ANGLO-INDIAN STYLE

The Anglo-Indian style is most closely identified with the Royal Pavilion at Brighton, England. There between 1815 and 1822 court architect John Nash took an existing building by Henry Holland, added a banqueting room at one end and a music room at the other, both more palatial in size than any of the original rooms, and changed its character totally. Nash's new exterior, though exhibiting classical symmetry, is thoroughly Indian in its details, such as the subtly curved domes, the minarets, the stone trellises or **jalis,** and the rows of columns on the facade.

Inside, the inspiration is less clear, Indian elements having been freely mixed with those of China and many other places (Figure 19–27). Some rooms, including one finished in bamboo and another in black and gold, have tent-shaped ceilings (Figure 19–28, page 525). A theme throughout is the palm tree, appearing as small columns in the window bays of some rooms and as giant ones in the Great Kitchen; in this last case they are of cast iron with fronds made of sheets of copper. In addition to Nash's work, parts of the pavilion's interior were designed by Frederick Crace, another member of the famous Crace family, who would later do decorative painting and gilding at Windsor Castle in the Gothic Revival and "Old French" styles.

Anglo-Indian furniture was also popular in Europe. Its precedents were Indian pieces brought back by Portuguese settlers in India in the sixteenth and seventeenth centuries and by Dutch settlers in the seventeenth and eighteenth. In the

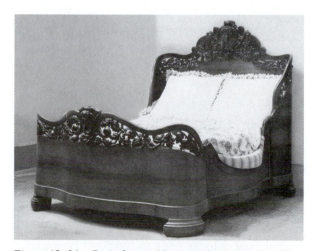

Figure 19–26 Bed of carved laminated rosewood by John Henry Belter, c. 1856.

COURTESY OF THE BROOKLYN MUSEUM OF ART, GIFT OF MRS. ERNEST VICTOR

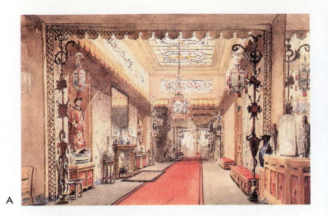

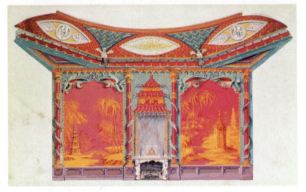

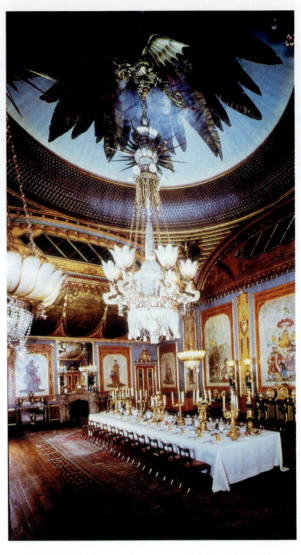

Figure 19–27 (a, b, c) Three images from John Nash's Anglo-Indian Royal Pavilion, Brighton. (a) A watercolor sketch of the corridor by A. W. N. Pugin, before 1820. (b) A design drawing made c. 1817 by Frederick Crace for a wall and part of the ceiling of the music room. (c) The banqueting room.

(A) COURTESY ROYAL PAVILION. (B) FREDERICK CRACE (ENGLISH, 1779–1859). DESIGN FOR THE WEST WALL OF THE MUSIC ROOM, ROYAL PAVILION, BRIGHTON, 1801–1804. BRUSH AND WATERCOLOR, GOUACHE, OVER GRAPHITE ON WHITE WOVE PAPER. 33.6 X 51.1 CM (13⅛ X 20⅛ IN.) WITH ADDITIONAL PIECE 49.0 x 46.1 CM HINGED AT TOP. COOPER-HEWITT, NATIONAL DESIGN MUSEUM, SMITHSONIAN INSTITUTION/ART RESOURCE, NY. PURCHASE IN MEMORY OF MRS. JOHN INNES KANE, PHOTO: SCOTT HYDE. 1948-40-9–A,B. (C) ROYAL PAVILION LIBRARIES AND MUSEUMS, BRIGHTON, ENGLAND, U.K.

nineteenth century, when Britain was the dominant colonizer in India, Anglo-Indian furniture, though chiefly made in India, was a mixture of design from both countries. Sometimes referred to as **raj furniture** (*raj,* the Hindu word for "reign" having been applied to British rule), such furniture typically had heavy carved wood frames but, for comfort in the intense heat of India, seats and backs of caning (Figure 19–29). Other characteristics were ivory or mother-of-pearl inlays and construction joined with wooden pegs to prevent problems with glue that dried out after shipping to a new climate.

THE MOORISH STYLE Closely related to the Anglo-Indian style of the Royal Pavilion, the Moorish style of the nineteenth century focused on the architecture and decoration of the Muslim inhabitants (the Moors) of northern Africa and southern Spain, more than that of the Muslims in India.

Fascination with Moorish design had long existed. In 1856 the English architect Owen Jones's *Grammar of Ornament* argued that the Moors were the inventors of fundamental principles of pattern and color use. Jones designed tiles in Moorish style for the Minton ceramic factory and a Moorish ceiling for his own house in London.

The Moorish style was employed throughout the Western world in architecture for hotels, theaters, and synagogues (perhaps to suggest the non-

Figure 19–28
Section through the Royal Pavilion, Brighton, as redesigned by John Nash, 1815–22. The room in the center is the banqueting room.

JOHN NASH, *THE ROYAL PAVILION*

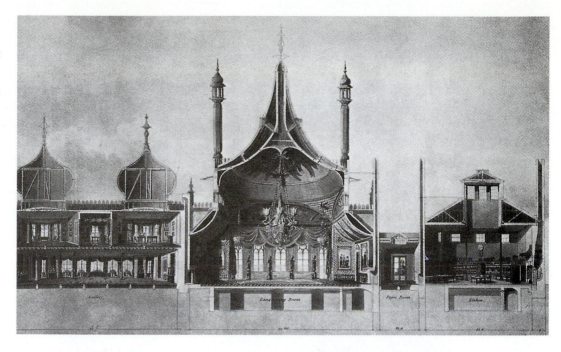

Figure 19–29 A late-nineteenth-century rosewood settee with cane seat and back in the Anglo-Indian style.

MIKE BELL ANTIQUES & REPRODUCTIONS

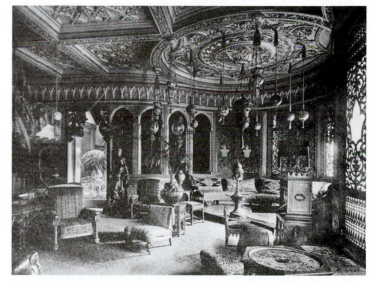

Figure 19–30 The Turkish Room in the John D. Spreckels house, San Francisco, designed by the Herter Brothers before 1900.

SAN FRANCISCO HISTORY CENTER, SAN FRANCISCO PUBLIC LIBRARY

European origins of Judaism). In interiors it has been thought especially appropriate for masculine retreats such as smoking rooms and billiard rooms. An example is the 1900 Turkish Room designed by Herter Brothers for the Spreckels mansion in San Francisco (Figure 19–30).

FAR EASTERN STYLES By the beginning of the nineteenth century, the Western world's love affair with the design of China and Japan (or with what Westerners imagined to be the design of

China and Japan) had already been a long one. London's International Exhibition of 1862 introduced Japanese design to many who had been unaware of it, including Christopher Dresser (1834–1904), who traveled throughout Japan in 1877 collecting merchandise for Tiffany and Company. His own austere

THE NINETEENTH CENTURY 525

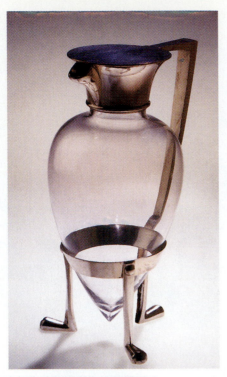

Figure 19–31 Christopher Dresser design for a claret jug, glass with silver mounts, 1879.

later work, such as metalwares with exposed rivets (Figure 19–31), would show his admiration both for Japanese simplicity and for undisguised industrial processes.

THE COMBINATION OF STYLES The nineteenth-century revivals outlined above were sometimes applied with considerable purity. More often, however, they were mixed and mingled with one another, producing stews flavored with every spice in the cabinet. Near the end of the century, however, came two styles that (although not unrelated to other styles) were relatively independent, original, and pure: the Arts and Crafts movement and Art Nouveau. Linking the two was the Aesthetic Movement. And within these movements was some design that would lay the foundations for the modernism that was to come.

The Arts and Crafts Movement

The **Arts and Crafts** movement can be considered another revival, not of any specific visual ex-

pression, but of a way of working: in an age of increasing industrialization, it sought to bring back handicrafts and to heighten the pleasure of the individual worker—a pleasure, it was thought, not possible in the factory. The movement's goal, in the words of one of its chief propagandists, painter and designer Walter Crane (1845–1915), was to "turn our artists into craftsmen and our craftsmen into artists." Eventually, of course, it did develop a distinctive visual character of its own—simple, solid, and more at home in a country cottage than in an urban mansion. Natural oak and redwood were used, colors were light earth tones (greens, tans, rust), floors were covered with wood, decorative tile, linoleum, and small area rugs, and furniture was plain, sturdy, and relatively sparse.

A precursor of the Arts and Crafts style was a group of English painters and designers called the Pre-Raphaelite Brotherhood, founded in 1848 by William Holman Hunt, John Everett Millais, and Dante Gabriel Rossetti. They shared a meticulously realistic technique, a resolve to be true to nature, and an admiration for Italian painting before the time of Raphael. Their ideas won the support of Ruskin and the admiration of the young William Morris (1834–96) who took from them his rather romantic view of the Middle Ages.

In 1859 architect Philip Webb (1831–1915) designed for Morris and his wife the first expression of what would come (after 1887) to be called the Arts and Crafts movement: the Red House on the outskirts of London. Named for its red bricks and red tiles, the house was not historicist (although there were some simplified echoes of the Gothic), yet it did not seek to completely overthrow tradition. The Red House's forms and decorations were derived instead from practical considerations, from an honest use of new developments such as iron beams and sash windows, and from a shared love of fine craftsmanship (Figure 19–32). The cooperative efforts of Webb, Morris, and their friends at Red House led to the formation in 1861 of a firm called Morris, Marshall, Faulkner, and Company that produced stained glass, wall hangings, wallpapers, fabrics, fireplaces, paneling, and furniture for other clients; after 1875 it would be called Morris and Company.

Other Morris residential interiors included those for his own country house, Kelmscott Manor, and for Standen in Sussex, also designed by Philip Webb

(Figure 19–33). For St. James's Palace, London, Morris decorated the Armoury, the Tapestry Room, the Throne Room, and other interiors, and he designed a dining room for the South Kensington Museum, now the Victoria and Albert.

Morris designed the first of his more than fifty wallpaper patterns in 1861, and in 1879 he began to weave tapestries. By then he had also tried his hand—almost always successfully—at furniture design, embroidery, glass, poetry, and politics, expressing in this last field his strong socialist ideas. In 1877 he founded the Society for the Protection of Ancient Buildings, and in 1888, with the founding of the Kelmscott Press, he entered the fields of book design and typography.

The greatest artistic achievements of Morris, among all these fields, were probably his skillful flat patterns, often floral in inspiration, for carpets, papers, and fabrics (Figure 19–34, page 529). But his most lasting contribution was his influence on the whole Arts and Crafts movement and on the general public. His standard for himself and for others, expressed in an 1880 lecture called "The Beauty of Life," was to "[h]ave nothing in your house that you do not know to be useful, or believe to be beautiful."

The English Arts and Crafts movement's effect on the continent of Europe was surprisingly faint, unless one includes the Germans' attention to their own national roots after the country's unification in 1871 and the Secession movement in Austria, which is better thought of as a branch of the Art Nouveau.

In the United States, however, the movement was taken up with enthusiasm. It seemed to flow

Figure 19–32 Stair hall, Red House, by Philip Webb, 1859. The simple oak stair has tall newel posts. The large cupboard with attached seat was painted by Edward Burne-Jones.

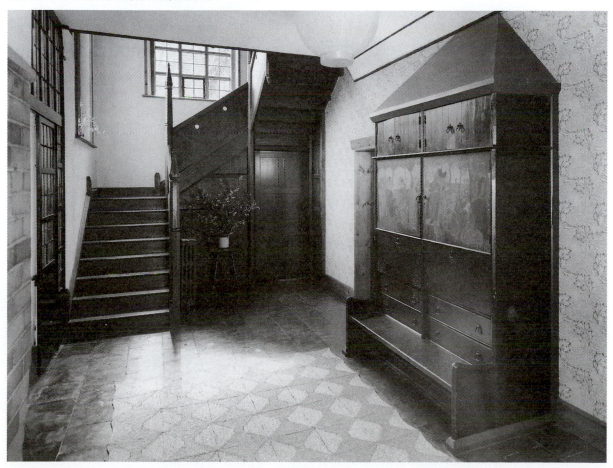

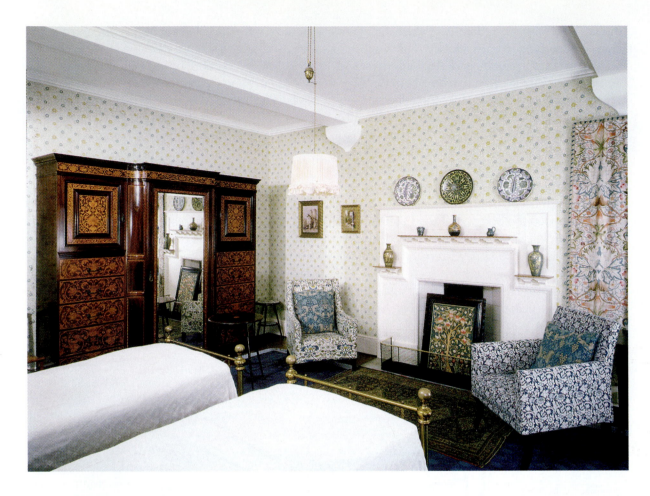

A

B

C

Figure 19–33a, b, c (a) Detail of William Morris's design for the north bedroom at Standen, Sussex, 1892, and two of its components. (b) The printed cotton chair upholstery is "Lodden" of 1884. (c) The wallpaper is "Powdered" of 1874 by William Morris (1834-96). Private Collection/The Stapleton Collection.

Figure 19–34 William Morris's "Kennet" fabric pattern of 1883 in two versions: as a silk damask in gold and gray (left); as a printed cotton in blue and yellow (right).

LEFT: WILLIAM MORRIS, "KENNET" (1883). SILK DAMASK. ACCESSION NO. T.11810. THE WHITWORTH ART GALLERY, THE UNIVERSITY OF MANCHESTER; RIGHT: WILLIAM MORRIS (1834–1896), KENNET, REGISTERED 1883, PRINTED COTTON. BIRMINGHAM MUSEUMS AND ART GALLERY, BIRMINGHAM, ENGLAND, U.K.

naturally from the plain, robust Romanesque Revival style of H. H. Richardson, and it suited the American taste for simplicity and strength. Arts and Crafts work was exhibited in both Philadelphia and Boston in the 1890s, and the Chicago Society of Arts and Crafts was founded in 1897. In Chicago the style was employed by a number of silversmiths and metalworkers, and art potteries sprang up in Cincinnati and elsewhere.

The chief figure among American Arts and Crafts, however, was Gustav Stickley (1858–1942), who had traveled to England in the 1890s and began producing his own **Mission** furniture in 1900. In 1901 he began publishing the *Craftsman*, a magazine devoted to Arts and Crafts; its first issue was dedicated to Morris, its second to Ruskin. Stickley would declare bankruptcy in 1915 and fold his magazine the year after, but only after years of success and broad popularity.

The Aesthetic Movement

The **Aesthetic Movement** of the 1870s and 1880s in England and somewhat later in the United States was closely related to the Arts and Crafts movement and also included elements of **japonisme,** a French term for the nineteenth-century

interest in Japanese design. But unlike the Arts and Crafts movement, which was concerned with morality, social issues, crafts guilds, and the evils of mechanization, the Aesthetic Movement concerned itself only with beauty.

The epitome of Aesthetic Movement interiors is a London dining room (Figure 19–35) designed for shipping and communications magnate F. R. Leyland in 1876 by James McNeill Whistler. Whistler covered the ceiling with gold leaf and with motifs resembling peacocks' feathers, he gilded the walnut shelves, and he painted the wooden shutters of the windows with long-tailed gold peacocks (Figure 19–36). The dominant and unifying color of the room, however, is a deep blue-green against which the gold sparkles and the numerous blue-and-white porcelain vases gleam.

By the last decade of the century, a new aesthetic movement was being born: the Art Nouveau. Unlike the revival styles, it had little apparent connection with the past, unless one sees it as a culmination of a century-long obsession with floral ornament. Unlike the Pre-Raphaelite, Arts and Crafts, and Aesthetic movements, it would extend beyond England and America to engage every country in Europe. But like the Aesthetic Movement, its concerns were purely visual.

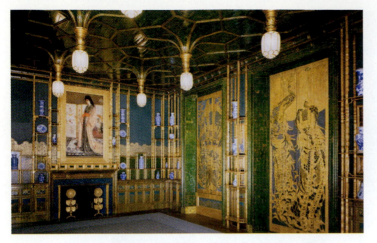

Figure 19–35 The Peacock Room, London, 1876, decorated by James McNeill Whistler as a setting for his painting, *The Princess,* seen over the fireplace, and for the owner's collection of porcelain. The pendant lights were by the room's previous designer, Thomas Jeckyll. This photo shows the room c. 1929.

JAMES MCNEILL WHISTLER, "HARMONY IN BLUE AND GOLD." THE PEACOCK ROOM, NORTHEAST CORNER, FROM A HOUSE OWNED BY FREDERICK LEYLAND, LONDON. 1876–77. OIL PAINT AND METAL LEAF ON CANVAS, LEATHER, AND WOOD, 13'11⅞" x 33'2" x 19'11½" (4.26 x 10.11 x 6.83 M). COURTESY OF THE FREER GALLERY OF ART, SMITHSONIAN INSTITUTION, WASHINGTON, DC. GIFT OF CHARLES LANG FREER, F1904.61

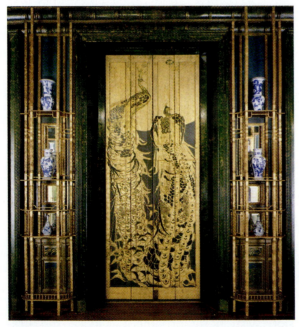

Figure 19–36 Long-tailed gold peacocks painted by James McNeill Whistler on the window shutters of his Peacock Room, London, 1876.

COURTESY OF THE FREER GALLERY OF ART, SMITHSONIAN INSTITUTION, WASHINGTON, DC F1904.61.

Art Nouveau

The **Art Nouveau** style was characterized by sinuous curves and asymmetry, both based on plant forms. It also exhibited a concern for creating complete stylistic ensembles, and, in some cases, an integration of ornament with structure. An early appearance of the style was in graphic design and furniture by English architect Arthur Heygate Mackmurdo (1851–1942) c. 1883 (Figure 19–37), and the following year it appeared in architectural ornament by the American architect Louis Sullivan (1856–1924) (Figure 19–38). Also in 1884, the Paris exhibition of the Union Centrale des Beaux Arts Appliqués à l'Industrie (later known as the Union

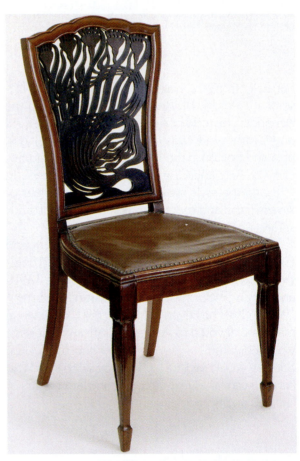

Figure 19–37 Design of a chairback by A. H. Mackmurdo, c.1883, made by Collinson and Lock. Its "whiplash" curves anticipated the Art Nouveau style, but the rest of the chair did not.

VICTORIA AND ALBERT MUSEUM, LONDON/ART RESOURCE, NY

Figure 19–38 Terra-cotta block designed by Louis Sullivan for his 1884 Rubin Rubel house, Chicago, 16 inches (41 cm) wide.

PHOTO: ABERCROMBIE

Centrale des Arts Décoratifs) showed the new floral style, including ceramics and glass by Emile Gallé.

Its first complete built example, however, did not come until a decade later: the Hôtel Tassel of 1892–93 in Brussels by Victor Horta (1861–1947). Its rooms were freely disposed around a central staircase and its iron structure exposed throughout but supplemented with a "capital" of nonstructural iron tendrils; mosaic floor patterns and painted walls and ceilings repeated the organic theme. Horta would continue the style in other Brussels buildings: in the Hôtel Eetvelde of 1894, built around a central skylit foyer (Figure 19–39), and in a department store, a house and studio for himself, and the Maison du Peuple of 1895–99, this last built as the headquarters of the Belgian Socialist Party.

Horta was soon joined by a fellow Belgian, Henry Van de Velde (1863–1957), who designed rugs, metalwork, and furniture (Figure 19–40) and contributed theoretical writings denouncing historic revivals and calling for the unification of the arts. In 1895 Horta was visited by the Paris art dealer S. Bing and invited to design three rooms for Bing's new Paris gallery, L'Art Nouveau, bringing the new style to France. In 1897 the Bing rooms, which featured eleven panels of stained glass by Louis Comfort Tiffany, were reconstructed for an exhibition in Dresden. From Dresden the style spread throughout Germany and Austria, where it was called **Jugendstil** (Youth style) and where its chief practitioners were August Endell and Herman Obrist; Van de Velde would move to Berlin in

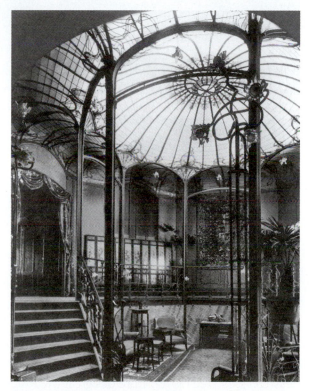

Figure 19–39 Victor Horta's foyer in his Art Nouveau van Eetvelde house, Brussels, 1894, its ironwork given linear floral forms.

VICTOR HORTA, VAN EETVELDE HOUSE. BRUSSELS, BELGIUM. 1895. SALON. MUSEUM OF MODERN ART, NEW YORK.

1900. Other exhibitions popularizing Art Nouveau were held in Munich in 1899, in Paris in 1900, and in Turin in 1902. Other galleries and shops, in addition to S. Bing, that promoted the style included

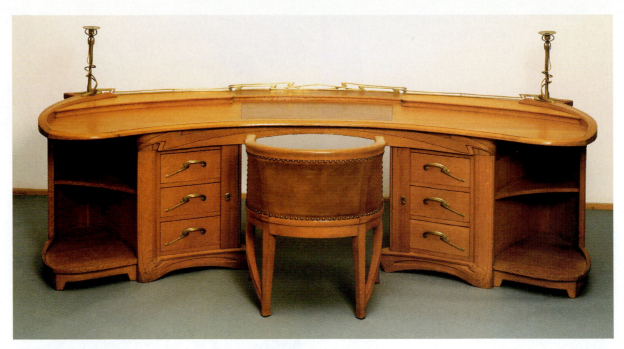

Figure 19–40 Curved oak desk designed by Henry Van de Velde in 1896.

HENRY VAN DE VELDE, OAK DESK, 1896. GERMAN NATIONAL MUSEUM, NUREMBERG, GERMANY. HG 10254.

Tiffany in New York and Liberty in London (with a branch in Paris beginning in 1890).

France accepted the new style with enthusiasm, especially in the cities of Paris and Nancy. The leaders of Art Nouveau in Nancy were the glassmaker, potter, and furniture designer Emile Gallé (1846–1904) (Figure 19–41) and, following Gallé's example, the ébéniste Louis Majorelle (1859–1926), who also produced ceramics as well as furniture. Describing nature as his inspiration (although his design was generally more abstract than Gallé's), Majorelle said, "My garden is my library." He successfully exhibited his furniture design at the 1900 Exposition Universelle in Paris (Figure 19–42), and his work in the following years was sumptuously ornamented. In 1914, with the outbreak of World War I, he moved to Paris, where he worked as an interior designer, and his work in the 1920s would evolve into the Art Deco style.

In Paris, the leader of the style was Hector Guimard (1867–1942). After study at the Ecole des Beaux-Arts, instead of the usual pilgrimage to Rome and Greece, Guimard traveled to England and Belgium, where he met Horta and studied his work. His Castel Béranger, a Paris apartment block, was finished in 1897, and soon after he was given the commission for entrance pavilions at all the Métro (subway) stations in Paris. There were 141 of these (of which 86 survive), and their style and their designer became known to every Parisian. Understandably, French Art Nouveau is sometimes called the *Style Métro*.

In Austria, a late branch (founded in 1897) of Art Nouveau was called the **Secession,** its members having "seceded" from their fellow artists and designers in protest against eclecticism and historicist revivals. The Secession was characterized by greater symmetry and straighter lines than mainstream Art Nouveau, following the model of Viennese architect Otto Wagner (1841–1918). Wagner's followers in the Secession movement included the architects Adolf Loos and Joseph Maria Olbrich, the architect and designer Josef Hoffmann, and the painter and designer Koloman Moser; we shall see some work by Hoffmann and Moser in the next chapter. Related to the Vienna Secession were the Munich Secession, founded in 1892 and including furniture designer Richard Riemerschmid among its members, and the Berlin Secession, founded in 1898.

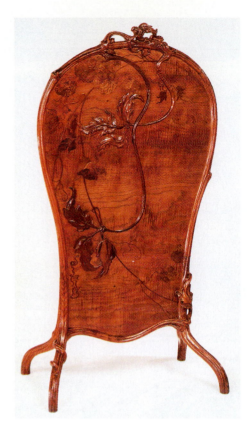

Figure 19–41 Designed by Emile Gallé before 1900, a fire screen of ash with marquetry and applied decoration in walnut, zebrawood, amboyna, and other woods.

The Art Nouveau style also appeared in Italy (where it was called *Stile Liberty* or *Stile floreale*), in Spain (*Modernisme*), in Scotland and England (Glasgow style), in the Netherlands (*Nieuwe kunst*), in Russia (*Stil' modern*), and in the United States (**Tiffany style**). Louis Comfort Tiffany, for whom it was named, is one of four Art Nouveau designers we shall consider in more detail.

LOUIS COMFORT TIFFANY (1848–1933)

Tiffany was the son and heir of Charles Louis Tiffany, who in 1837 had founded the jewelry and fine furnishings store Tiffany and Company. The son was more than a merchant; he was also a notable artist in many media, particularly in glass and particularly in the Art Nouveau style. In 1879, he formed an interior design firm, Louis C. Tiffany and Associated Artists, in collaboration with Samuel Colman, whose specialty was color; Lockwood de

Forest, knowledgeable about wood carvings and decorations; and Candace Wheeler, an educator, writer, and specialist in textiles.

Associated Artists, as the group was popularly known, was responsible for several important interiors commissions. For the Veterans' Room of the Seventh Regiment Armory, New York, the group, with Stanford White as architectural consultant, provided a heavily beamed ceiling with silver stenciling, a 10-foot-high (3 m) oak wainscot, enormous wrought-iron chandeliers, and a fireplace surrounded with blue Tiffany glass tiles (Figure 19–43). For the Union League Club in New York, which Tiffany's father had helped found, Associated Artists provided many, but not all, aspects of

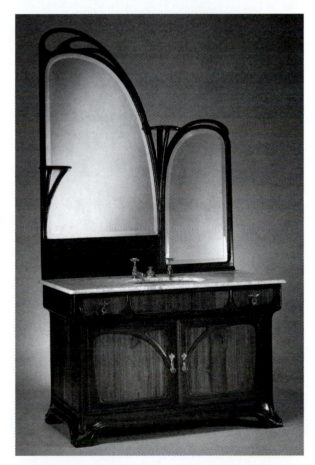

Figure 19–42 Designed by Louis Majorelle, a dressing table with a sink in its marble top. The cabinetry is of mahogany and ebony with gilt bronze pulls.

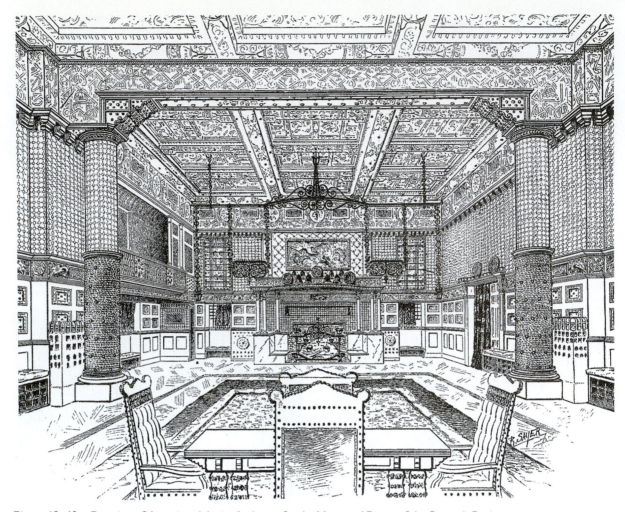

Figure 19–43 Drawing of Associated Artists' scheme for the Veterans' Room of the Seventh Regiment Armory, New York, 1879–80.

SCRIBNER'S MONTHLY 22, NO. 3, JULY 1881, P. 371, PHOTO COURTESY MARK TWAIN MEMORIAL

the interiors, including draperies for the major rooms and a large stained-glass window for the main staircase. For the White House, the designers covered the ceiling of the East Room with silver leaf and added a sienna-colored Axminster carpet; they gave the Red Room a new fireplace surround of Japanese leather and amber-and-red tiles; for the Blue Room they provided a delicate palette of blue-gray and silver with satin-upholstered furniture (Figure 19–44); and they designed a 338-square-foot (31 m²) colored glass partition that screened the comings and goings of the president and his family and guests from the more pub-

lic entrance foyer (Figure 19–45, page 536). Other work by Associated Artists included the interiors of the house of writer Samuel L. Clemens (Mark Twain) in Hartford, Connecticut, for several residences of Louis Comfort Tiffany himself, and for the H. O. Havemeyer house in New York, which was given a stair of perforated metal hung from the ceiling by iron straps. These predated the Art Nouveau style and mixed Japanese, Islamic, Byzantine, Romanesque, and other elements. Tiffany left Associated Artists in 1883 to form his own namesake company, which in 1892 was reorganized as the Tiffany Glass and Decorating Company and the

Tiffany Furnaces. The new company continued to design interiors, but its emphasis shifted to glass: stained-glass windows, glass mosaics, goblets, vases, and lamps.

It was in his glass that Tiffany captured the Art Nouveau spirit most purely. Sometimes Tiffany glass imitates nature directly, as in his Wisteria and Dragonfly lamps (Figure 19–46, page 537), but often the reference is more abstract. Not only the forms of his glass, but also its surfaces and colors expressed the flowing forms of nature. His most important and most characteristic technical de-velopment was the treatment of the hot glass with metallic oxides to create overlapping layers of iri-descent colors; he called the products of this process **Favrile** glass (Figure 19–47, page 537). He also used gold to create rich, corroded glass-ware that might have been made by the Romans and left buried for centuries. As Edgar Kaufmann, jr., once wrote in *Interiors,* Tiffany "loved the marks of age on everything—tints, effusions, incrusta-tions not given by man, but supplied by time and accident. Accident, the casual effect, was, fur-thermore, his approach to ornament: iridescence,

Figure 19–44 The Blue Room of the White House as designed by Associated Artists in 1882–83.

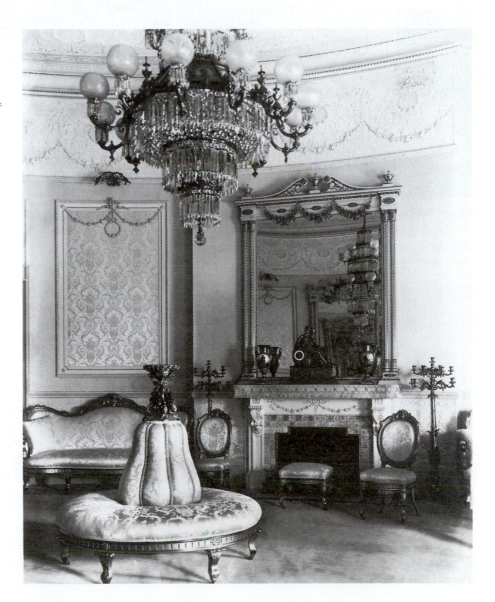

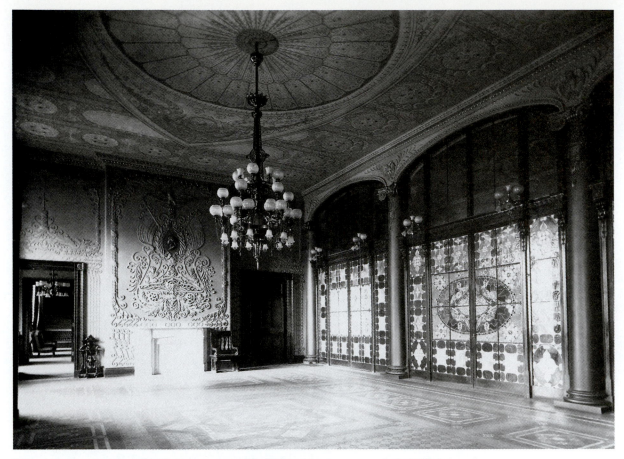

Figure 19–45 Associated Artists' treatment of the White House entrance hall, 1882, featured an enormous stained-glass screen. When Theodore Roosevelt moved into the house in 1902, he reportedly ordered his own designer, Charles Follen McKim, to destroy it.

COURTESY OF THE LIBRARY OF CONGRESS

acid etching, flowered or marbleized patterns that swell, stretch and converge according to the craftsman's puff and twist at the glass."

Fine, thin wares were within Tiffany's repertory, but he also developed an attractive, thicker, often milky glass that he called *paperweight glass*. He designed huge chandeliers for the Havemeyer house and electric lights for the Lyceum Theater, both in New York, as well as gas sconces for the White House. His lamps were first offered to the public in 1895. In 1911 he would be commissioned to design an enormous (1,800-sq.-foot, 167 m$^2$) glass curtain for the Palacio de Bellas Artes in Mexico City, still in place. Collections of Tiffany glass can be seen today at the Metropolitan Museum of Art, New York; the Morse Gallery of Art, Winter

Park, Florida; and the Chrysler Museum, Norfolk, Virginia.

Tiffany's design beginning about 1890 defines the Art Nouveau style at its best. Next, however, we shall consider three designers within that style whose work is so personal and idiosyncratic that their work stretches any such definition to the breaking point: Gaudi, Mackintosh, and Sullivan. All three, indeed, might be surprised to find themselves grouped under the Art Nouveau heading—or under any heading, for they followed highly individual visions.

ANTONÍ GAUDI (1852–1926) The Spanish version of Art Nouveau was dominated by one city, Barcelona, and within Barcelona by one fig-

ure, Antoní Gaudi y Cornet. A pious man, Gaudi was influenced by his area's medieval history and the structural logic and craftsmanship of its buildings. He was interested, too, in the ideas of Ruskin and Viollet-le-Duc. In 1883, the young Gaudi was appointed architect of Barcelona's cathedral of the Sagrada Familia, a monumental work that occupied much of his time until his death; it is still incomplete.

Important among Gaudi's other commissions were the Casa Battló of 1904–6 (Figure 19–48), the Parc Güell of 1901–2, the chapel for the Colonia Güell of 1908–15, and the Casa Milá of 1906–10. This last, an apartment building with a rocky, undulating facade (giving it the local nickname of *la pedrera*, "the stone quarry") is a thorough demon-stration of Gaudi's ability to combine structure, interior planes, plasterwork, tile work, balustrades, hardware, grilles, and furniture of his own design into a rhythmic whole. As Jean-Paul Bouillon has written, Gaudi's integrated design follows Viollet-le-Duc's principle that "decoration adheres to the building not like a garment, but the way skin and muscles adhere to man."

CHARLES RENNIE MACKINTOSH (1862–1928)

Another highly original talent whose work is related to the Art Nouveau was the Scottish architect, designer, and painter Charles Rennie Mackintosh. He was an apprentice, then a partner in the conservative Glasgow architecture firm Honeyman and Keppie, his first demonstration of individual genius coming in his 1895 competition-winning design for the Glasgow School of Art, which was built in sections between 1896 and 1909 (Figure 19–49, page 539). In 1900 he married Margaret Macdonald, who

Figure 19–46 Louis Comfort Tiffany's Dragonfly electric lamp with a stained-glass shade, c. 1900. The bronze base is in the form of a twisted waterlily 27 inches (69 cm) high.

TIFFANY STUDIOS, NEW YORK. ELECTRIC LAMP IN HOLDEN DRAGONFLY SHADE AND TWISTED-STEM WATERLILY STANDARD, CA. 1910. COLORED GLASS, COPPER FOIL, BRONZE; H: 27 INCHES. CHRYSLER MUSEUM OF ART, NORFOLK, VIRGINIA. GIFT OF WALTER P. CHRYSLER, JR. 71.8123.

Figure 19–47 An example of Tiffany's iridescent-surfaced Favrile glass, c. 1900, 14 inches (35 cm) tall.

CORNING MUSEUM OF GLASS, CORNING, NY, GIFT OF MR. EDGAR KAUFMANN, JR. 62.4.19.

would be his constant collaborator. Other highlights of his career included residential designs such as Windyhill at Kilmacolm, 1899–1901, and Hill House at Helensburgh, 1902–5 (Figure 19–50, page 540), and the interiors of a number of tearooms in Glasgow (Figure 19–51, page 540). He spent his last years in London and the South of France, concentrating on watercolors of flowers and landscapes.

His building exteriors have little overt decoration but have carefully proportioned dispositions of window groups. His interiors, like those of Gaudi, are impressively comprehensive and cohesive compositions that include structure, cabinetwork, furniture, lighting, carpets, and other details. In the case of the tearooms, design attention extended to window curtains, flower vases, and cutlery. In Thomas Howarth's words, Mackintosh was "an intensely humane person willing to lavish time and creative energy on both large and small things in order to delight the observer."

The character of Mackintosh's design, however, could never be mistaken for that of Gaudi. The Spaniard's sensuous curves, writhing and looping, are replaced by the Scotsman's precise rectilinearity, repeated parallels, and staccato squares, many enlivened with an occasional curve and all presented with delicacy and grace. Mackintosh's linear version of the Art Nouveau would have much more influence than the style's more convoluted manifestations on the Secessionist style that was beginning in Vienna.

Just as a Gaudi interior seemed to demand Gaudi furniture, a Mackintosh interior called for more Mackintosh. His earliest furniture was sturdily made of dark-stained oak and owed something to the Arts and Crafts and Aesthetic movements. From 1900 to c. 1904 his furniture forms grew more attenuated, and he experimented with painting them with white enamel. Insets of purple glass appeared, and upholstery of pink or purple silk was stenciled with stylized flowers. Later furniture was often ebonized and its design dominated by squares and ovals (Figures 19–52 and 19–53, page 541).

LOUIS SULLIVAN (1856–1924) The American architect Louis Sullivan was a master of ornamental design that was more clearly in the mainstream of the Art Noveau style than that of either Gaudi or Mackintosh (Figures 19–38 and 19–54, page 542). But Sullivan's ornament was applied to building compositions that were foursquare, direct, and thoroughly foreign from any-

Figure 19–48 Interior view of the gallery, Casa Battló, Barcelona, by Antoní Gaudi, 1904–6. The chairs are also Gaudi's designs.

INSTITUTO AMATLLER DE ARTE HISPANICO, BARCELONA, SPAIN

Figure 19–49 Tile panels designed by Charles Rennie Mackintosh for the stair hall of the Glasgow School of Art, Glasgow, 1896–1909.

thing remotely floral. They show the influence of H. H. Richardson's Romanesque Revival. In his mature work, ornament plays an important role in humanizing those bold forms, but its role is always a secondary one. An example is the interior of the National Farmers' Bank, Owatonna, Minnesota, 1907–8 (Figure 19–55, page 542). Other works included the Wainwright Building in St. Louis (1890–91), a pioneer expression of a new building

form, the skyscraper, and the Transportation Building at the Columbian Exposition of 1893, a simple, robust composition that refused to conform to the eclecticism of that exposition's "White City."

The relationship between form and ornament in Sullivan's work has attracted much attention. Historian Nikolaus Pevsner wrote in 1946 that "Sullivan was in fact just as much a revolutionary in his ornnament as in his use of plain, smooth

Figure 19–50 The entrance hall of Mackintosh's Hill House near Glasgow, 1902–5, looking toward the main door with the foot of the stairs on the right.

MARK FIENNES/COUNTRY LIFE PICTURE LIBRARY, LONDON, ENGLAND

Figure 19–51
A 1995 reconstruction of Mackintosh's interior for the Ingram Street tea-rooms, Glasgow, designed in 1900. The beaten metal panel on the upper level, *The Dew*, is by Margaret Macdonald Mackintosh, and the large gesso panel to its left, *The Wassail*, is by Mackintosh himself.

PHOTOLIBRARY, GLASGOW MUSEUMS, GLASGOW, SCOTLAND

Figure 19–52 Mackintosh's ladder-back chair for a bedroom of Hill House, 1902.

CASSINA U.S.A. INC.

Figure 19–53 Charles Rennie Mackintosh's Side chair. 1897. Oak and black silk, 54 x 19 3/8 " x 18".

surfaces . . . [H]is theory of severe functionalism . . . cannot be understood without a careful look at his flowing ornament, nor his ornament without a vivid memory of the austerity of the main lines and blocks of his buildings." And Sullivan himself in 1892 had said, "I take it as self-evident that a building, quite devoid of ornament, may convey a noble and dignified sentiment by virtue of mass and proportion. It is not evident to me that ornament can intrinsically heighten those elemental qualities. Why, then, should we use ornament?" Answering his own question, he proposed that "we should refrain entirely from the use of ornament for a period of years" and suggested that in such a moratorium we would learn "the limitations as well as the great value of unadorned masses."

In his body of work, his contemporaries must have seen what they were accustomed to looking for, a great flourish of Art Nouveau exuberance. What Sullivan's true disciples—including Frank Lloyd Wright—would see were the strong forms beneath the flourish. They would help shape the great style of the following century, modernism.

Nineteenth Century Furniture and Decorative Arts

The furniture of the nineteenth century was at least as varied as the interior styles we have reviewed. For all the phases of neoclassicism in the first third of the century, for all the romantic revivals of the middle third, and for all the more orig-

IMPROMPTU

Figure 19–54 A 1922 ornament drawing by Louis Sullivan, published in his 1924 book *A System of Ornament*. . . .

AMERICAN INSTITUTE OF ARCHITECTS PRESS, WASHINGTON, DC

inal movements of the last third, appropriate furniture was designed. Some of it we have already seen. Here we shall note only those aspects that might not have been expected: the development of types of furniture not seen before and of new techniques for making furniture.

New Furniture Types

The most radical changes of furniture type that took place in the nineteenth century were probably those in Japan, where the new opening of the country to trade with the West after the treaty of 1854 brought a transition from floor-level living to chair-level living. The change was first effected in Japanese schools and offices, later in residences.

In the West, some new pieces evolved naturally from earlier ones. In seating, the Empire-period **récamier** was a daybed that took its name from

Figure 19–55
The banking hall of the National Farmers' Bank. Owatonna, Minnesota 1907–8, by Louis Sullivan.

PHOTO: INFINITY, INC., MINNEAPOLIS

a painting, Jacques-Louis David's 1800 portrait *Mme. Récamier* (Figure 19–56); the Second Empire *confidentes à deux places* and *indiscrets à trois places* were settees for two or three occupants; and the later **borne** was a large circular upholstered piece with a central backrest, like the one seen in the Tiffany design of the White House Blue Room, (Figure 19–44), which was popular in grand drawing rooms and hotel lobbies.

In sympathy with—but not limited to—the romantic revivals of the century were pieces called **fantasy furniture.** Antiques dealer Bruce Newman of Newel Art Galleries has classified some of these as *Horn and Antler* furniture, reminiscent of the American Wild West (Figure 19–57); Venetian *Grotto* furniture, concoctions of seashells and underwater imagery; and Swiss *Black Forest* furniture with carvings of bears and branches. Another category is the New York State *Adirondack* furniture, bristling with *real* branches and twigs.

Fantastic in another way, its sometimes far-fetched effort to be practical, is what has been called **patent furniture,** although some of it was never patented. These pieces were often meant as conveniences for travelers or those in small residences, and they often collapsed or served multiple functions. Tables of all sizes were given extra leaves so they could be extended, armchairs were given attached footrests that could be raised, and dressing tables were given fold-down mirrors and compartments for concealing bidets and chamber pots. The folding chair was patented in 1855. The so-called **Morris chair,** manufactured by William

Figure 19–56 A récamier in the portrait that gave it its name, Jacques-Louis David's 1800 *Mme. Récamier*.

Figure 19–57 A table made of horn and horn veneer by Wenzel Friedrich, San Antonio, c. 1885.

WENZEL FRIEDRICH, HORN CENTER TABLE, STEER HORN WITH HORN VENEER. 29⅛" x 27" x 19". THE WITTE MUSEUM, SAN ANTONIO, TEXAS. GIFT OF GERTRUDE AND RICHARD FRIEDRICH.

Morris beginning c. 1866 but probably not designed by him, was a lounge chair with removable cushions and a back that could be adjusted to different angles. Among other examples, Ann Ferebee has called attention to "a reclining railroad seat, prototype of today's airplane seat, and an adjustable barber's chair, prototype for today's dentist chair," and David A. Hanks has identified not only several forms of the sofa-bed, but also such wonders as the sofa-bathtub and the bed-piano.

Growth in the complexities of business and the quantities of paperwork demanded new and more elaborate desks, perhaps the most elaborate being those developed by William S. Wooton of Indianapolis. In 1874 he patented a desk with over a hundred storage compartments and a drop-down writing surface, all hidden behind two massive hinged doors that could be closed and locked; when these were open, the occupant was virtually in an office cubicle. Among the purchasers of Wooton desks, according to Ferebee, were oil magnate John D. Rockefeller, newspaper chief Joseph Pulitzer, and financier Jay Gould.

New Furniture Techniques

Primary among the new techniques that became available to nineteenth-century furniture makers were two advances in the use of wood: improvements in bending it and in laminating it. Both techniques yielded products lighter and more sparing of resources than construction of solid wood, and they were also faster and cheaper. Although many other people contributed, each of these developments had a special hero: Michael Thonet in bending and John Henry Belter in lamination. Also important was a new development in upholstery: interior springing.

MICHAEL THONET (1796–1871) AND BENT-WOOD The English and American Windsor chairs we saw in chapters 16 and 18 (and which were still being made in the nineteenth century) used spindles and curved back rails of bentwood, and in 1808 Samuel Gragg obtained an American patent for his Elastic chair, which had front legs, seat, and back formed from a single sheet of stress-bent wood.

In 1819 Michael Thonet opened a cabinet-making shop in the Rhine Valley and began experimenting with bending and laminating, splicing narrow wood strips together while cooking them in glue. By 1841, Thonet had patented his process, and soon he moved his business to Vienna. His medal-winning display at London's Great Exhibition of 1851 brought him international recognition. The company's first catalogue, issued in 1859, showed 26 items, all the chairs being similar below the seats but with different backs. The Thonet rocker was introduced in 1860, and an 1874 advertisement (Fig. 19–58) showed other additions to the line. The 1880s brought the addition of hatstands, stools, bedsteads, mirror frames, and more to the basic line of chairs and tables.

JOHN HENRY BELTER (1804–63) AND LAMINATED WOOD Belter came to America from Germany in 1833, by 1844 he was established as a cabinetmaker in New York, and in 1854 he was operating a five-floor factory on East 76th Street. Belter's florid designs in the Renaissance Revival style were made possible by a series of inventions.

His patents covered such things as sawing open-work patterns into curved chairbacks, laminating thin sheets of wood, their grains alternating directions, and then bending them in steam, and, perhaps of most importance, giving three-dimensional curves to laminated wood. Some Belter chairbacks were pierced with openwork decoration (Figure 19–26), but their real significance was Belter's ability to curve a plane both from top to bottom and from side to side. His techniques were precursors of the molded plywood chair shells that would be used by Charles and Ray Eames (with such different results!) in the twentieth century.

SPRING UPHOLSTERY A new degree of seating comfort came with the nineteeth-century addition of springs to the traditional upholstery package of webbing, stuffing (which could be hay, hair, wool, feathers, down, or other materials— even inflated pig bladders were given a try), and a top covering. Coil springs were first developed in the eighteenth century to ease the bumpy ride of horse-drawn carriages, but their advantages for interior seating soon became apparent. In 1822 Viennese upholsterer Georg Junigl patented an upholstery improvement with "the assistance of iron springs." In 1826 London carriage maker Samuel Pratt patented a chair with spiral springs that, when used at sea, was supposed to prevent seasickness, and two years later he obtained another patent for spring units that could be used on land simply to provide comfort. Pratt's springs could either be fastened directly to a wooden furniture frame or attached to a base of webbing and used in a loose cushion; it was soon found that, even within a wood frame, a base of webbing would give extra resilience. The earliest springs were cylindrical spirals of iron. They were replaced by spirals of steel wire that were either hourglass-shaped or pyramidal; such springs are still in use. The new construction required greater depth, not only for the springs themselves, but also for extra padding on top to keep the springs from breaking through. This new depth led eventually to the development of all-upholstered seating in which most or all of the frame was covered.

New materials and techniques were not limited to the field of furniture, of course. There were

Figure 19–58 An 1874 advertisement for Thonet Brothers shows a variety of bentwood furniture then available.

THE NEW YORK PUBLIC LIBRARY PHOTOGRAPHIC SERVICES

equally inventive developments in other parts of interior design.

New Synthetic Materials

The floorcloth of painted canvas, which we saw in both chapters 16 and 18, did not wear well. Floorcloths of "prepared varnished paper" were for sale in Philadelphia in 1822, but these must have worn even more quickly. Many experiments added materials—cement, coconut fiber, shredded

sponges—to the paint in order to make such products more durable and more resilient. An early success was Kamptulican, cooked up by Englishman Elijah Galloway in 1844 from a mixture of rubber and cork pressed between cast-iron rollers. Architect Charles Barry specified it for the corridor floors of London's Houses of Parliament in the late 1840s, and other manufacturers began to imitate it. It was expensive, however, and never widely popular. Historian Pamela H. Simpson also mentions Corticine or "'cork carpet," patented in 1871, and Boulinikon, described in 1879 as a composition of "buffalo hide torn to fine shreds, . . . wool and hair."

The big success among these experiments was **linoleum.** It was patented in 1863 by English inventor Frederick Walton, who took its name from the Latin words *linum*, meaning "flax," the source of both linen and linseed oil, and *oleum*, meaning "oil." It was made from linseed oil, gum, and cork pressed into a canvas backing, but its production, outlined by Simpson in her book *Cheap, Quick, and Easy: Imitative Architectural Materials, 1870–1930*, was long and complicated. As a consultant to the Armstrong Cork Company in Pittsburgh, Walton later brought his process to America, and linoleum was made by Armstrong from 1909 until 1974, when more resilient petroleum-based vinyls had come to dominate the market. Linoleum was advertised "for every room in the house," but it was always most popular for kitchens and bathrooms, where it was valued for being easily cleaned.

As early as 1876, Japanese embossed papers resembling leather were for sale at London's Liberty shop, and in 1877 another invention of Frederick Walton was an imitation leather called **Lincrusta Walton.** It was also made of linseed oil and gum, but instead of cork it contained wood pulp and paraffin wax. Meant for ceilings and walls rather than floors, Lincrusta Walton (from *linum* again and *crusta*, meaning "relief") was more flexible than linoleum, and its surface was embossed in low relief. When painted brown and glazed, it could resemble embossed leather; painted light colors, some patterns could pass for decorative plasterwork. In a three-part wall division, Lincrusta could give the effect of a leather-covered wall with a plaster cornice and a wood-paneled wainscot. It was widely used, appearing in the ocean liners *Servia* and *Ti-*

tanic, in the California State Capitol in Sacramento, and, in the 1880s, in the John D. Rockefeller mansion on New York's West 54th Street. A French company bought Walton's patents in 1880 and established a plant near Paris, supplying Hector Guimard with Lincrusta wainscoting to his own Art Nouveau design for the 1896 Castel Béranger. The *Compagnie Lincrusta-Walton Française* won a gold medal at the 1900 Paris exposition. And American production of Lincrusta was started in 1883 by a company in Stamford, Connecticut.

Lincrusta was vastly successful, but it found a competitor in **Anaglypta,** a lighter, more flexible, cheaper material made from paper and cotton pulp. It was developed by Thomas J. Palmer, a showroom manager for Lincrusta Walton, but his employer was not enthusiastic about its prospects, and Palmer secured his own patent in 1886 and marketed it on his own. Anaglypta (from the Greek *ana* meaning "raised" and *glypta* meaning "cameo") was primarily a substitute for plaster ceilings and friezes, not—like Lincrusta—for a range of materials. It was immediately successful, counting Christopher Dresser among its designers, and is still on the market in England. Seeing its success, Walton changed his opinion and countered with a similar product of his own called *Caméoid*. Introduced in 1896, it was also widely used.

Similar products described by Pamela Simpson include Tynecastle Tapestry and Cordelova (both embossed paper products), Lignomur (made of wood pulp), and fire-resistant Salamander (made of asbestos).

Another artificial substance that had great success beginning in the early nineteenth century was called *composition* or, more commonly, **compo.** It was a putty-like substance of linseed oil, glue, and resin that was pressed into decoratively shaped molds, the result then applied to woodwork or furniture. When painted, it was a convincing imitation of expensive wood carving. Robert Adam is said to have been a compo proponent in England, and it was successfully made in America by Robert Wellford of Philadelphia, who beginning in 1800 supplied it to all the cities of the East Coast. The Decorators Supply Company, founded in Chicago in 1893, eventually had branches in twenty American cities and a 120-page catalog of compo ornaments.

An even less expensive but less durable substitute for wood carving was **papier-mâché,** French for "chewed paper." It was made of recycled paper with a binder of glue, and was sometimes also used for making chairs and tables as well as trays and small decorative pieces; a slightly heavier version of papier-mâché was called **carton pierre.**

Ceramics and Glass

Nineteenth-century ceramics did not enjoy the dramatic manufacturing advances that revolutionized other decorative arts, such as textile production; fine ceramics continued to be hand thrown (though many were molded) and hand painted. Stylistically, they reflected all the styles and influences noted in the other arts, playing supporting roles in the changing scenes of Empire, Regency, romantic revivals, Arts and Crafts, and Art Nouveau design.

Technology transformed glassmaking in the nineteenth century. The efficiency of the production of cut glass was greatly increased by steam-powered cutting machines, and cutting became deeper and more intricate.

Perhaps the most dramatic new technique was for the production of **pressed glass,** in which ornamented surfaces are obtained by forcing molten glass into cast-iron molds. It was a far cheaper process than cut glass. The first glass press was developed in America in 1829, and pressed glass was introduced into England soon after that.

The glass artist Emile Gallé (1846–1904) opened his workshop in Nancy in 1874. His decorative glass techniques included *clair de lune,* which used cobalt oxide to produce a distinctive sapphire blue color; *verreries parlantes,* on which he inscribed poetic phrases; and glass with embedded metal foil and intentional imperfections such as crazing and air bubbles. He also developed an innovative method of fusing layers of colored glass to imitate eighteenth-century Chinese cased glass.

Near the end of the century, applying the principle of wood marquetry to glassmaking, he developed *marqueterie de verre,* inserting decorative glass pieces into larger glass bodies. His firm produced both inexpensive mass-produced pieces in the Art Nouveau style (Figure 19–59) and exquisite *piéces uniques.*

Enamels and Lacquer

Nineteenth-century Europe and America had a thirst for all things Eastern, and these included enamel and lacquerwork. Chinese **cloisonné** enamels of the Jiaqing era (1796–1820) continued the styles and techniques that had been established by the emperor Ch'ien Lung (1736–95). For most of the century Guangzhou (Canton) was the great center of enamelwares and also for enamels painted on ceramics (rather than being poured into cloisons); these last, called Canton enamels, were exported to the West in large quantities during the last quarter of the century. A high point in Chinese enamel artistry came in 1884, when the Dowager Empress Cixi, on her fiftieth birthday, was presented with a fine cloisonné phoenix and incense burner.

The Meiji period in Japan (1868–1912) also saw a flowering of enamelwork. One of its leading innovators was Kaji Tsunekichi (1803–83), and two

Figure 19–59 An Art Nouveau overlay glass table lamp designed by Emile Gallé after 1890. Christie's Images, London/UK.

Figure 19–60　Enamel cloisonné dish and small jar made by Yasuyuki Namikawa, Kyoto, 19 century Meiji period, Japanese (glass & copper).

of its best-known modern artists were Yasuyuki Namikawa (1845–1927) of Kyoto (Figure 19–60) and Sōsuke Namikawa (1847–1910) of Tokyo. These two developed techniques in which the cloisons remained invisible on the surface, giving a more naturalistic appearance.

Outstanding among nineteenth-century Japanese lacquer artists was Shibata Zeshin (1807–91). During the century, lacquerers slowly came to be regarded as artists rather than as craftspeople, and a department of lacquerwork was established at the Tokyo School of Fine Arts in 1889.

In France, Ferdinand Barbedienne was a leader of the nineteenth-century revival of enamelwork, and his gilt metal vase with champlevé enamel was shown at London's International Exhibition of 1862 and is now in the Victoria and Albert Museum.

Metalwork

In America, Paul Revere of Boston continued his work with silver until his death in 1818, and he was followed by Richard Humphreys (1750–1832), Simon Chaudron (1758–1846), and Anthony Rasch (1778–1857), all of Philadelphia, and by John Forbes (1781–1864) of New York.

In the French Empire and Restoration periods, exemplary gilt and bronze work was produced by Pierre-Philippe Thomire (1751–1843). Empire silversmiths included Odiot and Biennais, and they demonstrate two distinct poles of the Empire style. Jean Baptiste Claude Odiot (1763–1850), who was also a cabinetmaker, worked in a pure classical style, employing simple shapes and plain surfaces (although some of his last work has been called Rococo Revival in style). A coffee urn commissioned from Odiot by Thomas Jefferson is now at Monticello, and Odiot also designed Empire silver tableware for the royalty of Russia, Poland, and Naples.

Martin-Guillaume Biennais (1764–1843) produced silverware for Napoleon and his family beginning at least as early as the Consulate. His style was ornate, densely decorated with sphinxes, swans, seahorses, and all the emblems of Napoleon and Josephine. He also produced silverware and furniture to the designs of Percier and Fontaine. Biennais also designed for the Russian royal family, and his busy workshop is thought to have employed as many as six hundred workers.

Second Empire metalworkers in France included Charles Christofle and Ferdinand Barbedienne. Charles Christofle (1805–63) turned his attention from jewelry to silver household wares in the 1830s, and in 1842 he obtained a monopoly on the making of electroplated wares in France. His firm, which also produced some bronze furniture, is still in business.

Ferdinand Barbedienne (1810–92) first worked as a wallpaper manufacturer, but in 1838 he began the firm that would be known first as Collas and Barbedienne, then simply as Barbedienne. It produced reproductions of antique sculpture and a variety of decorative objects, many in metal, and furniture. In the years 1850–54 Barbedienne furnished the interiors of the Hôtel de Ville, Paris, in the Renaissance Revival style. His enamelwork has already been mentioned. After his death, the Barbedienne firm was continued by his nephew.

In England, silverware design was influenced by the 1806 publication of *Designs for Ornamental Plate* by architect Charles Heathcote Tatham. Tatham suggested "massiveness" as the chief criterion for good silver, and his advice was followed widely. Regency silver is based on elegant classical models, but often with a burdensome amount of decoration. In the Gothic Revival style, A. W. N. Pugin and others produced designs for all kinds of ecclesiastical objects in silver and other metals. In the last decades of the century, as we have seen, Christopher Dresser produced some simple, elegant silver pieces showing the influences of Japanese and Arts and Crafts design (Figure 19–31).

In the Art Nouveau vocabulary, Tiffany's partner Lockwood de Forest devised a fireplace surround for the Samuel L. Clemens house that was made of decoratively pierced sheets of brass over a backing of red marble. Margaret Macdonald Mackintosh, wife of Charles Rennie Mackintosh, and her sister Frances Macdonald provided hammered metal panels for Mackintosh interiors (Figure 19–51) as well as picture frames and other metal accessories.

Gorham, the American silverware firm still operating, was founded in 1831 by Jabez Gorham (1792–1869) and later managed by his son John and other relatives, In the late nineteenth century it produced silver in a variety of revival styles and, during the 1890s, Art Nouveau. Gorham also supplied silver overlays for the Arts and Crafts ceramics of the Rookwood Pottery.

The earliest use of metal for ceiling surfaces came in the late 1860s when sheets of corrugated iron began to be used as ceilings for utilitarian spaces in warehouses, factories, schools, and hospitals; for this purpose, metal was both more fire-resistant and less expensive than wood or plaster. Lighter and more easily installed tiles of stamped tin were in widespread residential use by 1895. They were available in hundreds of patterns, some imitating stucco or brick, and some manufacturers' staffs could also make custom designs. In addition to tin tiles for large ceiling areas, there were also tin medallions for the centers of rooms, tin borders, and tin beam covers; there were even tin panels that could be applied as wainscoting or as whole wall surfaces. Tin surfacing materials, particularly the ceiling tile, remained popular until World War I brought a metal shortage; today they are available again, used chiefly by renovators of old interiors.

Lustrous, silvery stainless steel became available in the middle of the nineteenth century and has been much used as an inexpensive substitute for silver in flatware, tableware, and other objects. Other substitutes include Sheffield plate (described in chapter 16), and nickel silver. Nickel silver is an alloy of copper, zinc, and nickel, and is sometimes called *German silver*; in the twentieth century it was often used for hotel and restaurant wares. Similar is the Chinese alloy Paktong, in use since the eighteenth century, but Paktong, having a larger percentage of copper, is slightly more yellow in color. Also similar is India's Tutenag, which combines copper, zinc, and nickel with traces of iron, arsenic, and silver.

A pewter substitute developed in the 1780s and popular in the nineteenth century was an alloy of tin, antimony, and copper called *white metal* or *Britannia metal*.

Another lustrous substitute for silver, chromium, was first produced at the end of the eighteenth century, and a process for plating it on base metal above a layer of nickel was devised in the middle of the nineteenth. It saw some military use in World War I, but it was not produced commercially until the 1920s.

Textiles

New machinery in the late eighteenth and early nineteenth centuries meant that complex multicolored patterns could be woven easily and quickly. Chintz and damask, satin and satin stripes, velvet and velour were all used extensively in the Victorian era. Among the textiles of Federal America, the printed calicoes of John Hewson (1744–1821) of Philadelphia were notable.

The role of interior textiles was greater in the nineteenth century than it had ever been before or has been since. Fabric was often draped beneath mantelshelves, and the fire openings themselves were sometimes curtained. Mirrors, chandeliers, tables, and lamps were all susceptible to being festooned with drapery. Doorways were hung with heavily draped **portieres,** often of tapestry. But the most elaborate fabric treatments were reserved for windows.

Some window treatments were extremely simple, especially in modest circumstances. Loudon's 1933 *Encyclopedia* suggested one that was merely a piece of calico with small rings sewn along its top by which it was hung from a cord. Other treatments had fabric hanging by rings from exposed curtain rods, usually with finials at each end. But such simplicity was exceptional. Most windows were treated with two basic elements: a heading across the top and curtains below. Both these elements could have several parts.

The heading could be a combination of a cornice board and a valance. The **cornice board** (not to be confused with the cornice, the top portion of

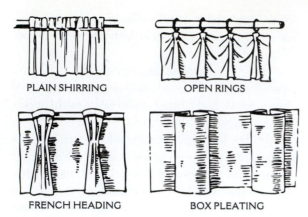

PLAIN SHIRRING OPEN RINGS

FRENCH HEADING BOX PLEATING

Figure 19–61 A few of the many types of headings for draperies or valances.

DRAWING: GILBERT WERLÉ

a classical entablature, which might be found above the window as the wall meets the ceiling) was a fixed projection at the top of the window treatment; it might be made of wood moldings or of fabric-covered wood. In England it was called a *pelmet*, in France, a **cantonnière.** Beneath the cornice, the **valance** was a horizontal strip of gathered, shirred, or pleated fabric (Figure 19–61) hung from the front edge of the cornice board and covering the tops of the curtains. If the bottom edge of either a cornice board or a valance were

fringed or elaborately scalloped, it might be called a **lambrequin**. Sometimes two windows in the same wall were treated as a single unit, with the cornice board and valance spanning the wall area between them (Figure 19–62). Sometimes the stiff cornice board was eleminated and only the fabric valance used.

Below this heading, the curtains were usually of two types. Closer to the glass was the **glass curtain** or **casement curtain** which was sheer and semitransparent. Farther from the glass were the **draperies** (never called "drapes" in professional usage), which could be hung in an endless variety of simple or fanciful arrangements. In most arrangements, the draperies met in the center at the top of the window and were held back to the sides 3 or 4 feet (90–120 cm) above the floor by fabric loops called *tiebacks* or by tasseled ropes or by looping the fabric over curtain pins projecting from the wall; these ornamental pins could be rosettes of metal, wood, or glass. If either the glass curtain or the drapery was closed at night and looped up during the day, its length was such that its hem reached the floor when looped up but "puddled" on the floor at night in a mass of folds.

Between the glass curtains and the draperies might be added more curtains, more opaque than the glass curtains, that could be drawn over the

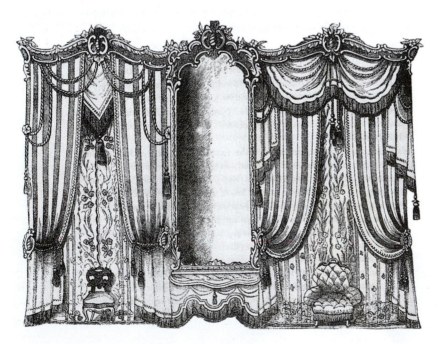

Figure 19–62 This illustration appeared in an advertisement in the October 1866 issue of *Godey's Lady's Book.* The fancifully shaped cornice board extends over two windows and a mirror between them. Two alternate schemes for valances and draperies are shown.

COURTESY THE ATHENAEUM OF PHILADELPHIA

whole window for privacy or light control. Or window shades might take that intermediate position. Simpler effects eliminated the draperies and used only glass curtains topped by a valance of fabric swags.

Finally, all these elements were generally trimmed with what is known collectively as **passementerie** (pahs-mahn-tree) from the French *passement*, a strip of lace. Types of passementeries include braids, cords, ropes, fringes, and gimp; this last term is usually used for a braid or other trim that is applied in an ornate pattern rather than used simply as an edging. And each of these comes in many forms; a small sampling of fringe types is shown in Figure 19–63. There were also singular, less continuous ornaments, such as tassels, bows, and rosettes.

The coordination of these elements among themselves and with the other parts of a room was a major design undertaking. Sometimes the cornice board was covered with the same fabric used for the draperies and tiebacks; sometimes not. And care was given to making the silk threads of the passementerie match the colors of the fabric, which often required custom dyeing, a service still available today.

CARPET In France, the establishment of the First Empire in 1804 revived both the privately owned carpet factory at Aubusson and the state-owned one at the Savonnerie with demands for replacing the palace carpets lost or damaged in the Revolution. The old designs were not duplicated, however, but replaced in the style of Percier and Fontaine. The new carpet patterns employed classical figures, floral bouquets, and classical military emblems, such as spears, trophies, and shields; the wreathed *N* also appeared. Napoleon's fall in 1815 meant the loss of an avid patron. The Savonnerie was combined with the Gobelins workshops in 1825, and the design of its subsequent products was influenced by the traditional Gobelins tapestries. At Aubusson, the old practice of hand knotting was threatened by the advent of machine weaving, and the new techniques were adopted in the 1830s and 1840s.

Figure 19–63 Examples of fringes used for draperies and upholstery work. The loop, moss, tassel, and cotton ball types are also used for slipcovers.

DRAWING: GILBERT WERLÉ

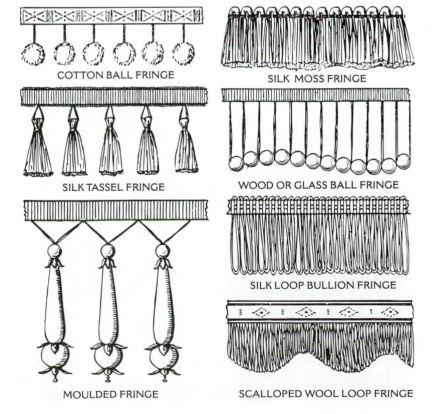

COTTON BALL FRINGE

SILK MOSS FRINGE

SILK TASSEL FRINGE

WOOD OR GLASS BALL FRINGE

MOULDED FRINGE

SILK LOOP BULLION FRINGE

SCALLOPED WOOL LOOP FRINGE

Figure 19–64 A wool wedding ryijy from Finland. Its date, 1810, is woven near the bottom of the central panel.

NATIONAL MUSEUM OF FINLAND, HELSINKI

In England, three important centers of carpet making were the towns of Kidderminster, Axminster, and Wilton. All three were active in the eighteenth century, and a strong, inexpensive wool floor covering, sometimes called *Scotch carpeting*, had been made at Kidderminster in the sixteenth century; in the last chapter we saw that some of it was said to be installed at Westover in Virginia. Axminster, on the River Axe, was the site of a workshop begun by Thomas Whitty in 1755, mentioned in chapter 16. It was continued by his daughters, sons, and grandsons, making hand-knotted carpets using the symmetrical or Turkish knot (Figure 9–39). Whitty's factory burned in 1828, and, although it was rebuilt, the company never recovered. In 1836 its looms and stock were bought and transferred to Wilton. Wilton weavers had begun in 1741 to make *Brussels carpets*, a type made with uncut loop pile, but not long after they began to make a new type with a dense cut pile, called *Wilton*. After acquiring Whitty's equipment, Wilton also began making hand-knotted carpets. The factory continued into the twentieth century as the Royal Wilton Carpet Factory, but the hand knotting stopped in 1957. William Morris, who had designed some machine-made carpets for Wilton, had also tried independently producing hand-knotted ones c. 1878, but his venture was not a financial success.

A revival of hand knotting was also attempted in Ireland, encouraged by the government to provide employment in the depressed area of Donegal. Based in the town of Killybegs and directed by Alexander Morton (1844–1921), the factory produced highly respected products.

A hand-knotting tradition also persisted into the nineteenth and even twentieth century in Finland, its best-known products being the small wool pile carpets called **ryijy** (Figure 19–64). Different areas of Finland developed their own traditional patterns for ryijy designs.

In Scotland, Richard Whytock of Edinburgh began in 1832 to use yarns pre-printed in stripes of several colors as the warp (which formed the pile) of carpets he called *Tapestry Brussels* or *Tapestry Velvet*; an ordinary Brussels carpet had been limited to six colors, but Whytock's could have over a hundred (Figure 19–65). Another multicolor technique was developed in 1839 by James Templeton of Glasgow, who inserted wool chenille tufts into a jute or linen backing to produce what he called a *Chenille Axminster*. In 1841 he was commissioned to make such a carpet for St. George's Chapel at Windsor Castle, and a decade later he showed one at the Great Exhibition in London; the chenille carpet, however, was never suitable for hard wear.

In America, there were a number of factories making Brussels-type rugs and carpets, the first established in Philadelphia in 1791. Others soon followed in Massachusetts, New York, and New Jersey, and one was set up within Sing Sing, the federal prison opened in 1838 in Ossining, New York. In 1844 a Brussels carpet with yellow stars on a scarlet background was woven in Germantown, Pennsylvania, for the floor of the United States Senate chamber. Among American innovators, Erastus Brigham Bigelow (1814–79), a Massachusetts inventor and one of the founders of the

Massachusetts Institute of Technology in 1861, developed several new kinds of carpet loom. One he invented in 1848 could weave carpet with either loop pile (Brussels type) or cut pile (Wilton), and it could produce them almost ten times as fast as a hand weaver. After Bigelow showed his loom at the Great Exhibition of 1851, Crossleys of Halifax, Yorkshire, England, bought his patent and licensed the machine to other English manufacturers. Other American inventors in the field were Alexander Smith and Halcyon Skinner. Skinner's loom patent was bought by the Tomkinson and Adam factory in West Yorkshire; with it Tomkinson and Adam would produce a machine-tufted carpet they called *Royal Axminster*. Hooked and braided rugs also continued to be popular in America.

In China, the old tradition of knotted-pile carpet weaving persisted into the nineteenth century as a northern folk art tradition; it formed the basis for the modern carpet industry centered in Beijing, Tianjin, and Shanghai.

West of China in Central Asia, carpet making was transformed in the nineteenth century from a cottage industry to mass production. The introduction of aniline dyes in place of vegetable dyes brought departures from traditional color schemes and produced some "fugitive" colors that faded quickly; and some carpets were washed in chlorine to age them artificially. In general, nineteenth-century Central Asian production increased, but quality declined. Since then, however, there have been some revivals of home weaving, and fine techniques have reappeared.

In the Middle and Near East, as well, old weaving traditions changed. Although carpet making remained a cottage industry, aniline dyes were adopted. With an eye on the export market, Western designs and motifs, such as the rose, were adopted. In the 1879s the Iranian carpet industry was revived by Tabriz merchants, and in the nineteenth century's last quarter a modern transportation system linked the Caucasus region to Europe, making the export of carpets far easier than before. In 1876 the Turkish government displayed a large collection of carpets at the Centennial Exhibition in Philadelphia; these were bought by the decorating department of the New York furniture store W. & J. Sloane, and Sloane's resale of them did much to promote such carpets' popularity in America.

Figure 19–65 An English warp-printed Tapestry Brussels carpet, mid-nineteenth century, 7 feet 4 inches (2.3 m) long.

VICTORIA AND ALBERT MUSEUM, LONDON/ART RESOURCES, NY

But the Philadelphia Centennial also showed a variety of patterns for wood parquet flooring, sometimes called *wood carpeting,* and the American craze for "Orientals" was somewhat dampened by new concerns about hygiene. In January 1884, according to Bishop and Coblentz, *Godey's Lady's Book* advised that wood floors were healthier than textile carpets, which could "harbor impregnating germs of disease and death."

Wallpaper

In America, the taste for English papers, which had been available for most of the eighteenth century, was replaced by a taste for French papers. Thomas

Jefferson, according to Joanne Warner of the Cooper-Hewitt Museum, "ordered 145 rolls of wallpaper from the Paris firm Arthur and Robert in 1790 to decorate his residence in Philadelphia, and in a comparable display of extravagance, Oliver Phelps, a prosperous merchant from Suffield, Connecticut, had five French papers, including one by Réveillon, hung on his walls."

Prominent among the fashionable French paper manufacturers after Réveillon were Pierre Jaquemart, Jean Zuber, and Joseph Dufour. Jean Zuber (1773–1835) joined the Dolfuss firm (a maker of Indian-style textiles, but with a wallpaper department) in Alsace in 1791 and changed its name to Jean Zuber et Compagnie in 1802. Zuber hired the painter Pierre-Antoine Mongin, whose specialty was the poetic landscape with courtly figures. Some of Mongin's papers for Zuber were based solely on imagination and written accounts, such as his "Swiss Views" of 1804, "Hindustan" of 1807, "Great Helvetia" of 1814, and "Italian Views" of 1818. Mongin's twenty-five-panel "Gardens of France" of 1821 may have been his finest work for Zuber; certainly it was frequently reprinted. Mon-

gin's successor was Jean Julien Deltil, who produced for Zuber such topical papers as the 1827 "Battles of the Greeks," the 1829 "Views of Brazil," and the 1834 "Views of America," a set of which would be hung in the White House during the Kennedy administration.

Zuber's chief competitor was Joseph Dufour (1757–1827), whose firm, established in 1804, employed Jean-Gabriel Charvet and Christophe-Xavier Mader as its chief designers. Like Zuber, Dufour produced large scenic papers, such as Charvet's "Sauvages de la Mer Pacifique" of 1804–5, and Mader painted **grisailles** based on mythology, such as the 1816 "Cupid and Psyche" (Figure 19–66). Later, military subjects became popular as well, such as Dufour's 1929 "French Campaigns in Italy" and Zuber's 1850 "War of American Independence."

The papers were often installed above wood wainscoting, and when greater economy was needed the whole effect was accomplished with paper; from floor to ceiling, above a three-dimensional baseboard, there was a paper dado about 2 feet (60 cm) high, a "fill" paper covering most of the wall, and a paper frieze at the ceiling. The rage for panoramic scenic papers was over by c. 1865, its decline probably reinforced by the growth of machine printing, as such printing produced relatively small motifs and relatively short repeats.

Floral motifs came to be overwhelmingly the most popular of the century, their popularity stimulated by the botanical engravings of Joseph Redouté and others. Roses, peonies, poppies, lilacs, and more covered not only wallpapers, but also fabrics, porcelains, and—in the form of carvings, mother-of-pearl and gilt inlays, and applied papier-mâché—furniture.

As the century progressed, however, these floral motifs became less realistic and more stylized. This trend was fueled by the Arts and Crafts movement in general and by William Morris in particular. Morris's early papers, such as "Daisy," "Trellis," and "Fruit," issued beginning in 1862, were drawn from nature but with no desire to give the illusion of nature; their elements were simplified, balanced, spaced apart, and flattened.

In 1879 Louis Comfort Tiffany and his partner Samuel Colman agreed to design wall and ceiling papers for Warren, Fuller and Company. The com-

Figure 19–66 A scene from the twenty-six-panel grisaille wallpaper "Cupid and Psyche" produced by Dufour in 1816.

DEUTSCHES TAPETENMUSEUM/STAATLICHE MUSEEN KASSEL, KASSEL, GERMANY

Figure 19–67 A machine-printed cotton designed by C.F.A. Voysey. Voysey's birds and plants were "symbols" rather than realistic.

pany hired art critic Clarence Cook to write the text for a book promoting their designs; it was published in 1881 with the title *What Shall We Do with Our Walls?* And at the end of the century, the wallpaper and fabric patterns of C.F.A. Voysey would carry Morris's abstraction a step further, showing birds, animals, and plants "reduced to mere symbols" (Figure 19–67).

Summary: Nineteenth-Century Design

The nineteenth century is the beginning of the modern world in which we live, and it is notoriously difficult to summarize ourselves. We think it is clear to us today which of the many varied nineteenth-century movements looked backward and which anticipated what was to come, but these judgments may change as the twenty-first century progresses, and, in any case, looking backward does not preclude aesthetic satisfaction.

Much of the history of the nineteenth century seems to have been one of struggles, rivalries, and competition. But the conflicting ideas we noted in the first paragraph of this chapter had, by the end of the century, been largely reconciled. The winners were the machine-made over the handmade, invention over tradition, and the new over the old. Some revivals of past styles would continue into the twentieth century, but in many ways the world had finally been made ready for design that matched the science and technology of the time. The nineteenth century had set the stage for the appearance of modernism.

CHAPTER

20

THE TWENTIETH CENTURY

If the previous chapter had been written in 1900 it would have been far different. What might have seemed a fair summary then would doubtlessly have omitted many things that later came to seem significant or prophetic, and would have included others that turned out to be dead ends. So describing the design of the twentieth century just after that century has ended is risky. Personal judgments and prejudices necessarily intrude as substitutes for perspective. Readers must beware of those intrusions, therefore, and form their own opinions of the material presented and the evidence around them.

The Determinants of Twentieth-Century Design

The division between the nineteenth and twentieth centuries is an arbitrary one, for the twentieth century is the child of the nineteenth, and the three factors that shaped nineteenth century design—technology, publications, and expositions—continued, with some modifications, to dominate.

Technology

The nineteenth century's efforts to deny the reality of industrialization could not succeed. Although nostalgia for pre-industrial forms and materials persisted into the twentieth century, design in the twentieth century learned to deal fully with—and benefit fully from—technology. Indeed, technological advances culminated at the end of the century with a single device, the computer, that affected not only many of the activities accommodated by interior design, but the process of interior design itself.

Publications and Publicity

In the twentieth century, publications remained important in the spread of design information. But "publicity" also became important as such information began to be spread not only by editorial messages but also by advertising. Skill in the manipulation of advertised images grew so greatly in the twentieth century that earlier ads now seem hopelessly naive. In the twentieth century, design influences that originated in any quarter—books, magazines, show houses, department stores—were immediately communicated to every quarter, and promoted instant fashions.

Twentieth-Century Styles

The twentieth century saw as many stylistic changes as the nineteenth. Many of the styles that flourished in the nineteenth century continued into the twentieth, and many new ones—some radically new—were added. We shall begin our survey with two that had nineteenth-century beginnings.

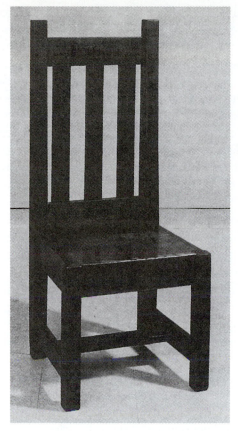

Figure 20–1 Elbert Hubbard's Roycrofter chair designed between 1905 and 1912.

PHOTO: THE ART MUSEUM OF PRINCETON UNIVERSITY, MR. AND MRS. R. W. BLASBERG COLLECTION

The Continuation of the Arts and Crafts Movement

The previous chapter described the Arts and Crafts movement's coming from England to America and the great success, during the first dozen years of the twentieth century, of the American designer Gustav Stickley. He called his version of the Arts and Crafts **Craftsman** style, and it also came to be called **Mission.**

Another designer whose work shared the Mission name was Elbert Hubbard (1856–1915). Like Stickley, he was an American who traveled to England and was much impressed by the Arts and Crafts movement in general and by the work and ideas of William Morris in particular. In East Aurora, New York, he founded a community of craftsmen he called the **Roycrofters.** His furniture was sturdy and severely plain (Figure 20–1),

and the Roycroft workshops also produced tooled leatherwork by Frederick Kranz, influenced by the sinuous curves of Art Nouveau, and hammered copper and iron work by Dard Hunter and Karl Kipp, which showed a knowledge of the Viennese Secession style. The Roycrofters survived until 1938.

Related to these New York manifestations of the Arts and Crafts were the West Coast work of Bernard Maybeck, Irving Gill, and the Greene brothers, and the **Prairie** style of architecture practiced in the Midwest by Walter Burley Griffin, Marion Mahoney, William Purcell, George Elmslie, and Frank Lloyd Wright. Stickley had written admiringly about many of these, as well as about Louis Sullivan, in his *Craftsman* magazine.

The West Coast work, responding to a sudden growth in population and prosperity there, can be exemplified by the partnership of Charles Sumner Greene (1868–1957) and Henry Mather Greene (1870–1954). On their way west to settle in Pasadena, California, they stopped at the 1893 World's Columbian Exposition in Chicago, where they were much impressed by a traditional Japanese pavilion called the Ho-o-den. This Japanese influence, together with Arts and Crafts and a respect for California's eighteenth-century

Hispanic architecture, blended into a complex and personal style, at once rustic and impeccably detailed (Figure 20–2). Best known of their many wood-framed "bungalows" was the Gamble house, Pasadena, of 1907–9 (Figure 20–3). The Greenes' success declined after about 1911, however, their style eclipsed first by more imitative Mediterranean and Hispanic work in California and later by modernism, which they never fully embraced. Their work was virtually forgotten until after World War II; since then their reputation has been revived, and their work is now considered masterful.

The Prairie style, though long and low like the Midwestern prairies, was actually practiced primarily in suburban areas like Oak Park, outside Chicago. Its horizontal forms were sheltered by gently pitched hipped or gabled roofs with widely overhanging eaves. The horizontal forms were emphasized on the exterior with long bands of wood, shingles, stucco, or masonry, and on the interior with strips of wood trim against plain plaster walls. Sturdy masonry chimneys and large fireplaces punctuated the space and the roof, fenestration was often long bands of casement windows, sometimes with panels of stained glass, and much seating and cabinetry was built in.

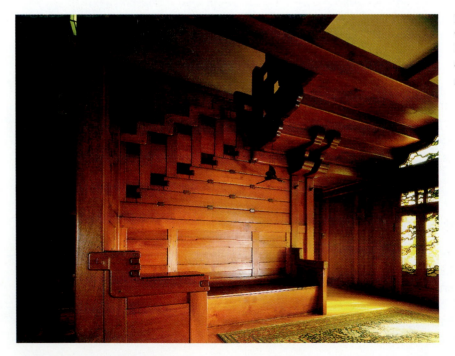

Figure 20–2 Joinery detail of the stair, Gamble house, Pasadena, California, by Greene and Greene, 1907–9.

MICHAEL FREEMAN

Figure 20–3 A fireplace inglenook with built-in seating in the living room of the Gamble house, Pasadena, California, by Greene and Greene.

The great genius of the Prairie style was Frank Lloyd Wright (1867–1959). Wright had trained as an apprentice to Louis Sullivan, whom we have characterized—because of his florid ornament—as a designer in the Art Nouveau style. More important for Wright's development than the ornament, however, was Sullivan's concern for the honest expression of both structure and use, summarized in his dictum "Form follows function." Wright left Sullivan's office in 1893, but even before that he had begun to do some residential design on his own. He designed the brick William Winslow house in River Forest, Illinois, in 1894, in 1901 he published a project for "A Home in a Prairie Town" in the *Ladies' Home Journal*, and in 1902 he de-

signed the Ward Willits house in Highland Park, Illinois. An important laboratory for his developing ideas was his own house and studio in Oak Park, a suburb of Chicago; he began it in 1889, adding to it and altering it almost continuously for twenty years (Figure 20–4).

Wright's first notable ventures beyond residential scale were for the Larkin Company Administration Building of 1904 in Buffalo, New York, which we shall see as an important step in the development of office design, and the Unity Temple of 1906, also in Oak Park. The main auditorium of Unity Temple (Figure 20–5) is a cubic space surrounded on three sides by balconies, lighted by art glass skylights, and articulated by

Figure 20–4 The children's playroom in Frank Lloyd Wright's house and studio, Oak Park, Illinois, 1889–1909.

PHOTO: JON MILLER, HEDRICH-BLESSING, COURTESY OF THE FRANK LLOYD WRIGHT HOME AND STUDIO FOUNDATION

Figure 20–5 The auditorium of Frank Lloyd Wright's Unity Temple, Oak Park, 1905–8.

PAUL ROCHELEAU

Prairie style strips of dark wood against tan plaster surfaces. Blocks of staircases stand at the corners of the space, as they had at the Larkin Building, their function clearly visible both inside and out. Wright's career would be long, distinguished, and varied, and will intersect often with the story of design in the first six decades of the twentieth century.

The Continuation of Art Nouveau

We have called the somewhat more geometric design of the Vienna Secession an outgrowth of the lyrical Art Nouveau, and have mentioned two of the movement's outstanding designers, Josef Hoffmann and Koloman Moser. In 1903 Hoffmann and Moser founded the **Wiener Werkstätte** (Viennese workshop), a cooperative of architects, decorative artists, painters, and sculptors; it would be active until 1932. Two important early commissions followed, the Purkersdorf sanatorium and the Palais Stoclet.

The Purkersdorf sanatorium, built near Vienna in 1903–5, was the first large-scale opportunity for the Werkstätte artists to display the integration of all their skills; it was also Hoffmann's first major step away from Art Nouveau fluidity toward simpler cubic forms; and in its plain surfaces, ample windows, and rationality of plan, it anticipated the sanatorium Alvar Aalto would design for Paimio, Finland, in 1929.

The Palais Stoclet, a large private house for a wealthy art collector in Brussels, continued the cubic vocabulary of the sanatorium but was decoratively richer. Its design occupied Hoffmann and all members of the Werkstätte from 1905 to 1911. Around a double-height colonnaded hall, Hoffmann arranged rooms of near palatial dimensions: a bedroom 31 feet (9.5 m) long, a dining room 49 feet (15 m) long, and a music room 59 feet (18 m) long. The house's exterior was of marble panels trimmed with bronze, and many interior walls and floors were marble as well, others being of inlaid rosewood or, in the dining room, mosaic murals by painter Gustav Klimt. Furniture, fabrics, carpets, hardware, lighting fixtures, art, and gardens were all designed as elements in the great ensemble.

In the same spirit, Hoffmann himself throughout his career designed furniture, porcelain, glass-

Figure 20–6 A dining chair of ash designed by Josef Hoffmann in 1908 with a grid of square members.
ICF GROUP

ware, silverware, fabrics, and all kinds of decorative objects. Many of these, even in the early years of the century, shunned the rich decorative effects of the Palais Stoclet and were severely geometric (Figure 20–6).

Leading Viennese design into less rational paths was a younger designer, Dagobert Peche (1887–1923), whose patterns for fabrics, curtains, and papers (Figure 20–7) were purposely unstructured. He compounded their disorienting effects by using several together in the same room. Peche's talents were obvious, however, and in 1915 Hoffmann appointed him manager of the Wiener Werkstätte artists' workshops, where he further developed his skills in work with ivory, ceramics, and leather.

Richard Riemerschmid (1868–1957) was a member of the Secession group in Munich, founded five years earlier than the group in Vienna, and

Figure 20–7 A 1913 wallpaper design by Dagobert Peche.

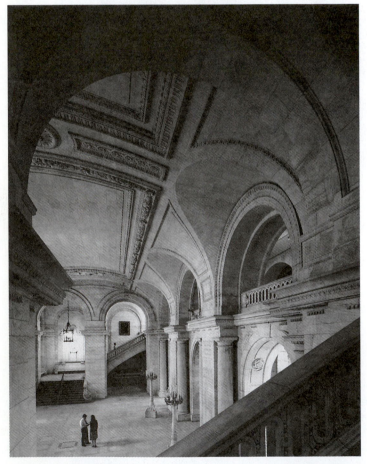

Figure 20–8 The marble-faced entrance hall of Carrere and Hastings's New York Public Library, finished in 1911.

he was also a founder of the Deutscher Werkbund group in Munich in 1907, established to promote German design. He began and ended his career as a painter, but between those periods he produced city planning schemes, architecture, interior design, furniture, lamps, glassware, porcelain (for the Meissen factory), stoneware, and silverware. He is best known today for his furniture, much of which is simple and sturdy.

The Continuation of Revivalism

Many of the historical revivals of the nineteenth century continued into the twentieth. The Renaissance Revival, having been given a boost by the 1893 Columbian Exposition in Chicago, was the most popular of all, and at the beginning of the century architects from America and all over Europe still hoped to train at Paris's Ecole des Beaux-Arts, where French Renaissance design was entrenched.

The style was responsible for some grand interiors, such as Carrere and Hastings's New York Public Library, finished in 1911 (Figure 20–8). This and other buildings all had interiors designed by the architects themselves, but interior design as an independent profession had been given a boost in 1905 when Stanford White of McKim, Mead, and White, who had designed the Colony Club in a Federal Revival style, secured the commission for the club's interiors for Elsie de Wolfe. De Wolfe's interiors, for the most part, demurely continued the building's Federal Revival character, but there were a few surprises, such as the Trellis Room, where she covered the walls with what the French call *treillage*, creating the effect of an outdoor pavilion.

For a series of other New York clubs, McKim, Mead, and White used French Renaissance and Georgian Revival styles. Between 1891 and 1916 these were the Century Club, the Metropolitan Club, the University Club (Figure 20–9), and the Harvard Club, and together they established a precedent for the entire building type and its interiors.

Sir Edwin Landseer Lutyens (1869–1944, pronounced "Lutchens") was the dominant English architect and designer of the century's first four decades. His houses were a personal mixture of

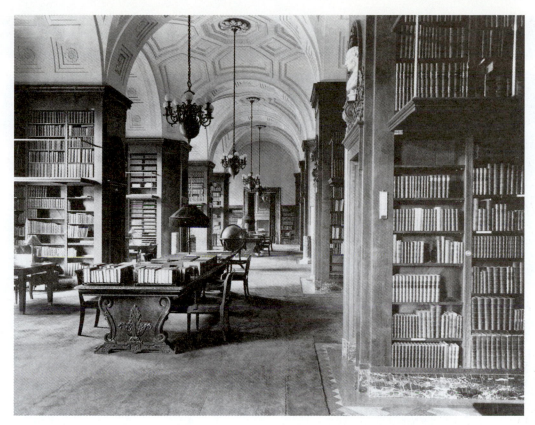

Figure 20–9 The library of the University Club, New York, by McKim, Mead, & White, 1900.

romanticism and classicism and an eclectic mixture of stylistic revivals, among which was Folly Farm, Berkshire, 1908, with classical elements, dramatically presented (Figure 20–10).

To the historical revivals it inherited from the previous century, the twentieth century added a new one, a revival of pre-Columbian American forms and motifs, especially those of Central and South America. Mayan decorative motifs appeared subtly in Frank Lloyd Wright's **textile block** houses of 1923–24, such as the Ennis-Brown House (Figure 20–11).

In furniture design, past successes were often repeated. Perhaps the most venerable of these was the Greek **klismos** chair, which made at least two reappearances in the twentieth century, first in T. H. Robsjohn-Gibbings's 1926 adaptation (Figure 4–41) and later in John Hutton's 1989 Academy chair for Donghia (Figure 20–12, page 565). In textiles as well, new patterns often reinterpreted older ones; Gretchen Bellinger's screen print "Golden

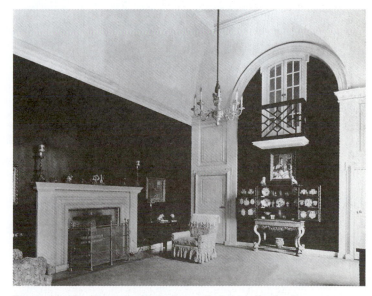

Figure 20–10 The hall of Folly Farm, Berkshire, England, by Edwin Lutyens, 1908. Its woodwork is white against walls painted a glossy black, and the open china cabinet is lacquered red.

Figure 20–11 Patterned concrete blocks in the living room of Frank Lloyd Wright's 1924 Ennis-Brown house, Los Angeles. The dining room, raised a few steps, is visible at the left.

© EZRA STOLLER/ESTO

Apples" (Figure 20–13), introduced in 1993, for example, adapted the thirteenth-century Chinese ink drawing *Six Persimmons* (Figure 11–15).

The Roots of Modernism

German architect Peter Behrens (1868–1940) was one of the fathers of modern design and a major proponent of artistic involvement in many areas. In addition to buildings and interiors, he was an educator, produced paintings and woodcuts, and, as artistic adviser to the giant German electric corporation AEG and other industries, he produced graphic designs and a wide array of product designs. Apprentices in the Behrens office included three young men who would be largely responsible

Figure 20–12 A version of the Greek klismos, this stacking chair was designed by John Hutton for Donghia. Introduced in 1989 as the Academy chair, it is now marketed as the Anziano.

Figure 20–13 "Golden Apples," a screen print silk wall or window fabric introduced by Gretchen Bellinger in 1993, has thirteenth-century Chinese precedents.

for the modern movement: Walter Gropius, Ludwig Mies van der Rohe, and Le Corbusier.

THE BAUHAUS (1919–34) Walter Gropius (1883–1969) was at least as important as an educator as he was as an architect. In 1919 he was appointed head of two German art schools; combining them, he formed the **Bauhaus** (building house) and became the new school's first director. Despite its name, it did not at first teach architecture; that was a goal realized in subsequent years. It began by teaching applied arts, with each workshop (carpentry, weaving, metalwork, etc.) headed by a pair of instructors—one of them an artist, the other a craftsman or technician. Its faculty members, some of whom began there as students, included painters Paul Klee, Wassily Kandinsky, and Johannes Itten, architect and furniture designer Marcel Breuer, painter Josef Albers and his wife, weaver Anni Albers, painter/sculptor/photographer László Moholy-Nagy, and others well-known today.

In 1925 the city of Dessau invited the Bauhaus to move there from Weimar, and in 1926 Gropius installed his school in architecture of his own design. Gropius's Dessau Bauhaus was an asymmet-

Figure 20–14 Bridge between two blocks of Walter Gropius's 1925 Bauhaus building, Dessau, Germany. The complex was restored in 1991.

rical composition of simple unadorned masses with some multistory glass walls, with a pattern of cantilevered balconies, and with a bridge over a city street, a complex housing classrooms, offices, and student housing (Figure 20–14). It defined modernism and offered a catalog of its possibilities.

Many of the Bauhaus's interiors and much of its furniture was designed by Marcel Breuer (1902–81), who had become head of the school's carpentry workshop in 1924. In 1925 he had begun

experimenting with tubular steel as a furniture material, producing the Wassily chair (Figure 20–15) and some nesting tables (Figure 20–16). Turning one of the tables on its side produced a cantilevered

structure, which Breuer then employed in a chair design that would be one of the century's most popular and most imitated: the **Cesca chair** (Figure 20–17). Gropius and Breuer would both leave the Bauhaus in 1928 to work in Gropius's Berlin architecture firm.

Gropius was succeeded as Bauhaus director by Hannes Meyer, who introduced architecture and city planning studies and emphasized technology over art. In 1930 Meyer was dismissed and replaced by architect Ludwig Mies van der Rohe (1886–1969), who would be one of the century's most influential designers. In 1930 Mies had just completed two landmarks of modern architecture, the German Pavilion at the 1929 international exhibition in Barcelona (Figure 20–18) and the Tugendhat house in Brno, Czechoslovakia, for both of which he also designed interiors and furniture.

Lilly Reich, Mies's frequent collaborator, took over the Bauhaus interior design and weaving stu-

Figure 20–15 Marcel Breuer's tubular steel and leather Wassily chair, 1925, named for Bauhaus painter Wassily Kandinsky.

COURTESY MARCEL BREUER & ASSOCIATES ARCHITECTS

Figure 20–16 Breuer's nesting tables with tubular steel frames and in graduated sizes.

GUNTER LEPKOWSKI/COURTESY MARCEL BREUER & ASSOCIATES ARCHITECTS

Figure 20–17 Breuer's cantilevered Cesca chair, designed in 1927 and named for his daughter Francesca.

COURTESY MARCEL BREUER & ASSOCIATES ARCHITECTS

Figure 20–18 Interior of Mies van der Rohe's German Pavilion at the 1929 Barcelona Exposition. The wall in the center is onyx and the one in the background is of translucent glass; the floor is travertine.

FUNDACIÓ MIES VAN DER ROHE, BARCELONA, SPAIN

dios in 1932, but in the fall of that year the Nazi regime forced the school in Dessau to close. Mies continued to run it as a private school in Berlin, but by 1934 the political situation in Germany had made it impossible to continue. Much of the past and present Bauhaus faculty fled Germany.

Mies went to Chicago as head of the architecture school at the Illinois Institute of Technology. Josef and Anni Albers went to Black Mountain College in North Carolina. Moholy-Nagy instituted a short-lived New Bauhaus in Chicago. Gropius went briefly to London and then to Cambridge, Massachusetts, where he was made head of the Harvard architecture school. Breuer joined Gropius as an architecture professor at Harvard.

The United States had thus become the home of many of the pioneers of the new design, but the years leading to and during the war of 1941–45 prevented much activity. Not only were building materials scarce and budgets tight, but also a federal law limited construction or remodeling (except for defense purposes) to two hundred dollars a year.

LE CORBUSIER (1887–1965) Meanwhile, apart from the Bauhaus, another pioneer of modernism had been developing his skills. Le Corbusier was born in Switzerland as Charles-Edouard Jeanneret. In 1917 he moved permanently to Paris and soon after took the pseudonym Le Corbusier. In the 1920s he designed some remarkable private houses—flat-roofed, cubistic, and startlingly white—in and around Paris, most notably the Villa Savoye at Poissy (1929–31). Then in 1935, in the design of a weekend retreat for himself in a wooded Paris suburb, Le Corbusier abandoned his white prisms for earthier, more natural materials, including roughly finished reinforced concrete, left unpainted (Figure 20–19).

Figure 20–19 Le Corbusier's own 1935 weekend retreat near Paris signaled a shift from pristine surfaces to more natural ones.

COURTESY FONDATION LE CORBUSIER, PARIS, FRANCE LI(6)146

Figure 20–20 The 1917 chair design by Gerrit Rietveld. He later painted it in black and primary colors, naming it the "Red-Blue" chair.

DRAWING: ABERCROMBIE

At the time of the design of these houses, Le Corbusier began working with a young avant-garde designer named Charlotte Perriand. Just as Lilly Reich would be a close collaborator with Mies for his interiors and furniture, Perriand would serve the same function for Le Corbusier.

An idea that was common to the work of Le Corbusier and to the Bauhaus, and one that would be important to interior design and furniture design throughout the century, was **modularity.** In 1925 Le Corbusier developed his Casiers Standard group of storage cabinets for the Pavillon de l' Ésprit Nouveau, the dimensions of which were based on a module of 15 inches (37.5 cm). Breuer began working on a similar system of modular units shortly after he took over the Bauhaus carpentry workshop in 1924, and they appeared in finished form in his 1926 Wilensky apartment, Berlin, his 1927 Piscator apartment, also in Berlin, and that same year at the Weissenhof Siedlung housing exhibition. Breuer's chosen module was 13 inches (33 cm).

DE STIJL Another development apart from the Bauhaus was the **de Stijl** movement, which had its home in the Netherlands. Gerrit Rietveld (1888–

1964) was its most brilliant architect, interior designer, and furniture designer.

Rietveld's first accomplishments were in furniture design. An unpainted armchair of 1917 was composed of sticks and planes, making a clear distinction between structure and support for the sitter, and a few years later he would paint it in various primary colors and name it the Red-Blue chair (Figure 20–20). His other furniture innovations included a 1919 sideboard with a structure as apparent as that of the Red-Blue chair, a number of asymmetrical chairs and tables, pendant lighting fixtures of three or four tubular glass lamps and the 1934 Zigzag chair made of four planes joined only at their edges. In 1971 the Italian manufacturer Cassina would revive both the Red-Blue and the Zigzag designs.

Rietveld's finest accomplishment, however, was a house he designed with its owner, Mrs. Truus Schröder-Schrader, in Utrecht, the Netherlands. Known as the Schröder house, it was completed in 1925. Its exterior is a composition of overlapping white and gray planes with touches of primary colors and black; inside, red, blue, and yellow surfaces predominate. The strikingly elementary vocabulary of forms and colors serves an equally striking functional program: the main floor's single room can become as many as six rooms by means of ingenious sliding and folding panels. It is the chief built example of de Stijl principles.

RUSSIAN CONSTRUCTIVISM A parallel development in Russia in the 1920s was the **Constructivist** movement. The revolution of 1917 had brought Communist rule and new optimism. New design followed. Important figures in the movement included Aleksandr Rodchenko, El Lissitzky, and Vladimir Tatlin. Constructivism was characterized by lack of ornament, exposed construction, economy of materials, and clarity of composition. Its achievements included painting, sculpture, architecture, graphic design, textile design, furniture design, and interior design. Architecture projects included a Palace of Labor building for Moscow and a building for the newspaper *Pravda* in Leningrad, both by the Vesnin brothers and both unbuilt. Interior design projects included a number of workers' clubs, conceived as important social and cultural institutions, meant to replace the dominant roles that both royalty and religion had enjoyed in czarist Rus-

sia, and other projects included furniture and even clothes for the workers of the new society. Constructivist work was shown in Paris in 1925, including a model workers' club designed by Rodchenko, and its ideas enriched current European design. In Russia itself, however, the Communist regime became aesthetically conservative and politically repressive, crushing the movement that had hoped to be its artistic representation.

ITALIAN RATIONALISM Another parallel development was the **Rationalist** movement (Razionalismo) in Italy in the 1920s and 1930s. It began in Milan with an aesthetic manifesto of 1926 proclaiming a need for rational building types, denouncing individualism, and sympathizing with the new political era of fascism. Like contemporary work being done at the Bauhaus and elsewhere, it reacted against nineteenth-century eclecticism and the Art Nouveau and proposed instead a sensible, simple, direct expression of function and construction. The most important Italian Rationalist was Giuseppe Terragni.

Terragni (1904–43) practiced in Como beginning in 1927, and in 1928 showed his work at Mies van der Rohe's Weissenhof exhibition in Stuttgart. His first important built work was the Novocomum apartment block in Como, finished in 1928, and another highlight was a demonstration house for the Milan Triennale exhibition of 1933 (Figure 20–21). His most famous work was the Fascist Party headquarters in Como, the Casa del Fascio, which he began to design in 1932 and which was completed in 1936; square in plan with carefully proportioned openings and unornamented white surfaces, it must have projected a dazzling sense of newness in the old city. Its interior (Figure 20–22) was furnished with some of Terragni's inventive tubular steel furniture.

FRANK LLOYD WRIGHT Before the arrival in America of the refugees from Germany, Frank Lloyd Wright had been the country's chief proponent of modernism, highlights of his career including the textile block houses already noted (Figure 20–11) and his own residential and educational complexes Taliesin in Wisconsin and Taliesin West in Arizona (Figure 20–23), both built and rebuilt in many stages. In 1936 construction began on one

Figure 20–21 The dramatic window wall of the 1933 House on a Lake for an Artist designed by Giuseppe Terragni and others for the Milan Triennale.

CENTRO STUDI GIUSEPPE TERRAGNI, COMO, ITALY

Figure 20–22 The boardroom of Terragni's Casa del Fascio, Como, Italy, 1932–36. The board table and cantilevered steel-and-leather chairs are Terragni's own designs.

CENTRO STUDI GIUSEPPE TERRAGNI, COMO, ITALY

Figure 20–23 In Frank Lloyd Wright's Taliesin West compound near Scottsdale, Arizona, 1938, light is diffused through white canvas roofs stretched above wood beams.

of Wright's most dramatic projects, Fallingwater, the Edgar Kaufmann house near Pittsburgh.

The choice of Wright for the Kaufmann country house had been urged by Kaufmann's son, Edgar, jr., who had been studying at Taliesin and who would later be a curator, historian, and connoisseur of modern design and decorative arts. The site featured a waterfall in rocky terrain, and Wright increased the drama by cantilevering parts of the house directly over the stream. Without violating his own principles of building in consonance with the landscape (for a stone-faced core anchored it structurally and visually), Wright proved himself a virtuoso of modern composition and structural daring. Inside (Figure 20–24) as outside, Fallingwater was a highly personal amalgam of elements that were natural and elements that could not have been achieved without technology.

These pioneering styles would all be temporarily overshadowed by a less thoughtful, more animated, and more superficial style, Art Deco. The

Figure 20–24 Living room of Fallingwater, the Kaufmann country house near Pittsburgh, designed by Frank Lloyd Wright in 1936.

Figure 20–25 Jacques-Émile Ruhlmann's desk design, c. 1926. It is of macassar ebony with inlaid elements of snakeskin, ivory, and silvered bronze.

VIRGINIA MUSEUM OF FINE ARTS, RICHMOND, VIRGINIA. GIFT OF SYDNEY AND FRANCES LEWIS. PHOTO: KATHERINE WETZEL. © 1997 VIRGINIA MUSEUM OF FINE ARTS.

triumph of modernism would be postponed until after World War II.

Art Deco

It was not until the 1960s that the term **Art Deco** was in common use. The source of the name was Paris's *Exposition Internationale des Arts Décoratifs et Industriels Modernes* of 1924 and 1925, aimed at developing export markets for French decorative arts and luxury crafts in a style that was simultaneously modern and in the French tradition.

The style thought to meet these requirements avoided the sinuous curves of the recently popular Art Nouveau. Plant forms were still a basis for decoration, but they were interpreted more geometrically, and the pale colors of Art Nouveau were replaced by stronger ones. Except for its rejection of Art Nouveau, however, Art Deco welcomed the influences of other styles and precedents. This amalgam was often expressed with exotic materials and techniques: rare woods and veneers, ivory and mother-of-pearl inlays, marquetry, and lacquerwork.

The cabinetmaker and interior designer Jacques-Émile Ruhlmann (1879–1933) was the finest furniture designer of his time, continuing the tradition of excellence of the great French **ébénistes** and emulating their marquetry and veneering techniques (Figure 20–25). In 1918 he began concentrating on furniture design, although his company would also provide fabric, carpet,

lighting, and upholstery. Ruhlmann's room designs for the 1925 exposition were important ones, including pieces by Jean Puiforcat, Jean Dunand, Edgar Brandt, Pierre Legrain, and other designers and craftsmen and thus exemplifying the role of the interior designer as an *ensemblier* or "Master of Works." For his furniture, Ruhlmann used ebony and amaranth woods, inlaying them with ivory and panels of leather and **shagreen** (sharkskin, sometimes dyed green). In the 1930s he experimented with chrome-plated steel, glass, and black lacquer.

After the 1925 Paris exposition, America took up the Deco style with great enthusiasm, even if without the luxury materials and finishes that had been available in France. Working in the style in America were a number of designers born in Vienna—Paul Frankl, Joseph Urban, and Kem Weber—and their work often leaned more heavily toward the Wiener Werkstätte than toward the style's other components. The American architectural masterpiece of Art Deco was New York's Chrysler Building of 1929 by William Van Alen, and the great monument of Art Deco interiors was the Radio City Music Hall of 1931 by Donald Deskey (1894–1989). On a residential scale, a high point was the New York apartment designed in 1937 by Jean-Michel Frank (with architect Wallace Harrison) for Mr. and Mrs. Nelson Rockefeller; the living room contained furniture by Frank, andirons and lamps by Diego Giacometti, an overmantel panel by Matisse, and paintings by Picasso (Figure 20–26).

Figure 20–26 The Nelson Rockefeller apartment, New York, designed by Jean-Michel Frank in 1937 and restored in 1978. The mural over the fireplace is by Matisse.

Perhaps the most characteristic furniture was Frankl's Skyscraper bookcase of 1928, emulating a cluster of tall buildings; the style was also seen in clocks, radios, tableware, graphics, wallpapers, and textiles.

American Art Deco greatly influenced—and gradually was replaced by—the **streamlined** look of locomotives and automobiles, a look employed as well in such stationary objects as home appliances and pencil sharpeners. A revival of interest in the Art Deco style was a design diversion of the late 1960s.

The Growth of Modernism and Other Postwar Developments

In contrast to the multiple and intersecting currents of the century's first four decades, postwar modernism would exhibit a new purity and independence. It was as if the seriousness of war had focused attention on serious design—or, at least, on design that presented itself with seriousness. Conservative, traditional interior design continued as well, as it still does today, clinging to its familiar swags and ruffles, its elegant details and polished woods, its expensive techniques and extraordinary effects, but even traditional design felt the influence of the modern spirit—bold, clean, simplified, and efficient. Modern was, for the most part, what the postwar world wanted and, not incidentally, what it could afford.

THE BAUHAUS INFLUENCE IN MASSACHUSETTS: GROPIUS AND BREUER We have mentioned that Gropius and Breuer taught

architecture at Harvard before and during World War II. Immediately after the war their classes grew enormously, and their first postwar students included I. M. Pei, Paul Rudolph, Ulrich Franzen, John Johansen, and Philip Johnson. A new generation of modernists was being trained.

Figure 20–27 Living room of Marcel Breuer's demonstration house built in the garden of the Museum of Modern Art, New York, in 1949.

EZRA STOLLER/ESTO

Gropius and Breuer had opened their own office while teaching, continuing their partnership until 1941. After that, Gropius pursued his ideas of collaborative design as a partner in a large firm, the Architects Collaborative, and Breuer pursued more personal design. In a series of modestly scaled houses, one built for himself in New Canaan, Connecticut, in 1947, another built for exhibition in the garden of the Museum of Modern Art, New York, in 1949 (Figure 20–27), Breuer enriched the Bauhaus vocabulary with his appreciation of vernacular American building materials such as wood siding and fieldstone walls.

THE BAUHAUS INFLUENCE IN CHICAGO: MIES VAN DER ROHE

In Chicago, Ludwig Mies van der Rohe was pursuing a more industrial form of the Bauhaus aesthetic in which the clear expression of structure was paramount. His earliest major client after moving there was the institution where he taught; for the Illinois Institute of Technology he designed a modular and cohesive master plan and a number of its buildings, including a small chapel that was the last word in **minimalism** (Figure 20–28) and Crown Hall, home of the architecture and industrial arts programs (Figure 20–29). In the same years, he designed a weekend house near Chicago for Dr. Edith Farnsworth

Figure 20–28 The altar of Mies van der Rohe's interdenominational chapel for the Illinois Institute of Technology, Chicago, 1952.

HEDRICH-BLESSING ARCHIVES, CHICAGO HISTORICAL SOCIETY

Figure 20–29 Stair in Crown Hall, the architecture building designed by Mies for IIT and completed in 1956.

HEDRICH-BLESSING ARCHIVES, CHICAGO HISTORICAL SOCIETY

with exterior walls completely of glass; it was finished in 1950, but the year before, acknowledging Mies's idea, Philip Johnson had completed his own version of a glass house in New Canaan, Connecticut (Figure 20–30).

CRANBROOK In the Detroit area, an alternative to the Bauhaus/Harvard educational tradition had been established by architect Eliel Saarinen in 1923, the Cranbrook School of Design in Bloomfield Hills. Fashioned as an academy with an emphasis on studio work rather than formal classes, Cranbrook sought an integration of architecture and urban planning with the crafts-based tradition Saarinen had known in his native Finland. Saarinen designed a number of buildings for the school over the next two decades, including a house for the president (himself, from 1932 to 1942), the interior of which he designed using his own furniture and textiles woven by his wife (Figure 20–31). Prewar Cranbrook students and faculty members who would become important postwar designers included architects and designers Eero Saarinen (Eliel's son), Charles Eames and his future wife Ray Kaiser, Harry Bertoia, Benjamin Baldwin, Ralph Rapson, Jack Lenor Larsen, and Florence Schust, who would become Florence Knoll.

LE CORBUSIER'S POSTWAR DEVELOPMENT
The chief modern master who had remained in Europe was Le Corbusier. His postwar work continued to explore two interests manifested earlier, that of natural and sometimes roughly finished materials and that of relating elements with modular dimensions. These apparently opposed values of roughness and precision combined to produce some emotionally powerful interiors, among them

Figure 20–31 The President's House, Cranbrook Academy of Art, by Eliel Saarinen with textiles by Loja Saarinen.

the small chapel of Notre-Dame-du-Haut at Ronchamp, France, finished in 1951 (Figure 20–32), and the more monumental government complex at Chandigarh, India, 1956–61.

THE NEW DESIGN PROFESSIONALS Elsie de Wolfe, it has been said, began the profession of interior design in 1905 by having business cards printed announcing her availability as a decorator; they showed a wolf bearing a rose in its teeth. Four decades later, with many others having followed her (and, as we have seen in previous chapters, with many others having preceded her as well), the need for design professionalism was clear. And it was needed not only for residential design, but also for a number of other specialized fields that we shall consider separately. Many architects continued to be concerned about their buildings' interiors, as many had always been, but there was an increasingly large group who, with or without architectural training, concentrated only on interiors or on furniture.

Among the traditionalists who chose the comforts of the past rather than the relative austerity of modernism were Elsie de Wolfe, her ghostwriter Ruby Ross Wood, and her sister-in-law Mrs. Edgar

de Wolfe. In England, there was the decorating firm Colefax & Fowler, established in 1934 and still in business; its English Country House style was shaped by three designers, Sybil Colefax, John Fowler, and the American-born Nancy Lancaster. Other notable traditionalists were Elsie Cobb Wilson, Nancy McClelland, Rose Cumming, and, on the West Coast, Frances Elkins.

FURNISHING THE MODERN INTERIOR: HERMAN MILLER European examples of modern interior design fired American designers with enthusiasm, but enthusiasm alone was insufficient: furniture and furnishings designed in the modern spirit were needed. These were first supplied to the American market by two companies, Herman Miller and Knoll. Their stories were important parts of the establishment of modern design in the United States.

The Michigan Star furniture company, founded in 1905, was purchased in 1923 by an employee, D. J. De Pree, who renamed it for his father-in-law and backer, Herman Miller. In 1930 De Pree hired designer Gilbert Rohde to direct the company's design, previously in a highly decorative Renaissance Revival style, and Rohde produced a series of sleek

new designs, for both residential and office use, modern but with an Art Deco slant. When Rohde died unexpectedly in 1944, De Pree asked George Nelson to take his place.

As design director, Nelson provided modern design undiluted by Art Deco, his early pieces including the 1946 slat bench and cabinets to rest on it, modular storage units (Figure 20–33), the 1947 Executive Office Group combining desk, storage, and lighting, the 1950 ball clock, and a series of pole-supported shelving systems. Later Nelson designs for Herman Miller included the 1955 Coconut chair, the 1956 Marshmallow sofa, the 1963 Sling sofa, and much more.

At least as important as his design, however, was Nelson's insistence that Herman Miller hire other designers he considered important, and among them were Charles and Ray Eames, Isamu Noguchi, and Alexander Girard. The Eameses' work for Miller was distinguished by experiments in molded plywood and molded plastic, and then by work in aluminum and leather, producing a series of some of the century's most admired seating designs.

FURNISHING THE MODERN INTERIOR: KNOLL

Hans Knoll, son of a German furniture manufacturer, came to New York in 1938 and established his own company, HG Knoll. Early successes in Knoll's furniture design included architect Eero Saarinen's Grasshopper lounge chair of 1946, his Womb chair of 1947, and his Tulip chair of 1957 (Figure 20–91), and sculptor Harry Bertoia's wire

mesh chairs of 1950 and 1952. In 1960 Knoll began adding the furniture designs of Mies van der Rohe to the line, including Mies's 1929 chair for the German Pavilion in Barcelona (Figure 20–34), and in 1968 Knoll began adding those of Marcel Breuer, eventually selling more than a quarter million of Breuer's 1927 cantilevered Cesca chair (Figure 20–17). To complement the furniture, Knoll introduced textile designs by Marianne Strengell in 1947, and they were followed by the textiles of

Figure 20–34 Mies van der Rohe's Barcelona chair in its original location, the 1929 German Pavilion in Barcelona.

Eszter Haraszty, Anni Albers, and Jhane Barnes. In 1954 Hans Knoll was killed in an auto accident, and Florence Knoll assumed the job of director. Later Knoll designers have included Gae Aulenti, the husband-and-wife team of Massimo and Lella Vignelli, Joe D'Urso, Charles Pfister, Robert Venturi, Richard Meier, and Frank Gehry.

Herman Miller and Knoll were still in business at the end of the century, having been joined by many other companies supplying modern design, including AI (Atelier International, the first importers of Le Corbusier's furniture to the United States) and ICF (International Contract Furnishings, offering designs by Alvar Aalto, Poul Kjærholm, Josef Hoffmann, Gwathmey Siegel, and others) in the United States, Vitra in Germany, and B&B Italia, Gavina, Cassina, and others in Italy. Prominent among U.S. companies specializing in office furniture were Steelcase and Haworth.

Figure 20–35 Alvar Aalto's Paimio chair, 1932, of bent plywood on a laminated wood frame.
MUSEUM OF APPLIED ARTS, HELSINKI, FINLAND

Scandinavian Modern

Scandinavian Modern made its greatest impact on American and European design in the two decades following World War II, but the style was also important before the war. In the earlier period it was sometimes called *Swedish Modern* and in the later period *Danish Modern*, but it comprised products from both countries and Finland as well.

ALVAR AALTO Scandinavia's greatest twentieth-century architect and designer was Alvar Aalto (1898–1976) of Finland, whose first important commission, the Paimio tuberculosis sanatorium, was completed in 1932. For Paimio, Aalto designed all the buildings and their interiors, hardware, lighting, glassware, porcelain, and furniture, including a chair of laminated wood (Figure 20–35). With its carefully calculated exposure to light and air, Paimio was a potent symbol of the healthy world promised by new technology, but its furniture of wood, rather than steel, also suggested that technology could be humanized. Many other Aalto designs followed and became internationally celebrated, the key buildings including the municipal library in Viipuri, 1933–35, the Villa Mairea in Noormarkku, 1938–39, the Finnish pavilion for the 1939 New York World's Fair, the Saynatsalo town hall, 1950–52, and the Edgar

Kaufmann, jr., suite of conference rooms at the Institute of International Education, New York, 1963–65 (Figure 20–36). Aalto's furniture design continued as well, incorporating experiments with laminating, slicing, and bending wood; best known of these was a little three-legged stacking stool designed for the Viipuri library and still being produced (Figure 20–37, page 579). Aalto's lighting fixtures, lamps, and free-form glass vases are also admirable.

DENMARK In Denmark, the father figure in the field of furniture design was Kaare Klint (1888–1954). He was a fairly conservative designer, best remembered today for his 1933 Safari chair, but his influential teaching at the Royal Academy's School of Furniture was based on his study of the solid construction and fine proportions of eighteenth-century English furniture.

One of the Royal Academy's students was Danish designer Finn Juhl (1912–89); a 1948 *Interiors* article by Edgar Kaufmann, jr., introduced his work to America, and Kaufmann hired him to design his 1951 *Good Design* show, second in a series of four exhibitions at New York's Museum of Modern Art and Chicago's Merchandise Mart that introduced well-designed home furnishings to a wide audience. Juhl also designed the Trustees Council Chamber at the United Nations headquarters,

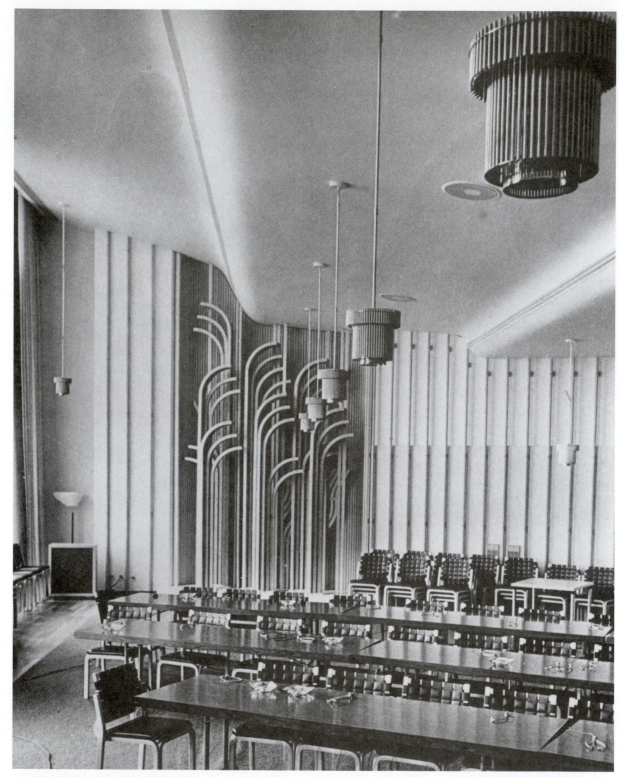

Figure 20–36 The Kaufmann suite of conference rooms, New York, designed by Aalto for Edgar Kaufmann, jr., and finished in 1965.

MUSEUM OF FINNISH ARCHITECTURE, HELSINKI

New York, in 1952 (Figure 20–38), offices and airplane interiors for SAS, teak bowls, carpets, and furniture.

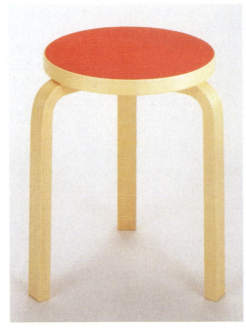

Figure 20–37 Aalto's three-legged stacking stool designed c. 1935.

Contemporary with Juhl were Hans Wegner (born 1914) and Jens Risom (born 1916); like Juhl, they continued the tradition of well-made wood furniture but with new, often sensuous forms. Wegner's notable designs include a 1944 armchair of Chinese inspiration, the Peacock chair of 1947 with radiating back spokes like a Windsor, and a 1949 teak-and-cane armchair so popular that it came to be called simply The Chair (Figure 20–39). Risom moved to the United States in 1939, where he was a prolific designer, first for Knoll, then from 1946 to 1973 for his own New York firm, Jens Risom Design. More recent designers in the wood tradition were the husband-and-wife team of Nanna Ditzel (1923–) and Jørgen Ditzel (1931–61).

Two other Danish designers abandoned the wood tradition and embraced new materials and techniques. The first was Arne Jacobsen (1902–71), an architect and designer of interiors, furniture, textiles, and ceramics. His stacking Ant chair of 1952 for the Fritz Hansen company sat on three metal legs. For the SAS Royal hotel in Copenhagen, 1958–60, he designed the building, the interiors, the furniture, the lighting fixtures, and the tableware; two of the furniture pieces were the Egg chair and the Swan chair. A generation younger was Poul Kjærholm (1929–80), who combined chrome with wicker and leather, producing elegant variations on

Figure 20–38 Finn Juhl's Trustees Council Chamber at the United Nations, New York, 1952. The multicolored grid at the ceiling accommodates both lighting and air handling.

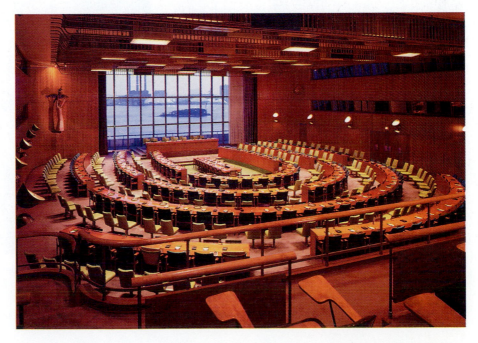

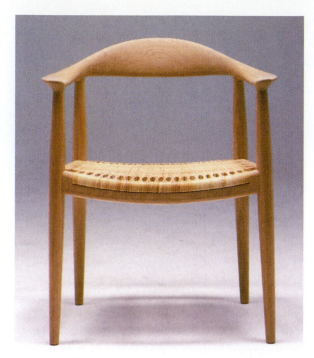

Figure 20–39 The Chair, designed by Hans Wegner in 1949 with a frame of teak (or other wood) and a seat of woven cane.

BRAHL FOTOGRAFI

Figure 20–40 The PK1 tubular stainless steel and wicker chair designed by Paul Kjaerholm, 1955.

PP MOBLER APS, ALLEROD, DENMARK

the earlier metal-framed chair designs of Breuer and Mies van der Rohe (Figure 20–40).

Italian Modern

In the previous chapter we mentioned the *Stile floreale*, Italy's version of the Art Nouveau, and earlier in this chapter we noted Italian Rationalism as one of the "roots of modern design." Italian design, particularly Italian furniture design, was a dominant factor internationally from the mid-1950s to the mid-1970s, characterized by lightness and wit, and the foundation for that dominance was laid decades earlier.

At the beginning of the century, Carlo Bugatti (1855–1940) produced highly idiosyncratic furniture designs, some of it asymmetrical, and much of it surfaced with parchment and embedded with beaten-copper plaques (Figure 20–41); his son and grandson would become known as designers of luxury automobiles. Also important early in the century were Eugenio Quarti, who had worked briefly in Bugatti's studio, and Ernesto

Figure 20–41 The Cobra desk and chair of gilt and inlaid parchment designed by Carlo Bugatti for his Snail Room at the 1902 *Esposizione* in Turin.

CARLO BUGATTI, "COBRA CHAIR" 77.4. BROOKLYN MUSEUM OF ART/ CENTRAL PHOTO ARCHIVE.

Figure 20–42 Vignelli Associates' own New York office, 1986.

PETER J. PAIGE

Basile; both designed furniture in personal versions of the *Stile floreale.* Later and more modern in their style were Carlo Mollino and Franco Albini. Brothers Umberto and Cesare Cassina founded their namesake furniture company in 1927; Cassina would still be an important source at the end of the century.

But it was Gio Ponti (1891–1979) who was chiefly responsible for the foundation for Italian modernism. He designed buildings (notably the Pirelli tower in Milan, 1956–58, and, in the United States, the Denver Art Museum of 1972), furniture, glassware, ceramics, cutlery, model rooms, monuments, exhibitions, urban designs, and espresso machines.

Lella Vignelli (1934–) and her husband Massimo Vignelli (1931–) literally brought Italian design to America, establishing an office in New York in 1966. Vignelli interiors, furniture, products, and graphics exemplify the spare elegance of the best Italian modernism (Figure 20–42).

But the elegant phase of Italian modernism that had begun in the 1950s—what was called *Bel design*—did not continue without competition. In the early 1970s, the movement's underlying optimism was dampened by terrorism and an oil-related economic crisis, and its concept of functional beauty began to be questioned. The **Anti-Design** movement was formed from new groups of design rebels—Radical Design, UFO, Global Tools, Gruppo 9999, Zziggurat, Studio Alchymia, and eventually Memphis.

The **Memphis** design cooperative was founded by Ettore Sottsass, Jr., in 1981 and made its sensational debut at that year's Milan Furniture Fair. Allegedly named for both the Egyptian city and the Tennessee city, it was seen by Sottsass as "quoting from suburbia," perhaps alluding to its imitation of the kitsch taste of the Italian middle class (Figure 20–43). Despite—or perhaps, perversely, because of—its high prices, Memphis was briefly taken up by a sophisticated following, its most publicized interior being fashion designer Karl Lagerfeld's apartment in Monte Carlo, which he furnished completely with Memphis furniture.

Japanese Modern

Frank Lloyd Wright, after his work in Japan between 1914 and 1922, had promoted traditional Japanese design ideas in America, and Antonin Raymond, an architect who had gone to Tokyo as Wright's assistant, stayed to work there and to popularize the new architectural ideas from Europe. In 1933 German architect Bruno Taut was invited to Japan by the Japanese Society of Architects and stayed three years; his 1937 book *Houses and People of Japan* showed similarities between traditional Japanese post-and-beam construction and the structural clarity of modern work.

By midcentury, despite the hostility of World War II, a mutual affinity had developed between Japanese and Western design. A traditional

Figure 20–43 The Carlton bookcase/room divider of plastic laminate on wood designed by Ettore Sottsass, Jr., in 1981, 76 inches (194.3 x 190 x 40 cm) high, part of the Memphis furniture collection.

Japanese house was built in the garden of the Museum of Modern Art, New York, in 1954, and that same year Walter Gropius visited Japan. Kenzo Tange (1913–) was an early leader in the new Japanese architecture, followed by Fumihiko Maki, Arata Isozaki, and Kisho Kurokawa, all of whom had worked in Tange's office. Maki, Isozaki, and Kurokawa all participated in the 1960 formation of the **Metabolist** group, which sought to express biological analogies by designing structures that could grow and change. Kurokawa, for example, designed the Nagakin Capsule Tower in 1972, in which compact mass-produced pods, furnished like train compartments, were affixed to a central shaft. Modern Japanese interiors were generally furnished with Western-style chairs and tables, but residences often had a small room floored with tatami mats, and traditional crafts such as pottery, lacquerwork, and paper lanterns were typically used.

By the 1960s, following the example of Le Corbusier (whose National Museum of Western Art was built in Tokyo in 1959), the early lightness of Japanese modernism had given way to the use of massive, sculptural forms in reinforced concrete. A masterly use of concrete work distinguishes the current buildings of Tadao Ando (1941–), many of which have poetic interior spaces with carefully manipulated natural light (Figure 20–44).

In furniture, Japanese designers have often taken a wry, ironic view of Western models (Figure 20–45), and it seems natural that three of them, Arata Isozaki, Shiro Kuramata, and Masanori Umeda, were invited to design pieces for Memphis in the early 1980s.

Figure 20–44 Tadao Ando's conference center adjoining the Vitra Design Museum, Weil am Rhein, Germany, 1993. As in much of Ando's work, interior wall surfaces are of exposed reinforced concrete.

Figure 20–45 Shiro Kuramata's How High the Moon armchair of steel mesh, 1986.

Reactions against Modernism

The antics of Memphis and the rest of the Italian Anti-Design movement and the biological metaphors of the Japanese Metabolists had moved beyond the self-imposed austerity, rationality, and uniformity of mainstream modernism. Such exclusiveness, some had come to feel, was incapable of expressing the varied experience of twentieth-century life, and that feeling was captured by architect Robert Venturi (1925–). Venturi's work (and, since 1967, his work with his wife and partner Denise Scott Brown) is full of such vitality, combines apparently conventional elements with unexpected ones, and uses a few simple moldings or pilasters as "shorthand" references to classical effects. Venturi's chairs produced by Knoll in 1984 are simple planes of bentwood, but cut into outlines that recall Queen Anne, Chippendale, and other past styles (Figure 20–46); they are clearly the result of modern industrial processes, but with historical references. Such combinations are sometimes intentionally jarring, but allow a remarkably appropriate solution in such cases as the Venturi firm's addition to the National Gallery in London, finished in 1991 (Figure 20–47).

Also in the postmodern idiom, Robert A.M. Stern mixed new and traditional forms. Charles Moore, with whimsy and humor, produced collage-like buildings and interiors, as in a house remodeling for his own use in New Haven, Connecticut (Figure 20–48). And Michael Graves employed a palette of muted tertiary colors (such as gray-blue-green and gray-red-violet) and forms that were cartoon versions of classical elements.

Others who have sometimes worked in a postmodernist manner include Stanley Tigerman and the firm of Hardy Holzman Pfeiffer. In Europe, its enthusiasts have included Hans Hollein in Austria, Aldo Rossi and Paolo Portoghesi in Italy, Ricardo Bofill in Spain, and Tomas Taviera in Portugal.

Figure 20–46
Two of Robert Venturi's 1984 plywood chairs for Knoll. The one at left is named Art Deco, the other Sheraton.

KNOLL INC.

Figure 20–47 Venturi Scott Brown and Associates' Sainsbury Wing, National Gallery, London, 1991.

PHOTO BY MATT WARGO, COURTESY VENTURI, SCOTT BROWN & ASSOCIATES

Offshoots of postmodernism were called **pop, supermannerism,** and **psychedelic** design. These were free of postmodernism's historical allusions, but alluded instead to the realms of advertising and popular culture. Large-scale graphic elements (called *supergraphics*) were often featured, and floor plans were spiky with elements angled at 45 degrees. In 1969 the young firm of Gwathmey and Henderson, predecessor of Gwathmey Siegel, designed a New York dance club called the Electric Circus in pop style. Alan Buchsbaum also worked with pop mannerisms in a series of shops, showrooms, and apartments (Figure 20–49). C. Ray Smith designed for himself an all-white Manhattan apartment that assumed different personalities as slide projections covering the walls and ceiling were changed, presenting in

turn images of Niagara Falls, Wright's Guggenheim Museum ramp, or Michelangelo's Sistine Chapel.

The New Eclecticism

Along with modernism and postmodern references to past styles, the past styles themselves continued to be used. But these were seldom still used in the pure forms that had previously been admired. The historic revivals of the nineteenth and early twentieth centuries had employed many past styles, but always one at a time—Greek in one interior, Gothic in another, French Renaissance somewhere else. The eclectic designers of the years after World War II employed many past styles and did not hesitate at mixing them in the same room. Rather than being a

Figure 20–48 Charles Moore's house remodeling for himself in New Haven, Connecticut, 1966.

NORMAN MCGRATH

simpler accomplishment than the more homogenous styles, the new eclecticism was successful only in the hands of the most talented; without the common denominator of style, interior elements had to relate well to one another by means of their inherent form, scale, pattern, and color. Those who were expert at such eclectic design included Jean-Michel Frank (before the war), Eleanor McMillen Brown (who in 1924 founded the firm McMillen Inc., still producing eclectic work today under the directorship of Betty Sherrill), Mrs. Henry ("Sister") Parish II and her partner and protégé Albert Hadley (Figure 20–50), William Pahlmann, Billy Baldwin, Denning and Fourcade, David Hicks, Mark Hampton, and Mario Buatta.

The Persistence of Modernism

Yet modernism is still flourishing. In the '70s, it began to rely for its effect on the display of in-

Figure 20–50 Sketch by Albert Hadley of Parish-Hadley for a library at the second Kips Bay Show House, New York, in 1974.

COURTESY ALBERT HADLEY

Figure 20–49 A 1968 hair salon in Great Neck, New York, designed by Alan Buchsbaum with oversize graphic elements.

NORMAN MCGRATH 901–53

dustrially produced materials, such as perforated metals, and of mechanical elements, such as air-conditioning ducts, not only left visible but often accented with bright colors. Charles and Ray Eames's 1949 house in Pacific Palisades, California, was an early example, its factory-like window sash and open-web roof joists frankly exposed in the interior, and Renzo Piano and Richard Rogers's 1977 Centre Pompidou in Paris was a later one, although there the exposure of services and structure was chiefly on the building exterior, keeping the interior spaces clear and flexible. Though the term *high tech* is no longer in use for such design, the practice continues (Figure 20–51).

Modernism in the last quarter of the century was practiced at the highest level both by interior designers and by architects who were exceptionally mindful of interior effects. Outstanding among

Figure 20–51 Raw steel security fencing is an interior element in the offices for Nokia, Mountain View, California, designed by Collin Burry of Gensler, 2000. The turned-wood stool tables were designed in 1960 by Charles and Ray Eames for the office lobbies of Time-Life Inc.

Figure 20–52 A reading room in the 1977 Yale Center for British Art, New Haven, Connecticut, with architecture by Louis Kahn and interior design by Ben Baldwin.

those architects were Louis Kahn (Figure 20–52), Richard Meier (Figure 20–53), Mexico's Luis Barragán (Figure 20–54), and Japan's Tadao Ando (Figure 20–44). Important also were Paul Rudolph; I. M. Pei and Partners; the partnership of Charles Gwathmey and Robert Siegel; the firm of Skidmore, Owings, and Merrill (SOM); and England's Norman Foster.

Outstanding among the interior designers whose work continued within the general bounds of modernism were Jack Dunbar (Figure 20–55), John Dickinson and Michael Taylor in California, Angelo Donghia, Ward Bennett, Davis Allen, Ben Baldwin, Joe D'Urso, Eva Jiricna, Carolyn Iu, John Pawson, Don Brinkmann of Gensler, Scott Bromley and Robin Jacobsen of Bromley/Jacobsen, and Donald Powell and Robert Kleinschmidt of Powell/Kleinschmidt (Figure 20–56, page 588).

Figure 20–53 Richard Meier's Smith house, Rowayton, Connecticut, 1967.

Figure 20–54 A corner of Luis Barragán's 1947 house for himself in Mexico City. The glass is held by a simple cross of support. The painting at right is by Josef Albers.

PHOTO: ARMANDO SALAS PORTUGAL, COPYRIGHT BARRAGÁN FOUNDATION, SWITZERLAND

Figure 20–55 An apartment in the Pierre Hotel, New York, by Lydia de Polo and Jack Dunbar of de Polo/Dunbar, 1984, was kept serenely spare.

PETER AARON/ESTO

Finally, there were those who tempered the severity of modernism, softened its hard edges, and sometimes combined twentieth-century furniture and effects with those from earlier times. These were modernists still, but not so strictly as others, and they included Warren Platner; Juan Montoya; Orlando Diaz-Azcuy; Clodagh; Bob Bray and Michael Schaible of Bray-Schaible; Peter Shelton and Lee Mindel of Shelton Mindel; Charles Pfister and his protégée Pamela Babey, now of Babey, Moulton Jue & Booth; John Saladino; and Ron Krueck of Krueck and Olsen and later of Krueck and Sexton (Figure 20–57). Among furniture designers, Paul McCobb for Winchendon and other manufacturers, Russel Wright for Heywood-Wakefield, and Edward Wormley for Dunbar offered popular versions of modern design, their vocabulary based on wood rather than metal.

The Specialization of Functional Types

The twentieth century brought to interior design a degree of specialization it had not known before. As functional requirements for interiors proliferated, designers began to limit the scope of their work to specific fields. The most basic division was into designers of residential work and designers of contract work; in this division, *contract work* means any sort of nonresidential design, and the name is derived from the fact that its elements are obtained by means of written contracts, not by individual purchases. Within both fields, however, there are further specialties, with some designers known for their hospitality work, for example, and others for their work in the health care field. Many design firms, of course, continue to do work in all fields.

Figure 20–56 Entrance foyer, Powell apartment, Chicago, designed by Powell/Kleinschmidt in 1985. The wall at left is faced with St. Laurent marble. The Rodin torso stands in front of teak cabinetry raised above the floor to admit a flow of light.

We shall look briefly at a few current fields of specialization, and we shall also touch on a newly required consideration applicable to all fields: **universal design.**

Kitchen and Bathroom Design

Residential design changed to accommodate the twentieth century's new equipment, most notably the automobile and, later, the television set. But the residential elements that were most dramatically transformed in the twentieth century were kitchens and bathrooms. In the first years of the

Figure 20–57 In a Chicago apartment designed by Krueck and Sexton in 1983, spaces are formed by sinuous walls of glass block, sliding curved-glass panels, and perforated-metal screens of varying density.

century both were just beginning to take their present form, to be furnished not with lightweight, movable objects such as chamber pots, tubs, and washstands, but with heavy, industrially produced equipment that was fixed in place. Appropriately, those pieces of equipment were called **fixtures.**

KITCHENS The twentieth century saw many advances in kitchen equipment, but the most revolutionary change in kitchen design came from a social development: the disappearance of the hired cook. As kitchen chores passed from domestic servants to family members, it became desirable to have the kitchen less acoustically and visually isolated. In the last half of the century, architects and designers began to open the kitchen to the dining room, to an informal recreational area called the "family room," and even to the living room. At the

end of the century, a "live-in kitchen" with conversation areas was often seen. With its greater exposure, the kitchen needed greater design attention, and that need gave rise to designers specializing in such work. The National Kitchen and Bath Association was founded in 1963 and would later begin certifying kitchen and bath designers based on their experience and passage of an NKBA examination. Prominent among many designers expert in such design were Florence Perchuk, Mary Jo Peterson, and Nancy Mullan.

BATHROOMS Residential bathrooms underwent a similar change, not because of decreased privacy but because of increased attention to personal health and well-being. Luxurious bathing facilities are as old as the Roman Empire, as we have seen, but standards of hygiene fell greatly in the centuries that followed. Josef Hoffmann's palatial Stoclet house of 1905–11 in Brussels sought a return of bathing splendor, its master bathroom being 19 feet 6 inches (6 m) square, faced with marble panels, and featuring an upholstered daybed. Another generous bathroom was finished in 1922 by Armand-Albert Rateau for Paris couturier Jeanne Lanvin, combining plaster reliefs, marble, bronze, glass, and stucco (Figure 20–58), and in 1926 Rateau designed a bathroom with gold lacquered walls for Madrid's Duchess of Alba. Beginning in 1920, bathroom fixtures were available in color. Among modernist bathrooms, one by Le Corbusier for his 1929 Villa Savoye near Paris featured a built-in chaise faced with tile; it was recalled by Gwathmey Siegel in the bathroom of their 1979 New York apartment for actress Faye Dunaway (Figure 20–59).

But another trend, typical of the century, was to see bathroom design as a technical problem to be solved. R. Buckminster Fuller's 1936 Dymaxion bath was a two-piece prefabricated metal unit containing all necessary equipment. Although it promised economy, speed of construction, ease of cleaning, and even the ability to be moved from house to house, it was never commercially produced.

Most bathrooms of the twentieth century were minimal and cramped, however, offering neither the pleasures of luxury nor the advantages of technology. In 1966 Cornell University professor Alexander

Figure 20–58 Armand-Albert Rateau's 1922 bathroom for couturier Jeanne Lanvin, Paris, had a curved plaster relief behind the marble tub. The covers of the toilet and bidet were painted in a faux leopard skin pattern.
MUSÉE DES ARTS DÉCORATIFS, PARIS, FRANCE

Figure 20–59 A unified composition of tiled surfaces by Gwathmey Siegel in a 1979 New York apartment bathroom includes a repeat of a built-in chaise designed by Le Corbusier fifty years earlier.
EZRA STOLLER/© ESTO. ALL RIGHTS RESERVED.

Kira published *The Bathroom*, showing the typical bathroom to be, in many ways, inconvenient, unsafe, and unhygienic. Unfortunately, most of his complaints were still valid at the end of the century.

Figure 20–60 A guest room in Frank Lloyd Wright's Imperial Hotel, Tokyo, 1922. The furniture is Wright's design, and the bed is reflected in mirrored closet doors.

Hospitality Design

The hospitality field is concerned with the design of hotels, restaurants, bars, clubs, casinos, ships, and all those interiors where people are sheltered, fed, and entertained for a brief while. It is a field in which design serves both function and fancy.

HOTELS Notable early-twentieth-century hotels include Henry Hardenbergh's 1901 Willard Hotel in Washington, D.C., and his 1905 Plaza Hotel in New York; the Willard's interiors were thoroughly and sensitively redesigned in 1986 by Sarah Tomerlin Lee of Tom Lee, Ltd., and the Plaza has undergone countless renovations. Frank Lloyd Wright's reinforced concrete Imperial Hotel in Tokyo was finished in 1922 (Figure 20–60) and the next year survived an earthquake that leveled most of the city, but was demolished in 1967.

Some hotels of enormous size and with grand interior spaces followed, such as the 47-story Waldorf-Astoria in New York, finished in 1931 in Art Deco style, and the 3,000-room Stevens (now Conrad Hilton) in Chicago, 1927, more historicist in design. The advent of the hotel of modern design came after World War II. Immediately after the war, in 1945, the Terrace Plaza Hotel was built in Cincinnati to designs by SOM. One dining room had murals by Joan Miró, another murals by Saul Steinberg (Figure 20–61).

More traditional hotel designs continued to be popular, however. Dorothy Draper, with a color palette of bold reds, greens, and pinks, some lavish drapery treatments, and large-scaled floral fabrics, devised a vocabulary of effects that might have been overbearing in a residence but suited the fantasy of a hotel stay. Throughout the second quarter of the century, her work included the Carlyle (1929) and Hampshire House (1937) hotels in New York, the Mark Hopkins in San Francisco (1935), the

Figure 20–61
The main restaurant of the Terrace Plaza Hotel, Cincinnati, 1945, designed by Davis Allen, Ward Bennett, and Benjamin Baldwin of SOM. Textiles were by Marianne Strengell, head of Cranbrook's textile department. The murals were commissioned from Saul Steinberg.

Figure 20–62 The Victorian Writing Room of the Greenbrier hotel, White Sulphur Springs, West Virginia, as designed by Dorothy Draper in 1947. The walls are painted a deep green.

COURTESY DOROTHY DRAPER & CO., INC.

Figure 20–63 A guest room of the Paramount Hotel, New York, designed in 1990 by Philippe Starck. The headboard is a reproduction of a painting by Vermeer.

PETER MAUSS/ESTO

Mayflower in Washington, D.C. (1940), and the Greenbrier in White Sulphur Springs, West Virginia, (1947), (Figure 20–62), this last often revised since her death by her protégé Carleton Varney.

Fantasy with a more modernist flavor but without modernist purity came in a series of exuberant hotels by Morris Lapidus, most notably the Fontainebleau, 1954, and the Eden Roc, 1957, both in Miami Beach.

In 1967 architect John Portman, dramatically expanding the atrium-centered plan of the 1892 Brown Palace hotel in Denver, designed the Hyatt Regency in Atlanta. Seventeen floors of circulation galleries surround a central lobby with a glazed roof, the space animated by cantilevered glass elevators. Portman reused the design with variations for other hotels in Atlanta, San Francisco, Los Angeles, and New York.

In 1985, with Andrée Putman's Morgan's Hotel, New York (designed with Haigh Space Design), a fashion was begun for relatively small, intensely characterful **boutique hotels.** Following Putman was Philippe Starck with the 1988 Royalton in New York, the 1990 Paramount also in New York (and also with Haigh Space Design, Figure 20–63), the 1995 Mondrian in Los Angeles, the 1996 Delano in Miami Beach, and the 2000 Sanderson in London.

RESTAURANTS Modern design came to restaurants as early as 1932 in Raymond McGrath's Fischer's Restaurant and Long Bar in London and 1938 in Alvar Aalto's Savoy restaurant in Helsinki,

Figure 20–64 Four Seasons Restaurant, New York, by Philip Johnson and William Pahlmann.

for which Aalto's designs included a famous free-form glass vase, and which was still popular at the century's close. More decorative work was represented by Elsie de Wolfe's cocktail lounge at the Savoy-Plaza, New York, in 1936, and Dorothy Draper's Camellia House dining room at the Drake, Chicago, in 1940.

A monument of modernism in 1958 was the Four Seasons restaurant on the plaza level of Mies van der Rohe's Seagram Building in New York. It was designed by Philip Johnson and William Pahlmann and incorporated Mies furniture, table settings by Garth Huxtable, and hanging sculptures by Richard Lippold (Figure 20–64). Two years later came the more casual, more colorful La Fonda del Sol in New York; designed with a Latin American theme by Alexander Girard, it used furniture custom designed by Girard and Charles and Ray Eames.

The young firm of Gwathmey Siegel (Charles Gwathmey and Robert Siegel) designed Pearl's in 1973 and Shezan in 1976, both in New York and both in a minimalist modern vocabulary. Warren Platner designed the American Restaurant in Kansas City in 1974 and Windows on the World atop one of New York's World Trade Center towers in 1976; the latter was redesigned by Hardy Holzman Pfeiffer in 1996.

In 1986 the two-level Palio restaurant was designed for New York's Equitable Center by SOM, with Raul de Armas the partner in charge and Paul Vieyra the senior designer. It incorporated chairs designed by Davis Allen, graphics and tableware by Vignelli Associates, and, in the downstairs bar, a wraparound mural by Sandro Chia (Figure 20–65).

Prominent among restaurant designers at the century's end was Adam Tihany. His many commissions included the 1985 Alo-Alo in New York, three Bice restaurants (New York in 1988, Los Angeles in 1990, and Paris in 1991), and New York's Remi in 1990. In 1997 he designed both the handsomely restrained Jean-Georges (Figure 20–66) and the anything-but-restrained Le Cirque 2000, both in New York and the latter replacing a Sarah Tomerlin Lee restaurant in the most exquisite room of McKim, Mead, and White's Villard Houses of 1885, by then incorporated into the Helmsley Palace Hotel. Philippe Starck's restau-

Figure 20–65 The bar of the Palio restaurant, New York, designed by SOM's Raul de Armas and Paul Vieyra in 1986. The chairs are a Davis Allen design, and the mural, covering all four sides of the room, is by Sandro Chia.

WOLFGANG HOYT/ESTO

rant designs included in 1990 the Teatriz in Madrid and in 1996 the Felix in Hong Kong.

In the year 2000, the Brasserie, originally designed by Philip Johnson on the ground level of New York's Seagram Building, was given a lively redesign by Diller and Scofidio, an array of television monitors behind the bar chronicling the arrival of guests. That same year, publishing giant Condé Nast opened its staff cafeteria designed by Frank Gehry (Figure 20–67).

DESIGN LIMITATIONS Despite their frequent displays of extravagance, hotels, restaurants, and most other types of hospitality design must be profitable. And because they accommodate the public, they are subject to strict fire and safety codes. Designers in this field at the beginning of the twenty-first century must work within numerous restraints. Hotel rooms must be designed so they can be efficiently cleaned every day. Restaurants must be efficient in the number of seats per table and the spacing between tables (guidelines for these being given in books of graphic standards), but must also provide clear access from tables to exit doors in case of fire and provide easy access for waiters from

Figure 20–66 Adam Tihany's Jean-Georges restaurant, New York, 1997.

PETER J. PAIGE

kitchen to table. The layout of a large restaurant kitchen is a formidable design challenge by itself. The provision of proper light levels and sound levels is also an important part of the designer's work.

Retail Design

Similarly, the design of shops, stores, and showrooms—collectively called *retail design,* even though some deal in wholesale transactions—must display imagination and establish character, but must do so within prevailing codes and in ways that encourage sales. Overall design must attract potential customers but must not distract those customers from the merchandise to be sold. This principle probably applied equally well to the shops in the Stoa of Attalos in ancient Greece, in the Forum of Trajan in ancient Rome, or on the ground floor of Renaissance palazzi.

In the middle of the twentieth century, the large department and specialty stores attracted the top design talent of the day. A single example among many is a series of rooms by William Pahlmann for the Bonwit Teller store in Chicago, 1949 (Figure 20–68).

By the last quarter of the twentieth century, however, the heyday of the large department store was over, replaced in favor by the small specialty store. By the end of the century, two designers had become preeminent. Both worked from offices in New York, but with international practices, and both also designed residences for a celebrity clientele. One was Peter Marino, whose work included stores for Barneys New York in New York, Chicago, Tokyo, and other cities, and whose other clients included Calvin Klein, Yves Saint Laurent, Chanel, and Valentino.

The other was Naomi Leff, who, after store design at Bloomingdale's, New York, had private commissions from Bergdorf Goodman and Dunhill, then made an international impression in 1985 with her conversion of New York's 1898 Rhine-

Figure 20–67 Frank Gehry's cafeteria design for the headquarters of Condé Nast publications, New York, completed in 2000.

MICHAEL MORAN PHOTOGRAPHY, INC.

Figure 20–68 The Grand Salon at Bonwit Teller, Chicago, designed by William Pahlmann in 1949.

COURTESY HEDRICH-BLESSING ARCHIVE, CHICAGO HISTORICAL SOCIETY

lander mansion into a flagship store for Ralph Lauren. Subsequent Leff clients have included Saks Fifth Avenue, Helena Rubenstein, Gucci, Carolyn Roehm, Christian Dior, Salvatore Ferragamo, and Giorgio Armani (Figure 20–69).

Throughout the twentieth century, retail design was highly responsive to fashion and a constant need for new images. At the end of the century, it also seemed that it must adjust to some functional changes in shopping patterns: to fewer salespeople and more self-service shopping, to automated stock reordering, to the use of laser-read price codes, and to the competition of catalog shopping and Internet shopping.

Health Care Design

Facilities for the sick, dying, poor, orphaned, insane, and transient have existed since ancient times. A notorious example from the Middle Ages was the Hôtel-Dieu in Paris, where patients were accommodated three or more to a bed, no matter what their illnesses; its mortality rate was appalling. As late as 1859, Florence Nightingale, nurse and crusader for cleanliness, heat, light, and fresh air in hospitals, felt it necessary to point out "as the very first requirement in a hospital that it should do the sick no harm."

By the 1870s, however, the work of Pasteur, Lister, and others had recognized bacteria, established principles of antiseptic surgery, and set a rational basis for health care design. As works of the early twentieth century, Josef Hoffmann's Purkersdorf sanatorium of 1903–5 and Alvar Aalto's Paimio sanatorium of 1929–32 have already been mentioned. A later innovator in health care design was Chicago-born architect Paul Nelson (1895–1979), who worked in both America and France. In 1934 for a surgery pavilion in Egypt, Nelson devised an egg-shaped operating room, its concrete shell studded with lights and its cornerless form facilitating cleaning and disinfecting. The Egypt project was not built, but the operating room design was realized in Nelson's Franco-American Memorial Hospital in St.-Lô, France, finished in 1954, which also featured mosaic murals by Fernand Leger. Nelson also designed three other major hospitals in France and in 1961 developed standards for materials and methods of hospital construction,

Figure 20–69 Entrance area, Georgio Armani shop, Boston, designed by Naomi Leff in 1993. Custom-designed lamps and wall sconces are of linen and ash.

PETER J. PAIGE

though he is best known today for his unbuilt Suspended House project of 1936–38.

Also innovative in the field was Le Corbusier who, at his death in 1965, was designing a vast hospital for Venice. Its patient rooms occupied the top of three levels, each windowless but lighted indirectly from large clerestories above a central circulation spine. These rooms would have been environments of minimal stimulation and great repose and would have been supplemented with communal areas and roof gardens. This last Le Corbusier project was never built, and its ideas never tested.

Today, health care is one of the most highly specialized areas of interior design. Its planning relationships, such as the distance from nurse's station to bedside or from emergency entrance to

Among the public and private agencies that offer publications, courses, and other informative services are:

- American Health Foundation, 1 Dana Rd., Valhalla, NY 10595, tel. (914) 592–2600, www.ahf.org. Offers educational material for nonprofessionals.
- American Hospital Association, 1 North Franklin, 28th Floor, Chicago, Il. 60606, tel. (312) 422–3000, www.ahaonlinestore.com. Offers educational material.
- American Public Health Association, 800 I St., NW, Washington, DC 20001, tel. (202) 777–2742, www.apha.org. Offers health-related books and periodicals.
- American Society for Clinical Laboratory Science, 7910 Woodmont Ave., Suite 530, Bethesda, MD 20814, tel. (301) 657–2768,

www.ascls.org. Offers information about laboratory design and equipment.
- Association for Health Services Research, 1801 K St., NW, Washington, DC 20006, tel. (202) 223–2477, www.ahsr.hp.org. Promotes and distributes health services research.
- U.S. Department of Health and Human Services, 200 Independence Ave., SW, Washington, DC 20201, tel. (202) 690–6343, www.hhs.gov. The federal government's chief agency for health protection. Its four operating divisions are the Public Health Service, the Social Security Administration, the Health Care Financing Administration, and the Administration for Children and Families.

operating room, are often matters of life or death; the psychological effects of its forms, shapes, and colors can also be critical to patient recovery; and its basic components, such as ceiling, wall, and floor surfaces, lighting, furniture, and textiles, must all be efficient, safe, germ-resistant, and easily maintained. For the selection of these components, guidelines are issued by a number of public and private organizations.

Health care is also a rapidly changing field. New medical discoveries and new advances in medical technology are quickly reflected in new interior planning and design.

Office Design

One of the twentieth century's finest office buildings was built very early in the century, Frank Lloyd Wright's Larkin Building in Buffalo, New York, 1904. Its chief interior space was a six-story atrium at the center of the main block, overlooked by balconies housing dozens of clerks and banks of files for the conducting of Larkin's vast mail-order business (Figure 20–70). Overhead windows into this atrium

Figure 20–70 The central atrium of Frank Lloyd Wright's Larkin Building in Buffalo, New York, 1904.

BUFFALO AND ERIE COUNTY HISTORICAL SOCIETY

were the main source of daylight for the interior, the exterior walls being largely blank to avoid views of an unlovely neighborhood. Not only were the workers ennobled in this room; they were pampered in such subsidiary spaces as a lunchroom, library, infirmary, and classroom. A pipe organ at the top of the atrium provided lunchtime concerts. In addition, Wright devised for the building a cooling and ventilating system that was an unprecedented amenity. As Edgar Kaufmann, jr., has written, Wright achieved in the Larkin building "an image of efficiency and human consideration unparalleled in commercial structures of that day." The building was torn down in 1950 to make way for a parking lot.

Thirty years later, Wright began the design of another landmark office interior, the Johnson Wax Company headquarters in Racine, Wisconsin, finished in 1939. Its great workroom, spreading horizontally this time rather than vertically, was again lighted from above, both naturally and artificially. Wright designed the furniture as well, as he had for the Larkin Building.

More influential on future offices than Wright's expansiveness, however, was the stacking of repetitive office floors in such modern towers as the Lever House by Gordon Bunshaft of SOM in the early 1950s and, across New York's Park Avenue from Lever House, the Seagram Building by Ludwig Mies van der Rohe in the late 1950s. For the perimeter of Seagram's typical floor, a luminous ceiling was designed by lighting consultant Richard Kelly using luminaires designed by Edison Price; it gave an even glow to both the interior and the exterior of the tower.

Two other steps in the integration of office architecture and interiors came in two more SOM buildings, the Connecticut General Life Insurance Company headquarters in Bloomfield, Connecticut, finished in 1957 with interiors by the Knoll Planning Unit, and the Union Carbide headquarters, New York, finished in 1960 with SOM interiors (Figure 20–71). In both these, the luminous ceilings were spread over entire floors, and all-pervasive modules were used to align structure, window mullions, office partitions, ceiling panels, desks, and files.

Such rigorous logic also ruled SOM's Chase Manhattan headquarters, New York, 1961, a complex accommodating 15,000 workers. But at Chase

Figure 20–71 In SOM's interior for the Union Carbide building, New York, 1960, all permanent elements are ordered by a three-dimensional module.

EZRA STOLLER/ESTO

new levels of amenity and sophistication were reached in some of the executive suites designed by SOM's Davis Allen. The office of David Rockefeller, the bank president, was a 30 by 30 foot (9 x 9 m) square of white walls and teak flooring furnished with comfortable custom seating, an impressive selection of art, and—most luxurious of all—a generosity of space (Figure 20–72).

These idealized office interiors were based on assumptions about office work, adjacencies, hierarchies, and equipment that were soon questioned. Some questions were raised by Robert Propst, a Colorado inventor who, in 1960, was named the first director of the Herman Miller furniture company's research wing. Propst's polling of office workers produced some interesting notions, such as a tie between "body motion" and "mental fluency," and designer George Nelson was asked to translate the research into a product line. Herman Miller introduced Nelson and Propst's Action Office in 1964. Cantilevered from aluminum legs, its work surfaces were faced with plastic laminate, edged with rubber, and could be covered at night by a roll of canvas or a wood tambour (Figure 20–73); the accompanying seat was not quite a chair but merely a tall, narrow perch.

Other questions were raised by two brothers in Quickborn, Germany. Eberhard and Wolfgang Schnelle, partners in a management consulting firm, had the radical notion that office furniture

Figure 20–72 The office of David Rockefeller at Chase Manhattan Bank, 1961. The design was by Davis Allen of SOM, assisted by Ward Bennett and Richard McKenna.

Figure 20–73 George Nelson and Robert Propst's Action Office for Herman Miller, 1964.

should be arranged not according to rank or organization charts but according to patterns of communication among the workers. This notion produced layouts that abandoned orderly rows of desks for informal clusters separated by empty space, screens, and plants. In the United States it was called **office landscaping,** and the first example was installed for a division of Du Pont in Wilmington, Delaware, in 1967.

The Quickborner Team, as it was called, claimed that no special furniture was needed for its plans, but it was clear that the new "landscaping" would work better if its furniture was lightweight and easily reconfigured as work patterns changed. Herman Miller's Action Office II in 1968 united desks and screens in the first of the partition systems that were still the norm at the end of the century. Among the many others that followed

were Ettore Sottsass, Jr.'s Sistema 45 for Olivetti in 1969 and Knoll's Stephens System in 1971, its interlocking wood panels a collaboration of Knoll's Bill Stephens and SOM's Charles Pfister. Doug Ball's Race system for Sunar in 1978 added an electrical raceway at desktop height, and important later systems included Bruce Burdick's glass-topped Burdick Group for Herman Miller in 1980 and Norman Foster's Nomos system for Tecno in 1986. And, of course, such off-the-shelf systems were supplemented with many custom designs for specific installations (Figure 20–74). Matching these systems in quantity and innovations were new office chairs, increasingly concerned with **ergonomic** considerations of healthier and more comfortable posture.

However the workstations are furnished, they must be supplied with power, voice, and data systems. The necessary wiring is often distributed above the finished ceiling and sometimes under the floor. The most flexible form of underfloor wire distribution is a raised access floor, surfaced with removable panels raised above the structural floor on pedestals; the removable panels are generally faced with carpet tiles.

Other factors affecting late-twentieth-century office design included legal activity. In 1962 the U.S. Congress passed the Revenue Act, allowing a 10 percent investment credit on personal property with a useful life of seven years. Fixed partitions, considered real estate, were not eligible for the credit, but movable partitions were, greatly encouraging the production and sales of panel systems. In 1970, Congress passed the Occupational Safety and Health Act, leading to the establishment of both the National Institute for Occupational Safety and Health **(NIOSH)** and the Occupational Safety and Health Administration **(OSHA).** Both NIOSH and OSHA affect many aspects of the design of office interiors and office furniture, including lighting standards, ventilation, materials specifications, and prevention of computer-related repetitive-strain injuries.

Nongovernmental activity included the formation in 1980 of the National Facility Management Association, known since 1983 as the International Facility Management Association, and in 1989 the founding of the International So-

Figure 20–74 Designed by Area in 2000, interiors for the Klasky Csupo animation headquarters in Hollywood include custom workstations of plywood, drywall, and colored acrylic panels assembled with steel angles.
JON MILLER/HEDRICH-BLESSING

ciety of Facilities Executives. Both these groups supported the new role of the facility manager, hired by businesses to work with designers, among others, to minimize cost and to maximize workplace efficiency, safety, security, and productivity. The client/designer relationship for large corporate office designs thus became considerably more complicated.

Finally, changes came to office design from changes in the nature of work. Increasingly, work was done individually at home rather than collectively in the office (giving rise to the term *telecommuting*), office work was done on an irregular schedule (*flextime*), and office workstations were made available to employees on a temporary basis (*hoteling*) rather than being permanently assigned. An early example of this last trend was the Switzer Group's facility in 1994 for IBM in Cranford, New

The National Institute for Occupational Safety and Health **(NIOSH)** is part of the Center for Disease Control and Prevention (CDC), which in turn is an agency of the U.S. Department of Health and Human Services. It is responsible for conducting research and making recommendations for the prevention of work-related illnesses and injuries. It can be reached at the Office of the Director, NIOSH, 200 Independence Ave., SW, Room 715H, Washington, DC 20201, tel. (202) 401–6997, www.cdc.gov/niosh/homepage.html.

The Occupational Safety and Health Organization **(OSHA)** is part of the U.S. Department of Labor. It provides compliance, technical, and training information about workplace safety and health. It can be reached at the U.S. Department of Labor, OSHA Administration Office of Public Affairs, Room N3647, 200 Constitution Ave., Washington, DC 20210, tel. (202) 693–1999, www.osha-slc.gov/SLTC.

In Europe, a comparable organization is the European Agency for Safety and Health at Work, based in Bilbao, Spain. It can be reached at http://europe.osha.eu.int/.

Jersey, which provided 180 workspaces for a total of 800 "mobile" employees. For such an office, more than size is affected; there is also a need for new types of equipment, including personal storage units that can be locked when not in use and wheeled to different locations as needed.

Transportation Design

Transportation-related interiors of the twentieth century were of two types: those of ground facilities such as railway terminals and airports from which transportation could be boarded, and those of the vehicles themselves. The prestige of the great railway terminal was high in the early decades of the century, with monumental examples built in major cities around the world, but that prestige later dwindled almost to nothing. At the end of the century, the design of new terminals had been replaced with the renovation of old ones, often involving filling their great spaces with popular shops and fast-food vendors.

Rail terminals were replaced in importance by air terminals, the most architecturally adventurous ones of midcentury being the TWA terminal at Kennedy International airport, New York (Figure 20–75), and Dulles International Airport near Washington, D.C., both finished in 1962 and both designed by architect Eero Saarinen. In 1978 SOM designed the giant King Abdul Aziz International Airport in Jeddah, Saudi Arabia, as a city of tents. Later examples included in 1992 the Stanstead airport near London and in 1995 the Chek Lap Kok airport in Hong Kong, both designed by Norman Foster, and in 1994 the Kansai International Airport, Japan, by Renzo Piano.

Designed for Dulles airport in 1962 by Charles and Ray Eames was the Eames Tandem Sling Seating, which was produced by Herman Miller and became a familiar sight in airports around the world (Figure 20–76).

Up in the air, aircraft interior design attracted the talents of industrial designers Henry Dreyfuss and Walter Dorwin Teague, architects Gerrit Rietveld and Edward Larrabee Barnes, designer Dorothy Draper, and textile designer Jack Lenor Larsen. In 1965 Alexander Girard began a corporate identity program for Braniff Airlines that included both plane interiors and plane exteriors. In 1968 Niels Diffrient began a series of plane interior designs for American Airlines. In 1993 Andrée Putman designed interiors of British Air's *Concorde*. Edward Perrault and Naomi Leff designed interiors of private jets.

On the road, Dorothy Draper designed interiors of the 1952 Packards, and Raymond Loewy

Figure 20–75 The TWA terminal at Kennedy airport near New York, designed by Eero Saarinen and completed in 1962.

Figure 20–76
Eames Tandem Sling Seating designed by the Eameses in 1962 for Eero Saarinen's Dulles International Airport. Black Naugahyde seats and attached tables are cantilevered from polished aluminum supports.

Figure 20–77 Designed by Shelton Mindel in 1997 for Celebrity Cruises' *Mercury,* a champagne lounge is visible through a teak-paneled drum.

MICHAEL MORAN PHOTOGRAPHY, INC.

designed both exteriors and interiors of the 1953 Studebakers.

At sea, the early-twentieth-century glamour of sea travel fell victim, like rail travel, to the greater speed of the airplane. But ships were still being built at the end of the century, fewer in number but some of them gigantic in size. Howard Snoweiss of Miami, noted for appropriately conservative hotel interiors for the Ritz-Carlton chain, was also producing appropriately spirited restaurants, casinos, and on-board theater/nightclubs for a series of cruise ships. And Shelton Mindel and others produced some dramatic spaces for Celebrity Cruises' *Mercury* in 1997 (Figure 20–77).

Institutional Design

This last category of twentieth-century interiors is a greatly varied one, including government buildings, community buildings, athletic facilities, schools, prisons, banks, stock exchanges, and museums. The importance accorded these different types of institutional interiors was also variable throughout the century, but on the whole museums were the institutions that attracted the most design attention.

Prominent among twentieth-century museum designs were John Russell Pope's classical revival National Gallery of Art in Washington, D.C., 1937; Frank Lloyd Wright's spiral-ramped Guggenheim in New York, 1959; Marcel Breuer's Whitney, also in New York, 1966, (Figure 20–78), and I. M. Pei's East Wing addition to the National Gallery, 1978.

As the century ended, design talent and public interest seemed focused even more strongly on the museum. Some museum commissions were the results of competitions, such as Robert Venturi and Denise Scott Brown's addition to the National Gallery, London, finished in 1991, and Yoshio Tanaguchi's expansion of the Museum of Modern Art, New York, a project just beginning as the century ended. Often cited as the architecture and interior design commission of the century was Richard Meier's giant complex for the Getty Museum in Los Angeles, opened in stages beginning in 1997. Others projected for completion in the twenty-first century included Steven Holl's addition to the Nelson-Atkins Museum of Art in Kansas City, Renzo Piano's addition to the Art Institute of Chicago, Zaha Hadid's project for the Contemporary Arts Center in Cincinnati, Tadao Ando's for the Modern Art Museum of Fort Worth, and Tod Williams and Billie Tsien's building for the new Museum of American Folk Art in New York. In San Francisco alone, Herzog and de Meuron were designing the new de Young Museum, Gae Aulenti the new Asian Art Museum, Ricardo Legoretta the Mexican Museum, and Daniel Liebeskind the Jewish Museum.

But the greatest newsmaker among late-twentieth-century museum designers was architect Frank Gehry, first with his Vitra Design Museum near Basel, Switzerland, opened in 1989 (Figure 20–79, page 604), then with his Guggenheim Museum, Bilbao, Spain, opened in 1997, both with interiors that broke dramatically from the established norm of rectangular white boxes for galleries. Other Gehry museums planned at the end of

Figure 20–78 In a gallery of Marcel Breuer's Whitney Museum, New York, 1966, movable partitions as well as lights are held in place by a suspended ceiling of concrete coffers.

the century were an addition to the Corcoran Gallery of Art in Washington, D.C., and another Guggenheim for a site in New York harbor.

Universal Design

Universal design simply means design that all can use, and it is specifically targeted at making interiors and their components accessible to the physically disabled. In 1968, the U.S. Congress passed the Architectural Barriers Act, mandating accessibility to federally owned or federally financed facilities and leading to formation of the Architectural and Transportation Barriers Compliance Board, commonly called the Access Board. That mandate was greatly broadened by the 1991 Americans with Disabilities Act.

The ADA, as it is called, affects interior design in myriad ways, requiring doorway, passageway, and toilet stall widths that can accommodate wheelchairs, for example; making elevator call buttons, drinking fountains, and kitchen sinks low enough to be used by the wheelchair-bound; giving flooring a nonslip surface; and making spaces safe for the hearing- and sight-impaired. Contested by some as a nuisance and added expense when it was new, the ADA is now accepted as an integral part of good design.

Interior Services

In the twentieth century, interiors were made much more habitable—but also much more complex—by the provision of new and newly improved

Figure 20–79 Interior of Frank Gehry's 1989 Vitra Design Museum near Basel, Switzerland. Displayed are, left, Gerrit Rietveld's Red Blue chair of 1917 and, right, two bentwood chairs made by J. and J. Kohn of Vienna, the left one designed by Josef Hoffmann in 1906, the one on the right the company's No. 14, c. 1880.

services. Among them were electrical power, emergency power backups, telephone service, elevators and escalators, fire safety equipment such as sprinkler systems, and burglar protection such as surveillance cameras and motion detectors. We shall look briefly at three of the most important of such services; lighting, mechanical systems, and acoustics.

Lighting

Perhaps the most dramatic improvement brought to interiors by the twentieth century was in the field of lighting. The quantity, quality, and control of interior lighting effects improved radically in those hundred years. At the end of the century, however, the most popular type of lighting for residential interiors was one invented in the nineteenth century.

LAMP TYPES The basis for the development of modern lighting was the invention of the **incandescent lamp** in 1880. It was the result of the independent and virtually simultaneous work of two inventors, Thomas Edison in the United States and Joseph Swan in England. The incandescent lamp generates light when an electric current is passed through a wire coil (called a *filament*), making the coil glow (or *incandesce*). In the first such lamps, the coil was housed in a vacuum within a bulbous glass container; later, gasses were added to improve the light quality.

 VOCABULARY TERMS FOR LIGHTING EQUIPMENT

Disregarding the popular uses of the terms "lightbulb" and "lamp," professionals working in any part of the lighting field make the following distinctions among terms that apply to types of equipment:

- *Bulb* applies only to the glass container for components such as filaments.
- *Lamp* applies to the entire light source, comprising, for example, filament, bulb, and electrical connection.

- *Luminaire* applies to a total lighting instrument, comprising, for example, lamps, reflectors, lenses, housing, and wiring. The terms "light," "fixture," and "fitting" are not used by professionals as synonyms for luminaires.

Hundreds of incandescent lamp types are available, each designed for a specific practical or aesthetic purpose. Four classes are most important (Figure 20–80):

- *General service* lamps (shaped rather like a pear) are the workhorses of the industry and come in a wide range of intensities and sizes. They produce light in all directions, and they should be used in equipment that will shield and direct their output in a useful manner.
- *Tungsten-halogen* lamps (often called *quartz* or *iodine* lamps) are small in size, rectangular in shape, and have a comparatively long life. They were introduced in the late 1950s. Their filaments are tungsten, and their bulbs are partly filled with halogen gas.
- *Reflectorized* lamps are fully enclosed lighting instruments. They include a light source, reflector, and lens within a single glass bulb that can be screwed into an electrical socket. One popular example is the PAR (parabolic aluminized reflector) lamp, shaped to efficiently direct its light in a single direction.
- *Decorative* lamps are designed to be visible, and their bulb shapes can be spherical, tubular, or made to resemble a candle flame.

These incandescent lamp types come in a variety of sizes, strengths (measured in wattages), finishes, and color coatings. Some bulbs are etched or sandblasted to produce a softer effect. Some are tinted. Some have inherent filters for special effects.

Another type of incandescent lamp is the *low-voltage* lamp. Standard household current is 120 volts, but these lamps operate at greatly reduced currents, many at only 12 volts, with the advantages of smaller size, longer life, and improved energy efficiency. In addition, the smaller size allows a more precise reflector design, often built into the lamp. A disadvantage is that, in order to convert the standard current to low voltage, a transformer is needed, but the latest generation of transformers is smaller than earlier ones. Another disadvantage is that the bulb surface of some low-voltage lamps can reach a high temperature, so contact with flammable materials must be avoided.

The other general category of lamps is that of the **discharge lamp.** In accordance with principles known since the early eighteenth century, the discharge lamp generates light when an electric current is passed through a gas or a metallic vapor, causing it to emit an invisible discharge of ultraviolet light, which becomes visible light when it passes through a phosphor coating on the inside of the

Figure 20–80 Representative shapes of incandescent lamps.

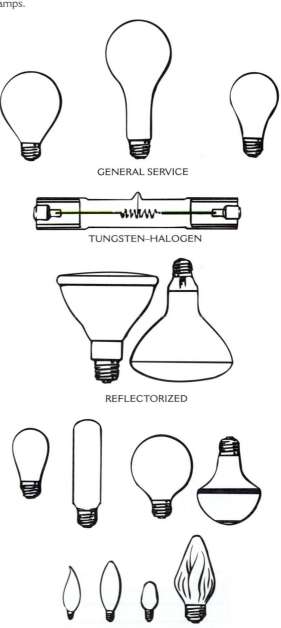

GENERAL SERVICE

TUNGSTEN–HALOGEN

REFLECTORIZED

DECORATIVE

glass bulb. In 1910 French chemist Georges Claude began making neon lamps, a type of discharge lamp using neon gas, and they were used that year to light the exhibition halls of Paris's Grand Palais. Now used chiefly in signage, the neon lamp can be made to produce a variety of colors by altering the gasses and phosphors used.

The fluorescent lamp was perfected in 1927 and was first successfully marketed in 1938 by Westinghouse under the name Lumiline. The fluorescent is now the most common of the discharge lamps, and the 4-foot-long (1.2 m) tube is its most common bulb shape. Fluorescent lamps are also available in other lengths, however, in compact versions, in U-shapes, and in circles (Figure 20–81).

Fluorescent lamps are more efficient than incandescent lamps, requiring less electrical energy for the same amount of light, producing less heat, and having life expectancies many times longer. Disadvantages are that they sometimes require additional electrical equipment called *ballasts* (although self-ballasted lamps are available) and the color of the light they produce is often cooler and less pleasing (although improvements in color are constantly being made and there are now many color choices). Fluorescent lamps have become the standard for commercial, public, office, and industrial interiors. Even in residences, energy-conscious building codes in some locations now require that the first light to be switched on in a kitchen or bathroom must be a fluorescent lamp, not an incandescent one.

Another category of discharge lamp comprises the high-energy discharge or HID lamps, including mercury vapor, sodium vapor, and metal halide. All of these emit large amounts of light and heat, too large for interior use except in spacious areas such as high-ceilinged lobbies, atriums, gymnasiums, and warehouses. The color of their light (very blue in the case of mercury, very yellow in the case of sodium) can also be a problem unless corrected.

Cold cathode lamps are similar in flexibility to neon but more efficient in light production; they can be useful in interiors because they can be concealed in small and intricately shaped coves.

FIBER OPTICS AND LASERS Neither incandescent nor discharge and, strictly speaking, not even a lamp, is a quite different way of transmitting light and light-carried information: fiber optics. The technology derives from the observation that light within a column of glass does not escape the sides of the column but is continually reflected inward and emerges only at the cylinder's end. This had very limited application until strands of fiberglass were substituted for glass with the same results. The fiberglass strands can be very thin, long, and light, can be bent or twisted as needed, and transmit light with virtually no heat. Fiber optics are used today for decorative lighting effects, as in bunches of small tubes each of which has a point of light at its end, and also for connections between, for example, telephone company cables and computer terminals. It seems likely that fiber-optic technology will soon be given other work to perform.

Also with possible potential for interior design use is laser technology (an acronym for *l*ight *a*mplification by *s*timulated *e*mission of *r*adiation). First introduced in 1960, the laser's intense, visible beams have proved effective in outdoor displays, but have not yet been harnessed for practical indoor application.

LUMINAIRE TYPES The two basic lamp types, incandescent and discharge, can be incorporated into a large number of luminaire types for different

Figure 20–81 Representative shapes of fluorescent lamps.

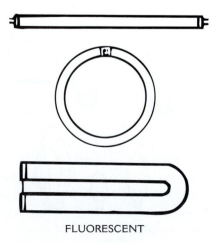

FLUORESCENT

Figure 20–83 The Boyd Lighting showroom in San Francisco, designed by Brayton and Hughes in 1996, employs a combination of natural and artificial lighting effects.

BRAYTON AND HUGHES DESIGN STUDIO

Figure 20–82 The CPM lighting showroom in San Leandro, California, designed by Tom Gass in 1997, displays a variety of lighting types and placements, including some lamps recessed in the floor.

PETER J. PAIGE

uses and placements (Figures 20–82 and 20–83). Some are meant to be hidden from sight; others are designed to be seen. Some types are:

- *Surface-mounted luminaires.* These are generally used only when space above the ceiling is too limited to allow the luminaire to be recessed or when the appearance of the luminaire should be visible. Luminaires can be mounted directly on the ceiling surface or they can be pendant (suspended below the ceiling).
- *Downlights.* These can be ceiling mounted, pendant, or recessed in the ceiling. In this last case, they are usually cylinders mounted so that their bottom surface is flush with the ceiling plane. They shine light directly down or as directed by an internal reflector.

- *Wallwashers.* The wallwasher is a type of downlight mounted near a wall and designed to wash that wall with light.
- *Lay-in fluorescents.* Not strictly a downlight, for it gives general, ambient lighting, the fluorescent fixture "laid in" above a suspended ceiling is a standard luminaire type for office, industrial, and retail uses. It almost always incorporates lenses and louvers to direct the light and to shield the fluorescent lamps from direct view.

The great twentieth-century innovator of these last three luminaire types was Edison Price (1918–97), whose workshop/laboratory/factory was located in New York. He calculated and built hundreds of new luminaire shapes with carefully designed filters, reflectors, and shields, working with lighting designers Richard Kelly, Claude Engle, and others, and architects Gordon Bunshaft, Louis Kahn, Mies van der Rohe, Marcel

Figure 20–84 Perhaps the first track lighting was this system in George Nelson's remodeling of the Herman Miller showroom in Chicago, 1948.

VITRA DESIGN MUSEUM

Breuer, and others to solve their specific lighting needs.

- *Sconces.* A sconce is wall mounted and directs its light upward, downward, or in both directions.
- *Track lighting.* Providing a mechanical means for lamps to be easily moved along ceiling-mounted or pendant tracks, track lighting seems to have first been used in 1948 in George Nelson's remodeling of the Herman Miller showroom in Chicago. Nelson had hired Jack Dunbar as his designer in charge of the job, and Dunbar packed wiring into sections of a prefabricated steel framing system called Unistrut and suspended them from the showroom's ceiling (Figure 20–84). Nelson suggested controlling the light quantity with theater-type dimmers, which he had begun to use in residential interiors. A more sophisticated track lighting system (and one more in accord with the growing body of electrical code restrictions) was developed in 1953 by Edison Price for Louis Kahn's Yale Art Gallery; it was based on the electrified tracks used for movable machinery in factories.
- *Strip lighting.* Strip lighting consists of multiple lamps housed in a linear luminaire. It is used in ceiling coves, behind glass-fronted cabinet doors, under stair treads, beneath bookshelves, and wherever a continuous band of light is wanted from an unobtrusive source.
- *Luminaires as furniture.* There is another large category of luminaires that are designed to be seen and that can be moved about like pieces of furniture. The most common examples are so-called table lamps and floor lamps. A list of outstanding examples among the century's thousands would have to include, in 1904, Mariano Fortuny's adaptation of stage lighting to an indirect luminaire that used an umbrella-like shape as a reflector; in 1924, William Wagenfeld's Bauhaus lamp with an opalescent glass globe above a clear glass base; in 1927, Walter von Nessen's swing-arm lamp; in 1934, Jacob Jacobsen's Luxo lamp on a flexible metal arm held in tension by steel springs, manufactured continuously since 1937; in 1970, John Saladino's lamp on a cylindrical glass base; and in 1977, Vico Magistretti's Atollo table lamp with cylindrical cone-topped base and hemispherical shade, both made of white-painted aluminum. These are all now considered classic designs.

But the century's greatest designer of luminaires as furniture has probably been Cedric Hartman (1929–). From his studio and factory in Omaha, he has produced a series of refined luminaires, tables, and other objects, almost all rendered in highly polished metal, the most admired and most imitated being the 1 WV floor lamp (Figure 20–85).

LIGHTING CONTROLS The most common control for luminaires of all types is a wall-mounted on/off switch (a *toggle* switch) generally placed at the entrance to a room. In all but the most utilitarian spaces, however, the additional flexibility in lighting effects offered by dimmers is invaluable. Dimmers operate by regulating the voltage (or electrical potential) flowing to the lamp. Until the last decade of the twentieth century, only incandescent lamps could be easily dimmed, but the development of the electronic ballast allows fluorescent lamps to be dimmed now as well.

In room lighting schemes where there is a combination of different lamp and luminaire types, each

type and each major grouping should have a dimmer of its own. In residential uses, personal control of dimming can vary room lighting to suit the activity or mood of any moment. In some large commercial or institutional uses, preset systems of dimmers can adjust lighting levels in accordance with a prescribed pattern.

LIGHTING EFFECTS Working with the two chief types of lamp—incandescent and discharge—and the several types of luminaires, and the varieties of lighting controls, the designer can achieve many different effects. In most cases, rooms are successfully lighted only with a combination of several effects. The three broad categories of lighting effects are *general lighting* (also called *ambient lighting*), *local lighting* (called *task lighting* when it is focused on a work surface of some sort), and *sparkle*. The influential American lighting consultant Richard Kelly used the terms *ambient luminance*, *focal glow*, and *play of brilliance*, and the contemporary designer John Saladino uses the terms *ambient lighting*, *work lighting*, and *art lighting*. For rooms in which the occupants will spend large amounts of time, the designer should provide lighting in all three categories.

LIGHT MEASUREMENT The determination of proper light levels for different parts of interiors is best done in collaboration with a qualified lighting designer. Many technical books and handbooks give tables of generally accepted light levels for specific circumstances and tasks (for example, 1 footcandle is recommended for a movie theater during a film, and 2,000 footcandles for an operating room during surgery). Even so, the designer will need to be conversant with the terms used.

The selection of a lighting design cannot wholly be reduced to scientific calculation, but must also include an element of personal taste, as must the selection of a color scheme. Indeed, the two are mutually dependent, for all artificial light has a characteristic color temperature, which can be measured in degrees Kelvin (°K), higher numbers representing cooler light and lower numbers warmer. The perceived color of any surface is therefore always the result of both

Figure 20–85 Cedric Hartman's I WV floor lamp, 1966, sometimes called the Pharmacy lamp.

- *Watt* is a measurement of electrical energy. Although lamp strengths are commonly identified by wattage, the number of watts *(W)* will be proportional to light output only within the same family of lamps. A kilowatt *(kW)* is 1,000 watts.
- *Lumen* is a measurement of light quantity. A 20-watt fluorescent lamp will produce slightly more lumens that a 75-watt incandescent lamp, thus being more energy efficient by producing more *lumens per watt* or *LPW*.
- *Footcandle* is a measurement of light arriving at a surface, 1 footcandle *(fc)* being 1 lumen per square foot. It is a measurement used chiefly in England and the United States; almost everywhere else the same quality (called *illuminance*) is measured by the *lux*. One lux *(lx)* is 1 lumen per square meter. In density of light, an illuminance of 1 fc is therefore equal to an illuminance of 10.76 lx.
- *Candela* is a measurement of light leaving a source in a specific direction (called *luminous intensity*). The candela *(cd)* has replaced an earlier measurement called candlepower *(cp)*.

its inherent or applied color and the type of light shining on it.

Mechanical Systems

In addition to the field of lighting, there were many twentieth-century advances in the fields of heating, ventilating, and air-conditioning. These, often collectively abbreviated as HVAC, are the factors that bring comfort to interiors; by providing fresh air and eliminating unhealthy airborne substances, they also promote health.

HEATING The type of fuel used, such as electricity, natural gas, propane gas, or, in the case of solar panels, sunlight, is often used to identify heating systems. The choice of fuel is dependent on local availabilities and economics. Coal and wood, the major fuels of the nineteenth century, have become obsolete (and, in some areas, forbidden by law) because of the air pollution they cause.

Heating systems also differ in the medium that distributes the heat, such as steam, hot water, or warm air. The choices of fuel and medium are related to the type of equipment, if any, that will be visible in an interior. Electric heating of room air is accomplished with small units, usually in the form of wall panels or baseboard strips. Steam and hot water heating, however fueled, will require metal radiators that can transfer their internal heat to the air around them. A sophisticated type of radiator is the fan-coil unit, often placed under a window, which uses a small fan to blow room air over heated coils. In warm air heating, the heated air is blown into a room from a remote heat source, such as a furnace, through ducts. What will be visible in the room are grilles, usually in the wall, at the ends of the ducts; return air grilles and ducts may also be needed to carry air back to the heat source. All these heating types are considered to be convection heating, because, even when radiators are involved, they are chiefly dependent on the movement of air within a room for the distribution of heat.

A heating type different from all the above is so-called radiant heating, in which the air is heated by radiation from a warm surface, most typically a floor. The floor is warmed by electric heating wires or tubes of heated water buried beneath its surface, and there are therefore no heating devices (except controls) visible in the room. Introduced midcentury, radiant heating originally used copper tubing, which was susceptible to breakage and leakage; at the end of the century, copper had been replaced by plastic tubing, which was more reliable. A requirement of radiant heating is that the flooring material be one that conducts heat easily, such as concrete. A drawback of radiant heating is that its

response time between the system's sensing a need for heat (as in an unexpected temperature drop) and its supplying heat may be longer than that of a convection system, but that drawback is being reduced by the growing sophistication of controls.

VENTILATING In 1900, ventilation of interior spaces was thought desirable to rid them of smoke and odors. By 2000, it had become clear that ventilation was necessary to rid spaces of a number of harmful substances in the air. Interior air, it is now known, should not only be changed often but also passed through filters that can remove some of those substances. Among those now believed to be harmful are five general types:

- *Carcinogens.* These are substances that may cause cancer, and they include tobacco smoke, airborne asbestos particles, and radon. Radon is a colorless, odorless, radioactive gas found naturally in the ground; it can enter interiors through sewers or through cracks or joints in foundation walls.
- *Toxins.* These are substances that are poisonous in various ways, and they include carbon monoxide, carbon dioxide, and formaldehyde. Some of them are emitted by common building materials, insulation, solvents, paints, or glues.
- *Positive ions.* Ions are simply electrically charged air particles, and the negatively charged ones are thought to be healthier than the positively charged ones. Negative ions can be depleted by metal ductwork, video display terminals, and other positively charged surfaces. While the danger of positive ions is minor compared with that of carcinogens and toxins, their quantity should sometimes be checked.
- *Ozone.* A form of oxygen that is valuable in the upper atmosphere as a protection against skin cancer, ozone may be harmful if breathed in large quantities. It can be produced in interiors by some chemical and electrical processes, such as the operation of unfiltered laser printers.
- *Particulates.* All airborne particles are particulates. Some of them are carcinogens; others include bacteria, viruses, pollens, and fungi.

Except for positive ions and ozone, these types include many different substances. The interior de-

signer can eliminate some of them by restricting the use of materials that emit them; in other cases other measures are indicated. As with heating and air-conditioning, proper ventilating of interiors often requires the consultation of a professional mechanical engineer.

AIR-CONDITIONING Air-conditioning is the treatment of interior air to improve its temperature, humidity, and cleanliness. Rudimentary air-conditioning was employed in the first two decades of the century primarily in industry and most particularly in textile mills, although in 1902 it was used in the Royal Victoria Hospital, Belfast, Northern Ireland, and, as we have seen, Frank Lloyd Wright provided air-conditioning in his design for the 1904 Larkin office building in Buffalo (Figure 20–70). A technical step forward came in 1906 when Willis Haviland Carrier patented a process he called "dew-point control." He established the Carrier Engineering Corporation in 1915. But it was not until 1929 that the first residential air-conditioning unit was marketed by Frigidaire; it was 49 inches (1.24 m) wide and weighed 200 pounds (90 kg). In 1939 Carrier successfully applied his technology to an entire skyscraper. Efficiency and miniaturization have increased greatly since then.

By the end of the century, air-conditioning had become an expected amenity in almost every interior. It had come to be seen, however, as bringing new problems; for example, air-conditioning systems that, for efficient energy use, recirculate indoor air were seen to promote a gradual buildup of indoor air pollutants, and buildings with permanently sealed window walls, another energy-saving feature, were also recognized as pollution prone. The early-twenty-first-century standard seems to be air-conditioning, but with operable windows for admitting fresh outside air when desired.

Acoustics

The father of modern acoustics for interiors was Wallace Clement Sabine. In 1895, as a twenty-seven-year-old assistant physics professor at Harvard University, he was asked to examine a new lecture hall in which few audience members could hear the lecturer. At the end of three years, Sabine

had not only solved the room's acoustics by bringing in sound-absorptive material, but had devised the formula that predicts the amount of such material needed. This formula, called the *Sabine law*, states that a room's reverberation time multiplied by its total absorptivity is proportional to its volume. Following that success, he was asked to advise on a more visible project, Boston's new Symphony Hall, then being designed by McKim, Mead, and White. Sabine prescribed the auditorium shape (like a shoe box) as well as its degree of absorptivity, and suggested the addition of a second balcony; when the hall opened in 1900, it too was a success, Sabine's reputation was made, and the science of acoustics was launched.

Today, interiors such as concert halls and theaters are seldom designed without the consultation of a professional acoustical engineer. For less acoustically sensitive interiors, however, interior designers are often on their own. Several factors may need to be considered:

- The reduction of unwanted exterior sounds. This may involve such measures as double glazing for windows, gaskets around doors, and sound-absorbing materials in air intake and exhaust openings.
- The reduction of unwanted sounds from adjacent rooms. Solutions include the provision of dead air space, sound-absorbing wallboard, or heavy masonry within interior partitions. Sound-absorbing material may also be needed in ventilation ducts that serve several rooms.
- The reduction of unwanted sounds within a room. The chief remedy here is the proper amount of sound absorbency on ceiling, wall, and floor surfaces and even on furniture. Another approach is to mask unwanted sounds with less objectionable ones, as in the "white noise" machines that emit barely audible noise; these find application in many open-plan office layouts with large numbers of workers separated only by low partitions.

RESOURCES — ACOUSTICAL SOCIETIES

There are many national and international societies that publish journals and informative papers or establish standards in the field of acoustics. A few of them are:

- Acoustical Society of America (ASA), 500 Sunnyside Blvd., Woodbury, NY 11797, tel. (516) 576–2360, www.asa.aip.org.
- American Society for Testing and Materials (ASTM), 100 Barr Harbor Dr., West Conshohocken, PA 19428, tel. (610) 832–9500, www.astm.org.
- Audio Engineering Society (AES), 60 East 42nd St., New York, NY 10165, tel. (212) 661–8528, www.aws.org.
- Institute of Noise Control Engineering (INCE), P. O. Box 3206, Arlington Branch, Poughkeepsie, NY 12603, tel. (914) 462–4006, www.users.aol.com/inceusa/ince.html.
- International Society of Audiology (AUDI), Audiological Center of the University Hospital Rotterdam, Dr. Molewaterplein 40, ML–3015 GD Rotterdam, The

Netherlands, tel. 31 10 463 9222, www.fgg.eur.nl/fgg/KNO/actif/isa.htm.
- National Council of Acoustical Consultants (NCAC), 66 Morris Ave., Suite 1A, Springfield, NJ 07081, tel. (973) 564–5859, www.ncac.com. Maintains a directory of qualified acoustical consultants in the United States.
- National Institute of Standards and Technology (NIST), part of the U.S. Department of Commerce and formerly called the National Bureau of Standards. Its publications, such as "Standards on Noise Measurements, Rating Schemes, and Definitions: A Compilation" (SD Catalog No. C13.10: #386), can be ordered from the Superintendent of Public Documents, U.S. Government Printing Office, Washington, DC 20402, or from www.nist.gov.

Designers working with acoustical engineers may want to be conversant with some of the field's technical terms and acronyms. A few of those are:

- *Decibel (dB).* A measurement of sound levels. A larger dB rating indicates a louder sound, with 1 dB indicating the faintest audible sound and 130 dB a painfully loud one. A normal business office might be rated at 50 or 60 dB.
- *Noise reduction coefficients (NRCs).* Also called *absorption coefficients*, they are measurements of the sound-absorbing quality of specific materials in a room. The higher the coefficient, the more sound is absorbed, total absorption being valued at one and total lack of absorption at zero. If the NRC of each material is multiplied by the surface area of that material, and if those results are added together, a total NRC for a room can be obtained.

- *Sound transmission classes (STCs).* Measurements of the ability of a wall, cubicle partition, or other object to transmit sound. The higher the number, the less sound is transmitted. A ¼-inch-thick (6 mm) sheet of Plexiglas, for example, has an STC of 27, a level at which normal speech can be heard through the material, although it may not be clearly understandable; an 8-inch (20 cm) concrete block wall has an STC of 49, a level at which normal speech is not transmitted, loud speech cannot normally be heard, and loud sounds other than speech can be heard only faintly.

- The achievement of a reverberation time (RT) appropriate for the room's function. An RT of half a second may be appropriate for office space, but a concert hall may require an RT of a second and a half.

Interior Materials

Previous chapters have often closed with surveys of furniture, arranged in groupings of chairs, tables, casegoods, and so forth, and of decorative arts, arranged by media. In the twentieth century, these two areas were so dominated by the materials with which they were made that we shall use those materials as our organizing principle.

Steel and Glass

The dominant materials of twentieth-century architecture were steel and glass, and that combination was important in interiors as well. Glass-topped steel tables were designed at the Bauhaus by Marcel Breuer in the '20s, and the type has persisted until the present. Among its myriad variations are two Italian ones from the early '80s, the Alanda table designed by Paolo Piva for the manufacturer B&B Italia in 1982 (Figure 20–86) and the Cardine table designed by Gae Aulenti for Zanotta in 1983 (Figure 20–87), the latter a reinterpretation of the traditional wood worktable resting on wood "sawhorses."

Glass in interiors is by no means limited to tabletops, of course. It has become a versatile and

Figure 20–86 The glass-topped Alanda table designed for the manufacturer B&B Italia by Paolo Piva, 1982.
B&B ITALIA

Figure 20–87 A glass-topped table designed by Gae Aulenti for Zanotta in 1983. Originally marketed under the name Gaetano, it is now called the Cardine table.

ZANOTTA SPA

Figure 20–88 Sandblasted glass blocks screen executive conference and dining rooms in the New York offices of Swiss Re, a branch of the Swiss Reinsurance Company of Zurich. The interior was designed by Gensler in 1998, with Don Brinkmann the design director.

NICK MERRICK/HEDRICH-BLESSING

varied material. It can be used in two layers (*double glazing*) enclosing a thin inner layer of dehydrated air or inert gas, giving a product that reduces heat transmission. It can be **tempered,** treated by heat so that it has greater strength and so that, if it does break, it will shatter into small, relatively harmless pieces. It can be **laminated,** bound to a layer of plastic for special visual effects, for safety, for reducing sound transmission, or for thermal insulation or the blocking of infrared radiation. It can also be sandwiched with wire mesh to produce **wire glass,** mandated by some fire codes for such locations as fire stair doors because the wire prevents shattering into dangerously large sheets. It can be made in the form of **glass blocks** with varying degrees of transparency (Figure 20–88). It can be made bullet-proof. It can be made sensitive to an electric current so that flipping a switch can change it from transparent to opaque. And it can be etched, mirrored, tinted, or painted for different appearances.

For all its new possibilities, however, glass in interiors is now often replaced by a whole category of materials that came into existence during the twentieth century: plastics.

Plastics

A plastic substance is one that, rather than being cut, chiseled, or molded, can at some stage simply be pushed into a desired shape. Glass and concrete are both plastic in that sense. A few plastic substances that occur in nature include *gutta-percha,* a vegetable gum found in trees in Madagascar and used there for making knife handles, and *keratin,* a material derived from animal horns, animal hoofs, and chicken feathers and once (in the mid-1950s) used for textile fibers. A similar material, used by Frank Lloyd Wright in the Larkin Building for floors, columns, desktops, and windowsills, was *magnesite,* a mineral substance mined in Greece that could be mixed with solvents and then poured and troweled like concrete.

When we speak of plastics with an *s,* however, we mean not only substances with malleability, but also ones that are organic (containing compounds of the element carbon) and synthetic (created not in nature but in the laboratory).

The plastics styrene, melamine, vinyl chloride, and polyester had all been invented before 1850,

and developments between 1850 and 1900 included many other types of plastics and shaping techniques such as screw extrusion and injection molding. It was not until the twentieth century, however, that these new materials and techniques began to be put to widespread use. In 1907 Leo Baekeland, a Belgian chemist working in the United States, found an efficient way to mold a plastic called phenol-formaldehyde; he patented his process in 1909 and called his product Bakelite. This first commercially successful plastic was used for electrical insulators, phonograph records, radio cabinets, telephones, and many other objects. Another popular plastic, polyvinyl chloride or vinyl or PVC, was developed in 1928 and patented by chemist Waldo Semon of the B. F. Goodrich Company in 1933; it was used as a rubber substitute during World War II, and in peacetime for shower curtains, raincoats, and automobile interiors. At the end of the century, vinyl was second only to polyethylene as the world's most widely used plastic. Since then, plastics have been used to make all manner of surfacing materials, textile fibers, adhesives, sealants, furniture, and industrial products. We shall see their usefulness demonstrated in many fields—in carpet manufacture, for one example.

Especially useful in interior applications are the finishing materials called *plastic laminates*. These are composed of layers of paper bonded together with an outer layer of thin plastic, the result being a thin, lightweight sheet with a durable surface. In practice, these laminate sheets are applied to stronger backings such as plywood or one of the wood composition boards described below. The surfaces of plastic laminates can be given a wide variety of appearances; they can have matte or glossy finishes, be in any color or pattern, and, if wanted, even imitate other materials, such as wood grain.

Clear plastics have been substituted for glass in furniture design, not only for table tops, but also for seating. Beginning in 1939 Elsie de Wolfe made popular a lightweight side chair made by Grosfeld House with a back splat of Lucite, a product that Du Pont had recently developed, and in 1957 the Laverne Company began producing its Invisible group of see-through plastic furniture.

Plastics are wonderful twentieth-century additions to the designer's materials palette, but their production has not been without some unwanted side effects. The manufacture of most plastics, for example, uses petroleum, a natural resource in danger of depletion, and the glues used in making and applying plastic laminates have sometimes given off unhealthy fumes.

Carpets

The chief carpet types in use today, according to their method of manufacture, are Axminster, Wilton, velvet, and tufted. In addition, there are both broadloom carpeting and carpet tile. Of course, there are other ways of distinguishing carpets as well—by color and pattern, for example, or by materials employed.

MANUFACTURING METHODS

- *Axminster.* In the chapter on English design, we noted that Thomas Whitty, a Devonshire weaver, began using a vertical loom to produce Turkish-type carpets at Axminster, England, in the eighteenth century. In 1874 two Americans, Alexander Smith and Halcyon Skinner, developed a power loom that could set individual tufts that had been dyed as wanted, thus allowing a great diversity of pattern. Smith and Skinner's loom was exported to England in 1878, and the type of carpet it produces is what is usually meant now by the name Axminster. It usually has a surface of cut pile.

- *Wilton.* Wilton carpets also have an English origin, as we saw in chapter 16. The Royal Wilton Carpet Factory, founded in Wiltshire c. 1740, still exists, but the name Wilton, like the name Axminster, is now applied to any carpet made with the Wilton method. That method pulls one color of yarn at a time to the surface and buries others in the body of the carpet, thus creating a sturdy backing. Wilton pile can be either cut or looped.

- *Velvet.* Velvet carpet is similar in appearance to Wilton, but without the yarn buried in the backing. It is therefore less durable. It is often made in a single color, and patterns are added by having the pile, which can be either cut or looped, in different heights for a "sculptured" effect.

- *Tufted.* Tufted construction sews the ends of looped pile to a prepared fabric backing and secures it there with a coating of latex or some other adhesive. For extra strength, a second backing is sometimes laminated to the first. Tufting is a fast method of carpet making and, although originally limited to solid colors, it can now produce any desired pattern. Tufted construction is often used for carpet tiles. Specialized carpet types with similar backing are **cord** carpets, which are surfaced with loops of yarn in parallel ridges, and **Berber** carpets, which have a smooth surface of tightly packed loops.

- *Other methods.* In addition to these four main construction types, there are also knitted, braided, hooked, and other kinds of handwoven rugs and carpets. Turkish and Persian carpets are still being made and are still popular, as are the distinctive rugs and carpets of India, Morocco, Portugal, and other countries.

MATERIALS Natural animal and vegetable fibers, including wool, cotton, and silk, have been frequently mentioned. Other natural fibers that were popular in the twentieth century are linen, hemp, rush, jute, sea grass, and sisal. These are generally woven into flat-weave rugs and carpets without pile, and they are often reversible. Some of these fibers are easily cleaned, others are easily stained, but all have a natural, pleasantly rough appearance and are generally inexpensive.

The twentieth century's great development in carpet material, however, as in drapery and upholstery material, was the introduction of synthetic fibers, those that originate not in nature but in the laboratory. Many variations among them are identified by their manufacturers with trademarked names, but almost all come from one of the following categories:

- *Rayon.* The oldest of the synthetic fibers is viscose rayon. It was first commercially produced in 1905 on the basis of work by the French scientist Hilaire de Chardonnet in the late nineteenth century. The American Viscose Company, a producer of rayon for consumer use, was founded in 1910. In 1918, acetate rayon, more crease- and stain-resistant than viscose rayon, was developed in England. Because of their sheen, the fibers were at first called *artificial silk*, the name *rayon* not being adopted until 1924. Some would class it not as a synthetic but as a regenerated fiber, as it is made chiefly from cellulose, an organic compound found in wood, flax, and hemp. Trade names for rayon fibers include Avisco, Coloray, Durafil, and Tricel.

 A similar product, acetate, is also made from cellulose; it was introduced in 1924 by the Celanese Corporation and is produced under the trade names Celaperm, Celaloft, and Chromespun. The same company introduced triacetate in 1954, calling it Arnel. Both are useful in textiles, but triacetate is chiefly used in clothing fabrics.

- *Nylon.* Nylon is synthetically made from air, water, natural gas, and petroleum, and is noted for its strength, elasticity, and resistance to damage. It is produced not only in the form of yarn, but also in sheets, coatings, and molded shapes. It was developed by industrial chemist Walter Hume Carothers in 1937. It was introduced by Du Pont in 1938 for use in brush bristles and two years later for use in hosiery. Nylon's trade names include Antron, Cadon, Caprolan, and Quiana.

- *Acrylics.* Hard-wearing but soft, lightweight but warm, acrylics are the result of a chemical process called *polymerization*, in which small molecules combine to create larger ones. Acrylic plastics were developed by Otto Röhm in Germany in 1927, but acrylic fibers for textiles were introduced by Du Pont in 1950. They have been sold under the names Acrilan, Chemstrand, Courtelle, and Orlon. Most acrylic textiles are light and fluffy, but acrylic fibers can be blended with other fibers for more substance.

- *Modacrylics.* Their name derived from *modified acrylics*, modacrylics were actually introduced a year earlier than acrylics, by Union Carbide in 1949. They are synthesized from coal, natural gas, salt, air, and water. Their fibers, called Dynel and Verel, among other names, are flame-resistant, washable, and quick-drying.

- *Olefins.* Olefins were first developed in the United States for specialized use in 1949, but it

was not until 1961 that Hercules, Inc., developed a textile-grade version. By-products of petroleum, olefin fibers are strong, light, and resistant to dirt, mildew, rot, and moths. They are often used in upholstery fabric, and they have been marketed under the names Herculon, Marvess, and Vectra.

- *Polyester.* This fiber, derived from petroleum, coal, air, and water, was introduced by Du Pont in 1953. It is strong, dirt-resistant, and impervious to strong sunlight. Its trade names include Ancron, Dacron, and Trevira.

- *Glass.* Glass fibers were introduced by Owens-Corning in 1936. They are naturally flame-resistant. Stiff when first introduced, they were later modified to become softer and more supple. The most common trade name is Fiberglas.

- *Metallic.* Metallic fibers have been developed that remain free of tarnish and can be woven into other fibers for reflective effects. An early fabric with metallic luster was made jointly by Du Pont and F. Schumacher beginning in 1928; it was marketed as Nemoursa Lacquered Fabric. A later, more familiar trade name is Lurex.

All the above can be blended with one another or with natural fibers for a great variety of effects in carpeting, drapery, or upholstery material. In addition, finishes can be applied to the surfaces of carpeting or fabric to make them more fireproof or more dirt-resistant, two of the anti-soil treatments being called Zepel and Scotchgard.

CARPET PADS

Although almost all late-twentieth-century carpets were made with backings of cotton, jute, latex, or a combination of protective materials, almost all also benefit from the use of a pad under them. Carpet pads add resiliency and comfort and they may also add to the longevity of the carpet. Some pads are made of hair or jute, others of foam rubber, sponge rubber, or urethane. Foam rubber is less porous and less springy than sponge rubber. Both come with a waffle-like texture, and both come in various thicknesses measured by weight; a "50-ounce" pad is a thin one; a "110-ounce" pad is a thick one. Urethane comes in varying thicknesses and also in varying densities.

Other Textiles

New synthetic materials also played a role in upholstery, curtain fabric, and other twentieth-century textiles. But that role was often paralleled by renewed appreciation for natural fibers.

TEXTILE DESIGN There was also new appreciation for the work of the textile designer. In the nineteenth century, William Morris had been known for his textile designs, among many other accomplishments, but in the twentieth century the work of specialists in the textile field came to be widely recognized. Weaver and educator Anni Albers, first at the Bauhaus and later at Black Mountain College, has already been mentioned, and another weaver-educator was Loja Saarinen at Cranbrook, who was succeeded as head of the textile department by Marianne Strengell in 1942. Strengell soon installed a power loom at Cranbrook and advocated cooperation with industry rather than a focus on handweaving; her students included Jack Lenor Larsen and Win Anderson.

Larsen and Dorothy Wright Liebes were two important American textile designers, both of whom were strong colorists and incorporated new and unusual materials in their fabrics. Liebes (1899–1972) established her textile studio in San Francisco in 1930, moving to New York in 1948. Her commercial clients included Du Pont, Bigelow-Sanford, and Sears Roebuck, and her materials palette moved beyond natural materials to include synthetic ones as well as bamboo, strips of leather, strips of cellophane, glass thread, and even ticker tape.

After Cranbrook, Larsen (1927–) opened a New York studio in 1952, his first commission to provide curtain fabric for the new Lever House by Gordon Bunshaft of SOM. His innovations included the first printed-velvet upholstery fabric in 1959 and the first stretch upholstery fabric in 1961. His 1960 casement fabric "Interplay" was woven of Saran-monofilament, and his 1970 "Magnum,"

Figure 20–89 Barbara Beckmann's hand-painted "Ginza Fish" fabric of 1990 was inspired by Japanese prints

BARBARA BECKMANN DESIGNS, INC.

designed with Win Anderson, mixed cotton with vinyl, nylon, polyester, and sparkling squares of Mylar.

Also important among early modern textile designers were Ray Eames and Alexander Girard, both of whom produced patterns for Herman Miller. Boris Kroll established his textile company in 1930 and opened a New York showroom in 1934. F. Schumacher introduced a collection of textile designs by Frank Lloyd Wright in 1955 and another in 1987. More recently, handsome and experimental fabric designs have come from Gretchen Bellinger, her 1985 "Diva" curtain fabric, for example, being studded with pearls and rhinestones. Concentrating on tapestries and other types of large ornamental fabric wall hangings have been Sheila Hicks and Helena Hernmarck. Barbara Beckmann is an outstanding designer of hand-painted and hand-printed textiles (Figure 20–89), and other important contributors to the end-of-the-century textile scene included Suzanne Tick and Hazel Siegel.

TEXTILE PROPERTIES Other twentieth-century developments have been the increasing demand for textile fire resistance and abrasion resistance and the development of new tests to determine those resistances. The Taber test and the Wyzenbeek test, for two examples, use repetitive abrasions by patented machines to measure dura-

bility. And fire resistance tests, measuring the spread of actual charring by fire, are the basis for rating fabrics from A to D, the A category being the most fire-resistant. Modern fabrics are also expected at times to be stain-resistant, mildew-resistant, moth-repellent, fungus-repellent, anti-bacterial, or antistatic, and a number of chemical substances and processes have been invented to impart such qualities.

FABRIC WINDOW AND WALL TREATMENTS The elaborate multitiered curtains popular in the nineteenth century were still in occasional use at the end of the twentieth, but in most cases they had been replaced by simpler hangings and by roller shades (which can either be rolled down from the top of the window or, with different hardware, up from the bottom), venetian blinds (with either metal or wood slats), vertical blinds, wood shutters, Japanese shoji screens, and other devices. Also in use were fabric shades raised not on spring rollers but on loops of cord hanging from the top of the window. These are of two chief types: the **Roman shade,** which, when raised, folds like an accordion into horizontal pleats, and the **Austrian shade,** which is gathered into swags, its lower edge a series of scallops between the cords.

Whatever window treatment is chosen, some factors not actually visible may be important to the effect that is visible. In most cases, for example,

window curtains should be lined; the added thickness will make them hang in more gracefully rounded folds, and the lining material will prevent unwanted light from coming through the curtain fabric and will help keep the fabric from fading. Some designers use a fabric with sheen, such as satin, for the lining and add a third layer or *interlining* of a substantial material such as flannel between the lining and the curtain fabric.

Similarly, walls upholstered with fabric gain in softness and depth if the walls are first covered in flannel and then covered again with whatever material has been chosen for the surface.

Upholstery and Bedding

Mattresses for beds came to be constructed in three principal ways: stuffed, foam, or coiled. (The fabric envelope filled with feathers or down was no longer in use, although such construction was still used for coverlets or duvets on top of the bed.) A stuffed mattress is typically made of a 5½-inch-thick (14 cm) pad of cotton or polyester wrapped with polyester foam; such construction can soon lose its resiliency and become lumpy. Foam construction is a fabric-covered slab of molded polyurethane; it is nonallergenic, lightweight, and resistant to insects and mildew, but it is relatively slow to recover its shape. Foam mattresses are graded by their density, the more dense ones obviously being more firm. Shredded foam is less comfortable than solid foam, will not last as long, and is more flammable.

The superior mattress construction is of coiled springs made of steel wire with cotton felt laid over them and with a layer of horsehair on top of the felt. The coils are typically 5½ inches (14 cm) high, and the total construction is about 7 inches (18 cm) thick, although some mattresses are up to 13 inches (33 cm) thick. The coils can be attached to one another at their edges or, preferably, they may be pocketed in individual muslin wrappers so that they move independently of one another. Other variables are coil size and coil density.

In addition to these three principle mattress types, waterbeds enjoyed a brief popularity in the '60s, although their support was too fluid for many tastes and there were sometimes disastrous leaks. At the end of the century, air mattresses were another popular alternative. They are inflated with electrically powered pumps, and the most advanced have sensitive controls for adjusting the mattress's degree of firmness. Coil mattresses and even air mattresses are generally paired with box springs in matching covers. A common sort of cover for mattresses, box springs, and pillows is called **ticking,** which is generally a sturdy cotton patterned with a fine stripe. The box spring is typically 7 inches (18 cm) high, and it should be framed with kiln-dried hardwood and have wooden slats supporting each row of coils. Commercial types have metal frames. In the case of both mattress

❖ VOCABULARY TERMS FOR MATTRESS SIZES

During the last decades of the twentieth century, mattress sizes became standardized in both length and width. The standards for length are:

- Regular = 75 inches (190 cm)
- Long = 80 inches (203 cm)
- Extra-long = 84 inches (213 cm)

The standards for width are:

- Daybed (doubling as a sofa) = 30 inches (76 cm)
- Single = 34 inches (86 cm)
- Twin = 39 inches (99 cm)
- Full = 54 inches (137 cm)
- Queen = 60 inches (152 cm)
- King = 76 inches (193 cm)

- *Full grain.* The best quality leather, full grain retains an intact top layer showing the animal's pore patterns.
- *Enhanced full grain.* Full grain that has been sanded, buffed, and shrunk, so that pore patterns have been removed.
- *Top grain.* Not a synonym for full grain, top grain denotes a leather with its pore pattern removed.
- *Corrected grain.* Grain with surface alterations, such as sanding or embossing, in imitation of a natural pore pattern. In addition to an artificial pattern, corrected top grain has often been subjected to heavy dyeing.
- *Buffed leather.* Leather that has had its top surface removed by abrasion.
- *Production grade.* The second or third layer of a hide, production grade leather has no natural pore pattern, does not breathe well, and has no elasticity.
- *Chamois* (pronounced "shammy"). A soft, pliable leather made from sheepskin.
- *Suede.* any leather with a soft, velvet-like nap.

and box spring, the top padding should be thick enough so that the coils beneath it cannot be felt. The box spring can have legs or casters attached to the bottom of its frame, or it can sit inside a wood frame with or without headboards and footboards. When a single decorative headboard is used for twin beds that are placed closely together, the box springs should be on casters so that they can be swiveled apart for making the bed. Placing mattresses and box springs close to the floor can decrease their apparent volume and make a small bedroom seem more spacious, but such placement will make the bed difficult to make.

Pillows can be stuffed with down, feathers, a mixture of down and feathers, latex or polyurethane foam (solid foam again being preferable to shredded), or Dacron polyester, this last a good choice for those with allergies. A mixture of 80 percent down and 20 percent goose feathers gives an excellent pillow. A good test is to press down hard on a pillow; the best ones of any type will spring back into shape quickly. A good pillow will come with two covers, an inner one (made of ticking) closed permanently around the filling, and an outer one that can be removed for washing; the visible pillowcase goes over both these. The ticking should be of the 8-ounce type; 6-ounce ticking makes a softer pillow but is less durable. Standard pillow sizes are 20 by 26 inches (51 x 66 cm), 21 by 27 inches (53 x 69 cm), and 20 by 36 inches (51 x 91 cm). Some designers like to add a small cylindrical bolster in front of the rectangular pillows.

Dressing a bed with pillowcases, sheets, bedspreads, blankets, and comforters and covering the sides of the mattress and box spring with draped fabric, upholstery, or wood construction are major factors in the design of a bedroom, as is the type of bed to be used. There are as many different solutions as there are tastes.

Leather

Leather is hardly a modern material. The tanning process, turning animal hides into leather by treating them with a solution made from tannin-rich tree bark, was developed in prehistoric times. But as mentioned in the chapter on Spanish design, vegetable tanning (including the use of bark) gave way to oil tanning and mineral tanning. In the nineteenth century, all these began to be superseded by chemical tanning. This process was greatly improved in the twentieth century, which also brought a new vocabulary of terms for various types and grades of leather.

The basic character of leather is, of course, unchanged. Part of that character is the small sizes and irregular shapes of animal hides, limiting leather surfaces to compositions of small pieces. One change is in the general attitude toward the use of animals for either hides or furs, particularly in the

case of endangered species. It remains, however, an attractive material in many ways: like wood, it has a natural and varied appearance, showing patterns of pores and even, at times, characterful scars and insect bites; it is generally fire-retardant; it is fairly durable; and, when of the best quality, it is slightly elastic, breathable, and able to wick away moisture.

Wood, Wood Composites, and Wood Substitutes

There were two main twentieth-century developments in the use of wood in interiors and furniture. The first development was that some wood species that had been in use for thousands of years became scarce, endangered, or extinct. Many species, of course, remain available for designers' use.

The second development was that ways were developed of using wood—or imitating wood—in new composition materials. There were also new types of hardware for use with wood. And there were new, safer, and more environmentally benign glues, lacquers, paints, stains, strippers, varnishes, and finishes.

ENDANGERED WOODS The protection of wood species is a relatively recent concern. U.S. organizations seeking such protection now include the Rainforest Action Network in San Francisco, the Rainforest Alliance in New York, the Tropical Forest Foundation in Alexandria, Virginia, and the Global ReLeaf program of the American Forestry Association in Washington, D.C. As some of these names suggest, the greatest threats are to the woods of the tropical rainforests. Such rainforests once covered 14 percent of the earth's land surfaces, and some expect that perhaps all will have been destroyed by the middle of the twenty-first century. As they are leveled, either for selling the wood, for using the wood as fuel, or to make way for more profitable crops, it is not only the trees that disappear, but also the entire ecologies that depended on the trees.

Any wood can be grown in a sustainable manner, with guarantees that new growth will equal or exceed cuttings, but very little tropical forestry has adopted such methods. Situations change constantly, but among the species that have been list-ed as endangered at some time in recent years and which should therefore be avoided without assurances of their sustainability are:

- African mahogany
- American elm
- American mahogany
- Brazilian mahogany
- Burmese teak
- sapele
- wenge
- ebony
- iroko (African teak)
- lignum vitae
- rosewood
- Cuban mahogany
- Thai teak
- zebrawood

RECONFIGURED WOODS The Egyptians wrapped wood furniture in sheets of gold, and throughout history we have seen the appearance of wood altered by inlays, marquetry, carving, painting, and stenciling. But in the twentieth century, the very composition of wood was altered to give it new characteristics.

An early example came during World War I, when Marshall Burns Lloyd developed a technique for using twisted paper, a wood product, as a substitute for wicker. He patented his system in 1917. His company, Lloyd Loom, became part of the Heywood-Wakefield furniture company in 1921 and is still in business.

About the same time, a fibrous board called Homasote came on the market. Made entirely of recycled newspapers, it has good insulating and acoustic properties and is used today for wall panels, carpet underlayment, roof decking, and tack boards. Soft and easily dented, Homasote and other types of **recycled newspaper board** are generally covered with fabric when used as wall surfaces.

Similar is a soft, low-density board called **soundboard** or building board. Generally ½ or ¾ inch (12 or 18 mm) thick, it has little strength, but its loose composition of wood fibers has good sound-absorbing qualities, and it is often used as ceiling surfaces or as an acoustic element within walls and partitions.

Oriented-strand board (OSB), also known as *flakeboard* or *wafer board*, is made by bonding wood strands with a waterproof binder under heat and pressure. It is usually ¼ inch (6 mm) thick and can be used for carpet underlayment or wall paneling.

More dense and generally more expensive than oriented-strand board is **particleboard,** also called *chipboard.* It is also composed of particles of wood waste bonded together under heat and pressure. Various densities are available, as are moisture-resistant and fire-resistant varieties. It is available in thicknesses of ⅛ to 1⅛ inches (3–28 mm). Particle-board is often used as an underlayment for flooring and for plastic laminate countertops. It is also made with a thin top layer of a plastic called *melamine;* melamine-faced chipboard is useful in cabinetry for such things as drawer bottoms and bookshelves, if exposed edges are finished with solid wood.

Even more dense is **fiberboard,** also called *medium-density fiberboard* or MDF. Its surfaces are generally denser than its core, and this lack of uniformity can make the finishing of exposed edges difficult. It is available in thicknesses of ⁵⁄₁₆ to 1⅜ inches (7.5–34 mm) and is used for cabinets, trim, and wall paneling; treated with a protective finish, it can serve as countertops.

In 1924 William Mason ground and pressed discarded wood chips into Masonite, an early example of what is called **hardboard** or *high-density fiberboard* (HDF). As its name suggests, HDF is denser than MDF, and it can be tempered in a curing process that adds further density and strength. Both MDF and HDF present surfaces that can take paint well, but some of the softer composition boards do not. Hardboard is available with two smooth sides or with one smooth and one rough side, and it is available in thicknesses of ¹⁄₁₆ to ½ inch (1.5–12 mm). It is used in cabinets, drawers, as countertops, wall panels, subflooring, or—cut into tiles and given a protective coating—as flooring.

LAMINATED WOODS Laminated wood products are made from thin sheets of actual wood. The most useful of these, produced commercially since 1910, is **plywood,** composed of stacked veneers that are glued together with the wood grain of one layer at right angles to the grain of the next layer. This alternation of grain direction gives plywood its surprising strength. There are generally an odd number of layers, so that the top and bottom surfaces have parallel grains, and the material's strength is somewhat greater in that direction. Plywood is most often sold in sheets measuring 4 by 8 feet (1.2 x 2.4 m), and it comes in softwood or hardwood and in a great range of thicknesses and surface finishes. For any given thickness, the number of layers (or plies) can also vary, a larger number indicating a product more dimensionally stable (less likely to warp) than a smaller number. Standards and grading practices for plywood are set by the American Plywood Association in Tacoma, Washington, and the Hardwood Plywood and Veneer Association in Reston, Virginia.

Other manufactured laminated wood materials include **blockboard,** in which outer surfaces of wood veneer cover strips of solid wood that are between ¼ and 1⅛ inches (6–28 mm) thick. And custom wood laminations have been an important material in the twentieth-century furniture design of Alvar Aalto, Marcel Breuer, Robert Venturi (Figure 20–46), Robert Danko, and others.

BENTWOOD Wood can be bent, of course, without dividing it into layers and laminating them. In the previous chapter we saw Viennese cabinetmaker Michael Thonet's use of steam for bending solid wood rods for furniture elements. The company headed by Thonet and his five sons continued to prosper in the twentieth century, perfecting its use of bentwood and experimenting with laminated wood as well, and in 1925 Le Corbusier chose the so-called Vienna chair, which had been produced by Thonet since 1870, for furnishing his *L'Esprit Nouveau* pavilion at the Paris Exposition; from that choice, the chair and the company became widely associated with modernism. Within the next three years Thonet was producing cantilevered tubular steel chairs designed by Ludwig Mies van der Rohe and Marcel Breuer. Just before World War II, a branch of Thonet left Europe for the United States. At the end of the century, three independent companies were operating successfully: one still run by descendants of Michael Thonet in Germany and Austria, another based in Czechoslovakia, Romania, and Poland, and the third in the United States. In Europe the name is pronounced "tonnet," rhyming with *bonnet* and with a silent *h;* in the United States it is pronounced "thonay."

VENEERS As we have seen, veneering, intarsia work, and marquetry have been popular since the Renaissance. But veneering took on a new importance beginning in the 1950s when improved glues, stains, and sealers became available. Veneers in use today are sometimes as thin as 1/50 inch (0.5 mm), so that they make highly efficient use of woods that have become rare or expensive. Moreover, a composition of veneer bonded to plywood, particleboard, or MDF is more stable than a solid piece of wood, which is subject to warping.

When used on large surfaces, veneers can be cut and joined so that different patterns are created. The veneer manufacturer can work with the designer to produce the desired effect, and can also supply samples (called **flitches**) of available veneer varieties.

IMITATION WOODS There are also boards that imitate wood but are made from other materials. *Strawboard*, for one example, is made from short pieces of straw, mixed with glue, and formed under pressure into a stiff board. *Cementitious backer board*, for another, has a concrete-like core between faces reinforced with glass fiber; it is usually 1/2 inch (12 mm) thick and is often used between a plywood underlayment and a finish of thin-set ceramic tiles.

A Plaster Substitute: Drywall

As the twentieth century began, interior walls and partitions were most often made of plaster applied to wood lath. As the century ended, this technique had been largely replaced by a quicker and less expensive one, the use of a plaster substitute called **drywall** and a variety of other names: *plasterboard, wallboard, gypsum board, gyp board, gypsum wallboard*, (GWB), and *Sheetrock* (this last name capitalized because it is a trade name). Like real plaster that is applied wet, drywall can provide a continuous, apparently seamless wall or ceiling surface (Figure 20–90).

The basic element of drywall, which can be attached directly to wood or steel studs without the use of lath, is a thin panel of processed gypsum (hydrous calcium sulfate, the substance that is the chief ingredient of plaster of Paris) between exterior sur-

Figure 20–90 In George Ranalli's renovation of the Calendar School in Newport, Rhode Island, 1981, drywall provides an apparently seamless interior partition.

faces of heavy paper. Such panels are most often 1/2 or 5/8 inch (12 or 15 mm) thick, but thicknesses of 1/4, 3/8 and 3/4 inch (6, 9, or 18 mm) are also made. Panel lengths are most often 8 feet (2.5 m), but lengths of 9, 10, and 12 feet (2.7, 3, and 3.7 m) are available. Panel widths are always 4 feet (1.2 m).

The edges of one face of the long sides of these panels are slightly tapered to a smaller thickness. When the panels are joined, therefore, these tapers meet to form a slight indentation within which a strip of reinforcing tape and a plaster-like substance called *drywall compound* or *taping compound* can be used to cover the joint. Another layer of drywall compound is usually used over the entire surface to fill any dents or low spots, and a third coat is added for greater smoothness.

If a textured surface is wanted, that can be applied in a fourth coat. Between each coat the surface should be allowed to dry for a day and then sanded. A whole family of specialized accessories—drywall screws, drywall nails, metal edge trims, metal corner beads, and more—is used in drywall construction.

A variant somewhere between real plaster and drywall in both cost and appearance is called *veneer plaster.* Sheets of drywall are again the foundation, but the tape over the joints is made of glass fiber, and the entire surface is coated with up to ⅛ inch (3 mm) of actual plaster. Because only one layer is needed and because the plaster dries by a chemical action called hydration (rather than by evaporation), the process is relatively quick, but its application requires more skill than does the drywall method.

Other variations are in the composition of the drywall panels. Ceiling boards are given slightly greater stiffness than wall boards to prevent sagging. Panels can be faced with metal foil as a vapor block or "prefinished" with a vinyl face. Panels called *type X* have greater fire resistance; panels called *greenboard* are resistant to moisture and have good sound-absorbing qualities, making them good choices for bathroom walls; and panels called *blueboard* have greater density in their gypsum core and are considered preferable for veneer plasterwork.

Asbestos and Asbestos Removal

Used in the middle of the century as a plaster substitute and as a wallboard were panels of asbestos board. Asbestos is an inorganic fiber that is non-combustible, weather-resistant, and dimensionally stable at high temperatures. It was widely used (in more than 30,000 American school interiors, for example) not only in wall panels, but also in ceiling tiles and in blanket and spray forms. It was discovered, however, that the fine asbestos fibers, when inhaled, could cause cancer, and in 1986 its use was stopped and its removal mandated in the United States by the Asbestos Hazard Emergency Response Act. Since then, asbestos application has no longer been an option, but in the early twenty-first century designers renovating old interiors are sometimes still having to deal with its removal. Removal requires extreme care to prevent the tiny fibers from becoming airborne, and must be done by specialists in such procedures.

New Metals: Aluminum and Stainless Steel

Stainless steel was invented in the middle of the nineteenth century, as we have noted, and perfected in 1912. It is a steel alloy with 10 to 20 percent chromium, and it can have a high polish. Chromium can also be used as plating over steel and other metals. Both stainless steel (commonly called *stainless*) and chromium plated steel *(chrome)* have been frequently used in furniture design, beginning with Breuer's 1925 chairs. Stainless has also found uses as interior surfacing, beginning with column covers for the Empire State Building in 1932.

Among all the metals in wide use today, aluminum is the last to have become usable. It was not until 1886 that Charles Martin Hall in the United States and Paul Héroult in France discovered the electrolytic process of producing aluminum. Within a couple of years, the company that would become Alcoa (the Aluminum Company of America) was founded in Pittsburgh and the company that would become Alusuisse was founded in Neuhausen, Switzerland. Compared with other metals, the newly available aluminum was surprisingly light in relationship to its strength, ductile, resistant to corrosion, and capable of taking a brilliant polish. Its surface can be anodized to prevent it from oxidizing and becoming cloudy, and the anodized coating can be given a wide range of colors. In the twentieth century, it played a major role in the development of aircraft, and also was used for cooking vessels and jewelry.

Aluminum also found a place in architecture (chiefly as building skins) and in interiors. The earliest important instance of its use in furniture design came in 1933, when a competition was held by the International Bureau for Applications of Aluminum. Entrants from fourteen countries submitted more than two hundred furniture designs, and the first prize went to Marcel Breuer; his aluminum chaise longue, armchair, side chair, office chair, and stool were in production the following year, designs that would have been excessively heavy in any metal other than aluminum

A later example was Eero Saarinen's Tulip chair, designed in 1956 for Knoll (Figure 20–91). Saarinen had hoped the chair could be produced as a single piece of plastic, but plastic at midcentury was not strong enough for the job. Only by casting the pedestal base in aluminum could it be made structurally feasible without being unattractively thick. Other designers who have successfully employed aluminum in furniture or other interior elements have included Eileen Gray, Gio Ponti, Philippe Starck, and Frank Gehry.

At the end of the century, in 1997, Gehry wrapped his Guggenheim Museum in Bilbao, Spain, in great billowing sheets of titanium, a metal never before applied to a building exterior at that scale. Despite its attractive appearance, however, titanium may prove too expensive for wide use. In our own century, unfamiliar metals and new alloys will almost certainly be developed.

Paint

Paint is made of two chief components: pigments that provide color and opacity, and binders that provide adhesion. Paints are identified by their color, of course, but also by their binders, which can be oil, water, varnish, glue, or synthetic resins.

It was only in the last third of the nineteenth century that commercially prepared paint began to be marketed, and that first prepared paint had an oil binder, which was considered superior for more than a century. The alternative, which became widely available after World War II, has a synthetic binder called *latex*, of which there are several types. Latex paints are water-soluble,

Figure 20–91 Eero Saarinen's Tulip chair for Knoll, 1957, has a molded plastic shell balanced on an aluminum base.
KNOLL, INC.

meaning that they can be easily washed out of brushes or fabrics with only water (if washed before they dry). They dry more quickly than oil paints and often require only one coat rather than several.

At the end of the twentieth century, the term *oil paint* was still in general use, but real oil paint was not. Environmental concerns had stopped the use of some pigments that contain lead and had also stopped the use of binders that emit volatile

�֍ VOCABULARY ▸ TERMS FOR PAINT

In addition to names for its colors and binders, paint is classified by its *luster,* the amount of light reflected from its surface. Ranging from least lustrous to most lustrous, the classifications are:

- Flat • Eggshell • Satin • Semigloss • Gloss

Generally, the most lustrous paint surface will be the most easily washable, but it will also be the most likely to show irregularities and imperfections beneath it.

Membership organizations of professional designers:

- ASID, American Society of Interior Designers, 608 Massachusetts Ave., NE, Washington, DC 20002, tel. (202) 546–3480, www.asid.org.
- IIDA, International Interior Design Association, 341 Merchandise Mart, Chicago, IL. 60654, tel. (312) 467–1950, www.iida.com.

Membership organization of interior design educators:

- IDEC, Interior Design Educators' Council, 9202 N. Meridian St., Ste. 200, Indianapolis,

IN 46260, tel. (317) 816–6261, www.idec.org.

Accrediting organization for interior design schools:

- FIDER, Foundation for Interior Design Education Research, 60 Monroe Center, NW, #300, Grand Rapids, MI 49503, tel. (616) 458–0460, www.fider.org.

Administrator of interior designer examinations:

- NCIDQ, National Council for Interior Design Qualification, 1200 18th St., NW, Ste. 1001, Washington, DC 20036, tel. (202) 721–0220, www.ncidq.org.

organic compounds **(VOCs).** In some parts of the United States there is a limit on the pounds of VOC per gallon, and in all the United States there are restrictions on paint manufacture issued from both OSHA (the Occupational Safety and Health Administration) and the EPA (Environmental Protection Agency).

What has been substituted for an oil binder is an oil-modified synthetic resin binder called an *alkyd*. Alkyd paints, like the earlier oil paints, are not water-soluble and must be thinned or removed with solvents, on which there are also environmental restrictions. (Turpentine, for example, is no longer in general use as a paint solvent.) The choice between latex and alkyd paint will depend on the surface to be covered and the effect wanted, and most designers will need the advice of a paint supplier or professional painter. A variant available in both latex and alkyd paint is enamel; enamel contains pigments that are more finely ground to give a smoother texture, and it produces surfaces that are harder, glossier, and more durable.

In addition to paints and enamels, there are primers and sealers used as foundations to provide a smooth and nonabsorbent surface on which to paint. There are also varnishes of alkyd, acrylic, or polyurethane that contain no pigment but provide durable surfaces for wood, stone, or other materials. And in addition to the normal procedures of applying paint evenly with brush, roller, or spray device, there are methods using rags, sponges, stencils, or combs that, in experienced hands, can give decorative effects such as shading, stippling, spattering, dragging, graining, and antiquing. When these special effects imitate other materials, such as wood or marble, they are called **faux finishes** from the French word *faux*, pronounced "foe" and meaning "false."

Professional Issues

This chapter, like those before it, has reviewed major changes in the style and appearance of interior design. More than most earlier chapters, it has also reviewed influential developments in technology. But another major part of the story of design in the twentieth century is that of professional development.

We saw that, in 1905, Elsie de Wolfe could appoint herself a designer simply by having some cards printed. By the end of the century, the situation was very different. As the practice of interior de-

sign had grown in prestige and as its value had become more widely recognized, the profession of interior design had also become much more structured. This was manifested in several areas: education, professional organizations, and designer certification.

Education

Among early twentieth century interior design schools were the Parsons School of Design, New York, founded in 1896, and Sherrill Whiton's New York School of Interior Design, chartered in 1924 by the New York State Board of Regents. Many others joined them, and by the late 1960s, with interior design programs established in many colleges and universities, it had become clear that standards needed to be established for what they were teaching. The Foundation for Interior Design Education Research (FIDER) was established in 1970 with the purpose of accrediting qualified programs in the United States and Canada based on campus visits, interviews with faculty members, observations of student work, and analyses of curricula. In 1973 the first five FIDER accreditations were announced; they recognized the programs at the University of Cincinnati, the University of Georgia, the University of Texas at Austin, Virginia Commonwealth University, and the University of Missouri, Columbia. By the end of the year 2000 the number of FIDER accreditations had grown to 137 programs, 115 of them full four-year programs in the United States and 6 of them full four-year programs in Canada.

This is a small number compared to the roughly five hundred such programs now operating in the United States and Canada, but it may be assumed that half that number fail to meet FIDER's standards. Others are as yet unaccredited because the accrediting process is a very expensive and time-consuming one, for which FIDER is dependent on the support of the profession.

Applying educational standards in other ways is an affiliation of interior design educators called the Interior Design Educators' Council (IDEC), founded in 1962. IDEC publishes a comprehensive interior design bibliography and, twice a year, a refereed journal of scholarly papers, *Journal of Interior Design*.

Professional Organizations

Organizations of professional designers were established in many countries during the century with the aim of exchanging ideas, educating the memberships, and gaining public recognition for the profession. In the United States, unfortunately, the history of such groups has been a confusing one, at times involving two competing groups and a consequent duplication of effort.

Perhaps the first U.S. group was the American Institute of Decorators (AID), founded in 1931; in 1961 it would change its name to the American Institute of Interior Designers, but would keep its acronym of AID. In 1957 the National Society of Interior Designers (NSID) was founded as a rival to the AID. In 1969 the two groups were joined by the Institute of Business Designers (IBD), an important subgroup of specialists in office design. The AID and NSID merged in 1975 to form the American Society of Interior Designers (ASID), but another new group was formed in 1979, the International Society of Interior Designers (ISID), having membership in the United Kingdom and other countries as well as the United States.

Throughout the '80s and early '90s there were efforts at unifying these and other, more specialized organizations. Finally in 1994 a degree of unification came with the merging of the IBD, the ISID, and the Council of Federal Interior Designers (a group of designers employed by the government), along with the Interior Design Educators' Council as a collaborating ally, into the International Interior Design Association (IIDA). The ASID, however, largest of all the groups, decided against joining, leaving the profession again at century's end with two rival organizations.

As these various groups have come and gone, general progress has been made in the direction of higher qualifications for membership. Although both major organizations offer a number of membership levels, full professional membership in either now requires a degree from a FIDER-accredited program, some time in actual design experience, and the passage of an examination.

Designer Certification

Membership in a professional organization, no matter what its requirements, came to seem insufficient for the identification of a qualified designer. In 1963, one of those organizations, the NSID, launched a program advocating the government licensing of designers. Three years later, the rival organization, AID, began a designer competency program headed by New York designer Louis Tregre; that work would be the basis of the future standardized examination for the profession. The National Council for Interior Design Qualification (NCIDQ) was founded in 1974 for the design and administration of that exam, and the following year it published the booklet "Guidelines for the Statutory Licensing of Interior Designers."

State legislatures, meanwhile, were becoming conscious that interior design was a profession whose products could profoundly affect the health, safety, and welfare of their users and that, therefore, membership in the profession should be regulated. In 1982 Alabama was the first state requiring interior designer licensing, followed by Connecticut in 1983 and Louisiana in 1984. Since then, many other states have passed similar requirements, all using passage of the NCIDQ exam as proof of competence. These laws are variously called registration, licensing, and certification, and they are of two basic types: title acts, requiring that designers be certified before they can use the title "interior designer," and practice acts, requiring that designers be certified before they can practice interior design. Title acts are much more frequent than practice acts. At the end of the century, a total of nineteen states plus the District of Columbia and Puerto Rico required some form of interior designer certification, as did eight provinces in Canada, and a total of 13,500 North American designers had been certified. In addition, twenty-three countries in South America, Africa, Asia, and Europe had some kind of government recognition of interior design qualifications.

Summary: Twentieth-Century Interior Design

Accurately summarizing a century so recently ended requires a degree of perspective that is not yet available. Many of the designers noted here are still at work, and their future design may take quite unexpected directions, shedding a different light on their work already done. Even among the careers that are finished, opinions are certain to change about what was important and what was not. This chapter must therefore be read not as a definitive account but as one observer's notes. Using those notes and their own personal observations, readers must then form their own summaries, concentrating on whatever they find most useful for their own progress.

Glossary

A

AALTO, ALVAR (1898–1976) Important Finnish architect and furniture designer.

ABACUS In architecture, the slab that forms the uppermost portion of the capital of a column.

ABSTRACT DESIGN Patterns or motifs that are not based on forms from nature.

AC Abbreviation for *alternating current*.

A/C Abbreviation for *air conditioning*.

ACACIA A light brown hardwood from Australia and Africa. In ancient times it was used by the Eastern nations for religious and sacred buildings; today it is used for furniture and for architectural and ecclesiastical woodwork.

ACAJOU French term for *mahogany*.

ACANTHUS A large leaf conventionalized by the Greeks for ornamental use, as in the capital of the Corinthian column.

ACCENT LIGHTING Lighting directed to emphasize a specific object or area. See also *ambient lighting* and *task lighting*.

ACCESS FLOOR In office buildings, a finished floor raised above the structural floor, allowing access through the panels of the finished floor to power cables and other equipment.

ACEITILLO West Indian hardwood with fine grain, somewhat resembling satinwood in color and appearance. Used for furniture.

ACETATE Fibers, yarn, or fabric made from cellulose acetate. The fabric has something of the look and feel of silk. Sometimes called diacetate to distinguish it from the more completely acetated *triacetate*.

ACOUSTICAL CEILINGS Ceilings treated with acoustical tiles or other material for the absorption of sound.

ACOUSTICAL TILES Sound-absorbent tiles.

ACOUSTICS The sound characteristics of a particular place; the study of such characteristics.

ACROTERION A block at the apex or at one of the low points of a pediment, often with carved ornament. The plural is acroteria. Also spelled acroterium.

ACRYLIC A synthetic plastic that resembles glass. In the United States and Germany it has been marketed under the name Plexiglass, and in England under the name Perspex.

ACRYLIC FABRIC Fabric from acrylic fibers, characterized by wrinkle resistance and a soft hand. Sometimes blended with wool and other natural fibers for improved performance. Brand names include Dynel and Orlon.

ACRYLIC PAINT A quick-drying synthetic medium.

ADA Acronym for the Americans with Disabilities Act, mandating accessible design. See *universal design*.

ADAM, ROBERT (1728–1792) AND JAMES ADAM (1730–1794) English designers in the neoclassical style. Known for architecture, interior architecture, and furniture.

ADIRE Indigo resist-dyed cloth, specifically that of the Yoruba people of Nigeria.

ADOBE A mud brick dried in the sun but not fired; a building made of such brick.

AEDICULE A miniature shrine or temple generally consisting of a pediment and entablature supported on a pair of columns or pilasters; a door or window frame resembling such a structure.

AEDICULE WITH EARS As above, with the ends of the entablature projecting slightly beyond the columns or pilasters.

AEOLIC An architectural order, a variant of the Ionic.

AERIAL PERSPECTIVE In interior design and architecture, a drawing giving the illusion of viewing from above. Also called a "bird's-eye view."

AFFLECK, THOMAS (ACTIVE 1763–1795) Philadelphia cabinetmaker in the Chippendale style.

AFRICAN SILK A type of wild silk made from the cocoons of moths feeding on fig trees.

AGATE WARE A type of pottery resembling agate or quartz. Made in England during the Eighteenth century by Wedgwood and other potters.

AGGREGATE Granular material such as gravel, pebbles, or small stone chips that can be bonded together in a matrix to form a material such as concrete.

AIA Acronym for the American Institute of Architects.

AIR CONDITIONING The treatment of air to control its temperature, humidity, and cleanliness.

AIRWOOD See *harewood*.

AISLE A passage between sections of seats, as in a theater or church.

AJOURÉ French term for a design in ceramics, metal, wood, or other material, in which a design has been produced by piercing holes.

ALABASTER A fine-grained, slightly translucent stone with a smooth milk-white surface. Used for ornaments and statuary.

ALABASTRON A type of Greek vase.

ALAE In a Roman house, alcoves at the sides of the atrium. The singular is *ala*.

ALBERTI, LEONE BATTISTA (1404–72) Early Italian Renaissance architect, scholar, and author.

ALLEN, DAVIS (1916–99) American interior designer and furniture designer.

ALLOY A mixture of two or more metals; for example, brass is an alloy of copper and zinc.

ALMERY See *ambry*.

ALTAR A place for worship, ritual, or sacrifice, often raised.

ALTARPIECE Painting, carving, or decorated screen above a church altar.

ALTERNATING CURRENT An electric current that (most commonly in the United States) alternates directions at the rate of 60 Hertz (60 times per second). In Europe, the more common rate is 50 Hertz.

ALUMINA See *China clay*.

AMARANTH A dark purplish wood imported from South Africa. It is usually fine-grained and figured and is much used in contemporary furniture.

AMBERINA GLASS A late-nineteenth-century glass with colors from amber to deep red.

AMBIENT LIGHTING General illumination. See also *task lighting* and *accent lighting*.

AMBO In medieval Italian churches, a raised stand for reading the gospel. It was later replaced by the pulpit.

AMBOYNA A rich brown wood, highly marked, with yellow and red streaks. Much used for modern cabinetwork and veneering. It is of East Indian origin.

AMBRY In residential interiors, a cabinet for food storage; in ecclesiastical interiors, a cabinet for the storage of altarcloths and altar vessels. In the second sense, it is also called an *almery*.

AMBULATORY In a medieval church, a walkway around a choir or chancel.

AMERICAN SILK A type of wild silk made in the area of Oaxaca, Mexico, from the cocoons of moths feeding on ailanthus trees.

AMORINI Italian term for childlike figures, such as cupids or cherubs. Used for ornamental purposes, especially during the Italian Renaissance. Young male figures are called *putti*.

AMPHORA A Greek vase form. A large, two-handled earthenware vessel with a narrow neck and usually an ovoid body, used for the storage of grain and other products.

ANDIRON Metal upright attached to a horizontal support for logs in a fireplace.

ANGEL BED In eighteenth-century England, a bed with a fabric canopy attached above the head to the wall or ceiling. Similar to the French *lit á la duchesse*.

ANIGRÉ A light, fine-grained wood.

ANILINE DYES Dyes derived from coal tar, often brilliant in color.

ANNEALING The process of slowly cooling a heated metal to make it more easily workable.

ANODIZING The process of treating metal (such as aluminum) with a smooth, durable finish by means of an electrochemical process.

ANSI Acronym for the American National Standards Institute.

ANTA A type of projecting pier similar to a pilaster placed behind a column at the end of a sidewall of a Greek temple, the base and capital of the pier differing from those of the column; also used in Egyptian architecture. The plural is antae.

ANTEFIX An upright conventionalized spreading leaf or fanlike ornament used at the ends of tile rows on the roofs of classical temples.

ANTHEMION A conventionalized honeysuckle or palm leaf ornament or pattern seen in Greek decoration.

ANTIMACASSAR Knit, crocheted, or embroidered cover placed over an upholstered chair back to protect it from the Macassar oil hair-dressing commonly used during the mid-nineteenth century. Also called a *tidy*.

ANTIQUE A work of art that, according to United States law, must be at least 100 years old.

ANTIQUITY A work of art or craft of the Classical era or older; ancient times.

APPLE A light-colored, fine-grained wood used for furniture. It is suitable for staining or natural finish.

APPLIQUÉ French term for an applied motif, a wall bracket or sconce. In fabric, a pattern that is cut out and sewn or pasted on the surface of another material.

APRON A board placed at right angles to the underside of a shelf, sill, seat, or table top.

APSE The semicircular or angular extension at the east end of a basilica or Christian church.

AQUATINT A method of engraving on copper by the use of a resinous solution of nitric acid.

ARABESQUE A scroll and leaf pattern with stems rising from a root or other motif and branching in spiral forms. It is usually designed for a vertical panel, and the sides resemble each other. See also *rinceau*.

ARANDA, COUNT OF BUENAVENTURA Spanish Renaissance art patron and founder, in 1727, of the Alcora ceramic factory.

ARBOR-VITAE An evergreen tree of the genus Thuya, native to North America and eastern Asia. An excellent building and furniture wood.

ARC LIGHT A high-intensity light created by a discharge of electricity (an arc) between two electrodes.

ARCA Spanish term for chest.

ARCADE A series of adjoining arches with their supporting columns or piers. The arcade usually forms a part of the architectural treatment of a corridor or passageway.

ARCADED PANEL A panel whose field is ornamented by two dwarf piers or columns supporting an arch form. Particularly used in early English Renaissance woodwork.

ARCH A structural feature spanning an opening, supported at the two lower ends, and composed of several wedge-shaped parts.

ARCHAIC Primitive or antiquated. In reference to Greek art, it denotes the period of development from 1000 to 480 B.C.

ARCHIEPISCOPAL CROSS A cross with two transverse arms, the lower one longer. Also called a *patriarchal cross*. See vocabulary box in Chapter 6.

ARCHITECT'S TABLE A combination drawing table and desk, with an adjustable lid that lifts to make a slanting surface.

ARCHITRAVE The lowest part of the three principal divisions of a classical entablature, corresponding to the lintel; usually molded. It is directly supported by the columns and supports the frieze. The term is also used to define similar moldings used as door or window trim.

ARCHIVOLT Ornamentation on the face of an arch.

ARCUATE OR ARCUATED Arched or archlike in form, distinct from trabeated.

ARFE OR ARPHE (fifteenth and sixteenth centuries) Family of famous German silversmiths whose work influenced the Plateresco architectural ornament of the Spanish Renaissance.

ARGAND LAMP Lamp invented by a Swiss named Argand in 1783. It had a round wick with provision for the introduction of air inside the wick as well as around the outside.

ARMARIUM A Roman cupboard for the display of family treasures.

ARMOIRE French term for a clothes wardrobe (Gothic and later). Also called a *garde-robe*.

ARMURE A kind of cloth with a rep background. The raised satin pattern, which is not reversible, is made of warp threads floated

over the surface. The pattern usually consists of small, isolated, conventional motifs arranged to form an allover design. A good upholstery material.

ARRAS Originally, a tapestry manufactured in Arras, France, during the Fourteenth and Fifteenth centuries. The fame of such tapestries was so great that the name of the town is sometimes used as a synonym for handwoven tapestries of Gothic design. There was also a notable porcelain factory in Arras in the late Eighteenth century.

ARRAZZI Italian name for the town of Arras, France. In Italy, sometimes used as a synonym for a Gothic tapestry.

ARRIS In architecture, the sharp edge formed by the meeting of two surfaces coming together at an angle. An example is the angle formed by the two sides of a brick. More specifically, the sharp edges occurring between two adjoining concave flutings of the shaft of a column.

ART DECO Style popular in Europe and America from the 1910s to the 1930s, inspired by cubism.

ARTESONADO Spanish term for Moorish woodwork or joinery, usually made of Spanish cedar, which is soft and fine-grained, somewhat like red pine.

ARTIFACT An article of great antiquity made by humans, especially prehistoric stone, bone, metal, or clay objects.

ARTIFICIAL LEATHER A substitute for leather that is made by coating a cotton fabric with a nitrocellulose preparation. This surface is then stamped to simulate the surface of real leather. Many varieties are made, which are generally known by trade names. Widely used at present for cheap grades of upholstery.

ART MODERNE See *Art Deco*.

ART NOUVEAU Style popular in Europe and America from the 1890s to the 1910s, characterized by sinuous curves derived from plant forms.

ARTS AND CRAFTS Artistic movement of the late nineteenth and early twentieth centuries, valuing craftsmanship above industrial techniques.

ARYBALLOS A type of Greek vase for oils and perfumes.

ASBESTOS A naturally occurring mineral fiber (a silicate of calcium and magnesium) once widely used for insulation and fireproofing, but later considered a hazard because the fibers were found to cause respiratory disease.

ASH A blond wood with a handsome figure and pleasing texture, which, because of its hardness, is not extensively used for interior work, though it can be used to produce very rich effects. It is well adapted to dark stained effects.

ASH, GILBERT (1717–85) American furniture maker working in New York. His son Thomas Ash (d.1815) was known as a maker of American Windsor chairs.

ASHBEE, CHARLES ROBERT (1863–1942) Architect, designer, and influential writer of the Arts and Crafts movement.

ASHLAR Masonry constructed of flat-surfaced stones with straight squared joints.

ASHRAE Acronym for American Society of Heating, Refrigerating, and Air Conditioning Engineers.

ASID Acronym for the American Society of Interior Designers.

ASME Acronym for American Society of Mechanical Engineers.

ASTM Acronym for the American Society for Testing and Materials.

ASTRAGAL In architecture, a small *torus* molding. Often used to denote a molding that covers the joint between adjacent doors or windows.

ASTRAL LAMP An oil lamp with swinging tubular arms, generally furnished with an Argand burner. Used in the early nineteenth century.

ASYMMETRICAL KNOT One of the two basic types of knot with which Islamic carpets are woven. See Figure 9–38. Also called a *Persian knot*, a *Senna knot*, or an open knot.

ATRIUM Originally, the principal central room or courtyard of a Roman house, with a central opening in the roof. Later, the forecourt of an Early Christian basilica. Now, an open space within a building or building complex.

ATTIC In classical architecture, a low wall above a cornice or entablature, usually ornamentally treated with statuary or inscriptions; from, or relating to, the area around the city of Athens, Greece.

AUBUSSON A tapestry-woven carpet without pile, named for the tapestry works in Aubusson, France.

AUDUBON, JOHN J. (1785–1851) American ornithologist and painter. Made illustrations for *Birds of America*.

AURICULAR STYLE Decorative style popular in seventeenth-century Dutch silverware and elsewhere, consisting of repeated shallow waves as might be found in a seashell or in the human ear (hence its name). The Dutch term is *kwabornament*, and the German term is *Knorpelwerk*. It is also sometimes called *lobate* style.

AUSTRIAN SHADE A shade or curtain shirred in vertical panels. As it is raised by a series of parallel cords, the material is gathered. See also *Roman shade*.

AUTOMATIC SPRINKLER SYSTEM A system that, upon detection of smoke or excess heat, automatically disperses water or other fire-extinguishing material.

AUVERA, JOHANN WOLFGANG VAN DER (1708–56) German Rococo sculptor and furniture maker.

AVISSE, JEAN (1723–C.1800) French furniture maker in the Rococo and Neoclassical styles, appointed *Maître Ébéniste* in 1745.

AVODIRE A blond wood with strong, dark brown vertical streakings. It has a fine texture and is much used for modern furniture, for veneering purposes.

AXIAL Descriptive of a room, building, or layout that is symmetrical about an axis.

AXMINSTER A pile carpet with a stiff jute back; the weave permits a great variety of colors and designs.

AXONOMETRIC DRAWING A measured drawing in which three sides of an object are made visible. See also *isometric drawing*.

AZULEJOS Spanish term for wall tiles produced in Spain and Portugal, painted with scenes of sports, bullfights, or social and amorous groups.

B

BAIZE Coarse woolen cloth used for surfacing desks and writing tables.

BALDACHINO Italian term for a canopy resting on columns, usually built over an altar. Also called a *ciborium*.

BALDWIN, WILLIAM ("BILLY") (1903–84) American interior designer.

BALL FOOT A loosely used term for any furniture foot or leg terminating in a ball.

BALL-AND-CLAW FOOT A furniture foot cut to imitate a talon or claw grasping a ball. Of Chinese origin, the motif was greatly used in English eighteenth-century furniture.

BALLAST A voltage-control device used with fluorescent and other electric-discharge types of lighting.

BALLIN, CLAUDE (C.1615–1678) Goldsmith and silversmith to Louis XIV. His nephew, Claude Ballin II, followed him in the same trade.

BALLOON SHADE A full, puffy window treatment.

BALUSTER An upright support that is made in a variety of turned forms. In general it curves strongly outward at some point between the base and the top; commonly an elongated vase or urn shape. Used for the support of hand railings and for furniture legs or ornament. See *spindle* and *split spindle*.

BALUSTRADE The railing along the open edge of a stair, including the *balusters*, the handrail, and the *newel post*.

BAMBINO Italian term for a child or baby, or the representation of such in any art medium.

BAMBOO A woody, perennial plant that grows in tropical regions. The wood is used for furniture, ornaments, building purposes, pipes, paper-making, and food.

BAMBOO-TURNED Wood turnings in mahogany and other woods that imitate natural bamboo forms.

BANDING In cabinetwork, a strip of veneer used as a border for table tops, drawer fronts, and so forth. In porcelain and other ceramic ware, a synonym for *edging*.

BANDY-LEGGED Literally, bow-legged. A lay term, used in old furniture inventories, for a chair or table with *cabriole* legs.

BANISTER Same as *baluster*.

BANISTER-BACK CHAIR A late-seventeenth-century American chair with back uprights consisting of split turned spindles or flat bars.

BANJO CLOCK A wall-hung clock in a banjo-shaped case.

BANKER A term of medieval origin for a piece of fabric draped over benches or chair backs.

BANQUETTE French term for bench, now used for a long, benchlike seat, usually upholstered.

BAPTISTERY A separate building or part of a church used primarily for the rite of baptism.

BARBOTINE French term for *slip*.

BARGELLO STITCH See *flame-stitch*.

BARKCLOTH See *tapa*.

BARLEY SUGAR TURNING An old name for a *spiral leg* on a seventeenth-century English chair. Also called a *barley twist*.

BARN DOORS Flaps that can be adjusted to direct the beam of a spotlight.

BAROCCO Italian term for *baroque*.

BAROQUE A style of architecture, art, and decoration that originated in Italy during the late sixteenth century and spread to other parts of Europe. It is characterized by large scale, bold detail, and sweeping curves. It was followed by the *rococo* style and overlapped the latter.

BARRAGÁN, LUIS (1902–88) Mexican architect noted for simple forms and strong colors.

BARREL VAULT See *vault*.

BARRIER-FREE DESIGN See *universal design*.

BAS-RELIEF French term for a low relief.

BASALT Dark green or brown igneous rock, sometimes having columnar strata. Egyptian statues were frequently carved in this material. Most often used now for paving.

BASALTES WARE Black vitreous pottery, made to imitate basalt. Specifically, a very hard black stoneware invented by *Josiah Wedgwood* in England in the 1760s.

BASE Any block or molding at the bottom of an architectural or decorative composition, particularly a series of moldings at the bottom of the shaft of a classical column.

BASE MOLDING A molding used on the lowest portion of any object or surface.

BASEBOARD In carpentry, a board placed at the base of a wall and resting on the floor; usually treated with moldings. Sometimes called a base screed.

BASILICA In Roman times, an oblong, three-aisled building used as a hall of justice. The central aisle, or nave, was higher than the side aisles and was usually pierced with windows placed above the roof of the side aisles. This plan formed the basis for later Christian churches.

BASKET WEAVE A textile weave in which the warp and weft are usually of large threads of similar size and in which the weft crosses the top of alternate warp threads.

BASSE-TAILLE A decorative process of applying translucent enamel over reliefs of gold or silver. Similar to *champlevé*.

BATIK Javanese process of resist dyeing on cotton, using wax in a design, then dyeing cloth, after which the wax is removed. The method is practiced by modern designers on silk and rayon and is imitated in machine printing.

BATTER The slope of a wall away from the vertical.

BATTERSEA ENAMELS Enamel work from a short-lived (1753–56) enamel factory in Battersea, England. The name, however, is often given to similar products from other factories.

BAUHAUS German school of art, crafts, and architecture from 1919 to 1933. Modernist style associated with the school's teaching.

BAY In architecture, the space between columns or isolated supports of a building.

BAY WINDOW A large projecting window that is polygonal in shape. If it is curved or semicircular, it is usually called a bow window.

BAYWOOD An alternate name for Honduras mahogany, which is lighter in color and softer than the Cuban or Spanish mahogany. Its fine marking makes the wood useful in veneered work.

BEAD A molding ornament that resembles a string of beads. Sometimes called pearl or beading.

BEAD-AND-REEL A half-round molding with alternating spherical and ovoid shapes.

BEAKER Tall drinking vessel with slightly flaring sides.

BEAM A long piece of timber or metal used to support a roof or ceiling, usually supported at each end by a wall, post, or girder.

BEAUX-ARTS The *École Supérieure des Beaux-Arts*, France's official school of art and architecture, founded in 1795. The traditional style based on the school's teaching.

BEDRUG A rug used as a bed cover.

BEDSTEAD A frame into which a mattress and linens can be fit.

BEECH A pale straight-grained wood much used for flooring and furniture. It resembles maple and birch and can be similarly used.

BEHRENS, PETER (1868–1940) German architect and industrial designer.

BELL TURNING For furniture legs and pedestal supports, a type of turning shaped approximately like a conventional bell. Common in the William and Mary style.

BELLADINE A raw silk from the Levant, used for tassels and fringes. Also spelled bellandine.

BELLINI, MARIO (B.1935) Italian industrial designer and furniture designer.

BELTER, JOHN HENRY (1804–1863) New York cabinetmaker, designer of elaborate rosewood and carved laminated forms.

BEMA In church interiors, a chancel or speaker's platform.

BENEMAN, GUILLAUME German-born cabinetmaker who settled in Paris, becoming one of the most important French craftsmen before the Revolution. Appointed *Maître Ébéniste* in 1785. He worked for Marie-Antoinette at St. Cloud and also produced some designs of *Charles Percier*. His name is sometimes spelled Benneman.

BENGALINE A plain-weave, warp-faced fabric of silk, cotton, or artificial fiber, more often used in clothing than in interior design.

BENJAMIN, ASHER (1773–1845) American architect and author of architectural handbooks.

BENNETT, WARD (B.1917) American interior designer and furniture designer.

BENNINGTON POTTERY Pottery originating in Bennington, Vermont.

BENTWOOD Artificially bent wood. Furniture or other objects made with such wood.

BÉRAIN, JEAN (1638–1710) French designer at the court of Louis XIV, responsible for much of the ornament, notably engraved *arabesque* and *cartouche* forms.

BERGÈRE French term for an all-upholstered low armchair, usually with an exposed wood frame and a soft seat cushion. (Louis XV and XVI periods, but still produced today.)

BERLAGE, HENDRIKUS PETRUS (1856–1934) Dutch architect and designer of glassware and furniture, a teacher of Ludwig Mies van der Rohe.

BERNINI, GIOVANNI LORENZO (1598–1680) A leading architect, sculptor, and painter of the Baroque period of the Italian Renaissance. Designer of the *baldachino* and the colonnade of St. Peter's.

BETTY LAMP A small oil lamp used in colonial America, designed to be hung from a hook.

BEVEL The edge of any flat surface that has been cut at a slant to the main area.

BIANCO-SOPRA-BIANCO Italian term meaning white-on-white, used to describe a tile-painting technique developed by Bristol potters.

BIB OR BIBB OR BIBCOCK A faucet with a downward-bent nozzle.

BIBELOT French term for a small art object for personal use or as decoration.

BIBLIOTHECA The library in a Roman house.

BIBLIOTHÈQUE French term for a large bookcase.

BIBVALVE A bib with a handle that screws to close the flow of water or other liquid.

BID An offer to perform specified work at a specified cost.

BIEDERMEIER Style popular with the middle classes of central and Eastern Europe and Scandinavia from the 1810s through the 1830s.

BIFOLD DOORS A configuration of one or more pairs of doors, in which one folds against the next.

BILSTON ENAMEL Enamel ware made in the English town of Bilston.

BIRCH A fine-grained wood, strong and hard, usually a light brown in color. It requires no filler, takes paint and stain well, and can have a natural finish or be stained to imitate walnut, mahogany, and other more expensive woods. It is much used for doors and trim as well as for flooring, where it competes successfully with oak.

BIRD'S-EYE Wood with fine circular markings caused by fiber distortions in the growth of the annual rings of the tree. It is most frequently found in sugar maple.

BIRD'S-EYE PERSPECTIVE See *aerial perspective*.

BISCUIT Pottery that has been fired once and has no glaze or a very thin glaze. Sometimes called bisque. Sometimes a distinction is made in which unglazed porcelain is called biscuit ware, but unglazed pottery of lesser quality is called terracotta.

BLACK WALNUT In spite of its extensive use at a period when design was at its lowest level, it is one of the most beautiful woods grown in the United States. It has a rich color, takes a high polish, and shows a very handsome figure. It is fine-grained enough to allow intricate carving, though its open pores call for the use of a filler in finishing. It is among the more rare and expensive woods because of wasteful cutting at the end of the nineteenth century.

BLACKAMOOR A statue of a Negro used for decorative purposes during the Italian Renaissance and revived in the Victorian period.

BLACK-FIGURE VASE Ancient Greek vase with black figures painted on a red pottery ground.

BLANC-DE-CHINE European name for white porcelain figurines and objects imported from Te-hua, Fukien, China, from the seventeenth century onward.

BLEACH The process of removing the original color or of whitening a fabric by exposure to air and sunlight or by the chloride process.

BLIND NAILING The nailing of boards through their edges so that the nail heads are covered by adjoining boards.

BLOCK FOOT A cube-shaped foot for a furniture leg, used by Chippendale in eighteenth-century England. Also called a *cube foot* or a *Marlborough foot*. When a block foot is slightly tapered, growing smaller towards the floor, it is called a *spade foot* or a *therm foot*.

BLOCK PRINT Fabric printed by hand, using carved wooden blocks. Can be distinguished from modern printing with metal rollers or screens by the marks of the joining of the pattern printed by different blocks. Screen printing has now been substituted almost entirely for hand blocking in the United States.

BLOCK-AND-SHELL A piece of *block-front* furniture with each panel topped by a shell carving.

BLOCK-FRONT A treatment of case furniture in which the front surface is articulated by a central panel sunk between two slightly raised surfaces of equal width. Often seen in English and American eighteenth-century furniture.

BLOCK-PRINTING A process of producing a colored pattern or picture on paper or textile by wooden blocks, each one producing a portion of the pattern in a single flat color.

BLUE-AND-WHITE WARE White ceramics decorated in cobalt blue.

BLUE RESIST A type of fabric using a *resist dyeing* technique and blue dye. Popular in Eighteenth-century England and the United States.

BOARDMAN, THOMAS D. (1784–1873) Hartford pewterer.

BOBBIN A device on which threads are wound for use in weaving.

BOBBINET See *net*.

BOBÊCHE French term for a candle socket.

BOCA CODE A U.S. building code issued by the Building Officials and Code Administrators.

BODY The clay or other material of which a piece of pottery or porcelain is manufactured, as distinguished from the glaze or finish later applied.

BOHEMIAN GLASS See *cased glass*.

BOIS DE LIT French term for a bedstead.

BOISERIE French term for carved woodwork.

BOIS NATUREL French term for unpainted wood.

BOKHARA Textile center of central Asia since the fifth century. Carpets of the style woven there.

BOLECTION MOLDINGS A series of moldings that project sharply beyond the plane of the woodwork or wall to which they are applied.

BOLECTION PANEL A panel that projects beyond its surrounding panels.

BOMBÉ French term for a swelling curve; when the curve is applied to the front of a piece of furniture, it swells outward toward the center, at which point it recedes again.

BONADER Wall hangings of peasant subject matter, painted on paper or canvas. Made in Sweden or by Swedes in America and used to decorate homes on feast days.

BONE CHINA Type of ceramic contaning bone ash.

BONHEUR-DU-JOUR French term for a small desk with cabinet top.

BONNET TOP In cabinetwork, a top with a broken arch or pediment, or a curved or scroll top with a central finial motif in the shape of a flame, urn, or other form.

BONNETIÈRE French term for a hat cabinet.

BORDER PATTERN A continuous running motif used in the design of bands, borders, and panel frames.

BORNE A large circular upholstered settee popular in the last half of the nineteenth century.

BORROMINI, FRANCESCO (1599–1667) The most imaginative architect of the Roman Baroque style. He influenced most of Bavarian baroque style as well as the design of St. Paul's Cathedral, London.

BOSS The projecting ornament placed at the intersection of beams or moldings. It is often a carved head of an angel, flower, or foliage motif.

BOSTON ROCKER General term formerly applied to any chair with curved supports. Synonymous with rocking-chair.

BOTEH The pear-shaped decorative motif repeated in the *Paisley* pattern.

BOTTA, MARIO (B.1943) Swiss architect and furniture designer.

BOTTICELLI, SANDRO (1444–1510) Italian Renaissance poetical painter of classical mythology and allegorical subjects.

BOTTONÉE CROSS A Greek cross with each arm terminated in a clover-like trefoil form. See vocabulary box in Chapter 6. Also called a *cloverleaf cross*.

BOUCHER, FRANÇOIS (1703–1770) French decorative painter under Louis XV.

BOUCLÉ Plain or twill weave in wool, rayon, cotton, silk, or linen. Distinctive by its small regularly spaced loops and flat irregular surfaces produced by the use of specially twisted yarns.

BOUILLOTTE French term for a small table with gallery edge (Louis XVI). Also, a foot-warmer.

BOUILLOTTE LAMP Late-eighteenth-century lamp in the form of a candlestick, often with three or four arms, often made of brass, and usually terminating at the top in a handle or finial by which it can be picked up.

BOUILLOTTE SHADE A shallow shade for a lamp or candle, sometimes made of *tôle*.

BOULARD, JEAN BAPTISTE (1725–1789) Both *ébéniste* and sculptor, appointed *Maître Ébéniste* in 1754. His most important work was a magnificent bed for Louis XVI at Fontainebleau.

BOULLE, ANDRÉ-CHARLES (1642–1732) Important French cabinetmaker, he was the first great *Maître Ébéniste* and in 1672 was appointed head cabinetmaker to Louis XIV. After his death his workshop was continued by his two sons, André-Charles and Charles-Joseph.

BOULLE WORK Marquetry patterns in tortoise shell and German silver or brass, introduced by André-Charles Boulle, and used as furniture enrichment in the seventeenth century.

BOURETTE A silk of inferior strength, made from short, rough, uneven filaments.

BOX-PLAITING Pressed folds in a fabric, sewed in place in series, as in a drapery.

BOXWOOD A light-colored, fine-grained wood used for *marquetry*.

BRACKET A flat-topped underprop that projects from a wall or pier and forms a support for a beam or other architectural member above it.

BRACKET FOOT A low furniture support that has a straight corner edge and curved inner edges. It was used in eighteenth-century English and American furniture. In the French bracket foot the outer corners are curved. It is a stunted *cabriole* form.

BRAD Small headless nail.

BRADSHAW, GEORGE AND WILLIAM (ACTIVE 1736–1750) English cabinetmakers and upholsterers.

BRAID A strip composed of intertwining several strands of silk, cotton, or other materials. Used as a binding or trimming.

BRAMANTE, DONATO D'AGNOLO (1444–1514) Italian Renaissance painter and architect of St. Peter's in Rome.

BRASS An alloy consisting primarily of copper and zinc.

BRASSES General term referring to cabinet hardware such as drawer-pulls and escutcheons.

BRAZIER One who works in brass; also a pan with feet, for holding embers, used as a stove for heating rooms until the nineteenth century.

BREAKFAST TABLE A small drop-leaf table, similar to a *Pembroke table* but with a storage compartment underneath for china and silver. Popular in England from the middle of the eighteenth century.

BREAKFRONT Cabinet piece, the front of which has one or more projecting portions.

BREUER, MARCEL (1902–81) Important Hungarian-born architect and furniture designer, an instructor at the Bauhaus and later with a practice based in New York.

BREWSTER CHAIR A chair named for Elder Brewster, one of the first settlers of New England. It has a rush seat and turned spindles.

BRIC-À-BRAC A miscellaneous collection of small articles or curios. Pronounced "breek-ah-brah."

BRIGHTON PAVILION CHAIR A six- or eight-legged bamboo chair with carved sides and back.

BRISTOL GLASS Glass popular in England in the second half of the Eighteenth century, characterized by its deep colors, including a rich cobalt called Bristol Blue.

BROADCLOTH Twill, plain, or rib weave, of wool and spun rayon, and cotton and rayon or silk. The cotton or spun rayon fabric has fine crosswise ribs.

BROAD GLASS See *flat glass*.

BROADLOOM A term of the carpet trade, referring to carpets manufactured in wide strips (9, 12, and 15 feet and over).

BROCADE A kind of weave; also, a finished silk cloth that, although made on a loom, resembles embroidery. The background may be of one color or may have a warp stripe, and its weave may be taffeta, twill, satin, or damask. A floral or conventional pattern in slight relief is usually multicolored and is produced by the filler thread. It is woven with the Jacquard attachment, and the threads that do not appear on the surface are carried across the width of the back. The finest old handmade brocades all included threads of real gold or silver. Excellent for draperies and upholstery, particularly in period rooms.

BROCADILLO An imitation brocade.

BROCATELLE A heavy silk fabric resembling a damask, except that the pattern appears to be embossed. The pattern (usually large and definite) is a satin weave against a twill background. Made with two sets of warps and two sets of fillers, it is not reversible, as the linen backing produced by one set of filler threads shows plainly. Its uses are similar to those of brocade.

BROCHÉ A silk fabric similar to brocade. The small floral designs, which are quite separate from the background pattern, are made with swivel shuttles to resemble embroidery. The filler threads not in use are carried only across the width of the small design and not across the entire back as in brocade. Pronounced bro-shay.

BROKEN PEDIMENT A triangular pediment that is interrupted at the crest or peak.

BRONZE An alloy of copper and tin.

BRONZE-DORÉ French term for gilded bronze.

BRUNELLESCHI, FILIPPO (1377–1446) Considered the earliest Italian Renaissance architect. Designed the dome of the Cathedral and the Hospital of the Innocents, both in Florence. Sometimes spelled Brunellesco.

BRUSSELS CARPET A carpet with a looped woolen pile and a cotton back, first made in Brussels c.1710 and made by machine in America after the middle of the nineteenth century.

BUCKRAM A strong jute cloth of plain weave, finished with glue sizing. It is used as a stiffening for valences, for interlining draperies, etc.

BUFFET French term for a cabinet for holding dining table accessories; also a table from which food is served.

BULBOUS FORM In cabinetry, a stout turning resembling a large melon; used for furniture supports during the early Renaissance in England, France, and Italy.

BULFINCH, CHARLES (1763–1844) American architect who designed the state capitols of Massachusetts, Maine, and Connecticut and put Dr. Thornton's plan for the Capitol at Washington into execution.

BULL'S-EYE See *oeil-de-boeuf*.

BUN FOOT A furniture support that resembles a slightly flattened ball or sphere. Common in Dutch and English furniture.

BUNDLE The unit in which wallpaper is delivered. In the trade in the United States a roll is 36 square feet of paper, but paper is delivered in bundles of 1, 2, or 3 rolls.

BUREAU French term for a desk or writing table.

BUREAU-À-CYLINDRE French term for a roll-top desk. Also called a *bureau-à-rideau*.

BUREAU-À-PENTE French term for a folding, slant-lid desk. Sometimes called a bureau-en-pente.

BUREAU PLAT French term for a flat writing table, often leather-topped, and often with small drawers in the *frieze*.

BURETTE, CHARLES MARIN French cabinetmaker who flourished toward the end of the Empire period.

BURL A curly-grained wood surface or veneer cut from irregular growths of the tree, such as the roots or crotches. Very common in walnut.

BURLAP Plain weave of cotton, jute, or hemp. Heavy, coarse, and loosely woven, in a variety of weights, and used for sacks, the backs of floor coverings, inside upholstery, and elsewhere.

BURNAP, DANIEL (ACTIVE 1780–1800) American clockmaker known for engraved faces.

BÜROLANDSCHAFT German term for *office landscape*.

BUTT JOINT In cabinetry, a type of joint in which the squared end of a plank meets the side or end of another plank head to head or at right angles.

BUTT-WOOD VENEER Veneer that is cut from the part of the tree where the large roots join the trunk. It has fine curly and mottled markings.

BUTTERFLY TABLE A popular name for a small drop-leaf table used in the American colonies; the raised leaf was supported by a board bracket cut to resemble a butterfly wing.

BUTTERNUT A wood that resembles black walnut in all respects except color, and may be similarly used, where a lighter effect is desired. It works easily, is hard and durable, and has a handsome figure, formed by the annual rings. It is sometimes used for flooring and ceilings, sometimes for interior finish and furniture. The trees grow throughout the United States. It is also called white walnut.

BUTTRESS An exterior support built against a wall. Particularly seen in Gothic architecture, where it was introduced as extra masonry to resist the heavy thrust of the arched stone roof of the building.

BY-PASSING DOOR One of two or more doors that slide to stack in front of one another, less accurately called a *sliding door*.

BYZANTINE Style of art and architecture produced in the Eastern Roman or Byzantine Empire, 330 A.D.–1453.

C

CAAD Acronym for computer-aided architectural design. Also see *CAD* and *CADD*.

CABINET-SÉCRETAIRE French term for a desk with cabinet above.

CABINET-VITRINE French term for a cabinet with glass doors.

CABLED FLUTING Term for the fluting of a column shaft when the lower parts of the flutes are filled with solid cylindrical elements.

CABRIOLE A term used to designate a furniture leg or support that is designed in the form of a conventionalized animal's leg with knee, ankle, and foot; used particularly in France and England during the eighteenth century.

CABRIOLE CHAIR A chair with an upholstered back of oval or cartouche shape.

CABRIOLE SEAT An upholstered chair seat of rounded shape.

CABRIOLET French term for a chair with a concave back.

CACHEPOT French term for a pot of china or porcelain used as a container.

CAD Acronym for computer-aided design.

CADD Acronym for computer-aided design and drafting.

CAEN STONE Limestone of a yellowish color, with rippled markings, found near Caen, in Normandy. Often used in French architecture and decoration.

CAFFIERI, JACQUES (1678–1755), AND HIS SON PHILIPPE (1714–74) French cabinetmakers and sculptors under Louis XIV and XV.

CAFFOY A wool plush fabric used in the early eighteenth century, an inexpensive version of cut velvet.

CAGE CUP A glass cup with a cage-like outer layer that is almost completely free of the inner body. In Roman times, such a cup was called a *diatretum*.

CALENDERING A fabric finishing process producing a flat, smooth, glossy surface by passing the fabric between heated cylinders.

CALICO A term formerly used for a plain woven printed cotton cloth, similar to percale. Its name is taken from Calicut, India, where it was first made. Sometimes spelled callicoa.

CALLIGRAPHY In general, beautiful penmanship; specifically the brushstroke work done by the Chinese for reproduction of the written characters of the Chinese language.

CAMBER A slight upward bend or convexity; a slight rise or arch in the middle.

CAMBRIC Plain weave linen or cotton. True linen cambric is very sheer. It is named for the original fabric made in Cambrai, France. Now coarser fabrics are called cambric and used for linings, etc.

CAMEL BACK Chair back of late Chippendale or Hepplewhite style, the top rail of which was in the form of a serpentine curve.

CAMEO A striated stone or shell carved in relief.

CAMLET A fine, smooth-surfaced blend of wool and silk or wool and linen made in imitation of an earlier fabric from Asia that had contained camel's hair or Angora goat hair. Other spellings include camlette, camblet, and Camelot.

CANABAS, JOSEPH (1712–97) French cabinetmaker appointed *Maître Ébéniste* in 1766. Particularly noted for mechanical contrivances, such as folding tables, for armies or to be carried aboard ships. His real name was Joseph Gegenbach.

CANAPÉ French term for a sofa or settee.

CANAPÉ-À-CORBEILLE French term for a kidney-shaped sofa.

CANDELABRUM A branched candlestick or lamp stand. The plural is candelabra.

CANEPHORUS In furniture or decoration, an ornament representing a maiden with a basket of offerings on her head. The plural is canephora. See also *caryatid*.

CANOPIC VASE A vase used by the ancient Egyptians to hold the organs of a dead person.

CANOPY A draped covering suspended over a piece of furniture, as over a bed or a seat of honor.

CANTERBURY An ornamental stand having compartments and divisions for papers, portfolios, envelopes, and so forth. It was used beside a piano to hold music or by a dining table to hold plates. It was popular in England from 1790 to 1890.

CANTILEVER A beam with one or both ends projecting beyond the supporting wall or columns. Used structurally for the support of projecting balconies, eaves, and other extensions.

CANTON CHINA Original blue-and-white china imported from the Far East from the seventeenth century until the Sino-Japanese War, 1938. A traditional staple in Chinese ceramic history.

CANTON ENAMELS Enamels with pink and gold decoration, similar to that of *famille rose* porcelain.

CANTONNIÈRE French term for a *valance*.

CANVAS A heavy cotton cloth in plain weave. It may be bleached or unbleached, starched, dyed, or printed. Used for awnings, couch covers, and whenever a coarse, heavy material is required.

CAPITAL In architecture, the decorative crowning motif of the shaft of a column or pilaster, usually composed of moldings and ornament. The most characteristic feature of each classical architectural order.

CAPTAIN'S CHAIR Nineteenth-century chair based on a low-back Windsor. Also called a *firehouse Windsor*.

CAQUETOIRE OR CAQUETEUSE Early Renaissance French term for a "conversation chair," a small, light chair in which to sit and talk.

CARCASE The structural body of a piece of wooden furniture that is covered with veneer. Sometimes called the core.

CARLIN, MARTIN (D. 1785) French cabinetmaker appointed *Maître Ébéniste* in 1766. He made charming, delicate furniture during the Neoclassical period, using rosewood and Sèvres porcelain.

CAROLEAN See *Restoration style*.

CARPET A fabric floor covering, generally covering an entire area from wall to wall; *broadloom*.

CARPET PAD A cushion used under a carpet.

CARPET TILE Modular units of carpet, usually square, and usually 18 to 24 inches in size.

CARRÈRE AND HASTINGS Important American architecture firm in the late nineteenth and early twentieth centuries. Among its work is the New York Public Library, finished in 1911.

CARRIAGE A heavy board notched to support stair treads.

CARTIBULUM In a Roman house, a ceremonial marriage table.

CARTOON The term used to designate a drawing or design made for reproduction in another medium, as the original design for a rug, tapestry, or painted mural decoration.

CARTOUCHE A conventionalized shield or ovoid form used as an ornament, often enclosed with wreaths, garlands, or scrolllike forms.

CARVED RUG A rug with the pile cut to different levels to produce a pattern.

CARVER CHAIR A type of Early American chair named for the governor of the Massachusetts Bay Colony. It is a simplified version of the *Brewster chair*.

CARYATID In architecture, a column carved in human female form. The male equivalent is called a *term*, and the female equivalent at furniture scale is a *canephorus*.

CASED GLASS Glass of one color coated with a thin layer of glass of another color. The outer layer is often cut away in decorative patterns to reveal the inner one. Also called *Bohemian glass* or *verre double* or *cup-overlay*.

CASEGOODS Any furniture used to contain objects, such as a desk, a bookcase, a hutch, or a cabinet. Also called case furniture.

CASEMENT CLOTH A lightweight cloth originally made of wool and silk in plain weave. Now made of cotton, linen, mohair, silk, wool, rayon, or a combination. Although usually neutral in tone, this material may be had in colors and is popular for draw curtains.

CASEMENT WINDOW A window hinged at the side to swing in or out.

CASHMERE A soft wool textile made from Indian goat hair. The same breed of goat is now raised in the United States.

CASSAPANCA Italian term for a long wooden seat with wooden back and arms, and with its lower portion used as a chest with hinged lid.

CASSONE Italian term for a chest or box with hinged lid. The plural is cassoni.

CAST The reproduction of a sculpture in metal or plaster using a mold.

CAST GLASS Glass that is formed in a mold rather than blown.

CASTER A small wheel fastened to supporting legs of heavy furniture to facilitate moving. First used in the early nineteenth century. Sometimes spelled castor.

CATACOMBS Underground chambers in Rome used by the early Christians as hiding places and for religious worship.

CATENARY ARCH An arch form that is in the shape that a chain takes when its ends are supported a distance apart.

CATHEDRAL A large, important church; specifically, a church that is the seat of a bishop, so called after the *cathedra* or bishop's throne that such a church contained.

CAVETTO A molding of concave form approximating a quarter-circle.

CEDAR A name applied to several woods that are fine-grained and fragrant. The North American cedar is a juniper; the West Indian is of the mahogany family. The wood is used for chests and for lining clothes closets. Persian cedar, or *nanmu*, is an eastern hardwood used for building.

CELADON A pale grayish green. Korean or Chinese ceramics of that color.

CELLA The interior chamber of a classical temple, in which usually stood the cult statue.

CELLARET A portable chest, case, or cabinet for storing bottles, decanters, and glasses.

CELLINI, BENVENUTO (1500–71) Italian Renaissance goldsmith and sculptor.

CELLULOSE An insoluble starchlike substance taken from plants to form the base of many synthetic materials.

CELTIC CROSS A cross with a small circle at the intersection of its vertical and horizontal arms. See vocabulary box in Chapter 6.

CEMENT A powder composed of alumina, silica, lime, iron oxide, and magnesia burned together and then pulverized. It is a key ingredient in (but never properly a synonym for) *concrete*.

CENOTAPH A funerary monument not containing the body of the dead.

CENTERING Temporary wooden framework used in the construction of vaults or domes. When the structure is finished and self-supporting, the centering is removed or "struck."

CERAMICS The art of molding, modelling, and baking in clay. The products of this art.

CERCEAU, JACQUES DU Sixteenth-century French architect and furniture designer under Henry IV.

CERTOSINA Italian term for an inlay of light wood, ivory, or other materials upon a dark background.

CHACMOOL An Aztec sacrificial stone in the shape of a reclining figure.

CHAIR RAIL The topmost molding of a *dado*, sometimes known as the *dado cap*. It is placed on a wall at the height of a chairback to protect the wall from being scraped.

CHAIR TABLE A chair with a hinged back that may be dropped to a horizontal position as a table top.

CHAISE French term for chair, usually applied to a side chair.

CHAISE-À-CAPUCINE French term for a low slipper chair.

CHAISE-BRISÉE French term for a chaise-longue in two parts (with foot rest).

CHAISE-LONGUE French term, literally "long chair," or chair for reclining. Also called a *duchesse*.

CHAITYA In India, a Buddhist or Hindu temple, generally in the form of a basilica. Its characteristic horseshoe-shaped window is called a chaitya window.

CHALICE A cup or goblet used for church sacraments.

CHÂLIT French term for a bedstead.

CHALLIS A soft woven fabric.

CHAMBERS, SIR WILLIAM (1726–1796) English architect and first treasurer of the Royal Academy. Author of *Treatise on the Decorative Part of Civil Architecture*. Adhered to Palladian tradition during the Greek revival. Shares honors with Chippendale in adapting Chinese forms to furniture, after traveling in the Orient.

CHAMBRAY A class of yarn-dyed, plain weave cotton or synthetic fabrics with a colored warp and white filling, often used for clothing. The name derives from the French town of Cambrai.

CHAMFER See *bevel*.

CHAMPLEVÉ A type of enamel in which the pattern is grooved in a metal base and the grooves are filled with colored enamels. Pronounced zhahm-play-vay.

CHANCEL The eastern end of a cruciform church, including the altar and the choir.

CHANDELIER French term for a hanging lighting fixture.

CHARGER A large dish.

CHAR-PAI In India, a rope bed.

CHARLES X French neoclassical style during the reign of Charles X, 1824–30.

CHASE An enclosure that houses mechanical equipment, ducts, or pipes.

CHASHITSU In Japan, a small pavilion or room used for the tea ceremony.

CHASING The tooling of a metal surface to smooth it or to raise a decorative pattern on it.

CHATTRI In Hindu architecture, umbrella-shaped forms atop slabs that are supported on posts. Also spelled chatri. The singular is *chattra*.

CHAUFFEUSE French term for a small, low-seated fireside chair (from the French *chauffer*, meaning "to warm"). Sometimes spelled chaffeuse. The English term is *nursing chair*.

CHECK A small crack that sometimes appears in lumber unevenly or imperfectly dried, perpendicular to the annual rings, and radiating away from the heart of the trunk.

CHECKERBOARD A pattern consisting of alternating light and dark squares.

CHEESECLOTH Unsized cotton gauze, sometimes used in cheesemaking.

CHELSEA FOOT Popular in the Chelsea section of London in the 1930s, an upholstered leg on a sofa, chair, or ottoman.

CHÊNE French term for oak.

CHENETS French term for andirons.

CHENILLE A type of woven yarn that has a pile protruding all around at right angles to the body thread. The yarn may be of silk, wool, mercerized cotton, or rayon and is used for various types of fabrics.

CHERRY A durable hardwood of a reddish-brown color, which is produced only in small quantities, the trees being usually too small for lumbering. It is often used to imitate mahogany, which it greatly resembles, and is used for marquetry and inlay. In Japan it is called *sakura*.

CHEST A piece of furniture used as a box or container.

CHESTERFIELD Named for the Earl of Chesterfield, an overstuffed sofa, usually with its arms and back on a continuous level.

CHEST-ON-CHEST A chest of drawers consisting of two parts, one mounted on top of the other.

CHESTNUT A softwood, sometimes white and sometimes brown, which resembles plain oak, but has a coarser grain. Where a quartered effect is not desired, it can take the place of oak and is generally much less expensive. Because of its strongly marked rings and coarse grain, it is unsuitable for fine detail. In Japan it is called *kuri*.

CHEVAL GLASS Literally meaning "horse mirror" because the frame holding it was known as a "horse." It is a large full-length mirror, usually standing on the floor, often pivoting around a horizontal axis. See also *pier glass*.

CHEVERET In late eighteenth-century England, a small lady's writing table, similar to the French *bonheur-de-jour*.

CHEVET French term meaning the head of a bed, a bedside, or a bolster. It also refers to the east end of a church, or chancel, including the *apse*, the *choir*, and the *ambulatory*.

CHEVRON An ornamental motif composed of V-shapes pointing in alternating directions. Also called a *zig-zag* or a *dancette*.

CHIAROSCURO Literally meaning "clear-obscure," an Italian term referring to a strong contrast of light and dark areas in painting.

CHI-CH'IH-MU See *jichimu*.

CH'IEN LUNG PORCELAIN Chinese porcelain from the reign of the Ch'ing dynasty emperor Ch'ien Lung (1736–95).

CHIFFON A descriptive term used to indicate the light weight and soft finish of a fabric, as in "chiffon velvet"; also, a sheer, gauzelike silk fabric.

CHIFFONIÈRE French term meaning a chest of drawers. Often anglicized as chiffonier.

CHINA The first European name for *porcelain* imported from the East.

CHINA CLAY A fine white clay and an essential ingredient of true *porcelain*. Also called *kaolin* or *alumina*.

CHINA SILK Sheer plain weave fabric that is nearly transparent and is dyed in various colors.

CHINASTONE A fusible crystalline mineral that is an essential ingredient of true *porcelain*. In its raw form it is known in China as *tzu-shih*, and in its prepared form of small white blocks as *baidunzi* or *pai-tun-tzü*, anglicized as *petuntse*.

CH'IN DYNASTY Chinese dynasty, 256 B.C.–206 B.C.

CH'ING DYNASTY The last Chinese dynasty, 1644–1912, sometimes called the *Manchu dynasty*. Also spelled Qing, but pronounced ching.

CHINOISERIE French term meaning an object or decorative motif in the Chinese manner.

CHINTZ A fine cotton cloth usually having a printed design. Chintz originated in India in the seventeenth century and its name means spotted. Practically all modern chintz is produced with the *calendering* or glazing process, which makes it more resistant to dirt. In washing glazed chintz, the glaze is lost and cannot easily be renewed. The shiny surface and stiff texture produced by glazing also add to its charm. Chintz may be printed by blocks, copper plates, screens, or rollers, or it may be plain, in various colors. It is widely used for draperies, slipcovers, lamp shades, and upholstery.

CHIP CARVING Wood carving in which patterns are made with triangular and diamond-shaped depressions in the surface. An ancient technique, chip carving can be made using the simplest knife blades and chisels.

CHIPPENDALE, THOMAS (1718–1779) Prominent English cabinetmaker and furniture designer. Published *Gentleman and Cabinet-Maker's Director* in 1754.

CHIPPENDALE, THOMAS III (1749–1822) Son of the above. Carried on his father's business with Thomas Haig, but became bankrupt in 1804. Worked mostly in the Regency style.

CHITON A tunic worn by ancient Greeks, frequently shown in classical ornament.

CHOIR The section of a church where singing is done, part of the *chancel*.

CHOS-N Period of Korean history better known as the *Yi*.

CHOU DYNASTY Chinese dynasty, 1045 B.C.–256 B.C. Pronounced "Joe."

CHROMA A term used to designate the degree of intensity, brilliance, luminosity, or saturation of a spectrum color. Yellow, near the center of the spectrum, is the most brilliant but has the least saturation and palest chroma. Red has a medium chroma; and blue, the darkest chroma, with the greatest saturation. Sometimes the term chromatic value is used.

CHRYSELEPHANTINE Compositions of gold and ivory, used for statuary and decorative objects since ancient Greek times.

CHURRIGUERA, JOSÉ (1665–1725) The most outstanding member of a Spanish Renaissance family of architects, who were mainly responsible for the baroque and rococo styles in Spain, later known as the *Churrigueresco*. Also a powerful influence in Latin America.

CHURRIGUERESCO The seventeenth-century Spanish style introduced by the architect Churriguera. It is characterized by elaborate ornamentation and curved lines.

CIBORIUM See *baldachino*.

CIMABUE, GIOVANNI (1240?–1302?) Florentine painter and a forerunner of the Italian Renaissance. Designed mosaics and frescoes. Pronounced chee-mah-bway.

CINQUECENTO Italian term for the sixteenth century in Italy (literally, the 500s). The first fifty years was considered the high period of Renaissance production.

CINQUEFOIL French term literally meaning "five leaves." A pattern resembling a five-leaved clover. See also *trefoil* and *quatrefoil*.

CIRCASSIAN WALNUT A brown wood with a very curly grain, one of the handsomest finishing woods, which comes from the region near the Black Sea. It is used largely for furniture and paneling, and is very expensive.

CIRCULATION The traffic pattern in a room or building; the space devoted to the traffic pattern, such as hallways and corridors.

CIRE-PERDUE French term meaning "lost wax." An early method of making bronze castings, in which it was necessary to destroy the sculptor's original wax model as well as the mold, thereby allowing only one casting to be made.

CISELEUR French term meaning a craftsman who ornaments bronze and other metals by chiselling.

CLAPBOARD WALL A wall of planks laid horizontally, each one slightly overlapping the one below.

CLASSIC A term applying to a work of art of the first class or rank, or an established standard and acknowledged excellence; also used as a synonym for classical.

CLASSICAL A term referring to the arts of Greece and Rome or any work based on such forms.

CLAVATED Club-shaped. Applied to turnings used as furniture legs and stretchers, especially as seen in early Spanish furniture.

CLAVICHORD Seventeenth-century stringed instrument, ancestor of the piano. Known in England in the Carolean, William and Mary, and Queen Anne periods.

CLAW-AND-BALL FOOT A type of carved foot representing a bird's claw grasping a ball; used in conjunction with a cabriole furniture leg; introduced in the early eighteenth century in England, and possibly of Far Eastern origin.

CLERESTORY A story above an adjoining roof. Clerestory windows in the nave wall of a church are those above the roof of the side aisles. In general, a window placed near the top of a wall. Also spelled clearstory.

CLOCHE Dome of glass fitted over a wood base to protect artificial flowers and waxworks from dust.

CLOISON French term for partition, applied to the divisions between sections of *cloisonné* or to divisions of stained-glass window tracery. Pronounced "klwa-zon."

CLOISONNÉ A type of enamel in which the various colors are separated and held by delicate metal partition filaments. From the French term *cloison*. Pronounced "klwa-zon-nay."

CLOISTER A covered passageway around an interior courtyard. Also the courtyard itself. A feature of medieval architecture.

CLOSE CHAIR A latrine in the shape of a chair, with a chamber pot beneath a hinged seat. Sometimes called a close stool.

CLOVEN FOOT Furniture foot resembling the cleft rear hoof of a deer.

CLOVERLEAF CROSS See *Bottonée Cross*.

CLUB FOOT A foot used with the English cabriole furniture leg in the early years of the eighteenth century. The foot flares into a flat pad form that is round in shape. See also *bun foot* and *pad foot*.

CLUSTERED COLUMNS The system of placing several columns in close proximity or overlapping their shafts to form a support. Commonly seen in the European architectural styles of the Middle Ages.

CMG Acronym for the Color Marketing Group, an organization that forecasts popular colors.

COBB, JOHN See *Vile*.

COBBLER'S BENCH Shoemaker's bench with seat, last holder, bin, and compartments for pegs and tools.

COCHOIS, JEAN-BAPTISTE French cabinetmaker appointed *Maître Ébéniste* in 1770. Inventor of dual-purpose and change-about furniture, such as a chiffonière that became a night table.

COCKFIGHT CHAIR Chair for reading and writing or viewing sports events, used by straddling the seat and facing the back. The back had a small shelf. Popular in England from the Queen Anne to Chippendale periods. Similar to the French *fumeuse*.

COCOBOLO A dark brown wood with a violet cast. It takes a highly polished finish and has been used for modern furniture.

COFFER An ornamental sunken panel in a ceiling, vault, or the lower surface of an arch, beam, or other architectural feature.

COFFRE French term meaning a chest.

COIFFEUSE French term meaning a dressing table.

COIR Fiber produced from coconut husks and used for doormats or roughly textured rugs.

COLD CUTTING The process of forming glass objects by chipping at them with flint or quartz tools.

COLLAGE Composition made up of pieces of paper, photos, wallpaper, and the like glued together to a background surface to form a pattern or picture. Term sometimes used interchangeably with *montage*.

COLONIAL REVIVAL STYLE Revival of the Colonial style, popular in the United States from the 1870s through the 1920s.

COLONIAL STYLE Strictly speaking, the style of the American colonies from their settlement to their independence. In practice, the term often includes aspects of American design after 1776.

COLONNADE A row of columns usually supporting an entablature and forming a part of the architectural treatment of a corridor or passageway.

COLONNETTE A small column.

COLOR TEMPERATURE A figure, expressed in degrees Kelvin, of the warmth of the color of a particular light source.

COLOSSAL ORDER In architecture, an order rising to the height of two or more floors.

COLOSSUS A stature of a human (or god) that is much larger than life-size.

COLUMBO, JOE (1930–71) Italian designer of furniture and lighting.

COLUMN An elongated cylindrical structural support, usually having a *base* and a *capital*. May be isolated or attached to a wall.

COMB BACK A type of *Windsor chair*, with a central group of spindles that extend above the back and are crowned with an additional rail.

COMMODE French term for a low chest of drawers, similar to—but generally wider than—a *chiffonière*.

COMPLEMENTARY COLORS Pairs of colors opposite each other on the color wheel—for example, red and green or yellow and purple.

COMPLUVIUM In a Roman house, the roof opening above the *atrium*.

COMPOSITE ORDER In architecture, a variant of the Corinthian order. The capital resembles the combination of an Ionic volute placed above rows of Corinthian acanthus leaves.

COMPOSITION A term in design used to indicate a grouping of separate parts that produce the appearance of a coordinated whole and are esthetically related to one another by position, line, and form.

COMPOSITION ORNAMENT An ornament made of putty, plaster, or other material, that is cast in a mold and applied to a surface to form a relief pattern. Called *gesso* in Italy and *yeseria* in Spain.

COMPOTIER French term for a container for stewed fruit, jellies, jams, and the like.

CONCRETE A mixture of sand and aggregate held together by *cement*. Concrete is *not* synonymous with cement, and the terms should not be used interchangeably.

CONEY, JOHN (1655–1722) Important Boston silversmith, goldsmith, and engraver.

CONFIDANTE French term for three seats attached as a single unit. The two outer seats are generally smaller and are separated from the center seat by arms. Hepplewhite illustrated such a piece in 1788. Sometimes seen as confident or as canapé-à-confident.

CONFORTABLE French name used for an all-upholstered chair.

CONNECTICUT CHEST A type of Early American chest with double drawers, standing on four short legs; usually decorated with split spindles painted black. Also see *Hadley chest*.

CONSOLE A wall table. Also, an architectural element projecting from a wall to support a pier or cornice.

CONSOLE-DESSERTE French term for a serving table.

CONTINUOUS FILAMENT YARN Yarn made from a group of extremely long parallel filaments. Yarns of this type include rayon, nylon, acetate, polyester, and other man-made materials, whereas most natural fabrics are made from spun yarn.

CONVENTIONALIZATION The reproduction of forms in nature with such changes as to make them more suitable to the particular mediums or materials in which they are reproduced. Simplifying or exaggerating natural forms in reproduction.

CONVERSATION CHAIR See *voyeuse*.

CONVERSATION PIECE Picture of a family group. See *genre*.

COOL COLOR Blue and the hues that are near blue, such as green, blue-green, blue-violet, and violet.

COPING The uppermost part of a wall, or a protective course of stone that covers the top of a wall.

COPOLYMER FINISH Nonblended mixture of enamel-like paints.

CORBEILLE Also spelled corbeil. A sculpture representing a basket of flowers and fruits.

CORBEL A shoulder or bracket set in a wall to carry a beam; one of a series of such shoulders or brackets, each projecting slightly farther than the one below; any stone, brick, or timber-work projecting as a shoulder to carry a load.

CORBEL ARCH An arch formed by *corbels*.

CORDUROY A cotton or rayon cut pile fabric with ridges or cords in the pile that run lengthwise. Extensively used for upholstery, especially in modern treatments. Probably derived from the French term *cord du Roi*, meaning "king's cord."

CORE The area of a multifloor building, usually centrally located, that contains elevators, fire stairs, mechanical shafts, toilets, and other facilities of common use throughout the building.

CORE FORMING Glassmaking technique in which ropes of soft glass are wound around a core of earth or dung.

CORINTHIAN ORDER The most elaborate, slender, and graceful of the classical orders of architecture. The capital is enriched with two rows of acanthus leaves.

CORNER BLOCK In carpentry, the block of wood used to form a junction between the sides and head strip of door and window trim. In cabinetmaking, any block similarly used.

CORNICE The projecting, crowning portion of a classical *entablature*, uppermost of the entablature's three parts; or a crown molding.

CORNUCOPIA Decorative motif resembling a horn, its larger end overflowing with flowers, fruit, and so forth.

COROMANDEL A hard dark-brown wood with black stripes that grows in India and China and is much used for furniture. Also called coromandel ebony or calamander.

COROMANDEL LACQUER Chinese export lacquer ware, named for the site of the British East India Company's trading post.

COROMANDEL SCREEN A folding screen surfaced with Coromandel lacquer.

COSMATI Members of the Cosmatus family of Rome, or those working in their style. The marble work practiced by them.

COUCH Layman's term for a *sofa*.

COUPE French term for a high-footed cup.

COURT CUPBOARD A low cupboard on short legs, after the French *court* for "short."

COVE A concave surface often used to connect a wall and a ceiling. A cove-molding similar to the *cavetto*.

COVE LIGHTING Lighting, usually of a ceiling surface, from a source hidden by a recess or ledge.

CRAPAUD French term for a low, upholstered armchair.

CRASH A group of cotton, jute, and linen fabrics having coarse, uneven yarns and rough texture. Used for draperies and upholstery, and often hand blocked or printed.

CRAZING Crackling in the glaze of ceramic ware.

CREAMWARE See *Queen's ware*.

CRÉDENCE French Gothic term for a sideboard.

CREDENZA A low furniture element with a work surface on top and files or storage compartments below. In office design, often placed behind a desk.

CRÈMAILLÈRE French term for a swinging crane on a hearth.

CRÊPE A descriptive term applied to a large group of fabrics that have a crinkled or puckered surface, which may be produced by highly twisting the yarn in weaving or by a chemical process. The materials are made of cotton, wool, silk, or a combination of fibers, woven in any basic weave.

CRÊPE DE CHINE A type of crêpe in which the yarn is made of raw silk.

CREPIDOMA The base of a Greek temple, usually three steps high, the highest step being called the *stylobate*.

CRESSENT, CHARLES (1685–1758) Important French cabinetmaker in the Régence and early Rococo styles, appointed *Maître-Ébéniste* in 1715. Ébéniste to the Duc d'Orleans.

CRESSON, LOUIS (1706–1761) AND HIS BROTHER MICHEL (1709–C.1773) French cabinetmakers. There were others as well with the same last name practicing in eighteenth-century France.

CREST RAIL The top rail of a chair back, sometimes elaborately shaped and carved.

CRETONNE A heavy cotton cloth with printed pattern similar to *chintz*, though the designs are usually larger and less detailed. The background may be plain or a *rep* weave. The name comes from the Normandy village of Creton, where it was first produced. Cretonne is usually unglazed. It is useful for draperies and upholstery.

CREWEL EMBROIDERY A kind of embroidery with a pattern of varicolored wools worked on unbleached cotton or linen. The spreading design covers only part of the background, and usually includes a winding stem with various floral forms. It was used extensively during the English Jacobean period for upholstery as well as for draperies. The designs were often inspired by the East Indian *tree of life* motif.

CRIAERD, MATHIEU (1689–1776) French cabinetmaker of Flemish origin, appointed *Maître-Ébéniste* in 1738.

CROCKET Ornament used on the sides of pinnacles, usually leaf or bud shaped; commonly seen in Gothic art.

CROSS In general, a decorative device with a vertical bar traversed by a horizontal one; more specifically, such a device that invokes the Christian faith. See p. 147 for specific types of crosses.

CROSS GRAIN Wood grain not parallel to the long dimension of the wood.

CROSS SECTION A section cut at right angles to the long dimension of a building, room, or object. Also called a transverse section.

CROSS-BANDING A narrow band of wood veneer forming the frame or border of a panel; the grain of the wood is at right angles to the line of the frame.

CROSSHATCHING In a drawing, shading obtained by superimposing overlapping rows of closely spaced parallel lines.

CROSSING In church architecture, the intersection of nave and transept.

CROTCH VENEER A thin sheet of wood cut from the intersection of the main trunk and branch of a tree, showing an irregular effect of graining.

CROWN MOLDING The topmost molding, particularly the *fillets* and *cymas* placed above the *fascia* in a classical *cornice*; or any molding at the top of a wall or structure.

CRUMB CLOTH A *floorcloth* for use under a dining table or sideboard.

CRUSIE Scottish term for a shallow oil lamp made of iron.

CRYPT A subterranean chamber or burial area.

CRYPTOPORTICUS In Roman architecture, a subterranean passage or a gallery formed by walls with a series of openings rather than by a *colonnade*.

CRYSTAL A clear and transparent quartz, resembling ice; an imitation of this material made in glass.

CSA Acronym for the Canadian Standards Association, the Canadian equivalent of the United States's Underwriter's Laboratories, or *UL*.

CUBE FOOT See *block foot*.

CUBICULUM A bedroom in a Roman house.

CUCCI, DOMENICO (C.1635–C.1704) French cabinetmaker under Louis XIV, born in Todi, Italy.

CUNEIFORM Literally, wedge-shaped. A system of writing on clay tablets used in Sumeria, Babylonia, and Assyria in which the characters were wedge-shaped.

CUPOLA A small dome.

CUP-OVERLAY See *cased glass*.

CURING The hardening process for freshly poured concrete.

CURULE CHAIR A seventeenth-century chair design based on the Roman *sella curulis*. Its curved legs and curved seat meet at the center of the front, and its back is also curved.

CUSP OR CUSPING Pointed termination of a trefoil, quatrefoil, or cinquefoil in Gothic architecture.

CUSPED ARCH In Gothic and Islamic architecture, an arch composed of many small arches joining in pointed forms.

CYCLOPEAN MASONRY Masonry using very large blocks, considered so heavy that only a monster such as the legendary Cyclops could lift them.

CYMA CURVE An S-shaped curve. In the cyma recta the curve starts and ends horizontally. In the cyma reversa the curve starts and ends vertically.

CYPRESS A wood with a light brown color, though it varies considerably according to its origin. It is a very handsome wood for interior use, quite inexpensive, adapted to all types of finish, and remarkably free from warping and twisting. This last property recommends it for kitchen use, or wherever heat and moisture are present. Cypress is too soft for flooring, though occasionally so employed, and too weak for structural timber; but for finish, few woods can equal it. It may be given a natural finish, or may be painted or stained to give almost any effect that may be desired, including imitations of many of the expensive hardwoods. A special treatment, to which cypress alone seems adapted, is so-called *sugi* finish, an imitation of Japanese driftwood. It is produced by charring the surface with a gasoline torch and rubbing off the charcoal with a wire brush. The spring wood burns away and the harder summer wood remains, leaving the grain in strong relief.

D

DA VIGNOLA, GIACOMO BAROZZI (1507–73) Italian Renaissance architect who wrote the *Treatise on the Five Orders* and revived the standardized proportions of *Vitruvius*.

DA VINCI, LEONARDO (1452–1519) Great Florentine painter, sculptor, architect, scientist, engineer, writer, and musician. One of the most imaginative and inventive figures of the Italian Renaissance.

DADO The lower portion of a wall, when treated differently from the surface above it. In the classical styles the dado usually has a base, shaft, and cap molding (see *chair rail*), and is often paneled or ornamented. A low *wainscot*.

DADO CAP The crowning or cap molding of a dado; sometimes called a *chair rail*.

DAGUERREOTYPE First photographic process invented in 1839 by Louis Daguerre in France. Involved the action of light on a plate sensitized by a solution of iodine and silver salts. Produced a faint image, which had to be viewed at an angle to be clearly seen.

DAIS A low platform raised above the level of the floor and located at one side or at the end of a room. In medieval times, used for dining; in modern times, for speaking to a group.

DAMASCENING OR DAMASCENE WORK A type of metal inlay. The design is incised by means of carvings or acid applications on a metal base, and the depressions are filled in with wires of different metals cut to fit. Usually the background is a base metal such as steel and the inlays are of more precious metal, such as silver or gold.

DAMASK A kind of *Jacquard* weave; also a fabric with a woven pattern similar to *brocade*, but flatter. In damask any combination of two of the three basic weaves may be used for the pattern and the background, provided that the weave of the pattern differs from that of the background. The pattern is made visible by the effect of light striking the portions of the fabric in the different weaves. Usually both *warp* and *filler* are of the same weight, quality, and color, though it may be woven in two colors. The pattern effect is usually reversible. Originally made of all silk, damasks are now made of linen, cotton, wool, and any of the synthetic fibers, or of combinations of any two. The name originated with the beautifully patterned silks woven in Damascus during the twelfth century and brought to Europe by Marco Polo. Damask is widely used for draperies and upholstery.

DANCETTE See *chevron*.

DANFORTH, SAMUEL (ACTIVE EARLY NINETEENTH CENTURY) Hartford, Connecticut pewterer.

DANTE CHAIR An X-shaped chair of the Italian Renaissance. Its legs cross and become the arm supports of the opposite side of the chair.

DAUM French family of glassmakers, best known for work in the *Art Nouveau* style.

DAVENPORT A *sofa*. The term was also used in England at the end of the eighteenth century for a small gentleman's writing desk.

DC Abbreviation for direct current.

DEAD SEAT OR DEAD BACK In upholstered furniture, a seat or back made without springs.

DEAL Generic term for any member of the pine family when it is cut up into planks. Also applied to furniture made of such planks. English and Early American use. Also used in England to designate standard merchandising dimensions of both pine and fir lumber. A misnomer for pine wood itself.

DECALCOMANIA A process of decoration in which printed designs on thin paper are transferred to other materials, such as wood trays, ceramic plates, or glass vases. An item used in the process is called a decal.

DECORATED STYLE The term given to English Gothic architecture c.1270–1370, characterized by elaborate, florid window tracery.

DÉCOUPAGE Decoration or picture-making by pasting down printed images, scraps of cloth, and other materials.

DEDICATED CIRCUIT An electrical circuit independent of the main circuit, meant to be used solely by computers or other specified equipment.

DELANOIS, LOUIS (1731–92) French cabinetmaker appointed *Maître Ébéniste* in 1761. A protégé of Mme. Du Barry, he did a large amount of furniture for Versailles.

DELFTWARE English term for the tin-glazed pottery and tiles made in Delft and in other Dutch cities. It was most often blue and white, but other colors were also sometimes used. In France, the term used is *faïence du Delft*, in Germany *Delfter Fayence*, and in Holland itself *Delfts blauw*.

DELLA ROBBIA FAMILY: LUCA, ANDREA, GIOVANNI, GIROLAMO (1400–1566) Italian Renaissance sculptors and originators of Della Robbia *faïence*.

DELORME, PHILIBERT (1515–1570) French court architect under Francis I, Henry II, and Charles IX.

DEMILUNE French term meaning semicircular.

DEMOTIC An abridged form of hieroglyphics, used by the Egyptians for ordinary correspondence conducted by the public scribes.

DENIM A kind of heavy cotton cloth, of a twill weave. Usually a small woven pattern is introduced, or warp and filler may be in contrasting colored threads. Originally called *toile de Nîmes*. Used for upholstery and draperies and, in modern times, for clothing.

DENTIL A small square projecting block in a cornice, part of a series as in a molding.

DERBYSHIRE CHAIR A popular name for a type of Jacobean chair of provincial origin.

DESKEY, DONALD (1894–1989) American interior designer in the Art Deco style, best known for his interiors for the Radio City Music Hall, New York.

DESORNAMENTADO The name applied to the severe style of architecture and decoration developed by the architect Herrera under the patronage of Phillip II of Spain. The word means without ornament.

DESSERTE French term for a serving table or sideboard.

DE STIJL Dutch modernist design movement founded c.1917.

DEWOLFE, ELSIE (1865–1950) American interior designer, sometimes considered the first professional interior designer of modern times.

DIAETA In a Roman house, a daytime resting area.

DIAMETER The longest line that can be drawn through the center of a circle and touching the perimeter in two places; the length of such a line.

DIAPER PATTERN An allover or repeating pattern without definite limits, particularly such a pattern employing diamond shapes or a diagonal grid.

DIAPHANIE In the nineteenth century, transparent designs applied to window glass in imitation of stained glass. See also *vitromania*.

DIATRETUM See *cage cup*.

DIFFRIENT, NIELS (B.1928) American industrial designer and furniture designer.

DIFFUSER A device through which the light from a fixture is modified or redistributed.

DIMITY A sheer cotton fabric.

DIMMER A device that, by controlling voltage, adjusts the intensity of light from a light source.

DINANDERIE Fifteenth-century metal alloy, the ancestor of pewter, being a combination of copper, tin, and lead. Used particularly in application to ornamental figures made in Dinant, Belgium.

DIORITE A type of dark-colored, hard stone much used in Egyptian sculpture.

DIP-DYEING The process of dyeing textiles after they are woven by dipping whole pieces into the dye. Dip-dyeing is also known as *piece-dyeing*. See also *yarn-dyeing* and *stock-dyeing*.

DIPHROS A Greek stool without arms or back, sometimes with folding legs. The plural is *diphroi*.

DIP-OVERLAY See *flashed glass*.

DIPTERAL In Classical architecture, having two rows of columns along each side.

DIPTYCH A painting or relief on two adjacent panels.

DIRECT CURRENT An electric current that flows in one direction only. Less commonly used than *alternating current*.

DIRECTOIRE STYLE The neoclassical style of the French Directory, 1799–1804.

DISCHARGE PRINTING Textile printing technique involving the removal of color by bleaching agents.

DISK SANDER A sanding machine with a circular rotating disk of sandpaper or other abrasive, used for smoothing floors and other surfaces.

DISK-TURNING Flat circular turning used as furniture ornament.

DISTANT COLORS Colors that produce the feeling of space and appear to recede, particularly light tones of blue and purple.

DISTEMPER Opaque watercolor pigments.

DISTYLE Having two columns.

DOME A hemispherical vaulted roof similar to an inverted cup.

DOMINO WALLPAPER Wallpaper imitating marble graining, similar to that produced by the Dominotiers in France in the latter half of the sixteenth century.

DOMUS A Roman town house.

DONJON The massive tower that was used as a final stronghold in medieval castles. Usually located in the interior of a courtyard. Also called a *keep*.

DORIC ORDER The oldest and simplest Greek order of architecture, also used by the Romans.

DORMER WINDOW A projecting upright window that breaks the surface of a sloping roof.

DORSER A term of medieval origin meaning a fabric hanging between a wall and a piece of furniture.

DOS-À-DOS French term for a chair with two attached seats arranged so that they face in opposite directions. Also called a *tete-a-tete*.

DOSSERET A block, usually tapered, placed above a column capital to help receive the thrust of arches or vaults. Also called an impost block, a super-abacus, or a super-capital.

DOTTED SWISS See *Swiss*.

DOUBLE-HUNG SASH Window sash divided into two sliding sections, one lowering from the top and the other rising from the bottom.

DOUBLET A pair, or the duplication of an outline in a surface pattern, usually in a reverse form.

DOUGLAS FIR A western wood that resembles white pine in its physical properties, but has, in addition, a very handsome curly grain that makes it more suitable for natural or stained finish. It is strong and durable, works easily, and is adaptable to almost every type of use. It is, moreover, fairly inexpensive, being produced in great abundance, probably more than any other single species. There are several other species of fir, but they are of relatively little importance. It is used extensively for large plywood or laminated sheets.

DOU-GONG In Chinese architecture, the system of wooden brackets that supports the roof.

DOVETAIL In carpentry, a wedge-shaped projection on the end of a piece of wood used to interlock with alternating similar grooves or projections on another piece of wood. Joint used to join the front and sides of a drawer.

DOWEL In carpentry, a headless pin of metal or wood (or sometimes ivory) used to hold two pieces of wood together.

DOWNLIGHT A lighting fixture that directs light downward. It can be recessed in a ceiling plane or surface mounted.

DRAPE The ability of a fabric to hang gracefully.

DRAPERIES Fabric hangings over or beside a door or window. The term "drapes" is not considered professional usage.

DRAPS DE RAZ Synonym for *arras*.

DRAW CURTAIN A curtain that may be drawn along a rail or other support by means of a traverse arrangement of cords and pulleys.

DRAWNWORK A pattern made by drawing threads from both the warp and weft of a fabric.

DRESSED SIZES The finished dimensions of sawn lumber, smaller than *nominal* dimensions.

DRESSER A cabinet with drawers or shelves.

DRESSOIR A dining room cupboard for the display of fine *plate*. A *buffet*.

DREYFUSS, HENRY (1904–72) American industrial designer.

DRIER A chemical preparation added to paint that causes it to dry quickly.

DROMOS A monumental approach to an Egyptian temple; a Greek racecourse.

DROP-IN SEAT An upholstered or caned seat that can be lifted from the chair frame for reupholstering or repair, in use since the early eighteenth century.

DROP-LEAF TABLE A table with sections of the top that are hinged and can be lowered.

DROP-LID A top or front of a desk hinged at the bottom and arranged to fall back, forming a surface for writing.

DRUGGET An inexpensive fabric or *floorcloth* used under a dining table to protect a more valuable floorcovering beneath it. Sometimes called a *crumb cloth*.

DRUM Circular supporting wall for a dome. Also the cylindrical stones used to build up a column shaft. Any feature in cabinetmaking resembling this shape.

DRUM TABLE A drum-shaped table, usually with a three-footed base, and often with a leather top.

DRUMMER, JEREMIAH (1645–1718) Massachusetts silversmith.

DRY PIPE AUTOMATIC SPRINKLER SYSTEM A type of sprinkler system in which the pipes are normally filled with air or nitrogen, rather than water. Only when a fire is detected is the gas emitted and replaced with water.

DRY-POINT An etching made from a metal plate upon which a picture has been scratched with a sharp-pointed metal tool.

DRYWALL Common name for gypsum board or similar wall-surfacing material.

DUBOIS, RENÉ Cabinetmaker to Louis XV and Louis XVI, appointed *Maître Ébéniste* in 1755.

DUCHESSE A *chaise-longue*.

DUCHESSE-BRISÉE French term for a *chaise-longue* with separate footpiece.

DUCK A closely woven cotton fabric, sometimes called awning stripe or awning duck, of plain or ribbed weave. The stripe may be woven in, or painted or printed on one side only. Often given protective finishes against fire, water, and mildew. Similar to canvas.

DUMB-WAITER In eighteenth- and nineteenth-century England, a tiered table of circular surfaces cantilevered from a central support. In modern usage, a small elevator for carrying material (not people) from one level to another.

D'URSO, JOSEPH PAUL (B.1943) American interior designer and furniture designer in a minimalist style.

DUST RUFFLE Fabric ruffle extending to the floor from the bottom of a mattress cover, presumably keeping dust from gathering under the bed.

DYNASTY A succession of rulers, usually connected by family ties.

E

EAMES, CHARLES (1907–78) American furniture designer, product designer, exhibition designer, and filmaker.

EAMES, RAY KAISER (1915–88) Painter and designer, wife and partner of Charles Eames.

EARLY ENGLISH STYLE Term given to English Gothic architecture c.1170–1240, characterized by lancet windows. The style was followed by the *decorated* and then by the *perpendicular* styles.

EARTHENWARE Pottery of coarse clay.

EASTLAKE, CHARLES L., JR. (1836–1906) English architect and furniture designer. Advocate of Gothic revival. Wrote *Hints on Household Taste* in 1868.

ÉBÉNISTE French term used to designate a high-grade cabinet-maker. See also Maître Ébéniste and Menuisier.

EBONY A handsome dark heartwood of a tropical tree. Black ebony or gabon comes from Africa, is hard and heavy, takes a high polish, and is used for furniture and inlay. Macassar ebony is a coffee-brown wood with black streaks, and is used for modern furniture. Coromandel and striped ebony are names that are also applied to macassar ebony. Ebony is sometimes red or green.

ECHINUS An ovoid shaped molding forming part of a classical *capital*. It springs from the *shaft* of the column, just under the *abacus*.

ECLECTICISM The borrowing and combining of art forms of various past periods, adapting them to contemporary conditions.

ECRAN French term for screen.

ECRAN-À-CHEVAL French term for a frame with sliding panel used as fire screen.

EDGING A narrow decorative band around the rim of a piece of porcelain or other object. Also called *banding* or, in French, *filage*.

EDO Old Japanese name for Tokyo.

EGAS, ENRIQUE DE (D. 1534) Plateresco architect of the Spanish Renaissance, designed Holy Cross Hospital in Toledo (destroyed).

EGG-AND-DART An ornament used as a molding decoration, consisting of ovoid forms separated by dartlike points. See also *bead-and-reel*.

EGGSHELL FINISH A semi-flat paint finish, more lustrous than a *flat* finish, but less lustrous than *semi-gloss*.

EGYPTIAN FAÏENCE A glass-like ceramic made in ancient Egypt, characterized by its turquoise color.

ELECTRIC-DISCHARGE LAMP A type of lamp that produces light by sending an electric current through a vapor. Specific lamps of this type are sometimes named according to the vapor used, such as mercury-vapor lamp.

ELECTROPLATING An electrical process of coating base metals with a very thin surfacing of a more valuable metal.

ELERS, DAVID, AND JOHN PHILIP ELERS (FL.1686–1722) Two brothers of German descent active as potters in Staffordshire, England, in the last decade of the seventeenth century.

ELEVATION In drafting, the vertical projection of any object. The delineation of an object or surface from in front, in which the dimensions are at specified scale, and not foreshortened as seen by the eye. Specifically, a drawing of a wall to scale to show its length, height, and various subdivisions and ornament.

ELGIN MARBLES The sculptures of the pediments and friezes of the Parthenon, named after Lord Elgin, who was responsible for having them removed to the British Museum in London.

ELLIPTICAL ARCH An arch in the form of half an ellipse. See vocabulary box in Chapter 7.

ELM A strong and tough wood, with a less interesting figure than most other hardwoods. When treated with stain and polish, however, it makes a fine appearance. Because of its durability, it is used in large quantities for furniture, and its use for interior work might well be more extensive.

EMBOSSING A process of stamping, hammering, or molding a material so that a design protrudes beyond the surface.

EMBROIDERY The art of decorating a fabric with thread and needle. Its origin is a source of conjecture, but the form known today was developed in Italy during the sixteenth century. Handwork embroidery is little done today, and consequently most embroideries used in interior design antedate machine production.

EMPIRE STYLE French neoclassical style from the time of Napoleon's emperorship, 1804–15.

EMPIRE STYLE, SECOND See *Second Empire style*.

ENAMEL A colored glaze that is used to decorate metal and ceramic surfaces; it becomes hard and permanent after firing. A substance that, in intense heat, vitrifies and adheres to a metal backing. A paint that imitates such a surface. Enamel ware refers to objects whose surfaces are treated with this material.

ENCAUSTIC PAINTING A method of painting with pigments mixed with hot wax. The wax mixture may be heated and applied with a spatula or brush, or it may be applied to the surface first, and the designs drawn with a stylus.

ENCAUSTIC TILE A ceramic tile first popular in medieval times, then again in England beginning in the 1830s and in America beginning in the 1870s. It is inlaid with a clay of another color before firing.

ENCOIGNURE French term for a corner cabinet or table.

ENCRIER French term for an inkwell.

ENDIVE Decorative motif similar to a cluster of acanthus leaves, used in the Louis XIV period and by Thomas Chippendale.

ENFILADE A series of doors and/or windows aligned along a shared axis.

ENGAGED COLUMN A column attached to a wall.

ENGRAVING The process whereby a design is incised with a sharp instrument upon a copper or steel plate; also, the impression printed from this plate.

ENROULEMENTS DÉCOUPÉS See *strapwork*.

ENTABLATURE The surfaces and moldings of a classical order of architecture, consising of the *architrave*, *frieze*, and *cornice*, and forming the upper portion of the order. The portion of the order supported by the column.

ENTASIS The slight curve on the shaft of a column. In the Roman orders the entasis reduces the diameter of the shaft at the capital

to five-sixths the dimension of the diameter at the base. The curve is limited to the upper two-thirds of the shaft.

ENTRESOL French term for a *mezzanine* floor.

EPERGNE An ornamental stand for the center of a dining table, with branching arms holding several containers that can be used for flowers, candles, or food. It is sometimes written with an accent (*épergne*), but because it seems to be of English origin rather than French it is more properly written without.

ESCABELLE An early French Renaissance stool or chair supported on trestles.

ESCRITOIRE French term for a desk with drawers and compartments, one of the drawers having a hinged front that folds down to form part of a writing surface; such a drawer. See also *scrutoire*.

ESCUTCHEON A shield with a heraldic device. In hardware it refers to a shaped plate for a keyhole or to a metal door fitting to which a handle or knob is attached. Also seen as *scutcheon*.

ESPAGNOLETTE In furniture design, a female bust carved on the post supporting a cabinet or table top. Used in the Louis XIV, Louis XV, and Régence styles.

ESTER A chemical compound used in the production of modern textiles.

ESTRADO Raised platform or dais at one end of main living room in seventeenth-century Spanish houses.

ÉTAGÈRE French term for a unit of hanging or standing open shelves.

ETCHINGS Prints from a copper plate upon which a drawing or design has been made by a metal tool and bitten in by immersion in acid.

ETRUSCAN Pertaining to the civilization that occupied Italy before the Romans; or, more rarely, another name for the *Tuscan order*.

ETUI French term for a container or box.

EUCALYPTUS A pale reddish-yellow figured wood, much used in modern decoration and also in ship-building. It is also called oriental wood or oriental walnut.

EVALDE, MAURICE French (originally German) cabinetmaker, appointed *Maître Ébéniste* in 1765. He worked for Marie Antoinette and made a famous jewel cabinet for her.

ÉVENTAIL French term for a fan.

ÉVIDENCE Sixteenth-century French term for a *dressoir* or *buffet*.

EXEDRA A public room in Roman or Pompeian dwellings; a semicircular niche or apse, often with raised seats.

EXPORT WARES Products made for sale abroad, particularly Chinese and Japanese products meant for sale in Europe and America.

EXTRADOS The exterior curve of an arch.

F

FAÇADE A building face, often the most prominent or most richly ornamented.

FAÏENCE French term for a type of pottery made originally at Faenza, Italy. It is a glazed biscuit ware, and the name is now popularly applied to many such decorated wares. See also *Egyptian faïence*.

FAILLE A kind of fabric with a slightly heavier weft than warp, producing a flat-ribbed effect. It is often all silk and lusterless. Used for trimmings and draperies.

FAMILLE NOIRE, VERTE, JAUNE, ROSE, AND SO FORTH French names that designate particular types of Chinese pottery having a colored background. Translated, the words mean "black family," "green family," "yellow family," and "rose family."

FAN VAULTING Vaulting in the form of inverted half-cones with concave sides and ribs of equal length.

FASCES A Roman ornament consisting of a bundle of rods enclosing an axe, for the Romans a symbol of power.

FASCIA In architecture, a molding whose section consists of a vertical flat surface, Particularly the projecting crown molding of a *cornice*.

FAUCES In a Roman house, a narrow passage from the street to the *atrium*.

FAUTEUIL French term for an upholstered armchair with open arms.

FAUTEUIL À CHÂSSIS French term for an armchair constructed with a simply built wooden frame inside a more elaborately carved frame. The inner frame can be removed for reupholstering.

FAUTEUIL DE BUREAU French term for a desk chair.

FAUTEUIL EN GONDOLE French term for an armchair with a deeply rounded back.

FAUX French term for the imitation in one material of another; *faux-marbre*, for example, is the imitation of marble with paint or plaster, and *faux-satine* is the imitation of satin in some other fabric. Pronounced "foe."

FAVRILE GLASS Name given to much of the glass produced by Louis Comfort Tiffany, some of it iridescent.

FEDERAL STYLE American period of architecture and design, from the establishment of the federal government in 1789 to c.1830. The leading designer of the period was Duncan Phyfe.

FELT A material that is made by matting together and interlocking, under heat and pressure, woolen fibers, mohair, cowhair, or mixed fibers.

FENDER Metal guard placed in front of a fireplace to keep burning logs from rolling out.

FENESTRATION The arrangement of windows in a building.

FENG SHUI Literally meaning "wind and water," the Chinese art of propitious placement of buildings, building elements, furniture, and burial sites. Pronounced "fung shway."

FENTON, CHRISTOPHER (1806–60) Manufacturer of Bennington pottery.

FERROCEMENT Construction with sand, cement, and wire mesh, often used for thin shells.

FERROCONCRETE Construction with steel-reinforced concrete.

FERRONERIE VELVET Antique Venetian velvet made with patterns imitating delicate wrought iron forms.

FIBERGLASS Fine filaments of glass woven as a textile fiber. It has great strength, yet is soft and pliable, and resists heat, chemicals, and soil. It is used for curtains.

FIDDLE-BACK CHAIR An American Colonial rush-seated chair of the Queen Anne type, with the back splat silhouetted in a form approximating a fiddle or vase shape.

FIDER Acronym for the Foundation for Interior Design Education Research, the body that accredits schools of interior design in the United States and Canada.

FILAGE French term for *edging*.

FILET LACE A lace produced by embroidering a pattern on a fine net, usually in thread similar to that of the net. See *lace*.

FILIGREE Ornamental openwork in a delicate pattern. Usually refers to the pattern made by fine gold or silver wires or plates formed in minute lacelike tracery.

FILLER Threads that run crosswise of fabric from one selvage to another. Synonymous with *weft*.

FILLET In architecture, a molding whose section consists of a small vertical flat surface, usually used at the start or finish of a curved molding.

FINIAL An ornament used as a terminating motif. A finial is usually in the form of a knob, pineapple, or foliage.

FIR See *Douglas fir*.

FIREBACKS Metal linings, often ornamented and usually of cast iron, placed in a fireplace behind the fire to reflect heat and protect the masonry.

FIREHOUSE WINDSOR See *captain's chair*.

FIRESIDE FIGURES Wooden silhouettes painted to resemble royal personages, guards, pages, etc. Used as fire screens and fireplace adornment in Europe during the sixteenth and seventeenth centuries.

FIRING The term used in pottery manufacture to describe the heating of the clay in the kilns to harden it.

FIRST STYLE PAINTING First in a succession of four styles used in Roman wall painting. Employed in the second century B.C., the first style was noted for its imitation of marble and is also called the *incrustation style*.

FIVE-COLOR WARE Type of Chinese porcelain popular in the Ming dynasty.

FIXED FEE A method of payment for design services in which the fee is agreed upon before the work is done.

FLAMBOYANT French term meaning flamelike, used to designate the late Gothic style in France, because the window tracery was designed in reverse curved lines resembling conventional flamelike forms.

FLAME-STITCH A fabric pattern of repeated jagged lines in different colors, resembling flames. Also called *bargello stitch* and *Florentine stitch*.

FLANNEL Wool or cotton twilled fabric of coarse soft yarns, napped. The ends of the fibers are loosened by revolving cylinders covered with bristles. It is not a pile fabric. Used for interlinings.

FLAP TABLE See *drop-leaf table*.

FLASHED GLASS Clear glass coated with a film of colored glass.

FLAT GLASS Glass made in flat sheets, such as common window glass. Also called *broad glass*.

FLAT PAINT The dullest, least lustrous type of paint or enamel finish.

FLEMISH FOOT Furniture foot used in Flanders, England, and France during the seventeenth century.

FLEMISH SCROLL An S- or C-curved ornamental form, possibly of Spanish origin, but associated with Dutch and Flemish furniture design and used in England during the Restoration and William and Mary periods.

FLEUR-DE-LIS The conventionalized iris flower used by the former kings of France as a decorative motif symbolizing royalty.

FLEURY, ADRIEN French cabinetmaker who worked between 1740 and 1775.

FLEURY CROSS Greek cross with each arm ending in a form like a *fleur-de-lis*. See vocabulary box in Chapter 6.

FLOCKING OR FLOCK PRINTING The application of very short fibers (flocks) to the surface of a fabric or paper to produce a textured effect. The flocks are held on with adhesive and may be applied electrostatically in order to keep them erect. They may also be shot onto the surface or mixed with the adhesive. Flock wallpapers are sometimes made by scattering powdered wool over a pattern printed in varnish on paper sheets.

FLOOD OR FLOODLIGHT A lamp that casts a broad beam of light.

FLOOR LOAD The weight of elements supported by a floor, more commonly called a *live load*, and usually expressed (in the United States) in pounds per square foot.

FLOORCLOTH An eighteenth- and early nineteenth-century floor covering made of canvas or heavy linen, sized, and decoratively painted. Used frequently in entrance halls and dining rooms (like a *drugget*) to protect more expensive floor coverings underneath. In America, sometimes called an *oilcloth*. The German equivalent is called a *wachstuch-tapete*.

FLORENTINE ARCH A semicircular arch that springs directly from a Renaissance column capital or pier and is trimmed with an architrave molding. Usually seen in series.

FLORENTINE STITCH See *flame-stitch*.

FLUID PLAN Type of planning in modern architecture, in which one room opens into another with little division between them, and the whole may be thrown open into one large area, if desired. Also called *free plan* or *open plan*.

FLUORESCENT LIGHTING Lighting by means of electric-discharge lamps in which an arc of electricity passes through mercury vapor and phosphors, lining the tube, convert the resultant ultraviolet energy into light.

FLUSH In architecture, a term referring to any surface that is on the same plane or level as the surface adjoining it.

FLUTES OR FLUTINGS Parallel concave grooves that are used to ornament a surface. In classical architecture they are commonly seen on shafts of columns and run in a vertical direction. Spiral flutings are frequently used on furniture supports. Short flutings are used as a *frieze* ornament.

FLYING BUTTRESS In Gothic architecture, an arch springing from the wall of a building to an exterior stone pier, intended as a counterthrust weight to resist the thrust of the arched roof.

FLYING FAÇADE See *roof comb*.

FOLWELL, JOHN (ACTIVE LAST QUARTER OF THE EIGHTEENTH CENTURY) Cabinetmaker of the Philadelphia-Chippendale school, maker of the furniture for the Continental Congress. Called "the Chippendale of America."

FONTAINE, PIERRE-FRANÇOIS-LÉONARD (1762–1853) French architect and designer, whose association with Percier made them the leaders of the Empire style.

FOOTCANDLE A measurement of light, one footcandle being the amount of light on one square foot of surface one foot away from a candle. One footcandle equals one *lumen* per square foot.

FORESHORTENING In drawing or painting, a diminishing perspective applied to an object or figure.

FORM A stool or long bench without a back.

FORNASETTI, PIERO (1913–1988) Italian decorative artist.

FORTUNY, MARIANO (1871–1949) Innovative fabric designer in silks and stenciled cottons. Born in Spain, he worked in Venice.

FORTY WINK CHAIR Obsolete name for a *wing chair*.

FORUM In a Roman city, the area of general assembly.

FOURTH STYLE PAINTING Last in a succession of styles in Roman wall painting. Popular in the second half of the first century A.D., it is also called the *intricate style*.

FOX EDGE A stuffed fabric tube used as edging on upholstered furniture.

FRACTUR PAINTING Decorative birth certificates, marriage certificates, and the like made by Pennsylvania Germans during the eighteenth and nineteenth centuries.

FRANCIS I STYLE French Neoclassical style during the reign of King Francis I, 1515–47.

FRANK, JEAN-MICHEL (1895–1981) French interior designer and furniture designer.

FREE-BLOWN GLASS Glass blown into the air rather than into a mold.

FRENCH BURL A term applied to a walnut that comes from Persia. It has small warts or knots that form on the side of the tree when young, giving the lumber an interesting curly grain. It is much used for cabinetwork.

FRENCH HEADING A term used in curtain making to designate the gathering of a drapery or valence into folds at regular intervals near the top. The folds are sewed together in place so that they will have a regular appearance.

FRENCH SHAWL See *swag*.

FRESCO Method of painting on wet lime plaster with tempera or other lime-proof colors. The plaster absorbs the pigment, and when dry, the painting becomes hard and durable and a part of the plaster.

FRESQUERA Spanish term for an open-work hanging chest used for storing food.

FRET A Greek geometric band or border motif, consisting of interlacing or interlocking lines; also known as the *meander* or *key* pattern.

FRIEZE In architecture, the central part of the classical entablature, below the *cornice* and above the *architrave*; or a horizontal painted or sculptured panel; or a horizontal member beneath a table top.

FRIEZE RAIL See *picture rail*.

FRIGGER Glassmaker's term for any small object made from left-over materials.

FRINGE Trimming for draperies and upholstery. Threads on cords are grouped together in various ways and left loose at one end.

FRISÉ A pile fabric with uncut loops. The better quality is made with two sets of fillers to provide greater durability. Patterns are produced by cutting some of the loops, by using yarns of different colors, or by printing the surface. As it is used chiefly for upholstery, it is made of wool, mohair, or heavy cotton. The name is a French term meaning curled. Pronounced "free-zay."

FRIT A granular material obtained from heating the ingredients of glass, then shattering the results in cold water. Frit is a basic component of *enamel* and of some *glazes*.

FRITWARE White ceramic ware made of frit, crushed quartz, and white clay, popular as an imitation of porcelain.

FULCRUM The headboard of a Roman *lectus* or couch.

FULL-TONE A color of which the hue is near its full chromatic value.

FUMEUSE French term for a smoking chair, similar to a *cockfight chair*.

FURNESS, FRANK (1839–1912) American architect working in and around Philadelphia.

FURRING Building out from a surface by means of wood strips, metal channels, or other devices. A column or wall so built is said to be "furred out."

FUSTIAN Twill-weave cotton fabric with a pile like that of *velvet*.

FUSUMA-E Japanese paintings on sliding screens.

G

GABARDINE Hard-finished twill fabric, with a steep diagonal effect to the twill, which is firm and durable.

GABON Black ebony.

GABOON Soft African wood, light brown in color, used for plywood, interior work, and sometimes for furniture.

GABRIEL, JACQUES-ANGE (1698–1782) French architect of the Petit Trianon and Place de la Concorde under Louis XV.

GADROON Elongated ovoid forms placed in a parallel series and projecting beyond the surface they enrich. Sometimes spelled godroon and derived from the French *gadron*.

GAINE An ornament or support in the form of a square post tapering toward the lower portion. It is usually crowned with a head or bust and has ornamental human or animal feet.

GALLÉ, ÉMILE (1846–1904) French glassmaker and furniture designer in the Art Nouveau style.

GALLERY A miniature railing placed along the edge of a shelf or table top, specifically the gallery-top table.

GALLOON OR GALON A narrow close-woven braid used for trimming draperies and upholstery. A heavy *guimpe*.

GAMBARD, AUBERTIN French cabinetmaker in the services of the court at Versailles between 1771 and 1779, made *Maître Ébéniste* in 1779.

GARDE-ROBE In architecture, a privy in a medieval castle; in furniture, an *armoire*.

GARGOYLE A projecting stone waterspout grotesquely carved in fantastic animal or bird form. Used in Gothic architecture.

GARNIER, JEAN-LOUIS-CHARLES (1825–1898) French architect best known for his Paris Opera House and for the Casino at Monte Carlo.

GARNITURE French term for any motif used for enrichment.

GARNITURE DE CHEMINÉE A set of ornamental objects for the mantel or chimney-piece, sometimes consisting of three or five porcelain vases, sometimes of a central clock and flanking candlesticks.

GATE-LEG TABLE A *drop-leaf* table with rounded ends, its leaves supported by wing legs ("gates"). It originated in the Jacobean era and was popular in colonial America.

GAUDÍ I CORNET, ANTONÍ (1852–1926) Spanish architect and furniture designer, working in a highly idiosyncratic version of the Art Nouveau style.

GAUDREAU, ANTOINE ROBERT (1680–1751) Cabinet-maker who worked for the French court from 1726, on the Tuileries, and on the Bibliothèque Nationale. His name is sometimes spelled Gaudreaux.

GAUFFRAGE Decorative embossing of leather.

GAUGE A measure of thickness in sheet metal or metal tubing; the distance between rows of tufts in a tufted carpet; the diameter of a wire or screw; the exposed length of a roofing tile or shingle; a screed.

GAUZE Thin, transparent fabrics made of leno or plain weave or a combination of the two. Formerly made of all silk, it is now made of cotton, linen, wool, mohair, synthetic fibers, or combinations. Especially useful for *glass curtains*.

GAZEBO Turret on a roof of a small garden shelter usually built of latticework; the shelter itself.

GEHRY, FRANK O (B. 1929) American architect and furniture designer.

GENIE A creature of ancient folklore fashioned like man but having supernatural powers; an imaginary form resembling this creature, used as an ornamental motif.

GENRE French term for art that depicts the activities of the common people; also, a category of subject matter, such as landscape, still-life, portrait, and so forth.

GEORGIAN STYLE English neoclassical style during the period that begins with the crowning of King George I and ends with the Regency, 1714–1811.

GESSO A prepared plaster of chalk and white lead that may be cast to make repeating ornamental forms in relief to be applied to wood panels, plaster surfaces. It is also used as a base coat for decorative painting on picture frames, small wooden objects.

GHIORDES KNOT A symmetrical knot used in carpet making. Also called a *Turkish knot*.

GIBBONS, GRINLING (1648–1720) English wood-carver and sculptor.

GIBBS, JAMES (1682–1754) English architect and furniture designer. Published architectural designs in book form. Follower of *Wren*.

GILBERT, CASS (1859–1934) American eclectic architect, best known for his Woolworth Building, New York, 1913.

GILDING Surface decoration in gold by any of several techniques, although the term is sometimes used for surface decoration in other metals.

GILLOW, RICHARD AND ROBERT (ACTIVE 1740–1811) English cabinetmakers in Lancaster (and later in London) who shipped much furniture to the British colonies in the West Indies. Robert Gillow (1701–73) was the father of Richard; another of his sons, Robert, was also a cabinetmaker.

GIMP See *guimpe*.

GIMSON, ERNEST (1864–1919) English designer of the Arts and Crafts style.

GINGHAM A lightweight, yarn-dyed cotton material, usually woven in checks or stripes. Useful for trimmings, draperies, and bedspreads.

GIRANDOLE French term for a type of branching chandelier, a wall mirror to which candle brackets are attached, or a wall sconce for candles.

GIRARD, ALEXANDER (1907–93) American architect, interior designer, and textile designer.

GIRARDON, FRANÇOIS (1628–1715) French sculptor whose work is at the Grand Trianon, Versailles, and the Louvre.

GIRDER A heavy beam used over wide spans and often supporting smaller beams or joists.

GLASS CAMEOS A type of *flashed glass* imitating carved onyx.

GLASS CURTAIN Curtains hung next to the glass of a window, usually sheer and translucent, often partially covered with heavier draperies.

GLAZE In painting, a transparent layer of color that modifies but does not completely obscure the layer beneath; in pottery, a durable, glossy finishing layer.

GLOSS PAINT Paint or enamel with the most lustrous finish.

GOBELINS Important French decorative arts factory during the late seventeenth and eighteenth centuries, best known for its fine tapestries.

GODDARD, JOHN (1723–85) Prominent member of a family of cabinetmakers in Newport, Rhode Island.

GÖGGINGEN A German ceramics factory active 1748–54.

GOLD SIZE An adhesive substance painted on a surface to which gold leaf is to be applied.

GOLDEN SECTION A proportion based on the division of a rectangle into two parts, with the ratio of the whole to the larger part being the same as the ratio of the larger to the smaller. It is the basis for many proportioning systems, including Le Corbusier's *Modulor*.

GONDOLA-BACK CHAIR A chair of the Louis XV style with a rounded back that continued to form the arms.

GOODHUE, BERTRAM GROSVENOR (1869–1924) American architect. His buildings include the Byzantine-style St. Bartholomew's Church, New York, 1919, and the Nebraska State Capitol, Lincoln, 1922.

GOODISON, BENJAMIN (D. 1767) English cabinetmaker of the early Georgian period, supplier of furniture to royalty between 1727 and 1767.

GOOSENECK LAMP Light fixture on a flexible stem.

GÖPPINGEN A German ceramics factory active 1741–78.

GOPURAM The monumental gateway to a Hindu temple; a lofty tower form that developed from such a gateway.

GOSTELOWE, JONATHAN A Philadelphia cabinetmaker who produced furniture in the Chippendale style during the last half of the eighteenth century.

GOTHIC The style of art and architecture prevalent in northern Europe from the twelfth to the sixteenth century.

GOUACHE An opaque watercolor pigment, or any picture painted in this medium.

GOUJON, JEAN (1510–66) French architect and sculptor who worked on the Louvre.

GOUTHIÈRE, PIERRE (1740–1806) French *ciseleur* and metal sculptor, who made *ormolu* mounts, ornaments, and lighting fixtures.

GOVERNOR WINTHROP DESK An early American desk with an upper cabinet, three or four drawers below, and a hinged panel that opens to form a writing surface. It is named for the first governor of Massachusetts, John Winthrop, but it was probably not in use until after Winthrop died.

GOYA Y LUCIENTES, FRANCISCO DE (1764–1828) Aragonese realistic artist and tapestry designer. Portrayed scathing and macabre scenes of Spanish life.

GRAFFITO WARE Ware of heavy pottery decorated with a roughly scratched design.

GRAIN The direction of fibers in wood or stone; in fabric, the direction parallel to the *selvages*.

GRAINING A painted imitation of the fiber lines of wood.

GRANDFATHER CLOCK Lay term for a *long-case clock*.

GRANITE Granular crystalline rock of quartz, feldspar, and mica. The hardest and most durable building stone.

GRAVES, MICHAEL (B.1934) American architect and table-ware designer in the postmodern style.

GRAY, EILEEN (1878–1976) Architect, interior designer, and furniture designer. Born in Ireland; worked mainly in Paris.

GREAT HALL The large, two-storied central hall of a medieval castle, used principally for dining and entertaining.

GREATBACH, DANIEL (ACTIVE 1839–60) Designer of Bennington pottery.

GREEK CROSS A cross formed of two bars of equal length meeting at right angles. See page 147.

GREEK KEY ORNAMENT See *fret*.

GREEN CHAIR An eighteenth-century American Windsor chair, often painted green.

GREENE, CHARLES SUMNER (1858–1957) AND HENRY MATHER GREENE (1870–1954) American architects, brothers and partners in a practice that produced notable buildings and furniture designs in an elegant, personal version of the *arts and crafts* style.

GREENOUGH, HORATIO (1805–1852) American sculptor who first remarked that the design should be based on the function of the object and the possibilities of the material from which it is made.

GRENADINE *Leno* weave fabric like *marquisette*, but finer. Plain or with woven dots or figures.

GRENDEY, GILES (1693–1780) London cabinetmaker of the Georgian period, and exporter of furniture on a considerable scale. His furniture was of a simple, domestic type, much of it *japanned*.

GRÈS French term for stoneware.

GRISAILLE French term for decorative painting in which objects are rendered in tones of one color, usually gray. Often intended to give the effect of sculptured relief panels.

GROIN VAULT See *vault*.

GROPIUS, WALTER (1883–1969) German architect and founder (in 1919) of the *Bauhaus*.

GROSGRAIN Ribbed or *rep* silk produced by weaving heavier *filler* threads so that they are covered with close, fine *warps*. Used for ribbons and draperies.

GROSPOINT See *needlepoint*.

GROSS FLOOR AREA Total floor area of a space or building, measured from the inside faces of its exterior walls and including circulation, interior wall thicknesses, interior columns, elevators, mechanical shafts. See also *net floor area*.

GROSSO, NICCOLÒ (FL. C.1500) Italian Renaissance ironsmith.

GROTESQUES In ornament, fanciful hybrid human forms, animals, and plants. In art, a combination of fanciful vegetation and fantastic human and animal forms, popular in ancient Rome and again in the Renaissance.

GROUT A mortar with a soupy consistency, used for setting tiles.

GUADAMACILERIA Spanish term for decorated leather produced by the Moors in Cordova, Spain, and elsewhere.

GUARANTEED MAXIMUM COST Also called an *upset price*. A cost limit that may be agreed upon in combination with another payment plan, such as an hourly fee.

GUAS, JUAN AND ENRIQUE (FIFTEENTH CENTURY) *Plateresco* architects of the Spanish Renaissance, perhaps of French origin.

GUÉRIDON In traditional usage, a small ornamental table, pedestal, or candlestand, a *torchère*. In modern usage, a serving table in a restaurant.

GUERITE A chair with a hooded top.

GUILLEMART, FRANÇOIS (D. 1724) French cabinetmaker, active under Louis XIV and the regency, appointed *Maître Ébéniste* in 1706. Built two commodes for the king's room at Marly.

GUILLOCHE In ornament, a band or border running pattern having the appearance of overlapping or interlacing circular forms.

GUIMARD, HECTOR (1867–1942). French architect and furniture designer in the *art nouveau* style. His best-known works are his entrances to the Métro stations in Paris.

GUIMPE Narrow fabric, with a wire or heavy cord running through it, used for trimming furniture, draperies, etc., as an edging. Often used to cover upholstery nails. Also spelled guimp or gimp.

GUL A geometric emblem used in Islamic carpet patterns.

GUM See *Red gum*.

GUTTAE Cone-like ornaments beneath the *mutules* of a Greek Doric order.

GWATHMEY, CHARLES (B.1938) Partner with Robert Siegel in the architecture firm of Gwathmey-Siegel.

GYPSUM A soft mineral consisting of hydrous calcium sulfate, it is used in *plaster of Paris, gypsum board*, and gypsum plaster. It is also used to retard the curing of Portland cement.

GYPSUM BOARD A wallboard with a gypsum core and paper facings, much used for the faces of interior partitions. A trade name is Sheetrock, and common names are *plasterboard* and *drywall*.

GYPSUM PLASTER Often the base coat in plaster, a substance of gypsum, water, and aggregate.

H

HADLEY CHEST A type of Early American New England-made chest that stood on four feet, usually had one drawer, and was decorated with crude incised carving. Also called a *Connecticut chest*.

HAIG, THOMAS English cabinetmaker, partner of Thomas Chippendale.

HAIR CLOTH A kind of cloth with cotton, worsted, or linen warp and horsehair filler. It is woven plain, striped, or with small patterns and is manufactured in narrow widths. As it is very durable, it is used for upholstery. It was popular during the mid-nineteenth century in England and America.

HALF JOINT A joint between two wood members in which the end of one is cut in half to provide a fit. See figure 2–26.

HALF-TIMBER A type of house construction in which heavy wooden posts and beams form the skeleton of the structure. The area between them is filled in with brick, stone, or plaster.

HALFPENNY, WILLIAM (D.1755) English architect, influential in popularizing the Chinese taste in architecture and decoration.

HALFTONE A color that in tonal value is approximately halfway between white and black; a photoengraving process in which the image is rendered in a pattern of tiny dots.

HALLETT, WILLIAM (1707–1781) Popular English cabinetmaker under George II.

HALLMARK The mark or marks that designate that a piece of metalwork has received an official approval of quality, particularly the approval issued by Goldsmith's Hall, London.

HALL TREE A floor-standing coat rack, often placed in a front hall.

HALOGEN LIGHTING See *tungsten-halogen lighting*.

HAMMER-BEAM TRUSS A form of roof support used during the early English Renaissance. It consists of a *Tudor arch* form in wood, each end of which rests on a large wooden bracket.

HAMPTON, MARK (1940–98) American interior designer.

HAN DYNASTY Chinese dynasty, 206 B.C.–A.D. 220.

HAND The tactile property of a fabric.

HANDKERCHIEF TABLE A folding table popular in the seventeenth century. Folded, its top was triangular and it was stored in a corner; unfolded, its top was square.

HANDS OF FATIMA Hand-shaped decorative motifs woven into Islamic prayer rugs.

HARD PASTE Name used to identify hard-bodied or true *porcelain*, made of *kaolin*, or *China clay*.

HARDOUIN-MANSART See *Mansart*.

HAREWOOD Its common name is English sycamore. It has a fine cross-fiddle figure and is much used for cabinetwork, particularly after it has been dyed a silver gray. Also called silverwood or airwood.

HARLAND, THOMAS (1735–1805) Organizer of the clock-making industry in Norwich, Connecticut.

HASSOCK A heavy cushion or thick mat used as a footstool.

HAUSMALEREI Pottery made in Germany by independent artists and amateurs, who decorated partially fired pieces and returned them to the kiln for glazing and further firing.

HAUT-RELIEF See *relief*.

HEDDLE In weaving, the bar of a loom that separates groups of *warp* threads to allow passage of the *weft*. Looms are sometimes classified as single-heddle or double-heddle types.

HEISEY GLASS Glass manufactured in the late nineteenth century by the A. H. Heisey Co. in Ohio.

HELLENISTIC Period of Greek art under Alexander (third century B.C.) when the center of culture moved to Alexandria from Athens. The period, which was characterized by extreme realism and theatricalism, lasted until Greece became a Roman colony.

HEMLOCK A wood seldom used for finish, particularly in the eastern United States. The western hemlock, however, is a far better wood than the eastern variety and can be used for finish wherever strength, lightness, and ease of working are desirable. It greatly resembles white pine and may be used in a similar manner.

HEPPLEWHITE, GEORGE (D. 1786) Famous English cabinetmaker. His *Cabinet-Maker's and Upholsterer's Drawing Book* was published in 1788 and revised the following year. He produced satinwood and inlaid furniture in the classical style. No authentic pieces of his are known to remain.

HERATI A floral motif on Islamic carpets.

HERRERA, JUAN DE Spanish Renaissance architect of the Escorial (1575–1584) and protagonist of the *Desornamentado* style.

HERRINGBONE A *zigzag* pattern.

HERTER BROTHERS American furniture designers and manufacturers prominent in the last half of the nineteenth century.

HERTZ A measure of frequency, meaning cycles per second. Sometimes spelled herz.

HEURTAT, NICOLAS (B.1720) Parisian furniture maker, appointed *Maître Ébéniste* in 1755.

HEX SIGN A good luck symbol often placed on the exterior of buildings by the Pennsylvania Germans. It is usually in the shape of a circle, enclosing a six-pointed star or other motif.

HEXASTYLE A building or building element with six columns.

HICKORY An American tree of the walnut family. Its wood is hard, tough, and heavy and is not used for decorative purposes.

HICKS, DAVID (1929–98) English interior designer.

HICKS, SHEILA (B.1934) American textile designer.

HID Acronym for high-intensity discharge.

HIERATIC An abridged form of hieroglyphics, used by the Egyptians, and reserved for religious writings.

HIEROGLYPHICS A system of writing used by the Egyptians, consisting of a combination of picture-writing and phonetic indications.

HIGH-INTENSITY DISCHARGE LAMP A type of lamp that includes the mercury, metal halide, and high-pressure sodium lamps.

HIGHBOY A tall chest of drawers supported by legs and usually crowned with cornice moldings or a pediment.

HIGH DADDY Eighteenth-century American term for a tall chest with six or more drawers in graduated sizes.

HIGH RELIEF See *relief*.

HIKING Distortion of a fabric due to swelling and shrinking as humidity changes.

HISPANO-MAURESQUE The term used to designate Spanish art productions that show an influence of both Moorish and Renaissance origin. Sometimes spelled Hispano-Moresque.

HITCHCOCK, LAMBERT (1795–1852) Connecticut furniture designer, noted for his Hitchcock chairs, wood chairs with rush seats, usually painted black and stenciled with gold fruit and flower decoration.

HOADLEY, SILAS (1786–1870) Clockmaker and partner of Eli Terry.

HO-NO-KI Japanese name for magnolia wood.

HOBAN, JAMES (1762–1831) American architect who designed the state capitol in Columbia, South Carolina, and the White House in Washington.

HOFFMANN, JOSEF (1870–1956) Austrian architect and designer, a pioneer of the modern style.

HOLLAND, HENRY (1740–1806) English interior designer and architect.

HOLLY A light-colored, fine-grained wood used for *marquetry*.

HOM Assyrian tree-of-life pattern.

HOMESPUN A term applied generally to handloomed, woolen textiles. It is also a trade name given to imitations made on power looms. Useful for curtains and upholstery in informal settings.

HONEYCOMB WORK See also *muqarnas*, *stalactite work*.

HONEYSUCKLE A decorative motif of Greek origin resembling a conventionalized fanlike arrangement of petals.

HONGMU A Chinese furniture wood.

HOOKED RUG A pile-surfaced rug made by pushing threads or strips of cloth through a canvas backing. By varying the colors of the pile, any pattern can be made.

HOPE, THOMAS (1770–1831) English cabinetmaker, designer of furniture in Regency style.

HORSESHOE ARCH An arch whose total curve is greater than a semicircle. Used in Moorish and Spanish architecture.

HORTA, VICTOR (1861–1947) Belgian architect, interior designer, and furniture designer in the Art Nouveau style.

HORTUS The rear garden of a Roman house..

HOTELLING A type of office design in which workspaces are temporarily assigned.

HSIA DYNASTY Ancient Chinese dynasty, once thought to have been legendary, now thought to have actually existed prior to 1766 B.C.

HUANGHUALI Chinese term for a fragrant rosewood used for furniture.

HUCHE French term for a hutch or chest.

HUE A color itself, as red or blue. Many tones of the same hue are possible. A tint is a hue with white added, and a shade is a hue with black added.

HUET, CHRISTOPHE (D. 1759) French decorative painter at the court of Louis XV.

HUET, JEAN-BAPTISTE (1745–1811) French designer of *toiles de Jouy* for Oberkampf and wallpaper for Reveillon.

HUFFELÉ, LAMBERT (D. 1766) French cabinetmaker appointed *Maître Ébéniste* in 1745. He was a collaborator of André Charles Boulle, the son of the famous *ébéniste* of Louis XIV.

HUMANISM Intellectual trend of the Renaissance, away from the study of theology and towards the study of human activities.

HUNT TABLE A crescent-shaped table, sometimes with drop leaves.

HUTCH A chest, the most common piece of furniture in the Gothic household.

HVAC Acronym for heating, ventilating, and air conditioning.

HYDRIA A Greek water jar with three handles.

HYPOSTYLE HALL A large room with its roof carried on many columns.

HZ Abbreviation for *hertz*.

I

ICON Portrait or image. In the Greek and Russian church, an image of a saint or sacred personage. Sometimes spelled ikon.

ICONOSTASIS In Byzantine churches, a screen, decorated with *icons*, that divides the *bema* from the *naos*.

IDEALISM The tendency in art to express universal or spiritual concepts.

IDEC Acronym for the Interior Design Educators Council.

IIDA Acronym of the International Interior Design Association.

IKAT A flat-weave textile, often patterned with resist dyeing techniques.

IKEBANA The most prominent Japanese school of flower arranging.

ILLUMINATION Hand decoration of manuscripts in color and gold and silver. Practiced to a great extent by monks in the monasteries in the Middle Ages.

IMARI WARE Japanese porcelain, often gilded and enameled.

IMPERIAL CARPET See *three-ply carpet*.

IMPLUVIUM In the *atrium* of a Roman house, the basin set into the floor that catches the rain falling through the *compluvium*.

IMPOST A feature or structural member upon which an arch rests. The level of the top of such a member is called the impost line, and a transitional sculptural block, usually tapered, at this level is called an impost block. In most arches, the impost line coincides with the spring line; exception is a *stilted arch*.

IMPOST CAPITAL In Byzantine architecture, a column capital shaped like the base of an upside-down pyramid, similar to an *impost block*.

IN ANTIS Between antae. See *anta*.

INCANDESCENT LAMP Popular category of lamp in which a filament (most commonly, tungsten) is heated by an electric current until it becomes incandescent. See also *fluorescent lighting* and *tungsten-halogen lamp*.

INCE, WILLIAM (ACTIVE 1758–1810) English cabinetmaker, follower of Chippendale, and partner of John Mayhew, with whom he published *The Universal System of Household Furniture* (1759–1763).

INCISED Cut into; said of a pattern or carving produced by cutting into a stone, wood, or other hard surface. The reverse of a relief carving, the pattern of which projects from the surface or background. Incised engraving is called *intaglio*.

INCRUSTATION STYLE See *first style painting*.

INDIA PRINT A printed cotton cloth made in India or Persia, with clear colors and designs characteristic of each country. The many colors are printed on a white or natural ground. Useful for draperies, bedspreads, wall hangings, and so forth.

INDIAN HEAD Permanent-finish cotton, smooth and lightweight. Colors are vat-dyed and guaranteed fast. Shrinkage is reduced to a minimum. Originally the trade name for a cotton *crash* made since 1831 by the Nashua Manufacturing Co.

INDIENNE French interpretation of the Indian printed cottons that were being imported into France in the late seventeenth century and during the eighteenth century. French designers produced them to supply the demand for this type of fabric at a lower cost than that of the imported originals.

INDIRECT LIGHTING Lighting in which all or most of the light is directed toward a ceiling or other surface from which it is reflected toward the viewer.

INDISCRET French term for a settee formed of three linked armchairs in a spiral arrangement, popular during the Second Empire.

INFRARED LIGHT Light with wavelengths longer than those of visible light and with lower temperature than visible light. See also *ultraviolet light*.

INGRAIN A flat-woven wool or wool-and-cotton carpet with a *Jacquard* design; usually reversible. See *two-ply carpet*.

INLAY Ornament or a pattern that is produced by inserting cut forms of one material into holes of similar shape previously cut in another material. The contrast of materials or colors produces the effect as well as the design of the cutting. Strictly speaking, *marquetry* is not inlay work, as both pattern and field are cut at the same time from a thin veneer. The inlaying of precious metals into base metals is called *damascening*.

INSULA A Roman apartment building.

INTAGLIO Incised or countersunk decoration, as opposed to relievo decoration, which is in *relief*.

INTARSIA An Italian type of wood *inlay* often used for the carvings of choir stalls.

INTRADOS The interior curve or *soffit* of an arch.

INTRICATE STYLE See *fourth style painting*.

IONIC ORDER One of the classical orders of architecture. The characteristic feature of the capital of the column is the spiral-shaped *volute* or scroll. The standard proportion of the Roman column is 9 diameters high.

IRISÉ See *rainbow paper*.

IRONSTONE A hard, opaque English stoneware imitating porcelain.

ISINGLASS A translucent glass substitute made from mica or from animal gelatins.

ISOMETRIC DRAWING A type of axonometric drawing in which the horizontal lines of the subject are represented by lines drawn at 30 and 60 degrees from the horizontal.

ISOZAKI, ARATA (B.1931) Japanese architect and designer.

ITTEN, JOHANNES German-Swiss design educator and color theorist, an instructor at the Bauhaus.

IZNIK WARE The most famous of Islamic ceramics and ceramic tiles, made from the end of the fifteenth century in blue-and-white patterns and later with red, green, and turquoise added.

J

JABOT Fabric at the sides of a swagged valance. Also called *tails*.

JACARANDÁ Brazilian *rosewood*.

JACOB, GEORGES (1739–1814) One of the most famous cabinetmakers of France, active during Louis XVI, Directoire, and Empire periods. Appointed *Maître Ébéniste* in 1784.

JACOB-DESMALTER, FRANÇOIS HONORÉ (1770–1841?) The son of Georges Jacob, very active as a cabinetmaker, in business with his older brother during the Empire period. Made furniture for Percier and Fontaine.

JACOBEAN The period in English history from 1603 to 1649, covering the reigns of James I and Charles I; the art, architecture, and ornament of that period.

JACOBSEN, ARNE (1902–71) Danish modern architect, furniture designer, and product designer.

JACQUARD, JOSEPH-MARIE (1752–1834) Inventor of the Jacquard attachment for producing colored woven patterns in machine-made textiles.

JACQUARD LOOM A mechanical loom type introduced by Joseph-Marie Jacquard in 1801.

JACQUEMART AND BENARD French wallpaper manufacturers, successors to *Reveillon*, 1791–1840.

JADE An imprecise term for various hard stones used in decorative carving. Two types are nephrite (a calcium-magnesium silicate) and jadeite (a sodium-aluminum silicate).

JALE In Indian architecture, a perforated screen or lattice. Sometimes spelled jalee.

JALOUSIE A slatted window blind.

JAMB The vertical side of a door or window frame.

JAPANNING A process, much used in the eighteenth century, by which furniture and metalwork were enameled with colored shellac and the decoration raised and painted with gold and colors.

JARDINIÈRE French term for a plant container. Pronounced zhar-deen-yare.

JARDINIÈRE VELVET A silk velvet with a multicolored pattern resembling a flower grouping set against a light background. The weaving is most intricate, as there may be several heights of velvet and uncut loops set against a damask or satin background. Originally made in Genoa.

JASPÉ A streaked or mottled effect in a fabric, produced by uneven dyeing of the warp threads. The name is derived from its resemblance to the mineral jasper. Pronounced zhas-pay.

JASPER An opaque variety of quartz that may be bright red, yellow, or brown.

JASPER WARE A name given by Wedgwood to a type of hard biscuit ware that he introduced in the late eighteenth century.

JEFFERSON, THOMAS (1743–1826) President of the United States and father of the classic revival in the United States. Designed Monticello (his own house) and the University of Virginia.

JENSEN, GEORG (1866–1935) Danish sculptor, ceramicist, and metalsmith.

JICHIMU Chinese furniture wood.

JOHNSON, PHILIP (B.1906) American architect.

JOHNSON, THOMAS (1714–C.1778) English author of books of eccentric and fanciful designs for carvings.

JOINERY The craft of assembling woodwork by means of mortise and tenon, dovetail, tongue and groove, dowels, and so forth.

JOIST A horizontal timber used to support a floor or ceiling.

JONES, INIGO (1572–1653) English Renaissance architect, responsible for the introduction into England of the Palladian style.

JONES, OWEN (1809–74) English architect, designer, and writer. Author of *The Grammar of Ornament*, first published in 1856, and *Examples of Chinese Ornament* (later called *The Grammar of Chinese Ornament*) in 1867.

JOUBERT, GILLES (1689–1775) French cabinetmaker renowned for small furniture, such as tables and secretaries, ornamented with wood inlay. Date of appointment as *Maître Ébéniste* not definitely established, but probably around 1749. Employed at court from 1748.

JUDAICA Objects related to Jewish religion or life.

JUGENDSTIL In German, literally, "youth style." The German version of *Art Nouveau*.

JUHL, FINN (B.1912) Danish architect and furniture designer.

JUNCTION BOX In electrical wiring, a box protecting a junction of cables.

JUTE A subtropical plant fiber used for carpet backing or for coarsely textured rugs.

JUVARRA, FELIPE (ORIGINALLY FILIPPO) Eighteenth-century architect, pupil of Bernini. Worked in Turin, and was called to Spain to design the Royal Palace.

K

KD Abbreviation for knockdown, a term applied to furniture that is shipped in pieces that must later be assembled. See also *package furniture*.

KACHINA North American Indian doll-fetish.

KAHN, LOUIS I (1901–74) American architect.

KAKEMONO A Chinese or Japanese painting, mounted on brocade and hung on the wall without a frame. A print imitating such an art work is called a kakemono-e.

KAKIYEMON, SAKAIDA (1596–1666) A Japanese painter and pottery artist who developed the use of colored enamel designs on Japanese porcelain. The name is also applied to decorations inspired by his works. His name is also spelled Kakiemon.

K'ANG A Chinese sofa

K'ANG HSI PORCELAIN Chinese porcelain made during the reign of the *Ch'ing dynasty* emperor K'ang Hsi (1662–1722). Wares include *blue and white*, *famille verte*, and *famille jaune*.

KANTHAROS A Greek drinking cup.

KAOLIN A white clay used in the manufacture of true *porcelain*, sometimes called *China clay*.

KAPOK A filling material used for stuffing upholstery and pillows.

KAS Dutch term for a cupboard or wardrobe.

KAUFFMAN, ANGELICA (1741–1807) Swiss decorative painter of furniture and interiors who worked in England. She was married to Antonio Pietro Zucchi.

KAUFMANN, EDGAR, JR Scholar of the history of architecture and decorative arts; curator of the *Good Design* exhibitions at the Museum of Modern Art, New York, in the 1950s.

KEEP See *donjon*.

KENT, WILLIAM (1685–1748) English architect, collaborated with his patron the Earl of Burlington in the design of Chiswick House. He was also a painter, landscape gardener, and furniture designer.

KENTE Ceremonial cloth woven in strips by the people of Ghana. Once used as clothing only by kings and important chiefs, it is now in common use on special occasions; once made only of silk, it is now sometimes made of synthetic fibers.

KETTLE BASE Synonym for *bombé*.

KETTLE STAND A stand or small table to hold a hot-water kettle for making tea or coffee. Popular in England in the eighteenth century.

KEY ORNAMENT See *fret*.

KEYAKI A Japanese wood, also known as *zelkowa*.

KEYSTONE The wedge-shaped central stone at the top of an arch.

KHAKI A heavy cotton twill fabric of an earthy color. The name is derived from a Hindu word meaning dust.

KIBOTOS In ancient Greece, a wooden storage chest.

KIDDERMINSTER CARPETS Carpets of the two-ply or ingrain type, made at the Kidderminster factory near Birmingham, England, beginning in the early eighteenth century. Popularly called *Scotch carpets*.

KIERSTEAD, CORNELIUS (ACTIVE DURING THE SEVENTEENTH CENTURY) Dutch silversmith who worked in New York and New Haven and was noted for his tankard designs.

KILIM Sometimes spelled khilim, khelim, or kelim. A double-faced rug without nap or pile, usually with hard-twisted wool filling and with a decorative geometric pattern.

KING-SIZE BED A large double bed, generally 72 inches to 78 inches wide and 76 to 84 inches long.

KINGWOOD A dark brown wood with black and golden yellow streakings. It comes from Sumatra and Brazil and is a fine cabinetwood.

KIRI A Japanese wood, also known as paulownia.

KIVA A ceremonial chamber in prehistoric structures of the American Southwest.

KJAERHOLM, POUL (1929–1980) Danish furniture designer.

KLEE, PAUL (1879–1940) Swiss painter and instructor at the *Bauhaus*.

KLINE A Greek bed. The plural is *klini*.

KLINIUM A sofa (*lectus*) in the Roman dining room (*triclinium*). Also called a *lectus tricliniaris*.

KLISMOS A Greek type of chair having a concave curved back rail and curved legs.

KNEEHOLE DESK Desk with a solid lower portion but with an opening for the knees of the person seated at it.

KNEE-KICKER A tool used in fastening carpet to a tackless strip.

KNOCK-DOWN FURNITURE OR KD FURNITURE Furniture sold as a kit of parts that the buyer must assemble. The English term is *package furniture*.

KNOLE SOFA A sofa, similar to one made in 1610–20 for the country house called Knole in Kent. It has arms that can be lowered to convert it into a daybed.

KNOLL ASSOCIATES American furniture company founded in 1938.

KNORPELWERK German term for *auricular style*.

KNOT-WORK Decorative motif typical of Celtic art, incorporating ribbon-like elements elaborately interlaced.

KNOTTED RUG An Oriental rug weave in which the surface or pile is formed by the ends of threads knotted around the warps, the weft threads serving merely as a binder.

KONDO In Japan, the chief room of a Buddhist monastery.

KORINA A wood resembling *primavera*, and having a light yellow color. Used for wall veneers.

KORYO One of the great periods of Korean history, beginning in the tenth century and ending in 1392. Along with the *Yi*, it constituted Korea's "golden age."

KRAAK PORCELAIN Chinese blue and white porcelain made for export to the Netherlands.

KRATER A wide-mouthed, two-handled bowl used by the Greeks for mixing wine and water.

KUFT WORK In India, the name for *damascening*.

KURAMATA, SHIRO (1934–1990) Japanese furniture designer and interior designer.

KURI Japanese term for chestnut wood.

KUWA The Japanese term for the wood known in the West as white mulberry.

KWABORNAMENT Dutch term for *auricular style*.

KYLIN A chimerical beast often used in Chinese decoration.

KYLIX A flat-shaped Greek drinking cup on a slender center foot.

L

LAC A resinous fluid secreted by an insect, an ingredient of *shellac*.

LACCA CONTRAFATTA Italian term for imitation lacquer work popular in the eighteenth century.

LACE An openwork textile produced by needle, pin, or bobbin by the process of sewing, knitting, knotting (tatting), or crocheting. Real lace is a handmade product, but in the late eighteenth century, machines were invented to imitate the hand productions. Probably first made in Greece, lace enjoyed a great revival in Renaissance Italy, particularly in Venice. Among the principal types are:
- *Brussels*, of several varieties
- *filet*, embroidered on a net
- *Irish*, principally of the crocheted type, although the *Limerick* variety is made on a net and the *Carrickmacross* variety is cut work
- *Nottingham*, a general term used for machine-made productions, particularly inexpensive lace curtains made in one piece
- *reticella*, a combination of drawn and cut work
- *Valenciennes, Cluny, Duchesse*, and *Chantilly*, elaborate bobbin-made patterns in which the ornament and fabric are identical

LACQUER Specifically, a hard varnish obtained from the sap of the lacquer tree (an Asiatic sumac), the base of Chinese and Japanese lacquer; more generally, any varnish or shellac dissolved in alcohol.

LADDER BACK A chair having a ladder effect produced by the use of a series of horizontal back rails in place of a splat.

LADYCHAPEL The most revered and elaborately decorated chapel at the east end of a cathedral, dedicated to the Virgin.

LAFARGE, JOHN (1835–1910) American stained glass artist.

LAKE A type of pigment, the result of combining a dye and a *mordant*.

LALIQUE, RENÉ (1860–1945) French glass artist and jeweler in the Art Nouveau style.

LAMBREQUIN French term for a valance board for draperies.

LAMP The part of a lighting fixture that is the actual light source. The lighting professional's term for what is commonly called a light bulb or tube.

LAMPAS A patterned textile with a compound weave having two *warps* and two or more *fillers*. The distinguishing feature is that the pattern is always a *twill* or plain weave, the background in *satin* or plain weave, or both, and may be in two or more colors. Philippe de la Salle made it famous, and it was much woven in the eighteenth and nineteenth centuries, so that the pattern is usually classical in inspiration. It is similar to a two-colored *damask*, but heavier. Silk lampas was much used for upholstery in the eighteenth century. Some fabrics commonly called *brocade* are more properly called lampas.

LANCET Tall, narrow window topped by a pointed arch.

LANG-YAO See *sang de boeuf*.

LANGLEY, BATTY (1696–1751) English architect, designer, and author of practical guides for designers, carpenters, gardeners, and others.

LANGLOIS, PETER (ACTIVE C. 1763–1770) English cabinetmaker, probably an immigrant Frenchman, who worked in a metal technique based on that of Boulle, using brass and tortoiseshell.

LANNUIER, CHARLES-HONORÉ (1779–1819) French cabinetmaker who produced Directoire- and Empire-styled furniture in New York; a contemporary and competitor of Duncan Phyfe.

LANTERN In architecture, a small structure placed at the crowning point of a dome, turret, or roof, with openings for light to come through. Frequently its purpose is decorative only.

LAPAUTRE, JEAN (1618–1682) Royal French architect under Louis XIV.

LAQUÉ French term for *lacquered*.

LARARIUM In a Roman house, a shrine for household gods.

LARSEN, JACK LENOR (B.1927) American textile designer.

LASALLE, PHILIPPE DE (1720–1803) French designer, manufacturer of textiles, and inventor of devices for weaving, under Louis XVI. Most famous for his *lampases* and realistic floral patterns.

LATH The base for constructing an interior partition, supporting plaster, Gypsum board, or some other finish material, and most commonly made of either wood strips or expanded metal.

LATIN CROSS A cross form with the vertical arm longer than the horizontal one. See page 147.

LATROBE, BENJAMIN HENRY (1764–1820) American architect who designed the Bank of Pennsylvania and who introduced the Greek revival to the United States.

LATTEN An alloy of copper and zinc similar to brass, but with a small amount of tin added. It was used in the American colonies, often for making spoons.

LATZ, JEAN-PIERRE (C.1691–1754) French cabinetmaker from the period of Louis XV.

LAUREL A dark reddish-brown wood with a pronounced wavy grain. It takes a high polish.

LAVABO French term for a washstand or washbowl, often with a fountain or water supply; the support for such an object.

LAVORO DI BASSO RILIEVO Italian term for work in *low relief*.

LEADING Lead strips that hold glass panes in a window construction.

LEBRUN, CHARLES (1619–1690) French architect, director of fine arts under Louis XIV, and, after 1663, head of the *Gobelins* works. He was responsible for the interior design of many rooms at Versailles, including the Galerie des Glaces, and for the design of many pieces of royal furniture. Sometimes spelled Le Brun.

LECORBUSIER (1887–1965) Important Swiss-born French modernist architect and furniture designer.

LECTERN A pedestal support for a large book or Bible.

LECTUS A Roman couch.

LECTUS TRICLINIARIS See *klinium*.

LED Acronym for light-emitting diode, producer of lighted signage often used on appliances and electronic equipment.

LEKYTHOS A long narrow-necked flask used by the Greeks for pouring oil.

LELARGE, JEAN BAPTISTE (1743–1802) Appointed *Maître Ébéniste* in 1786. There were three members of the same family with the same name. This one worked at Fontainebleau and made *bergères* and *fauteuils*.

LELEU, FRANÇOIS (1729–1807) Appointed *Maître Ébéniste* in 1764. Famous for marquetry. Worked under Oeben at Versailles. Also worked for Mme. Du Barry.

L'ENFANT, PIERRE CHARLES (1754–1825) French architect and engineer who arrived in America at the end of the eighteenth century. He planned the city of Washington, D.C.

LENO Type of weave in which pairs of *warp* yarns are wound around each other between picks of *filler* yarns, resulting in a loosely woven net effect. Various versions of this weave are used for *glass curtain* fabrics and others.

LENÔTRE, ANDRÉ (1613–1700) French architect famous for his garden designs at Versailles and Vaux-le-Vicomte.

LESCOT, PIERRE (1510–1578) French architect under Henry II; worked on the Louvre.

LETTO Italian term for a bed.

LEVASSEUR, ÉTIENNE (1721–1798) Appointed *Maître Ébéniste* in 1767. Made furniture for the Petit Trianon. Very celebrated.

LIEBES, DOROTHY (1899–1972) American textile designer, noted for strong colors.

LIERNE In a Gothic church, a short rib connecting two main ribs of a vault.

LIGHT BULB Lay term for a *lamp*.

LIGHTHOUSE CLOCK A small late-eighteenth-century clock covered by a glass bell.

LIGNEREUX, MARTIN ELOY (1750–1809) French designer associated with Jacob-Desmalter about 1798 in the furniture business, chiefly during the Louis XVI period. Previously he had di-

rected the design, making, and sale of various decorative accessories. Firm believed to have been discontinued in 1800.

LIME A white powder made from limestone and used in mortar; whitewash.

LIMOGES French center for the production of *porcelain* and *enamel*.

LINCRUSTA OR LINCRUSTA-WALTON A thick, embossed, leather-like wallcovering made of linseed oil, developed in England in 1877 by Frederick Walton, the inventor of *linoleum*.

LINENFOLD A carved Gothic panel enrichment that resembles folded linen or a scroll of linen.

LINGAM Phallus-shaped symbol of the Hindu god Siva (pronounced shee-vah).

LINNELL, JOHN AND WILLIAM William (c.1703–63) established an English cabinetmaking and upholstering firm c.1730. His son John (1729–96) joined the firm and continued it after his father's death. They worked in Rococo, Chinese, and Classical styles and designed furniture for some interiors by Robert Adam.

LINOLEUM A durable floor covering made of linseed oil and flax, invented in England in 1864 by Frederick Walton. The name derives from two Latin words—*linum*, meaning flax, and *oleum*, meaning oil.

LINOLEUM CUT A print made from blocks of linoleum that have been cut into grooves to form a picture or pattern.

LINSEY-WOOLSEY Early American textile blending wool and linen.

LINTEL A horizontal beam, supported at each end, that spans an opening.

LIST See *selvage*.

LIT French term for a bed, pronounced "lee". Some of many variations include:
- Lit à la duchesse A bed with a canopy suspended from the wall or ceiling; more rarely, a bed with a canopy supported by four bedposts
- Lit à la Française A bed placed with its long side against a wall with a canopy above
- Lit à la Polonaise A bed with pointed crown canopy
- Lit à travers A bed with its long side against a wall, but without a canopy
- Lit canapé A sofa bed
- Lit d'ange A bed with a small canopy cantilevered from the back bedposts
- Lit de repos A daybed

LITE OR LIGHT A pane of glass.

LIVE LOAD The load on a structure, not including the weight of the structure itself, but consisting of things added to it, such as interior constructions, furniture, stored material, and occupants.

LOAD BEARING Providing structural support to the parts of the building above.

LOBATE See *auricular* style.

LOCK, MATTHIAS (ACTIVE 1740–1769) Early English Rococo designer, a disciple of Chippendale and later of the Adam brothers.

LOEWY, RAYMOND (1893–1986) American industrial designer.

LOGGIA Italian term for a room or area with an open arcade or colonnade on one side.

LONG-CASE CLOCK Clock with a tall, narrow case designed to hold long pendulum weights. Since the late nineteenth century, more commonly called a *grandfather clock*.

LOOS, ADOLF (1870–1933) Austrian architect and designer, an early modernist.

LOST WAX PROCESS Called *cire-perdue* in France, the method of casting glass or metal with a wax model that is destroyed in the process.

LOUIS XIV French Baroque style identified with the reign of King Louis XIV, 1643–1715.

LOUIS XV French Rococo style identified with the reign of King Louis XV, 1715–74.

LOUIS XVI French Neoclassical style identified with reign of King Louis XVI, 1774–93.

LOUIS-PHILIPPE French Neoclassical style identified with the reign of King Louis-Philippe, 1830–48. It led to the *Second Empire style*.

LOUVER One of a series of slats placed at an angle to protect an opening from sun or rain.

LOVESEAT A *sofa* or *settee* large enough for only two people.

LOW RELIEF See *relief*.

LOW-VOLTAGE LIGHTING Lighting using less than standard voltage.

LOZENGE In ornament, a diamond-shaped motif.

LUMEN A unit measuring the flow of light energy.

LUMINAIRE A complete lighting fixture, including the *lamp*.

LUNETTE In ornament, a form resembling a crescent or half moon.

LUSTER A thin metallic (most often, copper or silver) glaze used on pottery to produce a rich, iridescent color. Used in Persian ceramics, Spanish and Italian faïence, and English and American ware. Also spelled lustre.

LUSTRE French term for a table light or wall sconce in crystal.

LUTYENS, SIR EDWIN (1869–1944) Important and highly eclectic English architect.

M

MACASSAR A seaport city in the Dutch East Indies exporting a type of ebony to which its name is given, macassar ebony. See also *antimacassar*.

MACHICOLATE Literally, to furnish with a projecting gallery. In medieval castle architecture, machicolations were openings in the vault of a portal or passage or in the floor of a projecting gallery, for use in hurling missiles down on the enemy.

MACKINTOSH, CHARLES RENNIE (1868–1928) Brilliant Scottish architect who developed a highly personal version of *Art Nouveau*. His most notable building, designed early in his career, was the Glasgow School of Art.

MACKMURDO, ARTHUR H (1851–1942) English architect and designer inspired by John Ruskin and William Morris.

MACRET, PIERRE (1727–96) Appointed *Maître Ébéniste* in 1758. Made furniture for Versailles.

MADRASSA Islamic religious school.

MAHAL OR MAHALL Indian term for a palace.

MAHOGANY A wood with a beautiful reddish color and handsome grain that has long made it a favorite for furniture. It is imported from South America and the West Indies, the various islands of which produce several distinct species. The best of these is found in Santo Domingo, and is sometimes known as Spanish mahogany. White mahogany or *primavera* has a creamy color and comes from Mexico. Mahogany is easily worked, takes

a high polish, and warps and shrinks but little. Honduras mahogany is known as *baywood*. In addition, mahogany for various purposes comes from Cuba, Africa, Nicaragua, Costa Rica, and the Philippines.

MAÎTRE-ÉBÉNISTE French term for a master cabinetmaker, a position of honor in the furniture makers' guild. Unlike the *menuisier*, the *ébéniste* worked with veneers, and the term comes from the French word for ebony, a wood frequently used for veneer.

MAJOLICA Italian and Spanish pottery coated with a tin enamel and painted with bright colors. See *faience*. Also spelled maiolica.

MAJORELLE, LOUIS (1859–1926) French furniture designer and manufacturer. His factory at Nancy produced pieces in *Art Nouveau* style.

MALACHITE A bright green stone, found chiefly in Russia.

MALLET-STEVENS, ROBERT (1886–1945) French architect and designer.

MALTESE CROSS A cross in which the four similar arms are wedge-shaped with their points meeting. See vocabulary box in Chapter 6.

MAMELUKE RUGS Cut-pile rugs or carpets made in Egypt.

MANCHETTE French term for a padded arm cushion on a chair or sofa.

MANCHU DYNASTY See *Ch'ing dynasty*.

MANDALA A Hindu or Buddhist symbol of the universe, often a circle enclosing a square.

MANDAPA In a Hindu temple complex, a large open hall.

MANDORLA Literally meaning "almond," an Italian term for an almond-shaped halo surrounding religious figures in some paintings and reliefs. Also called a *vesica piscis*.

MANNERISM Italian art style c.1520–90 that disregarded some classical rules in favor of exaggeration, energy, and distortion.

MANSARD ROOF Hipped roof with two pitches, the lower one steeper than the upper, named for François Mansart, who popularized it.

MANSART, FRANÇOIS (1598–1666) French classical architect. His works include the Orléans wing of the Château of Blois and the Church of the Val-de-Grâce, Paris.

MANSART, JULES HARDOUIN (1646–1708) Royal architect of Louis XIV. His most notable works include the Dome of the Invalides and parts of the Palace of Versailles, including the Hall of Mirrors. He was a great-nephew of François Mansart. His name is also seen as Jules Hardouin-Mansart.

MANTEL The projecting shelf above a fireplace.

MANWARING, ROBERT (ACTIVE 1765) English designer and author, known only through his publications of the *Carpenter's Complete Guide to the Whole System of Gothic Railing* and *The Cabinet and Chair-Maker's Real Friend and Companion*, 1765. His designs have originality, though the books' perspective is bad and the engraving is crude.

MAPLE A wood similar to birch, though usually lighter in color. It is adapted for the same uses, including flooring. Straight-grained maple is one of the handsomest woods for interior finish, while the curly or *bird's-eye* varieties are used for veneered furniture. It is very hard and strong.

MAQUETTE Miniature or model room, usually furnished to show the appearance of a proposed scheme of decoration.

MARATTI, CARLO (1625–1713) Italian artist, known for a decorative frame composed of twisted ribbons and bands of acanthus leaves.

MARBLING A painted imitation of the veining of marble.

MARE, ANDRÉ French designer, partner of Louis Süe.

MARLBOROUGH FOOT A *block foot*.

MARLBOROUGH LEG A heavy, straight-grooved furniture leg, with a *block foot*. Much used for English and American mahogany furniture in the mid-eighteenth century.

MAROT, DANIEL (1661–1720?) French designer of ornament, paneling, and furniture under Louis XIV. After the revocation of the Edict of Nantes, he emigrated to Holland and established the French Baroque style there; later, he introduced it to England.

MARQUETRY A flush pattern produced by inserting contrasting materials in a veneered surface. Rare, grained, and colored woods are the most common materials for marquetry, but thin layers of tortoise-shell, ivory, mother-of-pearl, and metals are also occasionally seen.

MARQUISE French term for a small sofa or wide armchair.

MARQUISETTE A sheer cloth having the appearance of gauze and woven in a *leno* weave. The cotton, silk, rayon, nylon, glass, or wool thread is usually hard-twisted to give it greater serviceability. An excellent *glass curtain* material.

MARTIN BROTHERS (GUILLAUME, ÉTIENNE-SIMON, JULIAN, AND ROBERT) Eighteenth-century French cabinetmakers during the reign of Louis XV. The four brothers introduced Chinese lacquer as a finish on French furniture. The finish and the furniture so treated are called *vernis Martin*.

MARTINES, ANTONIO An eighteenth-century Spanish silversmith whose work was influenced by Pompeian discoveries.

MASJID Arabic or Persian term for a *mosque*.

MASONRY Natural or artificial stone (such as brick) used for building construction; the art of building with such material.

MASSOK Indian term for a plain, hand-loomed, heavily ribbed cotton *rep* fabric.

MASTABA An Arabic word meaning bench. Applied to the early mound-shaped tombs of Egypt, and later to those built underground.

MATELASSÉ A fabric with two sets of *warps* and *wefts*. Its embossed pattern gives the effect of quilting. Imitations are stitched or *embossed*.

MATHSSON, BRUNO (1907–88) Swedish interior designer and furniture designer.

MAYHEW, JOHN See William Ince.

MCCOBB, PAUL (1917–69) American furniture and product designer.

MCCOMB, JOHN (1763–1853) American architect, designer of the New York City Hall in association with Joseph Mangin, a French engineer.

MCINTYRE, SAMUEL (1757–1811) Colonial American architect, master carpenter, and wood-carver, who designed many of the houses built in Salem, Massachusetts, in the classical tradition.

MEANDER See *fret*.

MEDALLION In ornament, a circular or oval frame having within it an ornamental motif.

MEDIUM The substance, material, or agency through which an artist expresses ideas. In painting, the vehicle or liquid with which

pigment is mixed or thinned, such as water, oil, wax, and so forth.

MEGARON In the architecture of Crete and Mycenae, an oblong (or, more rarely, square) hall with a columned porch.

MEIER, RICHARD (B.1934) American architect and furniture designer.

MENAGÈRE French term for a dresser with open shelves for crockery.

MENDELSOHN, ERICH (1887–1953) German expressionist architect.

MENDL, LADY See Elsie DeWolfe.

MENSA In a Roman house, a low dining table; a slab that forms the top of an altar.

MENUISIER A French joiner working with chairs and other furniture made from solid wood. See also *ébéniste*.

MERCERIZED MATERIALS Fabrics that have a lustrous surface produced by subjecting the material to a chemical process. The cloth is treated in a cold caustic alkali bath while held in a state of tension. By this treatment the yarn is changed from a flat, ribbonlike shape to a rounded form, making the cloth more lustrous, more durable, and more susceptible to dye. Mercerized cotton has a silky appearance. The process is called after its originator, John Mercer, an English calico printer.

MERCURY SWITCH OR MERCURY-CONTACT SWITCH An on/off switch for interior wiring in which the electric contact is by means of a tube of mercury and the switching is therefore silent.

MERCURY VAPOR LAMP An electric-discharge lamp producing light by passing an electric arc through mercury vapor.

MÉRIDIENNE French Empire term for a sofa or daybed with one arm higher than the other.

MERINO Spanish sheep, the ancestor of nearly all the wool-growing sheep in the world; the wool from such sheep.

MESQUITA Spanish term for a mosque.

METAL CLOTH A fabric the surface of which has a metallic appearance. It is made by weaving cotton warp threads with tinsel filling yarns. The latter are made by winding strips of metallic substance around a cotton yarn. Creases cannot be removed from this material. Useful for trimmings.

METAL HALIDE LAMP An electric-discharge lamp producing light with metal halides.

METOPE The space between the triglyphs of a Doric entablature, often featuring a sculptured relief.

MEUBLES French term for furniture. The singular form, for one piece of furniture, is meuble. The term *mobilier* is also used.

MEZZANINE A low-ceilinged story between two high ones, especially one placed above the ground floor. In French, an *entresol*.

MEZZOTINT A type of copper-plate engraving that produces an even gradation of tones, as in a photograph.

MICHELANGELO BUONAROTTI (1475–1564) Major Italian Renaissance painter, sculptor, architect, and poet. Called the father of the Baroque.

MICRON A unit of length used in measuring textile fiber thickness. It is equal to one millionth of a meter or .000039 in.

MIES VAN DER ROHE, LUDWIG (1886–1969) Important German architect and furniture designer, the last head of the Bauhaus and later director of the school of architecture at the Illinois Institute of Technology, Chicago.

MIHRAB A prayer niche in a Mohammedan mosque located so that the worshiper faces in the direction of Mecca. Sometimes spelled mehrab.

MILLEFLEURS French term literally meaning a thousand flowers. A term particularly used to designate a fifteenth-century Gothic tapestry pattern showing numerous small leaves, plants, and flowers.

MINARET Tower attached to a Mohammedan mosque, with one or more balconies from which Muslims are summoned to prayer. A large tower or lighthouse is called a minar.

MINBAR The pulpit in a mosque. Sometimes spelled mimbar.

MING DYNASTY Chinese dynasty, 1368–1644.

MINIATURE A small painting in illuminated manuscripts, also any very small painting or undersized object.

MINSTREL GALLERY The small balcony above the main entrance to the great hall of a medieval castle where the entertainers performed during the feasts.

MINTON English ceramics factory founded in 1796.

MIRADOR In Spanish architecture, a bay window or other element used as a lookout.

MIROIR French term for mirror.

MITER In carpentry, a corner junction of two strips of wood or other material, the end of each piece being cut at a similar angle, as in the corner of a picture frame or door trim.

MIXING TABLE Small sideboard or butler's cabinet, with compartments at the end for bottles.

MOBILIER French term for furniture. The term *meubles* is also used.

MOCK-UP A rough model, usually built full-size.

MODACRYLIC Type of synthetic textile fiber.

MODILLION The projecting bracket used to support the Corinthian cornice. Also frequently used as an independent decorative motif in architectural and furniture design.

MODULE A measuring unit for an architectural order. The full diameter or half diameter of the lower portion of the shaft of the column.

MODULOR A proportioning system developed and advocated by the modern architect *Le Corbusier.*

MOHAIR A yarn and cloth made from the fleece of the Angora goat. The fiber is wiry and strong, making a very durable textile. It is now woven in combination with cotton and linen into many types of plain, twill, and pile fabrics. Widely used for upholstery.

MOIRÉ A finish on silk or cotton cloth that gives a watermarked appearance. Woven as a *rep,* the marks are produced by engraved rollers, heat, and pressure applied to the cloth after it has been folded between selvages. The crushing of the ribs produces a symmetrical pattern along the fold. The pattern is not permanent, as cleaning and pressing tend to remove it. When made of synthetic fibers moiré holds the marks better than when made of all silk. Pronounced mwa-ray.

MONK'S CLOTH A heavy cotton fabric of coarse weave. Groups of *warp* and *weft* threads are interlaced in a plain or basket weave. Used for hangings and upholstery in informal rooms. Sometimes called friar's cloth.

MONOCHROME OR MONOTONE Decoration in a single color or different tints of one color. See also *grisaille.*

MONOLITHIC Literally, one stone. A structural mass of one solid piece, such as a concrete wall.

MONOSTYLE Having a single column.

MONTAGE A composition made by fitting together parts of various drawings or photographs and attaching them to a background.

MONTIGNY, PHILIPPE CLAUDE (1734–1800) French cabinetmaker appointed *Maître Ébéniste* in 1766. Repaired much of the furniture made by Boulle. That furniture which he made was inspired by the work of Boulle, but he copied his predecessor with taste.

MONUMENT In interior electrical work, a small, monument-shaped outlet box attached to the floor. Sometimes called a *tombstone*.

MOON GATE A circular opening in a wall large enough for human passage. Characteristic of Chinese architecture.

MOQUETTE An uncut pile fabric similar to *frisé*. It is woven on a *Jacquard loom* and has small, set patterns of different colors. When used for upholstery, it is made of mohair, wool, or heavy cotton. A coarse type is used for floor coverings.

MORDANT A substance, such as a metallic salt, used to give permanence to dyes.

MOREEN Wool upholstery fabric of the seventeenth and eighteenth centuries, often with a wool warp and a filler of wool, linen, or cotton.

MORINE An earlier spelling of *moreen*.

MORRIS, WILLIAM (1834–1896) Important English designer, founder and leader of the English Arts and Crafts movement.

MORRIS CHAIR Reclining upholstered chair designed by William Morris.

MORSE, SAMUEL F. B. (1791–1872) American painter and lecturer on fine arts as well as the inventor of the wireless telegraph.

MORTAR Binding material between bricks or stones, usually made from lime, sand, and water.

MORTISE A hole cut in a piece of wood and intended to receive a *tenon* projecting from another piece of wood.

MOSAIC Small squares of colored stone or glass (*tesserae*) set in cement and arranged in a picture or pattern. A popular and beautiful form of mural decoration used extensively in Early Christian and Byzantine art.

MOSQUE Mohammedan place of worship.

MOTHER OF PEARL Irridescent material that lines some seashells and is used in decorative trim or inlay work. Sometimes hyphenated: mother-of-pearl.

MOUNTS Ornamental or utilitarian metal work such as handles, drawer pulls, and *escutcheons*, used on cabinetwork.

MOZARABIC The arts in the Moorish parts of Spain in which Christian elements were in evidence.

MUDEJAR A transitional style of art in the Christian parts of Spain in which Moorish and Italian Renaissance details were seen in the same design.

MULLION A vertical or horizontal bar that acts as a division piece between windows or glass panels.

MULTIFOIL A pattern having many-lobed forms; an arch having more than five foils or arcuate divisions. Sometimes called a scalloped arch.

MUNSELL COLOR SYSTEM Color system devised by Albert F. Munsell, in which all colors are identified by three qualities: hue, value, and chroma.

MUNTIN A narrow bar that divides a window into individual glass panes. It is more slender than a mullion. (See also *honeycomb work*, *stalactite work*.)

MUQARNAS In Islamic architecture and ornament, collections of small *corbels* that form a transition from one plane to another. Also called *honeycomb work* and *stalactite work*.

MURPHY BED A bed that can be folded away into a closet.

MURRHINE Fragile opalescent glassware made by the Romans and used for ornamental and useful purposes.

MUSLIN A plain-woven, white cotton fabric, bleached or unbleached. Used for sheeting and other household purposes. Originally woven in the Mesopotamian city of Mosul.

MUTULE A projecting block above the *triglyph* of a Doric *frieze*.

MYRTLE A blond wood with fine markings. It is much used in cabinetwork for inlay and veneer.

N

NACRÉ French term for *mother of pearl*.

NAHB Acronym for the National Association of Home Builders.

NAIL CLAW Tool used for removing nails.

NANMU A wood used in China for building and decoration. It is aromatic and turns a deep rich brown with age. It is also called *Persian cedar*.

NAOS The main interior space of an ancient Greek or Roman temple, later becoming synonymous with *nave*.

NARTHEX A porch on the west end of a church, originally an accommodation for the unbaptized who were not allowed to enter the church. Sometimes called an antechurch.

NASH, JOHN (1752–1837) One of the foremost English architects of the Regency period.

NATURALISM The close imitation or representation in art of natural objects. Opposed to *conventionalization*.

NAVE The main or central part of a cruciform church, usually flanked by *aisles* and terminated by an *apse*.

NCIDQ Acronym for the National Council for Interior Design Qualification, the body that prepares and administers a uniform examination for the profession of interior design.

NEAR COLORS Colors that have an approaching tendency, therefore making a room appear smaller than it is actually. Dark tones, particularly those derived from red and yellow, are near colors.

NEC Acronym for the National Electrical Code.

NEEDLEPOINT An old-fashioned cross-stitch done on net, heavy canvas, or coarse linen. The threads are wool. The effect achieved is that of a coarse tapestry. Petit point and gros point are two variations of this embroidery. *Petit point* is very fine, made on a single net, and has about twenty stitches to a lineal inch. *Gros point* is coarse, made on a double net, and has about twelve stitches to the lineal inch.

NELSON, GEORGE (1908–1986) American architect and designer of furniture, exhibitions, graphics, and products, also known for his theoretical writings about design.

NEOCLASSICISM The revival of the forms and ornament of classical civilization, primarily that of Greece and Rome. The prevailing style in Europe and America from the middle of the eighteenth century to the middle of the nineteenth.

NÉO-GREC A branch of *Second Empire style* that focused on ornamental motifs with Greek, Roman, Egyptian, and Etruscan origins.

NET Open weave fabric. There are various types, as follows:
- *bobbinet*, machine-made net with hexagonal meshes
- *cable net*, coarse mesh
- *dotted Swiss*, a net with small dots
- *filet net*, square mesh, used as base for embroidery (the handmade variety having knots at corners of meshes, the machine-made variety having no knots)
- *maline*, net with a diamond mesh
- *mosquito net*, coarser than others, of cotton
- *novelty net*, made in a variety of effects
- *point d'esprit*, a cotton net with small dots over its surface in a snowflake effect

NET FLOOR AREA The occupied area of a room or building, not including partition thicknesses, mechanical shafts, and vertical transportation. Compare *gross floor area*.

NEUTRAL COLORS Colors that result from the mixture of several spectral hues. Pigments that have an admixture of white or black. Tints and shades. Hues that are at low chromatic values.

NEWEL POST A heavy post at the termination of the handrail of a stairway.

NICHE A recessed or hollow space in a wall, intended to hold a statue or ornament.

NIELLO A decorative inlay, black in color, in a metal surface.

NINON Often called triple voile. Sheer rayon used for *glass curtains*, made in various weaves.

NOGUCHI, ISAMU (1904–1988) American sculptor and furniture and lamp designer.

NOMINAL DIMENSIONS The dimensions of sawn lumber before it is dried and planed. The finished or dressed sizes of lumber are generally 1/2 inch less in width and 3/8 inch less in thickness than the nominal dimensions.

NON-BEARING WALL A wall or partition supporting only its own weight. Also called a non-load-bearing wall.

NOPA Acronym for the National Office Products Association.

NORMAN Term used for Romanesque architecture in the lands ruled by the Normans (such as England after 1066).

NOSING The leading edge of a stair tread, usually rounded.

NØSTETANGEN Norwegian glass factory founded in 1741.

NOTTINGHAM A machine-made lace curtain material first made in Nottingham, England; a ceramics factory in the same town.

NOVE Ceramics factory near Venice founded in the late eighteenth century.

NOVELTY WEAVE General name for a variety of modern fabrics, having unusual textural effects produced by using *warp* and *filler* of different size, color, or fibers, nubby yarns, or the introduction of tinsel, metallic threads, or even cellophane. Rayon and cotton are especially adaptable.

NOYER French term for walnut.

NRC Acronym for noise reduction coefficient, a measure obtained by averaging the sound absorbing coefficients of an acoustical material at four different frequencies (250, 500, 1000, and 2000 Hz.)

NUMDAH A wool-embroidered felt rug made in Kashmir.

NURSING CHAIR English term for a *chauffeuse*.

NYLON Generic term for a proteinlike chemical that may be formed into bristles, fibers, sheets, and so forth. Has extreme toughness, elasticity, and strength. Its fibers are used in almost all types of textiles where silk and rayon were previously used.

O

OAK The most important of all woods for interior use. It may be sawed, either plain or quartered, the latter being generally preferred for fine work because of the striking pattern produced by the medullary rays. Plain oak is less expensive, because there is less waste in its production, and it is used for the less important features or where durability rather than beauty is the chief consideration. Oaks are divided into over fifty species, but the differences in the wood are not great. They are all hard, durable, and very similar in grain. The wood lends itself well to carving of all kinds and is also well adapted to panelling. Because of its open grain, oak should be treated with a filler before applying stain or varnish. English and French oak have finer graining than the American variety.

OBD Acronym for the Organization of Black Designers.

OBERKAMPF, CHRISTOPHE-PHILIPPE (1738–1815) French textile designer, creator of *toile de Jouy*, and founder of the Jouy manufactory.

OBJECTS OF VERTU Literally, objects of excellence. The term is used in the antiques trade for small decorative objects made of precious metals and precious stones.

OBJET D'ART French term for any small art object.

OBVERSE The side of any medal, coin, or medallion, upon which is the principal design. Opposite to *reverse*.

OCCHIO DI BUE Italian for *oeil-de-boeuf*.

OCTASTYLE A building or building element with eight columns.

OCULUS A round window or roof opening; more rarely, a circular ornament or *rondel*.

ODEUM In Roman architecture, a small roofed theater. It was based on a Greek model called an odeion. The term *theatrum tectum* is also sometimes used.

OEBEN, JEAN FRANÇOIS (D. 1765) French cabinetmaker of the Louis XV period. Appointed *Maître-Ébéniste* in 1754. Worked for Mme. Pompadour and trained Riesener. His younger brother, Simon François Oeben, was also an ébéniste, and their sister married cabinetmaker Martin Carlin.

OECUS In a Roman *domus*, a large room for entertaining guests.

OEIL-DE-BOEUF French for "bull's eye," a round or oval window.

OEIL-DE-PERDRIX French for "partridge's eye," a type of porcelain decoration consisting of dots ringed with smaller dots.

OFFICE LANDSCAPE Type of office layout in which private offices are replaced by freely disposed workstations, their arrangement based on patterns of communication among workers. It was pioneered by the German Quickborner team. The German term is *Bürolandschaft*.

OFF-WHITE A color that is a pure white with a very slight admixture of a definite hue.

OGEE OR OGIVE A molding or an arch form composed of two opposing cyma curves whose convex sides meet in a point. A *cyma* curve.

OILCLOTH A fabric having a cotton base that has been coated with a preparation of linseed oil and pigments. Its finish may be smooth, shiny, dull, or pebbled. Used for table and shelf coverings

and other household purposes. In America, the term is also sometimes used as a synonym for *floorcloth*.

OILED SILK A thin silk that has been waterproofed by a process of soaking the silk in boiled linseed oil and drying it. It was originally used for surgical purposes, but has also been used as a drapery fabric, particularly for kitchen and bathroom curtains.

OINOCHÖE The Greek name for a wine pitcher.

OLBRICH, JOSEF (1867–1908) Austrian architect and designer, an important figure in the Vienna Secession movement.

OLIVE A light yellow wood with greenish-yellow figures. It takes a high polish and is popular for inlay purposes.

OMBRÉ A pattern consisting of stripes in gradations of a single color; a type of wallpaper more commonly known as *rainbow paper*. The word is derived from the French word for shadow.

ONION DOME A bulbous dome shaped like an onion, popular in Islamic architecture and seen in The Netherlands, Russia, and India.

ON-THE-GLAZE A pattern produced by colors applied to the pottery after the glaze has been added to the *biscuit*.

ONYX A beautifully banded, slightly translucent quartz.

OPEN PLAN A building plan with minimal built limitations between areas; in office design, a plan featuring work stations without doors or full-height partitions enclosing them.

OPPENORDT, GILLES-MARIE (1672–1742) Of Dutch origin, a French interior designer and ornamentalist of the *Régence* period.

OPTICAL BALANCE An approach to symmetry obtained by making the two halves of a composition similar in general appearance but not identical in detail.

ORDER OF ARCHITECTURE A term used to designate a classical column and entablature. The pedestal and attic are sometimes included. There are three Greek orders, the Doric, Ionic, and Corinthian, and five Roman orders, the Tuscan, Doric, Ionic, Corinthian, and Composite.

ORGANDY A lightweight, crisp fabric of muslin construction woven of very fine cotton threads. It may be white, piece-dyed, or printed, and is used for trimmings and glass curtains.

ORGANZINE A raw silk yarn. A textile made with such yarn.

ORIEL WINDOW A large projecting window that is supported by a *corbeled* brick or stone construction.

ORMOLU Gilded bronze, brass, or copper, often used for mounts on furniture, particularly that of the Louis XIV period. From the French *or moulu*, meaning ground gold.

ORREFORS Swedish glass factory founded in 1898.

ORTHOGONAL A drawing or construction in which chief elements are parallel or perpendicular to one another.

OSHA Acronym for the Occupational Safety and Health Administration.

OSTVALD COLOR SYSTEM Color system devised by Wilhelm Ostvald, in which all colors are identified by hue, value, and level of saturation.

OTTOMAN A backless low cushioned seat or an upholstered foot-rest.

OVOLO In architecture, a convex molding with a section approximating a quarter circle.

P

PACKAGE FURNITURE English term for *knockdown furniture*. See *KD*.

PAD FOOT A *club foot* that rests on a small disk, often used as a termination for a cabriole leg in an early eighteenth-century chair.

PAGODA In China and Japan, a tower, usually having several stories, built in connection with a temple or monastery. The word is of European origin, the Chinese equivalent being *ta*, and the Japanese equivalent being *shoro* (or sometimes *tahoto*).

PAHLMANN, WILLIAM C. (1900–87) A leading American interior designer of his time.

PAISLEY Printed or woven design in imitation of the original Scotch shawl patterns made in the town of Paisley.

PALAMPORE Hand-painted or resist-dyed cotton, chintz, and calico, made before the invention of block printing for fabrics. Original *tree of life* prints were so made in India.

PALAZZO Italian term for a palace or important town house.

PALETTE A small rounded board on which a painter mixes colors; the range of colors in use.

PALISANDER A brown wood with a violet cast. It comes from Brazil and the East Indies and is much used for modern furniture.

PALISSY, BERNARD (1510–1589) Early French Renaissance potter.

PALLADIAN WINDOW A three-part window, with two rectangular sections flanking a central arched section. Although named for Andrea Palladio, who used them frequently, they were invented by Bramante, used also by Sansovino, and described by Serlio. When the tripartite form is used for unglazed arcades, it is called a Palladian motif.

PALLADIO, ANDREA (1518–1580). Italian Renaissance architect and author of book on antique architecture. Noted designer of villas and churches.

PALMETTE A conventionalized ornamental motif derived from a fanlike branch of the palm tree.

PANEL A surface usually enclosed by a frame. Sometimes a surface of limited dimensions without a frame. In a sunk panel the frame is above or in front of the panel area. In a *bolection* panel, the panel area is above or in front of the frame.

PANEL-HUNG SYSTEM A furniture system in which elements such as files and work surfaces are hung from vertical panels.

PANIER French term for a basket or scrap basket.

PANNÉ A term applied to pile fabrics having a shiny or lustrous surface. This appearance is produced by having the pile pressed back.

PAPELERA Spanish term for a small cabinet intended to hold papers and writing materials.

PAPIER-MÂCHÉ French term for pulped paper, molded while wet into various ornamental forms or useful shapes.

PAPIER-PEINT French term for patterned wallpaper, used in the late seventeenth century to distinguish such paper from the plain type previously used.

PAPILLON, JEAN (1661–1723) French wallpaper designer and maker.

PAR LAMP Acronym for parabolic aluminized reflector, a type of lamp.

PARCEL Partly, as in the term "parcel gilt," meaning partly gilded.

PARGEWORK Ornamental plaster or stucco work applied to a flat surface in relief. The term is most often used when the work represents the wooden structural members that may lie above or beyond it. Sometimes called pargetry.

PARIAN WARE Term used in England and America for unglazed *porcelain* or *biscuit*.

PARIS ENAMEL *Basse-taille* work made in France beginning in the fourteenth century.

PARISH, MRS. HENRY II (1910–94) Known familiarly as "Sister" Parish, a leading American interior designer and partner with Albert Hadley in the firm Parish-Hadley.

PARQUET Flooring made of strips of wood laid in a pattern. The pattern of such a floor is sometimes known as parquetry.

PARSONS, FRANK ALVAH Design educator, head from 1910 to 1940 of the Chase School, founded in 1896 and renamed in his honor in 1940.

PARSONS TABLE Straight-legged table first designed at the Paris branch of the Parsons School of Design.

PARTI French term for a design scheme or concept.

PASHMINA A fine, soft wool gathered from the goats of Kashmir in northern India.

PASTEL A crayon made of a color or colors ground and mixed with gum and water, and used for art work. Any work made with this crayon. Pastel colors are commonly associated with light shades.

PÂTE DE VERRE An ornamental colored glass made in France in the late nineteenth century.

PATERA A round or oval-shaped ornamental disk, often enriched by a rosette or other ornament.

PATERNOSTER Literally, "our father." The term is sometimes used for a *bead and reel* molding. Also, a passenger lift on a continuously moving belt, as sometimes used in a parking garage.

PÂTE-SUR-PÂTE In ceramics, a French term for low relief decoration built up by successive layers of *slip*.

PATINA Incrustation that forms on bronze and other materials through chemical action. Also the gloss on woodwork and the mellowing or softening in color that develops with age.

PATIO An inner court, open to the sky.

PATRIARCHAL CROSS See *archiepiscopal cross*.

PEARWOOD A pinkish-brown, finely grained wood that is frequently used for inlay and fine cabinetwork.

PEDESTAL A supporting base or block for a statue, vase, or order of architecture. It usually is treated with moldings at the top and a base block at the bottom. Without moldings it is called a *plinth*.

PEDIMENT Originally the triangular space following the roof line at each exterior end of a Greek temple, accentuated by the moldings of the entablature. Later the same treatment was used as an ornamental feature and varied in shape, having segmental, scroll, and broken forms.

PEINTURES-VIVANTES High reliefs of religious groups, modeled and colored in lifelike reality, framed in fanciful architectural detail, and lighted by natural and artificial means that made them seem alive. Used extensively in Italy and Spain.

PELIKE A Greek storage vessel.

PELMET See *valance*.

PEMBROKE TABLE A small four-legged drop-leaf table with one or more small drawers under the fixed part of the top. It was popular in England after the middle of the eighteenth century. Also called a *sofa table* and similar to a *breakfast table*.

PENCIL AND PEARL Rather rare synonym for a *bead and reel* ornament.

PENDANT As an adjective, hanging; as a noun, a lighting fixture, ornament, or other object that hangs.

PENDENTIVE The triangular concave masonry surface that transmits the weight of a circular dome to four isolated corner supports. Shaped like a portion of the inside of a hemisphere, it originated in Byzantine architecture. See also *squinch*, another method of supporting a dome.

PENNE D'OISEAU French term literally meaning "bird's feather" and referring to a feather-like ornamental carving on wooden furniture.

PENTASTYLE Having five columns.

PENTES A fifteenth-century term for a *valance* or *lambrequin*.

PERCALE Plain closely woven fabric of muslin in dull finish, which may be bleached, dyed, or printed. Similar to *chintz*.

PERCIER, CHARLES (1764–1838) French architect and designer who, with P. F. L. Fontaine, established the *Empire style* in France.

PERGOLESI, MICHELANGELO (D. 1801) Italian-born decorative painter, architect, and furniture designer who worked in England under Robert Adam.

PERISTYLE A continuous row of columns surrounding a building or a court.

PERPENDICULAR STYLE Term for late Gothic architecture in England (c. 1350–1530), in which window tracery is dominated by vertical elements.

PERRIAND Charlotte (born 1903) French interior designer and furniture designer, a collaborator of *Le Corbusier*.

PERROQUET French term for a chair with legs crossed in the form of an X.

PERSANE Term used to describe the French eighteenth-century printed cottons that had designs inspired by Persian originals.

PERSE French term for *chintz*.

PERSIANA Venetian blind used in Spain.

PERSIAN CEDAR See *nanmu*.

PERSIAN KNOT See *asymmetrical knot*.

PESCE, GAETANO (B. 1939) Italian-born industrial and furniture designer.

PETIT POINT Embroidery done in a cross-stitch on a fine single net. The term is usually applied when there are more than 256 stitches to the square inch. Also see *needlepoint*.

PETITE-COMMODE French term for a small table with three drawers.

PETUNTSE The prepared form of *Chinastone*, an essential ingredient of true *porcelain*.

PEWTER An alloy of tin and lead that has a dull gray appearance and is used for tableware and ornaments. Originally it was intended as a substitute for silver. More rarely, an alloy of tin and some other metal.

PFISTER, CHARLES (1940–90) American interior designer and furniture designer.

PHYFE, DUNCAN (1768–1854) The most famous of American cabinetmakers, born in Scotland, settled in Albany, then moved to New York, where he headed a hugely successful furniture workshop, producing designs based on late-eighteenth-century English and Empire styles.

PICOTÉ A type of pattern design consisting of small floral or other motifs surrounded by numerous minute dots to soften their silhouette. Credited to Christophe-Philippe Oberkampf.

PICTURE RAIL A wall molding close to the ceiling, from which pictures can be hung. Also called a picture molding or a *frieze rail*.

PIECE-DYEING A term used in textile manufacturing to indicate that the fiber of a cloth has been dyed after the completion of the weaving. Compare *yarn-dyeing*.

PIECRUST TABLE A small table having a top with its edge carved or molded in scallops. Common in eighteenth-century English furniture.

PIED DE BICHE See *cloven foot*.

PIER A heavy vertical masonry support for a superstructure. This type of support lacks the detail and proportions of a column or pilaster.

PIER GLASS Originally, a glass or mirror designed to stand on the floor against a wall surface, also called a *cheval glass*; later, a mirror designed to be placed between windows, over a chimney-piece, or over a console table.

PIER TABLE A table, such as a console, meant to be used against a wall under a mirror.

PIETÀ Literally meaning "pity," an Italian term for an art work representing the dead Christ in the arms of his mother.

PIETRA DURA Italian term for an inlaid design composed of hard, semiprecious stones.

PIGMENT COLORS Colors made from natural or synthetic materials and used to produce the various hues in common paints. Opposed to the spectral colors produced by the decomposition of light.

PILASTER A flat-faced vertical projection from a wall, rectangular in plan but with the general proportions, capital, and base of a column.

PILE In textile and carpet construction, the upright ends or loops (if uncut) of thread that are woven at right angles to the *warp* and *weft*. The nap generally has the appearance of velvet.

PILE FABRICS Fabrics with raised loops or tufts (cut loops) that form the visible surface. Various types of pile fabrics are velvet, velours, frisé, moquette, plush, and terry cloth.

PILLAR A popular term used to designate a pier or column. Also an isolated structure used for commemorative purposes.

PILLAR RUG A rug designed to be wrapped around a pillar or column.

PILLEMENT, JEAN (1727–1808) French decorative painter and textile designer, noted for his *chinoiseries*.

PILLING Small tangles of fibers on the surface of a fabric.

PINCH PLEAT Three pleats pinched and sewn together at the top, left to fall open below.

PINE (WHITE) Known sometimes as soft pine, this was once the most important of softwoods, and is still used in large quantities, though its price is now rather high. It works easily and is used for both structural and finishing purposes, though it is nearly always painted, its texture being of little interest.

PINE (YELLOW) Called hard pine, it has several species varying greatly in strength and other properties. In general it is stronger and harder than white pine. It makes good and cheap flooring, trim, doors, and furniture. For interior finish, its natural yellow color is not very pleasant, but by the use of dark stains, effects are obtained that are little inferior to dark oak. Yellow pine grows in Georgia and the Carolinas, and the tree's needles are longer than those of white pine.

PINNACLE Small pyramidal or coneshaped turret used in architecture to crown roofs and buttresses. In the decorative arts, any form resembling the architectural feature.

PINTURICCHIO, BERNARDINO (1454–1513) Decorative painter of the Italian renaissance.

PIPING A method of applying and holding in place upholstery or padding to a curved surface by means of ribs resembling pipes.

PIQUÉ A heavy cotton fabric with raised cords running lengthwise. Used for trimmings, bedspreads, and curtains.

PIRANESI, GIOVANNI BATTISTA (1720–1778) Italian architect and engraver.

PITCH The slope of a roof surface, often expressed as a ratio of height to width (for example, 1 in 12, or 3 in 5); a distillate of tar; a quality of sound related to frequency; in carpet, the number of yarn ends in a 27-inch width.

PLACAGE French term for *veneering*.

PLAIN WEAVE A basic weave in which *warp* and *weft* are of the same size, and alternate over and under each other.

PLAIN-SAWING The cutting of a plank of wood from the outside edge of a tree trunk. The grain appears in V-shapes, unlike *quarter-sawing* in which the plank is cut through or near the center of the trunk and causes the grain to appear in parallel lines.

PLAN The horizontal projection of any object. The delineation of an object or surface from above. The shape or internal arrangement of an object as indicated by a section cut parallel to the ground. Specifically, a drawing showing the arrangement and horizontal dimensions of the rooms of a building.

PLAQUE French term for a plate or panel usually made of metal, glass, or pottery, treated with a surface enrichment, and used for decorative purposes.

PLASTER A paste-like substance that sets to form a hard finished material, most frequently composed of Portland cement, lime, sand, and water, but sometimes also containing gypsum, hair, or fibers.

PLASTERBOARD See *gypsum board*.

PLASTER OF PARIS Calcined gypsum, a quick-setting type of plaster used primarily for casting ornament.

PLATE A collective term for objects made of silver or gold.

PLATE GLASS A type of *flat glass* cast onto metal tables, first developed in France in the late seventeenth century.

PLATERESCO The name given to the period of Spanish art during the first half of the sixteenth century. The word is derived from *platero*, meaning silversmith, because the style of ornament often imitated the fine detail of the silversmith's work.

PLATNER, WARREN (B.1919) American architect, interior designer, and furniture designer.

PLENUM The space between a finished ceiling and the structural ceiling above, available for use for air supply, air return, etc.

PLIANT French term for a folding stool with legs crossed in the shape of an X. Sometimes spelled *ployant*.

PLINTH Square member at the base of a column or pedestal. In carpentry, the plinth-block is the small block of wood used at the bottom of door trim against which the baseboard butts. See also *pedestal*.

PLIQUE-À-JOUR A type of enameling in which translucent glass pastes are held in a metal network without backing, giving a small-scaled stained glass effect.

PLISSÉ A method of printing on plain weave rayon or cotton that produces a permanent crinkled surface in stripes or patterns.

PLOYANT See *pliant*.

PLUSH A fabric with a long pile. Made like velvet, its nap is sometimes pressed down to form a surface resembling fur. It may be

made of silk, wool, cotton, or any synthetic fiber. Extensively used for upholstery.

PLYWOOD Wood composition made of thin sheets of veneer glued together.

POCHÉ In a plan or section, the shaded areas that represent solids; to produce such areas.

POCKET DOOR A door that slides into a recess, sometimes less accurately called a *sliding door*.

PODIUM A pedestal; also the enclosing platform of the arena of an amphitheater.

POINT D'HONGRIE Needlepoint having a design vaguely resembling an irregular series of chevron forms or V shapes usually made with silk and used for chair upholstery.

POLE SCREEN Adjustable panel mounted on a vertical pole.

POLYCHROME An ornament or pattern in several colors.

POLYESTER An *ester* formed by polymerization, used in modern textiles.

POLYMERIZATION A chemical process in which small molecules combine to form larger ones.

POLYVINYL CHLORIDE Synthetic material made from the derivatives of petroleum, used for floor covering in both sheets and tiles. Abbreviated both as *PVC* and as *vinyl*.

POMEGRANATE Decorative motif or ornament used in many periods. Symbol of fertility.

PONGEE A fabric of plain weave made from wild silk in the natural tan color. It is very durable and has an interesting texture. Used for draw curtains. The name is derived from a corruption of two Chinese words that signify "natural color."

PONTI, GIO (1891–1979) Italian architect, designer, ceramicist, and magazine editor.

PONTIL An iron rod used in glass manufacturing to carry hot materials. A pontil mark is the permanent mark left by the pontil after the material has cooled.

POPLIN A fabric similar to a lightweight *rep*. It is made with a heavy filler, producing a light corded effect across the material. Cotton, silk, wool, synthetic, or combination fibers may be used in its weaving. A trimming and drapery fabric.

PORCELAIN A hard, vitreous, nonporous pottery. Opposed to earthenware, which, if unglazed, is absorptive. True porcelain is made of *kaolin* or *China clay* and *petuntse* or *Chinastone*.

PORCELANEOUS WARE Pottery with the appearance of porcelain. Also spelled porcellaneous.

PORPHYRY Rock composed of crystals of white or red feldspar in a red ground mass. A valuable stone for architectural or ornamental use.

PORRINGER A small, shallow one-handled bowl.

PORTICO A colonnaded porch or walkway. Also see *stoa*.

PORTIÈRE A curtain hung over a doorway.

PORTLAND CEMENT A powder chiefly composed of hydraulic calcium silicates, the cementitious ingredient of most structural concrete.

PORTLAND VASE Roman vase now in the British Museum, of blue-black glass with superimposed opaque white figures, having a cameo effect. It was copied in dark slate-blue *jasper* ware by *Josiah Wedgwood*.

POSSET POT English term for a small vessel to hold a posset, a mixture of milk and ale or milk and wine.

POSTMODERN DESIGN Design in reaction against modernism.

POTTERY Sometimes used as a synonym for *earthenware*; sometimes used as a more inclusive term covering all types of fired wares such as earthenware, *stoneware*, *porcelaneous ware*, and *porcelain*; a factory in which such wares are made.

POUDREUSE French term for a toilet table or vanity, so called because it once held wig powders.

PRACTICE LEGISLATION Laws that limit the practice of interior design (or some other profession) to those legally certified. See also *title legislation*.

PRE-RAPHAELITE BROTHERHOOD In the second half of the Nineteenth century, a group of artists who, with John Ruskin, revolted against the mechanization and eclecticism in the arts of the Victorian era and the decline in craftsmanship. They started a movement looking back to Italian primitives, to nature, and to hand production in the crafts. Members were William Morris, Dante Gabriel Rossetti, William Holman Hunt, John Everett Millais, Sir Edward Burne-Jones, and others.

PRECLASSIC The classification given to the arts and cultures of the Western peoples who preceded the civilizations of ancient Greece and Rome: Egypt, Babylon, Assyria, Chaldea, Persia, Crete, and so forth.

PRESS OR PRESS CUPBOARD In seventeenth-century England and America, a two-tiered cupboard with hinged doors and drawers.

PRESSED GLASS Glass that is ornamented in relief by pressing into a mold.

PRIE-DIEU A piece of furniture designed for kneeling in prayer. In the Middle Ages, the name was given to a small desk with a projecting shelf on which to kneel. In the seventeenth century and later it was given to a chair with a padded back, the user kneeling on the seat.

PRIMARY COLORS The three pigment colors, red, yellow, and blue, that cannot be produced by any mixture of other pigments. Combinations of any two of the primaries are known as *secondaries*. The combination of any secondary with a primary is known as a *tertiary*. The *spectral* primaries are those seen in the rainbow.

PRIMAVERA See *mahogany*.

PRIMING COAT A mixture used by painters for a first or preparatory coat.

PRIMITIVE Early, simple, naïve. The term applied to the early artists of any school or period when they have not yet mastered the later and more highly developed principles.

PRINCE OF WALES FEATHERS A decorative motif of three ostrich feathers tied together, a symbol of the Prince of Wales and popular in late-eighteenth-century English design.

PRINCE'S METAL A brasslike alloy of copper and zinc thought to resemble gold. It was used in the American colonies and in seventeenth-century England, where it was also called "Prince Rupert's metal."

PRONAOS In ancient Greek architecture, the vestibule leading to the *naos* of a temple.

PROPYLAEUM In ancient Greek architecture, the gateway to a sacred precinct.

PROSCENIUM In a theater of ancient Greece or Rome, the platform on which the drama was enacted; in a modern theater, the arch (often curtained) between the auditorium and the stage.

PSYCHE 1. An upholstered sofa dating from about 1840, designed with Greek curves. 2. French Empire term for a full-length mirror in a frame. Later called a *cheval glass*.

PSYKTER A Greek vessel for cooling wine.

PUGIN, AUGUSTUS WELBY NORTHMORE (1812–52) Victorian Gothic Revival architect and author.

PURE DESIGN The theory that all art and design is based on a set of universal, fundamental, and abstract principles that create the ideal of beauty.

PUTMAN, ANDRÉE (B.1925) French interior designer.

PUTTO Italian term for a young boy. A favorite subject in Italian painting and sculpture. The plural is putti.

PVC Acronym for *polyvinyl chloride*.

PYLON Monumental obelisk or the heavy mass of masonry at the entrance of an Egyptian temple.

Q

QING DYNASTY See *Ch'ing dynasty*.

QUARTER-ROUND A convex molding in the shape of a quarter circle. An *ovolo* molding.

QUARTER-SAWING To saw wood planks toward or through the center of the tree trunk. Also see *plain sawing*.

QUATERNARY COLOR An intermediate hue in the pigment color-wheel, formed by a mixture of a *tertiary* color with either its adjoining *primary* or *secondary* color.

QUATREFOIL A four-lobed ornamentation.

QUATTROCENTO Italian term for the fifteenth century (literally, the 400s).

QUEEN ANNE STYLE The style prevalent in England during the reign of Queen Anne (1702–1714), characterized by cabriole legs, shell ornaments, swan's-neck pediments, and other gracefully curved details.

QUEEN-SIZE BED A bed with a mattress width of 60 in. (152 cm).

QUEEN'S WARE A thinly glazed stoneware produced by Wedgwood. Also called *creamware*.

QUICKBORNER TEAM German management consultants from the Hamburg suburb of Quickborn, early developers of *office landscaping*.

QUILTED FABRIC A double fabric with padding between the layers, held in place by stitches that usually follow a definite pattern.

QUIMPER POTTERY Faience ware from a French factory founded at the end of the seventeenth century. Pronounced kim-pair.

QUINCUNX A building plan in which four subsidiary elements are arranged symmetrically about a central element, frequently used for Byzantine churches.

QUIRK An incised groove in a molding.

QUIRKED CYMA A *cyma curve* molding with a flat vertical band added top and bottom.

QUOIN A prominent brick or stone at the corner of a building.

R

RABBET In carpentry, a joint in which a recess in one piece of wood receives another piece of wood.

RAFRAÎCHISSOIR From the Louis XV period, a small table on casters, with drawers and shelves below, and with receptacles in the (usually marble) top for holding wine bottles. Also called a *servante*.

RAFTER A beam supporting a roof and usually following the pitch of the roof.

RAG CARPET A woven carpet using strips of fabric as the weft.

RAG RUG A braided carpet of fabric strips.

RAIL In paneling, any horizontal strip forming a portion of the frame; the vertical strips are called *stiles*. In a chair, the top member of the back.

RAINBOW PAPER A wallpaper with a design of softly blended colors. Also called *ombré* or *irisé*.

RAKU Japanese ceramics with a crackled glaze.

RANDOLPH, BENJAMIN (ACTIVE LAST HALF OF THE EIGHTEENTH CENTURY TO 1790) American cabinetmaker, a leader in the Philadelphia-Chippendale school.

RAPHAEL (RAFFAELLO SANZIO) (1483–1520) Important Italian Renaissance painter and architect. Painter of frescoes in the Vatican Palace.

RATINÉ Name of yarn and of fabric in plain or twill weave. Owes its coarse, spongy, nubby texture to the knotlike irregularities of the yarn used in the warp.

RATO A Portuguese *faience* factory founded in 1767.

RAVRIO, ANTOINE ANDRÉ (1759–1814) Brilliant French *ciseleur* in the Empire period.

RAW SILK Silk as it is reeled from the cocoon, before the gum has been removed.

RAYON A trade name for a synthetic fiber having a cellulose base. Originally highly lustrous, it can now be handled as a lusterless thread. It is more lustrous, stiffer, and less expensive than silk. In combination with silk, wool, or cotton its possibilities are limitless. Textiles of rayon are known by various trade names.

RAYONNANT The style of mid-thirteenth-century French Gothic architecture, characterized by window tracery in the form of radiating rays or spokes.

RÉCAMIER A daybed with scrolled head and a shorter scrolled foot, named for the Paris society hostess Mme. Julie Récamier (1777–1849), who was painted reclining on such a daybed.

RED CEDAR A wood little used for decorative purposes, though great quantities are used for making shingles and lead pencils. Its chief use as a finish wood is for the lining of clothes closets and chests. The small use made of cedar for finish is doubtless the result of its great variation in color, ranging from a decided red to almost white. Both colors are often found in a single piece, the heartwood being red and the sapwood white. Its odor is also too pungent for constant association.

RED-FIGURE VASE Ancient Greek vase with red figures showing through a black-painted background.

RED GUM A handsome, fine-grained wood, of a reddish-brown color. Sap gum is the sapwood of the same tree, and is much lighter in color. Red gum is much used for veneered doors, as well as for general interior finish, though its use has only become general in recent years. It may be used as a base for white enamel, or may be stained to imitate a variety of other woods, including walnut, mahogany, and maple, while selected specimens may even be found to imitate the striking figure of Circassian walnut. The figure of red gum varies in different trees, and it must be selected according to the use intended. In addition to various stained finishes, it may be given a natural finish by the use of wax, producing a handsome satiny effect that wears remarkably well.

REDWOOD A wood of a very handsome and uniformly red color, extensively used on the Pacific Coast of the United States, though seldom seen in the eastern states. It takes stain and paint readily,

and can be obtained in very wide boards because of the great size of the trees. It is used for open beams and trim.

REEDING A long, semicylindrical, stemlike ornamental form or a grouping of such used to enrich moldings.

REFECTORY A dining hall, especially in ecclesiastical or collegiate buildings.

RÉGENCE French style during the regency of Philippe, duc d'Orleans, 1715–1723. It was a transitional style between French Baroque and Rococo.

REGENCY STYLE English style during the regency of George Augustus Frederick, Prince of Wales, 1811–20 (later King George IV). It is synonymous with English neoclassicism.

REICH, LILLY (1885–1947) German designer of interiors, furniture, and textiles, known for her collaboration with *Ludwig Mies van der Rohe*.

REINFORCED CONCRETE Concrete strengthened with iron reinforcing rods.

RELIEF A type of decoration in which the design is made prominent by raising it from the surface or background of the material. High relief designates that the design is raised greatly; low relief (or *bas-relief*) that the design is only slightly raised from the background.

RELIQUARY A small receptacle designed to hold a sacred relic; usually made of ornamented precious metals enriched with jewels or enamel decoration.

RENAISSANCE Specifically, the period c.1400–1530 when there was a rebirth of interest in intellectual and artistic activity based on classical models; generally, any such rebirth.

REP A plain-weave fabric made with a heavier *filler* thread than *warp* thread (or vice versa), giving a corded effect, as in poplin or corduroy. A warp rep is made with heavier filler threads, producing a ribbing across the material. A filler rep uses coarser warps, and the ribbed effect is vertical. Rep is unpatterned and reversible, and may be made of cotton, wool, silk, or synthetic fibers. Used for drapery and upholstery purposes. Sometimes spelled repp.

REPOUSSÉ Relief work on metal materials, the design being pushed out by hammering the material on the reverse side; *embossed*.

REREDOS A screen or wall-facing set behind a church altar, usually decorated with sculpture or carving. Also called a *retable*.

RESILIENT FLOORING Floor covering, such as carpet or some kinds of tile, that is resilient.

RESIST DYEING A technique for producing a pattern or design on fabric. The sections to remain uncolored are coated with wax or other dye-resistant material before the fabric is dipped into the dye.

RESTAURATION STYLE French style during the reigns of Louis XVIII (1814–15 and, following Napoleon's "100 Days," 1815–24) and Charles X (1824–30).

RESTORATION STYLE English style during the period (1660–88) of the Stuarts' restoration to the throne following the Commonwealth. It replaced austerity with exuberance.

RETABLE See *reredos*.

RETICELLA Cutwork lace, similar to network or filet. See *lace*.

RÉVEILLON, JEAN BAPTISTE (D.1811) French wallpaper designer and maker from 1752 to 1789.

REVERE, PAUL (1735–1818) Boston silversmith, copperplate engraver, caricaturist, and bell-founder.

REVERSE The side of a coin or medal on which is placed the less important impression or design. The more important face is called the *obverse*.

REVETMENT A retaining wall; a facing of fine material over less attractive material.

REZ-DE-CHAUSSÉE French term for a building's ground floor.

RIB A projecting band on a ceiling, vault, or other surface.

RIBBAND BACK Chair back designed with a pattern of interlacing ribbons, similar to *strapwork*. Characteristic of the *Chippendale* style. Sometimes called ribbon back.

RIBBED VAULT See *vault*.

RICHARDSON, HENRY HOBSON (1838–86) American architect; leader in the Romanesque revival style.

RIEMERSCHMIDT, RICHARD (1868–1957) German furniture and product designer.

RIESENER, JEAN-HENRI (1734–1806) French cabinetmaker appointed *Maître Ébéniste* in 1768. Worked for Marie Antoinette. First worked under Oeben, and became his successor.

RIETVELD, GERRIT (1888–1964) Dutch architect and furniture designer of the *De Stijl* movement.

RINCEAU French term for a scroll and leaf ornament, sometimes combined with cartouches or grotesque forms and applied to friezes, panels, or other architectural forms. It is usually a symmetrical horizontal composition. Similar to an *arabesque*. The plural is rinceaux. In eighteenth-century England, it was spelled rainceau.

RISER The vertical surface between stair treads.

RISING STRETCHERS *X-shaped stretchers* or *saltires* that curve upward as they approach their intersection. Used in Italian Renaissance furniture.

RISOM, JENS (BORN 1916) Danish-born interior designer and furniture designer.

RITTENHOUSE, DAVID (1732–96). Philadelphia clockmaker.

ROBSJOHN-GIBBINGS, TERENCE HAROLD (1909–1973) British-American interior designer and furniture designer.

ROCAILLE Literally, a French term for an artificial grotto encrusted with elaborately shaped shells and rock formations. More generally, the term is used as a synonym for *Rococo*.

ROCOCO A style in architecture and decoration. It is characterized by lightness and delicacy of line and structure, by asymmetry, and by the abundant use of foliage, curves, and scroll forms of decoration. The name is derived from the French words *rocaille* and *coquille* (rock and shell), prominent motifs in this decoration.

RODRIGUE, VENTURA (1717–1785) Spanish architect who became a leading exponent of neoclassic style.

ROENTGEN, DAVID (1743–1807) French cabinetmaker of German origin, appointed *Maître Ébéniste* in 1780. Worked for Marie Antoinette. Sometimes spelled Röntgen.

ROGERS, RICHARD (B.1933) British architect.

ROGNON French term meaning kidney, applied to desks or tables with a kidney shape.

ROHDE, GILBERT (1894–1944) American industrial designer and furniture designer.

ROLL In the United States, a wallpaper trade and sales unit that designates 36 square feet of paper. Several rolls are usually included in a bundle or bolt or stick.

ROLLER BLIND Nineteenth-century term for window shade.

ROLLWORK See *strapwork*.

ROMAN SHADE A shade or curtain made in flat panels. As the panels are lifted, the material is pleated. See also *Austrian shade*.

ROMANESQUE The style of architecture prevalent in Europe between 800 and 1150 and in England after 1066 (where it is called *Norman*). It is characterized by round-headed arches and vaults.

ROMAYNE WORK Carved medallion heads in roundels, used as plaster ornaments, paneling details, furniture ornaments, or drawer pulls, characteristic of the English Jacobean and later periods. It is sometimes spelled Romagne.

RONDEL Round outline or object in a surface pattern; a small circular panel or window. Also spelled *roundel*. Also see *tondo* and *oculus*.

ROOD A cross or crucifix.

ROOD SCREEN In church interiors, an open screen separating the body of the church from the choir or chancel.

ROOF COMB In Mayan architecture, the ornamental continuation of the façade to a height far above the roof. Also called a *flying façade*.

ROOKWOOD POTTERY American ceramics workshop founded in Cincinnati in 1880.

ROPE BED Any bed with rope laced to the frame for holding the mattress.

ROSE WINDOW A circular window with *mullions* of *tracery* radiating from a center in wheel form, the spaces between being filled with richly colored glass. Originally introduced in Gothic cathedrals, the form was later applied to wood paneling and furniture design.

ROSENTHAL German ceramics manufacturer.

ROSETTE An ornamental motif formed by a series of leaves arranged around a central point. The leaves are usually arranged to form a circle, ellipse, or square.

ROSEWOOD A fine reddish-brown wood with black streakings. There are many varieties, of which the most popular is Brazilian rosewood, called *jacarandá*. It takes a high polish and is much used for fine cabinetwork and for musical instruments.

ROSSI, ALDO (1931–97) Italian architect and theorist.

ROTUNDA A building or room cylindrical in shape, usually topped with a dome. In Italy the spelling is *rotonda*.

ROUNDABOUT CHAIR A type of chair designed to fit into a corner, having a low back on two adjoining sides of a square seat.

ROUNDEL See *rondel*.

ROVIRO, HIPOLITO Spanish architect of the *Churrigueresco* style. He designed the Palace of the Marquis de Dos Aguas at Valencia (1740–1745).

RUHLMANN, ÉMILE-JACQUES (1869–1933) French interior designer and furniture designer in the *Art Deco* style.

RUNNING DOG Decorative motif of repeated scroll forms. Sometimes called a *Vitruvian scroll*.

RUSKIN, JOHN (1819–1900) Influential English writer and art critic.

RUSTICATION In stonework, a type of beveling on the edges of each block to make the joints between stones more conspicuous.

R-VALUE The measure of a material's resistance to heat flow.

S

SAARINEN, EERO (1910–1961) American architect and furniture designer, at times a collaborator with Charles Eames. Son of Eliel Saarinen.

SAARINEN, ELIEL (1873–1950). Finnish architect who moved to the United States and became president of the Cranbrook Academy.

SABOT FOOT See *spade foot*.

SACRISTY In a church, a small room for the storage of books, vestments, altar vessels, and the like.

SADDLE See *threshold*.

SAILCLOTH Very heavy and durable fabric, similar to canvas. Lightweight sailcloth is often used for couch covers, summer furniture, and so forth.

SAKURA Japanese term for cherrywood.

SALADINO, JOHN (B.1939) American interior designer.

SALTIRE An X-*shaped stretcher* of Italian origin between the legs of chairs, stools, or tables. Some saltires are *rising stretchers*.

SALVER A plate or tray for serving food.

SALVIATI Important Venetian glass factory founded in 1866.

SAMBIN, HUGUES (C.1515–C.1600) French architect and furniture designer under Catherine de' Medici.

SAMPLER A piece of needlework intended to show examples of a beginner's skill. Specifically, a small piece of linen embroidered with alphabets and naïve patterns; made by children in the early nineteenth century in Europe and in North and South America.

SANDERSON, ROBERT (ACTIVE 1638–93) Boston silversmith.

SANDWICH GLASS American pressed glass with lacy decoration, some (but not all) of it made in Sandwich, Massachusetts.

SANG DE BOEUF Literally, blood of the bull. A deep red glaze for pottery. The Chinese equivalent is called *lang-yao*.

SANGUINE DRAWING A drawing in red crayon or chalk.

SANSOVINO, JACOPO (1486–1570) Venetian architect and sculptor of the sixteenth century.

SARDONYX A type of *onyx* with alternating bands of milky white and reddish brown.

SASH The operable part of a window.

SASH BAR See *muntin*.

SASH CURTAIN A lightweight curtain that is hung on or nearest the sash of a window. Also called a *glass curtain*.

SATEEN A fabric, imitative of satin, with a lustrous surface and dull back. It is made with floating weft threads and is, therefore, smooth from side to side. It is usually made of cotton, the better quality being mercerized. Sometimes spelled satine.

SATIN A basic weave; also, a fabric having a glossy surface and dull back. The whole face of the fabric seems to be made of warp threads, appearing smooth and glossy. No two adjacent *warp* threads are crossed by the same *weft* thread, and the skip may vary from eight to twelve *fillers*. Because of the length of the warp floats, it is not an extremely durable material for heavy usage. It may be made of all silk, but is stronger when linen or cotton wefts are used. Used extensively for upholstery and draperies. There are several different types, as follows:
- antique satin, a type with a dull, uneven texture, heavy and rich looking
- charmeuse, with *organzine* warp and spun silk weft
- hammered satin, treated to give the effect of hammered metal
- ribbed satin, *bengaline* and *faille* woven with satin face ribs, giving a lustrous, broken surface; may have a *moiré* finish.

SATINWOOD A light blond wood with a satiny finish and a handsome figure, used for finishing only in the finest work. It is largely

used for furniture, and particularly for *inlay* and *parquetry*. Satinwood is cut from various species of trees that grow in India, Florida, and the West Indies.

SATSUMA WARE　Japanese ceramics from Satsuma province dating to the late sixteenth century. One type, made for Japanese use, was very simple earthenware; another type, made for export, was highly decorated tin-glazed ware.

SAUSAGE TURNING　Furniture turning resembling a string of sausages.

SAVERY, WILLIAM (C.1721–C.1728)　American cabinetmaker, prominent in the Philadelphia-Chippendale school, and particularly noted for *highboys*.

SAVONAROLA CHAIR　See *X-chair*.

SAVONNERIE CARPET　Knotted-pile carpet from the Savonnerie factory founded by Louis XIII in 1627.

SCAGLIOLA　Italian term for a composition of plaster and small chips of marble or other stone. It is durable and takes a high polish. Used extensively in eighteenth-century English interiors and still in some use today.

SCALLOP SHELL　In ornament, a semicircular shell with ridges radiating from a point at the bottom. This motif was especially common in furniture design during the Queen Anne and Georgian periods in England and the United States. It was also extensively used in the early Spanish Renaissance.

SCARPA, CARLO (1906–78)　Italian architect, interior designer, and furniture designer.

SCENIC PAPER　Wallpaper depicting a landscape.

SCONCE　Ornamental wall bracket to hold candles or electric bulbs.

SCOTCH CARPET　Common name for a *Kidderminster carpet*.

SCOTIA　A concave molding approximating a curve produced by two tangential curves of different radii.

SCOTT BROWN, DENISE　See *Robert Venturi*.

SCRATCH CARVING　Shallow or deep scratching to form a design, used in woodwork and pottery products.

SCREED　A form that limits the boundaries of a concrete pour; a tool used to smooth the surface of such a pour.

SCRIBE　In carpentry, to fit one material to another, as the side of a wooden strip to an uneven surface of plaster or adjoining wood surface. A scribe-molding is a small strip of wood that can be easily cut or bent to fit an uneven surface or cover up an irregular joint or crack.

SCRIM　A sheer fabric made like a *marquisette*, but with coarser cotton, wet-twisted thread. Sometimes a cheaper variety is not wet-twisted, which causes it to thicken when laundered. Used for curtains and needlework.

SCRITOIRE OR SCRIPTOIRE　See *scrutoire*.

SCROLL　A spiral line used for ornamental purposes, as in the *arabesque* and *rinceau*. A parchment roll used as an ornament.

SCROLL PEDIMENT　A broken pediment with each half shaped in the form of a reverse curve, and ending in an ornamental scroll. Usually a finial of some sort is placed in the center between the two halves of the pediment.

SCRUTOIRE　French term for a desk that has a blank top panel that can fold down to form a horizontal writing surface. Not exactly the same as an *escritoire*, in which only a drawer front folds down.

SCUTCHEON　See *escutcheon*.

SEAWEED MARQUETRY　An inlay of various woods in an *arabesque* design of small leaf and seaweed forms. Much used during the William and Mary period.

SECESSION　Austrian art movement founded in 1897 and based in Vienna, related to the *Art Nouveau* movement.

SECOND EMPIRE STYLE　French neoclassical style from the period of Louis-Napoleon Bonaparte's reign as Emperor Napoleon III, 1852–70. See also *Néo-Grec*.

SECOND STYLE PAINTING　Second in a succession of four styles used in Roman wall painting. Employed in the first century B.C., the second style was noted for its representation of buildings and colonnades and is also called the architectural style.

SECONDARY COLORS　Orange, purple, and green, each of which is produced by the combination of two primary colors.

SÉCRETAIRE　French term for a desk.

SÉCRETAIRE-À-ABATTANT　French term for a drop-lid desk.

SECTION　A term used to express the representation of a building, molding, or other object cut into two parts, usually by a vertical slice. The purpose of a sectional representation is better to show a silhouette shape or interior construction, showing vertical dimensions or heights. A section cut horizontally is commonly called a *plan*.

SEDAN CHAIR　Enclosed chair, carried by four men, used for transportation in the eighteenth century.

SEDDON, GEORGE (1727–1801)　English cabinetmaker, furniture designer, and upholsterer, active about 1760–1775. From 1793 to 1800, his firm was known as Seddon Sons and Shackleton, Seddon having taken his sons, George and Thomas, into partnership in 1785 and 1788, and his son-in-law, Thomas Shackleton, in 1793. Made much satinwood furniture.

SEDIA　Italian term for chair.

SEGMENTAL ARCH　An arch shaped as a part of a circle less than a semicircle.

SELLA　In ancient Rome, a folding stool.

SELVAGE　Sometimes called list and probably originating in the term self-edge. In fabric, it is a narrow woven edge parallel to the warp. Names of fabric manufacturers or names of patterns are sometimes printed at intervals on the selvage. Also called selvedge.

SEMAINIER　French term for a tall bedroom chest with seven drawers, intended to hold personal linens for each day of the week.

SEMI-GLOSS　Paint or enamel finish less lustrous than *gloss*, but more lustrous than *eggshell*.

SENNA KNOT　See *asymmetrical knot*.

SERGE　Silk, wool, cotton, or rayon in twill weave, with a clear and hard finish and a pattern of small diagonal ribs.

SERIGRAPH　See *silk-screen*.

SERLIO, SEBASTIANO (1475–1554)　Italian renaissance architect and theorist, author of the treatise *L'Architettura*, published between 1537 and 1575.

SERPENTINE CURVE　An undulating curve used for the fronts of chests, desks, cupboards, and similar pieces. The curve is formed by two tangential cymas.

SERVANTE　See *rafraîchissoir*.

SETTEE　A small sofa, sized to seat two. The distinction is sometimes made that a sofa is completely upholstered, but a settee is not.

SETTLE　An all-wood settee with solid panels at the ends.

SEVERE STYLE　See *desornamentado*.

SÈVRES Porcelain ware from the factory at Sèvres, France, founded in 1756.

SFUMATO From the Italian term for "smoky," a blurred effect in painting or decoration.

SGABELLO Italian term for a small wooden Renaissance chair, usually having a carved splat back, an octagonal seat, and carved trestle supports.

SGRAFFITO Italian term for a method of surface decoration using a pattern that is first scratched on the surface and then colored or revealing a colored ground beneath.

SHADE Something that serves to intercept light; a color or pigment that contains a percentage of black.

SHADOW PRINTS Also called warp prints. Fabrics with a pattern printed on the warp only; the filler is a plain thread. When woven, the design is blurred and indistinct.

SHAFT Central portion of a column or pilaster between the capital and the base.

SHAKER FURNITURE A type of furniture made in the late eighteenth and early nineteenth centuries by the Shakers, a religious sect in New York State and later in New England. The designs were plain and functional; built-ins were characteristic.

SHALLOON A twilled worsted fabric.

SHANG DYNASTY Early Chinese dynasty, 1766 B.C.–1045 B.C.

SHANTUNG A heavy grade of *pongee*. It is usually made of wild silk, cotton, or a combination of both.

SHEARER, THOMAS English furniture designer and author of *Designs for Household Furniture*, published in 1788. The designs are almost entirely limited to case furniture.

SHED In textile manufacture, an opening formed by the *warp* threads being lifted by a heddle; through this opening the shuttle holding the *weft* thread passes.

SHEER General name for diaphanous or translucent fabrics.

SHEFFIELD PLATE Triple-plated silver on copper. The plating process was invented by Thomas Boulsover at Sheffield, England, in 1743 and later refined by Matthew Boulton.

SHELLAC Natural resin derived from insects and dissolved in alcohol. It is used as a primer or sealer and can also be molded.

SHERATON, THOMAS (1751–1806) Noted English furniture designer and author of the *Cabinet-Maker's and Upholsterer's Drawing Book* (1791–1794). No authenticated pieces of his are in existence.

SHIKI A heavy silk or rayon *rep* made with irregular sized filling threads.

SHIRRING Gathering a textile in small folds on a thread, cord, or rod.

SHORO See *pagoda*.

SHUTTLE In weaving, the boat-shaped container for filling yarns that carries them through the *warp*.

SICK BUILDING SYNDROME The phenomenon of a building's physical characteristics causing the sickness of its occupants.

SIEGEL, ROBERT See *Gwathmey*.

SIKHARA The tower over the shrine of an Indian temple.

SILHOUETTE A profile or outline drawing, model, or cut-out, usually in one color. The outline of any object.

SILK Lustrous fabric woven from the filaments reeled from the cocoons of silk worms.

SILK CHIFFON Lightweight, sheer, plain silk fabric.

SILK SHANTUNG See *shantung*.

SILK-SCREEN Printmaking by the process of squeezing paint through silk, sections of which have been masked to produce the desired pattern. Also called *serigraphy*.

SILL In carpentry, a horizontal board or strip forming the bottom or foundation member of a structure, especially the board at the bottom of a window that serves as a finishing member for the trim and casing. A door sill is sometimes called a *saddle*.

SILLA Korean dynasty from the first to tenth centuries A.D.

SILOE, DIEGO DE (C. 1495–1563) Early Spanish Renaissance architect. He designed the cathedral at Granada and the "golden staircase" of Burgos cathedral.

SILVERWOOD See *harewood*.

SINGERIES Designs showing monkeys at play, popular in France during the Louis XV period. Literally, "monkey tricks."

SINGLE BED Bed with a mattress width of 34 in. (86 cm).

SISAL Fiber made from the spiky leaves of a subtropical bush. Made into rugs or carpet, it is attractively textured and hard-wearing, but easily stained and difficult to clean.

SIZE Gelatinous solution used for stiffening textiles, glazing paper, and in other manufacturing processes. It is also often used as a first coat in painting.

SKELETON CONSTRUCTION Building construction of posts and beams assembled before the walls are erected. In steel construction the walls are nonbearing, being supported by the steel work, and are merely screens against the weather.

SKIRT In cabinetry, the wooden strip that lies just below a shelf, window sill, or table top. Also called *apron* or *frieze*.

SKYPHOS A Greek drinking cup.

SLASH CUTTING In the milling of lumber, the process of making radial cuts rather than parallel slices.

SLAT A thin, flat, narrow strip of metal or wood, as in a window blind.

SLAT-BACK CHAIR A type of Early American chair with wide horizontal ladder *rails* between the back uprights.

SLEEPING CHAIR An adjustable chair with a back that can be lowered level with the seat.

SLEIGH BED A bed, resembling a sleigh, with headboard and footboard of equal height.

SLIDING DOOR A door that slides on a track. Specific types include the *pocket door* and the *by-passing door*.

SLIP In pottery, clay and water of a creamlike consistency used as a bath for pottery, to produce a glaze or color effect. A molding process using slip is called slip-casting.

SLIPPER CHAIR Any short-legged chair with its seat close to the floor.

SLUB The irregularites and nubs in a fabric, specifically a silk.

SLURRY Thin mixture of water with a soluble material such as clay or cement.

SMOKE CHAMBER In fireplace design, a transitional chamber between the fireplace throat and the chimney flue.

SMOKE DETECTOR A fire protection device that sounds an alarm when it detects smoke.

SNAKE FOOT In cabinet work, a foot carved to resemble a snake's head.

SNAKEWOOD A yellow-brown or red-brown wood with dark spots and markings. It is popular for *inlay* work.

SOANE, SIR JOHN (1750–1837) English architect of the *Regency style*.

SOCLE Plain, square and unmolded base or pedestal for a statue, or superstructure.

SOFA A long seat, able to accommodate at least two people. The origin is probably the Arabic word *suffa*. It is similar to a settee, but more completely upholstered. A common term, seldom used by professionals, is *couch*.

SOFA TABLE See *Pembroke table*.

SOFFIT The ceiling or underside of any architectural member.

SOFT PASTE Base of ceramics made before the introduction of *kaolin*, products of which lack the whiteness and extreme hardness of true *porcelain*.

SOHO TAPESTRIES Tapestries made in any of several tapestry workshops in the Soho district of London in the late seventeenth and early eighteenth centuries.

SOLAR A medieval term for an upper chamber in a castle. Usually the private room of the owner.

SOLIUM In ancient Rome, a seat of honor, sometimes carved in stone.

SOTTSASS, ETTORE, JR. (B.1917) Italian industrial designer and furniture designer, leader of the Memphis group.

SOUND MASKING See *white sound*.

SPADE FOOT A square, tapering foot used in furniture design. It is separated from the rest of the leg by a slight projection. Also called a *sabot* or *thimble* or *therm foot*.

SPANDREL The approximately triangular panel or wall space between two adjoining arches and a horizontal line above them. On the face of a multistory building, the panel between the top of one window and the bottom of the window above.

SPANISH FOOT Foot in the shape of an inward curving scroll. Used in eighteenth-century English and American furniture.

SPECIFICATIONS Written information supplementing construction drawings.

SPECTRAL COLORS The colors produced by a beam of white light as it is refracted through a prism. Although they are unlimited in number, they are usually designated as violet, indigo, blue, green, yellow, orange, and red. Commonly seen in the rainbow.

SPINDLE A long slender rod often ornamented with turned moldings or baluster forms. See also *split spindle*.

SPINET Keyboard instrument, ancestor of the piano, in which the sound was produced by the action of quills upon strings.

SPIRAL LEG A furniture support carved in a twist, with a winding and descending groove or fluting. Also called a *barley sugar turning* or a *barley twist*.

SPLAT A plain, shaped, or carved vertical strip of wood, particularly that used to form the center of a chairback. Sometimes spelled splad.

SPLAY A line or surface that is spread out or at a slant. A *bevel* or *chamfer*.

SPLINE In cabinetry, a small strip of wood inserted between and projecting into two adjoining pieces of wood to form a stronger joint between them.

SPLIT SPINDLE A long, slender turned and molded wooden rod that is cut in two lengthwise so that each half has one flat and one rounded side. Used as an applied ornament in seventeenth-century English and American furniture.

SPODE, JOSIAH (1733–97) AND HIS SON OF THE SAME NAME (1755–1827) Staffordshire potters, noted for transfer-printed *earthenware*, *stoneware*, and *bone china*.

SPONGE PAINTING Painting technique used in early America, in which paint is irregularly applied by dabbing the surface with a sponge.

SPOT OR SPOTLIGHT A lamp with a narrowly focused beam spread.

SPRIG A small ceramic ornament in relief, made in a mold and attached with slip to a pot before firing.

SPRING-LINE In architecture, the theoretical horizontal line in arch construction at which the upward curve of the arch proper starts.

SPRINKLER SYSTEM See *automatic sprinkler system*.

SPRUCE A variety of pine closely related to fir. Important ornamental tree with a soft, light, straight-grained wood used for interior and exterior construction and for sounding boards of musical instruments.

SPUN SILK Silk yarn made from waste fibers from damaged or pierced cocoons and weaving mill waste. Heavier and less lustrous than reeled silk.

SPUN YARN Yarn assembled from a collection of short fibers. Spun yarn includes cotton, wool, silk, linen, and most natural staples. Another general category of yarn is *continuous filament*.

SQUAB A removable chair cushion.

SQUINCH Arched corbelling at the corner of a square room to support a dome above. Another method of supporting a dome is the *pendentive*.

STALACTITE WORK Small vertical polygonal or curved niches rising and projecting in rows above one another so that they resemble stalactite formations. See also *muqarnas* and *honeycomb work*.

STAMNOS Greek vessel for the storage of wine, water, or spices.

STARCK, PHILIPPE (B.1940) French interior designer, furniture designer, and product designer.

STATUARY BRONZE Bronze that has been surfaced with an acid application causing its color to become a dark brown. A finish often given to bronze statues.

STEAMBOAT GOTHIC A richly ornamented type of Gothic Revival based on the appearance of steamboats and seen on nineteenth-century buildings of the Mississippi River valley.

STEINZEUG German term for *stoneware*.

STELA A stone slab or pillar used commemoratively, as a gravestone, or to mark a site. The plural is stelae.

STENCIL The method of decorating or printing a design by brushing ink or dye through a cut-out pattern.

STERLING A term used in connection with silverware, indicating that the silver is 92.2 percent pure.

STERN, ROBERT A. M. (B.1939) American architect and author.

STICKBACK Chair with a back of thin spindles, such as a *Windsor* chair.

STICKLEY, GUSTAV (1857–1942) American cabinetmaker in the arts and crafts style and founder of the periodical *The Craftsman*.

STIEGEL, HENRY WILLIAM (1729–1785) Pre-Revolutionary American glassmaker, founder of a factory at Manheim, Pennsylvania. Familiarly known as "Baron" Steigel.

STILE The vertical strips of the frame of a panel. The horizontal strips are called *rails*.

STILL-LIFE Paintings or decorative renderings of inanimate, motionless objects.

STILTED ARCH An arch "on stilts," in which the spring line is raised above the impost line.

STIPPLING Process of applying paint or ink to a surface in dot form, by means of a coarse brush or spray.

STOA In Greek architecture, a *colonnade* or *portico* enclosing an open area used for a public meeting space.

STOCK MILLWORK Milled lumber available in stock shapes and sizes, often in nominal dimensions.

STOCK-DYEING A term used in textile manufacturing to indicate that a fiber is dyed before being spun into a thread. See also *piece-dyeing* and *yarn-dyeing*.

STONEWARE A heavy, opaque, nonporous and nonabsorbent pottery made from a silicious paste.

STRAP HINGE A surface-mounted hinge with long plates of metal on either side of the hinge; one plate can be attached to the fixed surface, the other to the movable surface.

STRAPWORK A term applied to carved wooden *arabesque* and *rinceau* patterns of interlaced flat bands that appear as if cut from a sheet of leather. Sometimes the realistic effect is heightened by the representation of nailheads, as if the straps were being held to a background. Popular in England in the Elizabethan and Jacobean periods. It is sometimes called *rollwork*, and similar ornaments in France are called *enroulements découpés*. Also similar are the *ribband backs* (or *ribbon backs*) of *Chippendale* chairs.

STRETCHER A brace or support that horizontally connects the legs of pieces of furniture.

STRIÉ A fabric with an uneven, streaked effect produced by using warp threads of varying tones. A two-toned effect may be given to *taffeta*, *satin*, or corded upholstery materials by this process. Pronounced stree-ay. Similar to *Jaspé*.

STRING COURSE In architecture, a molding or projecting horizontal motif running along the face of a building.

STUCCO A material, usually textured, used as a coating for exterior walls. It is most commonly made from Portland cement, lime, sand, and water, although some modern versions may also contain epoxy or other man-made materials as binders.

STUD A small post, most commonly a nominal dimension of 2x4 inches, and of any height, used to form the wall construction in wooden structures. The studs support the joists and receive the *lath* or sheet material used for the finish.

STUDENT LAMP Nineteenth-century oil lamp with the oil reservoir higher than the burner, usually made of brass.

STUMPWORK OR STUMP EMBROIDERY A type of embroidered picture worked in silk or wool threads over padding, giving a relief effect.

STUPA An Indian sacred mound, precursor of the *pagoda*.

STYLOBATE The stone blocks or steps that form the lowest architectural feature of a Greek temple and upon which the columns stand.

SÜE, LOUIS (1875–1968) French architect and interior designer working in the Art Deco style in partnership with André Mare.

SUGI FINISH A Japanese method for finishing woodwork. The surface is charred and then rubbed with a wire brush.

SUI DYNASTY Chinese dynasty, A.D. 581–618, constituting, with the *T'ang dynasty* that followed, the "golden age" of Chinese art.

SULLIVAN, LOUIS H (1856–1924) American architect; early promoter of functional design in architectural structures.

SUMMER BEAM A large timber laid horizontally and used as a bearing beam. In Early American dwellings it was usually supported at one end by the masonry of the chimney and at the other end by a post, and it extended across the middle of the room. The name is derived from *sommier*, a French term meaning saddle or support.

SUMMER BED Two single beds placed together under a single canopy.

SUMMERS, GERALD (B.1902) English furniture designer.

SUNG DYNASTY Chinese dynasty, A.D. 960–1279.

SUPERIMPOSED ORDER The placing of one order of architecture above another in an arcaded or colonnaded building; usually Doric on the first story, Ionic on the second, and Corinthian on the third. Found in the Greek *stoas*, in Roman architecture, and later in the Renaissance.

SUZANI A variety of cotton grown in Turkestan; an embroidered wall hanging.

SWAG Cloth draped in a looped garland effect, or an imitation of such an effect in another material. At the end of the nineteenth century, it was called a *French shawl*.

SWAN, ABRAHAM Early-eighteenth-century English cabinetmaker known for his mantels, door and window trim, and staircases.

SWANSEA English pottery of the Staffordshire type.

SWASTIKA A cross composed of four equal L-shaped arms placed at right angles. A sacred symbol of ancient origin. Sometimes spelled svastika. Also called a fylfot, a filfot, or a gammadion, and with similarities to the Greek *meander*.

SWATOW WARES Chinese export porcelain of the *Ming* dynasty, erroneously supposed to have been shipped from the port of Swatow.

SWISS A very fine, sheer cotton fabric that was first made in Switzerland. It may be plain, embroidered, or patterned in dots or figures that are chemically applied. It launders well, but has a tendency to shrink. Often used for *glass curtains*.

SYCAMORE A wood that ranges from white to light brown in color. It is heavy, tough, and strong, and handsome in appearance. It is extensively used for finishing work.

SYMMETRICAL BALANCE Having the two halves of a design or composition exactly alike in mass and detail.

SYNTHETIC FIBERS These are made from various chemical compounds and are used as yarns in modern textile weaving. They are known by trade names given to them by individual manufacturers. Combinations of natural and synthetic yarns are often used. Among the leading types are those known as rayon, bemberg, celanese, dacron, fortisan, lurex, nylon, and orlon.

T

TA See *pagoda*.

TABER TEST A test to measure a fabric's resistance to abrasion. Similar to a *Wyzenbeek test*.

TABERNAE Small shops opening to the street along the front of a Roman *domus*.

TABERNACLE MIRROR A mirror in an architectural frame with a panel of painted glass above the mirror. Also *Sheraton mirror*.

TABLE-À-ÉCRAN French term for a table with sliding screen.

TABLE-À-ÉCRIRE French term for a writing table, a small version of a *bureau plat*.

TABLE-À-JEU French term for a game table.

TABLE-À-L'ANGLAISE French term for a dining room extension table. (Louis XVI and later.)

TABLE-À-L'ARCHITECT French term for a table with hinged top.

TABLE-DE-CHEVET French term for a night table.

TABLE-JARDINIÈRE French term for a table with top pierced for plant containers.

TABLE RUG A rug used as a table cover.

TABLINUM In a Roman house, a room with one side open to the *atrium*.

TABONUCO A light-colored, beautifully grained West Indian hardwood used for furniture.

TABOURET French term for a stool.

TACKLESS STRIP Wood strip with embedded tacks used for laying carpet.

TAFFETA The basic plain weave. Also, a fabric woven in that manner. The fabric is usually made of a silk fiber with warp and weft thread of equal size. It is often weighted with metallic salts. Useful for trimmings and draperies.

TAHOTO See *pagoda*.

TAILS See *jabot*.

TALAVERA DE LA REINA A group of Spanish earthenware factories.

TALBERT, BRUCE (1838–81) English furniture designer.

TAMBOUR French term meaning drum-shaped.

T'ANG DYNASTY Chinese dynasty, A.D. 618–906, constituting, with the *Sui dynasty* that preceded it, the "golden age" of Chinese art.

TAPA Cloth made in the Pacific islands from the bark of certain trees, particularly the paper mulberry.

TAPESTRY Originally a hand-woven fabric with a ribbed surface like *rep*. The design is woven during manufacture, becoming an essential part of the fabric structure. Machine-made tapestry is produced by several sets of *warp* and *filling* yarns woven with the *Jacquard* attachment, which brings the warp threads of the pattern to the surface. Machine-made tapestry can be distinguished from hand-woven by its smooth back and the limited numbers of colors used in the pattern.

TARLATAN A thin, open cotton fabric of plain weave that is almost as coarse as a fine *cheesecloth*. It is *sized*, wiry, and transparent, and made in white and colors. It cannot be laundered.

TASK LIGHTING Lighting specifically designed to aid work. See also *accent lighting* and *ambient lighting*.

TATAMI A traditional Japanese floor mat made of woven reeds, approximately 1 meter x 2 meters.

TATLIN, VLADIMIR (1885–1953) Russian constructivist architect and designer.

TAVERN TABLE Plain wooden table without leaves.

TAZZA Italian term for a large ornamental cup or footed salver.

TEAK A wood that is yellow to brown in color, often with fine black streaks. It is more durable than oak and is used for shipbuilding as well as for furniture.

TEMPERA A paint composed of pigments that are soluble in water. Sometimes glue or eggwhite is also added to the solvent.

TEMPLUM In Byzantine churches, a stone screen dividing the *bema* and the *naos*, a precursor of the *iconostasis*.

TENON In carpentry, a projection at the end of a piece of wood intended to fit into a hole (a *mortise*) of corresponding shape on another piece of wood.

TERM A tapered pedestal, smaller at its base, supporting a bust or sculptured figure; or a male *caryatid* standing on such a base.

TERNE An alloy of lead and tin, sometimes used for roofing.

TERRA COTTA A hard-baked pottery extensively used in the decorative arts and as a building material, usually made of a red-brown clay, but sometimes colored with paint or baked glaze; the color typical of such material.

TERRA SIGILLATA Roman ceramic ware made from fine red clay.

TERRAZZO A concrete made of small pieces of crushed marble and cement. Used for surfacing floors and walls.

TERRE-CUITE French term for *terra cotta*.

TERRY, ELI (ACTIVE EIGHTEENTH AND EARLY NINE-TEENTH CENTURY) American clockmaker.

TERRY CLOTH Heavy, loosely woven, uncut pile fabric, as used in bath towels.

TERTIARY COLOR A color that is formed by the combination of a *primary color* and a *secondary color*.

TESSELATED Imbedded with *tesserae*.

TESSERA A small cube of stone, marble, or glass used in making a mosaic. The plural is tesserae.

TESTER Canopy framework over a four-poster bed. Pronounced "tees-ter."

TETE-Á-TETE A *confidante*. Also called *dos-à-dos*.

TETRASTYLE Having four columns

THATCH Roof covering made of plant material such as straw, reeds, rushes, or palm leaves.

THEATRICAL GAUZE A loosely woven open cotton or linen fabric. Because of its transparency and shimmering texture, theatrical gauze is used for window draperies.

THEATRUM TECTUM See *odeum*.

THERM FOOT See *spade foot*.

THERMAE The public baths of ancient Rome.

THIMBLE FOOT See *spade foot*.

THIRD STYLE PAINTING Third in a succession of four styles used in Roman wall painting. Employed between c.20 B.C. and c. A.D. 50, the third style was also called the ornate style.

THOLOS In Greek and Mycenaean architecture, a round, domed building or tomb. The plural is tholoi.

THOMAS, SETH (1785–1859) American clockmaker, active in Thomaston, Connecticut, and founder of the Seth Thomas clock factory.

THOMIRE, PIERRE PHILIPPE (1751–1843) Brilliant French *ciseleur* in the Empire period.

THONET Furniture company founded in Austria in 1849 by Michael Thonet. Its first specialty was furniture using bentwood, but it later also produced furniture with metal frames.

THORNTON, DR. WILLIAM (1759–1828) First architect of the United States Capitol.

THREE-COLOR WARE Type of Chinese porcelain popular in the Ming dynasty.

THREE-PLY CARPET Flat-pile carpet using three layers of interwoven fabric, first developed in 1824 and also called an *Imperial*.

THRESHOLD Molding or strip fastened to the floor beneath or before a door.

THRONOS A Greek chair of honor.

THROUGH CUTTING In the milling of lumber, the process of cutting a log with parallel slices.

THROWN SILK Type of silk in which long filaments are thrown or twisted together, the more twists per inch producing the stronger product.

THRUST In architecture, the outward force exerted by an arch or vault that must be counterbalanced by abutments.

THUYA A dark red-brown wood from North Africa. It takes a high polish and is used in contemporary cabinetwork. It is also called citron burl, and *Arbor vitae* is of the same genus. The wood was known to the Chinese and Greeks. Used for table tops, turnery, and veneering.

TICKING Closely woven cotton in twill or satin weave. It usually has woven stripes, but they may be printed. Damask ticking is also made in mixed fibers and used for mattress covers, pillows, and upholstery.

TIDY See *antimacassar*.

TIE-BEAM In architecture, a horizontal beam that connects the rafters of a roof and prevents them from spreading. Used in truss construction to counteract the outward thrust of the slanting members.

TIE-DYEING Fabric patterning process in which, before dyeing, small areas of fabric are gathered and tied to prevent the penetration of the dye. The process has been popular in India, Indonesia, and other places.

TIELIMU Chinese furniture wood.

TIFFANY, LOUIS COMFORT (1848–1933) Prominent American glass artist in the *Art Nouveau* style, and son of the founder of Tiffany & Co. As an interior designer, he collaborated with Stanford White, Carrère and Hastings, and other architects.

TILLIARD, JEAN-BAPTISTE (1685–1766) French chair maker of the Louis XV period.

TILT-TOP A table top that is attached to a hinge on a pedestal support so that the top may be swung to a vertical position when not in use.

TIN GLAZE A ceramic glaze of lead to which tin oxide has been added, making it white and opaque.

TINSEL PICTURES Decorative objects made from cutout tinsel, paper, and pictures, mounted and pasted together.

TINT A color made from a pigment that is mixed with white.

TITLE LEGISLATION Laws that limit the use of the term "interior designer" to those professionals who are legally certified. See also *practice legislation*.

TOILES DE JOUY Famous printed fabrics produced at Jouy, near Paris, by Philippe Oberkampf, from 1760 to 1815. Modern reproductions continue the typical design of landscapes and figure groups in monotones of brick red, blue, or other colors on a white or cream-colored background. Effectively used for draperies, bedspreads, and wall hangings.

TOILES D'INDY Printed cotton and linen of floral or pictorial design, which began to be imported into France during the latter years of the seventeenth century from India and Persia.

TOKONOMA In a Japanese house, a niche that customarily holds a scroll or other art work and a flower arrangement.

TÔLE French term for painted sheet metal or tin; the useful or decorative objects made of such material.

TOMBSTONE See *monument*.

TONAL VALUE One of the characteristics of a color. The relative strength of a color in contrast to white or black.

TONDO A painting or relief in circular form. See also *rondel*.

TONGUE-AND-GROOVE A type of wood joint in which a long, narrow, straight projection, known as the tongue, fits into a corresponding groove in the adjacent piece.

TORCHÈRE Originally a French design from the Louis XV period and later, being a small table for holding a candle or candelabrum, also called a *guéridon*. The term is now used for a standing floor lamp with a shade that directs the (electric) light upward toward the ceiling.

TORUS In architecture, a convex semicircular molding.

TOWNSEND, JOHN (1732–1809) One of a famous family of cabinetmakers in Newport, Rhode Island, most noted for his *block-and-shell* pieces.

TRABEATED CONSTRUCTION Construction in which the supporting members are the post and lintel, as distinct from arched construction.

TRACERY The stone *mullions* in a Gothic window.

TRACERY PATTERN A pattern in woodwork, textile, or other material imitating stone tracery.

TRAM A type of *thrown silk*.

TRANSEPT In church architecture, that portion of the building that crosses the *nave* at right angles, near the *apse* or east end of the building.

TRANSITIONAL A style that shows evidence of two chronologically consecutive styles, possessing elements of both styles in its design.

TRANSOM The upper panel of a window or a window placed above a doorway.

TRAPEZA A Greek table; the plural is *trapezai*.

TRAVERTINE A type of limestone with irregular open cells.

TRAY-TABLE A small table, popular in the eighteenth century, with a low *gallery* around three (or all four) sides of the top surface.

TREAD The horizontal surface of a stair.

TRECENTO Italian term for the fourteenth century (literally, the 300s).

TREE-OF-LIFE PATTERN A pattern resembling a tree or vine, showing branches, leaves, flowers, and small animals. Originating in ancient Assyria, it was borrowed by the Persians, East Indians, and early English Renaissance designers, and was a feature of *palampores*. Also called *hom*.

TREFOIL A three-lobed ornamentation resembling a clover.

TRENCHER A large wooden platter upon which food is served.

TRESTLE TABLE A table supported on X-shaped trestles or sawbucks.

TRIACETATE Man-made fiber or fabric of cellulose *acetate*, similar to acetate, but more completely acetylated and able to withstand higher temperatures. Its heat tolerance allows it to be permanently pleated.

TRIC-TRAC TABLE French term for a backgammon table.

TRICLINIUM The dining room in a Roman house.

TRICOTEUSE French term for a small sewing table.

TRIFORIUM In a Gothic church, an arcaded walkway along the *nave* and above the level of the *arcade*.

TRIGLYPHS Blocks with vertical channels that are spaced at intervals between *metopes* in the *frieze* of the Doric entablature.

TRIPTYCH Any three-fold picture, usually of religious character, often an altarpiece.

TROFFER Long, linear lighting fixture, usually recessed with its visible surface flush with the ceiling.

TROMPE L'OEIL Literally, "fool the eye," a French term for illusionistic painting or carving.

TRUE SILK Silk made from a specific species of silkworm, the *Bombyx mori*.

TRUMEAU French term for the decorative treatment of the space over a mantel, door, or window, usually consisting of a mirror or painting or both. Specifically, the overmantel panel treatment of the Louis XV and VXI periods.

TRUMPET LEG A conical leg turned with flared end and shaped in the form of a trumpet.

TRUNDLE BED A term of Gothic origin for a child's or servant's bed on wheels, which was rolled under a full-sized bed when not in use. Sometimes called a truckle-bed.

TRUSS A support used for a wide span of roof or ceiling, consisting of beams or posts assembled together, often in a triangular manner, for greater rigidity and strength.

TUDOR ARCH A flat, pointed arch characteristic of English Gothic and early Renaissance architecture and decoration.

TUDOR ROSE Decorative motif seen in English Renaissance work consisting of a conventionalized rose with five petals, with another smaller rose inside it. It was the royal emblem of England, symbolizing the marriage of Henry VII of Lancaster (red rose) to Elizabeth of York (white rose).

TUDOR STYLE English style from the time of the reigns of the Tudor kings, 1485–1603.

TULIPIÈRE Vase for holding tulips, often of *Delftware*.

TULIPWOOD A light yellow wood with red streaks. It comes from Brazil and is much used for ornamental *inlay*.

TUNGSTEN-HALOGEN LAMP A type of incandescent lighting that has a tungsten filament inside a lamp filled with gas including halogen. The lamp is small, compared with others of equal power, but its surface can reach dangerously high temperatures. Other names for such lamps are *halogen*, quartz, and quartz-iodine.

TURKEY-WORK A handmade textile imitating Oriental pile rugs, produced by pulling worsted yarns through a coarse cloth of open texture, then knotting and cutting them.

TURKISH KNOT A symmetrical knot used in carpet making. Also called a *Ghiordes knot*.

TURNING In carpentry, a type of ornamentation produced by rotating wood on a lathe and shaping it into various forms with cutting tools.

TURPENTINE A resinous fluid used as a solvent and drying constituent in paint mixing.

TURRET A small tower superimposed on a larger structure.

TUSCAN ORDER A simplified Roman variant of the Doric order of architecture. It is plain and sturdy, and the standard proportion of its column is 7 diameters high. It has an undecorated *frieze* and a *cornice* without *mutules*. Sometimes called the *Etruscan* order.

TUSSAH SILK Wild silk, from cocoons of worms that have fed on oak or other leaves. Light brown in color. Used for *pongee, shantung*, and *shiki*.

TWEED Originally a woolen homespun material made in Scotland. Now the term is applied to a large group of woolen goods made from *worsted* yarns; they may be woven in plain, twill, or herringbone twill weaves.

TWILL A basic weave; also, the fabric woven in that manner. The *weft* thread is carried over one *warp* and under two. Sliding along one to the left on each row, still going over one and under two warp threads, a diagonal ribbed effect is achieved. A *herringbone* pattern is a variation of this weave, with which squares and zigzags can also be made.

TWIN BED A bed with a mattress width of 39 in. (99 cm).

TWO-PLY CARPET An *ingrain* carpet

TYG A mug with several handles or with two closely spaced handles, popular in sixteenth- and seventeenth-century England.

TYMPANUM In architecture, the interior triangular surface of a *pediment* bounded by the sloping sides and the lower molding.

T'ZU-CHOU A Chinese *stoneware*.

TZU-TAN Chinese furniture wood.

U

UBC Acronym for the Uniform Building Code, a code much used on the West Coast of the United States and as a model for many local codes.

UL Acronym for Underwriter's Laboratories, an independent testing agency. If an electrical device is tested and approved by the agency, it is said to be "UL approved." The Canadian counterpart is the Canadian Standards Association, or CSA.

ULTRAVIOLET LIGHT Light with wavelengths shorter than those of visible light. See also *infrared light*.

UNDERGLAZE A term used to define a pigment or pattern that is applied to pottery before the final glazing is applied.

UNICORN An imaginary animal with a single horn often featured in the arts of the Middle Ages. The symbol of chastity.

UNIVERSAL DESIGN Design that accommodates all, including those with physical disabilities.

UPS Acronym for uninterrupted power supply, used for computer equipment, emergency lighting, and so forth.

UPSET PRICE See *guaranteed maximum cost*.

USABLE SQUARE FOOTAGE The area within a building that can actually be used by its occupants (not generally including such shared facilities as lobbies, corridors, and toilets).

UTRECHT VELVET A velvet with a pattern created by flattening some areas of the pile. The term velours d'Utrecht is also sometimes seen, usually referring to a wool velvet.

V

VAISSELIER French term for a dining room cabinet and shelves.

VALANCE A horizontal feature used as the heading of over-draperies and made of textile, wood, metal, or other material; fabric in vertical folds falling from a pole or cornice over a door or window.

VALDEVIRA, PEDRO. (D. 1565) Spanish Renaissance architect. The cathedral of Jaen, the style of which had an important influence in Latin America, was begun under him.

VALUE OF A COLOR The relative amount of white or black in a color.

VAN BRIGGLE, ARTUS (1869–1904) American potter in the *Art Nouveau* style.

VANBRUGH, SIR JOHN (1664–1726) English architect, furniture designer, and scenic designer. His best-known works are Blenheim Castle and Castle Howard.

VAN DE VELDE, HENRI (1863–1957) Belgian architect and designer in the *Art Nouveau* style.

VANDERGOTEN, JACOBO (DIED 1725) Brussels tapestry maker called to Madrid by Philip V. Directed Spain's royal manufactory of tapestries and rugs.

VAN DYCK, PETER (ACTIVE DURING THE SEVENTEENTH CENTURY) Dutch silversmith in New York.

VAN RISAMBURGH, BERNARD II (C.1696–C.1766) One of a family of French cabinetmakers, van Risamburgh was a *Mâitre-Ébéniste* in service to Louis XV. His work is best known by the initials with which his furniture was stamped, B.V.R.B.

VARGUEÑO Spanish term for a cabinet and desk with a drop-lid.

VARNISH A coating, usually made of shellac and alcohol, that gives wood a glossy protective finish.

VAULT A roof constructed on the arch principle. A *barrel vault* is semicylindrical in shape. A *groin vault* is made by the intersection of two barrel vaults at right angles. In a *ribbed vault* the framework of arched ribs supports light masonry.

VEDUTA Italian term literally meaning "view" and applied to a painting or drawing of a scenic view. The painter of such a scene is called a *vedutiste*.

VEILLEUSE French term for a *chaise longue* of the Louis XV period.

VELOUR-DE-GÊNES Silk velvet. Made in Genoa and usually having a small allover pattern.

VELOURS A general term for any fabric resembling velvet. It is the French word for velvet, but has been so misused that it no longer has a definite meaning.

VELOURS D'UTRECHT See *Utrecht velvet*.

VELVET A fabric having a thick, short *pile* on the surface and a plain back. A true velvet is woven with two sets of *warps*, one for the back and one for the pile, which is made by looping the warp thread over a wire, which later cuts the loops. Cheaper velvets and some chiffon velvets are woven face to face and have two backs using two warps and two fillers. The pile is made by slicing apart the two pieces of fabric. Velvet may be plain, striped, or patterned. It may be made of all cotton, linen, mohair, synthetic fibers, or silk, though it is seldom woven with all silk threads. The finer quality may be used for draperies, and the heavier for upholstery. There are several variations, as follows:
- *brocaded*, a velvet with its pattern made by removing part of the pile by heat and chemicals
- *ciselé*, a velvet with its pattern made by contrasting areas of cut and uncut loops
- *embossed*, its pattern imprinted by rollers
- *façonné*, with a small pattern, similar to brocaded velvet
- *moquette*, uncut velvet with a large *Jacquard* pattern
- *nacré*, velvet with a pile of one color and a backing of another, giving an iridescent effect
- *panné*, having its pile pressed down in one direction by rollers under steam pressure
- *plush*, with deep and thinly woven pile, often with a crushed effect
- *upholstery velvet*, the heaviest type, with a stiff back and very thick pile

VELVET CARPET A type of carpet closely resembling a *Wilton*, but without the wool backing and consequently without the wearing qualities of the Wilton.

VELVETEEN A fabric sometimes called cotton velvet. It is not woven with a *pile*, but like a heavy *sateen*, with the *weft* threads floated loosely over the *warp*. It must then be sheared to produce a fine close pile. It is ordinarily made of cotton and is suitable for upholstery.

VENEER A thin sheet of finishing wood or other material that is applied to a body of coarser material.

VENETIAN BLINDS Window shades made of small horizontal slats of wood or other material strung together on tapes. The slats may be turned up or down to exclude or let in sunlight and to control views.

VENETIAN CARPET A reversible flat-pile carpet commonly woven of wool and jute.

VENETIAN ENAMEL From the late fifteenth and sixteenth centuries, wares of enameled copper, mostly in deep blue and white, with repeated flower motifs in white or gold.

VENETIAN FURNITURE Extravagantly curved and ornamented furniture of baroque and rococo influence, produced in Italy during the late Renaissance.

VENETIAN GLASS Glass made, since the tenth century, on the island of Murano near Venice.

VENINI, PAOLO (1895–1959) Venetian glassmaker of the twentieth century.

VENTURI, ROBERT (B.1925) American architect, designer, theorist, and author, in practice with his wife, Denise Scott Brown.

VERDURE TAPESTRY A tapestry design showing trees and flowers.

VERMEIL French term for gilded silver (or, less frequently, gilded bronze or copper).

VERMICULATION The carving of masonry blocks in imitation of worm tracks. Such blocks are said to be vermicular.

VERNIS MARTIN French term used as a term to describe the lacquer work done by a cabinetmaker named Martin and his brothers during the eighteenth century in France in imitation of Far Eastern lacquer.

VERRE DE FONGÉRE French equivalent of *waldgläs*.

VERRE DOUBLÉ French equivalent of *cased glass*.

VERRE ÉGLOMISÉ Glass decorated on the back by gilding or painting.

VERRERIE French term for a glass manufactory.

VERRIER French term for a glassware cabinet.

VERTICAL CIRCULATION Stairs, ramps, elevators, or escalators that connect different levels.

VESICA PISCIS See *mandorla*.

VESTIBULE An entrance hall or foyer.

VICTORIAN STYLE Strictly, the style prevailing in England during the reign of Queen Victoria, 1837–1901. In practice, the term extends almost a decade later in time and includes work in the United States during the same period.

VIGNELLI ASSOCIATES American multidiscipline design firm headed by Italian-born Massimo (b.1931) and Lella Vignelli.

VIGNETTE Ornamental motif, pattern, or portrait isolated in a large field.

VIGNOLA See *da Vignola*.

VILE, WILLIAM (DIED 1767) Partner of John Cobb from about 1750. Responsible for the finest *Rococo* furniture made for the crown in the early years of George III's reign.

VILLA In ancient Rome, a country estate, including both house and grounds; in later times, a country house or a small detached house.

VILLAPANDO, FRANCISCO CORRAL DE (DIED 1561) Spanish Renaissance architect who designed the silver choir screen of the Cathedral of Toledo.

VINETTE In Gothic ornament, a motif resembling vines and tendrils.

VINYL Common term for *polyvinyl chloride*.

VINYL FABRICS Textiles fused or coated with *vinyl*. In the coated types the vinyl is opaque, and the surface is printed or embossed.

VIOLLET-LE-DUC, EUGÈNE-EMANUEL (1814–79) French architect, author, and theorist, a key figure in the revival of Gothic forms.

VIS-À-VIS French term for two seats facing in opposite directions, attached in the center.

VITRIFICATION The process of becoming glass or glass-like, usually as a result of intense heat.

VITRINE French term for a curio cabinet with glass front (particularly Louis XVI). The term is still in use for showcases in museums or shops.

VITROMANIA Nineteenth-century practice of decorating plain window glass so that it resembles stained glass. See also *diaphanie*.

VITRUVIAN SCROLL See *running dog*.

VITRUVIUS POLLIO, MARCUS (FL.46–30 B.C.) Roman architect and architectural theorist.

VOC Acronym for a volatile organic compound, a material that can emit harmful vapors.

VOILE A light, transparent fabric of plain weave used for *glass curtains*. Hard-twisted thread is used to make it durable. It is usually piece-dyed, striped, or figured, and can be made of cotton, wool, silk, or any synthetic fiber.

VOLUTE A spiral, scroll-like form, as in the Ionic and Corinthian capitals; a similar shape at the end of a stair railing.

VOUSSOIR In architecture, a wedge-shaped block used in the construction of a true arch. The central voussoir is called the *keystone*.

VOYEUSE French term for a chair with a padded back rail. The occupant sat facing the back, arms resting on the pad. The equivalent English term is *conversation chair*.

VOYSEY, C. F. A. (1857–1941) English domestic architect and designer of furniture, wallpaper, and textiles. His style was inspired by the work of Arthur H. Mackmurdo and influenced that of Charles Rennie Mackintosh.

VYSE A spiral stair wrapped around a central column.

W

WACHSTUCH-TAPETE German term for a *floorcloth*.

WAG-ON-WALL A weight-driven clock with exposed weights and pendulum, intended to hang on the wall.

WAGNER, OTTO (1841–1918) Austrian architect and designer of the *Secession* movement.

WAINSCOT A wooden lining for interior walls, usually paneled. Any treatment resembling same. In classical interiors, the wainscot is usually divided into three parts—a base, a panel (corresponding to the shaft of a column), and a cap molding, this last part being also called a *chair rail*. A wainscot is also called a *dado*. The word

is probably derived from the Dutch *wagenschot*, which refers to a fine quality of quartered oak.

WAINSCOT CHAIR An early-seventeenth-century wooden chair used in England and America. Its back is paneled like a wainscot.

WAINSCOT CUPBOARD A *press cupboard*.

WALDGLÄS A rustic glass, usually with a green or brown tint, that was popular in Germany in medieval times. It is also known as forest glass.

WALNUT A light brown wood taken from trees that grow throughout Europe, Asia, and Africa. Much used for cabinetwork. There are English, French, and Italian varieties. The American walnut has a coarser grain than the European varieties and is often called English walnut or black walnut. The hickory tree has a similar wood and leaf, and is often called a walnut in the United States. See also *butternut* and *black walnut*.

WARM COLORS Red and the hues that approach red, orange, and yellow.

WARP In weaving, the threads that run lengthwise on a loom.

WATERFORD Famous Irish glass factory in operation 1784–1851.

WATERLEAF A conventionalized leaf pattern of classical origin used to enrich a *cyma reversa* molding.

WATTLE AND DAUB Construction made of interwoven poles or sticks (wattle) on which is plastered a layer of clay, dung, or mud (daub).

WAVE PATTERN A continuous pattern conventionally imitating a series of breaking wave crests.

WEALD GLASS English equivalent of *waldgläs*.

WEBBING Strips of woven burlap used as a support for springs in upholstery.

WEDGWOOD, JOSIAH (1730–1795) Staffordshire potter who established the Wedgwood works.

WEFT In weaving, the threads that run crosswise from selvage to *selvage* and are woven in and out of the *warp* threads by means of a shuttle or bobbin. These are also called the *woof*, but are now more commonly called the *filler* threads.

WEISWEILER, ADAM (C.1750–C.1810) Louis XVI ébéniste, appointed *Maître Ébéniste* in 1778.

WELTING Strips of material sewn between upholstery seams to give a finished appearance.

WHAT-NOT A set of ornamental shelves used to hold *bric-a-brac* and china.

WHIELDON, THOMAS (1719–86) A potter at Fenton, Staffordshire, England. The "Whieldon ware" named for him was a speckled earthenware also called "Tortoiseshell." Whieldon employed *Josiah Spode* as an apprentice and was an early partner of *Josiah Wedgwood*.

WHISTLER, JAMES ABBOTT MCNEILL (1834–1903) American painter, etcher, and decorator.

WHITE LEAD A heavy white substance that does not dissolve in water and is used as a base in paints when mixed with linseed oil.

WHITE SOUND A low, barely discernible background noise deliberately created to soften the effects of more potentially disturbing noise.

WHITE, STANFORD (1853–1906) American architect, partner in the firm McKim, Mead, & White.

WHITEWASH A thin water-base paint containing lime and chalk, also called whiting.

WHITEWOOD A trade name for poplar and cottonwood. There are several species, but all are characterized by a uniform grain of little interest, so that the wood is used mainly for shelving, interior parts of furniture, and cores in veneered work. It is soft and works easily, but is durable in ordinary use, excellent for painted surfaces.

WICKER Construction of interwoven pliant twigs, such as willow, often used in furniture.

WIENER WERKSTÄTTE Literally, "Vienna Workshop," a school and design center founded in Vienna in 1903. Its designers included *Josef Hoffmann* and Koloman Moser,

WILD SILK Roughly textured silk obtained from silkworms that feed on oak, cherry, and other leaves, rather than on cultivated mulberry leaves.

WILLARD FAMILY: SIMON, BENJAMIN, AARON, AND EPHRAIM (ACTIVE 1743–1848) Famous family of Massachusetts clockmakers. Simon is credited with introducing the *banjo clock* to America from England.

WILLIAM AND MARY The baroque style prevailing in England and America during the reigns of King William, 1689–1702, and Queen Mary, 1689–94.

WILLOW PATTERN Scenic pattern for porcelain and ceramic ware, Chinese in character though it originated in England. Very popular in the eighteenth century.

WILTON CARPET A carpet with cut woolen pile and a cotton back.

WINDSOR CHAIR Domestic wooden chair popular in eighteenth- and nineteenth-century England and America, its back composed of parallel vertical spindles. Also called a *stickback*.

WING CHAIR A tall upholstered chair with wings or ears projecting on either side of the back.

WINSLOW, EDWARD (1669–1753) Boston silversmith.

WIRE GLASS Glass with a layer of wire imbedded in it to protect against shattering. Also called wired glass.

WOOD CARPET An inexpensive alternative to *parquet*, consisting of thin pieces of wood glued to a fabric or paper backing that is nailed or glued to the floor.

WOODCUT A design engraved upon a block of wood in such a way that all the wood is cut away to a slight depth except the lines forming the design. For use in printing papers and textiles.

WORMLEY, EDWARD (1907–1996) Prolific American furniture designer.

WORSTED Yarn spun from combed wool. Fabric made with such yarn.

WREN, SIR CHRISTOPHER (1632–1723) English inventor, astronomer, and–after 1666–architect. He designed St. Paul's Cathedral and many other churches in London.

WRIGHT, FRANK LLOYD (1869–1959) Eminent architect and author, follower of Louis Sullivan in promoting functional and organic design in architecture and the industrial arts.

WYZENBEEK TEST Test of a fabric's reistance to abrasion by rubbing it with rollers covered in wire mesh. The number of cycles the fabric can withstand before breakdown is considered a measure of durability.

X

X-SHAPED CHAIR A chair, sometimes a folding chair, with legs in the shape of an X when viewed from the sides. Types of X-shaped chairs include the *curule chair*, the *Dante chair*, and the *Savonarola* chair.

X-SHAPED STRETCHERS Crossed *stretchers* between chair legs. See also *saltire*.

XENON ARC LAMP A lamp used in testing the degradation of fabric under ultraviolet light.

XYSTUS In Greek architecture, an *ambulatory* or *portico*.

Y

YARN A strand of textile fibers; the basic material from which thread, twine, or cloth is made. There are two basic categories of yarn: *spun yarn* and *continuous filament yarn*.

YARN-DYEING A process of dyeing the yarns before they are woven into a textile. See also *piece-dyeing* and *stock-dyeing*.

YESERÍA Spanish term for small lacelike patterns of plaster relief that were colored and used extensively on the walls of Moorish rooms.

YEW A close-grained hardwood of a deep reddish brown. It is a European evergreen and thrives especially in England. Frequently used in cabinetwork where an elastic quality is desirable.

YI Korean dynasty from 1392 to 1910.

YOKE A cross-bar in the form of two S-curves used for the top rail of chair backs, similar in profile to an ox-yoke. Typical of English Georgian furniture. A chair with such a feature is called a yoke-back chair.

YORKSHIRE CHAIR A popular name for a type of Jacobean chair of provincial origin. Similar to a *Derbyshire chair*.

YÜAN DYNASTY Mongol dynasty of China, A.D. 1260–1368. Its most famous emperor was Kublai Khan.

Z

ZARF A footed holder for a handleless cup.

ZEBRAWOOD A light golden-yellow wood with dark brown stripes. It is used for ornamental cabinetwork.

ZELKOWA A Japanese wood, also known as *keyaki*.

ZIG-ZAG See *chevron*.

ZITAN Chinese furniture wood.

ZUCCHI, ANTONIO PIETRO (1726–1795) Venetian painter who did decorative paintings for interiors and for some of the furniture of Robert Adam. He was married to the painter Angelica Kauffman.

ZWIEBELMUSTER A German phrase for "onion pattern," a pattern popular in Meissen porcelain and in wallcoverings and fabrics.

ZWISCHENGOLDGLAS A glass vessel ornamented with gold, the gold then protected by another layer of glass. The technique was used in ancient Rome and again, from the eighteenth century, in Germany.

Bibliography

CHAPTER 1 Design before History (before 3400 B.C.)

Berenguer, Magín. *Prehistoric Cave Art in Northern Spain*. Mexico: Frente de Afirmacion Hispanista A. C., n.d.

Chauvet, Jean-Marie, et al. *Dawn of Art: The Chauvet Cave*. New York: Abrams, 1996.

Fagan, Brian M. *World Prehistory, A Brief Introduction*. New York: Harper Collins, 1993.

Gowlett, John A. J. *Ascent to Civilization, The Archaeology of Early Man*. New York: Knopf, 1984.

Haviland, William A. *Cultural Anthropology*. 7th ed. Fort Worth: Harcourt Brace Jovanovich College Publishers, 1973.

Huyghe, René, ed. *The Larousse Encyclopedia of Prehistoric and Ancient Art*. New York: Prometheus, 1962. Especially André Leroi-Gourhan, "The Beginnings of Art."

Mellaart, James. *Çatal Hüyük, A Neolithic Town in Anatolia*. London: Thames and Hudson, 1967.

———. "A Neolithic City in Turkey." In *Scientific American*, April 1964, reprinted in *Prehistoric Times: Readings from Scientific American*. San Francisco: W. H. Freeman, 1983.

Turnbaugh, William A., et al. *Understanding Physical Anthropology and Archaeology*, 6th ed. St. Paul: West Publishing, 1996.

CHAPTER 2 Egypt 4500 B.C.–A.D. 30

EGYPTIAN FURNITURE MAKING AND WOODWORKING

Baker, Hollis S., *Furniture in the Ancient World*. New York: Macmillan, 1966. Baker is the son of the founder of the Baker Furniture Co. of Grand Rapids, MI, and himself the founder of the Baker Museum of Furniture in that city.

Killen, Geoffrey. *Egyptian Woodworking and Furniture*. Princes Risborough, Buckinghamshire, England: Shire, 1994.

———. "The Style and Development of Ancient Egyptian Furniture," *The Magazine Antiques*, Part 1, April 1997; Part 2, September 1997.

Richter, Gisela. *Ancient Furniture*. Oxford, England: Oxford University Press, 1926. We will see other books by Richter in the bibliographies for Greece and Rome.

Wanscher, Ole. *The Art of Furniture*. Oxford, England: Reinhold, 1966. Includes measured drawings of a few pieces.

EGYPTIAN WEAVING

Hall, Rosalind. *Egyptian Textiles*. Princes Risborough, Buckinghamshire, England: Shire, 1986.

Riefstahl, E. *Patterned Textiles in Pharaonic Egypt*. Brooklyn: Brooklyn Museum, 1945.

Roth, H. L. *Ancient Egyptian and Greek Looms*, 2nd ed. Halifax: F. King and Sons, 1951.

Thomas, Thelma K. *Textiles from Medieval Egypt, A.D. 300–1300*. Pittsburgh, Carnegie, 1990.

EGYPTIAN FAIENCE AND GLASS

Cooney, J.D. *Catalogue of Egyptian Antiquities in the British Museum, IV: Glass*. London: British Museum, 1976.

Friedman, Florence Dunn. *Gifts of the Nile: Ancient Egyptian Faience*. New York: Thames and Hudson, 1998.

Goldstein, S. M. *Pre-Roman and Early Roman Glass in the Corning Museum of Glass*. New York: Corning Museum of Glass, 1979.

Kaczmarczyk, A., and R. E. M. *Ancient Egyptian Faience*. Warminster: Arris and Phillips, 1983.

Nicholson, Paul T. *Egyptian Faience and Glass*. Princes Risborough, Buckinghamshire, England: Shire, 1986.

Riefstahl, E. *Ancient Egyptian Glass and Glazes in the Brooklyn Museum*. Brooklyn: Brooklyn Museum, 1968.

EGYPTIAN ARCHITECTURE AND DESIGN

Aldred, Cyril. *The Egyptians*. London: Thames and Hudson, 1961, 1984.

Badawy, Alexander. *Architecture in Ancient Egypt and the Near East*. Cambridge, MA: MIT Press, 1966.

———. *A History of Egyptian Architecture*, 3 vols. Berkeley: University of California Press, 1954–68.

Bagnall, Roger S. *Egypt in Late Antiquity*. Princeton, NJ: Princeton University Press, 1995. Egypt under Roman rule, with information about the Coptic language, Coptic Christianity, and Coptic art.

Bowman, Alan K. *Egypt after the Pharaohs, 332 B.C.–A.D. 642*. Berkeley: University of California Press, 1986. Paperback edition, London: British Museum Press, 1996.

Breasted, J. H. *A History of Egypt from the Earliest Times to the Persian Conquest*, 3 vols. New York: Scribner's, 1909. The work by James Henry Breasted (1865–1935) is the Great Pyramid of Egyptian scholarship, looking a bit old but still immense and awesome. Both Breasted and Flinders Petrie have a number of books about Egypt to their credit in addition to those listed here.

Budge, E. A. Wallis. *The Dwellers on the Nile*. London: Religious Tract Society, 1926. New York: Dover, 1977.

de Cenival, Jean-Louis. *Egypt*. Lausanne: Office du Livre, 1964. Part of the series Architecture of the World, this book has excellent photography by the editor of the series, Henri Stierlin, and an introduction by modern architect Marcel Breuer, in which he discusses the influence of Egyptian architecture on his own work.

Description de l'Egypte. Köln: Taschen, 1994. Despite the French title, the brief introduction is also in English. In any case, this is primarily a picture book, reproducing the thousands of drawings from the expedition to Egypt ordered by Napoleon in 1798, the same expedition that discovered the Rosetta stone. The drawings, displaying exemplary draftsmanship, were first published in 1802.

Edwards, I. E. S. *The Pyramids of Egypt.* Baltimore: Penguin, 1947, rev. 1964. A standard text.

Erman, Adolf. *Life in Ancient Egypt.* 1894. Reprinted, New York: Dover, 1971.

Fakhry, Ahmed. *The Pyramids.* Chicago: University of Chicago Press, 1962.

Hodges, Henry. *Technology in the Ancient World.* 1970. New York: Barnes & Noble, 1992.

Hurry, J. B. *Imhotep, the Vizier and Physician of King Zoser.* London: Oxford University Press, 1926, rev. 1928.

Huyghe, René, ed. *Larousse Encyclopedia of Prehistoric and Ancient Art.* London: Paul Hamlyn, 1962.

James, T. G. H. *Ancient Egypt, The Land and Its Legacy.* Austin: University of Texas Press, 1988.

————. *Egyptian Painting and Drawing in the British Museum.* Cambridge, MA: Harvard University Press, 1986.

Lloyd, Seton, Hans Wolfgang Muller, and Roland Martin. *Ancient Architecture: Mesopotamia, Egypt, Crete, Greece.* 1972. New York: Abrams, 1974.

Lucas, Alfred. *Ancient Egyptian Materials and Industries.* London: 1926. 4th ed., rev. J. R. Harris, London: Edward Arnold, 1962.

Malek, Jaromir. *Egyptian Art.* London: Phaidon, 1999.

Montet, Pierre. *Eternal Egypt.* New York: New American Library, 1964.

Orgogozo, Chantal. *The Discovery of Egypt: Artists, Travelers, and Scientists.* New York: Abbeville, 1993.

Petrie, W. M. Flinders. *Decorative Patterns of the Ancient World.* 1930. New York: Crescent, 1990.

————. *Egyptian Decorative Art.* London, 1895. New York: Benjamin Blom, 1972.

Pfeiffer, John E. *The Creative Explosion: An Inquiry into the Origins of Art and Religion.* New York: Harper and Row, 1982.

Reeves, Nicholas. *The Complete Tutankhamun: The King, The Tomb, The Royal Treasure.* New York: Thames and Hudson, 1990.

Robins, Gay. *The Art of Ancient Egypt.* London: British Museum Press, 1997.

Siliotti, Alberto. *Egypt: Splendors of an Ancient Civilization.* New York: Thames and Hudson, 1996. Oversize volume with impressive color illustrations.

Smith, W. Stevenson. *The Art and Architecture of Ancient Egypt,* Pelican History of Art series. Harmondsworth, England: Penguin, 1958. Reprinted, New Haven: Yale University Press, 1981.

Tiradritti, Francesco, ed. *Egyptian Treasures from the Egyptian Museum in Cairo.* New York: Abrams, 1999.

White, J. E. Manship. *Ancient Egypt, Its Culture and History.* 1952. New York: Dover, 1970.

Wilkinson, Richard H. *The Complete Temples of Ancient Egypt.* New York: Thames and Hudson, 2001.

Wilson, John A. *The Culture of Ancient Egypt.* Chicago: University of Chicago Press, 1951.

Woldering, Irmgard. *The Art of Egypt.* Baden-Baden, Germany: Holle, 1962. New York: Greystone, 1963.

CHAPTER 3 The Ancient Near East (2800–331 B.C.)

Amiet, Pierre. *Art of the Ancient Near East.* New York: Abrams, 1980. Wide-ranging text with over a thousand illustrations.

Burney, Charles. *The Ancient Near East.* Ithaca, NY: Cornell University Press, 1964.

Caubet, Annie, and Patrick Pouyssegur. *The Ancient Near East.* Paris: Terrail, 1998.

Contenau, Georges. "Egypt and Mesopotamia," in René Huyghe, ed., *The Larousse Encyclopedia of Prehistoric and Ancient Art.* London: Paul Hamlyn, 1962.

Du Ry, Carel J. *Art of the Ancient Near and Middle East.* New York: Abrams, 1969.

————. *The Birth of Civilization in the Near East.* New York: Doubleday, 1959.

Frankfort, Henri. *Art and Architecture of the Ancient Orient.* 3rd rev. ed. Baltimore: Penguin Books, 1963. A standard text.

Ghirshman, Roman. *The Art of Ancient Iran.* New York: Golden Press, 1964. Part of the series The Arts of Mankind, ed. by André Malraux and Georges Salles. Excellent photographs of Persepolis.

Kuhrt, Amélie, and Susan Sherwin-White, eds. *Hellenism in the East.* London: Duckworth, 1989.

Lloyd, Seton. *The Art of the Ancient Near East.* New York: Praeger, 1961.

————. "Architecture of Mesopotamia and the Ancient Near East." In Seton Lloyd, Wolfgang Müller, and Roland Martin, *Ancient Architecture: Mesopotamia, Egypt, Crete, Greece.* New York: Abrams, 1974.

Mahboubian, Houshang. *Art of Ancient Iran: Copper and Bronze.* London: Philip Wilson, 1997.

Millar, Fergus. *The Roman Near East, 31 B.C.–A.D. 337.* Cambridge, MA: Harvard University Press, 1995.

Nissen, Hans J. *The Early History of the Ancient Near East, 9000–2000 B.C.* Chicago: University of Chicago Press, 1988.

Postgate, J. N. *Early Mesopotamia: Society and Economy at the Dawn of History.* New York and London: Routledge, 1997.

Pritchard, James B., ed. *The Ancient Near East, Vol. I: An Anthology of Texts and Pictures.* Princeton, NJ: Princeton University Press, 1958.

————. *The Ancient Near East, Vol. II: A New Anthology of Texts and Pictures.* Princeton, NJ: Princeton University Press, 1973.

Roebuck, Carl. *The World of Ancient Times.* New York: Scribner's, 1966.

Saggs, H. W. F. *Babylonians.* Norman: University of Oklahoma Press, 1995.

Note: Some of these titles are also applicable to the next chapter, on Greece.

CHAPTER 4 Greece (2800–146 B.C.)

MINOAN AND MYCENAEAN PRECEDENTS

In addition to the following, the University of Pennsylvania Museum of Archaeology and Anthropology has published a series of scholarly texts based on its Minoan collection. For a Classical source, the *Oresteia,* the trilogy of plays—consisting of the *Agamemnon, Choephori,* and *Eumenides*—by the Greek dramatist Aeschylus has as its principal figure Agamemnon, King of Mycenae, and much of its action takes place in Mycenae. Among popular fiction, two novels by

Mary Renault, *The King Must Die* (1958), and *The Bull from the Sea* (1961), have settings in Minoan Crete.

Boardman John. *Pre-Classical: From Crete to Archaic Greece*. Harmondsworth, England: Penguin, 1967.

Branigan, Keith. *The Foundations of Ancient Crete: A Survey of Crete in the Early Bronze Age*. New York: Praeger, 1970.

Castleden, Rodney. *Minoans: Life in Bronze Age Crete*. London: Routledge, 1990.

Chadwick, John. *The Minoans*. New York: Praeger, 1971.

———. *The Mycenaean World*. New York: Cambridge University Press, 1976.

Cottrell, Leonard. *The Bull of Minos*. New York: Holt, Rinehart, and Winston, 1958.

Demargne, Pierre. "The Aegean World." In René Huyghe, ed., *Larousse Encyclopedia of Prehistoric and Ancient Art*. New York: Prometheus, 1957.

Evans, Arthur J. *The Palace of Minos at Knossos*. 4 vols. New York: Biblo and Tannen, 1921.

Farnoux, Alexandre. *Knossos: Searching for the Legendary Palace of King Minos*. New York: Abrams, 1996. Colorful little paperback in the Discoveries series.

Graham, J. W. *The Palaces of Crete*. Princeton, NJ: Princeton University Press, 1962.

Hampe, Roland. *The Birth of Greek Art, from the Mycenaean to the Archaic Period*. New York: Oxford University Press, 1981.

Higgins, Reynold. *The Archaeology of Minoan Crete*. New York: Henry Z. Walck, 1973.

———. *Minoan and Mycenaean Art*. New York: Praeger, 1967.

Hood, Sinclair. *The Arts in Prehistoric Greece*. The Pelican History of Art series. Harmondsworth, England: Penguin, 1978.

———. *The Home of the Heroes*. New York: McGraw-Hill, 1967.

———. *The Minoans: Crete in the Bronze Age*. New York: Praeger, 1971.

Marinatos, Spyridon. *Crete and Mycenae*. New York: Abrams, 1960.

———. *Minoan Civilization: Maturity and Zenith*. Cambridge, England: Cambridge University Press, 1962.

Martin, Roland. "Architecture of Minoan Crete and the Mycenaean World." In S. Lloyd, H. W. Müller, and R. Martin, eds., *Ancient Architecture: Mesopotamia, Egypt, Crete, Greece*. New York: Abrams, 1974.

Matz, Friedrich. *The Art of Crete and Early Greece: The Prelude to Greek Art*, The Art of the World series. New York: Greystone Press, 1962.

Mellersh, H. E. L. *The Destruction of Knossos: The Rise and Fall of Minoan Crete, 1970*. Reprinted, New York: Barnes and Noble, 1993.

Willetts, R. F. *The Civilization of Ancient Crete*. 1976. New York: Barnes and Noble, 1995.

———. *Everyday Life in Ancient Crete*. New York: G. P. Putnam's Sons, 1969.

———. "The Minoans," in Arthur Cotterell, ed., *The Penguin Encyclopedia of Ancient Civilizations*. Harmondsworth: Penguin, 1980.

THE PARTHENON

Virtually every book on Greek art mentions the Parthenon. Those with a specific focus on the building include:

Boardman, J. *The Parthenon and Its Sculptures*. London: Thames and Hudson, 1985. Well illustrated.

Bruno, Vincent J., ed. *The Parthenon*. New York: W. W. Norton, 1974. Essays on the history, the aesthetic refinements, and the sculpture of the Parthenon. Included is an eyewitness account of the building's bombardment in the seventeenth century. Glossary and excellent bibliography, arranged by topics.

Cook, B. F. *The Elgin Marbles*. London: British Museum, 1984.

Hambridge, Jay. *The Parthenon and Other Greek Temples: Their Dynamic Symmetry*. New Haven, CT: Yale University Press, 1924. An idiosyncratic view of the principles of proportion on which the Parthenon might have been based. Hambridge wrote a number of books on the system of proportion he called dynamic symmetry.

Haynes, D. E. L. *The Parthenon Frieze*. London: Batchworth Press, 1973. A portfolio of detail photographs.

Hitchens, Christopher. *The Elgin Marbles: Should They Be Returned to Greece?* London: Chatto and Windus, 1987. Also published by Hill and Wang, New York, 1987, under the title *Imperial Spoils: The Curious Case of the Elgin Marbles*.

Jenkins, Ian, *The Parthenon Frieze*. Austin: University of Texas Press, 1994.

Rhodes, Robin Francis. *Architecture and Meaning on the Athenian Acropolis*. New York: Cambridge University Press, 1995.

GREEK FURNITURE

Baker, Hollis S. *Furniture in the Ancient World*. New York: Macmillan, 1966.

Richter, Gisela M. A. *Ancient Furniture*. Oxford, England: Oxford University Press, 1926.

———. *The Furniture of the Greeks, Etruscans, and Romans*. London: Phaidon, 1966 (reprint).

Robsjohn-Gibbings, T. H., and Carlton W. Pullin. *Furniture of Classical Greece*. New York: Knopf, 1963. An appreciation and re-creation of Greek furniture by Robsjohn-Gibbings, a modern author and designer (1909–73).

GREEK VASES

Like the Parthenon, Greek vases are mentioned in almost every book on Greek art. Among more specialized texts are:

Arias, Paolo Enrico. *A History of Greek Vase Painting*. New York: Thames and Hudson, 1962.

Beazley, J. D. *Attic Black Figure Vase Painters*. Oxford: Oxford University Press, 1956. This and the following book are standard scholarly references, as are the 1974 and 1975 books by Boardman.

———. *Attic Red Figure Vase Painters*. Oxford: Oxford University Press, 1942.

Boardman, John. *Athenian Black Figure Vases*. New York: Oxford University Press, 1974.

———. *Athenian Red Figure Vases*. New York: Oxford University Press, 1975.

———. *The History of Greek Vases*. New York: Thames and Hudson, 2001.

Folsom, Robert S. *Attic Black-Figured Pottery*. Park Ridge, NJ: Noyes Press, 1975.

———. *Handbook of Greek Pottery: A Guide for Amateurs*. Greenwich, CT: New York Graphic Society, 1967.

Herford, Mary A. B. *A Handbook of Greek Vase Painting.* Sparks, NV: Falcon Hill Press, 1995. Reprint of the 1919 original published in Manchester and London.

Morris, Sarah P. *The Black and White Style.* New Haven, CT: Yale University Press, 1984.

Rasmussen, Tom, and Nigel Spivey, eds. *Looking at Greek Vases.* New York: Cambridge University Press, 1991.

Richter, Gisela M. A., and Marjorie J. Milne. *Shapes and Names of Athenian Vases.* New York: Metropolitan Museum of Art, 1935.

Shapiro, H. A. *Myth into Art: Poet and Painter in Classical Greece.* London and New York: Routledge, 1994.

Williams, Dyfri. *Greek Vases.* London: British Museum Press, 1985. Reprinted the same year by Harvard University Press, Cambridge, MA. A highly readable summary available in paperback.

GREEK DESIGN

Ashmole, Bernard. *Architect and Sculptor in Classical Greece.* New York: New York University Press, 1972.

Boardman, John. *Greek Art.* World of Art series. New York: Thames and Hudson, 1985. First published 1964.

Bonnard, André. *Greek Civilization.* New York: Macmillan, 1959.

Bowra, C. M. *The Greek Experience.* London: Weidenfield and Nicolson, 1957.

Carpenter, Rhys. *The Esthetic Basis of Greek Art.* 2nd ed., Bloomington: Indiana University Press, 1959. Interesting reflections on the character of Greek art.

Chamoux, François. *The Civilization of Greece,* trans. W. S. Maguinness. New York: Simon and Schuster, 1965.

Dinsmoor, William Bell. *The Architecture of Ancient Greece.* London: B. T. Batsford, 1950 (3rd rev. ed., New York: Biblo and Tannen, 1973). A standard text.

Doxiadis, Constantinos. *Architectural Space in Ancient Greece.* Cambridge, MA: MIT Press, 1977. For those with an interest in urban design issues.

Fairbanks, Arthur. *Greek Art, the Basis of Later European Art.* New York: Cooper Square, 1963.

Grant, Michael. *The Rise of the Greeks.* New York: Scribner, 1988.

Holloway, R. Ross. *A View of Greek Art.* Providence, RI: Brown University Press, 1973.

Kitto, H. D. F. *The Greeks.* Harmondsworth, England: Penguin, 1951 (rev. ed., 1985).

Lawrence, A. W. *Greek Architecture,* The Pelican History of Art series. Harmondsworth, England: Penguin, 1957 (rev. ed., 1973).

Martin, Roland. *Living Architecture: Greece.* New York: Grosset and Dunlap, 1967. Reprinted in Benedikt Taschen Verlag's Architecture of the World series.

Pollitt, J. J. *Art and Experience in Classical Greece.* New York: Cambridge University Press, 1972.

Richter, Gisela M. A. *A Handbook of Greek Art: A Survey of the Visual Arts of Ancient Greece.* Oxford: Phaidon, 1959 (New York: Da Capo, 1987).

Rider, Bertha Carr. *Ancient Greek Houses.* Chicago: Argonaut, 1964. Reprinted, New York: Benjamin Blom, 1967.

Schefold, Karl. *The Art of Classical Greece,* Art of the World series. New York: Greystone Press, 1967.

Scranton, Robert L. *Greek Architecture.* New York: Braziller, 1962.

———. "Interior Design of Greek Temples," *American Journal of Archaeology,* I, 1946.

Scully, Vincent. *The Earth, the Temple, and the Gods: Greek Sacred Architecture.* New Haven, CT: Yale University Press (rev. ed., New York: Praeger, 1969). Speculations, some of them controversial, of an eminent architectural historian.

Starr, Chester G. *The Origins of Greek Civilization, 1100–650 B.C.* New York: Knopf, 1961.

Vermeule, Emily. *Greece in the Bronze Age.* Chicago: University of Chicago Press, 1964.

CLASSICAL DESIGN

Boardman, John, ed. *The Oxford History of Classical Art.* New York: Oxford University Press, 1993

———, Jasper Griffin, and Oswyn Murray, eds. *The Oxford History of the Classical World.* New York: Oxford University Press, 1986.

de Burgh, W. G. *The Legacy of the Ancient World.* Harmondsworth, England: Penguin, 1967. Paperback reprint of a book first published in 1923. It surveys the contributions of the Hebrews, Greeks, and Romans.

Ehrenberg, Victor. *Society and Civilization in Greece and Rome.* Cambridge, MA: Harvard University Press, 1964.

Mertens, Joan R., et al. *The Metropolitan Museum of Art: Greece and Rome.* New York: Metropolitan Museum of Art, 1987. Over a hundred objects from the museum's collection.

Richter, Gisela M. A. *The Metropolitan Museum of Art: Handbook of the Classical Collection.* New York: Metropolitan Museum, 1930. Long outdated as a guide to the museum's collection, but still a useful survey.

Scranton, Robert I. *Aesthetic Aspects of Ancient Art.* Chicago: University of Chicago Press, 1964.

Tzonis, Alexander, and Liane Lefaivre. *Classical Architecture: The Poetics of Order.* Cambridge, MA: MIT Press, 1986. Excellent survey of the principles of classical composition, available in paperback.

CHAPTER 5 Rome (753 B.C.–A.D. 550)

ETRUSCAN PRECEDENTS

Steingräber, Stephan, ed. *Etruscan Painting: Catalogue Raisonné of Etruscan Wall Painting.* New York: Harcourt Brace Jovanovich, 1985.

ROMAN GLASS

Battie, David, and Simon Cottle, eds. *Sotheby's Concise Encyclopedia of Glass.* London: Conran Octopus, 1991, esp. the chapter "Roman Glass" by Martine Newby.

Dayton, John E. *The Discovery of Glass,* Bulletin 41, American School of Prehistoric Research. Cambridge, MA: Peabody Museum, 1993.

Fleming, Stuart J. *Roman Glass: Reflections on Everyday Life.* Philadelphia: University of Pennsylvania Museum of Archaeology and Anthropology, 1997.

Harden, Donald Benjamin, et al. *Glass of the Caesars.* Milan: Olivetti, 1987.

Hodges, Henry. *Technology in the Ancient World.* New York: Barnes and Noble, 1992.

Price, J. "Glass." In M. Henig, ed., *Handbook of Roman Art*. Ithaca, NY: Cornell University Press, 1983.

Tait, Hugh, ed. *Glass: 5,000 Years*. New York: Abrams, 1991.

Whitehouse, David. *Glass of the Roman Empire*. Ithaca, NY: Corning Museum, 1988.

POMPEII AND HERCULANEUM

Conticello, Baldassare, et al. *Rediscovering Pompeii*, catalog of an exhibition by IBM-ITALIA at the IBM Gallery of Science and Art, New York, 1990. Rome: "L'Erma" di Bretschneider, 1990.

D'Arms, John H. *Romans on the Bay of Naples*. Cambridge, MA: Harvard University Press, 1970.

Deiss, Joseph J. *Herculaneum, Italy's Buried Treasure*. New York: Harper and Row, 1985.

Etienne, Robert. *Pompeii: The Day a City Died*, trans. Caroline Palmer, in the paperback Discoveries series. New York: Abrams, 1992.

Feder, Theodore H. *Great Treasures of Pompeii and Herculaneum*. New York: Abbeville, 1978.

Grant, Michael. *Cities of Vesuvius: Pompeii and Herculaneum*. New York: Penguin, 1971.

Richardson, L., Jr. *Pompeii, An Architectural History*. Baltimore: Johns Hopkins University Press, 1988.

ROMAN

Barton, Ian M., ed. *Roman Domestic Buildings*. Exeter, Devon, England: University of Exeter Press, 1996.

Bieber, Margarette. *Laocöon: The Influence of the Group since Its Rediscovery*. Detroit: Wayne State University Press, 1967.

Boëthius, Axel. *Etruscan and Early Roman Architecture*. Harmondsworth, England: Penguin, 1978.

Clarke, John R. *The Houses of Roman Italy, 100 B.C.–A.D. 250: Ritual, Space, and Decoration*. Berkeley: University of California Press, 1991.

Davey, Norman, and Roger Ling. *Wall-Painting in Roman Britain*. Gloucester, England: Alan Sutton, 1982. Descriptions of restoration work based on assembling fragments.

Hanfmann, George M. *Roman Art*. Greenwich, CT: New York Graphic Society, 1965.

Hibbert, Christopher. *Rome: The Biography of a City*. New York: W. W. Norton, 1985.

Kähler, Heinz. *The Art of Rome and Her Empire*, Art of the World series. New York: Greystone Press, 1963.

Liversidge, Joan. *Furniture in Roman Britain*. London: Tiranti, 1955.

MacDonald, William L. *The Architecture of the Roman Empire, I: An Introductory Study*. New Haven, CT: Yale University Press, 1965.

———. *The Pantheon: Design, Meaning, and Progeny*. Cambridge, MA: Harvard University Press, 1976.

———, and John A. Pinto. *Hadrian's Villa and Its Legacy*. New Haven, CT: Yale University Press, 1995.

Mark, Robert, and Paul Hutchinson. "On the Structure of the Roman Pantheon," *The Art Bulletin*, vol. LXVIII, no. 3, March 1986, pp. 24–34.

McKay, A. G. *Houses, Villas and Palaces in the Roman World*, Aspects of Greek and Roman Life series, ed. H. H. Scullard. Ithaca, NY: Cornell University Press, 1975.

Richter, Gisela. *Ancient Italy, A Study of the Interrelations of Its Peoples As Shown in Their Arts*. Ann Arbor: University of Michigan Press, 1955.

Ward-Perkins, J. B. *Roman Imperial Architecture*, Harmondsworth, England: Penguin, 1981.

Wheeler, Mortimer. *Roman Art and Architecture*, World of Art series. New York: Thames and Hudson, 1985.

Yegül, Fikret. *Baths and Bathing in Classical Antiquity*. New York and Cambridge, MA: Architectural History Foundation and MIT Press, 1992.

CHAPTER 6 Early Christian and Byzantine Design (A.D. 330–800 and 330–1453)

THE MIDDLE AGES IN EUROPE

Adams, Henry. *Mont-Saint-Michel and Chartres*. Boston: Houghton Mifflin, 1913. Famous study that contrasts the Romanesque Mont-Saint-Michel with the Gothic Chartres, the unity of the thirteenth century with the diversity of the twentieth century, and the symbol of the Virgin with the symbol of the dynamo.

Beckwith, John. *Early Medieval Art: Carolingian, Ottonian, Romanesque*. New York: Thames and Hudson, 1964, rev. 1969.

Berenson, Bernard. *Studies in Medieval Painting*. New Haven, CT: Yale University Press, 1930. Essays on Cimabue, twelfth-century painting in Constantinople, fourteenth-century painting in Tuscany and the like.

Davis-Weyer. Caecilia. *Early Medieval Art 300–1150*, Sources and Documents in the History of Art Series, ed. H. W. Janson. Englewood Cliffs, NJ: Prentice Hall, 1971. An anthology of original sources and documents, published in association with the Medieval Academy of America.

Focillon, Henri. *The Art of the West in the Middle Ages*, 2 vols. New York: Phaidon, 1963, Volume I concentrates on the Romanesque, volume II on the Gothic.

Mâle, Emile. *Art and Artists of the Middle Ages*, Trans. Sylvia Stallings Lowe. Redding Ridge, CT: Black Swan, 1986.

Martindale, Andrew. *The Rise of the Artist in the Middle Ages and Early Renaissance*. London: Thames and Hudson, 1972.

Morey, Charles Rufus. *Christian Art*. New York: W. W. Norton, 1958.

———*Mediaeval Art*. New York: W. W. Norton, 1942. The first half of the book includes Byzantine design.

Saalman, Howard. *Medieval Architecture: European Architecture 600–1200*, The Great Ages of World Architecture Series. New York: Braziller, 1967.

Shaver-Crandall, Annie. *The Middle Ages*, The Cambridge Introduction to Art Series. New York: Cambridge University Press, 1982.

Snyder, James. *Medieval Art: Painting, Sculpture, Architecture, Fourth–Fourteenth-Century*. New York: Abrams, 1989

Stoddard, Whitney S. *Art and Architecture in Medieval France*. New York: Harper and Row, 1972.

von Heideloff, Karl Alexander. *Medieval Ornament*. Mineola, NY: Dover, 1995. Reprint of a work first published in the nineteenth century.

Webb, G. *Architecture in Britain: The Middle Ages*. Harmondsworth, England: Pelican, 1956.

EARLY CHRISTIAN ART AND ARCHITECTURE

Beckwith, John. *Early Christian and Byzantine Art*. Harmondsworth, England: Pelican, 1970. An authoritative survey.

Conant, Kenneth John. *A Brief Commentary on Early Medieval Church Architecture*. Johns Hopkins, University Press, 1942. Based on a series of lectures at Johns Hopkins in 1939.

Eco, Umberto. *Art and Beauty in the Middle Ages*. New Haven, CT: Yale University Press, 1986.

Krautheimer, Richard. *Early Christian and Byzantine Architecture*. Penguin, 1965; New Haven, CT: Yale University Press, 1986. A standard authority. The 1986 revision was prepared with the collaboration of Slobodan Ćurčić.

Lowden, John. *Early Christian and Byzantine Art*. Art and Ideas Series. London: Phaidon, 1997.

Lowrie, Walter. *Art in the Early Church*. New York: Pantheon, 1947.

MacDonald, William. *Early Christian and Byzantine Architecture*. Great Ages of World Architecture series. New York: Braziller, 1970.

Morey, Charles Rufus. *Early Christian Art*. Princeton, NJ: Princeton University Press, 1953. Covers the period before the eighth century.

Stewart, Cecil. *Early Byzantine and Romanesque Architecture*. New York: David McKay, 1954.

Temple, Richard, ed. *Early Christian and Byzantine Art*. London: Element Books and the Temple Gallery, 1990. Good illustrations of textiles, metalwork, frescoes, tile, and pottery.

Volbach, W. F., and M. Hirmer. *Early Christian Art*. New York: Abrams, 1961.

HAGIA SOPHIA

Balfour, John Patrick Douglas, Lord Kinross. *Hagia Sophia, A History of Constantinople*, Newsweek's Wonders of Man Series. New York: Newsweek Book Division, 1972.

Kähler, Heinz. ed. *Hagia Sophia*. New York: Praeger, 1967.

MacDonald, William. "The Structure of St. Sophia." *Architectural Forum*, May 1963, pp. 131–138, 210.

Swift, E. H. *Hagia Sophia*. New York: Columbia University Press, 1940.

ST. MARK'S, VENICE

The Treasury of San Marco Venice. Milan: Olivetti, with the Metropolitan Museum of Art, New York: 1984. Exhibition catalog.

Unrau, John. *Ruskin and St Marks*. New York: Thames and Hudson, 1984.

BYZANTINE ART AND ARCHITECTURE

Beckwith, John. *The Art of Constantinople*. New York: Phaidon, 1961.

Buckton, David, ed. *Byzantium: Treasures of Byzantine Art and Culture*. London: British Museum Press, 1994. Exhibition catalog.

DeIongh, Daniel Crena. *Byzantine Aspects of Italy*. New York: W. W. Norton, 1967.

Demus, Otto. *The Church of San Marco in Venice*. Washington DC: Dumbarton Oaks, 1960.

Grabar, André. *Byzantine Painting: An Historical and Critical Study*. Geneva: Skira, 1953.

Hamilton, J Arnott. *Byzantine Architecture and Decoration*. London: B. T. Batsford, 1933 (2d ed., 1956).

Handbook of the Byzantine Collection. Washington DC: Dumbarton Oaks, 1967.

Huyghe, René. ed. *Larousse Encyclopedia of Byzantine and Medieval Art*, New York: Prometheus Press, 1968. Trans. from the French original published by Librairie Larousse, Paris, 1958.

Jackson, Esther. *Art of the Anglo-Saxon Age, A.D. 597–1066*. Peterboro NH: Richard R. Smith, 1964.

Kazhdan, Alexander P., ed. *The Oxford Dictionary of Byzantium*, 3 vols. New York: Oxford University Press, 1991. Reference books with many relevant entries.

Kitzinger, Ernst. *Byzantine Art in the Making*. 2d ed. Cambridge, MA: Harvard University Press, 1980.

Lancaster, Osbert. *Sailing to Byzantium*. Boston: Gambit, 1969. Observations by a well-informed modern traveler.

Maguire, Henry. *Art and Eloquence in Byzantium*. Princeton, NJ: Princeton University Press, 1981.

Mango, Cyril. *The Art of the Byzantine Empire, 312–1453*. Sources and Documents in the History of Art Series, ed. H. W. Janson. Englewood Cliffs, NJ: Prentice Hall, 1972. An anthology of original sources and documents, published in association with the Medieval Academy of America.

Mathew, Gervase. *Byzantine Aesthetics*. London John Murray, 1963.

Rice, David Talbot. *Byzantine Art*. Rev. ed. Baltimore: Penguin, 1954.

Rodly, L. *Byzantine Art and Architecture, an Introduction*. Cambridge: Cambridge University Press, 1994.

Runciman, Steven. *Byzantine Civilization*. London: Edward Arnold, 1933; New York: Barnes and Noble, 1994.

———. *Byzantine Style and Civilization*. Harmondworth, England: Pelican, 1975.

Schug-Wille, Christa. *Art of the Byzantine World*. New York: Abrams, 1969.

von Simson, Otto G. *Sacred Fortress: Byzantine Art and Statecraft in Ravenna*. Chicago: University of Chicago Press, 1948. Concentrates on three churches: San Vitale, Sant' Apollinare in Classe, and Sant' Apollinare Nuovo.

BYZANTINE MOSAICS

Anthony, Edgar Waterman, *A History of Mosaics*. 1935. Reprint, New York: Hacker, 1968.

Demus, Otto. *Byzantine Mosaic Decoration*. London: Routledge, Kegan Paul, 1953. Many plates.

Gary, Dorothy Hales, and Robert Payne. *The Splendors of Byzantium*. New York: Viking, 1967. Minimal text, but many full-page plates of Byzantine mosaics.

Jolly, Penny Howell. *Made in God's Image: Eve and Adam in the Genesis Mosaics at San Marco, Venice*. Berkeley: University of California Press, 1997.

Mango, Cyril. "The Mosaics of Hagia Sophia." In *Hagia Sophia*, ed. Heinz Kähler, New York: Praeger, 1967.

"Mosaic." In *The Dictionary of Art*, vol. 22, ed. Jane Shoaf Turner. New York: Grove's, 1996.

CHAPTER 7　Romanesque and Norman Design (c. 800–c. 1200)

Beckwith, John. *Early Medieval Art*. New York: Praeger, 1964.

Busch, Harald, and Berne Lohse. *Romanesque Europe*. New York: Macmillan, 1960.

Conant, Kenneth J. *Carolingian and Romanesque Architecture, 800–1200*. Harmondsworth, England: Penguin, 1959, rev. 1966.

Davis-Weyer, Caecilia. *Early Medieval Art, 300–1150*, Sources and Documents in the History of Art series. Englewood Cliffs, NJ: Prentice Hall, 1971,

Demus, Otto. *The Mosaics of Norman Sicily*. London: Routledge, Kegan Paul, 1949.

Focillon, Henri. *The Art of the West, Volume I: Romanesque*. Ithaca, NY: Cornell University Press, 1963. Focillon's Volume II is *Gothic*.

Grabar, André, and Carl Nordenfalk. *Romanesque Painting*. New York: Skira, 1958.

Henderson, George. *Early Medieval*, Style and Civilization series. Harmondsworth, England: Penguin, 1972.

Kidson, Peter. *The Medieval World*, Landmarks of the World's Art series. New York: McGraw-Hill, 1967. This book divides its subject into three chapters: pre-Romanesque, Romanesque, and Gothic. Well illustrated, and with illustrations well tied to the text.

Martindale, Andrew. *The Rise of the Artist in the Middle Ages and Early Renaissance*. London: Thames and Hudson, 1972.

Mercer, Eric. *Furniture, 700–1700*, The Social History of the Decorative Arts series, ed. Hugh Honour. New York: Meredith, 1969.

Mouilleron, Véronique Rouchon. *Vézelay, The Great Romanesque Church*. New York: Abrams, 1999. Fine photography by Daniel Faure of the church's stone carvings.

Nebolsine, George. *Journey into Romanesque*. New York: Putnam's, 1969. A traveler's guide to Romanesque monuments in Europe, but with good general information about the style.

CHAPTER 8　The Gothic (1132–c. 1500)

STAINED GLASS

Armitage, E. Liddall. *Stained Glass*. Newton, MA: Charles T. Branford, 1959. A history of stained glass followed by technical information about producing it.

Arnold, Hugh. *Stained Glass of the Middle Ages in England and France*. London: A. and C. Black, 1956.

Brown, Sarah, and David O'Connor. *Glass-Painters*. Toronto: University of Toronto Press, 1991. Part of the Medieval Craftsmen series, which also includes small books on painters, embroiderers, and masons and sculptors.

Cowen, Painton. *Rose Windows*. San Francisco: Chronicle, 1979. Color plates and geometric diagrams of window patterns.

Grodecki, Louis, and Catherine Brisac. *Gothic Stained Glass, 1200–1300*. Ithaca, NY: Cornell University Press, 1985. Originally published as *Le Vitrail gothique au XIIIe siècle*.

TAPESTRY

Ackerman, Phyllis. *Tapestry: The Mirror of Civilization*. 1933. New York: AMS Press, 1970.

Jarry, Madeleine. *World Tapestry*. New York: G. P. Putnam's Sons, 1968.

Phillips, Barty. *Tapestry*. London: Phaidon, 1994.

"Tapestry." In *The Dictionary of Art*, vol. 30, ed. Jane Shoaf Turner. New York: Grove's, 1996.

Thomson, Francis Paul. *Tapestry, Mirror of History*. New York: Crown, 1980.

GOTHIC DESIGN

Anderson, William. *The Rise of the Gothic*. Salem, NH: Salem House, 1985.

Bony, Jean. *French Cathedrals*. Boston: Houghton Mifflin, 1951. Well illustrated with photographs by Martin Hürlimann.

Branner, Robert, ed. *Chartres Cathedral*. New York: W. W. Norton, 1969. An interesting collection of old and new descriptions of the building.

———. *Gothic Architecture*, The Great Ages of World Architecture series. New York: Braziller, 1964.

Burckhardt, Titus. *Chartres and the Birth of the Cathedral*. Bloomington, IN: World Wisdom Books, 1996. First published in German in 1962.

Busch, Harald, and Bernd Lohse. *Gothic Europe*, Buildings of Europe series. London: B. T. Batsford, 1959.

Cram, Ralph Adams. *The Gothic Quest*. New York: Baker and Taylor, 1907. Polemical text by an American architect of the Gothic Revival style.

Erlande-Brandenburg, Alain. *Gothic Art*. New York: Abrams, 1989. English translation of a book first published in France in 1983. Richly illustrated.

———. *Notre-Dame de Paris*. New York: Abrams, 1998. Photography by Caroline Rose.

Favier, Jean. *The World of Chartres*. New York: Abrams, 1990. First published in Paris in 1998 as *L'Univers de Chartres*. Photography by Jean Bernard.

Frisch, Teresa G. *Gothic Art 1140–c. 1450*, Sources and Documents in the History of Art series. Englewood Cliffs, NJ: Prentice Hall, 1971.

Gimpel, Jean. *The Cathedral Builders*, trans. Teresa Waugh. Salisbury, Wiltshire: Michael Russell, 1983; New York: Harper Collins, 1984. First published in France as *Les Bâtisseurs de Cathédrales*, 1961. Includes an eloquent account of the differing views of St. Bernard and Abbot Suger.

Goy, Richard J. *The House of Gold*. New York: Cambridge University Press, 1992. The Ca d'Oro, Venice.

Grodecki, Louis. *Gothic Architecture*, History of World Architecture series. Milan: Electa Editrice, 1978; New York: Rizzoli, 1985.

Henderson, George. *Gothic*, Style and Civilization series. Harmondsworth, England: Penguin, 1967.

Icher, François. *Building the Great Cathedrals*. New York: Abrams, 1998. A simple presentation of practical information about how the cathedrals were commissioned, funded, designed, and built.

Jantzen, Hans. *High Gothic: The Classic Cathedrals of Chartres, Reims, Amiens*. Princeton, NJ: Princeton University Press, 1984. First published in Hamburg, 1957.

Macaulay, David. *Cathedral: The Story of Its Construction*. Boston: Houghton Mifflin, 1973. Informative picture story of how the building was accomplished.

Mâle, Emile. *The Gothic Image: Religious Art in France of the Thirteenth Century.* New York: Harper and Row, 1958.

Martindale, Andrew. *Gothic Art.* New York: Thames and Hudson, 1985.

Panofsky, Erwin, ed. and trans. *Abbot Suger on the Abbey Church of St. Denis and Its Art Treasures.* Princeton, NJ: Princeton University Press, 1946. English translation of Abbot Suger's own account of the rebuilding of St.-Denis in the new Gothic style.

Simson, Otto Georg von. *The Gothic Cathedral: The Origins of Gothic Architecture and the Medieval Concept of Order.* New York: Pantheon, 1956.

Wilson, Christopher. *The Gothic Cathedral: The Architecture of the Great Church, 1130–1530.* London: Thames and Hudson, 1990. Winner of the Alice Davis Hitchcock Medallion of the Society of Architectural Historians of Great Britain for its "outstanding contribution to architectural history."

Worringer, Wilhelm. *Form in Gothic,* London: Tiranti, 1957. First published as *Formprobleme der Gotik.* See especially chapter XVIII, "The Interior Structure of the Cathedral."

CHAPTER 9 Islamic Design (A.D. 622 to the Present)

Arnold, Sir Thomas W. *Painting in Islam: A Study of the Place of Pictorial Art in Muslim Culture.* Oxford: Clarendon, 1928.

Aslanapa, Oktay. *Turkish Art and Architecture.* New York: Praeger, 1971.

Barrett, Douglas. *Islamic Metalwork in the British Museum.* London: The British Museum, 1949.

Barry, Michael. *Design and Color in Islamic Architecture: Eight Centuries of the Tile-Maker's Art.* New York: Vendome, 1996. Features photography by Roland and Sabrina Michaud.

Blair, Sheila S., and Jonathan M. Bloom. *The Art and Architecture of Islam, 1250–1800.* New Haven, CT: Yale University Press, 1994. Part of the Pelican History of Art series following the book by Ettinghausen and Grabar.

Bloom, Jonathan, and Sheila Blair. *Islamic Arts,* Art and Ideas series. London: Phaidon, 1997.

Brend, Barbara. *Islamic Art.* Cambridge, MA: Harvard University Press, 1991.

Creswell, K. A. C. *Early Muslim Architecture,* 2 vols. Oxford: P. Clarendon, 1932, 1940.

Dimand, Maurice S. *A Hand-Book of Muhammadan Art.* New York: Metropolitan Museum of Art, 1930.

Ettinghausen, Richard, et al. *The Arts of Islam: Masterpieces from the Metropolitan Museum of Art.* New York: Abrams, 1982. Published in conjunction with the exhibition "The Arts of Islam" at the Museum für Islamische Kunst, Berlin, 1981.

——— and Oleg Grabar, *The Art and Architecture of Islam 650–1250.* Pelican History of Art series. New Haven, CT: Yale University Press, 1987.

Frishman, Martin, and Hasan-Uddin Khan, eds. *The Mosque: History, Architectural Development, and Regional Diversity.* New York: Thames and Hudson, 1994.

Goodwin, Godfrey. *History of Ottoman Architecture.* London: Thames and Hudson, 1971.

Grabar, Oleg. *The Formation of Islamic Art.* New Haven, CT: Yale University Press, 1973.

——— *The Mediation Of Ornament.* Princeton, NJ: Princeton University Press, 1992. Based on the author's 1989 Mellon Lectures in the Fine Arts, the book uses Islamic ornament as a basis for studying the role of ornament in general.

Hillenbrand, Robert. *Islamic Art and Architecture,* World of Art series, New York: Thames and Hudson, 1999.

Hoag, John D. *Western Islamic Architecture,* The Great Ages of World Architecture series. New York: Braziller, 1963.

Irwin, Robert. *Islamic Art in Context: Art, Architecture, and the Literary World,* Perspective series. New York: Abrams, 1997. Includes interesting sections on artisan guilds, calligraphy, and Islamic art in Spain, Sicily, India, and China.

"Islamic Art." Various authors, in *The Dictionary of Art,* ed. Jane Turner. New York: Grove's Dictionaries, 1996, vol. 16, pp. 94–561.

Jereb, James F. *Arts and Crafts of Morocco.* San Francisco: Chronicle, 1996.

Michell George, ed. *Architecture of the Islamic World, Its History and Social Meaning.* London: Thames and Hudson, 1978. See especially chapter 5, "The Elements of Decoration: Surface, Pattern, and Light" by Dalu Jones.

Paccard, André. *Traditional Islamic Craft in Moroccan Architecture,* 2 vols. Saint-Jorioz, France: Editions Ateliers 74, 1980. Richly illustrated study by a French architect working in Morocco.

Papadopoulos, Alexandre. *Islam and Muslim Art.* New York: Abrams, 1979.

Rice, David Talbot. *Islamic Art,* rev. ed., World of Art series. New York: Thames and Hudson, 1975.

Scarce, Jennifer. *Domestic Life in the Middle East.* Edinburgh: National Museums of Scotland, 1996. Interesting details of urban households in Turkey, Iran, and Egypt between the sixteenth and nineteenth centuries.

Seherr-Thoss, Sonia P. *Design and Color in Islamic Architecture: Afghanistan, Iran, Turkey.* Washington, DC: Smithsonian Institution Press, 1968. With photography by Hans. C. Seherr-Thoss.

Smithsonian Institution. *7,000 Years of Iranian Art.* Washington, DC: Smithsonian Institution, 1964. Exhibition catalog, obviously not limited to Islamic art.

Vogt-Göknil, Ulya. *Living Architecture: Ottoman.* London: Oldbourne, 1966.

Wulff, H. E. *The Traditional Crafts of Persia.* Cambridge, MA: MIT Press, 1966. The emphasis is on the techniques and technology underlying the crafts, and there is an extensive glossary of technical terms.

THE DOME OF THE ROCK

Nuseibeh, Saïd, and Oleg Grabar. *The Dome of the Rock.* New York: Rizzoli, 1996.

IZNIK WARES AND OTHER CERAMICS

Atasoy, Nurhan, and Julian Raby. *Iznik, the Pottery of Ottoman Turkey.* London: Alexandria Press, 1989.

Moonan, Wendy. "Iznik Wares, Even Rarer Than Ming." *The New York Times,* May 29, 1998.

GLASS AND ROCK CRYSTAL

Carboni, Stefano. *Glass from Islamic Lands*. New York: Thames & Hudson, 2001.

Raulet, Sylvie. *Rock Crystal Treasures from Antiquity to Today*. New York: Vendome, 1999, especially pp. 59–79.

CALLIGRAPHY

Khatibi, Abdelkebir, and Mohammed Sijelmassi. *The Splendor of Islamic Calligraphy*. London: Thames and Hudson 1976. First published in French, 1976, as *L'Art calligraphique arabe*.

Schimmel, Annemarie, F. Déroche, and Wheeler M. Thackston. "Calligraphy." In "Islamic Art," *The Dictionary of Art*, ed. Jane Turner. New York: Grove's Dictionaries, 1996, vol. 16, pp. 273–88.

CARPETS

Coen, Luciano, and Louise Duncan. *The Oriental Rug*. New York: Harper and Row, 1978.

Dilley, Arthur Urbane. *Oriental Rugs and Carpets*, rev. Maurice S. Dimand. Philadelphia and New York: Lippincott, 1959.

Eiland, Murray L., Jr., and Murray Eiland III. *Oriental Carpets, A Complete Guide*. Boston: Little, Brown, 1998. Fourth edition, updated by the original author and his son, of the classic reference first published in 1973.

Ford, P. R. J. *Oriental Carpet Design: A Guide to Traditional Motifs, Patterns, and Symbols*. New York: Thames and Hudson, 1981.

Sakhai, Essie, *Oriental Carpets, A Buyer's Guide*. Wakefield, RI: Moyer Bell, 1995. Small but well-illustrated paperback guide by a prominent London dealer.

———. *The Story of Carpets*. Wakefield, RI: Moyer Bell, 1997.

Stone, Peter F. *The Oriental Rug Lexicon*. Seattle: University of Washington Press, 1997. Over 3,000 carpet-related terms defined, some with illustrations.

Summers, Janice. *Oriental Rugs: The Illustrated World Buyers' Guide*. New York: Crown, 1994.

von Bode, Wilhelm. *Antique Rugs from the Near East*. Ithaca, NY: Cornell University Press, 1984.

Wearden, Jennifer. "Carpet." In *The Dictionary of Art*, ed. Jane Turner, New York: Grove's Dictionaries, 1996, vol. 5, pp. 828–42.

CHAPTER 10 India (2500 B.C. to the Present)

INDIAN RELIGION AND PHILOSOPHY

Zimmer, Heinrich. *Myths and Symbols in Indian Art and Civilization*. Princeton, NJ: Princeton University Press, 1946.

———. *Philosophies of India*. Princeton, NJ: Princeton University Press, 1951.

HINDU ART AND ARCHITECTURE

Michell, George. *The Hindu Temple*. London: Paul Elek, 1977.

O'Flaherty, Wendy Doniger, et al. *Elephanta: The Cave of Shiva*. Princeton, NJ: Princeton University Press, 1983.

BUDDHIST ART AND ARCHITECTURE IN INDIA

Fisher, Robert E. *Buddhist Art and Architecture*. New York: Thames and Hudson, 1993.

Khanna, Madhu. *Yantra: The Tantric Symbol of Cosmic Unity*. London: Thames and Hudson, 1979.

JAIN ART AND ARCHITECTURE

Shah, U. P., and M. A. Dhaky, eds. *Aspects of Jaina Art and Architecture*. Ahmedabad, India: Gujurat State Committee for the Celebration of 2,500th Anniversary of Bhagavan Mahavira Nirvana, 1975, distributed by L. D. Institute of Indology, Ahmedabad.

Shah, U. P., ed. *Treasures of Jaina Bhandaras*. Ahmedabad, India: L. D. Institute of Indology, 1978.

ISLAMIC ART AND ARCHITECTURE IN INDIA

Berinstain, Valérie. *India and the Mughal Dynasty*, Discoveries series. New York: Abrams, 1998. Colorful little paperback

Gascoigne, Bamber. *The Great Moghuls*. New York: Dorset, 1971.

Koch, Ebba. *Mughal Architecture*. Munich: Prestel-Verlag, 1991.

Nicholson, Louise. *The Red Fort, Delhi*. London: Tauris Parke, 1989.

Stierlin, Henri, ed. *Islamic India*, Architecture of the World series. Lausanne: Office du Livre, 1969.

Tillotson, G. H. R. *Mughal India*. New York: Viking Penguin, 1991. A travel guide, but with good descriptions and illustrations.

THE TAJ MAHAL

Begley, W. E. "The Myth of the Taj Mahal and a New Theory of Its Symbolic Meaning," *Art Bulletin*, March 1979, pp. 12–37.

Pal, Pratapaditya, et al. *Romance of the Taj Mahal*. New York: Thames and Hudson with the Los Angeles County Museum of Art, 1989.

Rai, Raghu, and Usha Rai. *Taj Mahal*. New York: Vendome, 1986. Oversize photo album, but with some text.

INDIAN DECORATIVE ARTS AND CRAFTS

Aditi: The Living Arts of India. Washington, DC: Smithsonian Institution Press, 1985.

Aryan, Subhashini. *Crafts of Himachal Pradesh*. Middletown, NJ: Grantha, 1993.

Birdwood, George C. M. *The Arts of India*, especially the chapter "Art Furniture and Household Decoration." 1880; reprint, Jersey: Channel Islands, 1986.

Coomaraswamy, Ananda K. *The Arts and Crafts of India and Ceylon*. New York: Noonday, a division of Farrar, Straus, 1964.

Cooper, Ilay, and John Gillow. *Arts and Crafts of India*. New York: Thames and Hudson, 1996.

Jain, Jyotindra, and Aarti Aggarwala. *National Handicrafts and Handlooms Museum*. Ahmedabad, India: Mapin, 1989.

Jaitly, Jaya. *Crafts of Kashmir, Jammu, and Ladakh*. New York: Abbeville, 1990.

Krishna, Nanditha. *Arts and Crafts of Tamilnadu*. Middletown, NJ: Grantha, 1992.

Mode, Heinz, and Subodh Chandra. *Indian Folk Art*. New York: Alpine Fine Arts Collection, 1985.

Sen, Prabhas. *Crafts of West Bengal*. Middletown, NJ: Grantha, 1994.

Swarup, Shanti. *The Arts and Crafts of India and Pakistan*. Bombay: Taraporevala, 1957.

Watt, G., and P. Brown. *Arts and Crafts of India—A Descriptive Study*. New Delhi: Cosmo, 1979. First published in 1904.

INDIAN TEXTILES

Ashton, Sir Leigh, ed. *The Art of India and Pakistan*, especially the chapter "Textiles and the Minor Arts" by John Irwin. New York: Coward-McCann, 1948.

Askari, Nasreen, and Rosemary Crill. *Colours of the Indus: Costume and Textiles of Pakistan*. London: Merrell Holberton with the Victoria and Albert Museum, 1997.

Benedict, Rosalind Candlin. "'Paisley," *Interior Design*, February 1988, pp. 272–77.

Gillow, John, and Nicholas Barnard. *Traditional Indian Textiles*. London: Thames and Hudson, 1991.

Guy, John. *Woven Cargoes: Indian Textiles in the East*. New York: Thames and Hudson, 1998.

Irwin, John, and Margaret Hall. *Indian Painted and Printed Fabrics*, vol. I, *Historic Textiles of India at the Calico Museum*. Ahmedabad, India: S. R. Bastikar on behalf of the Calico Museum of Textiles, 1971.

Irwin, John, and Katharine B. Brett. *Origins of Chintz*. London: Her Majesty's Stationery Office, 1970. Includes a catalog of Indo-European cottons in the Victoria and Albert Museum, London.

Kokyo Hatanka et al. *Textile Arts of India*, especially the chapter "History of Indian Textiles" by Zahid Sardar. San Francisco: Chronicle, 1996.

Riefstahl, R. M. *Persian and Indian Textiles from the Late Sixteenth to the Early Nineteenth Century*. New York: E. Weyhe, 1923.

Rossbach, Ed. *Art of the Paisley*. New York: Van Nostrand Reinhold, 1980.

Skelton, Robert. *Rajasthani Temple Hangings of the Krishna Cult*. New York: The American Federation of the Arts, 1973.

Wheeler, Monroe, ed. *Textiles and Ornaments of India*. New York: Museum of Modern Art, 1956.

INDIAN CARPETS

Gans-Ruedin, Erwin. *Indian Carpets*. New York: Rizzoli, 1984.

Walker, Daniel. "The Fine-Weave Carpets of India," *The Magazine Antiques*, December 1997, pp. 824–31.

———. *Flowers Underfoot: Indian Carpets of the Mughal Era*. New York: Metropolitan Museum of Art, distributed by Abrams, 1997.

INDIAN MINIATURE PAINTING

Barrett, Douglas, and Basil Gray. *Painting of India*, Treasures of Asia series. Skira, distributed in the U.S. by World, Cleveland, OH, 1963.

O'Brien, Christine. *Indian Miniatures*. London: Studio Editions, 1994. Tiny book with twenty-five examples in color.

Topsfield, Andrew. *Indian Court Painting*, Victoria and Albert Introductions to the Decorative Arts series; reprint, Owings Mills, MD: Stemmer House, 1984.

INDIA

Brand, Michael. *The Vision of Kings: Art and Experience in India*. New York: Thames and Hudson, 1996.

Chandra, Pramod. *On the Study of Indian Art*. Cambridge, MA: Harvard University Press, 1983. A survey of scholarly treatments of Indian art.

Coomaraswamy, Ananda K. *The Dance of Siva: Essays on Indian Art and Culture*, especially "Hindu View of Art: Theory of Beauty." London: Simpkin, Marshall, Hamilton, Kent, 1924; reprint New York: Dover, 1985.

———. *History of Indian and Indonesian Art*. New York: Weyhe, 1927; reprint, New York: Dover, 1965.

———. *Introduction to Indian Art*. Madras: Theosophical Publishing House, 1913, reprint, Delhi: Munshiram Manoharlal, 1969.

———. "Ornament," *Art Bulletin*, 21:375—82, 1939.

Goetz, Hermann. *The Art of India,* Art of the World series. New York: Greystone Press, 1964.

Harle, J. C. *The Art and Architecture of the Indian Subcontinent*, Pelican History of Art series. Harmondsworth, England: Penguin, 1986. A standard authority. In addition to what is now India, it covers Pakistan, Nepal, Afghanistan, Bangladesh, and Sri Lanka.

Herdeg, Klaus. *Formal Structure in Indian Architecture*. Ithaca, NY: Center for Housing and Environmental Studies, Cornell University, 1967.

Huntington, Susan L., and John C. Huntington. *The Art of Ancient India: Buddhist, Hindu, Jain*. New York: Weatherhill, 1985.

Jaffer, Amin. *Furniture from British India and Ceylon*. Salem, MA: Peabody Essex Museum, 2001.

McLeod, W. H. *Popular Sikh Art*. New York: Oxford University Press, 1991. Popular bazaar prints.

Mukerjee, Radhakamal. *The Flowering of Indian Art*. New York: Asia Publishing House, 1964.

Rewal, Raj, et al. *Architecture in India*. Milan and Paris: Electa France, 1985.

Rowland, Benjamin. *Art and Architecture of India: Buddhist, Hindu, Jain*, Pelican History of Art series. Harmondsworth, England: Penguin, 1953. Rowland's book was replaced by Harle's 1986 book in the series. It lacks Harle's coverage of Mughal architecture, but it is more inclusive geographically, covering Southeast Asia as well as the areas covered by Harle.

Stierlin, Henri, ed. *India*, Architecture of the World series. Lausanne: Office du Livre, 1969.

Tadgell, Christopher. *The History of Architecture in India*, London: Phaidon, 1990.

Tillotson, G. H. R. *The Tradition of Indian Architecture*. New Haven, CT: Yale University Press, 1989. Focuses on building since 1850.

Volwahsen, Andreas. *Living Architecture: Indian*. New York: Grosset and Dunlap, 1969.

Watson, Francis. *A Concise History of India*. New York: Thames and Hudson, 1979.

Welch, Stuart Cary. *India: Art and Culture, 1300–1900*. New York: Holt, Rhinehart, and Winston with the Metropolitan Museum of Art, 1985. Catalog for the exhibition *India!* at the Metropolitan Museum 1985–86.

Zimmer, Heinrich. *The Art of Indian Asia.* New, York: Pantheon, 1955. Two volumes, compiled and edited by Joseph Campbell.

Chapter 11 China
(4000 B.C.–A.D. 1912)

Chinese Architecture

Béguin, Gilles, and Dominique Morel. *The Forbidden City, Center of Imperial China.* New York: Abrams, 1997. Part of the colorful, inexpensive Discoveries series.

Bussagli, Mario. *Oriental Architecture.* New York: Abrams, 1973.

Knapp, Ronald G. *China's Vernacular Architecture: House Form and Culture.* Honolulu University of Hawaii Press, 1989.

———. *The Chinese House: Craft, Symbol, and the Folk Tradition,* Images of Asia series. New York: Oxford University Press, 1990.

Liu, Laurence G. *Chinese Architecture.* New York: Rizzoli, 1989.

Zhuoyun, Yu. *Palaces of the Forbidden City.* New York: Viking, 1982.

Chinese Furniture

Berliner, Nancy. *Beyond the Screen: Chinese Furniture of the 16th and 17th Centuries.* Boston: Museum of Fine Arts, 1996.

———. "Furniture of the Ming Dynasty," *The Magazine Antiques,* August 1996, pp. 178–87.

———, and Sarah Handler. *Friends of the House: Furniture from China's Towns and Villages.* Salem, MA: Peabody Essex Museum, 1996.

Beurdeley, Michel. *Chinese Furniture.* New York: Kodansha, 1979. Excellent source.

Cescinsky, Herbert. *Chinese Furniture.* London: Benn Bros., 1922.

Clunas, Craig. *Chinese Furniture.* London: Bamboo, 1988. Chinese furniture in the collection of the Victoria and Albert Museum, London.

Ecke, Gustav. *Chinese Domestic Furniture in Photographs and Measured Drawings.* Peking: Editions Henri Vetch, 1944; reprint, New York: Towse, 1962; reprint, Mineola, NY: Dover, 1986.

Ellsworth, Robert Hatfield. *Chinese Furniture.* New York: Random House, 1971.

Kates, George N. *Chinese Household Furniture.* New York: Harper and Brothers,1948; reprint, Mineola, NY: Dover, 1962.

Tian Jiaqing. *Classic Chinese Furniture of the Qing Dynasty.* London Philip Wilson, 1996.

Wang Shixiang. *Classic Chinese Furniture of the Ming and Early Qing Dynasties.* London: Han-Shan Tang, 1986.

———. *Connoisseur of Chinese Furniture,* 2 vols. Hong Kong: Joint, distributed by Art Media Resource, 1990.

———. "Development of Furniture Design and Construction from the Song to the Ming," *Orientations,* January 1991.

Chinese Calligraphy and Painting

Brodrick, Alan Houghton. *An Outline of Chinese Painting.* New York: Transatlantic Arts, 1949.

Cahill, James. *Chinese Painting.* Treasures of Asia series. Geneva, Skira, and New York: Rizzoli, 1977.

Lai, T. C. *Chinese Painting.* Images of Asia series. New York: Oxford University Press, 1992.

Sirén, Osvald. *The Chinese on the Art of Painting.* Peiping: Henri Vetch, 1936; reprint, New York: Schocken, 1963.

———. *Chinese Painting: Leading Masters and Principles.* London: Lund, Humphries, 1956; reprint, New York: Hacker, 1973, 7 vols.

Stuart, Jan. "Beyond Paper: Chinese Calligraphy on Objects," *The Magazine Antiques,* October 1995, pp. 502–13.

Sze, Mai-Mai. *The Tao of Painting: A Study of the Ritual Disposition of Chinese Painting.* 2 vols. New York: Pantheon, 1956. The second volume is a translation of *Chieh Tzu Yüan Hua Chuan,* (Mustard Seed Garden Manual of Painting), written 1679–1701.

Yee, Chiang. *The Chinese Eye: An Interpretation of Chinese Painting.* Bloomington, IN: Indiana University Press, 1964.

Chinese Jade

Hansford. S. Howard. *Chinese Carved Jades.* Greenwich, CT: New York Graphic Society, 1968.

———. *Chinese Jade Carving.* London: Humphries, 1950.

———. *Essence of Hills and Streams: The Van Oertzen Collection of Chinese and Indian Jades.* New York: American Elsevier, 1969.

Laufer, Berthold. *Jade: A Study in Chinese Archaeology and Religion.* Chicago, Field Museum, 1912; reprint, Mineola, NY: Dover, 1974.

Salmony, A. *Carved Jade of Ancient China.* Berkeley, CA: Gillick Press, 1938.

———. *Chinese Jade through the Wei Dynasty.* New York: Ronald Press, 1963.

Chinese Lacquer and Coromandel Work

Scott, Rosemary. "China." In *Lacquer, An International History and Illustrated Survey.* New York: Abrams, 1984.

Chinese Bronzes

Ackerman, Phyllis. *Ritual Bronzes of Ancient China.* New York: Dryden, 1945.

d'Argencé, René-Yvon Lefebvre. *Ancient Chinese Bronzes in the Avery Brundage Collection.* Berkeley, CA: Diablo Press for the de Young Museum Society, 1966.

Li Xueqin. *The Wonder of Chinese Bronzes.* Beijing: Foreign Languages Press, 1980.

Chinese Enamels and Cloisonné

Bates, Kenneth F. *The Enamelist: A Comprehensive Study of Advanced Enameling Techniques.* Cleveland, OH: World, 1967.

Brinker, Helmut, and Albert Lutz. *Chinese Cloisonné: The Pierre Uldry Collection.* New York: Asia Society, 1989. First published in Zurich in 1985, trans. by Susanna Swoboda.

Chu, Arthur, and Grace Chu. *Oriental Cloisonné and Other Enamels.* New York: Crown, 1975.

Cosgrove, Maynard G. *The Enamels of China and Japan: Champlevé and Cloisonné.* New York: Dodd, Mead, 1974.

Garner, Sir Harry. *Chinese and Japanese Cloisonné Enamels.* London: Faber and Faber, 1962; rev. ed., 1970.

National Palace Museum. *Masterpieces of Chinese Enamel Ware.* Taipei: National Palace Museum, 1971.

Zapata, Janet. "American *Plique-à-jour* Enameling," *The Magazine Antiques,* December 1996.

CHINESE PORCELAIN AND OTHER CERAMICS

Atterbury, Paul, ed. *The History of Porcelain,* particularly the chapters "The Origins of Porcelain" by Richard Gray and "Qing Dynasty Porcelain for the Domestic Market" by Gordon Lang, New York: William Morrow, 1982.

Beilly, Roslyn. "Chinese Porcelain," *Interior Design,* June 1988, p. 148.

Beurdeley, Cécile, and Michel Beurdeley. *A Connoisseur's Guide to Chinese Ceramics.* New York: Harper and Row, 1974.

Beurdeley, Michel, and Guy Raindre. *Qing Porcelain: Famille Verte, Famille Rose.* New York: Rizzoli, 1987.

Cushion, John P. *Pottery and Porcelain.* London: The Connoisseur, 1972; New York: Hearst Books, 1972.

Donnelly, P. J. *Blanc de Chine: The Porcelain of Têhua in Fukien.* London: Faber and Faber, 1969.

Garner, Sir Harry. *Oriental Blue and White.* London: Faber and Faber, 1954; 3rd ed., 1970.

Hobson, R. L. *The Wares of the Ming Dynasty.* Rutland, VT: Charles E. Tuttle, 1962.

———. and A. L. Hetherington. *The Art of the Chinese Potter: An Illustrated Survey.* New York: Knopf; London: Benn, 1923; reprint, New York: Dover, 1982.

Honey, W. B. *Ceramic Art of China and other Countries of the Far East.* London: Faber and Faber, 1945.

Laufer, Berthold. *Chinese Pottery of the Han Dynasty.* 1909; reprint, Rutland, VT: Charles E. Tuttle, 1962.

McFadden, David Revere. "Early Porcelain in Europe." In *Porcelain: Traditions and New Visions,* ed. Jan Axel and Karen McCready. New York: Watson-Guptill, 1981.

Medley, Margaret. *The Chinese Potter: A Practical History of Chinese Ceramics.* New York: Scribner's, 1976.

CHINESE SILK

Anquetil, Jacques. *Silk.* New York: Flammarion, 1996.

Hanyu, Gao. *Chinese Textile Designs,* trans. Rosemary Scott and Susan Whitfield. New York: Viking, 1992.

Hawley, Walter A. *Oriental Rugs, Antique and Modern.* New York: Tudor, 1937; reprint, New York: Dover, 1970.

Rothstein, Natalie. "Silk." In *The Dictionary of Art.* New York: Grove's Dictionaries, 1996.

Scott, Philippa. *The Book of Silk.* New York: Thames and Hudson, 1993.

CHINESE DESIGN

Akiyama, Terukazu, et al. *Arts of China: Neolithic Cultures to the T'ang Dynasty—Recent Discoveries.* Tokyo and Palo Alto, CA: Kodansha, 1968.

Avril, Ellen B. *Chinese Art in the Cincinnati Art Museum.* Cincinnati: Cincinnati Art Museum, distributed by University of Washington Press, Seattle, 1997.

Buhot, Jean. *Chinese and Japanese Art, with Sections on Korea and Vietnam.* New York: Praeger, 1967. Originally published in French by Librairie Gallimard, 1961.

Burling, Judith, and Arthur Hart Burling. *Chinese Art.* New York: Viking, 1953.

Clunas, Craig. *Art in China.* Oxford and New York: Oxford University Press, 1997. Part of the excellent Oxford History of Art series, available in paperback.

d'Agencé, René-Yvon Lefebvre, ed. *Asian Art, Museum and University Collections in the San Francisco Bay Area.* Montclair, NJ: Allanheld and Schram, 1978.

Eberhard, Wolfram. *A History of China.* Berkeley: University of California Press, 1960; 4th ed., 1977.

Fenollosa, Ernest F. *Epochs of Chinese and Japanese Art.* 1912; reprint, New York: Dover, 1963, 2 vols.

Fry, Roger, Osvald Sirén, Laurence Binyon, et al. *Chinese Art: An Introductory Handbook to Painting, Sculpture, Ceramics, Textiles, Bronzes, and Minor Arts,* 3rd ed. London: B. T. Batsford, 1949.

Hutt, Julia. *Understanding Far Eastern Art.* New York: E. P. Dutton, 1987.

Lee, Sherman E. *History of Far Eastern Art,* 4th ed., New York: Abrams, 1982.

Moore, Janet Gaylord. *The Eastern Gate: An Invitation to the Arts of China and Japan.* Cleveland and New York: William Collins, 1979.

Munsterberg, Hugo. *A Short History of Chinese Art.* Philosophical Library, 1949; reprint, New York: Greenwood, 1969.

———. *Zen and Oriental Art.* Rutland, VT: Charles E. Tuttle, 1993.

Sickman, Lawrence, and Alexander Soper. *The Art and Architecture of China,* 3rd ed. Harmondsworth, England: Penguin, 1968.

Siu, Anita. "Splendors of Imperial China," *The Magazine Antiques,* March 1996, pp. 428–37.

Smith, Bradley, and Wan-go Weng. *China: A History in Art.* New York: Doubleday, 1978.

Sullivan, Michael. *The Arts of China,* rev. ed. Berkeley: University of California Press, 1967.

———. *An Introduction to Chinese Art.* Berkeley: University of California Press, 1961.

Swann, Peter. *Art of China, Korea, and Japan.* New York: Praeger, 1963.

Thorp, Robert L. *Son of Heaven: Imperial Arts of China.* Seattle: Son of Heaven Press, 1988.

Tregear, Mary. *Chinese Art.* New York: Oxford University Press, 1980.

———, and Shelagh Vainker. *Art Treasures in China.* New York: Abrams, 1994.

Watson, William. *The Arts of China to A.D. 900,* Pelican History of Art series, New Haven, CT: Yale University Press, 1995.

———. *Style in the Arts of China.* Harmondsworth, England: Penguin, 1974.

Wilkinson, Jane, and Nick Pearce. *Harmony and Contrast: A Journey through East Asian Art.* Edinburgh: National Museums of Scotland, 1996. Brief illustrated essays on lacquer, silk, porcelain, and other media.

Willetts, William. *Chinese Art*. Harmondsworth, England: Penguin, 1958.

―――. *Foundations of Chinese Art*. New York: McGraw-Hill, 1965.

CHAPTER 12 Japan (A.D. 593–1867)

KATSURA VILLA

Fujioka, Michio. *Kyoto Country Retreats: The Shugakuin and Katsura Palaces*. Tokyo and New York: Kodansha, 1983.

Isozaki, Arata. *Katsura Villa: The Ambiguity of Its Space*. New York: Rizzoli, 1987. Isozaki discusses the views of three earlier admirers of the villa—Bruno Taut, Horiguchi Sutemi, and Kenzo Tange— then gives his own interpretation. Color photography by Yasuhiro Ishimoto.

Naito, Akira. *Katsura: A Princely Retreat*. Tokyo, New York, and San Francisco: Kodansha, 1977.

Tange, Kenzo. *Katsura: Tradition and Creation in Japanese Architecture*. New Haven, CT: Yale University Press, 1960. Includes an introduction by modern architect Walter Gropius and black-and-white photography by Yasuhiro Ishimoto.

OTHER JAPANESE ARCHITECTURE AND ITS INTERIORS

Blaser, Werner. *Japanese Temples and Tea-Houses*, trans. D. Q. Stephenson. New York: Dodge, 1957.

Bussagli, Mario. *Oriental Architecture*, vol. 2. Milan: Electa, 1981. New York: Rizzoli, 1989.

Drexler, Arthur. *Architecture of Japan*. New York: Museum of Modern Art, 1955.

Harada, Jiro. *The Lesson of Japanese Architecture*. 1936. Boston: Charles T. Branford, 1954.

Morse, Edward S. *Japanese Homes and Their Surroundings*. Rutland, VT: Charles E. Tuttle, 1972. 9th ed., 1980.

Nishi, Kazuo, and Kazuo Hozumi. *What Is Japanese Architecture?* New York, Tokyo, and San Francisco: Kodansha, 1985.

Ooka, Minoru. *Temples of Nara and Their Art*. Heibonsha Survey of Japanese Art Series. New York and Tokyo: Weatherhill, 1973.

Soper, Alexander Coburn, III. *The Evolution of Buddhist Architecture in Japan*. Princeton, NJ: Princeton University Press, 1942.

Stierlin, Henri, ed. *Architecture of the World: Japan*. Lausanne: Benedikt Taschen, n.d. Features excellent photography by Yukio Futagawa.

Suzuki, Kakichi. *Early Buddhist Architecture in Japan*, Japanese Arts Library Series, ed. John Rosenfield. New York, Tokyo, and San Francisco: Kodansha, 1980.

JAPANESE FURNITURE

Clarke, Rosy. *Japanese Antique Furniture: A Guide to Evaluating and Restoring*. Tokyo and New York: Weatherhill, 1983.

Heinekin, Ty, and Kiyoko Heinekin. *Tansu: Traditional Japanese Cabinetry*. Tokyo and New York: Weatherhill, 1981.

Impey, Oliver. *The Art of the Japanese Folding Screen*. Tokyo and New York: Ashmolean Museum, Oxford, in association with Weatherhill, 1997.

Koizumi, Kazuko. *Traditional Japanese Furniture*. New York, Tokyo, and San Francisco: Kodansha, 1986.

JAPANESE PAINTING

Chambers, Anne. *Suminagashi: The Japanese Art of Marbling*, New York: Thames and Hudson, 1991. A brief history and do-it-yourself instructions.

JAPANESE TEXTILES

Ito, Toshiko. *Tsujigahana, the Flower of Japanese Textile Art*. New York, Tokyo, and San Francisco: Kodansha, 1985.

Yang, Sunny, and Rochelle M. Narasin, *Textile Art of Japan*. Tokyo: Shufunotomo, 1989.

THE ZEN INFLUENCE AND THE TEA CEREMONY

Fujioka, Ryochi. *Tea Ceremony Utensils*. New York and Tokyo: Weatherhill/Shibundo, 1973.

Munsterberg, Hugo. *Zen and Oriental Art*. Rutland, VT, and Tokyo: Charles E. Tuttle, 1993.

Suzuki, Daisetz T. "Sengai, Zen, and Art," *ArtNews Annual*, vol. XXVII. New York: Art Foundation Press, 1958, pp. 114–21.

WOOD-BLOCK PRINTS

Bicknell, Julian. *Hiroshige in Tokyo: The Floating World of Edo*. Rohnert Park, CA: Pomegranate, 1994.

Goldman, Paul. *Looking at Prints, Drawings, and Watercolours: A Guide to Technical Terms*. London and Malibu: British Museum and J. Paul Getty Museum, 1988.

Guth, Christine. *Art of Edo Japan: The Artist and the City, 1615–1868*. New York: Abrams, 1996.

Mayor, A. Hyatt. "Hokusai," *Bulletin*, vol. XLIII, no. 1. New York: Metropolitan Museum of Art, Summer 1985.

Nagata, Seiji. *Hokusai, Genius of the Japanese Ukiyo-e*. Tokyo, New York, and London: Kodansha, 1995.

Narazaki, Muneshige. *Sharaku the Enigmatic Ukiyo-e Master*. New York: Kodansha, 1983

Noguchi, Yone. *Hiroshige*. London: Kegan Paul, Trench, Trubner, and Tokyo: Maruzen, 1940.

Takahashi, Seiichiro. *Traditional Woodblock Prints of Japan*, Heibonsha Survey of Japanese Art series. New York and Tokyo: Weatherhill, 1972.

JAPANESE DESIGN

Addiss, Stephen. *How to Look at Japanese Art*. New York: Abrams, 1996.

Blaser, Werner. *Structure and Form in Japan*. New York: Wittenborn, 1963.

Boger, H. Batterson. *The Traditional Arts of Japan*. Garden City, NY: Doubleday, 1964.

Dresser, Christopher. *Traditional Arts and Crafts of Japan*. New York: Dover, 1994. Originally published in London by Longmans, Green in 1882 as *Japan: Its Architecture, Art, and Art Manufactures*.

Kakudo, Yoshiko. *The Art of Japan: Masterworks in the Asian Art Museum of San Francisco*. San Francisco: Asian Art Museum and Chronicle, 1991.

Lee, Sherman E. *A History of Far Eastern Art*, 4th ed. New York: Abrams, 1982.

———. *Japanese Decorative Style*. New York: Harper and Row, 1972.

Paine, Robert Treat, and Alexander Soper. *The Art and Architecture of Japan*. Harmondsworth, England: Penguin, 1955, 1975. A standard authority.

Saint-Gilles, Amaury. *Mingei, Japan's Enduring Folk Art*. Rutland, VT: Charles E. Tuttle, 1989.

Stanley-Baker, Joan. *Japanese Art*. New York: Thames and Hudson, 1992.

CHAPTER 13 The Italian Renaissance and Later Developments (Fourteenth to Eighteenth Centuries)

There are many excellent books relevant to the interior design of the Italian Renaissance, and some are listed below. One particular book must be praised above all others, however, for its encyclopedic text and treasury of illustrations. It has been more helpful than any other source in the preparation of this revision. It is Peter Thornton's *The Italian Renaissance Interior, 1400–1600* (London: Weidenfeld and Nicolson, 1991).

INDIVIDUAL ARTISTS, ARCHITECTS, AND DESIGNERS

Bernini

Marder, T. A. *Bernini and the Art of Architecture*. New York: Abbeville, 1998.

———. *Bernini's Scala Regia at the Vatican Palace*. New York: Cambridge University Press, 1997.

Wittkower, Rudolf. *Gian Lorenzo Bernini, the Sculptor of the Roman Baroque*, 2nd ed. London: Phaidon, 1966.

Borromini

Blunt, Anthony. *Borromini*. Cambridge, MA: Harvard University Press, 1979.

Bramante

Brushci, Arnaldo. *Bramante*. London: Thames and Hudson, 1973, 1977.

Brunelleschi

Avery, Charles. *Brunelleschi, Genius of the Baroque*. Boston, MA: Bulfinch/Little, Brown, 1997.

Battisti, Eugenio. *Brunelleschi*. New York: Rizzoli, 1981.

Klotz, Henrich. *Filippo Brunelleschi, the Early Works and the Medieval Tradition*. New York: Rizzoli, 1990.

Saalman, Howard. *Filippo Brunelleschi, the Buildings*. University Park, PA: Pennsylvania State University Press, 1993.

Giulio Romano

Hartt, Frederick. *Giulio Romano*. New Haven, CT: Yale University Press, 1958.

Leonardo da Vinci

Pedretti, Carlo. *Leonardo, Architect*. New York: Rizzoli, 1985.

Michelangelo

Ackerman, James S. *The Architecture of Michelangelo*. London: A. Zwemmer, 1961; Harmondsworth, England: Penguin, 1971. Despite its age, still the standard authority.

Argan, Giulio Carlo, and Bruno Contardi. *Michelangelo: Architect*. New York: Abrams, 1993.

Goldscheider, Ludwig. *Michelangelo: Paintings, Sculptures, Architecture*. London: Phaidon, 1953.

Murray, Linda. *Michelangelo*. New York: Oxford University Press, 1980.

Rolland, Romain. *Michelangelo*. New York: Crowell-Collier, 1962. Readable biography; no illustrations.

Wallace, William E. *Michelangelo at San Lorenzo: The Genius as Entrepreneur*. New York: Cambridge University Press, 1994. Unusual account that considers Michelangelo's relations with his clients as well as the results of his work.

Palladio

Ackerman, James S. *Palladio*. Balitimore: Penguin, 1966. Another standard text by Ackerman.

Boucher, Bruce. *Andrea Palladio, the Architect in His Time*. New York: Abbeville, 1998.

Holberton, Paul. *Palladio's Villas: Life in the Renaissance Countryside*. London: John Murray, 1990.

Puppi, Lionello. *Andrea Palladio, The Complete Works*. Milan: Electa, 1973; New York: Rizzoli.

Tavernor, Robert. *Palladio and Palladianism*. New York: Thames and Hudson, 1991.

Wittkower, Rudolf. *Palladio and Palladianism*. New York: Braziller, 1974.

Piranesi

Robison, Andrew. *Piranesi: Early Architectural Fantasies, A Catalogue Raisonné of the Etchings*. Washington and Chicago: The National Gallery of Art and the University of Chicago Press, 1986.

Wilton-Ely, John. *Piranesi as Architect and Designer*. New York and New Haven, CT: Pierpont Morgan Library and Yale University Press, 1993.

Raphael

Jones, Roger, and Nicholas Penny. *Raphael*. New Haven, CT: Yale University Press, 1983.

Penny, Nicholas. "Raphael." In *The Dictionary of Art*, pp. 896–910, vol. 25, ed. Jane Turner. New York: Macmillan, 1996.

Ponente, Nello. *Who Was Raphael?* Geneva: Skira, 1967. A much better book than the silly title suggests.

Pope-Hennessy, John. *Raphael*. New York: New York University Press, 1970.

Individual Works

Davanzati Palace

Rosenburg, L. C. *The Davanzati Palace, Florence, Italy.* New York: Architectural Book Publishing, 1922. Brief text with photographs and measured drawings.

St. Peter's

Bergere, Thea, and Richard Bergere. *The Story of St. Peter's.* New York: Dodd, Mead, 1966.

Lees-Milne, James. *Saint Peter's: The Story of Saint Peter's Basilica in Rome.* Boston: Little, Brown, 1967.

The Sistine Chapel

Chastel, André. *The Sistine Chapel: Michelangelo Rediscovered.* London: Muller, Blond, and White, 1986.

———. *The Vatican Frescoes of Michelangelo.* New York: Abbeville, 1980.

Pietrangeli, Carlo, et al. *The Sistine Chapel: The Art, the History, the Restoration.* New York: Harmony, 1986.

Raphael's Rooms in the Vatican

Davidson, Bernice F. *Raphael's Bible: A Study of the Vatican Logge.* University Park, PA: Pennsylvania State University Press, 1985.

Hersey, George Leonard. *High Renaissance Art in St. Peter's and the Vatican.* Chicago: University of Chicago Press, 1993.

MAJOLICA

Ladis, Andrew. *Italian Renaissance Maiolica from Southern Collections.* Athens, GA: Georgia Museum of Art, 1989.

Rackham, Bernard. *Italian Maiolica,* 2nd ed. London: Faber and Faber, 1963. Rackham also wrote 1933 and 1940 guidebooks to the Italian Majolica collection of the Victoria and Albert Museum, London.

GLASS

Perrot, Paul N., et al. *Three Centuries of Venetian Glass.* Corning, NY: Corning Museum of Glass, 1958.

Tait, Hugh, ed. *Glass: 5,000 Years.* New York: Abrams and the Trustees of the British Museum, 1991.

Turner, Guy. "*Allume Catina* and the Aesthetics of Venetian *Cristallo,*" *Journal of Design History,* vol. 12, no. 2, 1999, pp. 111–22. Oxford: Oxford University Press.

MURALS

Borsook, E. *The Mural Painters of Tuscany.* Oxford: Oxford University Press, 1960, 1980.

COLOR

Most of the writing listed here focuses on color in painting, but some of it is also applicable to color in interior design.

Ackerman, James. "On Early Renaissance Color Theory and Practice." In *Distance Points.* Cambridge, MA: MIT Press, 1991.

Barasch, Moshe. *Light and Color in the Italian Renaissance Theory of Art.* New York: New York University Press, 1978.

Gage, John. *Color and Culture: Practice and Meaning from Antiquity to Abstraction.* Boston: Bulfinch/Little, Brown, 1993.

Gavel, J. *Colour: A Study of Its Position in the Art of the Quattrocento and Cinquecento.* Stockholm: 1979.

Hall, Marcia B. *Color and Meaning.* Cambridge: Cambridge University Press, 1992.

Hills, Paul. *Venetian Colour: Marble, Mosaic, Painting, and Glass, 1250–1550.* New Haven, CT: Yale University Press, 1999.

TEXTILES

Adelson, Candace J. "Italy: Tapestry." In *The Dictionary of Art.* pp. 755–58, vol. 16, ed. Jane Turner. New York: Macmillan, 1996.

Anquetil, Jacques. *Silk.* Paris: Flammarion, 1995, esp. pp. 29–52, "Renaissance Italy."

Levey, Santina M. "Italy: Silk." In *The Dictionary of Art.* pp. 752–54, vol. 16, ed. Jane Turner. New York: Macmillan, 1996.

Scott, Philippa. *The Book of Silk.* New York: Thames and Hudson, 1993, esp. pp. 149–68, "Silk Weaving Comes to Europe."

THE BAROQUE

Bazin, Germain. *Baroque and Rococo Art.* New York: Praeger, 1964.

Busch, Harald. *Baroque Europe.* New York: Macmillan, 1962.

Highet, Gilbert. "Note on the Baroque." In *The Classical Tradition.* New York: Oxford University Press, 1949.

Lees-Milne, James. *Baroque in Italy.* London: Batsford, 1959.

Millon, Henry, ed. *The Triumph of the Baroque: Architecture in Europe, 1600–1750.* New York: Rizzoli, 2000.

Minor, Vernon Hyde. *Baroque and Rococo Art and Culture.* New York: Abrams, 1999.

Sewter, A. C. *Baroque and Rococo.* New York: Harcourt Brace Jovanovich, 1972.

Tapié, Victor-L. *The Age of Grandeur: Baroque Art and Architecture.* New York: Praeger, 1961. Published in France in 1957 as *Baroque et Classicisme.*

Walker, Stefanie, and Frederick Hammond, eds. *Life and the Arts in the Baroque Palaces of Rome: Ambiente Barocco.* New Haven, CT: Yale University Press, 1999.

THE ROCOCO

Kimball, Fiske. *The Creation of the Rococo.* Philadelphia: Philadelphia Museum of Art, 1943; New York: W. W. Norton, 1964.

Schonberger, Arno. *The Rococo Age: Art and Civilization of the 18th Century.* New York: McGraw-Hill, 1960.

ITALIAN RENAISSANCE ARCHITECTURE

Ackerman, James S. *The Villa: Form and Ideology in Country Houses.* Princeton, NJ: Princeton University Press, 1990.

Burckhardt, Jacob. *The Architecture of the Italian Renaissance.* Chicago: University of Chicago Press, 1985, trans. James Palmes, ed. Peter Murray, first published in German in 1867.

Coffin, David R. *The Villa in the Life of Renaissance Rome.* Princeton, NJ: Princeton University Press, 1979.

Hersey, George Leonard. *Pythagorean Palaces: Magic and Architecture in the Italian Renaissance.* Ithaca, NY: Cornell University Press, 1976.

Jestaz, Bertrand. *Architecture of the Renaissance from Brunelleschi to Palladio.* New York: Abrams, 1996. Colorful little paperback in Abrams's Discoveries series.

Lowell, G. *Smaller Italian Villas and Farmhouses.* New York: Architectural Book Publishing, 1929.

Masson, Georgina. *Italian Villas and Palaces.* London: Thames and Hudson, 1951, 1959.

Murray, Linda. *The High Renaissance and Mannerism: Italy, the North and Spain, 1500–1600,* World of Art series. New York: Thames and Hudson, 1995. Originally published in 1967 as two volumes, *The High Renaissance* and *The Late Renaissance and Mannerism.*

Murray, Peter. *The Architecture of the Italian Renaissance.* New York: Schocken, 1963.

Onians, John. *The Bearers of Meaning: The Classical Orders of Antiquity, the Middle Ages, and the Renaissance.* Princeton, NJ: Princeton University Press, 1988.

Payne, Alina A. *The Architectural Treatise in the Italian Renaissance.* New York: Cambridge Univeristy Press, 1999.

Wittkower, Rudolph. *Architectural Principles in the Age of Humanism.* London: Tiranti, 1952. The theories behind the architecture and design.

———. *Art and Architecture in Italy, 1600–1750.* Baltimore: Penguin, 1958; 6th ed. rev. Joseph Conners and Jennifer Montagu, 3 vols., New Haven, CT: Yale University Press, 1999.

———. *Gothic vs. Classic: Architectural Projects in Seventeenth Century Italy.* New York: Braziller, 1974.

ITALIAN RENAISSANCE INTERIORS, FURNITURE, AND DECORATIVE ARTS

Biscontin, J. "Antique Candelabra in Frescoes by Bernardino Gatti and a Drawing by Giulio Romano," *Journal of the Warburg and Courtauld Institute,* 57 (1994), pp. 264–69.

Clough, C. "Art as Power in the Decoration of the Study of an Italian Renaissance Prince: The Case of Federico da Montefeltro," *Artibus et historiae,* 31 (1995), pp. 19–50.

Cox-Rearick, J. *Bronzino's Chapel of Eleanora in the Palazzo Vecchio.* Berkeley: University of California Press, 1993.

Eberlein, H. D. *Interiors, Fireplaces, and Furniture of the Italian Renaissance.* New York: Architectural Book Publishing, 1916.

Griguat, Paul L. *Decorative Arts of the Italian Renaissance, 1400–1600.* Detroit: Detroit Institute of Arts, 1958.

Hunter, George Leland. *Italian Furniture and Interiors.* New York: Helburn, 1918.

Miller, Elizabeth. *16th-Century Italian Ornament Prints in the Victoria and Albert Museum.* London: V and A Publications, 1999.

Odom, W. M. *A History of Italian Furniture.* Garden City, NY: Doubleday, 1918.

Schottmüller, Frida. *Furniture and Interior Decoration of the Italian Renaissance.* New York: Brentano's, 1921. An introductory text and a fine collection of photographs.

Thomas, Walter Grant, and J. T. Fallon. *Northern Italian Details.* New York: The American Architect, 1916. Measured drawings and photographs.

Thornton, Peter. *Baroque and Rococo Silks.* London: Faber and Faber, 1965.

———. *The Italian Renaissance Interior, 1400–1600.* London: Weidenfeld and Nicolson, 1991. See the note at the beginning of this chapter's bibliography.

Waddy, Patricia. *Seventeenth-Century Roman Palaces: Use and the Art of the Plan.* New York and Cambridge, MA: The Architectural History Foundation and MIT Press, 1990.

ITALIAN RENAISSANCE DESIGN

Burckhardt, Jacob. *The Civilization of the Renaissance in Italy.* Oxford: Oxford University Press,1944; London: Phaidon, 1960. First published in German in 1860.

Burke, Peter. *The Italian Renaissance: Culture and Society in Italy.* rev. ed. Princeton, NJ: Princeton University Press, 1987.

Chambers, D. S. *Patrons and Artists in the Italian Renaissance.* Columbia, SC: University of South Carolina Press, 1971.

Chastel, André. *The Flowering of the Italian Renaissance.* New York: Odyssey, 1965. Part of the excellent Arts of Mankind series. ed. by André Malraux.

———. *Italian Art,* trans. Peter and Linda Murray. New York: Thomas Yoseloff, 1963. Published in France in 1956 as *L' Art italien.*

———. *Studios and Styles of the Italian Renaissance,* Arts of Mankind series. New York: Odyssey. Includes an extensive glossary/index with brief identifications of sites, artists, and terms.

Clark, Kenneth. *The Art of Humanism.* New York: Harper and Row, 1970. Illustrated essays of five artists: Dontaello, Uccello, Alberti, Mantegna, and Botticelli.

Cole, A. *Virtue and Magnificence: Art of the Italian Renaissance Courts.* New York: Abrams, 1995.

Durant, Will. *The Renaissance. A History of Civilization in Italy from 1304 to 1576 A.D.,* Story of Civilization series, Vol. 5. New York: Simon and Schuster, 1953. Durant takes a bewilderingly sour view of Italian Renaissance architecture, but there is interesting reading on other subjects.

Gombrich, E. H. *Norm and Form.* London: Phaidon, 1966, esp. the two essays "The Renaissance Conception of Artistic Progress and Its Consequences" and "Norm and Form: The Stylistic Categories of Art History and Their Origins in the Renaissance."

Hartt, Frederick. *History of Italian Renaissance Art: Painting, Sculpture, Architecture.* Englewood Cliffs, NJ: Prentice-Hall 1979; 4th ed. New York: Abrams, 1994.

Hollingsworth, Mary. *Patronage in Sixteenth Century Italy.* London: John Murray, 1996. Relationships between patrons and artists.

Letts, Rosa Maria. *The Renaissance,* Cambridge Introduction to the Arts series. New York: Cambridge University Press, 1981.

Murray, Linda. *The High Renaissance and Mannerism: Italy, the North, and Spain, 1500–1600.* London: Thames and Hudson, 1995. First published in 1967 in two volumes; now part of the World of Art series.

Panofsky, Erwin. *Renaissance and Renascences in Western Art.* Stockholm: Almqvist and Wiskell, 1960.

Paoletti, John T., and Gary M. Radke. *Art in Renaissance Italy.* Upper Saddle River, NJ: Prentice Hall, 1997.

Rowland, Ingrid D. *The Culture of the High Renaissance: Ancients and Moderns in Sixteenth-Century Rome.* New York: Cambridge University Press, 1998.

Shearman, John. *Only Connect. . . , Art and the Spectator in the Italian Renaissance*. Princeton, NJ: Princeton University Press, 1992; The A. W. Mellon Lectures in the Fine Arts, 1988.

Stokes, Adrain. *The Quattrocento*. New York: Schocken, 1968. First published in Great Britain in 1932.

Symonds, John Addington. *The Renaissance in Italy: The Fine Arts*. London: Smith, Elder, 1899.

Wohl, Hellmut. *The Aesthetics of Italian Renaissance Art*. New York: Cambridge University Press, 1999.

Wölfflin, Heinrich. *Classic Art: An Introduction to the Italian Renaissance*. London: Phaidon, 1994. First published in English as *The Art of the Italian Renaissance: A Handbook for Students and Travelers*, New York: Schocken, 1963. Chapters on Leonardo, Michelangelo, Raphael, Fra Bartolommeo, and Andrea del Sarto.

CHAPTER 14 Spain (Prehistoric Times to the Nineteenth Century)

THE ESCORIAL

Cable, Mary, and the editors of the Newsweek Book Division. *El Escorial*. New York: Newsweek, 1971.

El Escorial, Eighth Marvel of the World. Madrid: Patrimonio Nacional, 1967.

Kubler, George. *Building the Escorial*. Princeton, NJ: Princeton University Press, 1982.

———. "Palladio and the Escorial," in *Studies in Ancient American and European Art: The Collected Essays of George Kubler*. New Haven, CT: Yale University Press, 1985. First published in Italian in 1963.

Wilkinson, Catherine. "Planning a Style for the Escorial: An Architectural Treatise for Philip of Spain." *Journal of the Society of Architectural Historians*, XLIV, no. 1, March 1985, pp. 37–47.

THE ALHAMBRA

Grabar, Oleg. *The Alhambra*. Cambridge, MA: Harvard University Press, 1978.

Jones, Owen. *The Grammar of Ornament*, Chapter X, "Moresque Ornament from the Alhambra," 1856; reprint, New York: Van Nostrand Reinhold, 1982; reprint, Mineola, NY: Dover, 1987.

OTHER SPANISH ARCHITECTURE

Barrucand, Marianne, and Achim Bednorz. *Moorish Architecture in Andalusia*. Cologne: Benedikt Taschen, 1992.

Brown, Jonathan, and J. H. Elliott. *A Palace for a King: The Buen Retiro and the Court of Philip IV*. New Haven, CT: Yale University Press, 1980.

Byne, Arthur. *Majorcan Houses and Gardens*. New York: Helburn, 1928. Arthur Byne was an American architect and antiques dealer who lived in Spain for more than a decade, his clients for Spanish antiques including William Randolph Hearst and his architect Julia Morgan. Byne wrote a dozen books (some coauthored with his wife) on Spanish buildings, interiors, furniture, and decorative details. They are distinguished by valuable documentary photographs and measured drawings.

———. *Provincial Houses in Spain*, New York: Helburn, 1925.

———, and Mildred Stapley Byne. *Spanish Architecture of the Sixteenth Century*. New York: G. P. Putnam's Sons, 1917.

Clute, Eugene, ed., *Masterpieces of Spanish Architecture*. New York: Pencil Points Press, 1925.

Espinosa de los Monteros, Patricia. *Houses and Palaces of Andalusia*. New York: Rizzoli, 1998.

Harvey, John. *The Cathedrals of Spain*. London: B. T. Batsford, 1957.

Hernández Ferrero, Juan A. *The Royal Palaces of Spain*. New York: Abbeville, 1997.

Mack, Gerstle, and Thomas Gibson. *Architectural Details of Northern and Central Spain*. New York: Helburn, 1930. This and the following book have photographs and measured drawings of Spanish patios, doorways, ironwork, and other features.

——— *Arcitectural Details of Southern Spain*. New York: Helburn, 1928.

——— Van Pelt, John V., *Masterpieces of Spanish Architecture: Romanesque and Allied Styles*. New York: Pencil Points Press, 1925.

SPANISH INTERIORS AND FURNITURE

Brotherston, Jody. "Spanish and American Encounters in Interior Architecture." In *Spain's Hopes and Realities: Architecture, History and Politics*, ed. Jody Brotherston. Ruston, LA: Louisiana Tech University, 1993. Proceedings of an international symposium.

Burr, Grace Hardendorff. *Hispanic Furniture from the Fifteenth through the Eighteenth Century*, 2d ed. New York: Archive, 1964.

Byne, Arthur, and Mildred Stapley Byne. *Spanish Interiors and Furniture*, 3 vols. New York: Helburn, 1921–25; reprint Mineola, NY: Dover, 1969.

——— *Decorated Wooden Ceilings in Spain*. New York: Hispanic Society of America, 1920; New York and London: G. P. Putnam's Sons, 1920.

Doménech (Galissá), Rafael, and Luis Pérez Bueno. *Antique Spanish Furniture*. Barcelona, c. 1921; new edition with English translation by Grace Hardendorff Burr, New York: Bonanza, 1965. The authors were the first two directors of what is now the National Museum of Decorative Arts in Madrid.

Eberlein, Harold Donaldson. *Spanish Interiors, Furniture, and Details*. New York: Architectural Book Publishing, 1925.

Feduchi, L. *El Meuble Espanol*. Barcelona: Ediciones Poligrafa, 1969. An excellent survey, with text in English and three other languages.

Katz, Sali. *Hispanic Furniture*. Stamford, CT: Architectural Book Publishing, 1986.

Orso, Steven N. *Philip IV and the Decoration of the Alcázar of Madrid*. Princeton, NJ: Princeton University Press, 1986.

SPANISH METALWORK

Byne, Arthur. *Rejería of the Spanish Renaissance*. New York: Hispanic Society of America, 1914.

LEATHER

Waterer, John William. *Spanish Leather, A History of Its Use from 800 to 1800 . . .*, London: Faber and Faber, 1971.

Fabric and Tapestries

Galea-Blanc, Clothilde. "The Carpet in Spain and Portugal." In *Great Carpets of the World*, ed. Valérie Bérinstai et al. New York: Vendome, 1996.

Ortiz, Antonio Dominguez, et al. *Resplendence of the Spanish Monarchy: Renaissance Tapestries and Armor from the Patrimonio Nacional*. New York: Metropolitan Museum of Art, 1991.

Stone, Patricia. *Portuguese Needlework Rugs*. McLean, VA: EPM Publications, 1981.

Tiles

Castel-Branco Pereira, João. *Portuguese Tiles from the National Museum of Azulejo, Lisbon*. London: Zwemmer, 1995

Frothingham, Alice Wilson. *Tile Panels of Spain*. New York: Hispanic Society of America, 1969.

Portugal

Binney, Marcus, and Patrick Bowe. *Houses and Gardens of Portugal*. New York: Rizzoli, 1998.

Ferro, Maria Inês. *Queluz, the Palace and Gardens*. London: Scala, 1997. An eighteenth-century Portuguese royal palace in French Rococo style.

Kubler, George. *Portuguese Plain Architecture: Between Spices and Diamonds, 1521–1706*. Middletown, CT: Wesleyan University Press, 1972.

Levenson, Jay A., ed. *The Age of the Baroque in Portugal*. New Haven, CT: Yale University Press, 1993. Catalog of an exhibition at the National Gallery of Art, Washington, DC, in 1993 and 1994.

Luis Filipe, Marques da Gama. *Palacio Nacional de Mafra*. Lisbon and Mafra: ELO-Publicidade, Artes Gráficas, 1985. A guide to the palace in four languages.

Neves, José Cassiano. *The Palace and Gardens of Fronteira*. Quetzal Editores. Distributed in the U.S. by Antique Collector's Club, Wappingers Falls, NY, 1995.

Spain

Ainaud de Lasarte, Juan. *Art Treasures in Spain*. New York: McGraw-Hill, 1969.

The Art of Medieval Spain, A.D. 500–1200. New York: Metropolitan Museum of Art, 1993. Distributed by Abrams, New York. Catalog of a 1993–94 exhibition.

Barral i Altet, Xavier, ed. *Art and Architecture of Spain*. New York: Bulfinch/Little, Brown, 1998.

Cerici-Pellicer, Alexandre. *Treasures of Spain from Charles V to Goya*, Treasures of the World series. Geneva: Skira, 1965.

Dodds, Jeffilyn, ed. *Al-Andalus: The Art of Islamic Spain*. New York: Metropolitan Museum of Art, 1992. Distributed by Abrams, New York. Catalog of a 1992 exhibition first at the Alhambra and then at the Metropolitan.

Hagen, Oskar. *Patterns and Principles of Spanish Art*. Madison, WI: University of Wisconsin Press, 1948.

Kubler, George, and Martin Soria. *Art and Architecture in Spain and Portugal and Their American Dominions, 1500 to 1800*. Baltimore: Penguin, 1959.

O'Neill, John P. *The Art of Medieval Spain*, A.D. 500–1200. New York: Metropolitan Museum of Art, 1993. Distributed by Abrams, New York.

Pita Andrade, J. M. *Treasures of Spain from Altamira to the Catholic Kings*. Geneva: Skira, 1967. Distributed in the U.S. by World Publishing, Cleveland.

Tarradell, M. *Iberian Art*. New York: Rizzoli, 1978. Artifacts in pre-Roman Spain.

Tatlock, R. R., et al. *Spanish Art*. Published for *The Burlington Magazine* by B. T. Batsford, London, 1927. Illustrated essays on architecture, painting, sculpture, textiles, ceramics and glass, woodwork, and metalwork.

Vlieghe, Hans. *Flemish Art and Architecture, 1585–1700*, Yale University Pelican History of Art series. New Haven, CT: Yale University Press,1998. Presents the design of Flanders under Spanish rule.

Chapter 15 The French Renaissance and Later Developments (Fifteenth to Eighteenth Centuries)

Blunt, Anthony. *Art and Architecture in France,1500–1700*, Pelican History of Art series. Baltimore: Penguin, 1954,

Cliff, Stafford. *The French Archive of Design and Decoration*. New York: Abrams, 1999.

Cloulas, Ivan. *Treasures of the French Renaissance: Architecture, Sculpture, Paintings, Drawings*. New York: Abrams, 1998.

Costantino, Ruth T. *How to Know French Antiques*. New York: Clarkson N. Potter, 1961. Chapters on furniture, painting and drawing, sculpture, textiles, ceramics, glass, clocks, and more. An appendix offers an illustrated "Chronology of Chair Legs."

Frégnac, Claude, and Wayne Andrews. *The Great Houses of Paris*. New York: Vendome, 1979.

Gebelin, François. *The Châteaux of France*, trans. H. Eaton Hart. New York: G. P. Putnam's Sons, 1964. Descriptions of châteaux from the Middle Ages to the nineteenth century. Included is an argument for Leonardo da Vinci's influence on the design of Chambord.

Lambell, Ronald. *French Period Houses and Their Details*. Oxford: Butterworth, 1992. Photos and line drawings of balustrades, moldings, fireplaces, door handles, and other details from fifteen *hôtels particuliers*. Paperbound.

Thornton, Peter. *Seventeenth-Century Interior Decoration in England, France, and Holland*. New Haven, CT: Yale University Press, 1978.

Von Kalnein, Wend. *Architecture in France in the Eighteenth Century*, Pelican History of Art series. New Haven, CT: Yale University Press, 1995. First published in 1972.

Wheeler, Daniel, and the editors of Réalités-Hachette. *The Châteaux of France*. New York: Vendome, 1979.

The Rococo

Kimball, Fiske. *Creation of the Rococo*. Philadelphia: Philadelphia Museum of Art, 1943; reprint, New York: Dover, 1980. A standard work on the subject.

Park, William. *The Idea of Rococo*. Newark, DE: University of Delaware Press, 1992. A survey not limited to France.

Scott, Katie. *The Rococo Interior: Decoration and Social Spaces in Early Eighteenth- Century Paris.* New Haven, CT: Yale University Press, 1995.

Rococo beyond France: South German Churches

Harries, Karsten. *The Bavarian Rococo Church: Between Faith and Aestheticism.* New Haven, CT: Yale University Press, 1983. Deals with work within the eighteenth-century limits of Bavaria, thus omitting work in Franconia, such as that of Balthasar Neumann.

Hitchcock, Henry-Russell. *Rococo Architecture in Southern Germany.* New York: Phaidon, 1968.

Otto, Christian F. *Space into Light: The Churches of Balthasar Neumann.* New York and Cambridge, MA: The Architectural History Foundation and MIT Press, 1980,

The Eighteenth Century

Leben, Ulrich. *Molitor, Ébéniste from the Ancien Régime to the Bourbon Restoration.* London: Philip Wilson, 1992.

Myers, Mary L. *French Architectural and Ornament Drawings of the Eighteenth Century.* New York: Metropolitan Museum of Art, distributed by Abrams, 1991.

Whitehead, John. *The French Interior in the Eighteenth Century.* London: Laurence King, 1992; New York: Dutton, 1993.

Fontainebleau

de Montclos, Jean-Marie Pérouse. *Fontainbleau.* London: Scala, 1998.

Vaux-le-Vicomte

de Montclos, Jean-Marie Pérouse. *Vaux-le-Vicomte.* London: Scala, 1997.

Versailles

Arnott, J., and H. Wilson. *The Petit Trianon.* London: Batsford, 1908; New York: Architectural Book Publishing,1914. Oversized portfolio with measured drawings and photographs of the building, its interiors, its furniture, and details of its metalwork.

Berger, Robert W. *A Royal Passion: Louis XIV as Patron of Architecture.* New York: Cambridge University Press, 1994.

————. *Versailles: The Château of Louis XIV.* University Park, PA: Pennsylvania State University Press, 1985.

Constans, Claire, and Xavier Salmon, eds. *Splendors of Versailles.* Jackson, MS: Mississippi Commission for International Cultural Exchange, 1998. Exhibition catalog.

Mitford, Nancy. *The Sun King: Louis XIV at Versailles.* New York: Harper and Row, 1966. Illustrated biography with much information about the palace and its interiors.

Van der Kemp, Gérald. *Versailles.* New York: Park Lane, 1978.

Walton, Guy. *Louis XIV's Versailles.* Chicago: University of Chicago Press, 1986.

The Louvre

Berger, Robert W. *The Palace of the Sun: The Louvre of Louis XIV.* University Park, PA: University of Pennsylvania Press, 1993.

Chantelou, Paul Fréart de. *Diary of the Cavaliere Bernini's Visit to France,* trans. Margery Corbett. Princeton, NJ: Princeton University Press, 1985. An account by the royal steward who attended Bernini in France. Edited and with an introduction by Anthony Blunt.

Gould, Cecil. *Bernini in France: An Episode in Seventeenth-Century History.* Princeton, NJ: Princeton University Press, 1982.

Huyghe, René. *Art Treasures of the Louvre.* New York: Abrams, 1960. A survey of the collections, with a brief history of the building by Milton S. Fox.

French Furniture

Hughes, Peter. *French Eighteenth Century Clocks and Barometers in the Wallace Collection.* London: Trustees of the Wallace Collection, 1994.

Pradère, Alexandre. *French Furniture Makers: The Art of the Ébéniste from Louis XIV to the Revolution.* trans. Perran Wood. Malibu, CA: J. Paul Getty Museum, 1989.

Ricci, Seymour de. *Louis XIV and Regency Furniture and Decoration.* New York: William Helburn, 1929.

Souchal, Geneviève. *French Eighteenth-Century Furniture,* trans. Simon Watson Taylor. New York: G. P. Putnam's Sons, 1961.

Verlet, Pierre. *French Furniture of the Eighteenth Century,* trans. Penelope Hunter-Stiebel. Charlottesville, VA: University Press of Virginia, 1991. First published in Paris in 1955.

Watson, F. J. B. *Louis XVI Furniture.* London: Alec Tiranti, 1960; New York: Philosophical Library, 1960.

Ceramics

Amico, Leonard. *Bernard Palissy: In Search of Earthly Paradise.* New York and Paris: Flammarion, 1996.

Textiles

Verlet, Pierre. *Savonnerie: The James A. de Rothschild Collection at Waddesdon Manor.* Fribourg, Switzerland: Office du Livre, 1982, published for the National Trust, London.

Chapter 16 The English Renaissance and Later Developments(Sixteenth to Eighteenth Centuries)

Hardwick Hall

Girouard, Mark *Robert Smythson and the Elizabethan Country House.* New Haven: Yale University Press, 1983

See also Santina Levey's book under "Textiles."

The Banqueting House, Whitehall

Thurley, Simon. *Whitehall Palace, An Architectural History of the Royal Apartments, 1240–1690.* New Haven, CT: Yale University Press, 2000.

Blenheim

Fowler, Marian. *Blenheim, Biography of a Palace*. New York: Viking Penguin, 1989.

English Architecture

Betjeman, John. *A Pictorial History of English Architecture*. New York: Macmillan, 1970.

Cescinsky, Herbert. *The Old World House, Its Furniture and Decoration*. London: A. and C. Black, 1924; New York: Macmillan, 1924.

Lees-Milne, James. *English Country Houses: Baroque, 1685–1715*. London: Country Life, 1970.

Middleton, Robin, and David Watkin. *Neoclassical and 19th Century Architecture*. New York: Rizzoli, 1987. A two-volume work, the first volume *The Enlightenment in France and England*, the second *The Diffusion and Development of Classicism and the Gothic Revival*.

Stillman, Damie. *English Neo-Classical Architecture*. London: A. Zwemmer, 1988.

Stratton, Arthur James. *The Domestic Architecture of England during the Tudor Period*. London: Batsford, 1911. Photographs and measured drawings.

Summerson, John. *Architecture in Britain, 1530 to 1830*. Harmondsworth, England: Penguin, 1953

———. *Georgian London, An Architectural Study*. Harmondsworth, England: Penguin, 1962; New York: Praeger, 1970.

Watkin, David. *English Architecture, A Concise History*. New York: Oxford University Press, 1979.

Wittkower, Rudolf. *Palladio and English Palladianism*. New York: Thames and Hudson, 1983.

Jacobean

Mowl, Timothy. *Elizabethan and Jacobean Style*. London: Phaidon, 1993.

Wells-Cole, Anthony. *Art and Decoration in Elizabethan and Jacobean England: The Influence of Continental Prints, 1558–1625*. New Haven, CT: Yale University Press, 1997.

Thomas Chippendale

Chippendale, Thomas. *The Gentleman and Cabinet-Maker's Director*. New York: Dover, 1966. Modern reprint of Chippendale's third edition (London, 1762). First edition published 1754.

Gilbert, Christopher. *The Life and Work of Thomas Chippendale*. New York: Tabard Press; London: Cassell, 1978.

Hardy, Paul. "Thomas Chippendale" In *Encyclopedia of Interior Design*, ed. Joanna Banham. London and Chicago: Fitzroy Dearborn, 1997.

Robert Adam

Adam, Robert, and James Adam. *The Works in Architecture*, 2 vols. London, 1773–79; vol. 3, 1822.

Beard, Geoffrey. *The Work of Robert Adam*. New York: Arco, 1978.

Fleming, John. *Robert Adam and His Circle*. London: John Murray, 1962.

Harris, Eileen, *The Furniture of Robert Adam*. London: Tiranti, 1963. Reprint, London: Academy Editions; New York: St. Martin's Press, 1973.

Stillman, Damie. *Decorative Work of Robert Adam*. London: Tiranti, 1966. Reprint, London: Academy Editions; New York: St. Martin's Press, 1973.

Summerson, John. *The Iveagh Bequest: Kenwood, A Short Account of Its History and Architecture*. London: London County Council, 1951.

Tomlin, Maurice. *Catalogue of Adam Period Furniture*. London: Victoria and Albert Museum, 1982. Concentrates on furniture in the museum and at Osterley Park, the house designed by Adam between 1761 and 1780.

Yarwood, Doreen. *Robert Adam*. New York: Scribner's, 1970.

Henry Holland

Stroud, Dorothy. *Henry Holland: His Life and Architecture*. London: Country Life, 1950; Cranbury, NJ: A. S. Barnes, 1966.

John Linnell

Hayward, Helena, and Pat Kirkham. *William and John Linnell, Eighteenth-Century London Furniture Makers*, 2 vols. New York: Rizzoli, 1980

George Hepplewhite

Hepplewhite, A., and Co. *The Cabinet-Maker and Upholsterer's Guide*. London: 1788.

Thomas Sheraton

Beilly, Roslyn. "Sheraton Furniture," *Interior Design*, August, 1989, p. 110.

Fastnedge, Ralph. *Sheraton Furniture*. New York: Thomas Yoseloff, 1962.

Sheraton, Thomas. *The Cabinet-Maker and Upholsterer's Drawing-Book*. New York: Dover, 1972. Reprint of Sheraton's book first published between 1791 and 1793.

English Furniture

Beard, Geoffrey, and Christopher Gilbert, eds. *Dictionary of English Furniture Makers, 1660–1840*, Leeds: W. S. Maney, 1986.

Cescinsky, Herbert, with Ernest R. Gribbs. *Early English Furniture and Woodwork*. London: Routledge, 1922.

Edwards, Ralph. *English Chairs*. London: Victoria and Albert Museum, 1951.

———. *Georgian Cabinet Makers*. London: Country Life, 1944. Revised by Edwards and Margaret Jourdain in 1955 for the same publisher.

Fastnedge, Ralph. *English Furniture Styles 1550–1830*. Harmondsworth, England: Penguin Books, 1955. Reprinted 1961.

Gloag, John. *British Furniture Makers*. London: Collins, 1946.

Heal, Sir Ambrose. *The London Furniture Makers from the Restoration to the Victorian Era, 1660–1840*. London: Batsford, 1953. With a chapter by Robert Wemyss Symonds on "The Problem of Identification."

Hughes, Therle. *Old English Furniture.* New York: Praeger, 1963. A survey by furniture types: chests, chairs, tables, and so on.

Kinmonth, Claudia. *Irish Country Furniture, 1700–1950.* New Haven, CT: Yale University Press, 1993.

Lenygon, Francis. *Furniture in England from 1660 to 1760.* London: Batsford, 1914.

Rogers, John C. *English Furniture.* London: Country Life, 1950, revised and enlarged by Margaret Jourdain. First published by Country Life in 1923. A historical survey by wood types: "The Period of Oak . . . Walunt . . . Mahogany Furniture."

Strange, Thomas Archer. *English Furniture, Decoration, Woodwork, and Allied Arts.* London: Studio Editions, 1986.

Symonds, Robert Wemyss. *English Furniture from Charles II to George II.* New York: International Studio, 1929. Symonds was a prolific writer about English furniture in the 1940s and 1950s.

———. *Masterpieces of English Furniture and Clocks.* London: Batsford, 1940.

Synge, Lanto. *Mallett's Great English Furniture.* Boston: Little, Brown, a Bulfinch Press Book, 1991. Examples from the wares of the well-known London antique dealer.

White, Elizabeth, ed. *Pictorial Dictionary of British 18th Century Furniture Design.* Wappingers Falls, NY: The Antique Collectors' Club, 1990.

Wills, Geoffrey. *English Furniture,1550–1760.* Garden City, NY: Doubleday, 1971.

GRINLING GIBBONS

Beard, Geoffrey. *The Work of Grinling Gibbons.* Chicago: University of Chicago Press, 1989.

Esterly, David. *Grinling Gibbons and the Art of Carving.* New York: Abrams, 1998.

METALWORK

Rowe, Robert. *Adam Silver, 1765–1795.* New York: Taplinger, 1965.

CERAMICS

Cushion, John, and Margaret Cushion. *A Collector's History of British Porcelain.* Woodbridge, Suffolk: Antique Collectors' Club Ltd., 1992. Excellent history from the middle of the eighteenth century to the present.

Poole, Julia E. *English Pottery.* New York: Cambridge University Press, 1995. Examples from the collection of the Fitzwilliam Museum at the University of Cambridge.

WEDGWOOD

Dawson, Aileen. *British Museum Masterpieces of Wedgwood.* London: British Museum Press, 1984.

Kelly, Alison. *Decorative Wedgwood in Architecture and Furniture.* New York: Born-Hawes, 1965.

Reilly, Robin. *Wedgwood,* 2 vols. New York: Stockton; London: Macmillan, 1989.

TEXTILES

Levey, Santina M. *Elizabethan Treasures: The Hardwick Hall Textiles.* London: National Trust, distributed in the U.S. by Abrams, 1998.

WALLPAPER AND PRINT ROOMS

Banham, Joanna. "Print Rooms" In *Encyclopedia of Interior Design,* ed. Joanna Banham. London and Chicago: Fitzroy Dearborn, 1997.

Teynac, Françoise, Pierre Nolot, and Jean-Denis Vivien. *Wallpaper: A History.* New York: Rizzoli, 1982.

ENGLISH DESIGN

Bazin, Germain. *Baroque and Rococo.* New York: Praeger, 1964.

Beard, Geoffrey. *Craftsmen and Interior Decoration in England 1660–1820.* Edinburgh: John Bartholomew, 1981; London: Bloomsbury Books, an imprint of Godfrey Cave, 1986.

———. *The National Trust Book of the English House Interior.* London and New York: Viking Penguin, 1990.

———. *Upholsterers and Interior Furnishing in England 1530–1840.* New Haven, CT: Yale University Press, 1997. Published for the Bard Graduate Center for Studies in the Decorative Arts.

Brooke, Iris. *Four Walls Adorned: Interior Decoration 1485–1820.* London: Methuen, 1952. A readable account of English residential décor in the Tudor, Stuart, and Georgian periods, with an emphasis not on the great houses but on modest ones.

Cliffe, J. T. *The World of the Country House in Seventeenth-Century England.* New Haven, CT: Yale University Press, 1999.

Cornforth, John. *English Interiors 1790–1848.* London: Barrie and Jenkins, 1978.

Croft-Murray, Edward. *Decorative Painting in England 1537–1837.* London: Country Life, 1962 (vol. 1), 1970 (vol. 2).

Dutton, Ralph. *The English Interior, 1500 to 1900.* London and New York: Batsford, 1948.

Edwards, Ralph, and L. G. G. Ramsey, eds. *The Connoisseur's Complete Period Guides to the Houses, Decoration, Furnishing, and Chattels of the Classic Periods.* New York: Bonanza, 1968. Single-volume compilation of six period guides (Tudor through Early Victorian) published separately in 1956.

Fowler, John, and John Cornworth. *English Decoration in the Eighteenth Century.* London: Barrie and Jenkins, 1974.

Gore, Alan, and Ann Gore. *English Interiors: An Illustrated History.* New York: Thames and Hudson, 1991. Also published by Phaidon, London, in 1991 as *The History of English Interiors.*

Irwin, David. *Neoclassicism.* Art and Ideas series. London: Phaidon, 1997.

Jackson-Stops, Gervase. *The English Country House: A Grand Tour.* Boston: Little, Brown; Washington, DC: National Gallery of Art, 1985. Photography by James Pipkin. A survey of country house interiors arranged by room type—saloons, dining rooms, withdrawing rooms, libraries, chapels and so on.

———, ed. *The Treasure Houses of Britain: Five Hundred Years of Private Patronage and Art Collecting.* Washington, DC: National Gallery of Art; New Haven, CT: Yale University Press, 1985. Exhibition catalog of almost six hundred examples of art and decorative arts from British houses.

Jourdain, Margaret. *English Decoration and Furniture of the Early Renaissance.* London: Batsford, 1924.

———. *English Decoration and Furniture of the Later XVIIIth Century.* New York: Scribner's, 1922.

———. *English Decorative Plasterwork of the Renaissance.* London: Batsford, 1926.

————. *English Interior Decoration*. London: Batsford, 1950.

Lenygon, Francis. *Decoration in England from 1640 to 1760*. London: Batsford, 1914; 2d ed., New York: Scribner's, 1927. Part of the four-volume *Library of Decorative Art*.

Mortimer, Martin. *The English Glass Chandelier*. Wappingers Falls, NY: Antique Collectors' Club, 2000.

Pevsner, Nikolaus. *The Englishness of English Art*. London: Architectural Press, 1956. Reprint, Harmondsworth, England: Penguin, 1964. Based on radio lectures broadcast in 1955.

Sitwell, Sacheverell, ed. *Great Houses of Europe*. London and New York: Spring, 1961. Photography by Edwin Smith. Includes essays on Wilton and Blenheim, both written by John Summerson, and one on Hardwick Hall by Robin Fedden

Stratton, Arthur James. *Some XVIIIth Century Designs for Interior Decoration, with Details Selected from the Published Works of Abraham Swan*. London: Tiranti, 1923.

Sykes, Christopher Simon. *Private Palaces: Life in the Great London Houses*. New York: Viking, 1986.

Von Einsiedel, Andreas, and Nadia Mackenzie, with text by Margaret Willes. *Historic Interiors of England, Wales, and Northern Ireland*. New York: Abrams, 1999. Portfolio of color photographs of country house interiors.

CHAPTER 17 Pre-Columbian America (Before the Sixteenth Century)

THE OLMECS

Benson, Elizabeth P., and Beatriz de la Fuente. *Olmec Art of Ancient Mexico*. New York: Abrams, 1996.

Clark, John E., and Mary Pye, eds. *Olmec Art and Archaeology in Mesoamerica*. New Haven, CT: Yale University Press, 2000.

Coe, Michael D., et al. *The Olmec World: Ritual and Rulership*. Princeton, NJ: Art Museum, Princeton University, 1996. Catalog for an exhibition at Princeton and at the Museum of Fine Arts, Houston.

Drucker, P. *La Venta, Tabasco: A Study of Olmec Ceramics and Art*. Washington, DC: Smithsonian Institution Bureau of American Ethnology, 1952 (BAE Bulletin 153).

————, R. Hiezer, and R. Squier. *Excavations at La Venta, Tabasco*. Washington, DC: Smithsonian Institution Bureau of American Ethnology, 1959 (BAE Bulletin 170).

TEOTIHUACÁN

Berrin, Kthlees, and Esther Pasztory, eds. *Teotihuacán: Art from the City of the Gods*. New York: Thames and Hudson, 1993.

THE MAYAS

Andrews, George F. *Maya Cities: Placemaking and Urbanization*. Civilization of the American Indian series. Norman, OK: University of Oklahoma Press, 1975.

Gallenkamp. Charles. *Maya: The Riddle and Rediscovery of a Lost Civilization*. New York: David McKay, 1959; revised and reprinted by Viking, 1985.

————, and Regina Elise Johnson. *Maya: Treasures of an Ancient Civilization*. New York: Abrams, 1985. Catalog of an exhibition organized by the Albuquerque Museum.

LaFay, Howard, et al. "The Maya," *National Geographic*, vol. 148, no. 6, December 1975, pp. 729–811.

Miller, Mary, and Karl Taube. *The Gods and Symbols of Ancient Mexico and the Maya: An Illustrated Dictionary of Mesoamerican Religion*. New York: Thames and Hudson, 1997.

Morley, Sylvanus G., and George W. Brainerd, rev. Robert J. Sharer. *The Ancient Maya*, 4th ed. Palo Alto, CA: Stanford University Press, 1983.

Ranney, Edward. *Stonework of the Maya*. Albuquerque: University of New Mexico Press, 1974. Photography by the author.

Schele, Linda, and Mary Ellen Miller. *The Blood of Kings: Dynasty and Ritual in Maya Art*. New York: Braziller, 1986. Catalog for an exhibition first seen at the Kimbell Art Museum, Fort Worth.

Spinden, Herbert J. *A Study of Maya Art: Its Subject Matter and Historical Development*. Cambridge, MA: Peabody Museum, 1913; reprint, New York: Dover, 1975.

Stierlin, Henri. *Living Architecture: Mayan*. New York: Grosset and Dunlap, 1964. Later republished as *Architecture of the World: Mayan*, by Benedikt Taschen, Lausanne.

Thompson, J. E. S. *The Rise and Fall of Maya Civilization*. Norman, OK: University of Oklahoma Press, 1956.

THE AZTECS

Braun, Barbara. "Aztecs: Art and Sacrifice," *Art in America*, April 1984, pp. 126–39.

Clendinnen, Inga. *Aztecs: An Interpretation*. Cambridge, England: Cambridge University Press, 1991.

Soisson, Pierre, and Janine Soisson. *Life of the Aztecs in Ancient Mexico*, trans. David Macrae. Geneva: Editions Minerva, 1978.

THE MOCHE CULTURE, THE INCAS, AND PERUVIAN TEXTILES

Bennett, W. C. *Ancient Arts of the Andes*. New York: Museum of Modern Art, 1954. Catalog of an exhibition that was also seen in San Francisco and Minneapolis.

d' Harcourt, Raoul. *Textiles of Ancient Peru and Their Techniques*, ed. Grace G. Denny and Carolyn M. Osborne, trans. Sadie Brown from the original (published in Paris, 1934). Seattle: University of Washington Press, 1962.

Gasparini, Graziano, and Luise Margolies. *Inca Architecture*. Bloomington, IN: Indiana University Press, 1980.

Emmerich, André. *Art of Ancient Peru*. New York: André Emmerich Gallery, 1969.

McIntyre, Loren. "Lost Empire of the Incas," *National Geographic*, vol. 144, no. 6, December 1973, pp. 729–87.

Mason, J. Alden. *The Ancient Civilizations of Peru*. Baltimore: Penguin, 1957.

Minelli, Laura Laurencich, ed. *The Inca World: The Development of Pre-Columbian Peru*, A.D. 1000–1534. Norman, OK: University of Oklahoma Press, 2000. First published in Milan in 1992.

Morris, Craig, and Adriana von Hagen. *The Inka Empire and Its Andean Origins*. New York: Abbeville, 1983. Publication sponsored by the American Museum of Natural History.

Peternosto, César. *The Stone and the Thread: Andean Roots of Abstract Art*. Austin, TX: University of Texas Press, 1996.

Reid, James W. *Textile Masterpieces of Ancient Peru*. New York: Dover, 1986.

Stone-Miller, Rebecca, et al. *To Weave for the Sun: Ancient Andean Textiles in the Museum of Fine Arts, Boston*. New York: Thames and Hudson, 1992.

Treasures of Peruvian Gold. Washington, DC: National Gallery of Art et al., 1965. Catalog of an exhibition of a hundred objects in gold.

Von Hagen, Adriana. "Ancient Art of the Andes," *Art and Antiques*, May 1977, pp. 82–89.

THE NATIVE NORTH AMERICANS

Amsden, Charles Avery. *Navajo Weaving, Its Technic and History*. Mineola, NY: Dover, 1991. Reprint of a 1934 original.

Appleton, Le Roy H. *American Indian Design and Decoration*. Mineola, NY: Dover, 1971. First published by Scribner's in 1950 as *Indian Art of the Americas*.

Berlant, Tony, et al. *Mimbres Pottery: Ancient Art of the American Southwest*. New York: Hudson Hills Press, 1983. Catalog of an exhibition organized by the American Federation of Arts.

Covarrubias, Miguel. *The Eagle, the Jaguar, and the Serpent: Indian Art of the Americas —North America: Alaska, Canada, the United States*. New York: Knopf, 1954; reprint, 1967. Illustrated by the author, a prominent Mexican artist and muralist (1904–57).

Dillingham, Rick. *Acoma and Laguna Pottery*. Santa Fe, NM: School of American Research Press, 1992.

Dockstader, Frederick J. *Indian Art in America: The Arts and Crafts of the North American Indian*. Greenwich: CT: New York Graphic Society, 1966.

———. *Indian Art of the Americas*. New York: Museum of the American Indian, 1973.

———. *Weaving Arts of the North American Indian*. New York: Thomas Y. Crowell, 1978.

Douglas, Frederic H., and René D'Harnoncourt. *Indian Art of the United States*. New York: Museum of Modern Art, 1941; reprint, 1970. This catalog of an exhibition at MoMA is the first comprehensive treatment of native North American art history.

Evans, Glen L., and T. N. Campbell. *Indian Baskets*. Austin, TX: Texas Memorial Museum, 1952.

Feder, Norman. *Two Hundred Years of North American Indian Art*. New York: Praeger, 1971, published in association with the Whitney Museum of American Art.

Feest, Christian F. *Native Arts of North America*. New York: Oxford University Press, 1980.

Friedman, Martin, et al. *American Indian Art: Form and Tradition*. New York: E. P. Dutton, 1972. Catalog of an exhibition at the Walker Art Center, Minneapolis.

Harlow, Francis H. *Historic Pueblo Indian Pottery*. Santa Fe, NM: Museum of New Mexico Press, 1970.

James, George Wharton. *Indian Basketry*. Pasadena CA: privately printed, 1902; reprint, New York: Dover, 1972.

Mason, Otis Tufton. *Aboriginal Indian Basketry*. Mineola, NY: Dover, 1988. Reprint of a book first published in 1902 by the Smithsonian Institution.

Nabokov, Peter, and Robert Easton. *Native American Architecture*. New York: Oxford University Press, 1989.

Naylor, Maria, ed. *Authentic Indian Designs*. Mineola, NY: Dover, 1975.

Penney, David W. *Art of the American Indian Frontier*. Seattle: University of Washington Press, 1992.

Scully, Vincent. *Pueblo: Mountain, Village, Dance*, New York: Viking, 1975.

Tanner, Clara Lee. *Apache Indian Baskets*. Tucson: University of Arizona Press, 1982.

———. *Indian Baskets of the Southwest*. Tucson: University of Arizona Press, 1983.

———. *Southwest Indian Craft Arts*. Tucson: University of Arizona Press, 1968.

———. ed. *Indian Arts and Crafts*. Phoenix: Arizona Highways, 1976. Jane Turner, ed.

Various authors. "Native North American Art." In *Dictionary of Art*, pp. 541–679, col. 22. New York: Grove's, 1996.

Whiteford, Andrew Hunter. *Southwestern Indian Baskets, Their History and Their Makers*. Santa Fe, NM: School of American Research Press, 1988.

PRE-COLUMBIAN AMERICA

Covarrubias, Miguel. *Indian Art of Mexico and Central America*. New York: Knopf, 1957; reprint, 1971. Illustrated by the author.

Disselhoff, H. D., and S. Linné. *The Art of Ancient America: Civilizations of Central and South America*, Art of the World series. New York: Crown, 1960.

Emmerich, André. *Art before Columbus*. New York: Simon and Schuster, 1963. Photographs by Lee Boltin. An appreciative view of early Mexican cultures by a prominent New York gallery owner. The Emmerich Gallery has also published the catalogs *Abstract Art before Columbus* (1957) and *Sweat of the Sun and Tears of the Moon: Gold and Silver in Pre-Columbian Art* (1984).

Hardoy, Jorge Ferrari. *Pre-Columbian Cities*. New York: Walker, 1973. The author is an architect who worked in Le Corbusier's Paris studio and for whom the Hardoy (or "sling" or "butterfly") chair is named.

Krichman, Michael, and Eva Ungar Grudin. *Ancient American Art: An Aesthetic View*. Boston: Triad Press, 1981. Catalog for an exhibition at the Rose Art Museum, Brandeis University.

Kubler, George. *The Art and Architecture of Ancient America: The Mexican, Maya, and Andean Peoples*. Harmondsworth, England: Penguin, 1962; reissued by Yale University Press, 1993. An authoritative account, beautifully written.

Miller, Mary Ellen. *The Art of Mesoamerica from Olmec to Aztec*. New York: Thames and Hudson, 1986. Revised 1996 in the World of Art series.

Paz, Octavio. *Essays on Mexican Art*. New York: Harcourt Brace, 1987. Begins with three essays on pre-Columbian art.

Stierlin, Henri. *Ancient Mexico*, Living Architecture series. New York: Grosset and Dunlap, 1968. Illustrated with striking photographs by the author.

Townsend, Richard F., ed. *The Ancient Americas: Art from Sacred Landscapes*. Chicago: Art Institute of Chicago, 1992. Includes an extensive bibliography.

Various authors. "South America, Pre-Columbian. In *Dictionary of Art*, pp. 123–224, vol. 29. New York: Macmillan, 1996.

Various authors. "Mesoamerica, Pre-Columbian." In *Dictionary of Art*, pp. 177–266, vol. 21. New York: Macmillan, 1996.

Von Hagen, Victor Wolfgang. *The Ancient Sun Kingdoms of the Americas: Aztec, Maya, Inca*. Cleveland and New York: World, 1957.

CHAPTER 18 The Europeans in North America (Sixteenth to Eighteenth Centuries)

Brazer, Esther Stevens. *Early American Decoration: 1940; A Comprehensive Treatise Revealing the Technique Involved in the Art of Early American Decoration of Furniture, Walls, Tinware, etc*, limited ed.,1940; reprint, Springfield, MA: Pond-Ekberg, 1947.

Davidson, Marshall B. *The American Heritage History of Notable American Houses*. New York: American Heritage Division of Mc-Graw-Hill, 1971.

Drepperd, Carl W. *Primer of American Antiques*. Garden City, NY: Doubleday, 1944. Seventy-two brief chapters, each on a different aspect of American decorative arts: weather vanes, firebacks, pressed glass, mirrors, rugs, pewter, scrimshaw, buttons, samplers, and so on. Still a useful book.

——— and Lurelle Van Arsdale Guild. *New Geography of American Antiques*. Garden City, NY: Doubleday, 1948.

Dyer, Walter A. *Early American Craftsmen*. New York: Century, 1915. Chapters on Paul Revere, Samuel McIntire, the Willards, "Baron" Stiegel, and others.

Hume, Ivor Noël. *A Guide to Artifacts of Colonial America*. New York: Knopf, 1970.

Kettell, Russell Hawes, ed. *Early American Rooms*. Portland, ME: Southworth-Athoensen, 1936; reprint New York: Dover, 1967.

Neuerburg, Norman. *The Decoration of the California Missions*. Santa Barbara: Bellerophon, 1996.

Peterson, Harold L. *American Interiors from Colonial Times to the Late Victorians*. New York: Scribner's, 1979. Interiors seen in paintings, drawings, needlework, advertisements, and so on.

Quimby, Ian M. G., ed. *The Craftsman in Early America*. New York: W. W. Norton, for the Henry Francis du Pont Winterthur Museum, 1984.

Schwartz, Marvin D. *American Interiors 1675–1885*. Brooklyn, NY: , Brooklyn Museum, 1968. This guide to the museum's American period rooms has been superseded in part by a 1983 guide by Donald C. Pierce and Hope Alswang, also published by the museum, but both books are of interest.

ARCHITECTURE IN COLONIZED NORTH AMERICA

Fitch, James Marston. *American Building: The Historical Forces That Shaped It*. Boston: Houghton Mifflin, 1947; rev. ed., 1966.

Gowans, Alan. *Images of American Living: Four Centuries of Architecture and Furniture as Cultural Expression*. Philadelphia: J. B. Lippincott, 1964.

Kennedy, Roger G. *Arcitecture, Men, Women, and Money in America 1600–1860*. New York: Random House, 1985.

Morrison, Hugh. *Early American Architecture from the First Colonial Settlements to the National Period*. New York: Oxford University Press, 1952.

Pierson, William H., Jr. *American Buildings and their Architects: The Colonial and Neo-Classical Styles*. Garden City, NY: Doubleday, 1970.

Pratt, Dorothy, and Richard Pratt. *A Guide to Early American Homes: North and South*. New York: Bonanza, 1956. A combined edition of the original two volumes.

Waterman, Thomas T. *The Dwellings of Colonial America*. Chapel Hill, NC: University of North Carolina Press, 1950.

WESTOVER

Lane, Mills. *Architecture of the Old South: Virginia*. Savanna, GA: Beehive Press, 1987.

Waterman, Thomas T. *The Mansions of Virginia, 1706–1776*. Chapel Hill: University of North Carolina Press, 1946.

———, and John A. Barrows. *Domestic Colonial Architecture of Tidewater Virginia*. New York: Scribner's, 1932; reprint, New York: Dover, 1969. With scale drawings of the exterior facades.

MONTICELLO

Adams, William Howard. *Jefferson's Monticello*. New York: Abbeville, 1983.

Kimball, Fiske. *Thomas Jefferson, Architect*. Cambridge, MA: Riverside Press, 1916; reprint, New York: Da Capo, 1968. A pioneering study.

McLaughlin, Jack. *Jefferson and Monticello, the Biography of a Builder*. New York: Henry Holt, 1988.

THE WHITE HOUSE

Kimball, Marie. "The Original Furnishings of the White House," *Antiques*, no. 15 (June–July 1929), pp. 481–86; no. 16 (July 1929), pp. 33–37.

Monkman, Betty C. *The White House, Its Historic Furnishings and First Families*. New York: Abbeville, 2000.

Ryan, William, and Desmond Guinness. *The White House, An Architectural History*. New York: McGraw-Hill, 1980.

Seale, William. *The President's House*, 2 vols. Washington, DC: White House Historical Association, 1986.

———. *The White House: The History of an American Idea*. Washington, DC: American Institute of Architects Press, 1992.

FURNITURE

Bishop, Robert. *Centuries and Styles of the American Chair, 1640–1970*. New York: E. P. Dutton, 1972.

Bjerkoe, Ethel Hall. *The Cabinetmakers of America*. New York: Doubleday, 1957.

Comstock, Helen. *American Furniture, Seventeenth, Eighteenth, and Nineteenth Century Styles*. New York: Viking, 1962.

Evans, Nancy Goyne. *American Windsor Chairs*. New York: Hudson Hills Press, in association with the Henry Francis du Pont Winterthur Museum, 1996. An authoritative study.

Fitzgerald, Oscar P. *Four Centuries of American Furniture*. Radnor, PA: Wallace-Homestead, 1995. An enlarged edition of Fitzgerald, *Three Centuries of American Furniture* (Englewood Cliffs, NJ: Prentice-Hall, 1982).

Forman, Benno M. *American Seating Furniture 1630–1730*. New York: W. W. Norton, 1988. A Winterthur book.

Greene, Jeffrey P. *American Furniture of the Eighteenth Century: History, Technique, Structure*. Newtown, CT: Taunton, 1996.

Heckscher, Morrison. *American Furniture in the Metropolitan Museum of Art, Late Colonial Period: The Queen Anne and Chippendale Styles*. New York: Metropolitan Museum of Art and Random House, 1985. Two other volumes are planned.

Iverson, Marion Day. *The American Chair 1630–1890*. New York: Hastings House, 1957.

Kirk, John T. *American Chairs: Queen Anne and Chippendale*. New York: Knopf, 1972.

———. *Early American Furniture*. New York: Knopf, 1970.

Lockwood, Luke Vincent. *Colonial Furniture in America*. New York: Scribner's, 1951.

Lyon, Irving W. *The Colonial Furniture of New England*. New York: E. P. Dutton, 1977.

Madigan, Mary Jean, and Susan Colgan, eds. *Early American Furniture from Settlement to City*. New York: *Art and Antiques* Magazine, 1983. Excellent essays include "Country Chippendale" by Marvin D. Schwartz and "The Kast and the Schrank" by Joseph T. Butler.

Margon, Lester. *Masterpieces of American Furniture, 1620–1840*. New York: Architectural Book Publishing, 1965; reprint 1972.

Nagel, Charles. *American Furniture 1650–1850*. New York: Chanticleer, 1949.

Nutting, Wallace. *Furniture of the Pilgrim Century (of American Origin) 1620–1720*, 2 vols. New York: Dover, 1965. Reprint of a pioneering study first published in 1924.

Ormsbee, Thomas Hamilton. *Early American Furniture Makers*. New York: Thomas Y. Crowell, 1930; republished Detroit: Gale Research, 1976.

———. *The Windsor Chair*. Deerfield Books, distributed by Hearthside, New York, 1962. Despite the general title, the subject is American Windsors.

Ward, Gerald W. R., ed. *Perspectives on American Furniture*. New York: W. W. Norton, 1988. A collection of scholarly essays published for the Henry Francis du Pont Winterthur Museum.

SHAKER FURNITURE AND INTERIORS

Andrews, Edward Deming, and Faith Andrews. *Shaker Furniture The Craftsmanship of an American Communal Sect*. New Haven, CT: Yale University Press, 1937; reprint, New York: Dover, 1964. A pioneering study.

Becksvoort, Christian. *The Shaker Legacy: Perspectives on an Enduring Furniture Style*. Newtown, CT: Taunton, 1998.

Kindred Spirits: The Eloquence of Function in American Shaker and Japanese Arts of Daily Life. San Diego: Mingei International, 1995, distributed by the University of Washington Press, Seattle. Catalog of a fascinating exhibition comparing Japanese and Shaker pottery, baskets, chests, and so forth.

Kirk, John T. *The Shaker World: Art, Life, Belief*. New York: Abrams, 1997.

Meader, Robert F. W. *Illustrated Guide to Shaker Furniture*. New York: Dover, 1972.

Nicoletta, Julie. *The Architecture of the Shakers*. Woodstock, VT: Countryman Press, 1995.

Sprigg, June, and Paul Rocheleau. *Shaker Built, the Form and Function of Shaker Architecture*. New York: Monacelli, 1994.

———, and David Larkin. *Shaker: Life, Work, and Art*. New York: Stewart, Tabori, and Chang, 1987.

SAMUEL MCINTIRE

Kimball, Fiske. *Mr. Samuel McIntire, Carver: The Architect of Salem*. Salem, MA: Essex Institute, 1940; reprint Gloucester, MA: Peter Smith, 1966.

DUNCAN PHYFE

McClelland, Nancy. *Duncan Phyfe and the English Regency*. New York: William R. Scott, 1939; Reprint, Mineola, NY: Dover 1980.

CLOCKS

Drepperd, Carl W. *American Clocks and Clockmakers*. Boston: Charles T. Branford, 1958. An enlarged edition of a book first published in 1947.

METALWORK

Colonial Silversmiths, Masters & Apprentices. Boston Museum of Fine Arts, 1956.

Ward, Barbara McLean. "Boston Goldsmiths." In *The Craftsman in Early America*, ed. Ian M. G. Quimby. New York: W. W. Norton, 1984.

TEXTILES

Cooke, Edward S., Jr., ed. *Upholstery in America and Europe from the Seventeenth Century to World War I*. New York: W. W. Norton, 1987.

Cummings, Abbott Lowell. *Bed Hangings: A Treatise on Fabrics and Styles in the Curtaining of Beds, 1650–1850*. Boston: Society for the Preservation of New England Antiquities, 1994. Includes an essay by Nina Fletcher Little.

Hughes, Robert, and Julie Silber. *Amish: The Art of the Quilt*. New York: Knopf, 1990.

Little, Frances. *Early American Textiles*. New York: Century, 1931.

Montgomery, Florence M. *Textiles in America 1650–1870*. New York: W. W. Norton, 1984.

Peck, Amelia. *American Quilts and Coverlets in the Metropolitan Museum of Art*. New York: Metropolitan Museum of Art and Dutton Studio, 1990.

CERAMICS

Susan H. Myers. "The Business of Potting, 1780–1840." In *The Craftsman in Early America*, ed. Ian M. G. Quimby. New York: W. W. Norton, 1984.

Watkins, Lura Woodside. *Early New England Potters and Their Wares*. Cambridge, MA: Harvard University Press, 1950.

GLASS

Hunter, Frederick William. *Stiegel Glass.* Boston: Houghton Mifflin, 1914. A book that started a craze for Stiegel products; some of its attributions are now thought to have been overly generous.

McKearin. George S., and Helen McKearin. *American Glass.* New York: Crown, 1941.

Schwind, Arlene Palmer. "The Glassmakers of Early America." In *The Craftsman in Early America*, ed. Ian M. G. Quimby. New York: W. W. Norton, 19 84.

WALLPAPER, WALL PAINTING, AND STENCILS

Little, Nina Fletcher. *American Decorative Wall Painting 1700–1850* New York: E. P. Dutton, 1989. An enlarged edition of a book first published in 1952.

Lynn, Catherine. *Wallpaper in America from the Seventeenth Century to World War I.* New York: W. W. Norton, 1980.

Waring, Janet. *Early American Wall Stencils.* New York: W. R. Scott, 1943. First published in 1937 in a limited edition of copies as *Early American Stencils on Walls and Furniture.*

CHAPTER 19 The Nineteenth Century

TECHNOLOGY AS CATALYST

Art and Design in Europe and America 1800–1900 at the Victoria and Albert Museum. London: The Herbert Press, 1987.

Barzun, Jacques. *Classic, Romantic, and Modern.* Garden City, NY: Doubleday, 1961. First published in 1943 in Boston by Little, Brown as *Romanticism and the Modern Ego.*

Bishop, Robert, and Priscilla Coblentz. *The World of Antiques, Art, and Architecture in Victorian America.* New York: E. P. Dutton, 1979.

Butler, Joseph T. *American Antiques 1800–1900.* New York: Odyssey Press, 1965.

Cowan, Henry J. *An Historical Outline of Architectural Science.* Amsterdam: Elsevier, 1966. Includes some topics, such as heating and lighting, that affect interiors.

Giedion, Siegfried. *Mechanization Takes Command.* New York: Oxford University Press, 1948.

Kouwenhoven, John A. *Made in America: The Arts in Modern Civilization.* 1948. Garden City, NY: Doubleday, 1962.

Marx, Leo. *The Machine in the Garden: Technology and the Pastoral Ideal in America.* New York: Oxford University Press, 1964

Quimby, Ian M. G., and Polly Anne Earl. *Technological Innovation and the Decorative Arts.* Charlottesville, VA: University Press of Virginia, 1974, 1984. Papers from a 1973 Winterthur conference, with subjects including wallpaper, textiles, pressed glass, and John Henry Belter.

Schaefer, Herwin. *Nineteenth-Century Modern: The Functional Tradition in Victorian Design.* New York: Praeger, 1970.

Townsend, Gavin. "Airborne Toxins and the American House, 1865–1895," *Winterthur Portfolio,* vol. 24, no. 1, Spring 1989, pp. 29–42.

Tracy, Berry, et al. *Nineteenth-Century America: Furniture and Other Decorative Arts.* New York: The Metropolitan Museum of Art, 1970.

Wainwright, Clive. *The Romantic Interior: The British Collector at Home 1750–1850.* New Haven, CT: Yale University Press, 1989.

THE SCIENCE OF DESIGN: COLOR THEORY

Albers, Josef. *Interaction of Color.* New Haven, CT: Yale University Press, 1963. Instructive thoughts about color by the Bauhaus painter. An abridged version without the many color plates of the original was published by Yale in 1971.

Birren, Faber. *Color: A Survey in Words and Pictures from Ancient Mysticism to Modern Science,* Secaucus, NJ: Citadel, 1963. A prolific writer about color, Birren was a follower of color theorist Wilhelm Ostwald.

———. *Color and Human Response.* New York: Van Nostrand Reinhold, 1984.

———. *Color for Interiors, Historic and Modern.* New York. Whitney Library of Design, 1963.

Gage, John. *Color and Culture: Practice and Meaning from Antiquity to Abstraction.* Boston: Little, Brown, 1993.

Itten, Johannes. *The Art of Color,* New York: Van Nostrand Reinhold, 1961.

Kuehni, Rolf G. *Color: An Introduction to Practice and Principles.* New York: John Wiley, 1997.

Mahnke, Frank H., and Rudolph H. Mahnke. *Color and Light in Manmade Environments.* New York: Van Nostrand Reinhold, 1987.

Munsell, Albert. *A Color Notation.* Baltimore: Munsell Color Co., 1929. Reprint of Munsell's original 1905 publication.

Pile, John F. *Color in Interior Design.* New York: McGraw-Hill, 1997.

Wittgenstein, Ludwig. *Remarks on Colour,* ed. G. E. M. Anscombe. Berkeley: University of California Press, 1977. Provocative thoughts about color from the modern philosopher.

PUBLICATIONS AS STIMULANTS

Cook, Clarence. *The House Beautiful: Essays on Beds and Tables, Stools and Candlesticks.* New York: Scribner's, 1881; reprint, New York: Dover, 1995.

Eastlake, Charles L. *Hints on Household Taste.* London: Longmans, Green, 1868; reprint, New York: Dover, 1986.

Fitch, James Marston. *Architecture and the Esthetics of Plenty.* New York; Columbia University Press, 1961. Includes a good description of Catharine Beecher's writings.

THE NEOCLASSICAL STYLES

Honour, Hugh. *Neoclassicism.* Harmondsworth, England: Penguin, 1968.

Praz, Mario. *On Neoclassicism.* London: Thames and Hudson, 1969.

THE EMPIRE STYLE IN FRANCE

Grandjean, Serge. *Empire Furniture, 1800 to 1825.* London: Faber; New York: Taplinger, 1966.

Percier, Charles, and Pierre-François-Léonard Fontaine. *Recueil de decorations intérieures, comprenant tout ce qui a Rapport à ameublement.* Paris 1801, 1812, translated as *Empire Stylebook of Interior Design,* New York: Dover, 1991.

THE REGENCY STYLE IN ENGLAND AND AMERICA

Cornelius, Charles Over. *Furniture Masterpieces of Duncan Phyfe.* New York: Doubleday, Page, and Co. for the Metropolitan Museum of Art, 1922; reprint, New York: Dover, 1970.

Hope, Thomas. *Household Furniture and Interior Decoration.* London: Longman, Hurst, Rees, and Orme, 1807; reprint, New York: Dover, 1971. A later Dover reprint changed the title to *Regency Furniture and Interior Decoration.*

Morley, John. *Regency Design 1790–1840: Gardens, Buildings, Interiors, Furniture.* New York: Abrams, 1993.

Parissien, Steven. *Regency Style.* Washington, DC: Preservation Press, 1992.

Pilcher, Donald. *The Regency Style 1800 to 1830.* London and New York: B. T. Batsford, 1948.

Reilly, Paul. *Introduction to Regency Architecture.* London: Art and Technics, 1948.

Watkin, David. *The Royal Interiors of Regency England.* New York: Vendome, 1984. Focuses on seven residences: Windsor Castle, Hampton Court, St. James's Palace, Kensington Palace, Buckingham House, Frogmore House, and Carlton House.

JOHN NASH

Davis, Terence. *John Nash, the Prince Regent's Architect.* South Brunswick, NJ: A. S. Barnes, 1967.

Summerson, John. *The Life and Work of John Nash, Architect.* Cambridge, MA: MIT Press, 1980. Summerson's revised version of his own pioneering *John Nash: Architect to King George the Fourth,* published in 1935.

JOHN SOANE

Darley, Gillian. *John Soane, An Accidental Romantic.* New Haven, CT: Yale University Press, 1999.

du Prey, Pierre de la Ruffinière. *John Soane, the Making of an Architect.* Chicago: University of Chicago Press, 1982.

Richardson, Margaret, and Mary Anne Stevens, eds. *John Soane, Architect: Master of Space and Light.* London: Royal Academy of Arts, 1999.

Stroud, Dorothy. *Sir John Soane, Architect.* London: Faber and Faber, 1984.

THE FEDERAL STYLE IN AMERICA

Kenny, Peter M., et al. *Honoré Lannuier, Cabinetmaker from Paris.* New York: Metropolitan Museum of Art, 1998. Exhibition catalog.

Montgomery, Charles F. *American Furniture: The Federal Period (1788–1825).* New York: Viking, 1966.

KARL FRIEDRICH SCHINKEL

Schinkel, Karl Friedrich. *Sammlung Architektonischer Entwürfe* (Collection of Architectural Drawings). Berlin, 1866; reprint, New York: Princeton Architectural Press, 1989.

Snodin, Michael. *Karl Friedrich Schinkel, a Universal Man.* New Haven, CT: Yale University Press in association with the Victoria and Albert Museum, London, 1991.

Zukowshy, John, ed. *Karl Friedrich Schinkel 1781–1841: The Drama of Architecture.* Chicago: The Art Institute of Chicago, 1994.

THE BIEDERMEIER STYLE

Himmelheber, Georg. *Biedermeier Furniture.* London: Faber and Faber, 1974.

THE GUSTAVIAN STYLE IN SWEDEN AND NEOCLASSICISM IN THE NORTH

Groth, Håkan. *Neoclassicism in the North: Swedish Furniture and Interiors, 1770–1850.* London: Thames and Hudson; New York: Rizzoli, 1990.

Turner, Paul V. *Joseph Ramée, International Architect of the Revolutionary Era.* Cambridge, England and New York: Cambridge University Press and the Architectural History Foundation, 1996.

THE GOTHIC REVIVAL

Addison, Agnes. *Romanticism and the Gothic Revival.* New York: Gordian, 1967. The author also wrote under the name Agnes Gilchrist.

Clark, Kenneth. *The Gothic Revival.* London: Constable, 1928; reprint, London: John Murray, 1962.

Hersey, George L. *High Victorian Gothic: A Study in Associationism.* Baltimore: Johns Hopkins University Press, 1972.

Pugin, A. W. N. *An Apology for the Revival of Christian Architecture.* London: J. Weale, 1843; reprint, Frome, Somerset: Butler and Tanner, 1969.

Riding, Jacqueline, and Christine Riding, eds. *The Houses of Parliament: History, Art, Architecture.* London: Merrell, 2000.

THE GREEK REVIVAL

Cooper, Wendy A. *Classical Taste in America 1800–1840.* New York: Abbeville, 1993.

Crook, J. Mordaunt *The Greek Revival.* London: John Murray. 1972.

Tracy, Berry B., et al. *Classical America 1815–1845.* Newark, NJ: Newark Museum Association, 1963. Exhibition catalog.

Tsigakou, Fani-Maria. *The Rediscovery of Greece: Travellers and Painters of the Romantic Era.* New Rochelle, NY: Caratzas Brothers, 1981.

THE EGYPTIAN REVIVAL

Curl, James Stevens. *The Egyptian Revival: An Introductory Study of a Recurring Theme in the History of Taste.* London: George Allen and Unwin, 1982.

Egyptomania: Egypt in Western Art 1730–1930. Ottawa: National Gallery of Canada, 1994. Catalog of an exhibition at the Louvre, Paris, and the National Gallery of Canada, Ottawa.

The Renaissance Revival

Howe, Katherine S., et al. *Herter Brothers: Furniture and Interiors for a Gilded Age.* New York: Abrams, in association with The Museum of Fine Arts, Houston, 1994.

Schwartz, Marvin D., Edward J. Stanek, and Douglas K. True. *The Furniture of John Henry Belter and the Rococo Revival.* New York: E. P. Dutton, 1981.

Shopsin, William C., and Mosette Glaser Broderick. *The Villard Houses.* New York: Viking, 1980.

The Anglo-Indian Style

Head, Raymond. *The Indian Style.* Chicago: University of Chicago Press, 1986. Traces the influence of India on European design from the seventeenth century to the present.

Morley, John. *The Making of the Royal Pavilion, Brighton: Designs and Drawings.* Boston: David R. Godine, 1984.

Far Eastern Styles

Wichmann, Siegfried. *Japonisme: The Japanese Influence on Western Art since 1858.* New York: Thames and Hudson, 1999.

The Arts and Crafts Movement

Anscombe, Isabelle. *Arts and Crafts Style.* New York: Rizzoli, 1991.

Kaplan, Wendy. *"The Art That Is Life": The Arts and Crafts Movement in America, 1875–1920.* Boston: Museum of Fine Arts, 1987. Catalog of an exhibition in Boston, Los Angeles, Detroit, and New York.

———, and Elizabeth Cumming. *The Arts and Crafts Movement.* London: Thames and Hudson, 1991.

The Aesthetic Movement

Lambourne, Lionel. *The Aesthetic Movement.* London: Phaidon, 1996.

Merrill, Linda. *The Peacock Room: A Cultural Biography.* New Haven, CT, and Washington, DC: Yale University Press and the Freer Gallery of Art, 1998.

Spencer, Robin. *The Aesthetic Movement: Theory and Practice.* London and New York: Studio Vista/Dutton, 1972.

Art Nouveau

Bing, SamueL. *Artistic America, Tiffany Glass, and Art Nouveau.* Cambridge, MA: MIT Press, 1970. Reprint of four essays by the influential Parisian art dealer.

Bouillon, Jean-Paul. *Art Nouveau 1870–1914.* Geneva and New York: Skira/Rizzoli, 1985.

Escritt, Stephen. *Art Nouveau.* Art and Ideas series. London: Phaidon, 2000.

Madsen, S. Tschudi. *Art Nouveau.* New York: McGraw-Hill, 1967.

Selz, Peter, and Mildred Constantine, eds. *Art Nouveau: Art and Design at the Turn of the Century.* New York: The Museum of Modern Art, 1959. Catalog of an exhibition that opened at MoMA in 1960. A revised edition appeared in 1975.

Louis Comfort Tiffany and the Associated Artists

Faude, Wilson H. "Associated Artists and the American Renaissance in the Decorative Arts." In *Winterthur Portfolio 10,* ed. Ian M. G. Quimby. Charlottesville, VA: University Press of Virginia, 1975.

Kaufmann, Edgar, jr. "At Home with Louis C. Tiffany." *Interiors,* December 1957, pp. 120ff.

———. "Tiffany, Then and Now." *Interiors,* February 1955, pp. 83ff.

Koch, Robert. *Louis C. Tiffany, Rebel in Glass.* New York: Crown, 1964.

Antoní Gaudi

Collins, George R. *Antonio Gaudi.* New York: Braziller, 1960.

Dalisi, Riccardo. *Gaudi: Furniture and Objects.* Woodbury, NY: Barron's, 1980.

Sweeney, James Johnson, and Josep Lluís Sert. *Antoni Gaudi.* New York: Praeger, 1960.

Charles Rennie Mackintosh

Alison, Filippo. *Charles Rennie Mackintosh as a Designer of Chairs.* Woodbury, NY: Barron's, 1977.

Bilcliffe, Roger. *Charles Rennie Mackintosh: The Complete Furniture, Furniture Drawings, and Interior Design.* New York: E. P. Dutton, 1986.

Howarth, Thomas. *Charles Rennie Mackintosh and the Modern Movement.* London: Routledge and Kegan Paul, 1952; reprint, 1977.

———. "Charles Rennie Machintosh." In *Macmillan Encyclopedia of Architects,* ed. Adolf K. Placzek. New York: Macmillan 1982.

Kaplan, Wendy. *Charles Rennie Mackintosh.* New York: Abbeville, 1996. Catalog of an exhibition, organized by the Glasgow Museums, that traveled to New York, Chicago, and Los Angeles in 1996 and 1997.

Pevsner, Nikolaus. "Charles Rennie Mackintosh." In *Studies in Art, Architecture, and Design,* ed. N. Pevsner. New York: Walker and Co., 1968. First published in book form by Il Balcone, Milan, in 1950.

Louis Sullivan

Elia, Mario Manieri. *Louis Henry Sullivan.* New York: Princeton Architectural Press, 1996.

Kaufmann, Edgar, jr., ed. *Louis Sullivan and the Architecture of Free Enterprise.* Chicago. The Art Institute of Chicago, 1956. Exhibition catalog.

Pevsner, Nikolaus. *Pioneers of Modern Design: From William Morris to Walter Gropius.* Harmondsworth, England: Penguin, 1974. First published in 1936 as *Pioneers of the Modern Movement.*

Sullivan, Louis Henry. *A System of Architectural Ornament According with a Philosophy of Man's Power.* Washington, DC: American Institute of Architects, 1924.

———. "Ornament in Architecture." *Engineering Magazine,* vol.3. August 1892.

New Furniture Types

Brawer, Nicholas A., *British Campaign Furniture: Elegance Under Canvas, 1740–1914*. New York: Abrams, 2001.

Ferebee, Ann. *A History of Design from the Victorian Era to the Present*. New York: Van Nostrand Reinhold, 1970.

Hanks, David A. *Innovative Furniture in America from 1800 to the Present*. New York: Horizon, 1981.

Newman, Bruce M. *Fantasy Furniture*. New York: Rizzoli, 1989.

Michael Thonet and Bentwood

Ostergard, Derek E. *Bent Wood and Metal Furniture: 1850–1946*. New York: The American Federation of Arts, 1987.

von Vegesack, Alexander. *Thonet: Classic Furniture in Bent Wood and Tubublar Steel*. New York: Rizzoli, 1997.

Wilk, Christopher. *Thonet: 150 Years of Furniture*. Woodbury, NY: Barron's, 1980.

John Henry Belter and Laminated Wood

Schwartz, Marvin D., Edward J. Stanek, and Douglas K. True. *The Furniture of John Henry Belter and the Rococo Revival*. New York: E. P. Dutton, 1981.

Spring Upholstery

Cooke, Edward S., Jr., and Andrew Passeri. "Spring Seats of the Nineteenth and Early-Twentieth Centuries." In *Upholstery in America and Europe from the Seventeenth Century to World War I*, ed. Edward S. Cooke, Jr. New York: W. W. Norton, 1987.

Edwards, Clive D. "Upholstery." In *Encyclopedia of Interior Design*. ed. Joanna Banham. London and Chicago: Fitzroy Dearborn, 1997.

New Synthetic Materials

Bradbury, Bruce. "Lincrusta-Walton," p. 250ff, and "Anaglypta and Other Embossed Wallcoverings," p. 255ff. In *The Old-House Journal New Compendium*, ed. Patricia Poore and Clem Labine. Garden City, NY: Doubleday, 1983.

Kaldewei, Gerhard, ed. *Linoleum: History, Design, Architecture, 1882–2000*. Ostfildern-Ruit, Germany: Hatje Cantz, 2000.

Simpson, Pamela H. *Cheap, Quick, and Easy: Imitative Architectural Materials, 1870–1930*. Knoxville: University of Tennessee Press, 1999.

Textiles

Dornsife, Samuel J. "Design Sources for Nineteenth-Century Window Hangings." In *Winterthur Portfolio 10*, ed. Ian M. G. Quimby, Charlottesville, VA: University Press of Virginia, 1975.

Wallpaper

Cuadrado, John A. "Nineteeth-Century French Wallpaper." *Architectural Digest*, vol. 52, no. 10, October 1995, pp. 162ff.

Hoskinsk, Lesley. *The Papered Wall: History, Pattern, Technique*. London and New York: Thames and Hudson and Abrams, 1994.

Chapter 20 The Twentieth Century

Pile, John F. *Interior Design*, 2nd ed. New York: Abrams, 1995.

Riggs, J. Rosemary. *Materials and Components of Interior Architecture*, 4th ed., Englewood Cliffs, NJ: Prentice Hall, 1996. Originally published in 1985 as *Materials and Components of Interior Design*.

Tate, Allen, and C. Ray Smith. *Interior Design in the Twentieth Century*. New York: Harper & Row, 1986.

The Roots of Modernism

Banham, Reyner. *Theory and Design in the First Machine Age*. New York: Praeger, 1960.

Blake, Peter. *The Master Builders*. New York: Knopf, 1964. Still the most readable account of the work of Frank Lloyd Wright, Le Corbusier, and Ludwig Mies van der Rohe.

De Fusco, Renato. *Le Corbusier, Designer: Furniture, 1929*. Woodbury, NY: Barron's 1977.

De Long, David, ed. *Frank Lloyd Wright: Designs for an American Landscape 1922–1932*. New York: Abrams, 1996.

Hanks, David A. *The Decorative Designs of Frank Lloyd Wright*. New York: E. P. Dutton, 1979.

Johnson, Philip. *Mies van der Rohe*. New York: Museum of Modern Art, 1947.

Wilk, Christopher. *Marcel Breuer: Furniture and Interiors*. New York: Museum of Modern Art, 1981.

Wingler, Hans. *The Bauhaus*. Cambridge, MA: MIT Press, 1969.

The Growth of Modernism

Abercrombie, Stanley. *George Nelson: The Design of Modern Design*. Cambridge, MA: MIT Press, 1995.

Clark, Robert Judson, et al. *Design in America: The Cranbrook Vision 1925–1950*. Detroit: Detroit Institute of the Arts; New York: Metropolitan Museum of Art, 1983.

Larrabee, Eric, and Massimo Vignelli. *Knoll Design*. New York: Abrams, 1981.

Neuhart, John, Marilyn Neuhart, and Ray Eames. *Eames Design*. New York: Abrams, 1989

Scandinavian Modern

Hiort, Esbjørn. *Finn Juhl: Furniture, Architecture, Applied Art*. Copenhagen: Danish Architectural Press, 1990.

Kaufmann, Edgar, jr. "Finn Juhl of Copenhagen," *Interiors*, No. 108, 1948, pp. 96–99.

———. "Good Design '51 as Seen by Its Director and by Its Designer," *Interiors*, no. 110, 1951, pp. 100–103.

McFadden, David. *Scandinavian Modern Design*. New York: Abrams, 1982.

Oda, Noritsugu. *Danish Chairs*. San Francisco: Chronicle, 1999.

Pallasmaa, Juhani, ed. *Alvar Aalto Furniture*. Cambridge, MA: MIT Press, 1985.

Plath, Iona. *The Decorative Arts of Sweden*. New York: Scribner's, 1948; reprint, New York: Dover, 1966. Some modern design is included, but the emphasis is on vernacular arts and crafts.

Polster, Bernd. *Design Directory Scandinavia*. New York: Rizzoli, 1999.

Zahle, Erik. *A Treasury of Scandinavian Design*. New York: Golden Press, 1961.

ITALIAN MODERN

Ambasz, Emilio, ed. *Italy: The New Domestic Landscape*. New York: The Museum of Modern Art, 1972.

Neumann, Claudia, *Design Directory Italy*, New York: Rizzoli, 1999.

REACTIONS AGAINST MODERNISM

Collins, Michael. *Towards Post-Modernism: Decorative Arts and Design Since 1851*. Boston: Little, Brown, 1987.

———, and Andreas Papadakis. *Post-Modern Design*. New York: Rizzoli, 1989. Focuses on furniture and decorative objects.

Johnson, Philip, and Mark Wigley. *Deconstructivist Architecture*. New York: Museum of Modern Art, 1988.

Klotz, Heinrich. *The History of Postmodern Architecture*. Cambridge, MA: MIT Press, 1988.

Skurka, Norma, and Oberto Gili. *Underground Interiors: Decorating for Alternative Life Styles*. New York: Quadrangle, 1972.

Smith, C. Ray. *Supermannerism: New Attitudes in Post-Modern Architecture*. New York: E. P. Dutton, 1977.

THE PERSISTENCE OF MODERNISM

Brownlee, David B., and De Long, David G. *Louis I. Kahn: In the Realm of Architecture*. New York: Rizzoli, 1991.

Dal Co, Francesco. *Tadao Ando: Complete Works*. London: Phaidon, 1996.

Kron, Joan, and Suzanne Slesin. *High-Tech*. New York: Clarkson N. Potter, 1978.

Martínez, Antonio Riggem. *Luis Barragán, Mexico's Modern Master, 1902–1988*. New York: Monacelli, 1996.

Siza, Alvaro et al. *Barragán: The Complete Works*. New York: Princeton Architectural Press, 1996.

KITCHEN AND BATHROOM DESIGN

Kira, Alexander. *The Bathroom*. New York: Viking, 1966, 1976. Still an important book, based on research showing the typical bathroom to be, in many ways, inconvenient, unsafe, and unhygienic.

Lupton, Ellen, and J. Abbott Miller. *The Bathroom, the Kitchen, and the Aesthetics of Waste*. New York: Kiosk, distributed by Princeton Architectural Press, 1992.

National Kitchen and Bath Association. *The Essential Bathroom Design Guide*. New York: John Wiley, 1997. Contains 735 pages of standards and dimensions.

———. *The Essential Kitchen Design Guide*. New York: John Wiley, 1996.

RETAIL DESIGN

Din, Rasshied. *New Retail*. London: Conran Octopus, 2000.

Fitoussi, Brigitte. *Showrooms*. New York: Princeton Architectural Press, 1988.

Novak, Adolph. *Store Planning and Design*. New York: Lebhar-Friedman, 1977. Written by a partner in the store-planning firm Copeland, Novak, and Israel, this book includes a large glossary of store-planning terms.

HEALTH CARE DESIGN

Hamilton, D. Kirk. *Unit 2000: Patient Beds for the Future*. Bellaire, TX: Watkins Carter Hamilton, 1993. Proceedings of a symposium on nursing unit design.

Malkin, Jain. *Hospital Interior Architecture*. New York: Van Nostrand Reinhold, 1992. Excellent survey by an outstanding designer in the health care field.

Marberry, Sara O., ed. *Healthcare Design*. New York: John Wiley, 1996.

Nightingale, Florence. *Florence Nightingale's Notes on Nursing*, revised, with additions, ed. Victor Skretkowicz. London: Scutari Press, 1992.

Riley, Terence, and Joseph Abram. *The Filter of Reason: Work of Paul Nelson*. New York: Columbia University and Rizzoli, 1990.

Verderber, Stephen, and David J. Fine. *Healthcare Architecture in an Era of Radical Transformation*. New Haven: Yale University Press, 2000.

OFFICE DESIGN

Albrecht, Donald, and Chrysanthe B. Broikos, eds. *On the Job: Design and the American Office*. New York: Princeton Architectural Press, 2000.

Brandt, Peter B. *Office Design*. New York: Whitney Library of Design, 1992.

Duffy, Francis. *The Changing Workplace*. London: Phaidon, 1992.

———. *The New Office*. London: Conran Octopus, 1997.

Kaufmann, Edgar, jr. "Frank Lloyd Wright." In *Macmillan Encyclopedia of Architects*. Vol. 4, ed. Adolf K. Placzek. New York: Free Press, 1982.

Kleeman, Walter B., Jr., et al. *Interior Design of the Electronic Office: The Comfort and Productivity Payoff*. New York: Van Nostrand Reinhold, 1991.

Lipman, Jonathan. *Frank Lloyd Wright and the Johnson Wax Buildings*. New York: Rizzoli, 1986.

Pile, John. *Open Office Planning: A Handbook for Interior Designers and Architects*. New York: Whitney Library of Design, 1978.

Pulgram, William L., and Richard E. Stonis. *Designing the Automated Office*. New York: Whitney Library of Design, 1978.

Quinan, Jack. *Frank Lloyd Wright's Larkin Building: Myth and Fact*. New York: Architectural History Foundation; Cambridge, MA: MIT Press, 1987.

Saphier, Michael. *Office Planning and Design*. New York: McGraw-Hill, 1968.

Vischer, Jacqueline C. *Environmental Quality in Offices*. New York: Van Nostrand Reinhold, 1990.

Zelinsky, Marilyn. *New Workplaces for New Workstyles*. New York: McGraw-Hill, 1997.

Transportation Design

Maxtone-Graham, John. *The Only Way to Cross.* New York: Macmillan, 1972.

Meeks, Carrol L. V. *The Railroad Station, An Architectural History.* New Haven: Yale University Press, 1956.

Zukowsky, John, ed. *Building for Air Travel.* Munich and New York: Prestel, 1996.

Institutional Design

Newhouse, Victoria. *Towards a New Museum.* New York: Monacelli, 1998.

Universal Design

Editors of *Interior Design* magazine, special issue "Universal Design: Making Interiors Work for Everyone," vol. 63, no. 11, August 1992.

Montuori, Don, ed. *American with Disabilities Act: ADA Compliance Guide.* Washington, DC: Thompson Publishing Group, 1992.

Perry, Lawrence G., ed. *ADA Compliance Guidebook: A Checklist for Your Building.* Washington, DC: Building Owners and Managers Association, 1991.

Furniture

Abercrombie, Stanley. *George Nelson.* Cambridge, MA: MIT Press, 1995.

Caplan, Ralph. *The Design of Herman Miller.* New York: Whitney Library of Design, 1976.

Edwards, Clive D. *Twentieth-Century Furniture: Materials, Manufacture, and Markets.* Manchester, England: Manchester University Press, 1994.

Larrabee, Eric, and Massimo Vignelli. *Knoll Design.* New York: Abrams, 1981.

Steelcase: The First 75 Years. Grand Rapids, MI: Steelcase, Inc., 1987.

Lighting

Abercrombie, Stanley. "Edison Price: His Name Is No Accident," *Architecture Plus*, vol. 1, no. 7, August 1973, pp. 34–43.

Davidsen, Judith. "Light of the World," *Interior Design*, vol. 68, no. 10, August 1997. Discusses differing lighting equipment and standards around the world.

Effron, Edward. *Planning and Designing Lighting.* Boston: Little, Brown, 1986.

Schiler, Marc. *Simplified Design of Building Lighting.* New York: John Wiley, 1992.

Smith, Fran Kellogg, and Fred J. Bertolone. *Bringing Interiors to Light.* New York: Whitney Library of Design, 1986.

Sorcar, Profulla. *Architectural Lighting for Commercial Interiors.* New York: John Wiley, 1987.

Steffy, Gary R. *Lighting the Electronic Office.* New York: Van Nostrand Reinhold, 1995.

Turner, Janet. *Lighting: An Introduction to Light, Lighting, and Light Use.* London: B. T. Batsford, 1994.

Watson, Lee. *Lighting Design Handbook.* New York: McGraw-Hill, 1990.

Mechanical Systems

Banham, Reyner. *The Architecture of the Well-Tempered Environment.* London: The Architectural Press; Chicago: University of Chicago Press, 1969.

Cooper, Jerry. "Reducing Radon: A Guide to Ventilating the Naturally Occurring Radioactive Gas." *Interior Design*, vol. 58, no. 4, March 1987.

Fitch, James Marston, with William Bobenhausen. *American Building: The Environmental Forces That Shape It.* New York: Oxford University Press, 1999. Updating of the book written by Fitch alone and published in 1972.

Giedion, Sigfried. *Mechanization Takes Command.* New York: Oxford University Press, 1948.

Ingels, Margaret. *Willis Carrier, Father of Air-conditioning.* Garden City, NY: Country Life Press, 1952.

U. S. Environmental Protection Agency, Indoor Air Division. "A Citizen's Guide to Radon: What It Is and What to Do about It." Washington, DC

———. "Radon Reduction Methods." Washington, DC

Acoustics

Beranek, Leo L. *Music, Acoustics, and Architecture.* New York: John Wiley, 1962. The focus is on large halls for music.

Cavanaugh, William J., and Joseph A. Wilkes. *Architectural Acoustics: Principles and Practice.* New York: John Wiley, 1999.

Egan, M. David. *Architectural Acoustics.* New York: McGraw-Hill, 1988.

Plastics

The first two books are readable and informative in a general way:

Bijker, Wiebe E. *Of Bicycles, Bakelites, and Bulbs: Toward a Theory of Sociotechnical Change.* Cambridge, MA: MIT Press, 1997. Essays on the development and cultural effects of the safety bicycle, Bakelite, and the fluorescent lamp.

Sparke, Penny, ed. *The Plastics Age: From Bakelite to Beanbags and Beyond.* Woodstock, NY: Overlook Press, 1993.

These other books give more specific and more technical information about different plastics, their chemical compositions, and their behavior:

Birley, Arthur W. *Plastic Materials: Properties and Applications.* New York: Chapman and Hall, 1988.

Dietz, Albert G. H. *Plastics for Architects and Builders.* Cambridge, MA: MIT Press, 1969.

Dubois, J. Harry, and Frederick W. John. *Plastics.* New York: Van Nostrand Reinhold, 1981.

Fenichell, Stephen. *Plastic: The Making of a Synthetic Century.* New York: Harper Collins, 1996.

Quarmby, Arthur. *Plastics and Architecture.* New York: Praeger, 1974.

Schwartz, Seymour S. *Plastics Materials and Processes.* New York: Van Nostrand Reinhold, 1982

Wood

Edlin, Herbert L. *What Wood Is That? A Manual of Wood Identification.* New York: Viking, 1969.

Forest Products Laboratory, U. S. Department of Agriculture. *The Encyclopedia of Wood*. New York: Sterling, 1980.

Hoadley, R. Bruce. *Understanding Wood*. Newtown, CT: Taunton Press, 1980.

Jackson, Albert, David Day, and Simon Jennings. *The Complete Manual of Woodworking*. New York: Knopf, 1996.

Major, Stephen P. *Architectural Woodwork*. New York: Van Nostrand Reinhold, 1995.

Ostergard, Derek E., ed. *Bent Wood and Metal Furniture 1850–1946*. New York: American Federation of Arts with the University of Washington Press, 1987.

von Vegesack, Alexander. *Thonet: Classic Furniture in Bent Wood and Tubular Steel*. New York: Rizzoli, 1997.

Wilk, Christopher. *Thonet: 150 Years of Furniture*. Woodbury, NY: Barron's, 1980.

PROFESSIONAL AND BUSINESS ISSUES

Analysis of the Interior Design Profession. Washington, DC: National Council for Interior Design Qualification, 1998.

Laiserin, Jerry. "Digital Architect: Emerging Standards for Design Data," *Architectural Record*, October 2000, p.185ff.

Siegel, Harry, with Alan M. Siegel. *A Guide to Business Principles and Practices for Interior Designers*. New York: Watson-Guptill, 1982.

Thompson, Jo Ann Asher. *ASID Professional Practice Manual*. New York: Whitney Library of Design, 1992.

Index

G

Gabriel, Ange-Jacques, 363, 368
Gaines, John, 475
Gallé, Emile, 532, 547
Galleoti, Domenico, 333
Gallery-top tables, 430
Galloway, Elijah, 546
Gamble house, 558, 559
Game tables, 378
Gamio, Manuel, 450
Gandon, James, 511
Gargoyles, 184
Garnier, Charles, 509–510
Garnier, Pierre, 363
Garniture de cheminée, 260, 465
Gasparini, Mattia, 331–333
Gateleg tables, 429–430, 483
Gaudi, Antoní, 536–537
Gauffrage, 345
Gehry, Frank, 577, 593, 603, 604, 625
Gensler, 586, 614
Gentleman and Cabinet-Maker's Director, The
 (Chippendale), 416, 464–465
Geometric patterns
 Indian, 226–228
 Islamic, 199
Geometric period, 53–55
George III, 510
George IV, 510
Georgian style, in America, 464–467
Georgian style, in England
 early, 404–408, 424
 late, 408–413
Gérin, Claude-Humbert, 387
Germany/Germans
 Art Nouveau, 531
 French Rococo, 361–362
 Gothic, 181
 Gothic revival, 519
 Neoclassicism, 514–515
Gerona, cathedral of, 323
Gesso, 30
Ghiaccio, 306
Ghiberti, Lorenzo, 182, 305
Ghirlandaio, Domenico, 290
Giacometti, Diego, 571
Giaquinto, Corrado, 330
Gibbon, Edward, 97
Gibbons, Grinling, 404, 408, 437
Gibbs, James, 470
Gil de Hontañon, Rodrigo, 324
Gilding, 30
Gill, Irving, 558
Gillow, Robert, 414
Gilt bronze, 386–387
Ginori, Carlo, 304
Giotto, 182, 308

Giralda Tower, 322–323
Giraldilo, 323
Girandoles, 438, 496–497
Girard, Alexander, 576, 592, 602, 618
Glaber, Raoul, 166
Glasgow School of Art, 537, 539
Glass
 American, 495–497
 blocks, 614
 cage cups, 126
 cameos, 126
 cast and blown, 125–126
 curtain, 550
 Egyptian, 31–32
 French Renaissance, 389
 Islamic, 213–214
 Italian Renaissance, 306–307
 mold-blown, 126
 19th century, 547
 painted, 126–127
 pressed, 547
 Roman, 125–127
 stained-glass windows, 185–188
 Tiffany, 535–536, 537
 20th century, 613–614
 window, 125, 171
Glaze, 255
Glomi, Jean-Baptiste, 307
Glory of Spain, The (Tiepolo), 330
Glory of the Spanish Monarchy, The (Tiepolo),
 330
Gloucester Cathedral, 159, 177, 180
Gobelins, the, 391
Goddard, John, 477
Goddard family, 477
Godefroid of Huy, Netherlands, 165
Goes, Hugo, 441
Gole, Pierre, 356
Goodison, Benjamin, 414
Gorham, Jabez, 549
Gothic
 architecture, 170–183
 carpets, 171
 cathedral, 173–183
 defined, 169
 divisions of, 180
 English, 180–181
 French, 178–180
 furniture, 190–191
 German, 181
 houses, 170–173
 Italian, 181–183
 ornaments, 183–190
 revival, 518–519
 Spanish, 320–324
 summary of design, 191–193
 Survival, 518
 timeline, 171

*Gothic Architecture, Improved by Rules and
 Proportions* (Langley), 413, 470
Goujon, Jean, 353
Gouthière, Pierre, 386–387
Governor's Palace, Williamsburg, 469
Goya, 331
Graffito, 494
Gragg, Samuel, 475, 544
Grammar of Ornament, The (Jones), 200,
 505, 524
Grandfather clocks, 489
Granello, Nicolás, 326
Graves, Michael, 583
Gray, Eileen, 625
Great hall, 171–172, 398
Great Mosque, Kairouan, Tunisia, 202–203
Great Pyramids of Giza, 14–16
Great Sphinx of Giza, 15, 16–17
Greece/Greek
 Archaic period, 55, 72
 architecture, 58–71
 calendar, 54
 Classical period, 56
 Crete, 48–49
 Dorians, 51–52
 Egyptian influence on, 51
 Fourth Century, 56
 furniture, 75–80
 Geometric period, 53–55
 Hellenic sculpture, 72–74
 Hellenistic period, 56–57, 74–75
 houses, 68–71
 influence of, on the Romans, 94
 influences on the art of, 47–53
 Ionians, 52
 Minoans, 48–49
 Mycenaen, 50–51
 Orientalizing period, 55
 ornaments, 81–84
 Persian influence on, 52
 revival, 519
 Roman and Greek gods and goddesses, 94
 sculpture, 71–75
 summary of design in, 88–91
 temples, 55, 58–68
 timeline, 53
Greek orders, 62–68
 Corinthian, 56, 66
 Doric, 52, 55, 56, 63–65
 Ionic, 52, 56, 65–66
 Roman variations of, 100–103
Greeks, origin of term, 63
Green chair, 482
Greene, Charles Sumner, 558, 559
Greene, Henry Mather, 558, 559
Grès, 257
Gricci, Giuseppe, 331
Griffin, Walter Burley, 558

Nineteenth-century furniture and ornaments, 541
 ceramic and glass, 547
 enamels and lacquer, 547–548
 metalwork, 548–549
 new techniques, 544–545
 new types, 542–544
 synthetic materials, 545–547
 textiles, 549–553
 wallpaper, 553–555
Nineveh, 35, 39, 44
Nippur, 37
Nishi-Honganji temple, 275–276
Noguchi, Isamu, 576
Norman design
 defined, 154
 differences between Romanesque and, 155–156
 revival, 520
Norton, John, 494
Notre Dame, 178
Nusbaum, Jesse, 460
Nylon, 616

O

Obelisks, 17
Oberkampf, Christophe-Philippe, 394
Obrist, Herman, 531
Occupational Safety and Health Administration (OSHA), 599, 600, 625–626
Oculus, 104
Odeum, 106
Odeum of Herodes, 60
Odiot, Jean Baptiste Claude, 548
Oeben, Jean-François, 359, 377, 382, 386
Oecus, 108
Office design, 596–600
Office landscaping, 598
Ogee arch, 314
Ogive, 186
Oilcloth, 494
Oinochoë, 87
Olbrich, Joseph Maria, 532
Old St. Peter's, Rome, 135–136
Old Stone Age, 4–6
Olefins, 616–617
Olmecs, 448–449, 450
Olympic Games, 54–55
Olympieum, 66, 67
Olynthus, 68
Onion dome, 228
Oppenordt, Alexandre-Jean, 356
Opus sectile, 128
Opus vermiculatum, 127–128
Oriental carpets, 217
Orientalizing period, 55
Oriented-strand board (OSB), 621

Ormolu, 386–387
Ornaments
 American, 487–497
 Byzantine, 149–152
 Chinese, 252–264
 Egyptian, 19–20
 English Renaissance, 433–444
 French Renaissance, 385–395
 Gothic, 183–190
 Greek, 81–84
 Indian, 231–232
 Islamic, 199–200, 205–222
 Italian Renaissance, 301–311
 Japanese, 278–281
 Moorish, 316–317
 19th century, 547–555
 Portuguese, 347–348
 Roman, 123–129
 Romanesque, 161, 164–166
 Spanish, 339–347
Ornate/Third Style, 115
Ostvald, Wilhelmn, 505
Ottowas, 459
Oudry, Jean-Baptiste, 391
Ovolo, 81
Owens-Corning, 617

P

Pad foot, 425
Paestum, 55, 56, 63
Pahlmann, William, 585, 592, 594
Painted glass, 126–127
Paintings
 cave, 2, 4–5
 Ch'an (Zen) Buddhism, 251–252
 Egyptian, 27–28
 Gothic, 171
 Italian Renaissance, 287–288
 Japanese, 279–280
 lacquer and Islamic, 207–208
 of Roman walls, 114–116
Paints
 Çatal Hüyük, used in, 7
 Egyptian, 27
 terms for, 625
 20th century, 625–626
Paisley motif, 236–237
Pajama, 235
Palaces
 See also under name of
 Indian, 228–229
 Italian Gothic, 183
 Italian Renaissance, 289–291
 Mesopotamian/Persian, 40
 Minoan, 48–49
 Moorish, 319–320, 321
 Mycenaen, 50–51

Palácio Real, Madrid
 Gasparini Room, 331–333
 Porcelain Room, 331
 Yellow Room, 330–331
Palais Stoclet, 561
Palampores, 234, 440
Palatine Hill, 96
Palazzo Albrizzi, 295
Palazzo del Té, Mantua, 284
Palazzo Ducale, Gubbio, 308
Palazzo Ducale, Urbino, 307–308
Palazzo Farnese, Rome, 284, 291
Palazzo Pitti, Florence, 284
Palazzo Reale, Pórtici, 305
Palazzo Vecchio (Old Palace), Florence, 182, 290–291
Paleolithic period, 4
Palio restaurant, 592
Palissy, Bernard, 388
Palladio, Andrea, 284, 292, 293, 406
Palmer, Thomas J., 546
Palmette, 222
Pantheon, 97, 103–104, 139
Papalera, 337, 338–339
Papier-mâché, 232, 547
Papiers de tapisserie, 390
Papillons, the, 390
Parcel gilt, 438
Pargework, 398
Paris enamels, 256
Parquetry, 385
Parroquia, 322
Parthenon, 52, 56, 59–62, 64, 83, 84, 90
Particleboard, 622
Pashmina, 234
Passementerie, 551
Pastiglia, 300
Patent furniture, 543
Patera, 419
Pawson, John, 586
Paxton, Joseph, 502
Payntell, William, 497
Pazzi Chapel, 283, 284, 303
Peale, Charles Willson, 460
Peche, Dagobert, 561, 562
Pedestal, 102
Pedestal table, 508
Pediments, 58–59
Pei, I. M., 573, 586, 602
Pelike, 87
Pembroke tables, 430
Pendentive, 141, 206
Pennelli, Giovanni, 333
Perchuk, Florence, 589
Percier, Charles, 504, 507–508, 519, 520
Pergamon/Pergamum, 56, 57
Pericles, 59
Peristyle, 109